CARELESS LOVE

Also by Peter Guralnick

LAST TRAIN TO MEMPHIS: The Rise of Elvis Presley

SEARCHING FOR ROBERT JOHNSON

SWEET SOUL MUSIC: Rhythm and Blues and the Southern Dream of Freedom

NIGHTHAWK BLUES

LOST HIGHWAY: Journeys and Arrivals of American Musicians

> FEEL LIKE GOING HOME: Portraits in Blues and Rock 'n' Roll

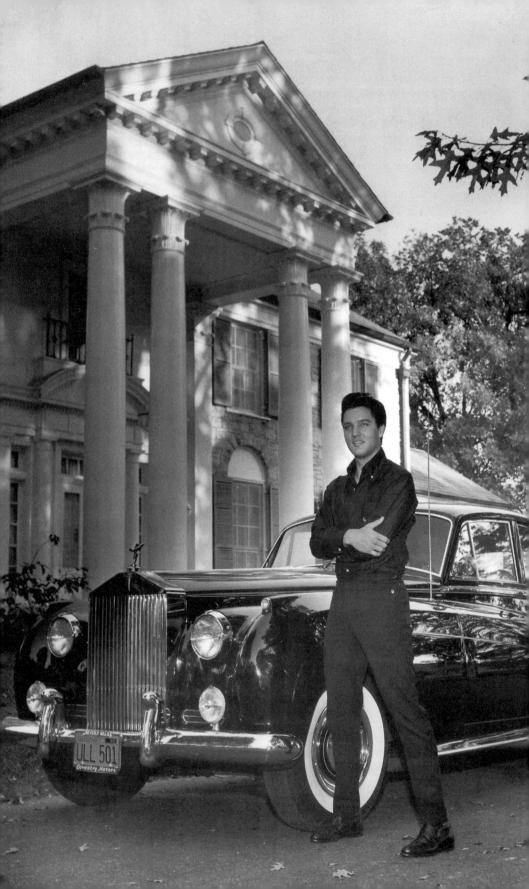

CARELESS LOVE

THE UNMAKING OF Elvis presley

PETER GURALNICK

LITTLE, BROWN AND COMPANY BOSTON , NEW YORK , LONDON

Copyright © 1999 by Peter Guralnick

All rights reserved. No part of this book may be reproduced in any form or by any electronic or mechanical means, including information storage and retrieval systems, without permission in writing from the publisher, except by a reviewer who may quote brief passages in a review.

FIRST EDITION

FRONTISPIECE: GRACELAND, FALL 1960. (ROBERT WILLIAMS)

Permissions to quote from copyrighted material appear on page 767.

All photographs are copyrighted by the photographer and/or owner cited, all rights reserved.

Library of Congress Cataloging-in-Publication Data

Guralnick, Peter.

Careless love : the unmaking of Elvis Presley / Peter Guralnick. — 1st ed.

p. cm.

Includes bibliographical references and index.

ISBN 0-316-33222-4

I. Presley, Elvis, 1935–1977. 2. Rock musicians — United States — Biography. I. Title. ML420.P96G85 1998 782.42166'992—dc21

[B]

98-25778

10 9 8 7 6 5 4 3 2 1 MV-NY

DESIGNED BY SUSAN MARSH

Printed in the United States of America

For Jacob and Nina and for Alexandra

Contents

AUTHOR'S NOTE xi

PROLOGUE: HOMECOMING, MEMPHIS, MARCH 1960 3 GERMANY: MARKING TIME October 1958–March 1960 9 ELVIS IS BACK March 1960–January 1961 55 THE COLONEL'S SECRET January 1961–January 1962 91 NEGLECTED DREAMS January 1962-April 1964 121 SPIRITUAL AWAKENINGS April 1964–April 1966 173 FAMILY CIRCLE April 1966–May 1967 227 THE LAST ROUND-UP June 1967-May 1968 269 THE BLUEBIRD OF HAPPINESS May-June 1968 293 A DAY AT THE RACES July 1968-August 1969 319 A NIGHT AT THE OPERA September 1969–September 1970 361 A COMIC BOOK HERO September 1970–January 1971 401

A STRANGER IN MY OWN HOMETOWN January 1971–February 1972 431

ON TOUR March 1972–January 1973 459

FREEFALL February–October 1973 487

THE IMPERSONAL LIFE Fall 1973–December 1974 519

A LEAF IN THE STORM January 1975–January 1976 555

HURT January–December 1976 593

ELVIS, WHAT HAPPENED? January-June 1977 619

"PRECIOUS LORD, TAKE MY HAND" Summer 1977 641

NOTES 663 BIBLIOGRAPHY 730 A BRIEF DISCOGRAPHICAL NOTE 743 ACKNOWLEDGMENTS 744 INDEX 747

Author's Note

It's difficult to be a legend. It's hard for me to recognize me. You spend a lot of time trying to avoid it. . . . The way the world treats you is unbearable. . . . It's unbearable because time is passing and you are not your legend, but you're trapped in it. Nobody will let you out of it except other people who know what it is. But very few people have experienced it, know about it, and I think that can drive you mad. I know it can. I know it can.

- James Baldwin, interviewed by Quincy Troupe

THIS IS A STORY of fame. It is a story of celebrity and its consequences. It is, I think, a tragedy, and no more the occasion for retrospective moral judgments than any other biographical canvas should be. "Suspending moral judgment is not the immorality of the novel," Milan Kundera wrote in what could be taken as a challenge thrown down to history and biography, too. This suspension of judgment is the storyteller's *morality*, "the morality that stands against the ineradicable human habit of judging instantly, ceaselessly, and everyone; of judging before, and in the absence of, understanding." It is not that moral judgment is illegitimate; it is simply that it has no place in describing a life.

Elvis Presley may well be the most written-about figure of our time. He is also in many ways the most misunderstood, both because of our ever-increasing rush to judgment and, perhaps more to the point, simply because he appears to be so well known. It has become almost as impossible to imagine *Elvis* amid all our assumptions, amid all the false intimacy that attaches to a tabloid personality, as it is to separate the President from the myth of the presidency, John Wayne from the myth of the American West. "It's very hard," Elvis declared without facetiousness at a 1972 press conference, "to live up to an image." And yet he, as much as his public, appeared increasingly trapped by it.

The Elvis Presley that I am writing about here is a man between the ages of twenty-three and forty-two. His circumstances are far removed from those of the boy whose dreams came true in the twenty-second year of his life. It is not simply that his mother has died, testing his belief in the very meaning of success. With or without his mother by his side, he would have had to grow up; he would have had to face all the complications of adulthood in a situation of almost unbearable public scrutiny, a young man little different in temperament from the solitary child who had constructed a world from his imagination. The army was hard for him not just because he was temperamentally unsuited to it but because it was something he knew he had to succeed at, both for himself and for others. The artistic choices he faced when he returned to an interrupted life were far more ambiguous than the good fortune he had so innocently embraced, and he never came fully to terms with the burden of decision making that those choices placed upon him. His natural ability to adapt, his complex relationship with a manager whom he perceived not just as a mentor but as a talisman of his good luck, served him in both good and bad stead. He constructed a shell to hide his aloneness, and it hardened on his back. I know of no sadder story. But if the last part of Elvis' life had to do with the price that is paid for dreams, neither the dreams themselves, nor the aspiration that fueled them, should be forgotten. Without them the story of Elvis Presley would have little meaning.

I've tried to tell this story as much as possible from Elvis' point of view. Although he never kept a diary, left us with no memoirs, wrote scarcely any letters, and rarely submitted to interviews, there is, of course, a wealth of documentation on the life of Elvis Presley, not least his own recorded words, which, while seldom uttered without some public purpose, almost always offer a glimpse of what is going on within. I've pursued contemporary news accounts, business documents, diaries, fan magazines, critical analyses, and the anecdotal testimony of friends and eyewitnesses not with the intention of imposing all this on the reader but simply to try to understand the story. In the end, of course, one has to cast aside the burden of accumulation and rely on instinct alone. There is always that leap of faith to be made when you accept the idea that you are painting a portrait, not creating a web site. Certainly you have to allow your gaze to wander, it is essential to take every possibility into account, not to prejudge either on the basis of likelihood or personal bias - but you also have to recognize that with the angle of perception changed by just a little, with a slightly different selection of detail, there may be an altogether different view. This is

where the leap of faith comes in: at some point, you simply have to believe that by immersing yourself in the subject you have earned your own perspective.

I have spent eleven years with Elvis. Much longer if I go back to the pieces I originally wrote to try to tell the world why I thought his music was so vital, exciting, and culturally significant, how it was part of the same continuum of American vernacular music that produced Robert Johnson, Hank Williams, Sam Cooke, the Statesmen, Jimmie Rodgers, and the Golden Gate Quartet. I still think that — but immersion in the subject has changed my view in other, more subtle ways. Once I saw Elvis as a blues singer exclusively (that was my own peculiar prejudice); now I see him in the same way that I think he saw himself from the start, as someone whose ambition it was to encompass every strand of the American musical tradition. And if I am still not equally open to his approach to every one of those strands, I can at least say that I have awakened to the beauty of many of the ballads I once scorned and come to a new appreciation of the gospel quartet tradition that Elvis so thoroughly knew.

In the course of writing these two volumes, I interviewed hundreds of people, some dozens of times. There were moments, certainly, when I felt as if I had at last gained access to Elvis' world; just as often, I was made aware that no matter how long one peers in from the outside, it is never quite the view from within. That's why it's so important to keep going back — not just to try to understand the sequence of events but to give the picture a chance to come into deeper focus. You want to try to capture the chipped paint on the doorknob, the muted conversations in the hall; you want the reader to hear the carefree exuberance of Elvis' laugh - even if none of these things ever fully emerges from the background. Perhaps there is no need to point out that this is a task that can drive both writer and interview subject almost mad. But what struck me again and again, as it has struck me with every book that I have written, was the graciousness of the participants, their own curiosity about what actually happened, about others' perspectives on events in which they themselves had participated. There was no question in my mind that almost without exception everyone I interviewed was telling the truth as he or she saw it. Interpretations might be shaded, time frames telescoped — but there was no conscious attempt at distortion, save for the universal human impulse to see oneself at the center of the picture.

I have tried to respect those truths. I have tried to understand each of the witnesses' stories. But most of all I have tried to understand Elvis', and

XIV 💊 AUTHOR'S NOTE

to give the reader, too, a new basis for understanding by delineating the context in which frequently well-known events occurred. That search for context - sometimes it can be not much more than how the weather was - is, as much as anything else, at the heart of my own deep-seated belief in research. Not that ultimate meaning can ever be uncovered (I must admit, I have my doubts about ultimate meaning), but, on the most basic level, how are we ever to understand cause and effect if we don't know which came first? History may well be, as Arthur Schlesinger, Jr., has suggested, "an argument without end," but it can provide fruitful grounds for debate if certain rules of evidence are observed. There is room for the widest variety of interpretation, Schlesinger points out, so long as we recognize that we are establishing "small truths [in order] to place them in larger contexts and perspectives," that "we are prisoners of our own time and our own experience." So, too, are the protagonists. "Thomas Jefferson and Benjamin Franklin did not sit around a table and say, 'Isn't it great living in the past?'" in the formulation of historian David McCullough. "They didn't know any more how it was going to come out [than we do]." Which to me means that one must respect not just the story but the way in which it develops; judging the past by the standards of the present sheds little light on understanding, it represents no more than the I-told-you-sos of history.

There are no villains here. The story of Elvis' inexorable decline — what could almost be called the *vanishing* of Elvis Presley over a period of time — is neither a simple nor a monolithic one, and it may have no greater moral than the story of Job or Sophocles' *Oedipus Rex:* Count no man lucky until he has reached his journey's end. The kind of fame that Elvis experienced requires constant reinvention if one is to escape its snares — and, as more than one friend of Elvis remarked, his desire to escape was ambivalent at best; as much as he may at times have been tempted, he was not about to throw away the identity he had so assiduously created, he *enjoyed* being Elvis Presley.

The last few years of his life amounted to little more than a sad diminution; this is what has become the basis for the caricature that we so often see repeated in our pathographic times. More significantly, the music with which he made his mark has become a battleground for competing ethnocentric claims: Elvis Presley, whose democratic vision could not have been broader or more encompassing, is used as the centerpiece for accusations of cultural theft. This is a misunderstanding not just of Elvis Presley but of popular culture, which even in its purest forms cannot help but represent the polyglot borrowings that radio and the phonograph record first introduced almost a century ago. You don't have to *like* Elvis Presley — but it's impossible, if you listen to his music, not to recognize both his achievement and his originality. He was no more a copy of blues singer Arthur "Big Boy" Crudup than he was of bluegrass pioneer Bill Monroe — though they, along with a far-flung range of influences (Roy Hamilton, Mario Lanza, Dean Martin, Clyde McPhatter, Jake Hess), were among his heroes, and he unquestionably absorbed their music into his own. That music exists, like all art, without explanation (if it could be formulized, why wouldn't everyone do it?), but it came about no more by accident than Duke Ellington's carefully worked-out compositions or Robert Johnson's blues. That is what the story keeps coming back to in the end — the music. That is the mystery that will continue to reward repeated explorations, long after the frenzy of fame is finally gone.

CARELESS LOVE

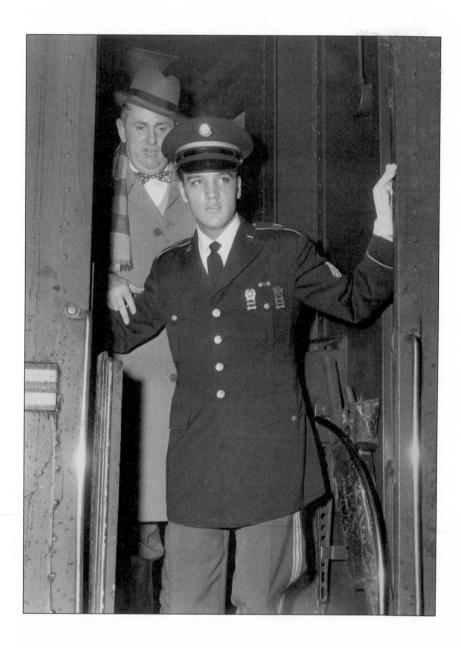

UNION STATION, MEMPHIS, MARCH 7, 1960. (JAMES REID)

PROLOGUE: HOMECOMING, Memphis, March 1960

HEY LEFT IN THE AFTERMATH of a blustery winter storm. The newly promoted sergeant emerged from the Fort Dix, New Jersey, paymaster's office with a mustering-out check of \$109.54 for travel expenses, food, and clothing. "Don't forget my commission," growled his manager, Colonel Tom Parker, loud enough for newsmen to hear, and Elvis Presley smilingly handed him the check. He then strode toward a chauffeur-driven limousine surrounded by six MPs, as the post band played "Auld Lang Syne." Six teenage girls emerged from the crowd and the MPs closed ranks, but the young soldier slowed down, smiled, and stopped to chat with his fans. He reached into his traveling case and pulled out six autographed pictures, one for each girl, then disappeared with his manager into the limo as his army buddies yelled, "Go get 'em, Elvis."

It was two years since he had left civilian life, seventeen months since he had last set foot on American soil. He leaned back in the seat, a broad smile illuminating his handsome twenty-five-year-old features, and cast a backward glance at the forty-car caravan of reporters, photographers, and fans that fell in behind them on the snowy highway. It seemed in some ways as if he had never been away, in others that he was still a stranger in a foreign land. His fingers drummed nervously on the plush upholstery - he had scarcely slept the previous night, and even now he felt such a mix of emotions that it would have been impossible for him to express them all. He had told reporters that the only thing on his mind was to rest up at home for the next few weeks, but that was not in fact true. He had an RCA recording session coming up on which he knew everyone was pinning their hopes; his guest appearance on "Frank Sinatra's Welcome Home Party for Elvis Presley," a television special, was scheduled in less than a month; and Hal Wallis, who had signed him to his first motion picture contract just four years earlier, was planning to start production on G.I. Blues the moment these other obligations were fulfilled.

4 👁 PROLOGUE: HOMECOMING, MEMPHIS, MARCH 1960

If he was certain of one thing, it was that his manager had a plan. The Colonel, heavy, saturnine, his hooded eyes veiling an expression of amused avidity that Elvis sometimes thought he alone could read, had staved in constant touch with him throughout his army hitch. He had never come to see him in Germany — he was too busy orchestrating all the elements necessary to sustain his single client's career — but he had maintained almost daily communication and provided a steady stream of encouragement. both strategic and paternal, even in the darkest days. No detail was too small for the Colonel to take up. He had continued to promote Elvis Presley merchandise, devised sales campaigns for each new record release, and hustled small-time theater owners when Paramount rereleased King Creole and Loving You the previous summer. He had fought the army to a standstill over plans to enlist Elvis as an ambassador-entertainer, refused to cave in to RCA's increasingly importunate demands to have him record something — anything — while stationed in Germany, and then used the shortage of product to improve their bargaining position. He had negotiated movie deals in a climate of doubt (Will Presley's Appeal Last? was a typical headline, and a typically voiced studio sentiment whenever money was being discussed) and had been so successful at it that they now had three starring vehicles lined up for this year alone, including two "serious" pictures for Fox.

Above all he had kept Elvis' name in the headlines for the entire two years, a feat that Elvis had never believed possible — and he had shared every detail of the campaign with his protégé, confiding his strategy, describing his "snow jobs," bolstering the homesick soldier when he was down, praising him for his courage and forbearance, making him feel like a man. They were an unbeatable team, a partnership that no one on the outside could ever understand, and Elvis was well aware that Colonel had not taken on one new artist in the time that he was away.

The present plan was more in the nature of a diversion, and Colonel was having fun with it. They were heading for New York, he had informed the press; they were going to have a big news conference at the Hotel Warwick and then spend the weekend there. But that, of course, was nothing like what he had in mind. He had in fact worked out five fully developed alternate routes and schemes, with any number of decoy vehicles and even a helicopter on standby if need be — but, really, his only intention was obfuscation, at which he was preternaturally adept. They lost the caravan of accompanying vehicles somewhere in New Jersey. "Elvis Presley myste-

prologue: homecoming, memphis, march 1960 👁 5

riously vanished from a snow-packed fan-laden highway," it was reported in the newspapers the following day, but in actuality they simply retreated to a hotel hideout in Trenton, where they rendezvoused with the rest of the group: three-hundred-pound Lamar Fike, who had accompanied Elvis to Germany and remained faithfully by his side the entire seventeen months; Rex Mansfield, Elvis' army buddy from Dresden, Tennessee, to whom the Colonel had gladly agreed to give a lift home; the Colonel's chief lieutenant, Tom Diskin; and assorted other record company representatives and members of the Colonel's staff. For most of the day they holed up in Trenton, with Colonel relaying confusing messages to the world at large through his secretary in Madison, Tennessee. That evening they took a private railroad car to Washington, where they boarded the Tennessean, scheduled to depart at 8:05 A.M. Once again they occupied a plush private car, attached to the rear of the train, but now their schedule was known to the world, published by the Colonel with the idea of giving his boy the kind of welcome a home-coming hero deserved.

There was a crowd of fifteen hundred in Marion, Virginia, twenty-five hundred in Roanoke, and substantial turnouts at smaller stops along the way. Elvis emerged on the observation platform at every one, slim and handsome in the formal dress blues he had had made up in Germany with an extra rocker on the shoulder designating a higher, staff sergeant's rank. It had been, he explained embarrassedly when challenged about the extra stripe, a tailor's mistake, but some of the more cynical reporters put it down as the Colonel's work, or, simply, Elvis' vanity. He never said a word at any of the stops, merely waved and smiled, and, in fact, somewhere in Virginia, Rex took his place on the platform at the Colonel's insistence, and with the Colonel's assurance that the fans would never know the difference.

Inside the car the Colonel and Elvis were rolling dice at \$100 a throw, and Elvis gave Rex and Lamar enough money so they could play, too. When Rex tried to return the several hundred dollars that he subsequently won, Elvis offered him a job as his chief aide. There would be lots more money, he said, if Rex would just stick with him, and a glamorous life to boot. Talk to the Colonel, he suggested, if Rex had any doubts.

To Rex's surprise the Colonel, whom he had been hearing about from Elvis ever since they had first met at the Memphis induction center two years before, advised against it. After listening carefully to Rex's wellformulated plans for the future and what he considered to be his prospects

6 👁 PROLOGUE: HOMECOMING, MEMPHIS, MARCH 1960

for business success, Colonel Parker "told me that he thought I was good enough to make it on my own and that I did not need to hang around Elvis. He said that I was not like most of the other guys that hung around and that his best advice was not to take the job. Then the Colonel told me not to tell Elvis what he said, because it would make Elvis mad. . . . He said he had given me his honest, sincere advice, but the final decision was still mine. Again, he said to me, 'If you tell Elvis that I told you not to take the job with him, I'll deny it.'"

In Bristol, Tennessee, a young reporter from the *Nashville Tennessean* got on, alerted by a collect call from the Colonel's staff. Presley, wrote David Halberstam, was "like a happy young colt. . . . He wrestled with some of his bodyguards, winked at the girls in the station, and clowned with his ever-faithful manager and merchandiser, Col. Tom Parker. 'Man, it feels good to be going home,' Presley said. 'So good.' Then he put a hand over the Colonel's receding hairline and said, 'Andy Devine [a portly Hollywood character actor], that's who it is. Andy Devine.' 'Quit pulling my hair out,' the Colonel said. 'I'm just massaging it for you,' Presley said. 'Every time you massage,' [the Colonel replied], 'I have a little less left. . . . '

"The Colonel, both remarkably excited and unshaven after the cloak and dagger days on the east coast . . . was pleased. Pleased with his boy, and pleased with the hordes of youngsters that he had to fight off. 'As many or more than before,' he said, pointing to the mobs. 'Better than ever.'"

Halberstam observed three thousand teenagers in Knoxville waving banners and signs, as the train made its stop at 8:55 P.M., less than eleven hours from Memphis. He could feel the excitement mounting, the young singer's nervous energy would allow him neither to sit still nor to sleep all through the long night. He continued roughhousing with his companions, practiced his quick draw, and threw in an occasional demonstration of the Oriental discipline of karate, which he had been studying seriously in Germany for the past few months. If he ever lost his voice, the Colonel remarked dryly, "we could make money with his wrestling." When Memphis reporters joined the party in Grand Junction at 6:15 A.M. and then at Buntyn Station a little more than an hour later, he was still wearing his dress uniform with Good Conduct ribbon and Expert's medal for marksmanship prominently displayed, but by now he had donned one of the two formal lace shirts that Frank Sinatra's nineteen-year-old daughter, Nancy, had presented to him at Fort Dix on behalf of her father. "If I act nervous, it's because I am," he told Press-Scimitar reporter Bill Burk. "I've been gone

a long time, a long time," he muttered almost to himself, as the train pulled into the station. What had he missed most about Memphis? he was asked. "Everything. I mean that — everything."

Two hundred fans, reporters, and the just plain curious were waiting when the train arrived at 7:45. It was snowing, and there was an icy wind, but the crowd chanted, "We want Elvis," as they massed behind a six-foothigh wrought-iron fence. "It was nice to have you aboard," said the conductor, H. D. Kennamer, shaking his hand. "Thank you, sir," said Elvis Presley, squaring his shoulders and plunging back into the life he had once known. He walked along the fence, shaking hands through the bars and recognizing familiar faces. He spoke briefly with various friends and fans, then indicated to the Colonel's brother-in-law and aide, Bitsy Mott, that he wanted to confer with Gary Pepper, a twenty-seven-year-old cerebral palsy victim who had recently taken over the Tankers Fan Club (Elvis had been assigned to a tank corps) and was holding a "Welcome Home, Elvis, The Tankers" sign above his head. Bitsy wheeled Pepper through the crowd, and they had a brief meeting, with Pepper apologizing that there wasn't a bigger turnout, it was a school day, after all. "Elvis bit his lip," reported the newspaper, "seemed to be trying to repulse tears, and said, 'I'll see you later, pal.'"

Then he was gone, scooped up in his old friend police captain Fred Woodward's squad car, arriving at Graceland less than thirty minutes later with lights flashing and siren screaming. "The gates swung open," reported the *Memphis Press-Scimitar*, "and Woodward's car . . . shot through at nearly 30 miles per hour. Then the gates closed. The king was once again on his throne."

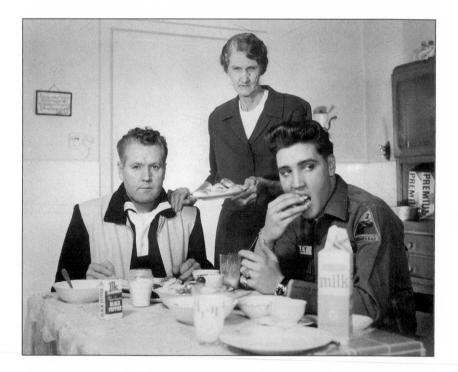

AT HOME, GERMANY, 1959: VERNON, GRANDMA, ELVIS. (COURTESY OF THE ESTATE OF ELVIS PRESLEY)

GERMANY: MARKING TIME

He was subdued on the troop train to Friedberg, just north of Frankfurt, some two hundred miles away, eating with the cooks in the kitchen car so as to have a moment or two of privacy, thanking each one individually for their hospitality. Military plans called for him to interact with the press and the public for the next few days — but *only* for the next few days, while he was still undergoing processing. A press conference was scheduled for the following morning, and he would undoubtedly be faced with the same kinds of questions that reporters came up with everywhere else. Did he still want to meet Brigitte Bardot now that she was formally engaged? What did he think of German girls, even if he had never met any? Would his music change? Would his popularity remain the same? Colonel said he just had to get through it; he had his job, the press had theirs, and there was no reason that they couldn't serve each other's needs. It was his job to be *like any other soldier*, and once this initial flurry of attention was over that was just what he would be.

It had been a strange and solitary crossing. Not so much because he was alone on the transport ship — he had made friends with a number of the guys — as because, with his mother gone, he was truly alone in the world. Seeking solace, he read and reread some of the poems about death and motherhood in the book he had been given by a fellow GI just prior to his departure, an anthology called *Poems That Touch the Heart*. He sought out the companionship of sympathetic souls, requesting to bunk with Charlie Hodge, the little guy he had met on the train to the Brooklyn Army Terminal who was a fellow southerner, singer, and veteran of show business himself. At night, Charlie said, he could hear him thinking about his mother he could tell by the way Elvis breathed, and he would try to cheer him up, telling him jokes, running through old vaudeville routines, until at last his friend dropped off to sleep.

Several days out to sea, Elvis and Charlie were put in charge of a talent show on the U.S.S. *Randall*, and they held auditions and staged the program, with Charlie MCing and telling jokes and Elvis playing piano in the backup band. Although he threw himself into the entertainment, he would not take the spotlight, saying that he didn't want to steal attention from any of the other GIs but giving rise at the same time to rumors that he had been forbidden to perform by his manager. He was generally liked by, but distant from, his fellow soldiers, who observed him with the same understandable mistrust that he might just as well have felt for them. "Charlie," he told his new friend, "you keep me from going crazy."

In Friedberg he was stationed at Ray Kaserne, a barracks for German SS troops during the Second World War. He got through the obligatory press briefings (he *was* interested in German girls; he planned to buy a guitar in Frankfurt, since he had not brought one with him on the ship; he would like to see an opera and attend some classical concerts while stationed in Germany). He was initially designated jeep driver for the commanding officer of Company D but was quickly transferred to Company C, a scout platoon, where he was assigned to drive for Reconnaissance Platoon Sergeant Ira Jones. Not only was Jones, a tough, no-nonsense enlisted noncom, deemed to be the man for the job; the fact that the company spent much of its time in the field on maneuvers might help to remove Private Presley from the public eye.

His family arrived on Saturday, October 4, and Elvis had dinner with them at their hotel in Bad Homburg that evening. It was a strange grouping, the young towheaded soldier, his handsome forty-two-year-old father and gaunt sixty-eight-year-old grandmother, plus two buddies from home, Red West and Lamar Fike. He was avid for news of Memphis, almost desperate to *connect*. He needed people he knew, people he could trust, and to Lamar there was no great mystery as to why any of them were there; "Elvis always kept his own world with him; he kept his own bubble." After dinner he posed for photographs with his father and grandmother, then reluctantly returned to camp. He was exhausted, he told reporters; he just wanted to get back to the barracks and get some sleep.

I T WAS HARD, harder perhaps than anything he had ever done — and army life was only part of it. Two days after his family arrived they changed hotels, and three weeks later, after Elvis had received permission to live off base with his two family dependents, they moved again, to the elegant Hotel Grunewald in Bad Nauheim, just twenty minutes from the base. There they had the whole top floor to themselves, but it was still cramped, with Red and Lamar sharing a bedroom and, more significantly, feeling distinctly out of place in the subdued setting of a European health spa for wealthy, primarily elderly visitors.

Red reacted, as he generally did, by blowing up at anyone and everyone who got in his way. Elvis wasn't paying either one of them anything, they were there as his friends, but he did tell his father to give them enough money to have a good time — a couple of hundred marks, or roughly \$50, a week apiece. Vernon, who couldn't see what either one of them had done to deserve such largesse, doled out no more than two or three marks a night to each, and they nursed their money, and their resentment, at Beck's Bar around the corner, where Red was prone to sharp altercations with fellow drinkers and local policemen. There had never been any love lost between Red and Vernon anyway, and with Vernon doing his share of drinking, there was the constant possibility that things could really get out of hand. For Elvis the only truly peaceful time of the day was when he was with his grandmother, "Dodger," who never judged him, who wanted nothing from him, who called him "Son" and recalled every day of his childhood with the clarity and wonder generally reserved for chronicling the lives of the saints.

There was a moment of confusion just after his arrival, when it seemed as if the army was breaking its agreement with Colonel Parker not to put any pressure on Elvis to perform. The Colonel had waged an extensive campaign to develop contacts in Washington and then to persuade them that it would be against the interests of the armed services for Elvis to appear as anything but an ordinary soldier, while remonstrating at the same time to Elvis that he should resist any such opportunities, however innocent they might at first appear. Nonetheless, John Wiant, the European editor of *Army Times*, approached Elvis and Vernon about a Christmas benefit for German orphans and pursued the matter with Colonel Parker after Vernon explained that he had no authority to accept or decline such an invitation. Even the Colonel was panicked for a moment, since clearly the pressure was coming from above, but he counseled Elvis to *make no commitments* and immediately advised his principal contact in Washington, E. J. Cottrell, the assistant chief of information at the Department of the Army, that not only would this be against everything they had both been working for, it would also end up costing the army money to provide the security necessary for a show of this sort — and if such security were not provided, it would look very bad for the army. Cottrell responded in an amused but sympathetic vein, and while the story got into the newspapers and continued to surface in one form or another for some weeks, it seemed to reflect little more than an ongoing struggle between the State Department and the army over the correct deployment of Private Presley, with the outcome all but conceded to Colonel Parker.

Gradually things began to settle into a routine. Because Elvis was up at 5:30 A.M., the rest of the household was, too, though they could go back to sleep, of course, once he left for the base at 6:30 in the black Mercedes taxi he had hired to take him back and forth. Many days he was home for lunch, and he never returned later than 6:00 P.M. except on Friday, which was "GI party night," when they scrubbed the latrines and cleaned the barracks, often until ten o'clock, in preparation for Saturday morning inspection. It was for the most part congenial enough work; he was improving his mapand compass-reading skills in preparation for maneuvers and keeping his jeep in top condition. And he had a little girl - she was sixteen, but she looked older - a typist with an electrical supply company in Frankfurt who had just showed up with a photographer the day after Elvis' family arrived in Bad Homburg. She and the photographer waited outside the hotel until Elvis emerged with his father, and when she approached him on the pretext of getting his autograph, not only the photographer that she was accompanying but all the other photographers who had staked out the hotel clamored for the two of them to kiss. Elvis was only too happy to oblige, and the papers were full of news of Elvis Presley's "German girlfriend," Margit Buergin, the next day. Lamar got her number for him, and he saw her a few times. She was a nice girl who lived with her mother and had to be home every night. Sometimes she even brought her little German-English dictionary along on their dates.

Home was a nagging memory that on occasion he could barely sustain.

He called some of his pals and told them how much he missed Memphis, kidding around about the German "chiclets"; he had his father call home on October 15 to order a generous supply of alfalfa pills from a Memphis pharmacy because he had heard that that was a good way to help keep your weight down. He wrote breezily to a few girls, confiding his unease but acting as if he could *handle it*. But Anita Wood was the only one to whom he truly unburdened himself — even though he was not exactly sure how he really felt about her.

He knew how he was *supposed* to feel. The papers had linked them almost from the day they met in the summer of 1957, and he knew that Anita was certainly expecting that they would get married someday. In fact, in a moment of desperation, just before he left, he had even spoken to her about bringing her over to visit once things got sorted out. He wrote to her now that she should keep herself clean and wholesome, that he had never, and would never again, love anyone in his life as he loved her, that he looked forward to their marriage and "a little Elvis." In another letter he referred to himself as a "lonely little boy 5000 miles away," even as he was denying the newspaper stories about Margit (referred to as Margrit in the American press), and added in a self-conscious p.s.: "No one ever reads this, OK?"

But even as he wrote and tried to communicate some of his feelings of helplessness and isolation, things were actually starting to look up. He heard from Janie Wilbanks, the girl he had met at the train station in Memphis when the troop train had pulled in on its way to the Brooklyn Army Terminal, that she was going to be coming over to visit her uncle, an army chaplain in Germany, sometime around Christmas and couldn't wait to see him again. His buddy Charlie Hodge, from the U.S.S. *Randall*, showed up at the hotel on his first weekend leave and fit right in with the rest of the group. Elvis prompted him to tell Vernon the same jokes he had told on their crossing, and his daddy got a good laugh for what seemed like the first time since Mama died. Red and Lamar obviously liked Charlie, too, and they all harmonized on some old gospel numbers, which they sang a cappella or accompanied by the guitar that Elvis had gotten on his first leave in Frankfurt, with Vernon, too, joining in on more than one occasion.

There was a flurry of activity just before the company went out on maneuvers at the beginning of November that reinforced this growing semblance of normality. Elvis heard that Bill Haley was going to be performing in Frankfurt and Stuttgart on October 23 and 29, and went to see him both times, with happy reunions backstage at which Elvis confided to the older star that if it hadn't been for Haley's help and encouragement, he might still be driving a truck. A few nights later, on the Saturday night before departure, he had another date with Margit, who told the press that he was "a very nice boy" and she liked him very much. The following night, November 2, according to a wire-service report, he threw a "noisy premaneuvers party in his hotel, where the sounds of his guitar and singing bounced down to the sidewalks below and caused a crowd to collect. Between plunks on his guitar he confessed he liked Margit 'very much' and added, 'And I'm glad her parents like me as well.'"

He got a peculiar call from a woman named Dee Stanley around this time; she was the wife of a master sergeant stationed in Frankfurt, she explained to him, and she just wanted to invite him to dinner with her family. She knew he must be lonely, and she wanted to show him that a foreign country didn't have to be so cold and inhospitable. After spending a few minutes trying to figure out what she was driving at, he eventually told her to call on Monday, when he knew he would be on maneuvers and Daddy could just handle it.

Then they were off to Grafenwöhr, a cold, dismal location near the Czech border. At first reporters hounded him for pictures, and soldiers and officers who hadn't seen him before asked for autographs. But then the reporters were banned, and the soldiers got used to his presence, and things settled down into a predictable routine over the next seven weeks. This was where he finally proved himself to his platoon sergeant's satisfaction, enduring the same harsh conditions as everyone else, showing himself to be a resourceful soldier in field exercises as his reconnaissance unit took eight prisoners thanks to a clever ruse that he had worked out, finally becoming one of the boys. The first weekend that they had leave to go back to Friedberg, a notice was posted that buses would be available at a cost of s6 round-trip. When a number of his fellow soldiers didn't have money for the fare, Elvis told Sergeant Jones that he would like to help out, giving Jones money to loan out to the soldiers, who eventually repaid Jones without ever learning the identity of their benefactor.

About two weeks into maneuvers he wrote Alan Fortas, his friend back in Memphis, a letter which, if it wasn't exactly cheery, could at least be described as more chipper than previous communications. After complaining about the weather and indulging in an uncharacteristic daydream that "a miracle" might happen to get him home sooner than March of 1960 ("Boy it will be great getting out"), he sent personalized greetings to friends and wrote of his social life, "I have been dating this little German 'chuckaloid' by the name of Margrit. She looks a lot like B.B. [Brigitte Bardot]. It's *Grind City*." Then, after declaring that he had to go off and "wade in the mud," he signed off as "Your Pal, Elvis Presley," with "Eri Viar Ditchi [Arrivederci]" scribbled on the back of the envelope as a postscript.

Almost every night he and Rex Mansfield and another friend, named Johnny Lange, went to the post theater, frequently viewing the same movie several nights in a row at Elvis' instigation. They would generally slip in late to avoid the gawkers and autograph seekers and leave early for the same reason, before the show was finished. Rex was the boy from Dresden, Tennessee, he had originally met at the Memphis induction center who had served with him at Fort Chaffee and Fort Hood, probably his best friend in the army. Even Red, suspicious of all outsiders, had to acknowledge that Rex was a regular guy, neither starstruck nor stuck on himself, someone who could fit into their world as if he had always belonged.

One evening at the post theater, just before Thanksgiving, Johnny came back from the lobby, saying there was a girl who wanted to get Elvis' autograph. Elvis asked if she was pretty, and when Johnny said she was, he had Rex bring the girl into the theater to sit beside him. The girl was practically petrified. All she had wanted was an autograph, but he treated her with such gentleness and respect, put his arm around her and asked for her name, "and from that moment on," she later wrote, "I was floating. . . . After the movie, Elvis walked me home, which was only about ten minutes from the theater. On the way home that first night we talked about the Army, what I was doing in Graf, and about my family. It seemed to me that Elvis was very interested in me personally and wanted to know all about me. We were standing by this tree, which was in sight of our dependent apartment house, when he kissed me for the first time. It was a goodnight kiss, and I asked him if he would like to come in and meet my parents, but he said some other time please."

Her name was Elisabeth Stefaniak, she was just nineteen years old, the daughter of a German mother whose husband had deserted her during the war; her stepfather, Raymond McCormick, was a U.S. Army sergeant stationed at Graf, and now she had a little half sister, Lindy, who was six years old. They dated practically every night for a week, and then on Thanksgiving Day he showed up unexpectedly at her house and stayed for Thanksgiving dinner. He impressed her parents with his manners, spoke with deep emotion of his mother, and then sang to them all with a guitar borrowed from a neighbor. On December 19, the last day of training, he told her parents that he needed a secretary with a good knowledge of German and

English and that Elisabeth would exactly fit the bill. "He wanted me to come to Bad Nauheim and live in his home. He said he, his father, and his grandmother would take full responsibility for me." To Elisabeth's astonishment her parents consented, and it was agreed that she would join him in Bad Nauheim sometime after the New Year.

Upon his return home he rapidly made up for lost time. The day after his arrival he leased a white BMW sports car to go with the old Cadillac he had bought from the company commander for his father to use and the beat-up Volkswagen bug he had gotten for the boys. Back at Ray Kaserne he threw himself into preparations for a Christmas party at the local orphanage and made a sizable financial contribution to the effort. In addition, the recon platoon was designated to clean the company area and decorate the Christmas tree for any visitors who might come in during the holidays. After working all day, everyone was getting ready to go on leave when one of the soldiers picked up a guitar and started to sing a Christmas song. One by one others joined in, and then the soldier with the guitar asked Elvis if he would like to take part, too. "'Yeah, all right," said a subdued Elvis, in Sergeant Jones' account, and he led the soldiers in song. At the end everybody else stopped as he performed "Silent Night," singing "as if in a trance, totally oblivious" to his surroundings. "Those going on pass didn't interrupt. They simply walked silently by Elvis, touched his shoulder, and walked out the door. Not another word was spoken after the song until Elvis broke the spell. 'Merry Christmas, everyone,' he said. 'Merry Christmas, Elvis!' they replied in unison."

I was Christmas at the Hotel Grunewald, too. Vernon gave Elvis an electric guitar, and they had a special holiday meal, but it didn't erase the bad feelings that Elvis continued to have about what was going on between his daddy and that woman Dee, who had called him out of the blue just before he left for Grafenwöhr. He blamed himself in a way; he should never have palmed her off on Vernon, who had accepted her invitation to dinner in the name of "downhome hospitality" and become a frequent visitor in her home. There he had met her three little boys, palled around with her husband, Bill, a sergeant with wild and woolly tales from his days as General Patton's personal bodyguard and a drinking problem that anyone could see, and eventually found his way into her bed. Now Vernon was behaving like a love-struck teenager, and Elvis could barely restrain his feelings of resentment when they met — it was too soon, she wasn't the right kind of

woman, it was an insult to his mother's memory. She tried to play up to him, just like so many of them did. She wondered coquettishly if Elvis remembered her from the time he had appeared in Newport News in 1956. She had only been a member of the audience, she said, but it had seemed as if he were singing directly to her. "Of course I remember you, Mrs. Stanley," he replied in his usual gracious fashion. "How could I ever forget someone so beautiful?" But he didn't like the way she put on a show for him any more than he liked what Vernon was doing, and he couldn't get it out of his mind that he might still be the one she had in her sights.

It seemed like they were all feeling the pressure of living at such close quarters. Red and Lamar were increasingly at Vernon's throat, and when Elvis found out that Vernon still had them on an allowance of a few marks a night, he spoke to his father sharply about giving them the amount that had previously been agreed upon. "Let them go out and try to get some money on their own," Vernon said angrily, expressing his own frustration at how out of hand the boys were getting now that Elvis was home and warning Elvis that their antics were going to get the whole party, including Grandma, thrown out of the hotel. Elvis didn't take any more kindly to his father's criticism than his father did to his and simply reminded Vernon of who was paying the bills. So he and the guys continued to chase each other around the hotel corridors with water pistols and set off fireworks whenever they felt like it, with Elvis generally taking the lead, just like he did at home.

It was the shaving-cream fight at the end of January that proved to be the final straw. Red was chasing Elvis, and Elvis locked himself in his room, so Red put paper under the door and lit it, trying to smoke him out. The fire got a little out of control, and they were just in the midst of putting it out when the manager, Herr Schmidt, appeared and informed them that their continued presence was no longer desired and that they should perhaps start looking for a new home without delay. No one was too unhappy about this outcome, not even Vernon, so long as any scandal that might get back to the Colonel could be avoided. They clearly needed a house of their own, where they would have the room and the freedom to be themselves without the scrutiny of outsiders, and where Grandma would be able to prepare a home-cooked meal and they wouldn't have to eat this damned German food and worry about any crotchety old convalescents having heart attacks whenever they felt like fooling around.

* * *

LISABETH MOVED WITH THEM when they finally found a place. She Γ had showed up, as promised, right after the first of the year, occupying the large corner room in their hotel complex that had until then been used as storage space for fan mail. Red and Lamar had set her up to answer the mail, instructing her in the fine art of forging Elvis' signature, which she could soon do almost as well as they. Mrs. Presley took to her right away, insisting that she call her "Grandma," Mr. Presley was always perfectly courteous and polite, and she liked the boys well enough, even though she knew that by Elvis' rules she could scarcely so much as glance at them, let alone have a private conversation — he said that any attention she paid to them would make him look like a fool. She accepted that even if she didn't understand it, just as she accepted all the other confusing elements that seemed to go with the situation. On the first night he came to her room and said that he would be spending the night with her, even though at Graf there had never been anything beyond kissing, and she was unclear as to what their romantic status was exactly. He explained to her that she didn't have to worry, that they wouldn't have full intercourse because he didn't do that with any girl that "he was going to see on a regular basis," because he couldn't risk getting her pregnant. "Such a risk would damage his reputation and image. That first night we sort of played around. Over the course of the next weeks and months, I went to bed with him almost every night."

But, she soon realized, she was not the only one. Within days of her arrival he took another girl to bed, then after Lamar took the girl home, Elvis knocked three times on the wall between their bedrooms, summoning her to him. Margit Buergin continued to be a frequent visitor, and within a week or two Elvis announced that Janie Wilbanks, the girl from the Memphis train station, was coming for a visit — but she came to accept that, too, and in time she and Janie would actually become friends.

Often she could hear him with his girls through the wall of her room, and while she doubted that Elvis did any more with the others than he did with her, it didn't really make her feel any better. "There would be at least a couple of girls each week, more on weekends. . . . These were often very beautiful girls [but] although I resented them, I knew they were not staying. I was. I did not let him see me cry [and] all the time I was telling myself how lucky I was. . . . He never apologized. I guess he never felt he owed me an explanation. I do remember the pain of getting into bed with him maybe ten or twenty minutes after another girl had left. Many times we never made love; he would sometimes just give me a good-night kiss and go to sleep. It was like a comfort thing for him."

They moved into the trim, neatly kept, three-story white stucco house at Goethestrasse 14, just ten blocks from the Hotel Grunewald, in early February. They were paying the equivalent of \$800 a month, several times the going rate, but it more than met their needs. It came equipped with a kitchen for Grandma to cook in, five bedrooms, a spacious living room for entertaining, and a landlady, Frau Pieper, who stipulated as a rental condition that she would maintain a room in the house both to serve as housekeeper and to oversee her American tenants. Frau Pieper and Grandma made an oddly matched pair — they shopped together, cooked together, drank together, clearly were fond of each other but frequently had fierce disagreements, though neither understood the other's language.

It was a less-than-perfect arrangement, but it was home, removed from the prying eyes of outsiders except at certain designated hours. At Elvis' direction a sign was immediately put up indicating AUTOGRAMME VON 19:30 20:00, and Elvis would emerge promptly at 7:30 in the evening to sign autographs with much of the neighborhood looking on. Grandma made biscuits and eggs and burnt bacon for breakfast every morning, and they all had a big family meal before Elvis went off to the post and everyone else went back to sleep. By now Elvis had bought at least ten pairs of nonissue tanker boots (which had to be special-ordered at the PX at \$45 a pair), and Red and Lamar were kept busy spit-polishing the boots and keeping the dozens of extra uniforms he had purchased as well pressed and clean. Elvis now came home for lunch almost every day, climbing over the fence in the back but after a while fooling almost none of the fans, who anticipated his arrival like clockwork.

It was in the evening, though, and on weekends that Goethestrasse 14 really began to feel like home. With the curtains drawn and the world shut out, lots of girls around, and the radio tuned to the Armed Forces Network playing the latest American hits, sometimes it could almost seem like there was not all that much to distinguish Germany from Graceland, except for the accent of some of the visitors. Elvis kept the record player constantly spinning with records by the Statesmen, the Harmonizing Four, Marty Robbins, Jackie Wilson, and Peggy Lee singing "Fever," and when they weren't listening to music, Elvis, Charlie, Red, and Rex would frequently brusque, sometimes harsh ways of a household full of men; and she came to like Red and Lamar, seeing another side of Red and feeling sorry for poor, garrulous three-hundred-pound Lamar, who was always falling for girls who were clearly using him just to get to Elvis. She and Grandma became great friends, and Grandma taught her to cook biscuits southernstyle, just the way Elvis liked them. Sometimes Grandma would talk about Elvis when he was a little boy, how different he was from all the other children, how he was the one member of the family who had ever really amounted to anything, and the two women shook their heads indulgently over some of the boys' carryings-on.

The one thing that Elisabeth found most difficult to accept was Elvis himself — the gulf that frequently existed between the public and the private personalities, the extreme mood swings that he would sometimes experience and the cruelty that he could exhibit. One time she went shopping with him, and he asked her to tell the saleslady that he was looking for a small wastepaper basket for his bedroom. Without thinking, she reminded him that he already had a wastebasket, and he turned on her in an instant. "Don't you ever tell me what or what not to buy," he said. "If I want a thousand trash cans in my bedroom, that's my business." They left the store without buying anything, and in the car Elvis told her "that he had planned to buy me a lot of clothes this day but [that] I had ruined it." From that experience she learned that "no matter what you thought, you don't tell Elvis what to do." And you made sure never to show anything but a positive demeanor.

He was, she finally came to realize, jealous of virtually any personal relationships among those around him that did not directly revolve around him. "One had to be very careful of what [one] said around Elvis, because he could turn on you in a second. [He] was suspicious of everybody, and yet his ego caused him to be naive in many situations." If you fell afoul of him, you were threatened immediately with expulsion, especially if you were male. And yet "he had a way of making anyone feel they were the most important person in the world to him."

There was never any question that she would stay.

IN MARCH HE DECIDED to venture to Munich on a three-day pass. A couple of months earlier he had done some publicity shots for the March of Dimes, and the photographer, seeing an opportunity to place the pictures with a movie magazine as well, brought along a pretty eighteen-

year-old actress from Munich named Vera Tschechowa, who spoke English and whose grandmother, Olga, was a renowned figure on the German stage. Evidently they hit it off, or at least Elvis was sufficiently attracted by Tschechowa's exotic good looks that he decided to pay her a visit, unannounced, two months later. Through her mother, Ada, a well-known theatrical agent, he discovered that she was performing with a small theater group in an experimental work and, undeterred by the fact that the play was being put on in German, said that he would like to see it for himself. "So he hired the whole theater and came together with his two fat and nasty bodyguards," said Tschechowa, who obviously was not impressed either by this "incredibly shy, typical American middle-class boy, well bred with a crease," or with his "hooligan [bodyguards] who were standing around him like walls, and I have to say that they were really ordinary, with [their] belching and farting and everything that belongs to it. I believe that he never went without them even to the toilet."

After the performance, which Vera deemed a "miserable" presentation, with only three, nondiscerning spectators, they spent much of the next two days together, visiting a movie set where a Viking film was being made, taking a boat ride, going to the zoo, having dinner with Vera's mother and various theatrical friends.

After dinner on the first night, Elvis indicated that he'd like to go to a nightclub, and Walter Brandin, a songwriter who was serving as Vera's "chaperone" for the evening with his wife, Elisabeth, suggested the Moulin Rouge, a sophisticated striptease club that he knew well. Some of the women in the party had never visited a striptease club before, but everyone was enthusiastic about the prospect, and they set off for the club in the big four-door Mercedes, which had replaced the Cadillac a couple of months before. Almost from the moment he arrived, the band started playing Elvis Presley songs and doing their best to coax their famous guest up onstage. According to Toni Netzel, a public relations manager for Polydor and one of the party, "he began to sing, and one of his bodyguards said that he should stop — he should know that he is not allowed to sing, it is forbid-den. Then he was singing at the table, and that wasn't allowed either."

In photographs from that evening he is wearing a dark suit, a narrow tie, his hair is upswept, and he looks alternately innocent and hungry for sin. With Vera and the rest of the theatrical party, he looks strangely jaded, his face a churlishly proprietary, almost dissipated mask, while with the half-naked strippers and some of the garishly made-up show people, he appears almost lost, an American abroad with an appetite so variously stimulated he does not even know where to begin. Elisabeth Brandin was impressed with his modesty, if not his independence: "We had a totally different version of Elvis Presley. I mean, we thought that he was crazy or that he would be flipped out in the same way as any other young singer. We were really surprised about his naturalness." She was also surprised, she said, by his meekness. He did everything that his bodyguards told him to do. When he went to the bathroom, his bodyguards went with him. It was because of the threats on his life, Lamar explained to her. "He answered that I should understand because they have so many contracts for the time after the army, that when a flipped-out woman gets the idea to throw some hydrochloric acid into his face or some other crazy shit, it would be over. . . . There was too much money to lose if something happened to him."

Elvis stayed at Vera's that night, while Red and Lamar remained at the Hotel Edelweiss. He rejoined them the following night because, he implied, Vera's mother had caught him in bed with her daughter. According to Vera, however, her mother just got tired of all the fans camping out in their garden and the restless, pent-up energy that Elvis seemed unable to control. "After he had bothered our animals, canaries, dogs, and cats long enough, my mother said to him, 'Now you better leave. There is the door. Bye!'" To reporters Ada Tschechowa simply remarked, "Elvis is a simple, intelligent boy, who, though he is rich, never forgets he once drove a truck for thirty-five dollars a week. He does his work as a soldier without whining. Teenagers do not have to be ashamed of such a hero."

He spent the next two days in Munich — and the next two nights at the club. After the first such evening, he joined Vera at breakfast with "bits of tinsel everywhere, in his hair and his eyebrows. I asked him what happened, and he only said, 'I stayed there.'" That was the last she saw of him in any case; "including the shooting [for the March of Dimes], I saw him three times." That didn't stop the press, which had covered their every move, from blowing it up into a full-scale romance. Vera was Elvis' "mystery date," and Vera's own sixty-five fan clubs protested her alliance with this boorish American. To his friends back home Vera became a symbol of his enviable new lifestyle; as Lamar said, "In some of the pictures he looks like a guy who's been having nonstop sex for six months." Elvis never went into a lot of detail with Red or Lamar or any of his other friends about the things he did with any of these girls. He never boasted except by implication, but they still felt like they were getting a pretty good idea, and among

themselves they frequently wondered if he would be doing anywhere near as well if he were not Elvis Presley; if there were ever a fair contest, Red for one had little doubt as to who would get the girl.

I E WAS A GOOD SOLDIER. On maneuvers he continued to show his HE WAS A GOOD SOLDIER. ON Induced in the was by now firmly ingenuity as a scout, but more important, he was by now firmly entrenched as one of the guys, and if another soldier gave him a hard time over his wealth or celebrity, he could give as good as he got. Sometimes he told them about his experiences in Hollywood, like the time he got a hard-on doing a love scene with Debra Paget in Love Me Tender, and he was uncanny at imitating his sergeant — but his sergeant was his biggest fan. To the executive officer of Company B, Lieutenant Taylor, who had previously served as commander of the scout platoon himself, he was "a gentleman ... a guy who cared a lot about other people" and, without much in the way of formal education, could speak intelligently both about world issues and about his own life. Nothing came without hard work, he stressed to the lieutenant; in this life you made your own luck. Once in a while he would express self-doubt, but then it was almost as if he would will himself to overcome it. "Sometimes I feel like just quitting," he said but he couldn't do that; there were "too many people depending on me. Too many people think I'm going places. Too damn many people."

He loaned out money cheerfully, without a second thought, and brushed off the inconveniences of fame, whether it was being pestered in the chow line by guys he didn't know or followed by fans who always seemed to figure out exactly where he was going to turn up. *He was making the best of it*, the Colonel told him over and over again in the phone calls and letters that never ceased to give him a boost on an almost daily basis. He was making everyone proud of him, Colonel said to cheer him up, *things were working out exactly as they had planned*. And Elvis believed that was just about the truth.

Colonel on his end was waging a fierce, multifronted attack, holding off on one flank impatient RCA executives, challenging on another the massed forces of Hollywood, finally — and most important — devising new and ingenious strategies to satisfy the fans. With RCA he had successfully withstood every pressure that a&r director Steve Sholes and vice president Bill Bullock had come up with *to get Elvis to record;* he had even turned down their invitation to him to travel to Germany at RCA's expense so that he could personally oversee a session which Sholes would produce. He had steadfastly refused to allow the overdubbing of unfinished recordings like "Your Cheatin' Heart" and "Tomorrow Night," which Elvis had deemed unsatisfactory for release; he had turned a deaf ear to Sholes' importunings that Elvis make a personal appearance at an industry function in Frankfurt; he had imperturbably resisted all of Sholes' dire warnings of what his stubborn strategy could do to Elvis Presley's career — what if sales of one of the new singles should dip under a million? Sholes demanded. This way lay ruin.

Nonsense, the Colonel responded, bedeviling Sholes by his very assurance. RCA knew exactly what it had in the can when Elvis went into the army, and Colonel had even bowed to Sholes' logic when he allowed Elvis to record in Nashville while on furlough the previous June. Surely the label didn't want to *flood the market*. RCA simply had to learn to harvest wisely what it had — and wouldn't now be a good time, in any case, to start thinking about putting out a second album of gold records, seeing the great success that they had enjoyed over the past twelve months with the first?

The record company simply had to stay the course, Colonel lectured Sholes with infuriating regularity, relaying to Elvis in Germany every twist and turn of their exchange, missing few opportunities to undermine Sholes' dignity and authority while at the same time making it clear that these were decisions for Elvis alone to make; it was up to Elvis to assess the material and determine what was suitable for the next single release. Over and over he emphasized that he — Colonel — knew nothing about the music, that he was merely supporting Elvis' judgments — but that Elvis was *right* not to want to record in Germany, where he was under so much pressure already, where he already had *a job to do*. Not to mention the fact that this very absence of surplus material, the reality that in no time at all RCA would be scraping the bottom of the barrel, couldn't hurt their bargaining position in the slightest when they returned to the negotiating table.

What Sholes and all the other RCA executives missed, Colonel insisted in letter after letter, was that it was Elvis alone that the fans wanted, not all these other singers and musicians with whom RCA wanted to clutter up the sessions. As early as January 9, Colonel came up with the idea of Elvis simply recording himself. All he had to do was to go out and get a tape recorder and then record one or two of those sacred songs that he did so well with just his own voice and piano. It could be done strictly on the q.t., without any publicity and without RCA having to know anything about it in advance — he wasn't sure if it made as much sense to Elvis as it did to him, but he *knew* the fans would be "wild" about it. Seemingly on little more than the strength of his own enthusiasm, Colonel wrote to Sholes five days later, hinting that he might have a surprise for the a&r director before too long, and the subject was revisited with Elvis from time to time, but there is no record that Elvis ever seriously responded to the proposal or did anything more than smile indulgently at his manager's touching faith in his powers.

In Hollywood negotiations were considerably more hard-boiled and frequently fraught with threats of litigation and counterlitigation. To begin with, in the fall of 1958, Colonel had planted a flurry of confusing, and sometimes contradictory, items in the trades about the likelihood of Elvis making his first post-army movie at Twentieth Century Fox. Hal Wallis naturally took strong exception to this stance, since by his interpretation of their contract Elvis was obligated to make his next movie for Wallis at Paramount, as the Colonel well knew. After fighting a furious rearguard action with Wallis and his partner, Joe Hazen, on various technical issues (such as whether army service merely delayed picking up an option or could actually cancel it) and even citing an unnamed German producer who wanted to pay them \$250,000 plus 50 percent of the profits for Elvis' services in a European production, Colonel finally bowed to what he surely knew to be inevitable, but not before extracting from Wallis \$175,000 plus a small profit participation for a picture for which they had no reason to expect anything more than \$100,000, including bonuses and profit participation. At this point Fox, far from withdrawing from the fray, indicated its intention to exercise its option not just for one but for two additional pictures, prompting the Colonel to remark, "Some snow job," when he reported these developments to Elvis and Vernon at the beginning of November. With Fox formally picking up both options by the end of the year, Colonel could barely restrain his jubilation. This would give Elvis three pictures in 1960 alone (one for Wallis, two for Fox), with a guaranteed income of over half a million dollars and negotiations with MGM still on the horizon. It should prove to Elvis once and for all, Colonel declared, that his fears about being forgotten were groundless, his career was not going to go away. In fact, this brought their picture setup into line with what the Colonel had been seeking all along. "The facts are now we do not have to call on Wallis every time with our hat in our hands."

It also seemed to bring out the Colonel's creative side. Not content with having virtually humiliated Wallis in business, the Colonel continued to

pepper the veteran showman with various demands, hoaxes, and suggestions, including an unsolicited scenario, which he said he was happy to submit free of charge — though he would gladly accept a retainer's fee if in Wallis' judgment he was deserving of it. In Colonel's scenario the action would take place on the Hawaiian Islands, because Hawaiian music looked like it might be the coming trend and Elvis clearly had the voice for it. The story line focuses on a gang of promoters who con Elvis into singing with some native Hawaiians — he is running away from his fans perhaps, his record company is frantically looking for him because they need material - but the promoters snow Elvis into singing for free, then surreptitiously record and bootleg the performance, to the natives' (and Elvis') financial disadvantage. In the end, Colonel assures Wallis, Elvis will bust open the conspiracy — but he hasn't gotten that far in his story yet, and in the meantime he has come up with another approach. In this one, Elvis is a foundling brought up by a traveling band of gypsies who live in wagons, sleep outdoors, and have the kind of lifestyle that will provide Elvis with the perfect opportunity to show off his rugged versatility and stay free of the goody-good image that is killing Pat Boone.

Wallis, it must be noted, remained patiently forbearing throughout, acknowledging the appeal of the Hawaiian angle but suggesting that the story line might be a trifle melodramatic. By January in any case he had settled on the almost inevitable first post-army picture, a comedy that would focus on Elvis' GI experience and that at this point was to be called *Christmas in Berlin*. Michael Curtiz, the much-respected director of *King Creole* and a longtime associate of Wallis, read the script and agreed that with certain minor changes this could be the best Presley picture yet, and the Colonel graciously accepted the verdict — for the time being anyway.

With the fans he was an altogether different figure. Like a gruff uncle able to let down his guard only when he is sure that he will not be perceived as "soft," the Colonel and his chief lieutenant, Tom Diskin, remained in constant touch with the loose confederation of fan clubs, extending little courtesies, bringing them up to date on the latest news and letting them know in one form or another that Elvis and the Colonel recognized and appreciated their loyalty. There were fan club contests in Europe, movie magazine contests at home, and stories planted in the press about everything from a one-hundred-city closed-circuit broadcast that would make history to the even more unlikely prospect of an Australian tour to a movie magazine story, "The Persecution of Private Presley," that the Colonel secretly encouraged for all the obvious reasons. On a more formal basis, Colonel Parker sent out over four thousand telegrams and congratulatory gifts and messages to fellow performers and show business eminences in his and Elvis' name on the occasion of openings, career milestones, or any other opportunity for mutual snowing. He traveled to theaters throughout the South to promote the rerelease of Elvis' movies, blanketed the Country Music Disc Jockey convention in Nashville, the Cotton Carnival in Memphis, and the Music Operators of America convention in Chicago with Elvis' name and achievements, and even put together an Elvis Presley Midget Fan Club to draw attention to his client. He did everything, in short, to keep Elvis' name in front of the public, *without ever actually exposing Elvis himself*, and at a time when other bigname artists' sales were dropping and the industry itself was in a slump, so far, he assured Elvis, his organization and hard work, together with Elvis' talent, had been able to keep them on top.

And he was right. For all of Steve Sholes' doom-filled prognostications, despite all of the nay-saying critics and all of the adversity they had to contend with, the Colonel's carefully conceived strategy of scarcity value and the painfully negotiated release schedule he had worked out with RCA was actually succeeding, and each of Elvis' new singles, spaced roughly four months apart, went at least as high as number four on the pop charts, while album sales for *King Creole* and *Elvis' Golden Records* more or less kept pace. He had succeeded, Colonel reassured him over and over again, by sticking to his guns and refusing to do anything but his duty to his country. He had proved all the doubters wrong, and with less than a year to go, they had only to stick to their plan.

VERNON AND ELISABETH were in an automobile accident on March 26, just after the photographer Colonel had dispatched from the States to take exclusive publicity pictures of PFC Elvis Presley, from which he expected they could pick up several thousand dollars profit (Do not under any circumstances, the Colonel admonished, let anyone get any free shots of you in uniform), had gone home. Vernon was driving when he lost control of the wheel, rolling over several times and ending up upside down on the other side of the autobahn. He was unhurt, but the Mercedes was a total loss, and Elisabeth had to be taken to a nearby hospital. Elvis' first reaction upon seeing the car was that he had lost his daddy now, too, but after determining that his father was all right, he went immediately to the hospital, where he found Elisabeth bandaged, medicated, and in a good

deal of pain. Without even asking her how she was feeling, "he wanted to know [if] Mr. Presley and I were engaged in advances toward each other. . . . This was why he thought the accident occurred." Elisabeth was shocked at first. Mr. Presley had always been a perfect gentleman toward her. But, she realized, it was merely one more indication of Elvis' pervasive mistrust and insecurity; "[he] was suspicious of everybody around him, even including his own dad."

Nor did it escape any of their attention that he was not especially pleased at his friend Rex's military success. The fact that Rex had been assigned to a more rugged outfit in the first place had always stuck in his throat, and now that Rex had achieved the position of tank commander, or acting sergeant, allowing him to wear sergeant's stripes before actually being promoted, Elvis' jealousy was plain for all to see. Plain enough that Rex never wore his uniform when he came around the house, despite the obvious pride he felt in his advancement.

As for Red, life in Bad Nauheim became more and more burdensome, as he grew restive under what he felt to be an increasingly arbitrary and autocratic reign. He had come to Germany strictly on impulse, on a wave of feeling precipitated by the deaths of Elvis' mother and of his own father within days of each other, just before his release from the Marines. But it hadn't really worked out from the start. Red was a hard-ass, and he chafed under the restrictions imposed not just by Vernon's penny-pinching ways but by what seemed like Elvis' own growing need to have everyone around him bow and scrape to his whims. Red felt like he had done the best he could — and he would have been the last to deny that he had caused more than enough trouble on his own. But the way that Elvis had started acting, the big-shot airs that he was always putting on, the way that he had come to believe his own publicity just pissed Red off and reminded him more and more of the reasons that he had quit originally in the summer of '56. From Red's point of view, this was a very different Elvis than the scared kid he had known in high school, or even the budding star that he had accompanied on his early travels in 1955 and 1956. That Elvis didn't think he was so high and mighty; he was grateful for the attention he got and didn't parade around like he thought he was God's gift to women and everyone else. That was the reason, Red theorized, that he took so readily to uppers: they "[brought] out a personality that he didn't have."

And then there was the other situation — Red didn't like taking orders from Elvis or anyone else, but he'd be damned if he'd take orders from that

hypocrite Vernon. Watching Vernon mooning over that drunken sergeant's wife, the three of them going around together like they were the best of friends while Vernon was fucking the wife - the worst of it came one night when they all went out and everybody got pretty smashed, "but Vernon and Bill really got drunk. We all ended up at Sergeant Bill's apartment. Luckily [he] passed out in his chair, because things were getting rough. Vernon was mouthing off. [Dee's kids] were crying, and I put them to bed." Vernon protested mightily when Red and Lamar carried him out and put him in a taxi. "He was cursing and yelling that he was going to have us on the first plane back to the States. But just as well we got out of there, because if Bill Stanley had woken up and heard all this going on, it might have got out of hand. He didn't know that Vernon and Dee were more than just seeing each other." And it wouldn't have done for Elvis to have found out about this drunken spree either: he had made it clear that he didn't like Dee, he didn't like his daddy to drink, and the thought of anyone replacing his mother, Red knew, was the one thing that was guaranteed to send him around the bend.

In the end Red simply announced that he was going home. Whether he jumped or was pushed (opinion was equally divided on the subject), he departed at the beginning of May, just around the time that Dee Stanley returned to Virginia with her boys "to get away and think." Whatever Red's private feelings, his public loyalty was unwavering, as he painted a rosy picture of Elvis and Vernon's experience in Germany in an on-air interview with Memphis DJ George Klein, a high school classmate and longtime friend of Elvis', shortly after his arrival home. Elvis' favorite off-duty activity was touch football, Red declared. His army life was a far cry from the night-owl existence he had lived as a civilian. His father, too, had made a good adjustment. "He has met a lot of people who speak English — soldiers' families mostly — and they visit quite a bit back and forth."

Elvis for his part could understand Red's feelings, but he needed someone from home besides Lamar. The first person he called was Alan Fortas, who might have given the matter more serious consideration except that he had already spoken to Red about the subject ("Red kept telling me, 'Whatever you do, don't go. I promise you, you'll hate it, and you and Elvis will never be the same'"). For a period of time he focused on Anita once again, and Colonel even set up a tentative date for her to visit, using her aunt as a cover — but the more Elvis thought about it, the less it seemed like a good idea, and even in his bluest moments, he was aware that it wouldn't answer his need for constant companionship. So he called Cliff Gleaves, not without a certain amount of trepidation but knowing that Cliff was always good for a laugh and had proved his loyalty if not his responsibility in the year and a half that he had palled around with them all prior to Elvis' army induction.

Cliff was in Baton Rouge trying his hand at show business when he got the call. A former DJ and natural entertainer who had blown his one line in *King Creole* out of stage fright, he was promoting his first record, "Love Is My Business," on Jack Clement's fledgling Summer label and working some Brother Dave Gardner comedy material into his act, "when the phone rings, and it's Elvis. He says, 'Cliff, I got a two-week leave in Paris coming up.' I didn't even ask him how are you or nothing. I said, 'Elvis, I'm on my way.'"

Not so fast that he actually got to go to Paris with them. With the tickets that Elvis supplied, Cliff managed to remain in transit for some time, stopping off in Memphis, New York, London, and one or two other points along the way before finally arriving in Germany at the beginning of June. When he did, he promptly took off again, upon his introduction to an airman named Currie Grant, who served as assistant manager of, and produced a variety show for, the Eagle Club in Wiesbaden, the largest air force club and community center in Europe.

Grant had originally met Lamar, Vernon, and Elisabeth the previous month when they attended a benefit for crippled children that he was hosting in Giessen. He hit it off with Lamar right away, and in exchange for an invitation to the Eagle Club, Lamar in turn extended an invitation to Currie and his wife Carol to come visit Bad Nauheim sometime after Elvis got back from maneuvers. The Sunday that Currie took Lamar up on his invitation just happened to coincide with the weekend of Cliff's arrival, and Rex noted the almost instantaneous reaction on Cliff's part to the news that Currie, too, was in show business. Within a matter of days, Cliff was off to Wiesbaden, having first secured a booking at the Eagle Club, and both he and the Volkswagen he had borrowed for transportation stayed gone for some time. Which was why Rex, and not Cliff, got to go to Paris.

I T WAS ELVIS AND LAMAR, Charlie and Rex who made the trip. First they stopped off in Munich, where they revisited the Moulin Rouge, and Elvis had his picture taken with Marianne, a stripper who had developed a routine, as the wire services gleefully reported, wearing "nothing but a standard-size Presley record." Then after two nights it was off to Paris in a private train car, where they were met on June 16 by Hill and Range cohead Jean Aberbach, a Viennese refugee who with his brother, Julian, had pioneered in the field of country and western song publishing before fate, in the person of Colonel Parker, brought them together with Elvis Presley.

Jean was prepared to take care of everything. He had made reservations for them at the plush Prince de Galles (Prince of Wales) Hotel, where they would occupy a suite on the top floor with a panoramic view of the Champs-Elysées and the Arc de Triomphe and he would be just down the hall. In addition, Freddy Bienstock, the Aberbachs' cousin and principal publishing go-between at recording sessions, was at their disposal, as was Ben Starr, the Hill and Range lawyer whom Elvis knew from his original RCA signing. Anywhere he and the boys wanted to go, anything they wanted to do could be arranged by Aberbach, a sophisticated and urbane forty-eight-year-old bachelor who with his brother maintained apartments and offices throughout the world; he and Freddy and Ben were just there to show the boys a good time. They brought regards from the Colonel, of course, who was sorry he could not be there himself, and from Hal Wallis, with whom Jean and his brother were already working on the upcoming motion picture, now retitled G.I. Blues, and who would, as Elvis knew, be arriving soon himself in Germany to shoot exteriors and army footage. If they wanted to see the sights, if they would like a guided tour of the city, they had only to ask.

Rex and Lamar were definitely curious, but Elvis was interested strictly in the activities after dark, so it was arranged that they would go to the Lido that night. After a brief press conference, which he handled with his customary aplomb ("In the spotlight he seemed to turn into another person," remarked Rex, who had never witnessed his friend in this kind of setting before), Elvis decided to give the famed sophistication of Paris a try. Here, reporters reassured him, he would not be bothered by the vulgar crowd; he could go out on the street without fear of being recognized, let alone accosted. The experiment lasted about ten minutes. That was how long it took a crowd of two hundred to swarm all over them at a sidewalk café just blocks from the hotel. It was over an hour before they were able to get back to the Prince de Galles, and while Rex and Lamar subsequently took advantage of Jean's offer to show them the sights, Elvis henceforth stuck to his original resolve.

Nights were a different matter altogether. The Lido was like a more licentious Las Vegas, and after one night the pattern was pretty much set. They woke up late in the day to have their one full meal, a huge 8:00 P.M.

breakfast. Then they would catch the first show at the Carousel or the Folies Bergère, and from there go on to the Lido, where the statuesque chorus line, the Blue Belles, were all English girls eager to make Elvis Presley's acquaintance. After the Lido closed, they would proceed to Le Bantu, a late-night club which didn't open until 4:00 A.M., bringing with them as many of the Blue Belles as wanted to come along. At the end of the evening Elvis would take his pick from among all the girls, leaving the rest for Rex, Charlie, and Lamar to choose from. One memorable night the entire chorus returned to the suite with them, and everyone was still asleep the next evening at 9:30 when the phone rang. It was the manager of the Lido, who announced to Lamar that he would like to begin his first show. Lamar told him to go right ahead and hung up without thinking any more about it. A moment later the phone rang again, and the same message was repeated. "Lamar got angry," observed an amused Rex "[and] this time . . . told the Lido manager ... to quit bothering us. The manager then told Lamar that he could not start his show, because we had his entire chorus line in our hotel suite. Needless to say, Lamar was a little embarrassed," concluded Rex, who in later life was at least as embarrassed by the recollection of his own actions, "but at the time it seemed to be all right."

That was how it went, a kind of Arabian nights existence in which they were shepherded from one improbable fantasy to another. One night at the Lido Elvis got up and sang "Willow Weep for Me" with the band. He was scared to death, he told reporters afterward. "For the first time in 15 months there I was in front of an audience. Then it flew all over me, boy — sudden fear." As for his army experience, "I had got used to a certain way of life. It's hard for anybody to adjust to the Army, and maybe it was harder for me than for most. But I was determined to adjust, because any other way I would only have hurt myself."

They were like a pack of schoolboys, whipping out their butane lighters (just recently introduced on the market) to see who could raise the highest flame should anyone be unwary enough to request a light. Poor Lamar, who had already lost his passport on the train, became the subject of even greater ridicule when he insisted that he had fallen in love with one of the dancers at Le Bantu. Elvis quickly investigated, invited the girl to join Lamar outside in their car, and almost fell over when Lamar discovered to his great surprise that his "'she' was a 'he.'" Elvis loved to tell the story about Lamar's great passion and how when all was said and done, "she had one bigger than he did!" At the end of their stay they were having such a good time that Elvis decided to give up their train reservations for one more night in Paris. He hired a limousine on the following day, and they arrived at the barracks in Friedberg just in time for the three soldiers to report back at midnight on the fifteenth day of their leave.

V^{ERNON MEANWHILE WAS TAKING an indefinite leave of his own. He had sailed from Bremerhaven the day the boys left for Paris, arriving in Memphis eight days later, on June 24. He had some business to take care of, he told reporters who noted his presence; he wanted to get the cars registered and ready for Elvis' homecoming in nine months; and he had a tooth that needed to be extracted while he was in town. But, of course, the real reason for his return was Dee, whom he was determined not to let go.}

He had accompanied her to the airport with her husband, Bill, and afterward the two men sat around drinking in the Stanleys' apartment, each of them despondent in his own way. He was afraid he might have lost his wife, Bill Stanley confessed, unaware of whom he had lost her to, and he asked Vernon to try to help him get her back. "You're my dearest friend," he declared in Dee's version of the story. "You took her shopping and gave her so much that I didn't. She loved you, you know. She'll listen to you...." That was finally too much for Vernon, and he called Dee even before she arrived at her sister's home.

He stayed for a month and a half, attending the Colonel's fiftieth birthday party in Madison, Tennessee, visiting his father in Louisville for the first time in quite a while and taking the opportunity to introduce him to Dee, mostly just trying to persuade her that they could really have a life together. In the *Memphis Press-Scimitar* it was reported that he was "so changed you wouldn't know him. . . . A friend said, 'He just goes around crying. He is so lonesome that sometimes he has one of his brothers spend the night in the house with him.'" And, it was further reported, he left untouched a broken windowpane that Gladys had fallen against — out of the deep grief that he and Elvis shared. But he brought Dee to Graceland. And he promised that he would provide a home there for her and her boys. "I got sent home from school," he told a local friend and fan, Dotty Ayers, leaving no question as to why Elvis was angry with him. "I don't think that it's this woman in particular," he said. "I think it would be any woman right now." By the time that he sailed from New York in early August, Dee had placed her boys, now eight, six, and three, in a home called Breezy Point Farms and made plans to join him in Germany.

H AL WALLIS ARRIVED in Frankfurt in mid August with a full crew for a couple of weeks of location shooting in Germany. He had gotten the Third Armored Division's permission to film tank maneuvers, along with more informal scenes at the base — all, the Paramount publicity apparatus hastened to assure the American people, at studio, not government, expense. Elvis was clear on his instructions — he was not to participate in filming in any way — but he did go to dinner with Wallis on several occasions and spoke excitedly about the upcoming production. He had put in a lot of time just preparing for this role, he declared, about seventeen months so far, and he thought he would have it just about right by the time he got out in March. Elvis even asked him for a script, Wallis told gossip columnist May Mann, but he was forced to refuse because he knew his star would have just gone ahead and memorized it on the spot.

At just about the time of Wallis' visit, on August 15, Captain Paul Beaulieu and his family arrived at the Rhine-Main air base and traveled from there to Wiesbaden, where Captain Beaulieu was to be stationed. Like most military families, the Beaulieus had moved around a good deal, but they had spent most of the past four years at the Bergstrom Air Force Base in Austin, where their oldest child, Priscilla, just fourteen, had been elected "Most Beautiful" and "Best Dressed" by her graduating classmates at Del Valle Junior High School the previous semester. Four years older than her brother Don, with a little sister of four and a newborn baby brother, Priscilla had only recently discovered that Paul Beaulieu, the man she had always assumed to be her father, had in fact adopted her after marrying her mother when Priscilla was three. Her real father, her mother explained in response to Priscilla's frantic questioning when she came upon a baby picture of herself with her parents, was a navy pilot who had died in an airplane crash when she was only six months old. She thought it would be best, she told her distraught daughter, if they kept this secret to themselves and didn't tell the other children — in fact, she thought it would be a good idea not to let Priscilla's father, who loved her very much, know that she had found out. Priscilla bowed to her mother's judgment, although she didn't understand her reasoning, and she couldn't help but feel like something of an outsider in the family from that point on. Which made it seem all the more unfair the following year to be forced to move *again* — and to Germany, of all places, this time.

For the first few days after their arrival she didn't do much of anything, refused to be appeased, rejected all offers of help. She was a beautiful girl with a snub nose, a childlike freshness of appearance, but a fully formed, adult expression and a mind of her own. Her mother did everything she could to coax her out of her mood of sullen resentment, and her father, who was strict but fair, tried to kid her out of it, but she continued to sulk with resolute determination, until at last she grew bored with the part herself. The family moved out of the hotel they had been living in and into a pension, and Priscilla started dropping by the nearby Eagle Club, which served as a kind of community center for air force families, every day on her way home from school. She would sit in the snack bar, listen to the jukebox, and write letters to friends at home. It was there that she met Currie Grant.

She didn't know who he was at first. He was just this good-looking, older guy in his twenties staring at her — but she was used to that. One day, while she was sitting with her ten-year-old brother, Don, he came up and introduced himself. She gave her own name with some misgivings and listened even more suspiciously as he explained that he was the entertainment director here at the Eagle Club, and was she by any chance a fan of Elvis Presley? She just stared at him — of course she was, who wasn't? She and her friend Angela had located Bad Nauheim on the map when she found out she would be going to Germany, and when they saw how close it was to Wiesbaden she told Angela she was going to meet Elvis over there. "I'm a good friend of his," said Currie Grant. "My wife and I go to his house quite often. How would you like to join us one evening?"

Eventually, her father agreed to it. After meeting Currie and getting Currie's assurances that his daughter would be well chaperoned by both him and his wife, Captain Beaulieu next contacted the airman's commanding officer and then — and only then — let her go, with the promise that she would be home by eleven o'clock without fail; the next day was a school day.

She wore her navy-and-white sailor dress with white socks and shoes. Brenda Lee's "Sweet Nothin's" was on the record player when she entered the room, and Rex thought she was a vision of loveliness. Elvis was sitting in his easy chair, with one leg thrown carelessly over the arm. He was

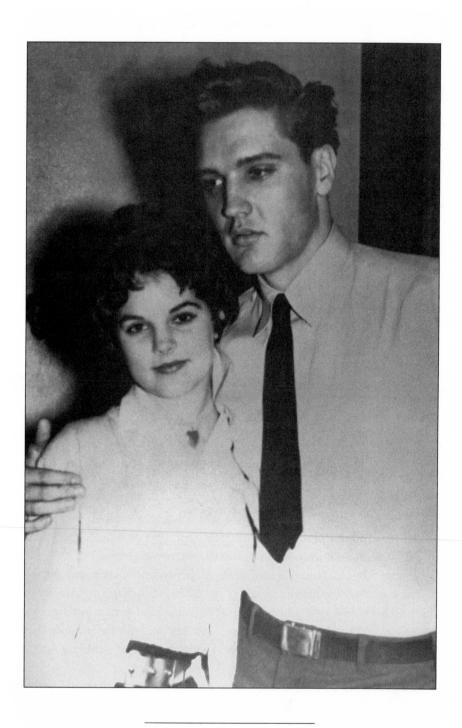

ELVIS AND PRISCILLA. (COURTESY OF THE ESTATE OF ELVIS PRESLEY)

wearing tan slacks and a red sweater and smoking one of his little cigars. To Rex it was obvious that Elvis was immediately smitten, but the fourteenyear-old was nearly struck dumb in her tracks.

As Currie led me over to him, Elvis stood up and smiled. "Well," he said. "What have we here?"

"Elvis," Currie said, "this is Priscilla Beaulieu. The girl I told you about."

We shook hands, and he said, "Hi, I'm Elvis Presley," but then there was a silence between us until Elvis asked me to sit down beside him, and Currie drifted off.

"So," Elvis said. "Do you go to school?"

"Yes."

"What are you, about a junior or senior in high school?"

I blushed and said nothing, not willing to reveal that I was only in the ninth grade.

"Well," he persisted.

"Ninth."

Elvis looked confused. "Ninth what?"

"Grade," I whispered.

"Ninth grade," he said and started laughing. "Why, you're just a baby."

"Thanks," I said curtly. Not even Elvis Presley had the right to say that to me.

He played the piano for her, singing some of his own songs but also, to her surprise, big, expressive numbers like Tony Bennett's 1953 hit, "Rags to Riches," and Mahalia Jackson's "I Asked the Lord," and, with the others joining in, Earl Grant's Nat "King" Cole–like ballad, "The End." The way he looked at her, it was obvious he was trying to impress her, but she didn't really know how to respond as she looked around the room, checking out the poster of Brigitte Bardot, watching all these adults competing for his attention and approbation. He took her into the kitchen, where she met his grandmother, and he consumed the first of five bacon sandwiches smothered with mustard. She tried to think of things to say, but for some reason it didn't matter, he just seemed to want to pour out his feelings to her, and when Currie came into the room and said it was time to go, Elvis begged her to stay a little longer. When Currie explained that she couldn't, Elvis said maybe she could come by again, but Priscilla doubted that he would remember, and she didn't get home till 2 A.M. anyway when they got held up by an impenetrable fog on the autobahn to Wiesbaden.

It was only a few days before she got another call from Currie: Elvis wanted to see her again. She couldn't believe it, and it threw the rest of the household into some consternation, but her parents eventually agreed to let her go, and before she knew it she was back in the house on Goethestrasse. This time it was clear from the start that she was the one: after playing the piano and singing to her, Elvis said, "I want to be alone with you, Priscilla." She looked around; there was no one near them.

"We are alone," I said nervously.

He moved closer, backing me against the wall. "I mean, *really* alone," he whispered. "Will you come upstairs to my room?"

The question threw me into a panic. His room? . . .

"There's nothing to be frightened of, Honey."

As he spoke, he was smoothing my hair. "I swear, I'll never do anything to harm you." He sounded absolutely sincere. "I'll treat you just like a sister." Flustered and confused, I looked away.

"Please."

She preceded him up the stairs, so it would "look better," and explored his room, finding letters from Anita and other girls carelessly strewn about, examining his books and records, all his uniforms, waiting almost breath-lessly for him to appear. At last, after what seemed like forever, he did, took off his jacket, turned on the radio, and sat down on the bed. Why didn't she sit down beside him? he said, as she imagined all kinds of unimaginable conclusions, but she was won over by his sweetness, his sincerity, his eyes, and they fell into a conversation from which she could scarcely be roused to go home. He was just like her, he felt things just like her, underneath "he was just a boy, he was afraid, he didn't know if he was going to have a career or not, he didn't know if he was going to come back to [his] fans — he was *stripped*, he was vulnerable." At the end of the evening he kissed her good night, and she clung to him desperately, not wanting to let him go. He was the one to pull away. They had plenty of time, he told her, kissing her on the forehead and addressing her for the first time as "Little One."

* * *

N THEIR FOURTH DATE he met her parents, at Captain Beaulieu's insistence. Up till then Currie had been taking her back and forth to Bad Nauheim, but Priscilla told Elvis that if he wanted to see her again, he was going to have to pick her up himself. He arrived with his father in the white BMW and sat nervously in the Beaulieus' living room waiting for her parents to enter. When they did, he jumped up and said, "Hello, I'm Elvis Presley, and this is my daddy, Vernon," as if they might not know who their visitors were. They made small talk while Priscilla nervously fretted; she knew what her father could be like, and she had seen and heard things at Bad Nauheim that she knew her father would never approve of. But Elvis was on his best behavior — he talked about his assignment with the scouts and looked smart in his army uniform. When Captain Beaulieu told him he would have to pick up Priscilla and bring her back himself from now on, just like a regular date, Elvis explained that by the time he got off duty and cleaned up, much of the evening was already gone, and would it be all right if his father picked their daughter up, he would bring her home.

Captain Beaulieu seemed to mull over this compromise solution, then posed the question directly: What was it exactly Elvis wanted with his daughter? After all, he had all these girls throwing themselves at him. Why Priscilla? Elvis seemed to really squirm at that one — Priscilla felt even more sorry for him for a moment, being subjected to this kind of inquisition, and Vernon, too, shifted uncomfortably in his seat. But then he declared, "Well, sir, I happen to be very fond of her," in that forthright manner of his that could make you believe just about anything he said. Priscilla was very mature for her age, he stated, and it got kind of lonely for him, being stationed so far away from home. "I guess you might say I need someone to talk to. You don't have to worry about her, Captain," he declared. "I'll take good care of her."

 $F_{didn't}$ take her home all the time, or even most of the time, and Vernon didn't take her home all the time, or even most of the time, and Vernon didn't always pick her up; it was Lamar as often as not who acted as the chauffeur, but that was no longer an issue. Her parents had been mollified, convinced for the time being anyway that he really was a nice, well-mannered young man.

Every night they ended up in his bedroom. Every night they ended up in each other's arms. He proved true to his promise: he didn't harm her, he wouldn't harm her even if she begged him to — she was too young, he told her; he wanted her to remain pure. Someday the time would be right, but for now there were lots of other things they could do. She felt closer to him than anyone she had ever known in her life. Through Grandma, whom she called Dodger now, just as he did, she got to hear all about what he was like as a child, she learned all the family stories, she heard how hard his mother could be on him sometimes but how she protected him from all harm. She felt totally a part of him, and yet she didn't know what her own role was supposed to be. She knew he had other girls, much as he might deny it. When she told him that she loved him, he put his fingers to her lips and said he didn't understand what he was feeling himself. "Daddy keeps reminding me of your age and that it can't be possible," he stumbled on. "When I go home. . . . Only time will tell."

It was worst when they were around the others. Earlier in the evening, before Priscilla preceded him upstairs, they were constantly surrounded, and he could be so different when other people were around, hiding the little boy that had been revealed to her, brutally brushing aside their secret life. She didn't know how she was supposed to be with him then. Then she was just the same as all the rest, waiting for him to reveal his mood, laughing when he laughed, sitting silently with a blank expression until he had something to say.

"I really felt I got to know who Elvis Presley was during that time. Not with ego — not the star that he felt he should portray. I saw him raw, totally raw, I saw him as he really was after he lost his mother. We talked so much, he shared his grief with me, he was very insecure, and he felt very betrayed by his father, that he would even fall for such a woman [as Dee Stanley]. He used to literally babble about how this couldn't be his father, about how "This will pass, once we get away from Germany, this will go away. . . .' He was at his most vulnerable, his most honest, I would say his most passionate during that time."

About his career he expressed trepidation, but he had utter faith in the Colonel. He showed her letters Colonel had written him, letters detailing *their* plan, showing how he was keeping the fans' interest alive, running down the list of all his pitches and promotions, telling Elvis not to worry. "He talked about how I'd meet the Colonel one day, how Colonel was working on a film project for him as soon as he got back and he was going to be in more films [after that]. He spoke of him very endearingly." And it was obvious that he trusted him implicitly, because, he told Priscilla,

Colonel was the whole reason he hadn't performed the entire time he was in the army, and, as in every other career decision, *Colonel had been right*.

She soaked it all in, no more surprised by his conviction on this subject than by his almost evangelical espousal of the benefits of yogurt, which he had only recently discovered and ate by the gallon. At the end of the evening they would listen to "Goodnight, My Love," the sign-off number on the armed forces radio station every night, and then Lamar would drive her home.

E VERYONE COULD SEE it was different right from the start. To Charlie there was no question that he had fallen in love at first sight. "Did you see the bone structure in her face?" Elvis demanded of his friend, as if somehow he had to explain it. "It's like the woman I've been looking for all my life." To Joe Esposito, a newfound army buddy from Chicago who had recently started playing touch football with them on the weekends, the source of the attraction was obvious ("Every Sunday afternoon Priscilla sat by herself on the sidelines watching the football games. I still have that image clear in my head. I've never seen anyone before or since so absolutely fragile and beautiful"), even if the underlying explanation might have been more mundane. "He knew she was young, and he was going to train her to be just the way he wanted her to be."

Even Elisabeth, who continued to sleep with him every night and was, of course, intensely jealous, knew immediately that this was something of a different order from all the other dalliances, from all the other girls who passed in and out of his life. She had thought for the longest time that he would never leave Anita; she passed on Anita's letters without comment and expected, like everyone else, that they would probably get married someday — but with this quietly pretty, petite brunette she sensed all certainty evaporating. "I often wanted to ask Elvis if he had fallen in love with Priscilla, but I knew better than to ask that question."

Otherwise, almost all of the talk, all of the focus was now, suddenly, on going home. Elvis spoke sometimes about bringing Elisabeth back to Memphis as his secretary. Sometimes he talked about taking them *all* home with him. But even as he was waxing nostalgic about how much they had all been through together, it was perfectly clear where his attention was increasingly directed, even when he was with Priscilla, who saw her dream evaporating before she had even been able to fully formulate it, who was growing more and more certain that he would go back to the States, and it would be *as if it had never happened*.

Communications from the Colonel were arriving at an ever accelerating pace - calls, telegrams, letters. The Frank Sinatra television special, which had first been announced in July, was now all worked out: it was to be subtitled "Frank Sinatra's Welcome Home Party for Elvis Presley," and Elvis would be receiving \$125,000, the highest fee ever paid for a guest appearance on television — and, the Colonel made sure to point out, for singing only two songs. The recording session that would take place just prior to the special was on his mind as well. He would debut his new single on the show, Colonel said, so he should be thinking about that -- that would be their first order of business at the session, and it had to be right. Otherwise they had RCA just where they wanted them. They couldn't write a new contract until certain tax issues had been cleared up, but the record company had already agreed to pay a full, "favored nations" publishing royalty on all songs in which they had a copyright interest, an important modification of the existing contract that stipulated a three-quarter rate on all such compositions, according to standard company policy. What this meant in light of Elvis' publishing partnership with Hill and Range, the Colonel was quick to point out, was a 25-percent upgrade in payment on virtually every song that he would record. Not only that, if any other RCA artist were to get a better deal, Elvis' deal would automatically kick up to the same level due to the "favored nations" clause in the contract. They had RCA practically eating out of their hand, the Colonel crowed — and it was all because they had stuck to their guns.

Elvis' mind for the most part, though, was on other things. He enjoyed Colonel's running account of his business successes, he loved to hear how Colonel had all the big shots jumping to his tune, and he certainly appreciated the way in which his manager was always looking out for him, the extent to which Colonel had provided a measure of insurance against the future — but what concerned him most of all, what Colonel had *freed* him to be able to concentrate on, was the music. That was what he focused on each night as he sat down at the piano, that was what he dreamt about more and more — the songs that he would actually record when he got home, the music with which he would once again be able to communicate to the world. There were a number of songs that he had been considering for some time: the Four Fellows' 1955 hit, "Soldier Boy," an understandable refrain ever since he had joined the army; "I Will Be Home Again," the old Golden Gate Quartet number that he and Charlie sang as a duet; classic r&b material like Clyde McPhatter's "Such a Night," and Vikki Nelson's "Like a Baby." He *knew* he was going to do a gospel album before the year was out, and to that end Charlie kept feeding him jubilee material, while Gordon Stoker of the Jordanaires sent him records by everyone from the black gospel group the Harmonizing Four, with their great bass singer Jimmy Jones, to the latest releases by the Statesmen and the Blackwood Brothers. Good old Dewey Phillips back in Memphis kept tipping him to songs he probably would never get around to recording, and Freddy Bienstock kept up a steady flow of Hill and Range material.

None of them seemed to fully recognize the new directions he wanted to explore — but then, how could they when it was territory he had always tended to shy away from since he had begun making records himself? He had always been drawn to the big-voiced, inspirational, near-operatic ballad singing of Roy Hamilton, for example, nominally an r&b artist whose "You'll Never Walk Alone" had shot to number one in 1954. He had recorded Hamilton's bouncy "I'm Gonna Sit Right Down and Cry (Over You)" upon his arrival at RCA in 1956, but he hadn't thought he was even close to ready to tackle Hamilton's more ambitious numbers - and who knew what Steve Sholes, the man who signed him, would have thought if he had? Now, with Charlie's encouragement, he worked constantly on improving his vocal technique - Charlie continued to show him tricks to help with his breathing and expand his range, and he employed those lessons on numbers like Hamilton's "Unchained Melody" and "I Believe," as well as the lilting Irish air "Danny Boy" and one of his other longtime favorites, Tony Martin's "There's No Tomorrow," a 1949 English-language adaptation of "O Sole Mio," which was itself based upon an Italian folk melody forever immortalized in the great opera singer Enrico Caruso's 1916 recording.

At first it frightened him to think what his fans' reaction might be. But then he fell back on the one precept that had guided him throughout his recording career: what you sang had to come from the heart; it couldn't just be a matter of following trends, because then the public would never believe you. Up till now he had relied on instinct alone, and his instinct had proved as reliable in music as the Colonel's in business. It wasn't as if he was putting on airs; this was music he had always loved — he could remember listening to Caruso's records as a child. So he pursued these new directions with the same unfaltering zeal that he always showed for a fresh idea, picking up tips from Charlie, studying familiar records by the Ink Spots and the Mills Brothers minutely for clues as to how to phrase, how to hit the note, preparing himself for the challenge.

Freddy did his best to get a cut-in on "There's No Tomorrow" so that they would be able to participate in publishing royalties, but when he failed, he came up with the idea of commissioning new lyrics, since the melody was already in the public domain. Elvis was open to the idea — it was the song he cared about, not the words - and they talked about it some more when Freddy came to Bad Nauheim to deliver acetates for Elvis' consideration. Everything was falling into place for the upcoming session. They would use most of the same musicians from the last session in Nashville in June of 1958, and even Scotty Moore, Elvis' original guitarist, was back in the fold — he had a song on which he wanted to make a deal. That was just the way things ought to be, Colonel said, a good business relationship, and if the other original trio member, Bill Black, was playing hard to get (Black had recently formed his own combo, which was starting to enjoy a little bit of success), well, there were plenty of good bass players in Nashville, Colonel declared, and it never did to beg. There was no question in Freddy's mind of Elvis' enthusiasm about getting back to work — he had never seen him anything less than 100 percent committed, but now he was practically champing at the bit. At the same time, Freddy's sardonic view of human nature was also satisfied during his visit as he observed Elvis' increasing discomfiture and watched him turn the record player up louder and louder to try to drown out the sounds of Vernon and his blond girlfriend in the next room.

IN OCTOBER ELVIS saw a magazine notice advertising the services of a South African doctor who specialized in dermatology and owned the patent rights to a unique method of treatment guaranteed to reduce enlarged pores and acne scars, which he felt might greatly improve his appearance in front of the movie cameras. He had Elisabeth get in touch with the doctor, Laurenz Johannes Griessel Landau, and they had an immediate reply from Johannesburg proposing a course of treatment which would remain entirely confidential ("Boy Scout's honor," promised the doctor), and would cost Elvis nothing except the dermatologist's expenses unless, and until, it proved successful. It would be Dr. Landau's pleasure to work with such an eminent patient, he suggested in the course of his initial ten-page letter, and in a four-page p.s., he mentioned that he would be bringing with him recordings of some of his own musical compositions. The correspondence continued while Elvis was on maneuvers in Wildflecken, and then Dr. Landau himself showed up in Bad Nauheim with no advance notice before Elvis had even returned from the field.

Treatments began on November 27 and continued several times a week for roughly two hours at a time for the next four weeks. Elvis was positive that he could see results and pointed them out to everyone around him, though no one else recognized any change and Vernon was convinced that the eccentric South African was going to bankrupt them. In early December Elvis began formal karate lessons as well after witnessing a demonstration by Jurgen Seydel, "the father of German karate," whom he sought out at his studio in Bad Homburg. He and Rex went twice a week at first, and before long Elvis was demonstrating what they had learned to Priscilla and everyone else in the household and giving lectures on the discipline required to master the art of karate and its superiority to other, cruder forms of self-defense.

Then on the day before Christmas Elvis emerged from a session with Dr. Landau in his bedroom with a look of horror on his face. The sonofabitch was queer, he told Lamar and Rex, he was going to kill the fucking sonofabitch. Landau was hustled out of the house right away, if only to keep Elvis from actually following through, but the South African reappeared that night with a letter that threatened to go to the press with photographs and tape recordings and accounts of "compromising situations" of which he had direct personal knowledge, including an illicit relationship with a "16-year-old" [sic] American girlfriend.

Vernon was utterly panic-stricken; he was convinced that this could mean the end of Elvis' career, and there were emergency calls to the Colonel and general consternation all around. Colonel remained unfazed, however, consulting with some of his high-level army contacts in Washington, and on his advice Elvis and Vernon got in touch with the army's Provost Marshal Division, which in turn referred the matter to the FBI. On January 6 Laurenz Johannes Griessel Landau (who turned out, not surprisingly, *not* to be a medical doctor) was on a plane to London, having received a small amount of money for his troubles but never to be heard from again.

* * *

A LL OF THIS EXCITEMENT cast something of a pall over the holiday season, but it didn't spoil the Christmas party that Elvis threw for some of the guys at his home, and by the time he had his twenty-fifth birthday party on January 8 at the local recreation center, Dr. Landau was little more than a memory. It was a gala affair, with close to two hundred in attendance, and the room filled with attractive women, but Elvis had eyes only for Priscilla. Charlie sang and Elvis joined in; Cliff, who had been AWOL for much of the last few months, put in a rare appearance; Joe Esposito and a bunch of the "regulars" presented a trophy inscribed ELVIS PRESLEY. MOST VALUABLE PLAYER. BAD NAUHEIM SUNDAY AFTER-NOON FOOTBALL ASSOCIATION, 1959; and Vernon and Dee, who had brought Priscilla to the party, acted like an old married couple, proudly surveying the scene.

Earlier in the evening Elvis had spoken to Dick Clark, the Philadelphiabased host of *American Bandstand*, by telephone, touching on his upcoming television and motion-picture appearances, all part of the stepped-up publicity campaign that the Colonel had been waging ever since November. For the first time, full-length features were beginning to crop up regularly in the American press; RCA put out a carefully orchestrated series of press releases and planted stories that posed the question, Will Elvis Presley Change His Style?; and there was a whole series of interviews scheduled over the next two months, which would climax, according to the Colonel's plan, in an avalanche of coverage of Private Presley's Triumphant Return Home. The reality of the life that he had left behind was beginning to impinge more and more on even his everyday activities, he had already begun to think about packing — but he still didn't know what he was going to do about Priscilla.

Grandma had seen where things were going almost from the start, and she felt very bad for Elisabeth, who had been her best friend in this godforsaken land. She didn't blame Elvis for it exactly, but she didn't like to see the girl left dangling on a string — and she saw the way that Rex was looking at her out of the corner of his eye. So she brought the two of them together, dropping oblique hints at first, then inviting them surreptitiously to her room, where she told them both exactly what she thought they should do.

At first they met at the apartment of a service couple who were part of the whole gang — the wife even helped Elisabeth with the fan correspondence. They had to be very careful, because Elvis seemed able to keep track of where everyone was at all times. Lamar and Cliff knew about the relationship and to Rex's surprise "seemed to really enjoy the intrigue of the situation. . . . Maybe it was their way of getting back at Elvis for some of the things that Elvis had done to them." Once they almost got caught, but a friend said that he was the one who had been seen with Elisabeth, so he, instead of Rex, was banished from the house. They had been seeing each other in this manner for a little over two months when the birthday party took place, and Rex could only observe helplessly as Elvis showered all of his attention on Priscilla while he could not so much as ask Elisabeth for a dance.

Finally, it was just too much for him, watching Elisabeth besieged by dancing partners, with one in particular making a blatant play for her. Out of sheer frustration he informed Elvis that this guy was trying to hit on Elisabeth, and he took a small measure of satisfaction when Elvis blew up, as Rex knew he would, and told the guy to get lost.

Elvis went to Paris a second time shortly after that, taking Joe and Cliff and his karate instructor, Jurgen Seydel, with him this time in addition to Lamar. The evening activities remained much the same, but during the day he now studied shotokan technique with a Japanese karate teacher that Jurgen Seydel introduced him to. Joe held the money for them on this trip, paid all the bills, and on Vernon's instructions collected all the receipts, impressing Elvis with his organizational skills. One night they went to the Café de Paris to hear the Golden Gate Quartet, and Elvis went backstage and sang spirituals with them for hours, dredging up songs that even the group had trouble remembering on occasion.

He was promoted to acting sergeant on January 20, two days after his return. It was somewhat of a bitter pill, since Rex had long since gotten his full promotion, and Elvis even took the occasion to state that Rex had probably made sergeant only because of his association with Elvis. "Rexadus," he said, "see what good things can happen to you because you know me."

He finally got his full sergeant's stripes on February 11 and threw a little party at the house, where everything was in a flurry of preparation, with Grandma busily packing, Vernon and Dee making plans for the future, and Priscilla desperately clinging to him every night, not wanting to go, not wanting him to go, ever — but if he did, why couldn't he take her with him? She didn't care about her parents, school wasn't part of the picture, and she couldn't even let on that she was tired, because one night when she fell asleep waiting for him to finish his karate class, he asked her how many hours of sleep she was getting. "After a second, I said, 'About four or five hours a night. But I'll be fine.' Elvis looked thoughtful and said, "Come upstairs a minute. I have something for you." He led me up to his room where he placed a small handful of white pills in the palm of my hand. "I want you to take these; they'll help you stay awake during the day. Just take one when you feel a little drowsy, no more than one, though, or you'll be doing handstands in the hallway."

"What are they?" I asked.

"You don't need to know what they are; they give them to us when we go on maneuvers. If I didn't have them, I'd never make it through the day myself. But it's okay, they're safe," he told me. "Put them away and don't tell anyone you have them, and don't take them every day. Just when you need a little more energy."

She trusted him, she believed him implicitly, but she put the pills away in a little box she had for her keepsakes — cigar holders, the sweet little notes he wrote her, things that would remind her of him when he was gone. And she tried to stay awake from then on.

Meanwhile, Elvis had business to take care of. In interview after interview he stressed that he felt as if he had really accomplished something. "People were expecting me to mess up, to goof up in one way or another. They thought I couldn't take it and so forth, and I was determined to go to any limits to prove otherwise. Not only to the people who were wondering but to myself." He couldn't wait to resume his career, he said. He didn't know what was going to happen, but whatever it was, the Army had been an invaluable experience and his manager, Colonel Parker, an unfailing source of support and sound advice. Yes, he expected to tour Europe, definitely. Maybe next year, though the timing was up to his manager. He would never change his style; he chose all his own songs by instinct, as though he was the one buying the record himself; more than anything, he wanted to be taken seriously as a dramatic actor.

As the day of departure drew near, he found to his surprise that it got harder and harder to let go, and he talked to each of the boys individually about staying in touch, about not allowing friendship to fade, about maybe going to work for him when they got home. Joe was the first to ship out, leaving a week before Elvis and Rex and promising at Elvis' last-minute urging that he would give up the bookkeeping job that he had been planning to go back to and report for duty as soon as Elvis called. Lamar and Cliff, of course, would continue in their familiar roles, Cliff as the comedian always good for a laugh until you got tired of him, Lamar the loyal butt of all jokes. Charlie promised he'd come by as soon as he'd had a chance to visit his mama and daddy in Decatur, no more than a hop, skip, and a jump away. Elisabeth would continue as his private secretary; there was no question of her loyalty, and he knew he could trust her to keep her mouth shut when she was around Anita. Rex was the one he really wanted, though. Rex had been with him all the way and was the lieutenant he needed, the most practical, the best-educated, in his own quiet way the most independent of the group.

Rex for his part was racked with guilt. After breaking off with Elisabeth in a series of painful confusions and misunderstandings, he had finally gotten back together with her just a week before they were scheduled to go. But then Grandma had become ill and Elisabeth had had to take charge of the preparations, so they had less time to themselves than ever, with more than two dozen trunks and suitcases and over two thousand records to pack. They could scarcely look at each other when they were around Elvis without immediately looking away again. Both of them were aware that if either one of them was to work for Elvis Presley, they could not continue their relationship, but Elisabeth was in no mood to go back to her family, who had just been reassigned to the States, and each remained confused and conflicted about how things were going to end.

March I dawned raw and gray. There was a press conference scheduled for Elvis at 9:00 A.M. in the enlisted men's club at Ray Barracks in Friedberg. Over one hundred reporters and photographers were present, flinging questions at Elvis almost as he walked in the door seventeen minutes late in a hand-tailored uniform. For the most part the questions were the usual ones: what did he think of his army experience ("I've learned a lot"); any prospects of marriage in the near future (Not really); had he kept a diary ("I haven't kept a diary, but I can tell you any date you would like to know. I would like to write a book"); what about his movie and recording plans? He even received a special certificate of merit from his commanding officer, General Richard J. Brown, citing his "cheerfulness and drive and continually outstanding leadership ability."

All in all, it was a masterful, utterly disarming performance, with the only sign of nervousness on Elvis' part the constant jiggling of his leg under the table. The one hitch came when he was asked about the air force captain's daughter, Priscilla Beaulieu, who was generally believed to be his "16-year-old [*sic*] girlfriend." Yes, he acknowledged, he had seen her a number of times over the last few months, she was a very pretty brunette with beautiful blue eyes. "She is a very nice girl. Her family is nice, and she is

very mature for her age." That sent reporters rushing to the phones immediately to call the girl's father, who, before making any comment, asked to know exactly what Sergeant Presley had said, since he wasn't going to say anything to embarrass either Elvis or his daughter. "There is nothing serious about this," Captain Beaulieu finally declared, after being debriefed. "The two of them have been great friends. They have had a real nice time knowing one another. But that is all there is to it."

Toward the end of the news conference Elvis spotted an old friend in uniform. "Marion!" he called out in utter surprise, recognizing Air Force Captain Marion Keisker MacInnes, whom he had not seen since she left Sun Records in the summer of 1957 and who was now stationed in Germany. "Marion," he repeated as she drew closer, "I don't know whether to kiss you or salute!" "In that order," replied Sam Phillips' former assistant, who had been the first to welcome him to his original label. When, a little later, he saw her being reprimanded by an army captain for overfamiliarity with a noncom, he rushed over to explain that they wouldn't even be having this press conference if it weren't for this lady. "This WAC captain," replied the army officer without so much as glancing at her, Marion later recalled. "Elvis said, 'Well, it's a long story, but she wasn't always a WAC captain.' Then he held my hand. He was determined that the army wasn't going to throw me out. That was a very significant thing for me; that was the first and only time that Elvis indicated publicly that he recognized the role that I had played."

The calls about Priscilla kept coming in all day. Elvis had lunch and returned briefly to the barracks to finish up some business, but he was back at Goethestrasse signing autographs by 5:40 P.M., emerging from the house several more times in the course of the evening to try to calm his near-hysterical fans. Priscilla stayed with him till late that night, pleading with him one last time to consummate their love. He told her that he loved her and promised that someday they would, when the time was right — but not now, she was still too young. She returned from Wiesbaden early the next morning after a sleepless night, and the two of them emerged from the house at II:IO A.M. to be hustled past a clutch of screaming fans, some of whom had never abandoned their post over the course of the long night. Then Elvis bade a temporary farewell to Priscilla and the rest of the family — Daddy and Grandma and Elisabeth and Lamar would all be flying out of Frankfurt by commercial airliner later in the day — joining his fellow GIs on a military bus that would transport them to the air base at

Rhine-Main. Reporters were already lying in wait by the time Priscilla arrived at the base, hurling questions at her, snapping her picture. She was wearing a kerchief knotted around her chin and a demure, high-necked, checked dress under a plain winter coat. She was very fond of Elvis, she repeated over and over again in response to their questioning, but that was all there was to it. "I'm too young for marriage," she had told one reporter the day before, "but I think Elvis is a wonderful boy — so kind, so considerate, such a gentleman. . . . He doesn't drink or smoke and doesn't even use bad words, like some boys do."

At the airstrip she was held back by a cordon of MPs, who would not permit her to say good-bye. Reporters picked up every nuance of this lover's farewell. "More than ten tall Air Force police surrounded Priscilla," reported the *New York Mirror*.

She cried. She ran towards Elvis, but the policemen pulled her back. . . . "They won't let me see her, they won't let me see her," said Elvis, disappointment written all over his tanned face.

Priscilla fondled the gold wristwatch with a large diamond that Elvis gave her for Christmas.

"He has promised to telephone me as often as he can. Elvis said he would rather telephone than write because he can hear my voice," the Air Force captain's daughter said.

The plane lifted off at 5:25 P.M. and *Life* magazine got a shot of Priscilla waving good-bye. "Girl He Left Behind," was the caption, and it was accompanied by another photograph of "16-year-old" Priscilla in the backseat of the car that had taken them to Ray Barracks, about to bestow "a last kiss [before] they separated."

"When he left, the car ride home was extremely painful. I didn't know if that was the last time I was going to see him, if he would ever call. It was always in my head, you know, why would he even call me? He was going back to Hollywood, and his days would be filled, where I'd be at home, I'd be at school, thinking of nothing but him, writing his name down on a piece of paper every day like a kid. Was it infatuation? Was it illusion? At the time it was very real for me. I was in love, and these were the first [deep] emotions I had ever felt. I wasn't sure if it was a good feeling or not, in a way I didn't like these feelings because I couldn't control them, I just knew they were very painful and very real."

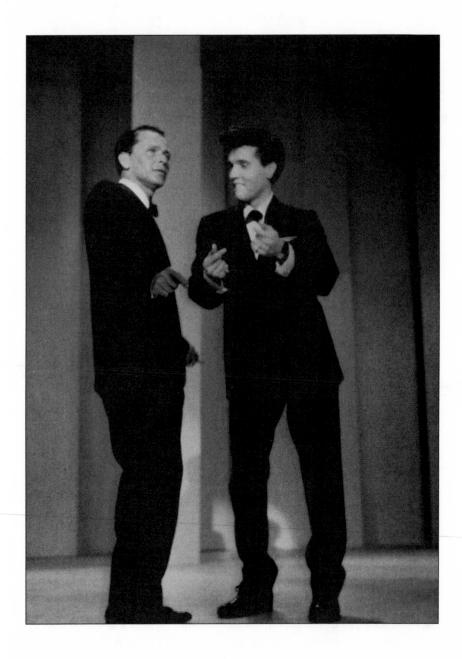

FRANK SINATRA SHOW, MARCH 26, 1960. (COURTESY OF THE ESTATE OF ELVIS PRESLEY)

ELVIS IS BACK

T WAS LIKE COMING HOME to a party for which all the places have been laid, all the guests provided with noisemakers and party hats, and only the occasional look of bewilderment on the guest of honor's face betrays a fear that he may somehow have wandered into somebody else's dream.

He was dressed all in black, with just a gold medallion around his neck to provide color and his light brown hair dramatically upswept, at the press conference that took place on the very day of his homecoming. Some fifty reporters crowded into the little building behind the main house at Graceland, which ordinarily served as his father's office. More than one reporter remarked upon the white nylon Christmas tree standing off in a corner with its lights twinkling and what looked like gifts still piled up beneath it, a memento of his last Christmas at home.

"Now, gentlemen," he announced from behind an austere metal desk with a sign that read "The Boss" on it, "I have called you here to discuss a very important matter." He chuckled as the assorted reporters picked up the allusion to one of President Eisenhower's televised news conferences. Then the questions came fast and furious. Had he chosen his first single yet? What had he learned from army life? Was his music going to change?

He carried it off with the same aplomb that he always seemed to keep in reserve for public occasions, declining only to pose with a doll that was thrust upon him from a pile of stuffed animals and other fan tributes. "It would look a little silly for a twenty-five-year-old man home from the army to be playing with dolls," he said, considerably more interested in sharing with reporters his knowledge of karate and more than ready to split a board for them if one could be obtained. "I just can't get it in my mind that I'm here," he said between questions. "I'm hungry, but I haven't even taken time to eat. I just keep walking around and looking." Behind him was a plaque that read, "Let not your heart be troubled. Ye who believe in God believe also in Me," and he smilingly posed for photographers as he cut and sampled a giant white guitar-shaped cake, said to have been baked by fans, that declared "Welcome Home Elvis," with "Hound Dog" and other song titles written in script on the side. He had no immediate plans other than to catch up on his sleep (he hadn't slept in twenty-four hours, he said, he had been so excited about getting home) and to renew old acquaintances. With that, Colonel Parker declared the press conference over, and Elvis retired to his bedroom upstairs in the main house, leaving Colonel to point out the financial intricacies of some of the deals he had made to the reporters who remained.

Anita came over after dinner. He had written to her "that the first night he got home we would not see each other because his family and friends and fans might be offended. So I was at his cousin Patsy Presley's house — I knew Patsy and Aunt Clettes and Uncle Vester were going out there, and I wanted to go so bad, but I knew what he had said. Then he called [and said], 'Come on out, Little, I want to see you.' So I went flying out there — I just can't explain, there are no words to explain the feeling that I had when I saw him again; it was like he'd never left."

Anita quickly made Elisabeth's acquaintance, and, after getting over her initial surprise that the drab, practically orphaned secretary that Elvis had described in phone calls and letters should turn out to be this pretty young girl, immediately started pumping her for information. She invited Elisabeth to spend the night with her sometime soon, and Elisabeth, barely acclimated to her new surroundings and still unsure what to feel about the position Elvis had put her in when he asked her to hide a half-gallon jar of amphetamines in her luggage, happily accepted — but not without hearing from Elvis right away that she had better be careful what she said.

He went to the cemetery the following day to visit his mother's grave. It was the first time that he had seen the Italian statuary that he and his father had commissioned as a monument, with an open-armed Jesus and two kneeling angels at his feet. The inscription on the gravestone read, "She was the Sunshine of Our Home." Afterward he was subdued and depressed, the visit brought back "memories and sadness," but he returned again and again.

He was almost as upset about his father. Vernon had been dodging the press ever since he had arrived in Memphis four days earlier with Grandma, Elisabeth, and an unidentified Dee, who had picked up the train in Virginia. At first denying that he even knew "the mysterious blonde" in dark glasses, kerchief, and a cream-colored coat, he was soon confounded by reporters who had eyes of their own and within a day had admitted to *Press-Scimitar* photographer James Reid, "Well, you know I'm not being honest with you. . . . I just can't talk about it yet." Dee stayed out of the way during the press conference and for the next few days, but Elvis could barely wait for them to leave for her brother's house in Huntsville. It was obvious even to reporters that they were planning to get married ("Let's not talk about that just now," Vernon was quoted as saying with a warm laugh), but for now Elvis simply didn't want to think about it. He tearfully visited his mother's room, which on his instructions had been kept exactly as she had left it. "He didn't seem like Elvis," said his aunt Lillian, who came by the house with the rest of the relatives looking for a job two days after his return and went back to work for him the following Monday.

But he was Elvis. And if his mother never entirely left his mind, other things were beginning to crowd in on it, too. He felt like a man who had been let out of prison. Just riding around town with Elisabeth on his motorcycle gave him a sense of freedom that he had sometimes thought he would never experience again. On Thursday night he went to the ice show at Ellis Auditorium accompanied by nine or ten girls and half a dozen guys. It was the same company he had seen in Frankfurt the previous year, Holiday on Ice, and he spent most of the evening reminiscing backstage with various members of the troupe. On Friday he dyed his hair black in preparation for the television filming just two weeks away, and he went out motorcycle riding with Lamar. Charlie and Joe showed up at the house, Red and Cliff were scheduled to arrive at any moment, and Anita, Alan Fortas, and George Klein came by after work every day. His cousins Gene and Billy and Junior Smith were constantly at his side, with Gene chattering away in his secret language, somewhere between pig Latin and double-talk, that only Elvis could understand.

The fans, too, were back at the gates. The whole gang in fact was reunited, except for Rex, who had not yet returned from visiting his family to give Elvis his decision about heading up the team. Toward the end of the week Elvis surprised Elisabeth with a car that he had picked out for her, a pretty yellow Lincoln, and even gave her driving lessons in it himself. He also told her she was free now to date others, and for the first time she saw her choice clearly: "I could stay with Elvis and be, only, his private secretary — or I could go with Rex." Without hesitation she called Rex ("I explained to him that I was calling from one of the Graceland phone lines . . . so I couldn't say everything I felt on the phone"), and he promised he would be there in just a few days.

Saturday night Elvis had a big party for all of his friends, taking time out to greet students from the Arkansas School for the Deaf who had shown up at the gate. On Sunday he returned to Ellis and watched the ice show's "performance for Negroes," spending most of his time backstage chatting and signing autographs but mounting the podium briefly in his formal dark suit to conduct the seventeen-piece orchestra with a lighted baton. He surprised everyone by extending an invitation to the entire sixtymember company to come out to Graceland the next day, and when they arrived in the two buses he had rented for the occasion, he greeted them at the door in black slacks and a maroon jacket, presenting each of the children in the troupe with a signed stuffed animal before taking everyone on a personal tour of his home. "If you'd rather just wander around the house, why, that's fine, too," he said. The only rule was that they had to "check [their] flash guns at the door." He was clearly proud of Graceland and proved to be an exemplary host, showing them his bedroom, with its carved figure of an Indian chief, its formal portrait of his mother and father, and Dr. Norman Vincent Peale's The Power of Positive Thinking and Dr. John A. Schindler's How to Live 365 Days a Year on the bed table next to his oversize bed. He pointed out his gold records and the soda fountain downstairs and proudly declared that there had been talk of Khrushchev coming to visit his home "to see how in America a fellow can start out with nothing and, you know, make good."

Rex showed up that evening while he was dressing to go to the movies, having rented the Memphian Theatre for himself and his friends from eleven o'clock on. "I was very serious about everything as I proceeded to tell him my decision to go to work again for the firm I had left when drafted into the army. I thought Elvis would be very upset with me, but instead he said he understood and wished me the best of luck. . . . I said I would like to spend a couple of days, and he said I could stay as long as I wished, and I would be welcome to come back anytime." Emboldened by his success, Rex next brought up the subject of Elisabeth while helping Elvis with his suspenders. Without alluding to any past connection, he said he would like to ask her out for the evening, maybe take her to a drive-in where they could be apart from the crowd. "Elvis was completely silent for a minute or so, and I held my breath. Finally, he said, 'Rexadus, you know Elisabeth will never love anybody but me,' still looking at himself with great pride and ego." Rex didn't reveal any reaction of his own, simply saying that he figured Elisabeth needed a break every once in a while. Elvis nodded thoughtfully and said he was glad it was Rex taking her out, since he knew he could count on Rex to always treat her like a lady.

Elisabeth left the next day. She told Elvis that she was going to see her parents, who were vacationing in Florida, even though by now everyone in the household knew that she was going off with Rex to meet his family. To throw Elvis even further off the scent, she arranged for Janie Wilbanks, the girl from Mississippi who had visited in Germany, to pick her up at Graceland, but just as they were leaving, Elvis came running out of the house and asked her to come back inside. Elisabeth's heart was pounding, as "Elvis looked [me] straight in the eye and asked if [I] was going to meet Rex." Evidently Cliff had been unable to keep her secret past the moment that she walked out the door, but Elvis chose to believe her when she told him he was just being silly; he knew that she was going to see her parents in Hialeah.

Rex and Elisabeth married less than three months later, sending Elvis a telegrammed invitation. Elisabeth remained in touch with Grandma, but except for a signed photo that he sent the following Christmas, neither she nor Rex ever heard from Elvis again.

N SUNDAY, MARCH 20, the whole gang left for Nashville in the Greyhound bus the Colonel had chartered for the occasion. The studio was booked under a false name, and some of the musicians were initially told that they would be working a Jim Reeves session. In addition to guitarist Scotty Moore, drummer D. J. Fontana, and the vocal backup group the Jordanaires, who had worked almost every RCA session from the beginning, the band consisted of the same group who had backed Elvis on his last session, while on furlough, in June of 1958. This was Nashville's A team of studio players, made up of pianist Floyd Cramer, brilliant countryjazz guitarist Hank Garland, stand-up bass player Bobby Moore, and percussionist Buddy Harman, who would once again double with D.J. on drums. With RCA executives Steve Sholes and Bill Bullock joining Colonel Parker, his assistant Tom Diskin, Nashville a&r head Chet Atkins, publisher's rep Freddy Bienstock, and engineer Bill Porter in the control booth, the anticipation bordered on outright tension, and it seemed almost eerie, according to Jordanaire Ray Walker, when Elvis finally walked in the back door. "He hadn't made a sound - you couldn't have heard it if he had but everybody, just like we were on pivots, turned, and there he was."

The first order of business, as it often was at any Elvis session, was to get something to eat, and Lamar was sent out to Krystal's for hamburgers, sweet milk, and fries. There was plenty of time to get reacquainted while they were waiting for the food, and they all listened to acetates and caught up as they ate. "Of course he talked to the guys about Germany and tank battles and all that kind of stuff," observed twenty-eight-year-old new-comer Bill Porter, who had arrived at RCA as chief engineer the previous year after five years of audio engineering on Nashville television station WLAC. "And karate demonstrations. Bobby Moore, the bass player, was also into karate, and he and Elvis got into a demonstration in the studio. This went on for about forty-five minutes." When Elvis finally started on the first tune, Porter sensed the Colonel, Sholes, and Bullock almost breathing down his neck. "They didn't say anything, but they wouldn't sit down until he got it down. [After that] they all started talking about other things."

The first tune, a rousing Otis Blackwell gospel-flavored number called "Make Me Know It," actually required nineteen takes, which must have prolonged the suspense a little, and the second, "Soldier Boy," which Elvis had brought home with him from Germany, took fifteen. With the third, "Stuck On You," a somewhat pedestrian mid-tempo rocker along the lines of "All Shook Up," they hit a groove, and even the difficulties that they encountered nailing down "Fame and Fortune," a kind of doo-wop ballad that Elvis could really sink his teeth into, didn't take away from the overall good feeling of the session.

By this time Porter had recognized that, for all of the big shots in the booth and the veteran musicians on the floor, it was Elvis who was calling the shots. The next-to-last number of the night, "A Mess of Blues," was probably the highlight of the session. Written by Doc Pomus and Mort Shuman, a new Hill and Range team who specialized in rhythm and blues material, it was the one song of the evening to escape formulaic predictability, and its sly sense of having fun with the genre suggested some of the very sense of freedom that had animated all of Elvis' best music from the first. Unlike "Stuck On You," for example, it was tailored to his image without being confined to it, and Elvis' high-spirited whoop at the end, a kind of wobbly falsetto, is almost reminiscent of his joyous exclamation at the conclusion of "Mystery Train." But there was nothing on the session that could not be said to be of a very high standard, and they concluded with an exuberantly dirty "It Feels So Right," whose dissonant chords matched its sexual message, just as the sun was coming up.

MARCH 1960-JANUARY 1961 👁 61

RCA wasted no time in capitalizing on the session's success. Within seventy-two hours they had pressed up 1.4 million advance orders for the new single ("Stuck On You" and "Fame and Fortune") and shipped them out in preprinted sleeves that announced only "Elvis' 1st New Recording For His 50,000,000 Fans All Over the World" in the absence of definitive titles at the time they had gone to press. They finalized arrangements, too, for a second session to follow the Sinatra taping, which would ensure completion of the album, already entitled *Elvis Is Back* and scheduled for mid-April release, before Elvis' departure for Hollywood. After all the frustrations of dealing with the Colonel, and all the worries that he had caused them, whether intentionally or just for sport, RCA executives Steve Sholes and Bill Bullock finally felt as if they had some breathing space. Judging by his attitude and performance, there seemed little question: *Elvis really was back*.

The train trip to Miami to tape the television show was little less than a repetition of the triumphant journey home just two weeks earlier. To Scotty Moore, who had seen the crowds from the beginning, "it was just unreal. The only thing I can relate it to was reading about Lincoln's body going back to Springfield or seeing movies of Roosevelt — his body coming out of Georgia after he died. Every little crossroads, every little town; you just can't imagine — they were *lined* with people. Even though you knew the Colonel had gone ahead and let all those little places know, still it was thrilling, just all the way down."

For Scotty the experience so far had had all the characteristics of a true reunion, with the stirring up not only of old memories but of some of the painful confusion that old memories necessarily involve. The train ride was simply more of an extended opportunity to try to recapture some of the feelings of easygoing good fellowship that he and Elvis and D.J. had shared on the road. "Everybody would just get in his car and be kibitzing. At one point it was getting late, it was like two or three in the morning, and he gave D.J. and myself a couple of little white pills and said, 'Here, these'll keep you awake, it's what they use in the army, driving tanks.' I never did take mine — couldn't have been very much. But I had never known him to do that before."

For the rest of the guys there was more of a sense of restless anticipation. For Joe and Lamar, Elvis' cousin Gene, and Peck's bad boy tagalong Cliff Gleaves, there was no question of not staying awake, even if all they were doing was playing cards, eyeing girls, or cracking jokes throughout

62 🔊 ELVIS IS BACK

the long night. For Joe, regarded with some mistrust by Elvis' Memphis sidekicks as a "slick operator" from Chicago, this was in reality his first taste of the big time. The session had introduced him to a whole new world, and now here he was on his way to Miami with the possibility of actually meeting Frank Sinatra. The Colonel, whom he had just met in Nashville, was obviously keeping an eye on him, and he felt in many respects as if he were auditioning for a job whose description he had not yet been given. But he was determined to keep on his toes and take care of business just like he had in Paris, and he figured the old man would accept him in the end. The Colonel for his part stayed mainly within his own little coterie, taking in everything that was going on around him, brusquely making his presence felt — but quietly exulting in the triumph that *his boy* had achieved in Nashville, confident now that nothing was going to stand in their way.

 $E_{\rm VIS\ AND\ JOE\ SHARED\ }$ two-bedroom penthouse suite at the Fontainebleau, with everyone else in adjoining rooms and the Colonel just down the hall. The first meeting between host and guest star in the Grand Ballroom was carefully staged, with Elvis dressed jauntily in a beige sports jacket and black fedora and Frank studiedly cool in baseball cap and sweater. Sinatra's pal, comedian Joey Bishop, unctuously requested an autograph for his niece and got word back from the Colonel that there would be a charge of \$1, while Sammy Davis, Jr., who had hung out with Elvis when he first came to Hollywood, greeted his old friend with undisguised, and unabashed, delight. Elvis spent the week nightclubbing and rehearsing, with the guys in constant attendance, but Scotty and D.J. and the Jordanaires (the rest of the band was picked up in Miami) were specifically excluded from all social activities by order of the Colonel.

The night of the taping, it was Frank, forced after all to swallow his intemperate criticism of rock 'n' roll to build a show around its principal representative, who appeared the more embarrassed of the two. It was not so much that he had changed his mind about the music, he was at pains to reassure the press. "But after all, the kid's been away two years and I get the feeling he really believes in what he's doing." As for Elvis, faced with a situation which could very well have become a repetition of the Steve Allen debacle, where he sang "Hound Dog" to a basset while dressed in top hat and tails, he carried himself with dignity, anchoring a creaky, almost painfully self-referential "Rat Pack" reunion (only Dean Martin was miss-

ing from the Sinatra gang) with an eight-minute appearance almost forty minutes into the show.

"Well, Elvis, that's our little welcome home gift," Sinatra declares. "All you seem to have lost is your sideburns." And then, turning to the audience: "Now, folks, what would you say if I was to sing another song now?" "No," come the carefully cued screams from the four hundred fan club presidents and members who have gotten their tickets from the Colonel. "WE WANT ELVIS!!" And with that the man of the hour comes slinking out from the wings, ducking his head and laughing self-consciously, his hair piled up like a waterfall, looking impossibly fresh, impossibly elegant in his perfectly draped tuxedo.

It is a marvelous performance of two fairly mediocre songs, his movements so subdued during the ballad ("Fame and Fortune") that even the planted audience does not know quite how to react. But then as he launches into "Stuck On You," we do, indeed, see a new Elvis, a modified Elvis, who suggests motion without precipitating it, who elicits genuine screams by indirection rather than assault. Sinatra at this point comes out for what is undoubtedly intended to be the knock-out punch, a two-song medley, with Frank singing one of Elvis' songs, Elvis one of Frank's. The older man opens with "Love Me Tender" and, by attempting to parody it, merely parodies himself; then Elvis launches into Sinatra's sophisticated "Witchcraft," for which he shows utter respect, indicating by a shake of his shoulders, the limp extension of his wrists, his bemused acceptance of a task which he is prepared to perform with elegance and humility. They conclude by harmonizing on the last lines of "Love Me Tender," then repeat the harmony after Frank declares, "Man, that's pretty." And that's it, except for a little additional comic dialogue and a plug that the Colonel has arranged for the upcoming production of G.I. Blues. It is, all in all, an amazing performance, and one that must have been deeply satisfying to a performer who had been worried whether he still had a place in show business. The subsequent ratings (the show broadcast a month and a half later, on May 12, with a 41.5 Trendex rating, representing a 67.7-percent audience share) can only have made the triumph all the sweeter.

And then it was back to Memphis — by chartered bus this time, as the Colonel felt the train gimmick had been played out, and funds were not unlimited. There was a week to go before the follow-up session in Nashville, and Elvis got a letter from the Colonel not long after getting home, running down some of the things that he should keep in mind when

he went back into the studio. All that he had to deliver in order to fulfill his contractual obligation to RCA were eight additional tracks. With four cuts in the can and a single already released, this would give the record company everything that it needed to put out an album, and he should record no more. It was the same set of rules that had always guided them; they didn't want to give RCA any more leverage in future contract negotiations than they had in the past. So far as material went, Scotty had made the standard deal required of any outside musical contractor: he had given up half the publishing to Elvis Presley Music and assigned one-third of the writer's royalties to Elvis Presley himself. Under these circumstances, Colonel advised, Elvis should do all he could to record Scotty's song. Also, Colonel had directed Freddy to clear "Fever" at a favorable royalty rate, along with "Are You Lonesome Tonight?," the first song that Colonel had ever directly asked Elvis to record. He knew it was old-fashioned, he told Elvis, a ballad with a dramatic recitation that had first been a hit in 1927, but he thought it could be right for Elvis' "new style," and he had a hunch that it could be a hit all over again. Elvis knew how much it meant to the Colonel both because Gene Austin, the first singer Colonel ever managed, used to feature it in his stage act and because it was his wife, Marie's, favorite song he probably would have done it just as a sentimental gesture. But he actually liked the song. The rest of the content of Colonel's letter left him less sanguine. The press had gotten wind of the fact that Dee and her children were living at Graceland, the Colonel advised him soberly, so it would probably be better not to set up any appointments at the house. He also wanted to call Elvis' attention to the fact that Joe's record keeping for the Miami trip had been sloppy and inefficient, and while this was entirely Elvis' business, if Colonel were to run his business this way, he wouldn't last very long.

The second session, on April 3, started once again at 7:30 on a Sunday evening and went straight through till morning. It was the same lineup of backing musicians as the last time, with the addition of saxophonist Homer "Boots" Randolph, a regular member of the Nashville A team who could double on percussion if saxophone wasn't called for on a song. Elvis' old drummer, D. J. Fontana, and Buddy Harman both continued to play drums, with Harman steadying D.J.'s time, and on the first track, "Fever," it was just bassist Bobby Moore and the two drummers providing a seductive backdrop for Elvis' interpretation of the 1956 Little Willie John r&b hit, which had enjoyed even greater success as a torch song for Peggy Lee two years later. Elvis' version falls somewhere in between the two, with a warmth and intimacy that stems not just from the erotic suggestion of the song but from a new vocal confidence and a new vocal control. By the time that they got to "It's Now or Never," the rewritten version of "O Sole Mio" that Freddy had commissioned, it was obvious that Elvis was reaching for something more than he had ever attempted before, and he delivered several performances that were impressive right up till the moment that he had to achieve the full-voiced operatic cadence with which the aria concludes. Trying to be helpful, Bill Porter suggested that they could always splice the ending on. "I said, 'We don't need to do the song all the way through.' He said, 'Bill, I'm going to do it all the way through, or I'm not going to do it.' And he finally did."

Over the course of the long evening they cut an extraordinarily diverse range of material — blues, ballads, standard pop fare from Hill and Range that he elevated by his passion, "Such a Night," done as a lilting tribute to Clyde McPhatter, much in the manner of "White Christmas," the Drifters homage on his 1957 Christmas album, for which he had been so roundly reviled by the critics. It was only as the session wound to a close, and with the Colonel's requisite eight cuts already under his belt, that he finally got around to the number that his manager had requested, along with Scotty's song and the Golden Gate Quartet tune that he had promised Charlie they would sing as a duet, despite Colonel's opposition.

He started with "Are You Lonesome Tonight?" at around 4:00 A.M., with just acoustic guitar, drums, and bass, the mood of the song strikingly similar to "My Happiness," the very first song he had ever recorded. He asked Chet Atkins if the lights could be turned down. "He chased everybody out of the studio, all the guests and everything - you know, studios back then were like supermarkets with bright fluorescent lighting, but he was singing in the dark." As this was going on, Bill Porter was editing the master take off the last reel and splicing it onto a master reel so that at the end of the session all the agreed-upon versions would be in a single place. "Well, I turned around and looked in the studio, and the lights were all out, and I couldn't see what the hell was going on, and then I hear the guitar and the bass and the Jordanaires humming a little bit, and Elvis started to sing. And then suddenly he starts talking right in the middle of it! If you listen closely, you'll hear them bumping the microphone stands because there were no lights out there. So we started the take again, and he got about, oh, maybe two or three bars into it, and Elvis said, 'Mr. Sholes, throw that tune

out, I can't do it justice.' Steve looks at me and says, 'Don't you dare, that's a hit, Bill.' He pushed the talkback button and said, 'The Jordanaires made a mistake, and I'd like to get one good take all the way through.'" So they did that, and that became the master, right up to the final bar.

After that he made short work of Scotty's tune, then summoned Charlie into the studio for their touching duet on "I Will Be Home Again." With eleven cuts in the can and the musicians almost out on their feet (this was not the end but the beginning of their working day: they had at least three Monday sessions scheduled), Elvis was in no mood to quit. He began strumming Lowell Fulson's "Reconsider Baby," an old blues that he had fooled around with at Sun, on his Gibson J-200, and despite themselves, everyone just fell in. Just as on the Sun sides, Elvis' rhythm guitar takes the lead, and piano, sax, and guitar all get gritty solos, but what carries the song is the manner in which Elvis' voice soars, giving the blues a kind of harmonic freedom that recalls no one so much as Little Junior Parker but in the end is Elvis' mark alone.

WITH JUST TWO WEEKS to go before leaving for Hollywood, Elvis occupied himself mainly with roller-skating wars at the Rainbow Rollerdrome, touch football games, moviegoing, and dating Anita. One night he called up gospel singer James Blackwood, one of his earliest inspirations, who used to admit him to the all-night singings at Ellis Auditorium for free when he was a teenager and with whom he had always stayed in touch. "He said, 'First night y'all have off and are not doing a concert, why don't you come out and let's sing?' We sang most of the night, all gospel, he wouldn't do anything else. I think he knew every song we ever recorded." He spoke of the gospel album he was planning to make before the year was out. He only hoped he would be worthy of the task.

The first Saturday after the session, he went on a \$4,000 shopping spree downtown, looking for a birthday present for his father. Somehow the fact that one of his purchases was a diamond necklace for Anita was immediately picked up by the papers, and both he and Anita spent much of the next few days denying that the gift meant anything special. He was in fact already dating another Memphis girl without Anita's knowledge, a nineteenyear-old singer and beauty contest winner named Bonnie Bunkley, whom he had met when she arrived at Graceland with her voice teacher to collect a teddy bear he had donated for a benefit at Whitehaven High School, her alma mater. They hit it off right away, and she would come by sometimes when he told Anita that he wanted to spend time by himself. He had an aquarium in the music room upstairs, and often they would just sit by themselves and listen to records and watch the fish in the tank. He got depressed sometimes for no reason, he said, his mother's memory was always with him. He was moodier than she would ever have thought from observing him in public, but he was always considerate of her and her feelings. Anita was never mentioned when she was around, and he asked if she and her mother might come to visit while he was making his movie in California.

Anita dyed her hair black to match his, and on Easter Sunday, April 17, the day before his scheduled departure, they attended the First Assembly of God Church together, where Elvis' presence caused such a commotion that they had to leave the service. Then it was off to Hollywood on another triumphant three-day whistle-stop trip, this time aboard the Southern Pacific's *Sunset Limited*. The party of eleven occupied two private cars at a cost of \$2,424.41 and, in addition to the Colonel's three-man staff, incorporated a personal retinue of six, including Joe, Gene, and Lamar, with newcomer Sonny West (Red's cousin) and last-minute addition Charlie Hodge. Charlie had been visiting for the last couple of weeks and accompanied them to the train. "We hadn't talked about me working with him or anything. So Mr. Presley and I are standing there and Elvis was standing at the door of the train, and he was waiting on his cousin Gene. And Elvis looked down and said, 'You want to go with me?' and I looked at him and I said, 'Why not?' And he said, 'Daddy, put him on salary!'"

Elvis had made it clear from the beginning that it was loyalty he was concerned about most of all. "What he said on the ship over to Germany was, 'Charlie, as long as you're cool' — he was talking about the press and all kinds of things like that — 'we can be friends for a long time.'" With Sonny and the others the same consideration applied. Sonny, three years younger than Elvis and just behind Red, with whom he was raised almost as a brother, at Humes High, had first met Elvis in March 1958 a few weeks after his discharge from the air force and just days before Elvis went into the service himself. His initiation had come in one of those vicious games of roller mayhem at the Rainbow, with Junior Smith refereeing and Sonny, a rugged ex-football player and boxer, ending up on the floor, decked by a girl. By the time that Elvis got out of the army, Sonny was dating Elvis' double first cousin Patsy Presley, and it seemed only natural that he would

68 💊 ELVIS IS BACK

start coming around. Elvis liked him from the start. He could use another good-natured, down-to-earth, physical type of guy to help take care of some of the simple tasks and problems that were always coming up; his only reservation about Sonny, he told Red at the time, was Sonny's language. "He's a heck of a nice guy . . . but he never stops saying 'sonofabitch.' He calls everyone 'sonofabitch.' I just [wish] he would stop saying it all the time."

Elvis took special pride in the guys he had around him. They proved you didn't need to surround yourself with college-educated "intellectuals." These down-home southern boys (with Joe the only exception — and he had Chicago "street" connections) were all smart, dedicated, and could take care of themselves. Cliff was a "character"; Red (who, like Cliff, was waiting for them in California, where he was working on Nick Adams' new television series, *The Rebel*) was a good old boy; Lamar capably filled the role of court jester; Charlie had show-biz connections; and Gene was family. Elvis tried to get Alan Fortas to come along with them on this trip, too, but Alan's family was still opposed. Elvis knew he would join up before too long, however; Alan wanted to be a part of things too much to risk being permanently left out.

They all had their individual identities, they all had their personal idiosyncrasies and specially delineated roles. Elvis was proud of having assembled a team much like the Colonel's, a group of guys with whom he could be comfortable and share some laughs and not have to worry about who he was or where he fit in. From Sonny's point of view, "I guess you could say we were a bunch of hicks, [but] there was a great warmth between us. No pettiness, just a bunch of young guys setting out for some excitement and going to conquer the world. It was fantastic, and the guy who was most fantastic was Elvis."

In his own role as leader Elvis maintained a somewhat different perspective. A leader, he knew, had a different role; a leader had to provide direction, inspiration, coalescence; most of all a leader had to believe in himself. He was aware, certainly, of the personality conflicts within the group. Joe had a very low opinion of Lamar; Charlie was seen as little more than a know-it-all by a number of the guys; Lamar was so devoted as to be jealous of anybody else who got Elvis' attention; and nobody but a blood relative would ever have understood Gene. Others might take this division as a drawback, but Elvis saw it as what the Colonel called "creative conflict." In an imperfect world one basic principle always applied: divide and conquer. This was his world, a comfortable space with a rattle and clatter all its own, its own constant hum of anticipation and excitement. When asked by a former girlfriend, Barbara Hearn, to name his pet likes and dislikes for a column she was now writing for the fan magazine *16*, he came up with enthusiasm for sports, staying up all night, fried foods, listening to old rhythm and blues 78s, Marlon Brando, making movies, and, above all, "having lots of people around me at all times." Among his dislikes were conformists, humorless sourpusses, insincerity, being alone, and not being able to attend church regularly. "I hate it most of all that my mother was not at home on my discharge from the Army. She prayed for that day so many times. It didn't seem right to return to a home without her."

THE CROWDS ON THE WAY OUT TO California were almost as over-I whelming as on his two previous train trips, and Elvis had to disembark at a siding outside Union Station in Los Angeles, for fear that some of his fans might get hurt. He reported for preproduction on April 21 and that night went out to a club in the Valley, the Crossbow, to see Lance LeGault, a Louisiana boy who Red said was a great rhythm and blues singer. They sat up in the closed-off balcony digging the music — Ray Charles, Jimmy Reed, Fats Domino, all the good old sounds - and in between sets Red introduced him to club owner Tony Ferra. There was a picture of Tony's pretty fourteen-year-old daughter, Sandy, on the club owner's desk, and when Elvis asked about her, Tony picked up the phone and gave her a call. "My dad said, 'I want you to meet Elvis Presley,' and put him on the phone, and he said, 'Your father told me about you, and I'd like to meet you.' It was ten o'clock at night, and I had school the next day, so I said, 'I'm sorry, I can't tonight.' And he said, 'Well, maybe some other time.'" Then he and the guys went back to the hotel, and Sandy Ferra thought she would never hear from him again.

"Stuck On You" hit number one the following week, a foregone conclusion after the preshipment of over a million copies to dealers, which was more a statement of confidence on RCA's part than a true reflection of sales, since the dealers could always ship them back. Elvis made his initial recordings for the soundtrack of *G.I. Blues*, too, but due to a new union agreement, he was forced to record at the RCA studio on Hollywood Boulevard rather than at Radio Recorders, where he knew the room, liked the people, and had grown to feel comfortable. For Elvis it was an

70 🔊 ELVIS IS BACK

altogether unsatisfactory situation, and on May 6 he went back to the old studio to redo half the songs after a week's worth of shooting on the film.

To assistant engineer Bones Howe it was a very different Elvis who returned to Radio Recorders than the one who had left two years before. "He came to the studio in full-dress uniform, with the piping around the sleeves [presumably his costume for the film], and all these guys around him, a whole new cast of characters. I was flabbergasted. He looked great, he had everything he could want, all the same people were there — but it just wasn't the same." Howe detected an absence of spontaneity, a searching for the spark rather than its actual presence. "It was like, 'Wait a minute. How did I do this? What was it I did?' Maybe through being away all that time he'd had [too much of] a chance to think about what he'd been doing and tried to figure out what it was. But something was gone."

Elvis himself seemed to sense that there was something missing from the movie from the start. With the exception of Pomus and Shuman's "Doin' the Best I Can," written in conscious emulation of songwriter Don Robertson's elegantly austere style, the songs for the most part were an undistinguished lot, and Elvis was disappointed at the exclusion of Jerry Leiber and Mike Stoller's compositions from the soundtrack for what the Colonel described as "business" reasons. In a phone call to Priscilla in Germany, amid fond endearments, he expressed his bitter frustration about the score. He had just had a meeting with Colonel Parker, he said, and informed him that half the songs in the picture should be cut. What did the Colonel say? Priscilla wondered. "Hell, what could he say? I'm locked into this thing," Elvis replied miserably, and they went back to talking about how someday she would be able to come over and see all of this for herself, dreamily planning for a future that was hard for either of them to believe would ever really exist.

By this time, though, he had met Sandy Ferra, and he was intrigued. He had called her a second time from her father's nightclub and got the same answer as the first: it was late, it was a school night, there was no way she could come out to meet him at this hour. Well, how about if they made a date for the *next* Thursday? he asked. Maybe her mother could drive her over. "So I asked my mom, and she said okay. They had the whole upstairs roped off for him, and he had a date that night with an actress named Kathy Kersh. So there I was with my little ponytail, and he held my hand and smiled at me. And I don't remember exactly what our conversation was, because this very attractive woman was on the other side of him. But then

he said, 'I'd like to see you again,' and he kissed me good night on the cheek when my mom took me home.

"A few days later Red West called and said, 'Elvis is having a party at the Beverly Wilshire Hotel, and he'd like you to come.' My mom said, 'No way. I don't care who he is — you're not going.' She talked to him and said, 'I don't care if you're King Farouk; my daughter is more important to me.' And he said, 'You know, I have a career, and I know your daughter is underage, and I promise you I'll respect her.' So my mom came on the date — I mean, she came with me. I thought, Well, you know, he's probably never going to want to talk to me again. I mean, how embarrassing! But he *liked* my mom. We sat in the kitchen in his Beverly Wilshire Hotel suite, and we had banana splits. And he was talking to my mom and telling her how much he missed his mom. He really liked talking to her; they had this great understanding.

"A few days later he called again. I thought he'd never call, and he called again, and my mom said, well, I could go, as long as I took another girl with me. So I would invite one or two girlfriends to go with me, and that was okay for a while, and then eventually she trusted him and let me start seeing him by myself, and I dated him for years."

The age difference never really struck her, though the difference in their professional circumstances did. Sandy was enrolled at the Hollywood Professional School, and she was flattered when he told her that she was a better dancer than his beautiful twenty-three-year-old South African co-star, Juliet Prowse, whose ballet training had led to her discovery by Hollywood choreographer Hermes Pan. She never thought of visiting him on the set, though, and she was under no illusions about using their friendship to advance her career. At the same time she felt perfectly comfortable in his company. "He was a very *young* twenty-four. I mean, he and the guys played like teenagers, they'd have water fights and chase each other through the halls and play hide-and-seek — kid stuff. So he didn't really seem older, and he didn't *act* older. We danced a lot — we'd dance and neck for hours, and then I'd go home. Sometimes we'd kiss for so long that my skin would be bright red, and I'd have to put makeup on my face for school the next day.

"You know, it was really strange. There were always all these other women. On nights when we had dates, I would be sitting there in my frilly little dresses, and girls would come in that would be half undressed, they'd tremble and they'd shake and they'd cry and they'd just go bonkers. But I felt pretty secure sitting there because he'd called *me*, because he wanted to see *me*. I mean, it never really bothered me, because the way I was raised, these other girls could do things that I wasn't going to do — nor did he ask me to. So I figured, *somebody's* got to be there for him to date in a more adult fashion, because I wasn't ready for anything like that. So we just had fun, and I think — I don't know, maybe he dated me because he didn't feel he had to be this Valentino, he didn't have to perform for me other than just to have fun, kiss me good night, then he could go to sleep and get up and go do his movie the next day. Whereas when he was dating these other women that were really women, I'm sure they expected more of him than I did. He told me that he felt very relaxed — tranquil — when he was with me."

Bonnie Bunkley, the girl he'd met in Memphis, came out with her mother for a weeklong visit, and he took them on the set where Dean Martin and Shirley MacLaine were filming *All in a Night's Work*. She met Currie Grant, too, the airman who had introduced Elvis to Priscilla in Germany, and Elvis said to him, "Doesn't she look like Priscilla?" Which kind of made her mad, even though she didn't know who Priscilla was. But otherwise he was a model host and never gave her reason to think he was anything but a perfect gentleman.

For Elvis and the guys on their own, on the other hand, Hollywood was just an open invitation to party all night long. Sometimes they would hang out with Sammy Davis, Jr., or check out Bobby Darin at the Cloister. Nick Adams and his gang came by the suite all the time, not to mention the eccentric actor Billy Murphy, longtime friend of John Wayne and Robert Mitchum, who traveled up and down Hollywood Boulevard invariably clutching the battered script about Billy the Kid that he had been working on for years. Elvis outfitted all of the guys in sunglasses and dark clothing, and they carried around briefcases so it would look like they had something to do. Gene's briefcase contained a hairbrush and a doorknob, and he had taken to wearing makeup and calling himself by a stage name, El Gino Stone; if anyone ever asked him about his duties, he said, "I don't do a goddamn thing. I'm Elvis Presley's cousin."

"None of us," by Joe's account, "slept more than a few hours at a time. We lived on amphetamines. We woke at five o'clock each morning to report to the set, then spent the rest of our time screwing around." Just as at the Hotel Grunewald in Germany, their escapades were beginning to grate on other residents of the hotel. Joe was not surprised. "Music blared continuously. . . . We ferried Hollywood starlets up and down in the elevators all day and all night. Elvis was breaking boards in his suite and trying to teach the rest of us karate, [and] when we weren't trying to break boards, we were running around the halls, waging water-gun fights that escalated into full-scale battles."

With the idea of pursuing his karate studies more assiduously, Elvis attended a demonstration by kenpo karate master Ed Parker at the Beverly Hills Hotel. Parker, a twenty-nine-year-old native of Honolulu with a degree in sociology from Brigham Young University, had developed a flexible new "street" approach to the art, and after his demonstration to a group of doctors, Elvis came up to him. "He said, 'I don't think you know me, but my name is Elvis Presley,' and I kind of laughed." He told Parker that he had studied karate while he was in the army and that he had subsequently been in contact with Hank Slamansky, an American karate pioneer, but that he saw in Parker's methods real creativity and innovation.

"He felt like I was kind of a rebel in my field, as he was in his. I didn't accept a lot of the Oriental methods, because I knew they didn't work on the street, but a lot of the other aspects could be revamped so they would be applicable." They spent some time out by the pool, talking about karate and the Islands, about Parker's royal Polynesian heritage and his Mormon beliefs. "His mother meant an awful lot to him, and he talked about how she kept him from physical activity for fear he might get injured or hurt. Now that she was gone, he found karate to be an avenue of pursuit that he wanted to be involved in, because he wanted the activity and the knowledge that stemmed from it. He talked to me about the fact that he was different than others. He was basically a very shy guy." Parker offered to give him lessons, and they discussed technique ("He was intrigued with the logic of what I taught"), but despite occasional contact over the succeeding months, and despite Elvis' continuing passion for the sport, it would be years before he finally applied to Parker for formal instruction.

He remained resolutely professional in his commitment to the film, though it became harder to hide his underlying resentment with each passing day. Colonel kept reassuring him that it was going to be a big success, that it would enable him to reach an older audience at a time when his own audience was growing older — but that didn't make him feel any better about the script, or the image of him that the script presented, which were the key elements that Colonel and Mr. Wallis were counting on to allow this expansion to occur. The character that Elvis played was at odds not just

74 👁 ELVIS IS BACK

with the characters that he had played in all of his pre-army films but with the very image of rebellion that had always defined him. Far from being an outcast, this Elvis Presley was safe, "social," and cheerfully domesticated, a conventionally bland Hollywood stick figure whose principal conflict comes in the ethics of "dating" a nightclub dancer (Juliet Prowse) in order to win a bet. The girl turns out to be unexpectedly down-to-earth, the army tank corps man that Elvis portrays proves as adept at baby-sitting as at seduction, there is plenty of sightseeing footage of Germany, and the highlight of the score comes at a puppet show for children when Elvis' character improvises a song. It is, in other words, a genuinely wholesome entertainment, a motion picture for the entire family, and not really all that far removed from those aspects of the real Elvis Presley that aspired to middle-class respectability. But it did not even begin to suggest the complexity of either the real Elvis or the real world that Elvis had come to know, and his feelings of foolishness and humiliation were not helped by the guys smirking over some of the "cute" bits he was given to do and his ineffectual attempts to control his amphetamine-racing speech.

They observed his romantic escapades with a somewhat keener degree of interest and respect. He was dating Judy Rawlins, an actress with a small part in the picture, and he met Tuesday Weld, the sixteen-year-old "sex kitten" who was about to start shooting Return to Peyton Place, around this time as well. But it was his relationship with Juliet Prowse, his co-star and Frank Sinatra's unofficial fiancée, with which his growing entourage was most intrigued at this time. Elvis made a big point of withdrawing to his dressing room with her every day, and before long the guys started banging on the door and yelling that Frank was on his way. One day Sinatra actually did show up, but Elvis emerged unruffled and unmussed after first telling Red to go fuck himself when he heard the same tiresome message once again. They were all intrigued by Elvis' stories of Juliet's athletic limberness, Lamar perhaps most of all. "He said Juliet liked to grab her ankles and spread her legs real wide. But then [later] he said it about another girl, too. I said, 'I thought that was Juliet.' And he said, 'Well, a lot of 'em do different things like that.' And I said, 'Oh, okay.'"

There was a steady stream of visitors on the set, arranged for the most part by the Colonel: Elvis greeted the king and queen of Thailand, Tennessee Ernie Ford and Minnie Pearl, the wife and daughter of the Brazilian president, Pat Boone, and three Scandinavian princesses in one day. The Colonel made a particular point of claiming credit for the royalty, citing it to Wallis as an example of the kind of tireless dedication he gave to thinking up new ways to promote the film. As he sat in the headquarters which Paramount had given him free of charge and surveyed the three rooms plastered with Elvis Presley album covers and sheet music, life-sized cutouts of the boy, and various items of merchandise large and small, the record player that he had gotten from RCA never ceased its steady stream of Elvis Presley hits. He had his own "wall of fame," on which he was pictured with celebrities from every walk of life, and his sense of overall wellbeing is reflected in interviews that he gave out at this time which for the first time focused on the Colonel alone.

Grizzled, unshaven, dressed in an untucked Hawaiian shirt, sandals, and a whimsical beanie, he made no apologies for himself as he entertained reporters' questions and detailed the business successes that he had achieved in guiding his boy's career. Yes, they were asking \$150,000 for television guest shots now, but he didn't expect to do any, he didn't want Elvis competing with his own movies. As far as the movies themselves went, he doubted that they would win any Academy Awards. "All they're good for is to make money." As for the money, "He relies on straight income, and so do I. When he works, he knows that about 90 cents out of every dollar that he earns goes to the government and a dime to him." The Colonel was in the 90-percent tax bracket, too, he implied, but, far from looking for any loopholes, he and Elvis took the attitude that "We're luckier than a whole lot of people, even as things are. . . . Somebody's got to pay the government for the country we've got."

It was almost as if he were speaking to an unseen audience; crude, blustering, crassly honest to a degree that appears as defiant of public opinion as reflective of it, he seems bound to proclaim his patriotism, his integrity, his *honesty* in a subtext that underscores every wisecrack he throws out. There was no question of his gruff affection for his client, but he made clear that they did not socialize, and he didn't handle Elvis' finances either. That was his father, Vernon's, job. "I'm not his father. . . . Our interests are different. And he doesn't need a nursemaid. . . . I just tell him, 'Don't forget to pay your taxes.' I tell him that every week when he's working. I've seen too many people get into bad trouble by forgetting to pay their taxes." And if the balloon ever burst? "He could go back to driving a truck. And I could always go back to being a dogcatcher. Head dogcatcher, that is."

Elvis must have smiled when he read some of the stories, if he even bothered to follow all the "snow jobs" the Colonel was handing out. He had heard it all before: the pet cemetery in Tampa; the Snowmen's League, the phantom organization in which Colonel had enlisted half of Hollywood;

76 👁 ELVIS IS BACK

the carny stories where the customer was always the mark; the movie that would someday be made of the *Colonel's* life (it would probably be produced by Bob Hope, he told Louella Parsons); all the ways in which he managed to bedevil poor Mr. Wallis and Mr. Hazen and then just flung it back at them when they finally capitulated to his demands. Colonel was a funny duck, there was no doubt about that — it was Elvis' little joke to call him Admiral, since he had no more claim on one title than on the other. He had his own ways and he stuck to them, you had to admire that about him. But more than anything else, *it had all turned out exactly like he said it would*. Elvis knew that Colonel was just having fun now, and his attitude was, Let the old man have a good time. He certainly was having a good time himself.

They took off for Las Vegas on the weekend that they finished shooting. The studio would not release Elvis until the following week, after all the footage had been screened, so he decided they should treat themselves to a little vacation. They had visited once during filming, and the boys were all excited about going back, but they had only gotten as far as Barstow when Elvis asked Gene for his kit bag. He mumbled something about wanting to brush his teeth, but everyone knew that was where he kept his pills, and when it turned out that Gene had forgotten the bag, Elvis got so angry that he had the whole caravan turn around and head back to L.A., cursing and yelling at Gene and the rest of the guys all the way.

Everyone was tired and depressed. Sonny, who had been as excited as any of them, watched while Elvis drove and smacked Gene in the chest every time he dozed off. "There will be no goddamn sleep, do you hear?" he announced as Gene jerked awake and indicated assent. "Joe in the back is dozing off," recalled Sonny, "and chewing gum at the same time. 'Joe, goddamnit, I said no sleeping.' Joe replies, 'I wasn't sleeping, just looking out the window.'" By the time they got back to the Beverly Wilshire, everybody had pretty much had it. It was early in the morning, and they all drifted off to bed. Just as they started to fall asleep, the phone rang. It was Joe. Now that he had retrieved his bag, Elvis had changed his mind; they were going to Las Vegas after all.

It was a long weekend. Elvis dropped \$10,000 at the crap tables, and they went to all the shows, catching Billy Ward and the Dominoes at the Dunes, Della Reese at the New Frontier, and Red Skelton at the Sands. The guys all wore their black mohair suits and sunglasses, there were more girls than you could trip over, and they got maybe two hours' sleep the whole weekend. The joke around town was that they were Elvis' "Memphis Mafia."

He was finally released by the studio the following Wednesday, June 29, and was so impatient to get home that he and Gene took a plane to St. Louis late that night, then rented a Cadillac and arrived at Graceland at three o'clock the following afternoon. Anita came over as soon as she was done with work, the papers reported, and they had a quiet evening at home with Gene and his wife, Louise, and Vernon, who was for the moment on his own but left the following day to join Dee at her brother's house in Huntsville. They were going to get married, he told Elvis. They were going to do it in Huntsville to try to throw reporters off the track. Elvis shrugged and wished him luck. He wouldn't attend the ceremony, he said, because he didn't want to take away from the attention that should go to Dee. Both of them knew that what he said wasn't what he really meant, but neither of them knew how to address their true feelings. They spoke briefly of transferring ownership of the house, so it would be in Elvis' name alone, but mostly they communicated in nods and silences, and in a shared sadness which neither could express.

Vernon and Dee got married that Sunday, July 3. The following day Elvis went to the cemetery on his motorcycle and was almost run down by a girl who spotted him kneeling by his mother's grave in prayer. "She spoke to me using a lot of jive talk," he was quoted in the *Press-Scimitar*. "She asked me where I would be later. I told her that she didn't need to use that kind of language, especially in the cemetery. I guess I was feeling a little depressed. As I was leaving a little later, she came back in the cemetery and swerved toward my motorcycle." She was smiling, he said, as if it were all a joke.

He bought a boat, went waterskiing out on McKellar Lake, just like he used to with his first love, Dixie Locke; he did all the same things, went to the movies, rented the Fairgrounds, took over the Rainbow for roller-skating parties — it wasn't the same. Toward the end of the month Vernon and Dee came home from their honeymoon and moved into Graceland with her three kids. He continued to speak well of Dee for public consumption. "She seems to be a pretty nice, understanding type of person," he had said when news of the marriage first began to leak out. "She treats me with respect, just as she does Daddy. She realizes she could never be my mother. I only had one mother and that's it. There'll never be another. As long as she understands that, we won't have any trouble." As for Vernon, "If he can

78 👁 ELVIS IS BACK

find happiness in some way, I'm all for him. . . . He is my father, and he's all I got left in the world. I'll never go against him or stand in his way. He stood by me all these years and sacrificed things he wanted so that I could have clothes and lunch money to go to school. I'll stand by him now — right or wrong."

He felt sometimes as if there were a weight pressing down on him that he could no longer bear. He was surrounded by friends and relatives, all dependent on him, all looking to him for help, for guidance, for handouts — for something. He could give them jobs, he could dispense money and favors, on the surface they all deferred to him, and he was clearly the one in charge — but in his darkest moments he suspected that it was all a masquerade, they were like bluebottle flies buzzing around a dung heap, with no more loyalty to him than a fly would feel. His uncles Travis, Johnny, and Vester, his aunt Lillian, his cousins Harold Loyd, Gene, Junior, Bobby, and Billy Smith, even his daddy, were in a state of constant contention, it sometimes seemed — Bobby using his name to pass bad checks, Daddy falling out with Travis and Vester over one thing or another, Lillian accusing Daddy of being tight with his money, one uncle getting drunk and opening the gates, inviting everyone in off the street, other relatives just taking the money he offered them without thanks, blowing it, and then coming back for more. With his father's new wife in the house, he felt as if there were a cloud hanging over him and over his mother's memory, and he left almost as soon as they arrived.

H E SPENT A WEEK in Las Vegas before having to go back to work. The new picture, *Black Star* (it was retitled *Flaming Star* after shooting had been completed), was the first of the two back-to-back productions the Colonel had sold to Twentieth Century Fox, and was a straight dramatic role. Originally intended as a vehicle for Marlon Brando, with a script by respected writers Clair Huffaker (author of the novel on which it was based) and Nunnally Johnson (screenwriter of *The Grapes of Wrath*), it reunited Elvis with producer David Weisbart, who had shown such faith in him in his first movie, *Love Me Tender*, and brought in talented forty-eightyear-old Don Siegel (who had made the original *Invasion of the Body Snatchers*) to direct. Everyone connected with the production saw it as a serious picture; Siegel in fact had initially objected to the selection of a leading man who in his view was widely considered to be "a laughingstock," until Weisbart, whose great success had come with James Dean's *Rebel Without a Cause*, overcame his objections. There was to be a minimum of songs (four were recorded at the soundtrack session on August 8, and in the end only two were used); there was a socially progressive, if somewhat confusing, story line in which Elvis played Pacer, a "half-breed" caught between two worlds; there was extensive location shooting scheduled and a fine supporting cast, including veteran actors Steve Forrest, John McIntire, and Richard Jaeckel, and the fiery fifty-five-year-old Delores del Río, playing Pacer's Indian mother, in her first Hollywood role since 1942.

From the start, though, there were problems in almost every aspect of the production. Not surprisingly, the Colonel contributed to them by insisting on every advantage he could get, and studio production head Buddy Adler's death in mid July was something of a factor, but the principal stumbling blocks were the relationship of star and director and the confusion of purpose that lay at the heart of the script itself. Elvis had gone into the picture with the idea that it could be his dramatic breakthrough, and he threw himself into it at first without reservation, but he felt little warmth coming from Don Siegel, and in fact he sensed that the director was laughing at him. Siegel's own recollection was that he "had a problem communicating with [Elvis]" because he could never get him alone, but Elvis was convinced the older man was looking down on him, that he was patronizing him about his karate, his cars, and his gang, and it only motivated Elvis to play the yokel with Siegel all the more. Every morning when he and the guys arrived on the set, they started off with karate exercises as though they were doing their daily calisthenics. He generously loaned Siegel his brand-new Rolls-Royce but allowed the director to think that it was his "childlike" way of bribing him to put off a difficult scene. And constantly during the breaks he and the guys would play nonstop games of touch football in one-hundred-degree weather at the Conejo Movie Ranch in Thousand Oaks, somewhat to the director's amazement and consternation. "[He] didn't know how we did it," recalled Sonny. "It was because of the uppers."

Unfortunately, this same ambivalence showed up in his performance. For all of his sincerity of commitment, for all of the tributes that he garnered from fellow actors and grips with respect to his thoughtfulness and cooperation, he never seems at ease in his on-screen role: he is stiff and unsure and forever gulping his words, and this most instinctive of performers ("Acting skill will probably ruin him," Weisbart had said when Elvis first arrived in Hollywood, "because his greatest asset is his natural ability") seems to have no instinct to fall back upon but flounders about instead for some stock theatrical gesture. The film itself would not have won any awards, with or without Elvis; there is a great deal of undifferentiated action, and it is confused in its message, which veers between the tragedy of being an "invisible" member of society, deprived of history and roots, and a fairly insipid plea for racial tolerance. Perhaps most surprising, it never really gives Elvis a chance to rise above a style of ensemble acting for which he is clearly not suited; whatever his billing, he is unquestionably playing a supporting role with few lines or situations that allow him to go beyond a somewhat passive, reactive response. At the end Pacer, desperately wounded and having seen "the flaming star of death," rides off into the desert to die alone. "Maybe someday, somewhere," he says, "people'll understand folks like us."

In the midst of shooting, Elvis was forced to find new living quarters, having finally been asked to leave the Beverly Wilshire after a number of incidents, culminating in Tuesday Weld throwing a fit in the hotel lobby when security wouldn't allow her to go upstairs. Joe looked at four houses and found one on Perugia Way, in Bel Air, overlooking the Bel Air Country Club. The house, owned by the Shah of Iran, was available on a six-month lease that could be extended and was perfect for their needs: it afforded privacy, space, and the opportunity for more and better parties. Elvis put up a painted photograph of himself, his mother, and father over the fireplace in the living room, and it was home.

The picture wrapped on October 7, and after a weekend in Las Vegas they started off on the seventeen-hundred-mile drive home. There was less than a month to go before the start of the next picture, but Elvis missed Memphis, and there was no question that he wanted to record his gospel album in Nashville, not Hollywood. At Graceland he quickly settled into his old routine but made little secret of just how conflicted he continued to feel about his father's remarriage and the presence of Dee and her boys in his home. "When I first came back," he told the *Press-Scimitar*'s Bob Johnson in an interview from Hollywood the previous month, "everything was strange. Now I'm lonesome, and so homesick it hurts. In some ways what I've got is good, and in some ways it isn't. I'd like to get back home again. But even that will never be the same."

Not long into his three-and-one-half-week stay, he heard from the Tau

Kappa Epsilon fraternity at Arkansas State College that they would like to induct him as a member. The letter came from chapter president Rick Husky, who had dreamt up the idea as a stunt, following in the wake of the bonanza of publicity their house had gotten when movie actor Ronald Reagan, passing through town in his role as corporate spokesman for General Electric, genially agreed to pose for pictures with the officers of the local chapter of his college fraternity. Husky, in the midst of a recruiting drive, saw Elvis Presley as a way of making TKE the most successful house on campus and concocted "a heartfelt memo about how we'd like to initiate him in the fraternity and give him an award as man of the year. Two days later there's a telegram slipped under my door from Elvis' secretary, Pat Boyd, saying that Elvis would be at Graceland at eight o'clock on Tuesday night. 'He'd love to see you and accept his award.'"

There was no award. There had been no thought of doing anything more than putting out the publicity announcement as a news item — but Husky, a resourceful young man majoring in journalism, wasn't going to allow that to stop him. He devised some appropriate wording, sketched out a design, and went to the local sporting goods store to have a trophy made up. They told him it would take at least two weeks, but when he explained his dilemma, somehow they came up with a plaque in time for the Tuesday appointment.

"We took an adult adviser to the fraternity, myself, and two other guys. We were cleared through the gate and went up; it was like a postcard you just drove up and there's this gorgeous building, like the White House, with a black Rolls-Royce parked outside. Joe Esposito opened the door and said, 'Elvis will be down in a minute,' and we go into the music room and look around. By now I'm getting totally nervous, but then Elvis came down and was absolutely terrific. He was just so genuine and sincere. And so we just very sincerely initiated him into the fraternity. He put his hand on the skull and swore an oath; we gave him the secret word, and I pinned him. He was really great."

In a way they were embarrassed by the very ingenuousness of his response. He told them how he had always wanted to go to college but couldn't afford it; he asked about the Arkansas State football team and said he hoped maybe he could attend some games. "My great love is football," he told them. "I always wanted to play, but I couldn't because I had to work." He reminisced about dances he had played in Jonesboro and other small Arkansas towns just a few short years ago. Wealth was in the eye of the beholder, he declared, proudly showing off his Rolls-Royce. "You know,

82 👁 ELVIS IS BACK

when I first got home with the car I was pretty proud of it," he said. "The first day I arrived, I left it parked outside, alongside my Cadillac limousine. The maid came in, and the first thing she said was, 'Mr. Elvis, I heard you got yourself a new car. I'd sure like to see it.' I told her that it was parked right outside and she said, 'Well, I just came from outside, and all I saw out there was some big, long white Cadillac and some old black car.'" When they were leaving, he told them, "This is one of the nicest awards that I've ever received. The plaque is certainly beautiful, and you can be sure that it will occupy a place of honor in my home."

 $\Gamma_{\rm go}$ bienstock showed up on the afternoon of October 29 to go over songs for the gospel session that was scheduled to start at 6:30 the following evening. Once again recording was to be confined to a single all-night session, and although the Colonel wanted to make sure that Elvis had the afternoon cleared for Freddy, there really wasn't all that much to go over, given that Elvis knew what he wanted to record and Freddy had already made cut-in deals on the publishing for many of the songs. Freddy did bring one new nongospel song with him, which he had commissioned Doc Pomus and Mort Shuman to adapt from another Neopolitan ballad ("Torna a Surriento") in the public domain. Elvis liked the new Pomus and Shuman number, "Surrender," very much. It offered him the opportunity to prove to his critics that the ambitious new direction he had first embraced with "It's Now or Never" (which had gone to number one the previous summer, far outstripping "Stuck On You" in sales) and "Are You Lonesome Tonight?" (due to be released as the new single within the next couple of weeks) was no fluke. He could not have been more excited about the gospel session either. But he shocked Freddy when he confessed to him about a recurring nightmare he had been having. In this dream there were no fans outside the gates, there was no Colonel Parker, and he felt alone, helpless, and deserted. The debonair young Viennese businessman didn't know how to react or what to say to Elvis, except to suggest that it was natural to doubt the reality of success when attempting to deal with such unimaginable popularity at so early an age. But it struck him as a curious confession nonetheless and a telling parable of the extent to which Elvis saw his own success linked to the continuing presence of his mentor.

The session itself was as inspiring as its genesis, as much a promise that Elvis was keeping to himself as a tribute to the quartet tradition on which

MARCH 1960-JANUARY 1961 👁 83

he had grown up. From the first confident, lightly swinging notes of the Trumpeteers' classic "Milky White Way," there was no question of either his fervor or his confident sense of just what he wanted to do, and it translated instantly to the background singers and the band. Charlie joined in on the next three numbers — "His Hand in Mine," "I Believe in the Man in the Sky," and "He Knows Just What I Need," each a Statesmen standard on which Jake Hess, perhaps Elvis' most direct vocal influence, had provided the original stirring lead. The session went off without a hitch, concluding at eight o'clock the following morning with a rousing version of "Working on the Building" and a grand total of fourteen sides. By then Chet Atkins had long since gone home, the musicians were all exhausted, and Bill Porter was feeling violently ill ("I had food poisoning that night and was throwing up; around five in the morning I said, 'Mr. Sholes, I've got to quit. I can't keep this up.' He said, 'One more song, Bill, one more song. Just hang in there.' I heard that about four times"). To Gordon Stoker and the Jordanaires the highlight came toward the end of the evening with "Known Only to Him," another of Jake Hess' virtuoso performances, on which all the singers got inspired, to the point where it was almost like having church.

One week later Elvis caught a flight to L.A., where he was scheduled to record the soundtrack for his next picture, *Wild in the Country*, on Monday, November 7. Advance notices for *G.I. Blues* (scheduled to open at Thanks-giving) were just beginning to come in and only echoed the enthusiastic embrace of the "new" Elvis which had first greeted the success of "It's Now or Never." Moreover, the soundtrack album, just out, gave every evidence of far outstripping *Elvis Is Back* in sales (surprisingly, that eclectic, and truly adult, album had not sold even half a million copies), while Colonel was in the first flush of his all-out campaign to promote the movie with an "exploitation" that involved distributing more than one hundred thousand paper army hats, which he had gotten RCA to pay for after Paramount turned him down ("We are always promoting," Colonel flung back defiantly at Hal Wallis).

At RCA, meanwhile, there was no question that the Colonel had won the war. To begin with, he had succeeded in undermining Steve Sholes' authority by persuading new RCA president Bob Yorke to move the decisionmaking process into marketing, where Bill Bullock, Sholes' nominal superior and the man responsible as much as anyone else for signing Elvis Presley to the label, was not inclined to challenge his authority. The result

84 💊 ELVIS IS BACK

was that nothing happened without the Colonel's okay: he dictated copy, he approved the artwork, by now he had even taken over the files that publicity director Anne Fulchino had painstakingly assembled and was charging RCA a licensing fee for the very photographs that had in most cases originally been paid for by the label. He had in addition convinced RCA to cede to Elvis the authority to run his sessions, pick his singles, select album cuts, and approve the sound mix, none of which would be formalized until the renegotiation of the contract option at the beginning of the new year but all of which was in place by the time that Elvis completed his gospel album, which would be titled His Hand in Mine and would be rushed out for Christmas release. RCA appeared to be so well trained at this point that they even offered to build Elvis a studio in his home so he could record whenever the inspiration took him — but the Colonel wisely urged him to turn the company down, seeing their generosity for what it was, a desperate attempt to generate more product and thereby undercut the Colonel's unassailable bargaining position.

W^{ild} in the Country started shooting on location in Napa, California, on November 9. Taken from J. R. Salamanca's well-regarded 1958 first novel, The Lost Country, the script had been written by prizewinning playwright Clifford Odets (Waiting for Lefty, Awake and Sing!); the director, Philip Dunne, was the author of such notable screenplays as How Green Was My Valley and The Ghost and Mrs. Muir; and the older woman, one of three principal love interests in the story, was to be played by the distinguished French actress Simone Signoret. Unfortunately, Signoret fell through, Odets was fired just as filming was about to begin, and studio head Spyros Skouras, in agreement for once with the Colonel, insisted that the number of songs in the picture had to be expanded in order to make it more of an "Elvis Presley" picture. There was the usual confusion of studio politics, there was the somewhat less common confusion of a script that appears to have been cobbled together just ahead of the actors' delivery of their lines, but it was on the whole a creditable venture with a good cast, a trio of women to fall in love with Elvis and vice versa (Tuesday Weld was the hoyden, Millie Perkins the dewy-eyed innocent, and twentysix-year-old Hope Lange capably, if somewhat improbably, filled in for Simone Signoret), and what appear to have been altogether honorable intentions.

MARCH 1960-JANUARY 1961 👁 85

Of all the principals, the only one who seems to have taken a dim view of the proceedings was Millie Perkins, and her reservations centered more on pretense than lack of aspiration. Perkins, a twenty-two-year-old who had been discovered and generally acclaimed for her only other previous acting role, the title part in The Diary of Anne Frank, saw the whole enterprise, probably with some discernment, as intellectually dishonest. She had no reservations about Elvis Presley as a person, and given the manner in which she had been plucked from a modeling career and awarded the starring role in a major motion picture, she could have had little objection to an attempt to do the same for a popular singer. But she saw Dunne as the kind of intellectual poseur who took pride in playing the Fifth Brandenburg Concerto for some of the love scenes ("I think I won a unique place in the directors' pantheon as the only director ever to make Elvis Preslev listen to Bach. As a matter of fact, he loved it," Dunne wrote in his memoirs). And, whether out of dissatisfaction with a movie career that had just happened to her ("I had never even thought of being an actress. I didn't know the movie business. I was very shy, very opinionated - I wanted to be in Paris"), or with a clarity of vision that came from being an outsider, she saw the entire enterprise as hopelessly compromised from the start, a phony attempt to dress things up in a self-serving way that kept stressing the lofty mission of art.

"I think that everybody making the movie thought, 'We're classier than all those other Elvis Presley movies. We're so much better.' Everyone was going around patting themselves on the back for being artists; they were going to do something with Elvis that other people couldn't, or didn't want to, do — and I think they didn't come up with the goods at all.

Elvis turned out to be someone I liked very much. I felt there was a man with a heart and soul there who truly cared about people. Certainly he treated me as if he cared about me; there was a mutual respect between us. But his life was on a level that my life was not on. I was married to Dean Stockwell at the time, and he was — I felt like he was drifting. The guys were on the set every day, you know, wrestling on the floor. I didn't even know what girls he was dating at the time, because it didn't interest me, his personal life seemed so silly. And yet I knew he was a victim of it. I felt like Philip Dunne fawned all over Elvis. Elvis' attitude was — I saw Elvis looking around that set and summing up people faster than anyone else could have, and I felt that

86 🔊 ELVIS IS BACK

after a short period of time he was disappointed in Philip Dunne, but he was too polite and well behaved to say anything.

He tried very hard to make this film better than his other movies, and you saw him trying and asking questions. And I just believe the sad thing is that [the director] did not have the ability to help Elvis through it. I remember doing this one scene; we were sitting in the truck, and we were supposed to be driving home from a dance or going to a dance, and in the script he was supposed to break into song, turn on the radio and start singing. And to me it was like, "Yuck," I was very young, and I thought, "My sisters are going to tease me, this is so embarrassing and tasteless." You see, I was a snob, too. But — and this was the nicest thing — while we were rehearsing, finally the director walked away, and Elvis looks at me and says, "God, this is so embarrassing. Nobody would ever do this in real life. Why are they making me do this?" So there we were, both of us having to do something and we just wanted to vomit.

He never used his star power — never. Maybe he should have. Maybe he did it on some other level, but he sure didn't do it on the set. I felt like he was younger than me, this very humble person who would make statements about what he believed in. And I would think, "He's saying that to show me he's a fine human being." All I know is that there was a person there with a refined heart and soul, and I say refined on any level you want to look at it. When you meet someone like that, you know they're there, even if they're sitting there eating fifteen lollipops — that's beside the point. That's just what they're doing at that time, but that's not the essence of the person. The essence of Elvis was as fine a person as I've ever met; he treated me as well as anyone has ever treated me in this business.

Her explanation of the failure of the film may well be correct, and certainly her insights into the ambivalent impulses of Elvis' nature are prescient, but they still don't explain what we see on the screen. If you were to pick out the one thing that is desperately wrong with *Wild in the Country*, leaving aside a script that is freighted with all the "sensitive young man" clichés of its time — it is Elvis Presley. He simply seems lost in the role, ambling his way through it, alternating between bouts of sullenness that start and end with bombastic declamation and equally silly posturings of trembling sensitivity. You look at the actor up on the movie screen, and he is simply not engaged. There is one moment early in the film when the character speaks of his dead mother, and a sense of genuine sorrow and regret seems to come through. Elvis is clearly visualizing his own experience, using emotions that he has himself felt to summon up a wellspring of conflicting feelings. But otherwise — nothing. He is flat, he blurts out his lines, there is an almost total absence of timing, conviction, commitment, tone. If you doubt your eyes, contrast this with his performance in *King Creole*, full of jauntiness, assurance, an ease and melodiousness of nuanced approach. Here, just two and one-half years later, there is no pulse, no beat between the lines, there is simply the sense of a young man running, in many cases racing, through his lines.

What role amphetamines may have played in this dramatic deterioration of affect and attitude is impossible to say. To Millie Perkins the waitingaround moments were always the most important moments on the set, a time when "your training as a human being to discipline yourself to do what you really believe in or do what you *say* you believe in" should kick in — and they represented Elvis' most conspicuous failure. She put it down to externals, the guys around him who kept him from growing, the lack of formal education that only added to his natural insecurity. The guys themselves, meanwhile, watched with a growing sense not so much of alarm as bemusement at the increasingly violent mood swings that Elvis sometimes exhibited, not always recognizing their employer as he gave in to sudden fits of unpredictable rage.

One time, on a weekend excursion to San Francisco, he pulled a derringer on a carful of guys who gave him the finger; another time, back in Hollywood, he flared up at Christina Crawford, who had a bit part in the picture and was dating Joe at the time, dragging her by the hair and cursing her out because she objected to Joe's lighting his cigar. It was not that they did not understand the reasons for his anger. Christina had no business knocking the boss's cigar out of his mouth; he was within his rights to get pissed off at her, and he'd always had a pretty hot temper anyway. But they noticed the differences, too, not just the loss of control but the absence of remorse in a nature that each of them saw as essentially soft-hearted, for good or for ill. They were all taking pills to keep going; they were all under stress, Elvis most of all, and in the end they just accepted his behavior as something that grew out of his role. It was like getting first choice of the girls, an unquestioned prerogative that went with the territory. Otherwise, it was the same old Elvis, the same kind of hijinks and good times that they always had on the set. Alan Fortas had finally rejoined the group for this film, lured by the promise of meeting Tuesday Weld, and he and Tuesday actually got to be good pals, the other guys all jibing at him for the puppy-dog devotion he showed the seventeen-year-old blond actress. Hope Lange liked to drink vodka, and Elvis uncharacteristically joined her throughout the filming, for the first time allowing the guys to have liquor in the house.

When they got back to Hollywood, it was just more of the same, except that Anita came out for a brief visit and started snooping around and found a recent letter from Priscilla in Germany. "In the letter there was something to the effect of — 'You need to call my daddy and talk him into letting me come over. I want to come really bad.' When Elvis came home from the studio, I confronted him with the letter, and we had a terrible argument. He said, 'She's just a young, fourteen-year-old [actually fifteen now] child, and she just has a bad crush on me. She wants to come over. We're family friends, army buddies, her daddy's a good friend of mine.' He just tried to smooth it over that way. Well, I did not understand, because I had seen pictures of Priscilla waving 'good-bye.' She was waving 'good-bye' like I was waving 'good-bye' when he left Memphis. Elvis kept saying, 'She's just so young. It means nothing.' But I was still perturbed. So, I went back to Memphis."

As soon as she left, he went back to dating Nancy Sharp, a wardrobe girl on the picture, and he continued to see Sandy Ferra, with whom he remained fascinated. "We'd just spend hours dancing in the living room, and then he would sit down at the piano sometimes and sing spirituals, and it was just beautiful. Cliff was around all the time at that point; he had 'Long Black Hearse' out — his 'big record!' — and a lot of times he'd get up and sing. I lived in the Valley, and different guys would pick me up in either the Rolls or a limo, and we'd go up to the house. There was always a line of girls standing outside, and we would drive through the gates, and usually the guys would have dates, and we'd sit in the den, or the maid would make up something for dinner, and we'd sit and watch TV and eat.

"One time I wore pants, and Lamar picked me up and didn't say anything, we drove out to the house and I walked in and Elvis was all dressed up, because he always got dressed up for our dates. So he said, 'Hi, baby,' and he kissed me on the cheek, and we sat down on the couch, and he did not speak to me for the next three or four hours. It seemed like an eternity. Then he kissed me good night, and he said, 'Don't ever wear pants again.' I said, 'Oooooh, I won't.' 'Cause he said he got all dressed up for me, and he expected me to get dressed up, too. So I always wore my prettiest party dresses from then on. No more pants."

The movie was briefly threatened by a new studio policy limiting shooting time to thirty-seven days instead of fifty, even for those shows currently in production. Philip Dunne threatened to quit several times before that problem was resolved, but the picture was still over schedule, and cast and crew were given just one week off for Christmas before shooting once again resumed. Elvis was just as glad to get back to California after discovering the changes that his father's wife had made in his home, and he and his daddy quietly agreed that no more changes would be made without his explicit approval.

The Colonel meanwhile had preceded him to Memphis to join the mayor in making an announcement about the big Memphis Charities show that he had been hinting at all year. Elvis would headline at Ellis Auditorium on February 25, the performance would benefit some two dozen Memphis charities plus the long-dormant Elvis Presley Youth Center in Tupelo, and, as per his long-standing policy with respect to benefits, even the Colonel would be buying his own ticket. "There will be no passes," he said. "This is going to be 100% charity."

Flaming Star opened strongly nationwide on December 21, though not as strongly as *G.I. Blues*, which had risen as high as number two on *Variety*'s weekly list of top-grossing films, ranking number fourteen overall for 1960 and grossing \$4.3 million in the last six weeks of the year alone. For Elvis' twenty-sixth birthday, on January 8, there was a small party on the set, and cast and crew presented him with a plaque portraying a cartoon Elvis clad in a karate ghi and breaking blocks of wood. "Happy Birthday, 'King Karate,'" was the message. On January 20 he was finally released by the studio and permitted to go home, though he was recalled briefly two and one-half weeks later to reshoot the ending when studio executives decided that Hope Lange's suicide after her abortive romance with Elvis' film character was "too bitter an ending." By this time, though, Elvis was busily preparing for his return to live performance, which was now scheduled to include not just one but two big charity shows that the Colonel was promoting with all of his customary flair and zeal.

THOMAS A. PARKER, HAWAII, CIRCA 1930. (COURTESY OF THE ESTATE OF ELVIS PRESLEY)

THE COLONEL'S SECRET

HE SECOND CHARITY CONCERT had come about as a result of a story the Colonel read in the Los Angeles Herald-Examiner on December 4, 1960, prompted by the nineteenth anniversary of the Japanese bombing of Pearl Harbor. The piece centered around stalled plans to erect a memorial to the victims of that bombing on the site of the U.S.S. Arizona, whose 1,102 officers and men remained entombed beneath the water. Three hundred thousand dollars had been raised over the course of the past fifteen years, but the War Memorial Commission was still \$200,000 short of the funds necessary to construct a monument in time for the twentieth anniversary of the attack the following year.

The story was prompted by a letter sent out to over sixteen hundred mainland newspapers by George Chaplin, editor of the *Honolulu Advertiser*, asking that they consider running an editorial on or about December 7 with an appeal for funds. The appeal brought in about \$20,000 from all around the country, but it also brought a telephone call to Chaplin from the Colonel. "Parker said Elvis was coming to Hawaii to make the film *Blue Hawaii* — and that if we could get an appropriate arena, and the tickets, ushers, lights, et cetera were for free, then Elvis would donate his services." Chaplin seized on the Colonel's offer, cleared it with the navy, explained that if they were able to raise \$50,000 they would have enough to complete the "bare essentials" necessary for a Memorial Day dedication, and issued an official invitation to the Colonel to come to Hawaii.

The Colonel arrived on January 7 to solidify arrangements with H. Tucker Gratz, chairman of the Memorial Commission, and held a press conference at the Hawaiian Village Hotel on January 11. Every penny that was raised would go to the fund, Parker announced, while stipulating that he and Elvis would pay for the talent on the show out of their own pockets. "This is the real McCoy, fellas. This is no gimmick. . . . You know, Elvis is twenty-six (last Sunday was his birthday), and that's about the average age of those boys entombed in the *Arizona*. I think it's appropriate that he

should be doing this." And then, once again, he reminded every dignitary present, along with all potential attendees, that "everyone's gotta buy a ticket — the governor, Admiral Solomons, Admiral Sides, commissioners — everyone, even me. Everyone in that hall will be a contributor to the *Arizona* fund."

The Colonel was riding high. The Memphis benefit on February 25 had already drawn an avalanche of publicity for what Colonel had billed as "the greatest one-day charity show box office in the country's history." With his return to Hawaii in this new public-spirited guise, made possible by Hal Wallis' embrace of the "Hawaiian story" (albeit without gypsies) that he had first proposed over two years ago, the Colonel couldn't have helped but feel a little smug. He had always believed that you made your own destiny, and while he remained a notorious disrespecter of nearly every form of social convention, he prided himself on his patriotism and public-spirited generosity, too. It was something he was convinced paid off in any number of different ways, and if one of those could be further proof of his boy's good character — and it could help the new picture in the process — well, so much the better.

Meanwhile, he had unfinished business to attend to. On January 6 he had completed yet another renegotiation and contract extension with Hal Wallis, raising the price per picture once again, to \$175,000 for the next three Paramount outings, \$200,000 for the two beyond those. At the same time he was vigorously pursuing the deal which, as he saw it, would ensure Elvis' future: a multi-picture arrangement with MGM for far more money than he could ever have hoped to squeeze out of Wallis, but, more important, one which would announce to Hollywood that Elvis Presley was a major motion picture star. On January 12, the day after the Hawaii press conference, he returned to the mainland and plunged back into the MGM negotiations, emerging on January 20 with a guaranteed four-picture deal at \$500,000 per picture and 50 percent of the profits. This meant, he announced jubilantly to RCA vice president Bill Bullock, that they were "sold out for motion pictures through 1965, which of course enhances the value of this great artist for your company also. The confidence shown in him by the motion picture industry undoubtedly will rub off to the benefit of all of us." And in a rare visit, he stopped by the house on Perugia that same day to deliver the news personally to Elvis, then accepted congratulations from all the guys as Elvis explained to them how the deal worked. "Just remember, boys," pronounced the Colonel, no doubt tamping his cigar vigorously to emphasize the point, "if we didn't have Elvis, I couldn't make these deals, and we wouldn't be having dinner in this beautiful home."

By now he had come up with yet another twist on the Hawaiian scheme, retaining the nonprofit principle at its core but proposing that an NBC television special be structured around the concert (the taped broadcast would combine documentary touches with the live performance) in a package for which Elvis would receive \$50,000 to recoup costs, the Arizona memorial would realize another \$100,000, and ownership of the program would revert to Elvis after a single showing. Like most of the Colonel's projects, eleemosynary and otherwise, this one was brilliant in its simplicity, simultaneously burnishing Elvis' image and benefiting the fund, and while in the end it fell through, it prompted venerable William Morris Agency head Abe Lastfogel to recognize the distance the Colonel had brought his single client. At one time, the diminutive talent agent pointed out to a small group of agency and NBC representatives studying the feasibility of this new proposition, Elvis Presley was seen by most people as an "oddity," with little staying power and less broad-based appeal. Now, Lastfogel declared, with the conviction of one who had had to be converted initially himself, that phase was finished. After the army experience, with this magnificent charity concert that the Colonel was putting on, the world could see Elvis Presley for who he truly was.

The work continued on various fronts, with Colonel shuttling back and forth between his various projects and Elvis returning home for a brief vacation. The house continued to feel strange to him — nothing more had been physically altered, and his father's new family was now living in the apartment that had been constructed from the garage behind the kitchen, but it remained unsettling, not just for him but for Vernon, too, who continued occasionally to sleep in his old bedroom, its closets still filled with Gladys' clothing. Elvis stopped by the cemetery almost every day, fussing with the flowers that were delivered each week on a standing order and cleaning up the area around his mother's grave. On February 2 he drove down to Tupelo with Anita and Joe and Gene, revisiting the scenes of his childhood, stopping by the Lawhon School to see his fifth-grade teacher, Mrs. Grimes, showing Joe, who had never seen Tupelo before, all the different places he had lived, the Negro community of Shake Rag, the Fairgrounds where he had sung in public for the first time, talking all the while about the world he had left behind. When they got to his birthplace on Old

Saltillo Road, they found the sign marking the site of the Elvis Presley Youth Center fallen down and tried without success to prop it back up. Elvis was visibly angry: the house, which was intended to be the centerpiece of the park, was still occupied, the fourteen-acre location had barely been cleared, the guitar-shaped swimming pool that Elvis had stipulated for East Tupelo's youth was not even on the architectural drawing board. He couldn't help but feel that if the park were in a more fashionable part of Tupelo, plans would have been much further along by now, and he and the Colonel had never been able to satisfactorily determine what had become of the \$14,000 he had donated from his performance at the 1957 fair. But he was not about to give up; he was *determined* to see this project through to completion — it was just as important as the Colonel's thing in Hawaii; there would be ball fields and recreational facilities and a teen center here someday.

On Saturday Gene's brother, Junior, died. Though he was only twentyeight, it came as no great surprise. Junior had been on a downward path ever since he had come home shell-shocked from Korea in 1953; he had always been unpredictable and moody, but he had become more erratic since Elvis' discharge from the army and was no longer even able to travel with them. Evidently he had been up all night drinking with his (and Elvis') uncle Travis, passed out in his cousin Billy's room, and suffocated on his own vomit.

Elvis went to Travis' house practically beside himself with anger and grief over a life so senselessly thrown away. Junior had been weak, but he understood Junior, and he understood how easy it was to lose control. "I can see him just standing there," said Eddie Fadal, Elvis' friend from Waco who happened to be visiting Graceland and accompanied Elvis to the house. "He just kept saying, 'It's all over, Junior, it's all over.'" Late that night he and his seventeen-year-old cousin Billy visited the funeral home, the same one that had interred his mother, and he got someone to let them in so they could view the body. At Elvis' instigation they took a tour of the premises and encountered two morticians, one working, one snoring in a casket. Elvis introduced himself, explained about his cousin, then interrogated the mortician who was awake about the mechanics of his work, about what happened to the body after death. It was, Billy thought, a little creepy - he himself was not particularly comfortable surrounded by all these corpses laid out on their slabs - but he thought he understood what Elvis was doing. "He had a fear . . . and he wanted to face that fear. And I think he was just trying to bridge that gap and hold on a little longer."

The Colonel was in the midst of a fever of preparations for the two charity shows, throwing out promotional challenges and hustling side celebrity tickets, when he received the latest in a series of letters from his brother Ad in Holland. Ad and an older sister had seen a photograph in the Dutch magazine *Rosita* the previous spring, showing Elvis Presley, just out of the army, standing at the opening of a train door. Behind him, wearing a hat and a long winter coat, was a man identified as his manager, Colonel Thomas A. Parker. To Ad and his sister the man in the photograph looked very much like their brother Andreas ("Dries"), whom they had not heard from since 1937, when the last of his letters from America arrived. The similarities were striking, and any doubt they might have had that this heavyset middle-aged man really was the same person as the brother they had last seen in 1929 was immediately erased by his uncanny resemblance to another brother, Jan, a policeman, as he looked today.

Ad contacted *Rosita*, whose editors were naturally skeptical at first. But Ad persisted, writing first to the Dutch Elvis Presley fan club, then to the fan club in Memphis, sending family pictures and news of their mother, who had died in 1958, heartbroken, Ad said, that she had never seen her son, Dries, again. Eventually he got a response of sorts, a perplexing letter that began in the third person but slipped into a first-person account midway through. Ad showed the letter to *Rosita* editor Leo Derksen, who concluded that "there was no doubt that Parker had written the answer personally. He denied everything. It was all a mistake, he wrote."

With that, Ad was able to persuade *Rosita* to sponsor him on a trip to America for a reunion with his famous brother, and at this point he started bombarding Dries with one letter after another, until finally the Colonel, with the pragmatism on which he had always prided himself, responded that yes, he would welcome Ad's visit but that he was very busy right now, he was scheduled to leave for Hawaii any day, but when he got back, Ad should contact him and he would be glad to see him. To his brother-in-law, Bitsy Mott, who worked security for Elvis, he grumbled that he had heard from a brother whom he hadn't seen in years, and now all of a sudden this brother was talking about coming to visit. "He wants something from me," the Colonel complained. "What's he up to?" But he never mentioned that his brother was Dutch.

The Chief Potentate of the Snowmen's League of America, Col. Tom Parker was on the phone from his suite in [Memphis'] Hotel Claridge, and he was joking and in fine fettle.

"That Mayor of yours, he's learning and he worked hard and one of these days he's going to make the grade," the Colonel said happily, "but I already made good on my end of the deal."

The Colonel was referring to his challenge to [Memphis] Mayor Loeb yesterday that if Loeb in 20 minutes would sell 10 of the \$100 tickets to the luncheon honoring Elvis Presley at Hotel Claridge at 12:30 P.M. tomorrow, the Colonel would match it by selling 10 himself. Mayor Loeb got on the phone, altho he said he was handicapped because in his position as Mayor he had to be careful to whom he made his appeals, and got 10 promises to buy the gold luncheon tickets, and two "almost certains." It took him 27 minutes.

"I just sold 14 more tickets," the Colonel said, "and it took me seven minutes on the phone. How many calls? Two. I sold eight on one call and six on another.

"Well, maybe it did run a little over seven minutes . . . maybe eight minutes. The long distance operator had trouble getting one number.

"So now that makes 96 tickets I sold."

 from Robert Johnson's "T-V News and Views," Memphis Press-Scimitar, February 24, 1961

There was very little left to be done when the great day finally arrived. Saturday, February 25 had been declared Elvis Presley Day throughout the state of Tennessee; not only the mayor but the governor was scheduled to attend, and comedian George Jessel was flying in from Hollywood to MC. All the top RCA executives from president Bob Yorke, Bill Bullock, and Steve Sholes on down would be there, not to mention William Morris Agency head Abe Lastfogel, the Aberbach brothers (Jean was flying in from Rome, where he had been conducting Hill and Range business), the Colonel's first show business client, Gene Austin, of "My Blue Heaven" fame, and virtually every Memphis civic leader you could name. Because the first show had sold out in less than twenty-four hours, a matinee performance had been added, and the Colonel was hustling unreserved \$3 seats to that. The Colonel in short was everywhere, "snowing" everyone from the highest lord high-muck-a-muck to the humblest citizen alike with his unique application of the salesman's credo: "There is nothing I can give you which you have not. But there is much, while I cannot give you, you can take."

Elvis held a rehearsal at Graceland on Friday, February 24. The whole studio band arrived from Nashville, along with Scotty, D.J., and the Jordanaires, and they ran through a program which combined some of Elvis' biggest early hits ("That's All Right," "Heartbreak Hotel," "All Shook Up," and, of course, "Hound Dog") with a judicious selection of recent recordings ("Such a Night," "Fever," "It's Now or Never," "Swing Down, Sweet Chariot," "Are You Lonesome Tonight?"). Elvis was visibly nervous but clearly excited, and they rehearsed late into the night.

The matinee performance, which began at 4:23 P.M., was characterized by the *Commercial Appeal* as bringing together elements from "Negro cottonfield harmony, camp meeting fervor, Hollywood showmanship, beatnik nonchalance, and some of the manipulations of mass psychology." At the evening show, the crowd grew restive during the Colonel's usual parade of tap dancers, acrobats, jugglers, and comedians, though they woke up a little for Boots Randolph's "yackety sax" and Brother Dave Gardner's sharp-edged satire. Then after a brief intermission Elvis came out, and MC George Jessel flung himself, palms down, at Elvis' feet, as wave after wave of screams and applause washed over the singer for a full three minutes.

"[He] grabbed the mike as if he were trying to eat it," the *Press-Scimitar* reported, remarking on his nervousness and evident rustiness after more than three years away from live performing. The *Press-Scimitar* reporter noted something else, too: there appeared to be a new edge of irony to his performance. He seemed more confident in some ways, indicating his amusement "at the frenzied zeal which some of his fans show for him. He would make it apparent when he twitched a hip or made one of those sudden gestures which cause the screaming excitement, that he was laughing at the response. He went out of his way several times to let photographers get a good picture. He would go all the way across stage and make a gesture to accommodate a photographer whom he knew." At the same time there was no question of his utter seriousness, his total

immersion in the moment. "He mixed his numbers beautifully. . . . It was easy to see by the smile on his face . . . that he knew he had the crowd going his way."

The transformation was something that he could never have anticipated, said the newest Jordanaire, Ray Walker, who hadn't sung onstage with Elvis before. "He just had kind of an effervescence about him. He would do some unexpected things and do them so well we'd forget to come in. Then he'd turn around and grin and call us a name." When Scotty, acting as bandleader, forgot a song that was supposed to have been on the program, or Elvis himself messed up some lyrics, he just went right on: he was masterful, in command, *he was where he was supposed to be.* For forty-nine minutes he commanded the stage, as comfortable in this role as the Colonel was in his, removed for just a moment from all the strain of pretending, from all the uncertainty of manufacturing an image, simply doing what he was meant to do. The following day it was announced that he had raised \$51,612 for twenty-six Memphis charities and the Elvis Presley Youth Center in Tupelo, which with a contribution of \$3,789.80 would receive the single largest share.

On March 8, he made another appearance, this time at the Tennessee State Legislature, where he was a special guest of a joint session of both houses, convened to honor him for "bringing fame to Memphis and Tennessee throughout the nation." He drove up with Joe and Sonny and Alan in the Rolls, disarmed the legislators and a gallery full of "truant teens" with a speech in which he called this recognition "one of the nicest things that has ever happened to me," proclaimed that he would never live in Hollywood, and got a "\$.10 tour" of the governor's mansion from Governor Ellington's attractive daughter, Ann, with whom he then sped off and spent much of the rest of the day. On the way back to Memphis he and the guys stopped off for forty-five minutes at the Tennessee State Prison, where Johnny Bragg, lead singer of the Prisonaires, the group Sam Phillips had brought to national fame on the Sun label in 1953, was incarcerated for a parole violation. Elvis toured the various workshops, prison dining hall, and death house, and spoke briefly with Bragg, asking if he needed a lawyer or if there was anything at all he could do for him. Then it was back to Memphis, a return to Nashville on the weekend for a quick recording session at RCA's behest, and more marking time.

* * *

H E FLEW OUT TO THE COAST ON March 18 in preparation for the *Arizona* benefit on the twenty-fifth and the start of shooting on *Blue Hawaii* two days later. The Colonel had already been in Honolulu for ten days, talking up the benefit, buying a half hour on all thirteen Oahu radio stations to advertise the concert with selections from Elvis' religious album, hustling the sioo tickets (he sold seventy-four before even leaving the mainland), thoroughly enjoying himself and the rare opportunity to get generals and admirals to jump at his command. Elvis was scheduled to record the *Blue Hawaii* soundtrack in Hollywood, and he had flown the whole band out from Nashville for the session and the concert. They relaxed and rehearsed at the house on Perugia, then went into Radio Recorders on March 21 to record a full fourteen-cut soundtrack album under the watchful eye of Hal Wallis over the next three days.

The song selection included everything from a number originally recorded by Bing Crosby in 1937 for another Paramount motion picture ("Blue Hawaii," the title cut) to several Hawaiian standards to the usual assortment of contemporary adaptations from the Hill and Range stable ("Rock-a-Hula Baby," "Beach Boy Blues"). Among the Hill and Range contributions was a pretty ballad based on an eighteenth-century French melody, "Can't Help Falling in Love," and yet another number in Elvis' recently acquired Mediterranean manner, "No More," adapted this time from the classic Spanish folk melody "La Paloma" and co-written by songwriter Don Robertson, two of whose more contemporary compositions Elvis had just recorded in Nashville the previous week.

The Nashville session had been scheduled strictly to fulfill a contractual commitment to RCA: twelve songs were required to make up a new studio album, and as per the Colonel's instructions just twelve songs were recorded, with the title assigned to the album that came out four months later, *Something for Everybody*, reflecting some of its compromised origins. The two songs that Robertson contributed, however, "There's Always Me" and "Starting Today," struck a fresh note, coming as close as you could get to the kind of moody late-night ballad one might expect from Frank Sinatra (if Frank Sinatra were to adopt country chord changes) and offering Elvis a rare opportunity for introspection and serious interpretation. After the session he told Freddy he'd like to meet Don Robertson, a Chicago psychiatrist's son whose country and western compositions consistently reflected a profundity born of determined simplicity, to the first night of

the *Blue Hawaii* soundtrack session, when his new song was scheduled to be recorded.

"I sat in the control room, and he came in during a break and introduced himself (he was standing there in his little captain's hat), and we talked some, and he told me how he got started in the music business. He was very charming, very humble, sweet, an altogether appealing person. That night, before I left he told me that some of the musicians and the Jordanaires were going to be coming up to his house after the session, and would I like to come? While I was there, he played me his version of 'There's Always Me' - it was the first time I heard it, and we listened on headphones because he didn't want the rest of the people in the room necessarily to hear it. I remember, he got almost operatic at the end, just like he did on 'It's Now or Never,' and he said, 'Listen to this ending.' He was very proud of it. And he talked with me about the lyrics, he was very interested in the lyrics. It was almost like he wanted me to know that he understood everything that was going on, everything that was intended in the lyric. I don't think I was overawed by him, but I was totally disarmed. He had this talent for making people feel comfortable, for letting you know that he really liked and respected you. And, you know, he told everyone that night that I was the one that had started Floyd Cramer's 'slip-note' style [the grace-note approach to country and western piano that was sweeping Nashville at the time]. I think he was kind of proud of me on that account."

Back in the studio the session proceeded along admirably professional lines. Joseph Lilley, the music supervisor, was a veteran of numerous Paramount musical productions, including five Bing Crosby pictures, and he was a stickler for an authentic Hawaiian sound, employing various top Los Angeles studio musicians and well-known steel guitarist Alvino Rey. When they finished, Hal Wallis was convinced that he finally had what he had been looking for all along: the soundtrack for a Bing Crosby picture, starring Elvis Presley.

ELVIS AIRPORT ALOHA IS WILD

"Hi, E-L-V-I-S . . . !"

The roaring greeting rolled like thunder across Honolulu International Airport at noon yesterday as 3000 teenage fans (and some not so young) greeted their hero, Elvis (The Man) Presley. Some had been waiting as long as $3\frac{1}{2}$ hours. A moment before at 12:15 P.M. the big Pan American Airways jet touched down. The other passengers got off — and then at 12:27 Elvis appeared at the rear door.

Actor Jimmy Stewart, his wife and four children came in yesterday on the same plane that brought Elvis Presley. But nobody noticed Jimmy.

He was dressed in a black suit and tight-fitting pants, with a ruffled white shirt and dark-patterned tie, broad-shouldered coat and black shoes with sidebuckles.

Screams filled the air. . . .

For 10 minutes the handsome lad with the baby blue eyes passed in review — just like they do in the Army — up and down in front of the crowd with the wire screen and a cordon of Honolulu military police between him and the fans. . . .

Presley and his party didn't venture into the crowd. Looking pale, Elvis paused only twice in his march up and down outside the fence.

Once he stopped to let a little girl give him a lei and he rewarded her with a sweet smile. And once he stopped to tell disc jockey Ron Jacobs of radio station K-POI that he was "happy to be back, and thank you all."

Well, thank you, too, Elvis Presley, for coming here on behalf of the Arizona Memorial Fund.

— Honolulu Sunday Advertiser, March 26, 1961

Veteran country comedian Minnie Pearl, a featured performer on the show, who had once briefly been managed by the Colonel and whose husband, Henry Cannon, had piloted Elvis frequently early in his career, was practically in shock at the reception. Colonel Parker had met them on the plane and told her that he wanted her to stick right by Elvis' side, so that she could be in all the pictures. "I didn't know what staying with Elvis involved. If I had, I wouldn't have [done it]. There is no way to describe the pandemonium. I never saw as many women in my life. They were screaming. They were yelling. I was just horrified. I thought, 'They're going to kill him.' And they would have if they could have gotten loose, I'm afraid. "Well, we [finally] got in the limos — they parked them right up next to the plane — and we got to the hotel, the Hawaiian Village. There's sort of a lanai overhang at the hotel, and when we got there, there were five hundred screaming women and no fence like they had at the airport. So it was very dangerous. Elvis and I got out of the limo — I never will forget, the police had this cordon of arms together holding the crowd back, but the crowd burst through, these women, screaming women, all ages, they burst through the police and started grabbing at Elvis, and, of course, that scared Tom Parker to death. We finally escaped and got inside the hotel, and I said to Elvis, 'How do you stand it?' And he said, 'I just got used to it.' And I said, 'You know, those women could kill you.' And he said, 'They're not going to hurt me.'"

The press conference was scheduled for 3:30 that afternoon, and the Colonel not surprisingly was everywhere. The press was represented, of course, by the two dailies, the Advertiser and the Star-Bulletin, but also by nearly one hundred student reporters from all twenty-seven Oahu high schools and middle schools. Elvis was laden down with leis and honors (one girl would not let go of him until the Colonel firmly disengaged him from her grasp) and politely answered all the usual questions about movies, touring, girlfriends, and karate. What about his army status? he was asked. "I'm in the stand-by reserve. They could call me up in an emergency." But not until after the show, the Colonel hastened to add. Did he have any plans to travel? "I might go to South Africa to catch wild buffalo," he said, as if in competition for laughs. But if he was, it was a competition he could not win. "Elvis answered questions with a matter-of-fact mumble," the Sunday Advertiser concluded its account. "Colonel Tom Parker, his manager, supplied the punch lines that brought laughter and applause from the students."

The show that night was another story. Even with the very poorest home recorder-quality sound, you have only to listen to the tape of the performance that has survived to sense the energy that was coming off the stage, to get a whiff of the ferocity of feeling that the music unleashed. There is certainly the same irony that *Press-Scimitar* reporter Bill Burk had remarked upon in his account of the Memphis show, the same playful toying with the audience, but there is something else besides: there is a sheer joyousness, a guttural exuberance of expression that refuses to be denied. By now the band had been playing together off and on for just over four weeks, and Elvis eggs them on with an enthusiasm not just for what they

JANUARY 1961–JANUARY 1962 👁 103

are able to do but for what they are able to permit *him* to do. Again and again he urges guitarist Hank Garland to solo, indicating his appreciation with grunts and exclamations that have nothing to do with the audience. The music crests and surges with an impulse all its own, and Elvis calls for Hank to solo again, he *demands* another sax solo from Boots, he forgets the words, even loses the structure of the song, but embraces the moment with pure, uninhibited feeling. To Boots it was "one of the highlights" of his life, and to Jordanaire Gordon Stoker, who had worked with Elvis steadily since 1956, there was a spontaneity to his performance that most closely resembled a man being let out of jail.

Listening to the recording, though, raises a question: you wonder why this quality couldn't have translated for Elvis into film. It was certainly present when he made *King Creole;* you even sense it in the tentative, wildly erratic groping for emotion that is his performance in *Love Me Tender* — in this first attempt at acting, in the absence of either knowledge or experience, there is a self-contained assurance that allows him effectively to bypass technique, even as you are aware of his technical limitations. He seemed, then, to have confidence in himself and in his mission. Now, as many people were coming to observe, he mouthed that confidence in any number of public situations, but it did not appear to be truly present.

It was not there, certainly, for the shooting of Blue Hawaii. The picture was intended to be a bright, fast-paced musical comedy, with a formulaic Hollywood approach. It had a good supporting cast portraying the usual stock characters, including thirty-five-year-old Angela Lansbury as Elvis' birdbrained southern mother. Elvis himself played Chad Gates, a rich boy who wants to throw aside his privileged status and embrace Island culture. There is the usual tri- or quad-angle romance, with an older woman, a younger true love (Joan Blackman playing Maile Duval, half Islander but, perhaps in a bid to mitigate any suggestion of miscegenation, also half French), and a much younger woman/misunderstood brat. Journeyman director Norman Taurog, a big hit with Elvis and the guys for his relaxed tolerance of their hijinks on G.I. Blues, was once again in charge, and Elvis has clearly loosened up enough to try some conventional bits of comedy at Taurog's instigation - there are playful double takes, lots of brisk and energetic business, and even some genial self-mockery to go with the spectacular Hawaiian sights and sounds and "production values" that are the hallmark of any Hal Wallis picture.

It is in nearly every way a direct answer to the two previous movies at

Fox, which Wallis detested and which for all of their serious aspirations had clearly not achieved what they set out to do. With Blue Hawaii there is little question that Wallis and the Colonel's intentions are fully realized, and if Elvis were merely to be considered as an agreeable presence on the screen, an innocuous addition to the scenery, the picture would have to be judged a success. He moves easily from scene to scene, delivers all fourteen songs with charm and panache (even the worst of them is beautifully sung), and for the most part gives the appearance of having a good time. And yet, underneath, one can sense the confusion and the fear — many of the lines once again are garbled or delivered with indifferent intensity, as if they were an embarrassment to get through; the familiar movements that Elvis has always claimed are natural to his music are appended to silly songs, as if they were a joke - one feels for him, one squirms with an embarrassment of one's own as he is asked to stand still for the trivialization of his music, as he is forced to publicly repudiate his commitment to rock 'n' roll.

The confusion expressed itself off the set in more hijinks, more conquests, more seeming need to declare out loud just who he was and who he was not. He was constantly surrounded by girls, and he and the guys partied every night to such an extent that eventually Hal Wallis had to move the female cast to another wing of the hotel, placing them on a ten o'clock curfew. Wallis had little use for the guys, but the Colonel needled him that he was just getting old, didn't he remember what it was to be young himself? On several occasions Elvis got together with Patti Page, who was married to Charlie O'Curran, Wallis' longtime choreographer of musical numbers (O'Curran went back to the first Paramount picture with Elvis, *Loving You*, and had worked most recently on *G.I. Blues*), and they harmonized on country songs far into the night.

The Colonel remained in imperturbable good humor. It seemed as if Hawaii had brought out all of his impishness, and he interviewed tourists, using the aluminum tube from his cigar as a microphone and identifying himself as a representative of Radio Pineapple; hypnotized the boys for Hal Wallis' amusement; and halted shooting one day by walking in front of the cameras and demanding a conference with Wallis. Wallis, who thought something really was wrong at first, anxiously inquired as to what the problem was. "Read the contract, read the contract," the Colonel angrily replied, although by now even Wallis was beginning to catch on. "You know, if Elvis provides his own clothes, he gets ten thousand dollars more." Wallis surveyed the scene, in which Elvis was wearing nothing but a bathing suit and riding a surfboard, and arched his eyebrows. "He's wearing his own watch," declared the Colonel without batting an eye. And the scene did not proceed until he took off the watch.

Just before they were scheduled to leave, Elvis and the guys were having dinner in the hotel dining room in Kuaui. Sonny got drunk at the bar, and when he saw a man and woman standing on the bridge that faced the dining room singing "Hawaiian Wedding Song," he was so overcome with good feeling that he joined them, unaware that they were part of the hotel floor show. Elvis and the guys got a big laugh out of that, but from then on Elvis gave Sonny the cold shoulder, "and he [was] telling all the crew what I had done as if it was a big crime. . . . I started to think he was a pretty phony bastard."

Instead of dissipating, the ill feeling only intensified once they got back to the mainland. Elvis was still seeing Tuesday Weld occasionally at this point, and one night she brought a girlfriend over to the house, whom Sonny started to promote for himself. "We had all been drinking a bit, so had Elvis. Tuesday and Elvis are on the couch, and I am talking to this girl. Elvis leans over and kisses her and says, 'You're really cute.' Well, I knew that was the end of me trying to score with this chick, because whatever Elvis wants in the way of women, he gets. . . . He has Tuesday there, and he wants this girl, too. Later on, he comes over and really plants a kiss on her." Sonny chose this as a good strategic moment to withdraw, and he and Gene began a private dialogue in whispered tones about which girl they'd rather have if both were available, with the vote pretty much going to Tuesday. Elvis for some reason assumed they were talking about him and demanded to know what Sonny had said, while Sonny for his part declined to reveal the true subject of their conversation until Elvis picked up a Coke bottle and said, "Tell me or I'll break your goddamn head open with this bottle." Sonny just stared at him. Elvis wasn't going to hit him, he said. And besides, he quit. He couldn't quit, Elvis declared. He was fired. "Then he drew back and punched me in the face. I didn't move. I didn't even feel the blow, but I could feel the tears of emotion coming out of my eyes, and I said quietly, 'I didn't think you could do that to me.'" Elvis gave him \$200 before he left and got him into the screen extras guild two weeks later, but he didn't apologize.

To Hal Kanter, the writer-director of *Loving You*, and the principal script writer on *Blue Hawaii*, it was a very different Elvis Presley on this picture

106 \infty THE COLONEL'S SECRET

than on the 1957 Hal Wallis production, and the difference could not just be explained away by age. To Anne Fulchino, the young RCA publicity director who had helped Elvis draw up a long-range plan for success when he first joined the label, the contrast was even more striking. Recently transferred to Los Angeles, she was brought to the set by Tom Diskin. "It was a while before he came over and talked to us, and when he did — you see, at the beginning I used to call him Chief, and I said, 'Hi, Chief,' and he just looked at me like he wished I hadn't come. We made some small talk, and then he said something like, 'This isn't what we had in mind at Klube's [the German restaurant across from RCA, where they had drawn up their plan], was it?' I said to myself, 'If I was making these crappy pictures, I wouldn't want to see anybody from my past either.' That's the reason I didn't hang around. Tom said, 'We can stay all day,' and I said, 'No, why don't we just take off?' He was obviously uncomfortable with what he was doing, he was frustrated and disgusted - it was all in his face. The emotion that I respected most was that he was ashamed of it, which meant that he knew better — but you could see that he was trapped. It was kind of like when your own child goes wrong, and you can't help feeling it — and I did."

Anita came out to see him while they were still filming, and she and Elvis gave the guys a dose of their own medicine, when they pulled off one of those tricks that Elvis and the guys generally liked to play on outsiders. They were all riding in the Cadillac limousine when Elvis decided to play dead, and she went along with him, crying out, "Elvis isn't breathing! He isn't breathing!" By the time that they pulled up in front of the house on Perugia, the guys were in a state of panic, and Lamar ran into the house yelling for someone to call an ambulance, but Elvis sat up at this point and confessed, "I just wanted to see what you guys would do."

Not everything went as smoothly. Patti Parry, an eighteen-year-old hairdresser who had met Elvis on Sunset Boulevard the previous October and had been hanging around in the role of everybody's little sister ever since, let her guard down one time when Anita asked nonchalantly, "Who's he been dating lately?" "Just Sandy Ferra," Patti responded innocently, and Anita was off, until Elvis calmed her down and convinced her that Patti was just a goofy kid who didn't know what was going on.

With Patti, though, he really blew his top. If she wanted to hang out with them, he told her, the first, last, and only rule that she had to remember was *deny everything*. What went on in the confines of his home, *anything* that she observed at any time, was privileged information, not to be shared

with anyone from the outside world, no matter how knowledgeable they might appear. Patti got the message: it was her choice to make, but if she wanted to continue to be part of things, she had to be loyal to him exclusively. Which she accepted, so she remained a member of the family.

That wasn't the only source of friction with Anita. Once again she came across evidence that he was staying in touch with that girl in Germany; there were more letters from her, more indications that she was still trying to get Elvis to bring her over to this country. He continued to deny it, he insisted that this was just a lovesick teenager's fantasy, he asked Anita to give him a little more credit, but he also pleaded with her not to say anything to anybody, and they made up for the time being. So she went back to Memphis, where she kept Grandma company at Graceland and waited for the record she had recorded the previous Christmas for Sun Records to come out. It was called "I'll Wait Forever," with a flip side that declared "I Can't Show How I Feel."

I have never seen Bob Hope as intrigued with anyone as he was with Col. Tom Parker at the MGM party honoring Bob and Lana Turner. The Colonel stood at the back door handing out pictures of Elvis Presley and on the back it said, "Elvis is now in 'Blue Hawaii,' a Hal Wallis picture." Mind you — a Paramount picture at an MGM party.

Bob wants to do a picture based on the life of the Colonel, who admits he's the greatest con man since Barnum. The Colonel gave Bob a citation on which all of Elvis' pictures made at other studios were mentioned.

Mrs. Parker, who is as quiet as the Colonel is lively, was with him and she seemed to enjoy meeting Bob, Lana and Janis Paige.

Bob wants Elvis to play himself in the life of Col. Parker, but the Colonel says, "No money, no deal."

— Hollywood gossip column item, May 1, 1961

The Colonel seemed without a care in the world. Everything was clicking: "Surrender" ("Torna a Surriento") had succeeded "Are You Lonesome Tonight?" at number one on the charts in March; the *G.I. Blues* soundtrack, out since the previous November, continued to alternate between number one and number two on the LP charts; and they had another movie starting up — for United Artists this time — in July. There had been an almost uninterrupted flow of publicity off the back-to-back charity concerts, and Colonel had recently written to Vice President Lyndon Johnson announcing their availability for other worthy causes in the future. They had raised over \$62,000 for the U.S.S. *Arizona* memorial, he informed the vice president. Now, more than ever, he declared, "we feel it proper to let you know that we are willing, able and available to serve in any way we can our country and our President in any capacity, whether it is to use our talents or help load the trucks."

He had created his own world, which even included his own club, the Snowmen's League, a W. C. Fieldsian celebrity roll without meetings or reality outside the Colonel's sardonic imagination, which cost nothing to get into and \$10,000 to get out of ("We've never lost a member," boasted the Colonel). It was nothing more in short than a celebration of the age-old concept of "snowing," somewhere between selling and conning, to which the Colonel had dedicated his life, its name a take-off on the Showmen's League of circus owners and carnival operators from whom the Colonel had taken his inspiration, its membership booklet a map of the League's method of doing business. The table of contents gave a hint of methodology, with references to the "melt and disappear" technique and the concept of "directional" snowing (which required the ability to make one's approach simultaneous with one's departure) as well as consequences of the snowing life ("with sufficient training one can develop the ability to go nowhere with devastating results") — but the real core of the book was the thirty-two blank pages and Complete Listing of Paid-Up Members in Alphabetical Order (also blank) at its center. Over the years induction into the Snowmen's League had come to be taken as a high honor in Hollywood, and its bemused membership included everyone from Hal Wallis and Joe Hazen to RCA executives, William Morris agents, newspaper columnists, and such prominent show business personalities as Frank Sinatra, Milton Berle, Bing Crosby, and Bob Hope. It was the Colonel's sole concession to social climbing, and, inevitably, one in which he dictated all the rules.

Meanwhile his brother Ad was scheduled to arrive any day now. Much to the Colonel's annoyance, he got a call from *Time* magazine around this time asking what the story was with this guy who claimed to be his brother from Holland; he didn't have a secret stash of wooden shoes, did he? The Colonel harrumphed and spluttered, effectively putting the reporter off, but he was furious at his brother: What was the matter with him, letting everyone know his business? Didn't he realize you could get more with honey than you could with vinegar? When he met him at the airport, he let him know just what he thought of such behavior — but in English, not in Dutch. He had forgotten all his Dutch, he claimed, and as he drove Ad back to his Beverly Hills apartment he laid down the rules of the game: he was to be addressed as Colonel at all times; now that their mother was dead, he was *not* interested in any of their other brothers and sisters; he was no longer the man his brother had once known, he had created not just a new life but a new identity.

The MAN KNOWN as Colonel Thomas A. (for Andrew) Parker had been born Andreas ("Dries") Cornelis van Kuijk in Breda, Holland, on June 26, 1909, to a father who was a liveryman and a mother whose parents were floating peddlers, traversing the Netherlands by its waterways and setting up a booth to sell their wares at local fairs and markets throughout the country. He grew up the fifth in a family of nine children, loving horses and animals generally, so fascinated by the circus, his siblings recalled, that he trained his father's horses to put on one of his own. When the van Bever family circus came to Breda as part of the great October carnival, Dries was captivated, volunteering to do odd jobs just so he could hang around. He taught his pet crow to sit on his shoulders and a goat to climb stairs.

He dropped out of school at thirteen or fourteen, helping out at the stable until his father's death in July 1925. Then the family dispersed, and he became a ward of his uncle in Rotterdam, going to work on the docks until, he said later, he got a job working for the Holland–America line. The next his family heard of him was a letter they got from a Dutch family in New Jersey declaring that Dries was living with them and doing well; he had been reluctant to write himself, but he was such a nice boy and they didn't want his uncle and aunt to worry.

He reappeared in Breda on September 2, 1927, his mother's birthday, remaining in town for a while and going to work on a shipping line between Breda and Rotterdam, before he disappeared again in May of 1929. The family didn't hear from him for a good while after that and never found out what the course of his wanderings had been. But it seemed clear that he had worked his way over to America once again on a freighter and found his way to Atlanta, where he enlisted in the army under the name of Andre van Kuijk, as part of a widespread recruiting drive to find volunteers to serve in Hawaii.

He was stationed at Fort de Russy at first, near Waikiki, then transferred to Fort Shafter, just outside Honolulu, as part of the Sixty-Fourth Regiment, an anti-aircraft unit, of the Coast Artillery. It was at Fort Shafter that he came under the command of Captain Thomas R. Parker, and it was from Fort Shafter that his family first heard from him again with a note that contained virtually no information but that was written in English and signed, inexplicably - Thomas Parker. His mother started getting bank drafts for \$5 apiece shortly thereafter; seventeen of them arrived between January 1930 and February 1932, all originating in Washington, D.C., and going directly into the Frank Laurijssen Bank in Breda with no name of sender attached. He wrote occasionally, sent one or two pictures with no explanation of where he was or what he was doing. ("Never an address," recalled one family member, "only funny pictures. In one Dries was standing next to a big American car, maybe a Buick, and it was taken in Honolulu. In another, Dries was sitting by a swimming pool. We figured that he was a chauffeur for a rich man.") In February 1932 the bank deposits stopped, and there was one final letter to his mother. After that, the family never heard from him again.

What probably happened was that he left the army at this point. He was, evidently, transferred, back to the mainland, to Fort Barrancas in Pensacola, Florida, and sustained a knee injury, which earned him an honorable medical discharge. Somehow at this point he found his way to Tampa, where the carnival folk all wintered, and in 1932 he joined up with the Johnny J. Jones Exposition, signing on with the much bigger Royal American Shows a year or two later. That was where he met his wife, Marie twice married and four years his senior, with a child from her first marriage — working the Hav-a-Tampa cigar stand on the grounds of the South Florida State Fair. He seems to have quit the carnival not long after meeting Marie and settled down in Tampa, where he became well known as the city's resourceful chief Dog Officer and where he, quite naturally, gravitated into show business, doing promotions first for Gene Austin and Roy Acuff and gradually expanding his show-business activities until, in 1944, he hooked up with Eddy Arnold and, with Arnold as his client, moved to Nashville at the end of the following year.

* * *

WHY HADN'T HE WRITTEN OVER all the years? Ad asked. Because, the Colonel said without blinking an eye, he and his wife had been destitute for much of that time. "Sometimes we had to live on a dollar a week. We slept in horse stables behind the horses. I did all kinds of things then. I went to the Indian territory, where I pretended to be a big wise white man. It so happened that sometimes I really predicted the future. I also had a canary and a few sparrows that I sprayed yellow and then sold. After a couple of weeks the people came back to me and said, 'This bird only says, "Peep!"" 'That's right,' I told them. 'It takes six weeks. It's got to feel at home.' I've been a dogcatcher, and I sold hot dogs. But I didn't want you to know all the things that I did. Besides, most of the time I didn't even have the money for stationery and a stamp. After that, the war came. I organized parties for the army, and that's how I got into the world of show business. At the end of the war I met a guy from Tilburg who served in the Princess Irene Brigade. He told me that Mother had died. She was in fact my only true tie with Holland, and when she was dead Holland was dead for me."

His brother accepted the account in the spirit in which it was offered, informing Dries that their mother had not actually died until 1958 but getting no visible reaction. He stayed in the storeroom of the Colonel's modest apartment, where he slept surrounded by stuffed animals, promotional items, and Elvis Presley merchandise. He was unable to penetrate his brother's elaborate web of fanciful inventions and was alternately intimidated by the manner in which Dries would bark orders into the phone and, as an entrepreneur of sorts himself, bemused by his brother's sheer audacity. Twenty-five percent of everything Presley made disappeared into the pockets of "the old Colonel," his brother boasted. "It fills 'em up nicely," Parker added, echoing an old Dutch saying.

Ad's visit lasted for seventeen days. In the course of his stay he met a number of the Colonel's friends and associates, including his wife's brother, Bitsy Mott, and he and Dries even went out to Elvis' home in Bel Air, where the Colonel simply introduced Ad as "my brother." When he returned to Holland, he had very little of a personal nature to convey to the rest of the family, and his other brothers and sisters suspected that Ad might have made his own deal with their wily "American" brother. His story ran in *Rosita* on July 1, 8, and 15, 1961, but no U.S. newspaper picked it up. The family made attempts to get in touch with the Colonel from time to time in subsequent years, but the only acknowledgment they ever got

month in Weeki Wachee Spring. Over three thousand solid citizens showed up, including the hastily convened Elvis Presley Underwater Fan Club, which put on a show in a large tank while Elvis and the guys, attired identically in cool dark continental suits, appreciatively looked on. Elvis attended with his co-star Annie Helm, as well as his father and stepmother (who had come down with the kids for a visit), while the Colonel orchestrated the bizarrely paranormal proceedings. This was the Colonel's old stomping grounds, and he demonstratively renewed acquaintanceships, as old friends from dogcatcher and carnival days constantly stopped by to wish him well throughout his Florida stay. At one point he even visited an elephant from the Royal American Shows, too old for the carnival now, whom the Colonel fed and clowned around with and encouraged to remember him.

Elvis enjoyed having his new boat on the river, went waterskiing frequently, and gave a good comic performance as idiot savant (and instinctive moral arbiter) Toby Kwimper. There was a decent screenplay for once, a good supporting cast, and the usual friction among the guys, as Joe got fired briefly for conspiring with the Colonel to get rid of a recent addition, Ray Sitton, known as "Chief," whom no one much liked to begin with but who, after Joe's reinstatement, became an accepted member of the group. The director, Gordon Douglas, invited Elvis to dinner one night, throwing him into a fit of consternation until the Colonel suggested that he bring all of the guys with him, explaining to Douglas afterward that Elvis was not comfortable except within his own circle.

Annie Helm, who was playing the ingenue role, observed it all with wide-eyed wonder. She was twenty-two years old, a seven-year veteran of television, modeling, and ballet, who had made one previous movie, but this was her big break. "I was not really a fan of Elvis' — I was so caught up in my own career I was almost like an old lady in my view of him — but I loved the part. I met him on location. He came over to my cabin on the day that I arrived and brought me a flower. He may have just picked the flower on the way over to the cabin, who knows? But we went for a drive and turned the radio on — and he was on the radio. It was a very bizarre date. I mean, I felt like I was in a small town with the poodle skirt and sneakers, like a little kid going out for a milkshake with my date. But we hit it off right away. He was so much fun, and there really was nothing to do down there except play cards at night and go out on the boat — I mean, we were all very bored."

They quickly drifted into a romance that seemed to her strangely impersonal in a way. "He loved to hang out with the guys. They made his word good. No one questioned what Elvis wanted. It wasn't that his demands were out of line — he just didn't want to put up with any nonsense. He had a lot of patience, he was always very polite, but he wanted things a certain way. It wasn't my idea of a fun date after a while. It was just me and the guys. That's sort of a strange way to spend your evenings with a person you care about.

"I always had fun with the Colonel. He liked to joke around, and that's the kind of relationship that I saw between Elvis and the Colonel. I think Elvis really cared about the Colonel. I remember the difference between Elvis' relationship with the Colonel and with his father. It was sort of like there was more of a reserve with his father. He was very polite, but I was shocked when I [first] found out that this was Elvis' father.

"When we were on location, we all took Dexedrine. I mean, in those days it wasn't considered drugs, I had doctors giving me Dexedrine diet pills from the time I was fourteen, because they wanted me to be emaciated as a model. You know, we used to stay up late at night, playing cards and goofing off until one in the morning, and then we'd have to be up early, so if I wanted a Valium to go to sleep, it was there, and then there was speed to keep us going during the day. I really was amazed at his talent — I used to tell him that. I don't remember him talking [much] about his feelings, but he did share with me that he was offered a part in *The Fugitive Kind* that was based on Tennessee Williams' play, with Elia Kazan directing. It was a wonderful movie, I mean, it was almost written for Elvis. He didn't say he had regrets, but my feeling was that he did.

"It was just never quite comfortable for me — I mean, it's abnormal to have a relationship with seven or eight guys. Naturally, they disappeared when we had romance, but then they came back again. In those days we were very promiscuous, and of course [I knew] he was having a lot of affairs, but we really adored one another, I mean, I really loved him. I just sensed that his life was very compartmentalized."

THEY SHOT THE INTERIORS in Hollywood. Elvis and Annie continued to go out for a while, but she knew instinctively that it was all over. Much of September was spent in Las Vegas, holed up at the Sahara, the casino owned by the Colonel's friend Milton Prell. Every night they went to the shows, Elvis and his guys, dressed identically in their dark glasses and dark mohair suits. The Colonel joked that they looked like a bunch of old men, but the Memphis Mafia had become almost as well known around town as Frank Sinatra's Rat Pack. They were living on speed and tranqs; for Joe, who liked to portray himself to Elvis as Broadway Joe, a sophisticated man-about-town, "it was a party like you wouldn't believe. Go to a different show every night, then pick up a bunch of women afterwards, go party the next night. Go to the lounges, see Fats Domino, Della Reese, Jackie Wilson, the Four Aces, the Dominoes — all the old acts. We'd stay there and never sleep, we were *all* taking pills just so we could keep up with each other."

The next picture started at the end of October after a brief return to Memphis and a four-tune Nashville session on October 15. Kid Galahad, the second in the two-picture deal with Mirisch, turned out to be a very different experience from the one he had in Follow That Dream. Once again he was playing a kind of idiot savant - an instinctively gallant boxer this time — but without the comic touch, or script, of the previous film. He was unhappy with his appearance (his weight had ballooned to nearly two hundred pounds), unmotivated about the film, and he felt generally putupon — just about the only consolation was taking boxing lessons from former world welterweight champion Mushy Callahan, who treated him with deference and for whom Elvis felt great respect. He was stung, on the other hand, by the indifference of Charles Bronson, who played the part of his tough but kindly trainer. Bronson, one of fifteen children of a Lithuanianborn coal miner and a combat veteran of World War II, made it very clear that he was unimpressed by Elvis' karate exhibitions. Elvis for his part indicated to Red, and to Sonny, too, now back from exile with no apparent hard feelings on either side, that he had no use for Bronson, whom he uncharacteristically dismissed as "a muscle-bound ape."

After three weeks of location work, they moved into a new house on Bellagio, just around the corner from Perugia. It was a Mediterranean villa with more room for the guys, and Elvis brought the husband-and-wife butler-and-cook team with them from Perugia. There were the usual family squabbles: Joe and Chief still didn't get along; Elvis took a liking to Sonny's girl with predictable results; a new guy, Marty Lacker, a friend of George Klein's who had come out with them for the first time, seemed to conceive of himself as Joe's assistant and rubbed everyone, including Joe, the wrong way; Elvis was always encouraging Lamar to spout off on subjects he knew nothing about, just setting him up for the kill; and Gene was feeling more and more left out.

About the biggest excitement was a chimpanzee named Scatter, whom Elvis had bought in October from a Memphis TV personality named Captain Bill Killebrew. Scatter was only the latest in a long line of simians that went back to Jayhew, a spider monkey who lived in a cage on the glassed-in porch on Audubon Drive in 1956. Killebrew had taught Scatter how to "drive" (Killebrew sat behind him with a setup that enabled him to steer, accelerate, and brake from the backseat), and Alan got him a chauffeur's cap and drove around in the Rolls with Scatter sitting on his lap, ready to duck below the dashboard whenever he saw anyone that might be impressed by the sight of a monkey at the wheel. Scatter introduced an unpredictable element into their lives: shortly after his purchase in Memphis, he bit Vernon's wife, Dee; he wrecked a hotel room in Flagstaff on the way out; best of all, he loved to look up girls' dresses, and he was an exhibitionist in the manner of all chimpanzees. The guys taught him to drink, too, and there was no end of Scatter stories, from his tearing out of all the phone lines in the house to his having simulated sex with a former stripper named Brandy to various hair-raising (and skirt-raising) escapades with nearly every other girl who came to visit. When there was nothing else to talk about, there was always Scatter.

 $E_{\rm vis}$ finished up the movie on December 19, which would have given them more than enough time to get home for Christmas — but what was the point? Vernon and Dee were still living at the house, though they had just purchased a three-bedroom, split-level ranch around the corner — but even if they had been able to move before the holiday, there was still no real reason to go home. The original plan, promoted by the Colonel, had been to go to Vegas for a few days of R and R. Billy and Marty returned to Memphis to see their families, and some of the other guys took off for varying lengths of time. But then Joe started dating Joanie Roberts, a twenty-year-old dancer at the Sands, and soon everyone else seemed to have found more than enough diversions of their own. Elvis flew in Bonnie Bunkley, his "other" Memphis girlfriend, for a few days, and he and Bonnie and Joe and Joanie frequently double-dated in the Rolls, with one of the guys driving and the rest tagging along. To Joan, who had come out to Vegas after completing her reign as Miss Missouri the previous summer but was as notable for her perky good humor as for her blond good looks, "Elvis was so wonderful and warm he was always more than polite. I can remember him yelling at the guys if any of them started to call somebody by their first name, 'I call him Mister, so you better call him Mister, too.' I don't know, I really accepted it all as normal. It was exciting to walk in and have everybody turn — he had so much mystique about him. You would walk into all the shows and get the first-class treatment: 'Come right here to the front row.' Everything was yours. Anything you wanted. All of that was exciting."

To Joe it was not quite so wholesome a vision. His own view of Elvis was an increasingly conflicted one, colored by his view of himself as a person with more street smarts and greater sophistication. "Elvis was very insecure. He knew nothing about the street. All he knew about was what he read in books." And his insecurity, Joe felt, led to weakness, fear of confrontation, an inability to assume responsibility, and a need to surround himself with potential scapegoats, whose number, Joe recognized, would always necessarily include Joe himself.

On New Year's Day they ran into the songwriter Don Robertson, in town to get married and also staying at the Sahara. "Elvis had met my wife, Irene, before, she had gone with me up to the house and he liked her a lot. Anyway, we sat in the coffee shop at the Sahara, Irene and me and Elvis and Joe or Lamar, just the four of us, and we got on the subject of weight. I had always had a struggle with my weight, and Elvis had, too — and Lamar was this wide. And Elvis said, 'I've got something for you. I've been taking some pills, and they just work great.' So after we parted company, one of his guys came down to where I was in the lobby and said, 'Elvis asked me to give this to you.' It was a big bottle of one thousand Dexedrine pills, and I started on them right away." Later Robertson spotted Colonel at the roulette wheel, losing what looked like thousands of dollars, "and we ended up sitting and talking very briefly. He said, 'You've been pretty lucky with Elvis, haven't you?' That was all he said, but the implication was that there was no talent involved on my part. I was just lucky."

Days stretched into weeks, weeks into a month and more. People came and went, Elvis celebrated his birthday on January 8 with a big cake supplied by the Colonel's friend Milton Prell — it seemed sometimes as if there was something almost holding him there. Three times they set out to leave, and three times they were forced to turn back on icy, snow-packed roads. He

JANUARY 1961–JANUARY 1962 👁 119

loved Las Vegas for one reason above all: time was meaningless here, there was no clock, there were no obligations. It was a place where you could lose yourself, a place you could indulge your every fantasy — it was, for Elvis, momentary respite from all the self-doubt, from all the questions lying in wait, lurking in the shadows, waiting to assault him.

PRISCILLA, WITH HONEY, 1963. (MICHAEL OCHS ARCHIVES)

NEGLECTED DREAMS

HEY FINALLY PICKED UP CAMP and returned to Memphis at the end of January. Vernon and Dee had by now completed their move, taking up quarters in their new house on Hermitage, just behind Graceland, and life soon returned to the normal round of moviegoing and other recreational activities. There was another session in Nashville, on March 18 and 19, at which Elvis cut ten new sides. With five tracks still in the can from the previous session plus one unused number from Blue Hawaii, this constituted precisely half of the 1962 contractual commitment to RCA, and there was little doubt that the rest would be taken care of by soundtrack recordings. Elvis threw himself into a number of Doc Pomus and Mort Shuman songs, including "Suspicion," the latest in a growing line of Italianate offerings. There was one particularly moving ballad in the Don Robertson tradition ("She's Not You," written by Pomus in collaboration with Jerry Leiber and Mike Stoller), but once again the most arresting element of the session was a song that Elvis brought to it himself, which he only got around to at the end of the first long night of recording.

"You'll Be Gone" was a number that he and Red had been working on, writing and rewriting it in informal jams for over a year now. Originally they had set it to the tune of Cole Porter's "Begin the Beguine," but then Porter's publishing company refused them permission to alter his composition in any way and Charlie Hodge suggested a basic, two-chord "Spanish" melody, to which they continued to add new lyrics. In the end the song that they came up with was musically melodramatic and narratively murky, a tale of dark passions and dawn partings (because of the murkiness, it's hard to be any more specific: whether the singer was abandoning or being abandoned by his lover remains, for me anyway, a moot point), but it was one into which Elvis poured all of his emotions, climaxing in an all-out musical crescendo that all but overwhelmed the song.

It might well have offered a lesson. Had there been anyone to analyze

the nonsoundtrack sessions of the last two years, they would certainly have noticed that new directions were being explored, that Elvis appeared tentatively to be trying to forge a new artistic identity composed of equal parts bravado (the aria-like quality of many of his most ambitious songs) and vulnerability (the utterly naked, painfully wounded fragility of some of the Don Robertson and Doc Pomus ballads). His very willingness to put his name on two of the songs, to claim actual authorship for the first time since 1956 (and not for business reasons this time), might have seemed to an outside observer evidence of a barely cloaked desire to reveal himself. But there was no such person. The Colonel increasingly saw these nonsoundtrack sessions as a waste of time, a diversion from their principal business of making movies. Steve Sholes and Bill Bullock, far from influencing anything going on in the sessions, were, by the Colonel's machinations, occupied almost exclusively just with getting Elvis into the studio. Freddy Bienstock was no more than a gatekeeper at this point, charged with shepherding properly credentialed songs in and out of the sessions. And the guys, with the notable exception of Red and Charlie, who were themselves actively involved in the music, and Lamar, who remained Elvis' biggest fan, just wanted to get the session over with and get back to Graceland.

Sometimes the studio players sensed what they took to be almost a soul weariness on Elvis' part, an acceptance of things as they were which, while it never compromised his professionalism, led to a numbing sense of defeat. In the view of Jordanaire Gordon Stoker, "he always tried to make the best out of any situation. Sometimes he'd walk over to us [at the sound-track sessions] and say, 'Man, what do we do with a piece of shit like this?' Sometimes he'd back up so far from the microphone that they would say, 'Elvis, you've just got to get closer to the mike'; they'd put a soundboard around him just to try to pick him up. But most of the time he would console himself with the idea of, 'Well, regardless of what I say, [they're] going to demand that I do this song, so I'll just do the best I can.'"

They returned to California right after the session for the new Paramount picture. There was no doubt in Hal Wallis' mind what image of Elvis *he* intended to convey. He would give the public what it wanted, Elvis the entertainer over Elvis the actor — a course that in his mind was only reinforced by the relative failures of Twentieth Century Fox's *Flaming Star* and *Wild in the Country*. His own *Blue Hawaii*, by way of contrast, had gone straight to number two on *Variety*'s weekly list of top-grossing films upon its Thanksgiving release and continued to do business well into the new year (it ended up as the fourteenth-highest-grossing film of 1962, doing a total of \$4.7 million worth of business for the two years). Meanwhile the album from *Blue Hawaii*, like *G.I. Blues* before it, shot to number one on the LP charts, far outstripping any studio album Elvis had released to date (with sales of over one and one-half million, it sold close to five times the number of *Elvis Is Back*, for example) and further confirming the wisdom not just of Hal Wallis' strategy but of the Colonel's grander plan.

To the Colonel the movies were just one more plum in the pudding, a promotional tool which could sell the music and which the music in turn could sell. Nothing could be simpler or more logical: the soundtrack album promoted the movie release, the movie release guaranteed a certain level of sales and publicity for the album. And as the Colonel perfected his own brand of synergistic opportunity (there were balloons, calendars, radio ads, photo opportunities, and a deluge of press releases to go with each sales campaign, every aspect of which the Colonel personally oversaw), it began to become apparent that there was no real need for anything but the soundtrack music. Why record separate singles and albums when the movie material sold better, was more easily controlled (there was no reason ever to go outside the Hill and Range catalogue; every song originated with Elvis Presley and Gladys Music and came complete with all the financial concessions that were a sticking point for so many outside songwriters), and could serve to fulfill all their commitments to RCA? It was a perfect setup in almost every way, and with the clause giving RCA nominal control over song selection long since deleted from the contract, and royalties and guarantees substantially improved as of the beginning of 1962 (Elvis and the Colonel were now to realize \$200,000, split 75 percent-25 percent between them, as an annual advance payment against royalties through 1966), there was little to spoil the Colonel's overall sense of well-being, save for the one thought never far from his mind, that even a good position could be improved.

FOR *Girls! Girls! Girls!*, Hal Wallis took the company to Hawaii once again for beautiful vistas, beautiful sunsets, and, needless to say, beautiful girls. It was a highly forgettable production, a decided step back artistically not just from the two United Artists films that immediately preceded it but even from *Blue Hawaii*. Norman Taurog was directing once again, and there were lots of familiar faces among the crew, but even the soundtrack

seemed somewhat of an afterthought, with only Otis Blackwell's "Return to Sender" rising above a level of dreary mediocrity.

They returned from Hawaii at the end of April and finished principal shooting on the Paramount lot on June 8. There were lots of parties and, *always*, lots of girls, but to Sandy Ferra, about to graduate from Hollywood Professional School at the age of sixteen, there remained a kind of innocence at the core. Even though she knew she was far from the only girl in his life, she didn't date anyone but him. Sometimes when they talked about the future, he told her that she was the kind of girl that he would like to marry, if and when the time came to get married. He remained very tender and protective of her, he never ever pressured her, but he could be jealous, too. When she went with a classmate to her senior prom, he became very upset, "so I had my mom come pick me up at the Beverly Hills Hotel, and she drove me up to the house, and then he drove me home."

Sometimes, she knew, his temper could flare up, and you just had to stay out of his way. Everyone talked about the girl that Sonny brought out to the house one time who decided that she wanted to leave while Elvis and Sonny were playing pool. She asked Sonny if he could move his car because she was blocked in, and Elvis got annoyed and told her to get somebody else to move the car, didn't she see they were in the middle of a damn game? The girl didn't know anybody else and, failing to recognize the familiar signs, asked Sonny again. "Goddamnit!" Elvis exploded. "Didn't you hear what I said? Get someone else to move it." The girl, embarrassed now and mad, cursed Elvis and called him a sonofabitch. That was when Elvis hurled his pool cue at her, striking her in the breast. It was probably because she had called him a sonofabitch, they all theorized afterward --you couldn't say that to Elvis, he took it as a slur on his mother. But how could Sonny's girl, how could any outsider have known that? It was just lucky she wasn't more badly hurt; it was fortunate, the guys all agreed when they discussed it among themselves, she didn't sue.

He was curiously inept in certain basic social ways. "He was so retarded," remarked one of the girls, who came up to the house regularly dressed in "my nice little tweed skirt, with my white blouse, black bolero jacket, stockings and heels — you didn't just go up in your blue jeans and T-shirt. All the girls dressed the same. The guys were more aggressive; they scored because a girl always had the idea that eventually she would get to Elvis [through one of them]. Elvis himself had nothing to say; if Scatter hadn't been there, we probably would have sat there all night looking at each other. The chimp became the focus of attention, all the conversation was centered on the activities of the chimp — it was like a buffer.

"One time Elvis took a friend of mine out of the room and made out on a couch upstairs — it was like heavy teen petting, and he got totally aroused, and all of a sudden he came all over his pants. He got embarrassed and said, 'Oh, look at all the babies we killed.' I'll never forget that statement. If he got involved [with some girl] on a casual basis and she put out really quickly and went to bed with him, I really don't think he'd see her again. Because that meant she was a bad girl. I don't know any of my friends who [had sex] with him. A lot of them made out with him, but they didn't go to bed with him, and one, who was just the ultimate good girl — I mean, she came from a Catholic family on the East Coast and was one of the few virgins in town — spent the night with him all the time but remained totally unsullied, because he just really respected her."

Few of the girls knew about the two-way mirror he had installed in the swimming pool cabana that served as a ladies' dressing room. Sonny had originally gotten a smaller version for the house on Perugia, where they had used it in the den for shows put on by the guys and their unsuspecting dates. The only way to gain access to the new one was by crawling under the house, but Elvis and the guys just took that as part of the game.

On Sunday afternoons all the girls came over to watch them play football at the little park on Beverly Glen, just off Sunset, five minutes from the house. They would play half a dozen games in a row, two or three touchdowns declared the winner, and Elvis' team always won. They played against teams made up of other young actors and singers, like Pat Boone, Jan and Dean, Ty Hardin, Bob Conrad, Ricky Nelson, and Bing Crosby's son Gary, while Elvis' team included Red and Sonny and the rest of the guys, plus ringers like Max Baer, Jr., the giant star of *The Beverly Hillbillies*, whose father had been heavyweight champ. Elvis always played quarterback, throwing himself into the fray with genuine abandon but taking the game utterly seriously, too, diagramming elaborate plays for his team, following developments in the National Football League religiously, and deeming the sport "a gift of the gods."

He was almost as excited about his new Dodge motor home, taking frequent trips out to George Barris' Kustom Automotive Products in North Hollywood, where he was having it tailored to his specifications. Barris, the thirty-seven-year-old "King of the Kustomizers" and car designer to the stars, had already fixed up his black 1960 Cadillac limousine with two telephones, an entertainment console, a refreshment bar, and a little electric shoe buffer, all gold-plated with a golden guitar insignia, while the car itself was painted in a white-gold Murano pearl with gold-plated trim and Elvis' name written in gold. He and Barris frequently conferred on the motor home, seeking some of the same "luxury yacht" feeling for a vehicle that Barris personally considered a piece of shit. "He'd be very much involved. He liked to make a selection of materials. He liked to see sketches. He was not some guy who would write up a ticket and then say, 'No, no, not that way.' He was excited every time he got something new, and he never was pushy to put himself on a different level from everybody else." He eagerly pointed out all the little conveniences and innovations (what Barris called the "toys") to the guys, oblivious of how many times he might have shown them off before. He kept checking about when the motor home would be ready - and then he practically floored Barris when he asked if he and Mrs. Barris might be willing to do Elvis a special favor and put up a houseguest for a few days: his girl was coming over from Germany for a visit.

I was something he had been planning for quite some time now. He had started talking to Priscilla about it in March, two years after they had last seen each other and months since their most recent telephone conversation. Priscilla had continued to write nearly every day; she continued to voice her hope that her parents would allow her to visit and that they would be reunited someday, but she had just about given up the thought of ever hearing from him again when he called and said that he wanted to make arrangements for her to come to L.A.

Her parents were, naturally, somewhat apprehensive about the prospect, and her dad set all kinds of conditions once he was even willing to discuss it. She had to finish her school year, he said, he wanted a complete itinerary, and he wanted to know where she was going to be staying and who would be chaperoning her (it would, of course, be out of the question for her to stay with Elvis). And she would need a first-class round-trip ticket.

She was sure that Elvis would be insulted and tell her to forget about the whole thing, she was furious at her parents and sulked in her bedroom for days — but Elvis only seemed to see each of the requirements as a challenge to get by, and one by one, in a series of phone calls and negotiations, he overcame each of the objections, until, in the end, a day was set. It all had to be carried out with the precision and hush-hush secrecy of a military operation, and maybe that was one of the things that appealed to him most. Not only was there Captain Beaulieu to mollify and security to be maintained (the Colonel didn't have to tell him what the consequences would be if the press ever got hold of this), there were Anita's acute suspicions to allay as well. With Joe's cooperation, he came up with a plan to throw her off the track, dispatching Joe's new wife, Joanie, to Memphis which, with the movie done, couldn't help but convince Anita that they would be home soon. Elvis even enlisted his father and Dee to divert her attention by taking the girls to look over a fishing camp that he said he was planning to buy.

The motor home was ready, the Barrises had prepared a room for Priscilla at their duplex in Griffith Park, Captain Beaulieu's conditions had all been met — everything was in readiness. One night Elvis sat all the girls down at the house on Bellagio and announced that there would be no more parties, that nobody would be allowed up at the house for the time being. This little girl who was coming to visit was very special, he said; they had been talking on the phone all these months, and now she was traveling all the way from Germany to see him.

JOE PICKED HER UP at the airport, pointing out some of the sights to her on the way back to the house. They were met at the door by Jimmy the butler, who informed her that "Mr. P. is in the den," and she followed Joe down the stairs to the source of the music and laughter she had heard when she entered the house. She didn't see Elvis at first; there were a bunch of people standing around a jukebox. But then she spotted him dressed in dark pants, a white shirt, and a dark captain's hat, leaning over the pool table, lining up his shot. She stood there for a moment, until at last he saw her, too. "There she is!" he shouted, throwing down his pool stick. "There's Priscilla!"

It wasn't the way she had envisioned it — candlelit, hesitant, intimate, alone. He kissed her in front of everyone, murmured how much he had missed her, and took her around the room to introduce her to all of the guys and their girls. She tried not to shrink from the attention, his and everyone else's; he told her she looked great and she wondered if she really did — and she wondered for the first time if she had made a big mistake. She wondered who was this confident, dark-haired twenty-seven-year-old man whom she had known as an insecure, fearful, fair-haired boy, and how could he possibly be interested in her?

The rest of the evening passed in a blur. He went on playing pool, coming back to her from time to time to give her a kiss, as if to make sure she was really there — but continuing to play the star role, while treating her like a prize possession meant to be casually shown off. He was no more at ease than she was herself, she realized, but he was not willing to admit it and covered his fear with a boastfulness that she failed to recognize at first. "It was a shock to me, he wasn't someone that I could just say, 'Gee, I'm feeling insecure now because I don't know anybody, because everyone is older and I'm the only girl here who is sixteen.' I didn't feel that I could confide in him; he had a wall put up, not from me, but he had his entourage around. I think he felt like he had to lock himself up into another person that was confident, I think for the boys he had to show that he wasn't about to let a woman control him or make decisions for him, that he was in charge."

It was only when they got behind closed doors that she saw the sweet, frightened, vulnerable boy that she had known. Then the barriers came down, just like they had in Germany, he revealed himself to her in a way that gradually allowed her to quiet her own fears. In his bedroom, in the early hours of the morning, they kissed and kissed, until she made it clear to him that she didn't want to stop with kissing. "Wait a minute, baby," Elvis remonstrated. "This can get out of hand."

"Is there anything wrong?" I was fearful that I wasn't pleasing him. He shook his head, kissed me again, then gently put my hand on him. I could feel for myself just how much he desired me....

"Elvis, I want you."

He put his fingers to my lips and whispered, "Not yet, not now. We have a lot to look forward to. I'm not going to spoil you. There'll be a right time and place, and when the time comes, I'll know it."

Although confused, I wasn't about to argue. He made it clear that this was what he wanted. He made it sound so romantic, and, in a strange way, it *was* something to look forward to. . . .

In the early-morning hours, he had Joe drive her over to the Barrises, so as to be sure to keep his promise to her father.

* * *

THE NEXT DAY HE WAS like a kid, showing her all around: he pointed l out the houses of the stars, the movie lots, places that he knew, places that he'd been. "We drove all over for hours, he was just so happy to see me — and that threw me, too. Because I couldn't understand: here he was doing what he loved — he could be with whoever he wanted to be with and yet here he was showing such enthusiasm and boyishness around me, trying to show me Hollywood." Later in the day he got the idea of going to Las Vegas. They had the motor home, it wasn't that much of a drive anyway, and Alan could take her shopping for something to wear - if she would just pre-write a series of postcards before they left, Jimmy could mail her parents one a day, with the appropriate Los Angeles postmark. The guys spent the rest of the afternoon and evening loading up, and around midnight they all piled in, with Elvis driving, Priscilla beside him, and Gene riding shotgun and babbling away in a language that only his cousin could understand. Every so often Gene would pounce on Elvis in an alarming sneak attack, but then he would scuttle to the back of the bus, where he was protected from reprisal by the rest of the guys, whose loud guffaws made Priscilla feel as if she would always be an outsider.

They arrived at the Sahara at 7:00 in the morning, and, after getting the room set up just the way Elvis liked it, with his RCA stereo system assembled, the lights turned down, and all the TV sets on low to provide an illusion of constant muted conversation, they went to bed. Elvis stared at her for a while before the sleeping pills took effect. "Do you believe this, baby?" he said. "After all this time, here you are. Who'd ever have thought we'd pull this off?" Then his words began to slur, as he said, "Let's not even think about you going back. We'll think about the other when the time comes."

 $E_{\rm as}$ hard a time getting used to the upside-down hours at first as she did to the celebrity life, but gradually she grew accustomed to both. She took amphetamines along with the others to wake up in the late afternoon, and she took sleeping pills in the early-morning hours to get to sleep. She was, in her own words, "adapting"; the uppers, she felt, allowed her to be more assertive, she had a whole new wardrobe and a whole new sophisticated, heavily made-up and beehive-coiffed image — what she was having the most trouble with was *Elvis*, getting used to him, getting used to his moods, just trying to figure out where she fitted in. "[It was like] he'd decided he was going to take me to Vegas and dress me up and show me to everyone, introduce me because he'd been talking about me to everybody for so long. It was just so hard for me to understand this, as a kid. I started looking at myself: 'What is it about me?' You know, I didn't quite understand it: 'What *is* it?' He showed me the best time, took me shopping, picked out everything for me, bought me everything — I couldn't look like a seventeen-year-old, that was one of the things he was trying to do. And the night was always for courting, he was always pursuing me, always trying to impress me. In a sense it was so normal; it was the exact same thing a seventeen- or eighteen-year-old would be doing in high school — he didn't have to do any of those things, but he was pursuing me as if there was still doubt: Will she still like me? — you know. Or: Am I impressing her enough? It was like he never really felt as if he had me, it seemed."

One time, early in the visit, he played her some acetates from his most recent recording session with a bunch of the guys around, and she made the mistake of giving him her honest reaction. She liked them, she said, they were really pretty, but she wished he would do something more in his old rock 'n' roll style, something like "Jailhouse Rock" — that was what the kids really went for. "Goddamnit," he exploded. "I didn't ask for your opinion on what style I should sing. I asked if you like[d] the songs, that's all yes or no. I get enough amateur opinions as it is. I don't need another one."

He marched into the bedroom and slammed the door, leaving her mortified and confused: How could she have been so stupid? It was just one more illustration of why she didn't really belong. There was nobody else around, and eventually the bedroom door opened, and she saw Elvis standing there in the doorway. He motioned to her to come inside, closed the door, and sat her down on the edge of the bed. To her surprise not only did he apologize, he spent the rest of the day trying to make up to her for it. But she learned to keep her mouth shut from then on whenever anyone else was around, she saw the others subjected to the same whims and flashes of temperament, and she learned that "there were definitely rules. You had to play by the rules. The more you knew, the longer you lasted."

On their last night together she begged once more for him to consummate their relationship, and while he still refused to deflower her, "he fulfilled my every desire. 'I want you back the way you are now,'" he told her. "'And remember, I'll always know.'"

She returned to her parents transformed. When she first saw them, "my

mother was crying with joy . . . and my father was wearing a big welcomehome smile. But as I came nearer, their expressions changed from delight to absolute horror. My father turned away angrily. For a moment my mother just stared. Then she reached into her purse, pulled out a mirror, and thrust it at me. 'Look at yourself. How could you walk off the plane like that?'" She immediately understood. Her makeup was smeared, her beehive hairdo was unkempt, she was not their little girl anymore. She felt ashamed and defiant. All she could think about was how she was going to get back to her lover.

 $E_{\rm LVIS\ AND\ THE\ GUYS\ RETURNED\ to\ Memphis\ just\ after\ Priscilla's}$ departure at the beginning of July. Memphis didn't really offer much in the way of diversion — not after Vegas. They rented the Memphian whenever Elvis wanted to go to the movies; they rented the Fairgrounds three or four nights a week; and Elvis proudly showed off the motor home to anyone and everyone who expressed an interest. There were lots of pills and lots of parties, and that was the summer that he and Anita finally broke up.

She would have had to be blind to have missed the change in him. There wasn't any need for anyone else to tell her, Elvis was the last person able to keep a secret himself. There was all this talk and all this scurrying around and all this plotting — and it was becoming increasingly obvious that Elvis was never going to marry her anyway. "I wanted a husband, and I wanted a home and a family — you know, some people might not have wanted that, but that's what I wanted, and I saw that girls were there continuously and that was not going to change. He led me to believe, and I did believe, that they were not important to him, but [that] because they were his fans he always treated them nice and that he would always come back to me; always, you know, after every episode he would just smooth things over, and there I'd be.

"[But at] this time, I was in my young twenties and I was ready to get married and have a family, and then the fact that this little girl [had come] all the way over from Germany — I mean, I couldn't believe it. So I just made the decision. It was a very *difficult* decision because I loved him, he was my first love and I hated to give up being with him, enjoying the fun and the super things that we did, because I knew there would never be anyone like that again or any way of life like that again — but I was ready for that step. So one afternoon, he was eating breakfast, Elvis and Mr. Presley were at the dining table, and I just shared with him that I was going to leave, that there was no future there, and we both cried, and Mr. Presley was very touched and said, 'I see things like this on TV, you know. Maybe you'll get back together sometime.' And I [said], no, I didn't think that would ever happen, and Elvis said, 'Oh, Little, I pray to God I'm doing the right thing by letting you go.' And I said, 'It's got to be that way,' and I went and called my brother because I had a lot of things out at Graceland, and he [came] and got all my things from Grandma's room and we loaded them up and I went home to Jackson and stayed there for quite some time."

Not before she released a statement to the paper on August 6, though, in which she announced that she was ready "to pick up the pieces of my career." Elvis was not ready to settle down, she told the *Press-Scimitar* reporter, and she had to start thinking about what she was going to do herself. She had a recording date coming up in Nashville, she said; the song's title was "Love's Not Worth It." Her previous release, the paper pointed out with some asperity, was entitled "I'll Wait Forever."

Elvis for his part felt both guilty and relieved. Some of the guys thought Anita was too focused on her career, he knew; even Colonel felt she sometimes liked seeing her name in print too much — but that wasn't the problem. He just couldn't give her what he knew she had every right to expect. Anita was the last link to Mama — Mama had really loved her, and if he had to be honest, that was probably what hurt the most. He had always told his mother that he would get married and have children someday, and he didn't like the feeling that her dream was still lingering like a broken promise in the air. But otherwise he didn't have any regrets. Not really. He knew that he had always treated Anita like a lady. And besides, he couldn't get that little girl in Germany out of his mind.

The NEXT MOVIE, tentatively titled *Take Me to the Fair*, took them to Seattle, Washington. MGM, stealing a page out of Hal Wallis' book, decided that shooting in a semi-exotic setting was the key to a successful Elvis Presley film, so for the first picture under their new 1961 contract they borrowed Norman Taurog to direct his fourth Elvis Presley vehicle and spent three weeks filming at the Seattle World's Fair. For a time there was talk of a live performance at the fair, but that fell through and life on the set was pretty dull, with the exception of the cream-pie and water fights that livened up the action and the elaborate practical jokes with which Elvis and the guys, their number now swollen to nine, sometimes amused themselves. (One of Elvis' favorites on this trip was calling for hotel room service after removing all the furniture from the room, then having it all back in place by the time the astonished bellboy returned with the manager.) Colonel saw any location shoot as a good opportunity for publicity, so he allowed a number of photographers on the set, planted a story on the new continental wardrobe that Elvis would be sporting in the picture (Elvis had grown up, said Hollywood couturier Sy Devore, who allowed that the entire wardrobe cost \$9,300 and included everything but underwear, because Elvis, Devore said, never wore any underwear), and, when they returned to the Hollywood lot, set up interviews with two trusted national reporters, Lloyd Shearer and Vernon Scott, for stories in *Parade* and *McCall's* magazines.

Shearer, who had first met a twenty-one-year-old Elvis Presley in Memphis in the summer of 1956 as he was about to make his first movie (this was the interview in which Elvis explained his theory of lasting motion picture appeal; he was not going to smile too much, he said, because if you smiled, you forfeited credibility: "I know you can't be sexy if you smile. You can't be a rebel if you grin"), encountered the same disarmingly honest approach the second time around. Although Elvis Presley was now a movie star who, Shearer noted somewhat credulously in his lead, "earned the staggering sum of \$2,800,000 on which he cheerfully paid, after all deductions, a federal income tax of \$1,700,000 [the previous year]," he remained "one of the most considerate, well-mannered young gentlemen in the movie community." Colonel Parker, too, remained the same, "a razorsharp mountain of a business manager," who happily confided all the financial details of his client's success.

What was changed, oddly enough, was the *effect* of the young man's candor. Where once it had protected him and prevented him, in the formulation of Sun Records office manager Marion Keisker, from "ever making a wrong move," now it unmasked him, revealing an uncertainty, an almost fatalistic sense of dissatisfaction which, while it never appeared in the published story, verged occasionally on a kind of wounded truculence.

He had been motivated from the beginning, he said, by respect for his fans. "I don't assume the attitude of, 'Get these people out of here,' like I have heard of being done. I don't just sign the autographs and the pictures and so forth to help my popularity or to make them like me. I do it because they're sincere, and if you don't do it, you hurt their feelings. Once you get involved in this business, your life is not your own, really, because people are going to want to know what you're doing, where you are, what you wear, what you eat — and you have to consider that these people are sincere."

As far as his own career went, there remained a lot to do, "but I feel that it takes time to accomplish certain things, you can't overstep your bounds." In that same vein, he wouldn't want to remain at a standstill. "I'd like to progress. But I realize that you can't bite off more than you can chew, you have to know your capabilities. I have people say to me all the time, 'Why don't you do an artistic picture? Why don't you do this picture [or] that picture?' Well, that's fine - I would like to. I would like to do something some day where I feel that I really done a good job. I think it will come eventually — you know, that's my goal. But in the meantime, if I can entertain people with the things I'm doing — well, I'd be a fool to tamper with it, to try to change it. It's ridiculous to take it on your own and say, 'Well, I'm gonna change, I'm gonna try to appeal to a different-type audience.' Because you might not. You might not. And if you goof a few times, you don't get many chances in this business. That's the sad part about it. So you are better off — if what you are doing is doing okay, you're better off sticking with it, till just time itself changes things. I mean, that's the way, I believe, really."

He spoke of his mother, whom Shearer had met ("Funny, she never really wanted anything — anything fancy. She just stayed the same all the way through"), his loneliness, and his guiding philosophy and motivation. "I like to entertain people. The money, or the financial end, is not the greatest aspect as far as I'm concerned. It can't be. Because if it was, it would show, and I wouldn't care about the other people, I wouldn't care about a performance that I gave. That's why I pick all my records and try to pick the best songs possible. I tried to do the best I can in the movies, you know, with the experience I've gotten, but looking at myself strictly as a human being, who's like I said been very lucky but whose life has blood running through my veins and it can be snuffed out in just a matter of seconds, not as anything supernatural or better than any other human being —"

But did he like himself? Shearer cut in, which seemed to bring him up short. "Sometimes," he said with a laugh. "No, what I mean by liking myself, I'm proud of the way I was brought up to believe and to treat people and have respect for people. I — when I am pushed to a certain point, I have a very bad temper, so much to the point that I have no idea

what I'm doing." Did he blow often? the reporter asked. "Not very often. In fact, I could probably count the times. But when I have, it's always been pretty bad — but that doesn't happen very often, and, of course, everyone has a temper — and then I don't like myself, you know, later."

If he could have done anything differently, he would like to have gone to college, but, he quickly suggested, one of the principal reasons was that he wanted to play football, he had had "a great ambition to play football — and I still [do], believe it or not." He had a touch football league back home, and he liked contact sports, where you dealt with your opponent "as a man, you know." He wasn't knocking people who liked golf or tennis or other things, but he liked rugged sports such as boxing and football and karate. He knew the numbers of all the NFL players, he watched as many games as he could, even got film from some of the NFL teams to study the action more closely.

What about these eight or nine guys that he had around him all the time? What exactly was their function?

Well, Elvis said, hedging on exactly who was and wasn't a member of the group, there really weren't eight or nine, there were just five, really, the others came and went. And they all had *jobs:* one was an accountant, his cousin Gene took care of the cars, and he felt sorry for his little cousin, Billy, who had had trouble finding a job because of his size. . . . But what about intellectual growth? Shearer said, coming back to the topic. Didn't he find some of these guys he had grown up with somewhat lacking?

No, he didn't, Elvis said with more than a touch of annoyance. He had thought about this question before, and he had his own approach to learning; it didn't necessarily depend on them. But they were all different, they had their own little tics, they were not dummies by any means. "I don't have them around because they're idiots. But now you can surround yourself with intellectuals or people [who are] your so-called equal[s], and there can be dissension, there can be jealousy, and that's bad. The only thing you can learn there is to become bitter. I have my own way of learning. I learn from the people I work with. I learn from everyday life itself. I mean, I'm not trying to impress anybody by having a group of intellectuals around — not that I'm knocking [intellectuals], but you can be fooled by having a group of people that you think you're learning something from, and you're not learning a damn thing. I had a girl say to me one night, 'Don't make the mistake, Elvis, of surrounding yourself with people you can't learn something from,' and the girl never caught it, but I got up and walked away from

her. I never said a word, but in so many words I was saying, 'I can't learn anything from you.'

"You can't fool yourself. I have my own way of thinking, and nobody else, regardless of their belief, can change me or make me think a certain way if I don't feel that it's right. There's not an intellectual son-ofa-gun walking the face of the earth that could make me believe a certain thing unless I really thought [it was right]. It's more important to try to surround yourself with people who can give you a little happiness, because you only pass through this life once, jack, you don't come back for an encore."

While his friends snickered in the background, he told Shearer that he wanted to marry ("I mean, who wants to grow old and be alone?"), that he might have liked to become a doctor if he had had the money to go to college ("I keep up with modern medicine, medical discoveries, diseases, I get doctor's handbooks, the *PDR*, which is [the] *Physicians' Desk Reference*, things like that"), and that he read philosophy and poetry, particularly a book called *Leaves of Gold*, which contained "different men's philosophy of life and death and everything else."

At the end of the interview Shearer asked him if he would do anything differently if he were entering the entertainment world today. No, Elvis said, "I would do exactly what I felt. I wouldn't make it a point to do a certain thing. I've got to do just like I've always done, going by impulse and the spur-of-the-moment. That's the only way I can operate." And if he had one lesson to impart to a son? He seemed taken aback, he didn't have a son, that was a difficult question to answer theoretically. But if he did? "I think my biggest thing would be consideration for other people's feelings," he said, whatever could keep you "from becoming hardened," whatever could make you "a better human being."

There were no more movies scheduled for the last two months of the year. There were no more recording sessions, because with the movie soundtracks all of his obligations to RCA had been fulfilled. And the tour that the Colonel had been talking about for the past year had never worked out; he wasn't sure exactly why. The original idea had been for RCA to finance it; he would appear in forty-three cities under the sponsorship of RCA's forty-three distributors, with a press conference in each city and a guarantee of over \$1 million. Colonel had even turned down a second MGM picture for this year so they could do it. But RCA had evidently lost some of its enthusiasm, and Colonel wasn't interested in their proposal to scale the tour down to eleven cities for a flat \$500,000. It wasn't worth doing if it wasn't going to be done right, Colonel said, and if RCA lacked the nerve to back what would undoubtedly have been one of the Biggest Tours in Show Business History, it was better to wait. Other opportunities would come along.

In the meantime, they were sitting pretty. They had three more MGM movies coming up, at a salary of \$500,000 per picture plus 50 percent of the profits after Elvis' salary earned out (this was at a time when a top moneymaker like Elizabeth Taylor might get \$750,000 for a picture — but one that cost twice as much and took twice as long to shoot). They had their old reliable Hal Wallis contract, which would once again pay \$175,000 for the next picture, presently scheduled to be filmed on location in Mexico. And in August Colonel had induced RCA to upgrade the contract, which had been renegotiated as recently as January, with a three-year extension (plus an additional two-year option, through 1971); two more nonrecoupable royalty points (to be divided equally between Elvis and the Colonel); a guarantee of \$320,000 a year against royalties, with \$240,000 to Elvis and \$80,000 to Colonel; and a nonrecoupable signing bonus of \$50,000 for each, with that bonus repeated for two years, then reduced to \$37,500 apiece for the next four years of the contract, which added up to nonrecoupable payments of \$600,000, split 50-50 between manager and client.

Colonel explained it all patiently to Elvis and Vernon, drawing a careful distinction between the 25-percent management fee he would continue to take on all formal contractual guarantees (both royalty payments and advances against royalties) and the special partnership arrangement that applied to bonus payments, as much a fruit of the Colonel's salesmanship as of Elvis' talents, which the Colonel (and the Colonel alone) could have gotten out of RCA. Elvis had no quarrel with his manager; he fully grasped the concept of what Colonel sometimes referred to as their "joint venture," and he took almost as much satisfaction in hearing all the details of how Colonel had put it over on RCA as the older man took in recounting them. But he had no one to share the story with. Vernon was never one to dwell on such matters, and though he dropped veiled allusions to the guys, they didn't really show much interest, and in the absence of anything better to do, they all headed for Las Vegas again when filming was over at the beginning of November.

138 👁 NEGLECTED DREAMS

They stayed for just two weeks this time, with a wearying sense of fragmentation and déjà vu. For all of his brave words to Lloyd Shearer, Elvis felt frustrated and bored, tired of the same situations, the same conversations, the small dramas of petty jealousy, endlessly repeated, that seemed to make up his daily life. Lamar had left in June; there had been a big blowup right after Girls! Girls! Girls!, and he was now road-managing for Sandy Ferra's friend and Hollywood Professional School classmate Brenda Lee. Red and Sonny were in and out of the group, trying to make their way in Hollywood; Charlie was off with veteran country singer Jimmy Wakely half the time; and he was increasingly worried about his cousin Gene, who seemed to be getting goofier by the minute and had almost ODed on their trip out to California in August. Gene had been driving for two days straight and was completely wired on uppers, so Elvis prescribed 500 milligrams of Demerol to calm him down. When that didn't work, Elvis gave him 500 milligrams more, but Gene mixed that with sleeping pills, and when Billy found him, he was passed out and barely breathing in the back of the motor home. Somehow they managed to revive him — but it was becoming increasingly clear that Gene could no longer fit in.

The way that Billy saw it, Elvis promoted conflict just to keep himself amused. He'd ostracize one of them for weeks at a time over an imagined slight, he'd fantasize that "there was a Judas among us . . . and he'd play one of us against another. This always happened when he heard that one of the guys had said something about him. And we were all guilty of that." Things always picked up a little whenever a new guy came into the group — that was what happened when Richard Davis and Jimmy Kingsley, who had hung around with them in Memphis, came out to California on vacation and Elvis invited them to stay, at first just for the shooting of *It Happened at the World's Fair,* then indefinitely. He didn't necessarily think about who might fit into the framework of the overall group, it seemed sometimes like he was just looking for a breath of fresh air.

The only thing he could really focus on now, in any case, was Priscilla's upcoming visit. He hadn't really thought a lot about what was going to happen next when she left in July, he hadn't been home for any length of time at Christmas himself since his mother died five years before, and he didn't have much of a plan when he first suggested that she come see him at Graceland — but it seemed like the more her parents resisted, the more determined he became, until finally they agreed to let her go *if* she were to be strictly chaperoned, as she had been in California when she stayed at the

Barrises' house. Elvis immediately said that she could stay with his father and stepmother, at their new home on Hermitage, and that he would even have them meet her plane in New York so she would not have to travel to Memphis alone.

He grew more and more excited as the day drew near, and he had Vernon call the moment they arrived at Hermitage so he could come over and drive Priscilla through the gates of Graceland himself. The annual Christmas display was fully mounted, the house was ablaze with lights, and there were fans at the gate snapping pictures of the life-sized Nativity scene on the lawn, but she could only think that she was finally here with him, after all these years she was actually about to see his home. The whole gang was waiting when she arrived — some of them she recognized, and some of them she was meeting for the first time — but Elvis whisked her away to his grandmother's room, and they had a brief but happy reunion. How had things been for Grandma since she'd been home? the seventeen-year-old girl asked her after Elvis left them alone. Grandma shook her head. She was worried about Elvis, she said. She thought he was still upset about his father's marriage. "He don't spend much time at Graceland anymore, and his Daddy's worried. . . . I don't know if he'll ever accept [the marriage]."

Later that night she was so worked up that Elvis gave her two big red pills to relax. She didn't wake up for two days, and when she did, it was to discover that everyone had been worried to death about her; Vernon and Grandma had wanted to call in a doctor right away, Elvis told her, but he had vetoed that. From her point of view, she was more concerned about the two days she had lost.

The whole visit was frustrating not just for its brevity but for the hint of domestic bliss that it suggested but could not deliver. Of course she didn't stay any longer at Hermitage than she had at the Barrises', and they tried to cram everything into the two weeks they had, as he introduced her, seemingly, to everyone he had ever met, took her roller-skating at the Rainbow, arranged for all-night screenings at the Memphian movie theater, and proudly showed her his hometown. He gave her a toy poodle that she promptly named Honey, they had a Christmas party for the whole gang, and then they celebrated New Year's Eve at a private party for friends, relatives, and fan club presidents at the Manhattan Club on Bellevue, where, to her embarrassment, she got drunk and had to be taken back to Graceland early. Later, when Elvis returned home, inebriated himself, they came closer to actually going all the way than they ever had before, until he reasserted that maddening self-control and withdrew at the last minute, saying, "No. Not like this."

It was over almost before it started. At the end of her visit, he tried to get her to stay, talking wildly, saying that he couldn't live without her. He even prevailed upon her to call her father, against her better judgment, and then he got on the extension to plead with Captain Beaulieu himself just to give them a few more days. Her father was obdurate, as she knew he would be, and Elvis was furious, calling his own father to come up to his office and cursing Captain Beaulieu in front of his daughter. Where did this two-bit army officer get off with his "cocky attitude [and all] his jargon about making agreements"?

"Now calm down, Son," Vernon told him, in Priscilla's account. "It ain't that bad. He was probably just concerned about her being home in time for school."

"School, what the hell do I care about school?" Elvis snapped, ignoring Vernon's efforts to soothe him. "Put her into school here, that'll solve everything. She doesn't need school. Hell, they don't teach you anything nowadays anyway."

"Well, Son, she's gonna have to go back. There ain't no two ways about it. . . ."

Gradually he calmed down, and Priscilla returned to her parents on the appointed day, but she made it clear to them she was returning as someone different: she was all grown up now, she was no longer going to be treated like a child. It was no longer the way it had been when she used to wonder if Elvis would even remember to call her, sometimes for weeks at a time; now she and Elvis were on the phone for hours practically every night, and he had only one thing on his mind: how to get her back. The key element of his plan, he told her, was surprise: she had to sugarcoat everything, be a good girl, get good grades in school, and *then* they would spring it on her parents that she wanted to come back to him and finish her senior year in Memphis.

She hadn't even been able to carry out the first phase of the plan. "From the moment I got off the plane my attitude was one of defiance," and against Elvis' advice she continued to maintain the posture of a daughter who had gone on strike. In the end she gave her parents an impossible choice: they could either let her go or watch her three younger siblings and the year-old twins get caught up in the maelstrom, too. Through her mother's reluctant intercession, Elvis was at last permitted to address her father on the subject. He turned on all his charm and assured Captain Beaulieu that if he were to allow his daughter to return to Memphis, the Vernon Presleys would provide her with a good home and she would get a good Catholic education *and* he would make sure that she graduated. "He said I'd always be chaperoned and that he'd take care of me in every way. Declaring his intentions honorable, he swore that he loved and needed and respected me. In fact, he couldn't live without me, he said, intimating that one day we'd marry."

In the end her parents capitulated. In early March, it was decided, she and her father would fly to Los Angeles, where Elvis was already working on his new movie. There Elvis and Captain Beaulieu would have a chance to talk man to man, and her father could get a few things straight; then she and her dad would go on to Memphis, where he would see to it that she got settled in with Vernon and Dee Presley and was properly enrolled at her new school before returning to Germany.

Elvis was halfway through *Fun in Acapulco* when she arrived. He had been excited about the foreign setting when he first got the script and started practicing his Spanish for the soundtrack, taking to wearing a cape around the house in preparation for a bullfight number. Early on there had been talk about location shooting in Mexico, but the Colonel put the kibosh on that, citing security concerns and his sense that there was "a lot of unrest down there."

Elvis took some time out from the movie to show Priscilla and Captain Beaulieu around. Every day he picked them up in the Rolls or his customized gold Cadillac and enthusiastically pointed out the sights, but then she was gone and he was left with the uneasy feeling that he had somehow charted a course whose outcome he could not fully predict or control. Sometimes he grew resentful at what he imagined Priscilla and Captain Beaulieu had forced him to do. He was only twenty-eight years old. Why should he be stuck with just one girl when he could have any woman in the world at the snap of his fingers? But then when he thought of who she was and what she had done — and what she was still prepared to do — he knew that he had done the right thing. Priscilla had given up everything for him, and she was now ready to be everything that he wanted her to be. She was too young to have gotten her values all screwed up or to harbor any false expectations of him — he would teach her to be the kind of woman that

142 🔊 NEGLECTED DREAMS

he needed, and as a result she would be the first to fully understand his needs. She was the one — if there was ever going to be a "one."

IN MEMPHIS PRISCILLA HARBORED doubts of her own. Without Elvis, and after the excitement of insisting on, and getting, her own way, she felt alone and more like a child than ever. Vernon drove her to school every day, imposing the same strict rules on her that he did on Dee's three little boys, and he was *very* tight with his money, forcing her to go back to him for even the smallest expense. She sensed that he was still suspicious of her; she recognized that "it took a while for Vernon to trust you, you didn't just walk in and be his best friend," but still it hurt. She hated school, she couldn't have any friends over to the house, and socially she was regressing to the level of the Stanley boys, getting into stupid squabbles with them *over nothing.* She was jealous about what she read about Elvis and his co-star Ursula Andress in the movie magazines, she didn't believe him when he said that he could never fall for a girl whose shoulders were broader than his, but she just waited for his calls.

Gradually she started spending more time with Grandma and became friends with one of the secretaries, Becky Yancey, and Elvis' cousin Patsy Presley, who also worked in Vernon's office behind the house. Soon she was spending so much time there that Vernon put up a sign: NO ONE BELONGS IN THE OFFICE UNLESS THEY WORK THERE, OR HAVE AN APPOINTMENT. She moved into Graceland not long after that, whiling away the hours in Grandma's room, as Grandma would reminisce about Elvis and Gladys and dip snuff or play hymns on the little organ that Elvis had given her as a present.

It seemed to Priscilla as if they all lived for his calls, every one of them. "Any time Elvis failed to call home for two days in a row, they worried that something terrible had happened to him in California. Elvis' enormous success and wealth notwithstanding, they were convinced that some misfortune was going to snatch it all away from them." Even Grandma was subject to the gloomy sense of foreboding that seemed to hang over all the Presleys' lives. If Priscilla went off with Becky or Patsy, "Grandma complained that she was being neglected. She reminded me that Elvis' old girlfriends used to stay with her every single night he was gone." Was it any wonder, then, that she felt miserable and abandoned? She couldn't wait for his return.

* * *

I ALL CHANGED THE MOMENT he got home. He rushed back from California as soon as shooting was finished at the end of March and bought her a pretty little bright red Corvair a few days later so she wouldn't have to rely on Vernon or Dee to drive her to school anymore. A reporter from the *Commercial Appeal* happened to spot him with Priscilla on his motorcycle the following day, and seized the opportunity for an impromptu interview in the parking lot of Chenault's restaurant after Elvis had dispatched his "pert . . . motorcycle partner" for milkshakes. Elvis proved to be in an unusually expansive mood. He gave the reporter Priscilla's name and age, explaining, in a variation of the story that she herself had given to a *Press-Scimitar* reporter the day before, that she was the daughter of an army officer that he had met in Germany whose family would be returning to the States soon.

"They sent her ahead because she wanted to graduate on time and she's attending Immaculate Conception High School now." People kept wanting to link him to her romantically, he explained, but she was just a friend. "I couldn't get married right now. It wouldn't be fair to the girl. Since I got out of the Army, I've been busy all the time making movies." Making movies, he acknowledged, was not really such hard work, "but I try to get better roles all the time. I always look over the scripts in advance, and I choose all my own songs. . . . I've gone through more than 100 numbers to get just one that I thought was right."

And what had he been doing since he got back to Memphis? Going to the movies mainly, he said. "I've seen *Lawrence of Arabia* and *To Kill a Mockingbird* since I've been home. Which one do you think will win the Academy Award? *Lawrence*, I'll bet, because more money was spent on it, but I think *Mockingbird* was really better — that's a wonderful movie."

He talked about his motor home and his own just-released film, *It Happened at the World's Fair*, which was the most expensive picture he had made to date and one of the best. "He discussed his career with concentration, carefully pondering his statements. Then he pushed his [familiar yachting] cap back on his head and said with a relaxed smile, 'It's great to be back in Memphis.'"

It was great to be back in Memphis. He and Priscilla frequently went motorcycle riding together, they attended the movies or went out to the Fairgrounds with the gang, he took her shopping and bought her clothes at various shops on Union Avenue, getting the store owners to open up after closing time and pointing out all the ways in which she could improve her appearance. He took her to his dentist to have porcelain caps put on her teeth, she dyed her hair to match his, he gave her extensive instruction in what he liked and what he didn't like in his "ideal woman."

Sometimes they'd go over to Vernon's in the early evening and just watch TV, and she would sit there watching "father and son relaxing, puffing on cigars, discussing the state of the world" or something less weighty, like the latest car that Vernon was restoring. Sometimes they stopped by the Memphis Funeral Home, where Elvis would show off his knowledge of embalming and ask questions prompted by his fascination with medical texts. Almost every night they stayed up till dawn, and then she would drag herself out of bed and off to school, drowsing through her half day of classes until at last she could drag herself home again and get some sleep until he woke up, with her still beside him, late in the afternoon.

She objected at first to the exotic menu of uppers and downers he prescribed for them both, but he overcame her objections by pointing to the *Physicians' Desk Reference* and declaring that there was nothing in it that he didn't know, or couldn't find out, about the medications. His total familiarity, not just with their effects but with their complicated medical names and ingredients, soon overcame her inhibitions, because, after all, as he pointed out proudly to her, it wasn't as if he *needed* the pills, they weren't anything habit-forming like heroin, he could *never* become dependent on them. Besides, if she didn't take them, how was she going to keep up with him? And if she didn't keep up with him, she was just going to get left behind.

It was a little like playing house — except it wasn't a house, it was a mansion, and it wasn't a family, it was a bunch of guys coming and going as they pleased. That was the hardest part. "None of them felt comfortable with me. He didn't want me looking at anyone else, not even the guys that worked for him. I was not to go in a room if one of them was there by himself, I was afraid to say anything to any of them for fear he would hear me and reprimand me later: What was I doing down there in the first place? What did you talk about? What were they talking about? I was with *him*.

"It was an emotional roller coaster, what to do and what not to do, what was right and what wasn't right. I'm sure I appeared cold, but I wasn't used to dealing with any of this. There was a pecking order there unbeknownst to me; there was a whole other world when women weren't around. I mean, I came from a family that was very traditional, very close — and to be thrown into a situation where I had to always be suspicious of who was thinking what, what was being said, how do I look?, who do I look to? I'm sure that they came up with the idea that I was very reserved. I was *petrified*. I did not want to do the wrong thing, because he couldn't — once he was upset, he wasn't the easiest person to live with."

Joanie Esposito, who was her best friend among the wives and girlfriends, felt sorry for her. "It was not that she was immature. She was quiet, and that's what gave her a leg up. But no one had taught her how to do [a lot of things], and it was hard, because she didn't have anyone to ask." Joanie tried to help her, and to cover for her as best she could. But Joanie was a married woman of almost twenty-two with a six-month-old child and her own home in Memphis, now that Grandma had moved downstairs to make room for Priscilla. And besides, the only person she really felt comfortable with was Elvis.

No one else really understood them; the life they led together was a secret life, and no matter how much the others might think they knew Elvis, she was the one who saw him without defenses, she was the one who had to deal with his true, unvarnished feelings, she was the one to whom he confessed all his secret fears and desires. More and more she pressed him to consummate their relationship, but he refused; it was a very sacred thing to him, he told her. "I want it to be something to look forward to. It keeps the desire there."

I sat up in anger. "What about Anita?" I yelled. "You mean you didn't make love to her the whole four years you went with her?"

"Just to a point. Then I stopped. It was difficult for her, too, but that's just how I feel."

There was more than one way to satisfy each other, he told her. "Instead of consummating our love in the usual way, he taught me other means of pleasing him." One of those ways was taking pictures. She dressed up in her schoolgirl uniform, sometimes she was the teacher seducing her student, "we were always inventing new stories, and eventually I learned what stimulated Elvis the most." They documented those stories with a Polaroid camera; Priscilla was mortified at first to have to keep going back to the drugstore for more film; she was sure that others suspected what they were using the film for, but Elvis just laughed. "It might create some excitement around here," he said. "This town's dead. Memphis needs a little gossip!"

Gradually she grew accustomed to it, it became *her* world, too. There were lots of laughs and plenty of good times. She resented the thoughtlessness of the guys; sometimes they were just so inconsiderate, but after a while she came to the conclusion that they were basically goodhearted, and she didn't feel quite so threatened. The best part was that Elvis was around almost the entire time. About the only time he was gone was when he went to Nashville for two nights at the end of May to cut what was intended to be his one studio album for the year, and then at least she was able to catch up on her sleep.

She paid attention to everything he said and did, laughed when he laughed, and kept out of the way when he was brooding; it was a way of life that simply required *alertness* at all times. The only thing really bad about it was school — it was just a total waste of time, a meaningless distraction, and she couldn't stand to have any of the guys see her in her little Catholic girls' school uniform. All she wanted was to graduate and get out, and she ensured that by persuading the girl sitting beside her in algebra to let her copy off her exam in exchange for an invitation to Graceland.

To her surprise, on Graduation Day, May 29, Elvis all of a sudden started acting like "a proud parent." While she tried on her cap and gown, he debated what he should wear to the ceremony, finally deciding on a blue suit. Priscilla eyed him nervously. If he were to attend, she knew, it would be a circus, all eyes would be on him, it would just be a *joke*. "Finally I worked up enough courage to ask him to wait outside, and explained why. Smiling his funny little grin, the one that came to his lips when he was hurt or upset, he agreed without hesitation. 'I hadn't thought about that,' he said. 'I won't come in. I'll just be outside in the car waiting for you. That way I'll kinda be there.'"

Afterward he threw a party for her, and she cast aside her cap and gown with the alacrity of someone more than ready to embrace her freedom. In snapshots taken at the time she appears ladylike and wary, her hair piled up in a huge black beehive that almost totally obscures her delicate features and might even suggest a kind of sullen indifference if it were not for the effort involved in the pose. For much of the next three weeks they shut themselves off in Elvis' bedroom and never even went downstairs. With the windows covered over with tinfoil and blackout drapes, it made no difference whether it was night or day. They called down to the kitchen for their meals, listened to gospel music, made sure not to miss *The Untouchables* or *The Tonight Show* on TV, and watched some of Elvis' favorite movies, classics like *Wuthering Heights, It's a Wonderful Life, Les Misérables,* and a sentimental 1940 remake of the Emil Jannings silent *The Way of All*

JANUARY 1962–APRIL 1964 👁 147

Flesh, in which a good man is ruined and, too ashamed to admit his failure to his wife and children, embarks upon a life of aimless wandering. Years later he returns to his hometown and finds himself outside his old house, watching his family open their Christmas presents. Though she doesn't recognize him, his wife invites the lonely old man in to share their good fortune, but the old man refuses and marches off into the snow alone. They both cried when the movie ended. Elvis had thought of doing it as a remake, he told her; he had even toyed with the idea of casting his father, Vernon, in the leading role.

It was their own private world, and in that world "Elvis could become a little boy again, escaping from the responsibilities of family, friends, fans, the press, and the world. Here, with me, he could be vulnerable and childlike, a playful boy who stayed in his pajamas for days at a time." They had pillow fights and played hide-and-seek, they retreated to a world of childlike fantasy. And she tried to put it out of her mind that he would be leaving her again right after he and the guys had their big annual fireworks war on the Fourth of July.

The movie that he was returning to Hollywood to shoot, *Viva Las Vegas*, was the first of two he was scheduled to do back-to-back for MGM this year. The Colonel had been working since January to get this second MGM production, not just for the substantial addition that it would make to their combined income but to hasten the renegotiation of a contract which, even at \$500,000 and 50 percent of the profits, he felt could stand some improvement. Elvis had had three top-grossing films in 1962, with *Blue Hawaii* leading the way. He had been ranked the fifth-most popular star in the *Motion Picture Almanac*'s annual poll of exhibitors, and MGM said they were really excited about this new film; they thought the chemistry between Elvis and his co-star was going to create a whole new market for Elvis Presley pictures. Elvis didn't know about that, but he knew he was really looking forward to meeting his co-star.

Twenty-two-year-old Ann-Margret was just coming off the explosive success of *Bye Bye Birdie*, the film version of the 1960 Broadway musical which told the story of an Elvis Presley–like rock 'n' roll singer who gets drafted. Pretty, vivacious, a gifted singer and dancer whose personal magnetism and bubbling energy overwhelmed even her substantial talents, she had been discovered in Las Vegas by George Burns three years earlier and

REHEARSING WITH ANN-MARGRET. (COURTESY OF THE ESTATE OF ELVIS PRESLEY) subsequently appeared in two other films. It was *Bye Bye Birdie* that put her on the map, though, and it was the director of *Bye Bye Birdie*, George Sidney, who had previously directed such lavish MGM musicals as *Annie Get Your Gun, Show Boat*, and *Kiss Me Kate*, who introduced his two stars on the MGM set. There was some polite small talk. Elvis, dressed formally in a dark suit and tie, said how much he'd enjoyed her in her latest film, and the two of them went their separate ways, though not before each sensed, according to Ann-Margret's later account, that the other was a true kindred soul.

Much of the first three days was spent in the recording studio. The score was, for once, something of a challenge, with a clever title track by Doc Pomus and Mort Shuman; a thoughtful, deeply romantic ballad, "I Need Somebody to Lean On" — on which Elvis lavished some twenty takes — by the same pair; Red's first movie cut, "If You Think I Don't Need You"; and three duets with Ann-Margret, recorded live in the studio on the third day of sessions. Then on the weekend the whole troupe moved to Las Vegas to begin location shooting on July 15.

Elvis and the guys, along with the Colonel and his staff, all stayed at the Sahara, just as they always did. On the first day of shooting, a reporter from *McCall's* magazine observed a rehearsal and noted that "Elvis makes a face and shakes his head. It is a flirty, cute expression that isn't in the script, but it delights Ann-Margret. She laughs and flirts right back. Whenever the dialogue brings Ann-Margret and Presley together, their roles suddenly become more than play-acting. An electricity from the two charges the crew with alertness."

By the time they returned to Hollywood two weeks later they were an item. "This is news to make the younger set flip," reported columnist Bob Thomas in an AP dispatch on August 6. "Elvis Presley and Ann-Margret are having a romance. At least that's the way it looks," wrote Thomas, who conceded that you couldn't always be sure with Hollywood romances but then went on to describe their behavior on the set. "They hold hands. They disappear into his dressing room between shots. They lunch together in seclusion." In short, it appeared that this was the real thing.

It was. The chemistry that was evident from their first moment together on-screen was borrowed from real life. From Ann-Margret's point of view, music was the catalyst. "Music ignited a fiery pent-up passion inside Elvis and inside me. It was an odd, embarrassing, funny, inspiring, and wonderful sensation. We looked at each other move and saw virtual mirror images." She was, Joe Esposito told Elvis, "a female you," and soon she was at the house almost every night, or he was over at the apartment she shared with her parents. They drove around listening to tapes in his new Rolls-Royce limousine, they rode motorcycles together (she shared his passion for Harleys), the guys always knew enough to disappear at the right moment — and if they didn't, Joe let them know. Everybody liked Ann they all referred to her by the name of the character she played in the movie, Rusty, but Elvis called her Rusty Ammo. She was funny, she was sexy, she was never anything less than a good sport, she was one of the guys. One night she and Elvis were sitting around watching TV with the gang, "an average, lazy night at home," when she and Elvis put on an impromptu show.

We snuck out of the living room. Then, without warning, he pushed open the big double glass doors. Everyone turned and looked. We were both on the ground, stretched out like cats, and in a husky growl he sang, "You got me runnin':" I answered in a similar voice, "You got me hidin'." [These are the first lines of the Jimmy Reed blues "Baby What You Want Me to Do?"] As we traded lyrics, we crawled across the carpeted room in time with the music while everyone clapped and laughed.

To Joanie Esposito, "Ann was wonderful. She would make him pick her up, and the four of us would go to a movie together, no one else. He didn't have to have everyone else with him to do things. It was a much more normal situation." From everyone else's standpoint she was just lots of fun. Sandy Ferra, who was working on the show as a dancer, was not jealous in the least, because they were such a great personality fit. "She was his alter ego; he just really liked her." George Klein, one of Memphis' most popular DJs by now, who was taking his annual two-week vacation in Hollywood to permit a walk-on appearance in another of Elvis' movies, couldn't fail to notice the spark. He had been around a lot of Elvis' girls — he had in fact introduced Elvis to many of them — but he had never seen Elvis act happier. To Patti Parry, who came around almost every night after getting off from her job at Neil Sloane's hairdressing salon, "She had spirit, and she wasn't afraid of him. They just had the best time."

It was against everything he had ever held — he was the one who was always criticizing show business marriages, telling Priscilla or Sandy Ferra that they shouldn't even be thinking about a career in entertainment, there wasn't room enough in one household for two performers. But maybe there were different rules for people like him and Ann; maybe, with all the energy she had, she could play every role without faltering; maybe, it began to occur to him, he had made a terrible mistake. He talked to her about his mother. "He'd describe her in the most heartfelt, childlike manner and talk about what a plain, simple woman [she] had been. He explained how she'd never been interested in the luxuries his money could buy. She didn't care. She only wanted to be able to love him and see him truly happy." Sometimes they talked about marriage, even though they both knew it could never be: "Elvis and I knew he had commitments, promises to keep, and he vowed to keep his word."

At one point he was so overwhelmed with his feelings for Ann-Margret, and so guilty over his inability to do anything about them, that he even approached the Colonel for help. One of the boys called to say that Elvis was on his way over to the Colonel's place at the Wilshire-Comstock Apartments, which told the Colonel right away that something was wrong because Elvis never just stopped by to visit. Elvis was obviously agitated when he arrived, but even if he had possessed true extrasensory powers, Colonel could never have guessed what was on his mind. He had a big favor to ask, he confessed hesitantly to his manager. He had Ann-Margret waiting outside in the car; he wanted the Colonel to manage her.

For once Parker was stymied. What the outside world failed to understand was that you didn't just say no to Elvis Presley, even if you were Colonel Parker; the boy was very persuasive and very determined and very accustomed to getting his own way. Above all, Parker was aware, you didn't embarrass him in front of others. And if he had promised his co-star that he could deliver the Colonel, there was no way that Parker was going to just turn him down flat. Instead he instantly agreed. He would be delighted, he said, to manage the young lady. Ann-Margret was a wonderful talent, and he believed he could really do something for her. The one thing that Elvis would have to understand was that this would take time and effort; Ann-Margret was not yet a star of Elvis' magnitude, and to get her the kind of deals that Colonel was able to get for Elvis would take - well, he wasn't going to shortchange Elvis; he hoped Elvis knew where his first loyalties were, but Elvis would surely understand that he would have to devote 50 percent of his time to his new client, at least at first. They talked for a little while more, but when Elvis went back to the car he was no longer so sure of himself, and he never brought up the subject again.

The Colonel saw bigger problems on the horizon. To begin with, the

director was giving the girl too many close-ups; some of the boys said it was because he was in love with her, but if that was the case, everyone else on the picture was in love with her, too. Colonel was embroiled with the studio in disputes over budget, over publicity, even over the soundtrack. They had a clause in all of their contracts that prohibited anyone else in the cast from singing without the explicit permission of the star. Of course, with the cute story the scriptwriter had come up with, which pitted the two co-stars against each other in an employee talent contest, and with all the publicity the girl had gotten from her last picture, there was no question that she should have one or two numbers, but then against his better judgment Colonel had let himself be persuaded to allow her to do those three duets with Elvis — and the way things were going, it looked like she might steal the picture if he didn't step in and put a stop to it. No one at the studio seemed to remember that this was an Elvis Presley picture — that's what they were paying for, and that's what was going to be delivered. Colonel was already deeply embroiled in a dispute with the publicity department over that very issue - they couldn't seem to grasp who was the star; they couldn't stop talking about the special quality that the girl brought to the picture and how they were going to expand Elvis' audience by putting the spotlight on her. What kind of a fool did they take him for? Were they all forgetting that Elvis Presley pictures always made money?

Colonel Parker fought back with every resource at his command, killing one of the duets completely and recasting another as a song for Elvis alone, vigorously protesting the way in which the director was favoring Ann-Margret and making sure that Elvis knew about it, letting MGM know that he would be perfectly happy to sit at home and forgo his own proven methods for promoting a picture (which, as MGM was aware, had always paid off in the past and which he was glad to deliver for a fraction of the cost) if the studio was really convinced that they had discovered a new way of minting money. In short, he fiercely defended the interests of his client at every turn.

What galled him most was the disregard that everyone seemed to have for the bottom line. No Elvis Presley picture had ever been budgeted at more than \$2.5 million in production costs, and his and Elvis' profit participation began only after all postproduction costs (roughly twice the production budget) had been recouped as well. But in this case for the first time they were going well over budget, and Parker realized he had no protection against the rising costs. No matter how successful the picture was, their share was necessarily going to be diminished by all the unnecessary frills and fancy production numbers that would not add a penny to the box office and that Hal Wallis would have known how to strictly control. It was all a rear-guard action by now, he realized; there was nothing he could do to make this picture right. On August 15 he finalized arrangements for the next film, to be produced by Sam Katzman, a veteran B movie producer currently operating out of MGM, who assured him that on his set costs would be carefully controlled, shooting time would be halved, and quality would not be sacrificed — and put all but the last in writing.

Meanwhile, Priscilla waited patiently at home. At first Elvis told her he thought she could come out at some point during the filming, but then he kept putting her off, and she saw the pictures and stories in the papers, and she was worried and confused. There was nothing to do in Memphis: she was bored to death. She had taken some modeling classes at the Patricia Stevens School and even did a little modeling during lunch hour at the Piccadilly Cafeteria, until someone told Elvis about it and he told her to stop. Now she was taking modern dance classes and working very hard at it, but she didn't know how Elvis felt about that. She kept trying to figure out different ways of reintroducing the idea of her coming out to see him, but every time she brought up the subject, he came up with another story of "problems on the set." What kind of problems? she ventured tentatively. Oh, you know, the usual kind, he said, as if she should know all about that sort of thing. The director was in love with his co-star, she was getting all of the close-ups, and Colonel warned him that if they didn't watch out she was going to steal the picture. Well, how about Ann-Margret — how did he get along with her? Priscilla asked sweetly. Oh, she was all right, he said, just "a typical Hollywood starlet," the kind he had often described when he was trying to reassure her, as "into their careers and their man comes second. I don't want to be second to anything or anyone. That's why you don't have to worry about my falling in love with my so-called leading ladies."

But she *did* worry. And she did keep pestering him. And she did keep seeing the stories. And she didn't know what to do.

They finished shooting on September 16, and whether to assuage his own guilt or to allay Priscilla's suspicions, Elvis came straight home. For all of Colonel's concerns, the picture was probably Elvis' best since *Follow That Dream*, and the first since he had gotten out of the army to exploit his genuine sex appeal — even if it did run in tandem here with Ann-Margret's. Some of the production numbers may have been a little over the top, but there was no need to worry about losing the fans through "artiness." In fact, this was perhaps Elvis' first legitimate Hollywood musical, in which the songs actually served the purpose of advancing character and plot, however skimpily developed those areas might be. There was even a big production number added at the end of shooting, in which Elvis and Ann-Margret attend a Vegas show, dance to a black quartet's version of a Leiber and Stoller tune called "The Climb," and Elvis gets up onstage and launches into an incendiary, if somewhat incoherent, version of Ray Charles' "What'd I Say." It's hard to imagine what may have prompted this last-minute addition, other than the sparks that Elvis and Ann-Margret were giving off on-screen and George Sidney's penchant for off-the-cuff musical inspiration. The song was not recorded in any case until August 30, five days before it was to be filmed. Completed in four quick takes, it might well have benefited from a more tempered approach, and despite the presence of the Jubilee Four, a black gospel group that included two members of the original Golden Gate Quartet, it comes across as a frenetic, irretrievably wholesome mess. Nonetheless, it gives a sense at least of Elvis Presley unleashed, as he mumbles — and on-screen Ann-Margret poutily mimics — Ray Charles' orgiastic moans, and the camera pans a soundstage full of all the frenetic activity of a Busby Berkeley water ballet.

Perhaps the most telling moment in the movie, though, was its most atypical, as the Elvis character, troubled over the failure of his relationship with Rusty, wanders in a kind of dream sequence in which the beautiful Doc Pomus–Mort Shuman ballad "I Need Somebody to Lean On" becomes his inner voice. It is his purest acting in the entire picture, as we see him in an overhead spotlight shot, singing now with a quiet, earnest sincerity that belies the surface charm of the rest of the show. It is a sequence that would not have been out of place in a Gene Kelly musical, and you can sense the quiet satisfaction that Elvis must have felt as words, music, and image all come together for once.

HAD A MONTH IN MEMPHIS before the next movie, *Kissin' Cousins*, was to start. Priscilla kept after him about what she had read, but he was steadfast in his denials, giving no ground but at the same time talking to Ann-Margret almost every night on the phone. Colonel told the movie people that Elvis wouldn't have time to go out to Hollywood to cut the soundtrack for the picture, so Gene Nelson and Freddy Karger, the director and musical director respectively, flew in to Nashville at the end of September and ran through ten tracks in two nights, with Nelson contributing percussion on a few of the numbers which he and Karger had preselected and sent on to Presley for approval ten days earlier. For the first time Elvis didn't record his vocals with the band and in fact did not do them at all until he got to California, though he was in Nashville and stopped by the studio briefly to say hello. To Boots Randolph, who played jug as well as saxophone on the session, while others contributed banjo and fiddle to emphasize the "hillbilly" flavor of the picture, it was all just part and parcel of the prevalent Hollywood view of Elvis Presley as "product," and guitarist Jerry Kennedy, who had been working sessions for two years now, felt sorry for Elvis, trapped in an atmosphere that more and more resembled a zoo. Two weeks later the film had started production on location in Big Bear in the San Bernardino Mountains, one hundred miles from the MGM lot in Hollywood.

The Colonel had sought out Sam Katzman to produce this picture for one very simple reason: he admired his work. The sixty-two-year-old Katzman, who had made the first rock 'n' roll picture, *Rock Around the Clock*, for \$300,000 in 1956 (Katzman liked to boast that it grossed \$4 million, giving it one of the highest margins of profit in Columbia Pictures' history), was known as the "King of the Quickies." Colonel had run into him at MGM while he was working on *Hootenanny Hoot*, which presented fourteen musical acts and was filmed in eight and one-half days. "It seems they were spending an awful lot of money on the Presley pictures, and me being a frugal producer, the Colonel figured we could save a few dollars. His last few pictures before I took over hadn't been going so good. The grosses had been dropping." And so the Colonel and Katzman talked business.

For once the Colonel felt like he had run into a kindred soul. Katzman prided himself on his ability to deliver a picture on budget; he had what he called a "below-the-line set limit, and we never [went] over our below-the-line." Which to Gene Nelson, who had won his spurs as a director with *Hootenanny Hoot* and was just the right man, Katzman felt, to direct an Elvis Presley picture, was not an inconsiderable ability. "The man knew how to make pictures," said Nelson, who had embarked upon directing after a career as an ice skater, a dancer, a character actor, and an occasional leading man. "The fact that he had lousy taste has nothing to do with it. He knew every angle, every possible way to 'cheat'; he could have done a good picture the same way and he would have been even more of a hero. He

just had lousy taste in writers, and he wouldn't know a story if it hit him in the face."

The more the Colonel and Katzman talked, the more they hit it off, and the Colonel even tried to get Katzman interested in one of his pet projects, the life story of Hank Williams, which he had been trying to sell MGM on for years, with Elvis in the leading role. It was a natural. It was a dramatic story, and MGM owned the music, so they could make it for peanuts and besides, the Colonel had a plan for promoting it by block booking it throughout the South. If Katzman were interested, he said, he would volunteer his promotional services even without Elvis involved, and when the producer indicated that he was ready to take him up on his offer and arranged to make *Your Cheatin' Heart* his next picture (after *Kissin' Cousins*) at MGM, that pretty much won the Colonel over and solidified the deal.

Katzman, Nelson, and the Colonel went location scouting before Elvis came out to California, and Colonel regaled his companions with tales of the carnival days. He described to them how his operation worked as well, and Katzman noted admiringly how he handled "all the exhibitors, all the publicity, all the sales, all the records — everything comes through his office. I don't know any campaign [that] he hasn't added to and improved." He indicated no interest in the script, other than whether or not there would be any writer's fees to pay, and since it was based roughly on a story by Bret Harte, who had been dead for over sixty years, he was satisfied on that point.

Gene Nelson was itching to get going, though first "I had to really talk myself into liking that kind of music. I couldn't stand it then, and I can't now. But if I was going to do this shit, you either fall in love with it or you don't do it at all — and I got myself very involved with Elvis. I mean, I began to listen to him; I ran all his pictures and really tried to see where he was coming from, what the attraction was. He was the handsomest sonofabitch that ever walked across a screen, you know. I mean, he couldn't dance worth a shit, he really couldn't, but he had these weird wiggles that he produced, which was — okay, that was part of his creativity." Nelson rewrote the script ("it was a little square"), and "just before Elvis arrived, I packed it up and sent it over to the Colonel. It wasn't the first time I'd ever written a script — it was the second — so I'm concerned. I sent a nice note. 'Dear Colonel, The script is finished. I hope you like it. If you have any suggestions, please feel free to call me.' The next day I get a call from the Colonel. 'I got your script. If you say it's okay, it's okay with me. As far as suggestions are concerned, for consultations I get \$25,000.' I was in shock. I mean, he was a big teaser. He really put me on!"

Production began in Big Bear on October 14 and, except for the weather and Nelson's understandable concern about keeping to the schedule (fifteen days had been allotted for the shooting), everything went well. To his great relief Nelson couldn't have found his star more cooperative. "I was quite nervous [about working with him]. He and Red, whenever there was nothing going on, would start doing karate, and everyone would gather around and watch. Then one day we were lighting the set for the big dance number, and I'm sitting in my chair facing the area that they're lighting, checking my script, and I hear, 'Uh, Mr. Nelson, can I talk to you for a second?' I say sure, so he sits down, and he says, 'I just want to tell you, I've been a big fan of yours for a long time.' I said, 'Really?' He said, 'Yeah, the first time I saw you in person was when I was fifteen or sixteen years old and I was an usher at this movie theater in Memphis, and you were in town with Virginia Mayo, and I heard music blasting in the street, and I left my post and ran out of the theater and sat on the curb with everybody else as this white Lincoln convertible went by, and you were sitting on the back with Virginia Mayo waving.' This was She's Working Her Way Through College. I did a one-of-a-kind dance number, a gym number that'd never been done before, where I used every [piece of equipment] in the gym; it was 1952, and Virginia and I were doing a kind of southern tour, there was a big banner on the side of the car with the name of the picture on it. He said, 'You know, I really love the stuff you do.' He didn't have to say that, but he wanted me to know that he was not unaware of my status."

The Colonel was all over the set, clowning, entertaining, donning Elvis' blond wig (Elvis played look-alikes in the picture, one dark-haired, one blond, and *hated* the wig), from Nelson's point of view generally defusing any tension on the set — and there was a good deal of that. "There got to be some really high-powered tension between me and Sam Katzman, because I'm busting my butt trying to get this thing finished in fifteen days, and Sam was really giving me a rough time. I remember one time the Colonel came on the set with an old-fashioned white car coat all the way down to his ankles, with the names of all of Elvis' pictures sewed on it and a funny hat, and he walked in and said, 'Well, fellas, what do you think of this?' Just, you know, trying to get us to relax and forget about whatever it was we were angry about."

Even Elvis was infected with the tension. "He'd never worked this way

before. But the Colonel explained how he would make more money [this way], and I explained that it was more like shooting a TV show than a movie, and he went along with it." For the most part Elvis and the guys seemed to be having a good time, there were lots of pranks and water balloon fights, but Nelson couldn't be bothered — "my mind was filled with meeting schedules." And whatever the guys might get up to as they were setting up for a shot, Elvis himself was never less than cooperative, always on time, eager to please and easy to direct.

Nonetheless, Nelson never felt like he really got to know him. "He was just so enigmatic. I mean, you felt compelled to try to figure out what really made him tick, because what he presented was not really Elvis, at least not all of it. I mean, why would he isolate himself with this bunch of idiots? What is going on? Well, I finally came to the conclusion that Elvis had no [insecurity] about what he was in the media, absolutely none. He knew he was great. He knew he could do anything he wanted. He knew the value of his status, and there was never any shyness or awkwardness about his persona onstage. However, I thought he suffered an acute lack of self-esteem as a human being. I found, not once but a number of times, that he felt that he was uneducated and had nothing to contribute in a conversation. As a performer, he wasn't adventuresome, he didn't really want to learn, because he was embarrassed and, besides, what he was doing worked, so why change it? I don't think he was ever involved to his full potential as an actor, but I could see moments when he would get involved in a scene. I think he could have been a very good actor, but mostly he would just be his charming self and get away with it — because he was Elvis Presley."

In four weeks the production was completely wound down. As Nelson recalled it, there were seventeen days of actual shooting, and Katzman was angry with him even then for going two days over schedule. There was unquestionably a science to it. When they got back to the studio, they started out on MGM's huge Stage 25 or 26, shooting exteriors to match the location shots, with giant pines, hills, and a farmhouse front. Then gradually they shut down the set, putting up an accordion wall as less space was required, letting electricians go "as we needed less lights, so that in a week's time we had maybe three guys up high." Toward the end the schedule was so hectic that Elvis offered to get sick. "I hadn't learned the patience and control that I have now, and I'd get uptight — and this upset Elvis. He came to me the last week and said he didn't like to work this way, it wasn't worth it. He said he knew what kind of pressure I was under, and he volunteered

to get sick or show up late if it would help. I thanked him and said to hang in, it was *my* problem."

They finished shooting on November 8. For all of Elvis' good-sport attitude toward the movie, and for all of Nelson's cheerful energy and inventiveness, it was probably the film that most embarrassed Elvis in his career to date. He knew the story was ridiculous, he hated the way that he looked (some mornings, according to his co-star Yvonne Craig, he didn't even want to come out of the dressing room he was so embarrassed), the processing technique which enabled the audience to see two Elvises onscreen at the same time was laughably amateurish, and in the musical grand finale you can spot Lance LeGault, as Elvis' double, walking toward the camera. He was obviously not intended to be seen from the front, but, Yvonne Craig noted, "Sam said it was too expensive to shoot over."

As perceived by LeGault, who had now made three pictures with Elvis as double and special choreographer's assistant assigned to the star, *Kissin' Cousins* marked a turning point in Elvis Presley films. "Up until that time certain standards had been maintained, but it seems to me from *Kissin' Cousins* on, we were always on a short schedule. It was like, 'It's good enough because it's Elvis, and it's in color, and we're gonna make two and a half times negative cost plus another two and a half times.' Sometimes [Elvis might] comment about this, that, or the other — but he'd go ahead and do it. Very seldom he might go over and say something to the director — but very seldom: he just kind of went along with it. I don't remember how long I was on *Viva Las Vegas*, but it seems like it was ten or eleven weeks, a long time. We weren't off a [few] weeks when, boom, we jumped back into *Kissin' Cousins*, which was shot in seventeen days. When they realized they could take this guy and do a film that quickly with him, from then on we were on quick pictures."

PRISCILLA HAD GROWN TIRED of waiting at home. There was nothing to do, and besides, she kept reading about Elvis and Ann-Margret riding around Bel Air on their motorcycles. More disturbingly, she kept picking up hints that something was going on. No one would say anything to her outright, but all the denials — even Elvis' — were less and less convincing. Finally, she insisted on coming out. Elvis kept saying he didn't have time for her, she didn't understand, he was completely tied up making a movie, and this movie in particular took *all* his time with the schedule

they were on. She told him she didn't care, she didn't need to be amused, she just wanted to be near him. Besides, she hadn't been out to California since she and her father had stopped off on their way to Memphis, and she'd hardly seen the house on Perugia, which he had moved back into at the beginning of the year; she just wanted a chance to visit.

Finally, she came out while they were still shooting the movie. She met Mr. Nelson and Mr. Katzman briefly on the set, the Colonel smiled at her benevolently without revealing a thing, and she realized that the guys were even more uncomfortable around her than ever. Then on November 8, the same day that production ended and Elvis signed a new deal to make a picture with Allied Artists for \$750,000 in 1964, there was a UPI story in the paper headlined "Elvis Wins Love of Ann-Margret." The story was filed from London, where Ann-Margret was attending the royal premiere of *Bye Bye Birdie*, and according to the wire-service report, "Ann-Margret says she's going steady with Elvis Presley, and 'I guess I'm in love.' . . . The redhaired 22-year-old beauty says she doesn't know yet if they will get married. 'Nothing has been fixed,' she said. Ann-Margret says she and Elvis have lots of fun together riding motor bikes. . . . 'But I cannot say when, or if, we will marry.' Added Ann-Margret, 'He's a real man.'"

Elvis came home from the studio with a newspaper that contained the story. "I can't believe she did it," he declared without preamble. "She had the goddamn nerve to announce we're engaged." For Priscilla it was as if her world had suddenly collapsed. All her suspicions, all the rumors and insinuations that he had so vehemently denied were true. Every major newspaper had picked up the story, he told her with an anger that barely masked his embarrassment and guilt. She would have to go home. The press would be all over him, Colonel thought it would be best if she were not around to complicate the matter even more.

I couldn't believe what I was hearing. Suddenly all the months of unbearable silence broke and I screamed, "What's going on here? I'm tired of these secrets. Telephone calls. Notes. Newspapers." I picked up a flower vase and hurled it across the room. . . . "I hate her!" I shouted. "Why doesn't she keep her ass in Sweden where she belongs?"

Elvis grabbed me and threw me on the bed. "Look, goddamnit! I didn't know this was going to get out of hand. I want a woman who's going to understand that things like this might just happen." He gave me a hard, penetrating look. "Are you going to be her — or not?" Eventually they both calmed down. "Elvis was very honest and very blunt with me: he told me in detail what their relationship had been. Basically, he said that she had paid him the highest compliment that a woman can give a man: here she was imitating him, and he was intrigued by it. He was *fond* of her as a person; he told me explicitly and in detail what the relationship was. But as far as it going anywhere, it could never have gone anywhere, because her career meant a lot to her, and his career meant a lot to him, and he wanted to have a family and a home with me. It was *very* hard to take. I was very hurt by it, because I didn't understand it at the time, but what he was relating seemed to me very truthful and very honest; [maybe it was] just the fact that he told me. . . ."

He promised that he would never see Ann-Margret again, but he and Priscilla had to be apart for now. His resolve lasted as long as it took to get Priscilla to leave. At her parents' urging, Ann-Margret called him from London. She had never said any of those things to the British press, she swore. She never would. Elvis said that he believed her and he wasn't surprised or upset, that was just the way reporters were — but was *she* hurt? She told him she was "terribly hurt by the lies."

Just after Ann returned home from England, President Kennedy was assassinated. She heard the news on the car radio, listening numbly to the minute-by-minute reports. "I drove to Elvis' house and found him glued to the TV. I sat down next to him. We stayed like that for the entire weekend, for what seemed an eternity — watching, waiting, and crying over the President's death. . . . [We] clung to each other, tried futilely to make sense of what had happened, and prayed for the future."

He returned to Memphis two weeks before Christmas, and although they continued to see each other and exchange secret messages well into the next year, soon she began thinking of him in the past tense. As for Elvis, he never made it clear exactly what he was thinking; some of the guys felt that he was simply too much of a coward to do what he really wanted to do, but he never confided his feelings to any of them. At home he continued to do exactly what he always had: he rented out the Memphian, listened to his gospel records, and he and Priscilla watched movie after movie on Graceland's home projection system; he made his customary Christmas charity contribution — \$55,000 this year to fifty-eight mostly local charities — and received a plaque in a modest ceremony at the mayor's office; he sent \$1,000 to his cousin Gene, who had left his employ the previous spring under somewhat shadowy circumstances and was having a difficult time catching on. He even purchased a wedding ring, which had the jeweler, Harry Levitch, a kindly man who had befriended him when he was just out of high school, all excited — until he found out it was to replace a ring that Elvis' grandmother had lost. On January 8 he celebrated his twenty-ninth birthday quietly at home, and then on the twelfth he traveled to Nashville to do a nonsoundtrack session for the first time since the previous May.

The May session had originally been intended to yield an album and a single, but as the Colonel's plan to concentrate exclusively on soundtrack recordings took greater hold, the album was set aside and the fourteen tracks dispersed among single releases ("Witchcraft," for example, became the B side of Fun in Acupulco's "Bossa Nova Baby" in October 1963) and "bonus cuts" on soundtrack albums. Elvis understood that this was merely good business; the Colonel had explained it all to him before, just as he had explained about the publishing: they had Hill and Range's top writers all vying for a spot in their motion pictures in a competition that prohibited anyone from taking advantage of the system. There were times when songwriters like Don Robertson or Doc Pomus and Mort Shuman might be favored, certainly, but they were well aware that they could just as easily be replaced (and frequently were) if they ever got too big for their britches. It might seem harsh, the Colonel conceded, but this was a dog-eat-dog world in which they were only doing what everybody else did before the other guy did it to them first.

Still, Elvis could not help but notice that sales were substantially down: "Return to Sender" had been his last million seller, in 1962, and if he had studied the matter more closely, he would have discovered that overall sales for this year's three new singles releases amounted to less than two-thirds of 1962's total, while album sales hovered in the 300,000 range. Nor did the quality of the movie songs or the declining standard of the new material that Freddy Bienstock brought to the sessions escape his notice. They might still have some of the top writers in the business, but it seemed like they weren't getting their best songs.

The reason for Elvis' return to the studio in January of 1964, however, had nothing to do with Freddy or the Colonel or song publishing but, rather, with a song in which he truly believed, Chuck Berry's "Memphis, Tennessee," which he had attempted at the last session but which he knew he could do better — in fact, he felt like it could be one of his strongest singles in years.

"Memphis" had first been released in its composer's version in 1959

with no great chart success. Then in the spring of 1963, just before the last Nashville session, Lonnie Mack had come out with his instrumental interpretation of the song, which ultimately was a number-five pop hit. Elvis' version was different from either one. With the heavy double drumming intro of Buddy Harman and D. J. Fontana, you would think that you were in for the kind of "jungle rhythms" and unrelenting vocal attack that Elvis brought to Little Richard's "Long Tall Sally" some years earlier, but instead, with his vocal entrance we hear a sweet-edged, delicate, almost keening plea as he recounts Berry's tale, in which the singer appears at first to be trying to call a wife or girlfriend in Memphis but then in a clever, and poignant, twist reveals that it is his six-year-old daughter whom he is attempting to reach ("We were pulled apart because her mom did not agree / And tore apart our happy home in Memphis, Tennessee").

The idea for the last session had been to achieve a true pop sound, and while not every song was worthy of the effort and not every arrangement did justice to every song, Elvis had worked out a consistent approach that pitted light, airy, almost ethereal vocals against fuzztone guitars and a heavily emphasized rhythm track for what seemed like a curious and deliberately incongruous effect. That was the tack he had taken with the Berry tune in May, and to a large extent it was the one he carried out now, in a version considerably more nuanced than Berry's, with the rhythm never faltering as Elvis maintains a tone of underlying wistfulness and deep melancholy through six highly focused takes.

The first and the last were clearly the outstanding performances (as with any Elvis recording session, the differences were relatively minor, with the aim being to get *inside* the song rather than to develop radically different variants), and while in the end it was hard to say whether he had surpassed the May version, he had at least satisfied himself that he had explored the song to the fullest. With that he went on to the only other scheduled business of the day, "Ask Me," an English-language adaptation of yet another Italian song, which he had also attempted at the last session. Here the instrumental approach was not so sure, with Floyd Cramer's roller-rink organ once again taking the lead, but Elvis contributed a stunning vocal that alternated between the top of his tenor range and a falsetto of almost heartbreaking fragility, adding eleven more takes to the six he had tried at the previous session.

There was clearly a certain amount of frustration, a continuing sense that the arrangement did not do justice to the Italian ballad's broad romantic sweep, but as you listen to the session develop, you become aware of a serious musician who remains unfazed and fully focused on his vision, one that he alone may grasp but that he will not relinquish until he has seen it through. Save for his unfailing politeness and the thoughtful deference he shows at all times to his fellow musicians, it's hard to reconcile this Elvis with the Elvis who is used as little more than a cardboard cutout or a piece of moving scenery in films like *Girls! Girls! Girls!* or *Kissin' Cousins* — but perhaps that is the point. For this one fleeting moment he, and we, are aware of the goal, for this single instant he is able to shed the trappings of fame and recognize, briefly, what it was he was seeking in the first place.

And then it is gone. Though there appear to have been no formal plans to record any additional material, Elvis did go on to record one more song, "It Hurts Me," a quietly passionate and beautifully articulated ballad pitched by Freddy and seconded by Lamar Fike, who had reconciled with Elvis at the recording session the previous May and was now working for Hill and Range in Nashville. The session ended before midnight, and he was back in Memphis by early the next morning. It might have crossed his mind how much more could have been accomplished, but then what would have been the point? The Colonel had his proven game plan, and Elvis had long since reconciled himself to his own need for going along with it.

T HE COLONEL, FOR HIS PART, was reasonably well satisfied. The kids still loved Elvis, and if they didn't love him as much as they once had, with a guaranteed income from RCA for the next seven years and an increasingly lucrative schedule of movies to keep them busy at least through 1964, there was no immediate cause for concern. His promotions continued to make money for him and Elvis; through controlled on-set interviews and photo opportunities he was able to keep Elvis' name constantly in the news; "Our gimmicks work," the Colonel boasted whenever he was challenged by any of the record company or movie studio college boys with their fancy suits and college degrees. "Look, you got a product, you sell it," he told Variety with a pride that was not at all belied by the disingenuousness with which it was put forth. There was no one capable of beating him at his own game, there was no one with a greater knowledge of the science of exploitation. No matter what changes in tastes or trends might lurk on the horizon, he was confident he could keep Elvis and himself in the 90-percent tax bracket for years to come. He didn't doubt his own abilities for a moment; he was getting just a little bit apprehensive about the boy keeping up his end of the bargain.

JANUARY 1962-APRIL 1964 👁 165

Wallis had written to him toward the end of the year to express his own apprehensions about Elvis' appearance. He had screened *Viva Las Vegas* at home, and Elvis to him looked "fat," "soft," "jowly." His hair was "atrocious": with its inky-black coloring, it looked like a bad wig. He had no business critiquing the MGM picture, Wallis admitted, that was not his concern — but Elvis' career was, and Wallis at this point was very concerned about that. For their upcoming picture, *Roustabout*, in which the Colonel had taken such an interest, Elvis had to understand that as a carnival roustabout he was playing a "rough, tough, hard-hitting guy." If he didn't change his appearance, the character would be completely unbelievable, and to that end Wallis wanted the Colonel to speak to Elvis about letting the studio hairstylist cut, color, and comb his hair the way they wanted for the character rather than come in with his own barber, haircut, and dye job.

He reiterated his concerns at the end of January, and no doubt to his surprise the Colonel agreed with him. The Colonel would convey his message to Mr. Presley just as it had been expressed, with full support, but in addition, the Colonel suggested to Wallis that he should "strongly impress" upon his production people that they convey their desires to Elvis simply and clearly, because if Elvis wasn't clear what was expected of him, he would naturally gravitate back to his own tastes and inclinations. Everyone would have to be instructed in this approach, Colonel wrote; proper coordination was necessary in order to ensure success.

The new picture itself was, as Wallis suggested, something very near and dear to the Colonel's heart. After first getting Wallis to agree to a production schedule that cut nearly two weeks out of the normal eight-week shooting schedule, and then eliciting \$45,000 in bonus payments (to be split equally between Elvis and himself, with an additional \$25,000 going to him as Technical Adviser), the Colonel devoted himself exclusively to his consultant duties, which for once had a creative, as well as a marketing, bent.

The idea for a picture with a carnival background went back to early 1961 and was, not surprisingly, the Colonel's — at least in part. More recently, as the studio had developed a script, the Colonel had come up with all kinds of suggestions, from toning down some of the more high-flown language to injecting many notes of actual "business" into the story. In his communications with Wallis, he was very careful to stress that he would not be party to a picture that cheapened carnival life, that this was a whole-some way of life in which the participants had a legitimate pride — and, it was clear, Colonel did, too. When *New Musical Express* ran a story on September 9, 1963, indicating that *Roustabout* would be based on the Colonel's

own life story, the Colonel reacted with the kind of righteous indignation that was always good for business (if the world was to understand that this was his life story, then he should be paid for it), but on this occasion, for once, his response seemed to reflect an underlying insecurity, an unacknowledged fear of accepting responsibility for something that he might truly be seen to be responsible for. It was as if, for the first time, the Colonel were exhibiting a creative nervousness of his own.

E LVIS RETURNED TO LAS VEGAS at the end of January. He wasn't scheduled to report for the picture until the beginning of March, but he was bored in Memphis, he was tired of playing the good boy — he was pissed off at feeling like he was somehow trapped and didn't know what to do.

It was Marty Lacker's first trip to Vegas. Marty had rejoined the group after they got back from California. With Gene gone, and Elvis' cousin Billy a new father at twenty and temporarily on the outs with Vernon over the cost of long-distance calls home, there was room in the organization, and Marty hadn't had much luck with any of the radio jobs he had picked up since leaving in early 1962. Elvis felt sorry for him, and he was an organized little guy — some of the others didn't much like him, but he was *different* — so Marty signed on, leaving his wife and one-year-old son back home in Memphis for a life of adventure that promised to be footloose and fancy-free.

He found it without any delay. Vegas was like nothing he had ever experienced. Elvis built it up to him as they drove cross-country in the motor home, with a caravan of cars trailing behind. "Elvis kept telling me how much I would enjoy Vegas and that the greatest thrill was to see the city, for the first time, all lit up at night.

We were about thirty miles outside Boulder City, Nevada, when the mobile home broke down. It was daytime, and Elvis kept insisting we would wait in the mobile home until it got dark because he didn't want me to see Vegas for the first time in the daylight. Twenty minutes later he said, "Let's get in the damn car and go to the nearest motel and wait 'till it's dark and then go into Vegas. . . .

We weren't in the motel more than a minute when we discovered they had no television. That blew the whole thing, and Elvis said, "Moon [his nickname for Marty because of his bald head], I'm really sorry, but let's get out of here and get the comforts of Vegas." It made not the slightest bit of difference to me, but he was really disappointed that his plan didn't work.

They stayed up all night and slept through the day. They went to all the shows, saw Fats Domino and Della Reese, insult comedian Don Rickles (who would not cut Elvis because, like Rickles, he was devoted to his mother), and Tony Martin, whose "There's No Tomorrow" Elvis had adapted as "It's Now or Never." Elvis dated Phyllis McGuire of the McGuire Sisters and refused to be put off by the fact that she was mobster Sam Giancana's girlfriend. One night they went to the Stardust, and just before leaving the suite Elvis handed Marty a box. Marty asked what was in it, and Elvis told him to open it. "The damn thing was packed so full of pills I spilled some on the floor when I raised the lid. It was like giving a baby a box of candy. I'd never seen so many in one place."

The opening act of the show they went to see was a sleight-of-hand artist billed as "the world's greatest pickpocket." They were sitting to the side as usual so they could make a quick exit, and Marty was sitting on the aisle. The featured performer walked around the club talking with individual members of the audience. While he was talking, he would pilfer a necktie or a wallet or a piece of jewelry, which the audience member would not miss until he held the item up in the air to general applause.

I had never seen the guy before, and I believed all of it. Well, I'm sitting there with this box of pills in my pocket and I begin to worry. What the hell would I do if he came over and managed to get the box?

I really started to get worried as the guy got closer to where we were sitting. I slipped the box of pills out of my coat pocket and held it under the table. I tried to kick Joe to get his attention, but he was watching the act and not concerned with me or the box. I finally leaned over to him and said, "Joe, take this damn box, man, that son of a bitch is liable to pick my damn pocket."

Not long after they arrived in Vegas, on January 30, Elvis' purchase of the U.S.S. *Potomac* for \$55,000 was announced. The *Potomac*, known as President Roosevelt's "floating White House" during the Second World War, had been operational up until the previous year and had most recently served as a tourist attraction in Long Beach. Its current owners, however, decided to auction it off on the eighty-second anniversary of Roosevelt's birth, and the Colonel persuaded Elvis on the spur of the moment that it might create the same kind of splash as the *Arizona* benefit in 1961 if they bought the boat and gave it to the March of Dimes.

Almost right away they ran into trouble. The March of Dimes didn't want the boat (they had no use for it, and it was too expensive a gift to maintain); on February 11 Colonel tried to give it to a Coast Guard unit in Miami, but the Coast Guard turned it down for similar reasons. The news-papers picked up the story and began to ridicule the purchase, referring to the yacht as a "white elephant" that nobody wanted and the singer and his manager couldn't unload.

Finally, on February 14, Colonel succeeded in giving the damn thing away to St. Jude Hospital in Memphis, a research center "dedicated to finding cures for catastrophic diseases of children" that had been founded and championed by comedian Danny Thomas. He had the boat towed to a new mooring and arranged to have one side painted in a hurry, in order to make a good impression on the press. Elvis and the guys drove in from Vegas the next day for the dedication ceremony at Long Beach, the guys all looking somber in their dark suits, Elvis dapper in a light continental suit, narrow patterned tie, and forelock of hair falling carelessly across his brow. Danny Thomas accepted the gift for St. Jude's, citing Elvis as a true humanitarian, and Elvis pointed out accurately that St. Jude stood near the spot on Alabama Street where he once had lived.

In the end the event generated a good deal of publicity, but Elvis was furious nonetheless. What had the old man been thinking, buying this piece of shit that nobody wanted and turning him into a laughingstock in the eyes of the world? He had agreed to it, it was true; as a student of history, and as an admirer of Roosevelt and Churchill and General MacArthur, he had been proud to purchase the boat on which great issues of the Second World War had been discussed. But the way this thing had gone, he was beginning to wonder if maybe Colonel was slipping. And besides, what did the old man mean, interrupting his Las Vegas vacation?

THE NEW SINGLE CAME OUT ON February 15, three weeks prior to the release of *Kissin' Cousins*, which had been rushed out ahead of *Viva Las Vegas* and block booked into five hundred theaters around the country. After a good deal of consideration, Elvis had finally decided to pair "It

Hurts Me" with the movie's title song — he preferred to wait for a better opportunity for "Memphis," which he continued to believe would be his best single in years. Preproduction on *Roustabout* was not scheduled to start until March 2, so they took their time coming back from Vegas, spending the greater part of the month there and only emerging groggily a few days before Elvis was booked into Radio Recorders for the soundtrack recording.

Filming started up the following week. Wallis had put together a good cast, with veteran character actor Leif Erickson playing the sentimental heavy (he's a drunk with an oppressive burden of guilt and a pretty daughter who fights Elvis at every turn but eventually comes around) and Hollywood legend Barbara Stanwyck, in a rare sixties screen appearance, deftly playing the part of the beleaguered carnival owner, a role originally offered to Mae West. The director, John Rich, was a television pioneer who had started out in comedy (*Our Miss Brooks*), graduated to westerns like *Gunsmoke* and *Bonanza*, and had just finished directing the first three seasons of the highly successful *Dick Van Dyke Show* when he signed with Wallis the previous year to make feature films. "I didn't know too much about the musical theater, I knew nothing about Elvis, I said, Why me? I had visions of doing rather grandiose pictures like *Becket*, but I was going to do the very best I could and [try to] catch up as quickly as possible."

The guys looked at Rich with suspicion; he was not the affable, easygoing sort of director that Norman Taurog was, and the atmosphere on the set was different from the start. Then Elvis injured himself on the third day, doing his own fight scene against Rich's better judgment.

"He came to me and said, Could he please do the stunt himself? I said, 'My God, no. What happens if you get hurt?' He said, 'I'm not going to get hurt. I really know how to do this stuff. You see, I'm a black belt in karate.' I said, 'Well, congratulations, I think that's wonderful, I suppose that's good in life, but this is a movie. And God forbid that you get hit in some way.' He said, 'I won't. I know these people, and they know me. I really want to do this.' He begged. He really did. And, finally, he said, 'I'll be totally responsible for this if anything happens.' Well, what do you do in a situation like that? I finally gave up and said okay. But it was a mistake, because he got clipped severely in the head, and it was like, 'Oh, God, there goes my life in the theater.' To tell Hal Wallis that I allowed the star to do a fight. I thought, This is not going to go down well.

"Of course we had to stop shooting, and I sent him off to the hospital, and he had four or five stitches in his forehead, but fortunately I had a way out. The script called for Elvis as a motorcycle rider to be run off the road [by Leif Erickson in an early scene], and I thought, There's no reason we can't put a Band-Aid over Elvis' eye. Wallis was quite pleased. He thought it was a damn good idea — as long as I could keep shooting. And Elvis was all right as soon as he got back. He was a little subdued, having caused all this trouble — he was *very* apologetic. But once I told him what I'd like to do, he said, 'Oh, that's great, because we can keep shooting.' He was just afraid we'd have to shut down."

The rest of the show was without incident. Under Rich's direction it had a better look than most of the Paramount pictures, and Rich was particularly proud of the authenticity of the carnival, which he set up on a huge cattle ranch in the Valley with over a thousand extras, and of several rather difficult, unbroken tracking shots that had Elvis singing one song while riding on his motorcycle, another to his girl as they spun around on the Ferris wheel. Rich substituted these, at no additional cost and with considerable technical ingenuity, for the conventional matte shots (a stationary Elvis against a moving background) that were called for in the script. He worked with Elvis on his lines, too, and Elvis did a decent job of recapturing some of his old rebel image, though the score was almost embarrassingly bad and the surliness that Elvis was called upon to exhibit, like the music, was clearly more synthetic than felt. There was, as well, continued friction between Rich and the guys, who fiercely resented their exclusion from the action, while Rich for his part had little use for them.

"I'm not one for fraternizing too much with the group that are around the players, but they were around quite a bit, and you couldn't ignore them. One thing that comes to mind that really troubled me: Somewhere in the middle of the picture I was in the editing room, looking over the cuts, and Elvis dropped by and started looking over my shoulder. I was working over the Moviola with my editor, and he became so fascinated with what I was doing that I showed him how we go from a long shot to a close-up, or why I was cutting something around something. He said, 'Can I come and look at this more often?' And then the guys said, 'Aw, come on, this is nonsense' only they didn't use the word 'nonsense.' And they took him away, and he never came back to the cutting room after that."

In the end probably the greatest problem was with the script, which, like the last three Paramount pictures, had been written by Allan Weiss to Hal Wallis' specifications ("Wallis kept the screenplays shallow. I was asked to create a believable framework for twelve songs and lots of girls") and

JANUARY 1962–APRIL 1964 👁 171

once again presented an Elvis who appeared only marginally less bored and listless than in any of his other recent ventures. On April 20, the last day of principal shooting, a story appeared in the *Las Vegas Desert News and Telegram*, which was headlined "Elvis Helped in Success of Burton-O'Toole Movie" and went on to explain just how:

Would you believe that Richard Burton and Peter O'Toole owe part of their current success to Elvis Presley? These two brilliant Shakespearean-trained actors, winning worldwide acclaim for their performances in *Becket*, might not have had the opportunity to star in the picture, were it not for Sir Swivel Hips. Don't laugh, it's not that Elvis refused either the role of Henry II or Becket. No, Elvis helped finance *Becket* indirectly. Producer Hal Wallis, who has made Presley's biggest hits, also produced *Becket*. And were it not for the revenue from Elvis' movies, there might not have been the wherewithal to film *Becket*. Says Wallis, "In order to do the artistic pictures, it is necessary to make the commercially successful Presley pictures. But that doesn't mean a Presley picture can't have quality, too." . . . At the moment Wallis is shooting *Roustabout*, starring Elvis. This story may not be the greatest, but then O'Toole and Burton can't sing like Elvis either.

It confirmed all of Elvis' worst fears. From the moment that he first became aware of the story, which appeared in one form or another all over the country, he freely expressed his anger and hurt. He was never going to be taken seriously as an actor; Wallis was just a double-dealing sonofabitch, and the Colonel wasn't any better — he was *never* going to get the opportunity to prove himself. The guys all nodded their heads in vociferous agreement, but if they'd thought about it, they might have recognized that most of all he was expressing his disappointment in himself. He was unhappy and disillusioned, profoundly dissatisfied with the way his life was going. He was ready for a revelation.

COLONEL PARKER, ELVIS, LARRY GELLER ON THE SET OF "SPINOUT." (COURTESY OF THE ESTATE OF ELVIS PRESLEY AND LARRY GELLER)

SPIRITUAL AWAKENINGS

HE REVELATION CAME in the form of a twenty-four-year-old hairdresser named Larry Geller, who arrived on Elvis' doorstep at 4:00 P.M. on the afternoon of April 30. Elvis' regular hairstylist, Sal Orifice, had just quit Jay Sebring's fashionable salon but told his client that Geller, a colleague for the last five years, would make a suitable replacement. Larry, who was working on their friend singer Johnny Rivers' hair when Alan Fortas called, jumped at the chance. He was met at the Bel Air gates by Jimmy Kingsley and guided back to the house on Perugia. There he was shown into the den, where he met Elvis, who was wearing a motorcycle cap perched at a jaunty angle on his head and who stuck out his hand and introduced himself, as if Larry would have no idea who he was. Why didn't they go back into the bathroom, Elvis suggested, where Larry could work undisturbed and they could talk a bit, too?

For the first hour or so the talk was little more than polite conversation. Elvis had heard a lot of good things about Larry from Sal, he told the young hairstylist. He explained that he had just finished shooting his new movie and was going to the studio the next day for publicity stills, so they couldn't do much other than maintain his present appearance. What he needed was a light trim and a little tinting just to match the way he looked in the picture. Larry was impressed with his courtesy, his thoughtfulness, his "common touch" — but he was not sure what lay behind the reticent manner. Then, just as Larry had finished spraying and shaping his hair, Elvis suddenly turned to him and said, "Larry, let me ask you something. . . . What are you into?"

Larry, who had devoted himself seriously to spiritual studies for the last four years, had no doubt that there was something out of the ordinary in the question and didn't hesitate in his response. "I said to him, 'Obviously, I do hair, but what I'm really more interested in than anything else is trying to discover things like where we come from, why we are

174 👁 SPIRITUAL AWAKENINGS

here, and where we are going.' As I'm saying this, I'm thinking he might think I'm some kind of a kook, but while I was talking, I noticed that Elvis' eyes were lighting up. . . . He said, 'Man, just keep talking, just keep talking.'

I talked about how, five years before, I had begun to wonder about life. Why? Is there a purpose to all this, or are the materialists and atheists right? . . . And what was *my* purpose?

Engrossed, Elvis hung on to every word. "What *is* your purpose?" he asked, looking into my eyes.

"If there is a purpose . . . then my purpose is to discover my purpose. It doesn't matter to me if that takes years or a lifetime. That's what we're born to do."

Elvis looked as if he'd been slapped. As he shook his head from side to side, he said, "Whoa, whoa, man. Larry, I don't believe it. I mean, what you're talking about is what I secretly think about *all the time*. . . . I've always known that there had to be a purpose for my life. I've always felt an unseen hand behind me, guiding my life. I mean, there *has* to be a purpose . . . there's got to be a reason . . . why I was chosen to be Elvis Presley."

For the next four hours he was like a parched man in the desert: he bared his entire soul. He told Larry about his mother; he told him about the hollowness of his Hollywood life; he told Larry all the things he secretly thought and could share with no one around him. "Man, Larry," he said, "I swear to God no one knows how lonely I get. And how empty I really feel." With that he burst into tears.

Larry was initially taken aback; he wondered if Elvis did this with everyone he met, if this was some kind of game. But then, as Elvis kept talking, exposing his innermost feelings in an almost painful rush of words and emotions, his suspicions were allayed, and *he* began to wonder, Why me? After a couple of hours there was a knock on the door. It was one of the guys concerned whether everything was all right — what was going on in there? Everything was *fine*, Elvis shouted through the closed door. "Leave us alone! I'll be out soon enough." Before Larry left, he had promised to quit his job with Jay Sebring and bring some of the books that he had been talking about to the studio the next day.

* * *

H E WAS AS GOOD as his word. He arrived on the Paramount lot at 8:00 A.M. the following morning with copies of *The Impersonal Life, Autobiography of a Yogi, The Initiation of the World,* and *Beyond the Himalayas.* By that evening, when Larry came out to the house with a King James version of the Bible, Elvis had devoured all of *The Impersonal Life,* and if the connection had not been made before, it was now written in stone. This was the book he had been looking for all his life, Elvis announced to Larry. This was the confirmation that he had needed.

The Impersonal Life had first been published in 1917, produced by a man named Joseph Benner who claimed not to have written it but merely to have been the vehicle for its transmittal, which came from a higher divine self. Its message, essentially, was that the truth lies within us all, that God is in fact "the divine I." "Are you ready?" came the question in the first few pages of the slender volume. "Do you *want* to go? . . . In order that you may learn to know Me, so that you can be sure it is *I*, your own True Self, Who speak these words, you must first learn to *Be Still*."

The book struck any number of chords for someone to whom it had been impossible to voice such questions or even to be sure that others asked them, too. It took into account human weakness and folly, saw these as equal parts of the divine plan. It offered hope, process, a path to selfimprovement, and redemption. It engaged a mind hungering for knowledge and lacking any clear focus, or even a true confidant, since the death of his mother. "It is really I, Who cause your personality thus to rebel; for your personality with its proud sense of individuality is still needed by Me to develop a mind and body strong enough that they can perfectly express Me. . . . [That individuality] is nothing but your personality still seeking to maintain a separate existence." All earthly events and conditions "have been but a Dream, from which you will fully awaken only when You (Humanity) again become wholly conscious of Me within."

Finally, as if anything else were needed to cement the bond, Benner declared: "I may be expressing through you beautiful symphonies of sound, color or language that manifest as music, art, or poetry . . . and which so affect others as to cause them to acclaim you as one of the great ones of the day . . . [and] hail you as a wonderful preacher or teacher." The book, which abounded in illustrations of the true connections between those things that passed for coincidence in this life, was copyrighted by the Sun Publishing Company.

"I don't believe that book," Elvis declared in wonderment to Larry. "Bring me more books like it. Whatever you think I need." They spent the evening largely in discussion of *The Impersonal Life*, talking about its meaning, talking about it specifically as it related to Elvis. The inner voice, he told Larry, was one he had been hearing since he was four or five years old; it had come to him first in the form of his dead brother Jesse's invocation "to care for other people, to put myself in their place, to see their point of view, to love them. It was like the voice of conscience." The book's message that "I will cause even you who thus seek to serve me to do many wondrous things towards the quickening and awakening of your brothers . . . I will cause even you to influence and affect the lives of many of those whom you contact, inspiring and uplifting them to higher ideals," really struck home. Once again they retreated for hours into the bathroom, where Larry washed and styled Elvis' hair; once again the guys grew impatient, querulous even over this bizarre and inexplicable diversion which their boss had chosen to take up.

Over the course of the next month Larry would arrive in his battered Volkswagen nearly every night, and they would consume the evening in extended bouts of philosophical discussion that excluded everyone else not just intellectually but physically as well. Quickly the whole tone of life at Perugia changed, and a grumbling mentality took hold among most of the guys. Why weren't they heading home for Memphis? they complained. They had a month between pictures. If there wasn't time to go home, why didn't they take off for Las Vegas and have some fun? If anyone suggested inviting some girls over or throwing a football around, Elvis appeared to be totally indifferent. Joe Esposito, whose primary concern was to make sure that things ran smoothly, was willing to give him the benefit of the doubt initially. "I liked Larry at first. He was a nice, good-looking guy, very polite - but strange. To me it was almost like he was brainwashing Elvis. He'd get him into that bathroom and cut and dye his hair, and they'd talk for hours at a time and go into all these things. We were having fun, and now all of a sudden Elvis is outside looking at the stars all night or reading these books — you get up in the morning, and he's sitting there reading a book and asking questions about religion. Hey, what about the football game that happened last weekend? We used to sit and watch football games. All that stuff was gone."

As far as Joe was concerned, Elvis was easy pickings for a self-styled guru like Larry; his passive personality played right into Larry's hands. "He was always gullible when it came to those things. He was always trying to figure out why he was the one picked to be who he was, why he was the one chosen — he was into all these things that you couldn't solve. He liked to show his intelligence by trying to find the answers that no one else knew."

The other guys almost universally agreed. Some of them started referring to Larry as the Swami or Rasputin or the Brain Scrambler and making cracks to his face as well as behind his back. Some of them referred to him as the Wandering Jew, but mostly what they felt was a seething, undifferentiated resentment. Elvis made a few perfunctory attempts to get Larry to explain to the guys what they were studying, even to get them to read some of the books, but with the exception of his cousin Billy and Charlie Hodge, who was at this point only an intermittent presence in the group and who had recently discovered Autobiography of a Yogi on his own, he was met for the most part with sullen indifference. To Sandy Ferra, on the other hand, Larry was like a breath of fresh air in a frequently suffocating environment. In Sandy's view, "The spirituality was always there, but Larry brought it out when he brought the books to him. I think it gave him some peace. I was eighteen, and I had read Gibran, I had read the Buddhist Bible, because I liked to look at other philosophies. Elvis gave me a copy of The Impersonal Life, and he said, 'You have to read this.' He had underlined it himself."

Larry, for his part, was getting to know a witty, insightful, impractical man riven with contradictions. The Elvis that Larry saw was shy, he didn't trust himself, he was afraid people might laugh at him, but he also possessed a quality of inner calm that permitted him to study himself minutely, without self-consciousness or vanity. "When Elvis appreciated something, when he appreciated beauty, he just appreciated it; it was timeless to him. Like a flower — a flower just exists now, it doesn't exist yesterday. It just is. If Elvis loved something, it just was. [That kind of appreciation] is different, perhaps 'abnormal.' But there's something beautiful and interesting about it." To Larry, Elvis possessed an uncanny ability to "read" people, too. "His intuition was highly developed, and very little escaped his notice." And yet, Larry felt, he had surrounded himself with people who had no sympathy for his spiritual needs or aspirations.

Larry was amazed not only at Elvis' desire for knowledge but at his aptitude for it. For someone who had never been exposed to any sort of formal study before, he seized upon the reading that Larry gave him with an unquenchable thirst. In addition to *The Impersonal Life*, which he kept going back to over and over again, he devoured Paramahansa Yogananda's *Autobiography of a Yogi*, Krishnamurti's *First and Last Freedom*, Madame Blavatsky's

178 👁 SPIRITUAL AWAKENINGS

translation of *Voice of Silence, Leaves of Morya's Garden*, and dozens of other books on numerology, cosmology, and metaphysics over the course of the succeeding weeks and months. "[He] was requesting a new book almost every other day. . . . It was never enough for him to simply read a book; he had to absorb it, think about it, question it, link its thoughts and ideas with all he had read before and things he had heard people say. Elvis dog-eared pages, highlighted passages, and jotted notes and questions on the endpapers and throughout the margins. For Elvis, reading wasn't a passive activity; each book promised a new adventure, a new way of viewing things."

The New MGM PICTURE, Girl Happy, the last in his 1961 contract, began with a recording session at Radio Recorders on June 10. Freddy Bienstock had assembled what was by now a typically desultory grab bag of songs, and Elvis was sufficiently embarrassed, while recording the title song on the first day, to beg the movie producer, Joe Pasternak, not to bring his vocal up in the mix. On the second day he walked out in the middle of the session after thirty-six takes of a number called, with no apparent attempt at irony, "Do Not Disturb."

The film itself was no better. Joe Pasternak, a sixty-three-year-old native-born Hungarian with a career in pictures dating back to 1929 in Europe, was a longtime Hollywood operator who had come to MGM in 1942, after first saving Universal with a string of Deanna Durban musicals. His original idea, while at Columbia briefly in 1957, was to cast Elvis Presley in *Gidget*, the first "beach movie." The studio turned him down, and he went back to MGM, where he had a hit in 1960 with a wholesome picture about college kids on spring break in Florida. That was what gave him the idea for *Girl Happy*. "Metro had signed him for four, and I was at Metro as an independent producer. I went to them and told them I had an idea for Elvis Presley. I knew he was a young guy and that he could sing well, and I did [this] picture, *Where the Boys Are*, with the same background, Fort Lauderdale — and I was crazy about the background. [So] they said, 'Go ahead and make it.'"

Like *Kissin' Cousins, Girl Happy* was done on a short production schedule. Elvis was to be paid his usual \$500,000 for six weeks' work and would get 50 percent of the profits after the first \$500,000 in profits had been recouped by the studio. The rest of the budget came to less than two times the star's salary, and the finished picture had a bargain-basement look, with no location shooting and poorly matched matte shots. On the set Elvis

seemed uncharacteristically subdued, almost dispirited. There were the usual celebrity visits; Ann-Margret came by from time to time to say hello, and the guys all liked co-star Gary Crosby, Bing's son, who had often played football with them at De Neve Park. Plus, they got a kick out of facing down the Secret Service detail accompanying Lynda Bird Johnson, the president's daughter, when she visted the set, as each group stood screened by dark glasses and impenetrable expressions, waiting for the other to blink.

Their old pal movie actor Nick Adams showed up for the Colonel's fifty-fifth birthday on June 26, and there was a cake and the usual celebration, but Colonel was absent with back trouble for much of the picture. On one of the few occasions that he was present, he gave an interview to gossip columnist Earl Wilson, throwing off the usual lines in typically boisterous and undiminished fashion. "Do you remember when we came out here?" he asked of no one in particular. "They didn't give us six weeks." What about marriage? Wilson asked. "There's a rumor, Colonel, that if Elvis ever gets married, you're going to have it in the Hollywood Bowl and sell tickets." "Untrue!" the Colonel responded with animation. "I always figured on a nice quiet wedding on top of an elephant."

Elvis, Wilson noted, was "as quietly non-circusy as his manager was the carnival barker when I found him in his portable dressing room." He had little to say about marriage or anything else other than to concede that he probably would get married someday as he glanced down embarrassedly at the floor.

I was a time in which he felt oddly distanced from his old life. Between his reading and his daily obligations at the studio, there was little time for anything else. Elvis was just counting the days till the movie was done; he wanted more time to devote to his spiritual studies and was impatient with the progress he was making. Larry told him that you needed to assimilate the lessons, that there were no shortcuts. But Elvis was sure that he could go faster once he got home to Memphis. Each night on the phone he told Priscilla excitedly about his new discoveries, he couldn't wait for her to meet Larry, he said; he knew the two of them were really going to get along.

Early in the summer Johnny Rivers' version of "Memphis" hit the charts. It took everyone by surprise, because Johnny had been a frequent visitor at the house over the last three years. He had played football with them, been accepted as one of the gang, and even jammed with Elvis on the Chuck Berry number after Elvis played him a test pressing of his own recording of the song. There was no question among any of the guys that Johnny had known Elvis was planning to put it out as his next single. Elvis should just release his version now and kill the little cocksucker's, they all muttered angrily among themselves. But Elvis would not; he just shook his head sorrowfully and said he didn't want to see Johnny anymore. And in July RCA quietly put out "Such a Night" from his first post-army session in March of 1960 (it had originally been released on the album *Elvis Is Back*), after Conway Twitty had enjoyed some chart action on the song in a version produced by Nashville newcomer Felton Jarvis for ABC Records.

With sales of little more than three hundred thousand, "Such a Night" barely outsold Elvis' last single, "Suspicion," another old album cut which had been rushed into release when Terry Stafford had a number-three hit with his version of that song earlier in the year. In fact, with the exception of "Kissin' Cousins," none of the four singles released so far in 1964 had sold half a million copies, not even the title cut from *Viva Las Vegas*. It might have been a more sobering time if the movie itself had not opened at number fourteen on *Variety*'s July 1 box-office survey, with glowing reports coming in from New York, Atlanta, Omaha, Cedar Rapids, and all over the country. But even if the movie had not done such reassuring business, it probably wouldn't have mattered all that much to Elvis. His mind was clearly elsewhere.

Colonel asked to meet with him just before he left for Memphis in mid-August. Larry and some of the guys accompanied him to the lot, waiting in the car while he talked with the old man. After about half an hour, Elvis emerged, "his face red," Larry later wrote, "his jaw clenched in anger. He quickly stepped into the car, and after one of the guys slammed the door behind him, he started screaming. 'How dare that sonofabitch!' Elvis shouted. 'He doesn't know the first thing about my life. He doesn't know anything about me. He said I'm on a kick, a religious kick. It's not a kick, it's my life. And my life is not a kick. It's real.'" He then glared at each of the guys except for Larry and declared meaningfully, "I wonder who gave him that idea. What happens in my house is my private business. It is none of the Colonel's affair, nor anybody else's."

For all of his brave words, though, Larry knew that the Colonel had gotten to Elvis and that this would not be the end of it. The Colonel had always been perfectly polite on the few occasions that they had met, almost excessively so, as if he were observing the newcomer, coolly taking his measure. But now it was clear that he had made up his mind and that, one way or another, battle was soon to be joined.

THE TRIP HOME WAS as unusual as every other aspect of their two-THE TRIP HOME WAS as unusual as any and one-half-month relationship. Larry sat up front beside Elvis in the motor home. "Elvis is driving, the guys are in the back, and we're all talking, and I'm just yacking about everything, metaphysics and God and life. But then every hour or so he'd pull over and start reading The Impersonal Life or some other book, and the guys started getting angry at me, 'cause they knew I'd started this. We got to the outskirts of Oklahoma City, and all of a sudden Elvis pulled over into a big lot. I'm sitting right there, and he turns to me and says, 'Would you step outside with me?' And I'm thinking, 'What the heck is going on?' He says, 'Okay, tell me the truth, who sent you here to give me this material? Where do you come from?' I'm about to open my mouth, and a car pulls up, and two guys jump out. Reporters. And they say, 'Can we have a picture?' And he says, 'Sure. If you take one with my friend.' He put his arm around my shoulder, and I'm thinking, 'I don't believe this. What's really happening behind this picture?' Anyway, they shake Elvis' hand, get in their car, and he turns to me and says, 'All right, answer me, who sent you?' I said, 'Elvis, you sent me. You know that.' He looked at me with a big grin and said, 'You're right.'"

Larry had come upon one big surprise already. A sometime recreational drug user, Larry had never taken pills of any kind, or, up to this point, seen any evidence of Elvis taking pills. Just outside of San Bernardino, though, Elvis offered him a couple of Dexedrine tablets, with the explanation that they were going to be driving through the night and that they wanted to be alert at all times. Larry took the pills with some misgiving, figuring that it *was* a long trip and they had so much to talk about.

And what a trip it was. As Elvis sat listening intently, I talked, and talked, and talked. I literally could not shut up, and while Elvis enjoyed hearing me ramble on and on about every spiritual book I'd ever read, every idea I'd investigated, by the next day my jaw was killing me. Only later did I learn that Elvis didn't want to "loosen me up," as he so delicately put it, for his benefit alone, but for the guys'. From the moment Elvis embarked on his spiritual studies, he never totally relinquished the idea that he could teach [the] others by his example. . . . That he

182 👁 SPIRITUAL AWAKENINGS

had some inkling of the guys' reaction was obvious. And just as Elvis set me up as the mouthpiece to say to the guys things he wanted to say himself, many of them answered him by making me a sort of walking effigy of the spiritual Elvis, the guy they didn't like. The wisecracks and insults they didn't dare hurl at their boss were aimed squarely at me.

The bad karma came to a head in Amarillo, where, as was common, a crowd gathered outside the motel where they had stopped to sleep for a few hours during the day. The guys all knew that this was a result of the Colonel leaking the location just to create a little excitement, but this time Elvis pointed the finger squarely at Joe. "It was about four o'clock in the afternoon, and there was this roar of kids outside. Hundreds of kids outside the motel room yelling, 'Elvis! Elvis!' What had happened was that they were announcing on the radio that Elvis was in town at this motel. I knew what had happened. Every time we'd stop, I'd check with Colonel and say, 'Okay we're here.' And Colonel called the radio station. But Elvis got pissed off at me, and we had a big fight, and I quit on the spot, and Jimmy Kingsley quit with me. I didn't leave, but I didn't ride with Elvis for the rest of the trip, I just stayed in the Pontiac station wagon pulling a trailer."

Everyone was a little taken aback, but this kind of thing happened all the time, and as they made their way back to Memphis the mood was subdued; they were more fed up than anything else at the constant, incomprehensible dialogue that continued to go on between Elvis and Larry. If things had been anything like normal, Joe would probably just have been hired back on the spot before they even got home, or Elvis would simply have acted like nothing had happened, but by the time they rolled through the gates of Graceland, Marty Lacker was firmly ensconced as the new foreman and Joe returned to Hollywood a couple of days later, still pissed off, a little fearful, but confident that he could find work based on all the connections he had made in the last four years.

In Memphis Elvis had to show Larry everything. They drove out Bellevue to Forest Hill Cemetery to see Gladys Presley's grave, and Elvis stood silently for fifteen minutes communing with his mother's spirit. One day Elvis gave Larry a car and told him to drive to Tupelo to see with his own eyes what Elvis had been telling him about. They drove around Memphis, and Elvis pointed out Humes High School, the public housing project where he had grown up, the various places he and his parents had lived, the places where memory resided. Elvis' father, Vernon, appeared reserved and suspicious, but that didn't really surprise Larry from the way Elvis had described his father. "I'm sure Vernon saw me not as his son's employee or friend, but as another weekly expense." It was Priscilla who came as the surprise. Far from being the warm, welcoming presence that he had expected, she appeared disinterested, dismissive, almost jealous of his role. She read Vera Stanley Alder's *Initiation of the World*, but with little interest or pleasure; her eyes glazed over when Larry started to talk of the Oneness of Being; she seemed to display a kind of unreasoning animosity toward him that bordered on fear.

"Larry was a total threat to us all. He would spend hours and hours and hours with Elvis, just talking to him, and he wasn't *anything* that Elvis represented; he didn't represent anything that Elvis had believed in prior to that time. Everyone wondered who he was, what he was doing there, what they talked about. When I first met him, I thought, Well, he's not so bad, he's really harmless. But then Elvis went the other way and became harmless, unthreatening, energyless — he became passive. Which was the total opposite of what he had been before. He read books studiously for hours and hours. He had conversations with Larry for hours and hours — he was going on a search for why we were here and who we were, the purpose of life; he was on a search with Larry to try to find it. You know, Larry would bring him books, books, books, piles of books. And Elvis would lay in bed at night and read them to me. That was the thing when you dealt with Elvis: if he had a passion for something, you had to go into it with him and show the same love he had for it. Or at least you had to pretend to."

To make him feel more at home, Elvis flew Larry's wife, Stevie, in, along with their two kids, Jova and Kabrel, and put them up with Larry at the Howard Johnson's just down the street. He continued to rent out the Fairgrounds, where Red went after Larry one time on the bumper cars. "He came at me as if he were protecting Elvis from me. Maybe in his mind he was. 'I'm going to kill you, you motherfucker!' he screamed. 'I'm going to get you!' And he did." At the Memphian they saw *Dr. Strangelove* three times in a row, then watched the final reel an additional three times before Elvis was satisfied. Peter Sellers was so subtle an actor, he had so many different bits of business going on in a single scene, Elvis told Larry, "that you don't always get him the first time, or even the second or third." They watched the Hal Wallis production of *Becket*, too, and Elvis once again wondered if he would ever get to play a substantial dramatic role in his own film career.

T WAS A VERY DIFFERENT GROUP under Marty's leadership. For sometime there had been serious division among the guys, and an undercurrent of resentment against Joe in particular for the way he acted — like he thought he was better than everyone else. Red had never liked him, and Elvis' cousin Billy Smith dismissed him as "a big college man" who established class separations within the group, even though Joe had never finished high school. Most of all, though, Marty, a brooding, naturally choleric man whose anger was fueled by amphetamines, just couldn't abide taking orders from Joe, and he encouraged everyone else to feel the same. There was never any question in his mind that given the same position, he could do it better, and even though he had railed at Joe's "military" organization, he unveiled a fussy eccentricity of his own as he swiftly established a new order in the Elvis world. With a nod from Elvis. he made up lists of duties for everyone: it was up to Marty to "call Mrs. Pepper [for] Movie Times (As Early As Possible); Transact Business and Correspondence with the Colonel's office for Elvis," and maintain a purchase order system for all charges in Elvis' name. Alan Fortas got the assignment to, "along with Marty, be responsible for Organization both in good and bad situations," maintain Elvis' scrapbook, and "be in den with Elvis as much as possible." Marty and his family (his pregnant wife, Patsy, and two small children) moved into the garage apartment behind the house that Vernon and Dee had once occupied, and in every way he tried to make himself as indispensable to Elvis as he could.

Two days before their scheduled departure for California, on the evening of September 21, Elvis was appointed deputy sheriff of Shelby County, a promotion over his previous title of "honorary chief deputy," by newly elected Sheriff Bill Morris. He was photographed and fingerprinted for his official badge, and he reminisced with Morris, who had grown up in the old North Memphis neighborhood and whose wife, Ann, had been a classmate of Elvis' at Humes High, about "the good old days" they had both known and how far they had both come. He told Morris that he had "always been interested in law enforcement" and, according to a *Press-Scimitar* account of the meeting, that he had "once applied for a job as a Memphis policeman but been turned down because he was too young — only 19." After a pleasant visit in which Elvis reiterated that he was still "crazy about Memphis" and that Ann-Margret was "great," he rejoined the guys outside and went off with them to the movies.

That Friday night, after postponing his scheduled midweek departure by two more days, he went to the movies one more time, screening *Dr. Strangelove* for the fifth time on this visit, along with two other pictures. There was still one opening on the staff left to fill after Elvis hired Mike Keaton, who had been hanging around in much the same way that Chief and Richard Davis and Jimmy Kingsley did a few years earlier. Keaton was quiet, introspective, a member of the First Assembly of God Church, and his wife's name was Gladys — he looked like a good fit, though no one was quite sure what his connection was. Then, on the evening of the twentyfifth, Elvis gave the nod to a considerably more familiar but, at the same time, less predictable choice.

Jerry Schilling was twenty-two years old and in the first semester of his senior year at Memphis State, where he was studying to be a teacher. A big, square-jawed ex-football player, he had left Arkansas State College when he lost his football scholarship due to a back injury, then followed his girlfriend to New York for a time and come back to Memphis the previous year to finish his education. Raised by his grandparents from the time of his mother's death when he was only one, he grew up shy and insecure, barely knowing his father, brought out of himself — like many of the guys — by his talent and love for sports. In 1954 he had been introduced to Elvis by Red, who had grown up with his older brother, Billy Ray, now a Memphis policeman. They were playing football at Guthrie Park in Elvis' old neighborhood, where Jerry, too, grew up, and they needed an extra player, so Elvis invited the shy twelve-year-old to join.

He had been hanging around the fringes of the group ever since, going out to the Fairgrounds with them, returning from Jonesboro, Arkansas, his first couple of years in college every weekend that he could, just to see what was going on. Elvis talked to him in a way that no one else ever had; "you just felt when he talked to you, it was like you were the most important person in the world. I mean, he knew how shy I was and that I really admired him, but people just didn't take time to go and talk about life with you like that. The feeling you had was that he felt like you understood him, and that's why he talked to you this way."

For all of his credentials, though, Jerry didn't seem to fit in with the rest of the group. He was perceived as a "liberal" in a world where the prevailing views were presumed to be conservative in terms of race and southern values; he was seen as something of a hothead by Marty in particular, who resented his youthful presumption and intellectual pretensions; and he was generally believed to be a Catholic (an equal sin among both the Jews and the Protestants in the group) because he had attended parochial school, even though his family background was as Southern Baptist as the majority of them. At this point he had been hanging around for so long that his presence was taken almost for granted, and everyone knew that Jerry really wanted it, but no one thought he was quite right for the job until Elvis finally gave him the nod, practically out of the blue.

Jerry was down at the Film Exchange with Richard Davis, returning the evening's viewing when he got a telephone call from Elvis. "It was almost four in the morning by the time I went out to the house, and he told me he needed me to go to work for him. I said, 'When?,' and he said, 'Now.' I said, 'Can I go home and get my clothes?,' and he said, 'We won't be leaving till this afternoon.' So I went home and got my stuff and came back and just sat out on the back porch thinking until they were ready to go. We left late that day."

The trip out was an education. Larry had already returned to California with his family, so even with the two new additions there were only five or six guys, and Elvis did most of the driving. Every time they pulled into a truck stop, they would toss a football around under the lights, with everybody diving for the ball and running around, until Jerry, who was still in shape for college football, was worn out. "I never could figure out how Elvis could play so damn long, seven or eight hours at a stretch, and then I found out that night, literally. He didn't give me anything himself, but he gave it to someone else, and then they gave it to me. I mean, I had never taken a pill in my life, but pretty soon I was playing like he was, and when we got to the hotel to rest for a few hours, I couldn't even go to sleep, I was so wide awake. The rest of that trip I don't think I ever ate. I ran after footballs, I was diving for the ball. I just thought, 'This is great' - 'cause I figured anything that he did had to be great, there couldn't be anything wrong with it. By the end of the trip, I think I'd lost about twenty pounds, and he was probably saying, 'What happened to the big guy I hired?'"

If that was a revelation, the arrival in California offered an even more graphic introduction into Elvis' world. When they got to the house on Perugia, Jerry was assigned Billy Smith as his roommate, but he was too excited to go to bed. "Everybody was beat and went to sleep, but I'd never been in a place like this before — there was a pool in the backyard, there were all these colored lights, and I was just sitting there in the den pretty much in the dark just looking around, when all of a sudden I hear the front door click, as if somebody's got a key, but everybody's in their room asleep. Anyway, I'm sitting there, and I see this woman with long hair walking across the room towards Elvis' bedroom, and she knocks on the wall, and I go, 'Miss?,' and she turns and screams, and the wall opens up, and Elvis is standing there, dying laughing. He says, 'It's okay, Jerry, it's Ann [Margret],' and she goes into the bedroom, and the next night he's telling everyone else the story!"

They began work on the new film, *Tickle Me*, for Allied Artists ten days later, on October 6. From Jerry's point of view, there was nothing about the new life that was not in some way enchanting. It was a dream beyond imagining to drive to the studio every morning with Elvis summarily reviewing his day's dialogue, then watch him deliver it letter-perfect on the set. Jerry was alternately fascinated and puzzled by Larry Geller, whom he had scarcely met before coming out to California, and he took to reading some of the books that Larry recommended with keen interest. Even shopping with Marty became a kind of surreal adventure, after Marty decided that the maids were spending too much money on food and assigned Jerry to follow him up and down the supermarket aisles, checking prices against the interminable lists he had compiled.

Most of all, though, what he hungered for was Elvis' approbation. "I practically didn't speak for the first few weeks. He knew I was sensitive, and sometimes he'd get pissed at the other guys just because they'd been around so long — but then he'd wink at me, like 'Don't worry about it.' After a while I realized he was almost as shy as I was; there were days when he would just brood over things, because he was so unhappy with the reality of his accomplishments. Then one day you'd see nothing but anger and I've never seen anyone with an anger stronger than his. If he had been just a nice guy, I don't know if I would have loved him as much, but the fact was that he had all this power; he had such extreme power that he could have gotten away with anything at this point. *And yet he chose to be sensitive* — most of the time. And those times that he didn't, you knew that they were very important to really understanding him."

The making of *Tickle Me* went no better and no worse than any of the other recent movies. Elvis' \$750,000 salary made up more than half of the \$1,480,000 budget, and with the star's 50-percent profit participation, Elvis and the studio were truly partners. This was Elvis' first picture for Allied Artists, and Colonel was well aware of the financial difficulties the studio was in. Earlier in the year he had magnanimously offered to let Allied head Steve Broidy out of their agreement, and when Broidy demurred, pinning

the studio's hopes for survival on the success of the new Elvis Presley picture, Colonel encouraged Norman Taurog, back at the helm for the fifth time and always an efficient worker, to do his best to bring the picture in under budget.

It was in August, just a month before the film's scheduled start, that the Colonel came up with his most ingenious ploy of all. In a dense two-page letter, dictated on August 21 "from the hospital bed at the apartment" (Colonel was still laid up with a bad back), he reported to Elvis on a three-hour meeting he and Abe Lastfogel had just had with Broidy and Ben Schwalb, the picture's producer. He had proposed to them what he had already discussed with Elvis: that they forgo any original soundtrack recording for this movie and substitute instead a dozen songs already recorded by Elvis and proven by LP release. Each of the songs would be owned by Elvis Presley or Gladys Music and would never have appeared on a single or EP. In this manner they could bypass all the problems and expenses associated with soundtrack recording (finding the right songs, paying for musicians and studio time, pinning Elvis down on a date) and yet retain a majority of the benefits (having a single, or even an EP, to promote the picture).

Mr. Broidy and Mr. Schwalb immediately grasped the advantages of such a setup, Colonel wrote to Elvis; it was now merely up to Elvis to endorse it. And to that end he was including a list of twenty-two songs that he thought might fit the bill. It was entirely Elvis' decision, of course, and he could select any ten or twelve other songs that he liked, if he so chose the producers just had to know by August 25, or else Elvis would have to come back to California a week or two early to record a fresh soundtrack.

Elvis did not object, though he did not respond until well after the Colonel's firm deadline. "Arrangements with records okay," was his terse, telegraphed conclusion. So for the first time, Elvis did not record a single new song for one of his motion pictures, and perhaps just as significantly, Colonel did not deliver a single tape to RCA.

Colonel was, as always, looking to the future. Under the amended 1961 agreement with Hal Wallis, there was just one picture to go at a salary of \$200,000, though the Colonel was confident that this, like every other aspect of their deal since 1956, could be upgraded. To that end he bombarded Wallis with a blizzard of complaints and correspondence all through the fall of 1964, prepared, as always, to give Wallis and his partner, Joe Hazen, the opportunity to show their appreciation for Elvis and the Colonel's loyalty to their original benefactors, despite the niggardly pay.

Roustabout opened to fairly tepid notices on November 11, just three months after the Beatles' *A Hard Day's Night* premiered in this country to rave reviews (it was called "the *Citizen Kane* of jukebox movies" in the *Village Voice*) and brisk summer business. This was one of the few things that the Colonel didn't note in his extremely active correspondence with Wallis that fall, which seemed aimed almost as much at bedeviling Wallis and Hazen as improving his client's working conditions.

Meanwhile, the Colonel was also in negotiations with MGM, and as the year wore on, he closed in on the sr million fee he had been seeking as a benchmark all along. It was part of a new three-picture deal in which only the first picture actually delivered the sr million, while the last two paid \$750,000 apiece, with profit participation for each at 40 percent from the first dollar. It was an unquestionable financial coup, but perhaps just as significantly, it explicitly embraced the principle established by *Kissin' Cousins:* that fewer shooting days promised greater potential profits for all.

He had the MGM deal wrapped up just before Christmas, even as he was concluding yet another agreement, this one with United Artists, for two pictures at \$650,000 apiece. Thus, by the end of 1964, Elvis was in effect the highest-paid star in Hollywood, not on a per-picture basis (though figuring in the profits, he might even have been in the running for that), but on the basis of his ability to make a minimum of three pictures a year at \$500,000 and up, with profits virtually guaranteed. By the time the Colonel had completed his negotiations, he had eight pictures scheduled over the next three years (at guaranteed salaries adding up to \$5,350,000), with new possibilities opening up seemingly every day. It was little wonder, then, that Colonel should express a certain sanguinity when he was interviewed in November on the set of *Tickle Me* by *New York Times* reporter Peter Bart. "We're doing all right the way we are going," he drawled to the reporter, lighting his cigar with a foot-high silver beacon. "Every year more money rolls in."

THEY RETURNED HOME at the end of November for the usual threemonth break. There was a brief contretemps among the guys over their Christmas present to Elvis: Marty went out and got a deluxe leatherbound white Bible and then had a sketch he had drawn of the "Tree of Life," with Elvis' name on the trunk and each of the guys' names on a separate branch, printed at the front of the book. Underneath the tree was one of Elvis' favorite quotations: "And ye shall know the truth, and the truth shall set you free," written in English, Latin, and Hebrew "to represent the religions of all the men who were his friends." Somehow, though, Marty neglected to inform Larry of the gift, an omission that Elvis immediately picked up when he failed to see Larry's name inscribed upon it. He refused to accept their present until Larry signed one of the branches that was still available at the bottom of the tree.

This wasn't the only snub that Larry was forced to endure. He continued to be made fun of for his lack of interest in contact sports (he preferred tai chi), his musical tastes (Bach), and his predilection for recreational drugs — and there were few tears shed when he was busted for marijuana by the Memphis police, a mess from which Larry was extricated only by the direct intervention of Elvis and his friend Sheriff Bill Morris. Even Larry's Jewishness was grist for the mill as the guys referred to him to his face as "Lawrence of Israel," but here, too, there was a clear sense of rivalry as well, particularly with Marty, who was at least as proud of his Jewish heritage.

Larry had introduced Elvis to new ways of thinking about Judaism early on when he had drawn a connection between Judaism and numerology (Larry contended that "rabbis change people's names according to numerological principles"), and Elvis had taken to wearing a gold chai around his neck when Larry explained to him that chai, in Hebrew, meant "life." Both Larry and Marty claimed credit for encouraging Elvis' decision that Christmas to have a new headstone placed on Gladys' grave - with a Jewish star on one side, a cross on the other — and while George Klein and Alan Fortas, the other Jewish members of the group, wholeheartedly approved, there was no question that some of the other guys remained skeptical of the whole enterprise. According to Marty it was not long afterward that he and Elvis came up with an idea for a watch that would alternate the cross and the Star of David on its face, as a symbol of universal brotherhood. He took a sketch to the jeweler Harry Levitch, who created a prototype from which he subsequently manufactured hundreds of the watches for Elvis to give to friends.

Clearly Vernon could not have been altogether pleased with these developments. Both Marty and Larry were well aware from talking with Elvis that Vernon was less than totally understanding of the need for such ecumenicism, and Marty was convinced that Vernon and everyone else in the family were anti-Semitic — and that the rest of the family was crazy, too. In the short time that the Lackers had been living at Graceland, Elvis' uncle Johnny Smith (Gladys Presley's brother) had threatened Marty's wife and come at Marty himself with a knife, while Clettes Presley (Vester's wife, and Johnny and Gladys' sister), who drank as heavily as her brother, had made it clear that she had little use for him, too. Marty didn't think much of Elvis' retarded uncle, Tracy, who went around saying, "I got my nerves in the dirt" and made noises "like he was getting ready to explode"; overall, it could be said that he took a pretty dim view of the whole clan.

Larry's perspective was somewhat more benign; he saw the family as victims of a general benightedness and lack of education, subject to the same opportunism that preyed upon the guys and doomed his own relationship with them, the fear that some undeserving newcomer was going to take away from them what was rightfully theirs. Mostly, though, the tensions were relatively muted, with Elvis and Vernon finally settled into a more comfortable relationship in which Vernon's life with Dee and her boys was simply an accepted fact and Vernon could walk from their new house on Dolan to his office behind Graceland through the back pasture gate, have a companionable breakfast in the Graceland kitchen, or come to visit at a moment's notice at any time, day or night.

In fact, the one abiding source of tension between father and son was money: Elvis had no idea what anything cost and couldn't care less, Larry observed; Vernon, on the other hand, "lived in constant fear that something . . . would befall them, and that one day he and Elvis would find themselves back in Tupelo . . . [a prospect that] struck terror in Vernon's heart."

Far more disturbing was Priscilla's fierce, undiminished, and virtually undisguised hostility toward him. Larry put it down to a lack of spiritual awareness on Priscilla's part, but for Priscilla it was a more visceral concern, in terms of her relationship with Elvis virtually a matter of life and death. Under Larry's influence, as she saw it, Elvis no longer took any interest in her. At night he would read to her in bed, but he simply refused to indulge in any of the sexual pastimes which they had substituted for actual lovemaking. He was, he told her, "going through a cleansing period, physically and spiritually. Any physical temptations were against everything he was striving for."

"Cilla," he said one night before we went to bed. "You're going to have to be pretty understanding these next few weeks, or however long it takes. I feel that I have to withdraw myself from the temptations of sex." "But why? And why with me?"

He was quite solemn. "We have to control our desires so they don't control us. If we can control sex, then we can master all other desires."

When we were in bed, he took his usual dose of sleeping pills, handed me mine, and then, fighting off drowsiness from the pills, pored over his metaphysical books.

As his soul mate, I was expected to search for answers as fervently as he did, but I just couldn't bear reading the ponderous tracts that surrounded us in bed every night. Usually within five minutes of opening one, I'd be sound asleep. Annoyed at my obvious disinterest, he awoke me to share an insightful passage. If I voiced the slightest protest, he'd say, "Things will never work out between us, Cilla, because you don't show any interest in me or my philosophies." Then, pointedly: "There are a lot of women out there who would share these things with me."

[At one point] I could bear it no longer. I lost control and started screaming.

"I can't stand it! I don't want to hear any more! I'm sick and tired of your voice going on and *on*! It's — driving — me — crazy!" I was hysterical, pulling at my hair like a wild woman.

"What do you see?" I demanded. "Tell me, what do you see?"

He stared at me, his eyes half-closed. "A madwoman, a goddamn raving madwoman," he answered, slurring his words because of the sleeping pills.

I fell on my knees beside him, crying. . . . By the time I'd finished my tirade, all I could hear was the faint sound of religious music playing on the radio. I looked up at him. He had fallen into a deep sleep.

On January 8 Elvis celebrated his thirtieth birthday. The guys gave him a tree of life medallion, and he spent the day at home, reading his books and quietly contemplating the past that had brought him to this point and the future that lay ahead. Before he left for Hollywood at the beginning of March, he reflected a little to *Commercial Appeal* reporter James Kingsley on the meaning of it all. "We have come a long way from Tupelo," he told Kingsley, who, next to Bob Johnson, had known him probably as well as any of the Memphis reporters. "I know what it is to scratch and fight for what you want." He could never forget the longing to be someone, he said, as he gave an outsider a rare glimpse of Graceland. "Behind the enormous white couch," Kingsley wrote, "were floor-to-ceiling red drapes, hung on pushbutton, electric traverse rods. A fireplace of smoky, molded glass dominates the opposite wall. Scattered around it are white chairs and multicolored cushions on a deep, white carpet. To the left is the dining room, where a star-shaped chandelier hangs above a walnut table. The chair seats, repeating the color theme, are covered in red velvet.

"Opening off the other end of the living room is the music room, with an ivory grand piano and an ivory TV set. . . . 'Do you think that house in Tupelo would fit in this room?'" he mused, proudly showing Kingsley the rest of the house (though it remained off-limits to the *Commercial Appeal* photographer), his seven or eight cars, motor home, and three motorcycles — and a way of life that was as deliberately unpretentious as it was whimsical. "His idea of an elaborate meal is a small steak and potatoes. Breakfast generally is well-done bacon, scrambled eggs, toast and coffee. . . . For snacks he fancies sandwiches made with jelly or peanut butter and mashed bananas." He was aware of his reclusive reputation, reported Kingsley, but was at pains to point out that "I certainly haven't lost my respect for my fans. . . . I withdraw not from my fans but from myself." He hoped to have children, he said, if he could only find the right girl. If he did, he said, "I would name my first daughter Gladys, after my mother."

Then he looked at his watch and turned to the reporter with a smile. "Look, let's quit this business. It's after eight, and the night's pretty outside. After all, I am one of the night people. The sun's down, and the moon's pretty. It's time to ramble."

B y the time the story came out on March 7, he was back in Hollywood, but for all the contentment that he had shown the reporter ("Elvis is as gracious as the caricature of the Southern gentleman . . . [his language] a mixture of colloquialisms strangely juxtaposed with the words of an intelligent man who was not content to let his education end with his graduation from Humes High School"), he was no longer the same man that he had been. For he had finally had his vision on the road to Damascus.

He had been waiting for it for so long that he thought it would never come. Larry kept telling him that he simply had to be patient, that you couldn't force these things, but he was not easily assuaged. He had been dedicating himself to his studies for almost a year now, he had read over a hundred books, and if something was going to happen, *it should have happened by now*. He had it out with Larry just before they got to Amarillo, pulling suddenly into a motel as Marty complained that they didn't have time to stop, they were scheduled to be in L.A. on the weekend to be ready for preproduction starting on Monday. Larry found Elvis in his room "looking worn and depressed. Without speaking, he rose, and, while pacing back and forth, kept shaking his head in dismay. Finally he declared firmly, 'All right, all right, Larry. Just tell me the damn truth, man. What am I doing wrong, huh? What's wrong with me? Maybe God doesn't love me or something. . . . All I want is to know the truth, to know and experience God. I'm a searcher, that's what I'm all about. You woke that up in me, and ever since I started, I haven't had one experience — nothing. I really believe in all the spiritual teachings. I really believe, only nothing happens, and I want it to. Oh man, I want it so bad. What the hell is wrong?'"

Larry was taken aback by the pain and confusion in Elvis' voice, "but I tried to keep calm while explaining how each idea we had discussed over the past months had its place among the others, how each built upon the others and together they formed something very beautiful. The spiritual readings, the meditation, our conversations — all these contributed to our development, but they were just parts, stages of a process that might continue for the rest of our lives. No one knows when that moment of revelation may come; it's not a 'prize' one 'earns.' For some, it never comes, but that is all the more reason to continue working toward God."

The conversation continued, as Larry attempted to show him that this was the one area in his life where it made no difference that he was Elvis Presley, that before God everyone was the same, and to experience God it was necessary to empty oneself of all expectations and preconceptions. "You have to drop your ego, Elvis," Larry told him, "and make room for God." He had to "forget the books, let go of your knowledge [and] become empty so God can have a place to enter." Finally, Elvis was mollified. "[He] looked down at the floor, then back at me, then grinned. Nodding in agreement, he said softly, 'Well, you're right.' He chuckled softly to himself. 'I guess I needed that. Let's hit it.'"

They set off across New Mexico and Arizona, into the desert; "an iridescent blue sky seemed to drape itself over the sacred mountains of the Hopi Indians and color everything in view with a peaceful, heavenly shade." Elvis drove without speaking, with Larry beside him and some of the guys in the back. Then outside Flagstaff it happened. Elvis suddenly gasped and cried, "Whoa!"

When I turned to him, he was slumped back in his seat, slackjawed, staring at the horizon. Following his gaze, I saw a cloud, a single white mass floating in the sky. From the clouds emerged a clear, definite, recognizable image.

"Do you see what I see?" Elvis asked in a whisper. I looked again. "That's Joseph Stalin's face up there!"

Try as I might to see it any other way, there was no denying that it was Stalin's face in the cloud.

"Why Stalin? Why Stalin?" Elvis asked, his voice breaking. "Of all people, what's he doing up there?"

Before I could answer, the cloud slowly turned in on itself, changing form and dimension until the image faded and gradually disappeared. I knew we had witnessed something extraordinary and turned to say so, but stopped when I saw Elvis, staring into the cloud, his eyes open wide and his face reflecting wonder. It's almost impossible to describe how he looked . . . but Elvis' expression was the one that you read of in the Bible or other religious works: the look of the newly baptized or the converted. He appeared so peaceful, so accepting, so open, so happy. It was something I had never seen before and I would never see again. . . .

Elvis swung the bus over to the roadside and brought it to a violent halt. "Just follow me, Larry!" he shouted as he bolted out the door and began running across the sand. I finally caught up, and as we stood in the cool desert breeze Elvis' face beamed with joy.

"It's God!" he cried. "It's God!" . . . Tears streamed down his face as he hugged me tightly and said, ". . . I thank you from the bottom of my heart. You got me here. I'll never forget, never, man. It really happened. I saw the face of Stalin and I thought to myself, Why Stalin? Is it a projection of something that's inside of me? Is God trying to show me what he thinks of me? . . . And then it happened! The face of Stalin turned right into the face of Jesus, and he smiled at me, and every fiber of my being felt it. For the first time in my life, God and Christ are a living reality. Oh, God. Oh, God," Elvis kept saying. Then he paused and added a peculiar aside. "Can you imagine what the fans would think if they saw me like this?"

"They'd only love you all the more," I said.

"Yeah," he said, "well, I hope that's true."

The rest of the trip was not without its awkward moments. Elvis basked in his newfound bliss, while the guys all fumed at this latest evidence of the boss's weirdness and almost perverse dedication to the bizarre. If they had had reason to mistrust Larry before, they were practically ready to kill him now. It seemed only appropriate to the fucked-up nature of the trip when the motor home, which had become separated from the rest of the group, caught fire in the Mojave Desert, just outside of Needles, California. Somehow Elvis and the guys on the bus found two taxis to take them back to L.A., and everyone naturally wanted to hear what had happened to them when they finally got home. All Elvis wanted to do, though, was to talk to Larry by himself. He shut the louvered doors to the den, and though he could hear the guys standing just outside trying to listen in on his conversation, he didn't seem to care — he had been up for thirty-six hours straight now, and he was still in the grip of his revelation. He just wanted to quit the business, he told Larry with a kind of certitude that he had never shown before. He wanted to become a monk.

JOE REJOINED THEM in California. He had not found it as easy as he had imagined it would be, striking out on his own; film industry connections that had seemed rock solid when he was working for Elvis Presley dried up when he was looking for work, phone calls that once would have been routed right through were not returned, and by Christmas he was practically broke. Then Elvis sent him a holiday check, and Joe called to thank him, and one thing led to another, and finally Joe swallowed his pride and asked if he could come back. Eventually it was worked out that Joe and Marty would be co-foremen, a state of affairs not really comfortable for either one but that both were for the moment prepared to accept.

On March 15 production began on the first film in the new threepicture deal with MGM, a light-hearted desert epic called *Harum Scarum*, with Sam Katzman back at the helm. Elvis had relinquished his plans for going into a monastery for the time being, won over by a combination of common sense, a couple of nights' good sleep, and Larry's argument that he had a responsibility to share his gift with the world. He had already recorded an embarrassingly mediocre soundtrack in Nashville, and he was frustrated that once again Katzman had allotted only fifteen days for production, but he was looking forward to resuming his collaboration with director Gene Nelson. And he was excited about the costumes that Nelson had designed for him, which were consciously intended to evoke Rudolph Valentino.

Whatever enthusiasm he felt pretty much evaporated on the first day of shooting, as it became instantly clear that the story was a joke, the sets shoddy, even Nelson was apologetic about the haste and slapdash quality of the production. The Colonel had a small marquee with flashing lights set up in front of his office on the MGM lot, but it seemed like an act of empty bravado, as its fifty-six-year-old occupant, still laid up with a bad back, rarely appeared on the set, relying on daily reports from his lieutenant, Tom Diskin, as to how the picture was progressing. At the end of the shoot, Elvis presented cast and crew with the Star of David watches that Harry Levitch had created, and he gave Gene Nelson an autographed picture that declared, "Someday we'll do it right."

I MIGHT ALL HAVE GOTTEN to him more if he had not been so immersed in his new life. While he was still making *Harum Scarum*, he started going out to the Self-Realization Fellowship's Lake Shrine retreat in Pacific Palisades just a few blocks from the ocean, and there he discovered an inner peace and a new mission in his quest for spiritual enlightenment.

The Self-Realization Fellowship was founded in 1920 by Paramahansa Yogananda, an Indian holy man who came to the United States in 1920 at the invitation of the International Congress of Religious Liberals in Boston and soon became a sensation on the Chautauqua circuit. By 1931, when he gave a series of lectures in Salt Lake City, he had been widely recognized as a unique phenomenon, "a Hindu invading the United States to bring God in the midst of a Christian community, preaching the essence of Christian doctrine." It was in Salt Lake City that Faye Wright, a seventeenyear-old free thinker, first heard him speak and informed her parents shortly thereafter that she had found her life's calling and was going to Los Angeles to serve Yogananda at the Fellowship's International Headquarters on Mount Washington. Three years after Yogananda's death in 1952, Wright became president of the Self-Realization Fellowship, under her adopted name of Sri Daya Mata. Yogananda's crowning work, Autobiography of a Yogi, a record of his spiritual search and encounters with remarkable men and women, from Luther Burbank and Rabindranath Tagore to Gandhi, "Therese Neumann, the Catholic Stigmatist," and "The Woman Yogi Who Never Eats," had long since been established as a spiritual classic, and the

inexplicable manner in which the Master's body failed to decay during the three weeks it was displayed in an open coffin after his death ("The absence of any visible signs of decay in the dead body of Paramahansa Yogananda offers the most extraordinary case in our experience," wrote the mortuary director of Forest Lawn) provided yet another example of his own remarkable powers.

For all of the vaguely "spiritualist" trappings of the movement, though, what was most remarkable about Yogananda was the commonsense quality of his teachings. They took a singularly ecumenical approach, far removed from the ideological purity of fundamentalist movements or the cult of personality celebrated by many charismatic orders. Yogananda's teachings offered an umbrella under which the seeker of any persuasion (Christian, Jewish, Buddhist, Hindu) could find spiritual solace — as well as a step-by-step program of meditation technique called Kriya Yoga that required dedication, discipline, and a commitment to process not necessarily exclusive of religious belief but not requiring it either. Elvis was fascinated from the moment he first read *Autobiography of a Yogi* at the start of his studies, and when he learned from Larry of Yogananda's "incorrupted" body, an element that seemed to tie in directly with his own obsession with mortality, he was all the more intrigued.

At the park in Pacific Palisades he met a monk named Brother Adolph, well into his eighties now, with whom Elvis frequently conversed and indulged in long philosophical discourses. Brother Adolph gave him further readings and referred frequently to Sri Daya Mata, who had returned from India the previous summer after a pilgrimage of nearly a year. Did Brother Adolph think Sri Daya Mata would consent to speak with him? Elvis asked. He was but a humble seeker and would value the opportunity to talk with her. Brother Adolph brought the request to Daya Mata, and she agreed to see him; she would be glad, she said, to meet with the famous entertainer, depending upon the exigencies of her schedule.

In the spring of that year, Elvis traveled to the Fellowship's headquarters, up the winding little roads that traversed Mt. Washington, a sharp rise dotted with modest bungalows on the outskirts of Los Angeles overlooking Pasadena. There he discovered a spacious, rambling estate, with beautifully maintained, tree-lined grounds and an open light-filled building that had once been a luxury hotel and spa to the burgeoning local film industry. There, too, he met fifty-year-old Daya Mata, whose calm, soft-spoken manner immediately impressed itself upon him, much as he had imagined that it would. What he had not been able to anticipate was the extent to which her serene, reassuring presence would remind him of his mother, Gladys Presley.

Daya Mata, whose followers referred to her affectionately as "Ma," was impressed for her part not just by the performer's evident humility but by his genuine dedication and thirst for knowledge as well. "I saw in him someone who was full of innocence, if you can understand the way I mean that. He was a naive, somewhat childlike individual who was caught up in the adulation of the world and enjoyed it, but, more than that, he felt a deep bond with his public; he was carried away by them and didn't want ever to disappoint them. That was what I noticed. Then we proceeded to talk about matters that were of great concern to him. He had done some reading. He was sinking. Here was someone who had everything the world could offer, [but] it didn't satisfy him. There was still an emptiness, and the only way to fill it was to turn within."

He spoke to her as he had spoken to no one in years. "When he came in, I could see that he was shy. I said, 'Now, Elvis, just relax. You've come to see me; just sit and talk. You can think of me as an old shoe if you want." As he got to know her, he unburdened himself more and more, confessed fears, acknowledged doubts that he would have been reluctant to voice explicitly even to Larry. The guys around him, he told her, didn't understand. "They didn't share his interests, they felt he was getting too involved, it was a threat to them, and it created a rift between them. They couldn't really relate to him, they didn't really understand his need, and evidently he couldn't confide it to them." Only when he was speaking about the Colonel did his characteristic caution reassert itself. "He was very careful about anything pertaining to his manager. I think he felt that Parker was a very important part of his life and as long as he was going to be an entertainer he had to follow [his advice], because he had steered him so well for so long. The only thing that concerned him was that the Colonel did not seem to understand his need to nourish his soul. He was nourished in every other way, but where was the nourishment for his soul?

"My point was to urge him to take a little time for himself. I didn't want to be the cause of any problems between him and his manager, but he was giving so much of himself away that he didn't have anything left for himself. My argument has always been, if you have twenty-four hours in a day, a man is pretty foolish if he can't even give half an hour out of the twenty-four to God. I urged him to take time for himself and his spiritual well-being, but he was very much pulled toward his following, he wished to please them, they gave him love."

Daya Mata saw in him the same impatience for "results" that Larry had observed, but she had seen this in others as well. He spoke to her about being given a "shortcut" to attain the enlightenment of Kriya Yoga, but she just shrugged it off. "Oh, well, that I didn't give him. I wouldn't do that. I've had that come to me from so many people, and I just said, 'Well, that's just set back a little. Just because someone has a name, that doesn't impress me. I'm not interested in that side of your nature. I'm interested in your soul.' There was one point where he wanted to wholeheartedly [join the movement], he wanted to teach the teachings, be more involved - but I told him that wouldn't be right because I could see his nature. He might be enthusiastic for a while, but then he would cool back and lean towards his other activities, [because] that was his life, he had another mission than that. Once, going out through the door, he came back just like a child, so sweet, and said, 'Oh, Daya Mata, I want you to know I love you.' And he meant it, just as he would if he was talking to his mother. He said, 'If only you could have met my mother.' I said, 'Oh, Elvis, I wish I had.'"

He felt a new serenity in his life. To the guys it seemed more like madness, and they felt increasingly alienated, resentful, bewildered, and angry all at once. Elvis appeared to be leaving them with his almost daily visions, his tales of going off in a spaceship, his delusions of being able to turn the sprinkler system of the Bel Air Country Club golf course behind the house on and off with his thoughts, his conviction that he could cure them of everything from the common cold to more serious aches and pains by his healing powers. To Marty he announced that a bird's song had turned into the voice of Christ, and under other circumstances they might have been tempted to commit him to a doctor's care, but reason told them that he would come out of this obsession, too, just as he had come out of all of his other momentary impulses and infatuations.

To Joe it was mainly a matter of the pills he was taking and his intense, unrealistic desire for something more — but that didn't make it any more palatable as their regular nightly parties became alcohol-free evenings of philosophical discussion, and Timothy Leary's *Psychedelic Experience* became prescribed reading for all. There was still the occasional football game, and there were still those rare times when they all went to Sandy Ferra's father's new club on Sunset, the Red Velvet, but it just wasn't the same; all the fun seemed to have gone out of it. The guys themselves were still alternating uppers and downers, and Marty and Alan in particular were developing substance-abuse problems of their own. When Marty did the expense reports, not infrequently he would stay up for two or three days at a time. "And one night, after I'd probably been up three days — I was sitting in the middle of the bed, writing. I had all the books and receipts around me. And I was so screwed up on pills that the last thing I remember, I looked at the clock and it was like two-thirty or three o'clock. The next morning I woke up and I was still in the same position, right in the middle of the bed. . . . But you couldn't help doing stuff like that when you were doing as many uppers as I was."

It was Marty, too, who principally reported to the Colonel, letting him know all the latest examples of Elvis' increasingly bizarre behavior. Marty conveyed the news with the same zeal with which he compiled all his other lists and reports, but it could not have been lost upon him that Colonel for once was baffled as to how exactly to proceed. Still virtually bedridden by his persistent back problems, he spent more and more time at the Palm Springs home that the William Morris Agency supplied him free of charge, where he could take daily steam baths at The Spa Hotel, reorganize his wife's freezer, or simply sit out in the sun by his pool and barbecue to his heart's content. Mixing and mingling in his eccentric way with Hollywood's most exclusive elite, he put on a good front to the world, but for the first time his patented combination of carnival sideshow and unassailable conviction was beginning to fray, his familiar braggadocio was starting to sound more and more like whistling in the dark.

To C. Robert Jennings, doing a story for the *Saturday Evening Post* around this time, he declared that his own seedy appearance and all the midway trappings of his offices (with their gaudy display of stuffed animals and Elvis pennants, posters, records, and merchandise) were aimed at discouraging all the stuffed-shirts and studio phonies from seeking him out. "The big shots are afraid to be seen with me," he said. "Saves a whole lot of time." As far as rumors of marriage were concerned, he denied them but noted that "Elvis promised to give me three weeks' notice if he ever gets married, so I'd have time to tie down some pretty good promotional deals." His personal credo, Jennings noted, was "Don't try to explain it, just sell it," though English music reporter Chris Hutchins, who interviewed him just a few months later, detected a considerably more chastened mood lurking beneath the rodomontade.

The world should not be surprised if he retired before too long, the

Colonel declared, noting the difference in age between himself and his boy. "Sooner or later someone else is going to have to take the reins." During the same visit the reporter sat in on a merchandising conference with two New York "tycoons" that offered the potential of \$80,000 in licensing fees. Just before the businessmen arrived, an old friend of the Colonel's from his carnival days showed up.

The friend had fallen on hard times and had with him a box containing several hundred balloons, which he offered to sell the Colonel for forty dollars. To help the man keep his pride, the Colonel bargained with him for half an hour, and finally bought the balloons for thirtyeight dollars.

As he closed the deal, the Colonel invited in the tycoons who had been waiting in an outer office. When the man had gone, one of them stormed at the Colonel: "You kept us waiting twenty minutes to buy thirty-eight dollars' worth of balloons when we have a deal worth eighty thousand to discuss?" Replied the Colonel: "It so happens that his deal was more vital to him than yours would be to you. I say 'would,' gentlemen, because I've just decided not to do business with you. Good afternoon."

He was, without question, a peculiar mix. For all of his unflagging desire to run things and his almost perverse need to keep colleagues off balance at all times, observed Gabe Tucker, a longtime associate who had just returned to the Colonel's employ after an absence of nearly a decade, Parker was more than capable of many equally impulsive acts of generosity. It was "one of the quirks of his personality to disguise his acts of kindness," Tucker noted, but it was loyalty and long-term relationships — not religion nor belief in the future nor faith in human nature — that were his only yardsticks. And it was loyalty that he was concerned about now.

Not that he suspected Elvis of disloyalty exactly; it was simply that for the first time in their long relationship he could not really tell where Elvis' loyalties lay. All this talk that he heard about the boy quitting the movie business — it had never come directly to him, and he didn't think it ever would. He and Elvis had an understanding — and he believed that Elvis would always try to live up to that understanding — that Elvis would not set out to deliberately embarrass him in any way. But at the same time, memories of his devastating split with Eddy Arnold in the summer of 1953 cannot have been far from his mind. The Colonel was a thoroughly prepared man — he prided himself on his ability to get the jump on his competitors by *knowing the territory:* that was what had made him such a great advance man, and if he had had to point to one reason for his success in a difficult and always unpredictable business, that would have been it. Preparation. Anticipation. Always staying two moves ahead of the other guy. But Arnold's defection was something that had caught him by complete surprise; Eddy's unilateral decision to leave him after nine years of unswerving loyalty simply as a result of differences of "style" had come like a bolt out of the blue. And while he had recovered almost instantly — never showing weakness, never admitting to error, teaming up with Hank Snow by the end of 1954 and finding his boy almost immediately thereafter — the memory of its suddenness, the fact that he had never seen it coming could not help but affect his demeanor now.

He couldn't see where Elvis was going. They were a team, but he didn't know what was on the boy's mind. And in the absence of knowledge, he retreated to familiar ground. He didn't want a confrontation with Geller; if he was confident of one thing, it was that Geller would eventually reveal his con, or else that Elvis would simply tire of it and move on to something else. In the meantime he would show that he could still deliver, just as he always had.

To that end, all through the spring he vigorously promoted *Tickle Me* it was, he loudly proclaimed, his biggest and most effective exploitation yet. On May 19 he sent Gabe Tucker to Atlanta for the picture's premiere with the gold Cadillac, which he had recently persuaded RCA to buy and put out on tour. If Elvis couldn't be there in person to promote the picture, at least his customized luxury car could. He put together fifty thousand publicity packages for local RCA tie-ins, purchased a hundred thousand balloons, and approved the two singles releases to be culled from the movie's soundtrack of old songs (the Colonel's favorite, "I'm Yours," was the B side of the second single) while directing an all-out campaign to sell the movie as "a wholesome family picture — downplay the sex." At the end of the day the picture saved Allied Artists, achieving the third-highest gross in the company's history (behind 55 Days at Peking and El Cid) and making a handy profit for Elvis and the Colonel to boot.

At the same time, he realized that something had gone seriously wrong with *Harum Scarum*. After viewing the first cut on June 17, he fired off a letter to MGM, stating that it would take "a 55th cousin to P. T. Barnum" to sell this picture and that, given the artistic debacle that had taken place, maybe the best thing to do would be just to "book it fast, get the money, then try again." As an afterthought, he added with uncharacteristic introspection, perhaps more time should be spent on the next picture to ensure a better result. To try to cram everything into a fifteen- or eighteen-day production period, with the star included in virtually every scene, was, the Colonel concluded, nothing less than a recipe for disaster.

A month later, still trying to salvage what he regarded as an essentially unsalvageable situation, he suggested that perhaps they should add a talking camel as narrator; at least that way the ridiculousness of the scenario might seem intentional, and the kids might see the camel as cute. It was a rare instance of the Colonel suggesting that he might have made a mistake and, while he continued to maintain a cheerful bluff, not a particularly happy one. But he forged ahead. The picture might still make money; for all its faults, it might do as well as *Kissin' Cousins*, maybe even a little better. By this time, though, he already had his eye on the next goal, which was — as always — to make the biggest and best deal yet.

I N APRIL JERRY SCHILLING got a Triumph 650 motorcycle. It took a few days before Elvis, who had always ridden a Harley himself, noticed it, but when he did, he asked if he could take it for a spin. He was so tickled by the way the Triumph handled that he decided everyone should have one. George Barris started calling around to dealers, and before long they were assembling nine Triumphs in the yard at three o'clock in the morning. Marty didn't want to ride a motorcycle, so Elvis bought Marty a car. Eventually he bought everyone else a car, too. But for the next couple of weeks they rode their motorcycles everywhere, roaring in and out of the Bel Air gates at all hours, until the neighbors got up a petition about the noise. Jerry was furious at this abridgement of their civil liberties, but Elvis just laughed it off and got a trailer to take the bikes back and forth to the gates.

His concern for civil liberties aside, Jerry was not a conventional part of the extended family in any way. In pursuit of his education, he was taking history courses at UCLA; he showed a broad curiosity about the world, from spiritual studies to current events; and in general he displayed an idiosyncratic mix of wholesome naivete, genuine loyalty, and stubborn independence that was not lost upon anyone in the group. Joe and Joanie Esposito called him "Mr. Milk," and Joanie saw him as very different from the others. "He was so funny. He would eat a doughnut with a knife and fork. And he wouldn't let any one type of food touch another on his plate. But he was open. And he would listen. And he was very sensitive. That's why I think there was a good relationship with Priscilla. And that's why I think there was jealousy on Elvis' part."

Jerry had already found out about the jealousy. Just before they left for California, he had been in the kitchen when Priscilla came down from the bedroom, obviously distraught. "I didn't realize they'd had a big fight — I guess he'd thrown a lamp, and the room was all torn up — but I just thought she was sick, and I asked her how she was feeling. We hadn't spoken all that much before because I was so shy, but I just kind of talked to her and then she went back upstairs, and I guess they got back into it and she said, 'Well, at least Jerry Schilling cares how I'm feeling.' And that's what did it. He came down and said, 'I don't need any goddamn guys asking Priscilla how she's feeling,' and all this stuff — and I was crushed. This was the first time he'd ever said anything upsetting to me, and I didn't know what to say. But the next day he just said, 'Let's go for a ride,' and he never mentioned it to me again, it was like, 'It's cool. I'm not pissed off at you.' And it was all right. But it left kind of a taste."

To the others Jerry was a little bit of a wild card who had the annoying habit of letting Elvis know exactly what was on his mind at any given moment. "Joe would say to me, 'Jesus, Jerry, why the hell did you have to say that? He was in a good mood.'" But Jerry fit in more with Elvis' own moods by his very openness and by his boundless admiration not just for Elvis' accomplishments but for his *character.* "I worked for this guy that I thought the world of, and he treated me better than I'll ever be treated in my life, but then there would be time periods when nothing would be happening, and there you were in this vacuum, and you would get moody and insecure, and I'll never forget Elvis telling me one time — he just picked up on my thought; we were sitting on the couch watching TV, and he said, 'You know, one of the most important things to learn in life is to be able to cope with not having anything to do.'"

They began the New MOVIE, Frankie and Johnny, for United Artists, at the Sam Goldwyn Studio in mid May. It was another dreary enterprise, offering little hope of satisfaction beyond contractual items of profit and loss to any of the parties involved. The soundtrack was done in a new

way to minimize time wasting and overcome Elvis' increasing distaste for the material. Instrumental tracks were recorded in the evening, Elvis' vocals the following day. The official rationale was that this was a more efficient, modern method of operation, but according to Alan Fortas the real reason was that Elvis threw a temper tantrum in the studio on the first night and this was the result.

The movie itself, a remake of a 1936 release with Helen Morgan, was directed in pleasant enough fashion by Fred De Cordova, who had directed Ronald Reagan in *Bedtime for Bonzo*, done *Leave It to Beaver* and *The Jack Benny Program* on television, and several years later would become the longstanding producer of *The Tonight Show*. The cast was competent, Elvis was visibly overweight, and perhaps the most notable aspect of the filming was the spiritual connection that he made with his co-star Donna Douglas. Instead of dating her, according to Sonny West, he took a genuine intellectual interest in her. They exchanged books and ideas, spoke of Daya Mata and the Self-Realization Fellowship to which she, too, belonged, and meditated together. He showed her many of his books, Larry noted proudly, "and they would go over his marked passages together."

At the conclusion of filming, once again he gave away dozens of the trademark "brotherhood" wristwatches and, while still on the set, donated \$50,000 to the Motion Picture Relief Fund in a special ceremony that the Colonel had arranged, with Frank Sinatra and Barbara Stanwyck showing up to accept the check. Even his generosity was viewed cynically and taken as further evidence of the boss's hypocrisy by some of the guys, who just as cynically took advantage of that very quality as they competed for financial assistance of their own, whether in the form of cars, cash, or jewelry.

To Joe there was no question of Elvis' charitable impulse: it was the thrill of seeing the expression on the recipient's face that motivated Elvis most of all. "Elvis was crazy about a TV show . . . called *The Millionaire*. Each week an ordinary person with a problem answered a knock at his door to find a messenger in a suit who announced that he was presenting the person with one million dollars from an anonymous donor." Elvis wanted to make a difference in people's lives, Joe believed, whether it was a close friend or a total stranger, and this was the simplest, most direct way he had figured out of doing it. To Lamar, though, it was also "a Band-Aid for the abuse he heaped on you the rest of the time. That was the blessing and the curse of Elvis."

The one real bright spot on the musical horizon was the success of

"Crying in the Chapel," his first top-ten hit in two years and his first million-seller since "Return to Sender" in 1962. And while it was true that the song had been recorded almost five years earlier for Elvis' gospel album (it had been held up all this time because Elvis had not been satisfied that his version matched Sonny Til and the Orioles' r&b original), it was gratifying nonetheless to be back on top, with three hundred thousand more sales than his last number-three hit, 1963's "Devil in Disguise."

It was all the more gratifying when the record reached number one on the British charts "for the first time," wire service reports pointed out, "since the Beatles rose to fame nearly three years ago" — and with a spiritual number to boot. Because, however sincere his public pronouncements that there was room for everyone in this business, however carefully phrased his well wishes for the Beatles' success, none of the guys missed that he saw the Beatles and the whole British invasion as a threat and that it galled him to be widely perceived as passé. It was clear that he himself was neither interested in, nor satisfied with, the music that was being released in his name, and for all the Colonel's pep talks and recitations of figures, numbers, and deals, there was no getting past the fact that the records were no longer selling as they once had, they no longer mattered as they used to. He admired the Beatles, he felt threatened by the Beatles, sometimes it made him angry how disrespectful the Beatles and Bob Dylan and the Rolling Stones were toward the public and their fans — but most of all he was envious of the freedom that they evidently seemed to feel and to flaunt. He, too, had once enjoyed that freedom, he, too, had once been in the vanguard of the revolution, and now he was embarrassed to listen to his own music, to watch his own films.

The CHARACTER THAT ELVIS was to play in *Paradise, Hawaiian Style,* Rick Richards, a pilot who operates a helicopter charter service, was intended to recap some of the rugged qualities of his *Roustabout* role. Norman Taurog's one-time assistant, Mickey Moore, who had worked with Taurog on *G.I. Blues, Blue Hawaii*, and *Girls! Girls! Girls!* as well as serving as assistant director on *Roustabout* and *King Creole*, was a familiar face in the director's chair, and with Allan Weiss as scriptwriter and the third Hawaii location shoot in five years, the feeling was more one of extreme déjà vu than the mere revisiting of familiar ground.

After much harassing, the Colonel had finally gotten Wallis to come up

with a \$90,000 bonus on top of Elvis' \$200,000 salary, with the bonus to be split 50–50 between Elvis and the Colonel. Nevertheless, he continued to convey a degree of disappointment that money alone could not assuage and immediately began his new campaign, which was the contract for the *next* picture.

Elvis was ill the week that he recorded the soundtrack, which Wallis might have deduced was the reason that he refused to bark like a dog during one of the songs. *Movie News* correspondent Derek Hunter reported that the star was "too sick to present himself for wardrobe fittings" and that when he arrived in Hawaii, it was "without his usual smiling face.... When Elvis finally went to work in front of the cameras, he was not his usual patient and polite self. He continually grumbled about the way his privacy was always being disturbed. He beefed about the circus that always surrounds him, and how he'd hoped to be able to get away from it all in Hawaii."

The ten guys that he brought along with him, together with his father and stepmother, might well have disputed that account, but the very fact that Elvis was for the first time being characterized in such terms is indicative of the extent to which he was allowing his feelings to show. He was as polite as ever to film crew and actors, he and Vernon and the Colonel laid a wreath on the monument to the U.S.S. *Arizona* that his efforts had helped to build, and he found himself fascinated by the lessons in Hawaiian customs, music, and culture provided by the Polynesian Cultural Center, a Mormonfounded college and retreat in Oahu that served as both a location and cultural adviser to the film.

Probably the most notable event that took place on location was that Jerry Schilling fell in love. Sandy Kawelo was a student at the center and one of the dancers who was being used in the picture. Jerry scarcely spoke to her during the week or so that they spent at the center, but on the final night there was a special party with elaborate floral arrangements for the departing film crew and a special dance recital. That was the first time that Jerry spent any real time with Sandy, and they discovered almost instantly how much they had in common.

"It was just a really moving experience in every way — the whole presentation. Elvis left with tears running down his face. Then when we walked out to the plane the next day, Sandy brought me a flower lei that she had made for me herself, and I wrote her a letter on the plane telling her how much I loved her. Elvis thought it was great and encouraged me to keep in touch with her, which I did, but I think I just moped around the rest of the time we were making the picture."

The general mood on the Paramount lot was not much different than Jerry's. To Jan Shepard, who had played Elvis' older sister in *King Creole* and had a small part in the new picture, the difference in the person she encountered now after an absence of seven years was almost heartbreaking. "He was not unfriendly, just very withdrawn and kept to himself in between takes — really, we scarcely saw him. Of course there was a whole different group of guys — he was now surrounded by an entourage — [but he] seemed very within himself, not as outgoing and fun-loving as before. He was preoccupied with theology books and seemed to be questioning his role in the scheme of things. One time he asked about Dolores Hart [his co-star in *Loving You* and *King Creole*, and a good friend of Shepard's, who had given up her film career to become a nun], and we had a little bit of a conversation. In the quiet moments he was still very sweet. When we reminisced about *Creole*, he said, 'Honey, that was my favorite picture.'"

May Mann, the Hollywood gossip columnist who had enjoyed good entree to Elvis ever since his arrival in Hollywood, noted the rumor that Elvis had left his own faith "to join an occult church." How can such a rumor grow? she asked herself, then Elvis, who explained that it was because of all the books he had been buying at an occult bookstore across the street from Paramount (actually Pickwick Books, on Hollywood Boulevard). "Some of the boys bought some of the books," Mann reported him as saying. "I began reading and . . . became very interested reading about religions. I was interested in self-realization — in finding one's true self. Who isn't? [But] I have never left my own church."

It is scarcely surprising that the Colonel should have felt it incumbent upon himself at this point to finally confront Larry, if only to let him know that he *knew* what was going on, whether or not he chose to do anything about it. The guys were all sitting around on the set one day when Colonel came by and indicated that he was going to "hypnotize" them. This was one of his favorite parlor tricks, though it was never clear whether he was indulging them or they were indulging him. In any case, soon he had Billy scratching like a monkey, Charlie barking like a dog, and one of the other guys impersonating yet another member of the animal kingdom. Larry watched and wondered: "What were the guys responding to? Hypnotic suggestion? Fear of the consequences if they didn't play along? The point is that Parker got people to do things they didn't necessarily want to do, a very powerful ability regardless of its source.

"See," he said, his face in a grin while his eyes seemed to bore through my head, "they're all hypnotized. But no," he added, as if answering a question no one else could hear or talking to himself, "we won't do one on Larry, because Larry knows hypnotism."

With that he gave me a conspiratorial smile and said to no one in particular, "Where's a chair for the Colonel?"

Several guys rushed over with chairs for the Colonel.

"And get one for Larry," Parker added, knowing that there was probably nothing the guys would rather do less.

Not too many days later, he announced in full hearing of everyone, "Larry, you missed your calling in life. You should have been on the stage. I'm telling you. I know. You should have been on the stage." And not long after that he inducted Larry into the Snowmen's League of America, ordinarily a much sought-after honor in the Colonel's circle ("A good Snower does not praise his own Snow ability," the Colonel was accustomed to advise the too-ardent suitor). Larry, however, did not take membership as a compliment. In fact, if he was interpreting it correctly, he saw it as a distinct insult. "Parker's actions always spoke louder than his words, and this gesture summed it up. In Parker's eyes, he and I were in the same league, so to speak, and I was a good enough snowman to earn his respect. I was working for Parker now." One time when Larry visited The Spa Hotel in Palm Springs, the woman who collected the steam room fee registered immediate recognition. "'Oh, you're Larry Geller!' she exclaimed, as if she had been looking for me. 'Yeah,' I answered, confused. 'I heard about you,' she said. 'I understand that you're a magician. Colonel Parker told me so.'"

ON AUGUST 27, A WEEK AFTER Elvis' return from Hawaii, the Beatles came to visit. The Colonel had been well aware of their impact on the popular scene ever since their first appearance on *The Ed Sullivan Show* the previous year when he had sent a telegram in his and Elvis' name wishing them success and a pleasant visit. Subsequently he had met with their manager, Brian Epstein, and brought presents for his boys (coveredwagon table lamps and gun belts personally selected by Mrs. Parker) from Elvis and him. There had even been some talk about trying to get the British group to sing one song with Elvis at the conclusion of *Paradise*, *Hawaiian Style* until Hal Wallis discovered that their United Artists movie deal precluded that. The meeting was something that the Colonel had long seen as a valuable publicity coup — *if* it could be arranged on his and Elvis' terms. He and Brian Epstein had been fencing over the details for some time, but in the end Epstein capitulated and Colonel presented it to Elvis as an opportunity to snow the world with very little expenditure of time or effort, though Elvis remained at best lukewarm about the prospect of hosting some kind of formal get-together for people he didn't know.

The Beatles arrived at 10:00 P.M. amid a flurry of switched cars, special police details, and elaborate security arrangements masterminded by the Colonel — but with hundreds of fans still gathered at the Bel Air gates. The whole gang (Joe, Marty, Alan, Red, Sonny, Larry, Jerry, Billy, Richard, Mike, and Chief, along with Priscilla, Joanie, and assorted other wives and girlfriends) was waiting anxiously at the house. Everyone was excited about meeting the Beatles, it seemed, except for Elvis, who was sitting on the long, L-shaped white couch in the den, watching a soundless TV when his guests arrived. He rose to greet them, introduced them to Priscilla and some of the guys, and then, when conversation flagged, picked up the bass that was plugged into an amp set up in front of the TV. Charlie Rich's "Mohair Sam," which had just entered the charts, was on the jukebox and Elvis played along with it over and over again, fingering the bass absentmindedly as if nothing more were on his mind than simply working out his part.

In the end everyone seemed to settle down a little, and events just took their own course. Ringo played pool with Richard Davis and Billy Smith; George, who looked to most of the guys to be stoned when he arrived, smoked a joint with Larry Geller and spoke to him about Hinduism out by the pool. John and Paul, after some desultory small talk, eventually picked up a couple of guitars and jammed a little with Elvis, while the Colonel and Brian Epstein gambled at a coffee table that converted into a roulette table.

The Beatles' overall reaction was one of disappointment, their response to Elvis a prickly mix of anger and disillusion ("To be honest," said their press officer Tony Barrow afterward, "I'd describe Elvis on that showing as a boring old fart — but I do know Ringo enjoyed his game of pool"). Nonetheless, they reciprocated with an invitation of their own: Why didn't Elvis and the guys stop by and visit *them* on the weekend? Elvis almost immediately demurred; he didn't know what his schedule was like,

212 👁 SPIRITUAL AWAKENINGS

he said, though he would see if he could work something out. The next day Joe called Beatles road manager Malcolm Evans to formally decline, but a number of the guys were still excited about the invitation, and on Saturday Jerry went up to the rented house in Benedict Canyon on his own, returning with Marty and Richard on the following day. John Lennon went out of his way to tell Jerry how much the evening had meant to him and that he would appreciate it if Jerry could tell Elvis "if it hadn't been for him I would have been nothing." Jerry carried the message back. "I was just thrilled, of course, and I told Elvis, but he didn't say anything, he just kind of smiled. That was it."

Before the end of filming, Tom Jones, the Welshman who had recently topped the charts with "What's New, Pussycat?," one of Elvis' favorite recent records and movies (he liked almost anything with Peter Sellers in it), stopped by the set and was practically tongue-tied with excitement. "[Elvis] was sitting in a helicopter. He sort of waved over in my direction, and I thought, 'Is he waving at me?' Just in case he was, I waved back. . . . Then he came over and said hello and said he knew every track on my album. We chatted for a while, and I asked him, 'Any chance I can get a photo together with you for the British newspapers?' . . . Then, as we were doing the photographs, he started singing songs off my album! I was really dumbfounded."

The remainder of filming proceeded uneventfully, and Elvis was finally released by Paramount on October 1, arriving home in Memphis six days later. He had made three movies in seven months, filming virtually without interruption and with very little to show for his efforts other than the deals and the money that the Colonel boasted about so incessantly. He was fed up with Colonel's way of thinking, he complained to Priscilla. He wanted to do straight dramatic roles, he told her with some bitterness, and all Colonel could talk about was the need to fulfill his current obligations. "He kept thinking that he was going to get good scripts. Elvis was very loyal. I would never have seen him breaking off with Colonel, but there were a couple of occasions when they both went at it on the telephone and didn't speak for a week or two. It all basically related to career."

The Colonel, MEANWHILE, had his own concerns about Elvis' career. He was concerned about record sales, but his policy of using up every conceivable scrap in the can, with only the movie soundtracks

offering new product (and in the case of *Tickle Me* not even that), had put him in the same position he was in when Elvis got out of the army: if RCA wanted this artist, and there was no question that they did, then they would have to pay him his true worth, in 1965 dollars.

All through the summer Colonel had been patiently negotiating with Harry Jenkins, Bill Bullock's replacement as RCA's executive in charge of Elvis Presley, and on September 21 the deal was finally concluded, with Elvis committed through 1972, a year beyond his present obligations, and the record company retaining a two-year additional option on his services. In exchange for what amounted, really, to a one-year extension, RCA would raise its guaranteed annual payments to Elvis from \$200,000 a year to \$300,000 (there was currently about \$1 million owed in back royalties, so the total would come to \$2.1 million in guaranteed payments over the next seven years, with \$1.1 million left to be recouped), with all of these payments split 75-25 between artist and manager. RCA would in addition pay out a \$300,000 nonrecoupable bonus, to be split 50–50 between Elvis and All Star Shows (the Colonel), along with an additional \$25,000 bonus to each party on January 1, 1966. The basic 5 percent royalty arrangement that had been established with the original 1956 contract remained in place; these royalties went against the \$1.1 million that had to be recouped. The "bonus" royalties, on the other hand (2 percent domestic, 1 percent foreign), which the Colonel had first negotiated at a lower rate in 1960 and which were split 50-50 because of their definition as special payments outside the scope of the regular contract, were free of any encumbrance and were to be paid out, no matter how much in arrears Elvis' recoupments might be. Finally, the \$27,000 annual payment that RCA had made to the Colonel since March I, 1960, for consultation, promotion, licensing of photographs, and general counsel and advice, was upgraded to \$30,000, with all arrangements explicitly acknowledged and signed off on by Elvis.

All in all it was a remarkable contractual upgrading for an artist who was no longer selling that many records — and for his manage. According to Alan Fortas, Colonel was openly jubilant. RCA, not surprisingly, put the best face on the deal, declaring 1965 to have been Elvis' by gest year ever, and pointing to the fact that "his sales reached an all-time $h_{\rm B}^{\rm th}$ in 1965," which was in no way true, whether you were looking at singles, albums, a weighted combination of singles and albums together, or merely Elvis' sales since his release hour the army (by comparison, he had sold approximately 40 percent more records in 1900). When Elvis For Everyone, a

collection of leftovers and rejected takes still left in the can, came out in August, the press release trumpeted, "This is the first Elvis Presley album since 1962 that is not a movie soundtrack."

For all the rhetoric, though, it seems clear that this new contract did come burdened with expectations and that all parties were in essential agreement, however different their interpretation of that agreement might be: something clearly had to be done. Colonel had gambled in his negotiations that RCA would do all that they could to hold on to their brightest star; now, with an incentive-laden new contract in hand, he was gambling that Elvis was prepared to deliver. For while it was against the Colonel's nature ever to concede a point, after the experience of the last couple of years, he had at last come around to the realization that Elvis had to go back into the studio and do what he did best: make records. About this there could be no debate.

He was busy on other fronts as well. From September on he negotiated seriously with Hal Wallis for one more picture, and by November they had finalized an arrangement whereby Elvis would receive an unprecedented \$500,000 plus 20 percent of the profits (a bargain price he would offer no other studio, Colonel hastened to remind the producer), and Wallis, exhausted, confided to his partner, Joe Hazen, that he would never do business with the Colonel again. Meanwhile, Colonel began talks with MGM about a new four-picture deal at \$850,000 per picture and 50 percent of the profits, up \$100,000 plus 10 percent in profits from the three-picture contract he had negotiated only last year.

With the promise of other deals for comparable sums, it looked as if he would soon have Elvis tied up through 1968, at a guaranteed income of nearly seven million dollars for the next three years *for pictures alone*. And this at a time of distinctly diminishing returns, when the motion picture companies, like RCA, might very well have been expected to question the reason for their continuing commitment. Elvis, Colonel was convinced, simply did not understand the forces that his manager had to contend with, but this did not give him pause for thought. With his relentless drive, his almost obsessive need to see every cautionary signal as a challenge, every relationship a game (the Colonel, Eddy Arnold had long ago observed, was missing an off-switch), Colonel had little doubt that Elvis would someday come to his senses and appreciate his efforts. When the MGM deal was finally worked out in January, he announced to Elvis with characteristic pride, and equally characteristic indirection, that as soon as the formal com-

tract was drawn up he would deliver the rest of the cake, but that Elvis already had the icing.

Within twenty-four hours of his return to Memphis, Elvis had gone motorcycle riding, rented out the Memphian, visited his mother's grave, and several days later was pictured in the paper "roaring around the drives of his Graceland estate in a low-slung Go Cart" after midnight. He bought a brand-new 1966 red Oldsmobile Toronado, and he bought a new Harley, too, arranging to have Priscilla's little white Honda motorcycle shipped in from the Coast so she could go riding with him. On October 22 his original bass player, Bill Black, died of a brain tumor at the age of thirty-nine, and Elvis was quoted in the *Commercial Appeal* to the effect that Black was "a great man and a person that everyone loved. . . . I can hardly explain how much I loved Bill." But he did not attend the funeral.

That fall, too, the Meditation Garden was completed. The previous year Marty Lacker's brother-in-law, Bernie Grenadier, who had an interior decorating business with his wife, Marty's sister Anne, had reconstructed the waterfall in the den, and Elvis had been so pleased with the job he did that, before they left for California, he gave Bernie the assignment to refurbish the gardens along the lines of the Self-Realization Park in Pacific Heights. It would be great, he said, just to have a place where he could meditate, "some place that's really pretty and peaceful where I could think and be by myself."

Bernie set out on the project right away, but actual construction didn't get going until well into the spring. According to Marty's highly detailed reports, Bernie was working on it night and day. He went to Italy to purchase marble statues of ancient Roman soldiers, and stained-glass windows were obtained from Spain to be set into a brick wall. He found brick for the wall in Mexico, commissioned arches and plantings, and built a fountain with fourteen different sprays and underwater light formations. It was to be a work of art.

Even after they returned home, Bernie made Elvis promise not to view it until everything was ready. At last Bernie told Elvis that he could take a look, and Elvis and Priscilla went out to the garden by themselves to survey the work. When he came back in, Marty recounted, there were "tears of joy in his eyes, [though] as was his way, he avoided Bernie for the rest of the evening. It was never easy for Elvis to express his appreciation." Appreciation aside, it became the source of considerable contention as well, according to Marty, when Vernon refused at first to provide final payment on Bernie's bill of \$21,000. It was typical of the way things were done in the Presley household, Marty sniffed, and he took it as one more example of Vernon's underlying anti-Semitism, a view not calculated to endear him to Vernon's son.

For Christmas the guys gave Elvis a statue of Jesus for the garden. Marty commissioned John McIntire, an instructor at the Memphis Academy of Arts, whom Jerry knew from taking classes there, to sculpt the statue. According to McIntire, "Jerry Schilling, Larry Geller, and Marty Lacker came in this big black car. They said, 'We want to do Elvis a Christmas present. Could you make a statue?' Marty posed, a short, little fat guy, with his arms sticking out. He said, 'Something like this. About four foot high. Could you do it? We only have five hundred dollars.' I said, 'No way.' They wanted marble. I had four weeks, it was December 6, 1965, when they came. I carved it in the front living room; it's the world's largest plastic Jesus (they [still] think it's marble). On the plaque on the bottom of the sculpture the bodyguards made this little poem up; the wording on it put [Elvis] on the same level as God."

Jerry got an even better present for Christmas. Sandy Kawelo came over from Hawaii to join him. He had been moping around for most of October when Elvis finally came to him one day and said, "You're no good to me anymore." Jerry was totally shocked. "I was just crushed. I said, 'What do you mean?' Then he smiled and gave me a round-trip ticket to Hawaii. He said, 'Go over there and get her and bring her back.'" Jerry followed the instructions he had been given to a T, staying in Hawaii for several weeks, persuading Sandy's family that his intentions were honorable, and finally meeting her at the Memphis airport one chilly afternoon just after Christmas. Jerry had been telling Grandma Presley for weeks all about his beautiful Hawaiian girlfriend. "I really loved Grandma — she was a very wise and great woman — but she would say, 'Son, why don't you get yourself an American girl?' Then Sandy came to Memphis, and we moved into the apartment complex right across the street — and Grandma just fell in love with her."

To Larry, Elvis seemed increasingly restive, which was hardly surprising, given the extent to which his world continued to be constricted, almost calcified. "In Elvis' life the outside world was a distant place he ventured out into but never really lived in. To outsiders, Elvis' observations on philosophy and religion were interesting; to most insiders, they were annoying. . . . The routines [were] immutable. The occasional employee might leave or come back again; Elvis might move from one house in Los Angeles to another; his recreational interest[s] . . . might shift, but these were imperceptible ripples in an otherwise static existence. Things happened, of course, but even the most dramatic event assumed the texture of an episode on a television series." To Jerry it was like they were all being drawn into a virtual world in which gradually the courtiers became as isolated as the king. "We were all together so much; we were all very much influenced by Elvis, because, let's face it, he was the center of everything that went on. It became normal to us to get up late in the afternoon and go to bed at sunrise, and because of that we became isolated from our families, our friends. We found ourselves relating to each other but not to anybody else. It was like you were in somebody else's environment. There was friction sometimes over salaries or over who did this or that, but Elvis always remained in control. It was a family; we all had our one-on-one relationships with Elvis, and everybody thought that was the special relationship. Elvis had a spiritual charisma about him that made you feel like he was your best friend, and you could always depend on him."

They celebrated New Year's Eve at the Manhattan Club once again, with bandleader Willie Mitchell playing his instrumental hits and various vocalists singing r&b songs of the day. Elvis had George Klein clear the dance floor at one point so he could get a better view of Vaneese Starks when she sang "Hound Dog," and he and Priscilla danced a couple of slow dances and one fast one before he said good night to his guests — over one hundred friends, family, and fans.

He didn't see as many movies as usual over the holiday season, because much of his time was consumed with the slot-car track that Priscilla had given him for Christmas. He and the guys had discovered slot car racing in California and started renting out the Robert E. Lee Raceway almost as frequently as they had once rented the Rainbow Rollerdrome. Priscilla got the home racing set from the proprietor of the Robert E. Lee and it was such a success that Elvis almost immediately started talking about adding another room on to the house to accommodate an expanded setup, something Marty volunteered his brother-in-law could very easily take care of.

It was during this same extended Christmas break that Elvis finally tried LSD. They had all tried marijuana brownies the previous August, and Elvis' interest in consciousness-expanding drugs had been stimulated by his reading, particularly Aldous Huxley's *Doors of Perception* and Timothy Leary's 1964 psychedelic manual. Some of the guys in fact had already taken acid at Elvis' urging, and under his supervision, but the fact that he himself had remained an observer occasioned a good deal of cynical commentary on their part. In Alan Fortas' view, "he was too scared to take it himself, and we were stupid enough to be his guinea pigs," and Red speculated that he wanted to see the effect of the drug on their creativity. In any case his interest in psychotropic effects was not lessened by observation, and when a fan gave him several hits of windowpane acid, he and Larry made plans to take a trip, under carefully controlled conditions.

That day finally came several months after their return to Graceland, and with Sonny (who had been part of the original experiment) as their monitor, Elvis, Priscilla, Larry, and Jerry all embarked upon the experience. They sat at the conference table in the room adjacent to Elvis' bedroom and started out soberly talking about the Leary book and the whole psychedelic experience. Larry, who was the only one with any direct knowledge of the drug, observed with interest as it gradually began to take effect.

About an hour and a half later, we stood up to walk around. Suddenly I noticed that we had lost Jerry. No one knew where he was, and I didn't know whether Jerry was actually missing or whether I was imagining it. Nevertheless, I joined in the search, and we found him lying in a closet, under a pile of Elvis' clothes. Through all this, Elvis obviously was really fighting the effects of the drug, trying his best to make it appear that he was not getting high.

We were having a pleasant, mellow trip when suddenly Priscilla began sobbing. She fell to her knees in front of Elvis and cried, "You don't really love me, you just say you do." . . . Next thing we knew, she was saying to Jerry and me, "You don't like me." When she started telling us that she was "ugly," I worried she might be having a bad trip [but] fortunately she soon snapped out of it. . . .

Like anything else Elvis did, he tripped Elvis-style. No beaded curtains, incense or Indian sitar music for us. Several hours after we had started, we turned on television and watched a science-fiction movie, *The Time Machine*, and sent out for pizza. As we were all coming down, we walked out behind Graceland and marveled at the beauty of nature, talked about how lucky we were to have such good friends and how much we cared about one another. As far as I know, it was the only time Elvis took acid.

When they returned to California, they moved into the new house on Rocca Place. Less than a mile from Perugia, it had been purchased and then rented out to them once again by Mrs. Reginald Owen, the widow of the British film actor, with whom Joe had been doing business ever since they moved to Bellagio in 1961. The new ranch-style home afforded considerably more room and privacy than the house on Perugia, and Joe and Marty got it ready for Elvis' arrival at the beginning of February. Marty took the bedroom next to Elvis' and decorated it with red-flocked wallpaper and black silk hangings draped from the walls; the rest of the house was decorated according to Marty's tastes in dark, solid colors, with Elvis' favorite color, blue, predominating.

Charlie Hodge came back just in time for the move. He had continued working for veteran country entertainer Jimmy Wakely off and on all these years, but now he had made up his mind to return for good. He was present for the recording of the soundtrack for the new picture, even playing some piano on the session, and his presence restored not just a lot of laughter but a lot of music to the house. Charlie was not really one for factions. He had a single loyalty, and while his undeviating devotion to it got on some people's nerves, he was just as capable of getting along with Larry, whom he genuinely admired, as he was with Red, who didn't admire Larry at all but whose love of music Charlie could equally well appreciate. Charlie was emotionally high-strung, he drank too much, and he was dismissed in some quarters as little more than a sycophant — but those quarters were hardly free of the same taint themselves, and overall, Charlie's renewed presence made a difference in the day-to-day mood of the house.

In addition, Rocca Place was meant at last to provide Priscilla with a California home. Some of the guys saw this as the first sign of capitulation in a "struggle of the will" in which "Priscilla very much wanted to get married and [Elvis] was not prepared to sacrifice his enviable bachelor status." She had always been excluded from their Hollywood trips, the ostensible reason being that she would be a distraction to Elvis in his work. But now here she was flying out to join them and doing her best to take over, to establish rules and standards of domestic behavior that could never have been contemplated, let alone enforced, so long as their Bel Air home remained a boys' club exclusively. Naturally, it was resented and perceived as yet another sign of the kind of weakness that had started to manifest itself when Larry first came on the scene. There were personal causes for resentment as well, which, even if they did not originate with Priscilla, ended up in her lap. As Billy Smith saw it, "Elvis basically told her to exert more control over the wives *and* the guys. He said, "They work for me, so if

you tell one of the guys to do something, he'd better do it.' She thought it was easy. She'd tell somebody to get her something, and if he didn't, she'd tell Elvis, and Elvis would blow up. The majority of the guys went along with it, but they left a lot of things unsaid."

Not surprisingly there was no end to the gloating when Priscilla got anything that could be perceived as a comeuppance. One time, for example, she suggested that she might like to visit the set in order to meet Elvis' co-star Shelley Fabares, about whom she had been hearing so much. Elvis said he didn't think that was such a good idea, but she persisted. The guys could hear every word of the argument; they could hear angry shouting and furniture being overturned. Priscilla was beside herself. Was there something going on on the set that he didn't want her to see? "I don't have a goddamn thing to hide," he announced. "You're getting a little too aggressive and demanding. It might be a good idea if you visited your parents for a while."

Shocked, I yelled, "Well, I'm not going!"

"I think you should. In fact, I'll help you." He walked over to my closet and proceeded to throw every piece of clothing I had on the floor, hangers included, along with my suitcase on top of the clothes.

"All right, woman. Start packing!" . . .

Sobbing, I started to pack, as he turned and strode out of the room. Moments later, I heard him yelling for Joe to make a reservation. "Get her on the next flight out. She's going back to her parents." There was a finality in his voice that I had never heard before. Hysterical, I began folding my clothes as he continued yelling in the other room. I packed slowly, stunned by the blow-up.

When he came back into the room, I felt humiliated. I continued folding clothes, sobbing uncontrollably. . . . I got up slowly and started toward the door. Just as I reached it, I felt his hand on my shoulder, turning me around, and then, miraculously, I was in his arms, and he was holding me tight.

"Now do you understand? . . . Do you see that you need this? You need someone to take you right to this point and put you in your place."

I was relieved and happy to be back in his arms. Anything he'd have said would've made sense to me in that moment. . . . This was Elvis' technique of keeping me under control.

He was equally capable, though, of defending her and turning that same controlling fury on the others. Larry and Charlie watched him fire every one of the guys in sight after one of the wives told Priscilla Elvis didn't want her there because he wanted to be free to have his other women. "That's it, that's it," he announced to the room at large. "I'm fed up with you guys and all the small talk, gossiping and bullshit. Now fuck off, all of you. I don't want to see your faces anymore. Call Daddy, tell him every word I said. This will make him real happy."

For the most part, to his surprise Elvis did not find Priscilla's presence as trying as he had thought it might be. Perhaps he simply enjoyed the diversion of a different situation, whatever its attendant difficulties. He took Priscilla out to the Self-Realization Park and even introduced her to Daya Mata, who, Priscilla agreed, bore a striking resemblance to Gladys Presley. If his life lacked a clear center (the new MGM picture, Spinout, once again directed by Norman Taurog, was as slight as anything else in which he had appeared, with a racing-car driver replacing the pilot hero of Paradise, Hawaiian Style), it at least had its peripheral pleasures. And he was very excited about the bus that George Barris was customizing for him, which Barris had promised they would have for the trip back to Memphis in April. It was a retired Greyhound D'Elegance coach, fully outfitted, its rear engine lined with lead to minimize noise, with a hydraulic driver's seat molded to Elvis' body, an elaborate stereo, full kitchen and sleeping quarters, and portholes once again to simulate that "luxury yacht" feeling. He went to Barris' North Hollywood shop several times a week to check on its progress, and was so impatient to try it out that on February 17, the night they finished the soundtrack recording, he induced Barris to break into his own shop (the Kustom King had forgotten his key) so that he and Elvis and Joe could take it on a trial spin to Las Vegas.

He also got a brand-new reel-to-reel Sony video camera and recorder, only recently introduced into the United States for home use. It didn't take him long to figure out the possibilities, and soon he was staging his own private dramas, just as he had with the Polaroid camera a year or two before. Sometimes he used Priscilla alone, sometimes in Priscilla's absence he got girls to wrestle for him wearing only white bras and panties, and occasionally he included Priscilla, too, in an expanded scenario. As to why exactly the underwear had to be all-white no one was altogether clear, but everyone knew that was the way Elvis liked it — it was just his thing. The tapes, too, were strictly for Elvis; sometimes the guys would see them lying around, but Elvis would just say they were TV shows he had recorded. "Okay," Joe once challenged him. "Show us what you recorded." In some embarrassment Elvis declined.

One day Elvis brought the bulky video camera to the set to show it to Norman Taurog. When Taurog responded politely to Elvis' enthusiastic sales pitch for the machine (it would be handy, he agreed, to have something like that for instant playback of scenes they had just done), Elvis gave it to him in an impulsive burst of generosity, even though he knew there was a long wait for the average customer for a new machine. He had no intention of waiting, however, as he made clear to Marty; it was up to Marty to find him an immediate replacement.

In keeping with the Colonel's newfound embrace of production values, the picture was filmed on seven soundstages, with five location sites, including Dodger Stadium. Tempers flared at one point when Red, who had never made any secret of his contempt for Larry, took a swing at him before being restrained by the other guys. Elvis on the other hand maintained spirited philosophical dialogues with several of his co-stars. He genuinely liked Shelley Fabares, with whom he had worked on Girl Happy; he gave Diane McBain an underlined copy of The Impersonal Life and spoke with her of the spiritual precepts of Yogananda; and he set out to save Deborah Walley, who had previously played the leading role in Gidget Goes Hawaiian and was presently lost in a sea of spiritual doubt and confusion. He told her, "Look, we've only got this moment together, so let's have it completely. No holding back. No wasting time on trivialities. I've got the word; I want to give it to you. I'm not a man, I'm not a woman - I'm a soul, a spirit, a force. I have no interest in anything of this world. I want to live in another dimension entirely." It was, according to Walley, the turning point of her life.

To movie columnist May Mann he spoke at length of his mother, of his upbringing, of their last Christmas together. When he was home, he went to the cemetery at least once a week to visit her grave, he told Mann, and he had flowers placed there weekly. The dreams he had of his mother were happy ones: "it's like seeing and being with her again." Graceland was the place he would always maintain as his home because of his memories of her. It was more than just a house to him; it represented "the residence of the heart. It is far more than a place of physical needs. . . . To me my home is all wound up with all the acts of kindness and gentleness that my mother and my grandmother and my daddy lovingly provided. . . . All of this love still remains within its walls. It's an enduring way of life for me." He wanted to get back to going to church, he said. "Church was our way of life since I can remember. The last time I went, there was so much confusion, and autograph-seeking, that out of respect I've stayed away. . . . I've been working on religious songs for an album. I feel God and his goodness, and I believe I can express his love for us in music."

That was, in fact, exactly what he was doing: immersing himself once again in the music. RCA had stipulated that it needed a new album, two new singles, and a Christmas single, to come out of a session tentatively scheduled for May. Perhaps with the idea of capitalizing on the success of "Crying in the Chapel," the album was specifically designated as a religious one, and Elvis and Charlie and Red started working informally on material almost from the moment of Elvis' arrival in California. Somewhat coincidentally, Red had recently added a second tape recorder to the one he had long owned in order to further his ambitions as a songwriter. He wanted to be able to produce his own rough demos without having to go into a studio, and with two reel-to-reel recorders, he felt, he could learn to overdub voices and instrumental parts. He got singers like Glen Campbell, whom he knew from the Red Velvet and the Hollywood musical scene, to demo some of his compositions for just a few bucks a session, but at the same time, he and Charlie started taping songs that they thought Elvis might be interested in — and not just religious ones either.

Almost as if to certify the wisdom of the Colonel's strategy, there was a growing renewal of interest within the entire household in music in general; every morning, before going to the studio, they listened to *Peter, Paul* & Mary in Concert or the trio's latest, See What Tomorrow Brings, and Odetta Sings Dylan was never far from the turntable. Elvis showed a keen interest in Ian and Sylvia as well, along with his usual gospel, blues, and rhythm and blues favorites, and when they all got together to sing, he was as likely to suggest Bob Dylan's "Blowin' in the Wind" as a Statesmen number, much as he may have detested Dylan's abrasive vocal quality and equally abrasive cultural politics ("My mouth feels like Bob Dylan's been sleeping in it," he frequently said, and Dylan's "Rainy Day Women #12 and 35," currently on the radio, infuriated Elvis, with what he saw as its casual advocacy of the drug culture).

These informal sessions drifted all over the place, just as easily jogged by a casual phrase or a recollected note as by sustained musical logic. What they came back to over and over again were the close harmonies with which Elvis had grown up, in which Charlie or Red would frequently take the lead and Elvis as often as not sang the bass part on gospel songs, Hawaiian numbers, and western classics like the Sons of the Pioneers' "Tumbling Tumbleweeds" or "Cool Water." Sometimes the whole gang got into the act, with even Sonny or Priscilla providing an impromptu, if uncertain, lead; Red and Charlie occasionally came up with song ideas of their own; and once in a great while Elvis just might try a demo that Freddy had sent him, singing against the recorded number, then working out his own approach to the song on piano, as Red faithfully documented the process.

It was, really, akin to a reawakening of the soul; just rediscovering the joy of singing led Elvis to further expand his listening tastes, which in turn motivated him to undertake greater vocal challenges. He listened to Caruso, Mario Lanza, and Hank Williams, Judy Garland, Aretha Franklin, and the Rolling Stones. He grew so consumed with admiration for Jimmy Jones, the bass lead for the black gospel group the Harmonizing Four, that he became determined to have Jones on his upcoming session and informed the Colonel and Freddy Bienstock to institute a search.

Colonel felt vindicated. He was under substantial pressure from RCA at this point to deliver; he had in fact been getting persistent telephone calls and letters from RCA vice president Harry Jenkins, somewhat nervous reminders of what they were all hoping would come out of this session, the high expectations that had been raised with the new contract. These were the kind of letters that in the past Colonel might have written to the company. They reminded him of his obligations, and under any other circumstances he would certainly have blown up at the unwonted presumptuousness of their tone. But he put up with Jenkins' reminders with remarkable equanimity, because he was convinced that until Elvis delivered, this was the only way for the game to be played.

He even put up with the recurrent rumor that he was about to sell Elvis' contract and retire with a forbearance that could only have been engendered by his growing confidence that they were past the worst of it. Just after Elvis' February arrival in Hollywood, he gave his good friend Jim Kingsley of the *Memphis Commercial Appeal* an interview that was intended to reassure Kingsley, and the world, that the reports of his demise were not to be believed. "Heck yes, I would retire, and so would my boy, Elvis — if we received enough money," he declared. "But if we retired, who in the heck would want us?" There were hundreds of people who depended on Elvis for their livelihood, he pointed out, as if speaking to a secret listener.

"The bigger an attraction you become, the more responsibilities you face. . . . Elvis is big enough to bear up under [those] responsibilities . . . and he also loves to work. I honestly believe that he will become one of the industry's great actors in the future."

It was a masterly performance, a perfect example of the good Snowman's last resort, his ability to hypnotize even himself. And now, as work on the film concluded, he could more honestly have stated his belief. He had always known that Elvis would tire of Geller's mumbo jumbo, at least as an exclusive diet; he might never let go of it altogether, but the boy's mind jumped around too much ever to settle on any one thing. That was where all these Johnny-come-latelies made their miscalculation: they all counted on the spontaneous enthusiasm, the heart brimming with love, the momentarily sunny day. But they didn't see the clouds on the horizon, they didn't understand the rules of the game, they didn't make provision for an uncertain future — that was what the Colonel was determined to do, for himself and for his boy.

LVIS AND THE GUYS left for Memphis on the weekend of April 16, Γ arriving home at 9:00 P.M. the following Saturday. Elvis drove the refurbished bus practically all the way himself, wearing his driver's cap and thin leather racing gloves. They made music much of the way, laughing and singing and listening to the tapes that Charlie and Red had put together. Whenever they got to a motel where they were going to stay for the night, someone had to lug the heavy video recorder to Elvis' room so he could watch his private tapes. The trip took a little longer than usual, because in Albuquerque Elvis suddenly got the urge to call one of the girls who had performed for him on some of the tapes to come and replicate her performance. The guys all groused as they waited first for her to fly in, then for Elvis to finish doing whatever he was doing with her. Everyone was impatient to get home to their wives and children and girlfriends. They were well aware that there was no contradicting the boss; every one of his whims had to be satisfied. But at least now those whims were finally getting back to something they could all understand.

WITH MOTORCYCLES, 1966: LARRY GELLER, MARTY LACKER, ALAN FORTAS, JOE ESPOSITO, ELVIS, ACTRESS DEBORAH WALLEY, JERRY SCHILLING. (COURTESY OF THE ESTATE OF ELVIS PRESLEY)

FAMILY CIRCLE

HE NEW WAVE of musical enthusiasm that had engulfed him in California continued with his return home on April 23. Within a week of Elvis' arrival in Memphis, three days had been set aside at RCA's Studio B in Nashville, starting on Wednesday, May 25. The seriousness with which this first nonsoundtrack session in two and one-half years was being taken was evident from the preparations that went into it. There was a flurry of correspondence between the record company and the Colonel, the Colonel and his assistant Tom Diskin, Diskin and Freddy Bienstock. Freddy in turn contacted Red West, who with Charlie Hodge now screened all of Freddy's demos for Elvis and passed along the title of every non-Hill and Range number for which Elvis exhibited any enthusiasm so that Freddy could make a deal on it before Elvis went into the studio. In addition, Red and Charlie continued to supply Elvis with tapes of songs in which they thought he might take an interest (Charlie, for example, supplied Elvis with the Sons of the Pioneers' version of the popular hymn "How Great Thou Art"), with Red on occasion pitching songs of his own. They continued to get together for impromptu singing sessions with no focus other than to go wherever the feeling took them, and they continued to talk excitedly about the gospel album that was to be the centerpiece of the upcoming session.

Elvis was disappointed when, despite all of Freddy's and Mr. Diskin's efforts, nobody was able to locate Jimmy Jones, the great black bass singer on whom he had set his heart for the session, but his disappointment was mitigated when Diskin suggested that they substitute the Imperials, a new all-star quartet put together by Jake Hess, former lead singer of the Statesmen and Elvis' boyhood idol. In addition to the Imperials, Elvis made sure that the Jordanaires, soprano Millie Kirkham, and two other female backup singers were all contracted for the session, bringing the total number of singers to eleven and making it possible to achieve the kind of massed choral effect that he had come to envision for the album. For all of the care

put into these preparations, and with all of the expectations on every side, there was one key element that came about strictly by chance, when Elvis' nominal Nashville producer, Chet Atkins, asked a newcomer on the RCA staff if he would mind taking Atkins' place in the control room. Chet had never been one for all-night sessions, and he thought Elvis and this young firecracker would get along well. That was how Felton Jarvis became Elvis' producer.

Jarvis, a thirty-year-old staff producer whom Atkins had brought over from ABC Records the previous year, jumped at the chance. Although he had cut his teeth producing r&b groups like the Tams in his native Atlanta, it was Elvis Presley who had first inspired him to go into the business. A printer by trade, he had seen Elvis while he was stationed at the Marine base in Norfolk, Virginia, in 1955, and it had changed his life. When he got out of the Marines, he recorded an Elvis imitation record ("Don't Knock Elvis") and went to work as a sheet music printer at Bill Lowery's NRC (National Recording Corporation) studio/label/publishing complex. NRC at the time was recording Joe South, Ray Stevens, Mac Davis, Freddy Weller, and Jerry Reed, all of whom would become bona fide stars in the next decade, and Felton hung around the studio so much that when the engineer quit he was hired. In 1961 he recorded a number-one r&b hit on a then-unknown group called Gladys Knight and the Pips. That led to a job doing promotion for ABC, which he parlayed into an a&r position when, in 1962, he produced a split session on an Elvis imitator named Vince Everett (whom he had discovered performing under his real name of Marvin Benefield in a talent contest and then renamed for the lead character in Jailhouse Rock) and Tommy Roe, another NRC alumnus, who had been kicking around on the fringes of the music industry for the last three or four years. Everett's version of "Such a Night," recorded by Elvis in 1960 but released only as an album cut, was a regional hit, but it was Tommy Roe's "Sheila" that made Felton's career. When it went to number one on the pop charts, Felton renewed his suit to join ABC's a&r department, and when the label indicated that it might be willing to entertain the idea if he were willing to forgo producer's royalties on his number-one hit, he seized upon the opportunity. His friends weren't sure he even knew what he was signing, but he knew what he wanted, and when ABC opened up a Nashville office the following year, he moved like a shot.

It was his enthusiasm, not his technical expertise, which everyone who came into contact with Felton first remarked upon. "Every man a tiger," was Bill Lowery's frequently repeated motto, but Felton carried it to a new extreme. In Atlanta Felton had owned a tiger, or at least a pet ocelot; in Nashville he soon acquired an anaconda, which he took swimming with him in the pool of his apartment complex until an elderly couple, out for an early-morning walk, noticed his unusual swimming companion, and he was forced to find new quarters. In Nashville, too, he quickly fell in with a group of young guys who hung out at the Pancake Pantry and traded stories of their adventures in the music business and their dreams of achieving success within it. No one could top Felton's stories for sheer irrepressible buoyancy, and everyone loved to hear him tell about his encounters with r&b stars like Lloyd Price and Fats Domino, whom ABC was bringing in to Nashville to record at that time. "Fel-tone, my man," Fats' invariable greeting to him, became a byword in certain circles in Nashville, and Felton soon acquired an industry-wide reputation for eccentricity, affability, and imagination.

In 1965 he came to RCA at Chet's invitation, co-producing Willie Nelson with Atkins, then recording Mickey Newbury, Jim Ed Brown, Floyd Cramer, and Cortelia Clarke, an old blind blues singer whom he recorded live, with traffic sounds and background noise, on the streets of downtown Nashville. He had an office right across the hall from Chet's, in which he constructed a tropical hut with a grass roof to house his snake, and there was no question that he tried his boss's patience on occasion. But Chet, who was himself of a drier, more phlegmatic nature, got a real kick out of Felton and, less than a year after his arrival at RCA, came up with the idea of connecting him with another decidedly antic spirit. A few days before the Presley session he came into Felton's office. "He just said, T'm going to carry you over, and maybe you all will hit it off." And so we did."

 $F_{P.M.}$, there was no question that he was taken with the hopped-up, almost hyperactive enthusiasm of this skinny young producer — it was a hell of a relief after Chet's damned indifference. At first conversation was somewhat strained. They talked a little about the material, they talked about some of the records that Felton had produced — Elvis couldn't get enough of hearing about Felton's experiences with Fats Domino, and Lamar, who hung out with Felton and his friends on a semiregular basis, goaded Felton to reveal more of himself.

230 🔊 FAMILY CIRCLE

They talked, too, about the sound of the records that Elvis had been putting out lately. As an Elvis Presley fan (Felton might very well have said, as Elvis Presley's *biggest* fan), Felton was well aware that "for a while before I started working with him, what they were doing was turning the band way down and Elvis way up, and it sounded like — it was just bad. It wasn't exciting. There was no excitement on the records. This is what I was trying to correct [because] Elvis had nobody to communicate with at RCA somebody in New York that didn't know anything would just mix it, and it wasn't mixed properly."

What Elvis wanted, he explained to Felton, was the kind of sound the Beatles and some of the other English bands were getting: it was a hotter sound; it jumped out at you, you got the sense that something was really happening. Felton eagerly nodded assent. It was a matter of feel, he told Elvis. "You get your excitement from the drums and the bass getting real funky — you got to have all that stuff up — and it's got to be mixed properly." And it became clear almost immediately that they would become not only friends but musical allies. Felton was, Elvis quickly realized, one of them. Chet recognized just as quickly that the two of them *had* hit it off and went home before a note was struck. The singers all gathered around Elvis at the piano and felt each other out — there was an edge of expectation in the air, and the new producer was in no hurry to get down to the business of recording, he was having so much fun just being a part of it all.

It was well after ten o'clock before they finally got to work, starting out with "Run On," a traditional number in the black spiritual tradition. Elvis took it in the manner of the Golden Gate Quartet, lightly swinging, coolly elegant — from the very first notes he was clearly in command, and Felton was just as clearly second in command, soothing, encouraging, carefully picking his way among potentially bruised egos, urging another take when he felt he could comfortably do so, holding back a little at first but always providing encouragement and reassurance.

To Jake Hess, who took a backseat to no one both as a pure singer and as a gospel music innovator, there was no way they could miss with all the positive energy in the room. "Elvis just really loved that sound; the adrenaline really pumped in him when he heard it. He wanted a big sound, and we sung like Elvis wanted it sung. We all had our parts written out, the chords, and we all stayed in the same chord, even though we stacked our harmony different than the Jordanaires. I don't think he cared so much [how] we blended, he just wanted that big sound." After seven takes they had a master ("Swing!" Felton urged, to kick off the final take), and they moved on to "How Great Thou Art," the nineteenth century Swedish hymn that had been popularized in its English translation by George Beverly Shea in Billy Graham's sixteen-week 1957 Crusade at Madison Square Garden. It was a bravura showpiece, and Elvis and Charlie and Red had been working on it all spring, though not off of Shea's rather formal model. Elvis saw the song, as he saw every number with which he made a passionate musical connection, as his opportunity to pour out his entire heart and soul, with no holding back, and that is what he did here. To Jerry Schilling, it was as if he had been taken over by another spirit as he built to a vocal crescendo that left him visibly shaken.

"He didn't do a lot of takes, but something almost frightening happened on that song; it was like he was just *drained* — he turned white and almost fainted when he finished. I wish I could verbalize it better, and I don't know if I'm talking about three minutes or three seconds, but it was as if something happened outside the normal experience. And I don't really think like that ordinarily — and it's not even my favorite song! But there was no question that for Elvis something really happened."

The rest of the night maintained the same high spirits, if not the transcendent aspect, of that moment. They ran into a little bit of trouble on "Stand By Me," a staple of the black gospel tradition, but aided by Felton's increasingly vocal encouragement, Elvis was able to overcome some difficulties with the feel and the lyrics and deliver a beautifully articulated, almost nakedly yearning performance on the eleventh take. The warmth of his voice, his controlled use of both vibrato technique and natural falsetto range, the subtlety and deeply felt conviction of his singing were all qualities recognizably belonging to his talent but just as recognizably not to be achieved without sustained dedication and effort. Perhaps even more instructive was his approach to the next song, "Where No One Stands Alone," one of Jake Hess' most challenging showpieces. The song was, really, beyond Elvis' range; it required a kind of projection that was not within his power at this stage. And yet he persisted, as if to underscore his commitment to the moment, taking the bridge over and over until at last, without ever quite getting it right (he was reduced to a kind of inelegant bellowing to push out a sound that appears to have been effortless for Jake Hess), with Charlie's coaching and Felton's encouragement, and the chorus obscuring some of his greatest difficulties, he achieves a hard-won but satisfactory result. It is a genuinely heroic effort, the very attempt in and of itself as touching as anything else to come out of the session — and it did not go unnoticed among many of the participants.

To Jake Hess it was one more example of the conviction of Elvis' singing. "Elvis was one of those individuals, when he sang a song, he just seemed to live every word of it. There's other people that have a voice that's maybe as great or greater than Presley's, I don't know, but he had that certain something that everyone searches for all during their lifetime. You know, he sang a lot with his eyes closed, and I think the reason for that was because he [wanted] to have a picture in mind at all times; if something was distracting him to where he couldn't put his heart into what he was doing, he would close his eyes, so he could get that picture of what he was talking about. That's the reason he communicated with the audience so well."

It was 4:00 A.M., and the Imperials were done for the night, but Elvis and Felton and the rest of the session singers and musicians never flagged. For Felton, actually working with Elvis merely served as proof of everything he had taken from Elvis' music in the first place. Felton's entire philosophy of recording rested on creating a sense of enthusiasm and spontaneity in the studio, and now to discover the man he had idolized for so long equally focused in his beliefs, equally committed to working all night if necessary *until the feeling was right*, made him feel in a way as if their meeting must have been fated. To guitarist Chip Young, working his first Presley session, Felton and Elvis were like mirror images of one another. Young, another native Atlantan, who had recorded Tommy Roe in the first place and then brought him to Felton, saw the effect the two of them had on each other. "Everything just started getting electrified when they came into the room." There was never any question, working with either one, that a musician was prepared to give his all, and then some.

Without hesitation, and with no apparent sense of any disparity between the sacred and the profane, they launched into "Down in the Alley," a raucous r&b hit by the Clovers which had been a favorite of Elvis' since its original release in 1957. "Funksville, Take One," announced Felton, as Elvis gave the backup singers their lyrics, and the good feeling in the studio was almost palpable. For this song Bobby Moore, who had been playing stand-up bass all night, switched to electric, Boots Randolph took a bleating saxophone solo, and they ran through nine quick takes, interrupted only by Elvis' uncontrollable laughter at Charlie's jokes and familiar hijinks. Everyone remained in high spirits all the way through, and while the results may not have been art, or even the equal of the Clovers', we get a sense of Elvis' untrammeled r&b side for the first time since 1960. In an even more improbable programming twist, Elvis announced that for the final song of the evening they would do "Tomorrow Is a Long Time," a Bob Dylan composition which had yet to be recorded by Bob Dylan but which Elvis had picked up from one of his favorite current albums, *Odetta Sings Dylan*. They took just three passes at it, including one false start, with a dobro part at the center of a lovely, lilting arrangement that was the antithesis of the pounding, not very subtle attack of the previous number. Elvis' vocal was focused exclusively on the lyrics, with very little in the way of stylistic embroidery or emotional interpolation, and the result is a delicacy and purity of tone rivaled only by some of his best earlysixties recordings.

At the end of the evening Elvis and Felton sat around, exhausted but feeling good. They talked about the all-night gospel singings that both had grown up with, and Elvis confessed that it had been his childhood ambition to join one of those great quartets. "We stayed," recalled Felton, "till the secretaries started coming in. Everybody else had gone but me and him. I said, 'Elvis, we better go; the people are starting to come to work.' He said, 'Lord, is it that late?,' and I carried him back to his motel."

The following evening pianist Floyd Cramer had another session booked from 6:30 to 9:30, so Chet's secretary, Mary Lynch, arranged for a twenty-three-year-old piano player named David Briggs, who had arrived in town the previous year, to fill in during what was sure to be a largely wasted time slot. Briggs, like Chip Young, had known Felton from the early days, when Felton brought many of his Atlanta acts to Muscle Shoals to record with a rhythm section that included David. Felton had in fact encouraged the entire rhythm section to move to Nashville for better working conditions and better pay, but it was Mary Lynch, in her position as Chet's studio booker, who had been throwing session work David's way and to whom he was now grateful for the chance at least to meet one of his idols.

No one expected there to be any need for Briggs' services, since Elvis rarely even showed up for the first couple of hours, but for some reason this time not only did he show, he came to work. "I was just there as a substitute, and they said, 'You know, Elvis, Floyd couldn't be here for a while, so this is David, and he's going to play whatever.' And he said, 'Yeah, okay, fine,' and he sat down beside me at the piano, and then, of all things, he wanted to do 'Love Letters' [a big r&b hit for Ketty Lester in 1962, and a pop hit for Dick Haymes two decades earlier], which is all piano. I mean, we were supposed to be doing a gospel album, and here Elvis was sitting beside me, wanting to do 'Love Letters' — and that was a hard song to play!

"I was scared to death. I mean, I had done a Beatles tour with Tommy Roe, but Elvis was something else. And then he wants the piano pulled up in front of him. He had all the lights turned out, put candles on the piano so he could see the lyrics, and he made everybody lay out except the bass player and D.J. on drums and Buddy Harman on tympani, I think. He had the piano moved up so he could be right on top of it — there was just that six-foot piano between us; man, it was a pretty tense situation."

Floyd showed up by the time they were actually ready to record. "I said, 'Great! Come in, Floyd, you've got it.' And I went back to the organ. Floyd ran through it once, and Elvis said, 'Where is that boy?' And I said, 'Oh, shit.' He was looking for me — he didn't even know who I was, and Floyd could have played it better, but he had gotten used to the way I was doing the song. That's just the way Elvis was. If he got used to something, and if he liked you, then you were just better than the next guy, even though you might not be a tenth as good. So — now talk about pressure. Not only was it Elvis, it was Floyd, who was probably the number-one keyboard player in town, sitting behind me on organ and laughing because he didn't give a shit; he'd been working all day and was sick of it. So that was my first encounter with Elvis. I probably had knots coming out of the back of my neck."

Elvis sang the song with delicacy and feeling, and they got a master on the ninth take, even if Briggs was never satisfied with his part, which he felt came out too saccharine. The rest of the session may not have offered quite as much offstage drama, but it was certainly as successful, with an easygoing, up-tempo black gospel number ("So High"), a mournful version of the quartet standard "Farther Along" that could very well have been offered as a tribute to Elvis' mother, and an interpretation of "In the Garden," a classic gospel piece that for Jake Hess was the highlight of the session. Elvis, Charlie, and Red closed out the evening with a trio version of "Beyond the Reef," with Red taking the lead, Charlie singing high tenor, and Elvis on second tenor and playing piano. It was one of the songs they had sung together all spring, a sweetly sentimental Hawaiian number popularized by Bing Crosby in 1950 (it was the B side of Crosby's "Harbor Lights," one of the first songs Elvis had attempted at Sun), and they imparted to it a freely nostalgic, almost spiritual quality, as they wrapped it up in two takes.

The next night was the final one planned, and the last on which the

Imperials could participate, since they were taking off on a Canadian tour early the next morning. Once again Elvis seemed to be simply following his instincts, choosing songs with little regard for prearrangement or publishing, and no doubt causing "the mighty Freddy," as the Colonel ironically referred to the song plugger, paroxysms of anxiety. The music didn't come easy; in fact they got only two songs in the first six hours. But it continued to reflect some of Elvis' warmest, most profoundly felt work. Toward the end of the evening, casting about for a fast number to offset the many slow, almost dirgelike tunes they had already cut, Elvis requested a lead sheet for "If the Lord Wasn't Walking By My Side," a recent Imperials release, which he then went on to record as a straightforward duet with his mentor, Jake Hess. Here for the first time we can hear Jake's voice truly unleashed, as the two singers toss phrases back and forth, and the clear lineage of Elvis' music unmistakably emerges. Listening to the first playback, Jake was a little taken aback. "I said, 'Man, I'm too loud, I've got to back out.' Elvis said, 'No, you don't back out. If anything, you step in and sing loud.' He said, 'This is your song. I'm recording with you, and I want to enjoy singing it like you're singing it.' The way it finally came out, my voice was not as strong as it was in the recording session. But it's still ridiculous."

A fourth night provided little more than a disappointing coda. For all the success of the gospel recordings, and all the good feeling engendered by the session, it had become obvious by now that the two new singles and Christmas record that the Colonel had promised RCA were unlikely to materialize. With the exception of "Love Letters," there was nothing even remotely resembling a single (the Dylan cut could scarcely qualify, since Freddy had no chance of making a publishing deal, and "Down in the Alley" and "Beyond the Reef" were more in the nature of personal indulgence than commercial product). The result was that another night was tacked on in hopes of fulfilling the RCA quota, but with little preparation and less suitable material, Felton had to scramble just to get the session off the ground. In the end much of the good feeling of the first three nights appears to have dissipated, and there is an edge to Elvis' voice in the between-takes chatter that seems to reflect a general change of demeanor. When they knocked off at ten o'clock, it was with little fanfare or regret, but Elvis did sign a photo to Felton that said, "You make me look forward to the next time."

The next time came sooner than either one of them expected. Two weeks later, on June 10, Felton had the whole group back together again to

236 👁 FAMILY CIRCLE

try to get the sides that were contractually required. Virtually all the participants from the first session were present, with one exception: Elvis was not there. He may have simply felt that he was being pressured; it may have been, as Red West believed, that he was just not in a "recording mood" whether due to a bad throat, an excess of pills, or even surreptitious advice from the Colonel. Whatever the case, Elvis was in a foul temper and refused to leave the motel room, dispatching Red, armed only with amphetamines to bolster his confidence, to go into the studio and cut reference vocals. "I was a nervous wreck, and I'm in there singing 'Indescribably Blue,' 'I'll Remember You,' and [my song] 'If Every Day Was Like Christmas.' And he's calling every hour and half, two hours, and saying, 'How's it going? How's it going?' And after we finished the third, he said, 'Come on, bring what you got, that's it.' We were going to do a lot more, but we did those three, and that was the end of it."

Of the three, two came with obligations attached, and the third, Don Ho's "I'll Remember You," was another of those achingly romantic Hawaiian numbers that Elvis loved so much and would continue to sing for the rest of his life but that fell into the same noncommercial category as some of his other equally whimsical choices. "Indescribably Blue," on the other hand, was a pretty, somewhat insipid ballad that Lamar had brought to the first session and, spurred on both by his belief in the song and by the fact that in his three years of employment at Hill and Range he had never gotten an Elvis Presley cut on his own, had been pushing for Elvis to record ever since. Of course, to be fair, for two and one half of those years, Elvis had been recording nothing but movie material, but Lamar was never one to take a backseat to anyone, and it must have galled him to see the Imperials get a cut at the previous session, to know that Red and Charlie all of a sudden had gained the inside track, when he had a song that he knew could be Elvis' first number-one hit in years, not to mention his own ticket to music industry respectability. Red, meanwhile, had been pushing Elvis to cut his Christmas song for close to a year, finally recording it on his own Brent label in the fall of 1965 only after it became obvious that Elvis was not going to get around to it in time for Christmas that year himself.

Listening to Red's scratch vocals on the songs is something of a revelation. "Indescribably Blue" is sung breathily in Elvis' key, but with a feeling that must have revealed hitherto unsuspected depths to some of the session musicians who knew Red as nothing more than a hulking, somewhat menacing self-described "bodyguard." The resemblance to Elvis' voice is uncanny, almost eerie in its precision, but what is even more remarkable is the tender quality of the performance not just on this song but on the two others that follow. With the completion of the third, his own composition, Red picked up a copy of the tape from Felton and, following Elvis' instructions, brought it back to the Albert Pick Motel. They listened to it a number of times, and Elvis expressed his satisfaction with the results, but he didn't show up at the studio the next night either, and the session was canceled. When he finally appeared on the third night, it was only to overdub his own voice, and whatever hopes Felton had for recording any additional material were dashed when Elvis took off for Memphis later that evening.

It was a puzzling end to a first meeting that had begun so promisingly just two weeks before, and no one knew quite what to make of it, least of all Felton. But if Felton was perplexed, RCA's Harry Jenkins must have been even more disturbed. After all the talk, after all the precise spelling out of obligations, after all the Colonel's lulling reassurances, the record label in the end was still left with an unsatisfactory result. They had their gospel album, to be sure, and maybe they could piece together two singles — though it seemed unlikely that there was any hit material from either session. They still had only half a Christmas single, and perhaps not surprisingly there was nothing left in the can. It seemed evident, too, that Freddy, after years in the Hollywood desert, could no longer deliver tunes to Elvis' taste or inclination, and it was hard to say what the long-term implications of that were likely to be. And, of course, the way that it had ended simply left everyone with a bad taste in their mouths. No one could fully interpret events, except to wonder if this wasn't Elvis' way (and perhaps the Colonel's as well) of saying that he wasn't going to be pushed around.

Elvis for his part must have thought better of his actions. Back home in Memphis he wrote Felton a warm letter of appreciation. "Please convey how much I deeply appreciate the cooperation and consideration shown to me and my associates during my last two trips to Nashville," he declared. "I would like to thank you, the engineers, musicians, singers, and everyone connected with the sessions. Please see that every one of them know my feelings. And as General MacArthur once said, 'I Shall Return.'"

Two weeks later, on June 28, he was back in Hollywood recording the soundtrack for his latest motion picture, *Double Trouble*, an MGM release with Norman Taurog once again at the helm. It was a full eightweek shoot in the course of which he presented his leading lady, Annette Day, with a blue-and-white Mustang, but undoubtedly the two most memorable events of the summer had nothing to do with the movie but instead revolved around visits from George Klein and Cliff Gleaves.

George was out for the start of filming, planning his two-week summer vacation as usual around Elvis' shooting schedule (this would be the sixth Elvis movie in which he would appear). Coincidentally, one of Elvis' favorite entertainers, rhythm and blues singer Jackie Wilson, was appearing at a club on Sunset called The Trip from June 30 to July 10. George knew Jackie, renowned almost as much for his acrobatic stage act as for his near-operatic voice, from promoting some of his headlining Memphis appearances on the television show that George hosted, a local version of Dick Clark's *American Bandstand* called *Talent Party*. Elvis had even seen Jackie perform while he was still working as lead singer for Billy Ward and the Dominoes ten years earlier in Las Vegas. So it was with Elvis' eager assent that George arranged for them all to attend Wilson's show.

Everyone was in a great state of excitement. With the exception of their occasional trips to the Red Velvet, it was almost unheard of for the whole gang to get out in L.A., and there was a flurry of preparations and security precautions to be carried out. George and Richard Davis went down to the club as a kind of advance party, and George called up James Brown, another frequent guest on his show, who was in town to give a concert of his own. Brown knew through George how big a fan Elvis was of his spectacular performance on The T.A.M.I. Show, a filmed concert that had been released in movie theaters the previous year, and he had sought an introduction from George on numerous occasions, including his latest Memphis appearance just two months earlier. Every time he called, though, he got word that Elvis was asleep — it became a running joke between him and George, and a source of embarrassment to the DJ, who was known as one of Elvis' best and oldest friends. Seizing the opportunity that this occasion provided, George issued Brown a special invitation to come see Jackie perform, and this time he guaranteed him an introduction.

The show was electrifying. Wilson, whom Elvis had recognized as a premiere performer when he first saw him in Vegas in 1956 ("I was under the table when he got through singing"), was no less mesmerizing now. There were a number of prominent contemporary rock musicians in the audience, including members of the newly formed Buffalo Springfield, and expatriate Elvis imitator P. F. Sloan, but it was James Brown that Elvis instantly sought out as soon as George told him that Brown was present

and would like to say hello. George thought Elvis might stand on ceremony, "but he got up and went over to [Brown's] table. Me and Richard went through the introductions, and they go through some small talk this is before showtime — and James Brown says, 'Man, Elvis, you sure do sleep a lot.' And Elvis almost fell on the floor, laughing. He said, 'Aw, James, you know how it is, being a night person. . . .' And James said, 'I know, brother,' and slapped Elvis' hand."

In between sets he finally got the opportunity to meet Jackie, too, and express his unreserved admiration for Wilson's talent. With what he had going for him, Elvis said, there was no reason Jackie shouldn't be the number-one singer in the world today, and he invited him out to the film set the following week. Larry Geller's particular memory of the meeting was that Elvis asked Jackie "about his profuse sweating. 'Man, I'll tell you,' [Wilson replied] 'the chicks really dig that.' Elvis said, 'How do you do it?' Wilson grinned and said, 'Hey, that's simple.' He showed us a large bottle of salt tablets and then revealed his secret. Each night before a show, he'd swallow a handful of tablets, guzzle a few quarts of water, then go onstage. Once he got moving, the sweat would wash off him like rain. Soon Elvis started incorporating this trick into his weight-loss regimen. It was dangerous, it depleted potassium and overtaxed the heart, but it produced one of Elvis' favorite things: an instant result with minimal effort."

It was a memorable evening in every respect, and undoubtedly one of the reasons that it loomed so large in everyone's respective (and sharply diverging) memories was that evenings like this happened so seldom. There was some of the same sense of excitement - or maybe it was just relief at anything resembling a break in the usual routine -- when Cliff Gleaves showed up later in the summer with nothing more than a flight bag and a Water Pik for luggage, all the way from Florida by way of Arizona. Some of the younger members of the group who had never met him but had long known him by reputation were at first enthralled. Cliff, Red's successor in Germany, where he had pursued a career as a singer and comedian, had by now pretty much given up any real show business ambitions and was living with his mother and father in Fort Lauderdale, Florida, occasionally entertaining in piano bars for the wealthy older ladies who wintered in the area. He continued to be the kind of self-styled free spirit who could still give everyone a good laugh, but the laughs tended to wear off after the first two or three days of a visit. And he had begun to encounter certain problems of his own, problems that he was surprised to

recognize for the first time in a friend he had always viewed as something of an "innocent."

"I was aware that the prescriptions that Elvis was taking — I did not know the names of the medications — were beginning to affect his personality. I saw the change, be it ever so subtle. Slight touches of the Colonel that were negative. Sense of danger that was never there before. All of a sudden the snake was down around his leg. *And he did not know*. If he had been aware, he would have had someone get that damn snake off of him.

"During this period I was taking pills, too, mostly Dexedrine. And if I was tired I'd just say, 'Have you got any more of these red ones?' Or, 'You got any more of those pink ones?' Sometimes he'd just grin and say, 'Here's the bottle.' I'll tell you this: Elvis didn't care if anyone else took them or not. He was getting off on them. He loved to sit there high and wiggle in the chair, just wiggle his legs with a big pitcher of ice water in front of him — he'd drink tons of water 'cause you could see it dehydrating him — just sit there and watch TV. He didn't give a damn whether you did any-thing. He was going to do what he wanted to do anyway."

PREPRODUCTION for what was to be the final Hal Wallis picture, *Easy Come, Easy Go,* was scheduled to begin on September 27, just three weeks after the conclusion of *Double Trouble.* The Colonel had already given Wallis no end of trouble himself, bedeviling him to the point of demanding a chair similar to one in Wallis' office as part of his final negotiations. Wallis had at last resigned himself to the end of a highly profitable, if highly stressful, ten-year relationship, and he said as much to John Rich, the director, who at this point was almost as disillusioned with Wallis as Elvis was. Rich had originally balked at the idea of working with Elvis on *Roustabout* but had made the best of it and even come to respect Presley for his professionalism and musical talent. Now after a disappointing two and one-half years in Hollywood, it was a different story.

"Wallis was really tightening up. He wanted everything done rapidly. [That was the attitude] from the word go. I remember telling him, 'Hal, I appreciate having done *Roustabout*. It came out rather well. But I would prefer not to do this picture.' And he said, 'Oh, just put them through their paces.' It was not my finest moment, but that was his assessment as to how the picture was to be made."

For somewhat similar reasons, all that Elvis seemed to bring to the pic-

ture was an accumulation of resentment. When it came to the soundtrack, he simply turned the job of song selection over to Red, and he arrived uncharacteristically late on each of the first two days of shooting — and with a haircut that Larry had given him at home, against Wallis' explicit instructions. He was overweight, Wallis complained to the Colonel, and the "inky-black" color of his hair dye made it look like he was wearing a wig. The Colonel offered no objections, but neither did he do anything to alleviate Wallis' concerns.

The picture dragged on almost interminably in a test of wills that had little to do with actual results. With the new stepped-up shooting schedule, production was completed in six weeks, but Elvis was not released until his contractual deadline a full two weeks later. He occupied much of the time in Palm Springs, where he had rented a house at the Colonel's suggestion just a week before the movie began. He needed a "getaway" retreat, Colonel told him, somewhere that he and Priscilla and one or two of the boys could just relax and get away from it all.

The house that they found, at 1350 Ladera Circle, was just around the corner from the one that William Morris furnished to the Colonel, a brandnew, ultra-modern structure (the design incorporated "glass and peanutbrittle stonework to inscribe four perfect circles on three levels," boasted a 1962 squib in Look magazine) built by Palm Springs developer Robert Alexander originally as a residence for his family. It had a tennis court, a waterfall, a free-standing fireplace in the living room, and, best of all, a wing that could serve as a private apartment for Elvis, with entry only from the outside off the circular pool. With neighbors like Frank Sinatra, Dean Martin, Bob Hope, and Bing Crosby, not to mention studio heads and powerful behind-the-scenes figures like William Morris founder Abe Lastfogel and Hal Wallis himself, it might have seemed that Elvis was at last joining the Hollywood establishment. With the exception of shopping sprees and occasional trips to the Spa Hotel, where the Colonel took his daily steam bath, however, he kept as much to himself in Palm Springs as he did in Bel Air. Indeed, he appeared more comfortable with the policemen who worked the security detail at his house or the air-conditioning servicemen who installed a powerful hotel-sized unit to keep the temperature at the meat-locker chill that Elvis preferred than he did with the movie-town high society all around him.

In fact, he felt more estranged from Hollywood than ever, as he stoically endured a movie that no one seemed to want to make and faced the

242 🔊 FAMILY CIRCLE

inescapable conclusion that, after all these years, to these people he was nothing more than a joke. Most of the time he just followed directions; he had learned long ago that it was all about finding your mark, and then just having whatever fun there was to be had along the way. But even the fun was drying up. He was sick of all the turmoil around him, he confessed to Daya Mata on one of his still-frequent visits to the Self-Realization Center on Mt. Washington. He was sick of all the infighting that was increasingly coming to dominate his life. RCA had sent him a telegram on August 30 renewing the option that had not been scheduled to be picked up for another year and a half ("Because of our confidence in you, we decided not to wait until 1968," it read in part. "Your complete cooperation and understanding over the last eleven years has been most sincerely appreciated"). He supposed that that was good — it was, as Colonel pointed out, a form of insurance — but he was as aware as anyone that his records still were not selling as they should ("Love Letters" from the May session got no higher than number nineteen and failed to sell half a million copies), his movies were not doing any business, and although the old man continued to keep up a good front, you could see that even he was beginning to wonder.

All this seemed only to exacerbate the tensions within the group. There was jealousy on every side, and Priscilla's growing role at Rocca and the new Palm Springs house just inflamed those tensions. Marty in particular raged at the way that Joe and Joanie alone were included in the Palm Springs plans every weekend and that the two couples seemed to socialize with each other more and more, even joining the Colonel and Mrs. Parker for Sunday dinner on occasion. Marty and Joe were barely speaking to each other at this point, Red and Sonny set themselves apart, Alan had gone home to be with his father, who was gravely ill, and Marty and Priscilla were squabbling all the time.

Meanwhile, the Colonel had stepped up his campaign against Larry; it was finally out in the open now, and where Elvis might once have spoken up in Larry's defense, now he no longer seemed to have either the energy or the belief for battle. One time in Palm Springs the Colonel got Elvis to tell Larry that the beard that he was growing was an embarrassment to the Colonel and Hal Wallis. They had seen Larry in the swimming pool at the Spa Hotel, Elvis dutifully reported, and "Colonel said that when you stood up in the pool you looked just like John the Baptist."

Another time, Larry was convinced, Colonel tried to set him up by having a mutual acquaintance, who was homosexual, ask Larry out to dinner and then hit on him. The inclusion of the musical number "Yoga Is As Yoga Does," which Elvis performed as a duet in *Easy Come, Easy Go,* was no accident, Larry felt, but intended, rather, as a direct insult to Elvis' (and Larry's) beliefs — but Elvis went ahead and recorded it anyway. Only after the scene in which it was included was shot did Elvis finally react. It was then, in Larry's account, that Elvis "stormed into his trailer, shouting, 'That son of a bitch! He knows, and he did it! He told those damn writers what to do, and he's making me do this.'"

The final indignity, according to Larry, came when the Colonel invited Larry and his family to visit for the first time at his home in Palm Springs. There he entertained Larry and his wife, Stevie, treated the kids to ice cream, and put on what Larry deemed a good, if somewhat puzzling, show of sociability. Upon their return to Los Angeles, however, "I saw that the back door was open. . . . Two large garbage cans had been upended, and trash was strewn throughout the house, along with human urine and feces. My initial impression was that a thief had broken in. But when I looked around, I could see that most of our portable valuables were still there. Only a reel-to-reel tape, along with some tapes Sister Daya Mata had made for me, my files containing palm prints and numerological and astrological charts on Elvis and other friends were missing." In addition, all of Larry's clothes had been taken, except for his underwear. Although there could certainly have been other explanations, Larry was led to one inescapable conclusion. When he shared it with Elvis, "our eyes met, and he looked away.... Shaking his head, he kept repeating, 'Damn! Damn!' Then he stared me straight in the eye, his way of telling me things he couldn't articulate. After a moment, he said, 'Lawrence, it's a dangerous fuckin' world. . . . '"

Whether or not he actually believed the Colonel would orchestrate so blatant an attack (and it seems as unlikely that Elvis would have believed this literally as that the Colonel — with his fine regard for legality and his almost compulsive need, in all of his affairs, to dot all his i's and cross all his t's — would have left himself exposed in this manner), he had his own reasons for mistrusting his manager. He was sick of being caught up in the petty politics of the business, and he was angry at Colonel for not protecting him better — there was nothing in the contractual arrangements that should have permitted either the studio or the record company to take their pound of flesh. As the days dragged on and he realized that Wallis wasn't going to release him anytime soon, he grew increasingly sullen, and even as he accepted the old man's invitation to spend Thanksgiving with him and Mrs. Parker in the desert, he seethed inside. This was not the kind of life he had set out to lead.

The Colonel, for his part, kept his thoughts largely to himself, except in those rarest of moments when he might let down his guard a little with a close business associate whom he could rely upon never to break the trust. There were problems, he confessed to Roger Davis, the forty-three-year-old William Morris attorney who had been delegated an increasing amount of Elvis Presley business as some of the more senior agents either phased out or concentrated on handling just a few oldtimers' accounts. "The Colonel would say to me, 'I'm having trouble with the boy.' You see, he couldn't control him [anymore]. I said, 'What's the matter?' And he said, 'Well, he's changing, you know. He's not the way he used to be.'"

THEY FINALLY ARRIVED HOME ON NOVEMber 29, just after Spinout opened nationally. It wasn't doing any real business, and the title track never rose above number forty on the charts, but Elvis was still in a pretty good mood as they got closer to Memphis. Just outside Little Rock they picked up George on WHBQ's 560 radio frequency. He was playing the country tearjerker "Green, Green Grass of Home" by Tom Jones, whom they all liked, and Elvis stopped the bus and had one of the guys call George and ask him to play the song again. When they got a little further down the road, Elvis put in another call, and this kept up the rest of the way to Memphis, with George dedicating each play to Elvis and all the boys and Elvis growing visibly more affected by the song's portrait of a condemned man's imagined reunion with his loved ones and the idealized small-town life he has forever left behind. Everyone got a good laugh out of the incident except for Red, who had brought Elvis the song the year before and been told by Elvis it was far too country for him to even consider recording.

When they finally arrived at Graceland in the usual caravan, the Nativity scene was illuminated, the house was alight, and — just as in the song everyone was outside to greet them, as they drove around the circle honking their horns. Elvis immediately went upstairs to survey the renovation of his quarters, which Marty's brother-in-law, Bernie, had once again supervised. He came back down with a broad smile. It was beautiful, he pronounced. He loved the black-and-red Spanish motif of the walls, and Bernie

APRIL 1966-MAY 1967 👁 245

had upholstered the ceiling with green Naugahyde, with two television sets imbedded in the material at an angle, so he could just look up and watch from his bed. Unfortunately, the redecorating had led to further financial strain between Bernie and Vernon, who was overseeing the work, and accusations had once again been made and names called. When Marty came back the following day, he thought he would be in line for more compliments, but instead "in front of a couple of the other guys, Elvis started screaming, calling my whole family names. . . . At first I was going to let it slide. But then he started getting really nasty. And it burnt a hole in me. I got up, and I said, 'Hey, fuck you! And fuck your father, and fuck your whole goddamn family! You don't talk about my family that way. They haven't done anything but good here. And you can kiss my damn ass.' . . . I was so upset that I took three sleeping pills and stayed in bed for three days."

It was a somewhat cheerless season around Graceland. Elvis made his usual Christmas contributions to virtually every Memphis charity of every color and denomination, bringing his total up to \$105,000 over the course of the year. On December 15 he gave George Klein a new canary yellow Cadillac convertible and then arranged for George to give his old Impala to Tankers Fan Club president Gary Pepper's father, Sterling, now a guard at Graceland. Alan's father was dying of cancer, and Elvis visited him at the hospital several times. They went to the movies most nights, but Elvis spent a good deal of time by himself upstairs, and his generally autumnal mood was reflected in an interview with Jim Kingsley of the *Commercial Appeal* at this time.

He liked to read, he told Kingsley, mainly religious works and medical textbooks, and he listened to gospel music a lot. He recalled one time, in 1954, when he and Scotty and Bill had played a club date outside of Shreveport just before Christmas and then were stopped for speeding on the way home. "It was cold, and I was sleepy. I woke up, and the officer asked, 'Who are you?' 'Elvis Presley, a singer.' The officer looked puzzled. Of course he had never heard of me. Hardly anyone had. I thought, 'Here goes my Christmas money for a traffic ticket.' But the officer let us go with a warning. . . . I gave a big sigh of relief. After the officer left, the three of us got out of the car and counted our money by the car headlights. The money was mostly in dollar bills. Man, that was the most money I ever had in my pockets at one time! I blew the whole bundle the next day for Christmas presents. . . .

"There is a lot of difference in Christmases today and when we were

246 👁 FAMILY CIRCLE

growing up in East Tupelo. [But] honestly, I can't say these are any better. We are just in a better position to spend. But that's not the important thing. It's the friendships and the devotion that really count. Everything is so dreamy when you are young. After you grow up it kind of becomes — *just real*."

 \mathbf{M} hat finally distracted him were the horses. First he decided to get one for Priscilla, next he asked Jerry Schilling if Jerry would mind his buying Sandy a horse so Priscilla would have someone to ride with, and then he got one for himself. After that, he decided everybody should have a horse, and there was a flurry of activity around Graceland as the old barn was renovated, Elvis bulldozed the little house out back where Billy and his family had once lived so that they could have a riding ring, and he started buying farm equipment at Sears and fancy saddles and western wear at the Ben Howell and Son Saddlery in Whitehaven. "Elvis would go out in the barn every day and every night," Marty noted with approval. "This barn, which he called House of the Rising Sun, a pun on the name of his horse, hadn't been used in years. He fixed up a little office for himself and wrote the names of the horses on the stalls with a big red marking pen. He'd write notes to himself like 'What I'm Going to Buy Tomorrow' and 'What I'm Going to Do Tomorrow.' And he would clean up the barn and buy new tack. He just loved it."

He took in his aunt Delta (Vernon's sister) after her husband, Pat Biggs, died of a heart attack. Not everyone liked Delta; even Elvis' cousin Billy Smith conceded that she "had a horrible temper, and she drank too much." But Pat, a former nightclub owner and big-time gambler, had always been one of Elvis' favorite relatives, someone who encouraged him to believe in himself, and as a result, according to Billy, "he felt like he needed to take Delta in." He set her up in the former maid's quarters by the kitchen, put her in charge of Grandma, and made sure that the funeral arrangements allowed everyone in the household, including the cooks and the maids, to attend.

All of a sudden it was starting to seem as if Elvis was reestablishing control; with the horses and the home improvements, with the decisiveness that he showed in taking charge of Pat Biggs' funeral and finding a place for his aunt, the guys all felt like they were beginning to see the old Elvis again, and it became open season on Larry. Just as the Colonel seemed to have sensed his new vulnerability, the guys gave Larry a harder time than ever, first for failing to share their enthusiasm for the cowboy life, then with renewed gibes at Lawrence of Israel and the Wandering Jew. Priscilla barely bothered to conceal her contempt, and while Elvis tried to make it right with Larry and explain her actions, just as he had tried to indicate his private disapproval of the Colonel's, he did nothing to stop them. Larry felt more and more left out by all this macho posturing. And now Elvis was talking about getting married.

I was something about which he clearly continued to feel a deep, almost physical ambivalence. Some months earlier he had asked jeweler Harry Levitch to make up a set of rings but then had him keep them at the store. "I put them in the safe, and [something like] six months went by, and nothing happened. So I asked Elvis, 'Did you change your mind?' And he said, 'No, I just can't make up my mind. It's just — it's a big step, Mr. Levitch.'" He confided his misgivings to Larry, too. "More than once Elvis remarked, 'Look at Jesus. He never married.' [And] I don't think that this necessarily pointed to a Christ complex, although certainly Elvis suffered from that to a degree. . . . But at age thirty-two Elvis sensed that a real marriage involved commitments he wasn't sure he could meet."

Rumors had been circulating for months, though, and Elvis had been getting clear signals from Priscilla, not to mention her father, about the promises he had made. The Colonel, too, was urging him to fulfill his obligations — and even if no one had said anything to him, he knew what he had to do. So just before Christmas he proposed. He came to her room with "his old boyish grin on his face and his hands were behind his back. 'Sit down, Satnin', and close your eyes.' I did. When I opened my eyes, I found Elvis on his knees before me, holding a small black velvet box. . . . I opened the box to find the most beautiful diamond ring I'd ever seen. It was three and a half karats encircled by a row of smaller diamonds, which were detachable — I could wear them separately. 'We're going to be married,' Elvis said. . . . 'I told you I'd know when the time was right.'" They showed the ring to Vernon and Grandma, but Elvis said they should wait to inform her parents. He wanted to tell her father in person.

Every day and night they would go riding en masse, and afterward they would all huddle together in the barn, in smaller or larger groups, conferring about the horses, talking about necessary improvements and repairs, just enjoying each other's company. For the first time in a long time there

248 👁 FAMILY CIRCLE

was a sense of a future to be shared and a feeling on almost everyone's part that they were embarked on a common enterprise. It wasn't like the slot cars, long since abandoned after Marty and Red got into an argument over the performance of their respective cars. This was different somehow, reminiscent of the good times they had had before Larry Geller ever came along. To Jerry Schilling, who had joined only in the aftermath of Larry's arrival and Joe's brief period of exile, "it was just really fun. We'd sit out in the barn talking until the sun came up. It was really like a family."

 $E_{\rm LVIS' NEW DEAL}$ with the Colonel went into effect on the first business day of the new year. They had initially spoken of it on the phone several weeks before, and the way that Colonel explained it, everything would just go on as it always had: the Colonel would continue to take care of business, with Elvis as his only client. The only difference was the new contract would recognize for the first time in businesslike fashion that Elvis was his only client, that they had formed, without ever really explicitly acknowledging the fact, a kind of partnership, and that what was called for now was a *partnership agreement*. Colonel would go on taking his 25-percent management fee on all existing contracts, and on all future contract guarantees as well — but that managerial split would apply only to the "flat payments" that derived from those contracts.

For example, if Elvis were contracted to MGM for a picture for which he was to receive \$750,000 plus 50 percent of the profits, Colonel would take his normal 25-percent management fee on that portion of the deal that represented salary, but on the profits there would be a 50–50 split, since, in essence, with all the work Colonel put into publicity and promotion on the picture, its success represented, really, a joint venture. Similarly, on the current RCA deal, the \$300,000 annual payment was subject to the usual 25-percent commission, but any additional payments or profits beyond that guaranteed amount would be split 50–50.

There were various minor permutations as set forth in letters that went out under Elvis' signature to RCA and William Morris (future profits from past film ventures would be split on the new 50–50 basis; merchandising, of course, was as always a 50–50 deal; and publishing remained unchanged), but the basic principle was a simple one: the embrace of a partnership concept that, as Colonel Parker explained it, had evolved over the years to the point that it existed in all but fully recognized contractual fact.

APRIL 1966-MAY 1967 👁 249

It was a partnership that existed in far more than contractual fact. Managers since time immemorial have sought financial advantage through the kind of partnerships, joint ventures, and side deals on which it might have been thought the Colonel wrote the book. Popular soprano Kate Smith's manager, Ted Collins, for example, had created a partnership with his client in 1930 and maintained it for over thirty-three years, and Patti Page and her manager, Jack Rael, had had a 50–50 deal since her early days of stardom. Even Bob Dylan, who in 1967 might have seemed the antithesis of Elvis Presley in terms of music business expertise and cultural sophistication, appears to have permitted similar opportunities for self-aggrandizement to his manager Albert Grossman, who, like the Colonel, took a 25-percent manager's share but, probably unbeknownst to his client, received a 50-percent share of the publishing from the firm to which he first brought the Dylan song catalogue.

To say that a practice is not without precedent does not, of course, condone it, but the Colonel had reasons of his own to seek a modification of terms at this juncture. The most compelling had to do with the notorious unpredictability of the business, compounded by the increasing unpredictability of his single client. If he was going to tie his future and devote all of his considerable energies to one performer, there was little question in his mind that he should be getting some equity, too, and he didn't hide his thinking either from his client or from anyone else with whom he did business.

For all of his reputation for deviousness among those who chose not to listen to what he was saying, in certain respects he could be the most straightforward of men, and what he was looking for now, perfectly straightforwardly, was some kind of insurance. At fifty-six he didn't know how many years he had left. His own health was not so good, his wife, Marie's, worse. If Mr. Presley wanted to take off in new and unproven directions, that was up to him, of course, but Colonel, for all of the relative simplicity of his living arrangements, had never pretended to aspire to the ascetic life. He enjoyed Palm Springs, he liked the comforts of the Spa Hotel steam room, he had come to appreciate the company of the rich and famous, and he felt he had earned his place among them. Perhaps the most compelling element of his thinking stemmed from the philosophy embodied in the title of the book he was always threatening to write, How Much Does It Cost If It's Free?: nothing was worth anything unless you placed a value on it. His services, he felt without any self-consciousness whatsoever, were worth 50 percent.

250 🔊 FAMILY CIRCLE

Elvis would have had no problem assenting to that proposition, and he indicated no compunction about signing the agreement. If it made the old man happy, then he was happy. Marty and the others could grumble and act like they knew what was going on, but only he and his father really *knew* what it took to sustain this kind of enterprise, how much faith Colonel had shown not just at the beginning of his career when everyone else said he was a flash in the pan but during those dark days when he was in the army and only the Colonel's ingenious schemes could sustain not just the business but Elvis' own faith in himself. Colonel had outwitted the sharpest Hollywood operators, and *he had never become like them*. There were no phony Hollywood affectations or social hypocrisies, no apologies for who he was or where he came from — the one obligation that he acknowledged was to *show up and do the job*, and in that he made no more demands of his star than he did of himself.

When, in the wake of their new arrangement, Colonel revamped the agreement with RCA to extend through 1980 — with the guaranteed payment of \$300,000 a year extending only through 1970 and subsequently reduced to \$200,000 a year for the next five years of the contract (one year beyond the term of the option that had been picked up in August) and nothing for the last five — Elvis never questioned the basis for the revision but instead sent telegrams to RCA expressing his gratitude "that it will be at least 1980 before there is a divorce" and declaring his faith that by then "we will have such a large catalog family that it will be cheaper to stay together." His wire to the Colonel simply acknowledged "the greatest Snowman on earth," seemingly taking as much delight in his mentor's exploits as the Colonel did himself. Others could talk and might well have pointed out that the new agreement actually reduced the guaranteed payment schedule substantially, thereby allowing Colonel's profit sharing to kick in that much earlier - if they had known any of the details of the deal. But they did not, and it was by intent that Elvis chose to leave them out of the picture. This was his secret life, if he could be said to have a secret life at all. He didn't need to scrutinize the fine points of a contract to know that he was being fairly dealt with. Two days after the RCA transaction went through, Colonel delivered a deal memo for another Allied Artists picture, this one to be made in 1968 at a salary of \$900,000. Elvis never doubted that there was something in it for the Colonel. But there was plenty in it for him, too.

*

Besides, his mind was elsewhere. The number of horses had quickly outstripped the number of stalls, and when Red ran down Elvis in the field one day playing out a Wild West scenario, it was apparent that Grace-land's thirteen and three-quarter acres had grown too small. At the same time it was equally apparent that nothing was going to discourage Elvis' zeal for acquisition, and he just kept purchasing more horses and more equipment until one day, as they were returning from a horse-buying trip in Mississippi, he and Priscilla spotted an immaculately maintained 160-acre cattle ranch called Twinkletown Farm, with a lighted sixty-five-foot-high white cross overlooking a small man-made lake, outside of Walls, Mississippi, just across the state line.

Not long afterward, they were out driving with Alan Fortas and a couple of the guys, when Fortas spotted a "For Sale" sign on the property. They turned around to read the sign and then drove out to the Twinkletown Airport, where Jack Adams, the ranch owner and one of the biggest used-aircraft salesmen in the world, had his headquarters. Ever the canny businessman, Elvis sent Alan in to inquire about the property (the idea was that if the owner knew it was for Elvis Presley, the price would immediately be jacked up), but Alan barely had time to introduce himself before "here comes Elvis walking in the door. Shit. Well, Adams was a smooth operator and a good salesman, and he said, 'Look, don't ask me how much I want for it; I'll give you the keys. Why don't you just spend the night?'

"Elvis said, 'But we got horses.' He said, 'Bring your horses down, get everybody, keep the place as long as you want. Then if you like it we can talk.' So we haul the horses down there, sit around, party all night, like typical cattlemen! Next day Elvis wakes up. He said, 'Alan, that was the best night's sleep I ever had in my life. Let's go buy this goddamn place.' I said, 'Elvis —' He said, 'Go buy it.' So I called Mr. Adams, and he said, 'I'll take so much for this and so much for that, and that includes everything — the cattle, the house, the furnishings and everything, except a few personal items and some clothes.' I said, 'Okay, I'll call you back,' and I went and told Elvis. Now I had had some experience in real estate. I knew we could beat him down. But Elvis just said, 'Look, goddamnit, how much does he want?' I told him. He said, 'Ask him how long it will take to get his stuff out of there.' I called Mr. Adams back, and he said, 'About fifteen minutes.' I said, 'Elvis wants to buy it.' And that was it, no negotiating, nothing."

On February 8 he put down a deposit of \$5,000 against the sale price of \$437,000. Within a week he had purchased at least five pickup trucks and a '63 Cadillac, and by the time the deed was filed on February 22 he had

bought more than two dozen vehicles, half a dozen house trailers, and six horse vans, not to mention numerous tractors, miscellaneous ranch equipment, septic tanks and water lines, and a quarter mile of temporary plywood fencing which would have to serve until the s12,000 eight-foot-high wooden fence that he had contracted for could be built. In all he managed to pay out well over \$100,000 in approximately two weeks, an orgy of spending that seemed to momentarily pacify Elvis but horrified Vernon, who was sure that they were all going to end up in the poorhouse. According to Priscilla, who was no more sanguine about Elvis' spendthrift ways but found it easier to act like a good sport, "Vernon literally begged him to stop, but Elvis said, 'I'm having fun, Daddy, for the first time in ages. I've got a hobby, something I look forward to getting up in the morning for.'"

He was having fun. "He liked it when everyone was together," Priscilla observed, "and he got upset when they wanted to leave." He named one of the new horses Mare Ingram for the Memphis mayor who kept trying to name a building or a highway after him, his latest effort — to call the Mid-South Coliseum the Elvis Presley Coliseum — shot down by a unanimous vote of the city commission. (This civic endeavor would not bear fruit until 1972, when a section of Highway 51 South running by Graceland was officially christened Elvis Presley Boulevard.) He named the ranch the Flying Circle G and put its brand (the letter G with a pair of wings) on every horse, every piece of livestock, and every pickup truck on the property. "It wasn't unusual," Priscilla noted, "to see him walking around the property, knocking on doors, waking everyone up, or checking on the horses in the earlymorning hours. He was having a ball, and there were days he didn't even want to take time out to eat — he'd walk around with a loaf of bread under his arm in case hunger pangs struck. ... On Sundays we had picnics, and all the girls chipped in on potluck. . . . We rode horses, held skeet-shooting contests, and combed the lake for turtles and snakes. There was fun, laughter. and a lot of camaraderie."

Out of that spirit of camaraderie he got the idea of deeding over an acre apiece to each of the guys. After all, if it was a commune in spirit, why shouldn't it be a commune in fact? He went so far as to draw up plans with Marty, but Vernon quickly put a stop to that. Vernon had always fancied himself a gentleman rancher, and if he could have restrained some of his son's excesses, he might have come to enjoy the role. But he was as helpless to control him as anybody else, and when he contacted the Colonel for advice, Colonel could offer nothing more than the familiar bromide that

Elvis would soon tire of his new plaything. In desperation he even tried to enlist Joe. "Vernon is coming to me and saying, 'Joe, he's spending too much money. I tried to tell him, and he said, "Hey, I'll get more if I need it." You've got to tell him.' So I talked to Elvis. I said, 'What are you doing with all this stuff?' Went on and on. And he said, 'It's okay, I want it now.' Sometimes he'd listen, sometimes he wouldn't. Sometimes he'd just get mad. He'd say, 'You don't like it? There's the fucking door.'"

Every day, according to Alan Fortas, was like the last day. To Mike McGregor, a saddle maker and rodeo rider whom Elvis had met the previous month while buying riding apparel and equipment at the western-wear shop on Millbranch, then put on salary to help take care of the horses, it was an experience never to be repeated. Mike told Elvis straight off that he couldn't work on Sundays because he had church, but Elvis said that was fine, as long as he could feed the horses first thing Sunday morning. "He was very thoughtful and very much a gentleman. He never told me, 'Go get this horse'; he always asked me did I have time to get him. I can never remember the man giving me a direct order. One of the fun times on the ranch was when it snowed down there, and they took the tractors and sleds and drove around and tore them up. One night one of the cows had a calf, and they were so excited everyone had to go see the calf." When one of the horses had a colt, "you would have thought [it was] royalty."

For Jerry Schilling, on the other hand, it was a deeper, darker dream, a dream of almost Edenic innocence and loss. "It was really beautiful at first. Sandy and I had a little trailer in front of the lake — it was the first real place of our own that we ever had. You'd wake up in the morning, the horses would be drinking out of the lake; Elvis and Priscilla would ride over, and we'd go for a ride, then have breakfast.

"But then Elvis got really busy, and it lost that overall good feeling. It got so competitive with all the trailers and trucks: who got this, who got that. And it got to the point where you began to feel that Elvis was just caught up in it, there was all this buying and giving with no real meaning behind it. Looking back on it, I have to think drugs were a part of it. I guess the climax came when Elvis showed up at our trailer one night; it was 2:00 A.M. and pouring down rain, and he's standing in the doorway, looking like an old cowboy, rain pouring off his hat, just standing there with a loaf of bread in his hands! He told me he needed to go somewhere. 'I need you to go with me.' We ended up going to the house of this pharmacist back in Whitehaven that we knew. Elvis just wanted to fill a prescription — whether it was Darvon or Tuinal or Dexamyl or Placidyls I don't know. The pharmacist didn't really care; I guess he should have, but, I mean, this was Elvis Presley. The point was, Elvis didn't even make any excuses. And up till then he had always been pretty secretive with the heavyweight stuff around me — like he didn't want me to know. That was when I thought it started to change."

Things once again had begun to get out of control. All of a sudden Elvis was incommunicado to the Colonel. The session for his upcoming picture, *Clambake*, had been moved to Nashville for the convenience of the star, but when it took place on February 21, the star flew back to the ranch after the first night and didn't even bother to show up on the second. Red, who had once again picked all the songs, covered for him, telling the music director that Elvis had a cold and doing the scratch vocals, which Elvis overdubbed on the third night, wearing a cowboy outfit and chaps.

It was just a few days until his scheduled departure for California, and Colonel was getting increasingly worried. He was frustrated with Marty, who had sunk into a miasma of pills and sullen noncommunication, and he finally fired off a letter to Mr. Lacker effectively relieving him of his coforeman duties. He knew all about the weight gain from Joe, and he was furious when Elvis finally worked up the nerve to tell him what he had suspected the boy was going to inform him of all along: that he needed more time, that he wasn't feeling well, that he would not be able to report for preproduction on schedule on March 3. This would have to stop, the Colonel thundered in reply; the movie companies had a great deal of money invested in their product and little patience with stars who took that money and then didn't deliver on their promises. He would have to obtain a doctor's certificate if he intended to postpone filming.

That was how Dr. George Nichopoulos first came into the picture. On Sunday, February 26, Elvis tried to contact his regular physician, but when he was not available, George Klein's girlfriend, Barbara Little, who was out at the ranch for the weekend with George, suggested Dr. Nick, one of the physicians in the medical group for which she worked.

Nichopoulos, the thirty-nine-year-old son of Greek immigrants who operated a restaurant in Anniston, Alabama, had graduated from Vanderbilt Medical School after completing all the course work for a Ph.D. in clinical physiology at the University of Tennessee in Memphis. In 1963 he had moved to Memphis permanently to take a position with the Medical Group, a consortium of physicians offering patients a full range of interlocking specialties. A soft-spoken man and a good athlete (he had played tailback on the Sewanee football team at 150 pounds), he had a modest, selfeffacing manner and a nice appearance, with a full head of white hair making his otherwise youthful looks particularly striking.

"I didn't know what to expect, I didn't know the kind of illness or what the problem was, but when I got there, he was complaining about saddle sores. They had been riding the last couple of days, and he was supposed to be in L.A. to do a shoot. Well, after I saw him, it seemed like his saddle sores were not all that bad; I think he just wanted to stay home for a few days. So we spent more time chit-chatting than treating his saddle sores.

"[My first impression of him was that] he was very polite, very humble. He was very respectful. In fact, during our whole relationship, he never called me by my first name; it was always Dr. Nick or Dr. Nichopoulos. And he would always raise hell with anybody that he interpreted as being disrepectful toward me [in that regard]. That night he seemed kind of depressed and lonely; he just wanted to talk. Even with everybody that was out there, to me he just sort of remained a lonely person. It seemed like they didn't have new things to talk about; everything was old hat.

"Of course, he liked to talk about medicines and the PDR, and what kind of symptoms do you get with this and what have you — I was amazed at how much he had educated himself. Anyway, I gave him some ointments to use on the sore places, and then he asked me if I could stop by his house and check on his grandmother on the way back. She had been sick with a cold, and she had heart trouble, too, so I said, okay, I'd stop by and check her out. Well, while I was there, one of the guys called for Elvis and said he had forgotten to ask me something; could I come back out to the ranch? I said, 'Can't we just talk about it over the telephone?' And whoever I was talking to came back and said, 'He'd like for you to come back out if you would.' So I went back out there [it was about a fifteen-minute ride], and we talked about nothing, really; he just wanted to talk. And he gave me something else he wanted me to do at the house on the way back into town, so I stopped back by the house and had another phone call from him. I played this game three times, and I wasn't very happy about it, but I called the Colonel and got a letter off. The Colonel questioned me [pretty closely]. 'You sure he can't do this? You know, as soon as he gets back in Memphis, he likes to hang around. We've got everything set up, the crews and everything, he needs to be here.' And I said I really didn't feel like he was going to be able to do it, there was a lot of action in the movie, and I felt like he might have some difficulty."

The conversation left the Colonel fuming, but there was nothing to be

done about it. He got the studio to revise their schedule, pushing back the start of preproduction to the following Monday, March 6, but he continued to worry that things were falling apart. He had thought that Elvis would come to his senses with Larry out of favor and things finally worked out with the girl. There were problems within the organization, to be sure. Some of the boys were no longer capable of pulling their weight (Alan, of whom Colonel was genuinely fond, was going to have to be left behind in Mississippi because of his drug problems, and Mr. Lacker's usefulness was plainly at an end), and this ranch business was going to have to be addressed if it did not swiftly run its course. But more than that, he needed an excuse to get matters out in the open with Elvis once and for all — and in a way that would assure him of the boy's attention. Because things couldn't go on like this much longer.

ELVIS ARRIVED IN CALIFORNIA ON Sunday, March 5. On the sixth he reported to the studio for wardrobe fitting, as planned, and that evening completed most of the one vocal overdub that remained to be done at Thorne Nogar's Annex Studio. Everything seemed normal, except for his weight, which was going to necessitate some costume changes. On Thursday, though, when Joe came to pick him up to go to the studio, there was clearly something wrong. The guys were just sitting around, and Elvis was nowhere in sight. He had staggered in woozily a few minutes earlier, they reported to Joe, and told them he had fallen during the night. He had hit his head on the bathtub and thought he might need to see a doctor, but they had simply gotten him back to bed and were waiting for Joe to take command.

Joe called the Colonel right away. There was no doubt in anyone's mind that it was the pills, and when Colonel arrived he closeted himself with Elvis in the bedroom, then came out looking grim and arranged for Elvis' regular physician, Dr. M. E. Gorsin, and a radiologist, Dr. George Elerding, to come over with portable X-ray equipment. Then he lit into the guys. What was the matter with them? he demanded. What did they think their job was? Why did they let him get this way? Someone was going to have to be with Elvis twenty-four hours a day — even if they had to go to the bathroom with him. From now on, he declared, things were going to be different around here.

The doctors' report was not so bad: Elvis had suffered a minor con-

cussion; no evidence of fracture could be identified. Additional X rays of the cervical spine indicated no fracture there either, though there was considerable limitation of motion due to muscle spasming. He was, in other words, bruised and in a good deal of pain, but with rest he should be fine. Everyone was looking daggers at Larry as Colonel announced that he wanted all of Elvis' books removed forthwith. "And don't you dare bring him another one."

Two days later Colonel called a series of meetings at which Elvis was present. First he met with Joe; then he met with Marty, whom he informed officially that he was no longer co-foreman, that he would no longer be writing checks, and that he would in future be in charge of "special projects." Although he went on to say that the first of these special projects was to be the upcoming wedding, for Marty this was little consolation. "I thought it was a joke, because the Colonel and Joe had already planned the wedding." He looked over at Elvis, but Elvis wouldn't look back at him. "To see Elvis acting that way, and to hear this old, fat bastard spewing edicts like he was Elvis' ruler just made me sick. In fact, it destroyed my desire to be part of the group."

To the rest of the guys Colonel simply laid down the law. With Elvis sitting there, he announced that there were going to be some big changes. From now on they would not be going to Mr. Presley with their personal problems and concerns. If they had any concerns they needed to address, they would go to Mr. Esposito, who was now the sole person in charge, and he would take care of them. "Some of you," he said, looking at Larry, "think maybe he's Jesus Christ, who should wear robes and walk down the street helping people. But that's not who he is."

There were going to be economies as well. Some salaries and expenses were going to have to be cut. Mr. Presley couldn't afford to just throw his money away, and everyone was going to have to earn his keep. For the present everyone would remain on payroll, but when they got back to Memphis, some of them would probably be let go. "It's nothing personal," Colonel declared. "It's just business." In addition, he said, with another meaningful glance at Larry, there would be no more discussions of religion, there would be no more books, and if anyone didn't like it, they knew where the door was. Larry felt sick. "Throughout Parker's tirade, Elvis never looked at me once." On the other hand, there was an aspect of it that didn't surprise him. "I knew this wasn't Elvis. I mean, obviously it was Elvis, but he looked very strange, as if he were under the influence of

258 🔊 FAMILY CIRCLE

something, and there's no doubt in my mind that he was drugged. . . . His eyes were glazed, haunted looking. And I don't think it's any coincidence that Elvis' descent into experimenting with the next level of psychoactive medication, very heavy downers and synthetic narcotics, followed his 'recovery.'"

Afterward everyone was in a state of shock. Jerry Schilling, sure that the Colonel had been looking directly at him while he was speaking about cutbacks, was already packing his suitcase when Elvis walked into his room and reassured him, "He wasn't talking about you." Billy, too, took it very personally. "I thought I was going to be one of the ones terminated. Or if not terminated, I knew I'd have to quit. Because me and [my wife] Jo were getting an apartment in California . . . and with cutting down on expenses there wouldn't be any rent money for the ones who wanted to stay." He offered Elvis his resignation, but once again Elvis reacted with surprise. "He said, 'Why?' I said, 'Because I can't afford to keep a home in Memphis and an apartment out here, and it'll be paid for.'"

Clambake started up two weeks later under familiar enough auspices, but true to the Colonel's instructions Larry was no longer allowed to spend any time in private with Elvis. Haircutting sessions, once the occasion for grand philosophical discussions, were now limited to half-hour time periods that were strictly chaperoned. Hostility from the guys reached new and undisguised heights, and Elvis didn't even bother to indicate secret sympathy. "You know," he said to Larry one day out of the blue, "those masters of yours have hidden motives. They're trying to control people's minds and use them for their own damn purposes."

The atmosphere on the set was one of almost enforced gaiety. Once again there were practical jokes, cherry bombs, cream pie and water balloon fights, with even the director, Arthur Nadel, getting into the act. It was like a staged remembrance of things past — but there was a wistful note, too, that did not escape some members of the cast. And it hardly seemed coincidental that Elvis kept listening to a single album over and over throughout the filming, a collection of song lyrics recited in heavily accented English by the French actor Charles Boyer. The album was titled *Where Does Love Go?*, and the fully orchestrated arrangements were as lushly romantic as Boyer's recitations, with melancholy spoken versions of "What Now My Love," Edith Piaf's "La Vie en Rose," Charles Aznavour's "Venice Blue," and "When the World Was Young." Elvis' favorite song by far was "Softly As I Leave You," a dying man's profession of love for his wife, and he gave the album to various members of the cast and crew while playing it again and again for the guys, who could not understand what he saw in its morbid mood.

Elvis and the Colonel, too, seemed back on the same old footing. To Bill Bixby, the second lead in the picture, who was meeting them both for the first time, "They were like Frick and Frack when they'd get together they really were. They were great put-on artists. The Colonel got me in on a mind-reading gag, and we worked it out with signals, Elvis and the Colonel and me. One of the guys would tell me a word that he was thinking of, and I'd never go near the Colonel, but he would get it [with these indicators]. It was a great way of entertaining ourselves."

The Colonel still had serious obstacles to overcome. If there was one thing Colonel hated, it was to be on the defensive, but with all these recent downturns in business, and now this latest embarrassment, which all the studio heads were bound to hear about sooner or later, it was no longer possible simply to paper over some of the problems with which they were faced. He had movie contracts that carried them through 1968, maybe into 1969, but he didn't know what he could look forward to after that.

He had gotten a taste of the new climate in which they would be operating when Paramount refused to release any money to him for the usual exploitation campaign on the final Hal Wallis picture, Easy Come, Easy Go, scheduled for Easter release. Wallis was embarrassed but couldn't pry any money loose, and on February 20 Colonel had angrily told Wallis' loyal lieutenant, Paul Nathan, that he wasn't going to do a goddamn thing for the picture. Three days later he found occasion to rethink his stance, as he informed "Colonel Wallis" in one of his masterful pieces of diplomatic correspondence. The average guy, he said, under these circumstances, would simply pull out. But he was not the average guy. He knew that Wallis always honored his promises and non-promises, and he was convinced that in the end Wallis would probably be overcome with "a warm feeling of generosity towards the good old Colonel." He could count on the fact that any evidence of such generosity would be gratefully accepted by the Colonel, and it was - when Wallis and his partner, Joe Hazen, coughed up \$3,500 from their personal funds. But Colonel was shaken nonetheless, and when Nathan wrote to Wallis in Spain after the film's opening, he

underscored the legitimacy of the Colonel's concern: "Obviously the star is not as big an attraction as he was."

Things were no more sanguine for Elvis at home. Marty, whom in a fit of remorse he had asked to be his best man, was at constant odds with Priscilla, who couldn't for the life of her understand why someone with such utter contempt for her should play so important a role in their wedding. Then, as if to make up for his own lapse of judgment, Elvis asked Joe to be co-best man, and he left it to Joe and Marty to work out the details. Billy Smith saw Elvis' behavior as increasingly erratic, though he was not sure of the underlying cause. More and more he saw his own role, and that of the other guys, as simply not to let things bother Elvis too much, "but we had our work cut out for us. And it got to be more than most of us could handle."

On March 15, during the enforced film break, Jerry and Sandy got married in Las Vegas. Jerry had wanted to get married for some time, and he definitely considered himself to be engaged, but at the same time he was very much aware of the less than subtle pressure he was getting from the Colonel, and he began to wonder if this might not have something to do with Elvis' evident reluctance to go through with the ceremony himself. He knew Colonel believed in marriage and propriety, and he accepted to a degree Colonel's professions of concern for his and Sandy's well-being, but still he couldn't help but feel that his own marriage was designed in some respects as a "trial run."

It was only after Jerry's wedding that Elvis finally agreed to a date as soon as the movie was over — and almost immediately Colonel started going to Las Vegas on weekends to tie up all the loose ends. Charlie Hodge drove him most of the time, and as they drove, Colonel would expound upon his thoughts about matrimony. "'Now, Charlie,' he said, waving his big cigar, 'when you finally decide to get married, let me handle it.' He shot an amused glance at me. 'When are you going to get married?'

"Not yet, Colonel," I said. "I'm still practicing."

He laughed.

"When you do decide, let me know," he said. "Charlie, we could make some money on it."

"Make money?" I said. "On my own wedding?"

He nodded. "Yes, we can. Now you listen to the old Colonel."

He outlined his plan as we sped along. . . . "I'll rent a football stadium, and you and your bride will ride in to the altar, located on the fifty-yard line, on a pair of big elephants." He smiled and pulled out a fresh cigar. "We'll charge admission for it."

I laughed. "Colonel, that's wild."

He waved the cigar at me like a magic wand. "It's not wild. There's money in it. Now you listen to the old Colonel."

He'd take me into the casinos with him when he wanted to gamble. I couldn't spend a dime of my own money. He knew I loved to gamble almost as much as he did.

He'd sit down at a roulette wheel and start putting out chips for both of us.

"Let's put a \$25 chip on this square for you, Charlie," he'd say. "And some here and here and here."

Whenever I won, it would be \$200.

The Colonel would say, "Now you'd better go wire Mrs. Parker some flowers."

He winked. "Listen to the Colonel. Go wire Mrs. Parker some flowers when you win."

I NVITATIONS WERE SENT OUT under a veil of secrecy: Lamar and Alan were omitted simply because they were not part of the group that was in California. In addition to the guys on the movie, it was just family, plus Colonel and Mrs. Parker, George Klein, and, unaccountably, Elvis' jeweler, Harry Levitch.

Rona Barrett sniffed out the news on April 27, stalking Joe and Joanie in the local market even as everyone was converging on Palm Springs. They flew out of Palm Springs in two chartered planes at around two o'clock Monday morning, May I, with Elvis and Priscilla taking Frank Sinatra's private jet. The engaged couple paid \$15 for a marriage license at the Clark County Courthouse at 3:00 A.M., then drove to the Aladdin Hotel, a fourhundred-room re-creation of the English Tudor style across the street from Caesar's Palace, recently purchased by the Colonel's friend Milton Prell, who had previously owned the Sahara, where they always stayed. For the next few hours they waited nervously in their suite until the Colonel finally indicated it was time, and then they were married in an eight-minute ceremony conducted by Nevada Supreme Court Justice David Zenoff that commenced at 11:41 A.M.

Just before the ceremony was about to begin, Red went to Joe's room to find out when he and his wife, Pat, and the rest of the guys and their

MAY I, 1967: RICHARD DAVIS, JERRY SCHILLING, GEORGE KLEIN, FREDDY BIENSTOCK (IN BACKGROUND), JOE ESPOSITO, PRISCILLA AND ELVIS PRESLEY, CHARLIE HODGE, MARTY LACKER. (COURTESY OF JERRY SCHILLING) wives, should get ready. With some embarrassment Joe told him what he had just learned himself: that with the exception of the two best men and Elvis' cousin Billy, none of the guys or their wives were to be included in the actual ceremony. The wedding was scheduled to take place in the relatively confined space of Mr. Prell's private living quarters, and since there wasn't room for everyone, Colonel had decided the only way to avoid accusations of favoritism was for none of the guys to attend — they could all just go to the reception afterward.

Red hit the roof. He had never made any secret of his feelings about Joe, but now he cursed him out as a chickenshit brownnose and came close to hitting him. What did Elvis know about all this? he demanded. The motherfucker didn't have any balls and never had. Red was fucked if he was going to attend the reception if he wasn't welcome at the ceremony itself. This was the so-called friend whom Red had asked to be best man at his own wedding. He hadn't asked to be here — he had come at Elvis' invitation. And he hadn't brought his wife to be humiliated by some asshole who didn't have the guts to tell him what he needed to tell him face-to-face. Colonel just better stay out of his way. He would beat the shit out of that sonofabitch if he so much as saw him. Fuck him. Fuck Joe. Fuck Elvis. Fuck them all. He was finished with all this bullshit.

The rest of them took it a little more diplomatically. There was the same feeling of resentment, there was the same sense of being let down, but mostly they put it on the Colonel, muting their disappointment for Elvis' sake — after all, it was his day, it wasn't his fault, he had never really had the guts to stand up to the Colonel anyway. Jerry Schilling saw denial almost as a matter of self-preservation. Elvis had given him so much, *as a friend*, and he had looked up to Elvis in such a way that he just wasn't prepared to deal with his own conflicting emotions at this point. "I don't think I even recognized how I really felt till years later."

As for Elvis, for all of his inner turmoil, and for all of the anger and ill feeling that were roiling around just outside the range of his vision, he still retained all of his ability to charm. Judge Zenoff wanted to meet separately with both the bride and the groom before the ceremony. "Colonel Parker brought Elvis off to the side of the room to meet me, and I chatted with him a few moments. My pre-ceremony meeting with Elvis was probably the most impressive part of the whole experience. I was simply amazed at the boy's modesty. He was low-key, handsome as a picture, very respectful and very intense . . . and so nervous he was almost bawling. Then I was

taken over to meet Priscilla. She was absolutely petrified. She couldn't open her mouth — just stood there staring at me and nodding a little bit when I explained things to her."

Priscilla would not have disagreed with his description. "We were both so nervous, I don't think either of us was aware of who was there and who was not. We hadn't slept all night long and were escorted into the room with the judge and everyone already there. We should have had Red there. Elvis agreed [afterward]: that was not right. And he understood how Red felt. But never did he think it would not be forgiven. It was an oversight. Now it could have been manipulative; I wouldn't put it past Colonel. And I think, too, from Red's point of view, this was a time when Elvis should have taken a stand. There were all those times he didn't as far as business was concerned. But this was personal, and he should have said, 'You get in here. I have a choice of who I want to be at my wedding.' I think basically that's where Red was coming from. Elvis didn't take a stand."

With the brief ceremony over, they snuck through the pool area to the Aladdin Room, where a press conference had been scheduled by the Colonel. In response to reporters' questions, Priscilla's father, Colonel Beaulieu, said that he had "known from the beginning" that Elvis and his daughter would be married someday. "Our little girl is going to be a good wife." When asked what had caused him to finally tie the knot, Elvis said, "Well, I guess it was about time," then turned disarmingly to his father. "Hey, Daddy, help me," he said. "I can't reach you, son," kidded Vernon with a proud grin. "You just slipped through my fingers." "Remember," said the Colonel, getting his two cents in, "you can't end bachelorhood without getting married."

There were about a hundred people at the reception, reported the *Commercial Appeal*, "a buffet banquet that by one estimate cost \$10,000 and featured such things as: ham and eggs, Southern fried chicken, roast suck-ling pig, clams Casino, fresh poached candy salmon, eggs Minette, oysters Rockefeller, and champagne.... A string trio played romantic ballads, including 'Love Me Tender.'... There was also a strolling accordionist."

Red held true to his vow, remaining in the hotel room with his wife and watching news of the wedding on television as the reception was taking place. He just wanted to catch the first flight back to Los Angeles, and he wasn't going to accept any more damn charity, but when it came time to purchase the plane tickets, he discovered that he had to borrow the money from Harry Levitch, the Memphis jeweler whose acts of civic philanthropy had originally helped Red get through high school. Then on the flight to L.A., Red found himself in the midst of half the wedding party, including Vernon and Dee. He didn't say two words to anybody, refusing even to give Vernon a glance. As far as he was concerned, this was it; he was never going to go back to work for Presley, that fuck.

Ironically, at almost that very moment, Red's principal nemesis, Larry Geller, was learning of the wedding through a newspaper headline. Larry had been feeling the cold wind of rejection ever since the Colonel's edict of two months before. It was, as Larry noted in his memoir, *"If I Can Dream," "open season on the Swami,"* and he had made up his mind to quit when, at the end of April, he called Elvis' house *"to tell him that I wasn't coming back. Jerry got on the line and said, 'Larry, you'd better come to the house right now. We're all going to Vegas.' I didn't respond. So they were all going to Vegas. What else was new? 'We're all going to Vegas,' he repeated, as if I would pick up on his meaning. 'No, Jerry,' I answered. 'I can't go.' . . . The next day when I went to the market, to pick up some groceries and the paper, I saw the front page headline, ELVIS PRESLEY IS MARRIED, running above a large photograph of Elvis and Priscilla smiling happily in their wedding attire."*

Most of the guests flew back to Los Angeles after the reception, while Elvis and Priscilla returned to Palm Springs. Three days later, on May 4, they flew to Memphis, leaving early the next day for the ranch. They were planning a reception at the end of the month for all of their hometown friends, but for the time being they had at least three weeks free and clear. Most of the guys accompanied them, but even so, it was, for Priscilla, a rare chance to be "alone" with her husband. "I loved playing house. I personally washed all his clothes, along with the towels and sheets, and took pride in ironing his shirts and rolling up his socks the way my mother had taught me. Here was an opportunity to take care of him myself. No maids or housekeepers to pamper us. No large rooms to embrace the regular entourage. . . . Although the rest of the group traveled with us, they respected our privacy as newlyweds and, for the most part, left us alone."

Some of the rest of the group adopted a more cynical view. Lamar, who had not even heard about the wedding until after the fact, drove over from Nashville and joined the newlyweds in the trailer they had

266 🔊 FAMILY CIRCLE

commandeered from Alan, who moved into the ranch house. "I guess you could say I went on their honeymoon with them. . . . I'd been with him from the beginning, so nothing had changed, really." Alan, for his part, goaded on by the pills, scarcely bothered to hide his resentment of Priscilla. He blamed her for exiling him to the ranch and felt that she was "conspiring with Vernon to find a way to get rid of us [the guys] or at least reduce our numbers. It wasn't that she didn't like us as individuals. She just felt threatened by our presence. I think she had a fantasy of a normal home life with [Elvis], one in which he went to work like other husbands, came home in the evening, helped her cook dinner, and then sat around with her at night. . . . 'We never have any privacy!' she told me once. And it was true. Just as she couldn't believe Elvis would want to take all of us and our wives down to the ranch, I found it odd that Elvis often circumvented her plans to be alone with him by inviting an entire herd of people to come along."

Still, it was an idyllic time. Elvis had had a porch and steps built for his trailer and a white picket fence around it. They rode horses and relaxed, and, in Jerry Schilling's view, "it was like we were all just friends. They spent a lot of time by themselves, and when they came over it was more like neighbors dropping by. We'd go out riding and maybe have a little picnic, and it was as if things had kind of calmed down for a little while." It was, said Priscilla, "almost like a commune effect."

At the end of the month, on May 29, they had the reception for their Memphis friends in the former slot-car room. Elvis and Priscilla dressed in the same formal clothing they had worn for the wedding, but it was an informal affair, with Elvis' doctor, dentist, painter, horse trainer, and electrician, all of his uncles and aunts and cousins and most of the guys, along with the entire Graceland staff making up the greater part of the small guest list. Priscilla felt a new sense of security not just as a young bride but as someone who had finally managed to put history behind her. One night when they were at Graceland, just before the reception, she persuaded Elvis to burn the books that the Colonel had banned. At three in the morning they dumped a large box filled with books and magazines into an abandoned well, poured gasoline over the pile, "and kissed the past good-bye."

Everyone remarked on how serene the newlyweds looked. Elvis' dentist, Dr. Lester Hofman, and his wife, Sterling, savored the moment as something very special. "There was a beautiful, lavish buffet. We figured if we were invited, the whole world would be there, but I don't think there were more than forty or forty-five people. Tony Barrasso [a well-known society bandleader who was dating Bonnie Bunkley, Elvis' former girlfriend, and would eventually marry her] was playing the accordion. I said, 'I am so thrilled you got married. I was about to give up on you.' He said, 'Mrs. Hofman, I wanted to be sure. Because I cannot imagine ever loving somebody enough to marry them and then falling out of love.' He said, 'That would just kill me.'" No one was prouder than Vernon, though. He practically beamed as he surveyed the festive scene, the head table decorated in green and white with white carnations, the grounds all decked out, his son looking handsome with his beautiful bride. Not at all characteristically, Vernon just kept pouring the champagne. He was very drunk and very happy.

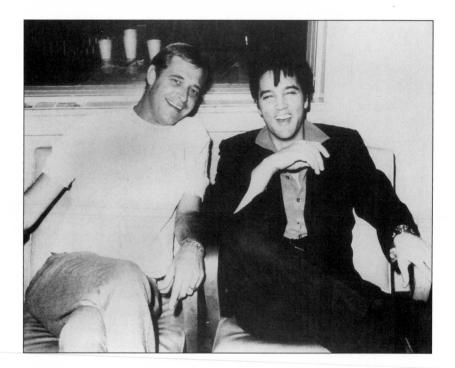

ELVIS AND FELTON JARVIS: "GUITAR MAN" SESSION, SEPTEMBER 1967. (COURTESY OF MARY JARVIS AND JOSEPH A. TUNZI, J.A.T. PUBLISHING)

THE LAST ROUND-UP

HEY LEFT MEMPHIS on June 10 in the big Greyhound bus that George Barris had customized so lavishly for Elvis. For the first time, in honor of his own marriage, wives were included on the cross-country trip, though, of course, children were not, and a long, leisurely, sight-seeing drive was planned. It was like a muchanticipated family vacation, with a visit to the Grand Canyon giving everyone a chance to act like typical tourists, and Joe's home-movie camera recording events in the same random manner that might memorialize any other kind of domestic event. Mostly they just enjoyed each other's company in an atmosphere that appeared to combine a newfound embrace of maturity with an almost desperate determination not to let go of their youth. Joe's movies show men performing self-consciously for the camera, feinting and dodging and taking occasional karate swipes at one another, as the women gaze on approvingly, pick wildflowers, and play the familiar role of wife, lover, friend. At the center of it all is Elvis, looking sober and silly at the same time, wearing a porkpie hat and seemingly suspended for a moment from the action as he quizzically contemplates just what could have caused all of this to come about, then once again throws himself back into the fray.

The MGM picture they were going out to do, *Speedway*, featured Elvis as a race-car driver for the third time and was to be director Norman Taurog's eighth Elvis Presley picture. Nancy Sinatra was the love interest; the guys played various roles; even Taurog's one-and-one-half-year-old granddaughter was given a small part. In keeping with his renewed commitment, Elvis actually worked till four in the morning on one of the two nights dedicated to soundtrack recording, completing two versions of "Suppose," the romantic ballad he had been experimenting with at home for over a year, but occupying himself for the most part with dispiriting material like "He's Your Uncle, Not Your Dad," the most egregious, but by no means the only, example of the standard to which Freddy Bienstock, and Hill and Range, had been reduced.

270 🔊 THE LAST ROUND-UP

Life at Rocca Place was fraught with some of the same tensions and contradictions that continued to be reflected in his career. It was a somewhat reduced retinue, with Red and Sonny and Alan all gone, though Gee Gee Gambill, who had married Elvis' cousin Patsy, filled in as best he could, moving into the house with Patsy, who had worked in the office at Graceland for years. There was no mistaking the difference in mood. Everyone recognized the inevitable changes that marriage, not to mention the Colonel's edict of three months before, was bound to bring, and everyone made their own adjustments. Jerry planned to stay in L.A. when the movie was done, making his living as an extra and bit player until he could figure out exactly what he wanted to do with his life. Billy was chafing at the bit to go home, looking to spend more time with his family and increasingly resentful of the arbitrary demands that his cousin so often put on him. Joe intended to make a more permanent home for himself out on the Coast with his wife and daughters, while Marty was definitely out of favor and Charlie tended to get under everyone's skin with his ceaseless chatter, his emotional fragility, and his sycophantic ways.

To Joan Esposito it was an incestuous world in which Elvis could be "so wonderful and warm — I always respected who he was, regardless. But as close as you could be as friends, he was still signing the paycheck." Nor was there ever any question as to who was calling the shots or the extent to which "you lived your life around their lives." Priscilla would probably not have disagreed — though she might have changed the possessive to the singular. "It was the whim of the moment. It was who was around at the moment, and that's why everyone wanted to be around. It was like some of the guys would say, 'You got to be around for the gravy.' Elvis was funny he would tell one person one thing, and then he would tell another person something else. [And they all thought] they knew him so well. I'm sure they knew parts of him that I didn't know, just like I as a woman knew parts of him they would never know — but a lot of times they just couldn't see him as a man."

Priscilla had her own reasons for resentment. Just before they left on the cross-country trip she found out that she was pregnant. Her first reaction was one of anger. Before the wedding she had asked Elvis if she should start taking birth-control pills, but he was adamantly opposed because, he told her, they had not yet been proven to be medically safe. She saw pregnancy as the end of all their dreams. "If I were pregnant, I knew that our plans to travel would have to be postponed. . . . For the first year I truly wanted to be alone with Elvis, without any responsibilities or obligations." She approached Elvis with a considerable degree of trepidation. "I expected him to react with the same mixed reactions I felt, but he was ecstatic . . . and immediately wanted to tell everyone." The instant that it was confirmed, he informed his father that he was going to be a grandfather. "You're going to be a gray-headed granddaddy," he teased him in the doctor's waiting room, as father and son shared a moment of unalloyed joy.

Priscilla was determined not to let pregnancy interfere with her normal life; "as far as I was concerned, the less people mentioned about my looking pregnant, the better," and she went on a program to lose, rather than to gain, weight. She experienced periods of despondency nonetheless, and she made no attempt to hide her deepest feelings from Joanie Esposito, who observed that "it just took all the glow off." For all of Priscilla's deepseated ambivalence, Elvis' own feelings seemed to run remarkably true. When Priscilla, in a moment of despair, confessed that she was contemplating abortion, Elvis said he would support her in whatever she chose to do. Brought face-to-face with the necessity of actually making a decision, she realized she couldn't go through with it. "'It's our baby,' I said, sobbing. 'I could never live with myself, neither could you.' There were no words, only his smile of approval; he held me tightly in his arms as I cried." And when he announced her pregnancy on the movie set, handing out cigars to cast and crew, he showed nothing but paternal pride, mixed with the understandable bewilderment of most first-time fathers. "This is the greatest thing that has ever happened to me," he told reporters. "We really hadn't planned to have a baby this soon. [When] Priscilla told me the good news . . . [at first] I was so shocked I didn't think I could move for a while. Then it began to dawn on me this is what marriage is all about." The Colonel confessed that he, too, was surprised, "but I've already got a contract drawn up for the new Presley singer."

MARTY WOULD BE DISMISSED before the movie was over, sent back to Mississippi to join Alan on the ranch. There, under the increasing influence of pills and depression, "all I really did was sleep," working as a caretaker and relief guard before going off the payroll for good in September. To Marty it was all part of an alliance of convenience between Vernon and Priscilla, cleverly encouraged by the Colonel, to cut spending and place Priscilla's friends in positions of power. There was no longer any question of who was mistress of the house, and Elvis and Priscilla spent the rest of the summer finishing up the movie, enjoying a long visit from Vernon and Dee, and on weekends getting away to Palm Springs with Joanie and Joe, where they relaxed and enjoyed themselves under the Colonel's watchful eye.

The Colonel continued to violate his own long-standing rule never to mix business and pleasure. Whether out of concern for Elvis' narrow escape from the clutches of mystical messianism, or out of approval for Elvis' newfound matrimonial state, the Colonel and his wife continued to socialize openly with the young people, frequently including Joe and Joanie in their Sunday dinner invitations. After dinner, in time-honored fashion, the men would talk among themselves, puffing on their cigars, while the women more often than not played Yahtzee with Mrs. Parker, who made up her own rules and never stopped complaining about being abandoned by her husband all week while he was off on a Hollywood movie lot.

Joan Esposito appreciated Colonel's sense of humor and his affection for her children, whose bedroom was filled with stuffed animals from his office. "One night in L.A. Joe called and said, 'Colonel wants to come home for dinner.' I said, 'We're having sloppy joes.' He told Colonel, who said he was so tired of restaurant food that would be perfect. So he came over and ate with us, and he just made you feel like he really appreciated it." Another time, driving back from Palm Springs with Joe, he suggested that they stop and split a beer. "I realized I'd never seen him drink before — not once. So I said, 'Did you ever drink, Colonel Parker?' He said, 'I can't drink.' He said, 'I completely change when I drink, my personality does, I get very mean. That's why I don't drink.'"

It was a whole different view of the Colonel than either Joe or his employer had ever seen, watching him putter endlessly around the pool area to which Mrs. Parker had banished him from the fussy plasticwrapped neatness of the house, pointing out some new feature on the outdoor barbecue that was his pride and joy. There was a little rock waterfall garden with a miniature Dutch windmill; he had a stove and a fully stocked refrigerator, another windmill on top of a white trellis, and everything was painted blue and white. It was never too hot for him; he loved to sit out in his deck chair, baking like a lobster in the hot, dry desert sun and telling them of his dogcatcher days in Tampa or life with the carnival, explaining once again the disappearing hot dog trick or (Elvis' favorite) how you took the customer for twenty-five cents on every ticket by pretending to make change with a quarter welded to the inside of your pinky ring.

As fond as he sometimes felt toward the old man, however, and as much as he appreciated his antics, Elvis was under no illusions as to why the Colonel wanted him in Palm Springs, and there was no question in anyone else's mind that he resented it. Everyone had the same sense of being under scrutiny, but for Elvis it was particularly acute since he was the prime object of observation. Jerry was the Colonel's principal driver to and from Palm Springs at this point. If he were not down for the weekend himself, Jerry would leave Los Angeles early Monday morning, arriving two hours later to collect the Colonel for his four- or five-day work week. "Lots of times I'd have breakfast with the Colonel when I got there or chitchat with Mrs. Parker — she was always saying, 'I just wish the Colonel would stay here.' Then I'd load up the car, and we'd drive back to L.A. with the windows rolled up and Colonel smoking cigars. And that's when he would start probing me about what was going on. It was the scariest thing in the world to me at first. I mean, he would always say he had nothing to do with Elvis' personal life. He had everything to do with Elvis' personal life, from our going to Palm Springs in the first place, where he could come and check up on us to — everything." Jerry didn't pretend to understand it all, but he knew that if Colonel had come right out and said what was on his mind, Elvis would probably just have blown. And if Elvis had expressed any of his own resentment, Colonel might have said things he could never take back. So they continued to circle each other warily, like an old married couple locked in a relationship from which neither could see any escape.

Business showed no signs of picking up. *Easy Come, Easy Go,* the picture made at Paramount the previous fall, had confirmed all of Hal Wallis' worst fears, failing even to recoup its costs (it grossed less than s2 million when it came out in March), with the soundtrack EP bottoming out at 36,000 sales. *Double Trouble,* released in April, did little better, with the soundtrack album selling approximately 185,000 but topping out in the high forties on the charts (in comparison, say, to 1964–65's *Roustabout,* which sold nearly half a million and went to number one on the charts). There was some consolation in the steady sales of the gospel album, *How Great Thou Art* (on its way to nearly three-quarters of a million units sold over the next few years), and in the moderate success (400,000 sales) of the year's first single, the song Lamar had originally brought to the first Felton Jarvis session, "Indescribably Blue." In addition, with only three pictures left on the MGM contract and National General alone exhibiting any real interest in future projects, the movie cupboard was just about bare. Others might

have sought solace or found false hope in the occasional success, the unreadable blip on the horizon, but Colonel was never one to hypnotize himself with pipe dreams. It was clear that changes were going to have to be made — by both Mr. Presley and himself. Figures, as the Colonel well knew, didn't lie.

The first result should not have been unexpected, though it may well have been coincidental: by the end of the summer Elvis had virtually shut down the Circle G ranch. Expenses, of course, had long since spun out of control, but the principal factor in his decision seems to have been that after six months Elvis had simply grown tired of the cowboy life. Most of the Ranchero pickups were gone by now; the mobile homes that were to have been the basis for his commune were being sold off one by one; the Santa Gertrudis cattle that Vernon had dreamed would make him a gentleman rancher were on the block; even Alan had been given notice that his days as ranch foreman were numbered. The word among the guys and all the various Presley and Smith relatives who depended upon Elvis for their living was that Colonel had warned him that he was going broke; Gladys' brother Travis, a gate guard like Vester Presley, said that he had heard that Elvis was spending \$500,000 a month just to keep things running. And even though no one really believed that Elvis would ever run out of money, least of all Elvis himself, he appeared for once to be acting on prudent financial advice.

Of greater long-term consequence was the whole business of his recording career. In June the decision had been made not to return to Nashville but to record in Los Angeles instead. It was a decision that may well have been taken principally for reasons of geographical convenience, but it seems more than likely that ditching the Nashville musicians with whom Elvis had become so comfortable, as well as the familar surroundings of RCA's Studio B, was part of the same attempt to "modernize" his sound that had begun with the introduction of Felton Jarvis the year before. Moreover, although Felton was still slated to produce the August session, and RCA's principal Nashville engineer Jim Malloy was being flown in to work the board, a new arranger-contractor had usurped much of the function that a producer ordinarily serves, hiring the musicians, helping to choose the material, and generally taking part in areas in which no one but Elvis or RCA had previously been involved.

Billy Strange, a flamboyant, thirty-seven-year-old session guitarist and entrepreneur who had grown up in the music business (his father was a well-known California country radio personality), had gained a foothold with Elvis and the Colonel, both from past soundtrack session work and from his connection with Elvis' most recent co-star, Nancy Sinatra. A big bluff man, not at all shy about proclaiming his qualifications, he was tied in with the new wave of Hollywood writers, producers, and studio players that in 1966 had helped create Nancy Sinatra's brief but explosive hit-making career. Billy shared with Elvis a taste for motorcycle riding and got along well with the guys, but mostly he just seemed like the right kind of person to accommodate himself to a situation that called for a different approach but not a radically different one.

The aim of the session was straightforward enough: two singles, four or five "bonus" tracks for the upcoming *Clambake* album (which would have only seven songs from the actual soundtrack), and an Easter single if possible. Billy's conception of the sound was contemporary country as played by crack L.A. musicians, with a brass section and fully worked-out arrangements, but he was as confounded as any of his predecessors by Elvis' all-over-the-map approach. Every time he thought he had the repertoire worked out and started to sketch in some arrangements, the lineup was apt to shift radically once again, and Elvis' enthusiasms (communicated now via Charlie Hodge) sent him scurrying to run down titles he might up till that moment never even have heard of.

Elvis resurrected Della Reese's "After Loving You" (originally an Eddy Arnold number) and Ray Peterson's "The Wonder of You" for the session. Both had been strong contenders the previous May, and he added to them such old favorites as Sanford Clark's rockabilly classic from 1956, "The Fool," Johnny Ace's posthumous 1955 r&b chart-topper, "Pledging My Love," and the Golden Gate Quartet's "Born Ten Thousand Years Ago," to which Charlie had introduced him in Germany. That summer he heard a new song on the radio called "Guitar Man" by fellow RCA artist Jerry Reed, and Freddy was instructed to work out the publishing on that, too, as well as on the old Jimmy Reed blues "Baby What You Want Me to Do?" and one of Vernon's all-time country favorites, "From a Jack to a King." Freddy's mind unfortunately wasn't really focused on the business at hand. Hill and Range had recently been forced to divest itself of its foreign publishing, and Freddy had been chosen to take over his cousins' holdings in Great Britain, with the presumption that his interests would be their interests. He apparently saw this as an opportunity to establish an independent identity, and as a result he was even less responsive than usual to the Colonel's and Tom Diskin's constant prodding. Nonetheless, the session took shape, and Billy

Strange felt that he was prepared for any eventuality as they got ready to go into the studio on the evening of Tuesday, August 22. That very day, however, Richard Davis ran over and killed a Japanese gardener who stepped out from behind a hedge on a curve that screened any view from the road. It was too late to notify Felton and Jim Malloy, who were already on flights coming into L.A., but Colonel, sensing that there might be a lawsuit brewing, and wanting at all costs to keep Elvis out of it, canceled the session, suggesting to Joe that it might be better for them all to get out of town for a few days. So Elvis, Joe, Priscilla, Charlie, Billy, and Gee Gee all headed for Las Vegas, where they remained for a couple of days before returning to Memphis without the session ever taking place at all.

I T WAS RESCHEDULED FOR NASHVILLE ON September 10, with all thought of Billy Strange's participation evidently forgotten and, in its place, a new focus, the recording of the Jerry Reed song whose driving acoustic sound Elvis couldn't get out of his head. Felton at this point was feeling increasingly hamstrung in his role as producer without portfolio, a kind of glorified cheerleader who could suggest neither material nor direction. As much as he loved Elvis and as thrilled as he still was by being in a position to contribute anything to the music, Felton couldn't help but conclude that he was in a box. He couldn't call a rehearsal session, he couldn't get Elvis to learn the material ahead of time, he couldn't even be sure that Elvis would show up. The only thing he felt confident of was his ability to establish an atmosphere that allowed Elvis to sound like he did "when he was just in there singing to himself" - and he was frequently thwarted even in that by the politics of the situation. As second engineer Al Pachucki saw it, it was like a marbles game, with everyone competing on one level or another for Elvis' attention, to the detriment of the business at hand. "That was a scene to see. Freddy would have his stack of records, and Lamar would walk in and slip his record on top. And then Freddy would do the same thing. And I would say, 'Man, I don't believe it. Look at these dudes, man, trying to get their material cut.""

At least this time there was some clear sense of direction, as the session kicked off with a rundown of "Guitar Man" — but it soon became apparent that there was no way they were going to get the Jerry Reed sound without Jerry Reed himself. Someone said they thought Reed had gone fishing, but nobody was sure how to get hold of him until Chet's assistant,

Mary Lynch, was finally able to locate him on the phone, and he agreed to come in. When he arrived, he looked, said Felton, "like a sure-enough Alabama wild man. You know, he hadn't shaved in about a week, and he had them old clogs on — that was just the way he dressed. He come in and Elvis looked at him and said, 'Lord, have mercy, what is that!'"

Reed was a genuine individualist, even in Nashville terms. Thirty years old, like Felton a native of Atlanta and a graduate of the Bill Lowery School of Music, he had been writing songs and making records off and on for over ten years. He got session work through an admiring Chet Atkins after moving to Nashville in 1962, but he had not really enjoyed any recording success until signing with RCA in 1965. "Guitar Man," which had reached number fifty-three in the country field just a few months earlier, was his first record even to chart. Nonetheless, Reed, a whirlwind of energy with a ready supply of infectious charm and irrepressible enthusiasm, was never bashful about his talent. He had strong opinions of his own from the start and never wavered in his belief that if he was going to make it, he was going to make it *his* way. "I never thought of myself as a Nashville recording musician. 'Cause I was a stylist. I [could] only play my stuff. And I wasn't worth a damn playing all that other stuff.

"See, I had my own tuning, and they were trying to record 'Guitar Man,' and they couldn't make it feel like my record. And I forget if it was Pete Drake or Charlie McCoy or Chip Young — one of those musicians said, 'Well, these guitar players in here are playing with straight picks, and, you know, Reed plays with his fingers.' So they called me, and I went down, and I hooked up that electric gut string, tuned the B-string up a whole tone, and I toned the low E-string down a whole tone, so I could bar straight across, and as soon as we hit the intro, you could see Elvis' eyes light up — he knew we had it."

Reed immediately took over the session. You can hear it from the first notes of the first take — Reed is coaching the musicians, encouraging them, egging them on, with Felton happy just to be presiding over something that is actually *happening*. There is a bright, shimmering surface to the music different in many respects from anything Elvis has ever recorded before but providing, at the same time, the kind of churning, driving rhythm that has characterized Elvis' music from the first. There is not the slightest question of Elvis' engagement. There is no self-deprecation, there is no wisecracking; all of the singer's attention is focused on the music. By the fifth take he has started to fool around with the song, introducing a hint of Ray Charles' "What'd I Say" on the outro, which by the tenth take has evolved into a full-blown quote so infectious that everyone just bursts out laughing.

Reed himself felt nothing but pure delight. "It was just a jamming session. I thought I was going to be so damn nervous I couldn't play, but it was right the opposite. I got pumped, and then Elvis got pumped, and the more he got pumped up, the more I did — it was like a snowball effect. To tell you the truth, I was on cloud nine. And once Elvis got the spirit, things really began to happen. When the guitars and the rhythm sounded right, I guess the guitar lick kind of reminded him of 'What'd I Say,' and he just sort of started testifying at the end. That was how it happened — one of those rare moments in your life you never forget."

They jumped, almost without pausing for breath, into the Jimmy Reed blues standard "Big Boss Man," and once again you can hear the "Alabama wild man" pushing, prodding, encouraging, contributing his exuberant personality and musicianship to every note. The whole room is reverberating by now, and Elvis is obviously totally at ease. On the seventh take he yells out, "Go apeshit!," and it is clear that everyone is relaxed and having fun. "That's a gas, man," Felton announces at one point. Elvis has roughened his voice for the blues, a tactic of which Felton obviously approves. He adjures Elvis to sound "like you're mad, like you're mean." By the time that they nail the song in eleven carefree takes, it feels like everyone is ready to go on all night long.

But then politics entered the picture once again. Freddy was supposed to have cleared the publishing on "Guitar Man" for the Billy Strange session, but whether due to the exigencies of his new business situation or because it had simply slipped his mind when he went on vacation the previous month, he had somehow neglected to approach Jerry Reed about it, a situation of which he now became embarrassingly aware. He got Lamar to try to deal with the songwriter (who held his own publishing), but Reed was in no mood to be bullied or sold out. "I remember saying, 'Why didn't you tell me this before I come here? I could have saved you all a lot of effort.' I started to get emotional now. I said, 'You done wasted Elvis' time. You done wasted all these musicians' time, and RCA's time: I'm not going to give you my soul.'" At this point Freddy got into it. Session leader Scotty Moore, who had witnessed his share of confrontations over the years, and even been involved in one or two, observed the scene admiringly. "They got Jerry off in a corner, but he wouldn't sell." Of course, it helped his position to know the song had already been cut and that Elvis loved it. Even for as independent a spirit as Jerry Reed, that knowledge could only have been emboldening. "I said, 'I know how important it is to have an Elvis Presley cut. I mean, I'm thrilled to death. And we can work out a split on this record — because I do appreciate the importance of it, and what it means. But,' I said, 'you are not going to get any of the copyright on this damn song.' He said, 'You know, it will be an important copyright.' And I said, 'I understand that, Mr. Bienstock.' But I wasn't really listening, because I had my side of the argument in concrete anyway. I can remember him saying, 'You know the record is not going to come out if we can't work out some kind of an arrangement here.' And I said, 'Mr. Bienstock, I'll put it to you this way. You don't need the money, and Elvis don't need the money, and I'm making more money than I can spend right now — so why don't we just forget we ever recorded this damn song?'"

The musicians watched practically open-mouthed. Nobody could recall a time when business had intruded so nakedly into an Elvis Presley session; everyone was aware of the arbitrariness of the rules, but no one had ever seen them challenged so boldly before. The upshot was that Reed left in high dudgeon and the session stumbled on, but the heart had long since gone out of it when they finally gave up at 5:30 in the morning. The next night they were back to the same old grind, fumbling around for songs, settling for the best of a mediocre lot, trying somehow just to get Elvis through. Elvis himself remained thoroughly professional, he didn't complain and did all that he could to work up some kind of enthusiasm, even on the most stubbornly recalcitrant material. It wasn't a bad session, and Elvis took over the piano bench for "You'll Never Walk Alone," the Rodgers and Hammerstein ballad which had been one of his favorites ever since Roy Hamilton's inspirational r&b version in 1954. He sang with all the full-throated fervor of Hamilton or Jake Hess, and although his playing remained necessarily limited, both rhythmically and melodically, it was always a measure of his engagement when he sat down at the keyboard to play. There was a moment when session guitarists Chip Young and Harold Bradley tried to get things going by playing a few bars from "Hi-Heel Sneakers," a 1964 Tommy Tucker hit with much the same bluesy appeal as "Big Boss Man." Elvis leapt to the bait, and they did a fine version of the song, but afterward Harold was told by Felton never to do that again. "I said, 'Do what?' He said, 'Pitch any songs.' He said Freddy Bienstock went bananas. I said, 'Okay, I didn't know, I thought we were making records.

If I had known we were playing games, I wouldn't have pitched it.' I said I wouldn't do it again."

The session broke off at 3:30 in the morning, with everyone feeling more than a little dispirited. On balance they had achieved what they set out to do: in two nights they had recorded nine separate songs, including a couple of singles, some B sides, and some album filler. But they never came close to recapturing the feeling they had glimpsed for the few hours that Jerry Reed was in the studio the previous night; it had slipped through their fingers, and no one knew how to get it back.

HERE WAS ABOUT A MONTH before the next film was scheduled to begin, and Elvis spent most of it watching two or three movies a night at the Memphian Theatre, traveling back and forth to the ranch on many days but doing more shooting than riding. Friday, September 29 was declared Elvis Presley Day by Tennessee Governor Buford Ellington, and Elvis celebrated by shooting off fireworks at Graceland all day (Billy got burned and Elvis did, too) and getting drunk at the Memphian that night, seemingly embarrassed, even while he was in the midst of the experience, by his public loss of control. Priscilla was supervising the upstairs redecoration of Graceland in preparation for the baby's arrival and remained determined not to let her condition restrict her in any way. An accomplished (and highly competitive) rider, she insisted on continuing to ride bareback until one day, as stable manager Mike McGregor watched, her horse, Diamond, swerved, and she went flying through the air. By the time that Mike got to her, "she was sitting in a mud puddle, a streak on her cheek . . . laughing." Priscilla told everyone about her adventure, and everyone marveled at her gutsiness and determination to keep going, even if some wondered about her common sense. Elvis tried to get her to promise to be more careful in future, but in Priscilla's mind it was part of a pact she had made with herself: she was going to have to show the same kind of reckless abandon that Elvis did if she wanted to be able to maintain any degree of self-respect.

ELVIS WAS BACK IN NASHVILLE ON OCTOBER I for the soundtrack recording of his new MGM picture, *Stay Away, Joe*. Scheduled to go into production the following week, it seemed at first glance a complete change of pace, a social satire that pitted Indian ingenuity against government bureaucracy and was to be shot entirely on location in Sedona, Arizona. Elvis' character was an Indian rodeo rider named Joe Whitecloud, "a wheeler-dealer who's always promoting something," from Elvis' point of view. He had high hopes that this film would provide him with "a more grown-up character," a role that he could play in sophisticated fashion somewhere between Paul Newman's Hud and Michael Caine's Alfie. That they were recording only three titles for the picture might have added to his overall optimism, except for the fact that one of the numbers, "Dominick," was written to be sung to a bull.

In a rare moment of candor Elvis told Harry Jenkins, the RCA vice president in charge of Elvis Presley product, who was present at the session, "God, Harry, I don't want to record this." He begged Felton, only halfjokingly, that if he ever died, "Promise me they won't put this out." Even Colonel was aware that Freddy had achieved a new low in terms of supplying soundtrack material, a fact of which he informed MGM marketing vice president Clark Ramsay somewhat obliquely in a telephone conversation the following day. Elvis had simply come up against "a blank wall" in the studio, Colonel apprised the MGM executive, and while he had done everything that was asked of him, and done it without complaint, the Colonel just wanted to go on record as to what the creative situation really was. It was as close to outright criticism in nonbusiness affairs as the Colonel was ever likely to come, but it was addressed to the wrong party. The Colonel might better have directed his criticism at himself.

The picture started a week later in Sedona, after Elvis had detoured for a few days with some of the guys to Las Vegas. The director, Peter Tewksbury, had a long and successful track record in comedy, though mostly in television (he had directed the long-running situation comedies *Father Knows Best* and *My Three Sons*), and the cast was somewhat better than usual, with veteran actors Burgess Meredith, Thomas Gomez, and Katy Jurado lending a touch of professionalism to the proceedings. Elvis rose to the occasion up to a point, offering his warmest and most relaxed performance since *Follow That Dream*, one of his last out-and-out attempts at an actual movie rather than an *Elvis Presley* movie, and perhaps his only legitimate comedy. Unfortunately, *Stay Away, Joe* lacked the earlier movie's coherence, story line, and point of view. It was a disaster, and everyone knew it was a disaster, a fireworks display without a payoff.

Still, they had fun on location. The Colonel clowned around, having his picture taken in the pool with several days' growth of beard and a mean snarl on his face, then getting the picture printed up in the same form as the Elvis pocket calendar that RCA gave out as a staple of its promotional material and proudly presenting it to fans, friends, and business acquaintances. The Colonel bought some ponies, too, and presented them to Elvis as a gift, with Alan Fortas and Mike McGregor coming out to pick them up and take them back to Memphis. More significantly, Elvis worked out an effective rapprochement with Sonny by getting him a speaking part in the picture, which certainly erased some of the resentment engendered by the wedding snub — even if Red continued to maintain his distance.

He repeated his hopes for the film in the form of the slightly shopworn mantra that he delivered to one of Colonel's chosen reporters, Joseph Lewis, on the set doing a story for *Cosmopolitan*. "I guess I'd like to prove myself as an actor, and to do that I'll have to take more chances. You can learn an awful lot just by hanging out with real good professionals, and there isn't a day that goes by that I don't pick up on something from the other actors. Right now, I'm still taking little steps because I'm not all that sure of my ability. There's a lot more I want to do before I call myself an actor." For all of the brave talk, though, the sympathetic reporter saw Elvis as "bored and bemused," a paradox combining a "plastic grin" with an "orgiastic fury of movements." He came alive, Lewis concluded, only in the fight scenes, "all sinew and cartilage exploding with kinetic energy. . . . At the end of the day, he nurses a bruised cheek and a sore shoulder, but he is happy."

THERE WAS AN ANNOUNCEMENT in the Memphis newspapers during the first week of filming that there would be a public auction at the Circle G on November 4. Tractors, trailers, television sets, and miscellaneous farm equipment were to be sold off, and eventually \$108,000 was raised, with two thousand potential buyers and fans in attendance at the auction. Colonel meanwhile was in a frenzy of activity, completing details on the upcoming Christmas radio special (he was buying a half hour of airtime on twenty-four hundred stations nationwide to play a selection of Elvis' Christmas and sacred tunes, "just our way of saying Merry Christmas"), completing the deal for next summer's picture with National General, and beginning negotiations with NBC on a new deal that seemed to be turning into something different from anything they had ever done before.

The radio special was straightforward enough, just a take-off on the Mother's Day specials they had done the previous two years, something for

the fans. The National General contract had worked out pretty much the way that he had wanted, \$850,000, plus 50 percent of the profits from the first dollar, but, according to Roger Davis, the William Morris lawyer who formally represented the deal, when Colonel tried to get the press to pick up on it as a significant industry story, he couldn't find any takers. Nor was he able to find any other studio willing to meet his asking price. "The aim was always the same: money," Davis observed. "The pictures weren't making any money, and nobody [else] was willing to come up with the kind of money the Colonel thought he should have. It was a matter of pride."

So he went to NBC. In October he contacted West Coast vice president Tom Sarnoff with the idea for a 1968 Christmas special. He had been in touch with Sarnoff off and on since 1965, when he proposed a picture that would premiere domestically with an NBC broadcast, then have a theatrical release throughout the rest of the world. Now he had come up with a scheme whereby NBC would get Elvis for his first television appearance in eight years, and in exchange the network would finance a motion picture which it could either produce itself or farm out to a mutually agreed-upon studio. The entire package would come in at the bargain price of \$1,250,000 (\$850,000 for the movie, plus an additional \$25,000 for the music; a mere \$250,000 for the special, with \$125,000 reserved for a second showing). What this all meant, the Colonel said to Sarnoff, was that he would be getting for his client the \$1,000,000 that he saw as a simple mark of respect, but NBC would be getting Elvis Presley at a steal.

Priscilla meanwhile had found a new home. Not content with either the privacy or the security arrangements that Rocca Place afforded, she had found a house atop a hill in the exclusive Trousdale Estates development. It offered a view overlooking all of Los Angeles, a location more discouraging of fan access, and, best of all, only four bedrooms, thereby ensuring some privacy for Elvis, Priscilla, and the baby. It would be their first real home, the first house in which they would live in Los Angeles that was not a rental; it would mark, Priscilla believed, a whole new beginning.

They bought it for something in excess of \$400,000, and Priscilla began remodeling right away with the idea of moving in the following spring, after the baby was born. Elvis seemed genuinely enthusiastic, and they spoke more and more of making their home in California for most of the year. When they returned to Memphis, though, in mid December, Elvis shocked Priscilla by announcing that he thought maybe they should consider a trial separation. He needed some space, he said, he needed a chance to think, and he felt like they could both benefit from some time apart. At first she was completely taken aback. She was devastated, bewildered, and seriously questioned her self-worth. But then when nothing else happened and the subject was dropped, never to be brought up again, she decided it must have been something he felt guilty about, whether a thought or a deed — with her husband there was never any simple way of telling.

"Elvis would do things like that when he didn't feel worthy, or he felt that he'd been bad and he didn't want to hurt me. He seemed to feel better after he said it. He had so many ups and downs; life would basically interfere with his emotions, [sometimes] on a daily basis. If his father upset him, or one of the guys, sometimes he'd go upstairs and not come down for two or three days. He'd remove himself, stay in his room and not come down; he had a very difficult time confronting his emotions, confronting conflicts. But eventually he'd come out of it.

"You went with the ride. Basically, you just went with it. One thing that I realized was that he loved the chase. And once the chase was over, I knew I didn't have to worry on anything — whether it was a new game or a girl or somebody new coming into the group. He would always come home. And once you realized that about him, you knew it was just a matter of time; it just depended on how long he wanted to play the game, and whether you wanted to wait."

They spent much of the Christmas season saying good-bye to the Circle G. The horses that Elvis had decided to keep were being shipped back to Graceland, but for the time being they all continued to ride at the ranch, where hayrides and snowball fights were organized as part of an extended farewell. On New Year's Eve Elvis rented out the Thunderbird Lounge for a party that once again included fan club presidents, relatives, and friends. There was a strange mood at the party this year, as Flash and the Board of Directors, Vaneese Starks, and Billy Lee Riley all entertained with a program of Memphis rock and rhythm and blues. Early in the evening Elvis started drinking Bloody Marys and mocking Lamar mercilessly. By the end of the night Elvis, Vernon, and Lamar were all drunk, and Elvis was ragging Lamar that he couldn't even hold his head up straight. As if to prove his point, he grabbed an ice bucket and stuck Lamar's head in it, then called out, "Hey, Lamar," and laughed some more as Lamar half-lifted his head out of the bucket and gave Elvis a sheepish grin.

* * *

THERE WAS ANOTHER NASHVILLE session scheduled for January 15 and 16 to record a new title track and any additional second and the and 16 to record a new title track and one additional number for Stay Away, Joe (MGM agreed in exchange to underwrite \$10,000 of the session), along with some new material for RCA. In addition to session work, Scotty Moore had been running his own studio in Nashville for the last few years, mostly engineering sessions, and Elvis now asked him if he could transfer some of Elvis' old r&b and hillbilly 78s to tape. Nothing could be easier, Scotty told him, all he had to do was bring them over, so he carried them to the session in a specially made-up carrying case designed to reduce breakage, all the brightly colored discs of his youth. It must have brought back poignant memories to both men, as their minds were cast back momentarily to a time when they were just starting out, when there was no way of telling how it was all going to end. Big Joe Turner, Ray Charles, Fats Domino, Hank Snow's "I'm Gonna Bid My Blues Goodbye," The Dominoes, Ivory Joe Hunter, The Four Lads. Here were the originals of "Lawdy, Miss Clawdy" by Lloyd Price, Big Mama Thornton's "Hound Dog" and "Baby, Let's Play House" by Arthur Gunter (both cracked), Lowell Fulson's another lifetime.

Jerry Reed was back for the session, strictly as a guitar picker this time everyone had gotten such a kick out of his playing, and Felton, for one, had quietly appreciated the stand he had taken, as he let Jerry know some weeks after the September date. Freddy had eventually worked out a cut-in deal with him on the publishing, with Elvis Presley Music participating only in Elvis' version of the song, which was about to come out as the new single that very week. No new material had been requested from Reed, however, and he was under no illusions that he would be asked for any.

They had a hard time settling on anything at first. That wasn't unusual in and of itself, but Elvis was in an odd mood — seemingly preoccupied one minute, belligerent the next, revealing himself in a fashion that few of the musicians had witnessed before. For all of the scrutiny that he was constantly under, Elvis ordinarily showed as little of his hidden self to these men as he did to the casual outsider. Just as on the movie set, he was invariably observed to be polite, deferential, soft-spoken — to the less sympathetic observer somewhat passive perhaps, definitely immature. Now, on the contrary, he was swaggering, boastful, profane, in a way that many of them didn't fully recognize. To Ray Walker, who had come in for his first session with the Jordanaires in 1958, it was a perplexing turnabout. "Presley had such a unique way of becoming what you needed him to be at the moment. That's where it really kind of surprised us. Because there were two terms that just made him furious in his early life: 'bastard' and 'sonofabitch.' He just couldn't stand them. And he never took the Lord's name in vain. In fact, around us he would never use 'slang' until this session, [but here] things got jokingly rough; there was some language going on."

There appeared to be very little suitable new material - once again Freddy had failed to do his job, and Elvis amused himself by chucking the acetates that Freddy and Lamar had submitted one after another up against the wall. Finally, after several hours, they settled on an old favorite, Chuck Berry's "Too Much Monkey Business," on which there was clearly no chance of a publishing deal. Elvis jumped into the song with both feet, egged on by Jerry Reed's guitar. Just as he had with "Guitar Man," Reed took a fresh, fundamentally acoustic approach, with an emphasis on the kind of light, dancing rhythm that drew as much from bluegrass and Elvis' Sun sides as it did from either contemporary country or rock 'n' roll. Evidently emboldened by their success, they next took up "Goin' Home," a tune Lamar had come up with for the picture, and struggled through thirty torturous takes. Over and over you can hear Elvis break off singing to the accompaniment of raucous laughter and forced hilarity from the guys. Over and over he fails to get past the first verse, declaring at one point, "I just don't know what I can do to improve this except go home." When they finally broke off at five in the morning, they had an acceptable master take but not much else, certainly nothing in the way of either good feeling or any sense of accomplishment.

The next night started out even worse. "Stay Away," the new title track, written to the melody of "Greensleeves," was no improvement on "Goin' Home," and Elvis continued to explode with inappropriate profanities and inexplicable displays of temper for the four hours that it took to get through it. There was more ridicule, more scornful rejection of Freddy and Lamar's offerings, until, finally, with the session in utter disarray and the participants in various stages of desperation, Jerry Reed was induced to submit a song that Felton thought might be suitable for Elvis, a talking blues called "U.S. Male" that had come out on an album that spring. Reed was, naturally, reluctant to repeat his previous experience, but by this time Freddy was so anxious for anything to come out of this session he probably would have offered Reed a cut-in on one of *his* songs. Jerry played the song for Elvis out in the hallway, and Elvis liked it, so they set out to get it on tape.

There was no doubt about the immediate pickup of energy that the song provided, and the braggadocio quality of its lyrics turned out to be a good match for Elvis' mood. But the strange vibes persisted, and after just one take, Elvis drifted off into a "blue" version of "The Prisoner's Song," which began "If I had the wings of an angel and the balls of a big hairy coon/I'd fly to the highest mountain and cornhole the man in the moon." On the next take, he declares, "I'm a fucked-up U.S. Male," which at this point he may very well have been. Two more songs like that, declared Felton, unable at this point to hide his exasperation, and they could have a complete "party album." And so it went, until they finally got a successful take, one that could certainly join "Guitar Man" and "Big Boss Man" in its brightness, differentness, and overall sense of engagement, but one that came from a very different place.

What could have been bothering Elvis so? Perhaps it was no more than what Priscilla observed when she made note of her husband's constant upand-down mood swings, a tendency not helped by his constant intake of "medication." But in some ways it appears to have been something more than that. The Colonel was unquestionably taking care of business — Elvis could see that, if only by the flurry of promotional activity that surrounded each new movie, every new single release. The problem was that this single-minded "exploitational" approach was no longer working. Because of the quarrel over publishing, "Guitar Man" had not initially come out as a single, and when "Big Boss Man" took its place in October, it sold no more than any other single, a disappointing 350,000 copies. It didn't sound the same to Elvis either, it didn't sound anything like the acetate RCA had shipped him: the bass wasn't as strong, the vocal had been pushed too far out in front. The Colonel, Elvis was convinced and told anyone who would listen, was continuing to mess with his music. He became almost obsessive on the subject, carefully comparing the acetate that the record company sent him with his memory of how the song had sounded in the studio and then with the record that was ultimately released, refusing to listen to RCA vice president Harry Jenkins' arguments that nothing had been altered, recordings simply sounded different depending on time, place, even mood, and, of course, equipment.

It had become an almost symbolic argument that required no response, as Elvis focused more and more on differences of vision between his manager and himself, and what had come across for so many years as benign encouragement now sounded more and more like woeful ignorance on the Colonel's part. Colonel's uncritical embrace of his music, his assertion that the fans just wanted to hear Elvis' voice, not all this instrumentation and fancy arrangements, was just one more maddening proof that the old man didn't know what he was talking about. It was the same argument that almost every artist has had with himself at one time or another, and deep down Elvis may well have known that what he was most frustrated by was his own inability to follow through, his own inability to commit to a sustained work process. But the Colonel remained an easy target, and there must have been a sense of panic on Elvis' part as the one thing the Colonel had always stood for, an unwavering instinct for business and its payoff in cold hard cash, was no longer proving effective.

It was little consolation, then, when Colonel told him right around the time of the session that the NBC deal had gone through. From Elvis' point of view this was just another one of the Colonel's schemes. He knew Colonel's mind: all Colonel wanted to get out of it was another fucking Christmas album, and what did he want to stand up and sing a bunch of Christmas carols on national TV for? He felt angry and frustrated, he felt like Colonel was turning him into a joke. The one person he could talk to about his doubts and fears, Sri Daya Mata, had been declared off-limits, and he had been made to feel ashamed of his association with her. If he could have expressed anything of his feelings to his manager — but Colonel didn't want to hear about his feelings, because that would have meant that Colonel had to reveal feelings of his own. Even his father, as close as they were, couldn't fully understand. He was alone.

PRISCILLA GAVE BIRTH to a baby girl at 5:01 P.M. on February I, after nine hours of labor. Elvis paced the waiting room just like any other expectant father, except the waiting room was a doctors' lounge specially set aside for Elvis and his entourage, and he had well over a dozen friends, family, and police security in attendance. Their arrival had been something of a comedy of errors. They had a carefully worked-out plan, with a decoy car to divert reporters, but when it came time to put the plan into action, someone forgot to tell the driver, Jerry Schilling, that they had switched hospitals, and Charlie had to convince him that it was Baptist General, not Methodist, where Priscilla would be having the baby. Elvis, too, was in something of a state of nerves. He was practically beside himself when Priscilla insisted on taking a shower and carefully applying her makeup after her water broke, but then he wasn't ready himself even after she was standing at the door, and he had to be reminded by his grandmother that it was Priscilla, not he, who was having the baby. When the doctor came out and told him he was the father of a girl, he passed out cigars and declared himself to be the happiest man in the world.

The baby was named Lisa Marie. If it had been a boy, the proud parents said, they would have called him John Barron, and while Priscilla denied that there was any particular significance to either name — and there may well not have been — it could not have been lost upon Elvis that the Colonel would take the baby's middle name to be a tribute to his wife. There was no further talk, in any case, of naming the baby Gladys after his mother, as he had told friends over the years that he might and declared to reporter Jim Kingsley that he planned to do in a 1965 interview in the *Commercial Appeal*.

They left the hospital four days later. Elvis was wearing a pale blue suit with a paler blue turtleneck, Priscilla a pink mini-dress, with her hair set in a big bouffant that had required the arrival of a hairdresser before she was ready to leave. There were about a hundred fans and student nurses gathered outside the hospital entrance, with patients and other nurses craning out the windows to get a glimpse of the celebrity couple as they left in a caravan of Cadillacs and Lincolns, Elvis and Charlie and Jerry and Joe and all the rest. "She's a little miracle," he told his dentist, Les Hofman, when Hofman came out to the house a few days later with his wife, Sterling, to visit. During the day, the Hofmans noted, the baby was kept in a crib downstairs between the kitchen and the back den, and Elvis could scarcely leave her alone — he kept picking her up so much that Priscilla finally had to tell him to put her down. But later in their visit, when Elvis started talking about going back to work, maybe even going out on tour, "Priscilla said, 'I'm going with you, wherever you go.' And he said, 'You're not dragging that baby around.' She was eleven days old," Sterling Hofman observed, "and I saw a look right then."

On February 14 he and Priscilla placed a wreath of red roses and another of white carnations on Gladys' grave with a card signed "Elvis-Priscilla-Lisa Marie." He left orders at the office that the card should be burned along with the flowers once the flowers wilted. They had a steady stream of visitors at the house, and Elvis went riding almost every day, spending more time with the fans at the gate than he had in many months. Priscilla's family stayed for three weeks, and he presented her eighteenyear-old brother Donnie with a brand-new Mustang before they left.

He remained at home for most of the month before flying out to California to start the next picture, which would eventually be called Live a Little, Love a Little and was based on Dan Greenburg's well-received comic novel Kiss My Firm but Pliant Lips. Like Stay Away, Joe, it was an attempt to cast Elvis in a somewhat unfamiliar role (he played a successful photographer) and show off his comedic talent, but it was as tired and stale as any of the other recent pictures, and with Norman Taurog directing once again and Michael Hoey, who had written the screenplay for Stay Away, Joe, performing the same function here, it wasn't any funnier. The soundtrack consisted of only four songs, with recording overseen by Billy Strange, the arranger-contractor for the canceled August session. No Nashville musicians were used; in fact, Strange called upon virtually the same lineup of top L.A. studio players that he had booked in August. Not surprisingly, the sound was altogether different from Felton's sessions - with elaborate orchestrations and a score that ranged from sophisticated Sinatra material to Danny Kaye children's songs to Jimmy Webb-influenced folk funk. The results were no more successful (almost all of the songs were wordy and awkward in the extreme), but they did represent a different direction, and Billy Strange brought in a talented young songwriter named Mac Davis, whose work gave promise for the future. Perhaps the only other notable aspect of the picture was that Red, working regularly as a stuntman and actor now both in television and the movies, played a bit part and staged one of his famous fight scenes with Elvis. They still kept their distance ----Red was still hurt about the wedding - but his presence on the set represented a kind of silent acknowledgment on Elvis' part. It was as close to an apology as he could come.

Elvis and Priscilla, meanwhile, were enjoying a newfound domesticity in their hilltop home in Trousdale Estates. Only Charlie and Gee Gee and Patsy lived with them now, and as Charlie described it, the arrangement was idyllic. "Joe and Joanie had their own place. They came by the house a lot. So did the Colonel and his aide, Tom Diskin. The dining room table was one of the Colonel's favorite places. He loved to sit there and puff on a big cigar and tell Elvis stories about his past exploits. . . . It was a happy time for all of us."

Not so happy for Priscilla, though there was no question of who was in charge now. Most of the guys had been banished or had left; even Billy Smith had departed that spring to start a new life with his family in Memphis, and the fans who used to hang out at Perugia and Rocca Place were in some disarray under Priscilla's new rule. One weekend in April they all traveled to Las Vegas to see Tom Jones, who introduced Elvis warmly from the stage even as Elvis carefully studied his act. The following weekend they spent Easter at the new, more "secure" house they were renting in Palm Springs, with an Easter egg hunt on the front lawn (Elvis cheated) and, of course, a visit with Colonel and Mrs. Parker. Everything looked just the way it was supposed to look. But this vision of cheerful domesticity was not anything like the reality that Priscilla knew.

Since the birth of their child, Elvis had refused to make love to her. Not only that, he was making it more and more plain that he was no longer attracted to her physically in any way. "He is still withdrawn," she wrote in her diary. "It's been two months, and he still hasn't touched me. I'm getting concerned." "I embarrassed myself last night," she wrote on April 20. "I wore a black negligee, laid as close to Elvis as I could while he read. I guess it was because I knew what I wanted and was making it obvious. I kissed his hand, then each finger, then his neck and face. But I waited too long. His sleeping pills had taken effect. Another lonely night."

Elvis had told her before they were married that he had never been able to make love to any woman he knew to have had a child — but she had never thought that stricture could apply to her. Now, she wrote, she was beginning to question "my own sexuality as a woman." Her physical and emotional needs were unfulfilled. Not long afterward, in doubt and desperation, she embarked upon an affair with her dance instructor. It was the ultimate act of defiance in the Elvis world, where the men were permitted to do whatever they wanted but the women were always expected to know their place. Some of the guys raised questions with Elvis about all the time Priscilla was spending at the dance studio, but he didn't want to hear about it. It was impossible, he exploded. Why didn't they just leave her alone? She tried to keep it a secret even from her best friend, but Joanie Esposito knew there was definitely something going on. "She was taking so many classes, and then there was an incident at the house when I came over one Sunday afternoon and rang the bell and wasn't invited in. But, you know, I think it was almost an innocent thing that occurred, if you can call it that. She didn't have anyone else. Her family wasn't there. Everyone in the world is telling her how lucky she is, and, you know, it didn't mean a thing. She was very lonely." It was, Priscilla realized, a turning point in her life; it wasn't what she wanted, but it was what she needed. She needed to remind herself that she was still there.

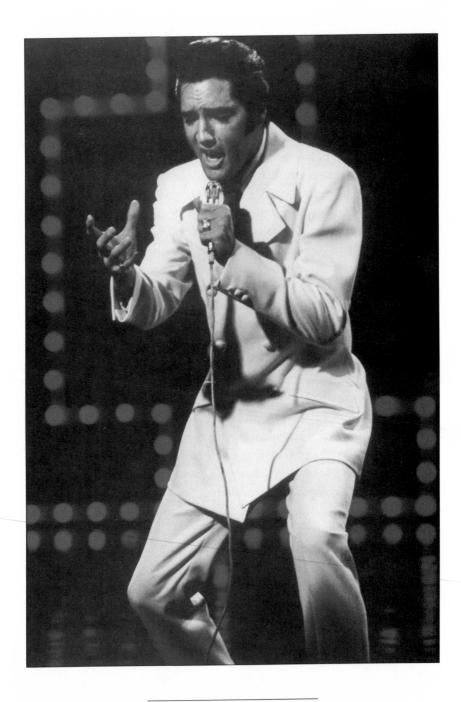

"IF I CAN DREAM," JUNE 30, 1968. (COURTESY OF JOSEPH A. TUNZI, J.A.T. PUBLISHING)

THE BLUEBIRD OF HAPPINESS

LVIS LEFT FOR HAWAII ON May 17, the same day that he met the director and musical director of his upcoming television special for the first time. He had been talking with executive producer Bob Finkel, the man who had put together the package for NBC, for the past week, and gradually his feelings about the show had begun to shift. Finkel, after a series of meetings with the Colonel, had finally persuaded the sponsor (the Singer Sewing Company), the network, and, most important, the Colonel himself, to abandon the original plan of simply presenting an hour of Elvis singing Christmas songs on a bare stage. The Colonel, who Finkel sometimes thought just liked to make them all jump through hoops, was the last to give in, but in the end he conceded the point with relative equanimity: so long as the production remained a one-man show, and the record company was able to get a soundtrack album and Christmas single out of it, he would trust Mr. Finkel to make the creative decisions.

Finkel's talks with Elvis began immediately after his release from *Live a Little, Love a Little* on May 8, coincidentally the same day that the executive producer got all parties to agree on the new format for the show. At first he found Elvis "as most people who dealt with him on this kind of basis found him, very courteous and kind and respectful, as I mentioned to him what I thought we would do." At their initial encounter he got no indication of Elvis' true feelings about the show one way or another, but then, as they continued to meet, Finkel informed the network and Singer, he sensed a real change in Elvis' attitude, to the point where he made the "rather revealing statement . . . that he wants this show to depart completely from the pattern of his motion pictures and from everything else he has done." He even implied to Finkel that he was "not interested in what Colonel Parker has to say about this show; he 'wants everyone to know what he really can do. . . . '" This led Finkel to the question, "Who was I going to get to do it?"

He had had his eye on a young director named Steve Binder for some time now. Barely out of his twenties but already a veteran of close to a decade of television production, Binder had gone to work for Steve Allen after graduating from USC, then directed *Hullabaloo* (NBC's answer to *Shindig*, the highly successful prime-time weekly rock 'n' roll show) and a 1966 Leslie Uggams special, as well as the 1965 theatrical release *The T.A.M.I. Show*, one of the first concert films to be shot with light handheld equipment, which had featured James Brown and the Rolling Stones, among others.

More recently, in association with his new partner, audio engineer Bones Howe, Binder had shot a bright, splashy, "mod" special starring Petula Clark, which had attracted a good deal of controversy when its pretty, blond British star embraced her principal guest, black singer and civil rights activist Harry Belafonte. To Finkel, Steve Binder was right in the thick of things. "I thought this was a guy who knew and understood the new music, so I decided, This is the guy for the job."

Binder was reluctant at first — Elvis didn't mean all that much to him. He was a fan of contemporary music: the Beatles, the Beach Boys, Jimmy Webb. But then when he talked to his partner about it, he discovered that Bones had worked with Elvis at Radio Recorders in 1956 and 1957 and was really excited about the idea: he thought Steve and Elvis would really hit it off. Elvis' approach to recording was very much like Steve's to doing a show, he told his partner — they both relied almost totally on feel. So a meeting with the Colonel was arranged.

That first meeting at MGM struck them both as a little bit like entering Ali Baba's cave. There were posters and flashing marquee signs and promotional material covering every wall of the Colonel's outer office. Everywhere you looked, Bones realized with a start, it said Elvis, "or there's his face or a catalogue or a gold record." Then when you went back through a maze of hallways, you arrived at the Colonel's private office, which consisted of a huge desk covered with papers and memorabilia and surrounded by giant pictures of Elvis, Elvis and the Colonel, the Colonel dressed up in a Snowman's outfit, the Colonel and Lyndon Johnson, the Colonel and Bob Hope. Tom Diskin's desk, much neater and about half the size of the Colonel's, was off to one side, and there was an enormous shipping room in which signs of busy activity could be glimpsed.

The meeting, like so many of Colonel's business get-togethers, was a 7:00 A.M. breakfast conference in his kitchen/"canteen," with its big stove, fully stocked freezer and refrigerator, and long table at the center of the

MAY-JUNE 1968 👁 295

room, at one end of which sat the great man himself in a high, straightbacked chair, looking for all the world, Bones thought, like the Wizard of Oz. "He showed us his memorabilia. He showed us scrapbooks of when he was a dogcatcher in Tampa, Florida." He told them stories, too, the usual assortment of tales about the carnival and his adventures in Hollywood, where — the point of the story always seemed to be — sharp city slickers were continually underestimating the poor old Colonel. Then he got to the point of the meeting. He said, "We're not going to tell you boys what to do creatively, because that's what we hired you for, but if you get out of line, we're going to let you know about it." He told them, "This is going to be the best special on the air, because we won't let it be bad." Then to their amazement he declared, "We don't care what material you submit for the show. If Mr. Presley likes it, Mr. Presley will do it. However, Mr. Presley must be the publisher of the material, or else we must communicate with the publisher, and arrangements must be made." At the end of the meeting he gave them both stuffed animals and a pocket calendar. He was confident that things were going to work out just fine, he said, in that gruff voice with its indeterminate accent, his face grizzled and unshaven but with the suggestion of a twinkle in his eye. "You guys are going to have a milliondollar experience," he told them with conviction, while fully aware that their million-dollar experience was limited to a \$32,050 salary between them.

They emerged from the meeting dazzled and slightly confused. They had done nothing, and yet they had gotten everything — everything, that is, except for financial reward. Still, they never wavered. Steve was totally sold on the project by now, even more so than Bones. There was no question in his mind that this show was going to be culturally significant, and he had only one goal, which had as much to do with Steve Binder as it did with Elvis Presley: "to do something really important."

Elvis met with Binder and Howe that Friday at their offices on Sunset Boulevard. Joe and a couple of the guys waited in the reception room while they talked, and at first Steve didn't think he and Bones were getting through. He was so wound up by now, though, that nothing was going to stop his evangelical pitch. This was a chance to really say something to the world, he declared to Elvis; this was one of those rare opportunities to create something of genuine consequence; this was Elvis' chance to proclaim, through his music, *who he really was*. Bones, quieter, a little older and more reflective in manner than his partner, reminded Elvis of when they had worked together at Radio Recorders in the old days. They talked about the way that Elvis had made records back then — what had most impressed him about Elvis' sessions, Bones said, was that they were not dictated by the clock but by Elvis' own emotional commitment. That was how they would approach the special, Steve jumped back in — forget about the network, forget about the fancy trappings; they wanted to do a show that nobody else in the world could do but Elvis Presley. It would all stem from *his* life, *his* music, *his* experience, Steve said. How did he feel about that?

"Scared to death," Elvis replied, consciously deflecting the tension. Well, they'd have a show sketched out for him by the time he got back from Hawaii, Binder said, laughing. There'd be time for him to make his mind up about it then. For all that any of them knew, it could be the end of Elvis' career — but then again, it just might be the shot in the arm he so clearly needed at this juncture. It was Elvis' turn to laugh now, and they shook hands all around. He left their offices not really sure what he was letting himself in for but convinced that at least it was going to be *different*.

With Elvis gone, Binder and Howe worked furiously to nail down a team and put together a script. They already had writers Chris Bearde and Allan Blye onboard, and they quickly settled on costume designer Bill Belew, orchestrator and arranger Billy Goldenberg, set designer Gene McEvoy, and choreographers Claude Thompson and Jaime Rogers — all but Bearde veterans of either Hullabaloo or the Petula Clark special or both. With Bearde and Blye, Steve roughed out a story line similar in approach to what he had outlined to Elvis, seeking a subtext in the lyrics of songs Elvis had already sung that would tell the story of his musical life. The Colonel for his part continued to fence with Finkel and NBC, erupting at one point when someone at the network came up with the idea of Elvis doing a walk-on during one of NBC's regularly scheduled shows in order to promote the special. Mr. Presley would be happy to do a walk-on, Colonel wrote Tom Sarnoff on May 28, for \$250,000. He knew Colonel Sarnoff would understand his not reducing the established price, the Colonel wrote, since he was sure NBC would not want to diminish in any way the value of its investment. Everything, in other words, was proceeding as normal.

Elvis meanwhile showed Priscilla Hawaii for the first time, took her to the memorial to the U.S.S. *Arizona*, where he proudly pointed out the plaque honoring Colonel Parker and himself, and brought his additional party of seven (Joe and Joanie, Charlie, Lamar and Nora Fike, and Patsy Presley Gambill and her husband, Gee Gee, had all come along on this "family vacation") to a karate championship put on by Ed Parker at the Honolulu International Center. It was the first time he had seen Ed since 1961, and the first time he had been able to attend the competition, which Parker had started in Long Beach in 1964. There was a flurry of introductions, and he spent much of the day talking karate with Ed and instructing Priscilla in some of the finer points of the sport and the particular strengths of each of the competitors, including twenty-five-year-old former champion Mike Stone, like Ed, a native Hawaiian, who had come out of a three-year retirement to compete in the tournament in which he had first won his name.

ELVIS RETURNED FROM HIS HOLIDAY thinner than he had been since he got out of the army, his sideburns longer, and, most significant, in a state of genuinely heightened anticipation about the show. Preproduction started on Monday, June 3, the day after his return. He reported to the Binder-Howe offices a little after 1:00 P.M., and, with the writers present, Steve ran through the approach that they had finally settled upon. At its heart was the Jerry Reed song "Guitar Man," which would be used as a kind of linking theme to tell a story that directly echoed Belgian playwright Maurice Maeterlinck's 1909 theater staple, The Blue Bird. In Maeterlinck's treatment a poor boy sets out to find fame and fortune and travels all over the world, only to discover in the end that happiness - in the form of the bluebird of the title — lies in his own backyard. Bones took a fairly dismissive view of the whole idea ("There was nothing original about it television writers just look for a connection"), and Steve was not altogether convinced they had found the unlocking key, but when they presented it to Elvis for his reaction, to Steve's amazement Elvis simply bought the whole thing. "We told him, 'We don't want you to like it one hundred percent. We want to get your input. What you like. What you don't like.' He said, 'No, I like it all.' And the essence of the show never changed."

Preproduction continued at the Binder-Howe offices for the next couple of weeks, until they were scheduled to move to NBC for full-scale rehearsals. Every day Elvis showed up with at least one or two of the guys, meeting with Steve and Bones and the writers over Pepsi and cigars. He was practically beside himself on June 5, the day that Bobby Kennedy was killed, and could talk of nothing but the conspiracy against the Kennedys and the assassination of Martin Luther King two months earlier. It was all the more terrible that Dr. King should have been killed in Memphis, he said, thereby only confirming everyone's worst feelings about the South. To Steve this was more than just idle talk. "He had read a whole lot of books about the Kennedy assassination, and I just felt a real sense of compassion on his part." That was something that Binder wanted to get into the special. "I wanted to let the world know that here was a guy who was not prejudiced, who was raised in the heart of prejudice, but who was really above all that. Part of the strength that I wanted to bring to the show was [that sense of] compassion, that this was somebody to look up to and admire."

They talked about music, too. Would Elvis sing a new song simply if it said something to him, Binder asked, irrespective of politics or publishing? Absolutely, Elvis replied. Would he have done Jimmy Webb's "MacArthur Park" [a song of vaguely psychedelic, definitely pretentious lyrical obscurity], which had just topped the charts for actor Richard Harris after the Association, whom Bones was producing, turned it down for publishing reasons? Of course, Elvis said, as if nothing like that could ever happen to him. He liked "MacArthur Park," he said, acquiescing to Binder's enthusiasm. He definitely wanted to say something more with his music than a song like "Hound Dog" could express. One day they went out on Sunset and just stood there watching the hippies go by, too stoned to realize they were walking past Elvis Presley, or simply not caring. Steve saw it as a truly humbling experience for Elvis, a kind of "giant step in his psyche," though to Bones it was more like he just got a kick out of the experience. "We were just four guys standing out in front of this building, and after a while we got bored and went back upstairs."

The script rapidly evolved. By June II it was pretty well set, with "Guitar Man" providing the story line, and a concert segment that featured some of Elvis' greatest hits. There was an "informal segment," too, which included scripted conversation with Charlie and one or two of the other guys and brief snatches of some of the most risible movie songs, with Elvis deprecating himself and the movies in a manner that comes across on the printed page as artificial and insincere. In reference to his patented sneer, he says, "I did the entire production of *Jailhouse Rock* on that look alone, baby," and the whole sequence is obviously intended to say, *Now you're finally getting to see the real me, the real Elvis Presley*. The show ends, of course, with the Christmas song that Colonel has insisted on from the start, to be followed by dialogue yet to be written. It was with that dialogue that Binder hoped Elvis would make his "statement," but the Colonel, he knew, remained implacably opposed.

There were meetings with various members of the production team. Elvis conferred with Earl Brown, the chorus arranger, and okayed some preliminary sketches that Bill Belew, the costume designer, submitted for his approval. He loved the black leather suit that Belew had designed for him in soft, flexible material. "The whole thing," Belew said, "was like the Petula Clark special; Steve did not want anything that reeked of 'Hollywood TV.' He wanted it all to have a fresh, new look. I said to Elvis, 'A lot of my themes come from people that I admire,' and when I saw Elvis, immediately 'Napoleonic' came to mind.' I explained to him that the collar standing up would frame his face. I said, 'I don't want any neckties on you, just soft silk shirts and around the neck a scarf.'" Elvis listened, nodded, and agreed to virtually every suggestion that Belew made. The designer was dumbfounded. He had never encountered such a lack of ego in a big star before. The one subject about which they had any disagreement was the gold suit that Belew designed to symbolize success, in homage to the suit the Colonel had had made up for Elvis in 1957. Elvis never explained his opposition but was clearly embarrassed by it, and in the end they worked out the same compromise solution that he had agreed to in the fifties: he would wear the gold jacket with a pair of black tuxedo pants.

Only with the music did there continue to be any sort of problem. Here Steve found himself stymied by two almost entirely unrelated developments. Bones had gotten himself into trouble early on by persisting in asking questions about the soundtrack album. He and Steve had long since given up any hope of making money on the special - they knew there were no residuals, and their small salaries barely covered expenses. But the issue of a soundtrack album had never been contractually addressed; in fact, against all evidence and common sense it had never even been admitted that there would be one, and Bones felt strongly that they should get some kind of override, a producer's royalty on the record when it was inevitably released. "I got as far as Diskin, and then the whole thing blew sky high. We got calls from NBC: 'What are you trying to do, sabotage the show? Elvis Presley doesn't have a record producer.' And so on. At that point Diskin started a tirade at me. He said, 'NBC hired you to do a special, not a record.' I said, '[The Colonel]'s got to be crazy if he doesn't put out a soundtrack album.' He said, 'We're not discussing it.' They said, 'Get Bones out. He's a troublemaker,' and at that point they moved me out."

Steve was forced to accept the situation for the time being and to keep Bones temporarily under wraps. At the same time, he was having no luck getting song arrangements out of Billy Strange, who the Colonel had said from the beginning would be Elvis' personal music director on the show. Without Strange's arrangements, the show's official musical arranger, Billy Goldenberg, could not go to work on the orchestrations, and without the orchestrations, no musical progress whatsoever could be made. Steve had little liking for the situation, and he tried every method he could to coax the work out of Elvis' man, but it seemed like every time he contacted Strange, the man came up with a different excuse. As far as Binder was concerned, Billy Strange was "The Man That Wasn't"; here they were less than two weeks from taping, and at this point he and Strange had scarcely even met.

That left Billy Goldenberg in an almost totally untenable position. A 1957 graduate of Columbia University who had apprenticed under the great Broadway composer Frank Loesser (*Guys and Dolls, How to Succeed in Business Without Really Trying*), Goldenberg had come to the show in the first place with the greatest reluctance, and then only out of loyalty to Steve. He had no interest in Elvis Presley — his personal tastes did not run to that kind of music — but he was persuaded by Binder's enthusiasm and obvious belief in the project. From the time that he had first arrived, though, he had been led to wonder just what his role was supposed to be.

He seemed to have no function in what were loosely deemed "rehearsals." "Every day Elvis would come in and sit around with his group and play guitar. I mean, some of it was very exciting. Elvis loved to improvise and talk about old times and play the songs and keep repeating them — he would get excited just by repetition. So that the intensity of the song seemed to grow as he kept playing it, almost to a climax. He could sing ninety-five choruses of 'Jingle Bells,' and he really wouldn't get sick of it. Then he might try another song on his guitar, and then he might decide he didn't like that song so much, so he'd go back to 'Jingle Bells' for another ninety-five choruses, and the whole group would be whooping and hollering and having a very nice time."

Goldenberg could see the cathartic value of it, but every time he mentioned getting down to work, one of the guys would say, "Billy will do that for us, and in my mind I'm thinking, Well, why am I here?" Then one day Billy Strange actually showed up, accoutered in cowboy hat and boots, and Billy Goldenberg felt all the more alienated. It was obvious to him that Billy Strange had a good rapport with Elvis, but it was just as obvious that he was not capable of providing any form of musical direction. "They just kept fooling around, playing the things that they knew how to do. I knew there was a section where they wanted to have a little improvisational work between Elvis and his guys, to show the relationship that went on with them. Which was all very nice — but it was just one section of the show. I kept looking at the script, and I said, 'Well, that's fine, but we have eighty percent of the show to do. What are we going to do?'" Steve was getting worried, too. He knew, better than anyone else, that they were running out of time. They would be moving into the NBC studio in just a few days, with prerecording scheduled to start on the twentieth and videotaping slated to begin a week later. Freddy had cleared all the songs, Finkel was doing a good job running interference with the Colonel, and Steve continued to have faith in his own improvisational instincts. But he needed to address the music, and he feared that when he finally did, the whole thing could blow up in his face.

Billy Goldenberg, as it turned out, was the one to precipitate the crisis. He came to Steve in the middle of the second and final week of prerehearsals, with his mind made up. "I told Steve, 'This is it. I don't want to be involved. Billy [Strange] is a very nice guy, and probably a wonderful arranger, but he just sits there and I don't see anything happening. I mean, there's no concept. Who's paying attention to what's on the written page?' So Steve said, 'Well, suppose I fire Billy Strange?'"

It was not a decision to be undertaken lightly. Steve had seen what had happened to his partner when he challenged the Colonel's authority, and this seemed like a far more central issue. But, with just a week to go before they went into the recording studio, he didn't see that he had any alternative. If he didn't do something right away, they simply weren't going to have a show. So he spoke to Strange, who seemed to seize on the opportunity to let Binder know he really didn't have time to work on the special with all he still had left to do on the *Live a Little, Love a Little* soundtrack and the new Nancy Sinatra album he had recently begun. And, without being sure of how exactly it had come about (and with at least two of Billy's songs still in the show), Steve recognized that they had arrived at a mutual parting of the ways.

But there was still the matter of telling the Colonel. He had seen the way that Finkel dealt with the Colonel, working constantly to keep him in a good mood, studiously avoiding the creation of even the appearance of any conflict between manager and client. Binder himself was highly cognizant of the delicate balance of power that prevailed and careful "never, ever to show any disrespect of the Colonel in front of Elvis. It was very, very important to the Colonel never to lose control." This time it didn't seem to matter what he said, though. The Colonel's matter-of-fact reaction to the news of Billy Strange's departure was simply that that was the end of it, that Elvis would surely walk out. He didn't say that he would *advise* Elvis to walk out; he seemed merely to be offering a prediction. "Bindel," as he had

come to refer to Binder, would have to take the matter up with Elvis himself, though the Colonel offered very little hope of a successful resolution.

"When Elvis walked in, I took him aside and told him what the problem was, and he just said, 'Fine. Do what you want to do.' And he never looked back." The Colonel never brought up the subject again either, thereby confirming two things to Binder: that Elvis and the Colonel were not one and the same, and that the Colonel, while perhaps incapable of formally conceding a point, in the end would always stay true to his word. Which in this case was that it was their show — unless they really fucked up.

It was at this point, with less than a week to go, that Bones came back into the picture. He and Steve both knew Billy Goldenberg's limitations they were the very qualities that had made Billy beg off in the beginning. He was a Broadway composer, an orchestrator and arranger with "legitimate" theater ambitions — but this show in the end was about rock 'n' roll. Billy would be great for the "Guitar Man" dream sequences and orchestrated set pieces, but when it came to working with a rhythm section, or even to convincing Elvis of the continuity between his past work and the present venture, there was no question that Bones was now the necessary link. He would function as a&r man and musical producer in charge of the whole project, they explained to Billy, who was more than happy to have an ally at last in this slippery new territory.

Billy worked frantically on the music over the weekend, starting work with Elvis on a regular daily basis only on June 17, the day they moved into NBC. He had already encountered resistance from the guys, mostly from Joe as their spokesman. "He would call up and say, 'Well, what are you going to do? What are we expecting here?' I said, 'You know, well, I'm going to work with Elvis.' He said, 'What kind of a band is it going to be?' I said, 'I want an orchestra.' He'd say, 'We don't like orchestras. Elvis works well with guitars. They can do everything.' I said, 'No, they can't do everything, because I have a lot of conceptual stuff to work out here.' He said, 'I don't know if that's gonna do, sonny. You go ahead and hire your orchestra, but if we don't like it, we're just gonna tell all the musicians to go home.'"

Up till now it had been only a minor annoyance — and one that Billy assumed stemmed as much from personal bias as musical issues. At this point, though, there was no time for the distraction of "semithreatening" phone calls; they needed to get the show back on track right away. So he called Finkel and said that he needed to be able to deal with Elvis directly, he didn't appreciate "being called by people and having to worry about whether I'm going to be killed for writing a dominant seventh." Finkel told him not to worry, that he would take care of the problem, and from that point on, Billy worked with Elvis alone. The man that he encountered, though, was very different from the Elvis Presley that he had been led to expect.

The first time that I walked into the studio, Elvis was sitting at the piano playing Beethoven's "Moonlight Sonata." So I think, "What's going on here? This is really interesting." And he says to me, "Oh, do you know this?" I said, "Yes, I know that." He said, "What happens after this?" and played the first part again. So I sat down next to him and played some more of it. He said, "That's great," and picked it up, and we spent the better part of our first rehearsal period learning the first movement of the "Moonlight Sonata"!

I was so surprised. It certainly did break the ice, and it was kind of a harbinger of things to come. But he was such an incredibly quick study. We went through "Guitar Man," and he had little suggestions. Always polite. Always respectful. So incredibly different than all the people around him. He had class. I mean, underneath all that stuff, suddenly I found this person I could relate to. It was fun working with him, because he would get excited about it, he would spark a creative thing — I mean, if I did a particular chord change, he might sing a particular riff or get an idea and say, "Do you think this is something that might work?" I'd say, "Let's play with it a little bit and find out." I was getting into what he was doing, and he was getting into what I was doing — it was a good, quick relationship that we formed and, as I say, a lot of fun.

We would go on night after night, and every night we would do a little bit of the "Moonlight Sonata." One night he was playing it on the piano, and the door opened, and in walked two or three of his guys. Immediately he picked his hands up from the keyboard, as if some strange, dark shadow had come over the place. They came in and said, "What the fuck is that?" He said, "Oh, it's just something we were doing." And they said, "Oh, it's awful," and he didn't make any remark, just picked up his guitar and started playing those old E-major chords again, that's what they wanted to hear, and that was the end of our rehearsal period for the day. I had to call Bob Finkel again and say, "Would you please get them out of here, because I can't do my work?" And he did. But Elvis couldn't wait to continue. Not altogether surprisingly, Charlie Hodge was the one guy to show any musical interest in what Goldenberg and Elvis were working on, but to Billy's great surprise the Colonel showed a considerable degree of personal kindness toward him. "He was always nice to me. He'd say, 'Tell me about yourself. What's your life like? What do you want to do?' He just loved stories, he wanted to hear everything about my background, and he would say, 'Is there anything you want me to do, to make it easier for you?' I mean, in terms of Elvis. He would say, 'My boy likes you a lot.'" Goldenberg had no idea what to make of all this, but he was grateful for it. Binder and Bones and Bob Finkel, too, all noted with relief what seemed like a significant change in the weather: for whatever reason, the Colonel, and Elvis, each no doubt for his own purposes and each in his own way, seemed finally determined to make this special work.

Things ran smoothly for the most part - or, more smoothly anyway — from this point on. Elvis worked hard on his dance steps with Lance LeGault, just learning to hit his marks on the intricately choreographed production sequences. The fittings with Bill Belew went smoothly, too, now that the crisis of the gold lamé suit had passed. Everyone on the show waited for Elvis to show signs of temperament, but he never did, applying himself to the job with the same kind of cheerfully democratic attitude that he had always shown on the movie set. Finkel, however, continued to have his hands full with the Colonel, who was never less than a fulltime job. Early on, Parker had gotten the William Morris agents assigned to him for the show to stand outside his office outfitted as Buckingham Palace guards. Finkel, not to be outdone, retaliated by reinventing himself as Admiral Finkel, requisitioning a Lord Nelson outfit from the costume department and appearing in three-quarter-length breeches and tricornered hat. At the Colonel's insistence they played a game called Honesty, in which the Colonel thought of a number, Finkel put up \$20, then tried to guess the number - and was, predictably enough, almost invariably wrong. Once or twice, just when Finkel figured he would never win, Colonel announced that he had finally guessed right and forked over \$20 with a long face, but over the course of two weeks of rehearsals, the executive producer in charge of Colonel Parker calculated that he must have dropped close to \$600. Finkel, under ordinary circumstances a man of conventional sobriety, sometimes wondered at himself, and at the strange hold the Colonel seemed to exert over him simply by virtue of his unorthodox charm. "I did funny things - he would do things to me, and I would do them back to him. I went to him one day, and I said, 'Colonel, I'm going to

beat you at these things. If I beat you and you admit it, I want your cane. I want to hang it up on my wall.' And he agreed."

The only substantive matter that the Colonel continued to bring up was the theme of the show itself: Elvis would end with a Christmas song. On that point he remained adamant, no matter how Binder tried to get around him on the subject. Steve continued to bring up the idea of Elvis delivering some loosely scripted closing remarks *after* he sang the Christmas song but he was always short-circuited by the Colonel's matter-of-fact, implacable, almost irrational opposition, seemingly, to Elvis' saying anything at all.

That was the only real hitch, though, in the increasingly well calibrated feel of an operation that was finally coming together. Binder believed in his team; he knew what they were capable of. And he believed in himself. Now, at last, he was beginning to believe in Elvis. There was no question that the show had Elvis' full attention by this time — he wasn't simply present, he was there, just like the rest of them, twelve, fourteen, sixteen hours a day. Every night after rehearsals were over, he would unwind in his dressing room, laughing and joking with the guys as he and Charlie sang and played their guitars. One night Steve wandered into what had by now become a familiar scene and suddenly experienced a revelation. This was the way to go. This could be their way to make a statement — with a totally unscripted improv substituting for the stiff, somewhat arch "informal" segment specified in the script. In a burst of enthusiasm he suddenly thought: they could shoot it in the dresing room, cinema verité-style; for a moment he wanted to just throw out all the produced segments — this could become not simply the centerpiece but the whole show.

In the end, reality reasserted itself. After talking with Elvis, he settled on the idea of flying in original guitarist Scotty Moore and drummer D.J. Fontana to make Elvis feel more at home, then doing the best he could to re-create the informal atmosphere of the dressing room in the small boxing ring of a stage that had been designed for the more formal live concert at the heart of the show. Instead of scripting it, the director just ran down some of the topics that he would like Elvis to discuss — the bit about being shot from the waist up on *The Ed Sullivan Show*, the judge in Jacksonville in 1956 who wouldn't let him move around onstage, prompting Elvis to retaliate by crooking his little finger to suggest the banned movements. These things were essential, Steve said, to reestablish the rebel image. And when Elvis expressed concern that he might not be able to tell the stories very well without lines to deliver, Steve was quick to reassure him that all he had to do was wing it; the musicians would cue him, and he could always have a piece of paper nearby with the topic sentence for each anecdote written on it. It would be fine, Steve said soothingly; the moment would supply its own inspiration. And if he ran out of things to say, as a last resort he could always go back to that Jimmy Reed song he and Charlie were always fooling with; its lyrics — with their constant refrain about "Going up, going down, up down, down up, any way you want me" — might supply their own commentary.

Scotty and D.J. flew in on the weekend, five days before filming was scheduled to start. Although they had been told nothing other than that they were there to jam, things quickly fell into place, and before anyone knew it, it was almost like old times, with much of the easy give-and-take of the early days. D.J. offered some of the most uninhibited reminiscences, with Charlie egging him on, while Scotty contributed his own characteristically wry commentary, gently deflating some of the more exaggerated claims but then, with a wink, adding some of his own. One night they went out to Elvis' house for a post-rehearsal dinner and talked about the future. He wanted to do a European tour, Elvis told them. He wanted to record at Scotty's studio, just "woodshedding" like they were doing now. "He asked me if I thought that would be possible, just go in there for about a week and see what we could come up with, like we used to. I said, 'No problem - if you leave about half your guys at home.' He said, 'That's what I'm talking about.' But, of course, it never happened." Both Scotty and D.J. were impressed with Binder, they were excited by his enthusiasm and by what seemed like his total dedication to the task at hand. They worried, though, that maybe they weren't contributing enough - D.J. kept asking him what exactly he wanted them to do. "But he'd just say, 'Don't do nothing, just do what you're doing. That's all I want.'"

Recording, meanwhile, had started up on the evening of the twentieth, as scheduled. They were working over at Western Recorders at 6000 Sunset, and for once all attention was focused on the music. Colonel had given Freddy explicit instructions that once actual recording had begun he was to stay out of it, a prohibition, he declared, that applied to himself as well. "If the Colonel can't stick his nose in, the other people are self-explanatory," he declared, while stipulating that it was Lamar's job to maintain good spirits, a task from which Freddy was pointedly excluded.

The band that Bones had put together was made up of many of the same top L.A. session musicians whom Billy Strange had assembled for both the aborted August and *Live a Little, Love a Little* sessions. "We had to fight the people at NBC — they wanted to keep their costs down and were trying to keep from hiring people outside of their staff orchestra. Steve and I

had some incredible meetings with them — you know, what will Elvis Presley say if he walks in and sees a bunch of old men who don't know anything about rock 'n' roll? We used some of the string players from NBC and some of the brass players, [but] we handpicked the rhythm section is what it boiled down to."

The idea was to prerecord everything except the two live performances (the concert and the informal segment with Scotty and D.J.) that remained at the center of the show. That way they would be able to use a prerecorded instrumental track as the backing for a live vocal wherever possible, but if Elvis appeared in a choreographed segment or was captured in a long shot in which the presence of a microphone might be visually obtrusive, they could simply plug in the vocal track at that point. Bones knew Steve's ability to switch back and forth between live and prerecorded sequences, and he knew exactly how he wanted to record Elvis, whose live vocals in the studio - even if they became "reference" vocals - were the heart of the show. "I gave him a hand mike. I felt that Elvis wasn't going to work within the framework of a contemporary recording artist, who lays down tracks and then overdubs and all of that. My responsibility was to get him to give the best performance that he could. One of the things that I've tried to do in [all the] years that I've been making records is to always consider the artist first. You never want to put the artist in a position where he has to be uncomfortable in order for you to do your job well. If you get a little drums in the vocal mike, I mean that's too bad, it may not be a perfect recording — but it [might] turn out to be a great performance that way."

Billy Goldenberg was practically beside himself with worry over the orchestrations — he had taken so much grief about them already, and he had worked so hard to try to get them to express something that was not immediately obvious, he was now suddenly overcome with an access of doubt about what Elvis' reaction might be. "Quincy Jones had at that time just written the score of *In Cold Blood* — it was very dark, very guttural, it was a mean score. And I thought it was wonderful. And I thought there must be a way of taking that concept and working it into a television show. That's how 'Guitar Man' [the central medley] came about.

"I wanted to tune in to Elvis underneath. I wanted to tune in to the perversity, frankly, that was deep down inside of him, but the only place that he would project it was onstage. I mean, he would sing and do all of the visual stuff that he did, and then after he finished he would laugh at it. But there was no question that he tuned in to the darkness, to the wild, untamed, animalistic things. That was [such] a big part of Elvis; he did not make his statement by being sweet. He was blatantly sexual, and that was something I wanted in the music. And if I could get that, I felt I was getting closer to the raw Elvis. Not the Elvis that came in the room to talk to you, because he was the sweetest person in the world, I mean, he was [the] good son — I think that was a lot of Elvis' problem."

Billy need not have doubted Elvis' reaction. They began with the long, complicated "Guitar Man" medley, which would be interspersed throughout the show and represented Billy's most direct statement of his theme. "First I rehearsed the orchestra alone, and everybody was in the control booth - Elvis, the Colonel, Finkel, the guys, everyone. It was a most frightening night for me. Anyway, we rehearsed it all the way through, and I was really quite happy with it, but as I finished I looked in the control room, and nobody was saying anything, and I thought, Well, they must have hated it. Then Elvis walks out into the studio, says hello to the musicians - we had a pretty large orchestra, violins, cellos, French horns, I think there were around forty or fifty pieces — and he says, 'What are these over here?' I said, 'Those are French horns.' He said, 'Ah, that's real interesting — do you think I can sing with that?' I said, 'Yeah.' He said, 'Well, can I try? Can I sing with the orchestra now?' And the guys came out, and they were kind of talking among themselves, making little negative comments, saying how this would never do. But Elvis is not listening to them. He goes into his little isolation booth, and I start up the orchestra, and he does the entire thing. And it was really dynamite. It was just - thrilling. He started very quietly, and then he built and built until it was just absolutely raucous, and he was bathed in sweat, at the end of this first rehearsal.

"Then the guys, of course, realizing that he liked it, said, 'Oh, that's terrific,' and I saw Steve breathe a sigh of relief, and Bones started to get into some of the musical things with Elvis. But Elvis just kept rehearsing this 'Guitar Man' sequence, and when he got through for the evening, it was like he had just fornicated. I mean, he was on such a high, he was so involved and excited and emotionally charged — I don't remember anything in my life like that, frankly. It was a high point."

It was that very intensity, Elvis' whole emotional involvement in the act of recording, that brought home to Steve all over again how much they needed an ending. To get this kind of passionate commitment out of him and then to end with "I'll Be Home for Christmas" would not only be a mistake, it would be in the nature of an aesthetic crime. It would betray the democratic vision that Steve had come to feel was the essence of the show. "All of a sudden I realized, I've got Elvis Presley, Colonel Parker, Confederate flags, a black choreographer, a Puerto Rican choreographer, and a Jewish director! Everything in the show was integrated — behind the scenes, and in front of the camera Elvis singing along with the Blossoms [the black, female, gospel-drenched backup group that Elvis had insisted upon], the dance sections black and white and — you know — purple. I mean, there was a spirit on that show where you hated to go to sleep because you were so anxious to go back [to work] the next day — we were all one big family."

That was what galled Steve most about the lack of any real conclusion. It was what goaded him to keep casting about for a different way to say those things that he knew Elvis felt but could never fully express — whether because he was not permitted to or because he was temperamentally disinclined. The finale should be a kind of summing up, Steve felt, a declaration of shared idealism. To that end he approached Earl Brown, the vocal arranger, about writing a song. "I took Earl aside, and I said, 'Earl, let me explain something to you. We're under the gun now, and what I need — instead of having him do a monologue at the end, let's do a song where we incorporate what his monologue would say. That was all I contributed: this is what I would like the song to be. So Earl went home and at seven o'clock the next morning he woke me up and said, 'Steve, I think I've got it. I really think I've nailed the song.' So I went into the studio, and Earl played the song for me — it was called 'If I Can Dream' — and I said, 'That's it. You've just written the song that's going to close the show.'

"So now I go to Bob Finkel, and I say, 'Bob, I've got the end of the show.' And he said, 'Do you realize what you're doing? The Colonel will blow his stack. It's got to be a Christmas song.' I said, 'It *can't* be a Christmas song. This is the song Elvis will sing at the end of the show.' I arranged for Elvis, Billy, Bones, and myself to go in the dressing room, and Earl sat down at the piano and played it through. Elvis sort of sat there listening. He didn't comment; he just said, 'Play it again.' So Earl sat there and played it again — and again. Then Elvis started to ask some questions about it, and I would venture to say Earl probably played the song six or seven times in a row. Then Elvis looked at me and said, 'We're doing it.'"

Bob Finkel meanwhile had been fending off the Colonel, Freddy, and the whole network contingent in another room. Everyone had stated their firm opposition to introducing a new element at this point, particularly an untried, untested, un-Christmas song, but when Binder came out of the dressing room with Elvis' wholehearted commitment to it, the Colonel never hesitated to embrace the tactical high ground. Steve had Earl play the song for everyone once again, but "before he had finished, the lead sheet was plucked out of his hand and run down to the publishing firm to make sure they had one-hundred percent of the copyright."

Billy wrote the arrangement overnight, and Elvis recorded it in five takes on Sunday, June 23, the last day of formal recording. Although he is singing to a full orchestral backing, it is the voice that predominates, as much as it would if he were singing unaccompanied, as the Colonel would undoubtedly have preferred. The song is a well-intentioned liberal statement about peace and brotherhood and universal understanding, but it is not the lyrics that command our attention over the gulf of years. It is, rather, the pain and conviction and raw emotion in Elvis' voice as he sings of a world "where all my brothers walk hand in hand" and almost screams out the last line: "Please/let my dream/come true/Right now."

There is no way of neatly summing up the meaning of the moment; it is one of those rare instances where Elvis pays no attention to formal boundaries, as his voice, deliberately roughened throughout the song, teeters perilously on the same dubious note at the conclusion of each finished take. Under any other circumstances, the song might seem no more than a trite, generalized plea for understanding set to a somewhat awkward, hyperdramatic melody, but somehow, whether because of Elvis' conviction or the listener's knowledge of its cost, the words take on worlds of meaning, the melody soars, there is a thrill — along with a wince at that final note — in every listening. As Steve Binder recalled, Elvis asked that the lights be dimmed for the final take, both in the studio and in the control room. "I think he was oblivious to everything else in the universe. When I looked out the window, he was in an almost fetal position, writhing on the cement floor, singing that song. And when he got done, he came in the control room, and we played it maybe fifteen times, he just loved it so much."

With the bulk of recording now complete, Elvis actually moved into his dressing room at NBC for the rest of the week. He was totally keyed up now, on edge in a way he had rarely been since abandoning live performing a decade before. His professionalism continued to be noted by the entire crew, he continued to impress everyone with his unfailing courtesy, politeness, and malleability — but there was something else now, too. For the first time in a long time he didn't bother to hide the fact that he really cared.

There was a press conference on Tuesday night, at which Elvis acquitted himself with his usual aplomb. He was doing the show, he said, because "we figured it was about time. Besides, I figured I'd better do it before I got too old." "We also got a very good deal," the Colonel jumped in. "Besides the special, we're doing one picture, which NBC is producing. I would call that one very good deal." Elvis paid lip service to his ongoing Hollywood career, spoke almost reflexively of his unwavering commitment to someday becoming a serious actor and his constant search for better scripts, and skillfully deflected any serious questions about life, art, or career. "I loved his attitude," said Binder, who had one or two things to say himself about a show that was in his opinion "a matter of video-history significance." "Every time they'd ask a question, he'd have a funny way of tapping me on the leg, as if to say, 'Watch me put the guy on with this one.' And it was fun to watch the press just sitting there. I think he got satisfaction just out of being on top of it. He never, ever had to be protected in that respect."

There was no disguising his jitteriness, though, as they began a complete run-through of the show the following day, and then on the twentyseventh taped the midway sequence before getting ready for the "informal" show that evening. "I know you're nervous, man," he told Alan Fortas, who, with the ranch closed, had come out to the Coast earlier in the spring and had now been drafted to actually *appear* on camera in the informal sequence. "I know you're scared," he repeated, though Alan had little doubt he was really talking about himself.

There was a moment of panic on the producers' part as well. Bob Finkel had left it to the Colonel to give out tickets for the show. "The Colonel said to me, 'I'll take care of it. The demand will be unbelievable.' I said, 'Okay with me.' We start at six o'clock that night, whatever the hell it was, and I look out at four o'clock, and there's nobody there. Nobody. I went to the Colonel, and I said, 'Where the hell are these people that should be lined up all day?' He said, 'I don't know.' I said, 'What did you do with the tickets?' And he gave me some damn-fool answer." No one understood the Colonel's rationale. Evidently he had given out batches of tickets to gate guards and waitresses, along with the usual fan club presidents, and just assumed that the crowds would show. Finkel put it down to grandiose expectations — or perhaps to the one final put-on that he would never be able to top. Binder saw it as more intentional, stemming from the Colonel's simple desire to prove them all wrong. Whatever the reason, the Colonel never let on, he just went ahead and acted as if everything were normal, and in the end he and Finkel rounded up an audience. Which the Colonel then proceeded to arrange so that the most adoring female fans were at the front and the audience could be expected to replicate the kind of response that it had offered in 1956 and 1957.

Elvis told Steve Binder at the last minute that he didn't think he could go on. He'd changed his mind, he said, he had decided that this was not a good idea. What did he mean he'd changed his mind? the shocked director demanded, and even Joe was momentarily taken aback. He had never seen Elvis like this before. He had witnessed normal stage fright, of course, but he had always marked it down to entertainer's ego, to Elvis' simply wanting to be reassured and told that it was all right. Now he was not so sure, but together he and Binder managed to calm Elvis down. There was an *audience* out there, Steve said, he couldn't let down his fans. It didn't really matter what he did, they'd have two full run-throughs, and if they didn't like anything from either show, they could just throw the whole thing out. But what if he froze up? Elvis insisted. What if he couldn't think of anything to say? "Then you go out, sit down, look at everyone, get up, and walk off," Binder said firmly. "But you *are* going out there."

There is little evidence of this sense of panic in the show itself, unless it lies in the kind of awkward self-deprecation ("What do I do now, folks?" are practically Elvis' first words to the audience) that has been an intrinsic part of his charm from the start. He appears calm but shy, modest but secure in his own beauty as the applause washes over him and he finds himself somehow, unexpectedly, at its center. The stage itself is a gaudily accoutered Hollywood version of a boxing ring (a small white square surrounded by a red border instead of ropes); there is barely enough room for the musicians, let alone their instruments, and D.J. sits expectantly, holding a pair of sticks poised not over a drum kit but an upside-down guitar case which Steve has seized upon wholeheartedly in the "improv" spirit of the occasion. There are five chairs arranged in a circle, with Elvis placed to command the attention of each, looking lean, lithe, and a little uncomfortable in his velvety black leather suit; even in repose, he appears ready to spring, with his long legs sprawled out casually in front of him. Almost as if to offset his sinuous charm, the three musicians - Scotty, D.J., and Charlie are all dressed in a kind of burgundy velour, as is Alan Fortas, who looks a little bit like a designer fireplug and whose presence onstage is only meant to reinforce the overall sense of cinema verité that the director is aiming for. Alan has never played an instrument, but Binder from the beginning has viewed Elvis' interaction with the guys as part of the informal, dressingroom atmosphere, so Alan sits uncomfortably with his hands resting on the back of a guitar which will become one more element in this homemade "rhythm band." The only other onstage participant is Lance LeGault, who crouches directly behind Elvis holding a tambourine, while Joe and Lamar

and Gee Gee hover watchfully in suits and ties, just a few feet from Elvis on the steps that lead up to the stage.

The small audience, no more than a couple of hundred, is strangely subdued — they seem more amazed that it is *Elvis* than at anything he might do, even as the object of their attention appears to be experiencing a similar sense of bewilderment, as he fumbles about for something to say, then glances down at the piece of paper with suggested subjects for discussion that sits on the glass tabletop in front of him. "This is supposed to be an informal section of the show," he jokes, "where we faint, or do whatever we want to do, especially me." He then makes a pass at returning to the script but gets no further than a few words about his first record and how "I first started out — in 1912," before pretending to lose the thread, casting his eyes down at the floor, and finally just trailing off, "And if I fall asleep here . . ." There are loud guffaws from the guys, as if to say, We don't really take any of this too seriously either.

And then, all of a sudden, everybody's feet are flying, as Elvis launches into a spirited, if not particularly tuneful, version of that first record, "That's All Right," and with "Heartbreak Hotel" breaks the tension once and for all not with a great performance but by forgetting the words to the song. One can't help but think that this is an instinctive ploy, because whether he actually remembers the words or not, he immediately enlists the audience's sympathy, declares his own vulnerability (while also rising above it), and sets the tone for the rest of the evening, an easygoing note of accidental inspiration. He also attempts to get up from his chair for the first time, a virtual impossibility given the chair's proximity to the edge of the stage and the absence of a guitar strap or boom mike — but that, too, sets a tone, as the audience comes to equate standing up with a kind of freedom, which Elvis struggles for the rest of the evening to achieve. This in turn lends further drama to the limited movement of which he is capable while seated, allowing him to elicit screams from the audience as his legs jackknife out from the chair in a variation on the gyrations for which he has always been known. By the time he begins the next song, the Leiber and Stoller ballad "Love Me," he is clearly in command, singing beautifully for the most part, frowning or pretending to belch when he doesn't, reaching out to the audience, as he always has, by mocking his own pretensions.

At this stage he must have run out of things to say, because, after switching guitars with Scotty, he takes Steve's advice and, for the first of three times in the course of this brief, hour-long set launches into the Jimmy Reed blues "Baby What You Want Me to Do?" "Are we on television?" he asks idly. "No, we're on a train bound for Tulsa," Charlie cackles. And from this point on, everything becomes slightly surreal — or, perhaps, it simply creates its own reality. For the rest of the show, Scotty never takes back his guitar; it is Elvis, who has never even played electric guitar on his own records, who now plays endearingly limited, bluesy, electric lead. The script might just as well be entirely forgotten by now, and yet its spirit is preserved in mockingly sardonic references to the topic suggestions. "It says here, 'Elvis will now talk about his first record and how things started happening after that," he woodenly intones, sharing the joke with the audience, as the guys' raucous response offers assent even before the joke is fully delivered.

It's hard to imagine what the producer and director must have been thinking — unless they were so caught up in the moment that there was no time to think. If they had suggested these ingredients from the outset as the formula for a network special, what would have been the Colonel's, the network's, the industry's response? And yet somehow it works. Elvis' inability to present himself as anything but himself, and the very amateurishness of that presentation; Charlie's wildly inappropriate behavior, the source of so much resentment within the group, and the "boys' night out" nature of his repartee; even the homemade, hit-or-miss quality of the music itself - all are strangely effective here. Each wildly unpredictable element seems only to encourage Elvis to forget himself all the more, encourages him, paradoxically, to find himself. It is 1955 and 1956 all over again, as, without rules, outside of all the normal guidelines of show business, of polite professional and social intercourse, with nothing in fact but a bemused instinct for his own charm, an innate belief in his ability to locate just what his audience is looking for, and a belief in that audience itself, Elvis explores uncharted territory, creates himself as he would like to be.

And then, for a moment, he disappears. He sings "Lawdy, Miss Clawdy" at Scotty's scripted request, repeating the verses over and over until he is, truly, lost in the music. He does charmingly melodic, almost crooning versions of "When My Blue Moon Turns to Gold Again" and "Blue Christmas," then launches into "Trying to Get to You," a number that he recorded at the end of his time at Sun and one which seems always to touch the deepest wellsprings of his emotions. The camera comes in for a tight focus shot as he plays once again with the notion of trying to stand. He is singing harder than he ever did, or ever had to, at the outset of his career, while playing with the audience, teasing it, miming emotion even as he feels it. He continues the process with Smiley Lewis' "One Night," where he does finally manage to stand and promptly pulls the guitar cord out of his amplifier. "I got to do it again, man," he says, and does — suspended between play and reality, unable at this point perhaps to tell the difference.

It seemed at first as if there would be little left for the eight o'clock performance. There was no attempt to turn the house for the second show, and perhaps out of a combination of the audience's familiarity with what was to come and Elvis' own sense of what he had accomplished, the second show was looser, louder, even more informal if possible. Jokes are delivered this time without the necessity of punch lines, lyrics are forgotten without even the artifice of conviction, and lines from the script are read out with even sharper sarcasm. "It's been a long time, jack," Elvis announces, as the guys whoop it up, repeating the lines that *they* have been given — "Aw, take it on home," "Tell it like it is," "Play it dirty" — like a mantra that has become an in-joke.

But then, just as you begin to think there is no way to reclaim the spell, Elvis once again finds what he is looking for at almost exactly the same point that it occurred in the earlier show. It starts, this time, with his rendition of "One Night," continues through a full-bodied version of "Love Me," and climaxes once again with "Trying to Get to You," as for a moment, at the end of the song, Elvis' eyes roll back in his head and he goes to another place, before moving on to a perfectly fine "Lawdy, Miss Clawdy," an explosive version of "Tiger Man" (the Joe Hill Louis blues he tried unsuccessfully to record while still at Sun), and "Memories," the syrupy Mac Davis-Billy Strange ballad that concludes both shows. It is, all in all, an astonishing triumph, even if you do not choose to overlook the panic-stricken start, but it really all comes down to that one moment in which not just self-consciousness, but consciousness itself, is lost, and it is little wonder that a number of those most closely associated with the production speculate that "after he finished singing, he was literally spent." After all, it is not so far from his own articulation in 1956 of what the sensation of being onstage was like for him. "It's like a surge of electricity going through you," he had said back then. "It's almost like making love, but it's even stronger than that.... Sometimes I think my heart is going to explode."

THE "STAND-UP" SHOW two days later was no less of an unmitigated triumph. It was done once again in two more or less identical sets before a live audience, but the idea this time was to present the hits, updated for "today's audience," as Steve felt they ought to be, by the Billy Goldenberg arrangements. Contemporary orchestrations or not, once

again Elvis was wearing the leather suit, and once again he betrayed his nervousness at the outset, reaching for the microphone with a shaking hand before launching into "Heartbreak Hotel." For this show the guitar is used strictly as a prop, and then only for the opening number of the opening set, as Elvis slides to his knees on the next number ("Hound Dog"), and then, perhaps inspired by his recent reacquaintance with Ed Parker, proceeds to strike karate poses throughout the rest of the show. It is a thoroughly masterful performance, as Elvis paces, pants, toys with the audience's affections (he hands out handkerchiefs dabbed with his sweat), whirls, and poses poised and animal-like. The atmosphere is charged, and Elvis himself is like a turbojet waiting to take off - there is no room for cool irony here, even if the songs are occasionally dated, the orchestrations fundamentally silly. By the time he gets to "If I Can Dream," which he will merely lip-synch at this and the second show (he will return the following day to record a live vocal, in different costume, to the backing track), so passionate is his commitment that even his lip-synching is convincing not only for its perfect synchronization, something he never seemed to bother much about in the movies, but for the utter sincerity of his gestures and facial expressions. It is as if he has finally become an actor by putting aside all that he has learned of acting and simply presenting the fire that he feels inside.

The following day, a Sunday, was the last day of taping and the last chance for Steve to get everything he needed before he began the delicate task of assembling the various elements and weaving them together in a rough cut to present to the sponsor, the Colonel, and the network brass later that summer. Bones had no doubt that Steve could pull it off. Despite increasing personal divisions with his partner, he knew of no one better suited to put a show together on the fly, make the right camera selections even as the action was taking place, and then match them up in such a way that they conveyed all the excitement you would get if you were actually present. The sound was going to be a problem, he knew, it was an antiquated, TV studio-board system — but the *feeling* was there. To Bob Finkel, who saw himself as having shepherded a very complex, difficult project to completion, "it was one of the most complete experiences I ever had in the business. There was no temperament, no 'they don't like it, fuck you, and walk out' — the execution of it, the success of it was all just very exciting."

To Steve Binder, on the other hand, it was more like a dream come true: the vision that he had pursued, against all business wisdom and common sense, had actually worked out. "I was looking for a keyhole. I didn't want to stop and go. I didn't want to pat him down for sweat or makeup or anything, just let him go out and do a live concert. I kept saying, 'It's okay to sweat, it's okay to have your hair mussed up.' I really feel in my gut if Elvis had done a clichéd Hollywood Elvis special, everybody in the business would have said the sets were magnificent, but Elvis would have been a laughingstock. But Elvis really socked it to them. And everything that everyone objected to — the sweat, the hair falling down his face — that was the blood and guts of the show, that was what people liked. And if there was anything they didn't like, it was the production numbers."

As for Elvis, Steve and Bones both felt they had witnessed a transformation which they could not imagine him easily setting aside. For Steve, who had studied the video monitors with fierce intentness as he cut the action live for broadcast, there was no question that "all of a sudden you could see the metamorphosis, all of a sudden the confidence started swelling. That was real cinema verité." It was even more evident to Bones when he came back into the dressing room after the second stand-up show. "Bill Belew had to just about cut the suit off him because he had sweated so much, and then Elvis said to whoever was in the room, 'Tell the Colonel I want to talk to him.' The Colonel came in, and he was just high from the experience, and he said, 'I want to tour again. I want to go out and work with a live audience.'" The Colonel, not surprisingly, was not about to discuss the matter in front of a roomful of strangers, but there was little doubt in Bones' mind that Elvis would stick to his new resolution.

Scotty and D.J. had long since gone home. It was the last time they would play with Elvis, and the last time Scotty ever saw him. There was no further talk of woodshedding; no call ever came. Steve and Bones had no further dealings with him either, once the show was finally edited and wrapped at the end of the summer; in fact, their own partnership broke up not long after. Bob Finkel, however, enjoyed his own quiet triumph in the end. When the Colonel returned home to Palm Springs at the conclusion of videotaping, he was astonished to discover the letters that had spelled out E-L-V-I-S on the show assembled in a giant display on his own front lawn. "I had the letters sent down with a generator, and when he got there, they were flashing." The Colonel never hesitated in admitting defeat. "He gave me his cane; I have it on my wall today." But in acknowledging defeat, he was not for a moment giving up the fight. There would be other battles, other contests, other causes to take up not much farther down the line.

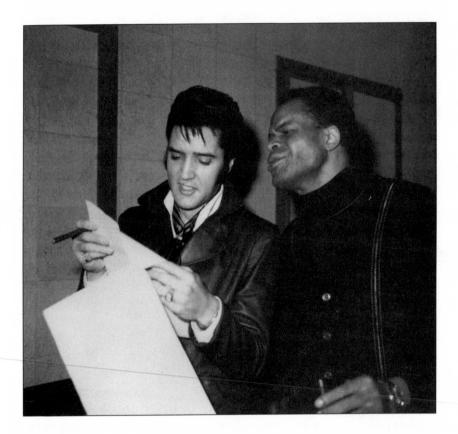

ELVIS WITH ROY HAMILTON, AMERICAN STUDIO, MEMPHIS, JANUARY 1969. (COURTESY OF JOE ESPOSITO)

A DAY AT THE RACES

OCATION shooting for Charro!, the hard-hitting western script for which Elvis had such high hopes, began on July 22 in Apache Junction, Arizona, after two weeks of preproduction. It was an almost immediate disappointment. Elvis arrived on the set, bearded and looking appropriately scruffy, only to discover that the script, not exactly a literary masterpiece to begin with but written in the new, bold manner of a Clint Eastwood "spaghetti western," had been bowdlerized past the point of recognition. The opening scene, which had originally included three ladies of the night not only baring their breasts but pulling their dresses up "beyond their hips, showing their crotches, turning and showing their bare buttocks, and this is routine, and who cares what anybody sees," became instead a standard barroom confrontation, and the writer-director, Charles Marquis Warren, a veteran of Hollywood and creator of such television westerns as Gunsmoke, Rawhide, and The Virginian, turned out to be not only crude in his approach but eccentric in a way that deflected any hope of achieving anything of substance.

By the time that they returned to Hollywood four weeks later, Steve Binder had assembled a rough cut of the special. It ran considerably over the allotted hour, but Steve was very proud of it and wanted Elvis to take a look. A bunch of the guys accompanied him to Binder's office at NBC, and they all watched on a small black-and-white television monitor. Elvis appeared to Jerry Schilling to be extremely nervous, but he said nothing until the others expressed their enthusiastic approval. Even then he remained uncharacteristically restrained, almost as if, Jerry thought, he were afraid to go out on a limb until the public registered its reaction.

The Colonel, who attended a more formal screening with NBC and RCA executives on August 20, was under no such constraint. Where was the Christmas song? he demanded of Tom Sarnoff the next day, in the midst of a detailed written critique of the show. There were too many production numbers, he declared in his two-page memo; the gospel section was too long; there was a poor selection of live cuts; and "Little Egypt," the belly dancer number that took place on the carnival midway, was nothing more than a fanciful indulgence. More than anything else, though, he was incredulous that after all their talks, after all the negotiations that had taken place and all the flexibility that he and Mr. Presley had shown in allowing what was by contract supposed to be a Christmas special to be reduced first to a show with only 50 percent Christmas content, then to a single Christmas song, he should now see a cut that eliminated even that one number. That number had to be put back in the show "or we will all lose a tremendous amount of promotion not only from my company, All Star Shows, but through many other mediums and the following of Presley fans." The bottom line, said the Colonel, was that the special could not be broadcast in its present form. If they wanted to present it as is, he suggested that they put the show on ice until the following summer "and do a complete Christmas show for this fall as per our contract." No one imagined that the Colonel might be bluffing, and "Blue Christmas," a throwaway from the informal section, was immediately substituted for the showstopping "Tiger Man."

There was a month and a half still to go before the next film, tentatively entitled *Chautauqua* and another intended departure, a 1920s-era comedy with a period look, was scheduled to start. Elvis spent much of September in Palm Springs with Priscilla and the baby before returning to Memphis at the end of the month. For the moment he seemed curiously up in the air. Aside from the still-unspecified NBC picture, there were no future film deals in sight, and with the television special yet to air, he was talking more and more about a return to live performing. In an interview the previous month, he had spoken of touring once again. "I'll probably start out here in this country and after that play some concerts abroad, starting in Europe. I want to see some places I've never seen before. I miss the personal contact with audiences." Significantly, the Colonel offered no demurral, except to remind the reporter, "in his best Micawberish voice," that "Elvis is a very generous boy."

Three days after their return to Memphis, on September 28, Dewey Phillips died. He was only forty-two, and Elvis had not seen much of him in recent years. In fact, Dewey had been something of an embarrassment, adopting the habit of calling everyone "Elvis" and insisting that Elvis (the *real* Elvis) would be arriving at any moment to pick him up on whatever corner he happened to be hanging out — or, more pertinently, to pick up the tab. Sometimes he showed up drunk or stoned at the Memphian Theatre, offering loud commentary throughout the movies to Elvis' considerable displeasure; occasionally he would climb over the wall at Graceland and make his way up toward the house until he was intercepted by a guard. His professional life was in disarray; his last stint on the air, in Millington, Tennessee, had ended in disaster three years earlier, as his speed-crazed rap became more and more incomprehensible to the naked ear. But he *was* still Dewey; he was still loved by his friends, who did their best to prop him up (both Elvis and Sam Phillips were among the biggest contributors to the support of Dewey's wife, Dot, and her children); he was still the man who *had first played Elvis Presley on the air*.

"I am awfully hurt and feel very sorry about Dewey's death," Elvis told reporter James Kingsley. "We were very good friends, and I have always appreciated everything he did for me in helping me in my career in the early days." He had been terrified the night that Dewey played his first record on the radio, he said, but Dewey calmed him down. "[He] kept telling me to 'cool it,' it was really happening."

The funeral on October I was held at the same Memphis Funeral Home where Elvis had mourned his mother. He and Priscilla and a few of the guys arrived together, but then he and Priscilla retreated behind the curtain that gave the immediate family privacy. Mrs. Phillips had not been certain he would attend; he had let her know through a friend that "he would not come if the family thought it would cause too much confusion. I didn't know if he was coming or not when they closed the curtains [but] Elvis came to pay his respects. . . . He came over to me and hugged my neck. I introduced him to Dewey's mother, and I told him I was glad he came and that Dewey would have wanted him there. He said, 'Mrs. Dorothy, Dewey was my friend.'"

Sam Phillips and his two sons Knox and Jerry, George Klein, and singer Dickey Lee were all pallbearers. Everyone joined in on "The Old Rugged Cross," one of Dewey's favorites, which he sang at the top of his lungs while shaving every morning. After the ceremony Elvis and the guys recalled some of Dewey's more outrageous exploits. He looked real natural in the coffin, someone remarked with conventional politeness, almost as if he were alive. "Sonofabitch sure looked dead to me," remarked Elvis amid gales of laughter that Dewey probably would have appreciated.

It was a time of death. Elvis' cousin Bobby, Billy Smith's older brother, who hadn't been right in years, took rat poison and died on September 13 while Elvis was still lingering in Palm Springs. Bobby was only twentyseven, and his father, Travis, who had worked the gate for years, was

322 🔊 A DAY AT THE RACES

gravely ill from cirrhosis of the liver, one of the main reasons Billy had quit Elvis the previous year. Just two months earlier, another of Gladys' brothers, Elvis' crazy uncle Johnny, whom no one much liked because he was such a vicious drunk but who, with Vester Presley, had taught Elvis to play guitar as a child, had died at forty-six. He had spent his last few months in the hospital, just wasting away from Bright's disease, a kidney ailment that killed him almost as quickly as liver disease had taken his sister — and at the same age. That really spooked Elvis. It seemed almost like the family was cursed.

The new film, which would eventually be called *The Trouble with Girls*, appeared no less cursed. The producers failed to follow any of the Colonel's suggestions for cashing in on the *Bonnie and Clyde* craze or utilizing some of the great old-time talents that he had wanted to put them in touch with. Instead, they just blundered along on their own, creating neither a believable story nor a believable setting for their star — though he looked good in a white suit that didn't seem to match up particularly with the period and long, black, muttonchop sideburns.

There was little hope now that anything was going to break before the special aired in December. *Speedway*, released in May, had barely made back its negative cost, while *Stay Away*, *Joe*, a March release, and *Live a Little*, *Love a Little*, which came out in October, did even worse. The soundtrack album for *Speedway* had been a disaster, the single release from *Live a Little*, *Love a Little* sold well under two hundred thousand, and the title song from *Stay Away*, *Joe* had not even merited release as an A side. MGM had exhibited no interest whatsoever in writing a new contract with a star they had done business with for over eleven years now, and the Colonel had no interest in entertaining offers from a position of weakness rather than strength.

In many ways it might have seemed to the dispassionate observer that Elvis' career was permanently stalled, that, like every big entertainer in the cycle of pop success, he was ready for the kind of professional afterlife that the Colonel's original client, Gene Austin, or Al Jolson had enjoyed for decades after his time of influence was past. But then "If I Can Dream," the climactic number that Earl Brown had written for the special, was released as a single on November 5, just as the finishing touches were being put on the album, with Elvis approving every last detail. The Colonel, meanwhile, was doing his customary job of building everything around the December 3 air date, orchestrating publicity, radio spots, billboard and trade advertising, even a radio special that would go out to fifteen hundred stations on December 1, to peak around the time of the broadcast.

The single took a little while to build, entering the Top 40 at the end of November and remaining on the charts for thirteen weeks, where it reached number twelve in mid January. This represented Elvis' highest chart position since 1965 and by far his greatest single sales (750,000) since "Crying in the Chapel" that same year. In the meantime the soundtrack album was released about a week before the special was scheduled to air, with a photograph of Elvis in his white Edwardian suit gripping the microphone, eyes closed, singing passionately, against the backdrop of the giant Elvis sign spelled out in red letters that had ended up on the Colonel's lawn.

I think I must have gotten the album the day it came out, and I can remember sitting with it in my hand, gazing at it almost incredulously as I tried to take in whatever information was to be deduced from its graphics (on the back Elvis was pictured both in the black leather suit and in the gold jacket) and from its credits (I couldn't believe that Elvis had actually performed such strong bluesy material as "Lawdy, Miss Clawdy," "Baby What You Want Me to Do?," and "One Night," along with the gospel number "Up Above My Head"). The reason that I stared so hard at the record was that I was determined not to listen to it until the show actually aired, not just because I didn't want to spoil the suspense but because I had gotten a review assignment for the special from the Boston Phoenix, a weekly in which I had been writing about the music I loved for the last couple of years. I had already published one story about Elvis earlier that year, pointing to a renewal of musical commitment on his part on the basis of little more than the three blues-oriented singles that he had put out in a row (my key piece of evidence was "Guitar Man"). I won't bother to apologize for my naivete. Suffice it to say that I was excited about the show.

"It's been a long time, baby," I quoted Elvis to lead off my review, then described how "in the first five minutes he managed to shrug off all the lethargic blandness that has characterized his public stance since his release from the army; he returned instead to the familiar mine of defiance and wounded alienation, his face poured sweat, the voice reclaimed its old wildness . . ." It was like nothing I had ever seen on television before, other than Howlin' Wolf's appearance on *Shindig*, both a revelation *and* a vindication (it was definitely not cool in 1968 to like Elvis, and his resurrection was as unlikely as Wolf's very appearance on national TV). I don't know if I can convey how truly thrilling a moment it really was — and, as much as the

performance may have held up over the years, I'm not sure that it can ever be as thrilling again. In many ways I (and others like me) may well have been Steve Binder's ideal viewers, as we read volumes into every gesture, strained to catch every aside, found justification at last for the hopeless faith that we had placed in the music.

Even amid certain strongly voiced critical reservations (the orchestrated medleys, I wrote, sounded like a reprise from a cheesy Broadway musical, the production numbers were "tasteless"), I could not hide my true feelings — nor would I have wanted to. "His public innocence of adulthood serves to enable us to suspend judgment as we are ourselves suspended," I concluded. "We begrudged him his retreat, and now that he's coming back he'll be subjected to the scrutiny of a new generation and perhaps to harsher judgments. It can't be helped. He may never regain his former success. What mustn't be forgotten is that ten years ago Elvis performed existential acts which helped to liberate an entire generation, and naturally in such terms success can only be incidental."

Not all the reviews were as starry-eyed. The *Hollywood Reporter*, eyeing the informal segments disapprovingly, declared that at times "it looked as though someone had accidentally taped the rehearsal.... For some unfathomable reason Elvis was set on a stage that did not look much larger than a two-by-four, jammed it with a four-piece combo, and fringed it with squealing youngsters. As though this was not enough, Elvis was wrapped in leather from neck to foot and bathed in hot lights, the combination of which was enough to make the perspiration flow like tears..."

Variety, too, took a decidedly mixed view. "He still can't sing. The words still are unintelligible. But that never was very important," Variety's critic opined, "[because] it is Presley's suggestion of simple, unthinking, illiterate sex, his intimation that he isn't going to bug you with hangups because he doesn't even know he has them that gives him his appeal to the inexperienced." "I don't think many viewers care to see singers sweat on TV," sniffed the *Los Angeles Times* reviewer. But Robert Shelton in the *New York Times* wrote a thoughtful review headlined "Rock Star's Explosive Blues Have Vintage Quality." And the ratings told an even better story. It may no longer have been possible to garner the 80-percent audience share that Elvis got when he appeared for the first time on *The Ed Sullivan Show*, but *Singer Presents ELVIS* was the number-one show of the season and, with a 32.0 Nielsen and 42 percent share, gave NBC its biggest overall ratings victory of the year. In addition, the "exploitation campaign" worked out almost exactly as the Colonel had hoped, with a *TV Guide* cover putting Elvis squarely back in the center of things, and numerous well-timed articles (including a separate piece in the *New York Times* that accompanied the review) focusing on his projected return to live performing.

The Colonel meanwhile was working frantically to make sure that this would actually take place. With that same sure instinct for timing that had always served him and his client so well, he had recently been in touch with Alex Shoofey, newly installed executive vice president at Kirk Kerkorian's still-under-construction International Hotel. The International, with 30 stories, 1,512 rooms, and a 2,000-capacity showroom, promised to be the biggest and most splendiferous casino-hotel in Las Vegas when it opened in July, a factor which alone would have recommended it to the Colonel had he not already been well acquainted with Shoofey, a fixture at the Sahara for years. He was also drawn to the independent spirit of the fifty-one-year-old Kerkorian, an eighth-grade dropout and World War II fighter pilot from Fresno who had started a charter service after the war and parlayed that into ownership of an airline (Transamerica) and a casino (the Flamingo, which he had stocked with former employees of the Colonel's pal Milton Prell). Kerkorian was a big-stakes gambler, well known as "a modest man in opulent surroundings," a description that might just as easily have fitted the Colonel himself, to whom the idea of playing the biggest, brashest, and newest casino showroom was the kind of bold maneuver to which he was always drawn. On December 10 he outlined his terms for the engagement to Abe Lastfogel of William Morris, who was conducting the formal negotiations.

He wanted \$500,000 for four weeks, one show per night, two on the weekends, with Monday nights off; if Shoofey preferred two weeks, he would give him that for \$300,000. Also, of course, he wanted the option of recording a soundtrack album plus a television special, with all facilities to be furnished by the hotel.

Nine days later, his offer was accepted with certain modifications that brought it more in line with standard Vegas practice. The International definitely wanted four weeks and would pay the \$500,000 he was asking if Elvis were to open the hotel; otherwise, the salary would be \$400,000, still the kind of money that only headliners like Frank Sinatra and Dean Martin could command. Like every other Las Vegas performer, Elvis would be expected to do two shows a night, but if any other star were to sign a contract requiring less of a commitment within a year of the engagement, the hotel would pay Mr. Presley a penalty of \$50,000. Separate suites would be available for Elvis and the Colonel; the making of an album and/or television special would be accommodated by the hotel; and the International would retain the option for a second engagement, to be exercised by the end of the first. In other words, if the option were to be picked up, Elvis would make approximately the same amount in eight weeks of performing that he would for eight weeks of filming — although, of course, with the cost of hiring a band, along with costumes, promotion, and other incidentals, he would have significant additional expenses.

The Colonel never hesitated, nor did he doubt for a moment that once Vegas saw Elvis, as always *the deal could be improved*. With somewhat uncharacteristic managerial prudence, he chose not to have his act open the showroom (it would be irresponsible, he felt, to have his star performer go into a room in which the bugs had not even begun to be ironed out), but in every other way he fully embraced the challenge. Filling a two-thousandcapacity room in Vegas while Frank Sinatra and Dean Martin were playing twelve-hundred-seaters, bringing Elvis back in triumph to the scene of his solitary failure thirteen years before, staging his return to live performing in a manner that would ensure maximum public exposure on a national stage, was a risk from which he did not flinch. In fact, by the Colonel's standards it was almost a clear-cut imperative, if only because *no one had ever done it before*.

I was at this point, with little input from the Colonel and, seemingly, little forethought of his own, that Elvis took a step almost equally bold. A recording session had been scheduled for early January to record an album and two singles for RCA as a start on the new year's contractual obligations. Sometime after Christmas, Felton came over from Nashville to talk about the session while some of the guys were at the house. Marty Lacker had just started work at American, a little studio in a run-down neighborhood in South Memphis that had produced an unprecedented string of sixty-four chart records over the last eighteen months for a variety of out-of-town labels. George Klein, too, had American connections (the studio's principal owner, Chips Moman, had produced some sides for a small label George had recently started up with a partner). And Red West, who had only just begun to come back into the picture with a Christmas visit to Memphis (he had been working steadily on the Coast in Robert Conrad's TV series *The Wild, Wild West*), had long-standing connections with Chips both as a songwriter and as an occasional recording artist.

Had Elvis ever thought of recording at American? George asked when he sensed Elvis' lack of enthusiasm for returning to Nashville and Felton's lack of any real commitment to it. The Memphis studio had a funky sound, and Chips was a proven hit maker, not to mention the fact that he had some of the best musicians in the world working for him. Best of all, it was convenient — Elvis would scarcely have to leave the house. Marty stressed the musical possibilities — Chips had some great songwriters working for him, and it had become obvious by now that Freddy was either too busy building up his own publishing or could simply no longer deliver hit records. With good material, a studio that practically guaranteed hits, and his own more active participation in the project, Marty argued, maybe making records could go back to being fun and break away from some of the music-business bullshit of Nashville.

Soon everyone was registering his support, even Felton, and in the end, as an informed source described it to *Variety* several months later, "Presley's friends, Marty Lacker [and] George Klein, convinced the singer . . . so subtly that he finally 'came up with the idea himself.'" At this point all that was left to do was to place a call to Chips, who did not hesitate for one moment to postpone an already scheduled Neil Diamond session for something in which he sensed both historic possibilities and a \$25,000 payday. And so a ten-day session was set up at American, with a January 13 scheduled start.

It was the kind of unplanned, uncontrolled, and uncontrollable event that the Colonel had always sought to protect himself against. Neither he nor Freddy trusted Marty Lacker, who they felt was always seeking to advance his own interests — but then, the Colonel didn't much trust Freddy at this point either. And if he was expecting support from Felton, he didn't get it. Felton's allegiance was strictly to Elvis, and after the debacle of the last two Nashville sessions, he was not about to insist upon clinging to previous practice. As far as Felton was concerned, Elvis could use some of Chips' hitmaking magic. Nor was he insecure about his own ability to produce in Memphis, just as long as he could bring his own engineer, Al Pachucki, with him. Felton prided himself on his ability to get along with anyone. Working at American was not going to be a problem, because he wasn't going to let it be a problem. But he was not altogether reckoning on Chips Moman.

* * *

LINCOLN "CHIPS" MOMAN was born in LaGrange, Georgia, in 1936, and gravitated to Memphis at the age of twenty-one, where he was involved in the formation of Stax, the great rhythm and blues record label. A flinty-eyed man of fierce intelligence who seemingly bore a permanent suspicion against the world, he was a student of the art of recording in a way that had never even occurred to Felton — or to Steve Sholes or Chet Atkins, for that matter. To Chips, "making the record itself" was all that he was into. "From the day I went into the Gold Star Studio in California [in 1956] to play a session, I never cared about anything else." Although he was also an accomplished songwriter and guitarist, to Chips getting the sound in the studio surpassed everything else — that and being in control of your recording situation. From Chips' point of view he had been screwed out of his share of Stax just when the record company started to get going, and he was never going to let that happen to him again.

At American he gathered a group of experienced Memphis studio players and formed a rhythm section that included guitarist Reggie Young, a veteran of the Bill Black Combo; the brilliant bass player and producer Tommy Cogbill; Mike Leech, who played bass when Cogbill was producing and wrote arrangements as well; keyboard players Bobby Emmons and Bobby Wood; and drummer Gene Chrisman. These musicians he bound to him with an unquestioning loyalty, some might say with all the mesmerizing influence of Colonel Parker himself. That was how American, which had assumed its present shape not as a label but as a studio-for-hire in 1965 and had been turning out hits ever since, had achieved such cachet. Recording at American had turned out to be something of a talisman of good luck for artists as diverse as Wilson Pickett, Dusty Springfield, Dionne Warwick, and the Box Tops. Which was how everyone around Elvis who had pushed for his selection of the studio hoped it was going to work out for him.

Elvis showed up on the evening of Monday, January 13, with a cold and a bad case of the jitters. None of the swagger that he frequently displayed in public situations was present. Instead, he appeared slightly subdued; despite the presence of his usual retinue he seemed almost alone. "What a funky studio," he remarked self-consciously as he came in the back door, and all his guys laughed uproariously, merely reinforcing a sense of skepticism among the musicians, who, for all their curiosity about Elvis Presley, wondered just what this was going to be about. Glen Spreen, who had recently joined the American staff as a writer and arranger, watched openmouthed as three or four of the guys reached for their cigarette lighters when Elvis pulled out one of his thin little German cigars. "I remember, it ran through my head: Why are these people doing this? That was the first thing. And the second thing that hit me was: Why does he put up with it?"

Nobody was really all that impressed ("I mean we were thrilled about Elvis," said trumpet player Wayne Jackson, "but it wasn't like doing Neil Diamond"). But the talk was all positive. And the songs that had been assembled included a good selection of material, with a tape from Billy Strange's discovery Mac Davis (who had written "Memories" for the special), several promising cuts from Lamar, who was pushing a song called "Kentucky Rain" by a songwriter named Eddie Rabbitt, plus eight or ten numbers that Elvis had been fooling around with at home. Felton's presence offered some measure of reassurance, of course, but facing a roomful of unfamiliar musicians who were probably going out of their way to indicate just how unimpressed they were put Elvis in a strange kind of mood, and when Chips called for the session to start, there was a distinct air of nervous tension in the room.

They began with "Long Black Limousine," working hard at first just to get the sound right, with Chips interacting easily with the musicians and making plain what he wanted to hear. In his communication with Elvis, he seems matter-of-fact, patient, almost subdued given his reputation — but there is no question from the outset as to who is in charge. Chips had been told by certain members of the Elvis camp that he should concern himself strictly with the sound board, that it was not up to him to embarrass Elvis by asking for a re-take or telling him when he was flat — Elvis' ears would tell him *that*, and besides, he went by feel, not by rules. From the start, though, it was obvious that Chips was not taking any of these admonitions very seriously. As Reggie Young observed, "We weren't yes-men, and that upset Felton. But every song we worked on, in our minds, was a potential number one." Or as Chips saw it, "I'm kind of a stubborn fellow. I guess I believe in what I do enough, so I think if a guy's hiring me [to do a job], I believe that's what he's hiring me for."

For an Elvis session the atmosphere was remarkably subdued. Even the guys seem cowed into a kind of grudging silence, and it is only as he really gets into the first song, a melodramatic country morality tale with a chilling ending, that Elvis' confidence starts to grow. By the ninth take he is practically screaming out his indignation at the fate of the small-town girl who, lured by the glamor of city life, returns home in a "fancy car for all the town to see" — except that fancy car turns out to be the long black

limousine of the title, the hearse in her own funeral procession. Rarely has Elvis sung so passionately in the studio, rarely has he revealed himself so nakedly, and if his voice is roughened by his cold, if his singing lacks some of the easygoing grace of some of his finest sides from the early sixties, rarely can he have taken so much satisfaction from the consistent application of effort and craft.

They moved quickly through "This Is the Story," one of Freddy's swellingly romantic European imports, then launched into "Wearin' That Loved On Look," a tough, bluesy number that Lamar had brought to the session. Elvis continued to be embarrassed by his hoarseness and the difficulty he was having controlling his voice, but he gave his all through fifteen arduous takes, sinking his teeth once again into the pure feeling of the song. By now the musicians had actually begun to sit up and take notice. Glen Spreen found that he was impressed despite himself, not so much with Elvis' technique as with his soulfulness, his ability to make a song live - it was almost like going to church. "We didn't have a real vocal booth," said Mike Leech, more an observer than a participant the first few nights, "but we had a baffle that the vocalist would stand behind, with a window in it. And he was back there just like he would be onstage, doing gyrations and the whole thing — because that was just the way he sang. He sang everything like that; he'd have his eyes shut and he was sweating pretty good at the end of each track — he just got into it." No one was too impressed with the whole sycophantic setup, or with Elvis' evident need for it. But they knew by now that at least this was going to be a real session.

LVIS' COLD WORSENED on the second night, but his spirit was, if anything, even stronger. Where they had knocked off at 5:00 A.M. the previous night, this time they went straight through until 8:30, once again cutting only four songs but focusing on them in a way that Elvis had not sustained in the studio since the 1966 gospel session. Unfortunately, the next night he was not able to come in at all, and Chips concentrated on cutting instrumental tracks for several new songs, including Mac Davis' "Don't Cry Daddy" and "Mama Liked the Roses" by American house composer Johnny Christopher, which had drawn an immediate emotional reaction from Elvis when he heard the demo. With those tracks done, the session was postponed until the following Monday, since it was clear that Elvis would need some time to get his voice in shape before they could continue. It might have seemed at this point that not much had been accomplished: eight rough vocals in two nights of recording on songs that for the most part Chips would have deemed not up to standard. But two things had been established. One was that Chips was in charge. More important, Elvis really cared. Despite all the concerns that had been voiced on his behalf, he had obviously taken to Chips' direction not just without objection but with enthusiasm. It was as if, guitarist Reggie Young observed, Elvis had become another member of the band. And once that happened, he could get down to the serious business of recording without any holdback — "I mean, he really worked at it."

They picked up where they had left off when he returned the following Monday, starting off with a number that Elvis had expressed some reservations about to begin with. "In the Ghetto" had come in with the seventeensong tape of Mac Davis songs that Billy Strange had submitted for the session. Elvis had been drawn to Davis' writing ever since Billy first delivered "A Little Less Conversation" for the Live a Little, Love a Little soundtrack the previous year. Since then Elvis had chosen five of the Atlanta-born songwriter's compositions (including "Don't Cry Daddy," which at the moment existed only as an instrumental track), and even the Colonel seemed to sense there was something special about Strange's twenty-sevenyear-old protégé, whom he had met for the first time at the Charrol session. "That first night Colonel Parker said [to me], 'Are you the boy who wrote that "Little Less Conversation"?' I said, 'Yes.' He said, 'You a pretty goodlookin' boy, you're going to be a star.' I said, 'Well, thank you very much.' He said, 'You want the Colonel to rub your head?' I'm looking around, and I'm thinking he's really putting me through the grease, but these guys with him are dead serious, they're all just looking at me. So I bent over, and he put his hand on my head, like Oral Roberts, and he said, 'You're going to be a star. You tell everybody the Colonel touched your head.""

Elvis' reservations about the song had nothing to do with stardom or songwriting talent, however. Rather, it was politics that concerned him, or the mere whiff of politics, in a business that has generally been guided by one cardinal rule: whatever an entertainer's personal feelings or political point of view, it is never worth alienating any substantial portion of your audience that might not agree with you.

Elvis had, it is true, gone against that precept in a general way with the "there must be a better world somewhere" sentiments of "If I Can Dream," but "In the Ghetto" was more in the nature of an explicit "message song,"

detailing the inevitable consequences of ghetto poverty and societal indifference (the song was originally subtitled "The Vicious Circle") and pleading for compassion for black youth. While these sentiments may well appear mild today, and the song's stance was somewhat softened by Davis' craft and the abstract, almost fairy-tale form in which he couched his tale, its subject remained controversial at the time, and even George Klein, a longtime champion of rhythm and blues who prided himself on his liberal views, cautioned Elvis against recording it. But when Chips countered that if that was the case, he thought he would just bring the song to Roosevelt Grier, the ex-football player whom he had recently signed to his own newly formed AGP (American Group Productions) label, George immediately saw the error of his ways and confessed to Elvis that he had made a mistake, that he believed that this was a number-one hit. With Joe's further encouragement, Elvis made up his mind to cut it, and so it became the first number that they tackled, and the only one that they took up, between nine o'clock Monday night and early Tuesday morning.

If you had never heard of Elvis Presley but were simply presented with the twenty-three meticulous takes of the song that he did on that night, it would be virtually impossible not to be won over. The singing is of such unassuming, almost translucent eloquence, it is so quietly confident in its simplicity, so well supported by the kind of elegant, no-frills small-group backing that was the hallmark of the American style - it makes a statement almost impossible to deny. Later, horns and voices would be overdubbed to add a dramatic flourish, but you can hear a kind of tenderness in these early takes that most recalls the Elvis who first entered Sam Phillips' Sun studio, offering equal parts yearning and social compassion. To the musicians, this was the clincher. "He just sang great," said trumpet player Wayne Jackson, an American regular who was observing the session in advance of doing overdubs. "The first time I heard 'In the Ghetto,' I just really felt slimy all over. I thought, 'Oh, my God, this is wonderful. This is it!" As the song develops, subtle adjustments are made, with Elvis quick to acknowledge mistakes and eager to get on with it - and one is provided with an incontrovertible glimpse of what the process might have been like for Elvis, if only he had been able to approach recording consistently as an art. Throughout it all Chips, ordinarily perceived as an abrasive man, is nothing but gently understated and encouraging, playing the session, the session musicians, and the singer as if they were a single finely tuned instrument.

A bridge had clearly been crossed. Tuesday night was devoted mostly to vocal overdubs, to which Elvis applied himself painstakingly, assiduously, and entirely at Chips' direction. On his own initiative he undertook sloppy, good-hearted versions of the Beatles' "Hey Jude" and the 1963 country hit "From a Jack to a King," in which Chips does not appear to have taken much interest and for which he may not even have been present. This was Elvis' time — you sense that he is making music simply for the fun of it, while Chips patiently awaits his next opportunity to contribute.

One of the purely coincidental factors not at all incidental to Elvis' mood was the presence of Roy Hamilton in the American studio that week. The thirty-nine-year-old Hamilton, a Georgia native who had burst upon the rhythm and blues scene some fifteen years earlier out of Jersey City, New Jersey, had been one of Elvis' chief vocal inspirations ever since he had first heard Hamilton's operatic version of the Rodgers and Hammerstein standard, "You'll Never Walk Alone" in 1954. Over the years he had returned again and again to Hamilton's virtuosic inspirational material, both in his listening and in his home singing sessions, and songs like "I Believe" (which he had recorded for his gospel EP in 1957), "Unchained Melody," "Ebb Tide," "Hurt," and "If I Loved You" had long since become part of his private repertoire. Hamilton, a classically trained singer who had started off in the gospel field, contracted tuberculosis in 1956 at the height of his popularity, and though he had resumed his recording career with some success after a two-year hiatus, he had never really been able to recapture his past position. He had only recently signed with Chips' little label, and now he was recording during the day while Elvis recorded at night, looking for the single that might put him back on the charts.

It was George Klein (who had seen Hamilton perform at small Memphis clubs several times over the past few years) who reported to Elvis that Roy was singing better than ever. Elvis could scarcely contain his enthusiasm. He wondered if George would call Chips up and see if it might be okay for them to go to a session. "I said, 'Come on, Elvis,' but he said, 'No, man, people don't like it when you just show up.'" So Klein requested formal permission from Chips, and the two of them went over to the studio, with Elvis at least as excited as he had been when he went to see Jackie Wilson.

He stammered out his admiration to Hamilton during a break, telling him how much the older man's singing had meant to him — and then he was moved to do something that totally floored the musicians who were watching: he offered Hamilton one of his songs. The song was "Angelica," a Barry Mann–Cynthia Weill collaboration that Chips had brought to the session and that represented exactly the kind of new pop direction that Elvis wanted to explore. "Man, he really loved that song," George Klein noted wonderingly, but he never hesitated in offering it to Hamilton, as if all of a sudden he had become someone like Lamar or Freddy, pitching Hamilton on what a great job he could do with the song. It was an unquestionable indicator of Elvis' feelings, certainly, and a source of some bemusement to the musicians, who were unused to such spontaneous displays of generosity and feeling from a star, but, they noted realistically, it may have been a source of considerably less amusement to the songwriters and publishing interests who lost out on an Elvis Presley cut by virtue of that generosity.

Listening to Hamilton's recorded version of the song is instructive and indicates not only that Elvis was right in his instincts as an a&r man but how indebted he was to the other man for his more ambitious "serious" style. Hamilton delivered a stunning, impeccably phrased version of the number, full of the kind of dramatic effects that Elvis was reaching for in songs like "It's Now or Never" and "How Great Thou Art," but offered up with the kind of effortless ease that only a true virtuoso can achieve. It is all the more instructive, then, that Elvis should not have let the sheer talent of his idols — singers like Jackie Wilson, Jake Hess, and Hamilton himself intimidate him but used it instead as a goad to achievement, the achievement of someone who, while he knew he could never match his models in technique, maintained his aspiration to join them solely on the strength of effort, dedication, and whole-hearted commitment to the music.

The following night, the last one scheduled, was the pinnacle of the session. Beginning after midnight, Elvis kicked off with a fervid version of "Without Love," a 1957 hit in the inspirational mode for Clyde McPhatter, yet another of his r&b singing idols, but one with a lighter, more sinuous voice than Hamilton. For the next number he sat down at the piano and launched into an impassioned version of Eddy Arnold's "I'll Hold You in My Heart" even before the four-track safety tape was rolling. It was strictly an off-the-cuff affair, one ragged take in which the band at one point indicates its intention to conclude while Elvis just keeps on going with all the gospel fervor of McPhatter or Hamilton. There was nothing for Chips to do, and he had no interest in contributing to such an amateurish endeavor — but there is something magical about the moment that only the most inspired singing can bring about, as Elvis loses himself in the music, words no longer lend themselves to literal translation, and singer and listener both are left emotionally wrung out by the time the song finally limps to an end. It was almost 4:00 in the morning, and after a quick detour for Bobby Darin's "I'll Be There," another of those numbers, like "From a Jack to a King," that Elvis simply wanted to do, they began work on the one song from the session that Chips would have been willing to bet money would become a hit, not coincidentally a song on which he held the publishing.

"Suspicious Minds" had been released the previous year on the Scepter label by its author, Mark James, Chips' most promising new staff writer. It was a grown-up tale of love and infidelity, expressing complex emotions in the form of a sophisticated soul ballad written in two distinct musical movements. James, who had recently enjoyed a huge songwriting hit with B. J. Thomas' version of his "Hooked on a Feeling," had done a good job on his own composition, and Chips' production was typically tasteful and spare, but the record had not been a hit. In the view of Glen Spreen, who had grown up with James and B. J. Thomas in Houston and had come to American because of his friendship with them, there was a reason: Mark's voice was too pretty, too lacking in rough edges. Elvis, he felt, would be able to add the missing element of passion. Like Chips, he was convinced that the song was a potential monster hit.

Taking exactly the same arrangement, to the point where you might almost confuse Elvis' backing track with the original, Chips once again brought enormous powers of concentration to the task, as we hear indications that Elvis is by now definitely feeling at home. "See see fuck you rider," he declares at one point when he messes up, and there are a number of "Goddamnit's," and even a karate routine scattered among the various takes. Even so, his own concentration never wavers, and his singing achieves the same remarkable mixture of tenderness and poise that it did on "In the Ghetto," with one significant element added — an expressive quality somewhere between stoicism (at suspected infidelity) and anguish (over impending loss). Everyone in the studio *knew* that this was the song. An atmosphere of excitement and anticipation runs all the way through its recording, and after getting a master in just four full takes, everyone said their good-byes at 7:00 that morning, confident that the job had been done.

The *Memphis Commercial Appeal* ran an interview in the paper later that day. After first describing how unusual this session really had been, reporter James Kingsley next quoted Chips, not ordinarily a man given to public encomiums, on the subject of "one of the hardest-working artists I have ever been associated with. What energy and enthusiasm he has while working." Elvis, far more accustomed to the limelight, turned to his producer and said with disarming plaintiveness, "We have some hits, don't we, Chips?" "Maybe some of your biggest," Chips replied without the least bit of hesitation.

I T WAS ONLY AFTER ELVIS AND PRISCILLA took off for Aspen with the gang for a brief ski and snowmobile vacation that the business issues raised with the recording of "Suspicious Minds" fully surfaced. Freddy had tried to get a piece of the publishing from the first, and when he became insistent on the point, Chips had suggested that he take his \$25,000 (the amount that RCA had paid to rent the studio) and stick it up his ass; if that was the way the record company felt about it, they could just forget about the session and they could forget about cutting the song. The dispute raged on for some time, with Tom Diskin backing up Freddy and no end in sight until RCA representative Harry Jenkins came down on Chips' side and they could finally get on with the actual recording. The debate for the most part was kept away from Elvis — or, it might be argued, Elvis kept away from it. But the bitterness lingered long after Elvis had left the studio, as threats were made, accusations and counteraccusations exchanged, and it was strongly hinted that "Mama Liked the Roses," the song by Johnny Christopher that Elvis had liked so much and another of Chips' copyrights, would not appear on the album if Chips was not willing to give up at least part of the publishing.

And yet even as this was going on, a follow-up session was being planned. Whatever twists and turns business might take, there was no one who failed to recognize what an extraordinary musical experience the past two weeks had been and how significant the seventeen sides they already had might prove commercially as well as artistically. Elvis' enthusiasm remained undiminished, and clearly it was in everyone's interests to continue. So Chips kept his publishing, and arrangements were made to resume recording at American in three and one-half weeks, though all the suspicions that Chips and the Elvis camp (Freddy, RCA, and the Colonel) had had of each other from the beginning were now multiplied a thousandfold, and Felton was left uncomfortably in the middle.

Elvis showed up at the studio on February 17 for six more days of

recording, which would yield another thirteen sides. Many of the songs that he recorded represented high points comparable to anything he had achieved during the first session, from "Stranger in My Own Home Town," the Percy Mayfield blues, a longtime favorite, to Della Reese's r&b version of Eddy Arnold's "After Loving You," which he had been fooling around with at home for years. With the environment familiar and the experience of proving himself already under his belt, Elvis showed all the easy confidence that he was used to displaying in Nashville, and his occasionally swaggering manner was in marked contrast to the insecurity of his first few days in the studio. The highlights of the session, though, were a trio of contemporary ballads conveying naked vulnerability. Eddie Rabbitt's "Kentucky Rain" was a song that Lamar believed in more strongly than anything he had brought to Elvis to date; "Any Day Now," Chuck Jackson's lyrical 1962 r&b hit, was a paean to male apprehensions ("Any day now I'll be on my own"); and Jerry Butler's "Only the Strong Survive," released so recently it had yet to even enter the charts, was an instant soul classic, almost tailor-made for Elvis, couched as it was in a mother's advice to her son. "Boy," the grown-up narrator recalls his mother saying to him, "I see you settin' out there all alone:

> Cryin' your eyes out 'Cause the woman that you love is gone Oh, there's gonna be, there's gonna be A whole lot of trouble in your life So listen to me, get up off of your knees 'Cause only the strong survive.

You cannot mistake the personal resonance that Elvis finds in the song, and along with "In the Ghetto" and "Suspicious Minds" it represents perhaps the most finely crafted achievement of the American sessions, announcing the birth of a new hybrid style, a cross between "Old Shep" and contemporary soul, in which Elvis can fully believe. Chips is never any-thing less than fully involved in the recording process, and neither his nor Elvis' attention wavers through twenty-nine bearing-down takes. Even Freddy Bienstock, who could scarcely have been heartened by the increasing diminution of his role (these were not songs *he* had brought to the session), was unable to restrain his enthusiasm. After the session was over, he happened to run into Bob Dylan on his flight back to New York. All he could

talk about to Dylan, who had just completed the recording of his own country album, *Nashville Skyline*, was the magnificent job that Elvis had done on "Only the Strong Survive."

With Elvis' participation completed on February 22, Mike Leech and Glen Spreen began work on the arrangements for string and horn overdubs, which were to begin a month later. "In the Ghetto" had already been selected as the first single, with an April release date planned, and a track listing was mapped out for the album that would follow shortly thereafter. The approach to arrangements was as innovative in intent as every other aspect of the sessions. "I wanted to give Elvis a different image," said Glen Spreen, articulating the philosophy that guided both Mike Leech and him. "I wanted to use the violas to play the same lines as the French horns so they could blend together as a color and then be complemented by the strings. I used syncopation with the strings — they're bowing — and I used a lot of cellos down deep and dark, especially on 'In the Ghetto,' because I wanted to bring out the darkness, the passion, as opposed to the force. I wanted to give [the voicings] some realism, because I thought Elvis had a very real, very soulful voice, and [I wanted to] pay attention to the *feeling* in that voice."

Not every arrangement worked as it was meant to, as Spreen and Leech would have been the first to admit, and the now almost open political warfare between Felton and Chips led to a number of unfortunate compromises, as Felton sought desperately to regain control, and, perhaps more important, credit, for a project he had supported from the first. Even so, Chips continued to have substantial input; whatever the political situation, and however irked he may have felt at this point at everyone else, there was no way he was going to walk away from this project until it was finished. Even the Colonel seemed to recognize the remarkable nature of the achievement, if only by his continued absence from the proceedings. He was proud of his boy, he was proud of the way Elvis had thrown himself into the recording sessions, just like he had into the television special — if Elvis simply took the same approach to Las Vegas, there was nothing that could stop them now.

Elvis meanwhile was fulfilling the last of his movie commitments, *Change of Habit*, a fanciful tale in which he played an idealistic doctor saving ghetto kids with the aid of nuns in civilian disguise, headed by Mary Tyler Moore. He gave it his best shot, working with thirty-six-year-old director Billy Graham, a graduate of *Omnibus*, the best known of televi-

JULY 1968-AUGUST 1969 👁 339

sion's classic experiments with culture prior to the advent of educational TV, and Sanford Meisner's well-known Neighborhood Playhouse, an alternative Method workshop for actors. Graham developed improvisational exercises in preproduction and worked with Elvis on different approaches to character motivation, discovering his star to be an apt pupil when his interest was engaged. "We'd do scenes where he would find out that one of his guys had fucked his wife or girlfriend, and some amazing things would come out. We'd always try to think of outrageous subject matter to make the improvisation more heated, more animated — he was good at that."

Graham stressed what he had learned from Sandy Meisner, that acting was reacting, and "Elvis liked that. I would say to him, 'It's not about figuring out how you're going to read your next line while the other guy is talking — but listen to what the other guy is saying, and that will dictate how the next line is going to come out.' Certain things he could do quite well. He could do humor. He could do a fight scene. But his line readings — a lot of them would be very conventional." Unfortunately, the shooting schedule was tight, and the score was uninspired, despite the presence of Billy Goldenberg, who found Elvis almost listless in his approach compared to the no-holds-barred engagement of the special — a difference that Goldenberg put down to an on-set affair, though it's hard to say what was different about this on-set affair from the one he had had while making the special.

Meanwhile, Las Vegas was rapidly approaching. On February 26, four days after the completion of the second Memphis session, Elvis flew out to officially "sign" the contract (which had not yet been fully worked out) on the roughed-in stage of the International construction site. Barbra Streisand would open the room in July, the International's publicity release announced, with Elvis following her into what was "being heralded as the world's largest showroom." On April 15, with no cameras present, he signed the actual agreement, and three hundred thousand copies of "In the Ghetto" were shipped by RCA, the picture sleeve blazoned with COMING SOON! FROM ELVIS IN MEMPHIS LP ALBUM (the Colonel would make sure that the next three hundred thousand changed the message to urge fans to "ASK FOR" the album). Two weeks after the ship date, the single hit the charts and stayed there for thirteen weeks, reaching number three on June 14 and giving Elvis not only his first Top 10 hit but his first gold record since the spring of 1965. More than that, it was clearly an impact hit, not just a fluke, following up not only on the sales success of "If I Can Dream" but the new direction that the previous single had announced.

The trades certainly took notice, with a *Variety* headline declaring, "'In the Ghetto,' Presley's 1st Protest Song, Stirs Singer's Younger Fans." On a less happy note, the success of the single led for the first time to an official declaration of hostilities between the Felton Jarvis camp and the Chips Moman camp, resolved only by the entrance of Colonel Parker, who was his own camp. For the first two weeks that the single was on the charts, *Billboard* listed Felton as producer; then, evidently at the instigation of Marty Lacker, the credit was assigned to Chips. Finally on the fourth week, the Colonel put his foot down. Elvis Presley records traditionally listed no producer, because Mr. Presley was his own producer. The record was simply to be listed without a producer's credit, like all other Elvis Presley records, and that was the end of it.

Nothing could dampen Elvis' spirits at this point, however. After finishing the movie, he returned to Hawaii at the beginning of May, and even the sale of the Circle G on May 20 for \$440,100 came more as a relief than anything else. Back home in Memphis, he was down at the gates with the fans almost every night, seemingly driven to reaffirm his roots on the eve of his return to live performing. Both the *Press-Scimitar* and *Commercial Appeal* took note of this marked change in both routine and attitude, as he frequently appeared on his horse Rising Sun, signing autographs and posing for pictures on the big stump just inside the gate, and sometimes even teasing the fans by singing a line or two from one of his songs. When he was asked how it felt to be home, he responded, "Great, man, I really love it, great," confiding to his uncle Vester that he needed to get used to the crowds again.

He was clearly worried and excited about the Vegas opening. He voiced his concern to the guys about whether the people would remember him, would they accept him, was it going to be like the old days? And he talked endlessly with Charlie about the ambitious program he had in mind, about how he saw this as an opportunity to showcase all the different kinds of music that had meant so much to him in his life.

H E SPOKE TO VIRTUALLY EVERY MUSICIAN of his acquaintance about accompanying him to Las Vegas during this time. He was in touch with Scotty and D.J., the Jordanaires, the Nashville session musicians,

some of the California players, and Chips' rhythm section, among others. In the end, though, he settled on a group he had never worked with before, led by a musician he had long admired but never met. With time fast running out and rehearsals scheduled to start in mid July, he called guitarist James Burton toward the end of June. Burton, a Shreveport native, who had joined Ricky Nelson in 1957 at the age of eighteen after first laying down the unmistakable lead on fellow Shreveporter Dale Hawkins' classic "Suzie Q," had been an L.A. studio stalwart since the early sixties. He was an extraordinarily versatile player who had worked with everyone from Merle Haggard to Frank Sinatra and even overdubbed several Elvis Presley movie tracks. It was Burton whose distinctive "chickenpickin" style had anchored the band on the popular Shindig television series, and he had not worked a club date in years when the phone rang one day at his Toluca Lake home. "I was getting dressed to do a recording session, and my wife answered the phone, and she said, 'You have a call from a Joe Esposito.' Well, the name didn't ring a bell, so I said, 'Take a message,' but she said, 'Well, it seems important,' so I took the call. Joe said, 'James, it's very nice to talk to you, but I have someone here who wants to speak with you, and I'll get back in touch later.' Then Elvis got on the phone, and we talked for two hours."

They talked about everything under the sun. After a while, it seemed almost beside the point that they had never met, with all the experiences that they had shared and all the acquaintances that they had in common. Elvis expressed his long-standing admiration for Burton's work, and then he asked the guitarist if he could put together a band for him. What he was looking for, he said, were musicians who could play "any type of music," the kind of player who, like Burton, was good at what he did and knew it. He told James that he used to watch him every week on the *Ozzie and Harriet* show because he was such a fan. Although Burton was not ordinarily much of a conversationalist, they seemed to really hit it off, and in the end James said, somewhat to his own surprise, that he would do it.

He set up auditions for Elvis' return to California in just a few weeks. The first player that he called, pianist Glen D. Hardin, a fellow Shindog, demurred, so Burton got Larry Muhoberac, a Memphian who had moved to L.A. in 1965 and had led the band that shared the bill with Elvis at his 1961 Memphis charity concert. He was also turned down by drummer Richie Frost, a fellow alumnus of the Ricky Nelson band, who simply didn't want the aggravation of a live gig. Jerry Scheff, a virtuoso bass player with whom James had recently worked on an album project, wasn't interested initially either but agreed to come to the audition at a little rehearsal studio on Franklin and Vine. "I told my wife — you know, I was sort of laughing — I said, 'I'll go down and check it out, but I'm not gonna do it.' I really wasn't into Elvis; mainly what I had played at that time was rhythm and blues and jazz. But I went down to the rehearsal, and I came home that night and told my wife, 'You gotta come down there and check this guy out!' She said, 'Ah, come on,' and I said, 'No, really, you've got to hear this guy,' and I didn't say anything else. But the next day he just blew her away. Blew us both away."

What had so overwhelmed Jerry, a red-headed "hippie" with alternative ideas and a taste for the alternative lifestyle, was the depth of Elvis' commitment to the music, the passion that he put into what was only supposed to be a band audition. Elvis, Scheff discovered, far from sitting back and passing judgment on the musicians' abilities, had actually come to do a show. "It was like it was just the band and him. He'd do what you'd like to do, all the songs he knew you'd have fun playing. He would entertain you; he knew what musicians liked to play. I just kind of played what I thought should be there and he liked it — even though I swear I didn't know what I was doing. Then some ladies came in, and we were sitting around, and he switched gears and started entertaining them. It was just that whoever happened to be there he would just entertain. He loved to sing for people, *he loved to knock people out.*"

The session to which Jerry took his skeptical wife the next day was the last in the series of rehearsal-auditions. Burton had gotten an okay from Elvis on rhythm guitarist John Wilkinson, a personable young folksinger signed to RCA whom James wanted to help out, so all that was left was the drum slot, which Burton assumed would be filled by Gene Pello, a seasoned session player. But Larry Muhoberac had told James about a young drummer with whom he had worked in Dallas named Ronnie Tutt, just now moving his wife and family to L.A. Tutt, Muhoberac thought, would be perfect for the job, and Ronnie proved him right when he finally got his chance. "I was the last drummer Elvis heard, and it was between me and one other drummer, who was doing all the Motown sessions. He was really good, and I could see that the rest of the band was really into his playing. But I just went up there and focused on Elvis. I really think I got the job because Elvis and I had such great eye communication onstage. He said that I didn't just do my own thing when I auditioned; I watched him. And you really had to, because it was like playing for a glorified stripper. With all

the moves he made, you had to play according to what he was doing." Ten bars into the first song, Jerry Scheff said, everyone knew. And with that the band was complete.

There was a gap of just one or two days before formal rehearsals were scheduled to begin. In the meantime the salary structure was established, with Burton as leader getting \$2,500 a week, and the other musicians \$1,000 to \$1,200, apart from Wilkinson, who got \$600. Two vocal groups had already been hired without auditions, strictly on the basis of Elvis' gut instinct. The Imperials, with whom he had worked on his 1966 gospel session and whose records he had continued to admire over the years, were a natural, even if Jake Hess was no longer with the group and the rest of the personnel was somewhat changed. The Sweet Inspirations, on the other hand, he had never met or seen perform, but he loved the sound of "Sweet Inspiration," their aptly named 1967 soul hit, and he was familiar with their spectacular backup work for Aretha Franklin. Most important, he felt that their black gospel harmonies, in combination with the Imperials' white quartet sound, would only add to the range of music — the full spectrum of American music that he wanted to present onstage. The Imperials would get \$3,750 a week, the Sweets, who were contracted to open the show and as a result got their rooms comped, were to be paid \$3,500. So with rehearsal costs figured in and payments to Bobby Morris, the orchestra leader at the International, who would provide arrangements on about half the songs in the act, total payroll came to roughly \$80,000 for the four-week engagement, an extravagance that must have galled the Colonel but to which Elvis would brook no opposition. All he was interested in was the show.

Toward that end he was having costume fittings with Bill Belew, who had created the black leather suit and "mod rebel" look for the television special. For this show Belew came up with variations on a karate theme, a two-piece ghi-styled "Cossack" suit, with brightly colored macrame belts and the high-collared Edwardian look of the special. "We taught him how to tie the belts so the cords would hang out and they would whip around. We made him seven suits, too, though from what I understand he [hardly ever] wore any of them onstage. But there were five or six of these black, white, [and dark blue] Cossack outfits; I'd take the sketches up to show him, or we'd make one just to see how it looked, and he'd just say yes or no. Once he felt confidence [in you], that was it; he'd never question [you] again." The only problem that Belew ran into came later, when Vernon questioned his bills (which came to more than \$11,000), but Elvis took care of that, too. Unlike his father, Belew felt, Elvis knew the value of show.

Rehearsals started on the eighteenth and continued for the next five days at RCA's Hollywood Boulevard studios. Like the auditions, the rehearsals were eye-opening for the five musician-participants, because each turned out to be a performance in itself. Everything, according to James Burton, the model of a well-organized studio player, was spontaneous. "We probably learned — right off the bat, we probably learned a hundred and fifty songs." With John Wilkinson, the one nonsession player in the group, Elvis was patient and instructive, showing him what he wanted but never showing him up. Wilkinson couldn't get the rhythm part to "It's Now or Never" right. "It's relatively simple, but I couldn't get it the way he wanted it. I was in a corner going through it and trying to get it the way James had showed me, trying to get it down [and] Elvis came over. I was singing the thing softly . . . and all of a sudden he's singing with me in harmony. When we got to the end, I said, 'Is that the way you want it?' He said, 'That couldn't be better.'"

Charlie was a constant presence, encouraging Elvis, propping him up in his enthusiasms, keeping track of the songs, laughing uproariously at Elvis' jokes. The program that Elvis started out with opened with "Memphis," the great "lost" single that Johnny Rivers had appropriated, and included both "Green, Green Grass of Home" and "Reconsider Baby," the blues that Elvis had recorded at his homecoming session. By the end of the week, all of these were gone, replaced in some cases by more contemporary material, in others by more predictable selections. There was much talk about pacing, and Charlie drew upon his own experience in show business to make suggestions for what would amount to the first hour-long set of Elvis' career. With Elvis' analytical mind and his natural flair for dramatics, Charlie felt, there was no way he could miss; the grandiosity of his ambition only raised the stakes. Everything that he had ever admired in music, he told Charlie, "he now had onstage with him. Every type of music that he enjoyed was now in his show. The front men did country or rock 'n' roll, there was the gospel sound with the quartet and the soul sound with the Sweet Inspirations, and together you had a beautiful choir. Then a big band sound [from the showroom orchestra] with things that swung and dramatic things that had a symphonic sound." To Charlie there was no limit to what Elvis was likely to accomplish.

They continued the rehearsals in Vegas, starting on the twenty-fourth.

Felton flew in to help supervise, just four days after his marriage to Chet Atkins' secretary, Mary Lynch. Barbra Streisand was still in the showroom, so run-throughs were conducted in either a rehearsal room or one of the ballrooms and for the first time included the two backup groups, who had never met.

The Sweet Inspirations went into the experience with a good deal of trepidation. For one thing they were not particularly fans of Elvis Presley. "I didn't know that much about Elvis," said Myrna Smith, the vivacious twenty-eight-year-old spokeswoman and de facto business manager for the group, "because that wasn't the kind of music that was played in my neighborhood." They were just sitting there when Elvis walked in for the first time. "He had on a chocolate-colored suit and a tan and looked absolutely gorgeous and walked over to us and introduced himself — like we didn't know who he was! Then he started singing our record, and we just chimed right in and fell in love with him like that.

"Rehearsals always were great. He went through the whole thing, just as though he were onstage, stopping only on occasion for something he didn't like or something he thought he needed to add. He just let us experiment. Sometimes, coming from the background that we did, which was kind of a gospel-soul thing, we would add something that would conflict with his music, and he would just say, 'I don't think I want you to sing that.' He always did it very diplomatically, but he knew exactly what he wanted to hear, and he added our group because he wanted the spice of soul, but he didn't want it to be overbearing."

Probably the thing that was most difficult for them was that their voices never blended very well with the Imperials. The white quartet, Myrna felt, "sang very straight, and we'd show them little things, but most of the time with our vibrato and their straight [singing] it would rub a little — I could hear that on the recordings." But, as Myrna came quickly to realize, that wasn't really the point. "The thing that made it so different was Elvis' presence — he just put so much into it, even at rehearsal you just had to look at him. It was very exciting. I've worked with Tom Jones, Aretha, some very heavyweight people, but his was the most exciting show I've ever worked in, [because] Elvis loved so much to sing and perform. I mean, Aretha could sing rings around Elvis if you're talking about vocal prowess, but as far as wanting to be on that stage, I mean, you just got drawn into it."

The Imperials had their own problems, but they, too, got swept up in the excitement. They had had real reservations about going into Las Vegas to begin with — as a gospel group, it wasn't where they wanted to be, and they worried about the effect it might have on longtime fans, but in the end they determined it was just too good an opportunity to pass up. They had no idea what to charge either and ultimately came to feel that they had shortchanged themselves. But they were won over by the same elements that had impressed the Sweets, and the rhythm section, too, for that matter — the sheer, irrepressible feeling that Elvis put into every song.

For the last two days, there were full rehearsals with the orchestra, which up till then had been working out the charts on its own under the direction of Bobby Morris. Glen Spreen had shipped in arrangements for some of the new songs from Memphis, but mostly they worked off the records, adding the kind of minimal flourishes and fanfares that the Dorsey brothers and New Frontier bands had interjected in 1956. Elvis was as keyed up for the opening as he had been for the television special, alternating between moods of manic excitement and utter, and abject, fear. During the week he visited a number of shows on the Strip, studying closely both the act and the audience's reaction to it. Three nights before his own opening he went with some of the guys to see Barbra Streisand at the singer's invitation. Streisand's show, a one-woman cabaret turn that had been only moderately well received and had drawn spotty crowds, did not particularly impress him. It was a helluva big stage to fill, he said to Charlie, and she looked awfully alone up there. That was not the way it was going to be for him, he said. He would be surrounded by his band, and he would have all those voices; he was not just going to be out there all by himself.

The Colonel Meanwhile was going ahead full steam with his own preparations. He had storerooms filled with posters, banners, balloons, one hundred thousand 8 x 10 glossies, fifteen thousand color portraits, calendars, catalogues, and souvenir booklets, all shipped in from Florida at RCA's expense. He had the city plastered with billboards, with even the taxis sporting little marquees that announced Elvis' opening. Despite one of the biggest advance sales in Vegas history (the room was 80 percent sold out by early July), he took out over one hundred radio and TV ads daily, explaining that "I don't like to take any chances," and his fourthfloor offices were a gaudy shrine covered with Elvis posters, after the model of his headquarters at MGM. It was an unparalleled promotional blitz, exceeding even the Colonel's most spectacular previous efforts, but as he announced to all and sundry, with that peculiar combination of pride and bluster that was his trademark, this was his job; it was his obligation to let everyone know that Elvis was coming — the rest was up to his star. "If you don't do any business," he told Elvis, "don't ever blame me. Because the gophers in the desert [will] know you're here! Believe me, everyone in town will know Elvis Presley is coming, but you're the only one that can bring them in." On the night of Barbra Streisand's closing, even as stagehands were tearing down the show, the Colonel and his crew, armed with hammers, ladders, and staple guns, were putting up posters, glossies, and even a souvenir booth in the lobby, so that by morning you could not have guessed that any other performer had ever been present.

Using the same technique that he had employed to promote Elvis' movies for the past decade, Colonel timed interviews, features, and publicity items to build up the opening, while the new album's June release elicited reviews and sales (it reached number thirteen on the *Billboard* chart at the end of July and got the *Rolling Stone* lead review a month later) to coincide with all the excitement. The NBC television special, too, was scheduled to be rebroadcast on August 17, as Colonel continued to work behind the scenes to arrange for Elvis' first appearance in front of his true noncelebrity public, at the Houston Livestock Show and Rodeo the following February. There was no question, the gophers were going to sit up and take notice.

O PENING NIGHT, JULY 31, was by invitation, one show only, with an A-plus celebrity list that the Colonel had been working on for the last two months. International owner Kirk Kerkorian delivered his pal Cary Grant, just as he had for the Barbra Streisand opening, while Colonel made sure that all of his own show business cronies and associates were present. There was a pantheon of music business celebrities, from Fats Domino and Pat Boone to Paul Anka, Phil Ochs, Carol Channing, Shirley Bassey, and Dick Clark — with most of the Strip headliners in attendance. Colonel had even arranged for a planeload of New York critics to be flown in on Kirk Kerkorian's private jet, while Elvis extended a special invitation to his first mentor, Sam Phillips, to come out for the opening.

There was a full-scale dress rehearsal in the afternoon, but by the time the curtain went up on the Sweet Inspirations at 8:15, Elvis had worked himself into such a frenzy that Joe had his doubts about whether or not he was going to be able to go on. "Everything was fine right up until that night. He just had no idea of how he was going to be received. He was pacing back and forth, back and forth; you could see the sweat just pouring out of him before he went onstage. He was always nervous before every show, but he was never nervous like that again."

The Sweet Inspirations did a stiff opening set, highlighted by dressed-up versions of "Born Free," "The Impossible Dream," and "How High the Moon." Sammy Shore, a forty-one-year-old comic whom the Colonel had spotted opening for Tom Jones, did a crowd-pleasing turn that centered around the exhortations of his alter ego, a black preacher named Brother Sam, and included such jokes as, "Youth is wasted on the young. Give us what the kids got, and you know what you'd have? A lot of old people with pimples." And then Elvis came out, unheralded, practically unannounced, to a vamp from, of all things, Carl Perkins' "Blue Suede Shoes," which he had practically massacred in a clash of over-the-top vocals and orchestral pretensions on the NBC special. This time there was no question of pretense; with his own handpicked band behind him he simply *rocked*, and almost in that instant, the whole room exploded.

The first few nights were not recorded, but from the evidence of subsequent recordings and from the response he got, it doesn't seem difficult to imagine just how explosive a moment it really was, as he roared from the Carl Perkins number into Ray Charles' "I Got a Woman" and then into "All Shook Up," taken too fast but still delivered with sledgehammer effect. Next came a surprisingly sincere "Love Me Tender," its simple folk melody amplified by the swelling chorus behind him, followed by a free-wheeling medley of "Jailhouse Rock" and "Don't Be Cruel" in which (the former) a "knocked-out jailbird" became a "knocked-out sonofabitch" under the influence of Elvis' high spirits. And then he spoke, in a human voice that both reassured an audience almost dazzled by his show and at the same time raised the level of nervous energy another notch. "Good evening, ladies and gentlemen," he said. "Welcome to the big, freaky International Hotel, with those weirdo dolls on the walls and those little funky angels on the ceiling [referring to the ornate semiclassical sculptures scattered around the room], and, man, you ain't seen nothing until you've seen a funky angel. Before the evening's out I'm sure I will have made a complete and utter fool of myself — but I hope you get a kick out of watching."

This was Elvis in overdrive; all the terror that Joe had glimpsed during

the day exploded now in a kind of manic release, but a release that was as instinctively controlled and responsive to his own sense of the audience's needs as it was the first time he ever set foot on a stage. Cary Grant was on his feet; comedienne Totie Fields stood on a table swinging a bottle; even waitresses who had "recently struggled through the ennuied debut of The Divine Barbra," as the *Los Angeles Herald-Examiner* reported, "were visibly swooning." It would have been a scene of rare abandon in any setting, but for Las Vegas, the ultimate repository of blasé show business values, this kind of uninhibited display was particularly noteworthy, carrying with it an implied embrace of genuine spontaneity on the performer's part.

No one in the room could have missed it, no matter what name they chose to put on it. The *New Yorker*'s Ellen Willis, a self-described skeptic, hailed "Presley's sustaining love for rhythm and blues." Richard Goldstein felt a wave of generational nostalgia sweep over him, "unnerved," he wrote in a *New York Times* feature entitled "A White Boy With Black Hips," "by the same shaky feeling your folks got from watching Sinatra on TV, a feeling you used to sneer at." Even those critics who did not know quite what to make of it (the *Hollywood Reporter* critic "got the delicious feeling that this was, indeed, one of the greatest put-ons in life") could not deny that it was in some strange way mesmerizing, while less distanced observers like the British reporter for the *Record Mirror* described "Presley, like a wild beast, roar[ing] through a long list of the songs that made him famous ... as ladies lost years and threw themselves at the feet of their leader in frenzied glory."

As he grew more secure, more of a sense of fun crept into his performance, something that may have escaped many opening-night critics and fans. This became most noticeable in the between-songs patter that evolved over the next few nights, which became increasingly revealing as he let his fondness for puns and wordplay run rampant. He invariably delivered "Mystery Train" and "Tiger Man" with gusto, but then, dredging up elements of the monologue that Steve Binder had urged on him for the television special, he gave the audience a little history lesson, too. It would change every night, but the essence of it always remained the same: how he had started out in show business almost by accident, while studying to be an electrician.

"But I was wired the wrong way. One day on my lunch break I went in to make a little demonstration record — I mean, I really wasn't trying to get into the business, but about a year and a half later the guy put the record out. No one had heard of me, but just overnight people were saying, 'Is he? Is he?,' you know, and I'm going, 'Am I? Am I?' I became pretty big in my hometown and a few parts of the country, and I started working nightclubs and football fields, little weird rooms where people are going, 'Hmm, hmm,' you know, and they threw me off the Opry, and Arthur Godfrey took one look and said, 'Nah, nah . . .' So I did that for a year and a half, and then I met Colonel Sanders — *Parker*."

Parker, he explained, got him on television.

So I went to New York, and people were saying, "Get him, get him, hot damn, he's just out of the trees." . . . So there was a lot of controversy, and I went on *The Ed Sullivan Show*, and the cameras were only filming from the waist up, you know, and Ed Sullivan is standing on the sidelines going, "Sonofabitch, sonofabitch," and I'm saying, "Thank you, Ed, thank you very much" — I didn't know what he was calling me at the time. And I did *The Steve Allen Show*, and they wanted to tame me down, so they had me dressed in a tuxedo and singing to a dog on a stool. The dog is peeing, and I didn't know it, you know, so I'm singing, "You ain't nothing but a hound dog," and the dog's going, "Ump, ump," and I'm going, "Back, back, you fool," and the dog ran out of the room.

So I did that show, and then I went to Hollywood. Hollywood is the next move, you know. That's what happens: you get a record, then you get on television, and then you go to Hollywood. So I made *Love Me Tender*, then I did *Loving You*, *"Loving* Her," loving whoever I could get my hands on at the time. So I did *Jailhouse Rock, King Creole*, four pictures, man, I was really getting used to the Hollywood bit. I had a Cadillac limousine, I had sunglasses on, sitting in the backseat, saying, "I'm a movie star, hot damn, I'm cool." Eating hamburgers and drinking Pepsi Colas, you know. "Better watch that squirrel, man, when he gets out of the trees!" So I was living it up pretty good when I got drafted, shafted, and everything else. Just overnight it was all gone, you know. I was in a different world, and I woke up, and it was gone.

At first they watched me to see what I was going to do. And when they saw I was just like them, then everything turned out okay. But the guys in the service must get awful lonesome, because they call each other "mother" a lot. . . . Anyway, I got out of the service in 1960, and I made some movies like *G.I. Blues* and *Blue Hawaii*, and several pictures that did very well for me. But as the years went by it got harder and harder to perform to a movie camera, and I really missed the people, I really missed contact with a live audience. And I just wanted to tell you how good it is to be back.

And then he would return to the show. *He never once lost them, he had them in the palm of his hand.* It was a triumph of the rarest sort, a triumph of class, in which, finally, he was able to achieve the validation he had always wanted but never explicitly sought — and strictly on his own terms.

For those closest to Elvis, that first night's performance was almost as much of a revelation as it was to the audience. To Priscilla, wearing a baremidriff white-fringed minidress with white go-go boots and ankle straps, an outfit that Elvis had personally approved, "it was the energy, the energy that surrounded the stage, and the charisma that he [conveyed] — I don't think I've ever felt that in any entertainer since. I mean, yes, other entertainers have a charisma, but Elvis exuded a maleness about him, a proudness that you only see in an animal. On the stage he'd have this look, you know, prowling back and forth, pacing like a tiger, and you look and you say, 'My God, is this the person that I —?' It was difficult to attach who he was to this person onstage. It was incredible." Joanie Esposito, who, like Priscilla, had up till now seen Elvis perform only at the taping of his television special, was almost as enthralled. "He was so charged up. He was so excited — he just got so high off the audience he did somersaults."

More than one person noted it was as if he were in another different world; there were moments when his eyes glazed over and you had no idea *what* he was going to do next. "It was like a different Elvis," said Patti Parry, the hairdresser who had been one of the gang for almost nine years now. "It was like a light coming on that stage — the electricity from the audience and the electricity from him, it was unbelievable. You forgot that this was your pal." His father sat proudly at the front-row family booth with Dee and the kids, quietly beaming. But it was Felton as much as anyone, still Elvis' number-one fan, who could barely contain himself. "He was like a wild man," the producer said, trying to describe it some years later to a friend. "He was all over that stage. I mean, he almost hurt himself — he was doing flips and cartwheels and all kinds of stuff; on 'Suspicious Minds' he'd be down on one knee and do a flip across stage and just roll. He was

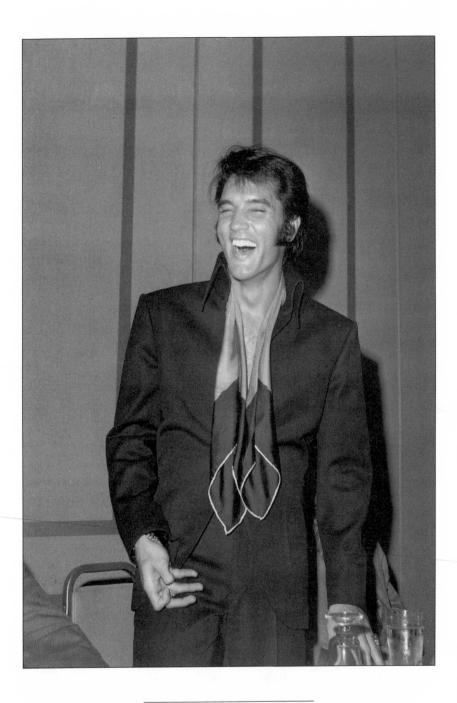

PRESS CONFERENCE, LAS VEGAS, AUGUST I, 1969. (ARCHIVE PHOTOS/FRANK EDWARDS FOTOS INTERNATIONAL) about half crazy until everybody talked him into not doing all those things, I ain't kidding you."

When he came offstage that first night, there was a feeling of almost palpable relief. The Colonel, who fiercely guarded against any display of outward emotion, had tears in his eyes when he came backstage — neither Joe nor Priscilla nor Charlie had ever seen anything like it. It was as if for just this one instant there were no veils, no disguises — the two of them simply stepped toward each other and wordlessly embraced. The Colonel's body shook with emotion. Then it was over. It was, Joe felt, the closest they had ever been.

In the pictures of the press conference afterward, Elvis appears proud, beaming, brimming with confidence, changed from his stage outfit to one of Bill Belew's mod suits, with a wide, multicolored silk scarf around his neck and a high Edwardian collar. Joe and Vernon flank him at the long banquet table, with Lamar, Sonny, and Charlie all sharing the spotlight and the Colonel presiding with W. C. Fields aplomb in a white butcher's smock covered with the stamped message ELVIS INTERNATIONAL IN PERSON. Elvis stood the entire time taking the predictable questions. Was he excited about his return to live performing? Had he grown tired of making movies? Did he think it was a mistake to have put out so many soundtrack albums? To each of which he replied affirmatively and diplomatically ("I was getting fed up with singing to turtles," he said in response to the last).

More photographs were taken. There was talk of performing abroad, and at one point Screaming Lord Sutch, a flamboyant British rocker who had run for Parliament, shouted out an offer of "one million pounds sterling for one appearance in England at the Wembley Empire Stadium for two concerts." The fee would include the documentary filming of the concerts and would require no more than twenty-four hours of Mr. Presley's time. "You'll have to ask him," said Elvis, deferring to the Colonel and looking slightly bemused. Colonel asked that the offer be repeated and then said, "Just put down the deposit." "All right, I will attend to it," said Lord Sutch. "Would you like to appear in England?" He *definitely* would like to appear there, responded Elvis without hesitation, "and it will be soon." With the press conference over, he had his picture taken with a beaming Fats Domino, who, Elvis insisted to cynical reporters, had been a tremendous influence on him and should be considered the real king of rock 'n' roll. Afterward, the whole party repaired to his seven-room suite on the twenty-ninth floor (the even more luxurious star suite on the thirtieth floor, to which he was contractually entitled, had not yet been completed), where the evening was relived over and over again.

S THE ENGAGEMENT WORE ON, Elvis' mood continued to loosen up, and with it his onstage demeanor. The monologue grew more and more zany, to the point that it sometimes seemed almost surreal. As the women in the audience grew increasingly demonstrative (they started throwing bras, panties, and half-slips, almost from the first show), he began to give out kisses, randomly at first, and then as a regular part of the performance. He first split his pants about two weeks into the engagement, and soon that, too, became a kind of ritual, with "Memories" sung one time from behind the curtain as he changed his trousers. One night he dissolved in hysterical laughter at Sweet Inspiration Cissy Houston's soprano obbligato during "Are You Lonesome Tonight?," and he could never get back to singing the song. Other nights he and Charlie would start fooling around, and the audience would be treated to the kind of spectacle that girlfriends and movie directors had learned to endure. And yet the show never lost its edge. Elvis was never anything less than fully engaged, the music remained for the most part crisp and taut - it was simply that the atmosphere became more genial, as was only natural for an entertainer who was beginning to feel more and more at home.

The Colonel was in his element, too, talking about carnival days, inducting new recruits into the Snowmen's League, basking in the sunshine of his newfound success but rejecting respectability at every turn. He was observed by more than one reporter dropping several hundred dollars at a time at the roulette table, a ubiquitous grizzled old character who merited at least a patronizing aside in every new story about the remarkable resurrection of Elvis Presley's career.

The International took more formal notice of the Colonel's presence, exercising its option for a second engagement the day after the opening, then tearing up Elvis' contract and raising him to \$125,000 a week three days later. This was attached to an extension which would have Elvis entertaining at the International twice a year for the next five years, thus guaranteeing the Colonel his yardstick \$1 million for eight weeks' work through 1974. As for any fears the Colonel might have of someone else surpassing the standard that had been set, there were numerous assurances and verbal guarantees that his boy would maintain "favored nations" status for as long as the contract lasted — that the casino would, in other words, match any improvement in salary or working conditions that any other Vegas headliner might achieve.

Colonel wasn't worried in any case. He was as confident now of Elvis' abilities as he was of his own. His only misgiving was that maybe things were getting *too* good; he watched the boy and he grew increasingly concerned that maybe he was beginning to feel too much at home onstage, as he let fly with scattershot off-color language and remarks that Colonel felt were inappropriate, particularly for the dinner show, at which there were frequently children in attendance. Elvis should watch himself, he wrote in a blunt note after the August 22 show. He knew that Elvis would not want to undo all the good they had done with the engagement so far, but he was also aware that he could merely relate this to Elvis, that Elvis was the only one who could do anything about it. It was, he implied, as it had always been, the two of them against the world.

Old friends and new showed up, bidden and unbidden. Cliff Gleaves cashed in the airline ticket that Elvis had sent him and drove out from Memphis with Sam Phillips, while George Klein and Marty Lacker put off their arrival until the first weekend at Elvis' request, so they could catch the act after some of the bugs had been ironed out. "The reception Elvis is getting here is incredible," they reported back to the Memphis Press-Scimitar. "You've got to see it to believe it." Chips and Memphis music entrepreneur Herbie O'Melle joined them midway through their stay, and Elvis' Memphis physician Dr. Nichopoulos, who had gotten Elvis out of the scheduled start of Clambake, met Colonel Parker in person for the first time after his brusque introduction on the telephone two years before. Jerry Lee Lewis almost got into a fight with the Colonel when he tried to clear the dressing room of everyone, including Jerry Lee Lewis. "I wouldn't let no loudmouth old man tell me who I could have a drink with," Jerry Lee announced brashly to Elvis and anyone else in the room who chose to listen, but he didn't get a flicker of recognition from Colonel.

Ed Parker, the karate instructor and former champion with whom Elvis had renewed acquaintance in Hawaii the previous year, showed up without notice accompanied by a party of four. As soon as he arrived, he contacted Joe and told him he wanted to see the dinner show and meet with Elvis afterward about a "training idea" that he had. From the audience Parker noted approvingly the extent to which karate — both movement and costume — played a part in the show. Then, toward the end of the performance, "Elvis took a moment for personal recognition. He introduced his wife, father, and then to my great surprise he turned in my direction. 'I have a close and dear friend in the audience,' he said. 'He is my karate instructor, a high-ranking belt, who is well known in his field. If any of you live in the Los Angeles area and are interested in karate, you should visit his schools.' He then called me by name and had me stand and face the audience as the spotlight singled me out."

Later in the evening, up in the suite, Parker broached his business idea, which had to do with building up the popularity of karate in general and the marketing of Parker's own "kenpo" system in particular. "My guests still could not believe they were in Elvis' private quarters, [but] Elvis at once put [them] at ease. He talked to them as if they were longtime friends. . . . When [they] asked a question or spoke to Elvis, he looked them in the eyes and listened intently." In conjunction with their conversation, Elvis asked Parker to conduct a karate demonstration "by executing moves and then explaining them, so that all who were present could understand the theory that I was trying to get across. Elvis was attentive, contributing a word, move, or gesture now and then but never, ever trying to steal the limelight." This, Parker, reflected later, marked the true beginning of their friendship.

Every night Elvis held court in his suite. One night Tom Jones might stop by, and the two of them would sing together until the sun came up. Another night it might just be the Imperials, with whom Elvis loved to harmonize on some of the old gospel songs. "Every night was like a command performance," remarked Imperials manager–keyboard player Joe Moscheo — to the point that some nights you might just prefer to slip away after a few words of perfunctory congratulation, so as to avoid getting stuck in the suite all night long. "A lot of times he just really wanted to sing, and he'd sit down at the piano and entertain for whoever was there. Sometimes there were a lot of big names, sometimes there was just a bunch of hangers-on, a lot of times it was just the guys." Whoever it was, the room was always filled with people, and Elvis was always singing. Some of the guys said it was just like the old days — but it was like the old days had never been.

Elvis was feeling particularly sanguine when he spoke with British music reporter Ray Connolly, writing for *New Musical Express*, in a rare private interview sanctioned, and attended, by the Colonel. "We didn't decide

to come back here for the money, I'll tell you that," Elvis told Connolly. "I've always wanted to perform on the stage again for the last nine years, and it's been building up inside of me since 1965 until the strain became intolerable. . . . I don't think I could have left it much longer." As far as the money went, it really didn't matter, he didn't even want to know.

He laughs, and throws his head back, showing all those perfectlykept teeth, and striking me with the smallness of his eyes and the exaggerated length of his eyelashes.

"Can we just say this?" says the Colonel, all homespun, folksy humor. "The Colonel has nothing to do with Mr. Presley's finances. That's all done for him by his father, Mr. Vernon Presley, and his accountant."

Mr. Presley, Snr., a fatter and greyer version of his son, if you ever saw one, nods at the formal third person way of speaking and takes another beer from the bar.

"He can flush all his money away if he wants to. I won't care," the Colonel adds. The humor is easy and good-natured — country style, if you like.

Judgment of another kind was offered by Sam Phillips when Elvis sought him out for a critique of the show. Phillips had had one piece of advice for Elvis when Elvis called to invite him out in the middle of rehearsals. "I said, 'Is the goddamn rhythm kicking you in the ass? *Where is the placement of the rhythm section*?' I said, 'Just put that rhythm out there, baby, just put it out there. 'That is your *i-den-ti-fi-cation*.' Well, when I saw the show, I want to tell you, I never heard a better rhythm section in my life. There was some raunchy-ass shit. I told him that. I said, 'Elvis, man, that was fabulous, but, you know, that song "Memories" has got to go!' I said, 'Goddamn, didn't that motherfucker bog down the fucking show?' And he said, 'Mr. Phillips, I just love that song.' And of course, he kept on singing it ever since."

"Suspicious Minds" was released at the end of August, with no accommodation whatsoever from Chips on the publishing. It had been overdubbed in Las Vegas a week into the engagement, incorporating the way that Elvis performed it onstage — with a kind of false ending in which the volume faded out, then came back up as the same three lines were repeated over and over in a four-and-a-half-minute coda that may well have been suggested by the Beatles' "Hey Jude" and featured the International horns. They recorded the new ending at United Recording, the eight-track studio that Bill Porter, the RCA engineer who had worked the board at all of Elvis' Nashville sessions from 1960 through 1963, had bought into three years earlier. It created a tricky technical problem for Porter, since all eight tracks were already filled, but he solved it by recording the horns live first over the stereo, then over the mono mix, and turning the volume down, then up again according to Felton's specifications. Glen Spreen, who had written the arrangement for the penultimate version, couldn't believe his ears when he heard the final product. "I mean, we laughed at it — let's put it that way — when we heard the fade. You know, to do that kind of thing live, because the audience is there and they're participating, they're with him, that's one thing, [but a record's something else]. Gene Chrisman was probably the most vocal about the whole thing - he used very blunt words in describing what he felt. Bobby Emmons just had this blank, amazed look on his face, and we all just kind of went, 'God, how can they do this?' as it kept going and going and going. But we couldn't do anything about it."

Glen's disgust was mirrored by Chips' reaction. For Chips it only confirmed all of his worst suspicions about the bunch he had been working with — the same people who had tried to take his publishing, had eliminated his credit, and now were trying to steal his sound. They were no better than *amateurs* in his view, turning an intricately worked-out production into a kind of audio joke, and the success of the record may only have been the last straw in the way of any kind of business relationship, though he continued to maintain good personal relations with Elvis for the rest of the year. The single — fade-out, coda, and all — turned out in any case to be Elvis' biggest record in seven years, his first number-one hit since 1962, proving perhaps that Elvis' judgment was as right in its own way as Chips'.

All of this turmoil escaped Elvis' attention in the wake of a monumental revival of popular interest in him and in his work. The figures alone from the Las Vegas engagement spoke volumes about its success: 101,500 paying customers, \$1.5 million in gross receipts, the most successful act in Las Vegas history (by comparison, Dean Martin attracted 50,000 in three weeks at the smaller Riviera earlier that summer). With the Colonel, the Colonel's staff, and all the guys, their wives and girlfriends, Elvis attended Nancy Sinatra's opening at the International the night after he closed. In keeping with the expansive way he was feeling, Colonel took out newspaper and radio ads in his and Elvis' name, urging people to attend the Sinatra engagement. After the show Colonel spotted Mac Davis, who had opened for Nancy, in the dressing room. "He remembered me, and he said, 'I told you you were going to be a star.' I said, 'Yeah, you rubbed my head.' He said, 'Did I really?' I said, 'Yeah.' He said, 'Well, then there ain't no doubt about it. You're gonna be a star.'" Then they all went off to a party hosted by Nancy's father, and Elvis had his picture taken with Frank Sinatra, a peer at last, no longer a pretender.

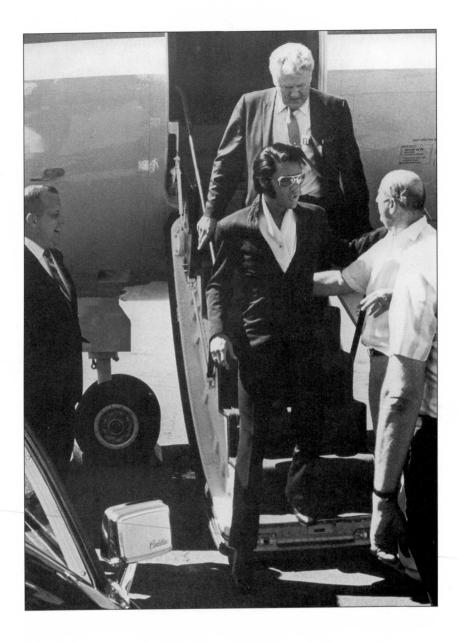

ON THE ROAD AGAIN: COLONEL MEETS ELVIS AND VERNON PRESLEY, PHOENIX, SEPTEMBER 9, 1970. (COURTESY OF THE ESTATE OF ELVIS PRESLEY)

A NIGHT AT THE OPERA

OR THE FIRST TIME IN almost ten years Elvis had nothing to look forward to. There was no movie coming up, no recording session, no television special — nothing in fact was planned until his return to Las Vegas at the end of January. He felt an enormous sense of release upon the conclusion of the August engagement, but he could find no outlet for its expression. All of a sudden it seemed like he had outgrown Memphis without even being aware of it, and for a month he restlessly shuttled back and forth between Las Vegas and Los Angeles, Los Angeles and Palm Springs, where the new house he had bought in April was now pretty much reserved for weekends with the guys. He returned to Memphis at the end of September, but it was plain to everyone, including Priscilla, that he had little interest in staying at home with his wife.

They traveled to Hawaii at the beginning of October on an all-expensepaid vacation for ten that the International had presented to Elvis in appreciation of his record-breaking engagement. Even Hawaii no longer held the attraction that it once had, and Elvis and Priscilla and Joe and Joanie hatched a plan to go to Europe with Jerry and Sandy Schilling and Elvis' cousin Patsy and her husband Gee Gee, returning to L.A. after only a week to get their passports. For a few days the European trip was all they could talk about, as they made plans and pored over maps and picked out the tourist attractions that they would like to visit. But then reality reasserted itself, with the Colonel insisting that Elvis would gravely offend his European fans if he were to visit England and France as a tourist before he played over there.

Everyone was up in arms at first. Elvis said he was just going to tell the Colonel to go fuck himself — whose fault was it that they had never been to Europe anyway? — and for a moment they all believed him. But then he turned around and accepted the Colonel's edict meekly and they went to the Bahamas instead, where Colonel knew some people and thought they would enjoy themselves. As it turned out, the island was hit with hurricane

winds on the second day, so they were limited to the restaurants and the casinos and came home after only a week, on October 29. Elvis stuck around barely long enough to change his clothes, showing up the next night in Las Vegas, where he was spotted by gossip columnist Rona Barrett playing blackjack at the International, "reportedly losing and signing markers while two beauties stood at his side catching soul kisses in turn, with each flip of the cards." When the gossip columnist revisited the scene in her November 6 column, she noted that "everybody is commenting on how good Elvis Presley looks these days while he's having fun at the International. . . . Elvis' answer in response to such compliments: 'That's what a bad marriage does for you!'"

To Priscilla, filling up her time with dance, acting, cooking, and calligraphy classes while Elvis went off on his unexplained jaunts to Dallas, Las Vegas, and Palm Springs, his behavior was consistent with the view she had increasingly come to have of him over the past year and a half: Elvis could be at ease only when he was performing; he could never be still except when he was fully engaged. She had listened to his evasions and witnessed his betrayals, large and small; she had tried to combat a conspiracy of silence by moving into a house intended for the two of them alone, not for the membership of a small, self-protective fraternity who had served to aid and abet his actions over the years. That hadn't worked, and their marriage no longer maintained even the appearance of intimacy, but what disturbed her most of all was that Elvis no longer seemed able even to fool himself. "During the lulls he wouldn't know what to do with himself. He was like a child. He would take pills or read or just eat — because he was bored. You know, he just had to occupy his time with something to do."

Elvis' own view was somewhat more ambiguous. Although he never permitted himself to fully acknowledge it, he was well aware that he had not been faithful to his ideals, that things were not working out in certain respects the way that he had planned. He could rationalize that his marriage to Priscilla was not a marriage of true minds, that in fact her failure to share his spiritual goals was a fatal impediment to any true union. And linked to that, though maintaining a logic of its own, was his sense that he himself had not yet discovered his intended role, that he still did not know what his purpose on earth really was, though in returning to performing he had come closer to it than he had in years.

He visited Daya Mata frequently once again. She told him of her pilgrimage to India the previous year, while he in turn expressed some of the feelings that impelled him to return to live performing. "He was very much pulled toward his following and wished to please them. He wanted to be a great spiritual influence on all these young people — that was at the basis of his desire. 'I want to feel God's love. I want to give back. I want to awaken in all these young people a closer relationship with God.' I think the thing that stymied him was a lack of — I don't know if patience is the right word, but the self-discipline of being able to stay focused on something long enough to see it through."

The success of his records, though, and the newfound reestablishment of his popularity brought him to a greater sense that he might be on the right track, and even as he returned to his spiritual studies, he took up karate once again, too — in a more formal way than at any time since he had begun his studies in Germany. Ed Parker, who, for all of his legitimate achievements in the field, was an equally energetic promoter both of karate and of himself, followed up on their initial meeting in Las Vegas with an offer to train Elvis both to incorporate karate more readily into his act and, now that he was once again more exposed to the public, so as to be better able to defend himself. Elvis took private lessons at Parker's studio in west Los Angeles, and Parker found him an apt, if erratic, pupil.

"When the spirit moved him, he would study for days on end. Determination was a big part of his character. He prodded, pried, and questioned. He was not only interested in how, but in why as well. . . . I can vividly remember his boyish grin when he was convinced that the techniques did work." Parker rewarded him with certificates of advancement from his own Kenpo Institute, which were sometimes as much in recognition of Elvis' dedication to the philosophy of the discipline as his achievement in it. From Ed's point of view, this was a distinction to be recognized more in the breach than in the observance. For there was no question of what Elvis Presley's advocacy could do for the movement as a whole, or for the popularity of Ed Parker's school of kenpo karate in particular.

As for Elvis, in the end, he felt, there was no need to resolve these dichotomies just now; all would become clear when his purpose became clear, his mission revealed. All else was merely temporal; the contradictions between what he desired and what he accepted would one day fade away, his dedication to doing something great would eventually overwhelm his weakness. He was a poor boy who had never forgotten where he came from and would never stop short of his destination. In the words of the 1966 hit from *Man of La Mancha* that had been one of his favorites ever since

he heard the Roy Hamilton version, he had dared to dream the impossible dream, and he had seen it come true. And he had done it just as other unheralded prophets had, with the same spirit of stubborn determination that Frank Sinatra sang about in his big hit of just a few months before: mistakes and all, he had done it his way.

Rehearsals for Vegas started in Los Angeles on January 10, almost three weeks in advance of the opening. Elvis couldn't wait to get going: there was new repertoire to rehearse and two new musicians to break in. Having to find another drummer had come as a highly unwelcome surprise, but Ronnie Tutt, the last-hired and lowest-salaried member of the band, apart from rhythm guitarist John Wilkinson, had been unable to come to financial terms with Tom Diskin and had chosen to go a more remunerative route. His replacement, Bob Lanning, was a competent L.A. session man who came highly recommended, but he possessed neither the fire nor the flair that Elvis was looking for in a drummer, and almost from the start of rehearsals he was determined to get Ronnie back, whatever the cost. Piano player Glen D. Hardin, on the other hand, was a perfect fit from the very first. A twenty-nine-year-old native of Lubbock, Texas, who had grown up playing with Buddy Holly's former backing group, the Crickets, then joined the navy, and met James Burton in L.A. upon his discharge, he had taught himself the rudiments of arranging while working with James and Jerry Scheff on the Shindig set. James had contacted him about the original Vegas gig, but he had turned it down because he was so busy with studio and arranging work. Then Larry Muhoberac decided he wanted to go back to playing sessions, and James called him again. This time he was ready.

"I went in there, and it was just James and Jerry and my friends — it wasn't like a real rigid rehearsal or anything. And we sat around and played two or three tunes. Seems like Elvis couldn't remember the words to something, and I knew the words — I think he was real comfortable with me. So we laughed and talked and just kind of hung out and had a good time. And after a while he said, 'Listen, I want you to go out there and make a deal with that guy over there.' I said, 'If you don't mind, I want to make a deal with you.' So he said, 'Okay, let's do it.' We stepped right out in the hall, and my deal was only two or three sentences long — it was not a very big deal at all, just a handshake, but a very good deal it was."

Hardin found Elvis' informal approach to the music equally refreshing. "Elvis didn't rehearse the way most musicians do. We'd just go over and sometimes work all night, playing all kinds of different songs. He liked to do it that way. He selected the music on the program, and he didn't want to be strapped into an inflexible program. He wanted you to be ready to play just about anything."

By the time they went into Vegas for rehearsals nine days later, in Hardin's estimation they had run down several hundred songs. They worked for ten days at the hotel, the same as the last time, first with the backup singers, then with the orchestra. At one point Elvis wanted to try the treacly Everly Brothers ballad "Let It Be Me," but there was no arrangement for the song, so Glen undertook to write one and had the band playing it when Elvis walked into the rehearsal room the next day. After that, there was more arranging work coming his way. "The first couple of things we did, we'd get together, and he'd play it on the piano, and he'd say, 'Look, man, right here I want the voices,' and he told me what to have them sing — he was real easy to arrange for."

The show that Elvis put together this time was considerably different from his presentation the previous August. The change in repertoire was dictated to some extent by the fact that they were planning to cut another live album, even though one had already been released from the first engagement. Evidently this was just part of the Colonel's ongoing philosophy of synergy. For those who could not afford to travel to Las Vegas, a live album was just the thing, the Colonel reasoned, and even for those couple of hundred thousand who were fortunate enough to have attended, what could serve as a better souvenir? There was no need for a producer, no studio time to book, the musicians were already under contract, and, just as with the movies, the appearance served to promote the record while the record in turn promoted not just the appearance but the star.

For Elvis, on the other hand, an opportunity was provided to fashion a show that reflected his more contemporary tastes. At rehearsals they focused on such recently recorded numbers as "In the Ghetto," "Don't Cry Daddy," Neil Diamond's "Sweet Caroline," and the brand-new single, "Kentucky Rain." In addition Elvis introduced covers of recent hits like Creedence Clearwater Revival's mythic evocation of southern roots, "Proud Mary," Tony Joe White's more down-to-earth piece of swamp funk, "Polk Salad Annie," and Joe South's brand-new "Walk a Mile in My Shoes," a synthesis of hippie sentiment, gospel feel, and Christian philosophy with which Elvis could fully identify. All were ambitious and appropriate choices, all required a certain humility on the singer's part, both artistic (in that he hadn't originated the song) and financial (he didn't own the publishing though in many cases publishing cut-ins were sought and granted). Another thing that many of the new songs had in common (along with others, like the Righteous Brothers' "You've Lost That Loving Feeling," which he had introduced the previous August) was a tendency toward musical or philosophical grandiosity as well as an implicit insistence that Elvis Presley was not going to be limited in his choices. And, as nearly every member of the band could attest by now, it was difficult not to be swept along in the passion of the moment, no matter what your aesthetic view of those choices might be.

O PENING NIGHT WAS FULL of the usual pomp and circumstance, with everyone from Fats Domino to Zsa Zsa Gabor in highly visible attendance. The Colonel, who had begun his work well in advance of Elvis' arrival, had the International decked out once again in Elvis decor, while Bill Belew had modified the simple two-piece karate-style costume of the August engagement to a very similar one-piece jumpsuit with more give (for greater freedom of movement) in the fabric. Sound was the one area where Elvis had experienced serious dissatisfaction throughout the last engagement, so this time he hired Bill Porter, the former RCA engineer who had overdubbed the horns on "Suspicious Minds" at his Las Vegas studio, to help Felton run the board. Though he had little previous experience with live shows, Porter leapt to the challenge, and, in the absence of effective house monitors, added a couple of Shure speakers so that Elvis could at last hear himself onstage.

"Apparently there is no stopping Elvis Presley," wrote *Commercial Appeal* reporter James Kingsley in his *Billboard* review of opening night, which pointed out the new versatility the star was beginning to show, as he did his own hits and those of others, exhibited genial good humor, gave out kisses, lay on his back, invited the audience to watch him while he took long drinks of water, and delivered his usual self-deprecating and charmingly off-the-wall monologues. Spotting Dean Martin in the audience, Elvis struck up a spontaneous version of Martin's 1964 number-one hit, "Everybody Loves Somebody"; he forgot the lyrics to four different songs in the course of the evening but stopped the orchestra and restarted the song each time ("I was nervous," he told the indulgent audience); and in the end he got a standing ovation when he closed the show with "Suspicious

Minds," coming back with the obligatory encore (the real closer by now), "Can't Help Falling in Love."

Though the majority of notices were raves (Robert Hilburn of the Los Angeles Times called Elvis' performance "a flawless demonstration of ... vocal ability and showmanship"; Frank Lieberman of the Herald-Examiner declared that "the new decade will belong to him"), not every critic took as rosy a view. Elvis' future biographer Albert Goldman, covering the engagement for Life, opened his review with a single italicized adjective: "Gorgeous! - or some equally effusive effeminate word - is the only way to describe Elvis Presley's latest epiphany at Las Vegas." The critique went on with sneering contempt to call into question Elvis' sexuality ("Not since Marlene Dietrich stunned the ringsiders with the sight of those legs . . ."), sincerity ("So compelling is his immaculate narcissism . . ."), and musicality ("He strums the acoustic instrument slung white around his neck with the carelessness of a practiced faker"), without conceding a single positive point. Goldman, identified as a professor of classics at Columbia University, appeared to be equally contemptuous of audience, performer, and venue (he seemed most exercised by the spectacle of "male cheesecake ripe for the eyeteeth of the hundreds of women ogling him through opera glasses"), but perhaps the one critical point where he is on firm ground is the extent to which Elvis' show seemed to have taken on the appearance of a series of still lifes and studied poses. Certainly Elvis remained apt to say or do anything that took his fancy, and in that sense the show continued to be spontaneous, unpredictable, almost, one might say, zany — but in another, more important respect, it had lost its sense of freshness, as Elvis tended to conclude each number with what Goldman described as "a classically struck profile — Elvis as the Discus Hurler, Elvis as Sagittarius, Elvis as the Dying Gaul." The Columbia professor may well have missed the good humor of some of the impersonations, but he got that they were impersonations, a far cry from the uninhibited, seemingly out-of-control reactions of the performer who had rocketed out of the fifties to do high-spirited somersaults on the International stage just six months before.

The rest of the engagement was predictably successful, setting new attendance records, creating new expectations, generating the kind of business that lifted up the whole town. Though Elvis was still apt to interject the occasional new song just on a whim, the show itself was by now pretty much set, a variation on the kind of performance to which Elvis had long been exposed in his visits to Vegas, where Frank and Dean and Sammy treated the stage as if it were their own living room, goofing on themselves but most of all on the squares who had paid to see them goof. Elvis always retained the deepest respect for his fans, he genuinely *loved* his audience in a way that it's difficult to imagine Martin or Sinatra even contemplating, but there was no question that he felt he was letting them in for a treat if he allowed them to see him as he really was, unbuttoned if not altogether unvarnished. To twenty-eight-year-old Frank Lieberman, the critic for the *Los Angeles Herald-Examiner*, Elvis confessed that Vegas had given him "a new life. I was human again. There was hope for the future. . . . I was able to give some feeling, put some expression into my work." It even re-excited his interest in making movies, he told Lieberman, who was rewarded with a twenty-minute interview for his rave review of opening night. "I want a good property to find out if I can act once and for all. Those others were nothing, but finding something good is hard. . . . I need something good. I just can't go back to girls and GIs and things like that."

The band members and singers were like extended family now, as he grew more and more at ease in his new domain. "As soon as the show was over, he was in our dressing room," recalled Myrna Smith of the Sweet Inspirations. "His guys would stay over in his dressing room, and he would just come in and sit down and talk about *everything*, his love life, everything. We had our arguments, but he couldn't stay mad for long, and if you went to him in private, you could get him to do just about anything. Just don't embarrass him — because he was so insecure, I think that was just [his nature]."

They had pillow fights and water fights, exchanged reading material (because Estelle was the most religious, he read her passages from *The Impersonal Life* and spoke of his mother's ongoing influence on his life), and flirted with an intimacy that never crossed over the line. The only thing they didn't feel comfortable about was when he asked them up to the suite after the show. "When you went up there," Myrna knew, "it was party time. We didn't have to go up to the suite, because our talks were in the dressing room. When he came into our dressing room, we were friends." According to the Imperials' Joe Moscheo, Elvis continued to be upset that the gospel quartet didn't visit his suite more often, but by now it wasn't that easy to gain access, even if they had wanted to. "It just seemed like there were always too many people making decisions. Joe Esposito would say, 'He's tired tonight, we don't want any visitors in the dressing room.' Lamar and Charlie are out in the hall, and they want to be the big shots — they're

saying, 'Don't even think about coming in.' I always felt like I was two or three times removed. The little bit of time you had with him, he always treated you so good. But there was always an underlying nervousness: you never knew when it was okay to talk to him and when it wasn't; there was always somebody telling you what you could and couldn't do. [And you got the feeling sometimes that] Elvis didn't even know it."

Even for those vouchsafed entry, there could be a sense of unease from the predatory atmosphere alone. It was an atmosphere of high school hijinks and sexual expectation, an extension of the competitive environment that had grown up around Elvis since he was twenty-one years old, but among men who were in their mid thirties now, each waiting until Elvis had made his choice for the evening so they could pounce on the women who were left. It was, said Glen D. Hardin, like a kind of "silly boys' club. . . . Just one big party." But a party from which wives and girlfriends were specifically excluded. It represented a reconstituting in many ways of the family that had been torn apart first by the arrival of Larry Geller, then by Elvis' marriage. It was, as Priscilla increasingly came to view it, a competition between "the crowd's adoration" and real life, a competition in which there was no possibility that real life could ever win.

It generated a different kind of excitement, too, than what they had become used to during what Joe called their "nine-to-five" Hollywood years. Then there was always time for the on-set affair — almost everyone had them — but at the end of a shoot you went home to your wife or girlfriend. Palm Springs had come to offer the same kind of limited opportunity for escape that Las Vegas had held out in the sixties, a world in which rules and restraints were temporarily suspended. Now they were actually *living* in that world, not just visiting, and the feeling gradually took hold not just with Elvis but among the guys as well that it was their wives who were married, not them.

FELTON RECORDED THE SHOW during the third week, sticking to individual selections so as to get only agreed-upon material without wasting too much tape. Despite the number of songs they had gone through in rehearsal, they still didn't have enough satisfactory selections to make up an album, so on the next-to-last day of recording, Charlie set up a quick afternoon run-through of three songs that Glen D. had arranged the night before, and they recorded them that night. "The Wonder of You" was the

kind of soppy love ballad, complete with big melodramatic ending, that Elvis was so often drawn to, while Ray Price's "Release Me" was a classic country weeper, and "See See Rider" a blues standard that Elvis had been interjecting into his act throughout the engagement. Even with these additions, they were still short, so in the end RCA was forced to add two numbers recorded the previous August to the album that was released as *On Stage* — *February 1970*, with neither the continuity nor the excitement of the live act.

The final night was like the breakup of camp. The midnight show went on until 3:00 A.M. and ended with Elvis at the piano singing "Lawdy, Miss Clawdy" and "Blueberry Hill," comedian Sammy Shore running around the stage blowing his trumpet, and Priscilla standing in line in a backless culotte dress to receive a long kiss during "Love Me Tender." ("I think I know that girl," Elvis remarked.) New sound problems had cropped up in the big room over the last week, and Colonel had threatened the hotel that if they were not straightened out, Elvis would not go on. Evidently they were, and Elvis gave what everyone agreed was one of his finest performances. Sometimes, he confided to the audience, he wished he could just go out there and do his show in the relaxed manner of Dean Martin, but he knew that if he didn't "'get it on,' folks would just say, 'Why, he can't move no more." So he got it on. Toward the end of the evening he introduced the Colonel and said, "He's not only my manager, but I love him very much." As the curtain came down, reported Elvis chronicler and devoted fan Sue Wiegert, "Sammy Shore ran out and started kissing Elvis' feet, which cracked up both Elvis and the crowd!"

The NEXT DAY THE COLONEL was off to Houston, where Elvis would headline the Houston Livestock Show and Rodeo at the Astrodome at the end of the week. There were six performances scheduled, three evening shows and three matinees, and the Colonel led an advance party to check out both hotel and security arrangements. Upon his arrival he learned that rumors had been circulating that there were no seats left for any of the shows, so he immediately took out \$10,000 worth of radio spots to advertise the availability of tickets. "Nothing was left to chance," reported *Houston Post* reporter Marge Crumbaker. "When Parker checked in that Tuesday, his first action was to walk into nearly every crevice of the Astroworld Hotel and map out the setup. . . . Elevators were studied. Halls sketched. Entrances and exits were noted. The roof was inspected. . . . The absolute professionalism of the business end was staggering."

Elvis arrived the following day aboard International owner Kirk Kerkorian's private plane, accompanied by a party that included Joe, Red, Sonny, Charlie, Gee Gee, Jerry Schilling, Cliff Gleaves, and his father, Vernon. The Colonel had tried to limit the size of the party, stressing in a letter to Joe that this was a very tight setup and they didn't need any hangers-on, but evidently either Elvis wasn't listening or he didn't agree, because just about everyone came along for the ride. It became apparent immediately at Thursday's rehearsal that the sound situation was hopeless. Even with Felton and Bill Porter doing their best, it was going to be bad, and Elvis told the band not to bother to try to fight it but to "just go ahead and play."

Elvis appeared twice the following day, between the chuck-wagon races and the calf-roping contest, making his entrance from backstage in an open jeep that circled the arena while his fans raced along beside. It was, remarked the Los Angeles Times' Robert Hilburn, the first true test of his grassroots popularity, as well as the first-ever Houston rodeo weekday matinee, and it was in some respects a disappointment. Elvis appeared visibly nervous, the acoustics were as bad as he had anticipated, and he apologized to the crowd, which numbered only 16,708, including the 4,000 handicapped children who were attending as guests of Elvis and the Colonel. After the show it was clear to everyone around him that he was distraught. According to Gee Gee Gambill, "He went back to the hotel . . . and lay down on the bed. 'Well, that's it. I guess I just don't have it anymore,' he said." Even the usually imperturbable Colonel seemed upset. After he got up from his nap, Elvis shook his head and said, "Well, I guess I just can't bring it in like I used to." But then, according to Gee Gee, they looked out the hotel window and saw the cars backed up for miles along the freeway leading to the Astrodome. "Well, I'll be damned," Elvis said. "I guess I've still got it after all."

"The setting [for the second show] was improved," the *Los Angeles Times* reported, simply by taking place in the evening. In addition, "Presley's voice was stronger, the stage rotation smoother and the pace sharper than at the matinee." Elvis himself, Hilburn concluded, "was masterful. His voice remained the best in rock-pop music, and his stage movements, less self-conscious than last summer . . . were in perfect harmony with the music." All the high-intensity electricity and showbiz glamor that marked his Las Vegas appearances were only highlighted here, and in the end the

audience of 36,299 (a Friday-night attendance record, eclipsing the previous one by 10,000) was on its feet cheering. The Saturday matinee surpassed previous years' attendance by 15,000, and Saturday night's crowd of 43,614 set a world record for indoor rodeo performances. By Saturday, though, wrote Hilburn, an astute observer, it was obvious "that the Astrodome challenge seemed to already be wearing off. He began some of the tonguein-cheek gestures that marked the latter days of the Vegas appearances and switched lyric lines on several songs."

The Colonel watched every show from the announcer's booth, a golf cap or an oversize Stetson perched incongruously atop his head, a cigar clamped firmly between his teeth. He felt a growing sense of satisfaction as he watched the crowd give itself to Elvis with mounting fervor, while Elvis, dressed all in white and clearly sensing their abandonment, seemed to accept it almost as his due. On Saturday night Priscilla flew in, presumably to dispel the rumors which had cropped up once again, this time in the Houston papers, of a growing rift in their marriage. She attended the Sunday afternoon performance in a black see-through outfit that was remarked upon by more than one reporter. There was a press conference, too, on Sunday afternoon, at which Elvis conceded that the sound system had bugged him on the first day, but that with the help of his own engineer, the problem had been straightened out. It was a big thrill to be making this appearance, he said, and he would like to do more. Officers of the rodeo presented Elvis with a limited-edition (number 343) Rolex "King Midas" watch, and Houston Sheriff Buster Kern gave him a gold deputy's badge. "I know you want to get out of town Monday," said the sheriff, "and this will help you." "How am I supposed to get out of town?" protested Colonel Parker. "Do you want me to hitchhike?" So the sheriff gave him a badge, too. In addition, Elvis collected a Stetson and five new gold records that RCA vice president Rocco Laginestra had flown down from New York to present. "I should be given an award for nerve," Elvis remarked goodhumoredly.

It was, all in all, Robert Hilburn summed up in what could be taken for the standard wisdom of the time, a capstone to "one of the most staggering reversals in the history of pop music . . . handled brilliantly by Colonel Tom Parker, a proven manager before he ever met Presley."

The Colonel was not yet done with his labors. While Elvis flew back to Los Angeles to relax and resume his karate studies, the Colonel began to put into effect some of his other long-standing plans. For one thing, he was not about to let the International take either him or Elvis for granted. Percs or no percs, plane or no plane, irrespective of Hawaiian vacations, he had informed newly named International president Alex Shoofey on the day of their final show that Elvis might very well not be returning to Las Vegas the following August. He was presently looking into an extended personal appearance tour, he told Shoofey, to be filmed over a long period of time, and he was also negotiating for a major motion picture, tentatively scheduled to begin shooting in late summer. He didn't want Shoofey to be caught short, and, of course, he was not closing any doors either, but he was sure that the hotel could appreciate his position. Evidently it did, because things were soon straightened out, and in fact, Shoofey came to him not a month later to see if Elvis might give a special performance at the hotel after a wildcat kitchen worker's strike had crippled Vegas ("The future of this resort community could well be at stake!" Shoofey wrote dramatically in his request), to which, of course, the Colonel instantly agreed, earning Shoofey and Kirk Kerkorian's further gratitude, even though Elvis was never actually called upon to perform.

Meanwhile, he continued to pursue another idea that had intrigued him for more than a decade: pay-for-view, closed-circuit broadcast of a live performance. The success and profitability of the concept had long since been established with sporting events — why not entertainment, too? the Colonel reasoned. He had originally tried to arrange just such a broadcast in 1960, when Elvis got out of the army, but ran into technical roadblocks. No one else in the entertainment field had tried it on any kind of scale in the intervening decade, though, so with his nose for firsts and financial breakthroughs of record-breaking proportions, the Colonel set his mind to the problem once again.

Two young promoters named Steve Wolf and Jim Rissmiller, who as Concert Associates booked some of the biggest rock acts into the Los Angeles area, had been pursuing him, going back to before the television special, with the idea of promoting an Elvis concert tour. After two years of letter writing, Wolf and Rissmiller, whose concert business had by now become a division of a larger and more diversified operation called Filmways, had finally gotten an appointment with the Colonel and laid out their projections for a fifteen-city tour which they estimated would net Elvis up to three-quarters of a million dollars. The Colonel rejected them out of hand. Elvis wasn't planning on doing any touring, he told them, and if he did tour, they had obligations to fulfill dating back to 1957. After the meeting Wolf and Rissmiller were left scratching their heads; they couldn't figure out what the meeting had been about, unless it was a test — and if it was, they had no idea whether they had passed or failed. They came back to the Colonel several times with various offers that met with no greater success, but then to their surprise the Colonel called for another meeting, right after the Astrodome.

This time they came in with a proposal for a single concert at the Anaheim stadium, which he turned down peremptorily but not without delivering a lecture in the friendliest manner on the necessity of their having their business more together if they wanted to be taken seriously. Then he dropped the blockbuster on them: what he wanted to do was closed-circuit.

It came as a total shock, though in thinking about it, they realized it shouldn't have. They had been talking for some time about doing a closedcircuit broadcast with the Rolling Stones, and the Colonel, they discovered early on, was exceedingly well informed. For all of his impersonations of an absentminded eccentric ("He comes to the door in a T-shirt and cap, he has these little glasses on the end of his nose, and I guess his whole thing is [to] throw you off guard"), he had demonstrated his acumen from the start, and now he bombarded them with facts and figures, ancillary rights issues that needed to be explored, and hard questions, finally asking them what they had in mind for a deal they hadn't even known they were coming in to discuss. Without giving them a chance to answer, "he gave us the deal *he* had in mind, and that was it. I mean, it wasn't an opportunity, like him saying, 'What would you give me?' He *told* us what we had to give him, and then said, 'Take it or leave it.' There was nothing in the middle."

They took it. The deal was for s1 million plus \$100,000 expenses, with 75 percent of the profits going to Elvis and the Colonel as well, once Concert Associates had collected the first \$500,000 for themselves. Wolf and Rissmiller now brought the deal to Filmways, on whom they would be relying not just for financial backing but for technological expertise, and the Filmways people almost "fell off their chairs — I mean, the scale was so large, the Colonel was talking about two hundred seventy-five cities, and the logistics of the thing were staggering." It had to be shot in Las Vegas, too, which didn't lend itself to the project as well as some other venues, and it had to be shot in four months, just a day or two before the August opening. There was, it appeared, no end to the stumbling blocks that the Colonel was prepared to put in their path, and he even critiqued their negotiating technique as he directed them to expand the broadcast on a global

basis with yet another partner who could set up deals for them in London and Japan. Still, everything was moving ahead according to schedule, with a March 15 deal memo summarizing all the terms, when Robert Hilburn picked up the story in the March 19 edition of the *Los Angeles Times*.

From the beginning the two promoters had been told that if any word about the broadcast leaked to the press, the deal was off. "We were even afraid to tell our wives. But then one day we look in the paper, and there's the story." It read suspiciously like an item planted by either the Colonel or the promoters, or both. "Elvis Presley has agreed to a nation-wide, closedcircuit TV appearance this summer that will bring in the largest fee ever paid an entertainer for a single performance." The broadcast would be "the first live closed-circuit broadcast of a music event in the U.S.," could gross up to \$5 million, and would be broadcast in color in major cities. It was no secret, Hilburn observed, that Parker and Presley wanted to expand upon the Vegas appearances. "But Parker had a problem in returning Presley to concerts. To maintain his image as 'King,' Presley needs 'super engagements'.... The closed-circuit packages are a first for the entertainment field. It is a match, both financially and in artist's prestige, for the Las Vegas and Houston engagements. In fact it would, if ticket sales match expectations, exceed them both."

The promoters were never sure where the story came from, but in any case the deal was off. Within a week the Colonel had directed the William Morris Agency to draw up a new contract, this time with Filmways exclusively — and no longer for a closed-circuit broadcast but for a concert film to be shot during the engagement itself, with Elvis to receive \$1 million, a profit split of 60-40, and 50-percent ownership of the negative. When that deal fell through, MGM, which had been proposed as the concert film's distributor and had been taken over in a stock coup by International owner Kirk Kerkorian some six months earlier, stepped into the breach with a sharply reduced offer of \$500,000 and 60 percent of the net profits, with MGM retaining full ownership of the negative and the film once again to coincide with the International booking. Perhaps as much to save face as because it continued to fit in with his goal of total synergy, the Colonel took it, seizing on the soundtrack album that would come out of the film and the fact that for a single four-week engagement at the International, Elvis would now take in an even \$1 million. The hotel would, of course, absorb many of the production costs, thus virtually ensuring that there would be profits to share, and the movie could not help but promote not just future appearances in Vegas but wider touring as well. From the Colonel's point of view, it was a matter of realpolitik. There was little choice between an unattainable ideal and cold, hard cash.

INJUNE ELVIS RETURNED to Nashville to record. Despite the dazzling success of the American sessions, both commercial and artistic, he did not go back to the Memphis studio for a number of reasons, most of them political. The continued sparring with Chips had merely served to reinforce all of the usual jealousies within the Elvis camp and lend further credence to the charges already brought against the producer (greed, disrespect, badmouthing Elvis) by various parties with various axes to grind. Also contributory was the situation of Elvis' official producer, Felton Jarvis, who might have had legitimate reason to be concerned if Chips had maintained an ongoing role but whose ultimate position was defined by contractual terms virtually dictated by Elvis himself.

Everyone knew how fond Elvis was of Felton. They had a relationship based on shared enthusiasms and mutual respect, and Elvis liked to say of his producer that he was the only man he knew who could get along with anyone. He wanted Felton with him not just when he recorded but when he appeared in Vegas, and if he were to decide to go out on the road, he expected him to be there, too — he wanted Felton, in other words, at his beck and call. RCA meanwhile was growing increasingly unhappy with this arrangement. Elvis was not the only act to whom the producer was assigned — and who was paying his salary, after all, during all of his extended absences from the studio? At the same time, Felton had worries of his own. He was beset with health problems — his blood pressure had reached dangerously high levels — and he was beginning to feel like he was being pulled from all sides. Finally Elvis said to him, "Why don't you just quit, produce my records, and not do anything else?"

So on June 1, three days before the scheduled start of the session, that is exactly what Felton did. With a new contract from RCA guaranteeing him \$750 for every master recording of Elvis' that he delivered and giving him a 2-percent royalty override, Felton left the security of a staff producer's position in exchange for what many felt (and common sense certainly told him) was the whim of a much less disciplined, and much less predictable, master. He guaranteed to deliver between fifteen and thirty-five sides from this first session, which many of his friends felt could be the immediate downfall of the whole arrangement and led Felton's wife, Mary, to believe that RCA or the Colonel was just trying to set him up. But Felton trusted his friend. He knew he was taking a chance, but Elvis had given him his word. The real problem, he confided to his wife, was not with Elvis anyway. It was with the material — that was what he was really worried about. But he felt sure they could get around it somehow.

The other significant problem was a technical one. The studio had been converted from a simple four-track to a sixteen-track board (with an intermediary eight-track setup in 1969) since the last time that Elvis had recorded there. What this meant was that the possibilities for overdubbing were enormously increased with all those open tracks. This carried with it, however, the same headache of selection that comes with any other exponentially expanded menu. In fact, to be utilized properly, the sixteen-track board required a major shift of aesthetic sensibility, since with the new setup a great deal of the ambient feeling of live recording was lost; that sense of audio roominess and space on which Felton and his engineer, Al Pachucki, had grown up was now sacrificed to a more distinct separation of sound, along with the far greater variety of choices and — for the technologically adept — the greater sonic possibilities. Unfortunately, neither Felton nor Pachucki was much more of a technician than their client, so what Felton focused on was the band.

This was his opportunity to finally put into effect the plan that had been in the back of his mind since 1966, when he first went to work for Elvis. Elvis had had his own session band in place when Felton came into the picture. Most of them had been around since 1958, with Scotty and D.J. going back to the beginning. Over the past four years Felton had brought in the occasional outside musician, but for the most part he hadn't tried to tinker with the setup. Now, after a two-year break from Nashville, with the television special, the American recordings, and Vegas all having intervened, he felt emboldened for the first time to bring in his own musicians, retaining only multi-instrumentalist Charlie McCoy and old Atlanta buddy Chip Young from the previous lineup. Otherwise, the new band was the original Muscle Shoals rhythm section, with whom Felton had first worked when he started recording Tommy Roe in 1962. It was Felton who had encouraged them to break away from Rick Hall's studio, where they were the foundation for the Muscle Shoals soul sound, and it was Felton who had first urged them to come to Nashville and given them work just after his own arrival in town. With James Burton taking lead guitar, it was a band

that could keep up with Elvis in anything he chose to do. These were players just as capable of reflecting Elvis' contemporary sensibilities as the American rhythm section, and, not at all insignificantly, they were a group who owed their jobs and loyalty to Felton alone.

Everyone in the band was excited about working with Elvis. David Briggs, who had played keyboards on the 1966 gospel session which had marked Felton's debut, was kidded by the others for carrying around a picture of Elvis in his wallet, while Jerry Carrigan, the brash young drummer whose obstinate brush cut seemed to announce that he would back down for no man, was thrilled just to be included. It was the bass player, Norbert Putnam, though, just beginning to branch out into production (he would have a huge hit the following year with Joan Baez' "The Night They Drove Old Dixie Down"), who subsequently summed up the band's collective feeling best. "I was scared to death," he recalled. "I remember standing in the bathroom looking in the mirror and saying, 'Dear God, don't let me be the one to screw up this session. Don't let me be the first guy to ruin it!'"

Felton wanted them playing when Elvis came in the room; he wanted them to create an up mood, he said, which everyone found a little odd, but no odder than the retinue of yes-men who entered the studio when Elvis did. As outsiders by definition (they came from Muscle Shoals, after all), each band member prided himself on his independence nearly as much as Chips, and it grated on them to a man to see Charlie fetch the water and wipe beads of perspiration from Elvis' face, to wait while Richard Davis wheeled in a big rack of clothes from which Elvis selected a fresh outfit three times on the first night alone, to witness Lamar leap up in the air at the conclusion of every take and exclaim, "It's a hit!" Even for James Burton, no outsider by anyone's definition but a newcomer to studio work with Elvis, it was a kind of education to watch Lamar and Freddy competing to get their demos heard, as Elvis looked on with a combination of amusement and scorn.

And yet for all of the extravagant show, it was no less evident to the musicians that Elvis felt comfortable in their company, and he made them feel just as much at home with him. At first it almost seemed to them like he would just as soon have put off the actual business of recording indefinitely and sit around and swap stories and sing old gospel songs. When he finally got down to work, though, they were amazed. Freddy's and Lamar's songs were god-awful in the opinion of nearly everyone in the

room, and Jerry Carrigan in particular bridled when the band was told, "If he smiles at you, you smile back, or he'll think you don't like him." But when it came down to the music itself, Carrigan observed, "it was like doing a show. He'd dictate where the accents were, you watched his hands, he'd go through the gyrations — it was a new band, and he was really inspired, his eyes were really bright, and you knew, *This was a star.*"

Musically the demands he made on them were both greater and less than what they had come to expect from session work. Elvis was hard on drummers, Carrigan quickly discovered, just as Briggs knew that he was hard on piano players, because he required so much intensity and unrelenting physical play. Everything, they soon realized, came down to feel. Despite the sixteen-track board — whose principal advantage, if you made proper use of it, was to ensure maximum separation — Elvis insisted that they all group tightly around him and watch his every move so as to be ready to shift gears at the slightest inclination of his head. The only way Al Pachucki could get a sound level sometimes was to stop the take by pleading some technical foul-up.

Otherwise, technical considerations scarcely entered into it, as, often, they would just be starting to learn a song when Elvis declared that they had a master take. It wasn't laziness exactly, just a different philosophy of recording and one with whose end result they were not always satisfied (in fact, it would be more accurate to say that they were more often *embarrassed*). But whatever their feelings in retrospect, there was one thing, Norbert recognized, that they had no need to be embarrassed about. "After I became a record producer, I started to understand what making a record is all about. As a player, I just wanted the rhythm section to be flawless and have a great feel. But once I became a producer, I started to understand that what a great artist has to do is to try to express through his voice the emotion of his message. And of all the artists I ever knew, Presley was absolutely the best at that."

The first NIGHT SERVED as something of a paradigm for the entire session. They started out with two of Freddy's new Euro-styled ballads, the kind of heavily scored, overblown compositions typical of Carlin, the British song-publishing catalogue Freddy had taken over from Jean and Julian Aberbach four years earlier, with the understanding that he would continue to maintain his cousins' former company "in trust." The extent to

which that trust had broken down became evident with an acrimonious blowup in October of 1969 (it essentially revolved around Freddy's belief, backed up by legally defensible action, that Carlin was an exclusive enterprise of his own), and now the cousins barely spoke. The Aberbachs had subsequently done all they could to get Freddy dismissed from his positions with Elvis Presley and Gladys Music, but the Colonel, for all of his reservations about "Herr Beanstalk," would not hear of it. As a result, Freddy remained tied to the two Elvis Presley publishing companies while pushing songs from his own British catalogue almost exclusively (Lamar took care of the Hill and Range catalogue proper), with Freddy's numbers governed by the time-honored Hill and Range cut-in formula when Elvis recorded them but otherwise unencumbered and serving the exclusive benefit of his rapidly evolving empire.

To Elvis it mattered little; he was just looking for good material. Nor was he above the Wagnerian grandiloquence of a song like "I've Lost You," the second of Freddy's offerings, which was just the kind of melodramatic portrait of a disintegrating marriage that seemed to really hit home. After seven serious takes, he found a brief diversion in the Golden Gate Quartet's "Born Ten Thousand Years Ago," which he had been fooling around with for the past several years. But then Freddy got him back on track with "The Sound of Your Cry," yet another sentimental extravaganza, on which he expended eleven excruciating takes. It went on in this schizophrenic fashion for the rest of the night, with two quick passes at Sanford Clark's 1956 rockabilly hit, "The Fool," which emerged while Elvis was waiting for Lamar to furnish him with lyrics for "Faded Love," the Bob Wills westernswing classic that had suddenly taken his fancy. After a couple of ragged but wonderfully high-spirited bluegrass numbers, with little parallel in the Elvis canon outside of "Blue Moon of Kentucky," they finished off the evening at 4:30 A.M. with a Ben Weisman adaptation of "Run Along Home, Cindy," an up-tempo folk song that Elvis took to readily enough and that gave Freddy four cuts to Lamar's none.

Felton must have breathed a sigh of relief. They had gotten something like seven masters in a single night's work, and there was no reason to think the pace would let up. In the next couple of nights they recorded an additional twelve masters and a studio jam. Some of the songs were better executed than others, some better suited to Elvis' style. Freddy retained his lead over Lamar, getting most of the big numbers — but only one or two songs gave Elvis the opportunity to really sink his teeth into them, and not necessarily those provided by either Freddy or Lamar. "You Don't Have to Say You Love Me," for example, was a song that Elvis had been drawn to ever since Dusty Springfield had first put it out in 1966. An Italian melody with bittersweet English lyrics, it had something that clearly touched Elvis, as he threw himself into painstaking efforts to work out an appropriate arrangement, then recorded the song in three quick takes. Simon and Garfunkel's quasi-gospel "Bridge Over Troubled Water" was another strong number to which he gave himself over completely, even if his very commitment to the song led him to overpower it without Chips' firm hand to rein him in. By the end of the third night they had twenty tracks in the can, and Felton had every reason to feel jubilant. Except that they had virtually run out of material.

Things might very well have ended right there. They began the fourth night with yet another of Lamar's maddeningly indistinguishable Shirl Milete compositions (an opinion voiced with some asperity by the singer himself), when all of a sudden Elvis abruptly shifted gears and launched into a soulful version of Eddy Arnold's 1954 hit, "I Really Don't Want to Know," written by one of Elvis' favorite songwriters, Don Robertson. With that, the session all at once took on a whole new cast, as Elvis and the band ran through one classic country number after another, almost as if everyone had been waiting for just such a moment to occur. First they polished off "Faded Love," the song whose lyrics Lamar had been searching for on the first night; next came Ernest Tubb's "Tomorrow Never Comes"; then Ray Price's "Make the World Go Away," Willie Nelson's "Funny How Time Slips Away," and a churchy variation on Stonewall Jackson's "I Washed My Hands in Muddy Water" very much influenced by Charlie Rich's 1965 version.

What distinguishes each of these songs is their openness to interpretation (all would have equal validity in a rhythm and blues, country, or, lyrics aside, gospel context), the enthusiasm with which Elvis attacks them (almost all are first takes), and, perhaps not coincidentally, the fact that nearly every one of them is sung just a little too fast. It is clear, though, that Elvis has found his groove, and when at the end of the evening David Briggs pushed him to recut "Love Letters" strictly because Briggs felt his piano part on the original 1966 version could be improved, Elvis never hesitated, entering into the old Ketty Lester rhythm and blues ballad with a will, not really improving on the original (which, whatever Briggs' reservations, has a delicate beauty of its own) but proving what Elvis continued to believe all through his life: that every moment was capable of providing a fresh new take on the subject.

By the last night everyone was a little weary, and Elvis stuck strictly to Freddy and Lamar's program, laying down five more tracks and winding up five days of recording with an astonishing thirty-four masters. The musicians were almost in a daze. In one sense it had been a highly frustrating experience, in which nothing was ever completed as they felt it should be - nothing was ever revisited, mistakes were never addressed; it was just pack up and move on to the next number once a proper tone had been established. In another, more important respect, though, it was an experience they wouldn't have given up for the world, the sense of being caught up in the eye of the storm. It was a phenomenon that none of them had ever really witnessed before either: the costume changes, the sense of panoply and intimacy inextricably combined, the picture of Elvis prowling around the studio putting on a performance for them, for the guys, and for the pretty dark-haired actress he had flown in for the session, too. In the end, Norbert realized, all it really came down to was feel. "It amazed me that he [would record] these very guttural, primitive songs - I call them 'primitive.' But I came to understand, he expressed so many things with his voice — the lyrical content had nothing to do with what was happening [for] him. He was the only artist I ever worked with that could zing you — with the 'Elvis thing' — whenever he wanted. He was the greatest communicator of emotion that I ever knew, from beginning to end."

 $E_{\rm continued}$ to make preparations for the rest of June, as the Colonel continued to make preparations for the movie and the Vegas opening in August. He informed the hotel that he was planning a special "ELVIS PRESLEY SUMMER FESTIVAL" this time, for which he would be shipping one hundred thousand special menus, fifty thousand 8 x 10 photos, one hundred thousand special postcards, sixty thousand four-color catalogues, twenty thousand souvenir photo albums, and twenty-five gross of special imitation straw hats, which hotel employees would be expected to wear throughout the engagement, all furnished in keeping with the terms of the Colonel's contractual understanding with the International. With Freddy he continued to be insistent that all i's had to be dotted, all t's crossed. They needed to be sure that every song that was to be used in the movie was con-

trolled by their publishing; there could be none of the kind of foul-ups that had occurred in the past. "Baron Bienstock must be fully aware that this is not a playtoy," he wrote to Julian Aberbach, in full awareness of the Aberbachs' quarrel with their cousin. "Unless there is a 100% serious attitude towards this project, we will have to research the possibility of handling it ourselves with a new, fresh company," he declared in his March 26 letter, thus raising the specter of a break not just with Freddy but with the Aberbach brothers as well, in case they were thinking that Freddy might sink on his own.

Rehearsals started in Los Angeles in mid July. Among the more than sixty songs rehearsed were sixteen from the June session, including some of the most ambitious. "You Don't Have to Say You Love Me," "Bridge Over Troubled Water," "I've Lost You," and "Heart of Rome," the last a challenging vocal piece on which they had failed to achieve a satisfactory master, were all extensively worked up, along with hard blues, tender ballads, and even "Froggy Went A-Courtin"" (not a serious contender). By the time they left L.A. on August 1, a good deal of film footage had already been shot. Ronnie Tutt was a welcome returnee on drums, new arrangements and orchestrations for the show were being written out on an almost daily basis by Glen D. and David Briggs in Nashville — but Elvis didn't meet his new orchestra leader for the first time until he got to Las Vegas.

Joe Guercio, a well-traveled music business hipster from the old school, had been hired to replace Bobby Morris as music director of the International just a few weeks before. A forty-two-year-old native of Buffalo, New York, he had worked with Patti Page for several years (he was the pianist on her 1953 hit, "How Much Is That Doggie in the Window?," the song that has frequently been cited as the red flag waved in front of the onrushing forces of rock 'n' roll), then Julius La Rosa, Steve Lawrence and Eydie Gorme, and Diahann Carroll, before finally landing in Vegas for good. Not surprisingly, he came to his new job as no great fan of Elvis Presley's music, which he was inclined to dismiss as little more than an amateur endeavor in the glitzy finger-snapping world that he had come to inhabit, an impression very much reinforced by his first meeting with the Elvis Presley organization.

"They came in, and they had no library. They just had their front line rehearsed, and they had all these charts, and they just come in and dump them on the stage, and I'm sitting there with twenty-five musicians! I said, 'What is this?' And they said, 'We'll let you know what we're going to do.' And I said, 'No, you guys are going to sort this stuff out. I'm not going to look through all this. I'm not a librarian.' I was pissed off from the day we met."

Glen D. offered to help sift through the material, which cemented a relationship between Guercio and the keyboard player, but rehearsals didn't go a whole lot better. As in the past, orchestra and rhythm section rehearsed separately to begin with, with the two joining up only at the end. "Then Elvis comes in, and they didn't introduce me at first, he just comes in and waves and calls a tune, and the rhythm section started playing. So I had the guys bring the tune up, and I said, 'When he hits the seventeenth bar — 'cause we had to pick a spot to come in on, I'm not going to direct Elvis Presley's players, they're all King Kong. I said, 'We'll all just come in on bar seventeen.' And I brought the band in then, and that's the first acknowledgment I got: he turned around and looked at me.

"The first band break they brought me down to meet him. Now it was time to meet King Henry the Eighth. We go down, and Joe Esposito says, 'This is Joe Guercio,' and I had a baton — I used to always use a stick. So he looks at the stick, and he says, 'Good job, maestro.' From that day on he never called me by my name. After the break he runs another tune; I don't remember what it was, but he stopped — he's trying to find an ending and trying to find an ending, and I say, 'That ending doesn't make it.' I said, 'Let's try doing this. Brass, give me a D.' And we came to an ending, and he loved it. And he'd turn around from then on when we started to come in. I was never into conversation with him; it was all eye takes. I'd get one second: I knew if it was right, I knew if it was wrong, I knew if he was getting off on it. It was [snap-of-the-finger] communication."

Afterward, Joe Esposito asked him how he thought it had gone. It was like "following a marble falling down concrete steps," Guercio responded with typical frankness. The next day he arrived at his dressing room and couldn't get in the door. "I finally push it open, and there must have been three thousand marbles on the floor and a sign on the mirror: 'Follow the marble.... Me.' From that day on, it was like I was one of the gang."

The rehearsals proceeded without further incident. It was a difficult, ambitious, and somewhat daunting task to try to organize such a large repertoire in such a short period of time, but Guercio and Glen D. threw themselves into it wholeheartedly, writing out new arrangements, refining old ones, trying to address some of the problems of not having a proper library or a systematic prior approach. Many of the orchestrations were written out in what Guercio contemptuously referred to as "'movie arrangements,' some were written for this size band, some weren't, and none of the rock shit was in there — none of the rock 'n' roll stuff had any charts." In the end, though, they managed to surmount most of the obstacles and to Guercio's amazement were actually ready on opening night.

"Opening night was when I was impressed by Elvis Presley. I mean, I've been onstage with a lot of stars — I hate to let the air out of their balloons, but they have no idea what a star is. Jesus Christ! It was unreal. It was just a group of songs, very little production — it wasn't as organized as a lot of Vegas shows. But, boy, if you want to talk about going out and grabbing people — Elvis Presley was a happening, and what he had going will never be again. There was a vibe you could pick up in the audience — it was unbelievable. I'm not going to say to you that musically it was the best in the whole world. It was charisma. He just loved to put other people around his little finger and do it, and he did.

"I don't think he saw himself at all. He was like a free spirit with the audience. I mean, with other performers it's here to there, they're disciplined people, but he was so undisciplined it was a joke. He was like a floater, man, he would just get into every seat in the joint. I don't think he was ever really at ease onstage. He would be floating, and then every time he felt an insecure moment, he would turn around and do a ha-ha to somebody, go to Charlie for a minute or somebody else — but he would always come back to home base. You talk to a lot of people who'll say discipline makes a star. Horseshit! Charisma makes a star. Sinatra, Michael Jackson, Streisand — he walked out there, and there was a whole other feel. He could walk across the stage and not even have to open his mouth."

Cary Grant came backstage after the show and pronounced him "the greatest entertainer since Jolson." To Robert Blair Kaiser, on the other hand, a former political correspondent for *Time* who was doing a feature for the *New York Times Magazine*, the whole thing was a bit of a letdown. MGM's five giant Panavision cameras seemed to distract Elvis, Kaiser reported, and he appeared frustrated by persistent sound problems and maybe a little bit thrown by the star-studded makeup of the audience. He was jittery enough that he even needed a lyric sheet for "I Just Can't Help Believing," one of the new songs in his act, and after the strenuous karate exhibition that now accompanied "Polk Salad Annie," he remarked, "I feel like an old stripper." Whatever self-consciousness Kaiser may have detected, however, Guercio's reaction is ample testimony to the compelling nature of his performance.

The Colonel, meanwhile, strolled confidently up and down the aisles, cigar in hand, "Elvis Summer Festival" imitation straw boater atop his head, greeting celebrities and fans alike with equal aplomb. He explained his concept of promotion to the *New York Times* reporter on the following day ("he said something," reported Kaiser, "about giving the people something special, something that would buoy them up, in the midst of this national recession"), made clear that he had no time for fancy financial legerdemain ("he has no investments of his own and he lets others [i.e., Elvis' father, Vernon] handle Elvis' investments. If he were Elvis' business manager, too, he wouldn't have time, you see, to put out all the banners and pennants and billboards. He only has one brain!"), and stressed the totality of his commitment.

"The Colonel," Kaiser observed, "always makes sure that he negotiates from a position of strength, always sure of every little detail, always thinking months and years ahead." Up till one the previous night, he was at his desk at eight o'clock that morning, working out last-minute details on the abbreviated tour for which he was at just that moment completing arrangements. Later in the day he would make the formal announcement: Elvis would be appearing in six cities, starting in Phoenix on September 9, two days after the Vegas engagement was over. RCA would promote the first date, Colonel was keeping Tampa for himself, but the promoters for the rest of the tour would be a group known as Management III, which consisted of a one-time MCA talent agent named Jerry Weintraub, who had just taken over the management of an unknown singer named John Denver; a concert promoter named Tom Hulett, who, with his Seattle-based company, Concerts West, had helped create the full-scale, modern-day rock tour with artists like Led Zeppelin and Jimi Hendrix; and Terry Bassett, a Dallas entrepreneur who, together with Seattle businessman Lester Smith and entertainer Danny Kaye, had provided the start-up money and working capital for Concerts West.

There would be one hundred security guards in each city, the Colonel announced, Elvis would travel from hotel to concert site in an armored truck, and ticket prices would be maintained at a reasonable level. "We are very happy with what we will receive for this tour," the Colonel declared, without specifying exactly how much that would be, "and realize that it will also put Elvis back in front of his demanding millions of fans." Elvis himself, according to *Commercial Appeal* reporter James Kingsley's account, was anticipating a worldwide tour in 1971 and was "delighted that we could work out a way to go back on the road after an absence of too many years. I am looking forward to hitting the road again."

ERRY WEINTRAUB HAD BEEN COURTING the Colonel for nearly two years now. A larger-than-life, self-proclaimed show business "character," who at thirty-two was just beginning to strike out on his own, Weintraub ascribed the genesis of the association, literally, to a dream. "I woke up one night in the middle of the night, and I woke my wife [singer Jane Morgan] and said to her, 'I just had a dream that I was going to present Elvis Presley at Madison Square Garden.' And she said to me, 'Great, that's great.' I said to her, 'But I don't know Presley. I don't know his manager, Colonel Parker.' She said, 'Well, you'll find him,' and went back to sleep." Through Harry Jenkins he got the Colonel's number and started calling just about every day. Turned down again and again, he finally got a meeting with the Colonel in the steam room of the Spa Hotel in Palm Springs, and that meeting led to another meeting, until finally he felt there was some chance of putting together a tour. It was at this point that he got in touch with Tom Hulett at Concerts West, whom he had met in passing through a music business attorney named Steve Weiss.

Hulett was the one with tour experience; Concerts West at this point billed itself as the biggest concert promotion company in the country (they boasted of putting on six or seven hundred shows a year throughout the world), and it was clear from the way that Weintraub's talks with the Colonel had gone that he was going to need to avail himself not only of Hulett's experience but of a substantial amount of his company's money as well. The two fledgling partners met at the Beverly Hills Hotel just fortyeight hours before the Vegas opening, hit it off, and agreed that if Weintraub could deliver Elvis they would work together on the tour. Two days later they attended the opening as guests of the Colonel and the next day made their deal.

Hulett recognized from the first that Weintraub would be the front man, both by nature and by need, and he knew from the moment that he saw Elvis Presley perform that this was something he wanted to be involved in. "That's when I realized Elvis Presley was Elvis Presley. I mean, God almighty, when he walked onstage, the place exploded, and *he* exploded, and it was one of the greatest nights of show business I've ever seen in my life. We had our meeting with the Colonel the next day, and he had already set up the concert in Phoenix, I think just to try it, and he said, 'Lookit, we're doing this show ourselves. Why don't you set up four more dates, and here's where I want to go.' He named the cities: Detroit, St. Louis, Miami, and Mobile — it made no sense. I said to Jerry later, 'Why not Phoenix, L.A., and Oakland? — it's a route.' But Jerry said, 'Don't ask, just do it.' So I got on the phone. Jerry was, like — I mean, we were told how the Colonel wanted to do things, and even though I knew it was wrong, Jerry was afraid to question the Colonel. Which I'm sure was the right decision. The Colonel said, 'I want you to get this kind of hotel, I want the security at the highest level, I want you to get this, this, this — and then call me.' It wasn't like Creedence Clearwater Revival, for example; with them, if I wanted to rent any building in America, I'd just rent the building and then go buy the ads. The Colonel said, 'Don't touch any advertising, and don't touch any promotion. Just get the facilities.' So that's what we did."

In the end they put up \$240,000 for their four dates, with RCA fronting \$50,000 for the Phoenix show and the Colonel going it alone in his adoptive hometown. It was a foolproof system for Elvis and the Colonel, something like a glorified version of record company support, with expenses unlikely to add up to more than \$150,000 at the outside, and thus a profit of \$140,000 or \$150,000 guaranteed before a single customer walked through the door. The promoter took all the risk and, even if you projected a sell-out at every location, it would be virtually impossible for the risk taker to come out with more than \$5,000 or \$6,000 per show, based on the size of the halls. Money was not the number-one concern for anyone at this point, though. From the Colonel's perspective, he was taking the greatest risk of all: putting Elvis' reputation on the line. Tom Hulett and Jerry Weintraub, on the other hand, were looking down the road: they were determined to prove that they were worthy of the Colonel's trust.

The Vegas engagement meanwhile followed its own idiosyncratic course, as Elvis grew more and more at ease onstage and once again started fooling around both with the audience and with the band. Eventually, he settled on a loose framework for the show, which could be changed whenever the spirit moved him but served as a guideline for the remainder of their stay. Filming was confined to the first four nights and captured what had by now become his practiced Vegas routine, with lots of laughs, lots of "squirrel" jokes ("When I was in high school, they used to see me coming down the street, and they'd say, 'Hot dang, let's get him, he's a squirrel, he's a squirrel, he just come down out of the trees'"), and goofs on the lyrics of some of his most familiar songs, along with a generous dose of highly romantic, unabashedly melodramatic singing. Elvis could go in an instant from an impassioned version of "Bridge Over Troubled Water" to trotting out a "laughbox" that he would introduce one night as Colonel Parker, another as "my producer." But while the trappings of the music could in many respects be equated with the theatricality of the costume (in this case, more often than not, a white jumpsuit with bell-bottom pants and fringes hanging down from the belt), there was little question of the continued dramatic impact of the show.

The day after filming concluded, on August 14, a paternity suit was filed in Los Angeles Superior Court by Patricia Ann Parker, a twenty-one-yearold North Hollywood waitress, who claimed that her pregnancy was the result of a sexual encounter with Elvis that had taken place during his last Las Vegas engagement. He made light of the lawsuit one night when he introduced Paul Anka, noting that Anka's wife was pregnant but "she didn't put nothing in the paper about me last week, did she?," while declaring on another occasion that Priscilla, who was in the audience, knew "that I didn't knock that chick up last week either — 'cause I use birth control." And yet for all of his outward show, there was no question that he was deeply disturbed. This was in fact the nightmare he had always feared most: the loss of the love of his fans. To gossip columnist May Mann he expressed a reaction that on one level might be seen as disingenuous, on another as the purest form of shocked disbelief. "How can anyone do this to me?" he declared, seeming to seek an exoneration that went far beyond the scope of the case. "I am completely innocent."

HE KNEW HE WAS NOT. But he was bored. Vegas had become a routine just like everything else. The music remained fresh in many respects: he continued to appreciate the musicians he had gathered around him; if he was looking for someone to blame, Jerry Scheff and Glen D. both noted, it was never a member of the band, always one of the guys. But things had changed in a way that could not be quantified. Just as the Colonel found release night after night at the roulette table, Elvis sought diversion in the constant procession of women who came at his summons, as it grew clearer and clearer not just to the inner circle but to the world at large that Elvis and Priscilla's marriage was a wide-open one, at least on his end. Even Robert Blair Kaiser, the *New York Times* reporter, noted the rumors, when he described a fan from Memphis approaching Vernon "while he plunked half dollars into his favorite slot machine [and asking] him boldly whether Elvis and Prissy were getting divorced. Said Vernon easily, with only a slight pause before he pulled down the handle of the machine, 'We worked that out. Everything's okay now.'"

What Kaiser missed in his portrait of this "vitally intense young man" without any serious "self-doubts [or] seeds of discontent" was the same thing that had escaped the notice of virtually every other reporter or outside observer who had covered the story. It was something that no one on the outside was likely to pick up, given how radically it departed both from public perception and public (and self-) image: with boredom once again setting in, Elvis was relying on prescription medications to a greater degree than he had since returning to live performing. The nature and pressure of his work, his inability to get to sleep after delivering two high-intensity performances a night, was always the excuse, and there was no more problem obtaining what he wanted in Las Vegas than there was in Memphis, Los Angeles, or Palm Springs - in fact, with a doctor on call twenty-four hours a day and a company-town perspective that the first, last, and sometimes only medical priority was making sure that the show would go on, it was even easier. Elvis had long ago learned that there was always a doctor or dentist more than willing to prove himself your friend simply in exchange for being able to say that he was close to Elvis Presley, and with his own encyclopedic knowledge of the PDR (which was never far from his bed table), he was able to manufacture the appropriate symptoms for virtually any kind of medication that might take his fancy. It was still mostly sleeping pills at this point, Placidyl now, in combination with "vitamin" injections, amphetamines, or a booster shot to get him going when he awoke in mid to late afternoon. Joanie Esposito, strictly an observer, and with her opportunities for observation increasingly limited by the restrictions now placed on wives' visits, watched them all, Elvis and the guys, with a certain motherly amusement. "They'd think it was so funny, you know, to laugh at each other, to sit there and try and fight it and see who could stay awake the longest until they all finally fell asleep."

More than any single factor, though, it just seemed as if there had been

a change in the weather. To Jerry Schilling, working as a film cutter at Paramount in pursuit of his union card but showing up faithfully every weekend to join the gang, "The first couple of times in Vegas Elvis was only concerned about the show. The only thing he did at the beginning was stay up at night with the musicians and have his friends and fans up and talk about the show. By the second year he started to get bored. He still loved it — you probably wouldn't have known it, but he slowed down a little, he was a little puffier looking. That's when he began to have a lot of time to just start getting into other things."

T HIS WAS THE ATMOSPHERE that twenty-five-year-old Kathy West-moreland came into when she joined the show as high soprano Millie Kirkham's replacement on Sunday, August 16. Kathy had agreed to take three weeks out of her busy L.A. session schedule to replace Kirkham, the Nashville backup singer who had come out at Elvis' request strictly for the filming. Upon her arrival, she was met by Felton Jarvis, who welcomed her to the show, introduced her to Colonel Parker (who in turn presented her with a straw hat), and gave her a huge stack of records to allow her to familiarize herself with the repertoire. She watched the show that night, with Millie still in it, and was shocked at the behavior of the fans. A classically trained musician whose father had appeared in The Student Prince and The Great Caruso with Mario Lanza, she had "never seen anything like that in my life, and I doubt if I ever will. These women, fully dressed in these glamorous evening gowns, literally running down the tables in their high heels, knocking over champagne bottles, stepping on other people's steaks." She was also overwhelmed by the music and "by the transformation of the man I'd just met downstairs into this gorgeous, just grand charismatic person."

She was terrified when it came time to go onstage the following night, but Elvis reassured her in her dressing room. "He told me, 'Don't worry about it, just relax and have fun. Remember, we're just here to make people happy.' But then he winked and said, 'But when I point at you, you better sing something, kiddo.' So — great!"

Despite her nervousness, Kathy fit right in. Looking somewhat prim in her dark brown pants and blouse beside the relatively unrestrained Sweets, she was more than open to learning from their rhythmic improvisations and intricate vocal harmonies. "I had a separate dressing room, but I would always go down to theirs and sit with them before the show. We really developed a strong, strong friendship; they made me feel really comfortable even though we were from such totally different backgrounds, and we would work out the most incredible harmonies and sounds, syllables I couldn't even emulate today if I attempted to recall them. They were so advanced in their rhythms and harmonies and just thinking in one mind." The Imperials, too, she found completely professional, "very polished, tight, and very, very precise in their vocal projection," and even if the overall choral effect was sometimes a little ragged, with the nine voices and disparate musical backgrounds occasionally failing to mesh, there was enough give-and-take that the overall feel came through — "it did create a musical impression which really affected people. There was something for everybody."

Most of all, though, it was Elvis she was intrigued by: his ambitions, his aspirations, his personality. She got to know him at first because he was always running in and out of the Sweets' dressing room, laughing and joking and just hanging out. After a while he started talking to her about the music. He asked her if the tea she was drinking was good for the voice, he was curious about her musical background, and her father's, too, he asked her opinion about some of the great tenors in history, like Caruso and Bjoerling. She discovered to her surprise that his own ability with a song could move her to tears, even when she didn't much like the song. When she remarked upon the power that he exerted over an audience, he said that he knew he could influence people's thinking, but that wasn't his intent. "I think it's important for me to just entertain . . . make people happy, help them forget all their troubles for a while. I think that's what I'm on this earth to do."

ON WEDNESDAY, AUGUST 26, the normal routine was dramatically interrupted when an anonymous call came into the security office at the International, offering information about a plot to kidnap Elvis. The following day the Colonel got a similar call, and then on August 28 Joanie Esposito was awakened at home in Los Angeles by a caller looking for her husband. He had information, he said, about a threat on Elvis' life which was to be carried out on Saturday night during the show. Forty-five minutes later the same man called back with additional information, stating that for \$50,000 in small bills he would reveal the name of the killer. At this point the FBI was brought in, and calls went out to everyone from Elvis' lawyer Ed Hookstratten, who believed the threats were related to the paternity suit in which he was representing Elvis, to Ed Parker, Jerry Schilling, and Red West, each of whom Elvis contacted personally. "I need you," was all he told Jerry on the phone. "I'll tell you about it when you get here. The plane's on the way." When Red arrived from Memphis, Elvis was so keyed up, "he just stumbled into my arms and hugged me."

All day long the newly created security detail went over plans, and in the dressing room before the show, Elvis cried and said good-bye to his father and all his friends. He didn't know what was going to happen, he told them, but he wasn't going to let them down — and he knew they wouldn't let him down either. "If some sonofabitch tries to kill me," he said, "I want you guys to get him, I want you to rip his goddamn eyes out. I don't want him sitting around afterward like Charlie Manson with a grin on his face, saying, 'I killed Elvis Presley.'"

They all took up their stations during the show, Sonny and Jerry in the orchestra pit, Red and Ed Parker on either side of the stage, everyone packing, including Elvis, who had a pistol in each boot. There were plainclothes police officers scattered throughout the crowd, Dr. Newman (the hotel doctor) was backstage with oxygen and blood supplies, and an ambulance was waiting outside — but then nothing happened. In the middle of the show a guy in the balcony called out, "Elvis!," and everyone flinched and thought maybe this was it, but all the man wanted was for Elvis to sing his favorite song. By the end of the evening everyone was emotionally wrung out, and while the assassin-kidnapper was never heard from again, the hotel remained on standby alert for the rest of the engagement. Looking back on the situation with some bemusement, Imperials singermanager Joe Moscheo sensed that Elvis was almost sorry when the adventure was over. "It was crazy. It was like he was disappointed that he didn't get shot!"

The night after the assassination threat, Jim Aubrey, the soft-spoken fifty-one-year-old head of MGM, known throughout the industry as "the smiling cobra," came backstage after the show to congratulate Elvis on his performance. As the man who had given the go-ahead to the just-completed concert film, Aubrey expressed enthusiasm about their ongoing venture and introduced Elvis to his companion, a dark-haired twenty-three-year-old starlet named Barbara Leigh. Elvis was, as ever, the consummate host, turning his attention to Ricky Nelson and his wife, Kris, and to Joyce Bova, a twenty-five-year-old staff member of the House Armed Services Committee whom he had met in Vegas the previous August and who was his guest at the show. His attention never strayed too far from Barbara, though, and while Aubrey was occupied with something else, he took the opportunity to get her phone number. Then he turned back to Bova, another stunningly beautiful woman, whom he invited up to his suite after the show.

Bova had been enormously impressed the first time they had met, when an International greeter picked her out of the ticket line and brought her backstage to meet the star. They had had dinner together in his suite afterward, and he had struck her as sensitive, intelligent, uncannily intuitive, a real gentleman. But she had not seen him since and felt that she might have angered him by turning down a number of impulsive invitations he had extended to join him in California (she couldn't, she explained - her committee was just beginning its investigation of My Lai), and angered him even more by persisting in bringing up his marriage in the face of his emphatic insistence that it was a marriage in name only. She had made this trip determined to find out "once and for all whether Elvis and I were illusion or reality," and from the way in which he greeted her and the warmth with which he invited both her friend and her to the suite, she was beginning to think that they might be reality. From the first, though, she noticed little signs that he was different somehow from the last time they had met. He appeared boastful in a way she didn't remember. talking nonstop about the assassination threat with a bravado that seemed almost cruel, patronizing Sonny and Red in a manner that she found distasteful ("You guys were really scared, weren't you?" he demanded of them, as if he weren't). Later, in the suite, he showed signs of irrational jealousy (and they hadn't done anything but kiss!); he seemed more than ever to be showing off, for her as much as for anyone else; and, she noticed, his leg kept quivering uncontrollably. But when he asked her to stay the night, she agreed without hesitation.

After everyone left, he seemed to undergo yet another, even more disturbing transformation, taunting her when she was expecting tenderness, treating her with a kind of crude disregard for her feelings. "You can't always be questioning me, Joyce," he said. "I'm tired of people telling me how I am, or how I'm not. How they think I'm different, how they think I change from one time to another. I'm always me. You got to believe in in the things I'm able to see ahead for us." Goaded by his indifference, she was led to ask the very question which she had already discovered was guaranteed to infuriate him: How could there be an "us" when he already had a wife? "This is ridiculous!" he exploded. He had already explained all that to her. "If you're going to stay, then stay." And with that he angrily flung a black silk pajama top at her. She didn't think she would ever see him again as she slammed the door behind her.

The next day he called Barbara Leigh at home. "The phone was ringing as I arrived, so I ran in and left my suitcase in the car, and it was Elvis, which was a real shock. He wanted me to come see him that Wednesday, but it was just before Labor Day, and I had plans to go away with Jim Aubrey on a cruise. Elvis said, 'Come on Wednesday and just stay with me for [the night].' So — this is a funny story — one of the guys met me at the airport and brought me back to the hotel, and he said, 'You can't come to the first show,' and I said okay. 'But you can come to the second.' So I waited around, and Elvis comes in after the first show and said, 'Darling,' and takes my hand, and said, 'You couldn't come to the first show because Jim Aubrey showed up with another woman.' Which was a shock to me. And then he looked at my dress and said, 'We got to get you something else to wear.' So he sent me out and bought me four or five evening dresses, and then he convinced me to stay, because he played on the fact that Jim didn't tell me about this other girl. Anyway, I ended up staying and having the best time, but he got me in a lot of trouble, because Jim just sat and waited and waited for me — he didn't know where I was!"

Meanwhile he still had Priscilla to juggle — she had flown in on Monday with two-and-a-half-year-old Lisa Marie in the wake of the assassination uproar — and he was continuing to get closer to Kathy, too. They talked more and more, not just about music but about their personal backgrounds, and then one night, when she was scheduled to have a date with rhythm guitarist John Wilkinson, John didn't show up, and Sonny asked her if she could attend a little party that Elvis was giving in his suite. She went up to the suite with little trepidation; Millie Kirkham, a respectable, happily married mother of two, had told her she had to see it if she ever got the chance — it was like a movie set; and that was how it struck her, filled already with the most beautiful, glamorously dressed women when she walked into the room.

Then all of a sudden Elvis came in the front door looking gorgeous, he just looked beautiful in this black velour-type suit with

the high collar, laced so his chest showed, and I expected him to walk over to the guys, but he just walked directly over to me and sat down and put his arm around me, and I was in shock. He even said, "Excuse me," and moved the next person over and started talking with me.

Then he visited with the other people, too, but I was right there, and I don't know how long it was, maybe an hour, an hour and a half, I'm just guessing, but then he grabbed my hand and said, "Kathy, I'd like for you to come in here. I'd like to show you something." So he took me into the bedroom, and I was like, "Oh, Lord, let me —" But he assured me not to worry, that this was the only place that we could really get away from everybody, and that it wasn't just a bedroom, it was a suite with a living room with a little coffee table and sofa — and in fact we did not go into the bedroom, we were in the living room section of it. So he sat with me on the sofa, and he still had his arm around me, and he told me how much he cared about me, you know, that he was interested in me and liked me, and when he kissed me, I crossed my eyes. Like, "Come on, you've got to be kidding." I mean, with all his glamorous women, I just wasn't his type — you know, How in the world? What is this? It just didn't make sense to me.

He said, "I talked to John [Wilkinson] about you this afternoon. I called John and asked him if it would be all right if I saw you and how serious was your relationship — and John said, "Well, fine." Well, of course he did. What was John going to tell him — no? But he did have the courtesy to ask! On the coffee table was a copy of Joel S. Gold-smith's *The Infinite Way*, and I had been reading it, and was carrying a copy of it with me. I think that was what really drew us together, that was what Elvis and I immediately clicked on.

They spent much of the night talking, mainly about spiritual matters ("seeking answers and gaining an understanding"), which Kathy had been exploring seriously for the past year. Kathy told Elvis that she was a virgin, and Elvis told her that he admired her for that and that nothing of a sexual nature would happen between them unless she wanted it to. Later that night, he walked her back to her room alone, but not before telling her that she shouldn't be concerned about Priscilla, they had an open marriage but had decided to keep certain things from one another both so as not to

embarrass themselves and for the baby's sake. Before the engagement was over, she had started sleeping with him, but they were not yet intimate. He was afraid to be alone, he told her, he was still having nightmares about the assassination threat. She knew there were others, but when there was no one else around, she was glad to be the one.

THE COLONEL MEANWHILE WENT about his business. As the New York Times reporter had observed, he was a tireless worker, and once filming was over he devoted most of his energies to the upcoming tour, flying in and out of each of the six cities to check out building and security arrangements, reassembling a road team that included everyone from principal associate Tom Diskin to RCA field men like Jim O'Brien to trusted lieutenants like Al Dvorin, who had handled concessions and overseen the shows from 1956 on — preparing once again, in other words, to go to war. Even to those closest to him, he remained an enigma, a man of such fierce domestic propriety that he called his wife, Marie, three times a day in Palm Springs, frequently putting associates on the line just to keep her amused, while at the same time he could pass members of the band every night in the hall without ever saying a word. He was a man of iron will, and yet some of his closest associates were growing increasingly concerned to see him at the roulette wheel every night, dropping thousands, sometimes tens of thousands of dollars at a single play.

It was his money, he could afford it, he might well have argued. Business was going well. Most of the tour dates were sold out, and Elvis was enjoying his third Top 40 hit of the year (his fourth if you counted "Don't Cry Daddy," which had reached its peak position on the charts in January), with the July 14 release of "I've Lost You." With two more singles still to be released, two mostly live albums (the second, the soundtrack to the motion picture, would ultimately include eight studio tracks from the recent Nashville session when it came out in December), three special albums on RCA's budget Camden line, and a four-LP set entitled *Elvis: Worldwide 50 Gold Award Hits, Vol. 1,* also released by special arrangement, they had not had so much product out at one time since 1956 — but now it was under considerably different circumstances. Under the 1967 revision of their contract, Elvis and Colonel split all recording profits (beyond contractually guaranteed advances) 50–50, as well as all monies from the first dollar on any deal outside the normal royalty setup. In July the Colonel

398 💊 A NIGHT AT THE OPERA

worked out a restructuring of this agreement, whereby advances were actually reduced, thereby making Colonel a fully vested partner that much earlier at precisely a time when sales were running at an all-time high. In this way he had a 50-percent interest in virtually every new record added to the release schedule, while each special deal was a partnership by definition. The Camden albums, for example, brought in \$300,000 in extra income, Worldwide 50 Gold Award Hits another \$200,000, with both sums divided equally between Elvis and the Colonel. There were a number of other permutations and cash bonuses attached to the deal, all split 50-50. Net income from personal appearances (two Vegas engagements, the Astrodome, and the upcoming tour) could be expected to bring in another \$1.5 million, the movie represented \$500,000 clear profit, and there remained substantial publishing income plus the possibility of a second tour (all of these still governed by the original 75-25 managerial split). All told. Elvis and the Colonel between them could look to realize at least \$4 to \$5 million in actual income, on which, after all the special deals were figured in, the split might come to 55-45 before the Colonel's own promotional tie-ins with RCA, the International, and MGM were even considered.

It should have been a comfortable living for them both, but neither was comfortable. Whether it was the overheated excitement of the moment or simply an ingrained restlessness of character, each was like an alcoholic who labors at his job with dedication until the end of the working day, then takes his first drink and forfeits all control. The rationalization was always the same: nobody could say they were not taking care of business. Their effect upon those around them was so overwhelming as to almost obliterate criticism. And while each had his own loyalists, each his own partisan camp, they were both happy so long as they could do whatever they wanted; they remained, for the time being, curiously well matched.

The ENGAGEMENT ENDED IN a flurry of good humor. One night, in his introductions, Elvis called for the spotlight to be shined on Abraham Lincoln and Joseph Stalin, just to see if Lamar was paying attention; he went on making his interminable string of puns ("Bear with us, and we'll all be bare together"), restarted songs or did the ending over just to get them right, and constantly made fun of Charlie onstage, dumping water on him and other members of the band and nimbly escaping retribution. On the final night, a special 3:30 A.M. show was added (the Colonel negotiated an additional fee of \$12,500). At one point Elvis did the vocal introduction to "Hound Dog," and the band failed to come in on cue. Elvis was furious at first, turning around to give them a piece of his mind, but then a fat little basset came waddling out onstage, and Elvis fell down on the floor laughing till the tears ran down his cheeks.

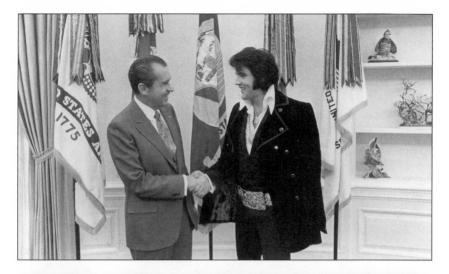

TOP: WITH PRESIDENT NIXON, DECEMBER 21, 1970. (NATIONAL ARCHIVES AND RECORDS SERVICE)

BOTTOM: WITH BADGES, DECEMBER 28, 1970: BILLY SMITH, FORMER SHERIFF BILL MORRIS, LAMAR FIKE, JERRY SCHILLING, SHERIFF ROY NIXON, VERNON PRESLEY, CHARLIE HODGE, SONNY WEST, GEORGE KLEIN, MARTY LACKER (STANDING); DR. NICK, ELVIS, RED WEST (IN FRONT). (COURTESY OF THE ESTATE OF ELVIS PRESLEY)

A COMIC BOOK HERO

WO DAYS LATER they were on the road. They flew out of Las Vegas, and Elvis insisted that Kathy travel with him on his plane, not on the band's, thereby ensuring that everyone in the troupe knew of their relationship. Phoenix was a wild success, though it prompted Robert Blair Kaiser, who rejoined them there, to raise questions about the future. "The crowd that filled the house was young," wrote the *New York Times* reporter, "screaming and stamping whenever he posed, pointed, stabbed and sprawled." They did not want to hear the new songs, Kaiser noted. They wanted the old. "How, I had reason to wonder, could Elvis ever move ahead if a majority of his people wanted him to fall back? Would the Colonel even let him try?"

These were not the questions uppermost in Elvis' mind at the moment. The Imperials had begged off on the tour; the Colonel hadn't given them enough notice, they said, and if this was intended as a negotiating ploy, it didn't work, as Colonel immediately replaced them with a group put together just for the tour by ex-Jordanaire Hugh Jarrett. The new group was good, but Elvis could sense the difference right away, and he missed the tight practiced harmonies that the Imperials contributed. He missed loe Guercio's big orchestra, too. For reasons of economy it had been decided to take out only Guercio and a single trumpet player, picking up the rest of the orchestra (fourteen more players) in Phoenix and each additional city that they played. From the start, Elvis was concerned that they wouldn't be giving the people their money's worth, and though the Phoenix pickup musicians were fine, it wasn't the same as the polished International orchestra. To make matters worse, the sound wasn't much better than it had been in Houston, with the band members barely able to hear themselves over the noise of the crowd - and there was a bomb threat, too, which Elvis didn't find out about until the next morning. When he did, he blew up at Kathy and everyone else for not telling him about it immediately, but most of all he was disturbed that once again someone should wish to do him harm.

"First this sonofabitch in Vegas wants to kill me," he mumbled as he pored over the papers. "Now this idiot wants to blow me to pieces. . . . Why?"

With RCA in charge of the Phoenix show, St. Louis was the first time that the new promoters got to show their stuff, and Tom Hulett was determined that everything should be done first-class. "I went out and hired Clair Brothers to do sound for our four dates, because I knew the show didn't have a setup and that was just something I would do. I remember Tom Diskin came over to the building around noon — he had given me stage diagrams, so when Elvis walked out it would feel like Vegas. When Diskin got there, it was pretty much ninety-five percent set up the way he wanted it, and he started moving a couple of things around. All of a sudden he notices these huge boxes being moved in on the stage. He says, 'Stop! What the hell's that?' I said, 'Tom, that's the sound system.' He said, 'We don't use sound systems.' I said, 'Wait a minute —' He said, 'There's one in the building.' I said, 'Wait a second, you can't - shit, the crowd won't be able to hear, and I'm going to get killed with refunds —' Then I realized: they hadn't worked since 1956, and there were no sound systems then, so to him here was a foreign object that Elvis might get mad at him about. I said, 'What the hell did you guys use in Vegas?,' and he said, 'Just these two speakers.' I never will forget, just these two Shures no bigger than the size of my couches if they were laid down. That was it, that was Elvis' entire monitor system, and the house system was the house system, whatever was in the facility."

Eventually it was agreed that Elvis would be the one to make the decision. If he didn't like it, they would disconnect the system, and Hulett and Weintraub, who had still not met Elvis at this point, waited shakily for the results. Elvis skipped the sound check in the afternoon, and when he came in that evening, Hulett had an instant of the gravest self-doubt. "He comes in the building with all the security in the world, and he's got all of his buddies with him, all in their sunglasses, and then Tom Diskin brings Weintraub and me back to the dressing room, and he goes, 'Elvis, I'd like you to meet the promoters —' And all of a sudden there's George Klein, who I know because he's the biggest DJ in Memphis and I had met him when I had brought Creedence and Three Dog Night in, but I didn't know he'd be here with Elvis, and George just goes, 'Tom!' and Elvis looks startled, and George says, 'Man, Elvis, we got it made. These are the best guys in America. These are the guys that do everybody. Tom, how you doing, man? I didn't know you were doing this tour.' So all of a sudden - instant credibility. Then Diskin says, 'Tom, tell Elvis about the PA system.' So I said to

Elvis, 'I hired a PA tonight, and I guess you never worked with one before, but it's what happens in big arenas. It's really great, I got you the best, and these people will do whatever you want.' And he looked sort of, 'Okay, okay,' and just dropped it.

"Well, the show started, and I'm a nervous wreck. I'm standing right by the side of the stage with Roy Clair, ready to pop the fucking button [to turn the system off], and Elvis starts the show, and in the middle of the first three notes, probably for the first time in his life, he heard himself. And he stopped and looked to his left and smiled and said, 'Ladies and gentlemen, we're going to have one heckuva show tonight.'"

It was great being back out on the road. There was a feeling of freedom that he didn't get in Vegas, and a sense that he was seeing his real fans once again, the true faithful who had first elevated him to stardom and were now going to keep him there. It helped a little bit to overcome the sour taste of the kidnapping, assassination, and bomb threats. It was almost like the old days, with the guys all around him once again: Joe and Charlie and Richard, Lamar working the lights, Sonny in charge of security — he had gotten Red, Jerry, and George Klein to take time off from their jobs, and he had even gotten his friend Dr. Nichopoulos to come out on the road with them, to take care of anything that might come up. "Isn't it fun traveling like this?" he asked Kathy as they looked out of their hotel window in Detroit. "Where do you want to go, honey?" he said. "Just say the word, I'll take us there."

The Colonel was working day and night to advance the tour, making sure that everything was right before Elvis ever hit town, then flying off to the next city early the next morning to set up all over again. Elvis flew Barbara Leigh in for the southern dates, telling Kathy he had so many relatives coming to see him he thought she had better move out. She told him she understood, but inside, "I felt as if I had been deserted and cast aside . . . and even though I understood about his family visiting and his being married, that was only an intellectual exercise. Emotionally I didn't understand at all."

Barbara was more pragmatic about it all, but she had her own frustrations with the road. She didn't really get along with the guys; "they didn't much like me because they kind of got the leftovers, and I stopped all the girls from coming around whenever I was around. It was just too exhausting for me, the other girls always competing, and I always had to put all this energy out just to keep Elvis' attention. It was interesting touring with him, but it wasn't a normal life, not with the guys all around, and it was tiring — with the hours we kept, I think it took me a week to get over it."

404 👁 A COMIC BOOK HERO

On the last day of the tour, in Mobile, Alabama, the Colonel had them booked into the Admiral Sims Hotel, where Elvis had last stayed in 1955. Put out with the accommodations (the Admiral Sims had evidently fallen on hard times and was, in Elvis' view, "the dump of dumps"), he had Joe try to find them better ones, but there were no rooms to be had. Everywhere he looked, Joe related to Elvis, he was met with the same response. They all told him, as if he should have known better than even to ask, "Don't you know Elvis Presley's in town?" At the conclusion of the tour Elvis gave out generous bonuses and had gold bracelets made up for all the guys with their secret nicknames on the back. There was a real sense of regret on everyone's part that the party couldn't just keep on going.

T O HIS CONSIDERABLE IRRITATION Elvis had to return to Nashville two weeks later to record. They needed two or three more cuts to complete the country album that had suddenly emerged at the June session, so he flew in on September 22 with every intention of finishing up in a hurry.

It was the same rhythm section, with the exception of guitarist James Burton, who had another gig and was replaced on this occasion by another Muscle Shoals alumnus, a very nervous Eddie Hinton. They started off with Anne Murray's "Snowbird," a Top 10 hit of the previous summer, then polished off "Where Did They Go, Lord?," a contemporary country ballad by Dallas Frazier and "Doodle" Owens, done in Elvis' new over-the-top style. Much like the last time, there was lots of laughter and joking around, but this time there was an edge to it that none of the musicians had seen before, a peculiar combination of jitteriness and anger that bordered on pure meanness. Elvis ordered his guys around with a peremptoriness that had no softening element, calling for water with annoyance and announcing to Felton that they'd better hurry up, he had a plane to catch. It's hard to quantify it exactly, but you can hear the mood in a strangely aggressive, wildly out-of-control version of Jerry Lee Lewis' "Whole Lotta Shakin'," which Elvis pronounces done after two takes ("We've been doing it too long already," he says before they even start) and a weirdly beautiful, ultimately inconclusive stab at "Rags to Riches," the 1953 Tony Bennett standard, which conveys some of the wired intensity of the session. Then he is gone, off to catch his plane presumably, leaving Felton behind to clean up the mess.

* * *

HE WAS BACK IN MEMPHIS two weeks later to collect his official deputy sheriff's badge in a private ceremony in the office of the new Shelby County sheriff, Roy Nixon. Although he had been an honorary deputy for several years, his new status permitted him to carry a pistol, and he proudly displayed his official officer's kit of badge, gun, handcuffs, and torch to all and sundry.

He stayed home just long enough to attend the National Quartet Convention's annual gospel show at Ellis Auditorium the following Thursday and Saturday nights, October 15 and 17, where he was introduced to the crowd by the convention's founder, James Blackwood, and flashbulbs went off as if it were the Fourth of July. On Saturday night, as he was getting ready to leave, Blackwood got J. D. Sumner (former bass singer with the Blackwood Brothers and presently the leader of his own group, the Stamps) and Hovie Lister, founder of the Statesmen, "[we all] were going to have our picture made with Elvis. While the photographer was getting ready, somebody said, 'Sing!' and Elvis started singing 'How Great Thou Art,' and the four of us made up a quartet while we were waiting for our picture!" Blackwood, a deeply religious man, was particularly pleased that Elvis seemed to have gone back to his old ways. There was a time, just before his marriage, that Blackwood had been worried about him. "I thought maybe he'd gotten away from his basic upbringing for a while, it had finally all got to him. There had been a time where for about two weeks Elvis was on my mind. I don't know why - I don't remember ever having anybody on my mind that long. It kind of bothered me, and I thought maybe he was going through something, that he needed someone's prayers. I wasn't around him enough to know, really. But my impression was, if he had changed, he'd changed back [now], he was the old Elvis, just down-to-earth and genuine. I felt like he would really like to be around people more than he was. I realized why he couldn't be. It was impossible. But I think he missed being with his friends."

E lvis: That's the Way It Is, as the performance documentary was now to be called, was hurtling its way toward a November opening. The Colonel had gotten his first look at it in a rough cut at the end of September and was deeply disappointed. Viewed today, it remains in many ways a reflection of its time, with split-screen gimmickry, a jumble of action images, and the muddled approach to rock 'n' roll that one might expect of a serious filmmaker down on his luck (with his brother Terry, thirty-nine-year-old

director Denis Sanders had produced both a 1954 Academy Award–winning short and the acclaimed 1962 antiwar picture *War Hunt*). But this wasn't what disturbed the Colonel. Not even Elvis' appearance, faintly puffy at times, not unhealthy exactly but by no means the picture of vibrant youth projected in the '68 special, upset the Colonel particularly; the fans would still love him, no matter how he looked. What concerned the Colonel most of all was the very thing that had always been his primary concern, whether the medium was records, television appearances, or motion pictures: the movie didn't focus on Elvis enough.

It would have been easy to dismiss the Colonel's criticism if he were not the Colonel. The bluntness of his language and the crassness of his concerns were in one sense measures of his lack of sophistication. But the three-page memo that he fired off to Jim Aubrey on September 24 summed up in a nutshell what was wrong with the film. Somehow the excitement that everyone took away from a live performance was missing from the screen, and the Colonel zeroed in on the elements that he perceived to contribute to this misimpression: the anticlimax of a director's ending tacked on to follow the climax of Elvis' stage show; the frequent cut-ins on Elvis' performance, "with great disadvantage to getting across seeing Elvis as he really is performing on stage"; the detracting references to the success of other big Vegas stars ("Every artist has a right to be big in his own way and there should be no comparison by voice or writing to help sell a picture. We must all stand on our own feet"); the put-downs of Elvis' movies ("I believe . . . the slurs on Blue Hawaii and G.I. Blues should be completely removed, as these were two of the most successful films ever made by Elvis ____ and they do not deserve to be mentioned as just trash in such a way"); the overuse of interview footage with the fans (all interview footage, the Colonel advised, ought to be "thoroughly checked [so that] it doesn't become monotonous and take away from the performance"); and the smarmy dismissal of Las Vegas itself for the kind of conspicuous consumption that could only alienate Elvis' true fans ("There is no reason to show an abundance of steaks in a truck in this picture when perhaps in Dalton, Georgia, where the picture may be showing, a family saved up money to see the picture and relinquished their hamburger for that night so that they could see Elvis. It has no meaning to the value of the promotion of the picture and it is much better to keep the picture down to earth as much as possible").

Most of all, without ever actually naming it, what he really seems to be objecting to is the director's implicit contempt for his subject, but he concludes his letter to Aubrey on an exhortatory note nonetheless, declaring that "Mr. Denis Sanders did a tremendous job with great enthusiasm and dedication. We are endeavoring to help put it together on a professional commercial basis." All unused performance footage should be reviewed, to be sure nothing has been overlooked. "Jim, as you know," he sums up, "Elvis, you, and I believed in this idea from the start. I tried to sell the idea for the past ten years but no one would or could see it. We are all grateful for your belief in it."

By October I the majority of the requested changes had been made and all songs cleared. By October I the Colonel had set up a November tour as well. This time he was going to give Management III the entire eightday tour, but this time, he decided, he would really put them to the test. He demanded a sI million deposit (by comparison, he had required only s240,000 from them for their four dates in September), though in exchange he offered a piece of the concessions. Jerry Weintraub took it as a challenge, and in fact, the delivery of the million dollars became one of his principal conversation pieces for the next twenty-five years. His partner, Tom Hulett, from whose company, Concerts West, most of the money came, took it more as a matter of business: this tour, focusing on the West Coast, would do bigger box office, offer greater exposure, and serve as the basis for a stronger future relationship. There was even talk at the outset of a closed-circuit broadcast from Los Angeles, though it fell through and the Colonel was once again forced to defer that dream.

Elvis spent the three weeks before the tour in California, mostly relaxing in Palm Springs. The first day he was back, on October 19, he picked up twelve pendants he had ordered from Schwartz-Ableser Jewelers in Beverly Hills. There was one for each of the guys to match the prototype he and Priscilla had sketched out at the conclusion of the tour and given to Sol Schwartz's partner, Lee Ableser, to design. Elvis had been wearing it himself for the last few weeks — a fourteen-karat gold necklace that came down in a V to a zigzag lightning bolt framed by the letters "TCB." It was the lightning bolt that compelled attention, an image that had captured Elvis at an early age, when it symbolized the transformation of everyday human being Billy Batson into superhero Captain Marvel in Elvis' favorite action comic book.

It had renewed its claim upon his attention on the September tour, when the baby-faced Los Angeles police officer who was beefing up their security told Elvis and the guys about his adventures impersonating a student on an undercover assignment at Hollywood High. He had been dating a girl and, evidently carried away with the impersonation, had slept with her. That was when he discovered the lightning bolt pendant around her neck, clear proof, he told them, that her father was the head of the West Coast Mafia, which had taken the lightning bolt as its symbol. Elvis loved the story and had the policeman tell it over and over again, but he gave other explanations for the design, too, recalling the time that lightning had split one of the statues in the Meditation Garden, as if to remind him of how fragile life could be and how tenuous was his own grip upon success. Whatever the meaning of the lightning bolt, there was no ambiguity as to what the three letters surrounding it stood for. TCB had entered the language with Aretha Franklin's 1967 hit, "Respect," but it had been a commonplace expression in black life for some time before that. It meant, simply, "Take care of business," and, with the lightning bolt, in Elvis' world, "Takin' care of business *in a flash*." The way that things were meant to be done.

He called Kathy just after he got back from Memphis, and a few days later sent a plane to bring her to Palm Springs. He was talking on the phone with Priscilla when she walked in the door, explaining why he couldn't come home right away. As soon as he got off, he expounded to Kathy once again on his views of marriage — it was the kind of thing that just didn't work for most people, he told her, and probably should be abolished.

She remained entranced by his charm, his thoughtfulness, his consideration. He recited poetry to her, read to her from his spiritual books, and shared some of his innermost thoughts with her. When he spoke about the death of his pet chimpanzee Scatter some years before ("Scatter was one of the best buddies I had around at that time"), he brought tears to her eyes. She was less moved when, on her first day in Palm Springs, they came into the dining room for Elvis' usual late-afternoon breakfast, and Elvis announced to all who were gathered at the table, "Hey, boys, you know what? Our Kathy is still a virgin." She stormed out of the room at that point and was on the verge of packing up her things and demanding to be taken back to L.A., when Elvis followed her into the bedroom and gave her his little-boy look. "I thought I saw the beginning of a smile on his face, but when he took a good look at me . . . he pulled me to him and held me close. 'Honey, I wasn't trying to shame you. I'm proud of your being a virgin. Not many girls could hold out this long. . . . Please understand, I wouldn't hurt your feelings for the world."

That night she gave herself to him, and the following night he suggested that she should go on the pill. She had to get back to L.A. right away, she told him regretfully, she had session work and television commitments to fulfill. "Just cancel out," he said. "You don't have to go to work, Minnie Mouse, I'll always take care of you." But he accepted that she took her responsibilities seriously, and she promised to come back on the weekend.

Barbara Leigh was a frequent visitor to Palm Springs during this time as well. Although she was far more worldly than Kathy ("In those days I had so many boyfriends and guys pursuing me — I think I was oblivious to right and wrong"), his relationship with her was much the same. "I think every woman that came into his life, he wanted to teach her. One of his favorite sayings was, 'When the pupil is ready, the teacher is willing.' And he gave me *The Impersonal Life*. That was really important to him. He told me his entire life story, from the first time he wrestled with a girl in the yard and saw her little white panties. He told me about how they treated him in school — he was an outcast because he was different, and it wasn't until he got up and sang in school that he won them over. He used to go down and sing with all the blacks in church — he really admired them. It was fun to be with him. We were always singing."

It was difficult to be with him, too. He was hard on the guys, and he kept Barbara hopping. "I was always up and down, getting him bottles of Mountain Valley water. 'Get this. Get that.'" He knew that she had had a child, but he didn't want to hear anything about it. Their sexual life was not what she had expected, even though he was very sweet and they made love frequently at first and he was always a wonderful kisser. But after a while, he started to have so many pills in his system "that it was very hard for him to be a natural man. It was like impossible." As in all of his relationships, he could be both cruel and kind, and Barbara soon grew accustomed though never used to the capriciousness of his nature.

Kathy came back the following weekend. At first it was just like it had been, with lots of laughter and Elvis showing her his vulnerability, too, "but that night, in the quiet stillness of each other's arms after a flurry of passion, things began to go topsy turvy. I think of the words we said to one another and to this day I regret what happened." What Kathy said was that she could no longer go on like this; she felt guilty, sinful, unworthy "because I could find no valid excuse for committing adultery, love or no love . . . Out of nowhere I said, 'We have to stop all this because I can't stand myself anymore.'"

At first Elvis didn't really believe her; he humored her until at last he realized she was serious. "Does that mean I have to get someone else, train

them just like I want them?" he snarled at her. Kathy couldn't believe what she was hearing. "Am I some kind of dog or puppy that you housebreak, train to be a good pet?" she demanded. "I'm a woman, a human being. . . . You will just have to find yourself another Gladys."

Afterward she didn't know what had made her say that. It was just an expression that she had heard as a child. He had talked to her about his mother, but Kathy didn't remember it if he had ever mentioned her name.

Eventually they made it up — he accepted her apology and came as close as he could to an apology himself. "But, like it or not, we had both crossed some invisible but forbidden boundary, entered a land that was strange to me. On the surface everything seemed the same. Elvis sang, I sang, we talked, we laughed . . . but there was a tension that hadn't been present before. . . . It was as if both of us were in mourning, but we didn't know who had died."

THEY WENT OUT ON TOUR two weeks later, starting in Oakland on November 10. The crowds were if anything even larger and more demonstrative — there was no question that Management III was going to get its money back. Elvis moved Kathy out of his room in San Francisco on the fourth night of the tour. This time she presumed it was for another woman, and her heart was broken for good. That was the night that "my dreams turned sour and ugly [and] I saw another side of Elvis I thought I would never be able to accept."

The two shows at the Inglewood Forum in Los Angeles the following day were the high point of the tour, a triumphant homecoming as frenzied in its fashion as Elvis' famed appearance at the Pan Pacific back in 1957. They took in over \$300,000 combined for matinee and evening performances, better than the Rolling Stones had done in 1969, and the day was marred only by the continuing unpleasantness of the paternity suit, when a process server masquerading as a fan served Elvis with papers at his hotel between shows. It put him in a bad mood for the rest of the day, and it was still on his mind when in the middle of the evening show he declared emotionally how much he owed to his fans. "I've got fifty-six gold singles and fourteen gold albums," he announced with uncharacteristic boastfulness. "If there's anyone out there who doubts it, if you ever come through Memphis you can come in and argue about it, 'cause I've got every one of them hanging on the wall. I'm really proud of it. I've outsold the Beatles, the Stones, Tom Jones — all of them put together." The next day, in San Diego, Richard Davis was fired and sent home, and though Elvis didn't do the firing himself (Vernon did), it was not difficult to extrapolate that a growing concern for loyalty was on his mind. To Kathy it seemed clear that he had never strayed far from that sense of exclusion that had accompanied him from childhood on. "People will come from miles around just to see a freak," he told her early in the tour as they watched the crowds arrive. It was a remark which, Kathy noted, "made everyone laugh, [and] Elvis laughed louder than anyone," but it seemed as if there was something fundamentally serious about the observation.

The tour wound up in Denver, where Elvis spent almost all of his time offstage with the policemen assigned to help protect the show. He quizzed them on their work, showed them the badges he had collected in Memphis, Beverly Hills, Houston, and Oklahoma City, and was disappointed when they reciprocated not with an official badge but with an honorary one of their own. They could get him a real badge, detectives Ron Pietrefaso and Jerry Kennedy said in light of his disappointment, it would just take a while. He told them he would come back to pick it up, maybe ride around with them a little on their beat. He seemed perfectly sincere, but they never believed he would until he actually showed up to collect his official badge some weeks later.

 ${f D}$ ACK IN LOS ANGELES he continued to pursue his new hobby. He ${f D}$ bought an arsenal of weapons at gun shops in Los Angeles and Palm Springs, contributed \$7,000 to the Los Angeles police community relations program (the largest single donation in the program's history, which may well have helped nail down the gold commissioner's badge he collected from Chief Davis), and he and the guys visited the Palm Springs and Beverly Hills police shooting ranges regularly. He had seen the movie Patton half a dozen times since its January opening, committing its patriotic lonewolf opening speech to memory in the same way that he had once memorized General MacArthur's Farewell Address. When he discovered that Patton's World War II colleague General Omar Bradley was a Beverly Hills neighbor, there was nothing for it but to seek him out, and he visited and exchanged gifts with the seventy-seven-year-old retired general on a number of occasions. He sought out Vice President Agnew, too, a regular visitor to Palm Springs, and tried to give him a commemorative gun, explaining how much he admired the vice president's patriotism, but Agnew demurred. He couldn't accept such a gift, he said, so long as he was

still in office, but, like General Bradley, he was impressed with the young man's sincerity and earnestness of purpose.

He saw more of John O'Grady, too, the ex–Los Angeles narcotics chief and private detective Elvis' lawyer Ed Hookstratten had brought in to handle the paternity case. O'Grady, a colorful character who claimed twentyfive hundred drug busts, held strong patriotic views, and had an opinion on just about every subject under the sun, fascinated Elvis with his tales of police work and his insider's knowledge of the peccadillos of various Hollywood celebrities, which he was happy to share. He dismissed the Colonel loudly as a "rude, crude sonofabitch," had no use for any of the guys except for Joe, and tried to convince Elvis that Jerry Schilling was a communist because of his liberal views.

One night the whole gang went out for dinner with O'Grady at Chasen's, and O'Grady introduced Elvis to Paul Frees, "the man of 1,000 voices," who was famous for his commercials, cartoons, and voice-overs. Frees was also an undercover narcotics agent and at O'Grady's prompting showed Elvis the federal badge he had recently obtained from the Bureau of Narcotics and Dangerous Drugs in recognition of his extensive undercover work. From that point on, all Elvis could talk about was getting his own BNDD badge.

On December 3 he started on a three-night, \$20,000 gun-buying spree at Kerr's Sporting Goods, where it took four salesmen to keep up with him as he purchased Christmas gifts both for people he knew and for people who wandered in off the street. At just around this time he got a construction permit for work on the \$339,000 house he had purchased the previous month on Monovale Drive in Beverly Hills' exclusive Holmby Hills section. The house on Hillcrest had grown too small for the life he was now leading - with all of the guys coming back he wanted more room, and he wanted grounds that offered a greater degree of privacy, now that Lisa Marie was beginning to grow up. Almost as an afterthought, he decided that Joe and Joanie, who had just gotten back from the European vacation he had given them at the end of October, needed a house, too. With two kids it was time for them to move out of the rental unit they had lived in all these years, so on December 8, after a somewhat arbitrary house search that yielded only impractical locations until Joanie finally put her foot down, he made a \$10,000 deposit on a new home for them in west L.A. He was about to surprise Jerry and Sandy with a similar show of largesse, but Joe volunteered that Jerry wouldn't be able to keep up the house payments on a film cutter's salary. So when he decided to buy Mercedeses for Barbara and himself at three o'clock one morning the following week, he got one for Jerry, too, as a kind of makeup for a gift he never knew he was going to get. He had already paid for his old friend George Klein's wedding in Las Vegas on December 5, flying in a dozen of the guys and putting them up at the International for the ceremony in his suite; he was in the midst of making similar financial arrangements for Palm Springs patrolman Dick Grob's December 11 wedding, for which he was about to present Grob, a weapons training specialist, with a brand-new Cadillac; and he had just handed over to Marty Lacker the planning for Sonny West's wedding in Memphis at the end of the month, which he was also financing.

He made all of his usual holiday-season purchases at Schwartz-Ableser Jewelers, where it was not unusual for him to spend \$20,000 to \$30,000 at a time ("He was very spontaneous," said co-owner Sol Schwartz affectionately; "he was like a kid in a candy store"). He also bought close to a dozen pairs of the new aviator-style tinted glasses he had been ordering from Optique Boutique ever since the beginning of August, when he got a prescription for reading glasses, with the latest purchases personalized with his initials and an engraved lightning bolt and TCB on a gold frame. By the time that he finally arrived home in Memphis on December 17, the bills were already starting to pile up, and Vernon was almost sick with worry. Elvis tried to placate his father the following day by getting him a new Mercedes, too, but Vernon could see the handwriting on the wall; he felt like his boy was going out of control again just like he had with that damned ranch. So he talked to Priscilla, and the two of them spoke with Colonel, and all three agreed that maybe now was the time for someone to confront Elvis.

That was what they did on Saturday the nineteenth. Vernon and Priscilla got Elvis off by himself and for once spoke frankly to him. They told him they had talked to Colonel, and Colonel agreed: Elvis was going to bankrupt himself and everyone else if things went on like this. Nobody was trying to tell him how to spend his money, but there had to be some checks and balances applied. You couldn't buy friendship, Vernon said, to which Priscilla responded with emphatic agreement. All these guys standing around with their hands out (along with Vernon, Charlie had received a Mercedes the day before, and to Vernon's mind, the other guys were just waiting in line) — did Elvis really think they were all his friends? He was just thinking of Elvis' interests, Vernon told his son. No one was trying to tell him that he couldn't have a good time.

He stared at them in disbelief. What were they talking about? It was his money, wasn't it? He had earned it. The Colonel agreed with them, they said? Fuck the Colonel. Finally he got so upset that Priscilla just left the room. With that, Elvis spun on his heel. "I'm getting out of here," he declared and walked out the door.

They didn't take him seriously at first. Priscilla had seen him blow up plenty of times like this before. He'd drive around for a while, realize he had nowhere to go, and then return in an hour or two as if nothing had happened. Elvis would be back, Vernon was convinced. He'd put money on it. Marty was supposed to be out at the house in a little while to go over the details of Sonny West's wedding, and Elvis wasn't going to miss out on that. But when Marty arrived, Elvis was still absent, and when they hadn't heard from him after a few hours, they began to worry. They called around some, they even tried the house in California, but they knew the maids would never say anything — not if they wanted to keep their jobs. So they just sat back and waited.

Jerry was the first to get any kind of word. The phone rang in his little Culver City apartment late that night. "It's me," said a voice at the other end mysteriously, as if the phone might be tapped. He told Jerry not to tell anyone that he had been in touch; he was calling from Dallas on his way back to L.A. from Washington, D.C. He wanted Jerry to meet his American Airlines flight with Gerald Peters, the new limousine driver, whom he had already called under similar conditions of confidentiality from Washington.

His face was alarmingly swollen when he emerged from the plane carrying only the incongruous little cardboard box that contained everything he had with him: toothpaste, a toothbrush, a bar of soap, a wash cloth, and a comb. Peters, a famously impressive figure who had driven for Winston Churchill and whom Elvis had dubbed "Sir Gerald" for his accent and his carriage when he started driving for them the previous month, had arranged to meet the plane out on the tarmac upon its arrival at 2:17 A.M. Jerry wanted to get Elvis back to the house right away. He was concerned about the puffiness of Elvis' face, but Elvis assured him it was just an allergic reaction to some medication he was taking for an eye infection, aggravated by his eating chocolate on the plane. And besides, they had to drop off the two stewardesses to whom Elvis had promised a ride home first. When they finally got back to Hillcrest, Jerry called a doctor and stayed with Elvis while the doctor examined him, because it wasn't someone that he knew and there was never any telling what an unfamiliar physician might do to ingratiate himself, or what he might be talked into doing.

After the doctor left with a mild warning to stay away from chocolate,

they stayed up for a while talking, and gradually Jerry began to get a sense of what had actually happened. Elvis had flown to Washington because it was the first flight out of Memphis, he said, though Jerry wondered if it might not have had something to do with that girl he had met in Vegas who worked for the House Armed Services Committee. Obviously he hadn't connected with her, though, or he wouldn't have checked out of the Hotel Washington so quickly, but he seemed pleased with himself nonetheless, as they watched the sun come up and he finally went to bed.

By the time that he got up that afternoon, he had come up with a plan. They were going back to Washington, he said. They needed to make plane reservations under the name of John Carpenter (a favorite pseudonym since he had played a doctor of that name in Change of Habit the previous year) and hotel reservations for the same suite that he had occupied the night before, under the name of Colonel Jon Burrows, another of his favorite aliases. He wanted the same limousine driver who had taken him around in Washington to meet them at the airport, and he needed Sir Gerald to cash a check for \$500 at the Beverly Hills Hotel so they would have some cash on hand. He didn't bother to explain to Jerry why they were doing any of these things, and he wouldn't listen to any of Jerry's remonstrations that he needed to be at work the following morning. The only concession that he would make to Jerry's concerns was to allow him to call up Sonny West in Memphis under conditions of strict confidentiality. Sonny could meet them in Washington, and Elvis agreed that it would be all right for him to let Vernon and Priscilla know that Elvis was safe — but no more than that. He knew he could count on Sonny to maintain security, and this way he would have Sonny with him if their business kept them in Washington for more than the twenty-four hours that Jerry was able to promise him.

In the airplane on the flight to Washington, Elvis ate some more chocolate, and his face swelled up some more. On impulse he gave away all the money that Sir Gerald had gotten for them to some soldiers headed home from Vietnam. When he learned from one of the stewardesses that Republican senator George Murphy of California was traveling on their flight, he went back impulsively to the tourist section to confer with him and, without saying anything to Jerry, started writing away furiously in longhand on American Airlines stationery immediately upon his return. When he finished, he handed the note to Jerry to take a look at it and see what he thought. At first Jerry wondered if Elvis had taken leave of his senses. "Dear Mr. President," it began: First I would like to introduce myself. I am Elvis Presley and admire you and Have Great Respect for your office. I talked to Vice President Agnew in Palm Springs three weeks ago and expressed my concern for our country. The Drug Culture, the Hippie Elements, the SDS, Black Panthers, etc. do *not* consider me as their enemy or as they call it The Establishment. *I call it America and* I love it. Sir I can and will be of any service that I can to help the country out. . . . I wish not to be given a title or an appointed position. I can and will do more good if I were made a Federal agent at Large, and I will help but by doing it my way through my communications with people of all ages. First and foremost I am an entertainer but all I need is the Federal credentials.

He had met Senator Murphy on the plane, he continued, and they had discussed "the problems that our country is faced with." He gave the President all the information necessary to reach him over the next few days, including the name that he would be registered under at the Washington Hotel and the names of the two men who would be there with him. "I will be here for as long as it takes to get the credentials of a Federal Agent," he wrote. He had done "an in depth study of Drug Abuse and Communist Brainwashing techniques" and would be glad to help in any way that he could "just so long as it is kept very Private." In case any further proof of his credentials was needed, he informed the President that he had just been nominated by the national organization of the Jaycees (though the announcement had not yet been officially made) as one of America's "ten most outstanding young men," an award that he believed President Nixon himself had once received. "I am sending you the short autobiography about myself," he concluded, "so you can better understand this approach. I would love to meet you just to say hello if you're not too busy." Then in a p.s. he added, "I have a personal gift for you also which I would like to present to you and you can accept it or I will keep it for you until you can take it." And on a final piece of paper, marked "Private and Confidential," he put down all of his and the Colonel's telephone numbers drawn up on a grid, with the Washington Hotel information underneath and a conclusion in the hopeful form of an address:

Attn, President Nixon via Sen George Murphy from Elvis Presley They dropped the note off at the White House gate at 6:30 that morning. Elvis was disappointed when the guard didn't recognize him at first, but then he perked up as recognition slowly dawned on the young soldier, who assured him that he would deliver the message at 7:30 A.M., when people started coming in to work. From the White House they went to their hotel, where the hotel doctor examined Elvis and came to the same conclusion as the doctor in Los Angeles: he would be fine if he would only stop eating all that chocolate.

Not long afterward, Elvis announced that he was leaving for the Bureau of Narcotics and Dangerous Drugs. Senator Murphy had promised to contact Bureau director John Ingersoll for him — it was Ingersoll, he reminded Jerry, who had signed Paul Frees' BNDD badge, and Senator Murphy had also promised to try to get Elvis an appointment with J. Edgar Hoover at FBI headquarters. He was wearing his new, jeweled, oversize glasses, a dark Edwardian jacket with brass buttons draped like a cape around his shoulders, and a purple velvet V-necked tunic with matching pants set off by the massive gold belt the International Hotel had given him in gratitude for his record-setting performance. Over a white, high-collared, open-necked shirt he wore the gold lion's-head pendant that he had just purchased from Sol Schwartz and his Tree of Life necklace with all the guys' names engraved on its roots and branches. If President Nixon were to telephone while he was out, he told Jerry, he could be reached at the Bureau.

He was gone no more than an hour when the telephone rang. The caller identified himself to Jerry as Egil "Bud" Krogh, deputy counsel to the President. He was in receipt of Mr. Presley's letter to the President, and he wondered if Elvis could stop by his office at the Old Executive Office Building on the White House grounds in about forty-five minutes. Jerry, who up to this point had felt as if he were doing little more than indulging a friend's whims while looking out for him at the same time, was flabbergasted. He had known when they got to Washington that they were going to do something, and he had been floored by the magnitude of Elvis' ambition and the boldness of his letter - but to get a call from the White House. . . . He immediately telephoned Elvis at the Bureau of Narcotics, where he was transferred to the office of Deputy Director John Finlator. "I'm not doing any good here," Elvis announced dejectedly before Jerry had a chance to tell him about the White House call. The instant he heard, his whole mood picked up. He would come by for Jerry in the limo in fifteen minutes. Jerry should just wait out in front of the hotel.

Krogh, meanwhile, was having second thoughts about how all of this was going to work out for him. A thirty-one-year-old junior functionary in the administration who had been given some responsibility for the development of a sweeping new drug control policy, he had received the Presley letter at about 9:00 A.M. from Dwight Chapin, another young presidential assistant who worked directly under Chief of Staff Bob Haldeman. Once Krogh had read it, he and Chapin talked, and while neither missed the artlessness of its language or presentation, each saw the potential value of the connection for an administration which so far had only managed to enlist such non-youth-oriented celebrities as game show host Art Linkletter, former Dragnet star Jack Webb, and evangelist Billy Graham in its war on drugs. Chapin then wrote Haldeman a memo recommending that a meeting with the President be held once Bud had screened Presley. "You know that several people have mentioned over the past few months that Presley is very pro the President," he wrote the President's chief of staff, concluding that "it will take very little of the President's time, and it can be extremely beneficial for the President to build some rapport with Presley. In addition, if the President wants to meet with some bright young people outside of the Government, Presley might be a perfect one to start with." Next to the last remark Haldeman had written, "You must be kidding," but he okayed the request, and now it was up to Krogh to draw up a memo for the President, explaining the purpose of the meeting and providing talking points and suggestions for future involvement that wouldn't draw guffaws from the President himself.

Sonny arrived in a cab from the airport just as Elvis pulled up in front of the hotel. On their way to the White House, Elvis was obviously nervous, playing with the chrome-plated World War II Colt .45 that he wanted to present to President Nixon and explaining exactly what had happened at the Bureau. Ingersoll had been out when he arrived, and Finlator turned him down flat. Nothing that Elvis said had been of any use: he had offered a donation to the antidrug program, but Finlator said the Bureau couldn't accept private donations. He had agreed to help further the Bureau's drug prevention program by announcing at each of his concerts that he and his guys didn't need drugs to blow their minds, they got high on music — but Finlator wouldn't budge on the subject of the badge. There was no such thing as an honorary BNDD badge, Finlator told him; badges went only to "those employees directly connected with the agency." When Jerry remonstrated that that was probably true, Elvis blew up. Fuck Finlator, he told Jerry and Sonny. He was going to get his badge from the President. Upon their arrival at the White House, Bud Krogh was doubly taken aback. First, he got a call from Bill Duncan, the head of the President's Secret Service detail, saying they might have a little problem: Mr. Presley had shown up in the West Wing lobby with a gun that he wanted to present to the President. Duncan said with what Krogh took to be "an edge in his voice. . . , 'Bud, you know we can't let him take a gun into the Oval Office.'" Krogh solved that problem by suggesting that the Secret Service agent simply accept the gift on behalf of the President, but then he encountered his second shock of the day when he saw how Elvis was dressed. Now he was really beginning to wonder if he hadn't gone too far out on a limb on this thing — or maybe even if he wasn't being pushed.

The initial interview went well, however. Everything that Elvis had suggested in his letter was borne out by his speech: his patriotism, his disapproval of the drug culture, his sincere desire to give something back in exchange for all that he had been given. He showed Krogh the two autographed pictures he had brought for the President — one of himself and Priscilla, one of Lisa Marie wearing a baby bonnet — and all the badges that he had gotten for his police work around the country. Krogh noticed that he kept scratching his neck and inquired about it, but Elvis reassured him that it was just a rash, it wasn't any problem.

At exactly the appointed hour of 12:30 P.M. Elvis and Krogh walked over to the Oval Office together, leaving Jerry and Sonny behind. It was too bad they wouldn't get a chance to meet the President, too, said the junior aide assigned to them — but Jerry wasn't so sure. "We said, 'Well, you know, Elvis will probably invite us over.' And this guy says, 'Well, it's really out of the President's hands. It requires more security if more than one person goes in there.' And Sonny said, 'Well, if I know Elvis, he's going to ask.'"

Krogh observed Elvis carefully as they entered the Oval Office. For the first time he seemed humbled by his surroundings. "He looked up at the ceiling, which had a large eagle emblazoned in the plaster. He looked down at the blue carpeting on the floor, which had another eagle centered on the Presidential seal. Eagles adorned the top of the armed services flags to the right of the President's desk. . . . I noticed Elvis observe everything and then hesitantly walk forward to greet the President. . . . As they started to shake hands, I said, 'Mr. President, this is Mr. Elvis Presley.'" Elvis was still wearing his sunglasses and holding his badges and pictures in his left hand."

After a few awkward moments Elvis showed the President his photographs and spread out his badges on the presidential desk. Then, taking off his sunglasses and laying them down beside the badges, he showed Nixon his cuff links, too, while White House photographer Ollie Atkins snapped pictures. Now showing off his belt, he spoke of having played Las Vegas recently, and the President responded awkwardly that he knew how difficult it was to play Vegas himself. Then, according to Krogh's contemporaneous memo, "the President mentioned that he thought Presley could reach young people, and that it was important for Presley to retain his credibility. Presley responded that he did his thing by 'just singing.' He said that he could not get to the kids if he made a speech on the stage, that he had to reach them in his own way. The President nodded in agreement."

At this point the conversation took an unexpected turn. The Beatles, Elvis said, as if he were tentatively trying out a new tack, had been a focal point for anti-Americanism. They had come to this country, made their money, then gone back to England where they fomented anti-American feeling. "The President," Krogh's memo continued, "nodded in agreement and expressed some surprise." Krogh meanwhile wondered where this conversation was going: Elvis had never said anything about the Beatles, either in his letter or in their pre-interview. "The President then indicated that those who use drugs are also in the vanguard of anti-American protest. Violence, drug usage, dissent, protest all seemed to merge in generally the same group of young people.

Presley indicated to the President in a very emotional manner that he was "on your side." Presley kept repeating that he wanted to be helpful, that he wanted to restore some respect for the flag, which was being lost. He mentioned that he was just a poor boy from Tennessee who had gotten a lot from his country, which in some way he wanted to repay. He also mentioned that he is studying Communist brainwashing and the drug culture for over ten years. He mentioned that he knew a lot about this and was accepted by the hippies. He said he could go right into a group of young people or hippies and be accepted which he felt could be helpful to him in his drug drive. The President indicated again his concern that Presley retain his credibility.

It was at this point that Elvis brought up the matter of the badge. He could be so much more helpful if he had some kind of official government sanction, just like he did in all the cities where he held the deputies' badges that he had brought to show the President. He described his meeting with John Finlator at the Bureau of Narcotics earlier in the day and his disappointment at its outcome. The BNDD badge was the mark of a true undercover operator, he said, exactly what he and the President envisioned his role could be: there would be no publicity, and he wouldn't be sacrificing his credibility at all. Could the President get him the badge? he wondered.

"The President," Krogh wrote in his later account of the meeting, "looked a little uncertain at this request. He turned to me and said, 'Bud, can we get him a badge?' I couldn't read what the President really wanted me to say. 'Well, sir,' I answered, 'if you want to give him a badge, I think we can get him one.' The President nodded. 'I'd like to do that. See that he gets one.' . . . Elvis was smiling triumphantly. 'Thank you very much, sir. This means a lot to me.'... Elvis then moved up close to the President and, in a spontaneous gesture, put his left arm around him and hugged him. President hugging was not, at least in my limited experience, a common occurrence in the Oval Office. It caught the President — and me off guard. The President recovered from his surprise and patted Elvis on the shoulder. 'Well, I appreciate your willingness to help, Mr. Presley.'" Elvis then presented him with the pictures and spoke of the Colt .45 commemorative issue that he had left for the President with the Secret Service. "That's very kind of you," said the President, and Elvis scooped up his badges and turned to go, looking, wrote Krogh, "like a kid who'd just received all of the Christmas presents he'd asked for." Then, as if it were little more than an afterthought, "he turned back to the President. 'Mr. President, would you have a little time just to say hello to my two friends, Sonny West and Jerry Schilling? It would mean a lot to them and to me.""

Sonny and Jerry would not have been surprised by anything at this point. By the time that they arrived at the Oval Office, it was Elvis who appeared to be in charge. "Sonny and I were just standing in the doorway in awe, and Elvis kind of good-naturedly shoved us from behind and said, 'Come on, guys, walk on in.' It was like he was saying to us, 'I've been in there, and I'm real comfortable. Don't get overwhelmed.' And yet he was really proud that he had set this thing up so Sonny and I could meet the President. He had this look on his face that he would have when he gave somebody a gift." Sonny was wearing his TCB pendant prominently outside his starched white shirt, and the photographer took a picture of the four of them, the President in that familiar hunched-over, earnest, and somewhat worried-looking pose, Sonny and Jerry with their eyes on Elvis as he makes a point respectfully but with unquestionable assurance that he is the center of all attention. "You've got a couple of big ones here," said the President, still awkwardly trying to make conversation. "It looks like Elvis is in good hands with you two guys." "They're good friends,"

volunteered Elvis helpfully. "And they're interested in helping out, too." The President then presented them all with the same gifts he had already given to Elvis: tie clasps and cuff links with the presidential seal on them. "You know, they've got wives, too," Elvis reminded the President, and together he and Richard Nixon rummaged through the President's desk drawer for suitable presents for the wives.

There was a special White House tour lined up for later, but first they were invited to have lunch at the White House mess, where, as Bud noted, staff members "accustomed to seeing heads of state, athletic champions and movie stars all gaped." Krogh then took them on their tour, but by this time Elvis had little interest in sightseeing, as secretaries popped out of their offices and he graciously signed autographs. They finally got back to Bud's office at two o'clock, with John Finlator showing up not long afterward with Elvis' badge. If the deputy director was humbled, he didn't show it, and he promised to send along the rest of Elvis' credentials as soon as they were ready. Leaving the White House, Sonny and Jerry never stopped to ponder the many strange things that had occurred on this day. As far as they were concerned, there was one thing, and one thing only, responsible for whatever had happened to them, good or bad: they were with Elvis Presley.

 $E_{\rm get\ back\ to\ L.A.}$ in time for work the next day. On their way to the airport Elvis renewed his long-standing suit to get Jerry to come back to work for him full-time. Sometime before, when his records weren't selling, George Klein had come up with the idea of getting someone to do independent promotion work for him, someone whose primary focus was Elvis Presley, not RCA. Now that the records were selling again, it seemed like a better idea than ever, and he and George were both agreed that Jerry would be perfect for the role. "He wanted to know what I made, and he said he would double it. I said, 'Look, Elvis, I know you want me to do this, but what if the Colonel has a problem with it?' He said, 'The Colonel's not hiring you. I'm hiring you. This is my business, and this is what I want you to do.' So they dropped me off at the terminal, and about two weeks later I get these business cards, printed up in red and black: 'Elvis Presley, Personal Public Relations, Special Deputy Jerry Schilling' - with a Star of David and a crucifix embossed in gold." The plan never did go into effect, because the Colonel stopped it, as Jerry knew he would, but Jerry went back on the payroll in a more amorphous capacity not long afterward, recognizing that

friendship couldn't always guarantee results but grateful that "Elvis had really tried."

It was Jerry's assumption that Elvis and Sonny would catch the next flight back to Memphis, but in fact Elvis had one last mission to carry out. He had been unable to get an appointment with J. Edgar Hoover despite Senator Murphy's intervention, but he was determined not to leave town without making one more attempt to see Joyce Bova again.

He reached her at work at the House Armed Services Committee. At first she was inclined to hang up on him, but then he flabbergasted her by apologizing for his behavior the previous August. She had to see him now after he had come all this way to Washington just to find her. Where and when could he have the limo pick her up?

She arrived with her identical twin, Janice, and Elvis amazed everyone by being able to immediately tell them apart. "Good thing I was right, man," he said. "Guy picks out the wrong woman in this spot, and he could get slapped!" After explaining how difficult it had been to get her work number, he gradually revealed — almost as an afterthought — the hectic events of the last few days. At first she and her sister thought he was kidding, but then he showed them his BNDD badge. "That sonofabitch Finlator, he didn't want to give it to me," he said, without the slightest trace of a smile, but Nixon had made him. Nixon was a smart guy, he said. "I knew he'd be glad I wanted to help him."

He persuaded Joyce to stay the night. Before they went to bed, he told her that she was a beautiful woman, but "you're a pure little girl, too, aren't you?...Joyce, I know this is new for you," he said, "but it's right, believe me." Afterward, "even though it had not happened for me, I knew he could make it happen... The fervid sex that had made him famous had, in reality, been gentler, a sweet and tender passion." The next morning she called in sick, and they had a late breakfast together. On the way to the airport he told her that he wanted her to have a private phone installed, just for the two of them. He was letting her know that he trusted her and expected nothing less than total loyalty in return.

 $B_{\rm He\ had\ gifts\ from\ the\ President\ for\ Priscilla\ and\ Lisa\ Marie\ and\ stories}}$ for everyone else. As he told Priscilla excitedly about his trip, "he was like a kid; it was like nothing had ever happened [to precipitate the trip]. He talked about how he got to meet President Nixon and told him all about

getting drugs off the streets and how he wanted to make a difference — he felt like this would be his in, I guess. It was a new challenge, and he did it; I think it really surprised him that he was able to get away with it, but he was definitely thrilled. It was the highlight of his challenges!"

Two nights later, on Christmas Eve, he dispensed four more Mercedeses, including one for Sonny for his service as security chief, one for Dr. Nick for his friendship and faithful attendance on the tours, and one for Bill Morris, who had been so instrumental both in helping Elvis to obtain his deputy's badge and in pushing for the Jaycee award. Later in the evening they all went to the Memphian Theatre, where they saw Robert Redford in *Little Fauss and Big Halsy*, and then in the early hours of the morning, Elvis stopped by police headquarters "to say hello to the men and women who had to work on Christmas. [He was] wearing a white suit and hair down to his shoulders," reported the *Commercial Appeal*, though Vernon Presley subsequently disputed the description: Elvis had not let his hair grow to shoulder length, his father asserted in a follow-up story.

Sonny's wedding three days later was a gala affair, with Elvis as best man and Priscilla matron of honor. Elvis showed up with former sheriff Bill Morris, present sheriff Roy Nixon, and their wives in the \$9,000 280-SL he had given Morris, now equipped with an official blue police flasher. He was wearing the "fur-cloth" black bell-bottom suit that had been Priscilla's Christmas gift, a white tie, a belt with gold eagles and chains, and a second belt adorned with the gold belt buckle set off by a large sheriff's star and his own official deputy number (six) with which Sheriff Nixon and some unnamed friends of the department had just presented him. He was armed with two guns in a shoulder holster, two pearl-handled pistols in the waist of his pants, and a derringer in his boot, and he could barely be persuaded at the last minute to give up the fifteen-inch police flashlight with which he had entered the building.

There was a brief reception at the church afterward, and then Elvis invited everyone back to Graceland, where the men all gathered for a picture in which they displayed the deputy's badges they had recently acquired en masse from Sheriff Nixon. Elvis sits comfortably at the center of the group, a proud paterfamilias with his legs spread slightly apart, the very picture of confidence and authority. He is flanked by Red and Dr. Nick, who kneel on either side of him. Billy Smith, Lamar, Jerry, Vernon, Charlie, Marty, Sonny, and George, plus the two sheriffs, all stand in the back holding up their police credentials with varying expressions on their faces but all seemingly seeking to convey the familiar outlaw-lawman celluloid image: for all of our differences we are family, their composite group portrait declares; we are the good guys — but don't fuck with us.

They were off to Tupelo the following day, so Elvis could collect yet another badge arranged for by his newfound friend, Bill Morris. He was jumpy, Tupelo sheriff Bill Mitchell noticed. Mitchell, an old-time fiddler who had first met an eleven-year-old Elvis Presley while playing behind him in Mississippi Slim's band, the group that backed up contestants on the WELO talent show down at the courthouse, was struck by the difference in aspect between the shy, needy child and this transparently insecure, swaggering young man surrounded by his entourage. "He paced the floor all the time. Just like you see a tiger walk a cage. Very ill at ease. Of course we talked about WELO — they were there a couple of hours, and everybody wanted their picture made with Elvis. I had gone to school with Bill Morris, so I deputized him, too." Also present were some of the friends with whom Elvis had grown up, among them the McCombs and the Farrars, who hailed him for being a "good neighbor" and presented him with a plaque entitled "Impossible Dream" that described how "a 'boy-next-door' type becomes a nationally known entertainer." Elvis took that to be quite a coincidence, since, he said, "The Impossible Dream" was the title of the next record he was planning to put out. Then he took the guys for a ride around town, pointing out the bleak urban renewal site that had once been the lively black ghetto called Shake Rag, visiting the Elvis Presley Youth Center that had finally been erected behind the home in which he had been born.

The following day, December 30, he was off to Washington once again with a group of eight that included Bill Morris, who thought he might be able to get Elvis an appointment with J. Edgar Hoover this time. The next morning Bill Morris took them all by the National Sheriff's Association, where Elvis paid for everyone to join (membership carried a life-insurance policy with it, and Elvis wanted all the guys to have one), and they visited the FBI Building, where Morris had arranged a special tour after being advised that Mr. Hoover was still out of town. Elvis was clearly excited, and the FBI agent who conducted the tour was impressed with his sincerity, "despite his rather bizarre personal appearance." The agent's memo went on to observe that "Presley indicated that he has long been an admirer of Mr. Hoover, and has read material prepared by the Director including 'Masters of Deceit,' 'A Study of Communism' as well as 'J. Edgar Hoover on Communism.' Presley noted that in his opinion no one has ever done as much for his country as Mr. Hoover, and that he, Presley, considers the Director 'the greatest living American.'

In private comments made following his tour, he indicated that he, Presley, is the "living proof that America is the land of opportunity" since he rose from truckdriver to prominent entertainer almost overnight. He said that he spends as much time as his schedule permits informally talking to young people and discussing what they consider to be their problems with them. Presley [explained that] his long hair and unusual apparel were merely tools of his trade and awarded him access to and rapport with many people particularly on college campuses who considered themselves "anti-establishment."...

Following their tour Presley privately advised that he has volunteered his services to the President in connection with the narcotics problem and that Mr. Nixon had responded by furnishing him an agent's badge of the Bureau of Narcotics and Dangerous Drugs. Presley was carrying this badge in his pocket and displayed it.

Presley advised that he wished the Director to be aware that he, Presley, from time to time is approached by individuals and groups in and outside of the entertainment business whose motives and goals he is convinced are not in the best interests of this country and who seek to have him to lend his name to their questionable activities. In this regard he volunteered to make such information available to the Bureau on a confidential basis whenever it came to his attention....

Presley indicated that he is of the opinion that the Beatles laid the groundwork for many of the problems we are having with young people by their filthy unkempt appearances and suggestive music while entertaining in this country during the early and middle 1960's. He advised that the Smothers Brothers, Jane Fonda, and other persons in the entertainment industry of their ilk have a lot to answer for in the hereafter for the way they have poisoned young minds by disparaging the United States in their public statements and unsavory activities.

It was suggested at the conclusion of the memo that in view of all of the above, not excluding "his favorable comments concerning the Director and the Bureau . . . as well as the fact that he has been recognized by the Junior Chamber of Commerce and the President, it is felt that a letter from the Director would be in order." And so on January 4 one was sent, indicat-

SEPTEMBER 1970-JANUARY 1971 👁 427

ing that "your generous comments concerning the Bureau and me are appreciated, and you may be sure we will keep in mind your offer to be of assistance." For now, though, Elvis had to get back to Memphis for the traditional New Year's Eve celebration at T.J.'s and some well-earned rest.

O^N JANUARY 9 the newspapers made public what Elvis had alluded to in his original letter to President Nixon: his selection by the national Jaycees as one of the nation's Ten Outstanding Young Men of the Year. Elvis was already in California preparing for his latest Las Vegas opening, but there was no question of his not attending the ceremony, which was scheduled to take place in Memphis on January 16. This was the public recognition he had been striving for all these years; it was in many ways for him the clearest proof of all of the American dream.

The Jaycee awards had been given out since 1939 and had gone to distinguished men in all fields, with one common denominator: they must all be under the age of thirty-five. Leonard Bernstein, Nelson Rockefeller, Orson Welles (twice), Howard Hughes, the Reverend Jesse Jackson, Teddy Kennedy, and Ralph Nader had all received the award, and Bill Morris had assured Elvis of the organization's staunchly patriotic credentials (ex-President Lyndon Johnson was a judge, and Vice President Agnew was slated to be the keynote speaker) before getting Elvis' permission to submit his name for consideration. Other honorees this year included a professor of biological chemistry at Harvard, a cancer researcher, the lieutenant governor of Minnesota, a civil rights activist from Boston, and President Nixon's thirtyone-year-old press secretary, Ron Ziegler.

He flew into Memphis with Priscilla just before midnight the night before the awards ceremony, missing the dinner that kicked off the weekend's festivities, which was attended by all nine of the other honorees. He stayed up till the early hours of the morning working on his speech, showing a single-mindedness of purpose that Priscilla had rarely seen in him, apart from his performing. "He stayed up in his office next to our bedroom writing on this little scratch pad, and he would show me what he had written and ask me what I thought. He was so nervous about making that speech. He was going to be in front of other millionaires, and he wanted to be explicit and intelligent to them. So he would read it to me, and I was amazed. I couldn't believe that this came out of him — he shocked me with the eloquence of his speech. I would have thought that he took it from something — I wouldn't have put it past him to do that, clever as he was — but I witnessed it. I mean it was just beautiful."

The two of them showed up bright and early the following morning for the prayer breakfast at the Holiday Inn Rivermont dressed to the teeth. Elvis was wearing his "fur suit," along with a pair of customized aviator glasses, his heavy gold belt, and the lion's-head medallion; Priscilla looked demure, her hair falling to either side of her scoop-neck white mini, with a large white corsage pinned to her left breast. Bill Morris sat to Elvis' right, as the guys did their best to keep photographers and autograph seekers at bay while the ceremony itself was going on.

At ten o'clock, after a speech by West Memphis political operative Deloss Walker, subbing for Arkansas governor Dale Bumpers, there was an informal question-and-answer period from which the press was excluded but at which, according to several of the participants, Elvis more than held his own. Standing next to presidential press secretary Ron Ziegler, his rings prominently on display, Elvis was asked if he felt that today's music had an adverse effect on young people. "Presley thought for a moment," the Press-Scimitar reported from its sources within the building, "and answered, 'Yes, I don't go along with music advocating drugs and desecration of the flag. I think an entertainer is for entertaining and to make people happy." The tone was very different from the formal press conference of the day before, at which black Boston City Council member Tom Atkins had challenged the ideals of the nation and the commitment of the President to civil rights, and Ziegler was left in the unenviable position of defending the status quo. The prayer breakfast ended with a query about religious beliefs. "Six or seven of the men said they didn't belong to a church," according to the Commercial Appeal, "and felt a certain hypocrisy about organized religion. But Elvis seemed to feel religion was very important in his life, not in the organized sense but in the sense that he had called on God many times for strength . . . [and] that 'God is a living presence in all of us.'"

At the luncheon he listened attentively as United Nations ambassadorappointee George Bush, filling in for Vice President Agnew, delivered a speech extolling the virtues of compromise and working within the system ("To guarantee that this country never accepts the violent answer, we need to get our great achievers to contribute in some way to our governmental system"). Afterward Elvis broke off from signing autographs and posing for photos when he spotted Sam Phillips' former office manager Marion Keisker (whom he had last seen on his final day in Germany) in the crowd. Excitedly he rushed over to embrace her and brought her back to his table, where he introduced her to Priscilla as "the lady I told you so much about," then turned to the guys and announced, "You know, she's the one who made it all possible. Without her I wouldn't even be here."

Because it was his hometown and because he was so proud of the honor that he was being given, he invited all of the award winners and Jaycee officials and their wives to a cocktail hour at Graceland, to be followed by a formal early dinner at the Four Flames, an elegant midtown restaurant. The guests all arrived promptly at five o'clock, with the household in a dither of preparation: there had never been anything quite like this at Graceland, and everyone deferred to Marty, who had made all the arrangements and seemed to know how these things were done. Once again Priscilla was amazed to see a side of her husband come out that she had never seen before, as he showed off his home with unabashed pride not just for its appointments but for what it said about his accomplishment simply in making the journey that he had made. At the restaurant, too, he played the genial host, making sure that everyone was taken care of, graciously presiding over a table set with place cards signed by the host and displaying the TCB logo in gold.

The ceremony at Ellis Auditorium at 8:00 P.M. merely continued the sense that he had stepped for a moment outside his own life. The citation accompanying his award spoke of his achievements in the entertainment field but also his many acts of philanthropy, which "he has intentionally concealed. . . . Elvis is noted for his strength of character. His loyalty to his friends is legendary. His long-standing contract with his manager consists of a mere handshake." When he got up to accept the award, he was visibly nervous. It was in his eyes and in his voice, shaky at first, then gathering confidence as he revealed himself to the world, revealed the vision that had fueled him from childhood on, capped by the words to a song that he had known from childhood but perhaps knew best from Roy Hamilton's heart-felt 1955 rendition.

"When I was a child, ladies and gentlemen, I was a dreamer. I read comic books, and I was the hero of the comic book. I saw movies, and I was the hero in the movie. So every dream that I ever dreamed has come true a hundred times. These gentlemen over here, these are the type who care, are dedicated. You realize if it's not possible that they might be building the kingdom, it's not far-fetched from reality. I'd like to say that I learned very early in life that: 'Without a song the day would never end/Without a song a man ain't got a friend/Without a song the road would never bend/Without a song . . .' So I keep singing a song. Good night. Thank you."

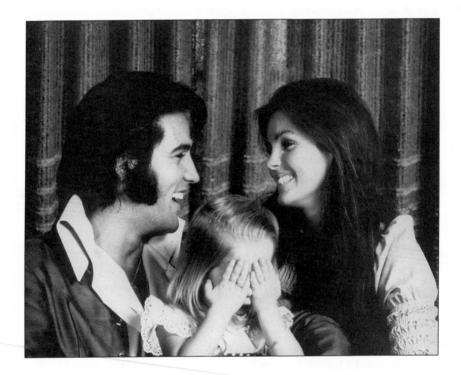

ELVIS, PRISCILLA, AND LISA MARIE, FEBRUARY I, 1971. (COURTESY OF THE ESTATE OF ELVIS PRESLEY)

A STRANGER IN MY OWN HOMETOWN

E OPENED IN VEGAS on January 26, accompanied by yet another death threat. There were flamboyant new outfits (a dark, two-piece "Cisco Kid" ensemble, with silver studs, an orange shirt, and ruffled cuffs was probably the most spectacular) and a new song list that once again leaned heavily on ballads and highlighted the inspirational, as exemplified by both "How Great Thou Art" (which had been introduced on the November tour) and "The Impossible Dream," with which he closed many of the shows. Although he had the flu during part of the engagement, and there was criticism even from the fans of some of his "off" nights, there was no question of his high spirits on the final evening as he sang a wild "Tiger Man" medley, then introduced Kris Kristofferson's bittersweet "Help Me Make It Through the Night," which seemed to reflect something of the prevailing mood. He also threw a glass of water at Joe Guercio, thanked the Colonel and Daddy and "all the people who've helped me," and stood at the end with his hands on his hips, smiling out at his fans.

Joyce Bova found him bored and distracted when she visited. He seemed boastful and self-absorbed, showed off his gun collection and badges, and one time when he wanted everyone's attention he simply sighted the chandelier with a loaded gun, then pulled the trigger on an empty chamber. There was a stunned silence in the room — until he himself doubled over in laughter. "It took only a second for his guys to join in," Bova observed, "laughing just as loud as Elvis. . . . 'Honey,' he said, finally getting control of himself . . . 'you gotta do some crazy things around here to stay sane.'"

It seemed sometimes like he almost needed to convince himself that he was who he said he was. The TCBs which had once been reserved exclusively for the inner circle were now given out almost indiscriminately to near-strangers, with matching TLCs ("Tender Loving Care") for the ladies. Jerry Schilling blew up when Elvis asked him to give International president Alex Shoofey his pendant, and even comedian Sammy Shore, not exactly an intimate, got his own. In the closed world in which they lived, the same stories were passed back and forth until they became common property, taking on the status of a larger myth whose literal origins were no longer relevant. When his Denver police friends came in at the end of the month's run, Elvis showed them his BNDD badge and held them spellbound with his tales of meeting the President — though privately the lawenforcement agents remained skeptical of some of the embellishments.

H E AND PRISCILLA RETURNED TO MEMPHIS at the beginning of March, a week after the engagement's end. Elvis had a recording session scheduled to begin on the fifteenth, and he stayed in his room decompressing for the first few days, emerging for the closed-circuit broadcast of the Ali-Frazier heavyweight championship fight at Ellis Auditorium on the eighth. The hall was packed, and "for one of the few times in his adult life," the *Press-Scimitar* remarked, "[Elvis Presley] was all but ignored"— in spite of his s10,000 gold belt, his rings, and his chains. He was accompanied by Bill Morris and nine or ten of the guys, and while the crowd seemed to split pretty much along racial lines, with most whites for the more stolid present champion, Joe Frazier, and blacks for the flamboyant Ali, Elvis indicated to the guys that he was for the ex-champ, both for his flair and his bad-ass style.

The Nashville session had been set up with three goals in mind. The first was a follow-up to the 1957 Christmas album, which had been such a strong-selling catalogue item over the years. The Colonel, always big on seasonal offerings, had been pushing for this for at least five years and now, with Felton's active collusion, had finally gotten Elvis to agree. Perhaps as a sop to the artist's own inclinations, RCA cited a new religious album as the second priority, with a pop album plus a couple of strong singles as the final goal.

Elvis appeared to be paying little attention to priorities as he started off the session with Scottish folksinger Ewan McColl's "The First Time Ever I Saw Your Face," a song he had long admired in Peter, Paul and Mary's 1965 folk version and which Joyce had begged him to record. It was very much in keeping with his increasing inclination toward high-flown, tender, and somewhat indistinct poetic sentiment, and he followed it with an anthemic version of "Amazing Grace," the eighteenth-century hymn which had recently been a Top 20 hit for folksinger Judy Collins. Next came two more Peter, Paul and Mary songs, "Early Morning Rain" and "For Lovin' Me," both written by the Canadian folksinger Gordon Lightfoot. With one more contemporary folk song that he had requested Freddy to clear, Kris Kristofferson's acutely mortal tale of sin and redemption, "Sunday Morning Coming Down," the session would have been well on its way toward an identity altogether different from anything either RCA or the Colonel had envisioned — but then it turned out that Freddy had failed to clear the song, and Elvis appeared to be in increasing physical discomfort, complaining that his eye felt like it was burning. At 1:30 A.M. the session was abruptly canceled, and Elvis returned to his hotel. When the eye didn't get any better, Dr. Nick flew in from Memphis early that morning with Dr. David Meyer, a retina specialist, and after a quick examination, Dr. Meyer administered a 100-milligram shot of Demerol, then a shot of cortisone directly into the eyeball to relieve some of the dangerous pressure that had built up. Then, against his protestations, Elvis was admitted to Nashville's Baptist Hospital.

Priscilla had already returned to California to supervise the ongoing decoration of the new house, so Elvis flew Barbara Leigh in to join him and even induced her to keep him company in his hospital bed. Dr. Meyer's initial diagnosis was confirmed by tests: Elvis was suffering from iritis and a form of secondary glaucoma, a condition aggravated in Dr. Nick's view by the dye from his eyebrows mixing with sweat and getting into his eyes. By now, with the pain abated and his fears assuaged, Elvis had come to relish the experience, and he told the story of getting the shot directly into his eyeball without anesthetic to anyone and everyone who came to see him over the next few days, including Tennessee governor Winfield Dunn.

By the time that he was discharged on Friday, Barbara had returned to California, and he flew in Joyce Bova to accompany him back to Memphis. She was shocked by his appearance; he looked worn and haggard and had little to say on the flight other than to gratefully squeeze her hand. His father met them at the airport and thanked her mutely, obviously deeply concerned. At Graceland she watched Mr. Presley help his boy up the stairs and was transfixed by this unexpectedly touching spectacle except for a moment when "I was frozen by the sight of Priscilla. A portrait of her hung by the foot of the stairs . . . shown in semi-profile with Elvis beside her . . . captured looking almost like brother and sister, both in facial structure and expression." Dr. Meyer had set up a kind of mobile hospital unit upstairs, and he gave Joyce the medication schedule, explaining to her how to use the oxygen tank, just in case it was necessary. "I knew you would come,

Joyce," Elvis said, just before he dropped off to sleep. "I knew you wouldn't let me down."

She took care of him for the next few days, in many respects the most extended period of intimacy she had ever enjoyed with him. They stayed in Elvis' bedroom, with its "velvet haremlike drapes cover[ing] the windows . . . dark wood furniture [that] was bulky and masculine . . . and a red-and-black color scheme that, in the dim light, made me feel hemmed in." His books on philosophy and religion were scattered all around the room, and she read to him from *The Impersonal Life*. It was, she felt, a very special time for them both, the surreal atmosphere only compounded by the Placidyl that they both continued to take. When she left, she asked shyly if she could take a supply of the pills with her to tide her over when she got back to Washington; they helped her to sleep.

H E SUMMONED HER TO RETURN just two and one-half weeks later. He introduced her to his grandmother, then left her alone with the old lady, who asked if she had any children and advised her "[not to] wait too long. A woman should have plenty of children. Then maybe you get lucky, and one of 'em turns out good." From what Joyce gathered, Vernon was the only one of her children that Grandma considered to have turned out any good, "'Cause," she said, "he made Elvis." Elvis was the natural subject of their conversation, because he was "the man we both adored."

He continued to show a new side of himself to her that weekend. It was an idyllic interlude for the most part, marred only by her concern about the pills, which seemed to influence nearly everything they did. She tried to talk to him about it, but Elvis just got mad or told her indulgently that he knew what he was doing. And despite all the evidence she believed that he did. Why don't you move into Graceland? he said to her one night out of the blue, as they lay in bed watching the news. Which seemed to her like a dreamy, perplexing, and unanswerable question to ask. "'Just think about it,' he said, in the most matter-of-fact, devoid-of-emotion tone, as if he were afraid to hear my answer. Which was just as well, I had to tell myself during the flight back to Washington. Because I didn't have one for him."

He was back in California just in time for the Easter egg hunt that Priscilla and Joanie Esposito had organized for the children. He spent some time at home, and he and Priscilla went to Las Vegas for their fourth anniversary, but mostly he and the guys continued to have good times in Palm Springs, racing around in dune buggies with their girlfriends in a world removed from all conventional constraints. Sometimes he would get up and preach after his own fashion, standing on a coffee table and shouting out, "Whoa, all ye Pharisees and motherfuckers," or declaring that a rich man's chance of getting into Heaven was "like a camel's ass trying to get through the eye of a needle." No one knew quite what to make of this, least of all the girls who had come for fun and now were getting Bible lessons in uniquely idiosyncratic fashion.

Priscilla was scarcely unaware. She just chose to leave it alone. "I felt that I just couldn't reach him anymore. He had bought his own image, and you couldn't have [a real] conversation with him; he would just discredit you and everything else. I don't care what anybody says — I think that deep down he wanted to be a family man. But he was serving too many masters, he was too dispersed — he had all this energy, and he didn't know what to do with it. He'd go off on one thing, and then there would be an interruption; he'd go off in [another] direction and then he was conflicted again. Because he had everything at his fingertips. It was the same with women. He wanted to have his cake and eat it, too — just like every man, I guess!"

While he was off on his own, Priscilla focused on her new passion: karate. Elvis had introduced her to Ed Parker, with whom he had been studying conscientiously for the past several months, and she was taking private lessons three times a week at his studio on Santa Monica. It gave her something to talk to Elvis about, and at Ed's instigation Elvis had contacted a Korean-born instructor named Kang Rhee in Memphis, with whom they could keep up their studies at home. Rhee taught a different kind of karate called Tae Kwon Do, which emphasized hand and leg quickness, and Ed recommended him without reservation, believing that Rhee's English was so broken and his personality so eccentric he had little to fear from the Korean as a rival.

 $E_{\rm LVIS\ RETURNED\ TO\ THE\ NASHVILLE\ STUDIO\ in\ dramatic\ fashion}$ in May, arriving for the makeup session in a black cape and carrying his diamond-and-ruby-encrusted lion's-head cane. This time there was no question of what the priorities were. The studio had been transformed by Felton into a Christmas scene with brightly wrapped boxes (all empty) under a gaily decorated Christmas tree. Lamar even dressed up as Santa

Claus, and the Colonel sent Elvis a Christmas card with a picture of himself as Santa standing next to Frosty the Snowman, and a message wishing Elvis luck with "a special Christmas album in May 1971 with the special sacred songs done by Elvis as only he can do it." It was signed, "From your pal and friend, The Colonel," with the tongue-in-cheek proviso, "This is a special inspiration photo not to be sold."

For all of the festive trappings, though, and the self-conscious air of celebration, Elvis was no more at ease than he had been at that strange session the previous September. To arranger Glen Spreen, a newcomer to Nashville, who had last worked with him at the Memphis sessions two years before, the differences were dramatic. "Instead of him coming in the control room and listening to a song and having Chips say, 'Let's do this one,' and Elvis, of course, having a response, here there was no planning, Lamar would just bring him a song, and we'd pick it up and throw it in the 'Let's do' or the 'Let's don't' corner. It was not enjoyable: we did the songs too quick. It was just, 'Let's get it over with.' I began to feel sorry for Elvis. Or sorry *about* him — I don't know which is the proper phrase. Maybe I was just seeing him more clearly; maybe I was just seeing more of the true Elvis than I had seen in Memphis. But it wasn't what I had expected, and my first thought was, I'd better figure out something else to do."

Norbert Putnam, too, was surprised and more than a little disappointed that things appeared to be getting worse rather than better. The weeklong session was less a musical collaboration than a theatrical event, and Norbert took little satisfaction in an atmosphere that he was beginning to see as fundamentally uncreative, with Elvis more interested in telling his stories and showing off his guns than he was in singing, and the Memphis Mafia always at full howl.

It was hard to say what exactly was different; certainly all of these elements might have been detected to one extent or another at the first Nashville session the previous June and were present in abundance in September. But then it had seemed as if they might simply be an aberration; now they set a tone that quickly translated to the musicians. Bored by all the self-congratulatory chatter, disappointed by what they saw as an almost total abdication of responsibility on Felton's part, they began to drift off during the increasingly lengthy breaks between songs, finding refuge in guitarist Jerry Shook's Winnebago (Shook was merely an interested bystander; he was not working the session), which was parked out behind the studio and came equipped with all the comforts of home: girls, dope, and booze. "All of a sudden," said drummer Jerry Carrigan, "nobody cared. We all felt, What can we do to get this over with? He'd settle for anything."

In keeping with the spirit of general anomie, Carrigan failed to show up at all on the second day. He had been put in charge of finding Elvis a date for the evening and evidently took his duties a little too seriously, spending much of the day running down leads, then sleeping through his late-afternoon alarm. By the time he arrived at the studio, Felton had enlisted Kenny Buttrey as the new drummer, and they finished up the Christmas album that night without him.

He was able to talk his way back into the session the following night, but even though he and Buttrey made an effective rhythm team, and despite the fact that they were now tackling more challenging material, it still wasn't any better. At Felton's prompting, Norbert managed to sneak in "Until It's Time for You to Go," a pretty ballad that Felton thought Elvis would really like by the Cree folksinger Buffy Sainte-Marie, whom Norbert was currently producing. The version that Elvis delivered was somewhat tentative, though, and even on Kris Kristofferson's "Help Me Make It Through the Night," a highlight of the Vegas show, the singing was insipid, almost an impersonation of sensitivity rather than the real thing. Finally, with "Lead Me, Guide Me," the first gospel cut of the evening, with the Imperials backing him, Elvis appeared to get untracked, but the prevailing mood undid him once again, as the session came to an abrupt halt with an impromptu karate demonstration in which Elvis disarmed Charlie and sent the gun he was holding through Chip Young's brand-new handmade Conde Hermanos guitar. Chip tried not to look too upset, but, as Joe Moscheo observed, he didn't look as if he found the incident all that amusing either.

Some of the gospel numbers that they tried over the next couple of nights gave hints of exciting new directions, contemporary approaches to gospel harmony that had earned the Imperials a certain amount of criticism within the quartet community because they verged on what was coming to be known as "Contemporary Christian" (with its incorporation of rock influences) rather than straightforward traditional religious singing. Elvis' focus was no more constant here, however, and his attention continued to wander. The musicians, too, continued to wander, especially now that there were no longer enough chairs for them to occupy, with all of the backup singers and all of Elvis' guys crowded into the control room between takes. The whole scene in fact took on a slightly surreal air, as the policemen who were there to provide security found their way into Shook's

438 👁 A STRANGER IN MY OWN HOMETOWN

van while the musicians were smoking dope and said, "Hey, boys, what are y'all smoking that stuff for? It's gonna put you to sleep. Let's give you something to keep you awake." With that they produced some amphetamines that they told the musicians "they had just confiscated from somebody, took them to jail, took their dope, and brought it to us. I remember they were some real great pills, and every time we'd see this big old guy as a paid guard at a party or something afterwards, he'd look over and say, 'Well, how are things in the wonderful world of marijuana?'"

Everybody knew that Elvis was against this kind of activity: he showed them all his federal narcotics badge and spoke with disapproval about rock groups that were known to have drug problems. The irony of someone who appeared to be stoned much of the time himself holding such views certainly struck them, but they never doubted his sincerity. "We used to joke about, 'Can you imagine being arrested by Elvis?' But we hid it from him, because we felt that he would be totally opposed." Every so often one of Elvis' guys would come out and say, "Hey, you're gonna have to come back in. You're supposed to be working." Finally Carrigan said, "'You want us to come back in, you're going to have to clear some of those people out and bring us some chairs so we can sit down. We're not going to stand around.' So they brought some chairs in, and we had to listen to Elvis tell his tales."

The session ground on for two more days, with each song coming harder than the last. In fact, except for "I'm Leavin'," another of Elvis' overthe-top ballads, to which they all committed a good deal of hard, sustained effort, the one real highlight of the session was a trio of songs that Elvis sang on the third-to-last night, just sitting at the piano by himself at four or five in the morning after everyone else had gone home. There were two beautiful ballads by one of his earliest r&b heroes, Ivory Joe Hunter, and a third song half-remembered from childhood, "I'll Take You Home Again, Kathleen," a staple for Irish tenors ever since it had been written nearly a century before. Yearning, wistfulness, loneliness, need — all were communicated with a naked lack of adornment that Elvis was seeming to find increasingly difficult to display in the formal process of recording.

He called for Joyce to join him in Nashville on the final day of the session when he would be working on vocal overdubs. He showed her around the studio, instructed her in the function of the board — "he gave her a tutorial on recording an Elvis Presley album," in the view of the somewhat cynical and decidedly unimpressed musicians still hanging around the studio, who, without any formal introduction, were under the impression that Joyce was Priscilla. "He showed her how to place the mike for the piano, called for more bass in the mix; he just wanted to bring her to a totally controlled environment." To Joyce it was something altogether different. When he sang, he sang *to her*. He was a different Elvis, transported by the music and "every inch the perfectionist at work. . . . It was obvious that despite all the high-priced technical talent RCA had taken pains to surround him with, Elvis was the man in charge."

He awoke in pain in the middle of the night. Joyce wanted to call a doctor to the hotel, but Elvis had Sonny charter them a jet, and when they arrived in Memphis an hour later, they went straight to Dr. Nick's house. Whatever the trouble may have been, Dr. Nick took care of it, and Joyce, somewhat abashed but emboldened by the privacy of the medical transaction, asked Elvis if Dr. Nick couldn't write her a prescription for Placidyl, too, so she wouldn't have to keep "borrowing" her supply from him. That night they watched news footage of the dedication of the Lyndon Johnson presidential library in Texas, where two thousand war protesters booed the appearance of both ex-President Johnson and President Nixon, setting Elvis off on a tirade about lack of respect for the flag among today's youth. When Joyce demurred, he backed down a little, which she took as a sign of trust. But he still continued to quiz her incessantly about her loyalty to him, and when she questioned him about his to her, when she spoke of the girls who flung themselves at him and the books in which he buried himself rather than pay any attention to her, he simply fobbed her off — as he did about the pills, a subject on which, as she was well aware, she was in no position to criticize.

H E RETURNED TO THE STUDIO in June to put the finishing touches on the gospel album, but things were no different than they had been. More and more the musicians spoke openly among themselves about his weird fluctuations of mood, about why he would have his bodyguards cordon off the bathroom when he was in there so that no one else could even go in and take a leak. The female backup singers were a constant source of annoyance, maintaining a steady stream of chatter among themselves, seemingly oblivious to Elvis' increasing irritation with them. And, of course, the musicians' own pill taking and toking went on, even as the session continued to focus on Jesus. They got through the work nonetheless, completing nine more masters in three days, bringing the total for the three sessions to forty-four, including an out-of-left-field "My Way," in which Elvis seems to take all the slings and arrows of fortune with a personal sense of triumph somewhat at odds with the world-weary tone of the song. He was working on some vocal overdubs when his frustration with the female vocalists finally boiled over. "I've run this damn song fifty times, and you still don't know your parts!" he announced, flinging down his microphone and storming out of the studio, never to return.

 ${f D}$ riscilla had begun her karate studies with Kang Rhee while Elvis was in Nashville. Elvis had met Master Rhee himself in March, showing up at the tiny storefront studio on Poplar with ten or twelve of the guys in an unembarrassed display of panache that Rhee, a small, studious man in his mid thirties with a limited command of English, was scarcely prepared for. "We don't have any air conditioning. We don't have any carpet, just tile. And he walk in with all those bodyguards with him. Black jumpsuit with a cane and sunglasses and a big jar of water. And then he wear the heavy wrist and leg weights. He told me, 'I heard about you many different directions, and I love to see you personally and then observe your class. Really, I don't have any class scheduled. But I invite several mean guys — Elvis coming in, so everybody want to come. And everybody showing off for him - breaking concrete blocks, then some fighting and sparring stuff, but my commands, my rules. And Elvis really impressed by the discipline of training under me, and that might be the reason that he is interested to join me."

Kang Rhee was impressed with Elvis, too: by his evident sincerity, his knowledge of and commitment to the sport, and by his spiritual qualities as well. "He knows already many different movements. He knows many different self-defense techniques. Meantime, he has lots of knowledge of the philosophy, and then he has all the time read very heavily, yoga, martial arts books, he all the time read. So he has a mental and physical very high standard as a martial artist: spiritual and mental is much more [his] strength. Stronger than any other person I can think of."

Elvis signed up on the spot, and signed up all the guys who were with him, for each of whom Master Rhee eventually devised a suitable nickname. Red became Mister Dragon; Sonny, Mister Eagle; Jerry, the Cougar; Charlie, the Cobra; and George, neither a particularly willing nor diligent pupil, joked that he should be called Mister Rat. Elvis was proudest of all of his title, Master Tiger, and at Master Rhee's invitation, in recognition of his spiritual qualities, led the group in prayer at the start of every session.

Priscilla showed up for her first lesson on June 9, the second day of Elvis' recording session, and Master Rhee was equally impressed with her. She showed the same seriousness as Elvis, but she had a physical grace that he lacked and a ferocity of concentration in the approach that she brought to her studies. "She has a beautiful kicking style, she heavily training [all the] time, no air conditioners, just lots of sweat and hard work. the most effort totally." When Elvis came home from Nashville three days later, she couldn't wait to show him the progress that she had made. "I think he was really proud of me; very few women were doing karate at that time. It's funny, in Vegas he would embarrass me, I'd be in a beautiful gown, and he would say, 'Honey, do that cat stance [for everybody],' and he wouldn't even think of what goes along with it in a dress. But I found I was having a great time, it's something I felt good at, it was something that he loved and I started getting into, and I actually loved it." As she continued with her studies, he made her show him all the new moves that Master Rhee was teaching her and became even more deeply involved himself. But when she returned to California the following week to supervise the redecorating, he sent for Joyce to join him at Graceland almost immediately.

THE HILTON HOTEL CHAIN took over the International at the end of June (the Hilton had assumed 50 percent ownership the previous August), and practically the first order of business was to ensure that their premier attraction, *Vegas*' premier attraction, would continue to appear in their showroom. The Colonel had an understanding that permitted Elvis to leave should any ownership change occur, so Hilton vice president Henri Lewin got in touch before the formal transfer even took place, and the Colonel was on a plane from Palm Springs to Las Vegas within hours of that initial conversation.

One might have thought that this would be the opening the Colonel had been waiting for. He had been agitating against the International all spring, evidently angling for the same kind of consultancy arrangement that he got in Hollywood, darkly hinting at movie deals just on the horizon that might prohibit Elvis from appearing at the hotel in August — but now he was all honeyed words. "I did business with Kerkorian, and I liked it," he told Lewin, a sophisticated, forty-eight-year-old veteran of the European hotel business, who was born in Potsdam, Germany, worked in the Far East, was interned by the Japanese during the Second World War, and arrived in the United States in 1946. "I have no reason not to trust that Hilton is not equally good or better." Lewin got the impression that this was a more than honorable man, as the Colonel made it clear that he would uphold the present contract without complaint, cavil, or renegotiation. On June 26 Lewin threw a surprise party for his new friend's sixtysecond birthday, to which Hilton president Barron Hilton, inducted as a Snowman just three days earlier, was not able to come but for which he made his most profound apologies.

It was not out of any newfound sense of passivity that the Colonel refrained from tactical engagement at this point. Rather, one would assume, he was observing a long-standing rule: better to let the enemy think they have you surrounded and strike when they are least prepared than engage in all-out warfare at a time when they have every reason to expect it. The Colonel was not laying down arms on any other front in any case. Once again in March he made a special deal with RCA, for three more Camden albums this time plus a second volume of golden hits. The Camden deal guaranteed \$180,000 against a reduced budget-line royalty rate, and the multiple-LP set of hits would pay \$525,000 by the beginning of the following year, with both advances, of course, split 50-50 between Elvis and the Colonel. In addition, for the boxed set, All Star Shows would supply 150,000 pieces of merchandise at \$1 apiece, and 25,000 Christmas cards for a proposed five-pack of Camden LPs, once again at \$1 apiece. There were various refinements to these and other deals, but the principle that the Colonel's merchandising skills were at least as valuable in a pecuniary sense as his client's musical ones was firmly established at RCA by now -though that didn't keep Colonel from complaining long and loud at every presumed infringement upon understandings written, oral, or yet to be articulated.

In the absence of the movie with which he had threatened Alex Shoofey in the spring, the Colonel had arranged for Elvis to play the Sahara Tahoe in Stateline, Nevada, just prior to the Vegas opening, with one week between the two engagements. They would be getting \$150,000 a week for the two-week booking, \$25,000 more than Vegas, with little extra outlay. Everyone appreciated the change of pace — things were a lot looser in Tahoe, there was less pressure, considerably less media scrutiny, and in fact less scrutiny in general, as many of the guys had their girlfriends join them, or made new girlfriends, an arrangement that worked fine until Joanie Esposito paid a surprise visit to Joe and couldn't figure out why she got the cold shoulder from so many old friends. The stage was better, the showroom more intimate, and Elvis seemed to thoroughly enjoy himself, although the high altitude left him and the band out of breath at times.

The show itself was pretty much the same — "The Impossible Dream" (which Elvis still had not recorded) remained the highlight of the set — but there were two major changes. Sammy Shore had been replaced as comedian, no big surprise to anyone, really, after Sammy's increasingly erratic offstage behavior. More significantly, Joe Guercio had perfected the new opening with which they had experimented in Vegas, an adaptation of Richard Strauss' Also Sprach Zarathustra, which had become popular through its use in Stanley Kubrick's epic, 2001: A Space Odyssey, as the film's semiapocalyptic musical theme. Guercio's wife, Corky, had suggested to him half-jokingly that the music reminded her of Elvis, and to his surprise, the orchestra leader agreed. When it turned out that Elvis, too, had had the same idea, they started fooling with it during the winter engagement, using it as a kind of overture to bring Elvis onstage sometimes, sometimes actually interrupting the show at Elvis' instigation just so the rhythm section could try it on the audience. Now, with Elvis' encouragement, Guercio developed the idea on a grand orchestral scale. "We set it up to the point where you got to the last chord, and the tympanist played the final set of eight notes, and it would build to such a frenzy that it was orgasm time from then until Ronnie Tutt [Elvis' drummer] took over — it was like the ultimate orgasm." That was how Elvis reacted to it, too: "he didn't want to be just a guy walking out there, he wanted to be a god." And with the 2001 theme, he was.

They shattered all attendance records in Tahoe, almost making up for what it cost the hotel when Elvis' salary triggered "favored nations" clauses in Johnny Carson's and Buddy Hackett's contracts (their pay had to be raised retroactively to reach the level of his). The show got great reviews, too (he worked so hard, remarked *Billboard* of the opening night, "you'd think he almost needed the money"), black comic Nipsey Russell was generally regarded as a big improvement, and the 2001 overture was much

remarked upon. There were several other high points, including a new approach to "You've Lost That Loving Feeling" that Elvis had been working on, where he stood pinned by a single spotlight, his back to the audience, then whirled about for the chorus — which worked fine except when he donned an ape mask that a fan had given him during his last Vegas engagement. The sound was fine, too, even though for the first time Felton wasn't there to supervise it. His kidneys had finally failed him, after almost two years of doctors fearing that this would be the inevitable result of his skyrocketing blood pressure. He needed to be on dialysis every few days now, but with his buoyant spirits it was hard not to believe him when he said that he would be back before they knew it.

They went into Vegas with barely a pause, and for the most part the reviews continued to be good, calling attention to the audacious overture and the Colonel's promotional flourishes ("Col. Tom Parker outdid himself," remarked Variety in its lead), though the critic for the Hollywood Reporter, generally something of a skeptic, called the performance "sloppy, hurriedly rehearsed, mundanely lit, poorly amplified, occasionally monotonous, often silly, and haphazardly coordinated." Elvis, he went on, "looked drawn, tired, and noticeably heavier," though the audience, he admitted, "couldn't have cared less. . . . They absolutely loved, honored, and obeyed his every whim." Bill Belew, who had developed a whole new "casual look" for the run (the Hollywood Reporter judged it not to be Elvis' sexiest or most flattering), was there, as usual, for opening night and thought that it was "fabulous," from the overture on. "I mean '2001' was just blaring out, and then the drums hit, and out he came. Kathy McEvoy, who used to go as my escort, leaned over and said, 'You can feel the sensuality and the sex oozing from that man." Some of the musicians grumbled that there was nothing to follow the opening with, that more time and effort had been put into the effects than the substance, and there was increasing talk of the two or three doctors who attended Elvis daily, the "vitamin injections" and "throat treatments" that he received constantly throughout his stay.

As the engagement wore on, Elvis' boredom and eccentricities of mood became apparent even to the outside world. Rona Barrett's column at the end of the run sought to explain them in terms her readers could understand, and while the account is hopelessly garbled and, as far as the Self-Realization movement and Daya Mata are concerned, a factual mess, there seems a somewhat ominous, and only thinly veiled, message for Elvis himself hidden between the lines.

JANUARY 1971-FEBRUARY 1972 👁 445

Further reliable word on why his latest International Hotel act was perhaps not up to Presley par is that he was quite ill at the time, and that, in addition, he was entranced with a program of self-realization, involving deep meditation and yoga. Seems the head of the selfrealization fellowship, on his deathbed, told his wife, Daya Mata, that Elvis was the next savior, Daya Mata relayed this inspiration to Elvis, and ever since, Presley has been deeply involved in the self-realization fellowship at Daya Mata's L.A. home. As a result of the program, Elvis attempted to meditate himself out of his physical pain during this International gig... and frequently went on stage in a kind of meditational fog... all of which could explain Elvis' behavior.

Another syndicated columnist, John J. Miller, reported on the almost equally evident estrangement between Elvis and Priscilla. Their new home had been Priscilla's excuse since the beginning of the year, but now that it was almost finished, she flung herself into the world of karate, focusing on her own studies and attending karate tournaments far and wide, sometimes with Joanie Esposito, sometimes just with some of the kids from the studio. She had begun taking a camera, "and I would get these great shots of guys fighting, and I would show Elvis and say, 'Look at this. I was at this tournament, and they have these great teams and great fighters like the Urquidez brothers, and he started asking me questions about them, and the next thing you know he wanted me to take a camera every time I went. During that time karate was at its best, almost like the Muhammad Ali era in boxing, and I pointed out all of these greats to Elvis — Bill Wallace and Chuck Norris and Jim Hawkins. It was the best time I ever had."

She also started to get to know one of the competitors, former international light-contact champion Mike Stone, whom she and Elvis had originally met at Ed Parker's international karate championships in Hawaii in 1968 and with whom she had even taken a few lessons at future film star Chuck Norris' studio. Over the course of the summer she grew closer to Stone, a native of Oahu with a Caucasian father, who in Ed Parker's eyes was "a great blackbelt, had that magnetism, and was a good bedroom athlete." At first their meetings were accidental — they might just run into one another at a tournament, he might show up at Chuck Norris' studio in Sherman Oaks — but soon Stone was calling the house, using the code name "Mickey," and three-year-old Lisa Marie had to be shushed from talking about him around the maids. As Priscilla's one true confidante, Joanie would baby-sit for Lisa, "and if Joe would call looking for Priscilla, I would say, 'Oh, she's in the bathroom, I'll have her call you.' Then I'd call her at Mike's, and she'd return the call." Others suspected, but whether or not they knew anything for sure, it seemed clear to everyone but Elvis that Priscilla had made a kind of decision. She was twenty-six years old now and increasingly self-confident, it was apparent that she was tired of being publicly humiliated. She knew the rules, but "I was not willing to play anymore."

Joyce Bova might have said much the same thing. She had become pregnant from their last time together, and she arrived in Las Vegas on August 16 with every intention of telling Elvis. A practicing Catholic, she had been genuinely troubled about the affair from the start and did not see abortion as an option, but it seemed like she would never get the opportunity to tell him, as he was always surrounded by sycophants, or it was the pills, or the mood wasn't right. Then, at a moment when she was feeling utterly alone and isolated from her feelings and everyone else, he put a record on the stereo, and she heard his voice singing "The First Time Ever I Saw Your Face," the song she had urged him to record. It was just a demo, he explained to her, as she expressed her unabashed delight at his recording of "their song." He wrote "To Joyce, with love" on the plain white cardboard cover and made her promise that she wouldn't listen to certain other unfinished cuts on the album. When he got rid of everyone else in the room, she thought she would tell him tonight for sure, but then she asked about his daughter, and with that strange sixth sense of his, almost as if he had an inkling of where she was about to go, he began talking about the sacredness of motherhood, how it was 'God's way of telling [a] woman she's not a little girl anymore," that with motherhood it was time to be "respected [but] I don't think a mother should be trying to be sexy and attracting men." When Joyce protested that sexuality was a part of human life, that "not every woman would lose her appeal just because she had a baby," he waved her objections aside. "Trust me on this, Joyce, I know I'm right."

She left Las Vegas without ever telling him and had the abortion three weeks later alone.

 $E_{\rm LVIS'\ DOMESTIC\ SITUATION\ }$ and his increasingly erratic behavior both on- and offstage were not the only openly talked-about secrets in Las Vegas during this period. The Colonel's friends and associates were

growing concerned about his behavior as well: more and more they were coming to see his predilection for gambling, which had seemed like a harmless aberration at first, as an addiction over which he had no control. It was something no one would ever have figured him for, but one by one all the signs fell into place as they watched him drop ever-larger sums of money at the roulette table, playing with a grim determination that seemed to blot out everything that was going on around him.

He was still, of course, wheeling and dealing, getting every benefit that the market would bear and giving even a sophisticated observer like Henri Lewin a lesson in the true meaning of free enterprise. Lewin saw the Colonel as a man so astute that "when you had him around, you could make money by picking his brain." And if he appeared sometimes to be cold and isolated, Lewin took that to be intentional on the part of a manager who in Lewin's view "worried about [Elvis] twenty-four hours a day" and very properly would never allow intimacy to intrude on his carefully maintained business edge.

But the gambling did intrude. According to Alex Shoofey, who continued as the hotel's president, the Colonel was "one of the best customers we ever had," good for at least \$1 million a year. Julian Aberbach, who had worked hand-in-glove with Parker for twenty-five years now, from the time of Eddy Arnold's first association with Hill and Range, was shocked at the change that he witnessed. "This was a man who never spent any money, who at one time had in excess of five million dollars — until he arranged for Elvis to go to Vegas. After that, things were never right." Julian's cousin, Freddy Bienstock, one of the inner circle since 1956, saw much the same thing: the Colonel loading up with free hotel food supplies for home consumption, from sides of beef to salted peanuts, getting everyone to contribute to his expenses so that he paid out virtually nothing for staff or office space, living in his Palm Springs home at the William Morris Agency's expense — and yet blowing every penny at the roulette table, not even a gamble you could win. Freddy tried to talk to him about it one time, and one time only. "He got very angry at me. He said, 'It's my money. I can do what I want. Don't talk to me about that.' And I never did again." No one could miss what was going on. "It made me sick," said concessionaire Al Dvorin, who went back nearly as far as Freddy — but he had no more idea what to say than the others. Even Tom Diskin, the Colonel's closest associate, was at a loss and found himself coldly rebuffed when he tried to express his concern. "I came into this world with nothing," Parker declared

with a fury barely masking his defensiveness and fear, "and it doesn't bother me one bit to go out with nothing. I don't have any children. Who am I hurting?"

Perhaps the most surprising aspect of it all was that the Colonel had actually spoken to the guys about just such a thing when they first went into Vegas two years before. "Don't get crazy," he told Joe, "and get hooked on gambling, 'cause the hotel and casinos will own you." Now they all talked about whether the casino owned him, but nobody knew for sure. What was going on with Colonel became as much a topic of conversation among the guys as what was going on with Elvis, and there was much speculation that his gambling had to weaken his negotiating position with the hotel. Nothing in his dealings with either the International or the Hilton, however, would suggest that this was true: he remained just as fierce, just as intractable, his motivation no more easy to anticipate or read than it had ever been. At the same time his dependence on something so manifestly outside his own control couldn't help but gnaw away at the Colonel's steely-eyed view of himself; the naked need so evident to old friends like Jean and Julian Aberbach and Tommy Diskin was not something he had ever before chosen to reveal.

There was no question of its effect on his relationship with Elvis. Elvis couldn't say anything, of course. As Joe noted, "Colonel had always told him, 'I'm not going to tell you what to do with your money — you do what you want to do. Your money is yours.' It's like Elvis would go out and spend a million dollars on the ranch or something like that, which was crazy, while Colonel was out there gambling. So what could he say?" They were locked in a relationship of mutual denial, just as they had always been linked by similarities of character and temperament not necessarily evident to the outsider at first glance. "As different as they might appear, they had the same kind of egos," observed Jerry Schilling. And neither ever wanted to display vulnerability — to the other or anyone else.

But Elvis was clearly showing signs of restiveness. He was thirty-six years old now, in every other relationship he was the dominant one and yet Colonel could always pull him back. Some saw it, almost literally, as a hypnotic power, a form of emotional blackmail that the old man could always exert on the younger one — but the fact was, it continued to come down to the same thing that the nineteen-year-old Elvis Presley had believed he was buying when he first signed on with the Colonel. Colonel was his talisman, Colonel was his luck, Colonel had held out the promise of success and delivered. And part of Elvis, the part that continued to pore over astrological and numerological charts and place his faith in the role of fate, believed that if he ever left the Colonel, his luck just might run out. He was increasingly frustrated with his manager, spoke of him as "Lardass" sometimes behind his back, talked all the time to the guys about what *he* wanted to do and what the Colonel was holding him back from doing with his old-fashioned, carnival-era ways — but he couldn't leave.

The most frequent subject of discussion was Europe, though not everyone believed that Elvis really wanted to go. The offers kept pouring in, and Colonel kept finding excuses to turn them down, but Priscilla for one was not convinced that Elvis, a creature of habit, saw any reason to abandon the comforts of home. Still, it did seem peculiar that Colonel would act so skittish every time the subject came up - surely the issue of tour security, Colonel's principal bogeyman, must have been dealt with before in Europe and Japan, and there were mysterious rumors going around that Elvis, with his highly attuned instinct for other people's cover-ups, was beginning to wonder about. One rumor had it that the Colonel had entered into talks with Tom Jones' flamboyant manager, Gordon Mills, with public speculation that Mills was going to buy him out. Another, circulating sotto voce among some of the fans and even printed in one of the fan club magazines, conjectured that the Colonel was Dutch, his real name "Andre Van Kuyk (Col. Parker to most people)," as the January issue of El News suggested. In what appeared to be one of those generic tabloid headlines, the Los Angeles Citizen News ran a story on September 23 raising the question, "ELVIS PRESLEY TO DUMP PARKER?" The only substantive reason they seemed able to come up with, though, was that Elvis sought the "romance of the road [while] the Colonel, who is \$\$\$-minded, prefers more direct ways of hitting the till [like] the Las Vegas method and movie studio lots."

EVIDENTLY UNBERNOWNST TO THE Citizen News, the Colonel had already set up another tour, once again with Management III, although he expressed growing exasperation with Jerry Weintraub's self-proclaimed extravagance of style and with what the Colonel testily saw as Weintraub's inattention to detail. The business arrangements were as before — a s1 million advance against 65 percent of the gross — but two months before they were scheduled to go out, on September 1, Colonel delivered a long list of particulars, "due to some unpleasant experiences on the past tour." Management III's performance would be "thoroughly scrutinized," he concluded, "for any future business for 1972."

There were other changes in the wind. The Imperials, who had missed the first tour the previous September due to a scheduling conflict, would not be accompanying Elvis on this one, or, from Colonel's point of view, on any other. He was fed up with their attitude, and they for their part were fed up with his. Citing another conflict (they backed up Jimmy Dean when they weren't working for Elvis, and were better paid for it), they sought a renegotiation of their contract, but the Colonel refused even to recognize their presence, pretending not to hear as Tom Diskin translated their demands to him as he stood at the gaming table.

They might still have elected to come back, but their fate was sealed when Elvis decided to hire J. D. Sumner and the Stamps as their replacement for the November dates. Sumner, who Joe Moscheo suspected had always coveted the spot, owned the booking agency that represented not only his own group but the Imperials as well and in fact was contractually empowered to cast the deciding vote in any stalemate in Imperials business affairs. Elvis had been drawn to Sumner's low bass ever since he had joined the Blackwood Brothers and moved to Memphis in 1954, when Elvis and his girlfriend Dixie Locke regularly attended their all-night singings at Ellis Auditorium. The Stamps signed on in early September, with the provision that J.D. himself, who did not always perform with the quartet, would contribute his vocal talents.

A new comedian was hired as well. Nipsey Russell had played only the one date in Tahoe, and his replacement in Vegas, Bob Melvin, was never considered anything but temporary, so the Colonel sought out Jackie Kahane, a forty-five-year-old Polish-born Canadian Jew who had been opening for Wayne Newton for the past seven years and was conveniently represented by William Morris. Kahane, who had been planning to take some time off after leaving Newton, was hired a month after the Stamps at \$2,500 for the November tour, joining Management III and the Stamps on the Colonel's "on-approval" list. Clearly Colonel saw this tour as a shakedown cruise in a number of ways.

It was a trial period for the Hilton, too. Whatever warm feelings Henri Lewin might have felt toward Colonel Parker were plainly based, in both men's estimation, on business, and the Colonel now saw it as time to improve his position with the hotel. To that end, at the conclusion of the engagement, he elicited \$25,000 bonus payments for both Elvis and himself as well as the use of Barron Hilton's plane for the upcoming tour "at a most favorable rate." That this was not the sum of his ambitions was made clear when he resolutely refused to confirm that they would be fulfilling the February engagement until well into November, and then only with the promise that the contract would be renegotiated upward. He even compiled a chart showing Elvis as Las Vegas' all-time box-office champ, averaging 3,840 attendance for his latest appearance versus 3,000 for Tom Jones, 2,600 for Barbra Streisand, and 1,800 for Glen Campbell — just in case further convincing was needed.

 $E_{\rm vale}$ and Priscilla finally settled into the house on Monovale after the Vegas run, with Hillcrest put up for sale at the beginning of August. Priscilla had been redecorating for eight months now, and the new house was designed with ample living space for Sonny and Judy West, Charlie Hodge, and anyone else of the guys who might want to temporarily bunk in. Elvis professed himself pleased with the decor (Priscilla described it as "very manly," with a den and game room for Elvis and a comfortable, country kitchen), but it was clear, even to the casual observer, that this was not a happy household, with Elvis and Priscilla increasingly preoccupied with matters outside the home. One time during the summer Priscilla and Joanie had gone down to Palm Springs and found a note from one of Elvis' girlfriends expressing grateful appreciation for their weekend together along with a second note to Sonny signed "Lizard Tongue." Priscilla confronted Elvis about the matter over the phone, and the guys all laughed about how he got out of it. There was no telling who might drop by, he told her, and how could anyone control what some of these girls might fantasize if they did? Priscilla didn't believe his explanation for a minute, but she was in the grip of her own conflicted feelings, and they were scarcely even living together at this point anyway. Whatever bruised pride she may have felt had more to do with the nature of appearances than reality; his actions only gave further sanction to her own.

* * *

THE TOUR OPENED IN MINNEAPOLIS, and everything went smoothly enough after Al Dvorin was promoted to announcer. He had no thought of the job for himself, but the Colonel fired the guy they had brought with them from Las Vegas after the first show. "I said, 'Colonel, we got two weeks of the tour. What do I do for an announcer?' He said, 'Al, I have a replacement.' I said, 'Great. Who?' He says, 'You.' I said, 'I've done everything you asked me to do: concessions, band leader, security, lighting, sound, advance work, check writing. I'm not qualified to work as an announcer.' I said, 'I got a voice like a sewer backing up. I'll make a fool of myself.' He said, 'Al, who's the boss?' I said, 'You're the boss.' He says, 'And you're the announcer.'"

Joyce flew into Cleveland, then traveled on with them to Louisville, where Elvis' seventy-four-year-old grandfather, Jessie, got a warm introduction from the stage and a brief visit after the show. She was amazed at the difference she saw not just in Elvis but in the crowds that came out to greet him. There was not a single high roller in sight, and with these true believers, it seemed, Elvis took his messianic role even more seriously, betraying more nervousness than she had ever seen in him before. He spoke to her constantly of his mission in life, about how it was given to him to make people's dreams come true. His hotel room was strewn with books and guns, the drapes drawn so it was dark, cool, and close, and he went nowhere without his JCC award and his BNDD badge. It was as if he were carrying around with him all the touchstones of his life. This was who he was.

The show had changed a good deal since the last time they had gone out, just one year ago. With the introduction of "2001," it had taken on an overt grandiosity which was only accentuated by Elvis' hyperbolic readings of "How Great Thou Art," "Bridge Over Troubled Water," and "The Impossible Dream." His costumes, his jewelry, and the poses that he struck only added to the sense of iconography increasingly attendant upon his performance, consciously contributing to the impression that he was somehow larger than life. When at the end of the show he opened up his silk-lined cape and stood there with his arms outstretched, his eyes shut tight, it was as if he were offering himself to the world, he looked, in the formulation of some reviewers, somewhere between a demigod and a giant bat.

The tour built to a crescendo, with bang-up final shows in Kansas City and Salt Lake City. It was a smooth, road-tested organization by now, a troupe that had won its spurs. The new additions had worked out well. Elvis loved J. D. Sumner's "zoom bass," even if some of the other members of the group had reservations about his musicality and personality, both of which they felt competed a little too blatantly for the star's attention. Jackie Kahane fit right in: he was perfect for the broad-based, middle-Americanfamily audience that both Elvis and the Colonel envisioned, inoffensively clean but with just enough ethnic and fag jokes to make everyone feel at home. By the time they completed the tour, they had earned a \$128,000 profit on top of the \$1 million advance from Management III. After the promoters had been reimbursed, and with all other costs figured in, Elvis and Colonel had \$804,000 to split between them on the new two-thirds-onethird basis that they had informally agreed would better reflect the division of labor on personal appearances. As a shakedown cruise, it had to be counted a success in every way, but Colonel was even more disenchanted with Jerry Weintraub than before and determined to find some other way to go in future, if only to teach the younger man a lesson in humility.

O NCE AGAIN THERE WAS LITTLE to do until the next Vegas opening, still two months away. The paternity suit was nearly settled, with the results of a series of blood tests indicating little likelihood that Elvis could be the father. Elvis was no longer seeing Kathy, and he had pretty much broken off with Barbara, who had moved in with Steve McQueen, the star of her latest picture, *Junior Bonner*, while on location the previous summer. He spoke to Joyce more and more about the likelihood of his leaving Priscilla, about Joyce quitting her job and moving into Graceland with him. Earlier she had not really believed his offer was serious; now she was afraid maybe it was. She saw their relationship as a kind of folie à deux, with the two of them stumbling around in a fog of pills and self-deception. She could no longer keep up with his rapid mood swings. She didn't believe she could save him anymore, and she wasn't sure she could save herself.

Christmas at Graceland was a cheerless affair. Where once Elvis had remained in California until the last possible moment, driving the guys crazy as Priscilla and the wives waited at home, now it was Priscilla who delayed her departure for Memphis, finally arriving with Lisa Marie just

454 👁 A STRANGER IN MY OWN HOMETOWN

in time for the holiday. Elvis seemed in good humor, as he played a joke on the guys when they all assembled on Christmas Eve for their annual bonuses. "Everyone remembered," wrote James Kingsley in the *Commercial Appeal*, "that last year some of his gifts included expensive Mercedes-Benz automobiles. . . .

As Elvis began to play Santa Claus this year he was in a happy-golucky mood as everyone gathered in his den and living-room expecting the usual gifts and "maybe a little something special."

With a sly grin on his face, the singer turned to his father, Vernon Presley, and asked: "Where are the envelopes, please?"

Vernon reached into his coat pockets and produced the envelopes. "Well, it's been a mighty lean year," said Elvis, whose income probably exceeded four million dollars in 1971. . . . As the envelopes began to be opened, the room fell silent. His special gift for 1971 was a 50-cent gift certificate to McDonalds's Hamburger's.

His joke over, Elvis later distributed his real gifts which included envelopes stuffed with cash for his employees.

Some of the guests in retrospect recalled a certain uncharacteristic reserve, a distance that they observed between Elvis and Priscilla - but it wasn't really all that different, and things certainly appeared to be normal over the next few days, as they watched Monday-night football and rented out the Memphian and Crosstown movie theaters, where Elvis had recently enjoyed Diamonds Are Forever and Dirty Harry and now caught up with Shaft. It wasn't until after Priscilla left, the night before New Year's Eve, that there was any inkling that something was really wrong - and then it was only because Elvis announced it. Priscilla had left him, he told everyone with that flair for self-dramatization that always got people's attention. She hadn't told him why; she had simply said that she no longer loved him, he declared in calls and conversations with one friend after another. But Joyce didn't see any major change when she came in for his birthday on January 8. He gave her a picture of Jesus and a gold ring and announced cryptically that one phase of his life was ending, another set to begin. "I'm past the age of Christ crucified," he said to her. "I can't wait much longer to plan the rest of my life's work."

* *

THE CAPE AND THE BALLADS were the most remarked-upon items when he opened in Vegas, with Marty Robbins' "You Gave Me a Mountain," "The First Time Ever I Saw Your Face," and Mickey Newbury's "An American Trilogy" all new to his act. Robbins' ballad, about a man whose wife has not only left him but taken his one "reason for living," their "small baby boy," built to a stirring climax in which the husband cries out, "This time, Lord, you gave a mountain," a sentiment with which Elvis evidently identified as he delivered the line with passionate feeling every time. "An American Trilogy," on the other hand, could almost have stood for an anthem of national reconciliation, joining together "Dixie," "The Battle Hymn of the Republic," and an old Negro spiritual, "All My Trials," in a swelling orchestral setting that never failed to bring down the house. Most of the reviews mentioned that there was less chatter than usual, that the onstage shenanigans had virtually dwindled away, though Robert Hilburn put his finger on the ongoing problem when he wrote in the Los Angeles Times: "Far from incorporating any important changes in his act, I found that virtually everything he added merely compounded my disappointment." The disappointment revolved not so much around Elvis himself, who "remains an amazingly charismatic figure," as around his "lack of care and direction in either (a) material or (b) his handling of it." Once, Hilburn wrote, "no one would dare touch a song Presley had recorded because he had done it so well." Now Elvis was a follower, presenting material already familiar in the versions of others without noticeably improving on them. He was, Hilburn concluded, "merely going through the motions," and perhaps the soul-weariness of Las Vegas was at fault.

Despite having to rent a private kidney machine (the dialysis unit of Las Vegas' Sunrise Hospital had shut down), Felton was on hand for the recording of yet another live album, which was intended to be called *Standing Room Only*. Over the course of the monthlong engagement, the shenanigans came back both on- and offstage, with the best one coming when the guys played their old gag on J.D. and the Stamps, dressing up as bad characters and pretending to stage an assassination attempt just to see the effect on the newcomers. Joyce came out to Vegas one last time, and, despite her feelings that she had no illusions left to shed, was shocked when she found herself in the ladies' room with a couple of working girls, who, thinking she was one of them, bragged of a twosome they had performed for Elvis. When she confronted him about it, he professed amused disbelief at her reaction. "Honey," he laughed. "I never touched those girls. . . . The two of them made love, and I just watched. . . . Just a little innocent fun." Once again, before she left, she tried to talk to him about the drugs, but she could never penetrate his shell of messianic conviction. People listened to him, he told her, "because I know what they want and need. Like you. You should listen to me more. . . . I know what's good for you, baby. One day they'll all listen." His message, he said, was understanding.

"We all have divinity inside us, Joyce," he said, setting aside his book. "Some of us just understand it more."

I took the plunge. "Elvis, if we're gods, or at least have this 'divinity' in us, why do we need drugs?"

"Silence is the resting place of the soul. It's sacred. And necessary for new thoughts to be born. That's what my pills are for . . . to get as close as possible to that silence."

She left the next morning before he awoke, thinking, "What a small, dull, shitty way for it to end."

Priscilla meanwhile had been out so far only for the opening. Her absence for the remainder of the engagement continued to spark rumors, but there was as yet no public knowledge of their separation or, for that matter, on Elvis' part, of the reasons for it. When she came in at the end of the run, she was determined to tell him, although Joanie begged her not to. His reaction, according to Priscilla's memoir and what she told Joanie and some of the wives afterward, was the kind of unrestrained fury she had seen on occasion throughout their marriage but not in this form. "He grabbed me," she wrote, "and forcefully made love to me. It was uncomfortable and unlike any other time he'd ever made love to me before, and he explained, 'This is how a real man makes love to his woman.'"

She and Joanie left the next morning without telling anyone good-bye. When they met out in the hall, Joanie didn't know if she had told him or not. "I said, 'Did you?' And she said, 'Yes.' I said, 'Oh, you didn't.' I don't know how she ever had the courage. When we got back to L.A., I got a call from Joe about six o'clock that night, and he was *hot*. He said, 'What's this about Mike Stone? Is it true?' He didn't know. He'd bet Red West one hundred dollars, because Red immediately said, 'I knew that blanketyblank-blank [Mike Stone] was sneaking around. I knew we couldn't trust him.' And Joe said to Red, 'No, Elvis is making it up, because he wasn't being a good husband, and he had to [come up with] an excuse for her to leave, other than just that he wasn't a good husband.' So he called and was furious at me. But I told him, 'If you'd been around, you would have known.'"

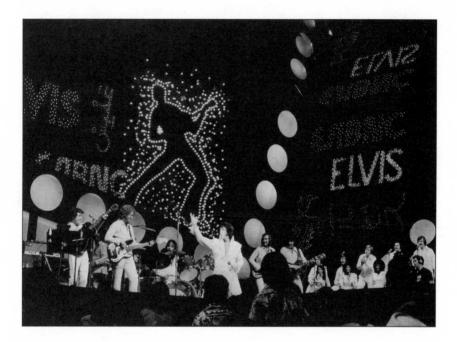

ALOHA FROM HAWAII, JANUARY 14, 1973: CHARLIE HODGE, JERRY SCHEFF, RONNIE TUTT, ELVIS, JAMES BURTON, JOHN WILKINSON, KATHY WESTMORELAND, THE SWEET INSPIRATIONS, J.D. SUMNER AND THE STAMPS (J.D. STANDING FAR RIGHT). (COURTESY OF THE ESTATE OF ELVIS PRESLEY)

ON TOUR

NE MONTH AFTER CLOSING in Las Vegas he was back in the studio, but not in Nashville this time. Instead, Felton, racked with pain and wasting away from the kidney disease that would kill him unless he got a transplant soon, came out to Los Angeles, where Elvis was scheduled to start filming rehearsals for the upcoming tour on March 30, the day after the recording session was finished. Six days later the tour itself would begin, the occasion for another hastily arranged MGM documentary film, which temporarily inherited the title of the live album (Standing Room Only) and which would generate another \$250,000 on top of the million dollars they were guaranteed by the concert promoters. It was just one more of the Colonel's intricately wrapped packages, but this time with a couple of differences: one was that the informal understanding that Elvis and Colonel had arrived at for a twothirds-one-third division of the income from personal appearances had now been formalized with a February 4 contractual agreement acknowledging the Colonel's "unique contributions" as a justification for his onethird share; in addition, Management III was no longer the sole promoter of the tour. Through a series of carefully executed maneuvers, Colonel had inveigled RCA to go into the concert business as RCA Record Tours, to put up half the money and take half the risk on Elvis' show, and thus in effect to undercut Jerry Weintraub's influence, with everything now taking place directly under the Colonel's supervision.

Elvis could not have cared less about any of this. He was, everyone agreed, in a funny kind of mood, even for Elvis — chastened, brooding, almost perplexed over what could have finally caused Priscilla to leave, after all he had done to drive her to it. Some of the guys thought it was simply the humiliation of her going off with someone else, particularly someone that Elvis knew and admired, but it seemed as much a mood of almost autumnal regret. He kept listening to that damned Charles Boyer album *Where Does Love Go?* over and over, until it just about drove them all crazy —

listening intently to those melancholy recitations, as if they alone might provide the answer to the question that the album's title posed, the one question that seemed to be forever on his mind.

The intent of the session was first and foremost to come up with a hit single, something Elvis had been sorely lacking for the last year. The latest single, the Buffy Sainte-Marie song "Until It's Time for You to Go," was the fifth in a row to fail to crack the Top 30, with sales having declined precipitately over the past two years from a reasonable expectation of three-quarters of a million to a current level of 250,000. Felton arrived in California with high hopes for the session and for one song in particular, which he had picked up from his friend Bob Beckham in Nashville, who, with the sudden, explosive success of Kris Kristofferson, his principal songwriter at Combine Music, had become one of the hottest publishers in the country. The song, "Burning Love," was by a young writer named Dennis Linde, who had never gotten a major cut but with this song had produced a real rarity, a credible contemporary version of rock 'n' roll.

Felton soon discovered, however, that Elvis was in no mood for rock 'n' roll. The song with which they started out the session was one that Red had written and brought to Elvis because he knew that Elvis would respond to it. It was called "Separate Ways" and stemmed from painful personal experience; all that Red had to do was change the little boy in the song, a victim of the breakup of his parents' marriage, to a little girl, and it suited Elvis to a T. He stuck with the number through twenty-one emotionally grueling takes, and then they all sat around listening to the playback for a long time. "God, you guys are trying to kill me," Elvis said to Red and some of the others, who were going through similar experiences of their own. But he loved the song.

The next choice he settled on was Kris Kristofferson's "For the Good Times," which, as the title might suggest, was equally awash in bittersweet nostalgia. And by the time they finished off the evening with Paul Williams' lachrymose "Where Do I Go from Here?," in spite (or perhaps because) of the presence of Elvis' own band in the studio for the first time, there was little question of rock 'n' rolling, or even of cracking the kind of joke that might impress a newcomer in between takes. To bass player Emory Gordy, substituting for Jerry Scheff for the session, the experience was altogether different from what he had been led by his fellow Nashville studio players to expect. "Elvis was really concentrating on his performance. I mean, he

was intense — he would listen to the playback, he'd get his part the way he wanted it, and he really concentrated."

From Felton's point of view, that was all very well, but he saw torpor where Gordy saw professionalism, he saw depression and an alarming lack of will — or perhaps it was just another kind of *willfulness* — and for the first time, he didn't feel that he, or anyone else, could really reach Elvis. Felton continued to have faith that Elvis could cut a hit record anytime he wanted. The trouble was, he wasn't interested in cutting a hit record. "He was trying to get something out of his system." It wasn't a question of his willingness to work; Felton might very well have wished that he had been as willing to work on the previous year's sessions. It was just that what they were getting was not what they needed right now, and Felton couldn't shake Elvis from his mood.

On the second night Felton finally got his way, but he was under no illusion that Elvis was doing it for any other reason than to indulge his producer. With the encouragement of Joe Esposito and Jerry Schilling, and with Charlie pounding away on acoustic guitar, they got a good, energetic version of "Burning Love," the song Felton had brought to the session, but it was tossed off in six quick takes, in almost throwaway style, and everyone could see that Elvis' heart wasn't really in it. They kept working till four in the morning but got only one more song that night and two the following night, including "Always On My Mind," another guilt-laden number that Red had brought to the session by "Mama Liked the Roses" author Johnny Christopher and Mark James, who had written what was by now practically Elvis' signature song about relationship problems, "Suspicious Minds."

The filmed studio "rehearsals" over the next couple of days were something of a pickup. He ran down the new songs for performance purposes and rehearsed a broad selection of old ones, giving out the kind of selfconscious stage directions that were meant to indicate who was in charge and even ending with a gospel jam that made the filmmakers feel as if they were privileged witnesses to a private moment. Gospel music, Elvis replied in answer to their eager questioning, was something he had grown up with from the time he was two years old, but it was just part of a musical landscape that included Mario Lanza and the Metropolitan Opera, too, a musical landscape that extended past borders of time and space and was always able to put your mind at ease. Often, after a show, he and the Stamps would get together and unwind with the kind of songs they were singing now. He had known J.D., he told them, since "he first came to Memphis to sing in a group called the Blackwood Brothers, and I was a big gospel music fan." It seemed like there was a special feeling among all the members of the group, said the filmmakers earnestly. "Well, I think it's because we constantly enjoy this music," Elvis replied. "You know, we do two shows a night for [four] weeks, but we never let it get old. Every time is like we do it for the first time — and that's one of the secrets."

The two filmmakers, Bob Abel and Pierre Adidge, scarcely knew him at all at this point. Fresh from the heady success of *Mad Dogs and Englishmen*, a last-ditch chronicle of the Woodstock generation that was almost as exhausting as the 1970 Joe Cocker tour it documented, they were already involved in a rock 'n' roll nostalgia film for Columbia (*Let the Good Times Roll*, featuring Chuck Berry, Little Richard, Fats Domino, Bill Haley, and Bo Diddley in concert), when MGM vice president Jack Haley approached them about this new project in February. Abel was not at all enthusiastic about taking on anything else at this point — he felt as if they had been through the wars with Joe Cocker and were lucky to have escaped. But Pierre Adidge insisted that they couldn't let this opportunity slip through their fingers; they should at least go to see Elvis' show in Vegas.

Bob Abel and Pierre Adidge came from very different backgrounds in film. Both in their early thirties, Abel had emerged from Colin Young's film class at UCLA with Francis Ford Coppola and Carroll Ballard and served his apprenticeship making television documentaries for David Wolper (*J.F.K: A Nation of Immigrants; Sophia: A Documentary Study of Sophia Loren; The Making of the President '68*), while maintaining a strong interest in music, cinemaverité technique, and the kind of split-screen special effects that had recently come into vogue. Adidge, a giant of a man as quietly self-possessed as Abel was garrulous, was a pioneer in sound recording whose audio partner, Jim Webb, had won wide renown for his work on Robert Altman's M*A*S*H. Together they had formed Cinema Associates in 1969 with the specific aim of making music documentaries, a calling which Abel likened to marrying the two great artistic statements of their time.

Neither one much liked the show that they saw in Vegas, and they were somewhat dismayed at the bloated appearance of the Elvis Presley that they met backstage — but at the same time, they were utterly, and completely, charmed. Elvis at first seemed under the impression that they were already committed to the project, but when he discovered that they were not, he drew them in, as he always did, by acting as if they were the ones who were doing the seducing and he was so glad of visitors from the outside world that he would have done anything to extend the visit. They told him they had no interest in repeating the wise-guy point of view of *That's the Way It Is,* a film that from Abel's perspective served to demean an aspect of the culture that they wanted to record and celebrate, but they got no response from Elvis on that issue. "I want to shoot the real you," Abel said without irony, "but the trade-off is, you've got to be open with me. If I feel that you're posing or doing something, I'll just turn the camera off. And then MGM will just be out a lot of money." "I like your honesty," Elvis said. "When do we start?"

Their meeting with Colonel Parker a week later was little more than a formality, and Pierre then went out with the Colonel on the pre-tour swing to scout locations, while Abel hired a crew and tried to pull everything together for the shoot. When they met up again at the rehearsal sessions, they knew that for all of their allegiance to cinema-verité ideals, and because of the very fact that they would be shooting with lightweight unobtrusive equipment, then blowing up the film to 70mm afterward, they would have to light Elvis carefully to try to minimize his eerily pale, strangely bloated appearance. It was not that he was fat — that would have been less disturbing to Abel, who recognized in Elvis some of the same traits that he saw in his partner's increasingly Demerol-addicted personality. He never doubted that Elvis would come through for them, though, even if, like so many outsiders to the Elvis world, he came to feel sorry for him.

"He had incredible native intelligence, the ability to read a human being, to watch someone's eyes and look inside their soul. He was very good with me. I think he was reading me, and he knew that he could switch from one aspect to another [of himself], and as long as that aspect was some part of him, that was okay with me. I mean, truth was truth. But I think there was a part of him that felt hollow, that he was a nobody, there were parts of him that he could not explore. I went into the rehearsals in a parochial sense, trying to get to know him, and the gospel part of it was a real insight. But I realized [after a while] with all of the musicians and bodyguards and sycophants around, that these guys had been around for seventeen years now telling the same stories and jokes, and what kind of a life is this? And do I film it? And if I film it, do I show it more than once to make a point?"

The first stop on the tour was Buffalo, just recovering from a long, hard winter and turning out in force for Elvis in the raw, rainy night. The idea was for Abel to shoot this performance on a little Sony videotape machine, then fly back to California and study the film for a day or two, rejoining the show with a full camera crew in Hampton Roads, Virginia. Although Abel thought he had seen just about everything there was to see on the *Mad Dogs and Englishmen* tour, the fervor of the crowd, Elvis' own level of commitment and the audience's hunger for him, the *interchange* that existed between audience and performer, created a sense of energy and spontaneity that he had never experienced before. Back in Hollywood he transferred the tape to three-quarter-inch and ran it frame by frame to study the structure and choreography of the show, making up a master sheet of the entire concert with the music laid out for the cameramen.

By the time that he caught up with the show again in Hampton Roads four days later, some of the magic was gone. What had seemed tentative and fresh as it was being worked out was now practiced and rehearsed, and while the smoother operation didn't make it any less exciting, he regretted in a way missing out on capturing some of the raw edges. There were eleven cameras in a complicated setup, with sound cued by camera, and all the sound sources fused into a deck from which a temporary scratch track would be created. The cameras operated on a staggered schedule so that, with eleven-minute rolls of film, there would never be a complete shutdown, and with the lightweight state-of-the-art equipment (French Éclair cameras, NASA headsets, Swiss tape recorders to which Abel and Adidge had U.S. rights, and Wally Heider's mobile recording unit), they were able to move and shoot in a way that Denis Sanders had not even been able to contemplate with That's the Way It Is. The biggest difference in the two documentaries, though, as Abel and Adidge would have been the first to concede, was that they believed in "the romance of heroes": to them Elvis was a folk hero whose mythic journey was the subtext of their show.

They shot the next night in Richmond, and then Abel returned to California while Pierre remained behind to get documentary footage. After reviewing the concert film that they had, Abel made up 3 x 5's of what they

might need in terms of both music and narrative threads, then rejoined the tour in Greensboro, North Carolina, where at MGM's directive he showed the Colonel some of the raw footage in a local moviehouse. Up till then he had felt as if Colonel had been watching them warily, afraid that with their youth and scraggly appearance, they might not really know what they were doing. Now "he pretty much gave us carte blanche, he said we had his blessings. I said we needed more access, and he said if we delivered, he'd deliver. He went into a long rap about how so many people had fucked over Elvis in the past, and he was the only one who'd looked after his image, and how careful he [had] to be. It was like the pep talk you get from a coach at halftime. He told us the story about people paying to get into the carny show, then paying to get out [when rain had made the field in which the carnival tent was pitched muddy, and he provided a donkey for the customers to ride out on without sinking into the mud and barnyard manure]. He said, 'Don't ever try to put something over on me, or you'll be up to your ears in elephant shit.' It ended with him saying, 'Go out there and make the best Elvis film ever.' And he slammed his cane down."

None of the other shows worked as well as the first, though they kept hoping for a repetition of Buffalo, or at least of Hampton Roads. They finished up in San Antonio, Texas, the next-to-last night of the tour, which gave them four concerts over two full weeks of shooting, with plenty of perfectly good footage to choose from. For Abel, though, it was Pierre's documentary crew which had captured the defining moment of the film. Elvis is sitting in his limo after the show in Jacksonville, Florida, a towel draped over his head. He is exhausted and speaking in broken phrases about the concert and whatever else is on his mind. "Hot time in Florida," he says and sings the line "Rainy night in Georgia," half under his breath before he and Charlie and Red harmonize briefly on "For the Good Times." Then there is a moment, accentuated in the finished film, in which Elvis is looking out the car window, his mind a million miles away, the same dreamy expression on his face as in the 1956 photograph that the directors use to illustrate his essential, unchanging isolation. It is a "small, private" revelation, as Abel described it, but what is left out of the movie is the revelation that precedes it in the car on the way to the concert, in which Elvis confides to the guys, with impish delight, that he had his face "buried in a beaver" the previous night, perhaps an equally defining moment.

To complete the film that they had envisioned (soon to be retitled *Elvis On Tour*), Abel and Adidge knew they had to have something special, and

466 🔊 ON TOUR

what they fought for over the next few months was a candid audio-only interview with Elvis to serve as a kind of glue to hold the picture together. The Colonel was no help to them here. This was the kind of unmanaged exposure to which he had been opposed all his managerial life; if they could get Elvis' approval, he wouldn't stand in their way, but they were on their own now, he shrugged, strongly implying that without him there was no way Elvis would go along.

He had not taken Jerry Schilling into account, however. Jerry had gone to work for Abel and Adidge as an assistant editor on the film as soon as they got back to Hollywood and had a chance to evaluate the footage. Elvis hadn't liked the idea of Jerry working for them at first; in fact, the filmmakers hadn't thought much of the idea themselves, with each party suspicious of the other's motives. Finally Jerry, who saw this as a long-awaited opportunity to move ahead in his chosen field after a lengthy apprenticeship at Paramount, managed to persuade Cinema Associates of his sincerity by volunteering to work on *Let the Good Times Roll* (their other rock 'n' roll film) exclusively. It was at this point that both parties finally saw the light, with each one embracing the idea that Jerry could give them a foot in the other's camp. Elvis, knowing Jerry's loyalty, was confident that his involvement in the editorial process would help keep the film on an even keel. Abel and Adidge, who were by now equally convinced of Jerry's integrity and sincerity, saw his involvement as their opportunity to influence Elvis.

That was pretty much how it worked out. Jerry had already convinced Elvis to allow the filmmakers to use some classic stills from the period of his earliest success (the Colonel opposed this on the grounds that you always sell your present, not your past), and he had persuaded the filmmakers in turn to include shots that were suitably "Brandoesque." The interview presented a greater challenge, but here, too, Jerry succeeded on the strength of his own conviction that this film was important, that the film was a record of the man, that the interspersed interview segments would provide context and story line, above all that Elvis would acquit himself well.

Elvis came into the MGM studio looking even paler and more bloated than he had during the tour. He apologized to the filmmakers for not having been able to accommodate them sooner — another tour had intervened, he had been busy with various domestic problems having to do with the breakup of his marriage, he told them, and a girl he had been going out with recently had just been killed in a car crash. He sat on a chair in the familiar dressing room, where he had made so many pictures, with his two interviewers across from him, a coffee table in between. Over Abel's objections a number of the guys were present, observing the proceedings somewhat balefully, but Elvis seemed to freeze them all out, except for Jerry, who was perched on a director's chair over Abel's right shoulder.

They started off by getting his reactions to some of the old photographs. The voice is warm, hesitant, genuinely self-effacing, you get the same sense that his audience got of him from the start: that he is communicating directly without the benefit of any kind of screen. The crowd reaction surprised him to begin with, he says, speaking of the show at the Overton Park shell. "The first time it happened, the first time that I appeared onstage . . . it scared me to death, man. I didn't know what I'd done." And, he said, in a real sense, it had never changed. "I work absolutely to [the audience], whether it's six or six thousand, it doesn't really matter; they bring it out of me — the inspiration, the ham." And if it didn't work? If it didn't go over? Pierre asked. "I change the songs around. I'll go back and stay up all night and work — working on it, you know, worrying about it, I find out what it is that's not getting off the ground, you know, the first four or five numbers. Because it's very important."

He still was scared before every performance, he never wanted to arrive too early for a show he still got so keyed up, and he demanded the same kind of intensity from his musicians. One time he heard some of the guys in the orchestra talking while he was onstage in Vegas: "Those guys were reading *Better Homes and Gardens* and stuff like that — they play music so well they can play their part and they'd say, 'Think I should build that patio on my house?'. . . So what I did, I switched songs on them. And the orchestra was there, they'd go into the intro, and I'd say, 'Whoa, I don't want to do that song, let's do something [else].' So they'd go through the sheet music real quick, and consequentially I got them; they *had* to watch me."

He spoke about the show, how it embodied all the elements that he had dreamt of since he was a child, when he would go out to Overton Park on a Sunday afternoon to hear the Memphis Symphony play. He spoke of singing, of how "I first realized that I could sing at about two years of age," and then later "people would listen to me around the housing project where I lived," but at school, "nobody knew I sang" until the eleventh grade. "I wasn't popular in school. I wasn't dating anybody at that school. I failed music — only thing I ever failed. And [then] they entered me in this talent show. . . . It was amazing how popular I became in school after that." What had his father thought about his playing the guitar for a living? Jerry asked,

prompting him to tell one of the old familiar stories that the outside world might like to hear. "My daddy had seen a lot of people who played guitars and stuff and didn't work, so he said, 'You should make up your mind either about being an electrician or playing a guitar. I never saw a guitar player that was worth a damn.'" Amid laughter, Elvis said, "It's funny, I say it to him every once in a while, and he just laughs about it, he gets embarrassed if I say it in front of somebody. Here I was having an epileptic fit [in his early performances], and they just happened to film it!"

They spoke of any number of other things, Elvis dispensed some of his usual bromides about the army and the early years, but he didn't become truly engaged until he started talking about the movies. "It was work," he said mildly at first. "It was a job. I had to be there at a certain time in the morning and work a certain amount of hours, and that's exactly how I treated it."

As time went on, however, and picture followed picture: "I cared so much until I became physically ill. I would become violently ill. I'd get a temperature, something would happen to me... at a certain stage I had no say-so in it. I didn't have final approval on the script, which means that I couldn't tell you, 'This is not good for me.'... I don't think anyone was consciously trying to harm me. It was just Hollywood's image of me was wrong, and I knew it, and I couldn't say anything about it, couldn't do anything about it... I was never indifferent, I was so concerned until that's all I talked about. It worried me sick, so I had to change it. Which I did."

Bob Abel tried to get him off the subject and have him talk about his *achievements* in pictures, the great dance sequence in *Jailhouse Rock* for which his own spontaneous movements had provided the inspiration, but Jerry brought him back to what he seemed to really want to talk about. "I had thought that they would . . . give me a chance to show some kind of acting ability or do a very interesting story, but it did not change, it did not change, and so I became very discouraged. *They couldn't have paid me no amount of money in the world to make me feel self-satisfaction inside.*"

"But you still did them, you must have forced yourself —" said Pierre.

"I had to. I had to."

It was a curious moment. No one was named — he explicitly acknowledged that there was no one to blame — but it was as if he were musing for a moment on his entire career, seeing it as a series of missteps in which he had never really taken control, with a bitterness that had never crept into his public discourse before (and that ultimately would not be revealed in the movie). "I really took it as long as I could," Elvis said. "Physically, emotionally, and everything." Then, appearing to recognize what he had said, he tried to backtrack: "Not all the movies were that bad. Um, in between, I would do something that was entertaining to people, just of a pure entertainment nature . . . they worked well on television." But then, seemingly unable to stop himself once again, he lashed out at Steve Allen for humiliating him on television sixteen years earlier, when he was forced to don top hat and tails and sing to a dog: "That was Steve Allen's humor. To me it was about as funny as a crutch. Again, I had to do —"

It was a most peculiar performance, forty minutes and out, the runaway rush of emotion contained once again by the time he got to the door. It would be hard to say what the Colonel's assessment of that performance might have been. In the time-honored tradition of the carnival, nothing was ever truly revealed, the curtain was never parted, the mask never taken off — and Abel and Adidge never really knew the man who was speaking to them, one mask was merely substituted for another. But at the same time, a deeper truth *was* revealed, the same one that Marion Keisker had intuited when an eighteen-year-old Elvis Presley first entered the Sun studio. "He was like a mirror," Sam Phillips' assistant had observed. "Whatever you were looking for, you were going to find in him. It was not in him to lie or say anything malicious. He had all the intricacy of the very simple."

THE TWELVE-DAY TOUR they had gone out on in June had proved two things. One was the roadworthiness of the crew. They were up to seventy or seventy-five troupe members now, including tech people, equipment handlers, orchestra members, and concessionaires. They traveled in three leased planes, with two complete stage setups, no longer a onceayear side trip, but a finely calibrated operation, with the Colonel leading the advance. They had even conquered New York, opening the tour with four shows at Madison Square Garden to a reception that went beyond Colonel's or RCA's or anyone else's expectations.

Elvis had never played New York before. After all the supercilious gibes and jeers that had come from there at the beginning of his career, he and Colonel had been understandably leery of exposing themselves to further humiliations — besides, the expense of the building, the promotional costs, and all the other costs of doing business in New York City were so far beyond what they were accustomed to pay elsewhere, there never seemed

470 🔊 ON TOUR

any point to it. But now there did. With the scope of their new operation, and the degree of acceptance that Elvis had achieved, it seemed like a challenge worth undertaking — and the Colonel added yet another twist when he attached a live album to it (the one that had been started in Las Vegas was to be jettisoned), with a release date one week after the last of the Garden concerts, to foil the bootleggers, Colonel said.

The gamble proved an almost unqualified success, as they sold out all four performances, eighty thousand tickets at \$10 tops, for a \$730,000 gross over three days. They captivated the New York press, too, with Colonel in his customary role as ringmaster introducing Elvis at a Friday afternoon press conference, Colonel in a cheap Summer Festival imitation straw hat and Elvis, in his patented star turn, dazzling jaded reporters with his usual combination of self-deprecation, braggadocio, and casual insouciance.

Why did he think he'd outlasted every other performer from his generation? "I take Vitamin E," he said quickly, then as the room erupted in laughter, "I was only kidding. I embarrassed myself, man. . . . I enjoy the business. I like what I'm doing." What about his image as a shy, humble country boy? Elvis seems momentarily baffled. "I don't know what makes them say that," he says with a look of some perplexity, then stands and opens up his light blue Edwardian-style jacket with bold plaid lining to reveal the International gold belt. "Elvis," asked one reporter, "are you satisfied with the image you've established?" "Well, the image is one thing and the human being another," he said, and then, in response to a follow-up question, volunteered, "It's very hard to live up to an image." His father sat to his left, the Colonel to his right. Vernon was asked about his son's overnight success, when he realized that celebrity had claimed his child. "Well, it's kind of hard to say," he said. "It happened so fast, it's hard to keep up with it, you know. Just, boom, overnight, and there it was." Did the father have any regrets? "No, no, I haven't. In fact, I've enjoyed it, really." "All kidding aside," Elvis said, taking over smoothly, "it happened very fast. My mother and father, all of us — everything happened overnight. We had to adjust to a lot of things very quickly. A lot of good things, I might add."

The only untoward incident came when Jackie Kahane, who tended to test the limits of a more sophisticated audience's patience, got booed off the stage the first night, but then the show rallied behind Jackie after Al Dvorin introduced the crushed comedian as "a personal friend of Elvis'" for the rest of the engagement and insisted that he be given all due respect because "we work as a family." The press fell all over themselves, on the other hand, to recognize Elvis: the *New York Times* alone ran three stories on the show, with the headline of Chris Chase's piece, "Like a Prince from Another Planet," summing up the overall reaction. "Once in a great while," Chase concluded, in a story that initially voiced skepticism, then surprise that skepticism could so easily be overcome, "a special champion comes along, a Joe Louis, a José Capablanca, a Joe DiMaggio, someone in whose hands the way a thing is done becomes more important than the thing itself. When DiMaggio hit a baseball, his grace made the act look easy and inevitable. . . . Friday night, at Madison Square Garden, Elvis was like that. He stood there at the end, his arms stretched out, the great gold cloak giving him wings, a champion, the only one in his class."

B ACK HOME IN MEMPHIS for a month at the end of the tour, Elvis had little thought of duende — he seemed more interested in finding a girlfriend. Out in L.A. he had been seeing a dancer named Sandra Zancan, to whom he had given a white sports car and a ruby ring, and for a while he was dating a go-go girl from T.J.'s in Memphis to whom he gave a white Mark IV. There were a number of other girls, but it was obvious to everyone that he was not his old self, and he made no secret of his continued preoccupation with Priscilla's departure.

Then on July 6 he met Linda Thompson at the Memphian Theatre. The twenty-two-year-old Thompson, a former Miss Memphis State and Miss Liberty Bowl and the present Miss Tennessee, had been invited to the Memphian by local RCA promo man Bill Browder, because he thought she might capture Elvis' interest. Linda, who was as bright and vivacious as she was pretty, was of enough different minds about the situation that she brought a friend, Jeannie LeMay (Miss Rhode Island), for protection and parked in a no-parking zone, just in case she needed to make a quick getaway. Once inside the theater, though, things went smoothly enough, as George Klein, who knew her from her frequent guest appearances on his television show, made sure that she felt comfortable, and Elvis couldn't have been more of a gentleman. She was amused when he tried the old yawn-and-stretch routine to put his arm around her, but he hastened to assure her that he was no longer married, that he had in fact been separated since January. When she said, "I'm really sorry to hear that, but I could have told you a long time ago, you should have married a Memphis girl," he burst out laughing.

472 🔊 ON TOUR

She didn't get home until four o'clock in the morning, and her aunt, with whom she was spending the summer, pumped her for details. "My Aunt Betty was a big Elvis fan, she was about his age. She said, 'So?' And I said, 'We met - ' And Jeannie said, 'He likes her. They were sitting there kissing. He had his arm around her. He wants to date her.' And my aunt was going nuts! 'Elvis! Oh, my God! Are you serious?' And then the phone rings, and she said, 'Who could that be?' And it was Elvis. He said, 'Can I speak to Linda?' And she said, 'Certainly, just one moment, please,' then screams, 'Oh, my God,' and hands over the phone. So I go to the phone, and his speech was a little slurred, and I thought, 'Gee, he wasn't drinking when I saw him at the movie theater. I wonder if he went home and had a drink or something.' I was so ignorant in so many ways. I didn't know anything about drugs. I said, 'Are you sleepy?' Are you really sleepy?' He said, 'Yeah, pretty tired.' But I just couldn't fathom it. He was saying things like, 'I'm so happy that I met you tonight. Where have you been all my life? I need to be with you. I can't believe I haven't met you before now.' Pretty strong stuff to say to someone you just met a few hours before. I'm going, 'Gee . . .' I remarked to my Aunt Betty, 'I think he might have been drinking!""

The next night she went back to the movies and then to Graceland after the show. She and her aunt Betty and uncle Steve and the kids were about to leave for Gulf Shores, Alabama, on vacation early that morning, but she went anyway, rode around on golf carts with the whole gang, and then accepted Elvis' invitation to go up to his bedroom. "Jeannie was saying, 'Don't go, be careful!' She thought he was moving in for the kill, but I went upstairs with him, and we just read. We kissed, we made out — which was wonderful — and then we read the Bible. We felt as if we'd known each other all our lives — and we kind of did [through knowing] how the other person was brought up. When I got back to my aunt's, she was going, 'Honey, honey child, where y'all been? We've got to leave out of here in an hour.' And all the way to Alabama we played Elvis tapes. And I said, 'Do you think I'll ever hear from him again?'"

She was gone for three weeks, without a phone for him to find her with. In the meantime Elvis met and dated Cybill Shepherd, another Memphis beauty queen, who had just completed *The Heartbreak Kid* and was on vacation from moviemaking and her steady boyfriend, film director Peter Bogdanovich. He remained in touch with Sandra Zancan, too, but he couldn't get Linda out of his mind. When she came home from Alabama, the phone was already ringing. It was Joe calling from L.A.; they had been trying to reach her every day since she left.

"Then Elvis got on the phone and said, 'Who do you think I am? I thought this was the beginning of something pretty great, and then you just disappear for three weeks like that.' So I think it probably captured his attention!" He wanted her to join him in Las Vegas, where he was opening in less than a week. She never had any hesitation. Though she was still a virgin and maintained strong religious convictions, there was no choice. "I had gone four years to Memphis State and was short twelve hours in Theater and English, a double major. I didn't [really] want to go back, and I didn't want to teach. I was thinking about coming to Los Angeles and starting my acting career, or becoming a stewardess for a while, or going to New York to be a model — I was ready to travel the world and do some fun things. Then I met Prince Charming, and he made my decision for me."

She flew out to Los Angeles the next day, then flew in to Vegas with Elvis, where he was starting rehearsals for his opening later in the week. In her college clothes she felt as if she was stepping into a big frat-house party — just without the keg. She couldn't believe how nice everyone was to her; she couldn't believe the luxuriousness of the appointments - even though they were only on the twenty-ninth floor during rehearsals, they had not yet moved up to the star suite. She realized on the first night, though, that there was something wrong, as that strangely "drunken" quality that she had heard on the phone reappeared in his voice. Earlier in the evening she had noticed all the pill bottles on his side of the bed. She asked him if he was sick, and he said no, he just had a little cold. Then they had dinner, and it was all very romantic, "he was so loving and affectionate, [but afterward] we were standing outside talking, and he seemed to stagger a little and to have slurred speech. I said, 'Are you okay?' And he said, 'Awww, I'm okay, honey, I just had a little sleeping pill.' I said, 'You take sleeping pills?' He said, 'Oh, yeah, I've had a problem sleeping ever since I was a kid.' I thought it was strange, but the whole experience was strange to me, too. I wish I had been more worldly, more knowledgeable. But I just accepted it and didn't realize the magnitude [of the problem] until a few weeks into the relationship."

Everyone liked Linda. Though she was not the only girl to visit in Vegas that summer (Cybill Shepherd and Sandra Zancan each came out while she was absent), by the end of the engagement he had made his choice. She liked to laugh, she was refreshingly natural and down-to-earth, she adapted

474 👁 ON TOUR

to his lifestyle, she was, in her own later assessment, "very young and very resilient and not enough of a total human being to have any predetermined notions about life and the rigidity of life. I was very happy to be with him, I was very happy to share life with him." She changed her sleeping habits, exchanged day for night, talked baby talk with him, and made him laugh with her antics — she became a "lifer," in the term the guys used to describe themselves. It was clear she was going to be around for a while.

Meanwhile the separation from Priscilla had become official on July 26. She had returned to Graceland the previous week to collect her things and pay Grandma an emotional farewell, though she swore she would stay in touch. At the end of July, Rona Barrett reported in her column that "Priscilla is very anxious at this time to regain her freedom, the reason allegedly being a karate expert named Mike Stone [with whom] Priscilla has been several times dining . . . in public places," and the July 30 Sunday Tribune's headline announced, "Black Belt Karate Man Splits Presleys." Elvis was getting reports that she had been spotted with Stone at various tournaments, laughing and animated, sometimes even handing out programs, in what must have seemed like an open rebuke to her former lifestyle. On August 18 it was announced that a divorce action had been entered in Santa Monica Superior Court. The terms of the settlement - a minimal \$100,000 lump payment (with \$50,000 to be paid upfront), plus \$1,000-a-month spousal and \$500 child support — were not reported but had been worked out in a joint conference with Elvis' lawyer Ed Hookstratten, and according to Hookstratten were all that Priscilla wanted, his own advice to the contrary notwithstanding. It amounted to an implicit rejection of anything that Elvis might have to offer her.

Elvis' own divided state was clearly indicated by the sharp acceleration in doctors' visits throughout the Vegas engagement. Where once he was content with medications before and between each show and before retiring for the night, now he was receiving medical attention up to five times a day, with results such as Linda observed. This was the first booking under the Colonel's new arrangement with the Hilton, which not only raised Elvis' salary to \$130,000 a week (with an increase to \$150,000 starting in 1974 and all previous verbal commitments still in place), but assigned a salary of \$50,000 to the Colonel for all of his efforts promoting the Hilton chain throughout the country. He had achieved this with hints about deserting the Hilton for Kirk Kerkorian's presently under-construction MGM Grand (hints which, in his usual fashion, he had communicated by denying news reports to that effect) and with a direct threat the previous March to vacate his offices and remove all of his belongings lock, stock, and barrel, because neither he nor his client was sufficiently appreciated. Elvis meanwhile put on a good show, though many reviewers remarked upon the star's somewhat somber mien: there was little karate, far less interplay with the audience than usual, and, seemingly, increased attention to music with an emphasis on heartache and loss. *Variety* applauded this evidence of renewed discipline "with a welcome absence of horseplay and inside gags." Some of the fans had mixed feelings about it — they worried about Elvis — while Robert Hilburn reported in the *Los Angeles Times* that the show had Elvis Presley operating at "only about 60% of his musical potential," even if it was a considerable improvement over the previous January.

On September 4, the final day of the engagement, Colonel set up a press conference between shows to confirm officially the date and place of an event that had first been spoken of in July, an NBC television broadcast via satellite transmission that would take place in Hawaii in January (it was to be called Aloha From Hawaii) and reach an estimated 1.5 billion viewers worldwide. With new RCA president Rocco Laginestra at his side, Elvis answered questions from reporters who had already been fully briefed on all the historic landmarks that this broadcast would establish: the first time that a full-fledged entertainment special would be beamed worldwide via satellite; the largest audience ever to see a television show, "in excess of one billion people," who would view it "on successive evenings beginning January 15, 1973"; "the first time in the history of the record industry" that an album (the follow-up soundtrack) would be released simultaneously on a global basis. Flanked by a poster board drawn up according to the Colonel's specifications and six rows of Elvis Summer Festival hats festooned with the names of each country in which it was hoped the spectacular would be broadcast, the RCA president congratulated the entertainer and his manager on their bold leap into the future while the Colonel beamed. As he had stated to reporters in an earlier press release, "It is the intention of Elvis to please all of his fans throughout the world." And if it was "impossible for us to play in every city" throughout the world, perhaps, it was implied, this would serve at least as evidence of their good faith.

Rocco Laginestra's presence was neither accidental nor merely the pro

forma appearance of a record company executive on behalf of his biggest star. In fact, as the accompanying RCA press release made clear, RCA was not merely the proud progenitor, it was the *producer* of the show in the form of RCA Record Tours, which had been set up to begin with solely at the Colonel's behest to co-promote the tours. Now, in a single swift coup, the Colonel was getting rid of Jerry Weintraub and Management III, with RCA Record Tours not only "presenting" the television special (this meant that they would be paid \$1 million by NBC, of which RCA got to keep \$100,000, while the star and his manager divided \$900,000 between them) but embarking upon a new arrangement with Elvis and the Colonel whereby they became the exclusive promoters of fifty Elvis Presley concerts, for a guarantee of \$4 million, plus a \$250,000 bonus, over the next fifteen months.

Under pressure from the Colonel on all fronts, they may have been lessthan-willing partners in this enterprise, but they were partners nonetheless. The Colonel had been squawking about one thing or another, mostly the alarming number of budget-line Camden albums that were coming back as returns, since early April. As Elvis' sales steadily fell, his manager leveled accusations of incompetence, and in case this did not carry sufficient weight, he raised the issue of "the many verbal agreements" that existed which had not been put in writing out of consideration for RCA's obligations to other artists with "favored nations" clauses in their contracts. Perhaps "new people" at RCA were thinking of not honoring these agreements; if that was the case Elvis and the Colonel would merely fulfill their contractual obligations, dispense with providing any additional product, and concentrate on touring, which was much more profitable anyway. In August, with two hits on the charts ("Burning Love," the single that Elvis had not wanted to record, eventually reached number two and was Elvis' first million-selling single since 1970, while Elvis As Recorded At Madison Square Garden was certified gold at the beginning of the Las Vegas run), the Colonel escalated both his rhetoric and his demands. He knew where RCA accounting had buried \$600,000 that was owed to them, he declared at an August 11 meeting; it was he, and he alone, who was keeping Vernon from making even harsher demands, by exercising, he hinted, certain discretionary judgments about what Vernon should and should not know; he was expecting, he concluded, a minimum of \$500,000 to \$600,000 to show up on their next royalty payment.

This was the climate in which RCA became his full-fledged partner. Like Hollywood studio heads before them, the company's executives were not so much intimidated as utterly baffled by the Colonel; they simply did not know what to make of him. In interoffice memos they discussed the problem, much as Hal Wallis and Joe Hazen had discussed the same problem over the years: How was it that this clownish figure, whom they were perfectly prepared to patronize for his lack of polish and lack of manners, always acted as if he held all the cards, even as they were looking at four aces? RCA's chief financial officer Mel Ilberman, as hardheaded a businessman as you could find, did not take easily to being bullied, but the Colonel had so many weapons in his arsenal, and it was so hard to tell just what target he had in his sights, that in October Ilberman raised the possibility in an internal memo of a complete buyout of Elvis' catalogue to date, just to get the Colonel out of their hair.

Meanwhile, Elvis took questions at the press conference, sitting slouched in an upholstered desk chair, in a white high-collared suit, looking relaxed to the point of boredom and unable to muster anything more than, "It's very hard to comprehend it. In fifteen years it's very hard to comprehend that happening. . . . It's very difficult to comprehend, but it's my favorite part of the business, a live concert." The Colonel, on the other hand, was practically brimming over with excitement at the idea that his long-standing dream was at last about to be realized. He had originally gotten the idea for satellite transmission from the live broadcasts of President Nixon's historic trip to China in February. He had had to overcome Elvis' initial opposition, sell the idea to RCA, and get Tom Sarnoff at NBC to go along with it. Then, with a November 18 date announced to match up with the conclusion of the November tour, Jim Aubrey had begged him to postpone the broadcast because MGM was planning to release Elvis On Tour in movie theaters at that time. With his usual instinct for adapting to whatever terrain happened to present itself, Colonel had made a tactical retreat. graciously acceding to Aubrey and acquiring a chit that might or might not ever come in handy. He kept the November concerts in Honolulu, though, and simply reconceived the plan on a grander scale, with a stand-alone show in January that would serve no other purpose than to embrace the world and its citizens.

* * *

The scale, and the ambitiousness, of the project just kept on growing as the Colonel worked out further details. Two weeks after the Vegas press conference Colonel got a letter from *Honolulu Advertiser* columnist Eddie Sherman, who had read in news accounts that there would be no admission charged for the concert, just voluntary contributions which would go to charity. Elvis and Colonel had made the first such contribution on the spot with a check for \$1,000. Why not make that charity the Kui Lee Cancer Fund? Sherman suggested in his letter. After all, Elvis and the Colonel had done so much for Hawaii when they graciously donated their efforts to the U.S.S. *Arizona* Memorial eleven years ago. Here was an opportunity to carry on their good work by raising money for cancer research in the name of a beloved Hawaiian musician, one of whose signature songs, "I'll Remember You," Elvis had recorded in 1966, the year of Lee's death, and still frequently performed in concert.

Much as he had when presented with the earlier challenge, Colonel seized upon the opportunity, and after the three November dates in Hawaii at the conclusion of their first RCA Records tour, he staged yet another press conference both to hype the upcoming special and to announce its dedication to the Kui Lee Cancer Fund. With Rocco Laginestra once again at his side, he set \$25,000 as the public goal, but privately he was committed to doubling that amount at the very least.

Elvis meanwhile had gotten caught up in the excitement himself. The idea had finally captured his imagination, and when he met with Bill Belew for costume ideas he brainstormed for something different, something that would say "America" to the world. "He came up with the American eagle [as a motif for the jumpsuit that he would wear]. It was one of only three times in all the times that we were together that he ever made any requests. We made an American eagle belt for it, a white leather belt about three or four inches wide with four or five ovals with American eagles on them. And, of course, the cape."

He met with Marty Pasetta, too, the experienced forty-one-year-old producer-director whom NBC had chosen for his familiarity with Hawaii (he had made five Don Ho specials), music (Bing Crosby, Glen Campbell, and Perry Como specials), and major events (he had produced and directed Grammy, Emmy, and Academy Award programs, as well as the Ice Capades). Pasetta had attended the Long Beach show on the November tour and came away decidedly unimpressed. It was a dull show from his point of view, full of posturing and tableaus, just not very exciting television. When he went to Vegas to see Elvis after the tour, he met first with the Colonel, arriving fully equipped with sketches of a stage setup that he felt might inject a little more pizzazz. In his conception the band was set up on a riser behind Elvis, the stage was lowered for greater audience accessibility, and there was a runway that extended out onto the floor. "The Colonel looked at it and made a very fast decision. He said, 'No way. That's not what he is all about.' I said, 'Well, wait a minute. I hate to be ruled out. I'd like at least to present this to Elvis and see what he might say.' He says, 'No, he's not going to do this. He won't do it. But if you really want to try. . . . But I'm against it. And I'll talk to him, too.'"

It was the old shell game, though Pasetta would have had no way of knowing it at the time. When he went upstairs to meet with Elvis, he was kept waiting as the guys glowered at him from behind dark glasses, "and I had my little drawings, and I said, 'Oh, my God, I'm going to be eaten alive.' Then Elvis came in, and they took out their guns and laid them on the table, and that really got me unnerved. I couldn't see Elvis' eyes behind his shades, but I figured, What the hell have I got to lose? [So] I said, 'I saw you in this show in Long Beach, and you didn't do much action, you were boring — but I'll tell you, I'm going to do something about that.'"

He went on in that vein, unveiling his sketches, explaining his idea to have lights that spelled out "Elvis" in different alphabets in "all the languages of the world," getting little reaction from either Elvis or his impassive bodyguards until he finally said, "And you've got to lose weight, because you're too fat." At that point, according to Pasetta, "Elvis threw off his dark glasses, leaned back, and started to laugh so hard he couldn't stop. Then he got up, walked over and hugged me, and said, 'I'll do whatever you want me to. I love the idea.' I said, 'We're gonna make super magic for the tube, and we'll do it together.'"

Pasetta immediately went about getting the set built on the mainland for shipment to Hawaii, where additional scenery was to be constructed. There was little more than a month's lead time, and an enormous amount to be done. Colonel volunteered several ideas to Pasetta, including a staged helicopter arrival, which eventually became the opening scene of the special, and a whole show, with bands, hula dancers, and little robots, for the crowd outside the arena waiting to get in. "He wanted a circus-type atmosphere, which was very apropos, because this was a unique, first-time [thing], the vibes in the air were just unmeasurable."

Most of all, everyone was excited by Elvis' evident excitement: he no

longer seemed passive and withdrawn, as he had for much of the year. He and Charlie and Red pored over material, coming up with a list of a dozen or so songs (including show staples like "You Gave Me a Mountain" and "My Way" and long-standing favorites like "What Now My Love" and "The Twelfth of Never") that had never been released on record by him before, looking for ways to introduce variety and pacing into the show. Elvis even went on a quick-fix diet that he had picked up in Vegas and, with Sonny and a couple of the other guys, took a daily injection that Sonny understood to include urine from a pregnant woman while eating no more than five hundred calories a day of dried food. Elvis was fully committed to the project, the guys all told each other; he seemed primed in every way for the challenge. Even the Colonel, who continued to pull off feats of never-beforeseen-or-dreamt-of prestidigitation, seemed willing to believe that this was all Elvis had needed all along. No one seemed to consider that this might be Elvis' own sleight of hand, that he might be putting on his best performance for them now.

H E AND LINDA spent virtually every minute of every day together. From the time that he closed in Vegas, she was almost constantly by his side. "I was with him twenty-four hours a day — I mean, he literally didn't even want to go to the bathroom unless I went in there with him. I realize it wasn't healthy, but he was my first great, great love, kind of my introduction to adult love, and I thought it was natural to be with someone all the time.

"He was very secure, very vulnerable with me — we were very much a part of each other. There were times when he was the father and I was the daughter, times when I was the mommy and he was the baby; sometimes he would say, 'I need to be little man, you need to be the big person now.' We kind of just geared off each other and understood the moods and became what the other needed for the moment. You know, honestly, my life just revolved around him."

She was surprised to discover how insular that life was; she was surprised in a way to discover how much he needed her. She realized early on that she had to be constantly vigilant, like a mother for her child; though he offered her pills she was never tempted, because several times he fell asleep while chewing his food, and he might have choked to death if she hadn't remained awake. It was a great romance but a great burden, too, and far from her world enlarging, she discovered like others before her, it actually shrank. They shared each other's passions, laughed at each other's jokes, read Elvis' books together, and called each other by pet names (Elvis frequently called her "Mommy," or "Ariadne" for the three-year-old in *Follow That Dream*). For Christmas he gave her a fur coat and a diamond ring, and, showing off for the guys, asked her to go upstairs and put on her Miss Tennessee banner and crown. "I said, 'Come onnn, that's really corny.' [But] I went up and put on an evening gown and my banner and crown and descended the stairs as if I were really into it, my beauty queen role. Then, when I got to the bottom of the stairs, I smiled, showing my blackened-out front teeth, and said, 'Is this what you have in mind, darling?' And he just died laughing."

They arrived in Hawaii on January 9, just five days before the show was scheduled to air. Elvis was accompanied by the usual retinue of guys, wives, girlfriends, family, and Memphis friends, adding up to close to two dozen in all. He and Sonny had succeeded in losing about twenty-five pounds apiece, but not before undertaking two full courses of the Las Vegas diet to do so, something about which Sonny had serious reservations since there were health cautionaries urging at least a three-month interval before renewing the regimen. Elvis had no such reservations, of course, and he looked better and appeared happier in Linda's constant, sunny presence. With the distinct upturn that business conditions had taken, it seemed as if happy times might at last have returned.

The money was certainly coming in once again from all sources: big screen, small screen, record sales, and personal appearances. *On Tour* had opened to good business in November, with an unusual flurry of publicity and glowing reviews (the lead story in *Rolling Stone* was entitled "At Last — The First Elvis Presley Movie"); it had even been nominated for a Golden Globe Award as Best Feature Documentary. Sales of the latest single, Red's "Separate Ways," paired at Elvis' insistence with another of the session's heartbreak songs, "Always On My Mind," had proved a little disappointing, but the record would eventually go on to sell half a million copies, well beyond any other single since 1970 except for "Burning Love." Moreover, in an off-the-wall maneuver which the Colonel had concocted to try to rescue the languishing Camden line (and his automatic 50 percent share of the proceeds), "Burning Love" had been employed as the lead-in

482 🔊 ON TOUR

to a hodgepodge of leftovers titled *Burning Love and Hits From His Movies*, which, in a marketing coup defying all logic of aesthetics and taste, had gone on to sell nearly a million copies. It was, RCA announced in the familiar language of the Colonel, an Industry First: "the first time that a current hit single has been included in an album on a budget label by the original artist," a breakthrough which had been achieved against all odds by virtue of "public demand and requests that the single be included in an album."

Felton attended the Aloha rehearsals, though he was not in charge of the project (this had been taken over entirely, in the wake of Felton's illness, by the home office in New York, with Joan Deary coordinating all details), and his only input would come in the quadraphonic mixing to be done in Los Angeles immediately following the show. He knew nothing about this new recording process (stereo doubled), and he had real misgivings about his future role at the record company, given Deary's evident ambition, but he looked and felt better than he had in years, after undergoing successful kidney transplant surgery in early October. He took comfort in the fact that Elvis had stuck by him through thick and thin, insisting that his old friend get paid for the Madison Square Garden recording when Felton was too sick to travel to New York and even finding Felton a kidney when, after two years, Felton's doctors at the Vanderbilt University Medical Center in Nashville still seemed unable to locate one on their own. Felton was down to 128 pounds and clearly dying when Elvis had taken matters into his own hands and contacted a kidney specialist from the Mayo Clinic, calling Felton excitedly when the doctor arranged for the operation within days. Felton was packed and ready to leave for Minnesota when all of a sudden, six days later, Vanderbilt suddenly came up with a donor, a discovery that Felton and his wife, Mary, always felt was less coincidence than recognition on the hospital's part that it might be watching a big donation go out the door. "Your husband is a jewel," Elvis told Mary Jarvis over and over during the three days of rehearsals, and while he was under no illusions about the Colonel's or RCA's loyalty to him, Felton was just glad to be there and could only trust to the friendship that had sustained his relationship with Elvis over the years.

Rehearsals were held at the Hilton Hawaiian Village while the set was being constructed. There were various technical problems to contend with, and Bill Belew back on the mainland had a scare when Elvis gave away his ruby-encrusted belt to the wife of actor Jack Lord, but Belew eventually located enough additional rubies to make up another belt and had it shipped over just in time for the show. Pasetta meanwhile had gotten all his scenic shots of the Islands (for the extended U.S. version that would air in April) by the time they got into the HIC Arena for rehearsal on Thursday. Everything was as he had shown Elvis in the original drawings: ceilinghigh strips of Mylar acting as a giant mirror, and enlarging the space, at stage right; a black scrim across the width of the stage at the back, with colored lights spelling out "ELVIS" in various configurations against it; and a guitar-wielding cartoon figure that would flash on and off. The runway extended well out into the audience, and Elvis got comfortable with the stage setup as tech crews ran their cables in the otherwise empty, cavernous room.

They kept on rehearsing almost up till the filmed run-through with an audience present on the night before the show itself. There continued to be technical problems to solve (getting rid of a persistent hum in the sound system by shielding all the cables with lead was the most challenging), but in the end everything went off more or less without a hitch. The Friday night rehearsal show got under way two hours after fans almost "literally stormed the inside of the arena when the gates opened at 7 P.M.," according to the Honolulu Advertiser, which reported further that "the audience went wild virtually without let-up through [the] non-stop repertoire of songs." Elvis had no trouble sustaining their hysteria, the filmed record shows, even if he himself never seems to have gotten particularly caught up in it. There is none of the manic energy of the '68 special nor even of the early Vegas shows, just a moment at the conclusion of "An American Trilogy," as the chorus swells, the percussion rolls, we are about to go into the "Glory, glory, hallelujah," peroration, and Elvis stands there meditatively, eyebrow cocked, his mind for a moment seemingly on destiny, as the music once again takes him far, far away. Then it is gone; he is off into "A Big Hunk O' Love," his 1959 hit. "You're a fantastic audience," he says, then launches into "Can't Help Falling in Love," which he ends down on one knee, his back to the audience, his cape spread out in that familiar pose of humble adoration, combined with self-adoration, that the world has come to accept as Elvis in any language.

There is no sense of tension, but this is only a rehearsal, after all plenty of time for drama at the actual performance. Except that when he takes the stage the following night, at 12:30 A.M. for his live audience in the Far East, he seems, if anything, even further removed. There are musical highlights, to be sure, but the overall atmosphere is even more stilted, and for all of his dramatic weight loss, Elvis appears strangely bloated, his expression glazed and unfocused. It is as if, in his Captain Marvel getup, his jewelry, his helmet of hair, Elvis has finally acceded to the need to be, simply, Elvis — there are no surprises, just effects.

"It was a thrilling compact hour — long on music, loud on screams," reported the *Honolulu Advertiser* admiringly, citing the "aura of the Big Time: a superstar doing a super performance, right before the eyes of the world." Thanks to Elvis and the Colonel's "philanthropic fondness for Hawaii," the original goal of \$25,000 for the Kui Lee Cancer Fund was more than tripled, eclipsing in the process the sum raised for the U.S.S. *Arizona*. To Joe Guercio, though, who did not have to be sold on the sheer charisma of the performer, "there was just not as much wind blowing through the show." Elvis was slower and less concentrated. "You could just feel it." Perhaps the most spontaneous moment came when he sailed his \$10,000 cape out into the crowd, where it was snagged by an *Advertiser* sportswriter. It was, reported the *Los Angeles Times* in its write-up the following day, "the highlight of the night."

The feeling of relief experienced by almost everyone connected with the show was almost palpable — although there remained much to be done. With the auditorium cleared, they still had to shoot five additional songs for the expanded American telecast, and then Marty Pasetta had to edit the show down by ten minutes for the delayed European broadcast to twenty-eight countries linked by EuroVision later that night. Joan Deary had her work cut out for her as well to get the album out simultaneously around the world within three weeks. But for Elvis and the band it was almost over. Colonel came in as they were recording "Early Morning Rain," the last number, and announced proudly that they had gotten the highest rating ever registered in Japan, with 37.8 percent of the viewers in a highly competitive six-network market. There was a sense of real jubilation in the air.

Not long afterward, the Colonel wrote Elvis a letter. Datelined Sunday morning, three A.M., January 14, 1973, it may have expressed as much sentiment as the Colonel had ever committed to paper, as he declared defiantly that *they* didn't need to hug each other to show their feelings because they could tell just by looking at one another from the stage and from the floor how the other felt. "I always know when I do my part you always do yours in your own way and in your feeling in how to do it best. That is why you and I are never at each other when we are doing our work in our own best way possible at all times." Life was short, many were quick to take credit after the fact, but Elvis knew who was really responsible for this idea: "this brainchild . . . came from you and me." The others — except for Mr. Parkhill from RCA Record Tours and Mr. Diskin and his troupe "and all your own selected talent"— were just Johnny-come-latelies. But Elvis didn't need to be reminded of that. Because "you above all make all of it work by being the leader and the talent. Without your dedication to your following it couldn't have been done."

ELVIS AND PRISCILLA, SANTA MONICA COURTHOUSE, OCTOBER 9, 1973. (MICHAEL OCHS ARCHIVES)

FREEFALL

E COULDN'T SEEM TO LEAVE Vegas at the conclusion of the February engagement. The guys all sat around impatient and out of sorts; they had wives and girlfriends to go home to, lives to pick up. Colonel departed to pursue his various schemes. But Elvis remained, with Linda at his side and Kang Rhee, whom he had flown in from Memphis for the last week of the show, on hand to provide entertainment and karate instruction twenty-four hours a day. There was, not surprisingly, some outright friction, with Red the most outspoken in his complaints. Elvis tried to address Red's concerns by writing him a letter in which, with Linda's help, he expressed some of his philosophy of life, but it didn't do much to dispel the cloud that seemed to be hanging over them all.

It had been an impossible month. As soon as filming for the satellite special was over, Elvis had just let himself go: his weight had immediately ballooned, and he had been out of it on pain pills, liquid Demerol, and heavy-duty depressants for much of the twelve days prior to the Vegas opening. *Variety* gave the show its usual pro forma endorsement, though the lead to the story indicated a certain amount of underlying ambivalence. "Colonel Tom Parker," the review declared, "has returned to the Hilton, hawking his elixir of unbottled sex and satisfaction, Elvis Presley." Perhaps struck by its own temerity, the "show business Bible" went on to assure its readers that "the product up for sale . . . possesses too much musicality to become the Colonel's mechanized doll — at least onstage."

Elvis saw a procession of doctors almost from the moment of his arrival, and his physical discomfort was increasingly evident the first week of the engagement (he was variously reported to have either flu or pneumonia), as the interaction of the diverse drugs led to throat and lung congestion, the congestion to further medication, and he was forced to cancel his midnight show five times in the second and third weeks. The Colonel, placed in the position of having to come up with an explanation, wrote an unusually conciliatory letter to the hotel, promising to make up for the missed performances and assuring Henri Lewin and Barron Hilton that he and Elvis would always live up to their commitments. Elvis, on the other hand, just didn't seem to care. One night he lost his voice onstage and panicked momentarily, but he found an ENT named Dr. Sidney Boyer who prescribed a throat elixir that restored it, and he saw Dr. Boyer almost every day of his stay after that, presenting him with a white Lincoln Continental in gratitude. He saw at least six other physicians as well, including his regular Vegas doctors, Thomas "Flash" Newman and Elias Ghanem, while complaining to a mystified audience that none of the doctors was able to discover the root of his problem.

The Hollywood Reporter was willing to attribute his apparent "lack of energy and interest" to the effects of his illness, and some saw it as the letdown inevitably bound to occur after the triumph of the Aloha show — but to those around him it was apparent that it went considerably further. Elvis appeared to be suffering from a kind of deep-seated malaise, which the guys, when they were feeling sympathetic, put down to continued brooding over the loss of Priscilla but in less charitable moments simply ascribed to the effect of drugs. The engagement in any case seemed to mark a kind of watershed. Frank Lieberman, the Los Angeles Herald-Examiner critic and Elvis' one close journalistic friend since his rave review of the February 1970 engagement, couldn't help but notice the difference, and even Muhammad Ali, whom Elvis had met in Vegas six months before and to whom he now presented a specially made-up robe declaring Ali to be "The People's Champion" for his February 14 title defense, couldn't miss the sadness at Elvis' core. "I felt sorry for [him], because he didn't enjoy life the way he should. He stayed indoors all the time. I told him he should go out and see people. He said he couldn't, because everywhere he went, they mobbed him. He didn't understand," said Ali, a lifelong fan, who probably more than anyone else in the world was himself in a position to empathize and understand. "No one wanted to hurt him. All they wanted was to be friendly and tell him how much they loved him."

On February 18, at the midnight show, the very thing that everyone had been half expecting and they had all been preparing themselves for ever since the 1970 assassination threat finally happened: four guys rushed the stage with what appeared to be ill intent, and the security team sprang into action. Red took care of the first "assailant," as bass player Jerry Scheff, Jerry Schilling, and the rest of the guys quickly moved in. Standing by J.D. to one side of the stage, Elvis took up a karate stance and knocked the second of the four men back into the audience. There was all kinds of confusion, and Elvis, inflamed, could not be calmed down. "Come on, you motherfuckers," he screamed, as his father wrapped him in a bear hug, but Elvis simply went limp and slipped out of Vernon's grasp. Finally Tom Diskin, who had been one of the first to rush to Elvis' aid, urged him to take his audience into consideration. "Think of the show, Elvis, get back to the show," murmured the Colonel's longtime lieutenant, but even then Elvis could not refrain from injecting a truculent note into his apology to the fans. "I'm sorry, ladies and gentlemen," he said. "I'm sorry I didn't break his goddamn neck is what I'm sorry about." And then he went on with the show.

Afterward, he couldn't stop talking about it. It was almost as though this was what he had been waiting for the entire engagement, and even though further investigation proved that the men were simply fans who had gotten a little out of hand, Elvis would have none of it. There could have been a drug connection, he suggested, it probably had something to do with his BNDD badge — but had they seen the way he took care of that one guy? He wouldn't have cared if he'd killed him. Maybe, he speculated, those guys had been sent by Mike Stone. Before long he had worked himself up into believing it. It would make sense. This was just the kind of thing that cowardly motherfucker would do. First he hides behind Priscilla. Now he sends hired killers to do his dirty work for him. He stole my wife, Elvis said. He stole my baby. The guys were starting to get worried now. They had never seen Elvis quite like this before. The quick flash of anger was one thing; they had all experienced that. But now it was as if an emotional undertow were pulling him down and sweeping him out further and further from shore. There was only one solution, he declared: the man had to die.

"You know it, Sonny," he shouted. "You know it. There is too much pain in me, and he did it. Do you hear me? I am right. You know I'm right. Mike Stone [must] die. You will do it for me — kill the sonofabitch, Sonny, I can count on you. I know I can." Mike Stone had to die, he kept repeating to Red and Sonny. "He has no right to live."

His books lay strewn all over the floor. Linda was in tears. It was no good to try to reason with him, as Red did when he suggested that it was Elvis, not Mike Stone, who had driven Priscilla away. After all, didn't he finally have what he'd said he always wanted — his freedom? Hadn't Elvis always told them he was the master of his own fate? No, Elvis practically screamed back at him, it was Mike Stone. Mike Stone was the start of all his

problems, and now Mike was trying to take his baby away from him, too. It was Mike who had persuaded Priscilla to try to limit Lisa's visits; wasn't that what she had said, after Lisa spent her fifth birthday with him in Vegas on February 1? She had said that *she and Mike* thought maybe Las Vegas wasn't such a good environment for a child. Well, maybe she was right, Red said. Elvis practically turned on him. *Didn't Red know that she had the baby sleeping in the same room with her and Stone?* He got his new M-16 out of the closet. "Doesn't anyone understand? Oh, God, why can't anyone understand? He has hurt me so much — you all know that. He has broken up my family. He has destroyed everything, and nobody cares. He is the one who has done it all."

He raged on the entire night. There was no reasoning with him. Finally Linda called Dr. Newman, who gave him a shot at 6:00 A.M. and returned half a dozen times in the course of the day as no amount of medication seemed able to calm him down or buy more than a couple of hours' sleep. He was still raving just as obsessively the following day, and the day after that, and finally Red contacted someone, a friend of a friend, about taking out a contract on Stone and got a price of \$10,000, which he brought to Elvis just before the dinner show. He had no idea what he would do if Elvis said to go ahead and give the guy the money; he didn't think he could actually make the call, but he couldn't seem to stop himself either. Elvis had a hold on him, Elvis had a hold on all of them; no matter how much he pissed you off, you couldn't say no to the motherfucker. He stared into Elvis' eyes when he told him, and Elvis was silent for a moment before he answered. "Aw, hell," he said at last. "Let's just leave it for now. Maybe it's a bit heavy. Just let's leave it off for now."

The final show was the usual off-the-wall kind of ritual celebration that both Elvis and the audience always seemed to enjoy, with Elvis making up all kinds of crazy lyrics and then delivering a dramatic recitation of "What Now My Love" that won him a standing ovation. He ran Charlie all over the stage fetching scarves until he practically dropped, then kept the spotlight on Ann-Margret, who was opening at the Hilton the next night, and declared seriously, "Leave the light on her, man. I just want to look at her." At the end of the evening he was down on one knee, his arms extended wide, the audience on its feet.

But then he couldn't leave. He just stayed and stayed. He and Linda attended Ann-Margret's opening. They went to other shows. He maintained

his karate studies with Kang Rhee, whose broken English and wonderstruck reaction to Las Vegas kept everyone amused for a while. Even Master Rhee, who was generally respected within the group for his integrity and the purity of his commitment to the sport, was dragged down in this atmosphere, though, jumping up on the couch and applauding as Elvis broke up the furniture in the suite to demonstrate his karate prowess. Ed Parker was in and out, and, beginning to sense that Kang Rhee might be a real rival, did all he could to plant the seed of suspicion among the other guys — which turned out to be not very hard to do after Elvis gave Master Rhee \$10,000, the first of five promised annual installments to promote his system of instruction and build up his schools in Memphis. From that point on, the talk never ceased, and by the time they finally broke camp and left for California on March 9, Kang Rhee, too, was trapped in the same hothouse atmosphere from which none of them seemed able to escape.

There was a spirit of entitlement that permeated the air. If one guy got something, everyone else wanted it, too; it was jealousy plain and simple in a sealed environment where the players never changed, the climate was always the same, and the outside world was regarded with scorn — if it was regarded at all. Joe, at the top of the heap and thus naturally subject to the jealousy of others but still subject to jealousies of his own, recognized just what was entailed. "Everything we did, we drove into the ground. What it would take somebody else ten years [to get tired of], we did in six months. Sometimes he'd get you so frustrated — I think he enjoyed doing it. You'd get pissed, and I don't know if it was a test to see if people'd still be with him, but then he'd sit and talk to you, and there was just something about him — he'd smile at you, and he could convince you of anything. Sometimes I thought about leaving, but I liked him too much, and I figured things were going to change. Everyone was just waiting for that day to happen."

THE COLONEL MEANWHILE had finalized the deal that RCA vice president Mel Ilberman had first broached the previous fall: with Elvis' full assent and enthusiastic support, he sold all rights to his client's back catalogue.

RCA, of course, like any record company, already owned the master recordings and the right to market them in perpetuity. That was never at issue, not even with the Colonel. What was constantly at issue, in endless nagging skirmishes that were never fully resolved, were matters of royalty

payments, the actual use to which the catalogue could be put (over which Colonel, whether by custom or contract, maintained absolute control), and other contractual elements that had never been put down on paper but that Colonel was always hinting might prove to be embarrassing to the record company if they were ever to be revealed to the world. What Ilberman was now proposing was to do away with this source of conflict once and for all by buying out Elvis and the Colonel. In exchange for a single lump payment the artist would give up all claim on future royalties, his manager would give up any potential ground for troublesome dispute, and RCA would establish once and for all their right to do whatever they wanted with all the music that had been recorded to date, using it to build up the RCA Record Club (one of Ilberman's fondest wishes), exploiting the back catalogue in a manner the Colonel had never permitted, wiping out all the disputes over foreign royalties, container deductions, and European album content with which the Colonel had continued to bedevil them over the years.

It was a gamble virtually unprecedented in the record business, which, like the Colonel and his client, dealt almost entirely in "now money" and put very little faith in the future ("catalogue" was a much derogated concept; publishing was where you built up a backlist, because a song could always have a new life, as opposed to an artist). Ilberman never thought the company would go for it. But desperate times called for desperate measures, and to his amazement, RCA president Rocco Laginestra authorized him to set up a meeting with the Colonel. Neither record company executive had any idea of what precisely to offer for the catalogue, and the financial people, probably just covering themselves, were for the most part opposed. So Ilberman had a schedule of royalty payments over the past seven years drawn up which showed that Elvis had received, on average, somewhere between \$400,000 and \$500,000 a year in domestic royalties, with an estimated 33 percent additional in foreign payments - in other words, roughly \$600,000 in a good average year. With that in mind, Laginestra came up with the figure of \$3 million, a prudent investment that could earn out for RCA in five or six years but one which Ilberman, who continued to wonder if the Colonel was somehow setting him up, felt was too low and could well be a foundering point before the real negotiations even kicked in.

The initial meeting was in Palm Springs not long after the conclusion of the Las Vegas engagement. The RCA executives made their pitch, and the

Colonel predictably said he would get back to them, but he didn't think it was going to be enough money, either for Elvis or his father. When he did get back to them the next day, it was with a counterproposal of \$5 million, which Laginestra immediately seized on, despite Ilberman's instincts that they could have bargained the old man down. Rocco just wanted to get the deal done, but the deal, Ilberman realized, was far from over. "The Colonel continued to talk in terms of restrictions on the catalogue, and Laginestra really didn't know what the Colonel was driving at, but I was very upset about that. We went to dinner that night at the Spa Hotel, and after dinner I kept raising the issue with the Colonel: we had to have the catalogue free and clear, without any restrictions. So he asked me for some involvement in packaging in the future for [his promotion company] All Star Shows, and I said yes. And I promised I would use the new stuff as well as the old stuff as much as possible on future packages — so that he and Elvis would be getting income in the future. I told him I would work with him on that, and I always did. We paid him for the packaging, the art (the Colonel had all the pictures) - we could have made our own pictures now and made the design, but this way he would get a royalty. And that was how we made the deal."

A contract that would actually come to \$5.4 million was formalized over the next couple of months but backdated to March 1, when the Colonel's new 50-50 personal management agreement with Elvis had gone into effect. Under the terms of this new agreement, the somewhat arcane "joint venture" language of Elvis and Colonel's 1967 contract, which defined contractual income alone as subject to a 25-percent commission, with all other income derived from recording (in other words, anything beyond RCA's annual guarantee, as well as any and all of the proliferating side deals) subject to a 50-50 split, was done away with, and the basic principle of partnership under which Elvis and Colonel had been operating for the past six years was, finally, explicitly recognized. From now on, all record income would be split down the middle, with touring remaining at a two-thirdsone-third division. Perhaps to ensure that there could be no question under which personal management agreement this one-time RCA payment was to fall, the payout was structured as if the old agreement were still in effect, with \$400,000 tacked on at the front end and divided 75-25 as if that were the "deal," and the \$5 million that represented the actual buyout treated as a "side deal," to be divided equally between the two principals.

That was not the end of it, however. There was, in addition, a new

494 👁 FREEFALL

seven-year contract, guaranteeing \$500,000 a year against royalty earnings on the two new albums and four singles for which Elvis would be contractually obligated each year. Moreover, at the conclusion of the seven-year term. Elvis and Colonel would each receive a \$100,000 bonus, not to be counted against royalties. In line with Ilberman's determination to keep the catalogue unencumbered, Colonel got a number of contractual guarantees of his own. He was to receive a \$50,000-a-year consulting fee for the duration of the contract for "assisting" RCA in the "development of merchandising and promo concepts" and for supplying RCA with "merchandising and promo material," plus \$10,000 a year for exploiting merchandising rights on the expired contract. Finally, for his assistance in helping RCA Record Tours in "planning, promotion and merchandising in connection with the operation of the Tour Agreement [and] records made," in essence for the seven-year duration of the new contract, he was to receive a grand total of \$1.35 million (\$150,000 the first year, \$200,000 every year thereafter) plus 10 percent of RCA Record Tours' profits off the top. In all, the Colonel was guaranteed \$1.75 million on top of his \$2.6 million share of the buyout itself and the \$1.75 million that he would get as his share of the new recording contract. Which meant that the Colonel would receive roughly \$6 million to Elvis' \$4.5 million from all of the deals combined (this might be likened to a professional athlete's seven-year contract for \$75 million in 1998 dollars, but with his agent getting four-sevenths of the money). Taking touring money into account (at least \$15 million, with Elvis getting \$10 million, but only after Colonel collected his 10 percent of tour profits beyond the promoter's guarantee), the overall package *could* be seen as a true 50–50 joint venture - and this was undoubtedly how the Colonel did see it, in one of the numerous alternative accounting approaches that he took to any subject, and that he would have taken toward this subject in particular after factoring in all the aggravation that he had to put up with and all the money that he was passing up, by retaining Elvis as his only client.

Not everyone saw it this way. To William Morris legal counsel Roger Davis, Colonel Parker was as brilliant in his instincts as any man he had ever met. Never less than a canny operator himself, Davis was quick to concede that the Colonel had taught him lessons about contract law; what he didn't understand was why Colonel continued to insist on operating on his own when he was so clearly out of his depth, as he was here with respect to tax advantages and long-term gain for both himself and his client. Jean and Julian Aberbach, who had built a publishing empire on the premise that ownership was everything, took much the same view. Although they were in the process of dissolving that empire themselves for a variety of financial and personal reasons (they had decided to sell Hill and Range the previous year, while maintaining ownership of the Elvis Presley and Gladys Music catalogues, along with Hank Williams' renewal rights, because of their uninterrupted record of profitability), they were doing so with an eye to the future. The Colonel, on the other hand, they saw as selling out Elvis for a mess of pottage — and then, more than anything, to satisfy his own gambling debts. They continued to have a real affection for their old associate, but as sophisticated men of business they could not be blind to his shortcomings either. The Colonel, in Julian's view, was a crude, blustering man without schooling. "He always had to be the big cheese, he had to dominate, he [could not] ask for any advice because it was demeaning — he knew everything. And he did not have long-term thinking."

And yet no one could say Elvis was an unwitting, or even unenthusiastic, participant, as he put his neat, flowing signature on the line marked "Approved" at the end of every one of Colonel's side deals. From Elvis' point of view as much as Colonel's, money was for spending, and what you spent it on was nobody's business but your own. There was never going to be any problem about money so long as the two of them kept their wits about them. It was almost karmic in fact, as he explained to Ed Parker, the way that money came in one door just as it was going out the other. He boasted to the guys how the old man had pulled the wool over everyone's eyes once again. And if the Colonel made some money for himself in the process — well, that was to be expected, there was plenty for everyone, and no one else could have made the deal anyway. The Colonel deserved his share.

The Colonel for his part was still working out the final piece of the puzzle. Ever since the Aberbachs had announced their decision the previous March, he had been trying to come up with a solution to the publishing problem that would be created when Hill and Range was dissolved. Although there was some sentiment for continuing to use Elvis Presley and Gladys Music as holding companies in which to deposit new compositions, it would have been anathema to the Colonel to sustain a partnership in which his partners were no longer pulling their weight. In any case, the situation between Jean and Julian and their cousin had long since become intolerable — and without Freddy there was no publisher presence.

The Colonel's first thought was to try to buy out the Aberbachs, but

that probably would have been doomed to failure even if Freddy had not been involved in the purchase bid. Next he came up with a scheme to have RCA buy Elvis' half of the publishing, but having already gone into the tour business on the Colonel's behalf and still in the midst of trying to work out terms for the acquisition of the masters, the record company understandably declined. He remained hopeful that RCA might still come through with financial support when he informed Elvis in the middle of the Vegas engagement that it looked like they might set up their own publishing through Freddy, with Elvis and Vernon and Lisa Marie owning 80 percent of it, and Freddy and Mr. Diskin each getting 10 percent. He tried to impress on Elvis, though, that plans were still unsettled and that it was very important both that Elvis make no commitments to recording any songs that friends might bring him until their situation was fully squared away and that this information be maintained in the strictest confidence. There was probably no great reason for all this drama other than to try to capture Elvis' attention. In the end it all came down to Freddy anyway, a surprising realization only if you were unaware of the Colonel's almost desperate penchant for loyalty, which some might see as a disinclination at least as great as his client's ever to venture outside his immediate circle of acquaintance.

In any case there was still much to be done, even as he was completing his deals with Elvis and RCA. Setting up new publishing companies proved more daunting than the Colonel had ever imagined, and the technical details dragged on over the next six months, but for all of the aggravation, and despite his keen awareness of Freddy's limitations, Colonel remained convinced that this could be the fresh start that they needed, that they were sailing into a brave new world — *if* he could keep the boy's mind on business.

The Aloha special aired domestically on April 4 to generally good reviews. The principal reservations expressed were that it was in its U.S. version too long, too much of a travelogue, and, in the manner of the current live show, too bombastic — but it was certainly accounted to be a success. The ratings (a 33.8-percent Nielsen, with a 57-percent share) bore out the advance hoopla, with the album, on the charts ever since the beginning of March, hitting number one at the end of the month, the first quadraphonic release, according to RCA, to achieve that honor. Elvis watched the show at home with a certain amount of trepidation but with none

of the edginess with which he had viewed the '68 special. He seemed to accept his own grandiosity, almost as if he had nothing left to prove.

An area in which he appeared far more intent on proving himself at this point was karate. Spurred on perhaps by Mike Stone's eminence in the field (Mike was "very much of a man," Priscilla was telling reporters and friends, and treated her "like a woman"), he was becoming more and more caught up in the sport, in much the same way that he had become caught up in other enthusiasms over the years. This was different, he might have protested, it was a discipline to which he had dedicated himself, in his own view, for nearly fifteen years — but now it began to take a more obsessive turn. On April 2 he prevailed upon Ed Parker to award him a sixth-degree black belt in kenpo karate (this was widely perceived as "selling rank" in karate circles, where such practices were not uncommon and were viewed as the equivalent of campaign fund-raising for a sport desperate for mass acceptance). This in turn only encouraged him to put greater pressure on Kang Rhee, whom he had flown out to accompany him to Parker's California Karate Championships in San Francisco. What he wanted now was for Master Rhee to go Ed one higher, with a seventh-degree black belt from his own Pasaryu school. Seven, he explained to his Memphis instructor, was a number of great spiritual significance to him, but Master Rhee was resistant. For all of his personal allegiance to Elvis, and his indebtedness to him, he continued to feel a greater loyalty to the sport.

There was a sense of excitement as they flew into San Francisco for the competition. By now there was virtually no one among the guys who was not caught up to one degree or another in the karate craze. Most were black and blue from daily workouts, and sprained wrists, backs, and ankles had become commonplace badges of honor. Not everyone was enamored of Ed's instruction methods, and jealousy over Kang Rhee's new position was rapidly growing, but there was a feeling of common enterprise and a sense of real enthusiasm, if only just to get out of the house. Driving in from the airport, Elvis had the limo swing by the Civic Auditorium, the tournament site, and there to his great surprise he saw his name emblazoned on the marquee. Back at the hotel he discovered that the newspapers, too, had carried notices of his upcoming appearance, which was advertised to include his participation in an exhibition of brick-breaking. Within minutes he was on the phone to the Colonel. Of course he couldn't make any public appearances, the Colonel thundered. What would the management of the Sahara Tahoe, where he was scheduled to open in less

than a month, and RCA Record Tours, which had a West Coast tour booked in a couple of weeks, think of his giving away for free what they were prepared to pay good money for? What was he doing hanging around with people who took advantage of him like this, who simply wanted to use his name?

Elvis didn't even try to argue. He dispatched some of the guys to get his name off the marquee and let the promoters know that he was leaving, then turned around and went home, bitterly disappointed both in Ed and himself. He got his seventh-degree the very next day, as Kang Rhee took the opportunity to do what a number of the guys, including Red and Sonny, Charlie, Jerry, and Lamar, had been urging him to do for some time: talk to Elvis about the pills.

"At the time I don't know anything about pills, I don't know anything about aspirin even myself, but the bodyguards explain to me, 'You just tell Elvis no pills, he not listen to anyone else, but he listen to what you say.' And I say, 'That's no problem.'" Elvis wouldn't come down at first when Master Rhee arrived at the house on Monovale, so fearful was he that he would be turned down in his standing bid for promotion. "Finally, he coming downstairs, and I told him that, 'You know, you the Master Tiger, king of the jungle, and when tiger has wound, he lick it well. Lick well, but not take any pills.' And he said, 'I understand.' Immediate response. And then he invite me his room upstairs, and he show me police badge, and pictures with Nixon, and then he's the narcotic agent. He says, 'I'm against drugs, and I do not believe in any kind of drug, even if I singing or anything like that.' He explain to me how clean he is himself." That was when Kang Rhee promoted Elvis to seventh-degree black belt, justifying it to himself by balancing it against all the good that Elvis had done for the popularity of karate and by how much the belt meant to Elvis himself. "He tell me many times, 'This black belt much more worth than my gold belt,' and he really have satisfaction with martial arts training. Simply, he do not care about anything else, and he trying to discover himself and overcome everything from bad to good. That's my impression at the time, see? But my regret is that I should more lead him, he elected me as instructor and I should lead him to much better ways, much stronger. But then I put him up over me when he trying to put me over him — [even though] he liked me because of my honest."

* * *

 $T_{\rm Coast\ tour\ to\ which\ the\ Colonel\ had\ alluded.}$ For bass player Emory Gordy, whose only previous dealings with Elvis had come when he filled in for Jerry Scheff at the March 1972 session and who was now replacing Scheff in the band, even this brief exposure amounted to a small revelation. He had been looking forward to rejoining Elvis after his productive recording experience (this was the session at which Elvis had recorded "Separate Ways," "Always On My Mind," and "Burning Love"), and the working conditions — pay, accommodations, the efficiency and comfort of the touring operation — could not have been better. The music alone turned out to be a disappointment. "I was really let down by the whole thing. Everybody had been there for so many years they were very set in their ways; I think they sent me about five hundred tunes to learn in a two-week period, and then we ended up doing the same show they had been doing in Vegas for the last [four] years. Occasionally, he'd get up there and start feeling real good and be very spontaneous, [but mostly] all the tunes were done so fast we just literally ran over them. There was no feeling involved."

In May they went into Tahoe in a peculiarly elongated seventeen-day booking, for which Elvis got paid a straight two-week salary of \$300,000, but the Colonel was to receive \$100,000 for "promotion." It was clear from the start that Elvis was "neither looking nor sounding good," according to the *Variety* review. "Some thirty pounds overweight, he's puffy, white-faced and blinking against the light. The voice sounds weak, delivery is flabby ... hit medley is delivered in listless fashion ... attempts to perpetuate his mystique of sex and power end in weak self-parody."

Variety's report turned out to be prescient, as Elvis canceled the last four days of his engagement, just one day short of two weeks, and Colonel was forced to forfeit his \$100,000 bonus. That was when everyone started to get worried. Undoubtedly alerted by the Colonel, Elvis' attorney Ed Hookstratten contacted John O'Grady, the retired Los Angeles police department narcotics detective who had been brought into the 1970 paternity suit by Hookstratten and subsequently gave Elvis the idea for getting his BNDD badge in Washington. O'Grady and his associate, Jack Kelly (Kelly was the former head of the Los Angeles office of the federal Drug Enforcement Agency), were given the task of ferreting out the sources for the prescribed drugs which were more and more obviously affecting Elvis' behavior. It took them no time to come up with four principal suppliers: a Los Angeles doctor who was giving him "acupuncture" treatments for the frequent injuries to his back and neck that he claimed to suffer in karate workouts; a Los Angeles dentist who made a specialty of house calls and painless treatment; and two Las Vegas doctors who appeared to be at his constant beck and call. Dr. Nick was specifically excluded from the circle of inquiry, because Vernon, who for the first time had been brought in on their concerns, vouched for the Memphis physician's overall commitment to Elvis' welfare.

The "investigation" went on for much of the next few months. All of the talk was in general enough terms to permit a certain level of deniability and, perhaps more important, to encourage a kind of unacknowledged self-deception, allowing them all to fool themselves for a time into thinking that the "problem" was not really of the dimensions that it was. But then Elvis nearly overdosed in St. Louis in the middle of his June tour, bringing home how serious the situation had become. And when, not long afterward, Elvis passed out in Hookstratten's office in the middle of a deposition attended by attorneys, secretaries, and a court reporter, it only further heightened his lawyer's concern. There were reports of incidents involving "civilians" (one girl was said to have almost died from an overdose of Hycodan in Palm Springs), and it seemed increasingly clear that the world was bound to learn of Elvis' self-destructive behavior, whatever containment methods were employed, unless something was done about it soon.

In the absence of any clear-cut direction from above, Hookstratten and O'Grady came up with a strategy that seems in retrospect somewhat questionable: O'Grady would contact all of the principal suppliers and try to frighten them into compliance; then O'Grady and Hookstratten would use their contacts among state and federal narcotics agents to put further pressure on the doctors, and by extension on Elvis himself, to straighten up. It seems hard to imagine how this plan could ever have worked without boomeranging back on their client (Hookstratten trusted his state contact, because, he said, "I had gone to law school with him and we were good friends"), but it seems even more doubtful that it was ever in fact actually implemented. What Hookstratten and O'Grady both found was that Vernon was torn between loyalty to his employer and loyalty to his son; the guys, too, were hopelessly compromised by the conflicting claims of friendship and employment; everyone, in fact, in a position to intervene was financially obligated to Elvis in one way or another. Even the Colonel seemed out of his depth, expressing bewildered consternation from time to time, but mostly just repeating the belief that sustained them all: Elvis

would pull out of this as he had so many times in the past; he had done it before, and he would do it again.

Hookstratten and the two detectives felt more and more as if they were crawling out on a limb that was about to be sawed off, but though each of them claimed at one time or another to have confronted Elvis after his own fashion, Elvis never expressed any resentment, and there were no flashes of anger, only the mildest demurral. He knew what he was doing, he told them, there was no problem; the reason he had passed out in Hookstratten's office, he explained to his lawyer, was that he had just been to the dentist and was feeling woozy from the anesthetic. "I said, 'Elvis, do you want to talk about it? Won't you please let us try to help you?' I thought I was going to get fired, but he gave me a gift instead, a slot machine that I'd always admired."

R CA COULD NOT HAVE BEEN happy to find themselves releasing yet another grab bag album (under the Colonel's by now almost generic title of *Elvis*) in the summer of 1973, especially after the great success of the *Aloha* soundtrack album. With no studio sessions since 1972 and virtually nothing left in the can, however, they had little alternative, their only consolation being the new contract and the new relationship (which the Colonel reassured them the new contract practically guaranteed) on which they were embarked. With that in mind George Parkhill, the Colonel's man at RCA, wrote Elvis on June 29, informing him in surprisingly peremptory terms that "in order to have the merchandise available . . . *we are planning* [italics added] a recording session in the middle of July." He gave Elvis the choice of where he might prefer to record but stressed that, under the terms of the March 1 agreement, RCA needed at least one new pop album, two new singles, and a religious album — a minimum of twenty-four tracks — from the session.

Since Parkhill at this point might just as well have been working for the Colonel (and as head of RCA Record Tours, to all intents and purposes actually was), it must be assumed that this letter was sent not simply with the Colonel's approval but at his behest. If he couldn't get Elvis to take his obligations seriously by any more direct method of communication, using RCA as an intermediary was a perfectly acceptable alternative.

It worked — at least initially. No one imagined that Elvis would leave Memphis in the middle of his four-week summer break, particularly when

502 🔊 FREEFALL

his daughter was visiting, so Marty Lacker, who had just started doing promotion for Stax Records, set up the session at Stax's McLemore Avenue studio in the old Capitol movie theater, practically next door to the First Assembly of God Church that Elvis had attended with his teenage girlfriend Dixie Locke. It made sense in every way: Stax was a legitimate studio, at the height of its success as a soul label, Marty had an in, just as he once had at American — and it was only five minutes from the house.

Elvis failed to show up at all on the first night, and on the second arrived five hours late, dressed in a sweeping black cape, white suit, and "Superfly" Borsalino slouch hat. The band included James Burton and Ronnie Tutt; the same American rhythm section that he had worked with in 1969 minus drummer Gene Chrisman; and, in Chrisman's place, complementing Tutt, drummer Jerry Carrigan from the 1970–71 Nashville sessions. For Carrigan, who had not seen Elvis in a couple of years, the whole experience was something of a shock. "It was the first time I ever saw him fat. His speech was slurred. It just seemed like he was miserable." "He just didn't seem to care," said American keyboard player Bobby Wood, echoing Carrigan's observation. "He was a totally different person."

Everything seemed to go wrong from the start. Felton Jarvis and his engineer Al Pachucki, already skating on thin ice after a disastrous confrontation with RCA executive Joan Deary over the quad mix of the *Aloha* album (Deary, who had no respect for either Felton's or Pachucki's technical skills or work ethic, had ended up supervising a complete remix), took a dim view of the whole Stax setup. The studio ambience, Pachucki observed, was very dry; there was no way to give the musicians different headphone mixes (in other words, the drummer got the same mix as the singer); and the console was hopelessly outmoded — the kind of eighttrack board that RCA had discarded in 1970 — which, with the nine singers that Elvis had insisted on bringing in to record live in the studio with him, made it virtually impossible to get any kind of clean separation.

The studio vibe was bad; the material, too, was something of an embarrassment — "horrible songs," in the view of Carrigan and the other musicians, that Elvis turned down just as fast as they were presented to him. Had the Colonel been there, he undoubtedly would have agreed with the musicians, and he must have winced when Tom Diskin made his report. Once again Freddy had failed to come through — despite the fact that he was now working for himself. The Colonel shook his head; he couldn't understand it. Freddy had all the motivation in the world to succeed — how could you improve on self-interest? But mostly it was Elvis, as everyone knew. At another time, in another mood, he might have shrugged it all off, he might have found something in the hackneyed tunes to spark his interest or simply pursued another direction altogether. Instead, the only thing that seemed to engage him was a karate exhibition he put on with Kang Rhee in the studio, which, after what the musicians had all heard about his putting a gun through Chip Young's guitar with a karate kick (Carrigan had been a direct witness), didn't leave anyone in a particularly sanguine frame of mind.

The next night he showed up wearing the same clothes but with Linda and Lisa Marie in tow — and once again several hours late. He seemed in a marginally better mood this time, and the material, too, was marginally better (primarily through the introduction of a Tony Joe White song that Felton had gotten from his friend Bob Beckham), but he recorded only three songs before departing in much the same disgruntled mood. The following night they got two more songs, and then on the fourth night of recording, with a new band in place (everyone else, anticipating that Elvis would work in his usual rapid-fire fashion, had made prior commitments), Al Pachucki discovered that Elvis' personal hand mikes had been stolen, and once Pachucki confirmed to Elvis that this was the reason for the bad vocal sound they were getting, Elvis just walked out and didn't come back. Felton went on recording instrumental tracks both that night and the next in the vain hope that he might return, but when he didn't, Felton shut the session down at 5:00 A.M. on the morning of July 26.

Of the thirty master numbers assigned to the session, only eight had been filled, with backing tracks for an additional four songs on which Elvis might or might not choose to overdub his vocals. It was a disaster any way you looked at it, and RCA felt badly let down. Colonel, too, was furious not just at the publishing debacle, to which he was convinced Felton had contributed by introducing his friend Beckham's songs, but at Elvis' own increasing refusal, or inability, to live up to his commitments. Most of all, though, the session was professionally catastrophic for Felton, whose sole perceived value to the Colonel and the company was his ability to get Elvis to deliver and who now, more than ever, found himself under fire from all sides, with no visible ally in sight. And yet Felton appeared to be the only one left with any faith in the future: he remained convinced that if they could just establish a good vibe at the next session, Elvis would pull himself together. All they needed was a good jam-type atmosphere, Felton expounded to an interviewer at around this time. "What I try to capture is to get him when he's just in there singing for himself. [That's why] a

504 🔊 FREEFALL

lot of the cuts don't have any intro — because they're just done that one time, and that's it. Elvis has to feel what he's singing," Felton explained, without bothering to detail just how difficult it was getting to sneak up on that feeling.

 $E_{\rm August \ 6}$ opening in Vegas. The subsequent reviews were if anything even more devastating than the Tahoe notices for their by now almost matter-of-fact recognition that something was seriously wrong.

"More overweight than he's ever appeared in Las Vegas . . . it's Elvis at his most indifferent, uninterested, and unappealing," declared the *Hollywood Reporter.* "He's not just a little out of shape, not just a little chubbier than usual, the Living Legend is fat and ludicrously aping his former self. . . . His voice, opening night, was thin, uncertain, and strained. His . . . personality . . . was lost in one of the most ill-prepared, unsteady, and most disheartening performances of his Las Vegas career. . . . It is a tragedy, disheartening and absolutely depressing to see Elvis in such diminishing stature."

To his audience it made little difference. Fan reports suggested that Elvis was "much happier," "full of fun for the most part," and seemed to be "enjoying the shows much more." But drug rumors were more prevalent than ever, and there were parties in the suite every night that frequently bore out the rumors. Two weeks into the engagement, at one of those parties, he broke the ankle of a woman named Beverly Albrecq in a karate demonstration that would eventually bring about a personal injury lawsuit, after Albrecq's husband found out how, and where, she had sustained the injury.

The shows themselves took on an increasingly surreal, if generally amiable, quality, climaxing on the final night with Elvis riding in on Lamar's back, a toy monkey attached to his neck. "Good evening, ladies and gentlemen and animal lovers," he announced. "I brought one of my relatives with me. I'm in trouble if he has to go to the bathroom!" It was all, it could be argued, in good fun, and the fans found it hilarious when he sang "Love Me Tender" with "X-rated" lyrics, but there were uncomfortable stirrings not just from the audience but onstage when he interpolated a verse that declared, "Adios, you motherfucker, bye bye, Papa, too/To hell with the whole Hilton Hotel, and screw the showroom, too." He performed "What

Now My Love" tossing back and forth on a bed that Sonny had pushed out onstage, sang the lyrics to "Suspicious Minds" to the melody of "Bridge Over Troubled Water" and vice versa (eventually he performed both songs seriously), and returned to the subject of the Hilton once again just as he was about to go into the "Mystery Train/Tiger Man" medley. "There's a guy here who works in the Italian restaurant," he said quietly, referring to his favorite waiter, who sometimes prepared meals for him in the suite. "His name is Mario, and these people are getting ready to fire him as soon as I leave, and I don't want him to go. He needs the job. And I think the Hiltons are bigger than that. There's no disrespect. I just want to wake up Conrad [Hilton] and tell him about Mario and his job, that's all." Then he went into the medley but stopped in the middle to announce, "This song is dedicated to the staff and hierarchy of the Hilton Hotel," then tore into the opening lines of "Tiger Man," which somehow seemed to take on added significance when he sang, "I'm the king of the jungle/They call me the Tiger Man."

The remainder of the show maintained much the same mix of the frequently ridiculous, the occasionally sublime. For the fans it amounted to a kind of invitation into Elvis' living room, as Elvis himself explicitly acknowledged when he said toward the end of the show, "I know we kid a lot and have fun and everything — but we really love to sing, play music, and entertain people. As long as I can do that, I'll be a happy old sonofabitch."

For the Colonel, though, there was little to be happy about; ever since the first mention of the Hilton, the Colonel had been fuming in the wings, and by the time that Elvis got offstage he was fit to be tied. He had heard all about this Mario, he knew all about Elvis' feelings in the matter — but they were not to be shared with the world. What the Hiltons did was their business and nobody else's, just like what he and Elvis did was their own private concern. He was fed up to the teeth. He had negotiated with Barron Hilton in good faith, he had devoted himself to the boy and covered for him again and again, he had built a career for him on exactly the terms that Elvis demanded: What was he trying to do now? Backstage he tried to talk to Elvis, but they couldn't communicate anymore. Everyone heard angry voices coming from the dressing room, and then the Colonel stomped out, and Elvis emerged more quietly a little later, as if everything had been all worked out.

There was the usual wrap party that night up in the suite. Tom Jones and singer Bobbie Gentry ("Ode to Billy Joe") were in attendance, and Elvis

506 👁 FREEFALL

had a surprise for Jones. He was aware that Tom had been having some difficulties with his vocal group, the Blossoms, so he had flown in a promising young gospel quartet from Nashville that included J.D.'s nephew Donnie Sumner (with the show until recently as a member of his uncle's group) and Sherrill Nielsen, whom Elvis regarded as one of the finest young tenors in the field and who had sung behind Elvis with the Imperials on the 1966 "How Great Thou Art" session. His intention was to present Jones with the quartet as a kind of gift, and to that end he had them perform for his guests, which no doubt hastened the end of the party.

The discussion with the Colonel was still on his mind as the evening wound down. The way the Colonel had talked to him — who did that baldheaded old bastard think he was? And what did he have to be so high and mighty about when everyone knew he was in debt to the Hilton up to his ass, which was why they were probably going to be playing there for the rest of their goddamn lives. People were talking about Europe, too — they were saying there was something funny going on, and Elvis had heard more than once that maybe Colonel couldn't leave the country because he was some kind of illegal alien or his birth certificate was messed up or something. For all Elvis knew or cared right now, though, he could have been a Martian — he was just an old man living in the past, his day was done. *Where the fuck did he get off talking to Elvis like that?* Call him, he said to Joe. Get the old sonofabitch up here.

The atmosphere was electric when the Colonel arrived at the suite. It was clear that the old man was still seething from the earlier confrontation, and Elvis was practically jumping out of his skin. There was no attempt on either man's part to hide his resentment now, and for the guys still in the room it was a scene as shocking to witness as any other intimate act of a marriage. For the first time that anyone could remember, they were actually shouting at each other in the presence of others, hurling ugly accusations back and forth until at last Elvis said, "You're fired," and the Colonel said, "You can't fire me, I quit," and each threatened to call a press conference the next day, and the Colonel said, "Fine, but if you want me to leave, you're going to have to pay up what you owe me," and stormed out the door.

The silence in the room was almost deafening. As much as they had all talked among themselves about just such a day, about Elvis' need for an upto-the-minute thinker like Jerry Weintraub who might have an expanded role in his organization for each of them, the bleak reality of the exchange hung like a chill in the air, as Elvis retreated into the bedroom with Linda, and they were all left to look at one another with a frozen sense of uncertainty and little left to say.

The Colonel had no such problem. He had, if anything, too much to say and was working on putting it all down in his fourth-floor warren of rooms and offices, papered over with reminders of all he had done for the boy. This was exactly what had happened to him twenty years ago almost to the day when Eddy Arnold had dissolved their long-standing relationship with a one-page letter stating his continued feelings of friendship but deepseated dissatisfaction with his manager's brusque manner of doing business. Then, as now, Colonel had been taken by surprise, but then he had needed a full week to recover and even after that period of adjustment had found himself unable to communicate with Arnold without betraying his hurt. Even as he declared that emotion had no place in this sort of exchange, he had defended himself at length in a rambling, discursive letter that alternated between angry justifications of his actions and a closely reasoned statement of account. In the end he had let Arnold go for a one-time outright payment of \$60,000 and the preservation of a limited social and business relationship. But it had not, in his mind, even begun to repay his investment, and it had not begun to make up for the hurt. This time he was determined simply to put the figures down on paper: the boy owed him, and he was not going to be shortchanged.

Colonel summoned Jerry Schilling when he had nearly finished with his accounting. Jerry arrived to find him in pajamas and slippers, his glasses pushed down on his nose, typing away in a cold fury. He had advanced money to Elvis over the years, there were bookings on which he had not taken his full commission, he had set up deals extending well into the future, there were residuals on all the movies, not to mention shared ownership of the two television specials. It was all very well for Elvis to strike out on his own if that was what he really wanted, but he was going to have to pay for the privilege. It was dawn by the time he ripped the last sheet out of the typewriter, and Jerry took the papers back up to a silent star suite.

The reaction the next day fell somewhere between panic and utter deflation. After the brave front he had put up the previous night, Elvis found himself now having to confront the Colonel's figures, as he and Vernon balefully studied the carefully added-up accounts and tried to decide who they might call to help them with this unprecedented situation. The negotiations went on in fits and starts for much of the next few days, with Jerry and Sonny the principal envoys in a war in which direct engagement

508 🔊 FREEFALL

was contemplated by neither side and information (and disinformation) was spread by neutral parties. Elvis heard that Colonel was ill through the hotel staff. Colonel heard that Elvis had put in calls to Tom Hulett and Ed Hookstratten without ever coming right out and saying what he wanted. It was as if each had taken his best shot and failed to knock the other man out; now they were just staggering around the ring, groggy and uncertain what to do next.

Vernon was sick about the whole business; he didn't know how they were ever going to come up with the money or even be able to proceed without the Colonel. Sonny was exhausted from staying up with Elvis all night every night. The shots the doctor gave Elvis didn't seem able to put him out for more than an hour or two, and Sonny got a summons to come back to the suite almost as soon as he himself lay down. Jerry and Joe, both of whose marriages had just broken up, were scheduled to leave for Europe the following week on a vacation that Elvis was paying for. They offered to put off the trip, but Elvis wouldn't hear of it. There was no question in anyone's mind that there almost *had* to be a reconciliation — but no one could figure out just how it was ever going to come about. Neither side seemed able to make a move.

Meanwhile, Jerry had conflicts and confusions of his own. He had started going out with Kathy Westmoreland on the June tour after watching the romance which had broken up his marriage that spring just drift away for no real reason that he could discern. Then his relationship with Kathy had gone bad, maybe because of the pressures of the engagement but also because of something that was going on between him and Elvis. He hadn't known what it was until Elvis revealed to him in a moment of remorse what, evidently, everyone else in the group already knew: that Elvis was the cause of the breakup of his previous relationship, that Elvis had fucked his girl. He couldn't believe it at first, even though he knew about Elvis and his stepbrother Billy Stanley's pretty young wife the previous summer, just before Linda came into the picture. But that was different. That was just Billy, whom no one took very seriously anyway — and when Elvis started telling everybody about it with that self-satisfied little smirk on his face, like he had somehow gotten away with something, Jerry just put it down to the pills. Now he wasn't so sure. "I don't know how it happened," Elvis tried to explain. "It just happened that one time," he said as if to reassure Jerry that he would not discover any further incidents of treachery even if he were to investigate. "I never did it with anyone else." Jerry was almost dumbfounded. "But she was the one I loved," he blurted out, before adding, "I'm just glad you're the one who told me, and not someone else." Sometimes he felt like he didn't really know Elvis anymore. But he remained a loyal lieutenant, even as he struggled to suppress the sense of betrayal that kept gnawing at him and remember the man he had loved and admired all these years.

Linda, too, was at a turning point. She was worn out. Elvis had been, so far as she knew, faithful for much of the first year of their relationship, an all-time record, he told her. And she had for her part devoted herself entirely to him, with a seriousness of purpose more suited to a nurse or mother than a girlfriend. Vernon had told her that she was just about the kindest person he had ever known; she reminded him of a favorite aunt, and he wanted her to be aware that her dedication had not gone unrecognized. That meant a lot to her, but she needed a break, and Elvis was ready for one, too. So when he suggested that he might run down to Palm Springs by himself for a little while when they finally got out of Vegas maybe she would like to do a little shopping herself — she seized upon the opportunity, even if she knew what it meant. She was twenty-three years old; she could imagine a different kind of life. She was still in love with him, but she had learned long ago that sexual love was not the essence of their relationship. And not just because of his physical condition — "he was certainly drug-impaired, but in some ways he also transcended the physical. He really did want to get to the heart of another individual. And, you know, it really did hurt my feelings, but I loved him so completely, I loved him enough like a mother loves a child, that I could really let him go."

Jerry and Joe left for Europe on the weekend, five days after the blowup, with the issue still unresolved. In the meantime Elvis had flown in Kang Rhee from Memphis, while Linda's parents and Dr. Nick remained as his guests, and his limousine driver, "Sir Gerald" Peters, brought him his blue Mercedes from Los Angeles. He continued to receive "acupuncture" treatments from his L.A. doctor, Leon Cole, who billed his Vegas visits to his patient, and he decided to sign the quartet he had brought in from Nashville (with whom he had been singing gospel music every day) after things failed to work out for them with Tom Jones. Almost as if to indicate how far removed he was from all the daily strife, he drew up a contract on a piece of scrap paper guaranteeing the backup group a flat \$100,000 a year essentially to be on call. They would become part of the show (a third vocal group, bringing the total number of voices behind him onstage to eleven), they would have their own segment, they would be free to pursue opportunities of their own but would be subject to his whim should he feel like summoning them to Memphis, Los Angeles, or Palm Springs - and, as if

510 🔊 FREEFALL

to prove his business acumen to any lingering doubters, he would get the publishing on all their songs. He named them Voice, after the single-issue spiritual journal *New Age Voice* that Larry Geller had put out and given to him in Vegas when he and Johnny Rivers had recently come to see the show.

Vernon was heartsick at this latest evidence of Elvis' profligacy; he didn't know what was going to become of them if Elvis didn't make up with the Colonel. Colonel, when he heard about it, remarked dryly that the group wasn't worth even \$50,000 to the show. But for the three singers, their manager, and the bass player who accompanied them, barely able up till now to eke out a living in Nashville, it was not just one more twist in an implausible storybook tale, it was manna from heaven — although they soon learned they were going to have to negotiate for their expenses, too, if they were to be at Elvis' beck and call.

It seemed as if things might go on like this forever in the strange new limbo in which they were all living. In some ways nothing much appeared to have changed — the Colonel made a deal with the International to get everyone's rooms discounted; business continued to be transacted independently by both parties; Elvis was still acting like Elvis. The only difference was that Elvis and Colonel weren't speaking to one another.

Elvis finally had Sonny contact Colonel just before they left Las Vegas. "We've got to call that old sonofabitch," he announced. "He's not going to call us." Sonny left the room after getting the Colonel on the phone, so he didn't hear the actual conversation, but his unmistakable impression was that it was Elvis who apologized. At this point it wouldn't have much mattered. Everyone was so exhausted by the emotional roller coaster they were just anxious for a resolution.

By the following week, Colonel felt sufficiently emboldened to assure RCA that Elvis would finish up his vocal tracks for the new album by the end of the month, so they wouldn't lose their November release date. The four instrumental tracks recorded in Memphis would be transferred to RCA publicist Grelun Landon in Los Angeles, who would be the nominal supervisor of a session that would take place not at RCA's Los Angeles studio but in Elvis' Palm Springs home — which from Colonel's point of view not only meant minimal disruption to Elvis' schedule but also virtually guaranteed that Felton would have nothing to do with the recording.

The very fact that another session was needed was Felton's fault, the Colonel strongly believed. Felton was to blame for the situation they were in. He catered too damned much to Elvis' whims and allowed Elvis to be drowned in a sea of voices and orchestration, when all the fans wanted to hear was *Elvis*' voice — the boy could record with a damned glockenspiel, and it would still sell. Just get him to put his voice on the tracks, the Colonel exhorted RCA. Let him know there was no time for any overdubs, no time for remixing, just have him get it right the first time. They would know better how to say all these things to Mr. Presley, he told the record company — and, of course, it was their decision in the end. As they were well aware, he would never presume to tell them their business; the only reason he was getting involved now was because of the unusual circumstances of the session and the concern they all shared about getting the product out on a timely basis.

The recording sessions, on September 22 and 23, did not go altogether as planned. Elvis turned out to have no interest in three of the four songs they had on tape; in fact, his greatest interest appeared to be in recording a demo tape on Voice, whom he had flown out a few days earlier not for the session but just to sing with him while he was in Palm Springs. Nor was his enthusiasm for the group limited to their music. Noting that Sherrill Nielsen could use a hair transplant, Elvis arranged for the operation to be performed in his living room the morning of the session, while he himself was undergoing acupuncture treatments for the broken finger he had suffered in a karate workout three days before.

It was not the scene that Grelun Landon had anticipated. Elvis was in his pajamas eating popcorn, Sherrill Nielsen's head was still bleeding underneath the bandages, and the door, propped open by a cable running to the RCA mobile recording truck parked outside, kept banging in the hot, dry desert wind. It wasn't until the end of the evening that Elvis finally got around to overdubbing his vocal on "Sweet Angeline," the one track from the Stax session that he deemed worthy of completion — but not before spending more than four hours on two song demos by his new group.

On the second night the story was no different, except that Elvis started off by cutting one of Voice leader Donnie Sumner's songs himself with a makeshift lineup that included Charlie on acoustic guitar, Sumner on piano, Voice bass player Tommy Henley, and James Burton, who was there presumably to overdub his guitar onto the prerecorded instrumental tracks. After overseeing three more Voice demos, Elvis started fooling around with Andy Williams' 1958 hit, "Are You Sincere?" It should never have worked — the song itself was a kind of blandly sentimental doo-wop ballad, and the backing was the same as on the previous number — but

512 🔊 FREEFALL

somehow the spareness of the arrangement, the incongruity of the instrumentation, the near-parodic swell of the voices seemed to release something in him, he was able to convey unself-conscious emotion as he posed the question that he was as inclined to ask of himself as of anyone else. Honesty, simplicity, the purely instinctual gut-level response — that was what his music was all about, it was what it had *always* been about. And if he had thought about it, he might almost have agreed with the Colonel that all the rest could be dismissed as just so much excess baggage.

The colonel was practically beside himself when he heard what had happened. Once again the most carefully worked-out plans had been laid to waste by the boy's thoughtless irresponsibility, and he was furious that RCA had not exerted greater control over the session. In a telephone conversation with Elvis the following day, he countered Elvis' insistence that the new songs be included on the album with his own even more emphatic insistence that if they were, it would have to be with Elvis' explicit understanding that nothing could be done to them — no voices or instruments could be added. He would do his best to try to get RCA to make the best of the situation, he said, but Elvis had to recognize the time bind he had put them all in. In subsequent conversations with RCA, Colonel drove home the same point in more explicit language than he had ever used with regard to his client.

This did not inhibit him, however, from blowing up at RCA just one week later when he learned that his worst fears about the sale of the catalogue were about to be realized, and Joan Deary, whom he had taken to be an ally in his struggle with Felton, was planning a November release for an anthology called Elvis - A Legendary Performer. From the publicity material, it was obvious that this was to be the first in a series of historical reissues in direct conflict with the artist's new product. Not only that, Deary had gone ahead and made her plans without even consulting him. With a deluxe booklet containing "pictures, old recording pages or session notes, pictures of early sheet music, magazine covers, recording information, and other similar memorabilia," there was no opportunity even to get in on the marketing end, and he was further affronted that Deary's memo, dated September 7, had taken more than three weeks to reach him. Without missing a beat he fired off a letter to his good friend Rocco Laginestra, the man who had engineered the masters buyout, pointing out that it was just this kind of precipitate and uncoordinated action that he had been concerned about when the record company first proposed the deal, that Rocco and Mel Ilberman had assured him he had nothing to fear from RCA, and that if RCA went ahead with such an ill-considered plan, it could cast serious doubt not only on the spirit of the agreement but on a relationship that had survived on the basis of trust for nearly thirty years now. The album release was quickly postponed till January, and the Colonel was henceforth included not just as an adviser to the series but as a paid consultant.

 $E^{LVIS'}$ DIVORCE DECREE was finalized on October 9. It was evident to Sri Daya Mata just how much the breakup of his marriage continued to be on his mind when he visited her not long before the decree came through. She had only recently returned from an eight-month pilgrimage to India, and their telephone conversations had not prepared her for the change she now saw in him. She was struck most of all by how miserable he appeared to be. The bright-eyed, sincere, if somewhat undisciplined young man that she had grown used to, the restless and resourceful spirit who could track her down in India just to make sure that she had not been harmed by an earthquake he had heard about on the news, seemed diminished somehow, robbed not just of his hope but of his beauty and ashamed almost to be seen by her like this. "I think that things were not turning out the way he hoped they would. He didn't have the energy, the enthusiasm, the feeling that he had in his earlier years. He was not at peace."

It was not the financial settlement that bothered him. His father was furious at Priscilla and so was his lawyer Ed Hookstratten for what they considered to be her going back on her word. He didn't care about that that was only money. What he was concerned about was something of far greater consequence, though he might have had difficulty putting his finger on it. It was the *rejection* that haunted him, the rejection that had come, as he always feared it would, in full view of the world. Perhaps even more than that, she had disrupted his dream; Sri Daya Mata might have said in her kindly way it was his "fantasy," and Priscilla would probably have agreed. But he had always imagined a picture of domestic bliss, the perfect lasting union he had promised his mother would someday come to pass. And now it was coming to an end, not by his own election (though he knew at heart that he had chosen it) but by the public decree of the state.

Priscilla had reopened the case in May, just before the Tahoe engagement. The settlement on the face of it was clearly one-sided: for a man of such wealth to pay little more than \$100,000 in a state where community

514 👁 FREEFALL

property was the rule, and for both parties to be represented in essence by the husband's lawyer, was patently unfair. *But that was what she had wanted*. Then she got involved in redecorating her new Pacific Palisades apartment (which Elvis had gladly agreed to pay for), and with part of the \$50,000 that she received as an initial payment toward the settlement, she opened up a designer clothing shop in Beverly Hills called Bis and Beau (her partner was a friend named Olivia Bis, Beau was from her maiden name). Evidently, the realities of doing business, not to mention the greater experience of her interior decorator and her new partner in the ways of the world, led her to a newfound appreciation for the financial realities of life. At least that was Ed Hookstratten's interpretation when he heard from her new lawyer that he was introducing a motion to set aside the agreed-upon settlement on the basis of "extrinsic fraud."

Since Hookstratten was the agent of the presumed fraud, Elvis had to hire a new lawyer, an associate of Ed's, and various depositions were taken over the course of the summer and early fall before the lawyers finally came to a new agreement. Elvis would pay \$725,000 in cash plus \$6,000 a month for ten years, which, together with Priscilla's half of the sale of the Hillcrest house (it had finally sold on August 31 for \$450,000), \$4,200a-month spousal support for a year, and 5 percent of the new publishing companies, amounted to close to \$2 million. In addition Elvis would pay \$4,000 a month for child support, and they would share joint legal custody of Lisa Marie.

On Tuesday, October 9, they met at the Los Angeles County Superior Courthouse in Santa Monica in the courtroom of Judge Laurence J. Rittenband and, after twenty minutes, walked out of the courthouse smiling for the horde of photographers and reporters who had gathered on the courthouse steps. Priscilla hadn't seen Elvis in a while and was both dismayed by his bloated appearance and bewildered at the dramatic physical change. He held hands with her throughout the proceedings in chambers, and she kept running her hands back and forth over his poor swollen fingers. They emerged blinking into the sunlight still holding hands, with Elvis looking slightly stunned in what appears to be a jogging suit with a flag on the lapel. Priscilla's stylish new look, set off by a three-quarter-length quilted patchwork coat that might well have come from Bis and Beau, seems fixed firmly on the future. She waved as she walked toward the car with her sister Michelle and was relieved when she saw him wink back.

*

 $S_{\rm Memphis}$ in a semicomatose condition. He had started having trouble breathing in California and chartered a plane to fly home. On the plane Linda noticed that his breathing was getting worse despite the steady administration of oxygen. Dr. Nick came out to the house and was shocked by what he found. Elvis appeared edematous, so swollen as to be virtually unrecognizable and barely able to breathe. Nick made every attempt to take care of him at home, leaving his office nurse Tish Henley on semi-permanent duty at Graceland, but when three days later Elvis' condition dramatically worsened and his breathing became noticeably stertorous, the worried physician had no choice but to admit him to the hospital.

In the hospital the first concern was to get him stabilized, and to that end Dr. Nichopoulos had him seen by a team of physicians, who all agreed that his condition was grave. After first satisfying themselves that he was not suffering from congestive heart failure as a result of the obvious buildup of fluids, they settled on the hypothesis that he was experiencing an extreme drug reaction, most likely to steroids of some sort. When he was well enough to talk, Nick questioned him about the medication he had been taking, but there appeared to be nothing in the various prescriptions that would account for his "cushionoid" appearance. One of the doctors asked him about the black and blue marks all over his body, and Elvis responded that they came from the acupuncture treatments that he had been receiving for the past eight or nine months. No one could understand how acupuncture needles could cause such a dramatic reaction until Elvis explained that the treatment was administered not just with the usual assortment of needles but with a syringe. When Nick asked Elvis what was in the syringe, he professed not to know. The doctor had told him something about using a local anesthetic to cut down on the pain and maybe a little cortisone to speed the healing process, but he wasn't really sure what exactly was in the mix. Nick pursued the matter in private with Joe Esposito, who now suggested that he thought there was something more to these injections which Elvis had been getting with increasing frequency lately. Nick called the doctor in California, and after informing him angrily that Elvis was a very sick man, finally got out of him what anyone around Elvis could probably have told him: Elvis was getting almost daily injections of Demerol, and far from being ignorant of the nature of the medication, he frequently touted the marvelous healing powers that Demerol possessed and had even flown the doctor in on a number of occasions to administer the treatment to friends. It was at

this point that Dr. Nick realized that his patient would have to be treated as an addict.

In the wake of that revelation he consulted with Drs. David Knott and Robert Fink, two specialists in drug addiction, and on the basis of their recommendations put Elvis on phenobarbital immediately to prevent a severe withdrawal reaction. The next day he started Elvis on methadone, a treatment frequently used to combat heroin addiction, and called in Dr. Larry Wruble, a gastroenterologist, who ordered X rays that showed a bowel ileus, or enlargement of the intestine, that was full of fecal material, undoubtedly a result of long-term opiate (tranquilizer) abuse and the principal cause of Elvis' distended abdomen. Because one effect of long-term cortisone use can be to aggravate a glaucoma condition, he called in the ophthalmologist, Dr. Meyer, too, who found that Elvis did indeed continue to have a mild case of glaucoma in both eyes, something he knew would concern Elvis when Elvis was alert enough to be concerned — but for the moment Elvis was too sick to care.

Over the course of the next few days the medical team closely monitored every one of their famous patient's responses, and Elvis was gradually weaned back to health. They noted strong indications of natural hyperactivity (involuntary movement of his limbs, intractable insomnia) and a disinclination to subject himself to hospital discipline (he sent out for Krystalburgers when he was supposed to be on a liquid diet and surreptitiously took a sleeping pill from his own supply after the nurse refused to give him one). After a liver biopsy, they found that organ to be infiltrated with fatty cells, a condition very likely brought on by medication abuse.

Nick explained his suspicions to Joe, and together they went out to Graceland to search Elvis' bedroom for evidence of exactly what he was taking. There they found three large bottles of pills (one thousand Dexedrine spansule capsules, one thousand Seconal, and another form of sleeping medication), all of which Dr. Nick subsequently disposed of. As Elvis got better, the methadone dosage was gradually decreased, and Drs. Knott and Fink, who had originally held out for Elvis to be admitted to Dr. Knott's drug treatment center, spoke seriously to their patient about the consequences of "iatrogenic and volitional polypharmacy." The patient, they noted, indicated "intellectual assent," though there appeared to be considerable doubt on the doctors' part that such assent would translate into resolve.

Linda was with him for virtually every minute of his more than twoweek stay. "I had a cot beside his bed for the first few nights, and he lowered his bed every night to the height of my cot. I kept sliding down, and he would reach over and grab me around the neck and pull me back up again. We were just trying to stay as close as possible. Finally, they brought in a hospital bed for me. Then they started treating me like a patient. I never got out of my gown, and the nurses would come in and say, 'And how are our patients today?' Once I tried to go downstairs and look at the magazine rack (I was going stir crazy), and I got dressed, and Elvis said, 'What are you doing?' 'I'm just going downstairs to look at the magazine rack.' He said, 'Oh, no, honey, if I can't have my clothes on, you can't.' He made me put my gown on and get back into bed. He was just like a little kid, and I was his little buddy. Whatever he had to go through, I had to go through. Some of my most precious memories [of him] are in the hospital. He was cared for. We watched television — we got hooked on the game shows; we liked *The Match Game*. Even after we went home, we watched them."

Jerry and Sonny alternated staying in the room next to Elvis'; his stepbrother Ricky Stanley started to bring in food from Graceland — meatloaf mainly. And late at night, after all the Memphis stations had gone off the air, Elvis and Linda would watch the closed-circuit images the hospital broadcast from the nursery. "The nurses would put 'Hi, Elvis,' on the incubators and cribs and come up to the camera and wave, because they knew Elvis liked to watch the babies. There was one little fellow who actually waved, and after that Elvis and I waved to each other that way. I found that little guy [later]. I tracked him down and sent him some shoes."

Gradually everything returned more or less to normal, although the hospital continued to have problems dealing with its celebrity patient, as even routine tests created something of a dilemma, and they were forced to schedule them in the middle of the night so as to avoid creating too much of an uproar among the nurses and other patients. In the midst of his hospital stay, when he was finally beginning to feel a little better, Elvis got a telegram from the Colonel informing him that he had worked out a new deal with the Sahara Tahoe and eliciting a telegram in return offering congratulations and authorizing the Colonel to sign the contract on his behalf.

ELVIS AND RED WEST, SEPTEMBER 16, 1974. (COURTESY OF THE ESTATE OF ELVIS PRESLEY)

THE IMPERSONAL LIFE

HE IDEA WAS, simply, to get well. The two and one-half months after his hospitalization was the longest period of sustained inactivity since he had returned full-time to live performing two years earlier. More to the point, it represented a commitment to the abstract ideas of self-discipline and moderation absent not just from his life but from his whole way of thinking for quite some time.

His illness had frightened everyone, not least Elvis himself, and he threw himself into the role of the good patient. Dr. Nick came by almost every day for the first three weeks after he got out of the hospital, generally straight from work. Elvis would often be getting up around this time, and they would have breakfast together either in his bedroom or in Lisa Marie's, which Elvis had set up as a kind of sitting room across the hall. Despite all of Dr. Nichopoulos' efforts to educate the staff about the importance of diet to Elvis' health, he couldn't keep the cooks from preparing all the food they normally prepared or the maids from serving it, so "a lot of times I'd go by at mealtimes just to eat part of his food, so he didn't eat too much." Convinced that there was no way to wean his patient entirely off sleeping pills, he placed him on a moderate amount of medication - Valmid, Valium, Placidyl, Hycodan - which at first he tried to control by ladling out one week's supply at a time. He learned right away, though, that a week could go by very quickly in the Elvis universe, and when he tried to enlist the guys in monitoring Elvis' intake, he soon discovered that they were no less susceptible to Elvis' powers of persuasion than the household staff. At that point he switched over to small packets of medication, which he or his nurse would deliver, and frequently administer, daily.

Often in the evening Vernon would stop by, and Nick would observe an intimate colloquy between father and son scarcely dependent upon words. No one had been more worried about Elvis than Vernon; his initial sense of panic, his instinctive fear that somehow his son was going to be taken away from him were perfectly evident when the doctor told him that Elvis would have to be hospitalized. And now his sense of relief, his gratitude that his son had been spared were just as transparent. For Dr. Nick the entire experience was an education. After spending so much time with his patient in Las Vegas and on the road, he was amazed to discover now both the limitations and the dimensions of Elvis' world. They spent almost all of their time together at first in Elvis' or Lisa's room, with Linda alone for company and the windows covered with aluminum foil, the two television sets in the ceiling as well as the one at the end of the bed softly murmuring while candles burned on the television stand. The room was full of books, hundreds of them, and most of what they talked about were the ideas that Elvis got from those books, abstract ideas about life and love, the afterlife and reincarnation. "A lot of times he would just stay up in his room and read. He would do a lot of writing in the margins of the books. I would think it would be interesting for someone to go back and put some of [those notes] together. Of course he liked to talk about medicine. He asked me to bring him a book on the colon one time, so he could understand it - it was really a sincere curiosity."

If on occasion he failed to stop by, he found that Elvis' feelings were hurt — and he found that he missed it, too. For the most part he didn't charge for his visits, and it was certainly an unusual doctor-patient relationship, but Nick came to feel a sense of privilege, and he was the kind of physician who prided himself on his ability to relate to his patients irrespective of background. His entire practice was based on an easygoing manner and direct affability that all his patients recognized.

He continued to address some of the other abiding health concerns: the hypertension, the enlarged intestine and related colon and bowel problems; he even tried to persuade Elvis to visit a sleep clinic in Arkansas, and when that attempt failed, got his friend and patient Sam Phillips to make a tape of ocean and rain sounds to help screen out some of the distracting noise that Elvis was bound to run into when he went back on the road. Linda was his best ally in all this: she kept up with the medications, looked out for shipments of unmonitored drugs from doctors in Las Vegas and California, and was a positive force in every way, doing her best to cheer Elvis up when he needed cheering, jollying him along when he complained that he was not a child — he didn't understand why Nick didn't trust him to regulate his own intake of medicines. "Linda was a really good influence on him. She tried to help him any way she could. She would bring out a different side of Elvis, his humor, his 'carrying on.'"

For Linda it offered a respite of sorts, a return to some of the relaxed good feeling with which their relationship had started out. It was nice to see Elvis enjoying himself, hear his bubbling laugh once again, watch him be able to take things a little more in stride. It was like a vacation in a way, with nothing hanging over them. Sometimes they would just get together with a group of friends and sing and fool around; one time at Linda's parents' house someone turned on a tape recorder as Elvis sang Hank Williams sad songs and Jimmy Reed blues in a warm, relaxed voice, offering up "That's All Right" and a falsetto version of "Spanish Eyes" with a loose confidence that seemed decades removed from the grandiloquence of some of his recent public declamations. He harmonized with Linda, then joined in on her Alpha Delta Pi sorority song, doing one verse with her in ricky-ticky double time. "Did you ever hear the little poem I wrote?" he asked innocently, then recited with earnest gravity: "As I awoke this morning/When all sweet things are born/A robin perched on my windowsill/To greet the coming dawn/He sang his song so sweetly/And paused for a moment's lull/I gently raised the window/And crushed his fucking skull." You can hear Linda's peals of laughter amid the general hilarity. "Oh, Lord, that's funny," someone says. "When you first told me that," Linda says, still laughing, "I thought, how beautiful, it's so pretty, the little bird . . ." It could be a group of friends anywhere, just hanging out and having a good time, not thinking about anything much except maybe that it was getting close to dinner. "Are you getting hungry?" Linda asks, and as if on cue everyone offers the same west Tennessee version of Shakespeare that Elvis had introduced them to. "He's got that lean and hongry look," they all explode in self-mocking drawls, savoring an old joke that scarcely needs to be repeated to trigger the response.

H E WENT BACK INTO THE STUDIO in December after a brief sojourn in Palm Springs, during which Linda visited Puerto Rico. Once again it was decided for the sake of convenience to record at Stax, and once again for all of the shakiness of his position Felton remained in nominal charge, though he was not permitted to use his own engineer. Instead, at Joan Deary's orders, New York studio manager Larry Schnapf sent down his head engineer and three assistants, along with the same sixteen-track mobile recording unit that had traveled to Palm Springs that fall, thus allowing them to bypass the Stax board altogether.

The new Stax session went far better than the last, due in large part to

Elvis' attitude. Two of Elvis' favorite Nashville players, pianist David Briggs and bass player Norbert Putnam, augmented James Burton and Ronnie Tutt to make up the basic rhythm section, and the room was filled with eleven backup singers, including the Stamps, Voice, Kathy Westmoreland, and a female studio trio. The material was a big improvement, too, as Elvis really got untracked on the first selection, a gospel-flavored, revival-styled number from "Burning Love" author Dennis Linde entitled "I Got a Feeling in My Body," and threw himself into everything from sentimental favorites like "Spanish Eyes" to Jerry Reed's hand-clapping "Talk About the Good Times" to a rueful cover of "Good Time Charlie's Got the Blues." Even on the rockers, though, you miss some of the lighthearted, easygoing sense of play that you hear on the home tape with Linda and that characterized even the most serious ballads of the early sixties, when Elvis seemed to glory simply in the freedom of his voice. It's hard to tell whether he no longer trusts that voice or merely deems it unsuitable for public occasions, but the overall impression is one of greater weight, less sheer fun. The session was as successful as any in the last three years nonetheless, throwing in such refreshing changes of pace as Chuck Berry's "Promised Land" and Red West and Johnny Christopher's "If You Talk in Your Sleep (Don't Mention My Name)" and coming up with a total of eighteen finished masters in seven days.

It was the business that remained the problem, with Freddy once again failing to deliver, despite what would appear to be his clear self-interest. Colonel was at a loss to understand why this should be so, unless it was that Mr. Bienstock had gotten so big he didn't have time for an Elvis Presley session — but the result was publishing chaos and a web of political intrigue that didn't do anybody any good. Red, Felton, Lamar, even Marty Lacker, were all competing for cuts, but except for Red's number and one song out of Nashville, the only copyrights that went to Elvis Music were two songs by members of Voice and a third that the group brought in. Elvis himself leaned toward numbers that he had worked on with Voice and even incorporated several duets with lead singer Sherrill Nielsen into the session, and the fact that Red always seemed to have the inside track on the single didn't sit well with other members of the group either. None of this contributed to any strong feelings of camaraderie, with Voice bearing the brunt of much (but by no means all) of the resentment, and Lamar at one point exploding, "Who wrote that piece of shit?," only to discover that it was the Donnie Sumner song that Elvis had brought into the session himself.

For Norbert Putnam it was a nonmusical moment that stood out. "We were having lunch as usual around midnight, and just by accident we were sitting together on a riser that had been pushed over in a corner. I remember I said, 'Elvis, I've got to tell you something. If it hadn't been for you, I wouldn't be here. I mean, thank God "Blue Moon of Kentucky" only had three chords in it!' Well, Elvis laughed, but then he started talking about going to England and Australia, and he said, 'I really want to go, but Colonel doesn't want to do it. He thinks if we put them off, that will just keep their interest up.' I said, 'What are you going to do?' He said, 'Put, I'm thinking about pulling away from the Colonel.'" It was as if, Norbert thought, he were trying out an idea he couldn't voice to any of the others, covered by a cloak of anonymity. And when the brief interlude was over, he simply said, "Okay, I guess it's time to go back to being Elvis."

The Christmas season continued in this mood, as he kept pretty much to himself, spending time with Linda and her family, getting introduced to racquetball by Dr. Nick, showing little of the boisterous spirit that had characterized Christmases past but none of the wild mood swings that had proved so disturbing lately either. He was growing increasingly worried about going back to work, he confessed to Dr. Nick, who on several occasions judged his insomnia to have worsened sufficiently that he sent a nurse out to Graceland to administer sleeping medication injections. Rehearsals were scheduled to begin at mid month, eleven days prior to the January 26 Hilton opening (at Dr. Nick's recommendation, and with Colonel's approval, the engagement had been shortened to two weeks), and Elvis was clearly ambivalent about getting back into the race.

F or the first time in three years he dispensed with the cape as part of his costume, and he was in good shape, reported the *Las Vegas Sun*, "at the top of his form, in good humor . . . extremely generous timewise, and a jam-packed Hilton main showroom responded warmly." This is not to say that he was without panache, or without the flashes of anger that had accompanied other recent appearances. "You sonofabitch," he snarled at one girl who yanked at his necklace, and at another show he kicked at another fan. But for the most part it was a relatively predictable appearance, with a solid, well-rehearsed repertoire and a new bass player, thirty-year-old Duke Bardwell, replacing Emory Gordy. Bardwell, who came in on the recommendation of drummer Ronnie Tutt, was such a late addition that he had to fit into Emory's stage clothes, not an easy

undertaking even after he had lost a good deal of weight. A lifelong fan, he was nervous from the start, and it didn't help any when a buzz from his bass amp irritated Elvis on opening night. For all of his adulation, though, he found the music itself a letdown, with little room for the kind of freedom and feeling that had originally drawn him to Elvis Presley as a teenager.

Voice, on the other hand, who, like Duke, were making their Vegas debut, had no such scruples about the situation: they were in fact excited about almost every aspect of their job, from Sherrill's featured duet with Elvis on "Spanish Eyes" to hanging out with Elvis in the penthouse late at night. For them it was all new, sitting alone with Elvis in his bedroom talking about philosophy and religion, looking out at the Las Vegas skyline lit up at night. He played them "Softly As I Leave You" from the Charles Boyer album over and over, telling them the story that singer John Gary had told him, how the song was really not a standard love song at all; it was about a man who was dying and telling his wife good-bye. Sherrill already knew the song, and one night the two of them sat down at the piano, and Sherrill started singing while Elvis, who had introduced the number in his August engagement, did the Charles Boyer recitation. "His dad, Vernon, was there, and he said, 'Elvis, that's beautiful. Why don't you do that onstage?' And he said, 'Well, I think we will.'" So he sent for Glen D. to sketch out an arrangement, and from then on, it was a featured part of the act. Sherrill knew that this only further fueled the resentment of everyone from the Colonel to the band members to the guys. "Everyone disliked us because we had an in that nobody else had. They were all [still] upset that he had hired us. But Elvis said, 'Don't let it bother you.' He said, 'If I want to buy an airplane and fly it over this hotel and crash it, it's my goddamn money, and I'll do with it what I want to.' 'Cause he knew [about the] jealousy."

With or without Voice there would have continued to be friction, if only because Elvis himself seemed to encourage it. Maybe, as some of the guys speculated, it relieved the boredom, but he never hesitated to set them off against each other in pursuit of his favor. His own behavior certainly did not lend itself to the tranquil life. For all of his reformed ways Elvis seemed increasingly careless not just of his own safety but of the safety of those around him. Red and Sonny in particular had even less respect for his judgment with firearms than they did for his karate skills, particularly when he was stoned. Now it seemed he just didn't much care as he shot out the dining room chandelier one night because he was "bored" and shot out television sets on the most casual whim. There was more than one occasion when he pulled a gun on Red, and Red dared him to use it. As Joe said, everyone was always "a little tense, not knowing how Elvis was from one day to the next." Linda had as much reason for concern as anyone else. She was not about to forget the incident the previous year when Elvis had shot at a light switch while she was in the bathroom, and the bullet went through the wall, nicking the toilet paper holder and shattering the closet mirror. When she emerged, understandably shaken, all Elvis had to offer by way of apology or explanation was, "Hey now, hon, just don't get excited."

No one understood how she could maintain her composure, let alone her sense of humor — but she did. And she seemed able to accept his other whims equally well. If Elvis wanted to be with another girl, Linda just made herself scarce, as she did on one occasion when Ann Pennington, a twenty-three-year-old model with a three-year-old daughter whom Elvis had met the previous fall, arrived in Vegas. To Joe, in charge of all the travel arrangements, it was like a game of musical chairs, but to Ann, even at the beginning of their relationship, it seemed more a matter of Elvis' trying to keep boredom at bay, as he told her all the familiar stories, impressed her with his knowledge of karate, and showed a tender side of himself that she could respond to with all the freshness that went with hearing and experiencing it all for the first time.

She was fond of Elvis, but it was no great romance — she realized early on it was never going to lead anywhere, and she couldn't help but observe that for Elvis, too, the flame was quick to flicker out. "I remember the first time I went to Palm Springs he was like, 'Will you come in the bedroom? I just want to kiss you.' I said, 'I don't know.' He said, 'I swear I won't do anything. I just want to kiss you.' He really did like more than anything just to cuddle and kiss; the other just wasn't very important." He loved to spend time in his room singing to her, and "he gave me a Charles Boyer album, there was a song 'Where Does Love Go (When It Leaves the Heart),' he would play it over and over and say, 'Listen to that, the way he says those lines. It's so romantic.'" Sometimes he would show off to her by telling the guys a joke and controlling their reaction. "He would say, 'Ann, watch,' and they would all laugh, and then he'd go like this [a snap of the fingers], and they'd just stop."

They read books together and talked about what they read, but if she offered any opinion about what she saw as evidence of his increasingly selfdestructive behavior, he would just tell her she didn't understand. "He said, 'You don't know what it's like to live this life. You don't know how hard it can be.'" One time they smoked pot together and laughed and laughed, but she awoke in the middle of the night to discover that he had wet the bed. "So I got on the very edge of the bed, and in the morning he said, 'God, Annie, I'm so sorry, why didn't you wake me? You laid in that one little place.' So he had the maids come up and carry the mattress out of the room. He didn't seem to be embarrassed; he was laughing, telling the guys, 'She lay in this one part, the only dry spot!' He was funny."

Even in the brief time she was with him, she was aware of other girls, because he told her. She had other boyfriends, too, but she found it hard dealing with someone so needy when she had a daughter to look after. It was hard on him, too, he told her. "He said he never liked to think that I had been with anybody else." It was during this engagement that he met another girl, named Sheila Ryan, to whom he was obviously attracted. Ann didn't meet her at the time, but it probably wouldn't have bothered her all that much if she had. She was never really in it for the long haul.

H E STARTED TOURING AGAIN three weeks after the Vegas close, a southern swing that brought him back to such once-familiar places as Monroe, Louisiana; Charlotte, North Carolina; Roanoke, Virginia; and Knoxville, Tennessee. Everything was pretty much as it had always been, though Dr. Nick went out with them this time in an official capacity — over the financial objections of both Vernon and the Colonel, and over the objections of his own medical group. They saw his serving the needs of one patient so exclusively not just as a potential loss of income to the partnership but as a threat to his independent judgment as a physician. Nick worked out an arrangement, though, where the group got paid the equivalent of what he would have been expected to bring in for every day that he was absent, and he went out with three suitcases full of what he judged might be necessary to serve the medical requirements of seventy-five people.

He worked out a protocol of medication for his principal patient, too, from the time that he arose in the morning until he went to bed at night. It encompassed everything from multivitamins and appetite suppressants to the throat decongestant and 500mm of Dexamyl prescribed as a pre-show treatment by Elvis' Las Vegas physicians to the painkillers that were often sought for back and neck strain to the packets of Amytal, Percodan, and sometimes Dilaudid that he needed to get to sleep after the show. Dr. Nick was constantly seeking to address Elvis' intestinal problems, which frequently led to constipation, and the administration of an assortment of laxatives, along with the shifting array of other depressants, could sometimes lead to incontinence. For the most part, though, he was able to keep Elvis on a pretty good balance of medications, occasionally substituting a placebo when Elvis became too demanding of something he didn't really need — although Nick suspected that with his sophisticated knowledge of the *PDR*, his patient was aware of the substitution more often than not.

The big surprise on the tour was the reemergence of Jerry Weintraub and Tom Hulett of Management III. Banished on Colonel's orders since the November 1972 tour, they had been brought back as promotion partners by RCA Record Tours head Mel Ilberman, who, with a change of administration at RCA and a new president, Ken Glancy, was having second and third thoughts about the appropriateness of a record company being in the tour business. Management III was committed to doing the job right this time, Ilberman informed Colonel early in the year, and after spluttering enough to eke every ounce of political advantage that could be gained from either party, Colonel conceded that Ilberman was probably right - with Tom Hulett he had always had an effective ally in bargaining for the buildings, and Jerry Weintraub had served sufficient penance and had enough other irons in the fire at this point to leave everything in Hulett's capable hands. Their addition would merely streamline the Colonel's team, which now included George Parkhill on a full-time basis (he had left RCA in the fall), Pat Kelleher and an RCA support system, and, of course, the Colonel's own staff, headed up as always by Tom Diskin and augmented by William Morris trainees — in all, a formidable army, ready to jump at the Colonel's command.

Elvis stayed in a separate hotel for the first time on this tour, and there was some grumbling about that, but overall morale was good. Voice was a focal point for whatever resentment did exist, and their general propensity for screwing up — habitual lateness, missing the airport bus, fundamentally unprofessional behavior — did not add to their popularity in any quarter. To Sherrill Nielsen the ensemble effect of all those voices was stunning: "I don't know of any act on the road that had the power when all of us were really with it. For a big ending it was just awesome." But the constant carping got to him, and there were rifts even within the group, so Nielsen left the tour after the fourth date, replaced as vocalist by the group's Swedish piano accompanist, Per "Pete" Hallin.

One old girlfriend flew in to join him in Monroe just as Sheila Ryan was leaving and was shocked to discover the naked need she saw Elvis display for the first time. Dr. Nick was scheduled to come in to give him his sleeping shot, "and I said, 'Elvis, you don't have to, you can go to sleep [without it]; just lay there and let it happen.' He had watched from his hotel room as all the people were leaving the arena, and he said, 'You don't understand. I can't just shut it off like that.' So Dr. Nick came in and set his case down, and then he went out to get something, and Elvis started going through his case. He told me, 'He gave me some pills the other night that look the same, but they're nonaddictive [placebos], and I know it, and he doesn't know I know it, but I know more about drugs than he does.' I said, 'Stay out of there. You don't do that.' 'No, no, I have to, I have to. Don't you say anything. Don't you tell him.' And he took the real ones and put the fake ones back in the case. The next morning I went to see Joe, and I said, 'Please don't say anything, but he exchanged the pills.' And Dr. Nick came in and said thank you and went and put the fake ones back. Elvis came in about an hour later and said, 'All right, who was in there? Who switched those pills?' And he looked at me and said, 'Did you do that?' I was like, 'No.' And he said, 'Someone was in there. I know the [pills] that were in there, they've been switched.' Everyone said, 'I don't know,' and he ranted and raved and was angry — and finally just let it go."

The tour ended in Memphis, where the Colonel, no doubt recognizing the problem of getting Elvis back into the studio again without a struggle, had sold RCA on yet another live recording, the occasion being Elvis' first hometown performance in thirteen years. Like every other appearance on the three-week tour, the five Memphis shows were sell-outs, and in fact the fifth was added almost as an afterthought, prompted by public demand and separated from the first four by already scheduled concerts in Richmond, Virginia, and Murfreesboro, Tennessee. It was only the last for which RCA brought in its mobile recording unit, capturing a performance no more worked out or planned than any other stop along the way. The result conveyed more of a sense of tour-end relief than the keyed-up exuberance that makes for a great live album, with on-the-scene reviewers noting the gaudiness of Elvis' costume and the dramatic unfurling of the American flag during his performance of "An American Trilogy." The Memphis Press-Scimitar compared Elvis to Julius Caesar and suggested that his entrance to the strains of "2001" might have been the high point of the show.

A FTER ALMOST TWO MONTHS OFF, there was a brief four-day California tour, which served as warm-up for eleven days in Tahoe. The San Francisco Examiner reviewed the Tahoe opening as "listless, uninspired, and downright tired," and Elvis missed two shows during the engagement with what was once again described as the flu. Sherrill Nielsen returned more or less on his own terms (he now sang with Voice but was no longer part of the group), and no one else's opinions changed much with respect to Elvis' "personal" backup singers. The most notable event that occurred in the course of their stay was that Red and David Stanley and several of the other guys beat up a land developer from Grass Valley, California, who showed up drunk and disgruntled outside the suite after paying a security guard to gain admittance for himself and his date. A number of fans witnessed Elvis simply standing there and observing the fight without doing anything to stop it, as four guys held the developer down, according to his later complaint, and the rest beat him to a bloody pulp.

 \mathbf{T} HE COLONEL WATCHED BALEFULLY from the sidelines. He had thought the hospitalization might throw a scare into Elvis, he had thought the boy might turn around — but things were as bad now as they had ever been, maybe worse if you considered that Elvis appeared to have hit bottom and was still sinking. Record sales were down, Joan Deary's Legendary Performer album, drawn exclusively from pre-1973 tapes from which neither Elvis nor Colonel derived a penny of income, had already outsold the last three current albums combined, and while there continued to be talk of a second satellite television show and the occasional movie offer still came in, Colonel knew better than anyone that he couldn't pitch a product he was not able to deliver. The one plan on which they still seemed able to agree was the road — it was something they were both used to by now, and the payoff was quick and sure. From the last two tours alone, between them the equivalent of roughly one four-week Vegas run, they had divided more than \$1.5 million (\$1 million to Elvis, \$500,000 to the Colonel) as opposed to the roughly \$400,000 they would have to split after completing their two 1974 two-week engagements at the Hilton.

They couldn't go on like this forever, Colonel knew. Sooner or later it would all dry up — especially if the rumors, and the effects, of the drug use didn't stop. As he had in the past, Colonel made half-hearted attempts to broach the subject with Elvis, but Elvis just blew up at him and told him to mind his own business, leaving Colonel, the master tactician, with little idea of what to do to avoid the appearance that he was losing control. He made a stab at explaining himself when he confided to Joe that they could not even contemplate a European tour with Elvis in this kind of condition,

and he blew up at Tom Hulett when he spoke of continued Japanese interest (Hulett had just taken the Moody Blues to Japan in January), citing security as well as medical concerns. Neither Joe nor Hulett altogether believed him, though they might have conceded the appropriateness of his concerns. But then they no longer believed that Elvis really wanted to go to Europe either; it just seemed like something he used from time to time to throw up in the Colonel's face when he really wanted to piss the old man off. Besides, everyone knew the only subject Elvis would take up seriously at this point — unless you wanted to get into a discussion of a spiritual nature — was karate, not just the practice but the philosophy and the mystique. He and Ed Parker, back in favor once again after Kang Rhee had spent some of the money Elvis had given him on a new house instead of on expanding his schools, were even talking about making a movie.

He was working simultaneously on his seventh-degree kenpo black belt with Ed, his eighth-degree in the Pasaryu system with Kang Rhee, and over the last year and a half had watched karate explode, as Kung Fu, the David Carradine television series, continued to grow in popularity, the Billy Jack movies had found a huge worldwide audience, and Bruce Lee's Enter the Dragon, released posthumously in August 1973, had finally vaulted the sport into the mainstream. Since the beginning of the year there had been a steady stream of karate films, frequently linked to the "blaxploitation" genre that had begun with Shaft, and Elvis had seen movies like Cleopatra Jones, Golden Needles, and Black Belt Jones over and over again. He studied the films, pointing out subtleties that none of the guys picked up, running the movies over and over, until everyone wished he would get on another kick. With his cousin Bobbie Mann, who had married a wealthy Memphis businessman, he got the idea of starting a karate school of his own and, against his father's advice, provided financial backing for the Tennessee Karate Institute in midtown Memphis, which Bobbie and Red West would run and for which he brought in heavyweight world champion Bill Wallace, formerly affiliated with Kang Rhee, as principal instructor. It was around this time, in the spring of 1974, that he first started getting serious about the movie.

"I want to be the baddest motherfucker there is," he said of his own proposed role in the film, which vacillated in conception between the kind of action feature that might give him the chance and the semidocumentary approach that Ed seemed to favor. He and Parker spoke of filming some of Ed's tournaments and sending a karate team around the world when he closed in Tahoe at the end of May. They were still lacking any structure for the movie, though, so Elvis had Jerry Schilling get in touch with Rick Husky. Husky, the former Arkansas State student who had inducted Elvis into his Tau Kappa Epsilon fraternity in the fall of 1960, was now an avatar of action TV. He had gained entree to the Elvis world through his former fraternity brother Jerry Schilling, and for the last two and one-half years had been a frequent visitor in Vegas. A writer/producer on such series as *The Mod Squad, Cade's County*, and the current ABC hit *The Rookies*, Husky was used to being kidded by Elvis about maybe someday writing a part for him, so he wasn't altogether surprised when he heard from Jerry that Elvis wanted to talk about working up a story line for the movie.

He arrived at the Monovale house to find Ed Parker already present and everybody watching TV. Elvis indicated that he wanted to talk to Rick and Ed alone in the den, but when they sat down on the heavy leather sofa and padded armchairs, Elvis could barely speak. "It was the first time that I'd ever seen him stoned. I remember saying, 'Elvis, I would really be excited to write something for you, but let me tell you how I look at this. I don't want to use the word "comeback" because you've never been gone, but you haven't done anything for a while, and I look at it like Frank Sinatra with *From Here to Eternity.* There was such focus on his coming back —'

Parker said, "We don't want to talk about *From Here to Eternity* and Frank Sinatra."

I said, "Look, Ed, can I just say what I'm going to say here —" Because Parker had this demeanor, you know. I said, "Elvis, if you come back in the right vehicle, something that has a dramatic role to give you some dimension —"

Elvis said, "Ed's right. I'm not talking an Academy Award."

I said, "I'm serious. Let's get something with a part you can really play that's not just a karate movie. The karate will come out of the story and the action —"

But basically the meeting never went anywhere, because Ed kept interrupting, and Elvis got up and did some demonstrations with Ed, you know stumbled around a little bit, and it was very sad, and I just tried to extricate myself from the meeting with the thought that, Maybe I'll get back in when Ed's not here or when [Elvis] isn't stoned. 'Cause I'm just not getting anywhere.

He did give it one more try. Recognizing Parker's long-standing involvement in the project, not to mention his financial interest, Rick sought him out at his studio on Santa Monica, but Parker barely gave him the time of day. Pissed off at Parker's attitude, but still motivated by the idea that he could do something that would be good for Elvis, Husky sat down and wrote an unsolicited thirty-page treatment revolving around an ex-CIA agent now running a karate school who sets out to avenge the death of a friend, set up and killed by a drug dealer. It was the old gunfighter coming reluctantly out of retirement and proving himself one last time, perfect for Elvis, Husky thought, and he took the script to Jerry, who left it in Elvis' bedroom. "But I never heard anything about it again — except later I heard that Elvis was going in a different direction with Ed Parker."

The direction in which he was going was the same one that Parker had been so insistent on from the first, a straight documentary focusing on karate philosophy and technique, *kenpo* technique, with Elvis supplying the narration. Ed brought in a former student and karate associate named George Waite to produce, and Waite in turn brought in filmmaker Bob Hammer as director. Together they planned to film up to half a dozen karate tournaments that Parker would set up around the state, and Ed put together an all-star team, including lightweight champion Benny Urquidez and kicking specialist John Natividad, that Elvis would sponsor and send to Europe to be filmed in competition that fall. At the same time, Elvis got together with Bill Belew to design a logo and uniforms with some of the same showy glitter that marked Elvis' stage costumes, an element altogether foreign (and some said inappropriate) to the world of karate.

To Ed Parker's surprise, for all of Elvis' brave words and all of the alienation that had so clearly grown up between his manager and himself over the last few years, he still sought the Colonel's approval on the project. "I told him, 'Dump the old bastard.' But he wouldn't. Which I admired him for." Colonel for his part had no admiration whatsoever for Parker and begged Elvis to promise that he wouldn't put up any money until they had at least had a chance to study the matter more closely. Elvis agreed, but eventually he put up the money behind Colonel's back.

Vernon might have been a more effective ally in the Colonel's campaign if he had not been going through some personal turmoil of his own. He had met a young divorced nurse named Sandy Miller on tour in Denver and moved her to Memphis with her two children earlier that year. Life on the road had affected him pretty much the same as everyone else, and he and Dee had never had an easy marriage. "He treated me like a child," said Dee, a tumultuous woman who now envisioned a career for herself as a profes-

FALL 1973-DECEMBER 1974 @ 533

sional songwriter. "He kept me in a cage." In June they finally decided to separate, and Vernon bought a home on Old Hickory Road, just around the corner from the house on Dolan where he had lived for the last ten years. Elvis wasn't going to shed any tears over the breakup of his father's marriage, but it didn't leave Vernon in any position to criticize either.

S IF TO MAKE UP for lost time, they embarked on yet another twenty- ${
m A}$ one-day tour in June, the third time they had gone out this year. This time Elvis and Colonel's 65-percent share of the gate was almost \$2 million with over \$1.5 million for Elvis and the Colonel to divide after expenses. More and more, though, Elvis' erratic behavior was being mentioned in reviews, even if it was not picked up on by fans. The gaudiness of the show, the camp aspects of some of its Vegas glitz, the lush showbiz sentiments and orchestrations of much of the music, the bizarreness of some of the spoken interludes, all these elements led critics to begin comparing Elvis to Liberace or Zsa Zsa Gabor, not unkindly much of the time and often with the puzzled nostalgia of a fondly recollected fifties childhood - but without any of the respect that you would give to a groundbreaking contemporary artist, or even an historical figure who still mattered. The whole troupe sang "Happy Birthday" to the Colonel on the airport runway in Louisville, as they arrived and he took off to prepare the way for them in the next city on their route. It was the Colonel's sixty-fifth birthday, ordinarily an occasion for sentimental gestures, but there was no sentiment to be detected on the Colonel's part, and certainly none on the part of anyone else.

The Vegas engagement in August represented an attempt at a major change of pace. Seemingly as weary as his critics of the predictability of his own show, Elvis had worked up an entirely different repertoire for the August 19 opening, dispensing with "2001" for the first time since it had been adopted more than two years before, substituting blues like "Big Boss Man," "My Baby Left Me," and "Down in the Alley" for more sentimental numbers, omitting the medley of past hits, and introducing recent material and songs that he had never done before to go with old favorites like "Polk Salad Annie," "Bridge Over Troubled Water," and "Can't Help Falling In Love," the perennial closer. Voice had an expanded role, opening the show and providing more of the close background singing, even if their musical shortcomings and unprofessional behavior had by now become obvious to everyone, including Elvis.

Listening to a tape of the August 16 rehearsal, or even opening night itself, makes it obvious that the same problems that had plagued the show before were still present, new song lineup or not. The blues for the most part were overblown, the maudlin ballads were no less maudlin, two of the new songs that Elvis was most enthusiastic about, Olivia Newton John's "If You Love Me (Let Me Know)" and "Let Me Be There," were the sugariest of pop confections (they were "such happy songs," Elvis said, helplessly trying to explain the attraction) — most of all, he is straining to push out his vocals in a way that seems to have become almost endemic by now, a reflection perhaps of his physical condition or maybe just a choice of style. Whatever the case, it is the same problem that manifests itself in the studio: where once it seemed his voice floated above the music, was capable of subtly suggesting emotion, even on the bravura pieces, now that voice struggles to summon up strength, trembles with a vibrato that seems both mannered and out of control, and substitutes a kind of thick-tongued bellow for the dramatic modulation that characterized showpieces from "It's Now or Never" to "Suspicious Minds." For the moment these shortcomings were obscured by the praiseworthiness of the effort. But one has only to compare the recorded evidence of this show with the Vegas engagements of 1969 and 1970 to recognize what a falling-off there has been. And one needn't travel far in the realm of speculation to imagine how disappointed, and fearful, Elvis himself at this point must have been.

This was not the critical view at the time. Opening night was reviewed more positively than any show since 1971, and even the *Hollywood Reporter* hailed "the best show . . . in at least three years. [Presley] looks great, is singing better than he has in years, and was so comfortable with his show — with almost all new songs — the packed Hilton showroom gave him several standing ovations."

Nonetheless, "2001" was back on the following night, along with much of the regular show, and within a few days it was as if the revolution had never occurred. It's hard to imagine what could have led him to abandon so quickly a program perceived in almost every quarter as a daring and creative move — other than a failure of nerve. Perhaps he did not sense that feeling of instant rapport welling up from the audience that he had come to almost need by now ("He seemed nervous and was not helped by a very poor audience who reacted very little," wrote Christine Colclough, a loyal British fan and perceptive critic, in a fanzine account of the opening that was in marked contrast to the *Hollywood Reporter*'s take). But additionally, one wonders if he didn't also feel that his famous "instinct," the one yard-stick by which he had always gone, had not somehow, suddenly and inexplicably, deserted him.

Linda for the first time was publicly banished during this engagement. She was highly visible at her ringside booth on the first four nights; then she was gone, replaced almost flagrantly by Sheila Ryan, whom Elvis referred to at subsequent shows as his "new girlfriend."

For Sheila it was not exactly what she had planned. Ever since she had met Elvis in February, it seemed like she had been running away from him, and even after going out on tour with him, she couldn't say that she felt any special closeness. Their first meeting had pretty much set the tone. "I went up to the suite between shows, and Elvis came up from the first show, you know, sweating. I was sitting at the little bar in the entranceway all by myself — you know, I looked like I was thirteen years old in those days, I had an angelic little face, and really my personality went along with it. I was very young, very naive, very midwestern, a blank canvas. So anyway I was sitting there kind of pinching myself, thinking this was just too weird, and he came over and sort of half-hugged me, he was sort of a little boyish, he made some comment about the way I was dressed because I had on a pair of slacks. I don't know what else we talked about, but we went to the second show, and afterwards we went back to the suite, to the bedroom, where he had his dinner.

He was just like a little kid, all excited about things, and someone at the show had given him a fire engine hat, someone else had given him a bib — they threw things at him all the time — and he put on this fire hat, and he put on this bib, and this is our first date. Not very cool at all, is it?

Anyway, he just went on about his normal routine, and then at some point I guess he kissed me. The way I felt about it, really, was I was doing it, but I wasn't in the situation, I was looking at the situation. I was observing sort of, from out of my body, thinking, This is just too bizarre. Then he gave me this gold cross that a fan had given him that said "EP" and had a star on it — I still have it as a matter of fact, it's the only thing I have from him. And then I guess he fell asleep. I don't know if he gave me pajamas, but we certainly didn't come close to having sex — it wasn't that kind of a thing, it was just getting to know him. But still I was expected to stay the night, which I didn't want to do. So I let him fall asleep and got up and got dressed and went home and got up and went shopping the next day, and when I got home, Joe called. "Goddamnit, where are you? Boss is furious. How come you left?" And I was — half of me knew what was going on, and the other half wanted to be independent. I knew, kind of, that was what he expected: he expected me to be there when he woke up. But I was this little rebellious thing. So I don't know. Joe is furious: "You better get back here right away —" Here I'd met the man once, and he's already furious at me. But I went back, and he was having his breakfast, and he was irritated and I was quiet — I was always very quiet, just kind of took it all in.

Well, then we addressed my clothing. I mean, I wasn't appropriate, I always dressed in men's trousers, not terribly feminine. So he had Suzy Creamcheese [*the* place to go for Vegas fashion] bring over a couple of racks of clothes and shoes and had this fashion show. I would go in and try something on, and if he liked it, he'd get it, and if he didn't, he wouldn't. So that kind of got me a tentative wardrobe. I was kind of like, "What's the matter with my clothes?," and he was very gentle in saying, "Nothing, they're fine, but you're my girl, you got to go into this place, and people will be looking, and I'd like you to look a certain way, is that okay?" And, you know, I guess it was okay, kind of.

Then I spent a couple of nights with him, and, you know, the sexual thing was never a big deal to him, you would think it was, but it wasn't. It was very unimportant - I mean, we had sex, but what he liked best was the petting, the kissing. He'd rather — you know when you're a kid in high school and neck and neck and neck and grope and do whatever you're doing? We did a lot more of that than anything else. It was adolescent - until all of a sudden you graduated into Mother. You were expected to take care of him, and basically that's what the role was — that's what my role very quickly became: to get him things in the middle of the night. He needed water, he needed pills, he needed Jell-O, he needed to be read to. That was what I did. There was still part of the relationship that was romantic, I suppose, for him - he was into the romance, you know. We would go out on the balcony, and he would sing songs to me, but it was really never romantic for me. I had no concept of what love was, I was embarrassed by the gifts and wasn't able to be gracious about it - that was the downfall of our first month together.

After the March tour she didn't hear from him for a while. She moved to Los Angeles and didn't try to stay in touch. Time went by, and one day Sheila called the house, and he got on the phone and sang, "Well, hello there, my, it's been a long, long time," the opening line of "Funny How Time Slips Away," and they started getting together again. Then in August she more or less officially replaced Linda.

OE COACHED HER THIS TIME — "because Joe liked me being with Elvis. There were women I think that didn't get in because Joe and the boys didn't like them. But Joe was saying, 'Now, Sheila, part of Elvis is giving, and he loves to give, and if you don't show him some sort of reaction, it's hard for him.' So I tried to learn that, you know. He gave me a car, and I remember going, 'Oh, God, it's beautiful, I love it!' And feeling like such a phony. I mean, it was me, not him. Here I am, twenty-one years old, and I've never owned anything in my life, and this man is giving me a brandnew Corvette, and I'm like, 'Thank you,' without emotion. There is something wrong there. So Joe was saying, 'Sheila, get real, will you?' Really, it was just Joe being a parent to me. And gradually I stopped looking at the relationship from the outside and became more relaxed with who he was - I mean, he was a very unusual person, he had unusual circumstances, he was just trying to be comfortable, it wasn't really at anybody's expense. You gave, and you got. Some of it was peculiar - but, you know, I've read bits and pieces about his sexual behavior, and how perverse and bizarre it was, and it really wasn't. It was innocent. He preferred pumping to actual sex. So how perverse is that? It wasn't whips and chains. Adolescent innocence was what it was all about."

Onstage in Vegas, though, it seemed something other than adolescent innocence, as his behavior grew more and more eccentric as the engagement wore on. Even to the fans it was evident that something was wrong. He seemed "sleepy," Christine Colclough wrote of the August 22 supper show; on August 23 and 24 he seemed "slightly tired"; and on August 26 it was announced at 10:00 A.M. that both evening shows were canceled. More disturbing were the increasingly lengthy stream-of-conscious monologues that would have had to concern even the most uncritical fan. The two things that seemed to obsess him most were the gossip columns and the decoration of the showroom. He did something about the latter in the early morning hours after the August 24–25 midnight show. "You know, I've never liked the way this showroom looked," he announced to bemused Hilton patrons in one variation or another from the following night on, right through to the end of the engagement. "It's too wide for a performer. I had this ramp made so I could come out a little closer to the audience." The wall decorations of the showroom in particular had always bothered him, he confided, the angels on the ceiling and the Louis XIV ladies and gentlemen who decorated the walls in cold marble splendor.

Put a spotlight onto the statues on that wall. Okay. That's nice. I don't know what it is, but that's nice. Tom Jones was in here the other night, and he's from Wales. I asked Tom who it [the statue on the wall] was, and he said it was King Edward. King George, sorry, excuse me, Your Majesty. Now take the spotlight and put it on those angels [on the ceiling]. Just look at those dudes, boy. Big fat angels! Put the spotlight onto this wall over here. You will notice a slight difference. Those of the Caucasian race. That's what it is, isn't it? Caucasian? It was on my army draft card. I thought it meant "circumcised"! Anyway, the other night I came down here at about four-forty in the morning with a couple of friends who work for me, Jerry Schilling and Red West. Red is a second-degree black belt in karate — he's got a school in Memphis, and I'm very proud of him. . . . Anyway, he climbed the fence where [hotel maintenance] keep their supplies, the paint and so forth, he climbed the fence, as high as this curtain; he went down and got a little can of black paint. He put it in his belt, came back, climbed over there, and we stacked up two tables. I got up with the paint and the brush, and I was Michelangelo, or the guy that painted the ceiling in the Vatican, the Sistine Chapel. I painted that statue. It took thirty minutes to do. The hotel haven't said a word. I just thought I'd share it with you.

So far as the gossip columns and movie magazines went, he reassured his public in digressions of equal length and intensity, if half of what they said about him was true, he would probably be dead by now: the magazines made it all up, and what they printed was pure junk.

Meanwhile the Colonel, in a development that can be considered only slightly less bizarre, was hawking copies of an album he had put out on his own newly formed Boxcar label to customers exiting the show. The album was called *Having Fun with Elvis On Stage* and was nothing less than a compendium of just such moments as the above, not quite as digressive (they derived from shows between 1969 and 1972) and somewhat cleaned up, but the detritus, really, of the onstage recordings that RCA had been putting out ever since Elvis' return to live performing five years earlier. The difference, of course, between the Colonel's collection and regular RCA releases was that *Having Fun with Elvis On Stage* was nothing *more* than a collection of such moments. It was in fact a spoken-word recording — which was what gave the Colonel license to put it out, at least by his own interpretation of the recording contract, an interpretation that RCA for some reason seemed in no hurry to challenge.

Boxcar had been set up as a Tennessee corporation earlier in the year, primarily, the Colonel said, to consolidate all of Elvis' nonperformance merchandising interests, in other words "to exploit and commercialize Elvis' name, image, picture and likeness . . . for commercial purposes on posters, photo albums, statues, pictures, buttons, medallions, etc." He was not, the Colonel was always quick to point out, your typical "'Polo Lounge manager'" but a show business manager who always "set about to enhance Elvis' performances with the color and excitement that fans came to expect in any Elvis activity." It was perhaps not entirely coincidental that the enterprise took its name from the gambling term for double sixes, a lucky throw in the game of craps, though Hawaiian DJ and promoter Ron Jacobs, a longtime associate of the Colonel's, cited Parker's cavalier philosophy of recording as the inspiration for the label. "He could make a hit record in a boxcar," the Colonel was accustomed to respond when asked how much the "Memphis sound" had contributed to Elvis' success. "Then people'd start talking about the 'boxcar sound.'"

It appears in any case to have been an attempt to establish merchandising on a more "businesslike" basis and in the process perhaps to reward long-standing associates like Tom Diskin and George Parkhill, who with Elvis were listed as minority stockholders (the Colonel retained 56 percent) in the new corporation. It was also undoubtedly another one of the Colonel's schemes whose ultimate Machiavellian purpose — whether generated by tax concerns, bookkeeping convenience, or simply a compulsion always to add one more layer of obfuscation to the mix — is probably not worth going into here. What *is* worth noting is that Boxcar would seem to have been the first chink in the Colonel's carefully constructed argument for partnership and joint-venture agreements with his sole client. Because Boxcar was clearly set up with the idea of diversification in mind. Already the Colonel had indicated to Kathy Westmoreland his interest in signing her to a limited management contract with the idea of recording her beautiful voice alone, with only an organ for accompaniment. Within a matter of weeks he would be talking to RCA about just such a plan and arranging for demos to be made on a previously unrecorded singer named Charlie Smith as well. For the present, RCA would manufacture *Having Fun with Elvis On Stage* through its Custom Records division, Boxcar would pay Elvis a fiftycent royalty per album for all concert sales, and RCA would undertake to distribute the album worldwide as a regular commercial release at some point in the near future, paying an advance of \$100,000 against royalties, to be split 50–50 between manager and artist. And while the arrangement with RCA made clear that this novelty album was specifically excluded from the terms of the regular RCA contract, it cannot have escaped the Colonel's attention that it might come to be accepted as Elvis' second contractually required album of 1974, should it prove impossible to lure Elvis back into the recording studio that year.

What he chose to ignore was any reaction that Elvis might have had to being made a laughingstock, even at a royalty rate of fifty cents an album, on what amounted to his own label. Even more surprising, given the Colonel's pride in his elephant's memory and mastery of human psychology, was his willful defiance of the lessons of the past: it was only when he set up Jamboree Attractions as a booking agency for other acts in 1953 that Eddy Arnold, his sole client at *that* time, chose to leave him, creating the necessity for Tom Parker to become the Colonel and begin the painful process of reinventing his life for at least the second time. Perhaps he was merely exasperated with his client, he may have simply come to the fatalistic view that what would be would be — but he never seems to have asked himself the question whether, at age sixty-five, he was ready to start all over again.

 $E_{\rm VIS\ MEANWHILE\ WAS\ FOCUSING\ more and more on karate in his Vegas act. For several nights running he donned a special karate outfit and put on an exhibition of his skills with Charlie as his foil during the performance of "If You Talk in Your Sleep." Then at the dinner show on September 1, with Ed Parker present, he put on a full-scale fifteen-minute demonstration with Red, which brought down the Colonel's ire and pretty much ended the exhibitions. But it did not stop him from continuing to expound upon the subject or from presenting certificates onstage to everyone in the troupe who had been working out with him in the suite each night. "I teach — we have a class upstairs," he explained to the audience. "I now hold the title 'Master of the Art.' . . . Now that I've reached eighth-$

degree, I can start my own karate organization. We are due to start our own style of karate under the heading of American Karate Institute. We intend it to become an Americanization of the art." He even recognized orchestra leader Joe Guercio, an adamant refusenik in what he referred to as "all that nonsense," by presenting him with a black belt tenth-degree baton.

The monologues went on and on, taking on a form, or formlessness, of their own, sometimes almost crowding out the music. On the last night he delivered what amounted to a kind of extended peroration, with Priscilla and Lisa Marie sitting with Sheila in the booth. He had just finished singing "You Gave Me a Mountain" early in the show, when he decided to offer a clarification of his domestic situation.

I want to make one thing clear. I've been singing that song for a long time, and a lot of people kind of got it associated with me because they think it's a personal nature. It is not. It's a beautiful song written by Marty Robbins, and I heard Frankie Laine do it, I think it was, and I just loved the song and it has nothing to do with me personally or my ex-wife, Priscilla. She's right here. Honey, stand up. [Applause] Come out, honey. Come out, come on out. Turn around, let them see you. [More applause] Boy she's — she's a beautiful chick, I'll tell you for sure, boy. Boy, I knows 'em when I picks 'em. You know? Goddamn.

Now my little daughter Lisa, she's six years old. Look at her jump up. Pull your dress down, Lisa. You pull your dress down before you jump up like that again, young lady. And then at the same booth is my girlfriend, Sheila. Stand up, Sheila. [Applause] Turn around, turn around, completely around. Sheila, hold it up. Hold it up. Hold the ring up. Hold up the ring. The ring. Your right hand. Look at that sonofabitch.

No, the thing I'm trying to get across is, we're the very best of friends, and we always have been. Our divorce came about not because of another man or another woman but because of the circumstances involving my career. I was traveling too much. I was gone too much. And it was — it was just an agreement that I didn't think it was fair to her, 'cause I was gone so much and everything. So I therefore, as decently as you can do that type of thing, we just made an agreement to always be friends and to be close and care — 'cause we have a daughter to raise — and for her to have whatever she wanted as a set-tlement.

After the settlement — it came out [at] about two million dollars. . . . Well, after that, I got her a mink coat. I know it. I'm talking about the mink coat. You hang loose over there. The — the XKE Jag after the settlement — just gave it to her. She got me — listen to this *tonight*, a forty-two-thousand-dollar white Rolls-Royce. [Cheers and applause] That's the type of relationship that we have. [His speech is noticeably slurred.] It's not a bad setup, is it, fellows? I mean, I got part of it back anyway. I wasn't hurting too bad, but I did get part of it back, you know. She bought the car just out of a gesture of love, and she likes this Stutz that I have. It's not a car, it's a Stutz — No, wheeew, God help me, no, it's called a stud — a Stutz. And she likes the stud. [Elvis laughs.] She likes the Stutz. Mike Stone ain't no stud — so forget it. She liked the Stutz and — so I'm going to give her the Stutz and she can give me the Rolls, okay? [Puzzled applause] But I wish [Mike Stone] was a stud, you know. He's a . . . nice guy.

I'd like to do a song here, ladies and gentlemen, that is one of the prettiest goddamn love songs I've heard in my life, man. I'll tell you. No, it is, it's one of the prettiest songs I ever heard in my life, I've never sung it, I've never recorded it. I never liked the damn thing till I found out — damn, I got a toothache — till I found out the story behind why it was written, and then I really didn't like it 'cause I don't like that type of stuff. So the next song — no, this is a true story of a song. It's been around for a long time. Charlie, take this belt off, it's going to cut me, castrate me, do something, you know. Really, I can't do that - I got things to do, places to - you know. Places to go and other tours and things and cities and chicks and all that jazz, you know. Look, I just be careful, son, don't let it get caught in the cord. I'll die out here. Electrocute my ass and — excuse me, folks. I mumble things — oh, damn, it's so tight you cut off my hair, man, I can't sing. You know, I sing from down in the gut anyway, shoe soles. It'll never get up here. [And he goes on to tell the story of "Softly As I Leave You," before reciting the lyrics, in hushed and reverential tones, over Sherrill Nielsen's soaring tenor voice.]

Later in the evening he introduced Ed Parker and John O'Grady, citing O'Grady's help with the paternity suit several years before, which O'Grady had now written about in a just-published memoir. "Turned out to be a complete conspiracy and a *hoax*, man," he announced to a startled audience, with reference to the lawsuit. "*There is just no way*. I had a picture

made with that chick, *and that's all*. And she got pregnant by the camera." There is a mixture of nervous laughter and applause.

But you know what she did? *She named the night*. And the night that she named, my wife was in — no, my wife was with me in L.A. — and that's the night she said. Ain't *no way* I'm going to fool around with her out there, are you kidding me? [He laughs insinuatingly.] Let me tell you something. If you like things like The French Connection, the Chinese connection, the British connection, the knee bone connection to the jawbone, the jawbone is connected to the hambone . . . [The band picks up the melody and rhythm of "Dry Bones."] You like that type of stuff, buy this book. It's called *O'Grady*. . . .

John just came back from New York, where he had a meeting of this — I have been a member of this organization for five years. International Narcotics Enforcement Officers Association. [He reads from an inscription.] "In recognition of the outstanding loyalty and contributions in support of narcotics law enforcement, this award is a special honor bestowed upon Elvis Presley.' And so forth. Lifetime member, International Narcotics Enforcement Officers Association. I just got that. [Applause]

So I don't pay any attention to rumors. I don't pay any attention to movie magazines. I don't read them. JUNK. [Much applause] I don't mean to put anybody's job down. I'm talking about — they got a job to do, they got to write something. So if they don't know anything, they just make it up. In my case, they make it up. I hear rumors flying around — I got sick in the hospital. In this day and time you can't even get sick. You are [dramatic pause] strung out. By God, I'll tell you something, friend, I have never been - strung out in my life, except on music. [More applause] When I got sick here in the hotel — I got sick that one night, I had a hundred and two temperature, and they wouldn't let me perform, from three different sources I heard I was strung out on heroin, I swear to God - hotel employees, jack, bellboys, freaks that carry your luggage up to the room, people working around, you know, talking, maids. And I was sick. I was getting — I had the doctor and had the flu and get over it in one day, but all across this town — STRUNG OUT! I told them earlier, and don't you get offended, ladies and gentlemen, I'm talking to someone else, if I find or hear an individual that has said that about me, I'm going to break their goddamn neck, you SONOFABITCH. [Screams and applause] That is DANGEROUS.

I will pull your goddamn tongue out BY THE ROOTS. [More cheers] Thank you very much anyway. How many people of you saw the movie *Blue Hawaii*? Probably the most successful song — let me get out of this mood — [And he goes into "Hawaiian Wedding Song."]

Priscilla was beside herself. "I was in shock. Because [in the past] he would never, ever let on to the audience what his emotions were. You know, singing was always his way of venting his emotions, how he felt about something — and he'd get onstage and sing his heart out. And any song, any given song, you know, he would beat it to death, with more emotion and more energy — but he never let it out in public. This was [so] out of character, for someone who had so much pride, you know — every-thing that he was against, he was displaying. It was like watching a different person."

H E STAYED IN VEGAS for a few days, going to shows with Sheila, putting on a brief karate demonstration in the middle of Tom Jones' performance at Caesar's Palace one night, comparing rings onstage with Vikki Carr at the Tropicana the next. Then, after a brief stay in California, he returned home with Linda, where he arranged to have a local crew film him at the Tennessee Karate Institute, the school he had set up for Red and his cousin Bobbie, which advertised itself as the place that Red and Elvis — "a seventh-degree black belt — work out together when Elvis is in town." He was there, he explained to reporters who had been invited to watch, in preparation for the start of production on his first motion picture, and he took the opportunity not only to congratulate head instructor Bill Wallace on his recent world championship but to "promote" Wallace to fourthdegree black belt in his own school.

In the film that survives, Wallace is wearing the stars-and-stripes uniform with which he had toured Europe as part of a championship "Team America" the previous summer, but Elvis more than matches him in trademark tinted glasses, a karate ghi with a flag insignia on the left breast and "EP" in Japanese-style calligraphy on the back, white bell-bottoms with an inverted pleat, and white Chelsea boots with stacked heels. Even as he is performing various demonstrations and commenting on others, his attitude appears lazily proprietary, almost as if he knows something that his intended audience — including Wallace and Ed Parker associate Dave Hebler, who has been with him as part of his security team for the last year — do not, and will *never*, know. He looks a little like the cat who has swallowed the canary, or perhaps several canaries, as he "showed he could take it by allowing Red West to punch him four times" without flinching, the *Press-Scimitar* reported, and yet at the same time appeared disturbingly unfit, blowsy and unfocused, his weight clearly having ballooned again since his closing in Las Vegas two weeks before.

The following day he started on a ten-day buying spree in the course of which he purchased well over a dozen vehicles for friends, relatives, and household staff. He also hired a new maid, Maggie Smith, after buying a car that she and her mother were thinking about purchasing for themselves at Sid Carroll Pontiac (he got her one of her own to commute to school several days later), bought a car for his cook's brother and a house for his cook, purchased a boat for Charlie Hodge, and got a double-wide trailer for his cousin Billy Smith so Billy and his family could live at Graceland and always be close by.

In between car purchases, on September 19, he visited Methodist Hospital with Linda to see her brother Sam and sister-in-law Louise's newborn baby. He had always liked Sam, who was dedicated to a career in law enforcement and worked for the sheriff's department while attending law school at night. It was through Elvis' efforts, in fact, and his connections in the sheriff's department, that Sam had been transferred from jail duty to the juvenile division shortly after they met, and the previous summer he had helped Sam and Louise purchase a new home. Still, even Linda was not fully prepared for the attitude of messianic benevolence he projected not just toward the new baby but toward the whole process of giving birth. After checking to make sure that mother and daughter were doing all right, Elvis told Linda he wanted to go into the labor room, where the surgical mask that the nurses gave him could not fully disguise his identity. "There was a lady there in labor, and Elvis came up to her and put his hand on her tummy and said, 'How you feeling, honey?' She said, "'Oh, my God, you look like Elvis Presley.' He said, 'I am Elvis Presley.'" But Linda was never sure if the woman realized it was not a hallucination.

Many wondered how Linda could slip back into her old role so easily after what was widely perceived as a sharp public rebuff. It was a question Linda frequently asked herself, and there was no easy answer. Unlike Sheila, she had no trouble either accepting, or showing her appreciation for, Elvis' generosity, and on the outside she maintained a cheerful attitude at all times. But she was no longer sure what exactly her role was, or what she wanted it to be. She knew he needed someone to look after him when all the other girls were gone, and with Joe out in California full-time now and the old gang no longer as close-knit as it once had been, she saw herself and Vernon as the last line of protection when everyone came around with their hands out. She knew they all thought that his manic moods came about just because he was stoned, and she felt like half the guys were hanging around because they didn't want to miss out on the gravy (while undoubtedly ascribing the same motivation to her); in the end, she just couldn't walk out on him at a time when she thought he might need her most.

In the midst of all these ups and downs, Elvis continued to work out his ideas for the karate movie, writing down his thoughts in childish block letters, sometimes dictating to Linda in a fever of excitement. Over a period of time the script became almost a summation of the very values by which Elvis would have liked to have been guided, a portrait of a world in which nobility and ideals were personified and the real meaning of karate came down to "helping a person help himself." All the "best men and best women in karate" would be featured, all of Elvis' teachers and heroes, from Ed Parker and Master Rhee to the best samurai swordsman, the best brick-breaking *karateka*, Bong Soo Hong from *Billy Jack*, David Chow from the *Kung Fu* series, and Jim Kelly, Joe Lewis, Bill Wallace, all national and regional champions. Every style of karate would be represented, so as to put across the idea that it was a philosophical *system* to which all true martial artists were dedicated: "Never to use that which is learned except in extreme emergencies. To protect myself, my friends, my loved ones . . .

And if seeing a fellow karateka using his skill to harm, to make afraid, to cripple or maim, to do all that is in my power to restrain with whatever force necessary, to report him to a board of regents comprised of 36 high-ranking black belts where he is subject to immediate dismissal, stripped of all his honors, turned over to the authorities, never to regain status in this association. This is one of the purposes of karate: to protect the weak, helpless, and oppressed of all classes, regardless of color, creed, or religion. [punctuation added]

It was an idealized world in which right triumphed over wrong, moral values were upheld, and Elvis was a true teacher, explaining and sometimes demonstrating both the technique and the philosophy behind it. At the end of the film "on a remote hill the camera is on a close-up of Elvis as he stands in fighting stance. The camera zooms back as he does a middle punch with a kee yap, and we see what looks like every karateka in the world doing the moves with him. He then does the Lord's Prayer in *Indian sign language* as a soft wind gently blows around him. The picture ends with *The Beginning* written across the screen."

B Y THE TIME that he went out on tour at the end of the month, whatever strides he had made toward moderation and health at the beginning of the year had long since been abandoned, and Tony Brown, the new keyboard player for Voice and a long-standing admirer who had journeyed out with J. D. Sumner at his own expense for the 1969 Las Vegas opening, was horrified to see the changes that had taken place. "My first night was College Park, Maryland. I was scared, my hands were sweating, and I'm backstage waiting for Elvis to arrive. He pulls up in the car, and he fell out of the limousine, to his knees. People jumped to help, and he pushed them away like, 'Don't help me.' He walked onstage and held on to the mike for the first thirty minutes like it was a post. Everybody's looking at each other like, Is the tour gonna happen? Is he sick? Is it gonna be canceled?"

Even Sonny was shocked. He had been out on the road with the Colonel, so he hadn't seen Elvis in a couple of weeks and, according to Dave Hebler, "he was so torn up . . . the tears just came to [his] eyes." The next night Elvis was fine, though at one point when there was a feedback problem, he snarled at Felton, "Shut that damn sound off, Felton, or I'll take your kidney away from you." Then in Detroit, the third date on the tour, Red and Ed Parker became aware of a cocaine shipment coming in through "a singer in a group that he had with him." According to Red, who had done the drug with him, Elvis had been introduced to cocaine through this singer and a "relative by marriage" some months before, and Red now went down to the singer's room with Parker and Dick Grob. "I kicked in the door and broke his foot and told him if he ever brought any more drugs around it was going to be a lot worse. [But] then Elvis found out about it and called us into his room and said, 'I don't like these bully tactics. I need [the coke].' And I said, 'Man, if you need it, I'm not going to say any more about it. You can have it.'" Everyone knew there was no point in saying anything anyway. Elvis had made his attitude very clear in the past: if you don't like it, he had said at one time or another to every one of them, there's the fucking door.

Newspaper accounts tried to puzzle out exactly what was wrong with Elvis. According to reviewers, he was "bored to death" in St. Paul, hostile and "disappointing" in Indianapolis, sick with the flu in Dayton, and "ill" enough in Wichita that many fans expressed regret that he hadn't canceled the concert. They ended up in Tahoe for four days at the conclusion of the tour, and by the last night, according to bass player Duke Bardwell, "Elvis was just standing there not really knowing what else to do, 'cause he [had] just pretty much run out of gas."

 $\mathbf{E}_{\text{LVIS TOOK SHEILA WITH HIM}}$ to Las Vegas immediately following the Tahoe engagement, putting himself under the care of Dr. Elias Ghanem, a fiercely ambitious thirty-four-year-old Palestinian refugee, who in Vegas had become part owner of the Sunrise Hospital Emergency Room, owner of a private jet service, and not coincidentally doctor to the stars. He had first seen Elvis as a patient in 1972 and, with Dr. Newman and the throat specialist Dr. Boyer, had rapidly become one of his primary Las Vegas physicians. Ghanem ordered a series of tests to check on bladder, colon, and intestinal conditions. A "non-penetrating ulcer crater" was discovered, along with "edematous mucosal folds" indenting the margin of the stomach, and a follow-up study was recommended in three or four weeks. Elvis meanwhile was staying with Sheila in the private bedroom and bath that Ghanem had added onto his house for celebrity patients undergoing the new "sleep diet" that the doctor recommended, which consisted for the most part of liquid nourishment and for which the patient was sedated much of the time in a form of radical appetite suppression.

Jerry Schilling came out to see him with a progress report on the karate film about two weeks into his stay. Jerry had now been named executive producer on the project, operating as Elvis' eyes and ears in much the same way that he had, unofficially, on *Elvis On Tour*. Here, though, since Elvis was putting up the money himself, Jerry got a commensurate promotion, serving in effect as "studio" supervisor as they entered into the preliminary stages of postproduction work. Jerry wanted to set up an office in Hollywood and hire a team of editors to synch up the footage and put together a preliminary cut to assess what had been shot and maybe even to attract a distributor who could be induced to put up the money to finish the film.

Jerry found Elvis in good spirits at Dr. Ghanem's, engaged, alert, quick to okay the location that Jerry had picked out on the corner of Hollywood and Vine and the hiring of the crew that he had selected. He was relieved to

see the project finally getting off the ground after all the squabbling and petty jealousies that he had witnessed at the outset of filming and the almost haphazard manner in which the Memphis footage in particular had come together. He was worried about Elvis after all he had heard about the recent tour, but he hoped that this new "sleep diet" might represent the first step toward getting him into the kind of shape he needed to be in to really focus on the project. They reviewed everything that had been accomplished to date. Fifty thousand dollars had been spent, and there were projections for at least \$75,000 more. No doubt to emphasize his disapproval without ever actually stating it, Colonel was putting it out among certain members of the inner circle that Elvis was so benighted he had already assigned more than 100 percent of the film's ownership - to Ed, to Colonel, to Vernon and the boys. Jerry was reassured as they went over the figures that Elvis seemed to know exactly what he was spending his money on and how the profits would be distributed — even if his conception of the profits might be a little exalted. It was a good, realistic discussion, ending on what Jerry felt was a justifiably optimistic note.

It was well past midnight when they finished, and Jerry declared his intention to go back to the hotel, but Elvis asked if he could stick around for a little while — there was something else he wanted to talk to Jerry about. Jerry had been going out with Myrna Smith of the Sweet Inspirations for the last ten months. He had worried about Elvis' reaction initially — Elvis had always admired Myrna and was close to all of the Sweets, but Jerry hadn't known how he might respond to the interracial aspect of the affair, given the strong political feelings of some of the fans, not to mention some of the guys. Elvis couldn't have been more positive about the relationship, though, and in fact, when Jerry and Myrna decided in the spring to move in together, "I told Elvis that I was going to get an apartment, and he said, 'What's wrong with your room [at the Monovale house, where Jerry had been living since the breakup of his marriage]?' I told him, 'I don't want to cause any problems with the fans.' He said, 'Look, you're my friend, Myrna's my friend. You're welcome in my house. Screw what anybody else thinks."" So they had continued to live at Monovale. But Jerry never made any secret of the fact that he would like a home of his own, and when Rick Husky decided just a few weeks earlier to put his West Hollywood house up for sale, Jerry was able to come up with a down payment but ran into a brick wall with the banks on the financing.

Now Elvis came forward with a plan. He would buy the house for Jerry, he would arrange the whole thing with Rick Husky — and he would do it

right away. They called Husky at three in the morning, and Elvis quickly negotiated a sale. "I got my checkbook out here, and I'm writing a check — is that okay?" Elvis told Husky, whom he had just wakened "out of a dead sleep. I say, 'Well, yeah, sure, Elvis.' And he said, 'Okay, so we got a deal?' I said, 'Yeah, okay, we got a deal.' He said, 'How soon can you move out? I'll send the guys up there to help you!'"

Jerry was unable to mask his emotions. When Elvis handed him the check, he dropped it, and he could barely come up with words to express his gratitude. Whatever doubts he may have felt in the past year or two, this confirmed all the faith he had placed in Elvis ever since he had first met him as a frightened, insecure twelve-year-old filling in for the team that needed an extra player in a touch football game at Guthrie Park in north Memphis in the summer of 1954. "Jerry, you know why I bought you this home?" Elvis said to him at the official housewarming some three weeks later. "I know I drove all those other guys crazy buying you this house, but your mother died when you were a year old, and you never had a home, and I wanted to be the one to give it to you."

 $E_{\rm LVIS\ SPENT\ THANKSGIVING}$ with Linda in Palm Springs, calling on Voice to fly in at the last minute — but as usual there was little for them to do, and they spent most of the time holed up at their hotel. He tried one more time to get the Colonel's approval for the karate project, and Colonel drew up a basic business plan with a number of simple variants. Elvis retained 50 percent of the profits in each of the formulations, with 15 percent going to Vernon, and varying amounts to Ed Parker, producer and director George Waite and Bob Hammer, and "the boys" (Red, Sonny, Joe, Jerry, Charlie, Lamar, Al Strada, and Dave Hebler). Ten percent was to be retained for overhead, and it was made clear that "percentage participants" did not draw salaries, and Elvis Presley retained 100 percent ownership of the film. In addition, Elvis' salary and personal expenses of \$300,000 would take first position, ahead of profits, and the Colonel would retain all merchandising rights. The addendum that the Colonel tacked on, however, made plain his true feelings and conveyed an unmistakable message to his client. "To produce a motion picture of this nature under any other conditions than those heretofore spelled out, would be a complete failure and would do irreparable damage to the reputation of the Artist and All Star Shows," he wrote. Furthermore, should the project go ahead without the Colonel's participation or guidelines, "as long as I am the exclusive manager of this artist, to protect the artist, and my reputation, it would be necessary to go to the extent of publicizing the fact that I am not personally involved in any of this project . . . [and] a letter must be sent to me by the artist and his legal counsel absolving me of any and all responsibility."

On November 19, the National Enquirer, anticipating Elvis' January birthday by a month and a half, ran a headline: "Elvis at 40 - Paunchy, Depressed and Living in Fear," along with an artist's rendering of the subject which graphically sought to convey all of those qualities. The story itself quoted newspaper critics, fans, policemen, maids, banquet managers, and other hotel employees who had observed him on the October tour and found him to be rambling, incoherent, paranoid, and almost desperately lonely. It was the kind of tabloid story that could have been laughed off if there had been no correspondence to real life, but coming as it did on the heels of RCA's official release of Having Fun with Elvis On Stage, and in the wake of so much dramatic personal upheaval, it would have been hard to say which was the greater exaggeration: the newspaper piece or the life on which it was based. He had become, as Sheila observed, "like the boy in the bubble. I mean, who cares? Who wants to live? He would say, 'Who the hell am I anyway? I'm a living legend!' Sometimes he lived it, but once in a while he'd just go, 'Oh, boy, what the fuck is going on? I'm just who I am. I'm just this little person.' It's not so complicated as it all seems. He was just this guy who had this wonderful charisma and things got blown way out of shape. He was just this innocent little guy."

He returned to Las Vegas at the beginning of December to put himself once again in Dr. Ghanem's care. Linda accompanied him this time, and Jerry once again came out to deliver a progress report. Elvis asked him about the new house and how Myrna was doing after spraining her ankle at the housewarming party. Everything seemed fine until the phone rang in Jerry's hotel room in the middle of the night. It was Elvis, but Jerry barely recognized the voice, it was so weak. "He said, 'Jerry, can you help me?' I said, 'What's wrong?' He said, 'I'm on the floor, and I can't walk. Nobody's here.'" By the time he got to the house, Linda was with Elvis, but there was still no sign of Dr. Ghanem, who kept much the same hours as his patient. When he finally got in, Jerry confronted the doctor, expressing angry disbelief when Ghanem insisted that he was unable to understand what could have happened, since he was simply treating Elvis with placebos. "I said, 'Goddamnit, I'm going to tell you something: this man is a proud man. He's been at your house for weeks, and I have to come pick him up off the floor — and you're telling me you're just doing placebos?' I guess I really blew up at him.

"Well, I go out there the next day, and Elvis is out of bed, he's on the exercise bike, and he is pissed. It's just me and Charlie there, and he knows — he knew I had a temper, not that he was afraid of it, but he just keeps looking at Charlie and saying, 'Goddamnit, when you fucking guys get your medical degree, then you can tell my doctors what to do.' And he — oh, man, he just went on and on. I knew not to say anything. I was just glad he was out of bed and on the bicycle and not falling on the floor. I knew after he calmed down I could talk to him. So I just acted like he really was talking to Charlie, and a couple of hours later I just said, 'Elvis, I'm telling you something: a year ago, when you were with Dr. Nick —' And he said, 'Oh, that sonofabitch charges too much money.' Which, you know, Elvis could care less about the money - but he's still being defensive. I said, 'All I know, Elvis, is you've been here, you've been in bed for a month [all told], and you're not doing anything or having any fun. I mean, it was pretty sad last night —' I had to be very careful not to embarrass him. 'All I know is, when we were back in Memphis last year, after you got out of the hospital, you were eating right and looking and feeling good, and we were really having fun.""

Jerry wasn't sure how much, if any, of it sank in, or whether or not he might just get fired on the spot, as Elvis kept pedaling away furiously on his exercise bicycle, and Charlie tried to puzzle out how he had gotten in the middle of it all. It wasn't long afterward, though, that Elvis and Linda returned to Memphis for the holidays.

I was a dismal Christmas. Voice flew in and out at every summons, but Elvis rarely felt like singing nowadays. On December 3 Red O'Donnell had reported in his column in the *Nashville Banner* that Elvis was on the blink with a tummy ulcer and that his next RCA recording session, put off once already from November to December, had now been postponed until "sometime in January." The karate movie was ingloriously shut down on December 24, the day after Elvis returned home, with no other explanation but "health problems." There had been a reasonably successful screening for influential Hollywood rock manager Elliot Roberts just four days earlier, but things were closed down in such a hurry that nobody got paid for the last two weeks, and a good many bills remained unpaid well into the following year.

On December 29, prompted by reports coming out of Memphis that Elvis was sinking into a deepening depression and was increasingly isolated from nearly everyone around him, the Colonel made a rare telephone call to Elvis and concluded that the reports were true. They had barely spoken since Palm Springs, but Colonel was now forced to recognize that Elvis would not be ready for his scheduled Las Vegas opening in less than one month's time. He directed Elvis to telegram him the next day with a message expressing his appreciation for "your signing any papers necessary for me while I am recuperating." He also contacted Henri Lewin at the Hilton, informing him that their mutual friend, Dr. Elias Ghanem, had pronounced Elvis unlikely to be ready for the January 26 opening and that in his judgment the best thing to do was to postpone right away. You can read the Colonel's discomfiture between the lines, but he put a good face on it, referring Lewin to Dr. Ghanem for the proper wording of the press release, which would not officially be sent out for another twelve days. He did everything he could have been expected to do, he carried out each distasteful task with his customary professionalism, but there is nothing to disguise the fact that for the first time he is being forced to admit that he and his client are unable to meet their obligations.

It had been a difficult year, though not one without its compensations. There had been no *Aloha from Hawaii*, but then you couldn't expect that kind of a once-in-a-lifetime triumph on an annual basis. Record sales were down, it was true, but Vegas attendance had never flagged, and the road show was doing better than ever. This year alone, in seven weeks of touring, they had earned approximately \$4 million after all expenses had been paid, in addition to the \$650,000 to \$700,000 they had netted in six weeks in Las Vegas and Lake Tahoe combined. Recording income added maybe another \$750,000 to be split 50–50, a comparatively negligible sum perhaps but handy disposable income for two such conspicuous consumers. The Colonel had little doubt he could keep the show going if given the opportunity, but one question continued to nag at him, refusing to go away: Was Elvis willing, or even able, to go on?

ELVIS AND LINDA. (COURTESY OF THE ESTATE OF ELVIS PRESLEY)

A LEAF IN THE STORM

Singer Elvis Presley privately observed his 40th birthday yesterday in selfimposed seclusion at his Graceland Mansion on Elvis Presley Boulevard. . . . He slept until about 3 P.M., when his uncle, Vester Presley, phoned in his birthday greetings from the guard house at the gate. Vester, who has worked as a security guard at Graceland since 1957 and has not seen his nephew since Christmas, said Elvis "talked like he was feeling pretty good. He said he was resting up and trying to get in shape to go on the road again. He doesn't plan to leave the house." . . . The reference to getting in shape came amid growing press reports that Elvis is "fat and 40."

— Memphis Commercial Appeal, January 9, 1975

T WAS AS IF a pall had descended upon the house. The bustling kitchen remained ready to cater to his every whim twenty-four hours a day; the guys all gathered downstairs to pay anniversary tribute, and perhaps to share in birthday largesse. But Elvis never came down. Only Linda and his cousin Billy had unrestricted access to his bedroom upstairs, as the world mocked him for failing to uphold the promise of eternal youth. Even Johnny Carson, whom he had long admired, made jokes about being "fat and forty," and Elvis told Billy that he could hardly watch the program anymore.

Linda, off on a shopping trip to New York just a few days before his birthday, protested the "heartless, cruel, vicious rumors" about Elvis using drugs, pointing out to *People* magazine that "Elvis is a federal narcotics officer!" To Elvis, though, she was beginning to express her true feelings for the first time, telling him tearfully that he was killing himself, no longer willing to be put off by his confident declarations of medical expertise or breezy assurances that he was going to live to see his grandchildren grow up and marry. The Elvis that she saw every day was a man suffering from severe depression, someone who was often barely able to get out of bed. What scared her most of all was that he seemed a willing partner in his selfimmolation, a secret conspirator who knew but simply didn't care. Once, not too long before, she had asked him what he thought was his biggest character flaw. "I'm self-destructive," he said, to her surprise. "You do recognize that?" she said. "Yeah, I recognize it," he admitted, "but there's not a lot I can do about it." And they never spoke of it again.

The Colonel was no less alarmed. And, like Linda, he had no one, really, in whom to confide his fears. Vernon didn't want to hear about it, because Vernon couldn't control his son. And Colonel knew that if he refused to book Elvis, somebody else would. Perhaps just as much to the point, if he took Elvis off the road, what would his own recourse be? The Colonel had always prided himself on his ability to survive by his wits — but now he found himself in a box of his own making. By focusing all of his efforts on a single client, he had built an intricate web of relationships, a maze of trust and contractual arrangements that effectively prevented anyone else from getting in. Now, though, he might have wondered, could he get out?

Finally, on Thursday, January 9, the day after Elvis' birthday, an event occurred that served to galvanize the Colonel's thinking. It was much like other turning points in the past — a random item in the newspaper that happened to catch the Colonel's eye. There had been a tornado in McComb, Mississippi, that had killed ten people, left hundreds homeless, and caused millions of dollars of property damage. The Colonel called Tom Hulett immediately, and together with former RCA executive George Parkhill they flew to Memphis the next day. It was Hulett's first visit to Graceland, and he was excited about seeing Elvis' home as well as his involvement in the Colonel's scheme.

"I had never been this much on the inside before, and here I was all of a sudden part of a unit going to see Elvis about possibly going back to work. Elvis came downstairs in a robe looking very heavy, and we sat at the big table in the dining room in tall, high-backed chairs. There was some small talk, and then the Colonel said, 'Elvis, you been reading about the problems down in McComb?' And he said, 'Yeah, it's really terrible.' The Colonel said, 'You know, I think we should go down and do a benefit for those people. What do you think?' And Elvis goes, 'You know, I don't know . . .' Because there was this funny shit going on between them, like Elvis is saying, 'I ain't gonna work,' and the Colonel is saying, 'I ain't gonna *let* you work' — and now the Colonel has finally found an outside vehicle to break the ice. And there I am sitting there, and Elvis is looking at me like, 'What are you doing here?'

"Finally, Elvis said, 'Well, I guess,' and the Colonel said, 'If we go down and do the benefit, we might as well add on a few dates.' That's when I got the connection. And Elvis goes, 'Well, I guess so.' 'Well, what if Mr. Parkhill and Tom and I go to Mississippi and [talk to] the governor and see how it looks?' Meanwhile, the Colonel already had the governor in tow, and everything was done. So after about an hour, Elvis says, 'Great, call me tomorrow and let me know what's going on.' Which meant he had agreed to go back to work. As soon as we get in the car, Colonel says to Parkhill, 'George, call the governor. I want a meeting tonight.' We were at the governor's mansion by eleven o'clock with the governor and all of his cronies. The Colonel says, 'I want you to get a hold of the Coliseum tomorrow, and I want all the concessions donated, all the stagehands donate their time, Elvis and the band donate their time, everything, everything goes in the benefit.' The governor says, 'How can [anyone] make any money then?' And the Colonel says, 'We ain't making any money here.' But then we added on three more shows in the same building [on the next tour] and made those non-benefit!"

The announcement went out to the papers the next day, and a full twoweek tour was booked by the following Tuesday to start three weeks after his rescheduled March engagement in Las Vegas. At almost the same time, Elvis put down a deposit of \$75,000 on exiled financier Robert Vesco's impounded Boeing 707, spurred on no doubt by Memphis singers Charlie Rich and Jerry Lee Lewis' recent acquisitions of private Lear jets and in pursuit of his own longtime dream to have a plane of his own. This was little more than a momentary diversion, however; to those around him his continued lassitude was of growing concern. Nine days later, in the earlymorning hours on January 29, Linda awoke to discover him struggling for breath. In a panic she called Vernon, and Dr. Nick had him admitted to the hospital right away. A "Presley source" cited a "liver problem which has nothing to do with alcohol," while Vernon put out a statement that "Elvis has been planning for several days about going into the hospital," but everyone knew what the problem was. Dr. Nick was simply hoping to get the medications under control again and make sure that no further systemic damage had been done to the liver or intestine.

Under hospital supervision Elvis quickly lost ten pounds, though his abdomen remained distended because of the way in which his colon was backed up, due to a combination of a congenitally twisted ganglionic fold and the poor muscle tone to which his overuse of laxatives was thought to have contributed. Once again there was real reason to be concerned about the liver, but no further deterioration was observed. In almost every respect this visit was just like the last: the windows were all covered over with aluminum foil; Linda joined him once again in his room, and they watched the newborn babies over the hospital's closed-circuit television system; at least one of the guys stayed with him each night in the suite. It was a kind of vacation from responsibility, but two events took place to interrupt the tranquillity of his stay.

The first was the kind of everyday occurrence that might well have been overlooked under ordinary circumstances. Elvis' aunt Delta got a package at the house with a Las Vegas postmark and gave it to Jerry and Sonny to take to Elvis at the hospital. Though they had long since given up trying to thwart Elvis in anything he set his mind to do, the idea of simply delivering an unmarked package to his sickbed disturbed both Jerry and Sonny, and when they opened it up, it came as no great surprise to discover a bottle of "heavy-duty" pain pills. Feeling that he had no alternative, Jerry took the bottle to Dr. Nick. "I thought, 'I may lose my fucking job, but I don't care.' But Nick said, 'No, you know what? I think Elvis is in a great place; just go ahead and deliver it, and we'll see what happens.' So I brought Elvis the package, and he asked everybody to leave the room, he told them he had to talk to me privately. He said, 'You know, my dad's got a real bad prostate problem, and I got some medicine for him, and I didn't want anybody to know about it.' He said, 'Just go and put it up in the cabinet.' So I did, and he never touched it, and after about five days Nick just said to him, 'What is this in here?' And Elvis went, 'I don't know. Just throw it away. It was probably the person in here before me.""

Vernon Presley had joined his son in the hospital by now. He had obviously been under a lot of pressure, looking and feeling poorly for some time, before he suffered a heart attack early on the morning of February 5. Once his father got out of Intensive Care, Elvis installed him in the room next to his, but he was still sick with worry. Vernon had never been in the hospital before, and the two of them found themselves drawn back to old times and frequently painful memories. One time, when Elvis' cousin Billy was in the room, Vernon tried to put the blame on Elvis for his heart attack. "He said, 'I can thank you for this.' [And then he] blamed him for Aunt Gladys, too. He said, 'You worried your mama right to the grave.' Elvis broke down and cried. It about killed him."

Nick continued to run drug screens, despite his sense that Elvis was in a better frame of mind. All of the tests came up clean until February 13, the day of Elvis' discharge from the hospital, when traces of unprescribed barbiturates showed up in his urine. Dr. Nichopoulos never confronted his patient directly, but in addition to prescribing Elavil for what he was beginning to sense was serious depression, he arranged that either he or his office nurse, Tish Henley, would stop by Graceland every day to administer the various medications.

THE COLONEL HAD SCHEDULED a recording session for March 10, eight days before the Vegas opening, but Elvis was determined to stick around Memphis to gain some strength and lose a little weight, at least until Vernon got out of the hospital. Some days Dr. Nick would drive out to Graceland several times at Elvis' summons, and he continued to find himself drawn into Elvis' world, against the advice of family and friends. He was not blind to its dangers, but clearly he was not blind to its attractions either - or to his patient's almost seductive charm. Even his family priest, Father Vieron, urged him to let Elvis go. "He told me that he thought I was doing myself an injustice, I was doing my practice an injustice, my patients, my family. . . ." But Nick remained steadfast in his purpose; he believed against all the evidence of his senses and observation that he could get Elvis straightened out. He did the best he could to get him started on a low-carbohydrate diet and got him playing racquetball again, a sport at which Nick excelled, first at the Y, then at Memphis State late at night. It was not unusual for him to be out with his patient until threethirty or four in the morning, then go to work just three hours later. He probably could not have said why he was doing all this, but as with anyone close to Elvis, it was obvious to him that there was a yawning emotional chasm in Elvis' life, and while it might be equally obvious that that chasm could never be filled, there was an almost universal impulse to try.

Elvis loved to watch old *Monty Python* episodes with Linda and Billy. He knew most of the shows by heart, and they would toss lines back and forth till the tears ran down their cheeks, but other times he would dwell on the past or seek out Dr. Nick for more serious discussions of medicine and philosophy. He saw a good deal of longtime RCA promo man Bill Browder, who had just had a number-one country hit under his stage name of T. G. Sheppard, during this period. "Up until 1974 we had been friends, but our friendship got deeper. If I went out on the road and had a problem, he

could relate, because he'd been through it twenty years earlier. Sometimes we'd just sit and watch the ten o'clock news, and I'd catch him saying almost word for word what the newscaster was saying, and I'd say, 'How did you know —,' and he said, 'I saw it at six.' He talked about marriage a lot with my wife and myself. He'd say, 'I don't want you two to ever split up,' and his voice would crack and he'd say, 'Bill, you don't know what's in store for you.' He said he got saved once when he was living in Tupelo, and he was filled with the most wonderful spirit, and he gave all of his comic books away. He was an intensely lonely person, so alone with his fame and his thoughts. He said, 'Those people don't love me in a personal way. They don't know what's inside me.'"

The SESSION ON MARCH IO at RCA's recording studios in Los Angeles bore a strangely unacknowledged weight. Elvis had failed to deliver a single studio cut in 1974, and while technically he may have fulfilled his contractual commitments with a haphazard live album and the Colonel's curious scotched-together construction, *Having Fun with Elvis On Stage*, there was little question of RCA's anxiety about their longtime star. His records were neither selling nor even being taken seriously. The *Los Angeles Times*' Robert Hilburn had responded to the release of his latest LP, *Promised Land*, by suggesting that maybe it was time for Elvis to retire (the album was "as bland and directionless as all those soundtrack albums Presley cranked out in the 1960s," Hilburn declared), and not one of his recent albums or singles had sold close to half a million copies. Still, no more thought or preparation appeared to have gone into this session than any of the last few, and Freddy failed to deliver a single usable cut from the new catalogue.

Elvis brought Sheila and Lisa to the first day's session and with little rehearsal embarked upon the Pointer Sisters' aptly titled "Fairy Tale" (suggested to him by Linda) in too high a key. The next song, "Green, Green Grass of Home," was the same mournful country number that Red had urged him to record in the mid sixties, before it became a hit for Tom Jones, and he sang it with real feeling, then tossed off Billy Swan's number-one hit of the previous fall, "I Can Help," in a single take. It was not that any of this material was unsuitable for Elvis, nor even that the results, however ragged in both the first instance and the last, were any great disgrace; it was simply that they were no more than whatever happened to capture Elvis' fancy at the moment, and they were done with no greater concentration, and no greater commercial potential for the most part, than if he had been singing them in his own living room. He concluded the evening with four takes of Don McLean's "And I Love You So," a Top 30 easy-listening hit for Perry Como two years before, which he sang directly to Sheila, whom he urged to "step up, let me sing to you, baby."

The second and third days of the session were neither better nor worse, with a nice quartet version of the Statler Brothers' barbershop-harmony hit of a few months before, "Susan When She Tried"; "T-R-O-U-B-L-E," a new rocker from Jerry Chesnut that Lamar had brought in; a faithful recreation of Faye Adams' number-one r&b hit from 1953, the strongly gospelinfluenced "Shake a Hand"; yet another number from the Voice catalogue, into which Elvis seemed to pour as much pride of discovery as feeling; and "Pieces of My Life," a Troy Seals ballad that Red had brought him, in which Elvis seemed to see his own life refracted.

In all, he recorded ten songs in three days, barely enough for one very truncated seventies-era pop album, with nothing left over for any of the three stand-alone singles that RCA had wanted from the session. The atmosphere was relaxed enough, but there was little of the sense of fun that had once permeated an Elvis recording session, and while there was a funky family feeling in the rough mix that Felton put together in the studio — with Voice frequently filling the full quartet role that Elvis had always envisioned for his backup singers — there was none of the urgency, none of the tension, none of the sense of joyous release that Felton was always hoping to inspire, and little opportunity to do so. There was no way the people in New York were going to be happy with this session, Felton recognized sadly - although, as he was well aware, it could have been worse. At one point Elvis had gotten it into his mind to record Cal Smith's 1974 number-one country hit, "Country Bumpkin," and Felton had had his wife, Mary, type out the lyrics. He couldn't for the life of him understand what Elvis saw in the song - as its title suggested, it went against everything Elvis had ever stood for, both privately and publicly. But he had given up remonstrating, it only seemed to make matters worse. When Elvis showed up at the studio that night, Felton handed him the lyrics sheet and asked with some trepidation when Elvis wanted to do the song. Elvis just looked at him as if he were crazy. "Country bumpkin?" he said. "Country bumpkin? I ain't no fuckin' country bumpkin."

* * *

REVIEWS OF THE March 18 Vegas opening were indulgent on the whole ("He looks healthy and sounds good," *Variety* reported), while fan reaction was ecstatic. Elvis could joke about his weight ("You should have seen me a month ago. I looked like Mama Cass"), but to his fans it made little difference. As Sue Wiegert, a true believer since she had first met him as a teenager in Hawaii in 1965, perceptively observed, "What the fans really wanted was just to share an hour or so with him." As overweight as he had ever been, he was unable to fit into any of his old costumes, and there was little of the panoply of the usual Vegas show. There were the usual erratic moments both on- and offstage, but the fans simply didn't care.

On the final night during the band introductions, a wild water fight erupted in which Kathy retaliated, and then Duke Bardwell, to whom Elvis had been giving a hard time all through the engagement, really let Elvis have it with his own water gun. "You sonofabitch!" Elvis exclaimed off mike, and it was obvious even to audience members that he was not fooling around, but they cheered nonetheless as he picked up a bottle of Gatorade and said, "You got an electric bass, son, what are you gonna do now? You're gonna drink a lot of Gatorade, that's what you're gonna do." Then as the band played "Jingle Bells," he said, "I'd like you to meet my manager," and Colonel Parker walked out onstage dressed as Santa Claus, followed by Lamar in another Santa Claus outfit leading Elvis' little chow, Get-Lo. The evening continued with a fan presenting Elvis with a pair of Mickey Mouse ears in exchange for a scarf and Elvis leading band and audience in the Mickey Mouse Club song, familiar to every television child of the fifties. After several more goofy requests and encores, with Elvis, the band, and the audience all joining in the common hilarity, Elvis declared seriously, "I'd like to say something now, ladies and gentlemen. I'd like to thank everybody onstage with me, really. I've been kidding them now for a couple of weeks, but, ahh . . . you've been really fantastic. I'd also like to thank all the people who came to Vegas, with the economy of the country the way it is and everything. It's really nice to see you when I walk out here on this stage." At the end of the performance, as the curtain came down, he stood out on the stage, shaking as many hands as he could, while the audience gave him a standing ovation.

The generic apology, if that was what it was, came too late for Duke Bardwell. He had been ready to quit for some time. He was tired of the erratic nature of the show, and he couldn't understand why Elvis was always picking on him onstage. After the last performance was over, he gave away his TCB, said good-bye to everybody, "shook hands and walked out of there. . . . I didn't like seeing what was happening to Elvis . . . and he actually embarrassed me very, very much a couple of times to where he obviously was just making fun of me to be mean. But I still always tried to remain loyal to the man, because I felt like he was ill. And I don't believe that all those people around him had his best interests at heart at all — only their own. They had nothing else in life than to be one of Elvis' cronies."

Elvis received the news of Duke's departure with equanimity. He had never much liked Bardwell's attitude, he told the guys, and Duke had never been the kind of bass player they needed anyway. If Jerry Scheff wasn't ready to come back yet, there were plenty of other good bass players to choose from before they hit the road again in April. His mind was on other things by now anyway; he was thinking about returning to the movies, but this time in a serious dramatic role.

Barbra Streisand had attended his performance on the evening of March 28, and they had met in his dressing room afterward. She was there with her boyfriend Jon Peters, until recently her hairdresser, who she said was going to produce and direct her next film, a contemporary adaptation of the classic Hollywood fable about success, *A Star Is Born*, with Streisand in the Judy Garland role. What they had in mind was to cast Elvis as Norman Maine, the male lead, played in the Garland vehicle by James Mason, who drowns his sorrows in drink as he watches his wife's movie stardom eclipse his own. In this version, rock stardom would replace movie stardom, language would be updated to reflect changes in both era and milieu, and the dramatic climax would come at a live concert rather than at the Oscar ceremonies.

Elvis was completely turned on by the meeting. He was excited by its subject (he knew the highly emotional 1954 picture well), he was pleased with the idea that Streisand would approach him in this manner, and he was proud of the way he had responded, flattering the Hollywood star just enough, he told Sheila, to inflame her interest but maintaining a good businesslike demeanor as well. He spoke excitedly about it for days to the guys — but he didn't tell the Colonel at first, and when he did, he became furious when Colonel raised objections: that Peters was totally inexperienced in filmmaking; that Streisand and Peters as a team would have a single interest in mind, and that it would not necessarily be Elvis'; that a deal in discussion was very different from the deal that you actually got on paper. Colonel didn't understand, Elvis ranted to anyone and everyone who would listen — this was his chance at last for a serious role. Colonel was no longer in touch; he didn't know what was going on.

But he let Colonel handle it, as he had let Colonel handle all of his business affairs almost from the day they met. And gradually he became persuaded of the wisdom of at least some of Colonel's reservations. He could be taken advantage of by a combination of self-interest and moviemaking naivete, Streisand and Peters could play upon his excitement just to get a better deal for themselves, it was tricky — he could be made to look like a loser just by taking on a loser's role.

Within a week, on April 4, First Artists - Streisand's production company — and Warner Brothers had made an offer of \$500,000 plus 10 percent of the gross receipts after break-even, with the movie producers retaining all music and record rights but Elvis and the Colonel free to produce, and profit from, the two live concerts at the heart of the picture. Ten days later Colonel outlined his terms to Roger Davis at William Morris, who would put it all in legal language and carry on formal negotiations. He wanted si million in salary for Elvis, plus \$100,000 in expenses and 50 percent of the profits from the first dollar, along with approval of any songs that Elvis was to perform, and an unspecified deal to be negotiated separately on soundtrack rights. Mr. Presley had indicated his strong desire to make the picture, Colonel conceded in his letter to Davis, who was by now experienced in reading between the lines, and Parker had been surprised to discover that Miss Streisand had made a personal approach on the matter — but he had made it clear to Mr. Presley that "we should hold out for our regular terms" and that "he should have the best deal possible" and not allow his enthusiasm for the project to influence the business end or allow the movie producers to cut "a cheap deal." He also wanted to inform Davis that someone was already planting items in the press and that he had "advised Presley to be handy in case we need him, as I feel very strongly that in this case he should be very much kept up-to-date by us on any negotiations."

Elvis never had to make himself available for negotiations. By the time that he went out on tour on April 24, the movie was already a thing of the past. Nearly everyone around him saw it as one more example of the old man interfering, and Elvis did nothing to discourage their thinking. But secretly he seemed almost relieved not to have to deal with a matter that had blown up so quickly from a long-awaited dream into something complicated, unfamiliar, and ambiguous all at the same time. In the end, he decided, it was just as the Colonel had told him: he was sorry that Colonel was right, but there it was. Streisand and Peters had thought they could take advantage of him; when they were finally confronted with the reality of the situation, that he had access to a strength and business acumen that they had never imagined he would possess, they simply went away.

Sheila, too, he could tell, was in the process of leaving. She said she wasn't, but she was — as she put up more and more resistance simply to going out on tour with him for a few days, as she took in without demurral, or any sign of jealousy or possessiveness, all the signs of turmoil in his life. From her point of view "there wasn't much at stake. I was his friend, I was his little pal, I was taking care of him. The physical side was never very much, and it just became less and less. I wasn't ever jealous — you know, Elvis thought I was a helluva girl." She made no objection when he took a model named Mindi Miller out on the first part of the tour. In fact she welcomed it and would have been happy if Mindi had taken to the life better than she herself did. For Sheila it was almost past trying to explain. She had become little more than a sounding board — but she didn't know how to break the relationship off.

THE TOUR ITSELF got generally lackluster reviews: Elvis was pale and I overweight; in many of the shows, according to the critics, he showed clear signs of exhaustion. But the fans loved him, and he and Colonel got to split a \$700,000 profit for two weeks' work. For the band it was a sadly dispiriting experience. To Jerry Scheff, coming back after an absence of two years, it was like returning to a world in which all the landmarks were familiar but the atmosphere was altogether changed. "I was used to this really kick-ass stuff; I mean, the music [had] always felt nervous to me because the energy was so high, even the ballads. And if you didn't keep it there, he'd turn around and look and say, 'Hey, what's going on?' So when I went back, there were no rehearsals, they just sent me a tape - and I hopped right into it intensity-wise. And Elvis immediately turned around and looked at me like, 'What are you doing?' And I sort of scoped things out and realized that everything had dropped down a couple of notches." Glen D., too, saw a turnaround that had started with Aloha and gradually reached the point where they were all just going through the motions. "Those first three, three and one-half years he just loved to sing, but now he'd just go out there and walk through it sometimes, and something made me think that he wasn't going to live to be an old man." Even the Jackson

At a

566 🔊 A LEAF IN THE STORM

benefit, a great success by any standard and the original impetus for the tour, was marred by a backstage atmosphere that seemed almost permeated with foreboding. Elvis was photographed with Governor Bill Waller looking very much at ease and just as "modest, shy, and gracious as he could be," in the words of the governor's wife, as he presented a \$108,860 check for the tornado victims. But the governor, an AP wire story reported, was "quickly rushed out [as Colonel] Parker, angered by what he thought were too many crowding into the backstage room, constantly shouted, 'Get them back, get them back.'"

 $T_{\rm HREE}$ weeks later they were back out on the road for yet another whirlwind tour, this one concluding with the pay dates in Jackson to which the Colonel had committed at his original meeting with the Jackson businessmen as well as a final show in Memphis. Once again the idea seemed to be to get in and out as quickly as possible, and this time they made even more money — \$811,000 profit for twelve days' work. Somewhat against his usual practice, Elvis was actively promoting his new single, "T-R-O-U-B-L-E," by singing it at every show, and he had lost enough weight that he was wearing nothing but jumpsuits again. The record didn't do anything (it sold little more than two hundred thousand copies), but there appeared to be a considerably higher level of engagement in Elvis' performance, as he returned to a more rocking repertoire and even retrieved numbers like "Burning Love" from long disuse. The highlights of the show remained "An American Trilogy," its patriotic closer, and "How Great Thou Art," so transcendent on occasion that audiences called out for Elvis to repeat the ending after he screamed out the line "O my God, how great thou art" in a transport of near-physical emotion.

Back home in Memphis, Elvis split his pants bending over to kiss a fan ("Of all times and places!" he remarked) but generally seemed in fine fettle, playfully chiding the audience that they could have saved their money and seen him for free in a network broadcast of *That's the Way It Is* the previous week. He went on to make the introductions in his usual kidding fashion, pointing out that J. D. Sumner and the Stamps had not been with him when he made the movie, nor had Kathy Westmoreland, who "after tonight [might] not be with me ever." The audience laughed good-naturedly at the harmless joke, but Kathy was stung by this latest in what she took to be a string of veiled and not-so-veiled sexual references. She was sure they stemmed from her refusal to take up her previous relationship with him on this latest tour — and from his disapproval of the fact that she was dating one of the members of the band. In Shreveport he had declared, "Oh, you were with me — but not in the movie," then offered up what she took to be a transparently insincere demurral ("No, no, Kathy's a good Christian girl"). On several other occasions she had watched him turn away from the mike and was certain she had heard him say, "Oh, she's a good lay," under his breath. She wasn't sure who else onstage might have heard him, and there were some in the troupe who felt that she was not above manufacturing drama on her own, but clearly she had reason to be upset — not just by Elvis' cruelty toward her but by the change in character that permitted such cruelty to be expressed. She couldn't even tell him what she was thinking, though, as the gulf between star and supporting cast now extended well beyond the mere separation of hotel facilities.

All of this in any case was lost on the public, who remained, as ever, adoring, and on the press, which continued to describe Elvis as if he were a cartoon hero, a fat, "sensuous clown," in the words of the *Memphis Commercial Appeal*, "[whose] singing seemed to come second to his clowning." The pants-splitting incident was picked up worldwide, and this as much as anything else may have been the catalyst that precipitated Elvis to enter Mid-South Hospital the following week for what the newspapers were calling "an extensive eye examination" but what was in reality cosmetic surgery to give him a more youthful appearance around the eyes.

He called up Dr. Nick on the spur of the moment to let him know that he had made up his mind to have the operation and, when Nick tried to remonstrate, informed him that he would go to California and have the operation done there if Nick didn't set it up right away. After examining him and trying to talk him out of the procedure, the plastic surgeon, a Dr. Koleyni, operated on him at 12:30 A.M. that night, and Elvis remained in the hospital for another day and a half, with Billy and Jo Smith staying with him the whole time. Billy, too, had tried to tell him he didn't need the operation, "but, of course he [wouldn't] listen." Afterward he quizzed all the guys about whether they noticed a difference and showed them where the tucks were hidden, but Billy thought he never looked the same afterward. "To me it ruined his eyes. He always had those sleepy, sexy eyes. And they took the droop out. The droop was part of his mystique."

* * *

H E HAD ONLY THREE WEEKS to recuperate before the start of his next tour. For most of that time his attention was largely occupied with the airplane whose purchase had been announced on June 11 but which he had in fact bought in April when the Vesco deal fell through. The plane, which he got for \$250,000, with complete refurbishing bringing the total to over \$600,000, was a ninety-six-passenger Convair 880 that Delta had taken out of service. He was going to have the interior done mostly in blue, the exterior in blue and white, with "Lisa Marie," the name with which he had christened his new plane, painted on the nose and "TCB" on the tail. Just as he had with the various cars and buses he had had George Barris customize for him over the years, he got caught up in every aspect of the design, which eventually comprised a penthouse bedroom with a custom-made queen-size bed, an executive bathroom with gold faucets and a gold washbasin, a videotape system linked to four TVs and a stereo system with fifty-two speakers, and a conference room finished in teak. As the plans evolved, he started flying down to Meacham Field in Fort Worth to check on the progress of the work, another reason he needed to get back out on the road. Vernon was still vainly trying to recover the \$75,000 they had put down on the Vesco plane, but as far as Elvis was concerned, that was water under the bridge. He was caught up in the idea of developing an air fleet just as obsessively as he had ever been in the all-but-forgotten karate movie just six months before.

They started off the tour in Oklahoma City on July 8, then played Terre Haute and Cleveland and Charleston, West Virginia. Elvis wanted Sheila to go out with him but, when he couldn't reach her on the phone, took Diana Goodman, the current Miss Georgia, whom he had spotted in a tour group outside the Graceland gates. Joe kept trying to reach Sheila, and when he finally did, she told him the truth. She had met someone while Elvis was out on the last tour (in fact, it was actor James Caan), and by now she was practically living with him. "Joe said, 'Oh, shit, well, Elvis wants you here — what are we going to do?'" They both agreed that it would be better for Elvis not to have to deal with this until he finished the tour, so they cooked up a story that Sheila had an ear infection and the doctor had forbidden her to fly. Elvis refused to be put off, though. He reacted just as she knew he would, calling a few days later to say he had been thinking about her ear infection and had come up with a solution: he would rent a lowflying plane. She didn't know whether to laugh or cry. "I think he knew, really. He just wanted me there." But when she demurred once again, this

time he finally seemed to accept it, telling her he would call when he got back home at the end of the tour.

The tour by this time was already spinning out of control. For all of Nick's efforts to keep his patient on an even keel, for all of Joe's attempts to spare him any problems he didn't need to be bothered with, for all of his fans' adoration and the environment which he had created to insulate himself from the world and its complications, there were things going on in his life that he could no longer control, emotions that he no longer seemed able to bottle up or hide. "How Great Thou Art" seemed more and more to have become almost a cry of pain, deemed inappropriate in some less pentecostal quarters for its raw emotionalism. In Springfield, Massachusetts, he tossed his guitar into the crowd, declaring, "Whoever got the guitar can keep the damned thing - I don't need it anyway"; in Uniondale, New York, at the Nassau Coliseum, he delivered a stunning version of "You'll Never Walk Alone," seated alone at the piano. It was a song he had sung over and over again in private ever since first being inspired by Roy Hamilton's 1954 r&b hit. The message was one of exaltation, God's presence in the midst of peril and fear, but much like the Twenty-third Psalm, the classic Rodgers and Hammerstein composition was dependent for its emphasis as much on the singer as the song — and in Elvis' case the hope expressed in the lyrics seemed balanced by a tone that reflected a heart-rending, almost desperate struggle for belief. The song was the high point of the show, something, Elvis announced, he had always wanted to do onstage, bringing his concert appearances even closer to the kind of unvarnished emotional truth represented by "How Great Thou Art" on the one hand and the water fights and verbal horseplay on the other.

In Norfolk, Virginia, on the next night, the verbal shenanigans got out of hand. Elvis had been riding Kathy for most of the tour, picking up pretty much where he had left off on the last. In Cleveland Kathy registered the words with which she heard him introduce her ("She will take affection from anybody, anyplace, anytime. In fact, she gets it from the whole band") in stunned disbelief, and in Nassau she heard him repeat the same message, adding only, "I mean affection, you fool." This time she was not just stunned, she was angry. He might have his own problems, he might not like who she was dating — but he had no right to treat her like this. "After the show in Nassau I grabbed the nearest bodyguard . . . and said, 'Get the word to him, tell Elvis to stop doing this to me. Tell him I've had it.""

Evidently that was the wrong message, because he started in on her

again at the matinee performance in Norfolk, Virginia. This time she pointed her finger at him and said, "You had better stop this," and he broke off and gave her a kiss. But when Tom Diskin spoke to Elvis again just as he was about to go onstage for the evening performance, his reaction was predictably, if inscrutably, contrary. Early in the show, according to a UPI account, he announced that "he smelled green peppers and onions and that his backup singers, the Sweet Inspirations, had probably been eating catfish." It was the kind of incidental, off-the-wall remark that under ordinary circumstances might have passed unnoticed, but now, with everyone aware of Kathy's problems and fearful that they were going to somehow rub off, Estelle Brown hung her head in embarrassment and he lit into *all* of the background singers, declaring, "Estelle, Sweet Inspirations, Stamps, if you don't look up, I'm going to kick your ass."

Estelle left the stage at this point, and Kathy moved over to take her place, but when Elvis got to the introductions, he glared at Kathy and the remaining Sweets and said, "Sorry for any embarrassment I might have caused you, but if you can't take it, get off the pot." Sylvia walked off this time, followed by Kathy, leaving Myrna alone onstage, "singing, clapping, and smiling through the remainder of the performance," according to the wire-service report.

Neither Kathy nor the Sweets knew exactly what he meant by the "catfish" remark; none of them thought it was racial — they just knew it was hostile, and there was an ugly undertone not just to that comment but to his whole demeanor. He tried to give Myrna a ring onstage, which she at first refused, then finally allowed him to put on her finger, at least until the show was over. Kathy, Sylvia, and Estelle all made up their minds to quit, and there was enormous consternation throughout the troupe about how this would be treated in the national press. Jerry Schilling, his position complicated by his relationship with Myrna, tried to mollify Elvis, who was livid at the disloyalty displayed by the singers' walk-off. "He wouldn't apologize. He wanted me to be his emissary, but I said, 'No, Elvis, I think this is yours.' He said, 'To hell with them. Myrna can just come out with me. Who needs the Sweets in the show anyway?'"

Everyone's position was sufficiently frozen that Felton called Millie Kirkham, Elvis' soprano backup from the sixties, who had last sung with him five years earlier during the filming of *That's the Way It Is*, and arranged for her to meet them in Asheville two nights later on a standby basis. At the same time, Kathy and the Sweets were persuaded by Tom Diskin to travel

to Greensboro the next day, though they made no promises to go on. And Dr. Nick simply looked on in dismay, as he saw all of his carefully orchestrated attempts at mood control come to naught, as he watched Elvis take off on an emotional roller coaster that resembled nothing so much as a cocaine binge and found himself increasingly puzzled, and defeated, by a kind of manic energy that he simply didn't know how to treat.

The next night in Greensboro, after getting an apology from Elvis, the Sweets did go on, but Kathy didn't, and Red told her that Elvis wanted to see her after the show. "I thought it was funny," he said by way of explanation for his off-color remarks, and when Kathy told him he knew it was not, he just shrugged, as if he were weary of the whole subject. "He was sitting on his bed wearing his karate pajamas, and he had a gun. He held up a giftwrapped wristwatch in one hand and a gun with the other. He leveled the gun at me. 'Which do you want, this or this?'

I tried to compose myself, but my heart was pounding, and my mind was whirling with all sorts of crazy thoughts. . . . I just smiled and said, "Why, I'll take the gift, of course, thank you!" I laughed, too, but inside I was in a turmoil. "Oh, God, what is wrong with him?! What is he going to do?" It was so scary I was feeling like every muscle was about to collapse from weakness, but outwardly I tried to remain calm. . . . "I have to leave the show, Elvis. I'll stay until this tour is over, but then I think it would be best for both of us if we weren't around each other." He grinned at me and shrugged. "If you think it's best, then it's best. I won't say anything to stop you if that's the way you feel."

Everyone in the troupe watched with concern, wondering what was going to happen next. Some were angry at Elvis, others disillusioned or disappointed. J. D. Sumner felt that Kathy and the Sweets should never have walked off, it was "unprofessional." Estelle accepted Elvis' apology as heartfelt; he talked to her quietly until in the end "he was just praying," but at the same time she recognized "a vast change" that had taken place in a person she had very much loved and admired. The following afternoon he changed his departure plans several times and finally left everyone who was supposed to be traveling on his private plane standing on the runway at the Greensboro airport because they had arrived a few minutes late. Lowell Hays, the jeweler, who, along with Dr. Nick, was one of the marooned, couldn't believe what he was seeing. "He had to send the plane back from Asheville to get us. As soon as we arrived, someone came up to me and says, 'Elvis wants you.' By now he knows he's messed up, and he wants to buy everybody something. He bought everything I had and [then] he wanted more. He said, 'Do you know any jewelers here in town?' I said, 'No, sir, but I can get the jewelry here in about an hour.' I called Memphis, made arrangements for them to get the jewelry together, jumped on the plane, and flew straight back. Elvis bought what I would call practically a whole jewelry store! He gave something to everybody in the group. He gave each of the Sweet Inspirations a five-thousand-dollar ring."

In Asheville the next day there was an incident that could have made all of this generosity moot. Elvis had developed a toothache in Greensboro and seen a local dentist twice. The tooth was still bothering him a couple of days later, and Nick arranged for another appointment. With the Asheville dentist out of the room, and Dr. Nick watching, Elvis started going through cabinet drawers searching for pharmaceutical samples. Nick remonstrated with him and was sure that Elvis would get caught, but he couldn't get him to stop until the dentist returned. When they got back to the hotel, he insisted on taking the medications away. "I guess I embarrassed him by taking them away [in front of other people]. Then I embarrassed him even more by refusing to give them back." Elvis got as mad as Nick had ever seen him, storming around the room, swearing and out of control, until finally he went into the bathroom to put on his pajamas so he could take a nap before the show. When he came out of the bathroom, he was carrying a gun, a little Beretta that he had by his side. Nick and Vernon were standing together, and as he put his arm around his father, whether by accident or design, the gun went off. The bullet ricocheted off a chair and hit Dr. Nick in the chest, causing more insult than injury ("All it did was give me a little burn on my chest") but scaring Vernon half to death and bringing security guards on the run. Elvis tried to laugh it off, but from Nick's point of view it was a wonder that someone hadn't gotten killed, and Vernon, still frail from all of his recent health problems, just shook his head and asked Elvis what he thought he was doing.

Perhaps the audience in Asheville sensed what was going on. Although the reviews were good and crowd response was enthusiastic, for one of the few times on the tour Elvis didn't get a single standing ovation and on the final night was so frustrated by the lack of reaction that he took requests, once again threw his guitar into the fans' midst, and gave away a \$6,500 ring from the stage just to try to get the audience going. Vernon was obviously

JANUARY 1975-JANUARY 1976 👁 573

upset but powerless to do anything to control his son's spending, and even Lowell Hays was disturbed by this latest evidence of Elvis' profligacy. In two days he had given away over \$85,000 in jewelry, and while it was Lowell's business to keep the customer satisfied (and his belief that if he didn't do it, someone else would), he didn't want to feel like he was taking advantage of Elvis or his father either. "I was standing there after the show looking all dejected, and he came over to where I was standing and said, 'I saw the way you looked. I know you're upset. You don't need to worry about it. I just have to work an extra fifteen minutes to pay for it.' And he just laughed, and then he went and got in his car."

 $B^{\rm Y \ NOW \ JEWELRY \ PURCHASES}$ were almost beside the point anyway. Elvis had moved on to more costly indulgences. After hearing that John Denver had given his manager a Rolls-Royce (his manager was Jerry Weintraub, co-promoter of the tours), Elvis decided to present the Colonel with his own airplane, a Grumman Gulfstream G-1, which he bought sight unseen in the middle of the tour. Elvis had it delivered to Colonel in Vegas on July 26, two days after the last Asheville show, but Colonel didn't really take it the way that Elvis had hoped. "You've got to be kidding," was his first response. And then he turned it down on the grounds that he didn't need a plane and couldn't afford one.

Two days later, on Sunday, July 27, Elvis bought and gave away thirteen Cadillacs at Madison Cadillac, including a blue Eldorado for Myrna for sticking with him through his troubles. He added a fourteenth when he discovered a black bank teller named Mennie Person, who was windowshopping with her family and admiring his Cadillac limo parked out front. "Do you like it?" he asked her. "I'll buy you one." And he bought her an \$11,500 Eldorado, telling the salesman to add it to the list, which with this final purchase came to \$140,000. When he found out that Mrs. Person's birthday was coming up in two days, he had one of the guys write her a check "to buy some clothes to go with the car."

Some of the guys showed open signs of contempt for his generosity, even as there was a mad scramble to get in on it. All sorts of explanations were advanced, from the need to buy friendship to the use of mood elevators and cocaine — but none of them could get at the sheer mindlessness of it all. And in many respects it was no different from the ranch, the police badges, Voice, the karate film; it was as if once the floodgates were open, he simply couldn't stop. And it was as if, in another way, he were seeking to still some profound disquiet, cover up a need he couldn't quite bring himself to recognize, and expiate some deep inner guilt.

On August 3 he put down \$26,000 as a deposit on a second airplane with which he could go visit his first (he signed a twelve-month lease at \$13,000 a month). Within two weeks he canceled the lease and bought an Aero Jet Commander for \$508,000, which he would in turn sell in another two weeks so as to purchase a Lockheed JetStar for \$900,000. At Dr. Nick's urging he had just signed off on another costly undertaking, the construction of his own racquetball court behind Graceland, so he could take exercise whenever the spirit moved him. He gave Marty Lacker \$10,000 to help save his marriage, and when he discovered that Dr. Nick was having trouble getting a bank loan for the construction of a new house, Elvis loaned him \$200,000 interest free, with no specified plan of repayment — something which Dr. Nick's better judgment as a physician might have warned him against (just as any of Elvis' friends might have taken heed of the strings attached to generosity in any form) but which an equally human impulse to better himself at no visible cost allowed him to accept.

From the perspective of Billy and Jo Smith, who had been living in their mobile home at Graceland for the past year, the root of the problem lay in the fact that Elvis no longer knew who to trust. The old guard was in disarray, but Elvis had little faith in the loyalty of the new guys. More and more he retreated to family, seeking to return to the kind of warmth and security that only family could provide. Who but his grandmother could fondly recall old times, then say to him without self-consciousness, "Son, if you don't quit [spending your money like] that, you're going to be broke." He indulged his daughter shamelessly, looking forward to her visits without really taking on any of the responsibilities of fatherhood, or even of babysitting, while at the same time holding up an idealized vision of a future for her, for himself, for the grandchildren that she would produce - that was markedly untroubled and turmoil free. With Billy and Jo he prayed frequently for those he loved. Sometimes he talked to Billy about just disappearing and taking on a whole other identity, but after Billy pointed out to him that then he would no longer be Elvis, he dropped the subject without ever returning to it again.

He tried Sheila one more time. "He called me at four o'clock in the morning and said, 'I want you to come home.' I said, 'Home? I *am* home.' He said, 'No, I want you to come to Memphis, and I want you to ride your

horse.' I said, 'What about Linda?' I don't know why I said that. I think I wanted to make it feel like there was some reason other than that I didn't want to be there, like it was his fault, when it really wasn't. I don't remember if he even asked me if I was seeing somebody else or not. If he did, I lied about it. I said that I needed some time to think about things, that I was confused. He had this tone in his voice that was pretty sad. He said, 'Okay, baby,' and that was the last time we talked."

He called a girl named Melissa Blackwood, whom he had met earlier in the month at a World Football League game. She was nineteen years old, about to start college in the fall, and had just finished her yearlong reign as Queen of the Memphis Southmen (recently rechristened the Grizzlies) which was how Elvis had first spotted her. He called her at her parents' house at three in the morning and wanted her to come out to Graceland right away, but she told him she needed a little time to fix herself up, so he said he would have someone pick her up at seven.

"We walked in the front door, and the guys said, 'It's up at the top of the stairs, the gold door.' I said, 'You mean I just walk up there?' And they said yes. And, boy, that was the longest staircase I ever walked up. They said, 'There'll be two sets of doors, just go through both of them,' and I did, and Elvis was in bed, he was sitting up in his bed in his blue pajamas, and he just looked so tired, I'll never forget. I just stood there, and he said, 'Come here and sit down,' and he kind of patted the bed by his side. I think he could tell that I was really kind of nervous, because he looked at me and said, 'I want to tell you three things.' The first thing was that he was going to be a perfect gentleman. He said, 'I'm not a make-out artist. I don't try to be.' He said, 'I apologize for this, but it's just the way I have to live.' So then I felt better, because he kind of held my hand, and we just sat and talked, and he called me 'Brown Eyes.' There was a little piece of hair on my forehead that grew down like a cowlick, and he played with that and said, 'Look at this hair,' just like I was a little child.

"After a while he told me to get out of my clothes and put these pajamas on that he had draped over a chair. And I looked at him like, Are you out of your mind? And he said, 'Melissa, I don't mean anything by it. I'll be more comfortable if you're wearing them, I'll feel like you're more at home.' So I went in the bathroom and put them on, and of course they were hanging off my arms, and I had the waist all pinned up in the middle, and I walked out and he just laughed — he thought it was the funniest thing. But after that he never once did one ungentlemanly thing or made a pass or did anything to make me uncomfortable. We just talked and watched TV, and he had a closed-circuit TV, and we watched the people down at the gate to see what was going on outside."

He talked about his childhood and about his father, who he told her had been very sick. He talked about numerology and religion and the meaning of life, how he felt trapped by his success. "I think it was like a dream that pulled him away from the rest of the world, and he was trying to find something to look forward to." To her great surprise he gave her a car that he arranged to have delivered to the house as they sat out on the front porch. "He didn't tell me anything about it, I guess he wanted to see my face when the car pulled up. And finally it came, and I said, 'What is this?' And I remember saying, 'Why? What did I do to deserve this?' And he said, 'You came.'"

After that they went back upstairs, and Melissa fed him yogurt and hot cereal, "and all of a sudden he was so sick he could barely hold his head up. He was just shaking, and it was an effort to swallow, and it scared me to death. Then he took a bunch of prescription pills, I held the glass of water and just fed it to him because he was that sick. He wanted to take some more, but I took the pills away from him. I said, 'You don't need them. You can fall asleep without them. I'll sing to you - anything.' Finally he said, 'All right,' but then he said, 'Will you just stay and hold my hand?' And he wouldn't let me leave. It was the strangest thing. I would sit there silent and think he was sound asleep and get up to leave, and he'd grab my arm and say, 'Don't go.' He wouldn't let go until he was sound asleep. And then I went downstairs, and I said to one of the guys, 'What are these pills? He's sick. We should call a doctor.' And he said, 'Don't worry about it. He's under a doctor's care. He'll be okay later. Don't interfere, you don't understand.' And they told me they thought it would be all right if I wanted to go home and show the car to my mother, he'd be asleep for some time, so I could go and do that."

When she came back, he was awake and Lisa Marie was in his room. He laughed when she walked in the door and said, "Well, I give her a car, and she leaves me in it" — but she could tell it really bothered him. He played a 45 of Roger Whittaker's "The Last Farewell," a minor hit from the past spring about a British soldier going off to war and envisioning his own death in the most maudlin terms. "He had Lisa play it over and over, maybe twenty times. He said, 'I just kind of like that song.'" Later in the afternoon they took Lisa to the airport. Charlie was going to accompany her on a commercial flight back to the Coast, "and he was crying when he hugged her, he was just miserable that he couldn't walk her to the plane. But then he cheered back up. He sort of had his ups and downs."

That night they flew to Meacham Field to see his plane. "He took me through the whole thing, showed me the places where they were building the furniture, told me, 'This is going to be here, and this is going to be there.' He was just so proud of it." By the time they got back to Graceland, Melissa's head was splitting, and she told him she had to go home and get some sleep, but he didn't want her to leave. "He said, 'I won't even be here. I'm going to the movies with some of the boys, and you can just sleep upstairs. You'll have your own place, your own bathroom, and everything.' I said, 'I'm sorry, I can't. This is all just too much for me.' He said, 'I've given you a car, I've given you everything, why don't you stay?' I said, 'Well, if that's why you gave me the car, I won't keep it.' And I gave the keys back. And he looked so hurt and said, 'That's your car. I want you to have it. If you don't keep it, I'll park it on the street, and no one's going to use it.' I was in tears, because it was embarrassing to try to tell him that I had to leave. He just couldn't understand. He came over to where I was sitting and got down on his knees in front of me and put his arms around my shoulders. I said, 'Elvis, I'm sorry. I care, but I can't just move in here.' And he said, 'I care, too, babe. That's the problem.' And he just kind of hugged me and was almost in tears, too. He said, 'I'm going to take you to the door, and be careful going home, and call me and let me know that you're there.' Then I did, and he started asking me to come back. I said, 'I just can't. I'll come any other time. I'll come tomorrow.' I went to the house the next day, and he wasn't there. I took him a card thanking him and trying to explain, but I don't know if he ever got it. I never heard from him again."

HET JO CATHY BROWNLEE, a hostess for the Memphis Grizzlies, when he attended another football game. George Klein was the vehicle for the introduction, though Brownlee had gone out with Charlie Hodge briefly two years earlier. He enjoyed her company from the first and invited her to the movies, then to Graceland, where he had a Grand Prix delivered in the early-morning hours, just as he had with Melissa. Then on August 9 Elvis showed up once again in the stadium press box and asked if she could sit with him during the game. He sang to her, as he had at the movies, and toward the end of the evening invited her to fly with him to Fort Worth to see his plane. They would probably go on to either Las Vegas or Palm Springs afterward, he told her, and when she told him she couldn't do it because she had a date, he got another girl who was at the game to go in her place.

He didn't get back for three or four days, but when he did he saw Jo Cathy every night until he left for Las Vegas at the end of the week. He tried to get her to go with him, but she and her mother had already signed up for a junket that was flying out two days later for his August 16 opening, and she was not about to break a long-standing commitment. "He didn't seem like he was in very good health at all. He was really overweight. One night he was chewing gum, and a bridge just fell out. He kept saying, 'Jo Cathy, the boy is just falling apart, falling apart."

He barely made it to Vegas. On the flight out, the plane was forced to make an emergency landing in Dallas, because he was having so much difficulty breathing. Red and Charlie were really alarmed — no matter what he did, he didn't seem able to get his breath — but after a few hours resting up at a nearby motel, "the effect of the pills," as Red observed dryly, "had worn off."

The opening was a disaster. He was "overweight," wrote the critic for *Variety*, showed "lack of stamina and poor vocal projection," and, according to the same review, "it is difficult for him to sustain creditable vocal lines or lyric commitments, and his dogging of main intent and purpose . . . is very noticeable." There were lengthy interludes by nearly every member of the troupe (including Kathy, who had been unable to maintain her resolution to leave), and "in addition, he lumbers around in travesties of quick karate moves or trademark pelvic gyrations. Presley admits he spent \$2,500 on his jumpsuit costume, an obviously poor design that stresses his ballooning midriff."

Some of his most ardent fans might have disagreed, and in fact he seemed cheerful enough as he continued the practice of taking requests begun a few weeks earlier in North Carolina. This time he sent Charlie out into the audience to collect the requests in a champagne bucket, and he shook his head good-humoredly at his inability to recall the lyrics to some of the more recent tunes. But even the fans were concerned about his appearance, and by his not infrequent references to the state of his health and the way that short bursts of energy seemed to alternate with signs of extreme weariness. Linda, who had rejoined him for the opening, was alarmed at how "out of it he was, even if people didn't [fully] realize it. He was just barely going through the motions, he was lethargic and [physically] uncoordinated — I think even he was aware that he was in trouble."

On the second night he lay down onstage shortly after the opening number and arrived on the run for the midnight show, explaining that he had been in the bathroom and repeating a story that Jo Cathy Brownlee had told him about a woman at a Memphis Grizzlies game who had said, "But I didn't think he did things like that." On the third night he wanted to cancel his performance, but the Colonel wouldn't let him. The people were already in their seats, and Colonel simply said, "I'm not going to go out there and tell them you're not appearing. If you want to do it, get your daddy to go out there and tell them." He did two brief, perfunctory shows, glancing at his watch the entire time he was onstage - he even wore the same suit for both. By the next morning all traces of his presence were gone. Every poster, every souvenir, every banner and photograph had been removed; there were just three small announcements posted around the lobby saying that "the remainder of the Elvis Presley engagement has been canceled due to illness." Elvis, it was said among the fans, had left through the front lobby at six o'clock that morning accompanied by Dr. Nick. Some claimed to have seen him carried out on a stretcher, but in reality he walked out under his own power.

The Colonel lost little time in doing all he could to put the best face on things. He assured Henri Lewin that he would speak to Elvis and his father in person, in Memphis, about a December makeup date that the hotel wanted very much to schedule at the beginning of the month. Lewin was not above using the discomfiture he was sure the Colonel would feel over the Hilton's disastrous August losses, but Colonel, despite his acute embarrassment at finding himself in such a disadvantageous position and while stressing, again and again, that he did not take his obligations lightly, was having none of it: he thought the week after Christmas would be more suitable for their purposes, and even though Lewin had already indicated that Ann-Margret, a good draw, was tentatively booked for the holiday season, Colonel insisted that that was the one time slot to which Elvis might be willing to commit. He further intimated that he might even be willing to include New Year's Eve at a special price of \$200,000 to \$300,000 beyond the regular pro rata remuneration, since that was the minimum sum that he and Mr. Presley could expect to realize from a single concert booking in a large metropolitan area on that date. At the same time he reassured Elvis that through his extensive contacts and canny negotiations with "the hotel,

talent, ad agency, radio, newspapers and others," he had limited their losses to \$39,000, of which he promptly assumed his share of \$13,000.

But however unabated his instinct for combat, the Colonel remained sick at heart. And even as he played his cards typically close to the vest, gossips were whispering that he had incurred a debt of up to \$5 million in the casino, and friction between him and his client continued to be reported in the press. If it had been something as simple as friction, Colonel might have seen a way out - he could have used an intermediary; Mr. Diskin, whom he trusted implicitly, might have assumed even more extensive ambassadorial duties. But this wasn't something that could be easily fixed; like any parent who has been conned once too often by a recalcitrant child, Colonel felt he could no longer place any faith in Elvis' assurances, and he could no longer deny that a real problem existed. The trouble was, the problem simply went too far beyond the realm of his own experience for him to get a purchase on it, and while he was always trying to monitor Elvis' situation through Joe, Sonny, Lamar, or one of the other guys, he lived in the same unacknowledged fear that gripped them all: that if he stepped too far over the line, Elvis would blow up at him and things might be said that could never be taken back. They had all seen how Elvis reacted to his father's occasional attempts at interference, snarling at one or another of the boys, "Just keep him the fuck out of my way."

M EANWHILE, DR. NICK FOUND a very different Elvis from the one he had encountered through most of the months of July and August: all of a sudden he was deflated, the manic energy had abruptly run out, all external confidence was gone. For insurance purposes Nick and Dr. Ghanem put out a statement under both their names that the cancellation was "prompted by a fatigued state which developed in recent weeks" and that there was no cause for alarm, their famous patient was simply being hospitalized "for conservation reasons." In reality, though, while the clinical signs continued to give some cause for alarm (a "fatty" liver, various chronic intestinal and bowel problems, a high cholesterol count), what worried Nick most were the emotional swings, very likely triggered by drugs, but perhaps equally reflecting a genetic predisposition to dangerous cycles of euphoria and depression. Once again he brought in a team of consultants, who did their best to address the various medical issues. This time the team included a pulmonary specialist to look into what was beginning to seem like "possible early chronic obstructive pulmonary disease," as well as Dr. John Nash, a surgeon, whom Elvis tried to persuade to perform an experimental new gastrointestinal bypass operation that Elvis had recently read about, which had been developed as a means of reducing dangerous obesity by surgery when all other methods had failed. Dr. Nash refused even to discuss such an operation solely on a cosmetic basis with either Nick or Elvis — and in the end Elvis was persuaded that there was too much risk involved, even though, it was noted in the physician's orders, the patient had great difficulty accepting the distended appearance of his stomach.

Linda remained with him throughout his hospitalization. President Nixon called ten days into his stay, which seemed to cheer him up a little. Frank Sinatra called, too, and told him not to let the bastards kill him which Elvis took to mean not just Vegas but the whole system. But mostly it was Marion Cocke, the motherly nurse who had taken care of him during his January visit, upon whom he relied for comfort and consolation. They spent hour after hour talking about the most mundane subjects, he gave her a Pontiac Grand Prix, and when she tried to refuse it, he said, "It makes me happy to see you happy." When he was released on September 5, two weeks after entering the hospital, he asked her if she would accompany him home, and she agreed, taking the all-night shift after her regular hospital hours were done, while Kathy Seamon, another nurse whom he had met in the hospital, took days.

At first he spent most of the time in his room. In Mrs. Cocke's eyes he was nothing but a very thoughtful, reflective, and considerate — if very subdued — young man. Nor did she have any inflated ideas about her own role or station: she was simply, she joked with anyone who asked, like a comfortable old pair of shoes. At Dr. Nick's suggestion she set up a kind of breakfast nook in Lisa's room, where she slept, and it served as an inducement to get him out of bed for meals. She made him banana pudding and darned his socks; under Dr. Nick's direction, with Kathy and Tish Henley, she carefully monitored his medications; they watched Monday-night football and *The Carol Burnett* and *Mary Tyler Moore* shows together in her room. "He talked about his family and I talked about mine. We just thoroughly enjoyed each other's company. Never, ever did he try to impress me." Scarcely anyone else except for Linda and his cousin Billy was admitted upstairs.

Gradually he started going out again, leading a pack of friends through the Graceland gates on the three-wheelers he had bought in August just before leaving for Las Vegas. One time he coaxed Mrs. Cocke to join them. "He looked back to me. 'Hang on, Mrs. Cocke.' And away we went. The next day at work someone said to me, 'You know, Mrs. Cocke, I could have sworn I saw you racing down Elvis Presley Boulevard on the back of a three-wheeler with Elvis Presley yesterday.' And I replied, 'You know I would never do anything like that.' And that was all that was said."

Linda returned to the Coast to pursue her acting career. She simply found it impossible to continue. "I started having anxiety attacks. I told Elvis, and he was just so — loving. But I can remember thinking that nothing was worth this. I mean, in some ways I felt very protected. I always felt no matter what happened, he could take care of it for me. I felt a very strong sense of security with him on one level — and then real anxiety on another. I mean, he was who he was; he wasn't going to change. He used to say to me, 'Honey, you're not going to change a forty-year-old man.' But in another way there was also this very naive, this almost infantile quality about him — very innocent and very pure, kind of pitiful. He definitely evoked a protective quality — he called me 'Mommy,' and I wasn't the mother of his child. But I was an incredibly maternal presence in his life."

At one time she had thought of having children with him, "but our timing was off. By the time he was ready to do that, I was seeing things a lot more clearly, thinking, There's no way I can save him if he doesn't want to be saved himself. He's with other women when I'm not here. That's no way to live. If we have a child, then I'm going to be parent, and he's going to be with some other girl. If I have a child, how am I going to be with him and be a mom, too?"

This was the man with whom she had shared her dreams and whom she had cared for "like a newborn baby." She had seen him in ways that few others had, he had confessed to her what she was convinced he would never share with anyone else — but she found the emotional proximity almost frightening. "One time in Las Vegas he was eating some chicken soup, and I went in the bathroom to get ready for bed. When I came back, his face was in the soup, and he was almost suffocating. I called the doctor, and he gave him a shot of Ritalin to revive him. When he finally woke up enough to talk, he said, 'Mommy?' I said, 'Yeah, honey, I'm here.' He said, 'I had a dream' — and it took him about fifteen minutes to get the words out. He said, 'I had a dream last night.' I said, 'What did you dream?' He said, 'I dreamed that you were my twin, and you let me come out first — but while you were saving me by letting me be born first, you suffocated to death.' I said, 'Well, honey, you did have a problem. You were not breathing right, and I had a doctor come in and give you a shot. Maybe that's why you dreamed that.' 'No. I had a dream. I dreamed that you saved my life.'"

It was too much. She loved him, but without acknowledging it fully even to herself, she was leaving. He seemed to accept it after his own fashion. He bought her a house just around the corner from Graceland so she could have some space of her own, and he got her an apartment in west Los Angeles now that Monovale had finally been sold. It would be for the two of them, he told her; they could spend time together there whenever he was on the Coast.

He started going out again with Jo Cathy Brownlee, the Grizzlies hostess, and for the next couple of months she embarked upon an impossible schedule, teaching school till mid-afternoon, up at Graceland in the early evening just as Elvis was arising, out all night with barely time for a shower before she went off to work again. She recognized that her whole life was subject to his whims, but she didn't mind so long as she was able to keep her sense of humor. One time he told her out of the blue that he didn't want to see her again until she got a nose job, and she told him that she didn't want to see him "until he had his whole body retreaded, and he just laughed." She tried to help him keep to the diet that Dr. Nick had prescribed - yogurt, lots of vegetables, low-cholesterol bacon strips; they would eat upstairs, read the newspaper, watch the news, then go out to play racquetball — the girls would have one game, the guys another. Usually there was a movie scheduled after that. "Everything was a big production. Everybody had a certain thing that they carried; somebody was in charge of lining up the movie theater, somebody was in charge of getting the car ready. He always carried this little leather pouch with all his police badges - he wouldn't go anywhere without his badges, they were his prized possessions." If you yawn, we're gone, Elvis told her at the movies, scarcely acknowledging that she had been up at that point for twenty-one of the last twenty-four hours. They flew to Dallas one time to take a look at a racquetball center that Dr. Nick knew about so Elvis could get some ideas for the court that he was building. They spoke of numerology, and Elvis asked Jo Cathy to read The Impersonal Life aloud to him. It was a strangely solitary life despite the crowd in which they often moved.

Jo Cathy soon learned that one of the responsibilities of being Elvis' girlfriend was to make sure that everyone got taken care of, and she was frequently sought out by the guys, their wives, even relatives and maids, when Elvis was in a gift-giving mode. No one, she realized, wanted to be left out, and there was plenty of opportunity for bruised feelings to arise simply as a result of Elvis' impetuous generosity. Sometimes she could be a force for good. When Jackie Wilson, one of Elvis' greatest r&b inspirations, suffered a stroke on September 29 while performing in Cherry Hill, New Jersey, George Klein made sure that Jo Cathy let Elvis know about the fund that was being started to help cover Jackie's medical expenses. George knew of Elvis' fondness for Wilson, as well as his admiration for his music, and Jo Cathy considered this advocacy "a very nice gesture." But not every gesture, of course, was as altruistic.

She observed Elvis' fascination with the police and police work. "I just think he always had the secret desire to be some kind of law enforcement officer. He admired the hell out of the police here in Memphis — it was like he would just love to change places with them. He could be around them for hours." At the same time, she felt that at bottom he wouldn't change places with anyone, "he enjoyed being Elvis." And she couldn't help but note that despite all his good resolutions, pills were still coming in from Las Vegas, and unbeknownst to Dr. Nick, Elvis was still getting prescriptions filled by one doctor or another around town.

One time Linda came back, and Jo Cathy was banished for a brief period. Then one Saturday at the end of October she came from her parttime job at the Mid-South Coliseum, "and he acted real surprised to see me. He didn't say anything for a while, and then finally he said, 'JC, I have another date tonight. If you'll just get what you need and go on home, I'll give you a call in the morning.' It just really rubbed me the wrong way here I was, dead tired from working three jobs and seeing him, too, and I was really mad that he waited until seven that night, although I think what it was was that somebody was supposed to tell me. So I went around and gathered up everything that I had at the house — I had it all in this little laundry basket — and he came in and said, 'Now you didn't have to be a bitch about this whole thing. I just asked you to get what you needed for the night and go on home. You didn't have to act like this.' So he just kind of stormed out of the room, and I stormed out, too. And that was the last time I saw him."

The Colonel had been doing his best since the beginning of September to get Elvis back into the recording studio, at one point even concocting a scheme to record half an album in the studio, with the rest to be recorded live in Vegas in early December during the dates he had finally acceded to. He couldn't have been more aware of their contractual obligations to RCA, and even before Elvis was released from the hospital, Colonel tried to interest the label in various "exploitations," including a selection of title songs from Elvis' movies and a special TV package made up of twentyfour previously released tracks plus two bonus numbers and a photo album which the Colonel would supply. There is no indication that RCA was overly interested in any of the Colonel's suggestions, and Elvis never went back into the studio that fall, nor were plans made to record the Vegas show.

The *Lisa Marie* was finally delivered late in the evening of November 10. The finishing touches had been applied in California, and the Convair 880 was parked out at Memphis Aero, the *Press-Scimitar* reported, with the JetStar sitting proudly beside it. For the maiden flight Elvis elected to take a brief run to Nashville, but in the next couple of weeks he flew all over the country to display its capabilities to family and friends. He boasted about the two computers he had onboard, so that if one failed there would always be a backup. He showed off all of the airplane's lavish appointments. "I can't believe this is mine," he told everyone he spoke to. "It's a dream come true."

H ^E WAS GROWING more and more nervous, in Marion Cocke's estimation, as the Vegas dates approached. They were playing at the deadest time of year, and while the Colonel always seemed to relish a challenge — in fact, part of his psychology was that it brought out the best in his boy — Mrs. Cocke was not so sure that Elvis was ready for one at this point. It was not just the burden of performing that rested uneasily on his shoulders; he felt like it was all coming down on him again — the weight of his responsibilities, the financial pressures, what to do about Linda, who had returned from California to accompany him to Las Vegas at a time when he was not so sure he wouldn't rather take someone else. Colonel had booked them for New Year's Eve, too, in a football stadium in Pontiac, Michigan, and was promoting the idea of setting some kind of attendance record — but what about the sound? What about the weather? What if it snowed? He had never worked New Year's Eve before, and he didn't know that he wanted to start now — but he knew he could use the money.

As per doctor's orders, he was limited to one show a night except for Saturdays — and as per Colonel's predictions, the room, and the hotel, were full at a time of year when 50 percent occupancy was the norm in Vegas. Voice was gone, finally done in by all the animosity and politics surrounding the August cancellation. But Sherrill Nielsen remained as a kind of dramatic second voice and featured tenor, and J. D. Sumner and the Stamps took over the opening slot, which J.D. had coveted ever since Voice had joined the show. Notices were reasonably good (Elvis was "looking good and sounding cheerful," announced the *Las Vegas Review-Journal*), but the same gibes and onstage fits of pique that had been directed at Duke Bardwell during the last full engagement were directed this time at band mainstay Glen D. Hardin, with much the same results. Though he didn't say anything at the time, Glen D. made up his mind to leave after the first of the year, and James Burton, a bandmate of Glen's in Emmylou Harris' Hot Band (to keep them, she keyed her touring schedule around Elvis'), was planning to leave, too. Ronnie Tutt, whose drumming was the glue of the band, missed two nights for the birth of his daughter, and his long-term loyalties were perceived by some to be linked to little more than his remuneration, which kept pace with James' at the top of the salary structure.

Elvis returned to Memphis immediately following the engagement and on Christmas Eve awoke from a dream which was so real, he told Marion Cocke when she arrived in the early evening, that he found himself "in a rage. He had dreamed that no one who worked for him cared anything about him other than for their salary checks. He had dreamed that he had gone broke, and when he needed them they walked out on him. In his dream during this turmoil, he said that I had walked in and said, 'Babe, everything's okay.' With that he laughed and we just sat there and visited."

They visited until three on Christmas morning. "[Elvis] asked me what I thought of the boys [who were waiting downstairs] — how I felt about each of them. I gave him my honest opinion." By the time that Elvis was finally ready to go downstairs himself, nearly everyone had left. There was little question of their bitterness, both at Elvis and at those less deserving than themselves. Marty Lacker described "all the relatives congregated [throughout that Christmas season] looking for a handout," and saw Elvis' growing reclusiveness as a desire to escape his own family. Lamar Fike simply felt frustration at knowing Elvis "was up there punching buttons and watching what we were doing [on the television monitors]. I was fuckin' mad . . ."

That evening (Christmas night) Elvis took everyone up in the *Lisa Marie*, and when they got back on the ground, he handed out jewelry he had personally chosen for each from Lowell Hays' selection. Elvis' aunt

Delta was on the plane, according to Marty, "and she was drunk. . . . All of a sudden Delta looked at me, and she said, 'You're a sonofabitch. I don't like you. . . . You ain't no damn friend of his. And I got a good mind to take this .38 I got in my purse and just shoot you dead.'" Then she looked over at T. G. Sheppard "and she said, 'And you ain't worth a shit either, you walleyed sonofabitch.' And she just kept on. She said, 'All you sonsof bitches are here for the same thing. You just want his damn money. Here's this goddamn jeweler, and Elvis has to buy you some of his crap.'"

At this point Elvis reacted. "Get this drunken bitch off this plane," he commanded, apologizing to both Marty and Sheppard — which appeared to be the end of it. At two o'clock that morning, though, Billy Smith heard "the damnedest racket there ever was. I jumped up and grabbed my gun, and I run to the door. Well, it was Elvis. He had his cane, and he was beating the door on my trailer. His hair was messed up, and he was wild-eyed and red-faced. . . . He was out of his mind, he was so mad. He said, 'Goddamnit, I'll kill that bitch. I'll sew her cunt up and throw her over that damn wall!' . . . He was just screaming. 'How dare she do something like that? Goddamnit, I took her in out of the goodness of my heart, and I'll kick her fat ass out. . . . She embarrassed the shit out of me."

Billy tried to reason with him. "I said, 'Elvis, let's sit down and talk this thing out. This is an old woman you're talking about. You know how she is when she gets to drinking.' He said, 'That ain't no reason for that bitch to insult my friends and ruin my Christmas.' We talked for a few more minutes, and he settled down some. I said, 'Look, what you need to do is go out there and tell her, "Don't ever do that again." But you don't want to kick her out. She's got nowhere to go.' And he said, 'Yeah, I guess you're right.' But then he broke down and started crying. He said, 'She had no right to do that. Those are my friends. I love her, too, but she's got no right to make me look like that.'"

N EW YEAR'S EVE IN PONTIAC was a public triumph — \$300,000 for an hour's work and, as the Colonel tirelessly pointed out to every reporter who would listen, a record gross (over \$800,000) for a one-night performance by a single artist. In addition the Colonel had gotten Boxcar recording artists, the Bodie Mountain Express, to open the show, perhaps in hopes of finally getting the group signed to RCA.

The show was not an unqualified triumph, however. For one thing its

sellout status, the first claim of any Elvis Presley performance, was questionable, as the Colonel quickly ruled twenty-seven thousand obstructedview seats not for sale after ticket sales leveled off at sixty thousand. The crowd seemed to have a good time despite the frigid weather, but Elvis himself appeared shocked when he first walked out onstage and saw the two-tiered arrangement, with band and singers positioned five feet below him in a setup that he would never have approved because it prevented the eye contact he considered essential to a good performance. It didn't really matter. The musicians were freezing, the sound was terrible, Elvis ripped his pants at the beginning of the show, and Joe Guercio told comedian Jackie Kahane disgustedly, "He's all fucked up."

T. G. Sheppard and his wife had flown with him to the gig in the *Lisa Marie.* He had persuaded Sheppard to give up a booking of his own because it was going to be such a big event. "He said, 'It'll be one of the largest crowds I've ever played, and I'm nervous about it, and I [want] to take my friends with me.' After the show he just exploded. Linda just sat and let it happen. A lot of stuff had been rubbing him that day." Eventually he calmed down and decided to fly home that night, and they ended the evening in Elvis' bedroom watching tapes of old *Monty Python* shows.

 $\mathbf{F}_{a}^{\text{OUR DAYS LATER Elvis arrived in Denver with a party of eighteen for a spur-of-the-moment ski vacation that he thought everyone would enjoy. Joe was given the task of locating condos in Vail at the height of ski season, while everyone else remained at the Denver hotel. Finally he and vice squad captain Jerry Kennedy and Ron Pietrefaso, the Denver policemen with whom Elvis had continued to be friendly since his first performance in the city five years earlier, managed to find four condos and a house on the slopes for Elvis and Linda, returning in triumph late in the day with their news. Joe was exhausted, everyone else had plans, but Elvis, caught up in the spirit of adventure, was determined to set out right away. For Joe that was the breaking point. "I finally said, 'Fine. You go ahead — but I ain't moving from my room. I'm sleeping for twenty-four hours. I'll meet you there.' He wasn't sleeping at all at this point — just going, going, going, wired to the wall. Everybody was fed up with just traveling, moving — it just wasn't any fun. It was like he was driving people away."$

The result was that Elvis found himself virtually alone on his forty-first

birthday. Everyone was either holed up in their condos or just generally pissed off. Finally, Linda called Jerry and Myrna at their condo and told them nobody was around and Elvis was really down and she was about to serve the cake. By the time they came over he had perked up a little, and later as they sat around talking, he asked Myrna if she had seen *Across 110th Street*, a nihilistic black gangster movie that was one of his favorite films of the last few years. "I made the mistake of saying no, and he told me the entire story, acted out every role, recited practically every line." It was one of his greatest acting performances, Jerry and Myrna both agreed, but one that they could have done without, as it carried on into the early hours of the morning.

For the next week the guys and their wives and girlfriends all took skiing lessons, while Elvis came out at night in ski mask, Arctic snowsuit, and goggles to go snowmobile riding on the slopes. "IT'S ELVIS THE NIGHT-STALKER," blazoned the tabloid headlines several weeks later, accompanied by a suitably blurry, almost lunar-looking picture. It was "a dream vacation," remarked Sonny, that turned into "a nightmare." Susan Ford, the President's eighteen-year-old daughter, wanted to meet Elvis, but after she wrote a letter to the newspaper protesting the special treatment that allowed him to run his snowmobiles on the slopes at night, he refused to have anything to do with her — another instance, Sonny and Red thought, of his messianic sense of self-importance.

He had plenty of time for his Denver police friends and even consulted with police surgeon Dr. Gerald Starkey for medication to treat an itch caused by the ski mask he had been wearing. All of the police officers noticed changes since they had first met him five years earlier, but for the most part he was on his best behavior with them, and Ron Pietrefaso continued to see the same self-effacing qualities that had first set Elvis apart from any other entertainer he had ever met. Occasionally they would talk late at night, and "he would speak about how nervous he got every time he went onstage. I asked him, 'Why?' He said, 'You just never know. Maybe they're not going to clap. Maybe - I mean, you just think all the worst things.'" He talked about sleeping all day and staying up all night. "He said, 'When I was a little kid, I couldn't sleep. I was really afraid of the dark, 'cause I didn't know what was going to happen to me.' [Speaking of the present] he said, 'I know in the daytime when I go to sleep that it's dark in my room, and I pretend like it's night, but I know it's daytime, and I'm not afraid to fall asleep. So I stay up all night, and I have my friends with

me, and I feel comfortable. In the morning, when everybody else is up and going to work, I feel safe because it's daytime — and then I can go to sleep.'"

As a thank-you gesture to his friends on the force, Elvis contacted Bob Surber, a salesman at Kumpf Motors in Denver, and had him open up his Lincoln showroom at 8:00 P.M., two hours after closing. He bought Mark IVs for Dr. Starkey and Jerry Kennedy, then drove to Jack Kent Cadillac, where he got Ron Pietrefaso a \$13,000 Seville, along with a Seville and an Eldorado for Linda and Joe's girlfriend Shirley Dieu after Joe turned down Elvis' Rolls on the basis that it would just make everyone else crazy. In all, the bill came to more than \$70,000, which might have marked the conclusion of Elvis' purchases, except that when Don Kinney, the host of KOA-TV's Denver Today, reported the story on January 20, he ended the broadcast by saying jokingly, "Mr. Presley, I don't want a big Cadillac, I would prefer one of those little sporty ones." Elvis was on the phone within minutes to tell him he could pick up his Seville at the same dealer. Ron Pietrefaso, who knew Kinney and had to get on the phone to reassure him the call was not a hoax, thought that might be carrying things a little far, "but there was just so much inside of him that wanted to be accepted, and he thought that was the only way."

By this time Joe was gone, the rental period was up, and Elvis had everyone jumping just like he had at the beginning of the vacation. He decided he wanted to stay for a few days more, and just after Jerry had finished finding them new accommodations, Elvis called at three in the morning and said that he wanted to switch houses right away. He offered no explanation, and Jerry was in no mood for games. "He said he was coming over, so I moved into the small bedroom to give him the master bedroom. When he showed up with Billy and Red, he was just totally wired. He said, 'I thought I told you I wanted you to move back into the house.' I said, Jesus, I've been working to find a place for three days straight. I need to get some sleep.' He said, 'You do?' I was getting really mad now, but he was like someone I didn't know. Finally, he stormed out of the room, into the living room, where Red was waiting. Red wrote in his book that Elvis pulled out a gun at that point and said, 'I'll kill the sonofabitch,' but when he came back into the bedroom, all he said to me was, 'Well, you can stay if you want to.' I said, 'You know what, Elvis? I don't want to stay here. In fact, I'm leaving.' He said, 'Well, I said you could stay.' His voice was shaking. He knew he had pushed me too far. I said, 'No, I'm leaving. I'm going home.'

The next day Elvis didn't remember the conversation, but Jerry stuck

with his decision. "There was no reason for me to stay. He was tired, everybody was tired — he just didn't want a lot of resistance. All I would have been was a pain in the neck. I said to him, 'You know, I've always said, "Friendship is more important to me than the job." He said, 'What are you talking about?' I swear to God, I think he meant it. I said, 'Look, Elvis, I just need change. There's no hard feelings.' He said, 'Well, I guess you have to do what you have to do.' I wasn't trying to be difficult. He had done more for me than anybody else in my life. It was just there were too many people bumping into each other, people were calling him 'Boss.' Everything lapsed into everything else, and the rest of the world was just this little tiny bubble that you couldn't really relate to anymore. You almost felt naked going out into the world when you left that environment, because it was all just based on him. But it was time."

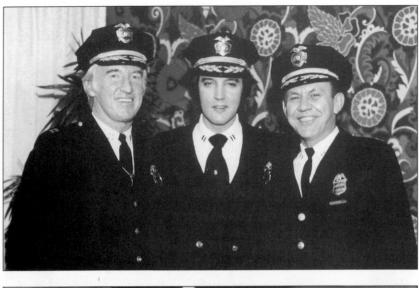

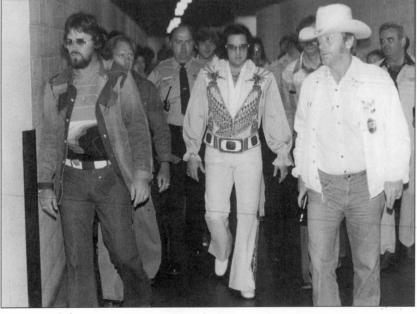

top: elvis in uniform, with denver police chief art dill (right) and captain jerry kennedy. (courtesy of the estate of elvis presley)

> BOTTOM: SONNY WEST, DAVE HEBLER, ELVIS, RED WEST, ATLANTA, JUNE 6, 1976. (LEE SECREST)

HURT

O DESPERATE WAS RCA to lure Elvis back into the studio that they revived the old dream of recording him at home. This time, however, both the nature and the reason for the plan were a far cry from its original conception fifteen years before. Then the idea had been to build a separate recording facility at Graceland, primarily to get around some of the obstacles the Colonel had put in the way of his artist recording too much. Now both Colonel and RCA were in full agreement: they needed to obtain product from an artist who appeared to have developed an almost pathological aversion to the recording studio. And far from building him a new state-of-the-art plaything, they now proposed simply to install temporary equipment in the den behind the kitchen, run lines out to the RCA mobile recording truck that would be parked behind the house, and make the best of whatever sound deficiencies arose.

It had been over two years since there had been anything like a regularly instituted plan; the perfunctory March 1975 session in Los Angeles had offered the only interruption to what amounted to Elvis' longest period of recording inactivity since he had first entered the Sun studio. Felton was confident the new arrangement would help solve some of their problems; it would at least allow them to catch Elvis whenever the mood happened to strike him. Elvis seemed enthusiastic about the idea, too. In fact, once he saw how the den looked without all the Polynesian-style furniture in it, he said he just might make the new decor permanent.

But then he left just days before the session was scheduled to start. One of his friends on the Denver police force, Detective Eugene Kennedy, troubled by domestic problems, had killed himself, and out of respect for the deceased and "because of friendship with Kennedy's older brother, Police Captain Jerry Kennedy, one of four Denver police officers," the *Denver Post* reported, "who received gifts of luxury cars from Presley earlier this month," Elvis flew out to the funeral. In addition, he arranged for J. D. Sumner and the Stamps to sing at the service, which he himself attended wearing the Denver

594 💊 HURT

police captain's uniform that his friends on the force had given him. He stood straight and tall at the Holy Name Church, a striking figure in his specially tailored jacket, customized TCB tinted glasses, and braided cap, looking for all the world like the man his mother had wanted him to be. He felt comfortable in the company of men who accepted him at face value, officers who had trusted him to accompany them on drug busts (even if they had never allowed him to get out of the car), and when they suggested going out to dinner at the Colorado Mine Company, one of their favorite hangouts, he readily agreed, striding proudly into the restaurant in his captain's uniform.

To Ron Pietrefaso's relief, none of the regular patrons appeared to pay any attention, and Captain Kennedy arranged for a special table around the corner from the main dining room where they could be assured of a little privacy. Not too long into the meal, though, Elvis announced that he had to go to the men's room, and when Pietrefaso suggested that he make use of the employees' rest room off the kitchen, Elvis insisted that he would use the regular bathroom just like everyone else. To Pietrefaso's amazement, somehow they were able to get him through the main dining room and back to the table without anyone seeming to notice. "I thought it was great. We were doing our job, and nobody was bothering him — but then he sat down for no more than five minutes and said, 'I need to use the rest room again." This time, Pietrefaso noted, Elvis hesitated for a moment in the long hallway where people waiting for a table were having drinks. Two women stopped in mid conversation as he walked past, and then, when he came out of the men's room, Elvis stopped directly in front of them, as if somehow he might have lost his way. "He gave one of those classic Elvis grins, and I heard one lady say, 'No, it can't be him!' And he turned around - it was too much, man, he turned around and said, 'It can't be who?' And the two women just started to scream." Then, and only then, would he allow himself to be guided back to his seat.

H E SHOWED UP for the first day of the recording session still dressed in his police captain's uniform. Everyone was waiting patiently for him to emerge from his bedroom, trying not to wonder if he was going to show up at all. Technical problems, and Elvis' schedule, had pushed the starting date back, which gave them only five days until James Burton and Glen D. Hardin were scheduled to go out with Emmylou Harris on a longplanned European tour. Felton didn't know if they could work that fast. RCA was expecting twenty new sides, which was the reason a full week had originally been set aside for recording. With some misgivings he made arrangements for a substitute guitarist and piano player to come in on February 7, along with a bassist to replace Jerry Scheff, who said he would have to leave then as well.

They got three cuts on the first night, though Elvis' lack of focus and energy was evident to all. Elvis' continued preference for downbeat material was not particularly heartening either, and even the high point of the session, George Jones' 1962 country hit, "She Thinks I Still Care," offered little hope of commercial success. He ended the evening with Roger Whittaker's maudlin "The Last Farewell," the song he had played over and over again for Melissa Blackwood the previous summer, but the musicians were no more able to grasp its fascination than Melissa had been.

On the second night, Elvis succeeded in recording just one song, Neil Diamond's "Solitaire," while spending most of the time trying to avoid accomplishing even that. He retreated to his bedroom periodically throughout the evening, took one member of the band or another upstairs to listen to gospel music, expounded upon numerology, and gave them all a viewing of his collection of police badges. At one point, when he was alone in his room with Red and Sonny, he explained a plot he had devised to rub out the drug pushers of Memphis. The session would provide them with a perfect cover, he said, laying out all the weapons with which they could accomplish the task — no one would even know they were gone. He showed them pictures of the principal dealers that he had gotten from the Memphis police, along with detailed information about the territory they controlled. "That's pretty heavy," Red said dubiously. He was bored with Elvis' fantasies and was not unaware of how close this particular scenario was to the plot of *Death Wish*, the Charles Bronson movie they had watched together many times.

The third night was no better; most of the time Elvis appeared to be struggling just to wake up, even when he was cutting "Moody Blue," a Mark James song Felton thought could really be a hit. Finally, on the next night something seemed to kick in, as they started out the evening with "For the Heart," a bright new up-tempo number from Dennis Linde, the author of "Burning Love." The song had more of a snap than anything they had tried to date, and Elvis seemed to respond to it, gaining confidence through numerous rehearsals and multiple takes until the song became the kind of seductively driving rock 'n' roll that had once been a staple of Elvis Presley music. It was with the next number, though, that Elvis was at last able to cut loose and release some of the emotional inhibitions that appeared to be crippling him. "Hurt," a highly charged recitation of the

596 💊 HURT

most melodramatic sort, had been a hit in a variety of interpretations over the years, but Elvis knew it best from Roy Hamilton's Top 10 r&b hit from 1954. Hamilton performed the song, as he did all of his greatest numbers, with the bravura vocal style that was his trademark, working his way up to a carefully controlled, beautifully articulated aria-like climax. This was clearly Elvis' model, but in the absence of the lush orchestration that marked Hamilton's hit, and with a voice that was more than a little frayed around the edges, he necessarily took a different approach. Opening with a bellow almost resembling a Tarzan yell, Elvis offers a version that is not so much an interpretation as an expression of the title sentiment, a kind of primal scream that can make for painful listening as you wonder if the singer will be able to sustain not just the notes but the mastery of his emotions. Compared with Hamilton's original, it reveals a crude, almost desperate grasping for technique. And yet at the same time, there is a note of triumph on Elvis' part, a pride in simply being able to get out what he is trying to say. This, he declares with as much bravado as he can muster, is who I am — despite all the pain, despite all the suffering, despite all the hurt, you can see: *I'm still here*.

He went on, at his father's request, to take a stab at "Danny Boy," the lilting Irish melody which like "Hurt" had its inspiration for Elvis in another over-the-top r&b performance, this one by Jackie Wilson. He was fully engaged by now, and while he was not able to sing the song in the key that he originally selected, he hung in through ten takes until he got a version even more heart-rending perhaps than if he had not been brought face-to-face with his own limitations. It was two o'clock in the afternoon by the time they finished. The musicians had been hanging around since nine o'clock the previous night, and out of deference to the general exhaustion, the starting time for the next night's session was moved back until midnight. But at least there was a feeling on everyone's part that *something* had been accomplished.

They might just as well have quit then and there. They did manage to get two undistinguished cuts on the fifth night, but with Burton, Glen D., and Scheff gone and a new lineup in place, the only song that they completed the following evening was a lackluster version of Willie Nelson's "Blue Eyes Crying in the Rain," a number-one country hit from the previous year. On the next night Elvis didn't show up at all, and after sitting around for a few hours trying to devise alternate strategies, Felton was finally forced to admit defeat and send the musicians home.

* * :

T EN DAYS LATER Elvis was back in Denver, with newspaper stories reporting that he was seeking a home somewhere in the area and Elvis hanging out once again with his newfound friends. This time, however, his visit came to an abrupt halt when the police officers attempted to intervene in what Elvis continued to see as strictly a private matter. Their intervention stemmed from an incident that had occurred after the funeral, when Elvis tried to get Dr. Starkey to give him Dilaudid for what he said was a painfully infected ingrown toenail. The police surgeon was very much taken aback, and after explaining to Elvis that he couldn't prescribe a heavy-duty painkiller for an injury of that sort, he went to Sonny and Red to try to find out what was really going on. He asked if Elvis was suffering from some kind of serious illness, since Dilaudid was generally prescribed for cancer patients and not infrequently abused by those who had grown addicted to its effects. He expressed his concerns to Captain Kennedy and Detective Pietrefaso as well, and this time when Elvis returned to Denver, they confronted him in his hotel room.

They knew he had a problem, they said, they couldn't help noticing how it affected him at times, and they were afraid other people might start to notice, too. They were speaking to him as friends now, not as police officers, they stressed — they simply wanted to help. He should understand that this was the sort of thing that could happen to anyone; they had witnessed it in their line of work over and over again, and they were sure he could lick the problem if he just put his mind to it. There was a private sanitorium they knew about, they could get him in and out without anyone ever having to know — all they wanted was for him to give the matter serious consideration.

Elvis just stared at them in disbelief. At first he didn't say anything, then declared in a tone of utmost hurt, "You don't think I can handle it, do you? You don't think I'm strong enough. *I know what I'm doing*. I can get off of this stuff anytime I want." But whether or not he really believed this would have been difficult to ascertain. Because two hours later he was gone.

He had other almost equally pressing problems. For one thing he was running out of money. With the exception of the makeup date in Vegas and the stadium show New Year's Eve, he had not worked since August but the bills kept piling up, hundreds of thousands of dollars of bills, for cars, planes, gifts, guns, jewelry, and clothing, anything in fact on which his eye might alight. To meet expenses with virtually no outside income coming in, he had borrowed \$350,000 against Graceland in November, but that was to be repaid in equal halves this year and the next. Meanwhile, there

598 💊 HURT

were the various lawsuits that had arisen from Red and Sonny's all-tooready roughness with the public; there was still half a million dollars to pay on the divorce; the airplanes (he had added a third, a Dessault Falcon, which he had bought as an "investment" in November) were a continuing drain of maintenance and finance charges; and it seemed like the cost of keeping up Graceland, and maintaining all his friends and relatives in the style to which they had become accustomed, was going up by the day.

With all of this weighing on him, he finally agreed to go back on the road in a hastily arranged mid-March tour, only to discover that he didn't have a band. Glen D. had handed in his notice to Tom Diskin not long after the Graceland session, and James Burton and Ronnie Tutt had indicated that they, too, intended to leave, but Diskin refused to accept their resignations. "You know how much he depends on you," he told Glen D. "I can't tell him you've quit." Finally Glen was forced to let Diskin know that he could do what he wanted, but Elvis was going to be in for a big surprise at the first show when he didn't see anyone sitting in the piano chair. It was only at this point that Elvis was brought into the picture and quickly approved the three Nashville musicians that Felton chose as replacements — though guitarist Billy Sanford (who had filled in for Burton on the last day of the February session) never actually got to join the group, as James changed his mind and came back for more money at the last minute.

They opened in Johnson City, Tennessee, for three nights running, in what amounted to a tacit admission on the Colonel's part that maybe they were better off out of the glare of the spotlight for the time being. It didn't affect the box office any - the six-day tour brought in over half a million dollars profit, which the Colonel magnanimously agreed to split on the old two-thirds-one-third basis, even though a new agreement, calling for a straight 50-50 partnership on live dates, had gone into effect on January 22. The new agreement for the first time spoke explicitly of an understanding "by both parties that these [tours] are a joint venture, and that Elvis Presley is responsible for the presentation of the staged performance, and Colonel Tom Parker and his representatives [for the] advertising and promotion." Elvis had no quarrel with the terminology; it was certainly in line with the governing language of the 1973 contract, which had established a 50-50 deal in every area but live performance. The way Colonel explained it, this new deal simply recognized the reality that they were co-promoters, or partners, in this respect as well, just as they had been from the start. As far as Colonel was concerned, it was the principle that was important, not the money, and with the new contract signed, he was glad to let the old

arrangement ride, at least until Elvis got back on his feet again. Which would happen in no time if they could just put some miles under them and get this show back on the road.

Linda accompanied him on this tour. So did Vernon and Dr. Nick. The two new players, Shane Keister on acoustic piano and Larrie Londin on drums, fit in well and in fact infused a new spirit into the music at times. To Londin, a three-hundred-pound powerhouse drummer with extensive experience both in the studio and on the road, working with Elvis was something of a revelation. They went into the first show without any rehearsals (the band showed up, but Elvis didn't), and when Larrie missed a visual cue, Elvis simply had them begin all over again. "He said to follow him — not to worry about the charts. He wanted everybody's attention onstage — you know, it was like, 'Be with me. I got an hour, and I'm gonna have *fun*!'"

Apart from the fans, who responded with undiminished ardor night after night, Larrie, a natural enthusiast, might have been the only one to take this view. To rhythm guitarist John Wilkinson, "it seemed like all the enthusiasm had just left. No matter how hard we tried to pump him up, Elvis would just stand there with his thumb hooked in his belt, it was like he was just there to sing a few songs and pass out a few scarves, but all the thrill had gone." "Hurt," "How Great Thou Art," and "America the Beautiful," his bicentennial tribute, were the highlights of nearly every show, imposing performances all, but in Charlotte he forgot lyrics, in Cincinnati he appeared "confused," and in St. Louis he was so overmedicated Dr. Nick could barely get him out onstage. "Elvis seems weak," *St. Louis Post-Dispatch* columnist Harper Barnes wrote of the perfunctory fifty-minute show, little wonder since, according to Dr. Nick, he didn't wake up till midway through the performance.

A second brief tour was booked in the aftermath of the first. It was scheduled to begin on April 21, with stops in Kansas City, Omaha, Denver, San Diego, Long Beach, Seattle, and Spokane, and led directly into an eleven-day Tahoe engagement paying \$315,000. For much of the tour Elvis was alarmingly congested, and he continued to suffer memory lapses even with songs he had been singing regularly since his return to live performing. Ronnie Tutt, who came back for this tour at a considerable raise in pay, observed that "there were nights he was so tired or so down I felt like I had to physically hit the drums much, much harder than I had before." To Myrna Smith and the Sweet Inspirations there was a clear physical dimension to the change. "[A lot of the time] when he first walked onstage, he'd be half asleep. . . . If you watched his show, you'd sometimes see him

600 💊 HURT

looking over at us, pleading with those eyes. We'd make more racket, trying to get him going, [and] he'd pull through it somehow. I've seen him sometimes when he was glassy-eyed [and] I thought, He is gonna fall."

The reviews were sometimes just as observant, and often no less empathetic. In Long Beach, the local paper reported, "An eerie silence filled the concert hall when he sang, 'And now the end is near' — the opening line to the Frank Sinatra favorite, 'My Way.' It was like witnessing a chilling prophecy." Even hard-boiled private investigator John O'Grady could not suppress an instinctive emotional reaction when he visited Elvis in Tahoe. "I felt so strongly for him I cried. He was fat. He had locomotive attacks where he couldn't walk. He forgot the words to his songs. I went backstage and looked at him, and I really thought he was going to die."

The musicians all talked about it among themselves, but, as former Voice accompanist Tony Brown, who had taken over the piano chair from Shane Keister, observed, "We all knew it was hopeless because Elvis was surrounded by that little circle of people, you know. . . . If you dared to ask, 'Can I have five minutes alone with [him]?,' the answer would be, 'Absolutely not!' [And if you ever] got around Elvis, he controlled the situation with idle chitchat." O'Grady was so strongly affected that he tried to take matters into his own hands, contacting Ed Hookstratten upon his return to Los Angeles and working out a plan with Elvis' lawyer to try to get Elvis enrolled in the drug treatment program at the Scripps Clinic in San Diego. Together they went to Priscilla with the plan, which guaranteed absolute confidentiality, and from what they understood, she broached it to Elvis, but that was where the matter stopped.

Just two and one-half weeks after the conclusion of the Tahoe run, he was back on the road again — for eleven days this time and more than s800,000 for Colonel and him to divide. Reviewers made frequent reference to Elvis' slurred speech and the way in which he seemed to stumble around the stage at times, but the crowds continued to turn out, and for the most part they continued to be enthusiastic. Once in a while there would be a show that reminded everyone of how it had been, and sometimes the band and the guys were able to take heart and imagine that maybe Elvis was going to pull himself together now and turn things around — but mostly the attitude was just to get through. Elvis' own attitude, on the other hand, seemed to Tony Brown to reflect a disrespect for himself and the fans that he had never shown before, even in his most erratic moments. "He'd be onstage some nights, and he'd suddenly just turn around and face us. He'd always pick out one person in the band, and he'd look at them and act silly. He'd just stand there, four or five minutes — not do anything. The audience would be screaming out song titles or applauding or stomping their feet. Elvis would have his back to the audience, and he'd be going like, 'Just listen to them stupid people . . .' and here we are with our hands on our instruments hoping he will call out something we know. Instead . . . he's just being Elvis out of control, saying, 'These people, they don't care if I'm good or bad. I can do anything, and they still love it.'"

He scarcely emerged from his room during the two and one-half weeks he was off in June. Lisa visited for ten days, but it was left to Linda to look after her, and to discipline her if she needed disciplining. One time she drove her golf cart out onto the highway, then stopped at the gate and posed for pictures for the fans — two things she was expressly forbidden to do. When Linda remonstrated that she'd been warned "one hundred times" not to go out on the highway, Lisa just told her to go to hell, showing little concern when Linda said she would have to tell her daddy about this. Others observed the little girl sitting for hours sometimes outside her father's darkened room just waiting for him to wake up. She was all he cared about, he burst out emotionally on occasion. But he didn't seem able to do anything about it, and he stayed holed up in the room, with only his books for company.

HERE WAS NO ONE he wanted to see. The new guys were little more than hired hands, and the old gang was all gone, scattered to the four winds. They all had lives of their own now: Joe was out on the Coast with his girlfriend Shirley Dieu; it seemed like Lamar hardly ever came over from Nashville except when things were being given away; he hadn't heard a word from Jerry since the confrontation in Vail; and Marty just brought him down. Meanwhile, Charlie was falling apart under the pressure, and even Sonny and Red were almost strangers to him now — there was a poisonous atmosphere of finger-pointing and suspicion different in degree from anything that had existed in the old days. He knew his father contributed to it with all his talk of budget-cutting and getting rid of the dead wood, sometimes even to their faces. That wasn't the problem, though. There had been quarrels in the past, and Vernon had never liked Red and Sonny — but that had never affected Elvis' feelings of closeness to them, not even when Red stayed away for two years after the wedding. Now he joked that they were the only guys he paid just to stay away from him.

602 🔊 HURT

He was pissed off at Joe and Dr. Nick, too. They had gotten him into a business deal a few months before that they assured him represented no risk and would almost certainly prove to be a good investment for him in the long run, but now it was threatening to blow up on them all. It was a plan to promote racquetball in much the same way that he had once sought to promote karate, in this case by building a chain of racquetball courts around the country which would go by the name of Presley Center Courts. In exchange for his name, as he understood it from them and their partner, Memphis developer and bond salesman Mike McMahon, he would receive 25 percent of the company, at no cost to him. They had broken ground on the Memphis and Nashville clubs in the middle of April, and everything seemed to be going smoothly when McMahon came to see him in Tahoe in May, but then things started to go wrong, as McMahon claimed that Elvis had to put up money for a buyout of the leases on the two buildings currently under construction, and when Elvis balked, informed him that by becoming 25 percent owner of the corporation, he was liable for 25 percent of its debts.

He went to the Colonel for advice, but Colonel just reminded him that he had been against this business all along, that he had told Elvis that nobody gets 25 percent just for doing a favor, and that it was too late for advice, now that he had gone ahead and signed all the partnership papers. Then he learned through one of the guys that McMahon, the only active partner in the business, had been drawing a small salary and was leasing a corporate vehicle, despite all of Nick's assurances that no one would be taking a penny out of the operation until it showed a profit. The whole thing just didn't feel right. It gnawed away at him until he didn't want to have any more to do with it, and then he shocked McMahon, who had had perfectly pleasant dealings with him to date, by calling up in the middle of the night "completely incoherent and irrational to the point where he was accusing me of different things . . . and then he told me he was going to kill me." Dr. Nick tried to tell the developer not to worry, that this kind of sudden rage was an occasional side effect of one of the medications that Elvis was taking and that it would soon wear off. But the feeling that he had been taken advantage of by his friends didn't wear off; it kept preying on him as he asked himself over and over, What the fuck were Joe and Dr. Nick thinking about when they brought him into this?

* * *

They went out again on June 25 on yet another eleven-day tour. Jerry Schilling, now working as road manager for pop singer Billy Joel, saw Elvis in Landover, Maryland, on the third date of the tour. It was the first time they had met since their January split, and Jerry was a little apprehensive, but Elvis gave him a warm embrace and kept Elton John waiting while they caught up on old times. The concert itself, like the one in Philadelphia the following night, was described by reviewers as "a show that consists mostly of a series of postures" by a performer "too tired — or bored — to care." Elton John, no stranger to excess himself, got the impression of immense loneliness. "He had dozens of people around him, supposedly looking after him, but he already seemed like a corpse." After the show, Jerry and Myrna were having drinks with Joe Esposito and Joe Guercio when the orchestra leader suddenly turned to Jerry and said, "You know, all he can do now is die."

There was a big blowup with Sonny in Fort Worth at the end of the week, their second visit to the city in just one month. The disagreement started out as a petty dispute over money — Vernon had canceled Sonny's wife and little boy's prepaid plane tickets to Texas — but it quickly escalated into more volatile issues of manhood and pride. Elvis finally settled the matter by telling Sonny to go ahead and have his family fly in, he would square things with Vernon, but Sonny was not surprised to hear "from a couple of guys later that [Elvis] was calling me every name in the book after I left." Sonny and Red had just about reached the point where they were sick of the whole thing. Others saw them as hostile; they saw themselves as truth tellers, and if Elvis didn't like it, he was just going to have to find someone else to clean up after him. "Some of the guys," Sonny was aware, "said we were intimidating Elvis about too many things [but] all of the intimidation part was only for his own good."

The tour ended in Memphis on July 5, with Elvis in his red-white-andblue bicentennial costume and "America the Beautiful" the highlight of the show. Everyone noted what a foul mood he was in, which was underscored when he avoided the gang that had gathered at Graceland before the performance. After the concert he went straight to his room, leaving the guests who had regrouped for the usual Fourth of July fireworks to go home puzzled and disappointed.

He left with Linda for Palm Springs the following night. Six days later Sonny and Red were fired. Sonny was at the dentist when he got a message from his wife that Vernon had "something important" to talk to him about.

604 👁 HURT

He called up right away, and after brushing aside Mr. Presley's objections that this was a matter that needed to be addressed face-to-face, listened incredulously as Vernon informed him that things hadn't been going all that well lately, and that it looked like they were going to have to let some people go. "Oh, I see, and I guess I'm one of the ones that's going to be let go?" Sonny said. "Yes, I'm afraid so," Vernon agreed in a subdued voice, informing Sonny that he would be given one week's severance pay.

Within a couple of hours Sonny found out who the others were. "I've been fired, man," Red said on the phone from California, and karate expert Dave Hebler confirmed that he, too, had gotten the axe. What hurt the most, Sonny and Red agreed, was that after all these years Elvis didn't even have the guts to tell them himself.

By now Elvis and Linda had retreated to Las Vegas, where Elvis placed himself once again under Dr. Ghanem's care and Linda did her best to reassure him that none of this was really his fault. He kept going over it again and again. He knew they meant well, but Daddy was right: they were costing him too much money with all the lawsuits. There were other ways of doing these things, but Sonny and Red were too old to learn and couldn't fit into the new professional security operation he was trying to create. They were like brothers to him and knew that if they ever needed anything they could always count on him. Linda listened and nodded and had no doubt that he believed what he was saying — but she could understand how Sonny and Red would feel about it, too. To be dismissed so unceremoniously after all these years, and not even to have the courtesy of being told man to man. "But that was Elvis' way," she recognized. "He never wanted to be the bad guy. So we just fled. But that also chagrined Red and Sonny and rightly so."

Dave Hebler was so outraged that he flew to Las Vegas for a direct confrontation, but he never got the chance, waiting for hours outside Dr. Ghanem's gate until he was at last informed that Elvis was not going to see him. As for Vernon, he felt no better about the decision than anyone else, even though he believed it to be the right one and Colonel backed him on it 100 percent — he was simply trying to protect his son, no longer just from others but from himself. And yet for all of his present-day problems there was still that element of Elvis' nature that made his father feel ashamed of any mean-spiritedness on his own part. Elvis had always possessed a generous heart, Vernon reflected; from the time that he was a little boy, he had never failed to take into account the other fellow's point of view. He had spoken to Elvis again and again over the years, "when I felt that he was carrying too big a crew [telling him], 'You don't need all of them, especially some who just seem to be out for what they want.' Elvis stopped me cold, answering, 'You see their wants. I look beyond their wants and can see their needs.'" In retrospect he would not be the least bit surprised if Elvis hired them back, Red and Sonny anyway, after a suitable cooling-off period.

 Γ lvis returned from the Coast just in time for the July 23 start Γ of another tour, his fifth so far this year. Once again they played backwater locales, from Syracuse, New York, to Charleston, West Virginia; once again the whole idea was to generate income (close to \$1 million in two weeks this time); and once again review after review spoke of the perfunctory nature of the performance and the sad state into which Elvis seemed to have fallen. In Hartford on July 28 Colonel lambasted Elvis for not putting forth more effort, for not giving the people their money's worth, and Elvis was so shaken that he sought out Tom Hulett after the show to ask if the fans still loved him. Hulett reassured him that they did, and audiences continued to demonstrate their affection in any number of ways, but as a reporter for the Newport News Times-Herald wrote, the adulation now was more "for what he was, what he symbolizes, rather than for what he is or how he sings now." There was, she went on, sounding a note that had become depressingly familiar from other recent write-ups and reviews, "no soul [in his music], no driving power behind his voice." Sometimes he had J. D. Sumner or Kathy Westmoreland take a solo spot in the middle of the show, because he just seemed too tired to go on.

The racquetball deal finally fell apart at the end of the tour. Elvis had his lawyer write a letter on August 10 that sought to disentangle him from the partnership once and for all: he was withdrawing his support, the letter stated, and wanted his name taken off the project. Elvis himself left for Palm Springs the same day, but the matter was still very much on his mind as he continued to mutter about firing Joe and getting rid of Dr. Nick for their betrayals. A few days later he called Nick in the middle of the night, totally "coked up and sort of psychotic, and he cussed me out about taking advantage of him. 'You're fired,' he said. And I said, 'You can't fire me. I don't work for you.' But he just told me he was going to get someone else to go out with him on the next tour."

Dr. Ghanem accompanied him when they went out again two weeks later, on August 27, along with Dr. Nick's nurse, Tish Henley, who had moved into one of the trailers behind Graceland with her husband in June so as to be able to administer his medication more efficiently. Linda's brother, Sam Thompson, who had been working for the Memphis sheriff's department for the last four and one-half years, was the new co-head of security with former Palm Springs police officer Dick Grob. And Larry Geller, with whom Elvis had been spending an increasing amount of time on his recent trips to California after first seeing him again in Vegas a few years earlier, officially rejoined the entourage for the first time since his unceremonious firing by the Colonel for attempted "mind control" in 1967. Elvis welcomed Larry's presence on the tour. Larry was just the person that he needed at this point, someone with whom he could carry on philosophical conversations, share ideas about books and spirituality, and breathe some fresh air into a world that had gone stale. Larry for his part didn't hesitate for a moment; he knew Elvis needed him, he was aware from their conversations that Elvis had missed him as much as he had missed Elvis, and he knew, too, that the atmosphere surrounding him was very different from what it had once been. Even Colonel Parker, Larry realized, could no longer afford to be so suspicious of him — the main idea now was just to keep the show running.

The first show, in San Antonio, was a "lackluster performance," according to one review, but it was a success by the new standard under which they were operating, and everyone reassured themselves afterward that maybe Elvis would respond positively to a new regimen set up by a new physician. The second date, a matinee performance at the Summit in Houston, dispelled any such illusions. Elvis was so "loaded," according to the testimony of one troupe member after another, that there was some doubt that he would even be able to take the stage, and when he did, he could barely talk, let alone walk, putting on a performance that embarrassed the whole show and made them wonder how much longer he could go on. The Colonel, who witnessed the entire performance, was beside himself. Not only was Elvis testing the limits of his audience's love, and their continued loyalty to him, he was testing the patience of the Houston policemen augmenting the security force, who, Colonel realized in a panic, were talking openly about Elvis' condition among themselves. All that was missing was some glory hound who wanted to be the one to take down Elvis Presley. Because everyone knew — there was no longer any way you could deny the evidence of your eyes.

He got Elvis out of town as quickly as possible, contacting his old friend Bill Williams, entertainment chairman of the Houston Livestock Show and Rodeo, to fix things with the cops. There was nothing he could do, however, to stop the review that ran in the *Houston Post* the following morning. "Elvis Presley has been breaking hearts for more than 20 years now," was critic and longtime fan Bob Claypool's lead, "and, Saturday afternoon in the Summit — in a completely new and unexpected way — he broke mine." The show was "*awful*," he wrote, "a depressingly incoherent, amateurish mess served up by a bloated, stumbling and mumbling figure who didn't act like 'The King' of anything, least of all rock 'n' roll." The fans, Claypool observed, almost didn't seem to notice; "faithful as always, they still came down front — came bearing gifts (a painting of Elvis, a sixfoot-long stuffed dog, a small teddy bear)." It made you wonder if they wouldn't always come, he wrote, "no matter how bad, how ill, how *uncaring* he would get. But for some of us it would never be the same, because the man who had given us the original myth of rock 'n' roll — the man who created it and *lived* it — was now, for whatever reason, taking it all back."

That night the Colonel had Joe call Dr. Nick. They needed him, Joe told the Memphis physician, making it clear he was speaking for Colonel as well as himself. Nick took this to be as close to an apology as he was going to get — he couldn't recall Colonel ever requesting a favor of him before. He said he'd be glad to rejoin the tour so long as he knew that this was what Elvis wanted. Not long afterward Elvis called and asked him to come back, and he met them in Mobile the next day.

The problem, once he had had the opportunity to confer with Tish, was not all that difficult to figure out. It revolved, as always, around issues of access and amount, and Nick soon had things back in proper proportion, establishing a protocol of dispensation that took into account the potentially debilitating effect of Donnatal on speech and motor functions and included an assortment of placebos among the multitude of depressants that Elvis required to go to sleep each night. With the reinstitution of such pragmatic measures, the tour was able to continue, and everyone was able to go back to pretending that nothing was really wrong. Bitsy Mott, the Colonel's brother-in-law and security director in the early days, had no such luxury. He had had a falling-out with the Colonel not long after Elvis' return to live performing, and he and his wife had not seen Elvis in some time when the show arrived in Tampa on September 2. They were shocked by his appearance when they visited with him before the performance, but they were even more shocked when Elvis took the stage. They couldn't help but cry as they watched, and they left before the show was over, not even bothering to say good-bye to the Colonel, who appeared no less dejected than they.

* * *

LMOST AS SOON AS the tour was over, Elvis once again began hear- ${
m A}$ ing rumors about the book that Red and Sonny and Hebler were said to be planning to write, a behind-the-scenes exposé that would reveal a world the fans had never imagined. There had been talk about just such a book almost from the day that his father had dismissed them, but Elvis insisted that it would never happen, that Red and Sonny would never betray him in this way. Now he was no longer so sure. The three disgruntled ex-bodyguards had approached first Rick Husky, then former Los Angeles Herald-Examiner critic Frank Lieberman about serving as their collaborator, and even asked Jerry Schilling to go in on it with them. Now Elvis heard that they had signed a deal with Star reporter Steve Dunleavy, and he joked cynically with the guys who were left about who was going to turn tabloid reporter next. There was no disguising his real feelings from those closest to him, however. As Linda saw it, "he was frightened, he was angry, he was hurt — he was like a kid, he became more fragile than ever. He just didn't realize that he had done something really hurtful to them, too."

He flew out to California at the beginning of October to join Linda in her new apartment and pick up a Ferrari for himself. John O'Grady and Ed Hookstratten were urging him to put a stop to the book any way he could, and he conferred with O'Grady, who was confident that Red and Sonny and Hebler could still be bought off. He gave Jerry Schilling a call, too, and invited him over to the apartment, ostensibly to thank him for turning down Red and Sonny's offer. Jerry was still there when O'Grady stopped by to report on the failure of his mission. He had offered each man \$50,000, along with an "education allowance" to help prepare him for a new line of work. They had turned him down flat, declaring that they were in too deep to back out now. O'Grady had gone to the meeting wired, and he offered to play back a tape of the conversation, but Elvis wasn't interested. The private investigator suggested a number of other alternatives just skirting the edge of outright intimidation, but Elvis didn't rise to the bait. He was sure he could straighten things out by himself, he said, if he could just get a chance to talk to them on his own.

He had the chance less than one week later, on October 12, the day after his return to Graceland. Red had called the previous afternoon, and Charlie explained that they had just gotten in and Elvis was asleep. Red made it plain that he didn't believe him and angrily accused Elvis of being stoned and listening in on the upstairs line. When Elvis called him back the next day, it was early in the morning out in California. "I guess I do owe you an explanation," he said, in the kind of weak, slurred little voice that Red had grown all too used to in the last year of his employment. What had happened was due to a combination of factors: Vernon's illness; "a lot of excess pressure" on the racquetball business; all the lawsuits; and, worst of all, "I don't know whether you heard it, but they were trying to prove us insane. . . . I'm talking about some influential people who were checking psychiatrist reports."

Red tried to steer the conversation back on course. "I couldn't believe it. You had left town. Your daddy called and talked about cutting down expenses and giving us one week's notice. They give Chinese coolies two weeks."

He didn't know anything about that, Elvis replied, the one-week thing. "It was like a fuse burning," he tried to explain. "It was just a series of things. If I could lay them out to you one by one, I could show the reasons for the separatisms." It was all the things he had already mentioned, the way in which unnamed parties were trying "to establish a pattern of insanity and violence," the fact that "the fun [had] ceased to exist."

"I guess all that pressure led up to our demise," Red said bleakly, seeking to pursue an agenda of his own. "It was a shock. We were broke. I sold my house. Hated to do that."

ELVIS (surprised): You sold your house?

RED: Oh yeah, . . . hated to do that. It was a bad time by all.

- ELVIS (philosophically): Well, I guess there never really is any good times. It was bad for me, too. . . .
- RED: I understand. But if I had just heard from you, it would have been easier to take.
- ELVIS: Well, in doing business and things of that nature, I don't do that.

They spoke of a number of other matters, always coming back to the same thing. With Hebler, just as with the racquetball deal, he had been seriously disappointed. "I think I became a dollar sign. . . . In the process he lost sight of Elvis. That can easily happen. It happened, man. I'd become an object, not a person. I'm not that sign, I'm not that image, I'm myself."

Then he brought up the one issue that had not been mentioned. He knew what Red thought, he knew what Red had said to Charlie just the day before, "[but] you're so wrong on one thing — and don't get paranoid. I'm talking to you as a friend on a private line, and there is no soul here. I'm not fucked up by no means. On the contrary, I've never been in better condition in my life."

"You *have* been pretty fucked up," Red demurred. "That's what I was talking about."

610 💊 HURT

Elvis seemed to read into this some kind of reference to his 1973 divorce, which in turn triggered a belated apology for Red's exclusion from the wedding nine years before. But "that was railroaded through. I didn't even know who was there in that little room the size of a bathroom with a Supreme Court justice. It was in there over and done so quick I didn't realize I was married. . . . That wasn't my doing. I had nothing to do with —"

RED: Let's get to the last couple, three years. Let's face it, you haven't enjoyed yourself.

ELVIS: I enjoy my work. . . .

- RED: We were always worried about you.
- ELVIS: You worried about me so much that you turned around and tried to hurt me. You see, I know what that is.
- RED: Well, that's after you hurt me. You hurt me and my family very bad.
- ELVIS: All I know, there was friction created in the group, the vibes were so bad, people were scared to move and everything, so who knows what the hell they were hearing and being told? I just know it got to be very, very tense. . . .
- RED: You got to get healthy, Elvis. You haven't been healthy for a while.
- ELVIS: Oh yes I am. I just had an absolute physical head to toe.... I keep hearing that shit about being fat and middle-aged.
- RED: No, no, you ate a lot, but you weren't fat, you could tell there was something else wrong, something was wrong inside. When I tried to talk to you about it, you'd get mad, you wouldn't listen.

Choosing to take this as a reference to his long-standing intestinal problems, Elvis hastened to assure Red that these had been straightened out. Aside from that, there was nothing wrong with him, despite what Red kept intimating; the real problem was a general failure to communicate on the part of the whole group. "Negative vibes . . . I could feel the negative things, but I couldn't exactly pinpoint what it was. I just reached a boiling point. It was a temporary thing — I didn't feel like I could communicate with anyone. I felt terribly alone, you know, like that [numerological] number eight. The [reading] that says they're intensely alone at heart." That was the way he felt, he said, and he knew that was the way Red felt because Red was a number eight, too. Number eights had "warm hearts toward the oppressed. But they hide their feelings [and] do what they please."

At this point Red seemed to conclude that the conversation was not going anywhere. "It bugged me when you were talking to Charlie and said I was all fucked up," Elvis said. "I'm not. I got a daughter and a life. What profiteth a man if he gains the world and loses his own soul? I love to sing — since I was two years old." In fact, he and Charlie had been singing just a little while ago, and they missed Red, they missed his harmony part on "Love Is a Many Splendored Thing." What could he say? Red replied. He missed singing it. "Well, look," Elvis said, "you take care of yourself and your family, and if you need me for anything, I would be more than happy to help out. I mean it. I don't give a goddamn — And that ain't got a goddamn thing to do with articles or no publications or none of that shit that I've heard — I've just heard rumors, bits and pieces. I have never sat down with anybody and had it laid out to me. I just know that you as a person, and Pat [Red's wife] — if there is anything I can do, any way of getting a job, anything else, let me know." Red expressed his appreciation on behalf of both himself and his family, who, he repeated, had been hurt as well. Which gave Elvis the opportunity to stress once again his own feelings of rejection.

All of us were hurt. It's like that song, "Desiderata": "Listen to the dull and ignorant, because they, too, have a story to tell." And then Hank Williams wrote, "You never walked in that man's shoes and saw things through his eyes." After analyzing the blamed thing, I can see it, I can see it clearly. That's why I'm saying, anything I can do at all. Worried about the book? I don't think so, not on my part. You do whatever you have to do. I just want you and Pat to know I'm still here.

H ^E WAS BACK ON THE ROAD two days later for yet another twoweek tour, another SI million for Colonel and him to divide. If there was any doubt about the outcome of his conversation with Red, or the status of their relationship, it was dispelled by a Steve Dunleavy story in the October 26 edition of *The Star*, midway through the tour. Under the headline "Elvis' dramatic plea to his ex-bodyguards: Don't write that book about me," it quoted at length from his and Red's conversation, which evidently had been taped without Elvis' knowledge. Its conclusion quoted Red as saying to the reporter, yet to be identified by *The Star* as the forthcoming book's author, "You can't be with a man since childhood and not feel something for him. . . . I just wish he would get well."

On October 29, two days after the tour was over, another recording session was scheduled at Graceland, but this time Elvis was barely able to muster the enthusiasm even to begin. Somehow they managed to get three tracks over the course of a first, very long night, but "he just wasn't interested," said pianist Tony Brown. "He couldn't seem to keep rhythm, he couldn't maintain any attention span; it was like we'd get one song, and he'd go upstairs for a couple of hours, and we'd just wait around." As at the earlier home recording session, he invited different members of the group up to his room at various points during the evening. This time he gave away items of clothing as souvenirs, including an entire "Superfly" outfit from 1973 with which he thought J. D. Sumner and the Stamps might spiff up their image.

On the second night it seemed for a while as if Elvis might not come down at all, and Felton had the players laying down instrumental tracks until at last he reluctantly appeared. He started work on "He'll Have to Go," a classic 1959 hit for country singer Jim Reeves, but almost as soon as he did, a shipment of motorcycles that he had been waiting for arrived, and Elvis insisted that everyone go outside and watch them get unloaded, then try them out on short runs back and forth to the gate or to Linda's house around the corner. Finally, any pretense that the session might continue was abandoned when Elvis once again retreated to his room, this time emerging with a Thompson submachine gun with which he goodnaturedly threatened to blow up the speakers. No one was sure whether or not he was joking, and Felton might have been tempted to try to persuade the musicians to stick around for another day or two just to see if Elvis might snap out of it. But Elvis put an end to any such speculation by apologizing and declaring that he was simply too distracted to continue. He was upset about Red and Sonny's book, he said, and he couldn't get in the right frame of mind for recording — but they would all get together again under happier circumstances soon, maybe next time in Nashville.

With that burden lifted off him, he zeroed in on the problem of getting everyone home with a focus and energy that had eluded him for the last two days. The West Coast–based singers and musicians were to be transported to Los Angeles on the *Lisa Marie* and met at the airport by his limousine driver Gerald Peters, while similar arrangements were made for David Briggs, Tony Brown, and Chip Young to fly into Nashville on the JetStar. Finally, over Joe's vociferous objections, he presented J. D. Sumner with his white Lincoln limousine as a gift, so that J.D. and the Stamps (to whom he had given a tour bus the previous July) could travel home in style.

For the next three weeks it seemed as if he were merely seeking somewhere to alight, flying to Denver, Vegas, or Palm Springs on a whim, Dallas for a hamburger. In his bedroom at home he pored over his books, consulting *Cheiro's Book of Numbers* whenever any serious plan came up for discussion. Linda was around for some of the time, but she seemed more intent than ever on her career as an actress, and even when she was in Memphis she spent more time at her house than at Graceland. George Klein fixed Elvis up with a couple of girls, and he dated a little, but his heart wasn't in it. He needed something more — his life was an empty wasteland. Then on November 19 he met Ginger Alden.

Ginger's twenty-two-year-old sister, Terry, the reigning Miss Tennessee, was the one George had thought Elvis would go for, but he brought the two of them out to the house, along with their older sister, Rosemary. The three sisters all waited downstairs for what seemed like hours while, they were told, Elvis practiced his karate. When they were finally ushered into his private quarters, Elvis almost immediately made clear his preference for twenty-year-old Ginger, a former Miss Traffic Safety and current Miss Mid-South, to whom he said, "Ginger, you're burning a hole through me." Ginger was distinctly ill at ease with all this attention — in fact, she barely said a word after her sisters left — but Elvis didn't mind: she seemed to listen and observe intently while Elvis showed her his books and explained that eight was a lonely number. It was almost daylight when he had one of the guys drive her home, having behaved like a perfect gentleman the entire time, she told her mother and sisters, who breathlessly awaited her report.

He called the next day, at first offering her a ride in his new Ferrari, "but then he determined I wasn't ready for that yet because it went so fast." Instead he invited her to drive out to the airport with him in his Stutz so they could take the JetStar for a spin and observe the Memphis skyline at night. It would be perfectly proper, he assured her — his cousin Patsy and her husband, Gee Gee, would be chaperoning them — and he repeated the same argument when he suddenly got the idea that they should all fly to Las Vegas instead. Ginger protested that she would have to call her mother first, but he told her she could do that when they got there, and if her mother didn't like it, they would just turn right around and go home. She thought her mother would be upset when she called, but Jo Alden's reaction was quite the opposite, as she seemed almost to encourage her youngest daughter in her latest conquest, simply telling her to be sure to be back the following day.

Ginger was a little disappointed that they weren't going to get to see much of Vegas: they went straight to Elvis' suite, and all Elvis wanted was for her to put on some oversize pajamas and come to bed. She was a little apprehensive about the pajamas until he gave her his solemn oath that it was out of spirituality that he was drawn to her, not carnality, and that he would treat her like a lady at all times. She wasn't sure whether or not to believe him, but then he fell asleep as she read to him, and the two of them lay innocently side by side until well into the next day.

It was "a different kind of a date" for sure, and she was not without misgivings that her boyfriend would disapprove, but her mother and sisters told her she would be very foolish to overlook an opportunity of this sort, and she didn't hesitate for a minute when Elvis called just one week later from San Francisco on the fifth day of his new tour. He wanted her to join him right away, he said, he was sending the JetStar to come get her — could she be ready in a few hours? She threw her things together, arriving in San Francisco the following morning, but she didn't see him all that day, nor was she invited to watch his performance that night. He would be with her right after the show, the guys kept telling her; there was just this little problem he had to deal with first. Finally, she went to bed hungry and depressed, without ever learning that the problem Elvis had to deal with was that Linda was still on the tour.

Linda had had a strong suspicion that Elvis was planning to fly someone else in from the first. Her suspicion was strengthened when he suggested with that furtive little boy's look in his eye that she seemed kind of worn out to him and that maybe he should have the JetStar take her back to Memphis. He would be okay, he said, he would just take a little time for himself. For once she didn't feel like giving him an easy out. In fact, after chiding him that he knew she always enjoyed a chance to go shopping in San Francisco, she actually challenged his story. "I said, 'You have another girl here, right? You're bringing another girl in.' 'Oh, honey,' he said. 'Of course not.' And he held me really close and said, 'I just want you to know, no matter what anybody ever tells you, no matter what you read, no matter what you hear, it's only you that I love.' I looked him right in the eye, and I said, 'You don't have another girl here?' He said, 'No, honey,' and I said, 'O-kay . . .' - but I said it very sarcastically. Normally if he had said something like 'It's only you I love,' I would have said something like 'Oh, you're so sweet,' but this time I distanced myself and just said, 'Okay' — like 'Yeah. Right. Sure.'"

Maybe it was because she had a secret of her own. Without Elvis knowing anything about it, Linda had developed a relationship with the piano player, David Briggs. "He was just the total antithesis of Elvis. I mean, he was bearded, blue jean-clad, kind of low-key, no ego, not traditionally good-looking, he just really downplayed everything, and I thought, You know what? There is life after Elvis." They liked to think they had been thrown together not just by fate but by Elvis himself, who kept urging the two of them to go out and enjoy themselves and do all the things that he couldn't do, taking advantage of the restaurants and shops in the various cities on the tour. What really started it, though, were the nights that Elvis was completely out of it or carrying on one of his interminable dialogues with Larry Geller that left room for the participation of no one else — she just felt like she had to get away. So she started playing cards with the guys at the beginning of their late-August tour, and very soon she and David gravitated toward a more intimate relationship, maintaining the fiction at first that their closeness was just a part of the general camaraderie. Everyone else watched with compulsive curiosity, uncertain whether what appeared to be happening actually was. Even after it became obvious, the two lovers pretended that it was still their secret, as the rest of the troupe nervously speculated on how long it would take Elvis to find out.

That was the backdrop for Linda's departure, and perhaps the reason she felt obligated to adopt a coat of protective cynicism for the first time in her four-year relationship with Elvis. She needed to go, she had finally come to realize, she just hadn't had the courage to pull away; now that the opportunity was provided for her, she was damned if she wasn't going to do her shopping first. When they parted, it was with the idea that she would see him back in Memphis, but for Linda this marked a watershed in her life, as she recognized once and for all that there was nothing she could do, "he was going to go ahead and slowly kill himself, no matter what I did. I couldn't make him happy, and I knew he wasn't going to change. So I left."

The next night Ginger attended the show in Anaheim. It was the final date of the tour, and the improvement in his performance was remarked upon by even some of his sharpest critics. He was inspired by Ginger's presence, he confessed afterward to Larry Geller — he thought this girl was really it. After the show, they stayed up all night talking and didn't even kiss. He was beginning to believe that he had discovered love on a higher plane.

They went straight from the road into Vegas. Ginger wanted to go home for a few days — she said that she missed her family — and Elvis let her, as long as she promised to come right back. Some of the guys grumbled that

616 💊 HURT

this girl wasn't for real, she was just a baby, and they had heard she was still seeing her old boyfriend, but Elvis was in no mood to listen. As Larry observed in his diary: "How long can the drugs and his feelings about Ginger keep him on this high?"

Not long, as it turned out. Vegas started out on a strong note, but it seemed both to fans and to other observers that Elvis quickly ran out of gas. Before the first week was out, he looked "very tired and quite sad," according to one fan report. He either talked a blue streak or didn't talk at all, he swore at the sound system and cut the show short on December 6, explaining that he was in too much pain from a sprained ankle to continue, and then at the late show on December 10, he announced casually, "I hate Las Vegas," in an aside that was cheered by the crowd. At the conclusion of the next song, reported British fan Martha Collins, he "picked up the mike on its stand and asked, 'Does anyone want this tinny sonofabitch?,'" and as the audience "cheered wildly" in response, declared, "I'm not going to get up here and try to sing, because these damn microphones are [so] cheap. I ain't gonna do it, you know. 'Cause this is my living, folks, my life."

Ginger seemed to occupy as much of his attention as the show. He arranged for "Sir Gerald" to pick up a special white-on-white Lincoln Mark V for her on the Coast and flew in her entire family for the conclusion of the engagement when Ginger announced that she missed them and was thinking of going home again. Ginger's mother, never shy, was quoted in the press to the effect that rumors of marriage at this point were premature and that the Lincoln Continental which Elvis had given her daughter was not to be construed as any kind of formal engagement gift — at least not as of that moment.

There were other things to worry about. Vernon was admitted to Sunrise Hospital on December 9 with what looked like another heart attack, but it turned out to be just a scare. The Colonel was rumored to have lost over \$1 million at the roulette table, and his uncharacteristically grim demeanor seemed to indicate that the rumors were true. It was Elvis that he was worried about most, however. "My artist," he declared balefully to a couple of startled European fans seeking an introduction, "is out of control."

It was obvious to anyone who saw Elvis that he was not well. Larry was concerned that, for all of his talk of the rejuvenating nature of his love for Ginger, he might be "killing himself, striving for her love and attention." The day that Vernon was released from the hospital, Larry found Elvis with beads of perspiration running down his face. "His eyes had a strange, haunted look. He stared at me, taking in deep gulps of air and breathing erratically. Trying to stand, he lost his balance, and as he fell he grabbed at the drapes with both hands to keep from hitting the floor. . . . He moaned, "This is it — I'm going out. I — ah — took too much — or someone gave me the wrong thing. I'm going . . . I'm leaving my body. I'm dying.'" Somehow Larry got him through it and sought out Dr. Ghanem, who "told me not to worry — that he'd check Elvis later."

The final night of the engagement was as disturbing as the rest, particularly for anyone accustomed to the high-spirited, freewheeling atmosphere normally associated with the end of any Las Vegas run. On this particular night Elvis clearly couldn't focus, he was unable to concentrate, at times it seemed as if he could barely wake up, wrote one distraught fan, who noted that the previous evening, "in an off-mike aside to the singers, he mouthed the words, 'Only one more night here,' and made a face as if he were about to throw up." When televangelist Rex Humbard came to visit with him backstage, Elvis seized desperately on his arrival, demanding of Humbard whether he should give up singing and devote himself to the Lord. He seemed momentarily comforted when the well-known minister assured him that he was doing the Lord's work simply by using his talent and giving pleasure to so many people, but then Elvis started talking about Armageddon and the Second Coming of Christ, and, Humbard testified, "I took both his hands in mine [and] said, 'Elvis, right now I want to pray for you.' He said, 'Please do,' and started weeping."

The story that Bill Burk wrote in the *Memphis Press-Scimitar* on December 15, three days after the Vegas close, presented as kind a reaction as anyone who cared about Elvis Presley could have had at the time. "After sitting through Elvis Presley's closing night performance at the Las Vegas Hilton," wrote Burk, a longtime supporter, "one walks away wondering how much longer it can be before the end comes, perhaps suddenly, and why the King of Rock 'n' Roll would subject himself to possible ridicule by going onstage so ill-prepared. Why carry on? For fame? He's perhaps the best-known, best-loved performer of all time. . . . For money? [Burk dismisses outof-hand the idea that Elvis could possibly need the money.] This may seem like one person's opinion. It isn't. . . . And yet they keep coming back, and they will pack his next road tour, which starts December 27 in Wichita and ends New Year's Eve in Pittsburgh. Once a king, always a king. Maybe that's it. And just maybe they're still coming because they think it might be the last time around."

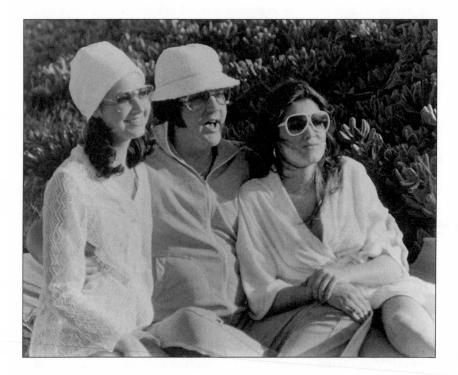

WITH ROSEMARY AND GINGER ALDEN, HAWAII, MARCH 1977. (COURTESY OF JOSEPH A. TUNZI, J.A.T. PUBLISHING)

ELVIS, WHAT HAPPENED?

UST AS HE HAD PROMISED, Elvis agreed to a new recording date in Nashville to make up for the November Graceland debacle. In hopes that something might be gained from an entirely new setting, Felton booked a week's worth of sessions at Buzz Cason's Creative Workshop, a comfortably up-to-date studio with which all of the Nashville players were familiar and where he thought Elvis would quickly feel at home. Recording was slated to begin on January 20, and everything was going according to plan until Felton heard from Joe just hours before the session's scheduled start that Elvis had gotten hung up in Memphis and wasn't going to be able to make it until the following day. Then on the twenty-first, with all the musicians assembled, Felton got another call from Joe. Elvis was in town, but he was going to have to stay at the hotel for the time being because he wasn't feeling very well. Felton wondered if he ought to hold the musicians, and Joe said he thought he should, at least for the time being. Over the course of the evening, however, the bulletins grew worse, as Elvis complained of a worsening of his throat condition and a doctor was called to confirm the existence of the problem. In the end Felton was forced to send everyone home.

What was bothering Elvis, Joe and Charlie and the rest of the guys all knew, was not a sore throat but hurt pride and a wounded heart. Ginger had refused at the last minute to accompany him to Nashville. They had had a big fight about it, and he had threatened not to go at all, but she remained adamant, coming up with one excuse after another, including the fact that she had never liked Nashville. His throat was just a way of making Ginger feel sorry for him, his cousin Billy concluded when Elvis told Billy that he wasn't planning to record even before their departure from Memphis. "If I have to," he said, "I'll say I'm losing my voice." As if somehow, by that refusal, he would get back at Ginger — and maybe even at the Colonel and RCA, too.

Linda might have motivated him, the guys all agreed; she would have

kidded him along and maybe even gotten him out of his funk. They blamed Ginger for just making matters worse. From their point of view, she had been nothing but trouble ever since her arrival on the scene, with Billy and Jo Smith the only ones who could communicate with her, and then only because they treated her like she was a little girl. What bothered everyone most was the way she had Elvis running around in circles, doing everything he could to try to impress her and her family. No one missed the fact that her presence could pick him up, as it had on New Year's Eve in Pittsburgh, where he gave one of his best performances in a long time. Nor did anyone doubt that he genuinely cared for her. It was just that no one could understand the attraction. The closest he came to explaining it was when he told Dr. Nick there was something about her that reminded him of his mother, but neither Nick nor anyone else could see what it was - she seemed to them like some high school kid flattered by all the attention but unsure what to make of it, guided more by her mother's ambitions than by any deep inner feelings of her own.

It was a subject that came up often in the month and a half since Elvis had taken up with the girl, and nearly everyone weighed in with their opinions in a far more public way than they would have dared with any of Elvis' other girlfriends. But Elvis remained impervious to argument and innuendo, even if it was clear that he cared far more about her than she did about him. One time Billy suggested to Elvis that maybe he should look for a woman closer to his own age, with whom he could share common interests and have meaningful discussions once in a while. "What in the hell could a forty-two-year-old woman do for me?" was Elvis' sexually swaggering reply, when it was perfectly evident to Billy and everyone else that Elvis' sex life was virtually dormant at this point.

Like it or not, though, his entire existence was dominated by Ginger and her family. When Ginger's grandfather died, Elvis flew all of the Aldens into Harrison, Arkansas, on January 3, for the funeral, and he and Charlie hummed conspicuously along as the minister sang "Amazing Grace." The following day he took Ginger and her sister Rosemary to Palm Springs, where he celebrated his birthday that weekend in quiet domesticity. Nor was he shy about the subject of marriage, as his Beverly Hills dentist, Max Shapiro (the man who specialized in house calls and "feel good" dentistry), came to find out. Shapiro, described by reporters Charles Thompson and James Cole as "a slight man in his late fifties [with] thick eyeglasses and a crudely tinted hairpiece that . . . slipped from side to side as Shapiro's behavior became animated," had come to see Elvis about financing the construc-

JANUARY-JUNE 1977 👁 621

tion of an artificial heart he was hoping to develop. He was accompanied by his fiancée, and after Elvis heard them discuss their wedding plans and learned they had already gotten a license, citing his own love for Ginger as an incentive, he insisted that they get married on the spot. Larry Geller had just left for L.A., but Elvis flew him back to perform the ceremony, for which Elvis supplied the rings and Ginger served as maid of honor. After the wedding, he spoke to Larry about someday performing a similar ceremony for Ginger and him, and then he had Dr. Shapiro go back to work on his and Ginger's teeth. There was no end to the ways in which he sought to please her, but after they returned from California, he found himself no less frustrated by her continued need to distance herself from him, to go home each night to her mother and sisters (and some said to her boyfriend), sometimes sneaking out of the house only after he had finally fallen asleep.

I NASHVILLE HE APPEARED able to focus on nothing but his recent quarrel with Ginger, and Felton was scarcely surprised when Joe called the day after their arrival and told him they were heading back to Memphis without ever having left the hotel. There was some talk of Elvis coming back at the beginning of the following week if his health were to improve, but Felton knew it was not going to happen and simply had the musicians overdub two songs from the last Graceland session while making sure that everyone would get paid in full for a lost week of work. Longtime loyalists for the first time began to voice their doubts that Elvis would ever return to the recording studio, and Felton seemed to slump visibly under the weight of his own defeated expectations.

David Briggs may have been the only one not to feel disappointed at the cancellation of the session. In fact, he had reason to experience a secret sense of relief. He had been surprised initially at his invitation, now that he and Linda were practically living together, and Linda hadn't wanted him to come, knowing firsthand both Elvis' volatility and his carelessness with firearms. David couldn't bring himself to turn Elvis down, though; in a peculiar way he considered himself loyal in every respect except one, and he thought Elvis might be able to understand that. Nor was he going to give in to fear, his own or anyone else's. So he had come to the session with no idea of what, or how much, Elvis knew — but he couldn't say that he was altogether unhappy to postpone finding out.

Just how widespread was the general sense of malaise can be gathered from a story published in the *Nashville Banner* the following week, which revealed with surprising accuracy, and in embarrassing detail, not only intimate aspects of Elvis' emotional state but the deep fissures that existed within the Presley camp.

"They say Presley is paranoid and that he's afraid to record," wrote Bill Hance in his column, "Wax Fax."

Presley, claiming he was sick with a cold, left here Saturday night, promising to return Monday to fulfill his recording contract with RCA, and to live up to his own slogan, "Taking Care of Business." When he failed to show in the studio, RCA officials and his personal manager, Colonel Tom Parker, reportedly "got hot." Parker, the tough businessman who has guided Presley's career for nearly twenty years, was quoted as telling Presley, "Get off your tail in that studio, fulfill your contract or there will be no more tours." Many Presley aides contend the singer's new girlfriend, Ginger Alden, 20, is "absolutely running him ragged." "One time," a friend said, "Ginger decided to leave Elvis . . . and the only way he could get her back inside the house was to fire a gun up in the air." [Hance then spoke with hotel workers who declared]: "They're driving us all nuts. . . . All this security mumbo-jumbo. They run in doors, out of doors, up and down hallways and elevators trying to hide from people. Who are they hiding from? ... No fans have come out here. Only you newsmen."

Four days after his return home, on January 26, he formally proposed to Ginger. It was not just his love for her, it was the conjunction of the stars, he explained; the twenty-sixth was an important date since two plus six added up to eight, and eight was his number. He had already called his jeweler, Lowell Hays, in the early hours of the morning and told him that he wanted a stone as big as his TCB diamond for Ginger's engagement ring, and because of the date he had to have it that night. When Hays informed him there was no way to locate another diamond like that in Memphis on such short notice, Elvis offered to fly the jeweler to New York, but Lowell convinced him that even in New York it would be impossible to find that kind of stone and get it mounted within the required time period. Finally, Hays came up with the idea of taking the eleven-and-one-half-carat center diamond from the TCB ring itself and putting it in Ginger's ring, replacing Elvis' diamond as soon as he was able to come up with a suitable substitute. It took all day to make the ring, but he had it back just in time for Elvis to propose to Ginger that night, kneeling down on one knee as she sat in the

special reading chair in his bathroom. Then Ginger called her mother, and together they accepted congratulations from Charlie, Vernon, and the Stanley boys.

Five nights later they flew to Las Vegas with Billy and Jo Smith, then continued on to L.A. to celebrate Lisa's ninth birthday and twenty-four hours later were home again. Sometimes Ginger wondered just what she had gotten herself into. No one had told her anything about what to expect, she had had no preparation for any of this, and Elvis just seemed to need her so desperately all of the time. Part of her came to feel that "maybe that's why I was put on earth. If I could make Elvis happy, I would have served my purpose." Another part questioned why it always had to be her: Didn't he have anyone else that he could call on once in a while? He had all these friends around — what was wrong with them? She tried to tell him that, but he just blew up at her. She didn't understand, he said. The only reason the others were around was because of the money.

 $E_{\rm go}$ LVIS REFUSED TO GO out on the next tour unless Ginger agreed to go with him. It was just a short ten-day hop, February 12 to February 21, kicking off in Florida and remaining in the southeast territory that he had crisscrossed again and again when he and Colonel were just starting out. Orlando, Florida; Montgomery, Alabama; Savannah, Georgia — little seemed to have changed save for the mode of transportation, the size of the operation, and the remuneration that he took from the show. His life, it must have occurred to him, had turned into an endless string of onenighters, from which it was beginning to seem increasingly unlikely he would ever be able to escape.

It did make a difference having Ginger with him, though. For one thing, it meant she couldn't go running home at night, and often after the show they read from his books until the soothing effect of the words and the delayed impact of the pills allowed him to go to sleep. To Kathy Westmoreland he spoke convincingly of his happiness, and Kathy had no doubt that it was real, although she could discern clouds on the horizon in the person of Ginger's mother and sisters. "He would say, 'She loves her family. Well, I'll bring the whole damn family.'"

That was what he did when he played Johnson City, Tennessee, once again on February 19, on the third-to-last night of the tour. The following night, in Charlotte, North Carolina, he called Terry Alden up onstage and had her perform her talent piece from the beauty contests, a short Russian toccata on the piano. "I'll get you for this," Terry mouthed at Elvis to his amusement, and his performance for the most part seemed to reflect his good mood. That didn't stop him from showing his frustration later in the evening, however, when he was unable to reach the high notes of his latest release, "Moody Blue," and he tore up the lyric sheet in a combination of bravado and helpless rage.

Somewhat to the consternation of his fellow musicians, David Briggs was still with the band. He had suggested Bobby Ogdin to Felton as a replacement, but Elvis let it be known that he didn't want any damned substitutes, and David decided maybe he should just go on taking Elvis' wishes at face value. Elvis continued to point proudly to David's playing, and he continued to look to David almost every night when he undertook to perform Roy Hamilton's "Unchained Melody" alone at the piano, just as he had with his earlier Hamilton-inspired version of "You'll Never Walk Alone." Like the Rodgers and Hammerstein number, "Unchained Melody" was the kind of highly dramatic, vocally challenging, almost operatic showpiece that served to inflame not just the audience but Elvis himself, no matter how tired or lethargic the rest of the program might be. To Briggs' amusement, he became part of Elvis' solo outing, "because there was one point in the bridge he could never get, and whenever he reached that point, he would say, 'Take it, David,' and I would play my note. It became a kind of comedy part of the act."

Less comedic was the moment when he realized that Elvis had become aware of Linda's and his relationship. "He had just come out onstage, and the audience was all going wild, and he turned around right in front of me and looked at me — and then he started pulling out every cord from every plug on my keyboard. Then he walked back in front of the stage to start the show. He never actually said anything, and I could never be sure exactly what he meant, but that was when I decided it was time to leave Dodge."

I F ELVIS HAD EXPECTED THINGS to change once the tour was over, he was sadly disappointed. Ginger continued to have her own friends, she had her family, and no matter how he raged or lamented to Billy and Jo Smith about her lack of interest, he couldn't seem to keep her by his side. As a special treat he decided to show her Hawaii, and he planned a two-week vacation at the beginning of March, which started out as a getaway for the two of them but soon grew into a party of thirty, with Ginger's family among the first to be included. For much of the time before the trip he

stayed in his room, talking mostly with Charlie and Billy and Dr. Nick. He talked quite a bit with Maggie Smith, too, the college student he had hired as a maid after buying a Pontiac right out from under her during one of his 1974 car-buying sprees. She was pregnant now, something she had confessed to Elvis only with the greatest reluctance because she knew how protective of her he was and how important he felt it was for her to complete her education. "He asked me, was I in love? I told him no. I said, 'Really, it was a big mistake.' So he said, 'Well, do you think you'll be happy like this?' And I said, 'Well, I don't know.' And it got to the point where everything was so quiet and sad up there that we were both crying. He was very patient with me afterwards, talking to me concerning the Bible - he loved to read me things and explain the way he felt they were. He believed in reincarnation. He gave me a copy of The Prophet and would pick things out and ask what did I think about that." Other black people assumed that he was prejudiced, Maggie knew, but "they didn't know. He really treated me more like a father than an employer."

They were scheduled to fly out on the evening of March 3, but first, Elvis decided, he needed to set his affairs in order. Dr. Nick, who would be accompanying the group to Hawaii, had gotten even deeper into debt on his new house, so Elvis signed over another \$55,000, on top of the \$200,000 he had already loaned him, though this time at Vernon's insistence it was at 7 percent interest and with a specified twenty-five-year payback. He had long since gotten over any feelings of ill will about the racquetball courts business, and besides, if he wanted to be practical about it, Dr. Nick was at this point his only regular physician. He made out his will, too — his father had been trying to get him to do it for years, and with Vernon and his Memphis attorney, Beecher Smith, present, and Ginger, Charlie, and Smith's wife, Ann, for witnesses, he affixed his signature in the early hours of the morning. It was a simple document that reposed total faith in Vernon as executor and trustee. "The health, education, comfortable maintenance and welfare" of Lisa Marie, Vernon, and Grandma were all specifically mandated in the will, and Vernon was authorized to expend funds for "such other relatives of mine living at the time of my death who in the absolute discretion of my Trustee are in need of emergency assistance for any of the above mentioned purposes," so long as the ability of the trust to meet the needs of the named beneficiaries was not affected. Upon Vernon's death all such additional assistance would cease, and upon his grandmother's, all funds would reside in a trust for his daughter and any other lawful issue he might have until she, or they, reached the age of twenty-five.

There were no other individual bequests and no specific mention made of any other person, despite what he knew to be the long-held belief of many of his relatives, and many of the guys as well, that they would be financially taken care of. The will, of course, did not address the reasons for these exclusions, but for all the generosity he had shown to the broadest circle of family and friends over the years, in the end it seems scarcely surprising that he should have returned to the same small, tight-knit, and set-apart group that had first nurtured him, when he and his mother and father occupied a lonely strip of safety in a hostile world.

With his business completed, he could take off for Hawaii, arriving on the morning of March 4. The whole party spent two days at the Hilton Rainbow Tower, then Elvis and the Alden sisters and a couple of the guys moved into a beach house at Kailua on the east side of the island, while the rest of the group continued to stay at the hotel. "Everyone looks older than they are," Larry Geller noted mordantly in his diary, but they followed the same protocol that they always had, as Ed Parker arranged for a visit to the Polynesian Cultural Center, Elvis made plans to show Ginger the U.S.S. Arizona memorial which were only canceled at the last moment, and they all played touch football on the beach. Everyone remarked on how relaxed Elvis seemed; at times he appeared to enjoy Terry Alden's company almost as much as her sister's, and Ginger even got him to play Ping-Pong with her, despite his protestations that he felt foolish swinging at a little ball that he could never keep on the table.

It was, Larry wrote, almost like old times, with everyone "relaxing and joking with one another, and by the expressions on everyone's face [looking] as though we died and went to heaven." But Larry was just as aware of the shortcomings of heaven as anyone else, with touch football games turning into worrisome displays of the sad physical state into which Elvis had fallen and other players casting about for excuses to get him to quit. "Somebody'd throw him the ball," said Kalani Simerson, a one-time entertainer who now operated a limousine service and had known Elvis since the early sixties, "and he'd catch it and start running, and he couldn't stop. He just wasn't able to control his own body. One time he ran right into a Cyclone fence."

He was no better directed even in less physically strenuous pursuits. As soon as they arrived, Charlie and Larry Geller contacted Bernard Benson, an eccentric British millionaire they had met in Las Vegas in December, who had urged them to come see him the next time they were in Hawaii. They returned from Benson's home enormously exhilarated. Elvis had to meet the Tibetan holy man that Benson had staying with him, they told Elvis, certain that this would be the thing to get him out of his fugue state. But Elvis declined with a strangely world-weary passivity. He didn't need to meet any spiritual masters right now, he said — he felt like he was on the right path.

Ten days into their stay he got sand in his eye, and the whole group packed up and went home because Dr. Nick was concerned that Elvis' cornea might be scratched and thought it would be best to recuperate at Graceland. No one expressed any great feelings of regret. For Joe it had been a painful exercise in nostalgia, and Larry saw little improvement in either Elvis' outlook or health. It was hard to gauge exactly how Elvis felt about it. With characteristic generosity he picked out a gift for each member of the party to serve as a remembrance of the good times that they had had and promised Ginger that next time they would have the experience for themselves. The whole trip had cost him something in the neighborhood of \$100,000, he confided to Larry, but what profiteth it to gain the world if you couldn't share your good fortune with your friends?

S carcely one week later Billy Smith was in real doubt that Elvis would make it to the plane scheduled to leave for Phoenix for the start of the second tour of the year. Billy had agreed to go out on the road again, after years of steadfast refusal, only because of his concern about his cousin's health. "We were supposed to leave late that night. Tish [Dr. Nick's nurse] said, 'If he was my son, I'd have him in the hospital.' Vernon said, 'Well, do what you can. . . .' So Dr. Nick put all these IVs in him . . . [and] all the way to the airport Elvis sat slumped with his hat over his eyes. He didn't say anything. Then when he got on the plane, he was just groggy, slurring his words. . . . [The following night], right before he stepped out on the stage, he said, 'You didn't think I'd make it, did you?' [But] he put on a hell of a show!"

Probably the principal reason for the mood he was in was that Ginger had balked at the very last minute about going out with him, and without her it was obvious he was not himself. The first few shows were received well nonetheless, and critics were reduced to scratching their heads in the manner of the Tempe, Arizona, reviewer who declared, "His music ran from the parody to the almost perfect. . . . but the faithful were happy. They came, they saw, and Elvis conquered." He wore the only two suits he could still fit into, and in Norman, Oklahoma, he might have choked to death if Larry and David Stanley hadn't realized that he had fallen asleep in the middle of a meal. "Is there much more time left?" Larry wrote in his diary, after putting Elvis to bed without his even being aware of what had happened. Meanwhile, his security chiefs, Sam Thompson and Dick Grob, drew up contingency plans to smuggle Elvis' body back to Graceland should it become necessary to try to cover up a drug overdose death on the road.

Often late at night Elvis would seek out Billy Smith just to talk about what was on his mind. One night Dick Grob discovered him wandering around in the hallway and led him to Billy and Jo's room. "Man," he told his cousin, "something unbelievable just happened. I dreamed I saw the face of God."

It had manifested itself in the form of "a white light so bright" he almost couldn't look at it, and he was obviously still shaken by the experience. The next thing Billy knew, he had climbed into bed with them, and "he talked for an hour and a half, and then in the next minute he was sound asleep. I looked at Jo, and she looked at me, and I said, 'I guess I'd better take him back down to the room.'"

In Alexandria, Louisiana, he put on virtually identical shows on successive nights that pretty much reflected the mood of the tour. "[He] was onstage less than an hour," the *Alexandria Daily Town Talk* reported, "he was impossible to understand . . . he never said one word to the audience or mentioned how nice or not nice it was to be in Alexandria or said. . . . 'Hope you enjoy the show.' He [simply] came onstage, did a few numbers, and then dashed off." Just as on other dates, he forgot lyrics, complained about the sound, arbitrarily stopped and started songs, and sometimes looked and sounded weary almost past the point of enduring. On the second night he changed the lyrics of "Can't Help Falling in Love," his perennial closer, to a cryptic declaration: "Wise men know/When it's time to go. . . ."

The following night, in Baton Rouge, he was unable to go on. The band was onstage, the governor and numerous members of the legislature, as well as the Baton Rouge chief of police and various other local dignitaries, were all in attendance, when Tom Hulett got a call that he'd better come back to the hotel right away, there was something wrong. He encountered a crowd of worried onlookers when he walked into the bedroom. "Their faces were all white, and they didn't know what to do — I mean, this had never happened before." Hulett, who had been through it all with acts like Jimi Hendrix, didn't hesitate for a minute. "I said, 'Fuck it, I'll cancel, we'll play it the next time around.' God, Elvis looked at me like — I mean, he got well. He said, 'What about the Colonel?' I said, 'I'll tell him you're sick.' And then I started putting out fires."

The first thing, Hulett emphasized, was to get Elvis out of town and into the hospital right away; they couldn't have everyone thinking this was "just a bunch of drug addicts fucking around in the hotel" — and they didn't want a lot of Baton Rouge doctors talking to the press. Dr. Nick made the call to Baptist Memorial Hospital administrator Maurice Elliott, even though he doubted there was anything seriously wrong with his patient, at least not in a physical sense. To Nick and Joe Esposito and the rest of the guys, Elvis was still just trying to prove something to Ginger. But it all came down to the same thing in the end: he was clearly not capable of continuing.

Back at the auditorium "howls of protest and shouts of 'rip-off'" filled the air when the announcement was made, but gradually, with the help of the police, the room emptied out, and most of the fans were assuaged with promises of a makeup show. Hulett called the Colonel in Mobile, Alabama, where he was busy advancing the next date. He accepted the news with grim resignation, asking only, "How bad is he?" He then set about canceling the rest of the tour. Everyone else just concentrated on shutting down the show and trying to get Elvis to leave town, which proved easier said than done now that the decision had been made. It was well past midnight when they finally left, and then Elvis insisted on going to Graceland upon their Memphis arrival, finally checking into the hospital around 6:45 in the morning.

Nursing supervisor Marion Cocke, Elvis' longtime friend, who had received a call from Graceland that he would be arriving soon, showed up just after his admission to find him completely worn out. She remained with him until almost noon, conversing quietly until at last "he said, 'Well, I'm really bushed, and I think I'm going to go on to sleep.' He said, 'Will you stay here for the night after you get off?,' and I said, yes, I had come prepared to stay, and I would be in my room [the one she always stayed in, next to his] right outside the door. And gee, I checked on him while I was making rounds, and when I got off I went to bed, and he slept the clock around, more than around, because he didn't wake up until around six o'clock P.M. the next day."

The Colonel meanwhile was doing damage control, calling up building managers to apologize and explain, then rebooking the four canceled shows for the tour after next, which was scheduled to begin at the end of May.

630 \infty ELVIS, WHAT HAPPENED?

Business would go on as usual, he hastened to assure RCA's Mel Ilberman, who was bound to be concerned not just in his capacity as record company executive but in his role as head of RCA Record Tours, still co-promoter of the show. They were fortunate that he had been able to reschedule all of the dates, he wrote Ilberman on April 4. Not only that, but due to his own resourceful management and careful bookkeeping, he had even been able to salvage a small profit from the tour. This was their first cancellation in almost seven years of road dates, he reminded his longtime associate in a tone that was never anything less than self-assured, but the Colonel gave himself a new sobriquet at the end, signing the letter "The Poor Magician."

Elvis stayed in the hospital only four days, as Nick saw little purpose in trying to impose a longer sentence. Elvis had Ginger bring in her engagement ring to show Mrs. Cocke, and Priscilla flew in from California with Lisa Marie, taking time to confer with Vernon on a new payout schedule for the divorce. Billy picked up Elvis in his beat-up little Corvair at four in the morning on April 5, and Elvis complained good-naturedly all the way home about the fact that Billy hadn't bothered to bring the Lincoln.

There were just two weeks before they were scheduled to go out again, and for a while Elvis did little but ride around on his golf carts and threewheelers, sometimes driving out onto the highway late at night, a strange wind-blown figure in housecoat, pajamas, and slippers.

He had another fight with Ginger, and this time he said he was breaking up with her for good. George introduced him to Alicia Kerwin, a twentyyear-old bank teller, whom Jo Smith screened before she was admitted to his bedroom upstairs. Almost instantly he opened up his heart to her, describing his dissatisfaction with Ginger and her family, who, he said, were just after his money. For all of his eccentricities, he impressed her as sincere and vulnerable and very much a gentleman, and when he asked her to accompany him to Las Vegas a few days later with the Smiths, she felt no hesitation about accepting. He seemed different on this trip than he had before; his attention was unfocused, his speech slurred, his behavior sluggish, and she was as surprised by his lack of physical attention to her as she was by all the medications on his bedside table and the constant attendance of Dr. Elias Ghanem in his hotel suite. Unbeknownst to Alicia, the physician's presence was scarcely accidental. According to Billy Smith, the real reason for the trip was "to get more prescriptions from Ghanem." Elvis had had another blowup with Dr. Nick, and he was evidently as determined to assert his independence in this area as in the romantic sector of his life.

From Vegas they continued on to Palm Springs, where Elvis bought Alicia a new car and had another bad breathing episode in the middle of the night. Alicia became so alarmed that she woke up Billy and Jo, and after contacting a Palm Springs physician, Billy called up Dr. Ghanem, too, to try to discover what could have caused this strange combination of respiratory distress and complete disorientation. After hearing Billy's description, Ghanem reassured him that Elvis had probably just taken too many Placidyls, but he flew to Palm Springs right away to make sure his patient was all right.

The following day Elvis got a phone call from Vernon that left him chastened and upset. As soon as he got off the phone, he called Colonel and after a brief conversation with him seemed even more upset. Alicia asked what was the matter, and Elvis explained that they were both angry at him because he hadn't told them where he was going and they had been looking for him for the last two days. He shook his head as if his life were not his own. Then his mood shifted; it was time to go home anyway, he said — he had a tour coming up. He would make arrangements to have her car shipped back to Memphis, he assured her, and she was left to look back on a five-day "whirlwind courtship" as puzzling for its lack of physical consummation as for any of the peculiar events that had actually occurred. Alicia returned to work, and Elvis promised he would call when he got back to town, though at this point she wasn't really sure how she felt about continuing the relationship.

Ginger went out with him on the tour, which started in Greensboro, North Carolina, on April 21. He was determined to keep her with him for the entire two-week duration this time, so when she said she was getting homesick, he made arrangements to fly her mother and sister Rosemary into Duluth on April 29. The reviews of his performance ranged from concern for his health to perplexity over how little he seemed to care, with one columnist in Detroit simply declaring that "he stunk the joint out." Some of the fans, too, were becoming increasingly voluble about their disappointment, but it all seemed to go right past Elvis, whose world was now confined almost entirely to his room and his books. He recruited Larry to help Ginger with her spiritual education and asked him to explain to her the special nature of his purpose on earth. Ginger meanwhile was occupied with more mundane matters, like redecorating the bathroom at Graceland in turquoise and white. To Larry he confessed some of his deeper concerns. He was worried about his health. He was worried about his appearance. He was worried about his hair, which was thinning on top. He spoke more and more about the book that Red and Sonny had written. How would it affect Lisa? What would his father and grandmother think?

They were in Duluth when the news broke that Colonel was planning to sell his contract. A headline story in the Nashville Banner cited authoritative sources "in Nashville, Memphis and Los Angeles" as confirming "Parker's decision to sell 'the boy,' citing health and financial problems as the primary reason." The Colonel had lost an enormous amount of money "at the Las Vegas Hilton Hotel gambling tables," the story went on. "'The Colonel isn't necessarily broke,' a source said. 'He just needs some money, like about a cool million he lost in December alone.'" The way in which he had dealt with similar losses in the past, the same anonymous source asserted (though there was in fact no evidence to support this charge), was to "trade out" Elvis' services in exchange for his debts. Now that Elvis was no longer appearing at the Hilton (again, an erroneous conclusion, since Elvis was scheduled to open the new Hilton Pavilion, as soon as construction of this seven-thousand-seat convention hall was completed in October), the Colonel was reduced to selling his contract. "Parker and Presley have reportedly 'not spoken' in two years," the story concluded with more truth than factual accuracy, "although Parker oversees all of 'the king's' concert engagements."

From St. Paul, where he was advancing the show, the Colonel's reaction was instantaneous. The Banner's story was "a complete fabrication," the Colonel declared to the rival Nashville Tennessean. "I'm here, I'm working with Elvis, I'm in good health, and I don't have any debts - at least none that I can't pay." Joe weighed in from Duluth in support of Colonel, labeling the story "a bunch of lies. . . . How do you sell a handshake to begin with? That's just stupid. Elvis and the Colonel have a written agreement, and they have no plans to break it." He went on to describe a cordial relationship between the two longtime associates and pointed out some other factual inaccuracies, but it was apparent to anyone who knew anything about the recent history of their tangled relationship that the story was, in essence, true. Too many people had heard Colonel complaining that Elvis was more trouble than he was worth, that he was intractable and could no longer be effectively managed. And too many people were aware, as Elvis' Los Angeles lawyer Ed Hookstratten was inclined to put it, that Colonel was "servicing a problem of his own." Elvis had no doubt about the story in any case: he knew in his bones it was true. And while the consortium of "West Coast businessmen" who were supposed to be buying his contract

never surfaced, driven off presumably by the glare of publicity, Elvis had never felt more betrayed or more alone.

Three days later, while they were in Chicago, Mike McMahon filed suit against him in Memphis circuit court for reneging on his contractual obligations to Presley Center Courts, giving him one more lawsuit to worry about and one additional piece of fodder for the tabloids to ridicule him with. The previous month alone The Star, in what seemed like a thinly veiled taste of things to come, had run a front-page story by Steve Dunleavy, Red and Sonny's collaborator, that was headlined: "Elvis, 42, Fears He's Losing His Sex Appeal," complete with a touched-up, haunted, and bizarre-looking photograph that certainly made the fear look justified. The story itself covered everything from the abortive Nashville session to Elvis' problems with Ginger to diet, depression, and the kind of sexual infantilism "not rare at all in people that age," a behavioral psychologist pointed out, that drove Elvis "to strive to maintain his relationship with younger girls." Then on April 26, the National Enquirer repeated many of the same accusations under the headline, "Elvis' Bizarre Behavior and Secret Face Lift," with a picture even more grotesque than the Star's. Here Mike McMahon was given a forum to deride his erstwhile partner, and Priscilla was quoted as saying that "the presence of Elvis' mother is still very much felt," to bolster the Enquirer's case that Elvis believed Graceland to be haunted. "So very sad," the article concluded, quoting a "friend."

On May 6, three days after the conclusion of the tour, he shot out a bedroom window and had to be sedated. To Jo Smith his behavior was becoming more and more that of someone incapable of making his own decisions, but at the same time she felt a wave of protectiveness for him, a kind of closeness she had never felt in all the years that she had regarded Elvis' hold over Billy as a threat to her marriage. "We had to take care of him and cater to him like a small child. I did things I never thought I'd do. Like when it came time for him to go to sleep, he liked to be put to bed, and he liked to be told good night — the whole send-off. . . . I had to talk baby talk to him, too.

One time I'd started into the kitchen, and Elvis called to me and said, "Come in here and sit with us."... So I went to his room, and he was in bed with a girl, sitting up. We talked for a while, and I got ready to go. He said to me, "Tell her all about the lamps." So I started telling her about these lamps that he had bought to go in my trailer. And he was almost asleep. He nodded off. So I started to get up, and he revived and said, "And tell her about the —" and named something else. Before I got out of there, he said, "Tell her that I have to get this medication because I'm getting ready for a tour." He said, "I've got to get my rest." He had this scratch on his hand, and he held it up and said, "This has to heal, and I need all my bodily fluids for it to get better." I said, "That's exactly right." Because I thought I could leave. But every time he'd almost go to sleep, and I'd get up and start to go out, he'd grab me and say, "Wait, tell her about the —" So I told about, and told about, and told about. Finally, he fell asleep.

THE NEXT TOUR STARTED in Knoxville on May 20, sixteen days after ing up appearances. The idea was simply to get Elvis out onstage and keep him upright for the hour he was scheduled to perform. "He was pale, swollen - he had no stamina," observed a Knoxville physician, who was shocked by his backstage glimpse of a man who appeared barely able to function. In Louisville, according to Larry Geller's account, Dr. Nick was forced to revive him once again, and in Landover, Maryland, Elvis left the stage for "nature's call," tossed two microphones to the floor, and according to the Washington Star reviewer, "just refused to turn it on," prompting the question for the reviewer as to whether or not he still could. Ginger left the tour in Binghamton, New York, after Elvis laid down an ultimatum that she would have to choose between him and her family once and for all. Elvis could barely contain himself, ranting and raving at the top of his lungs so that everyone else on the hotel floor could hear him from their rooms. Finally he got Larry to call Kathy because he couldn't bear to be alone. She had just gotten in from a date but agreed without hesitation to spend the night with him. He talked to her about Ginger - he was no longer sure they belonged together, he told her, there were just too many differences between them. She "listened and held his hand . . . until he finally fell sleep."

Over the next few nights he brought up things they had talked about often in the past, but now they took on a different tinge. He spoke to her about his mother, he talked about his pain, he spoke of his place in history. "How will they remember me?" he asked over and over again. "They're not going to remember me. I've never done anything lasting. I've never done a classic film." But then his mood would change. His mission in life, he said, was "to make people happy with music. And I'll never stop until the day I die."

In Baltimore, on May 29, he had to leave the stage again in the middle of the show, calling on Kathy and Sherrill Nielsen to carry on in the face of the crowd's growing restlessness until he came back thirty minutes later. He was "weak," "tired," "paunchy," and "pained," according to the *Variety* reporter who was present, and a building spokesman was left to attribute his "murmuring, swearing, and unscheduled hiatus to the reported intestinal problem that had kayoed Presley from an earlier . . . tour." When he returned to the stage, he "came on like gangbusters," according to the same report, "repeatedly thank[ing] the audience for hanging with him" and explaining that he had twisted his ankle and was forced to answer a call of nature — "and you don't fool around with nature." Later he declared, "There's nothing wrong with my health," but "at the finale there was no ovation, and patrons exited shaking their heads and speculating on what was wrong with him."

Somehow they got through the rest of the tour. They were in Macon on June 1 when the CBS concert special that the Colonel had put together was announced. It was scheduled to be shot at the beginning of the next tour less than three weeks away and called for a \$750,000 fee, to be split 50–50 between Elvis and the Colonel after \$10,000 had been assigned to All Star Shows for promotional expenses, with ownership to be shared by the two principals after a single repeat showing. This was the first time the Colonel had actually applied the full-partnership agreement that Elvis had signed more than a year before, but he had kept careful records, and with this tour for the first time he stipulated that the two-thirds–one-third division that continued to be observed represented a *temporary settlement only* and that all accounts would be settled up, and all monies owed him under the terms of that January 1976 agreement would be repaid in full by the end of the year.

The very fact that Colonel Parker could even contemplate a television special at this point took everyone by surprise. Even William Morris lawyer Roger Davis, who was in charge of contract negotiations, was taken aback, but Colonel simply shrugged and offered three variations of the same explanation to anyone raising so much as an eyebrow. Elvis needed a challenge and would not fail to rise to this one, he insisted on the one hand; it was Elvis, not he, who wanted the show, he might say on another occasion; more convincingly, he conceded that he had asked for so much money he never thought the network would go for it, and when they did, what choice did he have but to bring the deal to his client? His voice never lowered, his gaze never wavered, but for the first time that anyone could remember, he seemed to lack the conviction that would indicate he was either persuaded or amused by his own carny spiel. And the difference between tying a television shoot to shows in Omaha, Nebraska, and Rapid City, Iowa, and setting up a global event like *Aloha from Hawaii* was lost on no one, least of all the Colonel. But no one said anything, and Colonel, as always, pursued his own agenda without reference to outsiders' opinions — he was, no less than Elvis, utterly, and irremediably, alone.

By the time they got back to Memphis, Red and Sonny's book, now titled *Elvis: What Happened?*, had started to appear in serialized form in England and Australia, and Elvis fans around the world were exchanging shocked telephone calls. "The first two chapters are about him giving drugs to a girl and how he put a 'contract' on Mike Stone," wrote Donna Lewis in her diary after a friend read her excerpts on the phone. "*What horrible lies!*" Elvis was almost as anguished, and yet he could still lapse from time to time into a state of denial that allowed him to believe the book itself might never come out. That may have been one of the reasons he refused to respond to feelers from Frank Sinatra's camp about doing something serious to stop publication, but Larry thought it had more to do with guilt: part of him seemed to accept exposure as the punishment he deserved. On the other hand, sometimes he said to the guys that he felt like Jesus betrayed by his disciples.

On June 4 he rewarded Larry and Kathy with their own Lincoln Mark Vs, burgundy and white. He was just showing them some of the features of their new cars when Charlie, who had been drinking heavily once again, started mouthing off about how the wrong people had been rewarded and he was going to get a Rolls-Royce of his own. Elvis stopped in mid speech, and then, as Larry and everyone else watched, "turned away as if he were going to ignore [the remark and] swung around and caught [Charlie] on the bridge of his nose with a backhand. Then, realizing what he'd done, Elvis ran up the steps and into Graceland," while Charlie stood there, "stunned, [with] blood pouring down his face." Afterward, Elvis was clearly mortified, but he couldn't bring himself to apologize, sending Larry to make sure Charlie was all right. "He never hit me before," Charlie moaned as he lay on the floor of his room. "Why did he hit me? I love him. I know he loves me." But the most Larry could get out of Elvis was a promise to take it up with Charlie the next day.

He tried to do something for George Klein, who had been indicted by a federal grand jury in February for fixing a radio ratings poll. Recalling the way he had practically just walked into President Nixon's office when no one else thought Nixon would even know who he was, he put in a call to President Jimmy Carter on June 13, sure that Carter, a fellow southerner whom he had met at a 1973 concert in Atlanta while Carter was still governor of Georgia, would intervene. When the President called back twentyfour hours later, he couldn't seem to make him understand what he was driving at, though. They spoke for about ten minutes, with Carter getting the impression that Elvis was "stoned and didn't know what he was saying," other than that he was asking the President to pardon a friend who had not yet been tried. According to Carter biographer Douglas Brinkley, the President attempted "to ease Presley out of his paranoid delusions, calming his fears that he was being 'shadowed' by sinister forces and that his friend was being framed," but when Elvis called back at 8:45 the following morning, Carter didn't take the call.

They embarked on the fifth tour of the year just two days later. Ginger insisted on staying home to watch her sister Terry give up her crown as the reigning Miss Tennessee, but she rejoined him in Kansas City on the second night. Even with Ginger present, he seemed utterly exhausted. "In spite of what you may hear or you may read, we're here, and we're healthy, and we're doing what we enjoy doing," he announced to the crowd, but no one observing his pale swollen appearance, the awkward slow-motion manner in which he lurched about the stage, or his overall sense of confusion and self-doubt could have been taken in, no matter how much they might have wanted to believe his protestations. It was equally difficult for anyone on the show to believe they would be filming a television special the following day. More and more the feeling grew that they had set out on a doomed voyage, captainless, rudderless, with no hope of turning back.

The performance in Omaha the next night in front of the CBS cameras exceeded everyone's worst fears. One has only to listen to the complete, undoctored audio recording of the show to understand the panic that seems to have overtaken Elvis. His voice is almost unrecognizable, a small, childlike instrument in which he talks more than sings most of the songs, casts about uncertainly for the melody in others, and is virtually unable to articulate or project. He gives the impression of a man crying out for help when he knows help will not come. And even after more than twenty years it is almost unbearable to listen to or watch, the obliteration not just of beauty but of the memory of beauty, and in its place sheer, stark terror. "It was like he was saying, 'Okay, here I am, I'm dying, fuck it,'" said Tom Hulett, who up to the last minute was still hoping he might pull it off. "I've never seen a backstage area so sad."

Strangely enough, he rallied two nights later in Rapid City, Iowa, on the second night of filming. "I know I was terrible," he said to producers Gary Smith and Dwight Hemion, as if the first show had been an accident that had happened to someone else. He would do better this time, he assured them. And indeed he did. He looked healthier, seemed to have lost a little weight, and sounded better, too. All that Gary Smith was hoping for at this point was to try to capture some of the excitement of the crowd, some of the belief that the fans still placed in Elvis, and this he was able to do. But he got something else as well, something he had not bargained on and that would ultimately prove too raw for network broadcast.

It came at the end of the show when Elvis sat down at the piano and, with Charlie holding a hand mike, launched into "Unchained Melody," the Roy Hamilton number in which he so often seemed to invest every fiber of his being. Hunched over the piano, his face framed in a helmet of blueblack hair from which sweat sheets down over pale, swollen cheeks, Elvis looks like nothing so much as a creature out of a Hollywood monster film — and yet we are with him all the way as he struggles to achieve grace. It is a moment of what can only be described as grotesque transcendence, and when at the end he signals to Charlie, "I got it," and goes on to complete the song with no help from Charlie or Sherrill Nielsen or any of the other background singers who frequently sustained his notes now in the more difficult passages, the expression on his face, the little-boy sense of relief that he has actually pulled it off, is both entrancing and heartbreaking. And then it is back to the standard finale, the giving out of kisses and scarves and the ritual departure that make up the carefully constructed facade he has built to wall himself off from everything but the approbation of the crowd.

"Dwight and Gary were kind to him," was Joe Guercio's conclusion, "and still there was nothing really there." Just how desperate everyone was to believe otherwise, though, was made evident by a telephone conversation that took place between Myrna and Jerry Schilling right after the show. "Jerry said, 'How did it go?' And I said, 'It really went great.' He said, 'Well, how did Elvis look?' I said, 'He really looks good. He's lost a little weight.' And afterwards, when I watched it [when the show was broadcast in October], I just burst out crying. We were all wearing blinders."

There were five dates still left to play. Ronnie Tutt left after the Des Moines concert, citing a family crisis, and Larrie Londin was able to come in for the last two nights after Sweet Inspirations drummer Jerome "Stump" Monroe filled in for one show. In Madison, Wisconsin, Elvis was being driven from the airport to the hotel when he spotted two youths ganging up on an attendant at an all-night filling station. Over the protests of Ginger and his father, he leapt out of the limousine and struck a karate pose, offering to take the two bullies on. The fight broke up without any further blows being exchanged as the three participants stood in stunned recognition of who was intervening. "Presley did not leave until tempers were cool," reported one wire service account. "'He was willing to fight,' said Thomas McCarthy, one of several police officers providing Presley with security. 'That's the bad part.' Presley shook hands and posed for several pictures. He seemed amused by the whole episode as he got back into the limousine."

In Cincinnati he gave everyone another surprise when he grew irritated at the inadequacy of the hotel air-conditioning system and, deciding to take matters into his own hands, set out to find another hotel, heading down the street in his DEA jogging suit with his security detail behind. He was an hour late to the show that night because of what he termed "a technical hitch," but his performance was generally accounted to be a good one, and the show in Indianapolis the following night, the Colonel's sixtyeighth birthday, displayed an energy and a vitality that had been missing the entire tour. Perhaps it was because he had given up on hotels, flying home to Graceland after the Cincinnati show and returning with a planeful of friends and relatives. Rhythm guitarist John Wilkinson thought he seemed nervous before he went on, but he did an eighty-minute set, a third again as long as the average performance, and at the end, after strong versions of "Bridge Over Troubled Water" and "Hurt," he brought his father out onstage, introduced various friends and relatives, and with the conclusion of the final number put the mike down and walked back and forth shaking hands, as if he really didn't want to leave.

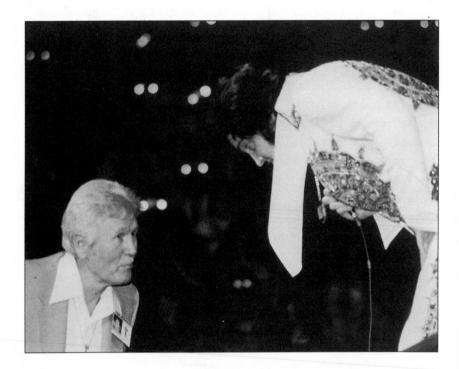

elvis and vernon, last tour. (courtesy of the estate of elvis presley)

"PRECIOUS LORD, TAKE MY HAND"

HE DAYS PASSED UNEVENTFULLY with little to distinguish one from another. It was a hot Memphis summer, but this scarcely impinged on Elvis, who rarely ventured outside his airconditioned room. There were to be no July 4 fireworks this year, and in fact the guys told him Ginger went out dancing to celebrate the holiday after saying she was leaving the house to go home. Elvis was still frustrated and angry at her inability to commit herself to the relationship. Didn't she understand he needed her? he said plaintively to Dr. Nick or his cousin Billy whenever he was feeling blue. But he grew more tolerant of what he came to see as a young girl's natural urges, and he continued to shower her with gifts — jewelry, clothing, a little Triumph sports car — he even offered to buy her family a house in Whitehaven so she could be closer to him, and when no suitable location could be found, promised to pay off the mortgage on their current home and put up the money for a swimming pool. There was no question that Mrs. Alden and the girls were all grateful — they seemed to look upon him as some kind of big brother who had struck it rich or something — but he wasn't sure it brought him any closer to Ginger, who still adamantly refused to move into Graceland fulltime. It seemed, he said to Charlie, like he was living out the words of the old song, this thing with Ginger was beginning to feel more and more like a "one-sided love affair."

He saw scarcely anyone except for Charlie, Billy and Jo Smith, and Dr. Nick. He tried to make Ginger jealous with other girls, but he had neither the energy nor the interest. Once in a while George Klein or some other friend from the old days might stop by, but he generally just watched them on the surveillance cameras and sent down word that he was tied up right now, maybe they could come back later. He wasn't close to any of the new guys. Sam Thompson and Dick Grob did a good, professional job running the security, Al Strada had been around for a while and he was a good little valet — but there was no one he could really talk to, and he had a growing

mistrust of his stepbrothers Ricky and David Stanley, who were responsible for much of his personal day-to-day business. He had done his best to educate them, to give them the advantage of his own experience, but Ricky was stoned most of the time, and David he suspected had more in common with Ginger than he did — they were always buzzing around together, and David was frequently covering up for her and taking her side. He didn't really know who to trust, so he just retreated to his room and his books and the medication that he needed to take his mind off the pain that never went away.

"All we did," Billy Smith recalled, "was sit up in his room and talk." Sometimes the talk consisted of calling up memories of some of the crazy things they used to do, sometimes it was little more than running through an old Monty Python routine, but mostly there was a grim obsessiveness that Billy had never experienced before, a paranoia about people, germs, past motivations, future events, that put Billy in mind on more than one occasion of Howard Hughes. Red and Sonny's book was the one subject Elvis always came back to. Sometimes he talked to Billy about having them killed. "One time I said, 'Look, they're not worth it. And anyway, you know it wouldn't change anything. It wouldn't even change how you feel about them. You know that deep down you really care about them, and that's what really gets you.' And he broke down and cried. It wasn't just a few tears. He was sobbing. And I cried with him because I couldn't stand to see him in that kind of pain. . . . But then he said, 'Goddamn them! . . . If they hurt my career, I *will* have them killed.'"

Nighttime was the worst; he dreaded sleep, even as he dreaded that sleep would never come. Over and over he dreamt the same dream, a variation, in one form or another, of the nightmare that had haunted him ever since success first arrived unbidden at his door. The core of the dream never changed: all his money was gone, the fans had abandoned him, the Colonel was gone, he was alone. What would the fans think when they read the book? he pressed Billy again and again. He started constructing elaborate defenses in case someone should yell something at him while he was onstage. "At first he thought he'd just say that a lot of things had been written about him, good and bad, and that he was not a perfect person." Then he decided maybe he should concede that it was true, he took certain medications, but that he needed them, and to prove it he would introduce Dr. Nick onstage. Finally, he settled on a strategy of limited confession, which would conclude with the statement that "After this tour I'm going to take time to get myself straightened out." But only, he made clear to Billy, if the issue came up in a manner that he just couldn't sidestep — "if the audience . . . started booing and throwing things."

Lisa arrived for a two-week visit on July 31. She was going to stay until just before he went out on tour again on August 16. Elvis told everyone he was looking forward to the tour; he said to Dr. Nick he thought it was going to be the best one yet, but at the same time he did nothing to get ready for it — he rarely exercised, he never put together any of the new material he continued to talk about introducing into the act, and he kept putting off the diet that he claimed he was going to start in on any day, if only to silence some of those damn critics who couldn't talk about anything but his weight. He alternated between bouts of depression and moments of defiance: What was a forty-two-year-old man supposed to look like anyway? He'd like to see some of those critics do as well at his age. But he never stopped looking in the mirror.

Ginger got her brother Mike's oldest child, Amber, who was a year older than Lisa, to come visit for much of Lisa's stay. She would take them shopping sometimes, and the two little girls seemed to play well together. Some mornings Lisa would wake up early and take her little golf cart with her name on the side and run it up and down the driveway. A lot of the time the girls would play with some of the kids from the trailers, or Ginger would take them for a swim. Elvis bought a pony for Lisa from his cousin Harold Loyd and decided he wanted Grandma to see her on it, so on the spur of the moment one day he just led the pony in the front door, where it promptly made a mess on the carpet.

At Ginger's urging he arranged a special treat for the girls, renting out Libertyland after hours on the evening of August 7 (Libertyland was the former Fairgrounds, now operating as a bicentennial theme park), as he once had night after night in the old days. He got cold feet at the last minute, telling Ginger he just didn't think he could make it, and when she insisted he had to, he had promised the girls, he told her he couldn't do anything about that now: he had already informed the park manager that their plans had changed, and the employees had probably all gone home. "Why, Elvis," she said, drawing herself up to her full height to protest this arbitrary and unfair decision, "I thought you told me you could do anything." And he was forced to have George Klein call the manager and set it up all over again.

They stayed until 6:30 in the morning, and the girls had a wonderful time, along with an accompanying party of twenty. Even Elvis seemed to

let himself go for once, riding the Pippin and the Little Dipper and the Dodgems and loading up the trunk of the Stutz with stuffed animals as the sun was coming up.

The first copies of Elvis: What Happened? had just started to arrive in the stores, and Elvis continued to feel alternating waves of rage and shame, but he tried to push it all to one side as he got ready for the tour, which was scheduled to start in Portland, Maine, and end in Memphis twelve days later. He spoke to his father with anticipation about going out again after almost two months off, and Vernon, pale and haggard from all the health problems he had endured over the last two years, his creased face set off now by a white wispy mustache, said he thought he just might join him this time, which perked Elvis up quite a bit. He started on the liquid protein diet prescribed by Dr. Nick a few days before they were scheduled to leave, and he began an intermittent exercise program, too, playing racquetball with Billy or riding his stationary bike for a few minutes each day. Billy and Jo thought they could detect a slight pickup in his mood and took some encouragement from it. On August 14, the nineteenth anniversary of his mother's death, he had flowers delivered to her grave, just as he had at least once a week since the day she died. She was never far from his thoughts, but he remained in good enough spirits to go for a motorcycle ride and, when a new jumpsuit that he had ordered didn't fit, he remarked to his cousin, "Billy, I'm just too damned fat."

He awoke at around four o'clock on the afternoon of August 15 and sent for Billy around seven. He thought maybe he'd like to see the new film about General MacArthur starring Gregory Peck — it wasn't supposed to be as good as *Patton*, but then, he didn't know many movies that were — so he gave Ricky the job of trying to set up a screening and was disappointed when the theater couldn't come up with an available print. He and Billy watched TV for a while; then he had Billy call Ginger to get her to come over for his 10:30 P.M. dentist's appointment with Dr. Hofman. He still wasn't sure if Ginger was going to be flying out with him the following night, and he was upset about that — but mostly, Billy thought, he was on edge just like he got before any tour. Which on balance was a good sign. He was even talking about going out to Vail again sometime soon so he could show Ginger the beauty of the country.

Billy helped him on with his black DEA sweat suit, and he pulled on a pair of black patent leather boots which he was unable to zip up because his ankles were so swollen. Dr. Nick stopped by for a few minutes to check on how he was doing, and once Ginger arrived, he stuck a pair of .45s into the waistband of his sweatpants and headed down the back stairs with Ginger and Charlie and his cousin. Joe Esposito, just in from California, was sitting in the kitchen with some of the guys, but Billy told him that Elvis was in a hurry and didn't really need anything right now, he'd catch up with him later.

Dr. Hofman cleaned Elvis' teeth and filled a couple of small cavities, then at Elvis' instigation cleaned Ginger's teeth, too, and gave her mouth a thorough examination. Elvis invited the dentist to come out to the house with his wife one of these days to see his Ferrari, and Dr. Hofman wondered if maybe he could hitch a ride out to California with Elvis on the *Lisa Marie* sometime so he could pay a quick visit to his daughter. They both had daughters out in California, Elvis said smilingly — why didn't they surprise them by flying out for lunch one day at the conclusion of this tour? Elvis was in good spirits when he left; neither of the teeth that Dr. Hofman had worked on was bothering him, he said — but he made sure to get some codeine tablets just in case one of them kicked up.

It was almost 12:30 A.M. by the time they got back to the house, and Elvis went upstairs without seeing anyone. He called down to Joe about some last-minute tour details and conferred with Sam Thompson, too, about taking Lisa back to California on a late-afternoon commercial flight. Then Sam went home to catch a little sleep, and Joe returned to his room at Howard Johnson's, where Larry Geller, too, was staying in anticipation of their departure sometime later that day. Larry had told Elvis he would have some new books for him on the tour, and he was not surprised to be awakened by a call from Al Strada requesting that he bring the books over to the house so Elvis could take a look at them right away. Larry took care to place Frank O. Adams' *Scientific Search for the Face of Jesus*, an inquiry into the mystery of the Shroud of Turin, at the top of the pile. It was a subject he and Elvis had spoken of often, and he was sure Elvis would get a great deal out of the book.

Elvis and Ginger meanwhile were having much the same argument they had at the start of any tour, with the same results. Elvis wanted her to fly out with him that night, and she said he knew she couldn't because she was having cramps, but she would join him before he even knew it. He was just being silly, she said, he'd probably just get sick of her if she stayed with him the entire time. Gradually he calmed down and they even started talking about marriage once again; he thought Christmas or his birthday might be the right date — maybe he would even announce it at the Memphis concert ending the tour.

Around 2:15 Elvis called Dr. Nick to let him know that one of the teeth Dr. Hofman had filled was bothering him and he needed some Dilaudid, so Nick prescribed six tablets and Elvis had Ricky Stanley pick up the prescription at Baptist Memorial's all-night pharmacy. Elvis called Billy a couple of hours later to see if he and Jo might like to play a little racquetball. Even though they had been asleep, Billy said sure, and he and Jo threw on some clothes and walked over to the house. It had been raining off and on all evening, and it started up again just as the four of them all walked out to the racquetball building under the covered walkway. Billy said he was sick of the rain, he just wished it would stop. "Ain't no problem," Elvis said good-humoredly. "I'll take care of it." And he held up his hands and it did. "See, I told you," he declared with that twinkle that never let you know whether or not he was really serious. "If you've got a little faith, you can stop the rain."

Ginger and Jo hit for a little while, and then the guys got out on the court, but Elvis tired rapidly, and soon the game degenerated into a game of dodge ball, with Elvis trying to hit Billy with every shot. Eventually he hit himself on the shin with his own racquet and quit. "Boy, that hurts," he said, lifting up his pants leg to reveal an ugly welt. "If it ain't bleedin'," said Billy, employing one of his cousin's favorite sayings, "it ain't hurtin'." And he and Jo burst out laughing as Elvis threw his racquet at him.

Afterward Elvis sat at the piano in the lounge area of the racquetball building and fooled around with a few numbers, ending with Willie Nelson's elegiac "Blue Eyes Crying in the Rain." Back at the house Billy helped Elvis wash and dry his hair, while Elvis idly glanced at the book on the Shroud of Turin that Larry had brought him. He talked about maybe taking Alicia Kerwin out on the first part of the tour, but he didn't give Billy any reason to think he was going to do anything about it. He spoke once again, too, of the plot he had hatched to kill Red and Sonny by luring them to Graceland on one pretext or another — but he didn't seem about to do anything about that either. This was going to be the best tour yet, he repeated in what had become almost a mantra by now, and Billy left just before Ricky Stanley arrived with the first of three packets of prescription drugs, or "attacks," that Dr. Nick left for Tish Henley to dispense each night. Each packet consisted of varying amounts of Seconal, Placidyl, Valmid, Tuinal, Demerol, and an assortment of other depressants and placebos which generally allowed Elvis to get several hours of sleep at a time.

Elvis was still awake a couple of hours later when Ricky brought him his second "attack," but when he called down for the third, Ricky had disappeared, even though he was supposed to be on duty till noon. Tish had already gone to work, so Elvis had his aunt Delta call her at Dr. Nick's office, and after conferring with the doctor, Tish gave her husband instructions to bring Delta the third packet, made up of two Valmids and a Placidyl placebo. When she arrived with the medication, Elvis informed his aunt that he was planning to get up at around seven o'clock that evening. Not long afterward, he told Ginger that he was going into the bathroom to read.

Ginger awoke around I:30 P.M., rolled over, went back to sleep for a few minutes, then called her mother. How was Elvis? her mother asked, and Ginger said she didn't know, he had never come back to bed, maybe she had better go check on him. She washed and put on her makeup in her own bathroom, then knocked on Elvis' bathroom door. When there was no answer, she pushed on it and discovered him lying on the floor, his gold pajama bottoms down around his ankles, his face buried in a pool of vomit on the thick shag carpet. In a daze she called downstairs and asked to speak to someone on duty, and the maid put Al Strada on the line. She thought there was something wrong, she told him. He had better come quick.

Al was bending over Elvis when Joe came bounding up the stairs, and together the two men managed to turn the body over and Joe tried to breathe some life into him. It seemed for a moment as if time were suspended, but then everything started happening all at once, as the bedroom quickly filled with people and Vernon arrived on Patsy Presley's arm, his face a mask of fear as he cried out, "Oh, God, son, please don't go, please don't die." Joe worked desperately on the body, but there was little doubt in his or anyone else's mind that Elvis was gone — his face was swollen and purplish, the tongue was discolored and sticking out of his mouth, the eyeballs blood red. Lisa arrived in the midst of it all. "What's wrong with my daddy?" she demanded, as Ginger closed the bathroom door. "Something's wrong with my daddy, and I'm going to find out," the little girl declared defiantly, and someone quickly locked the other bathroom door as Lisa ran around to try to get in.

People were wailing and screaming when the two firemen EMTs arrived with an ambulance from Engine House No. 29 in Whitehaven, just minutes from Graceland. The ambulance attendants witnessed what they later described as something like a scene of carnage, with up to a dozen people surrounding the almost unrecognizable body and begging them to do something — wasn't there *anything* they could do? A man in gold-rimmed

designer sunglasses with a football jersey that said "Hawaii '75," whom they later learned to be Al Strada, said he thought Elvis had overdosed, the same thing they had been told at the gate before they learned who the victim was.

There were no vital signs, and there seemed little doubt of the outcome as they loaded the body onto a stretcher and with help from Al and Joe and Charlie carried it out the front door to the waiting ambulance. Vernon tried in vain to join them but was gently restrained. "I'm coming, son," he called out desperately. "I'll be there."

Dr. Nick showed up in his green Mercedes just as they were coming down the drive. He was in such a frenzy that he drove into the gate, then leapt out of his car and joined Joe and Charlie in the back of the ambulance. "Breathe, Elvis, come on, breathe for me," he kept calling, as he frantically worked on the body the whole seven-minute ride to Baptist Memorial Hospital. He had a look of shock on his face, the ambulance attendants noted, almost as if he found it difficult to believe that Elvis Presley could ever die.

They arrived at the hospital at 2:55 P.M., twenty-two minutes after the initial call. Trauma Room No. I had been prepared, and a team of doctors and resuscitation experts was standing by, but there was little to be done, and finally they stopped by mutual consent. It was 3:30 P.M. Joe and Charlie and some of the other guys, who had come over on their own, were all waiting in Trauma Room No. 2 when Dr. Nick walked through the door. "It's all over, he's gone," said the physician, though his look alone would have been enough to tell them, and everyone started to cry. Charlie stumbled toward the door as if he needed to escape, but Joe stopped him. They had to be composed, Joe said through his own tears, before they went out and faced the world.

Joe and Dr. Nick both had immediate business to take care of. Joe asked hospital administrator Maurice Elliott if he could use his office and, with the door closed, called the Colonel in Portland. Colonel's reaction was impossible to read: there was a moment of what Joe could only interpret as stunned silence, then the old man started to enumerate all the things they would have to do, starting with canceling the tour. Joe was scarcely surprised as he ran down the list; in the seventeen years of their association, he had never known Colonel to linger on death. There was no time for nostalgia in the Colonel's world; when old associates died, they were scarcely spoken of again, the Colonel just moved on. After promising to call back as soon as he reached the house, Joe tried Priscilla next. She received the news with much the same mixture of shock and recognition that he might have expected. How was Lisa doing? she asked through her tears, and he tried to reassure her that Lisa would be all right.

Dr. Nick meanwhile had elicited a promise from Maurice Elliott that the death would not be announced until Nick was able to inform Vernon Presley personally. Elliott said he didn't know how long he could hold off the reporters who were already starting to gather at the hospital as word got out that Elvis had been brought in with "severe respiratory distress," but Nick hitched a ride back to Graceland with the ambulance attendants, whom he feared he might need when Vernon heard the news. He was carrying an autopsy consent form for Vernon to sign, something he and Maurice Elliott had determined would keep the state coroner's office from becoming involved and prevent the autopsy results from becoming public without the family's agreement. Joe would stay at the hospital to make the announcement as soon as Nick called to let them know that Vernon had been informed.

Lisa was crying when Dr. Nick walked in, and Vernon froze when he saw the bag full of Elvis' personal effects in the doctor's hand. "Oh, no, no, no," he cried. "He's gone." Nick walked up to Vernon and nodded. "I'm sorry," he said, as the bereft father's wails could be heard throughout the house. "What am I going to do?" Vernon cried, as the two emergency medical technicians stood by. "Everything is gone."

The room, as one of the EMTs, Ulysses S. Jones, Jr., described it, "was filled with hysteria. People were running all over the place crying and screaming and moaning. Vernon was shaking and trembling . . . he couldn't sit still. The doctor took him into the kitchen. . . . Lisa was running all over the house and crying, 'My daddy is gone!' . . . Ginger was walking around in a daze, but she finally calmed Lisa Marie down and gently took her into another room and closed the door." Nick in the meantime called the hospital and told Maurice Elliott they could go ahead and inform the press.

Joe as it turned out wasn't able to carry out the task. When he tried to address the assembled reporters, he got choked up every time he started to speak, and Charlie was no better, so it was left to Maurice Elliott, the hospital administrator who had come to know Elvis over the years, to make the announcement. "There were all sorts of TV cameras and radio microphones, and the room was just packed with people, and all of a sudden I was struck with the thought that, Good gosh, here I am in front of the world, and I am going to have to announce Elvis Presley's death."

There were fans already gathered outside the gates by the time that Joe

650 👁 "PRECIOUS LORD, TAKE MY HAND"

and Charlie returned to Graceland, courtesy of a lift from the police. At the direction of Elvis' security force, there had already been a complete clean-up in the bedroom, with the bed stripped and remade, the bathroom scoured, and everything put back in place as if no untoward incident had ever occurred. When Shelby County medical investigator Dan Warlick arrived not long afterward, accompanied by police lieutenant Sam McCachern and Assistant District Attorney Jerry Stauffer, the first person he saw inside the house was Vernon Presley, speaking calmly to someone on the phone. Before Warlick could fully register what was happening, Vernon's voice took on a tone of almost unimaginable desolation as he announced to the party on the other end, "My baby is dead. . . . They've taken him, he's gone, my baby is dead," and burst into uncontrollable tears.

Sam Thompson took the medical investigator upstairs, and after unlocking the doors to Elvis' bedroom suite, showed Warlick and his party into Elvis' study. "Scattered on couches forming a complete perimeter of the room was an assortment of teddy bears," wrote investigative reporters Charles C. Thompson II and James P. Cole in their authoritative study, *The Death of Elvis*. "They were everywhere, facing obediently toward an oversized desk with a placard reading ELVIS PRESLEY, THE BOSS. The walls were covered with leather or Naugahyde . . . the room blended a childish air with hard reality beginning with the largest animal and ending with the [empty] syringe Warlick noticed in front of the placard. . . . Warlick walked past the desk and out of the office-den and into the bedroom. On the far wall he spotted two or three television sets perched on a deep bookcase and staring at an angle toward the biggest king-size bed that Warlick . . . had ever seen. On top of the case he found a second syringe [empty] just like the first."

Warlick immediately ordered the death scene to be secured, but he was aware of the futility of the gesture even before entering the bathroom, where he noted a carpet that was deep red, a yellowish throw rug lying in front of the black toilet, and yet another television set, placed in view of the commode. "Two telephones and what looked like an intercom were mounted next to the toilet-paper dispenser," wrote Thompson and Cole in vivid summary of Warlick's later testimony. "Comfortable arm chairs were stationed around the bathroom. Dominating the room was a circular shower about seven feet in diameter. . . . A cushy vinyl chair rested in the middle of the shower. . . . To the right of the doorway was a twelve-foot-long light marble counter with a built-in purple sink. A mirror rimmed with oversized light bulbs ran along the wall at counter length. Stepping to the counter, Warlick inspected a black bag. It was like a doctor's bag with a big flap folding down to a latch in front. Inside was a complement of tiny black plastic drawers. All of them were empty."

So was the medicine cabinet, nor was there any evidence of even the most common household remedies in the bedroom. For Warlick it was a first in his four years as an investigator — to discover a total absence of medications, prescription or nonprescription, in the home of anyone but the most fervent Christian Scientist. The story that he got from the various interviews that he conducted that afternoon was sanitized, too. The only thing that appeared to have been missed, aside from the empty syringes, was the book that Elvis had in the bathroom with him when he died, a study of sex and psychic energy that correlated sexual positions with astrological signs. Warlick found a stain on the bathroom carpeting, too, that seemed to indicate where Elvis had thrown up after being stricken, apparently while seated on the toilet. It looked to the medical investigator as if he had "stumbled or crawled several feet before he died."

By the time that Warlick got back to the hospital just before seven o'clock, the autopsy was about to begin. Although he had no formal role in the proceedings, Dr. Nick's presence as an observer underscored the fact that this death from unknown circumstances, and possibly even unnatural causes, would almost certainly be examined as a private, not a public, matter, despite continuing agitation from the attorney general's office to move Elvis' body to the city hospital across the street, where the coroner would operate under official state auspices. Instead, armed with the consent form obtained from Vernon, nine pathologists from Baptist conducted the examination in full knowledge that the world was watching but that the results would be released to Elvis' father alone. "Our pathologists were concerned with somebody of Elvis' fame [that] the controversies that developed with President Kennedy's autopsy [not develop here]," said Maurice Elliott. "They wanted to be sure that the hospital wasn't embarrassed." At the same time they were intensely aware of the time constraints involved, and in fact they were scarcely done with the preliminary stages of the process when Shelby County medical examiner Jerry Francisco and Dr. Eric Muirhead, the hospital's chief of pathology, left with five of the hospital doctors and Dr. Nick to address an eight o'clock press conference that Dr. Francisco had called. There Francisco announced the results of the autopsy, even as the autopsy was still going on. Death, he said, was "due to cardiac arrhythmia

due to undetermined heartbeat." Muirhead, wrote Thompson and Cole in their book, "was noticeably embarrassed. He winced as Jerry Francisco ran roughshod over the physical evidence with a lot of cardiological doubletalk. But he didn't contradict the medical examiner. 'I wish I had spoken up,' Muirhead told his colleagues later." But there were in fact at that time no results to report.

The autopsy proper went on for another couple of hours. Specimens were collected and carefully preserved, the internal organs were examined and the heart found to be enlarged, a significant amount of coronary atherosclerosis was observed, the liver showed considerable damage, and the large intestine was clogged with fecal matter, indicating a painful and longstanding bowel condition. The bowel condition alone would have strongly suggested to the doctors what by now they had every reason to suspect from Elvis' hospital history, the observed liver damage, and abundant anecdotal evidence: that drug use was heavily implicated in this unanticipated death of a middle-aged man with no known history of heart disease who had been "mobile and functional within eight hours of his death." It was certainly possible that he had been taken while "straining at stool," and no one ruled out the possibility of anaphylactic shock brought on by the codeine pills he had gotten from his dentist, to which he was known to have had a mild allergy of long standing.

The pathologists, however, were satisfied to wait for the lab results, which they were confident would overrule Dr. Francisco's precipitate, and somewhat meaningless, announcement, as indeed they eventually did. There was little disagreement in fact between the two principal laboratory reports and analyses filed two months later, with each stating a strong belief that the primary cause of death was polypharmacy, and the Bio-Science Laboratories report, initially filed under the patient name of "Ethel Moore," indicating the detection of fourteen drugs in Elvis' system, ten in significant quantity. Codeine appeared at ten times the therapeutic level, methaqualone (Quaalude) in an arguably toxic amount, three other drugs appeared to be on the borderline of toxicity taken in and of themselves, and "the combined effect of the central nervous system depressants and the codeine" had to be given heavy consideration. Almost inexplicably, Dr. Francisco and the medical examiner's office would stick to their original diagnosis, and the debate over Elvis' death would rage for over twenty years, through lawsuits and legislative actions, medical disbarment and reinstatement, and attempts at blame, denial, and reconsideration too numerous

to mention. And yet all one has to do is look at Elvis' life, the accelerating dependence on medications available to him in almost unimaginable quantities, the willing enlistment of doctors who seemed never to give a thought to the dangers or likely consequences of what they were prescribing, and the incontrovertible evidence of the medical problems stemming primarily from the use of drugs that Elvis experienced over his last four years, to understand the causes of his death.

Joe was in charge of the funeral arrangements, but Vernon made clear his preference on every one of the significant details. The original plan was to conduct the service at the Memphis Funeral Home, where Gladys Presley's obsequies had been held, but Vernon insisted this time that the ceremony be at home — just as he and Elvis had wanted for Elvis' mother. He wouldn't budge in his determination to give the fans a chance to see the body either — they had remained loyal to Elvis throughout his career, and Elvis had always said that without them he would have been nothing. With these and various other considerations in mind, Joe sent the *Lisa Marie* out to California to pick up Priscilla, Jerry Schilling, Joe's present girlfriend Shirley Dieu and former wife, Joanie, and Priscilla's immediate family. He helped with travel arrangements for Linda Thompson and Ed Parker and a number of others, too, whom Priscilla had indicated she did not want on the plane, but for the most part he tried to discourage people from coming — it was just going to be too much of a zoo.

Vernon wanted a copper casket similar to the one in which they had buried Gladys, and funeral director Bob Kendall was able to find one in Oklahoma City while somehow managing to locate seventeen white Cadillac limousines for the funeral cortege, though there were only three in town. Elvis was to be buried in a white suit that his father had given him, and Vernon asked Charlie and Larry to do his hair so he would look good for the fans. South Central Bell requested that all Memphians restrict themselves to emergency calls because the circuits were so overloaded, and local florists were flooded with orders, over three thousand in all, requiring them to go far afield to meet the demand. At approximately 1:00 A.M., Vernon called the Reverend C. W. Bradley, minister of the Wooddale Church of Christ, which Vernon's estranged wife, Dee, had attended. Vernon scarcely knew Bradley, he was not much of a formal churchgoer himself, and Elvis had only met the minister on the occasion of one of his uncles' funerals, but Reverend Bradley was fully understanding of all the reasons why Mr. Presley would want his boy to have a proper ceremony. "He said, 'Brother

Bradley, will you be willing to do this funeral for my son?' I told him of course I would be willing. He then said, 'Now I know you don't have mechanical music at your church, and we're going to have an organ at the funeral. Will that bother you?'" Bradley told him that it would not, "and we began to discuss the type of service that he wanted."

There would, of course, be music, Vernon said, the kind of good oldfashioned quartet singing that Elvis had loved ever since he was a little boy — J. D. Sumner and the Stamps, the Statesmen, Jake Hess, and James Blackwood had all agreed to perform — and he hoped Reverend Bradley wouldn't mind, but televangelist Rex Humbard, from whom Elvis had sought counsel in Las Vegas the previous December, had asked to say a few words, too. The Reverend Bradley freely assented to all of these arrangements, and when Priscilla arrived with her party not long afterward, it was the occasion for more tearful reminiscences, in the midst of which Joe found an opportunity to give Priscilla back the private Polaroids and videotapes Elvis had kept of her all these years. It was three in the morning before anyone got to sleep, but the number of fans outside the gates continued to grow, and thirty hardy souls camped out all night on the sidewalk outside the Memphis Funeral Home.

Larry and Charlie reported to the funeral home in accordance with Vernon's request early the next morning. Charlie trimmed and colored the sideburns, while Larry cut and styled Elvis' hair, and then they consulted on the makeup job. Joe saw to it that all the furniture was removed from the living room before the casket arrived in a single white hearse, preceded by a motorcycle escort, shortly before noon. The crowd out front, which had grown to an estimated fifty thousand by now, clamored for a glimpse as the copper casket was carried up the steps and in the front door. Meanwhile, a number of fans had climbed trees on the grounds of Graceland Christian Church next door, and limbs could be heard snapping as they struggled to get a better view.

The coffin was placed in the archway between the living room and the music room on the far south end of the house, and family and close friends were given a chance to pay their respects before the public viewing that was to take place at mid afternoon. Vernon's knees buckled, and Grandma almost collapsed, but the Colonel, who had arrived from Portland early that morning, resolutely rejected any opportunity to view the body. So far as anyone could remember, Colonel had never attended a funeral before — though no one could recall his ever articulating his thoughts on the subject

either. He didn't really have to. No one could miss the intensity of his colloquies with Vernon in the kitchen, as he buttonholed the grieving father and tried to impress upon him the seriousness of the situation they were in, the need right now, even in the midst of mourning, to firmly fix their minds upon the future. It was almost like when Elvis was in Germany, he said the vultures were just waiting to swoop down on them and take over, already there were probably half a dozen manufacturers thinking they could just move right in and capitalize on an opportunity for name and product exploitation that rightfully belonged to Vernon and little Lisa Marie alone. Vernon nodded as Colonel emphasized that there was no time to lose, they had to circle the wagons right away — to wait even a few days could be fatal. Vernon's gaunt handsome face reflected a sorrow almost beyond expression; it was hard to tell how much he was able to take in as he assented almost mutely to the Colonel's every argument. Things would continue just like they always had, he agreed. Everything would remain exactly the same. He knew the Colonel had their interests at heart.

For the viewing, scheduled to last from three to five o'clock, the body was moved to the foyer, underneath a crystal chandelier just inside the door. White linen was laid out on the floor underneath the casket, and outside, the lawn was a sea of flowers. Wire reports described the scene as verging on mass hysteria, as "four at a time fans filed by the stone lions guarding the door, past the casket and back out the door into the 90-degree heat. Several mourners fainted on the marble floor and had to be carried out. A quarter mile away, down a driveway with a sheriff's deputy every few yards, a throng, stretching a mile on either side, pushed and shoved to be next through the gates. . . . Hundreds fainted in the heat. Many, revived with rubber gloves filled with ice, staggered back into the crowd and fainted again. Radios blared Presley's greatest hits [as] three police helicopters hovered over the mansion. Thirty National Guardsmen were called out to help the 80 policemen and 40 sheriff's deputies try to control the crowd."

There were bodyguards on the three exposed sides of the coffin, and Vernon hovered watchfully, as if to protect his son from ever-present dangers. He was no more able to protect him from betrayal in death than in life, though, as one of the cousins got a shot of Elvis in his coffin with a Minox provided by the *National Enquirer*, which Vernon would discover only when the tabloid ran the picture on the cover of its next issue. In the photograph Elvis looks pale and waxy, but he is still surprisingly handsome, composed and at rest in a way that seemed almost foreign to those who remembered a man rarely at rest. Dedicated diarist Donna Lewis expressed the feeling of many of the fans when she wrote in her journal that Elvis didn't look like himself at all: "he looked awful. . . . It hurt. It hurt deep!"

At five o'clock Vernon was persuaded by the mass of people still waiting outside the gates to allow the viewing to continue for another hour and a half. It had begun to rain lightly, but the crowd was not about to disperse and continued to file slowly forward until at last at the appointed time the order was given to shut the gate. "It seemed touch-and-go for a while," reported Chet Flippo in *Rolling Stone*, as the approximately ten thousand people still standing outside "surged at the gates amid boos and tears and sobs." But Elvis Presley fans had always been well behaved around their idol; even as the world scoffed, their loyalty had never been in doubt, and so it remained now. Amid expressed fears of a riot, a dozen policemen were finally able to close the gates, and after about thirty minutes the crowd slowly began to walk away. "The rock wall facing on Elvis Presley Boulevard [was] low enough to jump over," Flippo wrote, "but no one tried."

After the viewing, the coffin was moved back into the living room, where the service was scheduled to take place the next day, and the evening was given over to a kind of private wake. Soul singer James Brown requested, and got, some time alone with the body, but otherwise there was a notable absence of celebrities, which was very much in keeping with the kind of ceremony that Vernon had envisioned. Charlie seemed almost in a daze, Joe tried to keep an eye on the relatives at all times, and the Colonel was uncharacteristically silent, as Vernon returned to the living room over and over again to pat his son on the head.

It was after ten when word came up that nineteen-year-old Caroline Kennedy was waiting at the gate, and she was proudly escorted to the front door. Vernon couldn't get over that the slain President's daughter would come in the middle of the night to pay her respects, until he was quietly informed that she was working as a summer intern for a New York newspaper and had been interviewing people out on the street. "Elvis' Uncle Vester, Aunt Delta and Aunt Nash, [and his] 82-year-old grandmother . . . were all staring at a 10 o'clock news show about the day's events," she reported in a story that was eventually published in *Rolling Stone*, sketching in poignant portraits of the few moments that she was able to observe before being quietly asked to leave. Then, at Priscilla's request, Sam Thompson suggested that everyone go home so the family could get some sleep,

and he remained alone with the body all night until Dick Grob relieved him early the next morning. Thousands of fans still lingered outside the gates, and two were killed instantly when a 1963 white Ford driven by an eighteenyear-old man with what his mother described as "mental problems" plowed into a group gathered in the closed-off center lane of the highway at a speed of forty miles an hour.

At nine o'clock that morning one hundred vans began to carry the flowers to the cemetery, a task that took nearly four hours to complete and looked for a while as if it might not be done before the interment began. At noon guests started to arrive for the two o'clock service. The singers had all met in Charlie's room earlier to confer about their parts. At Priscilla's urging, Kathy was going to sing "Heavenly Father," which she always performed on the show to Elvis' rapt attention, with Statesmen founder Hovie Lister accompanying her on piano. James Blackwood, who had sung at Gladys Presley's funeral and known Elvis ever since he was a Blackwood Brothers teenage fan, would deliver Elvis' signature piece, "How Great Thou Art," with orchestra leader Joe Guercio symbolically conducting. Jake Hess, former lead singer for the Statesmen and one of the singers Elvis had most admired throughout his life, was present, too, to re-create "Known Only to Him," one of the many songs for which he was famous that Elvis had recorded in explicit homage to his idol. Finally, J. D. Sumner and the Stamps would contribute the majority of the program with a selection of hymns for the most part taken from songs they had performed on the show.

Linda wore lavender and Kathy came dressed in white, because that was how each felt Elvis would have wanted her to look. Nearly everyone else arrived garbed in one form or another of funereal black. Only the Colonel stood out in characteristically adamant exception. "You never wore a tie for him when he was alive," he admonished promoter Tom Hulett as they were about to leave their hotel — and made him go back and take it off. He himself was attired in his customary baseball cap, seersucker pants, and a blue short-sleeved shirt, fiercely unrepentant for any offense he might give. The two hundred invited guests quietly filed into the living room and waited for the service to begin. Tennessee governor Ray Blanton and Chet Atkins had arrived from Nashville, Ann-Margret and her husband, Roger Smith, had flown in from Las Vegas with Dr. Ghanem, and there was a substantial representation of the Colonel's associates and RCA executives but mostly it was just family and friends filling up the wooden folding chairs and spilling over into the hallway, where the Colonel remained leaning up against a wall peering in at the ceremony from time to time.

The service began with the playing of "Danny Boy" on the organ. It was scheduled to take no more than half an hour, but with Rex Humbard's guest sermon, all of the musical selections, plus a eulogy that comedian Jackie Kahane had asked Vernon if he could deliver, it was clear from the start that the ceremony would run considerably overtime. Humbard spoke of his meeting with Elvis in Las Vegas and how he had gotten down on his knees and prayed with him; Jackie Kahane, who had conceived of the idea for an informal tribute only when he realized no one else in the group was going to give one, delivered a brief but graceful speech touching on the sense of family that had grown up among them all and the generous and quirky spirit who had been their leader; when Kathy sang "Heavenly Father," with Hovie Lister accompanying her in a manner that bore little resemblance to the way Glen D. or David Briggs had played it on the show, she imagined she could hear Elvis "saying laughingly, 'That's not the way we arranged it.""

The main sermon, by Reverend Bradley, stressed the inspiring example that Elvis had provided of the potential "of one human being who has strong desire and unfailing determination." It spoke of Elvis' fundamental decency, and how "in a society that has talked so much about the generation gap, the closeness of Elvis and his father . . . was heartwarming to observe." But Elvis, Reverend Bradley acknowledged, was a "frail human being," too, "and he would be the first to admit his weaknesses. Perhaps because of his rapid rise to fame and fortune he was thrown into temptations that some never experience. Elvis would not want anyone to think that he had no flaws or faults. But now that he's gone, I find it more helpful to remember his good qualities, and I hope you do, too." Vernon's racking sobs could be heard throughout the ceremony, and afterward the mourners filed up one by one to say a final good-bye. Ann-Margret tried to console Vernon, but instead they both started to cry. Then the nine pallbearers -Joe and Charlie, Felton, Lamar, Jerry Schilling and George Klein, Elvis' cousins Billy and Gene Smith, and Dr. Nick — bore the coffin out the door. Just as they did, a limb on one of the big oak trees out in front snapped and fell, barely missing the funeral party, but Lamar didn't miss a beat. "We knew you'd be back," he wisecracked. "Just not this soon."

They made the three-and-one-half-mile journey to the cemetery in a cortege made up of forty-nine cars led by a silver Cadillac, a police motor-

cycle escort, a white hearse, and Vernon in the first of the seventeen white limousines. Both sides of the road were lined with a crowd estimated at fifteen to twenty thousand, and Joe saw Cliff Gleaves standing mournfully among them as the hearse drove by; evidently no one at the gate had known to let him in.

Once they arrived at the cemetery, the pallbearers carried the rose petal-strewn coffin past a massive bank of floral arrangements - hound dogs, crowns, and broken hearts, guitars and simple sprigs of red and yellow roses, all offered in humble tribute — up the steps of a stark gray mausoleum just a few hundred feet from Gladys Presley's grave. With the roses that had covered the coffin scattered on the mausoleum floor, the Reverend Bradley conducted a brief, five-minute ceremony in the mausoleum chapel, and then the family filed into the crypt one by one to touch or kiss the casket. Vernon remained alone with his son for a few moments after everyone else had left and had to be supported when he emerged from the building. Then the mausoleum was cleared, the Commercial Appeal reported, and "five workmen entered the room with a wheelbarrow full of sand, a fivegallon bucket of water, some cement, and a box of tools." They sealed the crypt with a double slab of concrete, then applied an exterior marble facing which would be inscribed later. "Even before the workmen had completed the entombment, people began entering the cemetery from the rear and pressing themselves against the heavy steel doors of the mausoleum." Meanwhile, everyone returned to Graceland for a "Southern supper," and later that evening Vernon directed that all the flowers be given away to the fans, who were gathered by the thousands at the cemetery at 8:25 A.M. the following morning when the gates were opened. By noon more than fifty thousand of them had showed up, and every last spray and blossom was gone.

Over the next couple of weeks the Colonel worked out the details of his new marketing plan with a man named Harry "The Bear" Geisler, whose company, Factors Inc., had just completed a highly successful Farrah Fawcett-Majors merchandising campaign. Vernon gave his formal approval to the continuation of Elvis' arrangement with the Colonel on August 23, one day before he was recognized by the court as official executor of the estate. The contract that he signed was the same in virtually every respect as the one Elvis had agreed to with the Colonel the previous year. It established Boxcar Enterprises, the Colonel's most recent corporate identity, as a kind of middleman for all merchandising rights, with 50 percent of all Boxcar income to be disbursed equally between Colonel and the Elvis Presley estate, the remainder retained as a reserve for all expenses (including substantial salaries and bonuses, paid out at the Colonel's discretion), with anything left over (which to date had come to nothing) to be divided 56 percent to Colonel and the remainder to the estate and Colonel's longtime associate Tom Diskin. Vernon signed the agreement with no evident qualms, and the Colonel continued to carry on business in the usual manner until he was challenged by the probate court of Shelby County, Tennessee, which elected to intervene on behalf of Lisa Marie, "a minor and sole beneficiary of the late Elvis A. Presley," following Vernon's death on June 26, 1979, the Colonel's seventieth birthday.

RCA would discover that Elvis was as great a sales phenomenon in death as in life. Red and Sonny's book, *Elvis: What Happened?*, sold over three million copies, perhaps largely as a result of the unanticipated timing of its release, and its two principal authors maintained a policy of virtual silence on the subject for nearly twenty years. Ginger Alden arranged to sell her own story to the *National Enquirer* in the immediate aftermath of Elvis' death for a reputed \$105,000, an amount that was substantially reduced when it was discovered that she had violated the exclusivity of her agreement with an interview that appeared in the *Commercial Appeal* on August 19. There was a bizarre and almost laughably inept attempt to steal Elvis' body just eleven days after the interment, and two months later, on October 27, Elvis and his mother were both reburied in the Meditation Garden at Graceland, after all zoning requirements had been met. "I guess they will finally get to rest," Vernon remarked at a small graveside gathering restricted to close relatives in the early evening.

Long before he was laid in the grave, the legend of Elvis' success, the one trademark it was impossible for even the Colonel to register, had been retailed over and over again, but now it was overwhelmed in a flood of reminiscences that at first strove to deny the "frail humanity" that bound him to the rest of the human race, then rushed to condemn him for it. The cacophony of voices that have joined together to create a chorus of informed opinion, uninformed speculation, hagiography, symbolism, and blame, can be difficult at times to drown out, but in the end there is only one voice that counts. It is the voice that the world first heard on those bright yellow Sun 78s, whose original insignia, a crowing rooster surrounded by boldly stylized sunbeams and a border of musical notes, sought to proclaim the dawning of a new day. It is impossible to silence that voice;

you cannot miss it when you listen to "That's All Right" or "Mystery Train" or "Blue Moon of Kentucky" or any of the songs with which Elvis continued to convey his sense of unlimited possibilities almost to the end of his life. It is that sense of aspiration as much as any historical signposts or goals that continues to communicate directly with a public that recognized in Elvis a kindred spirit from the first. That is what we have to remember. In the face of facts, for all that we have come to know, it is necessary to listen unprejudiced and unencumbered if we are to hear Elvis' message: the proclamation of emotions long suppressed, the embrace of a vulnerability culturally denied, the unabashed striving for freedom. Elvis Presley may have lost his way, but even in his darkest moments, he still retained some of the same innocent transparency that first defined the difference in the music and the man. More than most, he had an awareness of his own limitations; his very faith was tested by his recognition of how far he had fallen from what he had set out to achieve — but for all of his doubt, for all of his disappointment, for all of the self-loathing that he frequently felt, and all of the disillusionment and fear, he continued to believe in a democratic ideal of redemptive transformation, he continued to seek out a connection with a public that embraced him not for what he was but for what he sought to be.

"Well I've tried to be the same all through this thing, you know," he declared early on. "Naturally, you learn a lot about people, and you get involved in a lot of different situations, but I've tried to be the same. I mean, the way I was brought up, I've always considered other people's feelings; I've never — in other words, I didn't kick anybody on my way. I don't just sign the autographs and the pictures and so forth to help my popularity or make them like me. I do it because I know that they're sincere, and they see you and they want an autograph to take home, and they've got an autograph book, or they've got their little camera. They don't know the kind of life you lead, they don't know what kind of person you are. And so — I try to remember that. That's all. It's simple. It's just the way I was brought up [by] my mother and father to believe and have respect for other people. We were always considerate of other people's feelings."

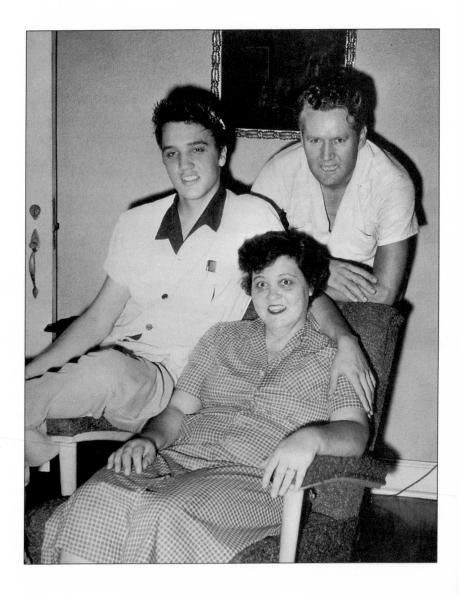

ELVIS, VERNON, AND GLADYS PRESLEY. (COURTESY OF THE ESTATE OF ELVIS PRESLEY)

Notes

THE MAJORITY OF THE INTERVIEW MATERIAL is my own, but Jerry Hopkins' interviews of various figures for his 1971 and 1980 volumes, *Elvis* and *Elvis: The Final Years*, have been a unique and invaluable resource. They were made available by the Mississippi Valley Collection at the University of Memphis (MVC/UMem) through the kind efforts of Dr. John Bakke. The Elvis Presley General Correspondence Files in the Hal Wallis Collection at the Margaret Herrick Library, Academy of Motion Picture Arts and Sciences Library, Beverly Hills (HWC/MPAS), provided unparalleled insight into the unique relationship between Wallis and Joe Hazen and Elvis and Colonel Parker. In addition, Stuart Goldman and Adam Taylor were good enough to share information and interview material assembled for their 1993 film, *Elvis in Hollywood*.

So far as full documentation of the business, day-to-day, and some of the personal elements of Elvis' life, I would have been adrift without the cooperation of the Elvis Presley Estate (EPE), and I owe much thanks and gratitude to Jack Soden for his generosity and encouragement as well as to archivist Greg Howell, who was unstinting in both his efforts and enthusiasm.

Many others contributed their time and resources, and I have tried to indicate my thanks and indebtedness both in these notes and in the acknowledgments that follow.

PROLOGUE: HOMECOMING, MEMPHIS, MARCH 1960

3 They left in the aftermath: The account of Elvis' departure from Fort Dix is gleaned from various newspaper stories in the *Memphis Press-Scimitar* ("Elvis Questioned About His Style and Romance" by Milton Britten, March 3, 1960; "Elvis, Parker Go to Swank New York Hotel," March 5, 1960); the *Memphis Commercial Appeal*; the Associated Press and UPI, March 3–5; the *New York Journal-American* ("Presley Takes to the Hills" by Charles Roland, March 6, 1960); and numerous other accounts.

4 his manager had a plan: All of the Colonel's multifarious plans, schemes, and promotional efforts are derived from correspondence, interoffice memos, and contracts November 1958–January 1960 (EPE).

4 He had kept Elvis' name in the headlines: The prevailing contemporary view of Colonel Parker's achievement is perhaps best expressed in Lloyd Shearer's June 19, 1960, *Parade* profile of the singer and his manager, in which Shearer details the Colonel's accomplishment in keeping Elvis' name alive throughout his two years in the army and states that "rarely in the annals of show business has any entertainer been more shrewdly booked, spotted and promoted than Elvis Presley."

4-5 The present plan: Bill E. Burk, "Elvis Home — Gets Warm Welcome," Memphis Press-Scimitar, March 7, 1960.

5 That evening they took a private railroad car: Richard Connelly, "Elvis Due Back in Memphis by Rail Tomorrow — Maybe," *Memphis Commercial Appeal*, March 6, 1960.

5 There was a crowd: David Halberstam, "Sergeant Elvis Smuggled Home in Big Fanfare of Secrecy," *Nashville Tennessean*, March 7, 1960.

664 🔊 NOTES

5 with an extra rocker on the shoulder: Memphis Press-Scimitar, March 7, 1960.

5 Inside the car: Rex and Elisabeth Mansfield, Elvis the Soldier, pp. 135–136.

6 Colonel Parker "told me": Ibid., p. 137.

6 "like a happy young colt": Nashville Tennessean, March 7, 1960.

6 "we could make money": Memphis Press-Scimitar, March 7, 1960.

7 "Everything. I mean that": Malcolm Adams, "Elvis Wanted 'To Get Home,'" Memphis Commercial Appeal, March 8, 1960.

7 Two hundred fans: Memphis Press-Scimitar, March 7, 1960; Memphis Commercial Appeal, March 8, 1960.

GERMANY: MARKING TIME

9 He arrived in Bremerhaven: The account of Elvis' arrival and early acclimatization stems primarily from *Private Presley: The Missing Years* — *Elvis in Germany* by Andreas Schroer; Alan Levy's *Operation Elvis*; William J. Taylor, Jr.'s *Elvis in the Army;* Ira Jones' *Soldier Boy Elvis;* and Albert Goldman's *Elvis.* See also Rex and Elisabeth Mansfield's *Elvis the Soldier;* "Der Elvis" by Gary Paul Gates, *Memories,* spring 1988; and numerous news accounts. In addition, Bernard Seibel of the German Elvis-Fan-Club prepared a valuable chronology and provided German clippings from his own research.

9 He was met at the dock: A press account prepared by Boris Jankolovics and wired October 8, 1958, presumably at Colonel Parker's instigation, estimates five thousand fans (EPE).

10 At night, Charlie said: Interview with Charlie Hodge, 1989.

10 Several days out to sea: Interview with Charlie Hodge; Mansfield, *Elvis the Soldier*, pp. 33–34; letter from Private Donald Petit, *Elvis in the Army* (1959 fan magazine), p. 63.

10 "Charlie," he told his new friend: Charlie Hodge, Me 'n Elvis, p. 10.

10 He got through the obligatory press briefings: New York Post, October 2, 1958.

10 His family arrived: New York Journal-American, October 5, 1958.

10 "Elvis always kept his own world": Interview with Lamar Fike, 1988.

11 they changed hotels: Hotel bill (EPE).

11 three weeks later: Hotel Grunewald bill from October 28 (EPE).

11 Elvis wasn't paying either one: Interviews with Lamar Fike and Charlie Hodge; Red West et al., Elvis: What Happened?, pp. 173ff; Alanna Nash, Elvis Aaron Presley: Revelations from the Memphis Mafia, p. 153.

11–12 There was a moment of confusion: Correspondence between Colonel Parker and E. J. Cottrell, Assistant Chief of Information, Department of the Army, October 14–15, 1958; New York Post, October 30, 1958; Levy, Operation Elvis, pp. 82–83.

12 Many days he was home: Variety, March 25, 1959.

12 And he had a little girl: "Elvis Kissed Me, by Margit Buergin, age 17, Frankfurt, Germany," *Photoplay*, March 1959; *New York Journal-American*, November 1 and 2, 1959.

13 He called some of his pals: *Memphis Press-Scimitar*, October 21, 1958; interviews with Alan Fortas and George Klein, 1990; Alan Fortas, *Elvis: From Memphis to Hollywood*, p. 100.

13 alfalfa pills: Memphis Press-Scimitar, October 16, 1958.

13 He wrote breezily: Rose Clayton and Dick Heard, eds., Elvis Up Close: In the Words of Those Who Knew Him Best, p. 161.

13 he had even spoken to her: Ibid., p. 155.

13 He wrote to her: The October 28, 1958, letter is quoted in both *Elvis World* 21, p. 13, and Albert Goldman's *Elvis*, p. 294.

13 In another letter: Goldman, Elvis, p. 298.

13 He heard from Janie Wilbanks: Memphis Press-Scimitar, September 10, 1959; interview with George Klein; Mansfield, Elvis the Soldier, pp. 32, 49.

13 Elvis prompted him to tell: Hodge, Me 'n Elvis, p. 13.

13 they all harmonized: Interview with Charlie Hodge; BBC interview with Charlie Hodge; Trevor Cajiao, "Red West: This Is What Happened, Part 1," *Elvis: The Man and His Music* 22, March 1994, p. 13; Mansfield, *Elvis the Soldier*, p. 58.

14 he might still be driving a truck: John W. Haley and John von Hoelle, Sound and Glory, p. 189.

14 he had another date with Margit: AP and UPI reports in New York Journal-American, New York World-Telegram, and New York Daily News, November 2, 3, 1958.

14 a woman named Dee Stanley: Dee Presley et al., *Elvis, We Love You Tender;* Billy Stanley, *Elvis, My Brother,* pp. 1–4; Goldman, *Elvis,* p. 304; interview with Lamar Fike; Nash, *Elvis Aaron Presley,* p. 160; West et al., *Elvis: What Happened?,* p. 185.

14 Then they were off to Grafenwöhr: Jones, Soldier Boy Elvis, pp. 90ff, 123.

14–15 he wrote Alan Fortas: Fortas, *Elvis: From Memphis to Hollywood*, pp. 101–103. The letter is reproduced with a November 14 postmark.

15-16 One evening at the post theater: Mansfield, Elvis the Soldier, pp. 41-44.

16 Back at Ray Kaserne: Jones, Soldier Boy Elvis, pp. 174-177.

16 Vernon gave Elvis an electric guitar: Levy, Operation Elvis, p. 94.

17 She tried to play up to him: Dee Presley et al., Elvis, We Love You, p. 49.

17 he spoke to his father sharply: Interview with Lamar Fike.

17 It was the shaving-cream fight: West et al., *Elvis: What Happened?*, pp. 178–179. They appear to have moved between February 10 and February 23, as indicated by letters from Colonel Parker (EPE).

18 Elisabeth moved with them: Mansfield, Elvis the Soldier, p. 49.

18 He explained to her: Bob Graham, "Elvis and Elisabeth," The [London] Sunday Times Magazine, August 3, 1997, p. 30.

18 Elvis knocked three times: Mansfield, Elvis the Soldier, p. 49.

18–19 "There would be at least a couple of girls": The [London] Sunday Times Magazine, August 3, 1997, p. 30; also Mansfield, Elvis the Soldier, pp. 49–50.

19 They moved into . . . Goethestrasse 14: Goldman, *Elvis*, pp. 299ff; Nash, *Elvis Aaron Presley*, pp. 147ff; West et al., *Elvis: What Happened?*, pp. 179ff; Schroer, *Private Presley*, pp. 36ff.

20 Charlie brought Elvis an album: Interview with Charlie Hodge.

20 In his first extended interview: This January 30, 1959, interview with DJ Keith Sherriff was transcribed in *Movie Life*, May 1959, which was supplied to me, along with a description of the circumstances of the interview, by Sherriff's daughter, Linda Raiteri.

20 He talked to them about the movie contracts: Mansfield, Elvis the Soldier, passim.

20 They had fireworks battles: Ibid.

20–21 Elvis had his own private barber: Ibid., p. 49; Schroer, Private Presley, p. 41; Nash, Elvis Aaron Presley, p. 164.

21 the pills that a sergeant had introduced him to: Mansfield, *Elvis the Soldier*, pp. 67–68; Priscilla Presley, *Elvis and Me*, p. 52; West et al., *Elvis: What Happened?*, p. 186; interviews with Charlie Hodge, 1989, and Joe Esposito, 1990–1998.

21 Rex still wondered: Mansfield, Elvis the Soldier, pp. 67-68.

21-22 As for Elisabeth: Ibid., pp. 50-54.

22 "One had to be very careful": Ibid., p. 148.

22–25 In March he decided to venture to Munich: The account of the trip is based primarily on *Private Elvis*, edited by Diego Cortez, in which interviews with Vera Tschechowa, Toni Netzel,

and Elisabeth Brandin are included; also, Schroer, *Private Presley*; West et al., *Elvis: What Happened?;* Nash, *Elvis Aaron Presley*; and "Elvis on a Date with His Mystery Girl" (fan magazine article, 1959).

25 he got a hard-on: Jones, *Soldier Boy Elvis*, p. 210. Further observations and quotes from both Jones and Taylor, *Elvis in the Army*.

25 "Sometimes I feel like just quitting": Taylor, Elvis in the Army, pp. 96–97.

25–26 Colonel on his end: The Colonel's encouragement of Elvis, his articulation of longrange plans, and his negotiations on various fronts are all meticulously documented in his voluminous and energetic correspondence (EPE).

26 when they returned to the negotiating table: Elvis' RCA royalty rate was amended on May 7, 1959. Ren Grevatt's March 7, 1960, *Billboard* article, "Added Leeway for Phenom's Recordings," provides considerable insight into the upshot of all the Colonel's machinations.

27 Colonel had planted a flurry of confusing . . . items: September 15 and November 24, 1958, stories in *Variety*, among others.

27 Colonel finally bowed: Parker letter to Elvis and Vernon, November 10, 1958 (EPE); contract with Wallis, possibly backdated to October 28. All of the correspondence with Wallis and Joe Hazen is available in the Elvis Presley General Correspondence Files, Hal Wallis Collection, Margaret Herrick Library, Academy of Motion Picture Arts and Sciences Library (HWC/MPASL).

27 "we do not have to call on Wallis": Colonel to Elvis and Vernon, November 18, 1958 (EPE).

28 In Colonel's scenario: Colonel to Hal Wallis, December 13, 1958. Wallis reply December 18 (HWC/MPASL).

28 In this one, Elvis is a foundling: Colonel to Wallis, December 18, 1958 (HWC/MPASL).

28 Wallis . . . remained patiently forbearing: Correspondence between Wallis and various writers and producers, January 1959 (HWC/MPASL).

28 stories planted in the press: May Mann, *Elvis and the Colonel*, p. 98; James Gregory, *The Elvis Presley Story*, p. 100; Levy, *Operation Elvis*, p. 64; Colonel's correspondence (EPE).

29 On a more formal basis: Colonel's correspondence, passim (EPE); Pat Embry, "The Colonel," *Nashville Banner*, June 12, 1987; interviews with Al Dvorin 1996–1998.

29-30 Vernon and Elisabeth were in an automobile accident: Mansfield, *Elvis the Soldier*, pp. 53-54.

30 Elvis' jealousy was plain for all to see: Ibid., p. 59.

30 As for Red: West et al., *Elvis: What Happened?*; Nash, *Elvis Aaron Presley*; interview with Red West, 1996; Jerry Hopkins interview with West (MVC/UMem).

31 "Vernon and Bill really got drunk": West et al., Elvis: What Happened?, pp. 185-186.

31 Dee Stanley returned to Virginia: Dee Presley et al., *Elvis, We Love You*, p. 54; telephone bills from Germany from May 13 (EPE).

31 an on-air interview with Memphis DJ George Klein: Memphis Press-Scimitar, May 8, 1958.

31 "Red kept telling me": Interview with Alan Fortas.

31 Colonel even set up a tentative date: Colonel Parker's correspondence with Elvis and Vernon, May 1959, establishes an estimated June 17–19 date of arrival, with various contingency plans. Elvis' frequent phone calls are confirmed by telephone records (EPE).

32 he called Cliff Gleaves: Interview with Cliff Gleaves, 1990.

32 he promptly took off again: Mansfield, Elvis the Soldier, p. 98.

32 wearing "nothing but a standard-size Presley record": AP wire report, June 17, 1959.

32–33 it was off to Paris: The primary sources here are interviews with Lamar Fike, Charlie Hodge, and Freddy Bienstock; Mansfield, *Elvis the Soldier;* West et al., *Elvis: What Happened?;* and Nash, *Elvis Aaron Presley.*

34 "Lamar got angry": Mansfield, Elvis the Soldier, p. 95.

34 One night at the Lido: New York Journal-American, June 21, 1959.

34 his "'she' was a 'he'": Nash, Elvis Aaron Presley, p. 166.

35 He had some business: New York Post, July 8, 1959.

35 He had accompanied her to the airport: Dee Presley et al., Elvis, We Love You, p. 55.

35 "so changed you wouldn't know him": Memphis Press-Scimitar, July 8, 1959.

35-36 "I got sent home from school": Clayton and Heard, Elvis Up Close, p. 164.

36 he was not to participate in filming: Colonel to Elvis, July 2, 1959 (EPE).

36 He had put in a lot of time: Mann, Elvis and the Colonel, pp. 87–90.

36 Priscilla, just fourteen, had been elected: Suzanne Finstad, Child Bride: The Untold Story of Priscilla Beaulieu Presley, p. 40.

36–39 Her real father: Priscilla Presley, *Elvis and Me*, p. 22. Most of the following account, and all of the quotes, come from Priscilla's book. It should be noted that Currie Grant in Suzanne Finstad's *Child Bride* claims that it was the fourteen-year-old Priscilla who approached him and he who was the not-so-innocent victim. From the testimony of those who were present — Cliff Gleaves, Lamar Fike, Joe Esposito, Charlie Hodge, and Rex and Elisabeth Mansfield in their book — Priscilla's certainly seems the more credible account, and that is the one I have chosen for the most part to follow here.

39 Elvis was immediately smitten: Mansfield, *Elvis the Soldier*, p. 98; interviews with Charlie Hodge, Cliff Gleaves, Joe Esposito, et al.

39 "As Currie led me over": Priscilla Presley, Elvis and Me, p. 28.

40 ""We are alone,' I said nervously": Ibid., p. 31.

40 "he was just a boy": Interview with Priscilla Presley, 1995.

40 At the end of the evening: Priscilla Presley, Elvis and Me, pp. 35ff.

42 "I really felt I got to know": Interview with Priscilla Presley.

42 "He talked about": Ibid.

43 the benefits of yogurt: Ibid.

43 "Goodnight, My Love": Ibid.

43 "Did you see the bone structure": BBC interview with Charlie Hodge.

43 "Every Sunday afternoon": Joe Esposito, Good Rockin' Tonight, p. 48.

43 "He knew she was young": Interview with Joe Esposito, 1990.

43 "I often wanted to ask": Mansfield, Elvis the Soldier, p. 121.

44 for singing only two songs: Colonel to Elvis, January 9, 1960 (EPE).

44–45 There were a number of songs: The intended repertoire for this and future sessions derives from the Colonel's correspondence (EPE), interviews with Freddy Bienstock, Cliff Gleaves, Priscilla Presley, and Charlie Hodge; Peter Cronin interview with Gordon Stoker; Schroer, *Private Presley*, p. 5; and home tapes recorded in Germany.

45 a steady flow of Hill and Range material: Interview with Freddy Bienstock, 1992; David M. Nichol, "Here Comes Elvis Presley!," *Chicago Daily News*, February 20, 1960.

45 what you sang had to come from the heart: Elvis expressed this sentiment many times, most proximately in Pat Anderson, "Elvis Fears Nothing — But His Fans," *Nashville Tennessean*, March 22, 1960.

46 studying familiar records by the Ink Spots: Interview with a girlfriend who chooses not to be identified, 1995.

46 Freddy did his best: Colonel to Elvis, January 9, 1959 (EPE).

46 he had a song: Colonel to Elvis, October 31, 1959 (EPE).

46 Freddy's sardonic view: Interview with Freddy Bienstock.

46–47 In October Elvis saw a magazine notice: Nearly all of the information on the Landau incident is contained in the FBI files on Elvis Presley, Part 1, pp. 88–111.

47 Vernon was convinced: Priscilla Presley, Elvis and Me, p. 45.

668 💊 NOTES

47 Elvis began formal karate lessons: Elvis' initial fascination with karate was described in interviews with Red West, Joe Esposito, and Charlie Hodge; also, see Mansfield, *Elvis the Soldier*, pp. 58, 68, 156. Elvis kept his original "Testakarte Karate" from Seydel's school in his wallet, with his first test dated December 6, 1959 (EPE).

47 The sonofabitch was queer: Mansfield, Elvis the Soldier, p. 55.

47 Vernon was utterly panic-stricken: Emergency call to Colonel Parker logged December 26, 1959 (EPE).

48 his twenty-fifth birthday party: Esposito, *Good Rockin*', p. 39; Mansfield, *Elvis the Soldier*, p. 107; interview with Joe Esposito, 1990; Dee Presley et al., *Elvis, We Love You*, p. 52.

48 ELVIS PRESLEY. MOST VALUABLE PLAYER: Esposito, Good Rockin', p. 40.

48–49 Grandma had seen where things were going: The account of Rex's courtship of Elisabeth is derived primarily from Mansfield, *Elvis the Soldier*, pp. 109–110. Also interview with Cliff Gleaves, and Hodge, *Me'n Elvis*, p. 44.

48–49 Lamar and Cliff knew: Mansfield, Elvis the Soldier, p. 103.

49 Elvis went to Paris: The account of Elvis' second Paris trip is based primarily on interviews with Joe Esposito and Cliff Gleaves; Ernst Jorgensen interview with Orlandis Wilson; and Schroer's *Private Presley*, p. 133. The dates are established by bills from the trip (EPE).

49 "Rexadus," he said: Mansfield, Elvis the Soldier, p. 103.

49 his full sergeant's stripes: AP dispatch, February 16, 1960; Schroer, *Private Presley*, p. 140; Mansfield, *Elvis the Soldier*, p. 103.

49 "After a second, I said": Priscilla Presley, Elvis and Me, pp. 51-52.

50 "People were expecting me to mess up": Armed Forces Network (AFN) interview.

50 his manager, Colonel Parker: *Chicago Daily News*, February 20, 1960. The rest of his responses are divided between this extensive interview, the AFN broadcast, and various other February 1960 interviews, all of which cover more or less the same ground.

50-51 he talked to each of the boys: Interviews with Joe Esposito, Cliff Gleaves, Lamar Fike, and Charlie Hodge.

51 Rex was the one: Mansfield, Elvis the Soldier, p. 136.

51 more than two dozen trunks: Memphis Commercial Appeal, March 3, 1960.

51-52 Over one hundred reporters: Robert Johnson, "Elvis Leaves Army! — Memphian's Eyewitness Report," *Memphis Press-Scimitar*, March 1, 1960. Both the press conference and various observations about life and love are contained in this story (which features Marion Keisker as the eyewitness, using her married name, MacInnes) and Thomas Pappas' "Homeward Bound — And He's Leaving 'Very Pretty Brunet' in Germany," also in the March 1 edition of the *Memphis Press-Scimitar*, See, too, Schroer, *Private Presley*, pp. 150ff.

52 "Marion!" he called out: Interviews with Marion Keisker, 1979, 1986; Jerry Hopkins interview with Marion Keisker (MVC/UMem); plus March 1, 1960, *Memphis Press-Scimitar* account.

53 She was very fond of Elvis: AP report, March 1, 1960; New York Mirror, March 2, 1960.

53 "More than ten tall Air Force police": New York Mirror, March 3, 1960.

53 "Girl He Left Behind": "Farewell to Priscilla, Hello to U.S.A.," Life, March 14, 1960.

53 "When he left": Interview with Priscilla Presley.

ELVIS IS BACK

55–56 He was dressed all in black: This account of Elvis' homecoming is drawn primarily from Thomas Michael, "Elvis and Fans Share Thrills at His Joyous Homecoming," *Memphis Commercial Appeal*, March 8, 1960; Bill E. Burk, "Elvis Plans to 'Stay Right At Home' for a Few Days," *Memphis Press-Scimitar*, March 8, 1960; Malcolm Adams, "Elvis Wanted 'to Get Home' but 'Kind of Likes' Uniform," Memphis Commercial Appeal, March 8, 1960; AP report in Nashville Tennessean, March 8, 1960.

56 He had written to her: BBC interview with Anita Wood.

56 he asked her to hide a half-gallon jar: Bob Graham, "Elvis and Elisabeth," The [London] Sunday Times Magazine, August 3, 1997, p. 32.

56 she had better be careful: Rex and Elisabeth Mansfield, *Elvis the Soldier*, pp. 139, 141. According to Elisabeth's account in *Elvis the Soldier*, Anita was waiting for Elvis at Graceland when he came back from the train station, but I have rearranged the chronology in order to conform to the more common recollection.

56 He went to the cemetery: Barbara Hearn, "Elvis Answers 40 Intimate Questions," 16, August 1960.

56 "memories and sadness": Memphis Press-Scimitar, July 7, 1960. Elvis spoke of all of his visits as having this effect.

56 "the mysterious blonde": UPI report, March 6, 1960.

57 "Well, you know I'm not being honest": James Reid, "Elvis' Dad, Blond Arrive Together at Station," *Memphis Press-Scimitar*, March 5, 1960.

57 "Let's not talk about that": Ibid.

57 "He didn't seem like Elvis": Interview with Lillian Fortenberry, 1988.

57-58 he went to the ice show: For this and other details of Elvis' nearly two weeks at home, the *Memphis Press-Scimitar* and *Commercial Appeal* are the principal sources of information.

57 "I could stay with Elvis": Mansfield, Elvis the Soldier, pp. 140–141.

58 "I was very serious": Ibid., p. 143.

59 except for a signed photo: The [London] Sunday Times Magazine, August 3, 1997, p. 32.

59–61 "He hadn't made a sound": Ray Walker quoted in Rose Clayton and Dick Heard, eds., Elvis Up Close: In the Words of Those Who Knew Him Best, pp. 168–169. With regard to this session, I interviewed Scotty Moore, Bob Moore, Buddy Harman, Freddy Bienstock, Joe Esposito, and Bill Porter, among others. In addition, Pat Twitty, "What Happened When... Elvis Started Waxing Again," New Musical Express, April 1, 1960, and Pat Anderson, "Elvis Presley: Lonely Man in a Crowd," Nashville Tennessean, April 24, 1960, both focus on the sessions.

60 "Of course he talked": Interview with Bill Porter, 1993. See also John W. Rumble, "Behind the Board: Talking with Studio Engineer Bill Porter," *Journal of Country Music*, vol. 18, no. 1 and no. 2, vol. 19, no. 1 (1996–1997); and David Okamoto, "Engineering the Hits for Elvis," *Gazette Telegraph* (Denver), August 15, 1988.

61 "it was just unreal": Interview with Scotty Moore, 1990.

61 "Everybody would just get in his car": Interview with Scotty Moore, 1989.

61-62 For Joe and Lamar: Joe Esposito, Good Rockin' Tonight, p. 61.

62 he was determined to keep on his toes: Interview with Joe Esposito, 1990.

62 The first meeting: Esposito, Good Rockin', p. 61.

62 Joey Bishop, unctuously requested an autograph: May Mann, *Elvis and the Colonel*, p. 99.
62 excluded from all social activities: Peter Mikelbank, "D. J. Fontana: Elvis' Drummer Capsulizes the King's Career," *Goldmine*, August 14, 1987, p. 14; Jerry Hopkins interview with Gordon Stoker 1971 (MVC/UMem).

62 "But after all, the kid's been away": Rick Du Brow, "500,000 Await Elvis Today," UPI report, March 5, 1960.

 $63\,$ four hundred fan club presidents and members: The best accounts of the taping are in TV Guide, May 7–13, 1960.

63–64 Elvis got a letter: Colonel to Elvis, March 30, 1960 (EPE). Despite the Colonel's frequent assertions over the years, I have been unable to locate any Gene Austin recorded version of

this title. I asked the Colonel about this, and he was adamant that Austin had recorded it. He may well have, but it is now my assumption that it must at least have been a part of his stage act.

65 Bill Porter suggested: Interview with Bill Porter.

65 he had promised Charlie: Interview with Charlie Hodge, 1989.

65-66 "He chased everybody out of the studio": Interview with Chet Atkins, 1988.

65 Bill Porter was editing: Interview with Bill Porter. It should be noted that in Porter's recollection the first complete take was the basis for the master, and the ending was spliced from the fifth and last, but the reverse appears to have been the case.

66 One night he called up gospel singer James Blackwood: Interview with James Blackwood, 1988.

67 Elvis' presence caused such a commotion: BBC interview with Anita Wood; Shelley Ritter interview with George Klein.

67 another triumphant three-day whistle-stop trip: "Presley Hits H'wood Like Ton of Bricks," *Billboard*, April 25, 1960.

67 a personal retinue: Newsweek, May 30, 1960.

67 "We hadn't talked about me working with him": Interview with Charlie Hodge.

67 Sonny, three years younger than Elvis: Red West et al., Elvis: What Happened?, p. 26.

68 Elvis took special pride: In a 1962 interview with Lloyd Shearer he reveals both his insecurity and his pride; also see "Is This a 'New' Presley?," *Newsweek,* May 30, 1960, where Elvis says "defensively" of an unnamed Joe: "He was a bookkeeper before he went in the Army."

68 "we were a bunch of hicks": West et al., Elvis: What Happened?, p. 250.

68 A leader . . . had a different role: Two of Elvis' favorite inspirational homilies were "The Penalty of Leadership" and Theodore Roosevelt's "The Man Who Counts." In *Good Rockin' Tonight*, Joe Esposito describes Elvis having the former framed on his wall at Goethestrasse 14 in Germany.

69 his pet likes and dislikes: Barbara Hearn, "Elvis Presley: My Hates and Loves," 16, November 1960.

69 that night went out to a club: Interview with Lance LeGault, 1990; interview with Sandy Ferra Martindale, 1995, who cited the date from her diary.

70 "He came to the studio": Interview with Bones Howe, 1989.

70 "business" reasons: The Colonel effectively cut Leiber and Stoller out of the picture by insisting that they operate under the same rules as every other Hill and Range writer, a deal he had long since learned they would not accept. Also, letter to Jean Aberbach, November 23, 1959 (EPE).

70 "Hell, what could he say?": Priscilla Presley, Elvis and Me, p. 64.

70 By this time . . . he had met Sandy Ferra: Interview with Sandy Ferra Martindale.

71 his beautiful twenty-three-year-old South African co-star: Background on Juliet Prowse comes primarily from Jon Whitcomb, "Elvis and Juliet," *Cosmopolitan*, October 1960.

71 "He was a very young twenty-four": Interview with Sandy Martindale.

72 the eccentric actor Billy Murphy: Interviews with Joe Esposito, Cliff Gleaves, George Klein; for (a little) more on Murphy, see *Last Train to Memphis*, pp. 439, 470.

72 Gene's briefcase: Alanna Nash, Elvis Aaron Presley: Revelations from the Memphis Mafia, p. 81.

72 "I don't do a goddamn thing": West et al., Elvis: What Happened?, p. 250.

72–73 "None of us," by Joe's account: Esposito, *Good Rockin*', p. 84; also, see Sonny West on the life in West et al., *Elvis: What Happened*?, p. 189.

73 Elvis attended a demonstration: Interview with Ed Parker, 1990.

73 "He was intrigued": Ed Parker, "'The King' and I" (article in British fan magazine).

74 it was his relationship with Juliet Prowse: This story is told in fairly close variants in West et al., *Elvis: What Happened?*, p. 253; Nash, *Elvis Aaron Presley*, p. 176; and, with Red West as narrator, in Clayton and Heard, *Elvis Up Close*, pp. 177–178. The point is always the same.

74 "He said Juliet liked to grab her ankles": Nash, Elvis Aaron Presley, p. 176.

74–75 The Colonel made a particular point: Colonel to Hal Wallis, summer 1960 (HWC/MPASL).

75 he entertained reporters' questions: Mann, Elvis and the Colonel, p. 134; Billboard, April 25, 1960, re \$150,000.

75-76 "All they're good for is to make money": Jean Bosquet, "Parker Learned Name — Fast," New York Journal-American, June 13, 1960.

75 "I'm not his father": Ibid.

75 "He could go back to driving a truck": "The Man Who Sold Parsley," Time, May 16, 1960.

76 the movie that would someday be made: Louella Parsons column, New York Journal-American, June 27, 1960.

76 Elvis' little joke to call him Admiral: Lloyd Shearer feature, Parade, June 19, 1960.

76 They had visited once: Hotel bill May 28–29 (EPE). West et al., *Elvis: What Happened?*, p. 190, has this as their first visit.

76-77 as far as Barstow: West et al., Elvis: What Happened?, p. 191.

77 The joke around town: Nash, Elvis Aaron Presley, p. 190.

77 he and Gene took a plane: Memphis Press-Scimitar, July 1, 1960.

77 They were going to do it: James White, "Elvis Decided Weeks Ago Not to Attend Dad's Wedding — Here's Why," *Memphis Press-Scimitar*, July 7, 1960. The quitclaim to Graceland was executed on August 12 (EPE).

77 "She spoke to me": Memphis Press-Scimitar, July 5, 1960.

77 "She seems to be a pretty nice . . . person": Memphis Press-Scimitar, July 7, 1960.

78 His uncles Travis, Johnny: For some detail on intrafamilial tensions, see Harold Loyd, *Elvis Presley's Graceland Gates*, pp. 42, 47; Nash, *Elvis Aaron Presley*, p. 101; interview with Lillian Fortenberry; numerous letters from Vernon in Germany to his lawyer at home (EPE); and Donna Lewis' diaries, *"Hurry Home, Elvis!*," vols. 1 and 2.

78 he felt as if there were a cloud: Robert Johnson, "Even Movie Stars Get Homesick," Memphis Press-Scimitar, September 9, 1960.

78 "a laughingstock": Don Siegel interview in 1972 radio documentary, "The Elvis Presley Story," cited in Gerry McLafferty, *Elvis Presley in Hollywood*, p. 51.

79 overcame his objections: Don Siegel, *A Siegel Film: An Autobiography*, pp. 222–227. See also Lee Belser, "Elvis Can Act, Says Director," *Los Angeles Mirror*, November 30, 1960.

79 There was to be a minimum of songs: Peter Whitmer suggests many additional studio complications in *The Inner Elvis: A Psychological Biography of Elvis Aaron Presley*, pp. 319ff.

79 Siegel's own recollection: Rolling Stone, September 22, 1977.

79 they started off with karate: Conversation with Lamar Herrin, 1990.

79 He generously loaned: Siegel, A Siegel Film: An Autobiography, p. 227.

79 nonstop games of touch football: Sonny West quoted in Rolling Stone.

79-80 "Acting skill will probably ruin him": Jerry Hopkins, Elvis, p. 163, quoting from an interview by Joe Hyams in the New York Herald Tribune.

80 Tuesday Weld throwing a fit: Esposito, *Good Rockin'*, pp. 84–85; Albert Goldman, *Elvis*, pp. 331–332, tells a story not involving Tuesday but, rather, a water fight and an elderly guest.

80 a six-month lease: The original lease dated from September 10 and was at a rate of \$1,400 a month (EPE).

80 Elvis put up a painted photograph: Goldman, Elvis, p. 334; Alan Fortas, Elvis: From Memphis to Hollywood, p. 150.

80 "When I first came back": Memphis Press-Scimitar, September 9, 1960.

80–81 he heard from the Tau Kappa Epsilon fraternity: Interview with Rick Husky, 1995; Rick Husky, "World Famous Entertainer Presented Coveted Award," *State College Herald*, November 4, 1960.

82 a recurring nightmare: Interview with Freddy Bienstock, 1992. See also Nancy Anderson, "My Cherished Memories of Elvis," *Elvis Presley: A Photoplay Tribute*, 1977, p. 11.

83 there was no question of either his fervor: Interviews with Bob Moore and Gordon Stoker: also Peter Cronin interview with Bob Moore, 1993.

83 Chet Atkins had long since gone home: Jay Orr interview with Gordon Stoker.

83 "I had food poisoning": Interview with Bill Porter.

83 To Gordon Stoker and the Jordanaires: Trevor Cajiao interview with Gordon Stoker, *Elvis: The Man and His Music* 25, December 1990, p. 23. It should be noted that publishing was cleared on "Crying in the Chapel" prior to this session, despite the long-standing popular belief that the song's release was held up for five years on that issue. Evidently, Elvis was simply not satisfied with his version of the song.

83 the "new" Elvis: Billboard, July 18, 1960, re the song; Variety, November 2, re the movie.

83 his all-out campaign: Colonel's correspondence with Hal Wallis, October 10, 18, 19, 1960 (HWC/MPASL).

83–84 At RCA, meanwhile: Colonel's correspondence with RCA, January–February 1960, with a January 15 memo for January 18 and 19 meetings in which his control (and, essentially, ownership) of all photos is established particularly crucial. In addition, a special three-quarters of I percent royalty to All Star Shows for promotional activities is established, with a final contract, effective January I, certifying all of these terms and more, signed on March I, 1960 (EPE). Further insight into the meaning of these maneuvers was provided in interviews with Joan Deary, 1990, and Anne Fulchino, 1993.

84 they even offered to build Elvis a studio: Elvis letter to RCA vice president Bill Bullock, November 8, 1960, formally declining the offer; interview with Scotty Moore, 1990.

84 Wild in the Country started shooting: Background on Wild in the Country is derived primarily from Elaine Dundy, Elvis and Gladys, p. 302; Whitmer, The Inner Elvis, p. 322; Mann, Elvis and the Colonel, p. 128; and interview with Freddy Bienstock.

85-86 the only one who seems to have taken a dim view: Interview with Millie Perkins, 1990, from which all Perkins quotes derive.

85 "I think I won a unique place": Philip Dunne, Take Two: A Life in Music and Politics, p. 299.

87 he pulled a derringer: West et al., *Elvis: What Happened?*, p. 258. Alan Fortas in *Elvis: From Memphis to Hollywood*, p. 132, says it was pain pills for a boil that loosened Elvis' inhibitions.

87 he flared up: Fortas, Elvis: From Memphis to Hollywood, p. 151; Esposito, Good Rockin', p. 83.

88 Elvis uncharacteristically joined her: Fortas, Elvis: From Memphis to Hollywood, p. 130.

88 Anita came out for a brief visit: Anita Wood quoted in Clayton and Heard, Elvis Up Close,

p. 180. It should be noted that Wood has placed the date of this event in various interviews at several different junctures, including the filming of *Blue Hawaii* five or six months later. Because May Mann has Anita visiting at this time (*Elvis and the Colonel*, pp. 116–117), and because of the date of Elvis and Anita's breakup in the summer of 1962, I have chosen this particular version as the earliest dating of the argument, though I think it more than likely the same discussion arose more than once.

88 "We'd just spend hours dancing": Interview with Sandy Martindale.

89 The movie was briefly threatened: Dunne, Take Two, p. 295.

89 given just one week off: Ticket receipts for four for return flight from Memphis January 2 (EPE).

89 he and his daddy quietly agreed: Arlene Cogan is quoted as believing that it was the drapes that were the issue in Clayton and Heard, *Elvis Up Close*, p. 182; also, interview with Lillian Fortenberry.

89 "There will be no passes": Memphis Press-Scimitar, December 20, 1960.

89 there was a small party: A photograph of the party, with cast and cake, is in Fortas, *Elvis: From Memphis to Hollywood*, p. 130.

89 he was recalled: Memphis Press-Scimitar, February 5, 1961.

THE COLONEL'S SECRET

91 "Parker said Elvis was coming": Sue Wiegert, "Elvis: Precious Memories," vol. 1, p. 97.

91-92 "This is the real McCoy, fellas": Honolulu Advertiser, January 12, 1961.

92 "the greatest one-day charity show": Memphis Press-Scimitar, February 8, 1961.

92 the "Hawaiian story"... that he had first proposed: Colonel letter to Hal Wallis, December 13, 1958 (HWC/MPASL).

92 "sold out for motion pictures through 1965": Letter to Bill Bullock, January 20, 1961 (EPE).

92–93 "Just remember, boys": Joe Esposito, *Good Rockin' Tonight*, p. 60. Esposito has this taking place at Graceland, but given the Colonel's excitement and the fact that Elvis was only released by Fox on that day, there seems little doubt that if the Colonel visited anywhere, it was Perugia Way. Alan Fortas has the Colonel calling Elvis and the guys to the studio at 10:30 in the morning and getting MGM to throw in an ashtray, though he dates this as 1963 in *Elvis: From Memphis to Hollywood*, pp. 213, 216.

93 yet another twist: This was proposed at a January 16, 1961, meeting, whose minutes reveal that Colonel claimed to be bypassing a lucrative Australian appearance for the charity concert. Colonel proposed that the television show could end with Elvis on a flower-strewn barge at the *Arizona* memorial singing "Peace in the Valley." Lastfogel's comment stems from this same meeting (EPE).

93 its closets still filled with Gladys' clothing: Billy Stanley, Elvis, My Brother, p. 5.

93 the flowers that were delivered: Bills for weekly order (EPE).

93 he drove down to Tupelo: Interview with Joe Esposito, 1990; see also reference to this trip at the February 25 press conference for the Memphis charity concert.

94 He couldn't help but feel: Elvis' disappointment about the lack of progress on the park was frequently and volubly expressed. See also Jerry Hopkins interviews with Jim Ballard, J. M. Savery, and John Tidwell, as well as articles in the *Tupelo Daily Journal* on August 26, 1960, June 8, 1962, and October 18, 1965, among others, on the (very slow) rate of progress. The view of East Tupeloans in general that they were somehow being shunted aside was expressed both to me and to Elaine Dundy by Tupelo historian Roy Turner.

94 Gene's brother, Junior, died: Alanna Nash, Elvis Aaron Presley: Revelations from the Memphis Mafia, p. 213; interview with Joe Esposito, 1990.

94 "I can see him just standing there": Interview with Eddie Fadal, 1993.

94-95 "He had a fear": Nash, Elvis Aaron Presley, p. 207.

95–96 the latest in a series of letters: Much of the information about the Colonel's background in Breda, and his family's discovery of his fame, comes from the Dutch journalist Dirk Vellenga, who, in addition to his published work, *Elvis and the Colonel*, generously shared his manuscript and views with me. **97** Elvis held a rehearsal: *Memphis Press-Scimitar*, February 25, 1961; interviews with Scotty Moore, 1990, Bob Moore, 1989. See also the Hawaii press conference.

97-98 The matinee performance: Memphis Commercial Appeal, February 26, 1961; Memphis Press-Scimitar, February 27, 1961.

98 "He just had kind of an effervescence": Jerry Hopkins interview with Ray Walker, 1971 (MVC/UMem).

98 On the way back to Memphis: Nashville Banner, March 9, 1961; Colin Escott liner notes to Prisonaires CD on Bear Family Records.

99 just twelve songs were recorded: One, "I Feel So Bad," was eventually removed from the album lineup to be released as a single.

99–100 Julian Aberbach invited Robertson: Bar Biszick interview with Don Robertson, 1993.100 "I sat in the control room": Interview with Don Robertson, 1989.

101–102 "I didn't know what staying with Elvis involved": Shelley Ritter interview with Minnie Pearl, 1990.

102 The press conference was scheduled: Honolulu Sunday Advertiser, March 26, 1961.

103 "one of the highlights": Jan-Erik Kjeseth interview with Boots Randolph, *Elvis: The Man* and His Music 8, September 1990, p. 27. Gordon Stoker and Ray Walker describe Elvis' spontaneity in their 1971 interview with Jerry Hopkins, and Walker has Elvis sliding across the stage (MVC/UMem).

104 Hal Wallis had to move the female cast: Fortas, Elvis: From Memphis to Hollywood, p. 165.

104 Wallis had little use for the guys: Ibid., p. 168.

104 Elvis got together with Patti Page: English music weekly article on Charles O'Curran, c. summer 1961; Colin Escott interview with Patti Page.

104 he interviewed tourists: Jerry Hopkins interview with Ron Jacobs (MVC/UMem). Alan Fortas has a variant on this story in *Elvis: From Memphis to Hollywood*, p. 162.

104 hypnotized the boys: Fortas, Elvis: From Memphis to Hollywood, p. 165.

104 and halted shooting one day: This is an oft-repeated story with many variants. This version stems from Allan Weiss' interview for the documentary *Elvis in Hollywood*; Jerry Hopkins' interview with Ron Jacobs; and my interviews with Al Dvorin, 1996–1998, who has the Colonel charging for his own walk-on.

105 "and he [was] telling all the crew": Red West et al., Elvis: What Happened?, p. 260.

105 "We had all been drinking": Ibid., pp. 260–261; Fortas recounts the same incident in Elvis: From Memphis to Hollywood, p. 145; Albert Goldman has another variant in Elvis, p. 336.

105–106 To Hal Kanter: Interview with Hal Kanter, 1993.

106 "It was a while before he came over": Interview with Anne Fulchino, 1993.

106 one of those tricks: Fortas, Elvis: From Memphis to Hollywood, p. 171.

106–107 Patti Parry, an eighteen-year-old hairdresser: Interviews with Pat Parry, 1991 and 1995.

107 Once again she came across evidence: BBC interview with Anita Wood.

107 "I'll Wait Forever": The single, Sun 361, was released on June 25, 1961.

108 "we feel it proper": Colonel's telegram to Vice President Johnson, April 22, 1961.

108 He had created his own world: All information on the Snowmen's League, including booklet and member correspondence, is from EPE. See photo section of Larry Geller and Joel Spector's "If I Can Dream: Elvis' Own Story," for reproduction of cover and table of contents.

109 he was furious at his brother: Vellenga manuscript, pp. 189–192.

109–111 The man known as Colonel: This bare-bones outline of the Colonel's Dutch biography and early experiences in America is dependent upon research kindly supplied by Dirk Vellenga. 110 His mother started getting bank drafts: According to Vellenga, this was the outgrowth of an army program to encourage soldiers to help out their dependents.

111–112 "Sometimes we had to live on a dollar a week": This and most of the rest of the account of Ad's visit is from the *Rosita* article appearing in three successive weekly issues from July 1, 1961. It was translated by Sander Donkers. Some additional details were furnished by Dirk Vellenga from his interviews with the family.

111 the Colonel simply introduced Ad as "my brother": There is much debate about whether or not Elvis deduced from this anything of the Colonel's origins — or whether, more in keeping with the Colonel's sense of humor, Ad simply remained mute. Lamar Fike told me that he thought Elvis suspected, but in Nash, *Elvis Aaron Presley*, p. 65, he expresses his certainty that Elvis did not know. In a 1990 interview Gabe Tucker spoke of "Elvis' suspicion that that's the part of the world he come from," but I suspect Lamar is right when he says in the Nash book that if Elvis *had* known, he never could have kept it secret. Just how widespread the knowledge was in Holland is indicated by numerous conversations I have had with Dutch fans and writers over the years and the 1970 publication in English of Hans Langbroek's *The Hillbilly Cat*, setting forth the basic facts before any non-Dutch researcher had come across them.

111–112 the only acknowledgment they ever got: Vellenga manuscript and correspondence.

112 pressure from Steve Sholes and Bill Bullock: Bullock letter to Colonel, May 4, 1961 (EPE).

112 The idea of a home studio: Memphis Press-Scimitar, March 30, 1961.

112 Bullock wrote to the Colonel: May 4 letter. The Colonel's response came the next day, touching on everything from poor singles selection by RCA to threats of audits on foreign sales to the fact that Elvis would have no interest in a studio of his own anyway.

112 two other Pomus-Shuman contributions: Trevor Cajiao interview with Mort Shuman, *Elvis: The Man and His Music* 8, September 1990; interview with Doc Pomus, 1984.

113 Red had actually been writing songs: Background on Red West's songwriting comes primarily from various interviews by Trevor Cajiao in *Elvis: The Man and His Music* and *Now Dig This!*; also Jerry Hopkins interview with Red West (MVC/UMem). Both "Big, Big World" and "A Thousand Years," the back of Pat Boone's number-one hit "Moody River," charted in May 1961.

113 to get Hill and Range interested: Tom Diskin wrote Freddy Bienstock a number of letters about Red between January and May 1961. Freddy appears totally indifferent until on May 19 Diskin stipulates that Elvis is "interested in the song 'You'll Be Gone'" (EPE).

113 He had fooled around with it: Jerry Hopkins interview with Red West (MVC/UMem); Red spoke to me about the origin of the song in 1989.

113 Red got married: Memphis Commercial Appeal, July 1, 1961; interview with Joe Esposito, 1990.

113 after a riotous Fourth of July fireworks fight: Rick Husky, "My Amazing Weekend with Elvis," *Movieland and TV Times*, October 1961.

113 he and the guys all left: Fortas, Elvis: From Memphis to Hollywood, p. 177; Nash, Elvis Aaron Presley, p. 225; various local Florida clippings supplied by Bill Bram.

114 the bizarrely paranormal proceedings: Ger Rijff and Jan van Gestel, *Elvis: The Cool King*, pp. 8ff; various local accounts (clippings and interviews) supplied by Bill Bram.

114 he even visited an elephant: Goldman, Elvis, p. 133.

114 to get rid of a recent addition: Fortas, *Elvis: From Memphis to Hollywood*, p. 232; Nash, *Elvis Aaron Presley*, p. 230; interview with Joe Esposito, 1997.

114 The director, Gordon Douglas: Jerry Hopkins interview with Gene Nelson (MVC/ UMem).

114–116 Annie Helm, who was playing the ingenue role: Most biographical information and all quotes from interview with Anne Helm, 1995.

116 The Colonel joked: Fortas, Elvis: From Memphis to Hollywood, p. 173; Nash, Elvis Aaron Presley, p. 258.

116 "it was a party": Interview with Joe Esposito, 1990.

116 his weight had ballooned: Memphis Press-Scimitar, April 3, 1963. In this interview Elvis says that his weight was up to 197 pounds during the making of Kid Galahad.

116 "a muscle-bound ape": West et al., Elvis: What Happened?, p. 263.

116 they moved into a new house: Nash, Elvis Aaron Presley, p. 190; Esposito, Good Rockin', p. 95; interview with Joe Esposito, 1997.

116 Elvis took a liking to Sonny's girl: Marty Lacker et al., Elvis: Portrait of a Friend, p. 39.

116-117 Marty Lacker, a friend of George Klein's: Fortas, Elvis: From Memphis to Hollywood, p. 187; Nash, Elvis Aaron Presley, p. 233.

117 a chimpanzee named Scatter: Bill E. Burk, *Elvis Through My Eyes*, p. 183; *The Record*, vol. 1, no. 8, p. 17; Fortas, *From Memphis to Hollywood*, p. 195. His biting of Dee Presley is described in Dee Presley et al., *Elvis, We Love You Tender*, p. 68; his wrecking of the hotel room is detailed in Nash, *Elvis Aaron Presley*, p. 239; his exhibitionism is described everywhere.

117 When there was nothing else to talk about: Interview with Jan Walner, 1991.

117 a three-bedroom, split-level ranch: The January 21, 1962, Memphis Commercial Appeal describes the house and has the Vernon Presleys moving in "shortly after Christmas."

117 The original plan: Patsy Andersen, "Farewell to Elvis' Friend, Alan Fortas," Graceland Express, vol. 7, no. 3, 1992.

117–118 Joe started dating Joanie: Interviews with Joe Esposito, 1990, and Joan Esposito, 1995.

118 the songwriter Don Robertson: Interview with Don Robertson.

118 Three times they set out: Nash, *Elvis Aaron Presley*, p. 236; interview with Joe Esposito, 1990.

119 time was meaningless: John L. Smith, "Longtime friend of Elvis reveals truth beyond the icon" (article on Joe Esposito in Las Vegas newspaper, February 1995).

NEGLECTED DREAMS

121 over a year now: First mention of looking into rights situation with "Begin the Beguine" in letter from Tom Diskin to Freddy Bienstock, January 3, 1961 (EPE).

122 to claim actual authorship: "I've never written a song in my life," Elvis declared in numerous early interviews. To *Dig* magazine in 1957 he responded to a question about his early songwriting credits with more than a trace of self-consciousness. "It's all a big hoax. It makes me look smarter than I am," he said, though he admitted reluctantly that he had had "an idea for a song. Just once" (*Dig*, 1958).

122 "he always tried to make the best": Ernst Jorgensen interview with Gordon Stoker.

123 far outstripping any studio album: Elvis' biggest album seller to date, *Elvis* (his second LP, which came out in 1956), had sold little more than 500,000 copies.

123 there was no real need for anything *but* the soundtrack music: The March 1, 1960, RCA contract spelled out that "any musical composition recorded for motion pictures shall be considered a part of this commitment against the eight single record sides and the two long play records required annually" (EPE).

124 "so I had my mom come pick me up": Interview with Sandy Martindale, 1995.

124 the girl that Sonny brought: Red West et al., *Elvis: What Happened?*, pp. 27ff; also, Alan Fortas, *Elvis: From Memphis to Hollywood*, p. 152; interview with Jan Walner, 1991; Patsy Guy Hammontree, *Elvis Presley: A Bio-Bibliography*, p. 49.

124-125 "He was so retarded": Interview with Jan Walner.

125 the two-way mirror: Fortas, Elvis: From Memphis to Hollywood, pp. 139, 191; West et al., Elvis: What Happened?, p. 279.

125 crawling under the house: Fortas, Elvis: From Memphis to Hollywood, p. 191; Fortas quoted in Rose Clayton and Dick Heard, eds., Elvis Up Close: In the Words of Those Who Knew Him Best, p. 188.

125 "a gift of the gods": Billy Stanley, Elvis, My Brother, p. 37; also, 1962 interview with Lloyd Shearer. The information about the football games comes from numerous interviews and written accounts.

125-126 Barris, the thirty-seven-year-old "King of the Kustomizers": Interview with George Barris, 1995.

126 put up a houseguest: Interview with George Barris. At first Elvis thought of Hal Wallis, according to Priscilla Presley (1995 interview).

126 He had started talking: Priscilla Presley, Elvis and Me, p. 67; interview with Priscilla Presley.

127 With Joe's cooperation: Interviews with Joe Esposito, 1990, and Joan Esposito, 1995.

127 Elvis sat all the girls down: Interview with Pat Parry, 1995; also Joe Esposito, Good Rockin' Tonight, pp. 94-95.

127 Joe picked her up: Esposito, Good Rockin', pp. 94-95.

127 They were met: Priscilla Presley, Elvis and Me, p. 69.

127-128 She wondered who was this . . . man: Ibid., pp. 70, 71; interview with Priscilla Presley.

128 "It was a shock": Interview with Priscilla Presley.

128 "Wait a minute, baby": Priscilla Presley, Elvis and Me, pp. 73-74.

129 "We drove all over": Interview with Priscilla Presley.

129 Every so often Gene would pounce: Gene Smith, Elvis's Man Friday, pp. 258–259.

129 "Do you believe this, baby?": Priscilla Presley, Elvis and Me, p. 79.

130 "[It was like] he'd decided": Interview with Priscilla Presley.

130 she made the mistake: Priscilla Presley, Elvis and Me, p. 83.

130 "there were definitely rules": Interview with Priscilla Presley.

130 "he fulfilled my every desire": Priscilla Presley, Elvis and Me, p. 92.

130-131 "my mother was crying with joy": Ibid., p. 93.

131 Elvis proudly showed off: Interviews with Barbara Bobo, 1992, and Bettye Berger, 1989.

131 There were lots of pills: Fortas, Elvis: From Memphis to Hollywood, p. 201.

131 "I wanted a husband": BBC interview with Anita Wood.

Says It's All Over," Memphis Press-Scimitar, August 6, 1962.

133 removing all the furniture: Fortas, Elvis: From Memphis to Hollywood, p. 201.

133 the new continental wardrobe: "Just a Drab Butterfly," Seattle Post-Intelligencer, September 17, 1962.

133 this was the interview: Lloyd Shearer interview for Parade magazine, August 6, 1956.

133 the second time around: Lloyd Shearer, "Elvis Presley: How He Changed His Public Image," Parade, November 4, 1962. Elvis' actual income for 1961 might have been closer to the tax figure cited above.

133 from "ever making a wrong move": Interview with Marion Keisker, 1982.

133-136 "I don't assume": This, and all subsequent quotes, are from Shearer's on-set interview, first released by RCA as a promotional LP in 1985.

136 he would appear in forty-three cities: Undated two-page proposal, specifying that All Star Shows would have "sole direction" and RCA "no voice in the presentation in any manner of the Elvis Presley show or its talent." Bullock's counterproposal is noted drily on a brief postscript (EPE).

137 Colonel had induced RCA: August 2 and 30, 1962, memos with respect to contract to take effect September 1 (EPE).

138 Gene had been driving: Alanna Nash, *Elvis Aaron Presley: Revelations from the Memphis Mafia*, p. 250; Fortas, *Elvis: From Memphis to Hollywood*, p. 200; Smith, *Elvis's Man*, p. 273; Charles C. Thompson II and James P. Cole, *The Death of Elvis*, p. 181. Both the amount of medication and the direction of the trip vary from account to account.

138 "there was a Judas": Nash, Elvis Aaron Presley, p. 274.

138 Richard Davis and Jimmy Kingsley: Fortas, *Elvis: From Memphis to Hollywood*, p. 236; interview with Richard Davis, 1990.

139 she could stay with his father and stepmother: The original plan appears to have been for Joan Esposito, who had just given birth to her first child a month before, to fly to Germany to accompany Priscilla on the flight (Suzanne Finstad, *Child Bride: The Untold Story of Priscilla Beaulieu Presley*, p. 144).

139–140 The whole gang was waiting: Priscilla Presley, *Elvis and Me*, pp. 97ff. The primary basis for this account of Priscilla's visit is her book, and all quotes from Priscilla Presley come from that source.

140-141 "From the moment I got off the plane": Ibid., pp. 111ff.

141 wearing a cape: Interview with Pat Parry, 1991.

141 Colonel put the kibosh on that: Paul Nathan memo to Hal Wallis, June 1, 1962, on the Colonel's reluctance to travel to Mexico (EPE).

141–142 he would teach her: Priscilla Presley, *Elvis and Me*, p. 115; interviews with Linda Thompson and Sandy Martindale touching on this subject.

142 "it took a while": Interview with Priscilla Presley.

142 NO ONE BELONGS IN THE OFFICE: Priscilla Presley, *Elvis and Me*, p. 120. The sign is still in Vernon's office.

142 "Any time Elvis failed to call": Ibid., p. 123.

143 a pretty little bright red Corvair: *Memphis Press-Scimitar*, April 2, 1962. This same article refers to Priscilla staying with Vernon and Dee because they are friends of the Beaulieu family.

143 "They sent her ahead": Memphis Commercial Appeal, April 3, 1963.

144 he gave her extensive instruction: Priscilla Presley, Elvis and Me, p. 137.

144 "father and son relaxing": Ibid., p. 192.

144 Sometimes they stopped by: Interview with Priscilla Presley.

144 the exotic menu: Priscilla Presley, Elvis and Me, p. 152.

144 "None of them felt comfortable with me": Interview with Priscilla Presley.

145 "It was not that she was immature": Interview with Joan Esposito, 1995.

145 "I want it to be something to look forward to": Priscilla Presley, Elvis and Me, p. 130.

145 "Instead of consummating our love": Ibid., pp. 130–131.

146 she couldn't stand to have any of the guys see her: Fortas, Elvis: From Memphis to Hollywood, p. 209.

146 "Finally I worked up enough courage": Priscilla Presley, Elvis and Me, p. 156.

146–147 For much of the next three weeks: Ibid., pp. 157–159.

149 "Elvis makes a face": McCall's article quoted in Ann-Margret: My Story, p. 110.

149 "This is news to make the younger set flip": Bob Thomas, "It Looks Like Romance for Presley and Ann-Margret," Memphis Press-Scimitar, August 6, 1963.

149–150 "Music ignited a fiery pent-up passion": This and subsequent quotes by Ann-Margret are from *Ann-Margret*, pp. 110–112.

150 "Ann was wonderful": Interview with Joan Esposito.

150 "She was his alter ego": Interview with Sandy Martindale.

150 never seen Elvis happier: Shelley Ritter interview with George Klein.

150 "She had spirit": Interview with Pat Parry, 1991.

151 "He'd describe her": Ann-Margret, pp. 116–117.

151-152 For once Parker was stymied: Esposito, Good Rockin', p. 97; interviews with Andrew Solt, Joe Esposito, and Jerry Schilling.

151–152 the director was giving the girl: According to Ann-Margret, p. 99, George Sidney had put up \$60,000 of his own money to shoot a new beginning and ending for Bye Bye Birdie that would provide a showcase for her performance alone.

152 Colonel Parker fought back: Esposito, *Good Rockin*', p. 98; Priscilla Presley, *Elvis and Me*, p. 167; Colonel's subsequent correspondence with MGM in the spring of 1964 (EPE).

152–153 What galled him most: Colonel–MGM correspondence from April 1964 through an undated "Summary of Publicity and Promotion and Exploitation Activities . . . carried out by Colonel Tom Parker," all of which highlight MGM's supreme confidence and the Colonel's cold fury (EPE).

153 "problems on the set": Priscilla Presley, Elvis and Me, p. 167.

153 Elvis came straight home: The Memphis Press-Scimitar of September 21, 1963, has him home on that date.

155 he and Karger had preselected: Gene Nelson letter to Elvis, September 19, 1963 (EPE); interview with Gene Nelson, 1995.

155 the "hillbilly" flavor of the picture: Peter Cronin interview with Boots Randolph, 1993.

155 Jerry Kennedy ... felt sorry for Elvis: Interview with Jerry Kennedy, 1990.

155–156 Katzman liked to boast: Bob Thomas, "Katzman Making Big Money Film," AP dispatch, November 1963. Further biographical detail on Katzman and his picture-making methods from Gene Nelson interview and Jerry Hopkins interview with Sam Katzman (MVC/UMem).

156–159 "talk myself into liking that kind of music": Interview with Gene Nelson.

158 "I hadn't learned the patience": Jerry Hopkins interview with Gene Nelson (MVC/ UMem). It should be noted that Nelson also assigned this story to the shooting of his subsequent picture with Elvis, *Harum Scarum*, but at whichever point it occurred the moral is the same.

159 according to his co-star: Jerry Hopkins interview with Yvonne Craig (MVC/UMem).

159 As perceived by LeGault: Jerry Hopkins interview with Lance LeGault (MVC/UMem).

160 "Elvis Wins Love of Ann-Margret": Memphis Commercial Appeal, November 8, 1963.

160 "I can't believe she did it": Priscilla Presley, Elvis and Me, p. 176.

160 "I couldn't believe what I was hearing": Ibid.

161 "Elvis was very honest": Interview with Priscilla Presley.

161 Ann-Margret called him from London: Ann-Margret, p. 118.

161 "I drove to Elvis' house": Ibid., p. 121.

161 too much of a coward: Fortas, Elvis: From Memphis to Hollywood, p. 273.

161 in a modest ceremony: Memphis Press-Scimitar, December 17, 1963.

161 under somewhat shadowy circumstances: Smith, Elvis's Man, p. 275; Nash, Elvis Aaron Presley, p. 251.

162 He even purchased a wedding ring: Connie Lauridsen Burk, "Twice!!," *Elvis World* 37; interview with Harry Levitch, 1995.

162 sales were substantially down: The one exception was *Elvis' Golden Records Volume 3*, a greatest-hits compilation which sold almost a million copies after the Colonel dictated its precise makeup down to the most prosaic elements of the artwork and got \$75,000 (to be split 50–50 with his client after expenses) as a flat price for 275,000 souvenir photo albums tied in to his granting of permission for this unscheduled release (RCA agreement May 21, 1963 [EPE]).

164 with a guaranteed income from RCA: RCA exercised its option to extend Elvis' recording contract for another two years on December 17, 1963, thereby assuring a comfortable level of income at least through 1971 (EPE).

164 "Our gimmicks work": Colonel to George Parkhill, February 15, 1963 (EPE).

164 "Look, you got a product": Michael Fessier, Jr., "Elvis Hits s20,000,000 Gross Jackpot," Variety, January 15, 1964. This article details the Colonel's positive financial frame of mind — and shows solid grounds for his optimism.

165 Elvis to him looked "fat": Hal Wallis to Colonel Parker, December 10, 1963 (HWC/ MPASL).

165 He reiterated his concerns: Wallis to Colonel, January 28, 1964 (HWC/MPASL). Wallis' concerns no doubt were influenced by the precipitous drop in profit levels, from \$832,000 for G.I. Blues and \$1,015,000 for Blue Hawaii in 1961 to just \$30,000 for 1962's Girls! Girls! Girls! and a substantial loss (\$350,000) on the previous year's Fun in Acapulco (figures from Frank Rose, The Agency: William Morris and the Hidden History of Show Business, p. 268).

165 the Colonel agreed with him: The Colonel's reply, same day (HWC/MPASL).

165 a production schedule: Elvis was paid for eight weeks, plus one week of preproduction, but shooting occurred during only six of them, thereby cutting down considerably on expenses.

165 The idea for a picture: There is talk with Wallis about this picture going back to 1961 (HWC/MPASL), and gossip items concerning a film on the Colonel's experiences starring Elvis begin at least as early.

165 all kinds of suggestions: Colonel to Wallis, summer and fall 1963 (HWC/MPASL). Also, interview with Allan Weiss for *Elvis in Hollywood*, 1993.

165 a wholesome way of life: Interview with Allan Weiss for Elvis in Hollywood.

166 he should be paid for it: Tom Diskin to Hal Wallis, September 9, 1963 (HWC/MPASL).

166 on the outs with Vernon: Nash, Elvis Aaron Presley, p. 246.

166-167 "Elvis kept telling me": Marty Lacker et al., Elvis: Portrait of a Friend, pp. 46-48.

167 "The damn thing was packed so full of pills": Ibid., p. 348.

168 Finally, on February 14: Grelun Landon press kit prepared for RCA on the sale of the Potomac; Memphis Commercial Appeal, February 15, 1964; Fortas, Elvis: From Memphis to Hollywood, p. 230; interview material from Grelun Landon, Joe Esposito, et al.

168 Elvis was furious: Nash, Elvis Aaron Presley, p. 312.

168 he had been proud: Roosevelt and his adviser, Harry Hopkins, went on a cruise of the Bahamas on the *Potomac* immediately following the passage of Lend Lease in March of 1941 (Robert E. Sherwood, *Roosevelt and Hopkins*). Elvis told Jerry Schilling that many of the elements that went into the Atlantic Charter (signed in August) were discussed onboard.

168 Elvis had finally decided: Just how important "Memphis" was to Elvis is indicated by Colonel–RCA paperwork on January 12 and 13 considering (and then rejecting) its release as the next single (EPE).

169–170 "I didn't know too much": Interview with John Rich, 1996.

170 the score was almost embarrassingly bad: Even Hal Wallis expressed his dissatisfaction in a communiqué to his assistant Paul Nathan on March 6, 1964. Elvis' unhappiness is indicated by a letter from Nathan to Tom Diskin on the same date (HWC/MPASL).

170 continued friction between Rich and the guys: West et al., *Elvis: What Happened?*, p. 269; interview with John Rich.

170 "Wallis kept the screenplays shallow": Interview with Allan Weiss for Elvis in Hollywood.

171 It confirmed all of Elvis' worst fears: West et al., Elvis: What Happened?, p. 273; Larry Geller and Joel Spector, "If I Can Dream": Elvis' Own Story, p. 154; Nash, Elvis Aaron Presley, p. 358; interview with Jerry Schilling, 1995.

SPIRITUAL AWAKENINGS

173–175 a twenty-four-year-old hairdresser named Larry Geller: Background information, as well as the account of Geller and Elvis' first meetings, comes from Larry Geller and Joel Spector, "If I Can Dream": Elvis' Own Story; interview with Larry Geller, 1989; Rose Clayton and Dick Heard, eds., interview with Larry Geller, Elvis Up Close: In the Words of Those Who Knew Him Best, pp. 208–209; Jess Stearn, The Truth About Elvis; and interview with Johnny Rivers, 1995.

176 Joe Esposito . . . was willing to give him the benefit of the doubt: Interviews with Joe Esposito, 1990, 1996.

176-177 "He was always gullible": Interview with Joe Esposito, 1990.

177 Some of them started: Stearn, The Truth, pp. 27–28.

177 mostly what they felt: Alan Fortas, Elvis: From Memphis to Hollywood, p. 234; Alanna Nash, Elvis Aaron Presley: Revelations from the Memphis Mafia, p. 318; interview with Pat Parry, 1991.

177 Elvis made a few perfunctory attempts: Interviews with Joe Esposito and Charlie Hodge.

177 "The spirituality was always there": Interview with Sandy Martindale, 1995.

177 The Elvis that Larry saw: Interview with Larry Geller; Geller and Spector, "If," p. 269.

177 "When Elvis appreciated something": Interview with Larry Geller.

177 "His intuition was highly developed": Geller and Spector, "If," p. 139.

178 "[He] was requesting a new book": Ibid., pp. 99–100.

 $178\,$ His original idea, while at Columbia: Jerry Hopkins interview with Joe Pasternak (MVC/UMem).

178 Elvis seemed uncharacteristically subdued: Fortas, Elvis: From Memphis to Hollywood, p. 233.

179 Colonel was absent with back trouble: Colonel correspondence, spring through fall 1964 (EPE).

179 an interview to gossip columnist Earl Wilson: Undated clip, on Girl Happy set.

179 Each night on the phone: Interview with Priscilla Presley, 1995.

180 There was no question among any of the guys: Fortas, *Elvis: From Memphis to Hollywood*, p. 227; Nash, *Elvis Aaron Presley*, p. 202; Marty Lacker et al., *Elvis: Portrait of a Friend*, p. 203; interviews with Joe Esposito, Jerry Schilling, Red West, et al. It should be noted that Johnny Rivers today denies both the knowledge and the rift.

180 glowing reports: MGM internal reports, May-June 1964 (EPE).

180 Colonel asked to meet: Geller and Spector, "If," p. 83; Stearn, The Truth, p. 29.

181 "Elvis is driving": Interview with Larry Geller.

181-182 "And what a trip it was": Geller and Spector, "If," pp. 59-60.

182 "It was about four o'clock": Interview with Joe Esposito, 1996.

183 "I'm sure Vernon saw me": Geller and Spector, "If," p. 63.

183 "Larry was a total threat": Interview with Priscilla Presley.

183 "He came at me": Geller and Spector, "If," p. 76.

183 "that you don't always get him": Stearn, The Truth, p. 36.

184 It was a very different group: Nash, Elvis Aaron Presley, p. 314.

184 "along with Marty, be responsible for Organization": Fortas, Elvis: From Memphis to Hollywood, p. 239.

184 Marty and his family: Nash, Elvis Aaron Presley, p. 316.

184 He told Morris: Ada Gilkey, "Elvis Presley Gets Promotion — by the New Sheriff," Memphis Press-Scimitar, September 23, 1964.

185–187 Jerry Schilling was twenty-two years old: This and subsequent quotes and background information come from interviews with Jerry Schilling, 1990–1998.

682 🔊 NOTES

185 He was perceived as a "liberal": Nash, Elvis Aaron Presley, p. 322.

187 Elvis' \$750,000 salary: Thomas M. Pryor, "Presley As Top-Money Star," Variety, July 23, 1965.

187–188 Earlier in the year: Abe Lastfogel's letter to Steve Broidy of June 12, 1964 (EPE), refers to the Colonel's offer of "several months ago"; see also "'Tickle'-d?' Allied Artists Ecstatic," *Variety*, July 28, 1965.

188 Colonel wrote to Elvis: Colonel to Elvis, August 21, 1964; Elvis' telegrammed reply is merely stamped "September 1964" (EPE).

189 the highest-paid star: That this was a common perception is indicated by Hedda Hopper's column of January 31, 1965, in which Elvis was referred to as the "highest paid star in the business" as well as *Variety*, July 23, 1965 (Vincent Canby, "[Presley] Bests Liz, Cary, Audrey Income").

189 "We're doing all right": Peter Bart, "Hollywood: Money Man from Memphis," *New York Times*, November 22, 1964.

189–190 Marty went out: Lacker et al., Portrait, p. 101.

190 He refused to accept their present: Stearn, *The Truth*, p. 33.

190 he was busted for marijuana: Geller and Spector, "If," pp. 89, 93–94; Nash, Elvis Aaron Presley, p. 373.

190 "rabbis change people's names": Geller and Spector, "If," pp. 67–69.

190 he and Elvis came up with an idea: Lacker et al., *Portrait*, p. 63; also interview with Harry Levitch, 1995. Levitch and Elvis' dentist, Les Hofman, and his wife, Sterling, spoke to me about the strong impact of Judaism on Elvis, and Levitch described Elvis taking him out to the cemetery to show off the newly engraved Star of David on his mother's grave.

190 Marty was convinced: Nash, Elvis Aaron Presley, p. 387.

190–191 Elvis' uncle Johnny Smith: Ibid., p. 422; Lacker et al., Portrait, p. 235.

191 "I got my nerves in the dirt": Nash, Elvis Aaron Presley, p. 419; Priscilla Presley, Elvis and Me, p. 146.

191 Larry's perspective: Geller and Spector, "If," p. 87.

191 Vernon . . . "lived in constant fear": Ibid., p. 159.

191–192 "going through a cleansing period": Priscilla Presley, Elvis and Me, p. 206.

192–193 he reflected a little: James Kingsley, "At Home with Elvis Presley," Memphis Commercial Appeal, March 7, 1965.

194–196 He had it out with Larry: Geller and Spector, "If," pp. 107–110.

196 He just wanted to quit the business: Ibid., p. 112; Stearn, The Truth, p. 50; interview with Larry Geller; Peter Whitmer, The Inner Elvis: A Psychological Biography of Elvis Aaron Presley, pp. 352ff.

196–197 he was excited about the costumes: Priscilla Presley, *Elvis and Me*, p. 211; interview with Gene Nelson, 1995.

197 "Someday we'll do it right": Jerry Hopkins interview with Gene Nelson (MVC/UMem).

197–198 The Self-Realization Fellowship: Background on the Self-Realization Fellowship from information supplied by Karen Lanza at the Fellowship.

197 "a Hindu invading": Los Angeles Times, January 28, 1925.

198 "The absence of any visible signs": Paramahansa Yogananda, *Autobiography of a Yogi*, p. 478.

198 a monk named Brother Adolph: Geller and Spector, "If," p. 133; interviews with Larry Geller, 1989, and Sri Daya Mata, 1996.

198–200 he met fifty-year-old Daya Mata: Interview with Sri Daya Mata. This conversation was bounded by Sri Daya Mata's observance of appropriate rules of confidentiality with respect to private confidences and revelations.

200 his almost daily visions: Interviews with Jerry Schilling, Joe Esposito, et al.; virtually every memoir; Albert Goldman, Elvis, p. 370; Whitmer, The Inner Elvis, p. 352.

200 evenings of philosophical discussion: Geller and Spector, "If," pp. 96, 98; interviews with Joe Esposito, Jerry Schilling.

201 "one night, after I'd probably been up three days": Nash, Elvis Aaron Presley, pp. 329-330; Lacker et al., Portrait, p. 349. Alan Fortas writes of the drugs in Elvis: From Memphis to Hollywood, p. 268.

201 daily steam baths: Marge Crumbaker and Gabe Tucker, Up and Down with Elvis Presley, pp. 115-116; interviews with Jerry Schilling and Susan Aberbach. It is Tucker who speaks of the Colonel reorganizing the freezer.

201 "The big shots are afraid": C. Robert Jennings, "There'll Always Be an Elvis," Saturday Evening Post, September 11, 1965.

202 "Sooner or later someone else": Chris Hutchins, "Colonel Tom Parker's Retirement," New Musical Express, January 1966.

202 Parker was more than capable: Crumbaker and Tucker, Up and Down, pp. 112, 115, 144, 145.

202-203 his devastating split with Eddy Arnold: This is documented in the Colonel's anguished letter to Arnold on August 29, 1953 (EPE).

203 he vigorously promoted Tickle Me: This is borne out by numerous bills and letters from February 11, 1965 (EPE).

203 the picture saved Allied Artists: Variety, July 23, 1965.

204 a talking camel as narrator: Letter to Robert O'Brien, July 16, 1965. See also June 18 letter to Robert Whiteman with various other suggestions and observations (EPE).

204 nine Triumphs in the yard: Interviews with George Barris, Joe Esposito, Jerry Schilling, et al.; Fortas, Elvis: From Memphis to Hollywood, p. 251, plus virtually every other memoir. The num-

ber of motorcycles differs in each of these accounts, generally coming out between nine and twelve. 205 "He was so funny": Interview with Joan Esposito, 1995.

205 "I didn't realize": Interviews with Jerry Schilling, 1994, and Priscilla Presley; see also Priscilla Presley, Elvis and Me, p. 141.

205 "Joe would say": Interview with Jerry Schilling, 1990.

205 offering little hope of satisfaction: See Whitmer, The Inner Elvis, p. 355, on William Morris head Abe Lastfogel's bleak view.

206 Elvis threw a temper tantrum: Fortas, Elvis: From Memphis to Hollywood, p. 249.

206 Instead of dating her: Red West et al., Elvis: What Happened?, p. 271.

206 "they would go over his marked passages": Stearn, The Truth, p. 167.

206 he . . . donated \$50,000: UPI report, June 28, 1965.

206 his generosity was viewed cynically: Nash, Elvis Aaron Presley, p. 327.

206 the thrill of seeing the expression: Interviews with Joe Esposito; Joe Esposito, Good Rockin' Tonight, p. 32; Fortas, Elvis: From Memphis to Hollywood, p. 252.

206 "a Band-Aid for the abuse": Nash, Elvis Aaron Presley, p. 368.

207 "for the first time . . . since the Beatles": AP report, Houston Chronicle, June 9, 1965.

207 he saw the Beatles . . . as a threat: Fortas, Elvis: From Memphis to Hollywood, p. 249; Esposito, Good Rockin', p. 106; Nash, Elvis Aaron Presley, pp. 296–297.

207 some of the rugged qualities of his Roustabout role: Hal Wallis to Colonel, pre-Thanksgiving 1964 (HWC/MPASL).

208 he continued to convey a degree of disappointment: Just how much disappointment is indicated by an August 3, 1965, letter in which Colonel directed his assistant Jim O'Brien to pack up all their trunks "so it looks like we are getting ready to leave" (EPE).

208 he refused to bark like a dog: Paul Nathan to Hal Wallis, August 1965 (HWC/MPASL).

208 "too sick to present himself": Derek Hunter, "Trouble in Paradise," Movie News, May 1966.

208 Jerry Schilling fell in love: Interviews with Jerry Schilling.

209 "He was not unfriendly": Interview with Jan Shepard, 1992. See also Sue Wiegert, *Elvis: Precious Memories*, vol. 2, p. 108.

209 Elvis had left his own faith: May Mann, Elvis and the Colonel, p. 189.

209–210 Larry watched and wondered: Geller and Spector, "If," pp. 102–104.

210 he had sent a telegram: Chris Hutchins, Elvis Meets the Beatles, p. 74.

210-211 Subsequently he had met: Ibid., p. 88; Jerry Hopkins interview with Jack Good (MVC/UMem).

211 There had even been some talk: Paul Nathan to Hal Wallis, November 18, 1964 (HWC/MPASL).

211 Elvis remained at best lukewarm: Esposito, Good Rockin', pp. 106ff.

211 The Beatles arrived: This account of the Beatles' visit is derived primarily from interviews with Joe Esposito, Jerry Schilling, and Larry Geller; Hutchins, *Elvis Meets the Beatles*; Esposito, *Good Rockin*'; Geller and Spector, "If"; *The Beatles Anthology* (1995 ABC television special); and Tony Barrow in Spencer Leigh, *Speaking Words of Wisdom*.

212 "[Elvis] was sitting in a helicopter": Clayton and Heard, Elvis Up Close, p. 213.

212 "He kept thinking": Interview with Priscilla Presley.

213 On September 21 the deal was finally concluded: This was the date on which Elvis wrote RCA a letter accepting the terms of the agreement. The actual contract, reaffirming those terms, was executed on October 12 (EPE).

213 Colonel was openly jubilant: Fortas, Elvis: From Memphis to Hollywood, p. 248.

213 RCA... put the best face on the deal: RCA internal memo/publicity release including January 8, 1966, birthday wire to Elvis. See also November 16 publicity release repeating the claim (EPE).

214 he would never do business with the Colonel again: See correspondence throughout the year, primarily between Wallis and Hazen, in which Wallis advises Hazen on October 18 that "this is the agreement and it will have to be signed or we will have to forget about it" and Hazen reacts to one last feint by the Colonel one week later by declaring the new conditions "untenable" and advising that they simply walk away (HWC/MPASL). Also, interview with Joe Hazen, 1993.

214 a new four-picture deal: This was finalized in a memo of January 13, 1966 (EPE).

214 other deals: Within three months Colonel had agreed upon the outlines of an \$850,000 deal for a new picture with Steve Broidy, formerly with United Artists (EPE).

214-215 he announced to Elvis: Colonel to Elvis, January 18, 1966 (EPE).

215 "roaring around the drives": Memphis Press-Scimitar, October 13, 1965.

215 "a great man and a person that everyone loved": Memphis Commercial Appeal, October 22, 1965.

215 the Meditation Garden was completed: Nash, *Elvis Aaron Presley*, pp. 386–387; Lacker et al., *Portrait*, pp. 85–86. In Geller and Spector, *"If*," Larry Geller writes that he, Marty, and Elvis "designed" the garden but makes clear that "we didn't actually come up with a detailed design or plan for it, but Elvis' ideas about the mood he wanted to create there were very definite" (p. 127).

215 there were "tears of joy": Lacker et al., Portrait, p. 86.

215 Vernon refused . . . to provide final payment: It should be noted that the job was not completed until mid December, with the final bill submitted at the end of the month. Vernon paid a balance of \$10,148.83 (on a total of \$20,912.26) on January 4 (EPE). From Marty's account, it seems evident, however, that some words must have been exchanged.

216 one more example of Vernon's underlying anti-Semitism: Marty Lacker recounts two other incidents convincingly in his book. However, others in the group suggest that Vernon Presley's reaction was characteristically, and always, about money, and — put charitably — stemmed from fears of his son being taken advantage of. These others feel that Vernon was distinctly, and surprisingly, unprejudiced and confined his judgments, right or wrong, to individuals.

216 According to McIntire: Robert Gordon interview with John McIntire; Audrey West, "Idyllic Graceland Setting Includes Sculptor's Work," *Memphis Press-Scimitar*, September 26, 1977; interviews with Jerry Schilling. See also Geller and Spector, "If," p. 127.

216 "You're no good to me anymore": Interview with Jerry Schilling, 1995.

216 "In Elvis' life the outside world was a distant place": Geller and Spector, "If," p. 157.

217 "We were all together so much": Jerry Hopkins interview with Jerry Schilling (MVC/UMem).

217 They celebrated New Year's Eve: Memphis Commercial Appeal, January 9, 1966; interview with David Porter, 1995; Donna Lewis, "Hurry Home, Elvis!": Donna Lewis' Diaries, vol. 1, p. 82.

217 the slot-car track that Priscilla had given him: Memphis Press-Scimitar, December 30, 1965; interview with Joe Esposito, 1996.

217 an expanded setup: Lacker et al., Portrait, p. 86.

217–218 Elvis finally tried LSD: Interviews with Jerry Schilling and Larry Geller; Lacker et al., *Portrait*, p. 258; Fortas, *Elvis: From Memphis to Hollywood*, p. 268; West et al., *Elvis: What Happened?*, pp. 280–281; Geller and Spector, "If," p. 149; Priscilla Presley, *Elvis and Me*, p. 213; Esposito, *Good Rockin*', pp. 122–124; Clayton and Heard, *Elvis Up Close*, p. 217; Nash, *Elvis Aaron Presley*, p. 336; Whitmer, *The Inner Elvis*, p. 356. Needless to say, the accounts differ at various points.

218 "About an hour and a half later": Geller and Spector, "If," p. 149.

219 the house was decorated: Interview with Joe Esposito, 1996.

219 Charlie Hodge came back: Jerry Hopkins interview with Red West (MVC/UMem); Sherry Daniel, "Elvis, Charlie and the Music," *DisCoveries*, August 1991.

219 "Priscilla very much wanted": West et al., Elvis: What Happened?, p. 271. See also Nash, Elvis Aaron Presley, p. 323.

219 "Elvis basically told her": Nash, Elvis Aaron Presley, p. 362.

220 "I don't have a goddamn thing to hide": Priscilla Presley, *Elvis and Me*, pp. 179–180; see also West et al., *Elvis: What Happened?*, p. 218.

221 "That's it, that's it," he announced: Geller and Spector, "*If*," p. 155. Larry places the story during the filming of *Paradise, Hawaiian Style*, but since it hinges on Charlie's return (and in light of others' versions of the same story), I have placed the incident here.

221 He took Priscilla: Ibid., p. 210; interview with Sri Daya Mata.

221 Greyhound D'Elegance coach, fully outfitted: Interview with George Barris.

221 a brand-new reel-to-reel Sony video camera: Goldman, Elvis, pp. 343–344; Nash, Elvis Aaron Presley, p. 370; Fortas, Elvis: From Memphis to Hollywood, p. 154; West et al., Elvis: What Happened?, pp. 282–283; plus numerous other accounts all document Elvis' interest in videography.

222 "Show us what you recorded": Esposito, *Good Rockin*', p. 181. Joe says here that he and "one of the guys" watched some of the tapes once and that they were "very sexy" but "wouldn't even merit an 'R' rating in today's mainstream movies." Marty Lacker (in Nash, *Elvis Aaron Presley*, pp. 371–372) describes the same incident, characterizing the tapes as "sensual and erotic" but "not particularly raunchy." Lacker, never one to downplay Elvis' failings, goes out of his way to dispute Goldman's more sensational account.

222 Tempers flared: Geller and Spector, "If," pp. 150-151.

222 he gave Diane McBain an underlined copy: Wiegert, "Elvis: Precious Memories," vol. 1, p. 91.

222 "Look, we've only got this moment": Goldman, Elvis, p. 373.

686 💊 NOTES

222 he told Mann: Mann, Elvis and the Colonel, pp. 156–158.

223 Charlie and Red started working informally: Interview with Red West, 1996; home tapes (EPE).

223 every morning, before going to the studio: Interviews with Jerry Schilling; Sherry Daniel interview with Charlie Hodge, *DisCoveries*, August 1991. Elvis' musical interests and repertoire can be further deduced from tapes discovered at Graceland in 1996 and correspondence throughout the year with Freddy Bienstock (EPE).

223 its casual advocacy of the drug culture: Interview with Jerry Schilling, 1993.

223-224 These informal sessions: Interview with Red West.

224 He listened to Caruso: Geller and Spector, "If," pp. 80, 116; interview with Charlie Hodge, 1989.

224 admiration for Jimmy Jones: This is an admiration borne out by innumerable interviews, memoirs, and books. Tom Diskin's actual search for Jones is documented in correspondence culminating in a letter to Elvis on May 13, 1966, which states, "I have made countless calls on Jimmy Jones and no one seems to be able to locate him" (EPE).

224 persistent telephone calls and letters: Jenkins' letter of May 4, 1966, underscores the sense of urgency (EPE).

224 "Heck yes, I would retire": Memphis Press-Scimitar, February 2, 1966.

225 arriving home at 9:00 P.M.: Lewis, "Hurry Home, Elvis!," vol. 1, p. 121.

225 listening to the tapes: Esposito, Good Rockin', p. 75.

225 someone had to lug: West et al., *Elvis: What Happened?*, p. 370, has this happening in Oklahoma City on a single night; Nash, *Elvis Aaron Presley*, p. 370, has a girl flying into Albuquerque by prearrangement and staying for four nights. There are other variants but little question that the core story is true.

FAMILY CIRCLE

227 Diskin suggested that they substitute the Imperials: Diskin's letter of May 13, 1966, in which he confesses his inability to locate Jones, goes on to recommend the Imperials. Ernst Jorgensen believes that Chet Atkins' secretary, Mary B. Lynch (who booked all the sessions and was a friend of Jake Hess'), had a hand in recommending the group.

228–230 That was how Felton Jarvis became Elvis' producer: Interviews with Chet Atkins, Bob Beckham, Bill Lowery, Lamar Fike, Harry Warner, Jake Hess, and Mary Jarvis; also Al Cooley and Jerry Flowers interviews with Felton Jarvis, 1973 and 1980 respectively; Lola Scobey, "Controversies About Elvis," *Cash Box*, September 3, 1977.

229 "He just said, 'I'm going to carry you over'": Jerry Flowers interview with Felton Jarvis.

230 "for a while before I started": Al Cooley interview with Felton Jarvis.

230 "Elvis just really loved that sound": Interview with Jake Hess, 1991.

231 "He didn't do a lot of takes": Interview with Jerry Schilling, 1995.

232 "Elvis was one of those individuals": Jerry Hopkins interview with Jake Hess (MVC/

UMem). For the sake of the narrative, I have changed most of the verbs into the past tense.

232 Felton's entire philosophy of recording: Ernst Jorgensen interview with Al Pachucki, 1996; Al Cooley and Jerry Flowers interviews with Felton Jarvis.

232 "Everything just started getting electrified": Interview with Chip Young, 1988.

232 "Down in the Alley," a raucous r&b hit: Although it was not released until 1957, the song had originally been recorded in 1953. The Clovers' "Fool, Fool, Fool" and "Little Mama," from 1951 and 1954 respectively, were early features of Elvis' act.

233 "We stayed": Jerry Flowers interview with Felton Jarvis.

233–234 a twenty-three-year-old piano player named David Briggs: Interviews with David Briggs, 1988–1998.

234 "I said, 'Great! Come in'": Peter Cronin interview with David Briggs, 1993.

235 "I said, 'Man, I'm too loud'": Interview with Jake Hess; Ernst Jorgensen interview with Al Pachucki.

235 "You make me look forward": Interview with Mary Jarvis, 1989.

236 as Red West believed: Trevor Cajiao interview with Red West, *Elvis: The Man and His Music* 22, March 1994, p. 9; Ernst Jorgensen interview with Red West, 1995; Red West et al., *Elvis: What Happened?*, p. 303.

236 Red, armed only with amphetamines: West et al., Elvis: What Happened?, p. 303.

236 "I was a nervous wreck": Interview with Red West, 1996.

237 They listened to it a number of times: Interviews with Red West and Jerry Schilling; West et al., *Elvis: What Happened?*, p. 303; Alanna Nash, *Elvis Aaron Presley: Revelations from the Memphis Mafia*, p. 384. Not surprisingly, there are as many variations as there are sources.

238–239 one of Elvis' favorite entertainers: The sources for Elvis' admiration for Jackie Wilson and James Brown once again are legion and diverse, including interviews with George Klein, Jerry Schilling, and Wilson chronicler Simon Rutberg; correspondence with Alan Leeds and Cliff White; Alan Fortas, *Elvis: From Memphis to Hollywood*, p. 232; James Brown with Bruce Tucker, *James Brown: The Godfather of Soul*, p. 165; and Tony Douglas, *Lonely Teardrops: The Jackie Wilson Story*, pp. 243–244.

239 he invited him out to the film set: The closeness between the two singers is indicated by their continued contact in Las Vegas in the seventies, Elvis' frequent references to Wilson's talent, and the fact that Wilson carried the two on-set photographs of himself and Presley (one inscribed, "Jackie, you have a friend forever") with him everywhere.

239 Larry Geller's particular memory: Geller and Spector, "If I Can Dream": Elvis' Own Story, p. 119.

239–240 Cliff Gleaves showed up: Cliff's visit and background are described in Nash, *Elvis Aaron Presley*, pp. 377–378, as well as in interviews with Joe Esposito, Jerry Schilling, George Klein, and Cliff Gleaves. As in other matters, I have tried to make the best sense I can of somewhat warring versions of the same story.

240 "I was aware that the prescriptions": Interview with Cliff Gleaves, 1990.

240 a chair similar to one in Wallis' office: Paul Nathan to Hal Wallis, November 7, 1966 (HWC/MPASL).

240 Wallis had at last resigned himself: Wallis correspondence, 1966, passim.

240 "Wallis was really tightening up": Interview with John Rich, 1996.

241 against Wallis' explicit instructions: Paul Nathan to Hal Wallis, September 29, 1966; Wallis to John Rich on the following day (HWC/MPASL).

241 He was overweight: Wallis to Colonel, September 6, 1966; see also Paul Nathan to Wallis, August 1, 1966 (HWC/MPASL).

241 he had rented a house: The one-year lease at 1350 Ladera Circle began on September 21, 1966 (copy of lease supplied by Leonard Lewis).

241 He needed a "getaway" retreat: Interview with Joe Esposito, 1996.

241 The house that they found: Allene Arthur, "Elvis in Palm Springs," *Palm Springs Life*, August 1995; Bruce Fessier, "Remembering Elvis in Palm Springs," *The Desert Sun*, May 2, 1995; "The Way-Out Way of Life," *Look*, 1962.

242 Joe and Joanie alone were included: Nash, *Elvis Aaron Presley*, p. 365; interviews with Joe and Joan Esposito.

242 One time in Palm Springs: Geller and Spector, "If," p. 145.

243 Elvis "stormed into his trailer": Ibid., p. 144.

243 "I saw that the back door was open": Ibid., pp. 147–148.

244 There were problems: Interview with Roger Davis, 1995. Also, interview with Gabe Tucker, 1990, and Gabe Tucker's entertaining firsthand accounts of life in Palm Springs as well as his somewhat more secondhand anecdotes of Elvis and the Colonel's growing estrangement at this time in Marge Crumbaker and Gabe Tucker, *Up and Down with Elvis Presley*.

244 He was playing the country tearjerker: Marty Lacker et al., *Elvis: Portrait of a Friend*, p. 62; Nash, *Elvis Aaron Presley*, p. 417; West et al., *Elvis: What Happened?*, p. 304; interview with Joe Esposito. Most of the sources differ on where the song was first actually heard, and Red West points out with some acerbity that he had brought the song to Elvis in Jerry Lee Lewis' version the year before, but Elvis either failed to pay attention or simply forgot.

244 everyone was outside: Donna Lewis, "Hurry Home, Elvis!": Donna Lewis' Diaries, vol. 1, p. 204.

244 He came back down: Nash, *Elvis Aaron Presley*, pp. 391–392; see also Lacker et al., *Portrait*, p. 87.

245 he gave George Klein: Memphis Press-Scimitar, December 17, 1966. See also Lacker et al., Portrait, p. 98; Fortas, Elvis: From Memphis to Hollywood, p. 253.

245 an interview with Jim Kingsley, "Christmas to Elvis Means 'Just Home," *Memphis Commercial Appeal Mid-South Magazine*, December 25, 1966 (italics added at end).

246 Elvis bulldozed the little house: Nash, *Elvis Aaron Presley*, pp. 351, 397; Elvis Presley Enterprises, *Elvis at Graceland*, p. 20; Mary Jenkins, *Elvis: The Way I Knew Him*, p. 19; Lewis, "Hurry Home, *Elvis"* vol. 2, pp. 1–26; interviews with Alan Fortas, Jerry Schilling, and Joe Esposito.

246 "Elvis would go out in the barn": Nash, Elvis Aaron Presley, p. 397.

246 "he felt like he needed to take Delta in": Ibid., pp. 420-421.

246 the funeral arrangements: Jenkins, *Elvis: The Way I Knew Him*, p. 28. The funeral was on January 15, 1967.

246 it became open season on Larry: Geller and Spector, "If," pp. 151-152.

247 he had asked jeweler Harry Levitch: Interview with Harry Levitch, 1995.

247 "More than once Elvis remarked": Geller and Spector, "If," pp. 161–162.

247 Rumors had been circulating: Letter from Vernon Presley to Jim Hannaford, June 2, 1966, re "recent articles in newspapers and some magazines." According to Vernon there was "no engagement and no marriage plans" (Jim Hannaford, *Golden Ride on the Mystery Train*, vol. 2, p. 29).

247 "his old boyish grin": Priscilla Presley, Elvis and Me, pp. 221–222.

248 the slot cars, long since abandoned: Lacker et al., *Portrait*, pp. 61, 270. In June the track was given away to the Boys' Club (Lewis, *"Hurry Home, Elvis!,"* vol. 2, p. 97); also, bill from the Robert E. Lee Raceway, June 18, 1967, for disassembling and moving the track (EPE).

248 "it was just really fun": Interview with Jerry Schilling, 1996.

248 They had initially spoken of it: The Colonel's letter to Elvis, January 2, 1967, refers to "our understanding on the telephone a few weeks ago," though this may have been more in the nature of a legalism, since the letter was the official agreement, along with a brief note to RCA from Elvis of the same date authorizing the new management commission.

249 the kind of partnerships: The history of the Kate Smith–Ted Collins management arrangement comes from Richard K. Hayes, *Kate Smith*, pp. 16–17; Colin Escott interviewed Patti Page and Jack Rael on the subject of their long-term contract; information on the Albert Grossman–Bob Dylan publishing arrangement, as well as other similarly creative business ventures, comes from Fred Goodman, *Mansion on the Hill*, pp. 88, 103–104, 129, and passim.

249 At fifty-six he didn't know: Crumbaker and Tucker, Up and Down, passim.

249 His services, he felt . . . were worth 50 percent: Discussion with Colonel Parker, 1993; see also the Colonel's 1982 response to the "Report of Guardian Ad Litem In Re: The Estate of Elvis A. Presley, Deceased" (EPE).

250 "it will be at least 1980": Telegram from Elvis to Norman Racusin, January 23, 1967; also to Harry Jenkins, same date (EPE).

250 Colonel delivered a deal memo: Though this elicited another tribute to "the numberone potentate of all time" from Elvis, the deal itself never actually went through (EPE).

251 The number of horses: Information on the actual number varies somewhat but hovers around sixteen, with only eight stalls available at Graceland. Eventually the number of horses on the ranch grew to around thirty.

251 Red ran down Elvis: Nash, Elvis Aaron Presley, p. 397.

251 he and Priscilla spotted: The story of the purchase of the ranch comes from a variety of sources, including interviews with Alan Fortas, Jerry Schilling, and Joe Esposito; Shelley Ritter interview with Mike McGregor; Priscilla Presley, *Elvis and Me*, pp. 216ff; Fortas, *Elvis: From Memphis to Hollywood*, pp. 26iff; Bill E. Burk, *Elvis Through My Eyes*, p. 129; Nash, *Elvis Aaron Presley*, pp. 396ff; Rose Clayton and Dick Heard, eds., *Elvis Up Close: In the Words of Those Who Knew Him Best*, p. 222; Lacker et al., *Portrait*, p. 77; Lewis, "*Hurry Home, Elvis!*," vol. 2, pp. 1–44; various stories in the *Memphis Press-Scimitar* and *Commercial Appeal* at this time; *DeSoto Times*, February 10–18, 1967; etc.

251 On February 8 he put down a deposit: Receipt from Mid-South Title Company (EPE).

251–252 Within a week he had purchased: Purchase records (EPE); Lewis, "Hurry Home, Elvis!," vol. 2, pp. 17–18; Memphis Commercial Appeal, February 18, 1967; Fortas, Elvis: From Memphis to Hollywood, p. 263; Lacker et al., Portrait, pp. 77, 81; Priscilla Presley, Elvis and Me, p. 226; Shelley Ritter interview with Mike McGregor; etc. The exact number of trucks, trailers, and horse vans may never be known, but it escalated with almost incredible rapidity.

252 they were all going to end up in the poorhouse: Lewis, "Hurry Home, Elvis!," vol. 2, p. 46.

252 "Vernon literally begged him": Priscilla Presley, Elvis and Me, p. 226.

252 "He liked it when everyone was together": Ibid., p. 227.

252 to name a building or a highway: See *Memphis Press-Scimitar*, February 22, 1967, re January 4 mayoral proclamation, among other things. The renaming of the highway is covered in both Memphis papers, May 30, 1971, and January 20, 1972.

252 "It wasn't unusual": Priscilla Presley, Elvis and Me, p. 226.

252 a commune in fact: Interview with Joe Esposito, 1990; Lacker et al., Portrait, p. 82.

253 "Vernon is coming to me": Interviews with Joe Esposito.

253 "He was very thoughtful": Shelley Ritter interview with Mike McGregor; see also Lewis, "Hurry Home, Elvis!," vol. 2.

253 "It was really beautiful at first": Interview with Jerry Schilling, 1996. See also Nash, *Elvis Aaron Presley*, pp. 403ff.

254 Red . . . covered for him: Lacker et al., *Portrait*, p. 330; Ernst Jorgensen interviews with Red West and Ray Walker.

254 he finally fired off a letter: Colonel to Marty Lacker, February 28, 1967 (EPE). See also Fortas, *Elvis: From Memphis to Hollywood*, p. 257, re his and Marty's consumption of "pharmaceuticals."

254 He knew all about the weight gain: Fortas, *Elvis: From Memphis to Hollywood*, p. 266; also interview with Joan Esposito, 1995, re the "two-hundred-pound club."

254 he was furious: Interviews with Joe Esposito, Alan Fortas, and Priscilla Presley. According to Joe, the Colonel "called one day and said 'We're going to get sued. The picture is not going to be made, and we're going to have to give all the money back.'"

254–256 That was how Dr. George Nichopoulos first came into the picture: Interview with Dr. Nichopoulous, 1996. Much of the background on Dr. Nick comes from Stanley Booth, "The King Is Dead!, Hang the Doctor!," in Martin Torgoff, ed., *The Complete Elvis*.

256–258 Elvis arrived in California: The dating of this incident comes from travel, studio, and doctors' records (EPE). The anecdotal account of the incident and the meeting that followed stems from interviews with Joe Esposito, Jerry Schilling, and Larry Geller; Nash, *Elvis Aaron Presley*, pp. 412–415; Geller and Spector, "*If*," pp. 165–167; Jess Stearn, *The Truth About Elvis*, p. 171; Priscilla Presley, *Elvis and Me*, pp. 231–232. I think I need hardly say: accounts differ.

257 "Some of you," he said, looking at Larry: Geller and Spector, "*If*," p. 167. It should be noted that Larry places this meeting two weeks after the incident, though nearly everyone else has it occurring in the immediate aftermath of Elvis' fall.

258 "I thought I was going to be one of the ones": Nash, Elvis Aaron Presley, pp. 415-416.

258 "You know," he said to Larry one day: Stearn, *The Truth*, p. 175; Geller and Spector, "*If*," p. 168.

258 The atmosphere on the set: West et al., *Elvis: What Happened?*, p. 273; Billy Smith and Marty Lacker, *"Clambake* Crazy Times," *Elvis: The Record*, vol. 1, no. 1, May 1979; Lacker et al., *Portrait*, p. 45; Jerry Hopkins interview with Red West (MVC/UMem).

258 a wistful note: Jerry Hopkins interview with Bill Bixby (MVC/UMem).

259 he gave the album to various members: Interview with Lance LeGault, 1990; also, Will Hutchins in Sue Wiegert, *"Elvis: Precious Memories,"* vol. 2, p. 35.

259 "They were like Frick and Frack": Jerry Hopkins interview with Bill Bixby (MVC/UMem).

259 Paramount refused to release any money: Colonel–Hal Wallis correspondence, February 20–23 through May 3, 1967, including Paul Nathan memos (HWC/MPASL).

260 at constant odds with Priscilla: Nash, *Elvis Aaron Presley*, p. 429; interview with Priscilla Presley.

260 Billy Smith saw Elvis' behavior: Nash, Elvis Aaron Presley, p. 424.

260 Jerry and Sandy got married: Interviews with Jerry Schilling; also interview with Charlie Hodge, 1989, plus Crumbaker and Tucker, *Up and Down*, pp. 119–120, re marriage and the Colonel's sense of propriety.

260 "Now, Charlie," he said: Charlie Hodge, Me 'n Elvis, p. 75.

261 Rona Barrett sniffed out the news: Barrett dispatches April 27 and April 30, 1967; Lewis, "Hurry Home, Elvis!," vol. 2, p. 54, has Barrett reporting the next day on the radio that Elvis would be married in Palm Springs that weekend; see also Rona Barrett, Miss Rona: An Autobiography, pp. 207–213.

261 They flew out of Palm Springs: The principal reporting on the wedding appeared in the *Memphis Press-Scimitar*, May 1, and the *Memphis Commercial Appeal*, May 2, 1967. I relied in addition on interviews with Priscilla Presley, Joe Esposito, Joan Esposito, Harry Levitch, and Jerry Schilling. See also Priscilla Presley, *Elvis and Me*; West et al., *Elvis: What Happened?*; Lacker et al., *Portrait*; Nash, *Elvis Aaron Presley*; Geller and Spector, "If"; Clayton and Heard, *Elvis Up Close*; May Mann, *Elvis and the Colonel*; Albert Goldman, *Elvis*; et al.

263 Red hit the roof: For Red's and others' reactions to their exclusion see West et al., *Elvis: What Happened?*, pp. 222ff, p. 329; Lacker et al., *Portrait*, p. 106; Nash, *Elvis Aaron Presley*, p. 432; Priscilla Presley, *Elvis and Me*, p. 237; and Goldman, *Elvis*, p. 398; also, all interviews listed above, plus Jerry Hopkins interview with Red West (MVC/UMem).

263 "Colonel Parker brought Elvis": Clayton and Heard, Elvis Up Close, p. 229.

264 "We were both so nervous": Interview with Priscilla Presley.

264 "Our little girl": Memphis Commercial Appeal, May 2, 1967.

264 "Remember," said the Colonel: AP report, May 2, 1967.

265 Red found himself in the midst: Interview with Harry Levitch; West et al., Elvis: What Happened?, p. 225.

265 "open season on the Swami": Geller and Spector, "If," pp. 169-170.

265 it was, for Priscilla, a rare chance: Priscilla Presley, Elvis and Me, p. 244.

266 "I guess you could say": Nash, Elvis Aaron Presley, p. 432.

266 He blamed her: Fortas, Elvis: From Memphis to Hollywood, p. 265.

266 Elvis had had a porch and steps built: Lewis, "Hurry Home, Elvis!," vol. 2, pp. 47, 52.

266 "it was like we were all just friends": Interview with Jerry Schilling, 1996.

266-267 the reception for their Memphis friends: Lewis, "Hurry Home, Elvis!," vol. 2, pp. 83-86. See also Fortas, Elvis: From Memphis to Hollywood, p. 272; Billy Stanley, Elvis, My Brother, p. 64; Priscilla Presley, Elvis and Me, pp. 241-242.

266 she persuaded Elvis: Priscilla Presley, Elvis and Me, p. 234; interview with Priscilla Presley. 266 "There was a beautiful, lavish buffet": Interview with Lester and Sterling Hofman, 1989.

THE LAST ROUND-UP

269 wives were included: Alanna Nash, Elvis Aaron Presley: Revelations from the Memphis Mafia, p. 605; Marty Lacker et al., Elvis: Portrait of a Friend, p. 108; Joe Esposito, Good Rockin' Tonight, p. 76; also, interviews with Joe and Joan Esposito; Joe Esposito's home movies.

270 "so wonderful and warm": Interview with Joan Esposito, 1995.

270 "It was the whim of the moment": Interview with Priscilla Presley, 1995.

270-271 she was pregnant: Priscilla Presley, Elvis and Me, p. 248.

271 "it just took all the glow off": Interview with Joan Esposito.

271 "'It's our baby'": Priscilla Presley, Elvis and Me, p. 250.

271 "This is the greatest thing": UPI dispatch, July 13, 1967.

271 "all I really did was sleep": Nash, Elvis Aaron Presley, p. 434.

272 the Colonel and his wife continued to socialize: Interviews with Joe and Joan Esposito. See also Marge Crumbaker and Gabe Tucker, Up and Down with Elvis Presley, for tales of life in Palm Springs; also Charlie Hodge, Me 'n Elvis, p. 84, re Colonel's relationship with Elvis and Priscilla at this time.

273 Jerry was the Colonel's principal driver: Interview with Jerry Schilling, 1996.

273 only three pictures left: Colonel's memo of January 26, 1967 (EPE).

274 Elvis was spending \$500,000 a month: Donna Lewis, "Hurry Home, Elvis!": Donna Lewis' Diaries, vol. 2, pp. 110ff. Lewis details the selling-off of much of the ranch and the consolidation of staff.

274-275 Billy Strange, a flamboyant . . . session guitarist: Background information on Billy Strange comes primarily from a 1988 interview.

275 Elvis' all-over-the-map approach: Elvis' approach to repertoire was gleaned largely from correspondence with Hill and Range and tapes of the songs Elvis was listening to, which were discovered in 1996 at Graceland (EPE).

276 Colonel . . . canceled the session: Interviews with Joe Esposito, Billy Strange, Ed Hookstratten, and Jerry Schilling; Ernst Jorgensen interview with Jim Malloy; Jerry Hopkins interview with Hal Blaine (MVC/UMem); Nash, Elvis Aaron Presley, p. 320; Alan Fortas, Elvis: From Memphis to Hollywood, p. 226.

276 all headed for Las Vegas: ticket receipts (EPE).

276 he was in a box: Interview with Mary Jarvis, 1989.

276 He couldn't call a rehearsal session: Jerry Flowers and Al Cooley interviews with Felton Jarvis.

276 "That was a scene to see": Ernst Jorgensen interview with Al Pachucki.

277–279 Reed was a genuine individualist: Much of the background on Reed, and all of Reed's quotes about the session, come from a 1993 interview kindly arranged by Mary Jarvis.

278–280 "They got Jerry off in a corner": Interview with Scotty Moore, 1989. See also Nash, *Elvis Aaron Presley*, p. 437; Ernst Jorgensen interview with Al Pachucki; interviews with Freddy Bienstock and Chip Young; and joint interview with Harold Bradley, Jerry Kennedy, Bob Moore, and Buddy Harmon, conducted by Ernst Jorgensen and me, 1995.

280 about a month before the next film: Lewis, "Hurry Home, Elvis!," vol. 2, pp. 129–142.

280 "she was sitting in a mud puddle": Mike McGregor quoted in Hodge, Me 'n Elvis, p. 81.

281 "a wheeler-dealer who's always promoting something": Joseph Lewis, "Elvis Presley Lives," *Cosmopolitan*, November 1968.

281 "God, Harry, I don't want to": Ernst Jorgensen interview with Al Pachucki.

281 "Promise me": Jerry Flowers interview with Felton Jarvis.

281 Colonel apprised the MGM executive: Memo of Colonel's telephone discussion with Ramsay, dated October 3, 1967.

281–282 they had fun on location: Fortas, *Elvis: From Memphis to Hollywood*, p. 267; Lewis, "Hurry Home, Elvis!," vol. 2, p. 145, on the ponies; Red West et al., *Elvis: What Happened?*, p. 273; and interview with Jerry Schilling.

282 He repeated his hopes: Cosmopolitan.

282 There was an announcement: UPI dispatch, October 12, 1967.

282 Tractors, trailers, television sets: Memphis Press-Scimitar, November 7, 1967.

282 the upcoming Christmas radio special: UPI, December 9, 1967.

283 "The aim was always the same": Interview with Roger Davis, 1995.

283 In October he contacted . . . Tom Sarnoff: Colonel's summary of business and promotional activities, 1967 (EPE).

283 in excess of \$400,000: Albert Goldman, *Elvis*, p. 405, has the price at \$425,000; Nash, *Elvis Aaron Presley*, p. 437, calls it a \$400,000 house.

284 "Elvis would do things like that": Interview with Priscilla Presley.

284 hayrides and snowball fights: Interview with Joan Esposito.

284 On New Year's Eve: Sue Wiegert, "Elvis: Precious Memories," vol. 2, p. 20; interview with David "Flash" Fleischman, 1995; Lewis, "Hurry Home, Elvis!," vol. 2, pp. 163ff.

285 some of Elvis' old r&b and hillbilly 78s: Information and list from Scotty Moore.

285 Felton, for one, had quietly appreciated the stand: Interview with Jerry Reed.

285-286 "Presley had such a unique way": Ernst Jorgensen interview with Ray Walker.

286 Elvis amused himself: Interview with Jerry Schilling.

286 Reed was, naturally, reluctant: Interview with Jerry Reed.

287 The Colonel, Elvis was convinced: Interviews with Priscilla Presley, Jerry Schilling, Joe Esposito; just about every Elvis memoir, including Geller and Spector, "*If I Can Dream*": *Elvis' Own Story*, p. 142; Nash, *Elvis Aaron Presley*, p. 303; Priscilla Presley, *Elvis and Me*, p. 189. In correspondence between Harry Jenkins and Tom Diskin, January 3, 1968, Jenkins presents a remastered version of an unnamed selection "as a result of Elvis' request." Jenkins explains that remastering could cause a bass drop-off, but he doesn't believe that it has. This is but one of many examples (EPE).

288 Priscilla gave birth: Memphis Commercial Appeal, February 2, 1968; AP dispatch, February 3.

 $\mathbf{288}$ a doctors' lounge specially set aside: Jerry Hopkins interview with Maurice Elliott (MVC/UMem).

288 a comedy of errors: Interviews with Joan Esposito and Jerry Schilling; Shelley Ritter interview with Nancy Rooks; Jerry Hopkins interview with Maurice Elliott (MVC/UMem).

289 There was no further talk: Lewis, *"Hurry Home, Elvis!,"* vol. 2, p. 198. When a fan asks Elvis why he didn't name Lisa Marie *"Gladys," "Elvis said they didn't want to name her after any-* one." See also Sandra Shevey, *"Priscilla Presley: My Life With and Without Elvis Presley," Ladies Home Journal*, August 1973, p. 139.

289 They left the hospital: *Memphis Commercial Appeal*, February 6, 1968; *Memphis Press-Scimitar*, February 5, 1968; Jerry Hopkins interview with Maurice Elliott (MVC/UMem).

289 "She's a little miracle": Interview with Lester and Sterling Hofman, 1989.

289 the card should be burned: Lewis, *"Hurry Home, Elvis!,"* vol. 2, p. 201; Maria Davies, *"The King Returns to His Kingdom: Vegas Revisited"* (a British fan's report on Las Vegas, February 1970, that appeared in Rex Martin's *Official Elvis Presley Fan Club News Service*). Elvis speaks here of leaving the flowers with a card, contrary to his practice.

289 They had a steady stream of visitors: Lewis, "Hurry Home, Elvis!," vol. 2, pp. 194ff.

290 "Joe and Joanie had their own place": Hodge, Me 'n Elvis, p. 83.

290–291 there was no question of who was in charge: Fortas, *Elvis: From Memphis to Hollywood*, pp. 274ff; Billy Stanley, *Elvis, My Brother*, p. 81; May Mann, *Elvis and the Colonel*, p. 172; Nash, *Elvis Aaron Presley*, pp. 434–445; also see Wiegert, *"Precious Memories,"* vols. 1 and 2, re fans at various homes; and interview with Sandi Miller, 1990. Lewis, *"Hurry Home, Elvis!,"* vol. 2, reports on the comings and goings of the guys throughout.

291 One weekend in April: Chris Hutchins, Elvis Meets the Beatles, pp. 147–148; Tom Jones interview in Rose Clayton and Dick Heard, eds., Elvis Up Close: In the Words of Those Who Knew Him Best, p. 233; Bill E. Burk, Elvis Through My Eyes, p. 185.

291 an Easter egg hunt: Wiegert, "Precious Memories," vol. 1, p. 71.

291 "He is still withdrawn": Priscilla Presley, Elvis and Me, pp. 258-259.

291 Some of the guys raised questions: West et al., *Elvis: What Happened*?, p. 229; interview with Pat Parry, 1991.

291 "She was taking so many classes": Interview with Joan Esposito.

THE BLUEBIRD OF HAPPINESS

293 He had been talking with executive producer Bob Finkel: Interview with Bob Finkel, 1995. The chronology of decision making, and the picture of the evolution of the show, stems primarily from internal memoranda re meetings and communications between the network, the sponsor, the advertising agency, and the Colonel beginning on March 28, 1968 (EPE). In the Memorandum Report of the May 8 meeting it was noted that Singer representative Alfred DiScipio "was able to convince Parker that the program ought not to be a purely Christmas oriented show" but instead should feature Elvis' hits of the last eight or ten years, telling "the story of Presley as the initiator of a style of music which has become an integral part of our contemporary culture." The Binder-Howe Production Company was confirmed by Bob Finkel as "the production entity" for the special eight days later.

293 At first he found Elvis: This and all subsequent quotes from Finkel come from my 1995 interview, unless otherwise noted.

293 Finkel informed the network: Internal memorandum from Farlan I. Myers re telephone conversation with Finkel, May 16, 1968.

294 a young director named Steve Binder: Much of the background information that follows is from interviews with Steve Binder and Bones Howe, 1989–1992.

694 🔊 NOTES

294–295 Everywhere you looked: Jerry Hopkins interview with Bones Howe (MVC/UMem); also, Jerry Hopkins interview with Steve Binder and my interviews with Steve Binder and Bones Howe.

 $\mathbf{295}\,$ "to do something really important": Jerry Hopkins interview with Steve Binder (MVC/UMem).

295–296 Elvis met with Binder and Howe: Interviews with Steve Binder and Bones Howe.

296–297 a karate championship: Interviews with Ed Parker and Priscilla Presley; Ed Parker, *Inside Elvis*, p. 36.

297 "There was nothing original": Interview with Bones Howe, 1989. All subsequent quotes from Bones Howe are from this interview, unless otherwise noted.

298 The script rapidly evolved: Various dated draft versions of the script.

298–299 He loved the black leather suit: Interview with Bill Belew, 1995.

 $299{-}300\,$ Bones had gotten himself into trouble: Jerry Hopkins interview with Bones Howe (MVC/UMem).

300 That left Billy Goldenberg: Interview with Billy Goldenberg, 1993.

300 "Every day Elvis would come in": Jerry Hopkins interview with Billy Goldenberg (MVC/UMem); the tenses have been changed.

300 Then one day Billy Strange actually showed up: My interview and Jerry Hopkins interview with Billy Goldenberg, plus a somewhat dissenting interview with Billy Strange, 1988; see also Finkel memo to Steve Binder on June 12 re keeping rehearsals to a minimum of people because of Elvis' tendency to get distracted.

300–301 "They just kept fooling around": Interview with Billy Strange.

301 a mutual parting of the ways: Billy Strange has a different version of the story which focuses exclusively on the pull of his movie responsibilities.

301 there was still the matter of telling the Colonel: Interview with Bob Finkel.

301 "never, ever to show any disrespect": Jerry Hopkins interview with Steve Binder (MVC/UMem).

302 It was at this point: Jerry Hopkins interview with Bones Howe (MVC/UMem).

302-303 "He would call up and say": Interview with Billy Goldenberg.

305 The only substantive matter: My interviews and Jerry Hopkins interviews (MVC/UMem) with Steve Binder and Bones Howe.

306 if he ran out of things to say: Rehearsal tape for "impromptu" section.

306 He wanted to do a European tour: Interview with Scotty Moore, 1989.

306 "But he'd just say": Jerry Hopkins interview with D. J. Fontana and Scotty Moore (MVC/UMem).

306 "If the Colonel can't stick his nose in": Colonel to Freddy Bienstock, June 20, 1968 (EPE).

306–307 "We had to fight": Jerry Hopkins interview with Bones Howe (MVC/UMem).

307 "I gave him a hand mike": Ibid.

307 "Quincy Jones had at that time": Interview with Billy Goldenberg.

 $\mathbf{308}{-}\mathbf{309}$ "All of a sudden I realized": Jerry Hopkins interview with Steve Binder (MVC/UMem).

309–310 Bob Finkel meanwhile had been fending off: I have tried to sort out the chronology of this story as best I can, but needless to say some of the anecdotal detail is in dispute amid the thicket of oral recollections.

310 "we figured it was about time": Los Angeles Times, June 27, 1968.

311 "I loved his attitude": Muncie Evening Press, November 30, 1968.

311 "Every time they'd ask a question": Jerry Hopkins interview with Steve Binder (MVC/UMem).

311 "I know you're nervous": Alan Fortas, Elvis: From Memphis to Hollywood, p. 2.

311 "The Colonel said to me": Interview with Bob Finkel. This story has been repeated many times, but it should be noted that Dwight Whitney's account, "The Indomitable Snowman Who Built Himself — And Elvis Too," in *TV Guide*, November 30–December 6, 1968, tells it differently, describing a stampede for seats, with the best seats going (by the Colonel's intention) to hard-core fans.

312 Elvis told Steve Binder: Interviews with Steve Binder and Joe Esposito; Joe Esposito, Good Rockin' Tonight, p. 136. See also Peter Whitmer, The Inner Elvis: A Psychological Biography of Elvis Aaron Presley, p. 358.

315 "after he finished singing": This was said — but not for attribution — in more than one interview that I conducted. See Whitmer, *The Inner Elvis*, p. 369.

315 "It's like a surge": Interview with June Juanico, 1991.

315–316 The "stand-up" show two days later: I should make it clear that in my descriptions of both the sit-down and the stand-up show I am describing not what was broadcast but the unedited performances themselves, as they have appeared on bootleg videos. Obviously there is much more to the televised special, but I wanted to focus here simply on the performance as a live show.

316-317 Bones had no doubt: Interview with Bones Howe.

316-317 "it was one of the most complete experiences": Interview with Bob Finkel.

A DAY AT THE RACES

319 they all watched: Interview with Jerry Schilling, 1990.

319–210 The Colonel, who attended a more formal screening: Colonel to Tom Sarnoff, August 21, 1968 (EPE).

320 In an interview: Vernon Scott, "Elvis Getting Ready to Go on Tour Again," *Memphis Press-Scimitar*, September 27, 1968.

320–321 Dewey had been something of an embarrassment: Randy Haspel, "Tell 'Em Phillips Sencha," *Memphis,* June 1978, p. 60; interviews with Joe Esposito and George Klein.

321 "I am awfully hurt": Memphis Commercial Appeal, September 29, 1968.

321 he had let her know: *Trenton [Tenn.] Herald-Gazette,* August 17, 1978; Charles Raiteri and Louis Cantor interviews with Dot Phillips.

321 "Sonofabitch sure looked dead": Joe Esposito, *Good Rockin' Tonight*, p. 248. This story has been held up as an example of Elvis' thoughtlessness in many anecdotal accounts, but that interpretation would seem to be contradicted by his kindness to Mrs. Phillips and his isolation from any of the storytellers during the service itself. It seems quite plausible, on the other hand, that he did, or would, show off for the guys with a kind of false bravado.

322 the family was cursed: Billy Smith speaks of "all those deaths" in Alanna Nash, *Elvis* Aaron Presley: Revelations from the Memphis Mafia, p. 218.

323-324 I quoted Elvis to lead off my review: Boston Phoenix, December 11, 1968.

324 "it looked as though someone had accidentally taped": *Hollywood Reporter*, December 5, 1968.

324 "He still can't sing": Variety, December 5, 1968.

324 "I don't think many viewers": Los Angeles Times, December 4, 1968.

324 "Rock Star's Explosive Blues": New York Times, December 4, 1968.

325 the fifty-one-year-old Kerkorian: Background on Kirk Kerkorian and the International Hotel comes primarily from Dial Torgerson, *Kerkorian: An American Success Story;* Peter Bart, *Fade Out: The Calamitous Final Days of MGM;* and Charles Fleming, "The Predator," *Vanity Fair,* February 1996.

325 "a modest man": Bart, Fade Out, p. 100.

325 headliners like Frank Sinatra and Dean Martin: By way of comparison, Nick Tosches has Martin's 1969 salary at the Riviera at \$100,000 a week plus \$20,000 a month as a "talent consultant" in Tosches, *Dino: Living High in the Dirty Business of Dreams*, p. 389. It should not be lost sight of, however, that Martin acquired 10 percent of the Riviera at this time.

326–330 Sometime after Christmas: Background on the American sessions and Elvis' initial arrival at the studio comes from diverse sources, including interviews with George Klein, Chips Moman, Mike Leech, Glen Spreen, Reggie Young, Gene Chrisman, Wayne Jackson, Mark James, and Joe Esposito; Al Cooley interview with Felton Jarvis; Alan Fortas, *Elvis: From Memphis to Hollywood*, p. 288; Nash, *Elvis Aaron Presley*, pp. 444, 454ff; and Marty Lacker et al., *Elvis: Portrait of a Friend*, pp. 114ff, 187.

327 "Presley's friends": Variety, June 18, 1969.

328 Lincoln "Chips" Moman: Background on Chips Moman comes primarily from my 1986 book *Sweet Soul Music: Rhythm and Blues and the Southern Dream of Freedom.*

331 "That first night Colonel Parker said": Jerry Hopkins interview with Mac Davis (MVC/UMem).

332 even George Klein . . . cautioned Elvis: Rose Clayton and Dick Heard, eds., *Elvis Up Close: In the Words of Those Who Knew Him Best*, p. 237.

332 With Joe's further encouragement: Interviews with Joe Esposito.

332 "He just sang great": Shelley Ritter interview with Wayne Jackson.

333 The thirty-nine-year-old Hamilton: Background on Roy Hamilton comes primarily from Peter Grendysa, "Roy Hamilton: Never Walking Alone," *Goldmine*, April 1979, and Peter Grendysa, "The Roy Hamilton Story," *Soul Survivor* 5, summer 1986. In addition to "I Believe," Elvis had recorded Hamilton's "I'm Gonna Sit Right Down and Cry (Over You)" at his second RCA session in 1956 and would go on to record several more Hamilton titles, including "Hurt," in later years.

333 "I said, 'Come on, Elvis'": Interview with George Klein, 1988; see also Lacker et al., *Portrait*, p. 119.

334 he offered Hamilton one of his songs: Interviews with George Klein, Gene Chrisman, and Reggie Young; also Trevor Cajiao interview with Bobby Wood, *Elvis: The Man and His Music* 26, March 1995, p. 9.

336 "one of the hardest-working artists": James Kingsley, "Relaxed Elvis Disks 16 Songs in Hometown Stint," *Memphis Commercial Appeal*, January 23, 1969.

336 the business issues raised: Interviews with Chips Moman, Freddy Bienstock, George Klein, and Herbie O'Mell; see also Lacker et al., *Portrait*, pp. 117–119. Nearly every other previously named source in this chapter has his own version of the story.

336 it was strongly hinted: This is inferential on my part. "Mama Liked the Roses" appears on the original album listing of March 12 with the title crossed out and "OUT" written beside it and circled (BPE).

336 a follow-up session was being planned: Correspondence regarding this second session begins on January 29 (EPE).

337–338 All he could talk about: Interview with Freddy Bienstock, 1992.

338 "I wanted to give Elvis a different image": Interview with Glen Spreen, 1995.

338 Chips continued to have substantial input: Chips was involved at least through August on the evidence of paperwork and overdubs, not to mention his presence at Elvis' Las Vegas opening (just before the final overdub on "Suspicious Minds"). The friction between Felton and Chips can be deduced from nearly every interview I conducted, including interviews with Mary Jarvis; from the opposing overdub sessions in Memphis and in Nashville; from the public conflict

over producer's credit; and from the musical results — not to mention the fact that Elvis never returned to American.

339 "We'd do scenes": Interview with Billy Graham, 1996.

339 "heralded as the world's largest showroom": From International publicity director Nick Naff's official publicity release.

340 a Variety headline: Variety, June 18, 1969.

340 at the instigation of Marty Lacker: Nash, *Elvis Aaron Presley*, p. 462; *Billboard* charts, May 3, 10, 17, 24, 1969.

340 at the gates with the fans: Donna Lewis, "Hurry Home, Elvis!": Donna Lewis' Diaries, vol. 3 (unpublished manuscript), mspp. 58ff; Memphis Commercial Appeal, June 8, 1969; Memphis Press-Scimitar, July 9, 1969; Harold Loyd, Elvis Presley's Graceland Gates, p. 29. See also Maria Davies' Official Elvis Presley Fan Club News Service account of the February 1970 Las Vegas engagement, in which Vester Presley explains that Elvis spent so much time at the gates "to get him used to the crowds again" — even though the Colonel didn't like it.

340 he saw this as an opportunity: Interview with Charlie Hodge, 1989.

341-342 he called guitarist James Burton: Interview with James Burton, 1991.

341-343 Jerry Scheff, a virtuoso bass player: Interview with Jerry Scheff, 1989.

342–343 Tutt, Muhoberac thought, would be perfect: Trevor Cajiao interview with Larry Muhoberac, *Elvis: The Man and His Music* 22, March 1994.

342 "I was the last drummer": Stephanie Bennett, "Tutt," Modern Drummer interview (undated clip), p. 24.

343 the salary structure: Tom Diskin to Lou Goldberg, July 17, 1969 (EPE).

343–344 costume fittings with Bill Belew: Interview with Bill Belew, 1995; Jerry Hopkins interview with Bill Belew (MVC/UMem).

344 "We probably learned": Interview with James Burton.

344 "It's relatively simple": John Wilkinson, quoted in Lacker et al., Portrait, p. 193.

 $344\,$ The program that Elvis started out with: Meticulous song lists were kept for each rehearsal (EPE).

344 Charlie drew upon his own experience: Interview with Charlie Hodge.

345 Felton flew in: Interview with Mary Jarvis, 1989.

345 "I didn't know that much about Elvis": Jerry Hopkins interview with Myrna Smith (MVC/UMem).

345 "He had on a chocolate-colored suit": Clayton and Heard, *Elvis Up Close*, p. 244. The Hopkins interview resumes next paragraph.

345 the thing that was most difficult for them: Interview with Myrna Smith, 1990; my interview with Estelle Brown, 1996, provided similar insights into the feelings of the group.

345-346 The Imperials had their own problems: Interviews with Joe Moscheo, 1989, 1993.

346 Three nights before: Telegram invitation from Bill Miller to the 2:15 A.M. show (EPE).
346 she looked awfully alone: Charlie Hodge, *Me 'n Elvis*, p. 123; interview with Al Dvorin,
1995; Jerry Hopkins interview with Bill Jost (MVC/UMem); Albert Goldman, *Elvis*, pp. 438, 441;
Nash, *Elvis Aaron Preslev*, p. 473.

346 one of the biggest advance sales: Variety, July 9, 1969.

346 "I don't like to take any chances": Memphis Commercial Appeal, August 3, 1969.

347 "If you don't do any business": Esposito, Good Rockin', p. 142.

347 the Colonel and his crew: Goldman, Elvis, p. 442.

347 Colonel continued to work behind the scenes: The contract was signed on August 14 (EPE).

347 an A-plus celebrity list: Grelun Landon invitation file.

347 most of the Strip headliners: Billboard, August 6, 1969.

698 🔊 NOTES

348 Joe had his doubts: Interview with Joe Esposito, 1990.

348 The Sweet Inspirations did a stiff opening set: Perhaps the two best general sources for a description of the entire show are Robert Christgau, "Elvis in Vegas," *Village Voice*, September 4, 1969; and Maria Davies, "A report of the happening of the decade," a detailed British fan club report, which covers the nights of August 20–23 and August 29.

348 "Good evening, ladies and gentlemen": This is a pastiche based on a number of accounts, but particularly on Jerry Hopkins, *Elvis*, pp. 371–372, and Maria Davies, as cited above.

349 even waitresses ... "were visibly swooning": Los Angeles Herald-Examiner, August 12, 1969.

349 "Presley's sustaining love for rhythm and blues": New Yorker, August 30, 1969.

349 Richard Goldstein felt: New York Times, August 10, 1969.

349 the Hollywood Reporter critic: Hollywood Reporter, August 13, 1969.

349 "Presley, like a wild beast": Record Mirror, week ending August 9, 1969.

349–351 "But I was wired the wrong way": This is an edited version, somewhat condensed and elided, from several different sources, including Jerry Hopkins' *Elvis*; Maria Davies' account; Judy Kuniba, "Fun with Elvis on Stage July 26, 1969," *Elvis International Forum*; Donna Lewis' *"Hurry Home, Elvis!*," vol. 3; the (misnamed) bootleg CD *Opening Night, 1969*; and *Collector's Gold* (RCA 3114). It is evident that as the month wore on, the asides became looser and the language more risqué, but the constancy of the subject matter indicates how close this monologue was to the way Elvis really saw it, jokes, puns, and self-deprecating references notwithstanding.

351 "it was the energy": Interview with Priscilla Presley, 1995.

351 "He was so charged up": Interview with Joan Esposito, 1995.

351 "It was like a different Elvis": Interview with Pat Parry, 1991.

351 "He was all over that stage": Al Cooley interview with Felton Jarvis.

353 neither Joe nor Priscilla nor Charlie had ever seen: Interview with Joe Esposito; Priscilla Presley, *Elvis and Me*, p. 273; Charlie Hodge in Sandra Choron and Bob Oskam, eds., *Elvis! The Last Word*, p. 68; Red West et al., *Elvis: What Happened?*, p. 290.

353 Screaming Lord Sutch, a flamboyant British rocker: Rodney Bingenheimer, "It's All Happening," Go, August 15, 1969.

354 dropping several hundred dollars at a time: James Kingsley, "Presley Faces Toughest Challenge in Las Vegas," *Billboard*, August 9, 1969; Ellen Willis, "Musical Events" column, *New Yorker*, August 30, 1969.

354–355 The International took more formal notice: The initial letter from International Vice President Bill Miller exercising the option was written on August 1; the formal agreement upping Elvis' payment and extending the option through 1974 was executed on August 4 and signed by Elvis, Colonel, and Alex Shoofey (EPE).

355 Elvis-should watch himself, he wrote: Note dated August 22, 1969, written on plain white paper (EPE).

355 "The reception Elvis is getting here": Memphis Press-Scimitar, August 21, 1969.

355 "I wouldn't let no loudmouth old man tell me": John Fergus Ryan, "One Night With the Killer," *Oxford-American*, August–September 1995; also, interviews with George Klein and David Briggs, Trevor Cajiao interview with Larry Muhoberac, *Elvis: The Man and His Music* 22, March 1994.

356 "Elvis took a moment": Ed Parker, Inside Elvis, pp. 45-48.

356 "Every night was like a command performance": Interview with Joe Moscheo, 1989.

356–357 "We didn't decide to come back": Ray Connolly, "Elvis the Husband Talks About Elvis the Pelvis," *New Musical Express*, undated clip (prior to August 15, 1969).

357 "I said, 'Is the goddamn rhythm kicking you in the ass?'": Interview with Sam Phillips, 1989.

358 a tricky technical problem for Porter: Interview with Bill Porter, 1993.

358 "I mean, we laughed at it": Interview with Glen Spreen.

358 101,500 paying customers: Los Angeles Times, September 2, 1969.

359 "He remembered me": Jerry Hopkins interview with Mac Davis (MVC/UMem).

A NIGHT AT THE OPERA

361 They traveled to Hawaii: Information about the trips to Hawaii and the Bahamas and the aborted trip to Europe comes primarily from interviews with Jerry Schilling, Joe and Joan Esposito, and Priscilla Presley; also air bills (EPE) and passport issuance records; see also Marty Lacker et al., *Elvis: Portrait of a Friend*, p. 273.

362 "reportedly losing and signing markers": "Rona Reports," October 31 and November 6, 1969.

362 "During the lulls": Interview with Priscilla Presley, 1995.

363 "He was very much pulled": Interview with Sri Daya Mata, 1996.

363 "When the spirit moved him": Ed Parker, "'The King' and I," undated clipping (article in British fan magazine).

363–364 In the words of the 1966 hit: Sterling Hofman is only one of several witnesses who noted Elvis' fascination with the song. "He was smitten with it," she said in my 1989 interview with her. Elvis recorded "My Way" the following year and continued to sing it with the deepest conviction till the end of his life.

364–365 "I went in there": Interview with Glen D. Hardin, 1990.

364 "Elvis didn't rehearse": Glen D. Hardin quoted in Patsy Guy Hammontree, *Elvis Presley:* A Bio-Bibliography, p. 63.

 $365\,$ "The first couple of things we did": Jerry Hopkins interview with Glen D. Hardin (MVC/UMem).

365 The show that Elvis put together: From rehearsal records (EPE).

366 Porter leapt to the challenge: Interview with Bill Porter, 1993.

366 "Apparently there is no stopping Elvis Presley": James Kingsley, "Presley 'Shakes Up' Las Vegas Audience," *Billboard,* February 7, 1970.

366 he forgot the lyrics: Frank Lieberman, "Elvis IS Still the King!," Los Angeles Herald-Examiner, February 4, 1970.

367 "a flawless demonstration": Robert Hilburn, "Charisma of Presley Still Rocks Vegas," *Los Angeles Times, February 5, 1970.*

367 "the new decade will belong to him": Los Angeles Herald-Examiner, February 4, 1970.

367 "Gorgeous!": Albert Goldman, "A Gross Top Grosser," Life, March 20, 1970.

368 "a new life": Frank Lieberman, "A Legend That Lives," Los Angeles Herald-Examiner, February 8, 1970.

368 "As soon as the show was over": Interview with Myrna Smith, 1990.

368 he read her passages: Interview with Estelle Brown, 1996.

368–369 "It just seemed like": Interview with Joe Moscheo, 1990.

369 a kind of "silly boys' club": Peter Cronin interview with Glen D. Hardin, 1993.

369 a competition between "the crowd's adoration": Priscilla Presley, Elvis and Me, p. 277.

369 the feeling gradually took hold: Interviews with Joe Esposito and Jerry Schilling, among many similar references.

370 The final night: Maria Davies, "The King Returns to His Kingdom: Vegas Revisited!," Rex Martin's *Official Elvis Presley Fan Club News Service;* Sue Wiegert, *Elvis: For the Good Times,* p. 113; Jerry Hopkins interview with Johnny Rivers (MVC/UMem).

700 🔊 NOTES

370 New sound problems: Colonel to Alex Shoofey, February 23, 1970 (EPE).

370-371 the Colonel led an advance party: Marge Crumbaker, "A King in a Velvet Jail," Mid-South Magazine, Memphis Commercial Appeal, May 24, 1970.

371 The Colonel had tried to limit the size: Colonel to Joe Esposito, February 11, 1970 (EPE).

371 "just go ahead and play": Jerry Hopkins interview with Glen D. Hardin (MVC/UMem).

371 the first true test: Robert Hilburn, "Whole Lot of Shakin' Going On in Houston," Los Angeles Times, March 2, 1970.

371 "he went back to the hotel": Interview with Gee Gee Gambill: *Elvis: The Record,* vol. 2, no. 1, p. 19.

371-372 "The setting [for the second show]": Los Angeles Times, March 2, 1970.

372 Priscilla flew in: Maxine Mesinger, "Elvis Separation Rumor Is Dispelled," Houston Chronicle, March 2, 1970.

372 a capstone to "one of the most staggering reversals": Robert Hilburn, "Triumphant Return of the 'King,'" *Los Angeles Times*, undated clipping, c. March 15, 1970.

373 he had informed newly named International president: Colonel to Alex Shoofey, February 22 and 23, 1970 (EPE).

373 "The future of this resort community": Shoofey to Colonel, March 16, 1970; also followup letters from Shoofey and Fred Benninger to Colonel, March 21 and 26 (EPE).

373–376 Meanwhile, he continued to pursue another idea: Nearly all of the anecdotal information (and all quotations) on plans for this closed-circuit broadcast comes from Jerry Hopkins' interview with Steve Wolf and Jim Rissmiller (MVC/UMem); in addition there are written records of the terms for this and the various subsequent deals in the Colonel's papers (EPE); see also Robert Hilburn in the *Los Angeles Times*, March 19, 1970, and a similar Frank Lieberman report in the *Los Angeles Herald-Examiner* from around the same date. My summary of the negotiations, I'm sure, misses a few stages and may well miss more than a few of the Colonel's subtleties, but it is the best I could put together with the information available.

376–378 He wanted Felton with him: Jerry Flowers and Al Cooley interviews with Felton Jarvis; also interviews with Mary Jarvis, 1989, and Bob Beckham, 1995.

376 "Why don't you just quit": Al Cooley interview with Felton Jarvis.

376 a new contract from RCA: Ernst Jorgensen's and my interviews with Mary Jarvis; RCA paperwork supplied by Mary Jarvis.

378–379 Everyone in the band was excited: The material on the musicians' perspective on this session comes primarily from interviews with David Briggs, Chip Young, Jerry Carrigan, and Norbert Putnam.

378 Even for James Burton: Interview with James Burton, 1991.

379 "If he smiles at you": Jerry Hopkins interview with Jerry Carrigan (MVC/UMem).

379–380 The extent to which that trust had broken down: Interviews with Julian Aberbach and Freddy Bienstock; Bar Biszick's interviews with these and other players and insights on the same subject. In my interview with him, Bienstock credited the Colonel's loyalty with saving his position.

382 "It amazed me": Interview with Norbert Putnam, 1991.

382 He informed the hotel: Colonel to Alex Shoofey, June 23, 1970 (EPE).

383 "Baron Bienstock must be fully aware": Colonel to Julian Aberbach, March 26, 1970 (EPE).

383-385 Joe Guercio, a well-traveled music business hipster: Interviews with Joe Guercio, 1995 and 1998.

384 like "following a marble": Jerry Hopkins interview with Joe Guercio (MVC/UMem).

385 Cary Grant came backstage: Interview with Millie Kirkham, 1989.

385–386 To Robert Blair Kaiser: Robert Blair Kaiser, "The Rediscovery of Elvis," New York Times Magazine, October 11, 1970.

386 There would be one hundred security guards: James Kingsley, "Elvis Plans Tour After Wowing 'Em in Las Vegas," *Memphis Commercial Appeal*, August 12, 1970.

387 Jerry Weintraub had been courting the Colonel: Interview with Jerry Weintraub, 1995.

387 Hulett was the one with tour experience: Interview with Tom Hulett, 1990.

388 they put up \$240,000: Tour contracts and records (EPE).

389 trotting out a "laughbox": Sue Wiegert provides a good description of the show in *For the Good Times*, pp. 115–118.

389 a paternity suit was filed: Various news accounts; Jerry Hopkins interview with John O'Grady (MVC/UMem); interview with Ed Hookstratten, 1995; John O'Grady and Nolan Davis, O'Grady: The Life and Times of Hollywood's No. 1 Private Eye, pp. 166–168.

389 "How can anyone do this to me?": May Mann, Elvis and the Colonel, p. 211.

389 it was never a member of the band: Interviews with Glen D. Hardin and Jerry Scheff.

390 a fan from Memphis approaching Vernon: New York Times Magazine, October 11, 1970.

390 "They'd think it was so funny": Interview with Joan Esposito.

391 "The first couple of times in Vegas": Interview with Jerry Schilling, 1997.

391 That was the atmosphere: Principal sources for background on Kathy Westmoreland are my 1990 interview and Kathy Westmoreland, *Elvis and Kathy*.

391 she had "never seen anything like that": Interview with Kathy Westmoreland.

392 "I think it's important for me to just entertain": Westmoreland, *Elvis and Kathy*, p. 37. Although I have taken the quote somewhat out of sequence in the book, it expresses a belief that Elvis articulated again and again.

392–393 an anonymous call came into the security office: FBI Files for Elvis A. Presley, part I, pp. 55–63; also incident reports, one dated August 26, 1970, the other (undated) evidently written on August 28; August 28 notes "per telephone conversation with Ed Hookstratten"; undated letter regarding security precautions from Colonel to Elvis, with copies to Vernon Presley, Tom Diskin, George Parkhill, Joe Esposito, Jim O'Brien, Lamar Fike, Bitsy Mott, Sonny West, Richard Davis, and Charlie Hodge (EPE). Also, interviews with Jerry Schilling, Joe and Joan Esposito, Pat Parry, and Joe Moscheo. See also Jerry Hopkins manuscript account (MVC/UMem) plus numerous Hopkins interviews.

393 "I need you": Interview with Jerry Schilling, 1997.

393 When Red arrived: Red West et al., Elvis: What Happened?, p. 291.

393 "If some sonofabitch tries to kill me": Jerry Hopkins manuscript account (MVC/UMem); Sonny West in Clayton and Heard, *Elvis Up Close*, p. 247.

393 Dr. Newman . . . was backstage: Doctor and ambulance bills (EPE).

393 "It was crazy": Interview with Joe Moscheo.

393–394 Jim Aubrey, the soft-spoken fifty-one-year-old head of MGM: Background on Jim Aubrey comes largely from Peter Bart, *Fade Out: The Calamitous Final Days of MGM*, pp. 32ff.

393 a dark-haired twenty-three-year-old starlet: Interview with Barbara Leigh, 1990.

394 Then he turned back to Bova: Joyce Bova, *Don't Ask Forever: My Love Affair with Elvis*, pp. 6rff. Both Joyce Bova and Barbara Leigh refer to the presence of Rick and Kris Nelson in the room, as well as Jim Aubrey, though neither was aware of the other's presence. Bova dates the meeting to just after the assassination threat, and Leigh places it in the same time frame.

394 Bova had been enormously impressed: Bova, Don't Ask Forever, pp. 11-42.

394 She had made this trip determined to find out: Ibid., pp. 54-72.

395 "The phone was ringing": Interview with Barbara Leigh.

395-396 "Then all of a sudden Elvis came in": Interview with Kathy Westmoreland.

397 he called his wife, Marie: Jerry Hopkins interview with Stan Brossette (MVC/UMem); see also Jerry Hopkins, "Don't You Go Winnin' Elvis No Oscars," *Rolling Stone*, September 17, 1970.

398 Net income from personal appearances: This is the roughest of estimates. It is merely intended to give an idea of both the range of income possibilities and the way in which income was, theoretically, divided. I've tried to project figures on the basis of contracts, record sales, and my limited business understanding, but it would require an accountant of considerable sophistication to make his way through the maze of deals and side deals that the Colonel set up for both Elvis' benefit and his own. One thing should be clear from all of this, however: by now the arrangement was essentially a partnership, in the Colonel's view anyway, and one to which each partner contributed his own skills and expertise.

398 Elvis called for the spotlight: Wiegert, For the Good Times, pp. 116–118.

A COMIC BOOK HERO

401 "The crowd that filled the house": Robert Blair Kaiser, "The Rediscovery of Elvis," *New York Times Magazine*, October 11, 1970.

401 The Imperials had begged off: Interview with Joe Moscheo, 1989.

401 For reasons of economy: Interview with Joe Guercio, 1995; tour records (EPE).

402 "First this sonofabitch in Vegas": Kathy Westmoreland, *Elvis and Kathy*, p. 45 (italics and ellipses added).

402–403 "I went out and hired": Interview with Tom Hulett, 1990.

403 "Isn't it fun traveling like this?": Westmoreland, Elvis and Kathy, p. 48.

403 "they didn't much like me": Interview with Barbara Leigh, 1990.

404 "the dump of dumps": Interview with Joe Esposito, 1990.

405 to collect his official deputy sheriff's badge: UPI dispatch, October 13, 1970.

405 the National Quartet Convention: Memphis Press-Scimitar, October 15–16, 1970; Memphis Commercial Appeal, October 15.

405 "[we all] were going to have our picture made": Jerry Hopkins interview with James Blackwood (MVC/UMem); correspondence with James Blackwood.

405 "I thought maybe he'd gotten away": Jerry Hopkins interview with James Blackwood. I have changed the tenses.

406-407 The bluntness of his language: Colonel to James Aubrey, September 24, 1970 (EPE).

407 He demanded a \$1 million deposit: Interview with Jerry Weintraub, 1995.

407 twelve pendants he had ordered: Bill from Sol Schwartz and Lee Ableser, Fine Diamonds and Jewelry (EPE).

407 the prototype he and Priscilla had sketched out: Jerry Hopkins interview with Sol Schwartz (MVC/UMem); Joe Esposito, *Good Rockin' Tonight*, p. 100.

407–408 an undercover assignment at Hollywood High: George Klein remarks at the 1982 annual Elvis Presley Memorial conference at the University of Memphis (MVC/UMem); Alanna Nash, *Elvis Aaron Presley: Revelations from the Memphis Mafia*, p. 480; interviews with Jerry Schilling, 1995, 1997.

408 the time that lightning had split one of the statues: Westmoreland, Elvis and Kathy, p. 81.

408 He called Kathy: Ibid., p. 55.

408 "Scatter was one of the best buddies": Ibid., p. 66.

408 "Hey, boys": Ibid., pp. 57-58.

409 Barbara Leigh was a frequent visitor: Interview with Barbara Leigh.

409-410 "that night, in the quiet stillness": Westmoreland, Elvis and Kathy, pp. 68-70.

410 That was the night: Ibid., p. 74.

410 "I've got fifty-six gold singles": "Random Notes," *Rolling Stone*, December 24, 1970. See also Maria Davies in Rex Martin's *Official Elvis Presley Fan Club News Service* 37–38 on the intrusion of the process server and Elvis' subsequent mood.

411 Richard Davis was fired: Nash, Elvis Aaron Presley, p. 516; Trevor Cajiao interview with Richard Davis, Elvis: The Man and His Music 14, March 1992.

411 "People will come from miles around": Westmoreland, Elvis and Kathy, p. 77.

411 He told them he would come back to pick it up: Interview with Ron Pietrefaso, 1995.

411 the largest single donation: Los Angeles Times, September 7, 1977.

411 he visited and exchanged gifts with the seventy-seven-year-old retired general: Interviews with Jerry Schilling, Cliff Gleaves, and Joe Esposito; also, Sue Wiegert, *Elvis: For the Good Times*, p. 119; Donna Lewis, *"Hurry Home, Elvis!": Donna Lewis' Diaries*, vol 3 (unpublished manuscript), msp. 172.

411–412 He sought out Vice President Agnew: Jerry Hopkins interviews with Jerry Schilling and John O'Grady (MVC/UMem); Red West et al., *Elvis: What Happened?*, p. 313.

412 He dismissed the Colonel: Marty Lacker et al., Elvis: Portrait of a Friend, p. 342.

412 One night the whole gang went out for dinner: Interviews with Jerry Schilling — but virtually every memoir and biography, and innumerable interviews, have recounted this incident with little variation save for the location of the dinner.

412 a three-night, \$20,000 gun-buying spree: Jerry Hopkins interview with salesman Jerry Knight (MVC/UMem); West et al., *Elvis: What Happened?*, p. 83. In the latter the figure is put at \$19,792; Jerry Knight recalls a sum of \$28,000; and Jerry Hopkins puts it at \$38,000 in his *Elvis: The Final Years*, p. 1.

412 he got a construction permit: The construction permit was dated December 10, the deed November 9, 1970 (EPE).

412 Joe and Joanie . . . needed a house, too: Interviews with Joe and Joan Esposito; Esposito, *Good Rockin*', p. 169; Lacker et al., *Portrait*, p. 150.

412–413 he decided to buy Mercedeses: Interviews with Ed Hookstratten, Barbara Leigh, George Barris, and Jerry Schilling.

413 "He was very spontaneous": Jerry Hopkins interview with Sol Schwartz (MVC/UMem).

413 Vernon and Priscilla got Elvis off by himself: Interview with Priscilla Presley, 1995; Priscilla Presley, *Elvis and Me*, p. 285; Billy Stanley, *Elvis, My Brother*, p. 105; Lacker et al., *Portrait*, p. 141; Goldman, *Elvis*, p. 462; et al.

414–417 Jerry was the first to get any kind of word: This account has been constructed primarily from various interviews with Jerry Schilling over the years, both Jerry Hopkins' (MVC/ UMem) and my own, as well as Hopkins' interview with Gerald Peters (MVC/UMem).

416 "First I would like to introduce myself": Elvis' letter has been published in facsimile form in a number of books, including Fred L. Worth and Steve D. Tamerius, *Elvis: His Life from A to Z*, and Egil "Bud" Krogh, *The Day Elvis Met Nixon*.

417 Egil "Bud" Krogh, deputy counsel to the President: Krogh's account in *The Day Elvis Met Nixon* is an invaluable and detailed portrait. Unfortunately, Krogh has one preliminary screening meeting with Elvis that does not appear in other accounts. Given Chapin's memo to H. R. Haldeman, the absence of a follow-up memo from Krogh, the fact that times are not noted on existing memos, and the apparent chronology of Elvis' day, I am at a loss as to how to resolve this discrepancy and have chosen to go with Jerry Schilling's version of events. In other respects, the two accounts contradict each other only in minor detail.

418 "You know that several people have mentioned": Krogh, The Day Elvis Met Nixon, p. 14.
418 badges went only to "those employees": John Finlator, The Drugged Nation: A "Narc's" Story, p. 103.

704 🔊 NOTES

419 Duncan said with . . . "an edge in his voice": Krogh, The Day Elvis Met Nixon, p. 26.

419 "He looked up at the ceiling": Ibid., pp. 32–33.

420 Krogh's contemporaneous memo: From Bud Krogh to The President's File, December 21, 1970, as reproduced in Bruce Oudes, ed., *From: The President: Richard Nixon's Secret Files*, p. 194.

420–421 It was at this point: The point is located only in my imagined reconstruction on the basis of what I hope to be informed guesswork deriving from the various anecdotal accounts. Obviously, tapes of this meeting, if they exist, may alter our understanding of its chronology and tone somewhat.

421 "The President," Krogh wrote: Krogh, The Day Elvis Met Nixon, pp. 35-38.

421 "Sonny and I were just standing in the doorway in awe": Jerry Hopkins interview with Jerry Schilling (MVC/UMem); see also West et al., *Elvis: What Happened?*, p. 236.

422 staff members "accustomed to seeing heads of state": Krogh, *The Day Elvis Met Nixon*, p. 44.

422-423 "He wanted to know what I made": Interview with Jerry Schilling.

423 He had been unable to get an appointment: FBI memo, December 22, 1970, FBI Files for Elvis A. Presley, part 1, p. 10.

423 one more attempt to see Joyce Bova: Joyce Bova, *Don't Ask Forever: My Love Affair with Elvis*, pp. 75ff; interview with Jerry Schilling. Chronology once again is a problem; according to Bova's recollection Jerry was the one who called her, but Jerry has no memory of any connection being made while he was still in Washington. It could have happened either way, but both recollections agree: Jerry was no longer around when Elvis and Bova met.

423 "Good thing I was right, man": Bova, Don't Ask Forever, p. 78.

423 "That sonofabitch Finlator": Ibid., pp. 84–94.

423-424 "he was like a kid": Interview with Priscilla Presley.

424 he dispensed four more Mercedeses: Memphis Press-Scimitar, December 30, 1970.

424 in the early hours of the morning: Seattle Post-Intelligencer, December 27, 1970; undated clipping from the Memphis Commercial Appeal, c. December 28.

424 He was wearing the "fur-cloth" black bell-bottom suit: *Memphis Press-Scimitar*, December 29 and 31, 1970.

424 He was armed with two guns: Nash, Elvis Aaron Presley, p. 501.

424 the deputy's badges they had recently acquired: Ibid., p. 502; Jerry Hopkins interview with Jerry Schilling (MVC/UMem).

425 "He paced the floor": Interview with Bill Mitchell, 1990.

425 "The Impossible Dream" was the title: "Elvis Makes 'Quiet Visit' to Tupelo," *Memphis Press-Scimitar*, December 30, 1970. Although he never recorded this song in the studio, he did start using it as a closing number in Las Vegas the following month. See also Nash, *Elvis Aaron Presley*, p. 19, re Shake Rag.

425 Elvis paid for everyone to join: Lamar Fike has this taking place the previous day in Nash, *Elvis Aaron Presley*, p. 502, but this would be impossible according to Joyce Bova's chronology in Bova, *Don't Ask Forever*, pp. 110ff.

425 they visited the FBI Building: FBI Files for Elvis A. Presley, part 1, pp. 7–8, memo dated January 4, 1971.

427 "your generous comments concerning the Bureau": J. Edgar Hoover to Elvis Presley, January 4, 1971, Ibid., p. 3.

427 The Jaycee awards had been given out: Most of the background on the history of the awards and its honorees comes from the Jaycee program that Elvis kept (EPE).

427–428 "He stayed up in his office": Interview with Priscilla Presley.

428–429 The two of them showed up bright and early: Much of the background for this account of the JCC dinner stems from reports in the *Memphis Commercial Appeal* and the *Memphis Press-Scimitar*, January 16 and 17, 1971.

428–429 he spotted Sam Phillips' former office manager: Interview with Marion Keisker, 1988; interview with Jerry Schilling.

429 Priscilla was amazed to see a side: Interview with Priscilla Presley.

429 At the restaurant: Bills indicate a considerable amount of detail (the party cost \$1,907.51 for one hundred guests for Chateaubriand dinner and bar) (EPE). For a more descriptive record, see *Memphis Commercial Appeal*, January 17, 1971.

A STRANGER IN MY OWN HOMETOWN

431 He also threw a glass of water: Sue Wiegert, Elvis: For the Good Times, p. 125.

431 "It took only a second for his guys to join in": Joyce Bova, Don't Ask Forever: My Love Affair with Elvis, p. 148.

432 Elvis showed them his BNDD badge: Interviews with Ron Pietrefaso, 1995, and Billy Ray Schilling, 1996.

432 "for one of the few times in his adult life": *Memphis Press-Scimitar*, March 9, 1971; George Klein remarks on Elvis' admiration for Ali at 1985 annual Elvis Presley Memorial conference at the University of Memphis (MVC/UMem). See also Thomas Hauser, *Muhammad Ali: His Life and Times*, p. 481.

433 Dr. Nick flew in from Memphis: Interviews with Dr. George Nichopoulos, Barbara Leigh, and Joe Esposito; also, Red West et al., *Elvis: What Happened?*, p. 286; *Memphis Press-Scimitar*, March 17 and 23, 1971.

433–434 "I was frozen by the sight of Priscilla": Bova, *Don't Ask Forever*, pp. 160ff. All subsequent quotes from Bova are from her book.

434 He introduced her to his grandmother: Ibid., p. 177.

434 "'Just think about it,' he said": Ibid., p. 192.

435 "Whoa, all ye Pharisees": This and other expressions like it (including the parable of the camel's ass) show up in numerous interviews and memoirs, including Joe Esposito, *Good Rockin' Tonight*, p. 122; West et al., *Elvis: What Happened?*, p. 168; Rose Clayton and Dick Heard, eds., *Elvis Up Close: In the Words of Those Who Knew Him Best*, p. 255. See also Jerry Hopkins, *Elvis: The Final Years*, p. 85.

435 "I felt that I just couldn't reach him": Interview with Priscilla Presley, 1995.

435 at Ed's instigation Elvis had contacted: Interviews with Ed Parker, 1990, and Kang Rhee, 1995.

435–437 carrying his diamond-and-ruby-encrusted lion's-head cane: Interview with Norbert Putnam, 1991. Other details about the session come from interviews with Jerry Carrigan, Glen Spreen, David Briggs, Chip Young, and Freddy Bienstock; Al Cooley interview with Felton Jarvis; and Alice Alexander, "He Knew the 'Private' Elvis," an interview with Felton Jarvis in the August 21, 1977, *Nashville Tennessean*.

436 "Instead of him coming in the control room": Interview with Glen Spreen, 1995.

437 "All of a sudden," said drummer Jerry Carrigan: Jerry Hopkins interview with Jerry Carrigan (MVC/UMem).

437 Carrigan failed to show up at all: Interview with Jerry Carrigan, 1989.

437 the session came to an abrupt halt: Interviews with Chip Young, Jerry Carrigan, Glen Spreen, and Joe Moscheo, among others.

438 "We used to joke": Interview with Norbert Putnam.

706 🔊 NOTES

438 Finally Carrigan said: Jerry Hopkins interview with Jerry Carrigan (MVC/UMem).

438–439 He called for Joyce to join him: Bova, *Don't Ask Forever*, pp. 193ff; group interview including Norbert Putnam and Jerry Carrigan conducted by Ernst Jorgensen and me, 1995. These are two very different recollections of the same event, with the musicians recalling how they "faked the stuff" and Joyce failing to recall the musicians.

439 Elvis, transported by the music and "every inch the perfectionist at work": Bova, *Don't Ask Forever*, p. 196.

439–440 his weird fluctuations of mood: Group interview with Norbert Putnam, Chip Young, David Briggs, Jerry Carrigan, and Kenny Buttrey conducted by Ernst Jorgensen and me; interviews with Jerry Carrigan, both mine and Jerry Hopkins'.

440–441 Elvis had met Master Rhee himself: Interview with Kang Rhee. Elvis' first badge from Kang Rhee, a fourth-degree black belt, is dated March 29, 1971 (EPE).

441 The Hilton Hotel chain took over the International: Correspondence between Barron Hilton and the Colonel from June 23, 1971, would indicate that the Hilton chain had effectively taken over by this date. For specifics on the business transaction, see Dial Torgerson, *Kerkorian: An American Success Story*, p. 245, which places the date of the actual sale on July 1.

441 The Colonel had an understanding: Jerry Hopkins interview with Henri Lewin (MVC/UMem).

442 "I did business with Kerkorian": Ibid.

443 Joanie Esposito paid a surprise visit: Esposito, *Good Rockin*', p. 127. Jerry Hopkins' interview with John Wilkinson (MVC/UMem) and my interview with Joe Guercio, 1995, reinforce the sense of atmosphere.

443 "We set it up": Interview with Joe Guercio.

443 Elvis' salary triggered "favored nations" clauses: Undated trade magazine account of the engagement from Colonel's scrapbooks (EPE).

444 "Col. Tom Parker outdid himself": Variety, August 14, 1971.

444 the critic for the *Hollywood Reporter* . . . called the performance: *Hollywood Reporter*, August 12, 1971.

444 it was "fabulous," from the overture on: Interview with Bill Belew, 1995.

445 "Further reliable word": Rona Barrett column, September 9, 1971.

445 the almost equally evident estrangement between Elvis and Priscilla: "Memo from John J. Miller," *San Francisco Sunday Examiner and Chronicle*, August 22, 1971.

445 "I would get these great shots of guys fighting": Interview with Priscilla Presley.

445 "a great blackbelt": Interview with Ed Parker.

446 "if Joe would call looking for Priscilla": Interview with Joan Esposito, 1995.

446 She knew the rules: Interview with Priscilla Presley.

446 Joyce Bova might have said much the same thing: Bova, Don't Ask Forever, pp. 226–239.

447 "when you had him around, you could make money": Jerry Hopkins interview with Henri Lewin (MVC/UMem). The tenses have been changed.

447 a manager who in Lewin's view "worried about Elvis": Henri Lewin, "Better Late Than Never," *Las Vegas Style*, March 1994.

447 "one of the best customers we ever had": Rose Clayton, "Colonel Parker Accused of Ripping Off Elvis," *Rolling Stone*, September 17, 1981.

447 "This was a man who never spent any money": Bar Biszick interview with Julian Aberbach, 1995; also my interview with Julian Aberbach, 1995. Similar views were expressed by Jean Aberbach in Albert Goldman, *Elvis*, p. 500.

447 Freddy tried to talk to him: Interview with Freddy Bienstock, 1992.

447 "It made me sick": Interview with Al Dvorin, 1996.

448 "Don't get crazy," he told Joe: Interview with Joe Esposito.

448 Now they all talked: Alanna Nash, Elvis Aaron Presley: Revelations from the Memphis Mafia, p. 471.

448 "Colonel had always told him": Interview with Joe Esposito.

448 "As different as they might appear": Interview with Jerry Schilling.

449 spoke of him as "Lardass": Interview with Freddy Bienstock.

449 The most frequent subject of discussion was Europe: Interviews with Priscilla Presley, Joe Esposito, Lamar Fike, Jerry Schilling, and others.

449 the Colonel had entered into talks with Tom Jones' flamboyant manager: *Melody Maker* and *New Musical Express* articles, September 1971; also, correspondence between Tom Diskin and *New Musical Express*, Gordon Mills and Tom Diskin, and Colonel and Gordon Mills between October 27 and November 1, 1971 (EPE); interview with Jerry Weintraub, 1995.

449 he expressed growing exasperation: Colonel to Management III, September 1, 1971 (EPE); interview with Tom Hulett, 1990.

450 they sought a renegotiation of their contract: Interviews with Joe Moscheo, 1989, and J. D. Sumner, 1990.

450 A new comedian was hired: Interview with Jackie Kahane, 1995.

451 he elicited \$25,000 bonus payments: Barron Hilton to Colonel, August 30, 1971 (EPE).

451 he resolutely refused to confirm: Colonel to Alex Shoofey, September 7, 1971; the Colonel finally confirmed the booking in a letter of November 24 and offered to look after the promotion, merchandising, advertising, etc., "assuming that you have not made other arrangements." Shoofey was not able to contain his "deepest personal appreciation" in his reply the following day (EPE).

451 Priscilla described it as "very manly": Sandra Shevey, "Priscilla Presley: My Life With and Without Elvis Presley," *Ladies Home Journal*, August 1973, p. 139.

451 One time during the summer: West et al., *Elvis: What Happened?*, p. 227; Priscilla Presley, *Elvis and Me*, p. 282; Nash, *Elvis Aaron Presley*, p. 508; Esposito, *Good Rockin*', p. 125; et al.

452 "I said, 'Colonel, we got two weeks'": Interview with Al Dvorin.

452 Joyce flew into Cleveland: Bova, Don't Ask Forever, pp. 276ff.

452 Elvis' seventy-four-year-old grandfather, Jessie: Bill Peterson, "Some of Elvis Presley's fans are old enough to be his grandparents," *Louisville Courier-Journal*, November 8, 1971.

453 The paternity suit was nearly settled: Rona Barrett column, November 5, 1971; Los Angeles Citizen News, December 2, 1971.

453 he had pretty much broken off with Barbara: Interview with Barbara Leigh, 1990.

453 He spoke to Joyce: Bova, Don't Ask Forever, pp. 316ff.

454 "Everyone remembered," wrote James Kingsley: Kingsley, "Elvis Plays Santa Claus — With Sly Grin on Face," *Memphis Commercial Appeal*, December 31, 1971.

454 Some of the guests in retrospect recalled: Nash, *Elvis Aaron Presley*, p. 527; Billy Stanley, *Elvis, My Brother*, p. 134; Hopkins, *Final Years*, p. 48.

454 in calls and conversations with one friend after another: Interviews with Lester and Sterling Hofman, Pat Parry, Alan Fortas, Ed Parker, and Dr. George Nichopoulos. All testify to Elvis' highly emotional reaction.

454 Joyce didn't see any major change: Bova, Don't Ask Forever, p. 363.

455 Robert Hilburn put his finger on the ongoing problem: Hilburn, "Fan to Fan: What's Happened to Elvis," Los Angeles Times, February 6, 1972.

455 Despite having to rent a private kidney machine: Interview with Mary Jarvis, 1989.

455-456 Joyce came out to Vegas one last time: Bova, Don't Ask Forever, pp. 364-383. All quotes are from this source.

456 "He grabbed me": Priscilla Presley, Elvis and Me, p. 298.

708 🔊 NOTES

456–457 Joanie didn't know: Interview with Joan Esposito. It should be noted that in her book (*Elvis and Me*, pp. 298–300) Priscilla indicates that she did not tell Elvis about Mike Stone. West et al., *Elvis: What Happened?*, p. 231, has Priscilla telling Pat West that Elvis "took her right on the spot when he knew another man was in the picture." But no man is named.

ON TOUR

459 Through a series of carefully executed maneuvers: Colonel had gotten a commitment from RCA president Rocco Laginestra as early as December 2, 1971, with the actual contract executed on January 28, 1972 (EPE).

459–460 a mood of almost autumnal regret: Ernst Jorgensen interview with Red West; Jerry Flowers interview with Felton Jarvis; and interviews with Jerry Schilling, 1990, and Pat Parry, 1991.

460 he had picked up from his friend Bob Beckham: Interview with Bob Beckham, 1995.

460 Elvis was in no mood: Al Cooley and Jerry Flowers interviews with Felton Jarvis.

460 The song with which they started out: Ernst Jorgensen interview with Red West; Trevor Cajiao interview with Red West, *Elvis: The Man and His Music* 22, June 1994, p. 11.

460 they all sat around listening: Interview with Jerry Schilling, 1997; also Ernst Jorgensen and Trevor Cajiao interviews with Red West.

460-461 "Elvis was really concentrating": Peter Cronin interview with Emory Gordy, 1993.

461 "He was trying to get something out of his system": Jerry Flowers interview with Felton Jarvis.

462–465 The two filmmakers, Bob Abel and Pierre Adidge: Most of the background on Abel and Adidge, and on the actual filming of the show, comes from my and Jerry Hopkins' interviews with Bob Abel.

463 "I want to shoot the real you": Interview with Bob Abel, 1995.

464 Back in Hollywood he transferred the tape: It should be noted that while Abel remembers simply filming the performance, there is an audiotape which indicates that he filmed the rehearsal in Buffalo as well.

465 "he pretty much gave us carte blanche": Jerry Hopkins interview with Bob Abel (MVC/UMem).

466–467 Finally Jerry, who saw this as a long-awaited opportunity: Interviews with Jerry Schilling and Bob Abel. The approximate date of Elvis' interview by the filmmakers is established by the recent death of go-go girl Kathleen Selph on July 19, to which Elvis refers at the beginning of the interview.

469 "He was like a mirror": Interview with Marion Keisker, 1988.

469-470 the expense of the building, the promotional costs: Interview with Tom Hulett, 1990.

470 Jackie Kahane... got booed off the stage: Interviews with Jackie Kahane, 1995, and Al Dvorin, 1996, among others.

471 "Like a Prince from Another Planet": New York Times, June 18, 1972.

471 dating a go-go girl: This was the same girl who was killed in the car crash in mid July.

471 his continued preoccupation with Priscilla's departure: Interview with Glen Spreen, 1995; Jerry Hopkins interview with Bill Browder (MVC/UMem); Red West et al., *Elvis: What Happened?*, p. 284; Billy Stanley, *Elvis, My Brother*, p. 161.

471–474 Then on July 6 he met Linda Thompson: Much of the background and all of those quotes not otherwise specified come from my interviews with Linda Thompson, 1990 and 1995.

473 "I had gone four years to Memphis State": Jerry Hopkins interview with Linda Thompson (MVC/UMem).

474 She had returned to Graceland: Priscilla Presley, Elvis and Me, p. 300; Memphis Press-Scimitar, July 27, 1972.

474 The terms of the settlement: These can be gleaned from the petition filed by Priscilla's new attorney to set aside the settlement the following July (see Goldman, *Elvis*, pp. 517–518); also, interview with Ed Hookstratten, 1995.

474 a salary of \$50,000 to the Colonel: Barron Hilton to Colonel, April 20, 1972. Elvis' salary emendation was formalized on the same date (EPE).

475 a direct threat the previous March: Colonel to Alex Shoofey, March 27, 1972 (EPE).

475 "with a welcome absence of horseplay": Variety, August 23, 1972.

475 Robert Hilburn reported: Los Angeles Times, August 18, 1972.

475 all the historic landmarks: Laura Deni, "TV Satellite Opens Era for Concert Show," *Bill-board*, September 16, 1972; Joseph A. Tunzi, *Elvis '73: Hawaiian Spirit*. The claim that this was the first worldwide satellite broadcast of an entertainment special was somewhat debatable in that the broadcast was not actually worldwide and Andy Williams had already done something of a similar nature for the European market.

476 a new arrangement with Elvis and the Colonel: The Colonel proposed this initially in a letter to George Parkhill on August 24, 1972; terms for the contract were sketched out on August 31 and the contract signed on September 12 (EPE).

476 he raised the issue: Colonel to Harry Jenkins, April 2, 1972 (EPE).

477 He had originally gotten the idea: George Parkhill deposition with respect to Colonel Parker in the matter of the estate of Elvis Aaron Presley, September 1, 1981 (EPE).

477 Jim Aubrey had begged him to postpone: Jim Aubrey and Doug Netter telegram to Colonel thanking him for his cooperation, August 14, 1972 (EPE).

478 Colonel got a letter from *Honolulu Advertiser* columnist Eddie Sherman: Eddie Sherman to Colonel, September 18, 1972 (EPE).

478 he set \$25,000 as the public goal: Billboard, December 16, 1972; Honolulu Advertiser, November 21, 1972.

478 he met with Bill Belew: Interview with Bill Belew, 1995.

478–479 He met with Marty Pasetta: Much of the background information and all of the quotes come from my interview with Marty Pasetta, 1995, unless otherwise noted.

479 Colonel volunteered several ideas: The execution of several of these ideas is described in the *Hollywood Reporter*, January 25, 1973, as well as in Jerry Hopkins' interview with Eddie Sherman. It should be noted that Al Dvorin was instrumental in conceiving of, booking, and carrying out much of the circus atmosphere.

480 Elvis even went on a quick-fix diet: Charles C. Thompson II and James P. Cole, The Death of Elvis: What Really Happened, p. 341; Alanna Nash, Elvis Aaron Presley: Revelations from the Memphis Mafia, p. 554.

480 "I was with him twenty-four hours a day": Interview with Linda Thompson, 1995.

481 "I said, 'Come onnn'": Jerry Hopkins interview with Linda Thompson (MVC/UMem).

481 He and Sonny had succeeded: Thompson and Cole, The Death of Elvis, p. 341.

481 It had even been nominated: It won the Best Documentary award in a tie with Walls of Fire.

482 "the first time that a current hit single": RCA publicity release, October 9, 1972.

482 he had real misgivings about his future role: Interview with Mary Jarvis, 1989; interview with Joan Deary, 1990; Mary Jarvis letter, February 18, 1993, with RCA paperwork; Ernst Jorgensen interview with Mary Jarvis; Al Cooley interview with Felton Jarvis. With respect to the kidney transplant, evidently because of his disillusionment with what he took to be the hospital's opportunism, Elvis never made the donation.

710 🔊 NOTES

482 There were various technical problems to contend with: Interview with Joan Deary; Sue Cameron, "Coast to Coast," *Hollywood Reporter*, January 25, 1973.

482 Elvis gave away his ruby-encrusted belt: Jerry Hopkins interview with Bill Belew (MVC/UMem); also, my interview with Belew.

483 tech crews ran their cables: Interview with Dick Baxter, 1989.

483 fans almost "literally stormed the inside of the arena": Honolulu Advertiser, January 13, 1973.

484 "It was a thrilling compact hour": Honolulu Advertiser, January 15, 1973.

484 "there was just not as much wind": Interview with Joe Guercio, 1995.

484 "the highlight of the night": Los Angeles Times, January 15, 1973.

484 the Colonel wrote Elvis a letter: EPE.

FREEFALL

487 There was . . . some outright friction: Red West et al., *Elvis: What Happened?*, pp. 166, 194–195; Albert Goldman, *Elvis*, p. 483.

487 "Colonel Tom Parker," the review declared: Variety, February 7, 1973.

487 he was variously reported: *Hollywood Reporter*, February 6, 1973; Sue Wiegert, *Elvis: For* the Good Times, pp. 138ff.

487–488 The Colonel, placed in the position: Colonel to Barron Hilton, February 16, 1973 (EPE).

488 he saw Dr. Boyer almost every day: Doctor's bills, January 25–March 4, 1973 (EPE); West et al., *Elvis: What Happened?*, p. 194; Alanna Nash, *Elvis Aaron Presley: Revelations from the Memphis Mafia*, pp. 556–557.

488 his apparent "lack of energy and interest": Hollywood Reporter, February 6, 1973.

488 Frank Lieberman, the *Los Angeles Herald-Examiner* critic: Jerry Hopkins interview with Frank Lieberman (MVC/UMem).

488 "I felt sorry for [him]": Thomas Hauser, Muhammad Ali: His Life and Times, p. 481.

488–490 four guys rushed the stage: Wiegert, For the Good Times, p. 139; AP dispatch (undated clipping); West et al., Elvis: What Happened?, p. 316; Kathy Westmoreland, Elvis and Kathy, p. 145; Goldman, Elvis, pp. 507ff; interview with Linda Thompson, 1995.

489 "You know it, Sonny": West et al., Elvis: What Happened?, pp. 3-5.

490 Finally Linda called Dr. Newman: Interview with Linda Thompson; doctor's bills (EPE). There were nine visits by the doctor on February 19, six more the following day.

490 "Aw, hell," he said at last: West et al., Elvis: What Happened?, p. 10.

490 The final show was the usual: Wiegert, For the Good Times, pp. 140, 141.

490–491 He maintained his karate studies: Interviews with Jerry Schilling, 1995, and Kang Rhee, 1995.

491 Elvis gave Master Rhee \$10,000: The canceled check is dated March 7 (EPE).

491 "Everything we did": Interview with Joe Esposito, 1990.

491–494 The Colonel meanwhile had finalized the deal: Interviews with Mel Ilberman, Joan Deary, Roger Davis, and Grelun Landon; George Parkhill deposition with respect to Colonel Parker in the matter of the estate of Elvis Aaron Presley, September I, 1981 (EPE); also, the Colonel's own affidavit in his answering lawsuit, June I, 1982 (EPE); Guardian Ad Litem's Amended Report In Re the Estate of Elvis A. Presley, Deceased, No. A-655, filed July 31, 1981; various RCA memoranda and contractual proposals (EPE).

493–494 A contract that would actually come to **\$5.4** million: All of the figures are in the Ad Litem report; the interpretation is my own. Just by way of financial comparison, Atlantic Records was sold lock, stock, and barrel in **1967** to Warner Seven-Arts for somewhat less than **\$20** million,

and Neil Diamond signed a \$4 million contract with Columbia in 1971 (ten albums at \$400,000 an album) that on the surface does not seem the equal of Elvis'. (Clive Davis, *Clive: Inside the Record Business*, pp. 150ff, describes negotiating the Diamond deal.)

494 after factoring in all the aggravation: Colonel's rationale was expressed again and again in his last years, to which I can personally attest. Also, see Thomas Jordan and James Kingsley, "Fairness of Colonel Parker's 50 Per Cent Fee Is 'Hair-Pulling' Question," *Memphis Commercial Appeal*, October 2, 1980, and Randall Beck, "'Suspicious Minds,'" *Memphis Press-Scimitar*, September 8, 1981, which are to a large extent a rehash of the Colonel's response to the Ad Litem accusations and his affidavit in his own lawsuit (EPE). "All I know is, I sleep very good at night," the Colonel said, with respect to his conscience being clear.

494–495 Not everyone saw it this way: Interviews with Roger Davis, Julian Aberbach, Tom Hulett, and Grelun Landon; Jean Aberbach quoted in Goldman, *Elvis*, p. 500.

495 no one could say Elvis was an unwitting, or even unenthusiastic, participant: Interviews with Jerry Schilling, Joe Esposito, Lamar Fike, Mel Ilberman, Ed Parker. According to Jerry Schilling, Elvis was very proud of the deal and spoke of it explicitly, though he rarely talked business.

495–496 he had been trying: Various correspondence between Colonel and Hill and Range, Colonel and Freddy Bienstock, and Colonel and RCA, from March 1, 1972 (EPE).

496 he informed Elvis in the middle of the Vegas engagement: Colonel to Elvis, February 13, 1973 (EPE).

496 the first quadraphonic release: RCA publicity release, April 30, 1973; Billboard, May 5, 1973.496–497 Elvis watched the show: Interview with Jerry Schilling.

497 Mike was "very much of a man": Sandra Shevey, "Priscilla Presley: My Life With and Without Elvis Presley," *Ladies Home Journal*, August 1973, p. 144.

497 this was widely perceived as "selling rank": Interview with Bill Wallace, 1997.

497 What he wanted now: Interview with Kang Rhee.

497–498 the newspapers, too, had carried notices: Newspaper accounts in the *San Francisco Examiner*, April 5–9, 1973, reflect the arc of expectations of the tournament directors. In the *Examiner* on April 5 and 7, Presley, "an avid karate fan," is scheduled to put in an appearance at Sunday night's (April 8) championship finals. The story on April 9 cites a clause in his Tahoe contract as having prevented him from participating but still has him watching the program from the stands — a direct contradiction of everyone's memory. The paper is also wrong about the Tahoe opening, which it implies will take place the following week. Interviews with Ed Parker, Kang Rhee, Jerry Schilling, and Joe Esposito offer various degrees of difference and occasionally sharply conflicting accounts. See West et al., *Elvis: What Happened?*, pp. 71ff, for another view.

498 "At the time I don't know anything about pills": Interview with Kang Rhee.

499 "I was really let down": Ernst Jorgensen interview with Emory Gordy; also, Peter Cronin interview with Emory Gordy.

499 Elvis was "neither looking nor sounding good": Variety, May 16, 1973.

499–501 Ed Hookstratten contacted John O'Grady: Interview with Ed Hookstratten, 1995; Jerry Hopkins interview with John O'Grady (MVC/UMem); Charles C. Thompson II and James P. Cole, *The Death of Elvis: What Really Happened*, pp. 120ff; Marty Lacker et al., *Elvis: Portrait of a Friend*, pp. 342–343; Marge Crumbaker and Gabe Tucker, *Up and Down with Elvis Presley*, pp. 194, 201, 205–208.

500 Elvis nearly overdosed in St. Louis: Thompson and Cole, *The Death of Elvis*, p. 324; Nash, *Elvis Aaron Presley*, p. 578; Peter Harry Brown and Pat H. Broeske, *Down at the End of Lonely Street: The Life and Death of Elvis Presley*, p. 372.

500 Elvis passed out in Hookstratten's office: Interview with Ed Hookstratten, 1995. In the December 20, 1977, *National Enquirer*, John O'Grady speaks of what appears to be the same incident taking place in *his* office.

501 George Parkhill . . . wrote Elvis: Parkhill to Elvis, June 29, 1973 (EPE).

502 Marty Lacker . . . set up the session: Lacker et al., Portrait, p. 205.

502 "It was the first time I ever saw him fat": Interview with Jerry Carrigan, 1989.

502 "He just didn't seem to care": Jerry Hopkins interview with Bobby Wood (MVC/ UMem).

502 Felton Jarvis and his engineer Al Pachucki, already skating on thin ice: Interviews with Mary Jarvis and Joan Deary; Ernst Jorgensen interview with Al Pachucki; various RCA communications with Colonel post-*Aloha*, indicating Deary's, RCA's, and Colonel's dissatisfaction with Felton, and Felton's own letter to new RCA president Ken Glancy on March 6, 1974, gratefully acknowledging that for the first time in almost two years he feels that he has a "good working relationship with the Company" (EPE and Mary Jarvis).

502–504 The studio vibe was bad: Interviews with Jerry Carrigan, Reggie Young, Freddy Bienstock, Charlie Hodge, Lamar Fike, and Kang Rhee; Ernst Jorgensen interview with Al Pachucki; Jerry Hopkins interviews with Bobby Wood and Bobby Emmons (MVC/UMem); Trevor Cajiao interview with Bobby Wood, *Elvis: The Man and His Music 26*, March 1995; interview with Larry Nix in Rose Clayton and Dick Heard, eds., *Elvis Up Close: In the Words of Those Who Knew Him Best*, p. 273.

503 the publishing debacle: Freddy Bienstock to Felton Jarvis, August 23, 1973 (courtesy of Mary Jarvis). Bienstock suggests that it would be a good idea that Felton make things right with his "good friend" Bob Beckham before Freddy takes the matter up with Colonel Parker. I think there is little question that Colonel was already aware of the situation, whether implicitly or explicitly.

503-504 "What I try to capture": Al Cooley interview with Felton Jarvis.

504 "More overweight than he's ever appeared": Hollywood Reporter, August 13, 1973.

504 Fan reports suggested: Christine Colclough's extensive report on the engagement in Rex Martin's Worldwide Elvis News Service Weekly.

504 he broke the ankle of a woman: Hospital bills (EPE); Jerry Hopkins interview with Gene Dessel (MVC/UMem); West et al., *Elvis: What Happened?*, pp. 195–197; news reports of the incident and its aftermath.

504–506 "Good evening, ladies and gentlemen": The first quote and some of the description is from Christine Colclough; most of what follows is from Sue Wiegert's account in Wiegert, *For the Good Times*, p. 144.

505–510 For the Colonel, though, there was little to be happy about: This account of the Colonel's reaction and the bitter argument that followed, including the twelve-day stand-off, is based on a wide variety of sources, including interviews with Jerry Schilling, Joe Esposito, Lamar Fike, Charlie Hodge, Tom Hulett, and Ed Hookstratten; Jerry Hopkins interview with John Wilkinson (MVC/UMem); West et al., *Elvis: What Happened?*, pp. 306ff; Lacker et al., *Portrait*, pp. 322, 329; Nash, *Elvis Aaron Presley*, pp. 589ff; Joe Esposito, *Good Rockin' Tonight*, p. 203; Crumbaker and Tucker, *Up and Down*, pp. 194ff; Goldman, *Elvis*, p. 520.

506 he had flown in a promising young gospel quartet: Ernst Jorgensen interview with Sherrill (today known as Sean) Nielsen; interview with Tony Brown, 1989.

506 he was some kind of illegal alien: The suspicion that the Colonel was Dutch — or that there was something "funny" about his background — came up in my interviews with Ed Hook-stratten, Mel Ilberman, Julian Aberbach, and Grelun Landon; also in Trevor Cajiao's interview

with Red West in *Elvis: The Man and His Music* 22, June 1994, as well as in Esposito, *Good Rockin'*, p. 197, and Dirk Vellenga ms., pp. 193ff. While none of these sources had any insight into the extent of Elvis' suspicions, most tended to agree that his general alertness to conversational undercurrents and social situations, what several of the guys referred to as almost a "sixth sense," along with his awareness of the Colonel's almost pathological aversion to foreign travel, would suggest that he must at least have had his suspicions.

507 when Eddy Arnold had dissolved their long-standing relationship: Arnold's original letter was written on August 21, 1953, with the release agreement signed September 4 (EPE).

508–509 Jerry had conflicts and confusions of his own: Interviews with Jerry Schilling. See also Billy Stanley, *Elvis, My Brother*, pp. 160, 166, 194, 197, re Elvis' relationship with Billy's wife; West et al., *Elvis: What Happened?*, pp. 278–279, re both Jerry and Billy.

509 Linda, too, was at a turning point: Interview with Linda Thompson.

509–510 he drew up a contract on a piece of scrap paper: West et al., *Elvis: What Happened?*, p. 306; Ernst Jorgensen interview with Sherrill Nielsen. Other background on Voice's arrangement with Elvis comes from my interviews with Tony Brown.

510 Colonel felt sufficiently emboldened: The Colonel's point of view can be deduced from a memorandum of his telephone conversation with RCA on September 25, 1973 (EPE). Although this took place two days after the session's conclusion, it covers the entire rationale for the way in which the session was conducted and obviously reflects the Colonel's prior thinking.

511 Elvis arranged for the operation to be performed: Doctors' bills indicate that both Elias Ghanem and Leon Cole were in attendance on Elvis in Palm Springs, while Dr. Juan J. Tur performed the surgery on Nielsen (EPE).

511 not the scene that Grelun Landon had anticipated: Jerry Hopkins interview with Grelun Landon (MVC/UMem) and correspondence with Grelun Landon; also my interview with James Burton and Ernst Jorgensen's interview with Sherrill Nielsen; James Burton in Clayton and Heard, *Elvis Up Close*, p. 271.

512 The Colonel was practically beside himself: Memo of September 25 telephone conversation, as above (EPE).

512 From the publicity material, it was obvious: Joan Deary's cover letter to the Colonel, dated September 27, 1973, included a memorandum on the Legendary Performers series which had originally been sent to the Colonel's man at RCA, George Parkhill, on September 7 (EPE). Perhaps because Parkhill was sick, the Colonel never got this memorandum until he received the September 27 letter, a lapse that he made the most of.

512 he fired off a letter: Colonel to Rocco Laginestra, October 1, 1973 (EPE).

513 "I think that things were not turning out": Interview with Sri Daya Mata, 1995.

513–514 Priscilla had reopened the case in May: Elvis Aaron Presley v. Priscilla Ann Presley (divorce). Orange County, California, Case #D-57002, 1972; interview with Ed Hookstratten; Rona Barrett column, July 5, 1973; Suzanne Finstad, *Child Bride: The Untold Story of Priscilla Beaulieu Presley*, pp. 250–265; Jerry Hopkins, *Elvis: The Final Years*, p. 99; Goldman, *Elvis*, p. 517.

514 On Tuesday, October 9, they met: Priscilla Presley, *Elvis and Me*, pp. 303–304; Sheila Weller, "Priscilla Presley: Surviving Elvis," *McCall's*, May 1979, pp. 14, 173; Jack Jones, "Elvis Presley Ends Marriage with a Kiss and \$1.5 Million," *Los Angeles Times*, October 10, 1973; "Elvis and Priscilla End Six Years of Marriage," AP wire-service report, October 10, 1973.

515–517 Six days later he was admitted to Baptist Memorial: Interviews with Linda Thompson, Dr. George Nichopoulos, Joe Esposito, Jerry Schilling, and Bill Wallace; Jerry Hopkins interviews with Maurice Elliott, Linda Thompson, and Jerry Schilling (MVC/UMem); *Memphis Press-Scimitar*, October 15 and November 2, 1973; Thompson and Cole, *The Death of Elvis*, pp. 283,

714 🔊 NOTES

334, 339ff; Clayton and Heard, *Elvis Up Close*, p. 273; Lacker et al., *Portrait*, p. 311; Esposito, *Good Rockin'*, p. 210; Nash, *Elvis Aaron Presley*, pp. 576–577. The chronology is established by an October 11 bill for the chartered plane (EPE) and Elvis' hospital admission four days later.

517 authorizing the Colonel to sign: Elvis to Colonel, October 24, 1973 (EPE).

THE IMPERSONAL LIFE

519–520 Dr. Nick came by almost every day: Interview with Dr. George Nichopoulos, 1996; Stanley Booth, "The King Is Dead!, Hang the Doctor!," in Martin Torgoff, ed., *The Complete Elvis*.

521 For Linda it offered a respite of sorts: Interviews with Linda Thompson, 1990, 1995.

523 "We were having lunch as usual": Interview with Norbert Putnam, 1995. Background on the session comes from interviews with Dick Baxter, David Briggs, David Porter; Larry Nix interview in Rose Clayton and Dick Heard, eds., *Elvis Up Close: In the Words of Those Who Knew Him Best*, p. 277; Ernst Jorgensen, *Elvis Presley: A Life in Music*, pp. 373–379; and RCA paperwork (EPE).

523 "You sonofabitch": Sue Wiegert, Elvis: For the Good Times, p. 145.

523–524 a new bass player, thirty-year-old Duke Bardwell: Trevor Cajiao interview with Duke Bardwell, *Elvis: The Man and His Music* 31, June 1996.

524 Sherrill already knew the song: Ernst Jorgensen interview with Sherrill Nielsen.

524 Red and Sonny in particular had even less respect: Red West et al., *Elvis: What Happened?*, pp. 77–87. There is an enormous amount of anecdotal information on any number of television and furniture shoot-outs, but see also the *Pasadena Star News*, September 18, 1977, which quotes a reference to Elvis' deposition in a 1974 lawsuit.

525 he pulled a gun on Red: West et al., Elvis: What Happened?, pp. 194–197.

525 everyone was always "a little tense": Interview with Joe Esposito, 1990.

525 Linda had as much reason for concern: Interview with Linda Thompson, 1995; West et al., *Elvis: What Happened?*, pp. 77–78; Charles C. Thompson II and James P. Cole, *The Death of Elvis: What Really Happened*, pp. 326–327. There is some disagreement not only about what Elvis was shooting at but about chronology as well, but the presence of "Hamburger James" Caughley, who left the entourage in September 1973, seems to place it in this time frame.

525–526 to Ann, even at the beginning of their relationship: Interview with Ann Pennington Cassidy, 1991.

526–527 Nick worked out an arrangement: Interview with Dr. George Nichopoulos; according to Thompson and Cole, *The Death of Elvis*, p. 200, Dr. Nick received \$76,000, the group \$147,000 between 1970 and 1977.

527 The big surprise on the tour: The reintroduction of Management III into the equation was first announced in a letter from Mel Ilberman to the Colonel on January 7, 1974. The Colonel protested bitterly to Ilberman and RCA president Ken Glancy on February 7, suggesting that in "thirty-three years" of dealing with the company "I have never felt so strongly that I was skating on thin ice" and making less than veiled threats (EPE). In the end everything was resolved, probably according to what the Colonel had in mind all along.

527 "I don't know of any act on the road": Ernst Jorgensen interview with Sherrill Nielsen.

528 The Memphis Press-Scimitar compared Elvis to Julius Caesar: Memphis Press-Scimitar, March 18, 1974.

529 A number of fans witnessed Elvis: Complaint filed by Edward L. Ashley in the United States District Court for the District of Nevada, October 11, 1974 (EPE); *Pasadena Star News*, September 18, 1977; Hopkins, *Elvis: The Final Years*, p. 122; Marty Lacker et al., *Elvis: Portrait of a Friend*, p. 311.

529 Colonel made half-hearted attempts to broach the subject: Thompson and Cole, *The Death of Elvis*, p. 356. The Colonel's awareness of Elvis' situation, and his seeming inability to do anything about it (along with his views on European travel), were elucidated in interviews with Joe Esposito, Tom Hulett, and Jerry Schilling. See also Lacker et al., *Portrait*, pp. 320–322.

530–532 he started getting serious about the movie: Background on Elvis' renewed interest in karate, the Tennessee Karate Institute, and the karate film stems primarily from interviews with Ed Parker, Rick Husky, Bill Wallace, Big Al Holcomb, Bert Lovitt, and Jerry Schilling; also Jerry Hopkins interviews with Rick Husky and Bill Belew (MVC/UMem); *Memphis Commercial Appeal*, July 5, 1974; various karate badges (EPE); Linda Jackson and Vera Jane Goodin, *Elvis & Bobbie*.

531–532 He arrived at the Monovale house: Interview with Rick Husky, 1995. All quotes are from this interview.

532 eventually he put up the money behind Colonel's back: Joe Esposito, *Good Rockin' Tonight*, p. 218; Colonel Parker in conversation, 1995; various memos and bills from September 21, 1974, including the Colonel's very disapproving notes on a contract proposal for "Documentary Karate Film," November 20, 1974 (EPE).

 $532{-}533\,$ "He treated me like a child": Jerry Hopkins interview with Dee Presley (MVC/ UMem).

533 The whole troupe sang: Interview with Glen D. Hardin, 1990.

534 "the best show . . . in at least three years": Hollywood Reporter, August 23, 1974.

534–535 "He seemed nervous": This and all further quotes from Colclough are from her account in Rex Martin's *Official Elvis Presley Fan Club News Service*. Colclough described performances from August 19 to 28; Martha Collins wrote up shows between August 26 and August 29; while John Andrews covered the rest of the engagement in a five-part series. Taken together, these offer detailed and scrupulously observed coverage of the show.

535-537 "I went up to the suite between shows": Interview with Sheila Ryan Caan, 1990.

537 both evening shows were canceled: Devoted fan Donna Lewis wrote in her September 23 diary entry ("Hurry Home, Elvis!": Donna Lewis' Diaries, vol. 3 (unpublished manuscript), msp. 339): "They're saying that Elvis has used drugs since the army, but it's gotten really bad in the past three years. . . . I think that it's a bunch of lies and all the rumors are because of Elvis' poor health."

538 "Put a spotlight onto the statues": I've quoted this directly from Hopkins, *Final Years*, pp. 131–132. It appears to stem from the September 1 dinner show. Close variations on the same monologue were reported by Martha Collins in her account of the August 27 midnight show and John Andrews in his report on the August 30 dinner show, among others.

539 "to exploit and commercialize Elvis' name": From Colonel's September 2, 1977, affidavit in the state of California, county of Los Angeles, re the continuation of his merchandising agreement with Vernon Presley in the aftermath of Elvis' death; also Colonel's response to the Ad Litem accusations and his affidavit in his own subsequent lawsuit (EPE).

 $539\,$ "He could make a hit record in a boxcar": Jerry Hopkins interview with Ron Jacobs (MVC/UMem).

539 to reward long-standing associates: There were a number of different percentage formulations, as listed in both the Colonel's papers (EPE) and the Ad Litem reports, and it's hard to say which took precedence when (and for how long).

539–540 Colonel had indicated to Kathy Westmoreland: Interview with Kathy Westmoreland, 1990; Colonel's correspondence with RCA re Boxcar and Boxcar artists from August 15, 1974 (when the *Having Fun* deal was signed), through the following year (EPE).

540 "I teach": Hopkins, Final Years, p. 133.

716 🔊 NOTES

541 He even recognized orchestra leader Joe Guercio: Interview with Joe Guercio, 1995.

544 "I was in shock": Interview with Priscilla Presley, 1995.

544 he arranged to have a local crew film him: *Memphis Press-Scimitar*, September 17, 1974; *Memphis Commercial Appeal*, September 22, 1974; interviews with Bill Wallace and Al Holcomb; film footage. The advertisement was in the *Commercial Appeal*; the quote about showing "he could take it" is from the *Press-Scimitar*.

545 a ten-day buying spree: *Memphis Commercial Appeal*, September 24, 1974; *Memphis Press-Scimitar*, September 27, 1974; Jerry Hopkins interviews with Maggie Smith and car salesman Howard Massey (MVC/UMem); Lewis, *"Hurry Home, Elvis!,"* vol. 3, msp. 338; Alanna Nash, *Elvis Aaron Presley: Revelations from the Memphis Mafia*, p. 598; bill for 1975 Woodcrest three-bedroom double trailer (EPE).

545 he visted Methodist Hospital: Interviews with Linda and Sam Thompson; Jerry Hopkins interview with Linda Thompson (MVC/UMem).

545 he had helped Sam and Louise purchase a new home: Interview with Sam Thompson, 1989; sale papers for the August 1 purchase (EPE).

 $545\,$ "There was a lady there in labor": Jerry Hopkins interview with Linda Thompson (MVC/UMem).

546 Elvis continued to work out his ideas: Interview with Linda Thompson.

547 "My first night was College Park": Jerry Hopkins interview with Tony Brown; additional background information from my interview with Tony Brown, 1989.

547 Even Sonny was shocked: West et al., Elvis: What Happened?, p. 308.

547 "Shut that damn sound off, Felton": Interview with Mary Jarvis; similar story from Donnie Fritts, 1988.

547 Red and Ed Parker became aware of a cocaine shipment: Lacker et al., Portrait, pp. 326-327; see also Esposito, Good Rockin', p. 208; Thompson and Cole, The Death of Elvis, p. 346.

548 Newspaper accounts tried to puzzle out: Lee Cotten, Did Elvis Sing in Your Hometown, Too?

548 "Elvis was just standing there": Trevor Cajiao interview with Duke Bardwell, *Elvis: The Man and His Music* 31, June 1996.

548 Ghanem ordered a series of tests: Medical bills (EPE).

548–550 Jerry Schilling came out to see him: Interviews with Jerry Schilling, Linda Thompson, Sheila Caan, Dr. George Nichopoulos, and Bert Lovitt (re setting up the office and reviewing the film).

549 he had already assigned more than 100 percent: In interviews with Tom Hulett and Joe Esposito, among others, both suggested it was their understanding at the time that Elvis had given away 130 to 150 percent of the film. Elvis' own notes on the final page of the script indicate that this was not true.

549–550 he would like a home of his own: Interviews with Jerry Schilling and Rick Husky; the conversation is dated by the deed to Jerry's house.

550 as usual there was little for them to do: Interview with Tony Brown.

550–551 "To produce a motion picture of this nature": The Colonel's addendum is dated November 20, 1974 (EPE).

551 "like the boy in the bubble": Interview with Sheila Caan.

551 "He said, 'Jerry, can you help me?'": Interview with Jerry Schilling.

552–553 The karate movie was ingloriously shut down: Interview with Bert Lovitt, 1995, with reference to his contemporaneous work diary.

553 a message expressing his appreciation: December 30, 1974, telegram from Elvis to Colonel (EPE).

553 He also contacted Henri Lewin: Colonel to Henri Lewin, December 30, 1974 (EPE).

A LEAF IN THE STORM

555 Elvis told Billy that he could hardly watch: Alanna Nash, Elvis Aaron Presley: Revelations from the Memphis Mafia, p. 507.

555 "heartless, cruel, vicious rumors": "Elvis the Pelvis Turns 40, But He Isn't All Shook Up," *People,* January 13, 1975.

555–556 To Elvis, though, she was beginning to express her true feelings: Interview with Linda Thompson, 1995; also, Elizabeth Daroff, "Elvis," *McCall's*, July 1980, p. 142.

556 if he refused to book Elvis: Interviews with Jerry Schilling, Joe Esposito, Tom Hulett; Charles C. Thompson II and James P. Cole, *The Death of Elvis: What Really Happened*, p. 356; Marge Crumbaker and Gabe Tucker, *Up and Down with Elvis Presley*, p. 210.

556–557 "I had never been this much on the inside before": Interview with Tom Hulett, 1990. Confirmation of Hulett's story comes from Elvis' telegram to the Colonel on January 13, 1975 (EPE), and Colonel's reference in his eighty-fifth-birthday booklet to flying to Jackson one Sunday (January 12) with his staff.

557 Elvis put down a deposit of \$75,000: New York Daily News, January 21, 1975.

557 Dr. Nick had him admitted to the hospital: Memphis Press-Scimitar, January 30, 1975.

557 A "Presley source": Memphis Commercial Appeal, January 30, 1975.

558 Linda joined him once again: Interview with Linda Thompson.

558 Elvis' aunt Delta got a package: Interviews with Dr. George Nichopoulos and Jerry Schilling; Marty Lacker et al., *Elvis: Portrait of a Friend*, pp. 302, 316, 330–331; Rose Clayton and Dick Heard, eds., *Elvis Up Close: In the Words of Those Who Knew Him Best*, p. 280.

558 the two of them found themselves drawn back to old times: Jerry Hopkins interview with Maurice Elliott (MVC/UMem).

558 Vernon tried to put the blame: Nash, Elvis Aaron Presley, p. 624.

559 "He told me that he thought I was doing myself an injustice": Stanley Booth, "The King Is Dead!, Hang the Doctor!," in Martin Torgoff, ed., *The Complete Elvis.*

559–560 Elvis loved to watch old *Monty Python* episodes: Jerry Hopkins interviews with T. G. Sheppard and Linda Thompson (MVC/UMem); my interviews with Dr. George Nichopoulos and Linda Thompson.

560 Robert Hilburn had responded to the release of his latest LP: Hilburn, "Elvis: Waning Legend in His Own Time?," Los Angeles Times, January 19, 1975.

561 Elvis had gotten it into his mind: Ernst Jorgensen interviews with Mary Jarvis and Tony Brown.

562 "You should have seen me a month ago": Memphis Press-Scimitar, March 14, 1975.

562 "What the fans really wanted": Sue Wiegert, Elvis: For the Good Times, p. 150.

562 a wild water fight erupted: Ibid.; Len Leech account in Rex Martin's Worldwide Elvis News Service Weekly; Trevor Cajiao interview with Duke Bardwell, Elvis: The Man and His Music 31, June 1996.

563–565 Barbra Streisand had attended his performance: The date is established by a writeup in *For EP Fans Only*, vol. 3, nos. 1 and 2, 1975. The meeting was described in interviews with Joe Esposito, Jerry Schilling, Sheila Caan, and Rick Husky; Red West et al., *Elvis: What Happened?*, pp. 317–318; Joe Esposito, *Good Rockin' Tonight*, p. 206. The business denouement is documented in correspondence between Colonel Parker's office and Roger Davis at William Morris, between April 4 and April 15, and Davis' letter to First Artists on April 14 (EPE).

565 "there wasn't much at stake": Interview with Sheila Caan, 1990.

565–566 "the music [had] always felt nervous to me": Interview with Jerry Scheff, 1989.

565 Glen D., too, saw a turnaround: Interview with Glen D. Hardin, 1990.

718 🔊 NOTES

566 just as "modest, shy, and gracious as he could be": Jackson Clarion-Ledger, May 6, 1975.

566–567 who "after tonight [might] not be with me ever": Christopher Brown, On Tour with Elvis, p. 211.

566-567 Kathy was stung: Kathy Westmoreland, Elvis and Kathy, pp. 277-278.

567 a fat, "sensuous clown": Memphis Commercial Appeal, June 20, 1975.

567 he had made up his mind: Interview with Dr. George Nichopoulos; Peter Harry Brown and Pat H. Broeske, *Down at the End of Lonely Street: The Life and Death of Elvis Presley*, p. 390, Nash, *Elvis Aaron Presley*, p. 629. The quotes from Billy Smith are from the last named.

568 his attention was largely occupied with the airplane: All of the purchase information on the airplane comes from purchase orders and bills (EPE), unless otherwise noted.

568 she told him the truth: Interviews with Sheila Caan and Joe Esposito.

569 "How Great Thou Art" seemed more and more to have become almost a cry of pain: Lee Cotten, *Did Elvis Sing in Your Hometown, Too*?, pp. 198, 200.

569 he delivered a stunning version of "You'll Never Walk Alone": Ibid., pp. 203–204; For EP Fans Only, vol. 3, nos. 3 and 4.

569–571 Elvis had been riding Kathy for most of the tour: Westmoreland, *Elvis and Kathy*, pp. 278ff; interview with Myrna Smith, 1990. The account of the incident that followed derives primarily from these two sources, plus interviews with Kathy Westmoreland, Estelle Brown, Joe Esposito, and Jerry Schilling; Esposito, *Good Rockin'*, p. 168; West et al., *Elvis: What Happened*², pp. 30off; J. D. Sumner, *Elvis: His Love for Gospel Music and J. D. Sumner*, pp. 51ff. Needless to say, these accounts do not correspond in every detail.

570 "he smelled green peppers and onions": UPI dispatch, July 25, 1975.

570 "Sorry for any embarrassment": Ibid.

570 Felton called Millie Kirkham: Interview with Millie Kirkham, 1989.

571 "I thought it was funny": Westmoreland, Elvis and Kathy, p. 284.

571 J. D. Sumner felt that Kathy and the Sweets should never have walked off: J. D. Sumner, *Elvis: His Love for Gospel Music*, pp. 50ff.

571–572 The following afternoon he changed his departure plans: Jerry Hopkins interview with Lowell Hays (MVC/UMem); Jerry Hopkins, *Elvis: The Final Years*, pp. 155–157.

572 "I guess I embarrassed him": Clayton and Heard, *Elvis Up Close*, p. 292; also, interview with Dr. George Nichopoulos, 1996, and Beth J. Tamke, "Doctor Talks About Elvis' Problems, His Life and Death," *Memphis Commercial Appeal*, August 25, 1977. West et al., *Elvis: What Happened*?, p. 81, has a slightly different story, in which the television set was hit.

573 Lowell Hays was disturbed: Jerry Hopkins interview with Lowell Hays (MVC/UMem). The \$85,000 figure comes from Hays' six invoices dated July 24 (EPE).

573 Colonel didn't really take it the way that Elvis had hoped: *Memphis Commercial Appeal*, July 27, 1975; see also Nash, *Elvis Aaron Presley*, pp. 607–608; West et al., *Elvis: What Happened?*, p. 310; Hopkins, *Final Years*, p. 201.

573 Elvis bought and gave away thirteen Cadillacs: *Memphis Commercial Appeal*, July 29, 1975; *Newsweek*, August 11, 1975; Jerry Hopkins interviews with car salesman Howard Massey, Jo Cathy Brownlee, and Myrna Smith (MVC/UMem); interviews with Myrna Smith, Jerry Schilling, and Kathy Westmoreland.

574 On August 3 he put down \$26,000: All airplane information from purchase orders and bills (EPE).

574 the construction of his own racquetball court: Interview with Dr. George Nichopoulos. Vernon signed the agreement with contractor John Tomlinson on July 18, 1975 (EPE). The information on Marty Lacker's \$10,000 loan comes from Lacker et al., *Portrait*, pp. 162–163, and Elvis' financial records (EPE). **574** when he discovered that Dr. Nick was having trouble getting a bank loan: Interview with Dr. George Nichopoulos; Clayton and Heard, *Elvis Up Close*, p. 294; public records of a deed of trust drawn up between Charles H. Davis and D. Beecher Smith II [Elvis' lawyers], Trustees, and George C. and Edna S. Nichopoulos, parties, July 29, 1976.

574 "Son, if you don't quit [spending]": Shelley Ritter interview with Mike McGregor.

574 With Billy and Jo he prayed frequently: Nash, Elvis Aaron Presley, p. 630.

574–575 "He called me at four o'clock in the morning": Interview with Sheila Caan.

 $575\,$ "We walked in the front door": Jerry Hopkins interview with Melissa Blackwood (MVC/UMem).

577-578 He met Jo Cathy Brownlee: Jerry Hopkins interview with Jo Cathy Brownlee (MVC/UMem).

578 He barely made it to Vegas: Lacker et al., *Portrait*, p. 321; West et al., *Elvis: What Happened?*, pp. 198–199; J. D. Sumner, *Elvis: His Love for Gospel Music*, pp. 63ff; Thompson and Cole, *The Death of Elvis*, p. 304; Hopkins, *Final Years*, p. 167; interview with Linda Thompson.

578 He was "overweight": Variety, August 22, 1975.

578 short bursts of energy seemed to alternate: Christine Colclough report on the August 1975 engagement for Rex Martin's *Worldwide Elvis News Service Weekly*. Many of the specific descriptive details concerning this engagement are from Colclough's account.

578–579 how "out of it he was": Interview with Linda Thompson.

 $579\,$ a story that Jo Cathy Brownlee had told him: Jerry Hopkins interview with Jo Cathy Brownlee (MVC/UMem).

579 "I'm not going to go out there and tell them": West et al., Elvis: What Happened?, p. 198.

579 He assured Henri Lewin: Correspondence between Colonel and Lewin, August 25–27, 1975 (EPE).

579–580 At the same time he reassured Elvis: From Colonel's record of his accounting for the engagement (EPE).

580 gossips were whispering: Speculative news items in *Hound Dogs*, vol. 10, no. 4, and *Memphis Flash*, vol. 3, no. 2 [fan magazines].

580 Colonel felt he could no longer place any faith in Elvis' assurances: Lacker et al., *Portrait*, pp. 320–321, 329; Randall Beck, "Parker Calls Elvis Headstrong Client," *Memphis Press-Scimitar*, September 9, 1981; Henri Lewin, "Better Late Than Never," *Las Vegas Style*, March 1994, p. 33; interview with Jerry Schilling, 1997.

580–581 Meanwhile, Dr. Nick found a very different Elvis: Interview with Dr. George Nichopoulos.

581 President Nixon called: Undated clipping, referring to the call coming in at 11:30 A.M. on the Saturday of Labor Day weekend.

581 Frank Sinatra called, too: Interview with Linda Thompson.

581–582 But mostly it was Marion Cocke: Marion Cocke, *I Called Him Babe: Elvis Presley's Nurse Remembers;* Jerry Hopkins interview with Marion Cocke (MVC/UMem); undated *Memphis Press-Scimitar* clipping re Elvis' gift of the car.

581 "He talked about his family": Shelley Ritter interview with Marion Cocke.

582 "He looked back to me": Ibid.

582-583 Linda returned to the Coast: Interview with Linda Thompson.

583-584~ He started going out again with Jo Cathy Brownlee: Jerry Hopkins interview with Jo Cathy Brownlee (MVC/UMem).

584–585 even concocting a scheme to record half an album in the studio: Elvis' telegram to Colonel of October 21, 1975 (EPE), embraces this plan, with every evidence (including Colonel-like language) of having been dictated by the Colonel.

720 🔊 NOTES

585 Colonel tried to interest the label: September 4 and 8, 1975, letters from Colonel to Mel Ilberman (EPE).

585 The Lisa Marie was finally delivered: Memphis Press-Scimitar, October 31 and November 12, 1975.

 $585\,$ "I can't believe this is mine": Jerry Hopkins interview with T. G. Sheppard (MVC/ UMem).

585 He was growing more and more nervous: Cocke, *I Called Him Babe*, pp. 107, 138. See also Patsy Guy Hammontree, *Elvis Presley: A Bio-Bibliography*, pp. 96–97, for an account of his relationship at this time with a young Memphis woman named Dawn Bonner (also mentioned by Cocke).

585 the room, and the hotel, were full: Jerry Hopkins interview with Henri Lewin (MVC/UMem); Cotten, *Did Elvis Sing in Your Hometown*, *Too*, p. 218.

586 Glen D. made up his mind to leave: Interviews with Glen D. Hardin, 1990, and David Briggs, 1988; Trevor Cajiao interview with Glen D. Hardin, *Elvis: The Man and His Music* 35, June 1997; Ernst Jorgensen interview with Tony Brown; Jerry Hopkins interview with Grelun Landon (MVC/UMem).

586 he found himself "in a rage": Cocke, I Called Him Babe, p. 112.

586 Marty Lacker described "all the relatives": Nash, Elvis Aaron Presley, p. 647.

586 Lamar Fike simply felt frustration: Ibid., p. 647.

587 "and she was drunk": Ibid., pp. 649–650. Mrs. Cocke tells a variant on the jewelry story in *I Called Him Babe*, p. 115, but seems to have missed out on the dramatics. The Nash book has this incident happening Christmas Eve.

587 Billy Smith heard "the damnedest racket there ever was": Nash, *Elvis Aaron Presley*, pp. 650–653. According to Billy, Elvis made his aunt call up everyone on the plane afterward and apologize.

588 Elvis himself appeared shocked: Jerry Hopkins interview with Marty Harrell (MVC/UMem).

588 Joe Guercio told comedian Jackie Kahane disgustedly: Peter Whitmer, *The Inner Elvis:* A Psychological Biography of Elvis Aaron Presley, p. 416; rhythm guitarist John Wilkinson describes Elvis as "glassy-eyed" in his interview with Jerry Hopkins (MVC/UMem).

588 "He said, 'It'll be one of the largest crowds I've ever played'": Jerry Hopkins interview with T. G. Sheppard (MVC/UMem).

588 Four days later Elvis arrived in Denver: Interviews with Joe Esposito, 1997–1998, and Ron Pietrefaso, 1995; West et al., *Elvis: What Happened?*, p. 319.

589 Finally, Linda called Jerry and Myrna: Interviews with Linda Thompson, Jerry Schilling, Myrna Smith.

589 "IT'S ELVIS THE NIGHTSTALKER": The Star, February 10, 1976.

589 It was "a dream vacation": West et al., Elvis: What Happened?, p. 319.

589 Susan Ford, the President's eighteen-year-old daughter: Interview with Ron Pietrefaso; West et al., *Elvis: What Happened?*, p. 320, offers a variant on this story.

589 "he would speak about how nervous he got": Interview with Ron Pietrefaso.

590 Elvis contacted Bob Surber: *Denver Post*, January 16 and 20, 1976; interviews with Ron Pietrefaso and Joe Esposito; West et al., *Elvis: What Happened?*, p. 242.

590 Don Kinney, the host of KOA-TV's Denver Today, reported the story: Denver Post, January 21, 1976.

590 "but there was just so much inside of him": Interview with Ron Pietrefaso.

590–591 By this time Joe was gone: Interview with Jerry Schilling; West et al., *Elvis: What Happened?*, pp. 319–320.

HURT

593 they now proposed simply to install temporary equipment: Interview with Joan Deary, 1990; Jerry Flowers interview with Felton Jarvis; Gerry Wood, "Presley's House Now His Studio," *Billboard*, March 13, 1976; Ernst Jorgensen, *Elvis Presley: A Life in Music*, p. 394.

593 "because of friendship with Kennedy's older brother": *Denver Post,* January 29, 1976; J. D. Sumner, *Elvis: His Love for Gospel Music and J. D. Sumner,* p. 60; interviews with Ron Pietrefaso, 1995, and Jerry Kennedy, 1998.

594–596 He showed up for the first day of the recording session: Information on the session comes primarily from interviews with Glen D. Hardin, Norbert Putnam, David Briggs, James Burton, Mary Jarvis, and Myrna Smith; Trevor Cajiao interview with Glen D. Hardin, *Elvis: The Man and His Music* 35, June 1997; Shelley Ritter interview with Nancy Rooks; Colin Escott, "James Burton: Play It, James!," *Goldmine*, October 4, 1991, p. 18; Rose Clayton and Dick Heard, eds., *Elvis Up Close: In the Words of Those Who Knew Him Best*, p. 303; Red West et al., *Elvis: What Happened?*, pp. 239–240, 319; Jerry Hopkins, *Elvis: The Final Years*, pp. 180ff; Joseph A. Tunzi, *Elvis: Highway* 51 *South, Memphis, Tennessee*, introduction by Ronnie Tutt.

596 He went on, at his father's request: J. D. Sumner, Elvis: His Love for Gospel Music, p. 78.

597 Ten days later Elvis was back in Denver: *Denver Post*, February 19 and 20, 1976. The drug intervention is reported convincingly in West et al., *Elvis: What Happened?*, pp. 200ff, and in Sonny's and Red's testimony in Marty Lacker et al., *Elvis: Portrait of a Friend*, pp. 314 and 328. The quote has been constructed from these and other anecdotal accounts. It should be noted that all of the police officers involved have denied any suspicion of Elvis' drug use from the time of his death until the present day.

597 he had borrowed \$350,000 against Graceland: November 25, 1975, Deed of Trust, as printed in Margo Hoven Green, Dorothy Nelson, and Darlene M. Clevenger, *Graceland*.

598 "You know how much he depends on you": Trevor Cajiao interview with Glen D. Hardin, *Elvis: The Man and His Music.*

598–599 a new agreement, calling for a straight 50–50 partnership: The agreement is printed in the Report of the Guardian Ad Litem In Re the Estate of Elvis A. Presley, Deceased, No. A-655, Exhibit 11, filed September 29, 1980; the fact that the Colonel continued to take only one-third is indicated in Exhibit 12, which seems to represent the Colonel's account of all monies posthumously owed (though it differs slightly from other figures he later presented in court [EPE]). The Colonel's willingness to forgo his contractual due for a period of time in order "to assist Elvis" in meeting "certain financial demands which he faced" is spelled out in the Colonel's affidavit of June 1, 1982, in his countersuit against the Estate (EPE).

599 working with Elvis was something of a revelation: Interview with Larrie Londin, 1991.

599 "it seemed like all the enthusiasm had just left": Jerry Hopkins interview with John Wilkinson (MVC/UMem).

599 "Elvis seems weak": Harper Barnes, "Gold-Spangled Elvis: Flashes of the Old Fire," *Rolling Stone*, May 20, 1976.

 $599\,$ he continued to suffer memory lapses: Jerry Hopkins interview with Marty Harrell (MVC/UMem).

599 "there were nights": Rose Clayton and Dick Heard, eds., Elvis Up Close: In the Words of Those Who Knew Him Best, p. 307.

599–600 "when he first walked onstage, he'd be half asleep": Ibid.

600 "An eerie silence filled the concert hall": Long Beach Press Telegram, April 26, 1976.

600 "I felt so strongly for him I cried": Charles C. Thompson II and James P. Cole, *The Death of Elvis: What Really Happened*, p. 123.

600 "We all knew it was hopeless": Clayton and Heard, Elvis Up Close, pp. 307-308.

600 Together they went to Priscilla with the plan: Thompson and Cole, *The Death of Elvis*, p. 123; Jerry Hopkins interview with John O'Grady (MVC/UMem); and O'Grady quoted to the same effect in "Elvis and Drugs: The Truth at Last," *National Enquirer*, December 20, 1977; interview with Ed Hookstratten, 1995; Billy Stanley, *Elvis*, *My Brother*, p. 230.

600-601 "He'd be onstage some nights": Clayton and Heard, Elvis Up Close, pp. 312-313.

601 it was left to Linda to look after her: Interview with Linda Thompson, 1995; Donna Lewis, *"Hurry Home, Elvis!": Donna Lewis' Diaries*, vol. 3 (unpublished manuscript), msp. 368.

601 She was all he cared about: Larry Geller and Joel Spector, "*If I Can Dream*": *Elvis' Own Story*, p. 220.

602 a chain of racquetball courts around the country: The tangled story of the racquetball franchise is contained in various business documents from February 13, 1976 (EPE). Other principal sources include interviews with Joe Esposito and Dr. George Nichopoulos, 1996; Jerry Hopkins interview with Mike McMahon (MVC/UMem); Thompson and Cole, *The Death of Elvis*, pp. 150–154; "A First for Elvis," *Memphis Press-Scimitar*, April 21, 1976; West et al., *Elvis: What Happened*?, pp. 325–327.

603 "He had dozens of people around him": Philip Norman, "Elton John," *Rolling Stone,* March 19, 1992.

603 Jerry and Myrna were having drinks: Interview with Jerry Schilling and Joe Guercio, 1995.

603 There was a big blowup with Sonny in Fort Worth: Lacker et al., Portrait, pp. 312-313.

603 Everyone noted what a foul mood he was in: Ibid., p. 210; Lewis, "Hurry Home, Elvis!," vol. 3, msp. 374.

603–604 Six days later Sonny and Red were fired: West et al., *Elvis: What Happened?*, pp. 322–323. Virtually every other account seems to derive from this one.

604–605 Elvis and Linda had retreated to Las Vegas: Interview with Linda Thompson.

604 Dave Hebler was so outraged: Linda Jones interview with Dave Hebler, Elvis: The Man and His Music 27, June 1995; Alanna Nash, Elvis Aaron Presley: Revelations from the Memphis Mafia, p. 668.

604–605 Elvis had always possessed a generous heart: "Elvis, By His Father Vernon Presley, As Told to Nancy Anderson," *Good Housekeeping*, January 1978, p. 160.

605 Elvis was so shaken that he sought out Tom Hulett: Joe Esposito, *Good Rockin' Tonight*, p. 228.

605 the adulation now was more "for what he was": Lee Cotten, Did Elvis Sing in Your Hometown, Too?, p. 251.

605 Elvis had his lawyer write a letter: Richard Powelson, "Suit Claims Presley Illegally Ended Deal," *Memphis Press-Scimitar*, May 3, 1977.

605 A few days later he called Nick: Interview with Dr. George Nichopoulos; Clayton and Heard, *Elvis Up Close*, p. 310.

606 the atmosphere surrounding him was very different: Interview with Larry Geller, 1989; Geller and Spector, "*If*," pp. 179ff, 199; also, interview with Kathy Westmoreland, 1990. Elvis' view of Larry is sustained by Westmoreland's account of her first meeting with him in 1973. In Geller's book Elvis introduces Larry to her as "the heaviest motherfucker I've ever met in my life," and Kathy communicates pretty much the same views without the language.

606 a "lackluster performance": Cotten, Did Elvis Sing in Your Hometown, Too?, p. 252.

606–607 "Elvis Presley has been breaking hearts": Bob Claypool concert review, *Houston Post,* August 29, 1976.

607 the Colonel had Joe call Dr. Nick: Interviews with Joe Esposito, Dr. George Nichopoulos, and Joe Guercio.

607 he and his wife had not seen Elvis in some time: Marge Crumbaker and Gabe Tucker, *Up and Down with Elvis Presley*, pp. 218–219; *The Stars and Stripes*, August 18, 1977.

608 he joked cynically with the guys who were left: Lewis, "Hurry Home, Elvis!," vol. 3, msp. 385.

608 "he was frightened": Interview with Linda Thompson.

608 John O'Grady and Ed Hookstratten were urging him: Interview with Ed Hookstratten.

608 He gave Jerry Schilling a call, too: Interviews with Jerry Schilling, 1994 and 1995.

608-611 "I guess I do owe you an explanation": A transcript of the telephone call is contained in West et al., *Elvis: What Happened?*, pp. 324-332.

612 "he just wasn't interested": Interview with Tony Brown, 1989.

612–613 As at the earlier home recording session: Information on this session comes primarily from interviews with David Briggs, Chip Young, Jerry Scheff, and Tony Brown; Jerry Hopkins interviews with Myrna Smith, Tony Brown, and John Wilkinson (MVC/UMem); J. D. Sumner, *Elvis: His Love for Gospel Music*, pp. 66ff; Tunzi, *Elvis: Highway 51 South, Memphis, Tennessee.*

613–614 Then on November 19 he met Ginger Alden: This account of the first ten days of Elvis and Ginger's relationship is based mainly on Hopkins, *Final Years*, pp. 202ff; Albert Goldman, *Elvis*, pp. 545ff; Jerry Hopkins interviews with Ginger and Jo Alden (MVC/UMem); Frank Thorsberg, "Last Love Picks Up the Pieces," *Nashville Tennessean*, August 16, 1978; "The Elvis Legend: One Year Later," *People*, August 21, 1978.

614-615 Linda had had a strong suspicion: Interview with Linda Thompson.

615 she started playing cards with the guys: Interviews with Myrna Smith, Tony Brown, Mary Jarvis, Ed Parker, Lamar Fike, Dr. George Nichopoulos, Joe Esposito, David Briggs.

615 the improvement in his performance: Robert Hilburn, "A Less Weighty Elvis Spectacle," *Los Angeles Times*, December 2, 1976; Goldman, *Elvis*, p. 549.

615 He was inspired by Ginger's presence: Geller and Spector, "If," p. 205.

616 "How long can the drugs and his feelings about Ginger": Ibid., p. 207.

616 "very tired": Rosalinda, "Vegas 2nd–12th December," 1976 (a British fan's report).

616 he "picked up the mike on its stand": Martha Collins in Rex Martin's Worldwide Elvis News Service Weekly.

616 He arranged for "Sir Gerald": Jerry Hopkins interview with Gerald Peters (MVC/UMem); Goldman, *Elvis*, p. 550.

616~ Ginger announced that she missed them: Jerry Hopkins interview with Ginger and Jo Alden (MVC/UMem).

616 the Lincoln Continental which Elvis had given her daughter: *Memphis Press-Scimitar*, December 10, 1976.

616 The Colonel was rumored: Bill Hance, "Elvis Presley May Be Sold by Colonel Parker," *Nashville Banner*, April 29, 1977. The Hance story attributed the Colonel's rumored losses to "a source." In Geller and Spector, "*If*," pp. 217 and 231, Larry hears the rumor in Vegas and then has Elvis confirm it in conversation.

616 "My artist," he declared balefully: Interview with Ger Rijff, 1998.

616-617 Larry was concerned: Geller and Spector, "If," pp. 212-214.

617 "in an off-mike aside": Martha Collins, in Rex Martin, above.

617 televangelist Rex Humbard came to visit: *Pasadena Star-News*, September 18, 1977; *Memphis Press-Scimitar*, August 30, 1977; *National Enquirer*, September 6, 1977; Patsy Guy Hammon-tree, *Elvis Presley: A Bio-Bibliography*, p. 124; interview with James Blackwood, 1988. Humbard, a pioneer in televangelism, had recorded widely in the thirties and forties with a family group, the Humbard Singers, and later formed the celebrated Cathedral Singers (from which two of the original Imperials emerged) to further his Ohio-based ministry, the Cathedral of Tomorrow. Hum-

724 👁 NOTES

bard had attended Elvis' Las Vegas show the previous December, and Elvis dedicated "How Great Thou Art" to him (see John Andrews' report in Rex Martin's *Worldwide Elvis News Service Weekly*).

617 "After sitting through Elvis Presley's closing night performance": Bill E. Burk, "Presley a Mere Shadow," *Memphis Press-Scimitar*, December 15, 1976.

ELVIS, WHAT HAPPENED?

619 Felton heard from Joe just hours before the session's scheduled start: Background on the session comes primarily from interviews with Joe Esposito, David Briggs, Tony Brown, Jerry Scheff, Freddy Bienstock, and Ernst Jorgensen interview with Sherrill Nielsen; also Colonel letter to Mel Ilberman, February 7, 1977 (EPE).

619 They had had a big fight about it: Jerry Hopkins interview with Ginger Alden (MVC/UMem); Albert Goldman, *Elvis*, p. 553; "The Bizarre Behavior of Fat, Aging Elvis Presley," *National Enquirer*, April 26, 1977.

619 his cousin Billy concluded: Alanna Nash, Elvis Aaron Presley: Revelations from the Memphis Mafia, p. 691.

620 he told Dr. Nick there was something about her: Interview with Dr. George Nichopoulos, 1996; Rose Clayton and Dick Heard, eds., *Elvis Up Close: In the Words of Those Who Knew Him Best*, p. 328.

620 "What in the hell could a forty-two-year-old woman do for me?": Nash, *Elvis Aaron Presley*, p. 694.

 $620\,$ Elvis flew all of the Aldens: Jerry Hopkins interview with Jo and Ginger Alden (MVC/UMem).

620 he took Ginger and her sister Rosemary to Palm Springs: Ibid.; Marty Lacker et al., *Elvis: Portrait of a Friend*, p. 347; Charles C. Thompson II and James P. Cole, *The Death of Elvis: What Really Happened*, pp. 126–127; Larry Geller and Joel Spector, "If I Can Dream": Elvis' Own *Story*, pp. 225–226.

621 making sure that everyone would get paid in full: Jerry Hopkins interview with Tony Brown (MVC/UMem). All the other sources on the session are the same as those listed above.

621–622 a story published in the *Nashville Banner*: Bill Hance, "Presley Comes to Town, But It's 'No Show' at Studio," *Nashville Banner*, January 28, 1977.

622 he formally proposed to Ginger: Jerry Hopkins interviews with Ginger Alden and Lowell Hays (MVC/UMem); Goldman, Elvis, pp. 551–552; Lawrence Buser, "'World's at a Standstill' for Elvis' Fiancée," *Memphis Commercial Appeal*, August 19, 1977.

623 Five nights later they flew to Las Vegas: *Memphis Press-Scimitar*, February 2, 1977; Donna Lewis, *"Hurry Home, Elvis!"*: *Donna Lewis' Diaries*, vol. 3 (unpublished manuscript), msp. 398.

623 Sometimes Ginger wondered just what she had gotten herself into: Thompson and Cole, *The Death of Elvis*, p. 213; Goldman, *Elvis*, pp. 552–553.

623 "He would say, 'She loves her family'": Interview with Kathy Westmoreland, 1990.

623–624 The following night... he called Terry Alden up onstage: Jerry Hopkins interview with Ginger Alden (MVC/UMem); Lee Cotten, *Did Elvis Sing in Your Hometown, Too?*, pp. 288–289; Stein Erik Skar, *Elvis: The Concert Years*, p. 219.

624 David Briggs was still with the band: Interviews with David Briggs, 1988 and 1998, and Tony Brown 1989.

625 "He asked me, was I in love?": Jerry Hopkins interview with Maggie Smith (MVC/UMem).

625 Elvis signed over another \$55,000: Once again a deed of trust was drawn up, but now with payments of \$1,802.85 per month, beginning on April 1, 1977, and continuing through February 1, 2002.

625 He made out his will: Nash, *Elvis Aaron Presley*, p. 697; Jerry Hopkins, *Elvis: The Final Years*, p. 209; Last Will and Testament of Elvis A. Presley, Deceased, filed August 22, 1977 (public record).

626 "Everyone looks older than they are": Geller and Spector, "*If*," pp. 239ff. The account of the trip is also based on interviews with Larry Geller, Joe Esposito, Charlie Hodge, and Ed Parker; Jerry Hopkins interview with Ginger Alden (MVC/UMem); and Hopkins, *Final Years*, pp. 209–210.

626 "Somebody'd throw him the ball": Hopkins, Final Years, p. 210.

626–627 Charlie and Larry Geller contacted Bernard Benson: In addition to Geller's account (in Geller and Spector, "*If*," p. 243), see Charlie Hodge, *Me 'n Elvis*, p. 173, on the original meeting with Benson in Las Vegas. Benson published a fable on "the life and music of Elvis Presley" called *The Minstrel* shortly after Elvis' death.

627 The whole trip had cost: Geller and Spector, "If," p. 244.

627 "We were supposed to leave late that night": Nash, Elvis Aaron Presley, p. 700.

627 "His music ran from the parody to the almost perfect": Arizona Republic, March 24, 1977.

628 "Is there much more time left?": Geller and Spector, "If," p. 247.

628 his security chiefs . . . drew up contingency plans: Thompson and Cole, The Death of Elvis, p. 314.

628 "Man," he told his cousin: Nash, *Elvis Aaron Presley*, pp. 665–666. Billy has this occurring in 1976, but I am unaware, from his or any other account, of Billy going out regularly earlier than March of 1977.

628 "[He] was onstage less than an hour": Alexandria Daily Town Talk, March 30, 1977 (as quoted in Skar, Elvis: The Concert Years, p. 223).

628–629 The following night, in Baton Rouge, he was unable to go on: This account is based primarily on interviews with Tom Hulett, Joe Esposito, Sam Thompson, Ed Parker, Larry Geller, Lamar Fike, and Dr. George Nichopoulos; also Jerry Hopkins interview with John Wilkinson (MVC/UMem) and Geller and Spector, "If," pp. 248ff. See also *Memphis Press-Scimitar*, April 1, 1977, re the crowd's reaction. It should be noted that some accounts have the Colonel present while Tom Hulett, among others, recalls him as already being in Mobile. Since Hulett was the principal person dealing with the Colonel in this crisis, and as it was Parker's usual practice to be a day ahead of Elvis on the tour, it seems reasonable to accept Hulett's version of events. It should go without saying that this is not the only point of contention among the various accounts.

629 "he said, 'Well, I'm really bushed'": Jerry Hopkins interview with Marion Cocke (MVC/UMem).

630 Business would go on as usual: Colonel to Mel Ilberman, April 4, 1977 (EPE).

630 Priscilla flew in from California: Jerry Hopkins interview with Ginger Alden (MVC/UMem); Lewis, *"Hurry Home, Elvis!,"* vol. 3, msp. 403; Vernon Presley correspondence with Harry Fain, April 5, 1977 (EPE).

630 Elvis complained good-naturedly all the way home: Nash, Elvis Aaron Presley, p. 702.

630 Elvis did little but ride around: Lewis, "Hurry Home, Elvis!," vol. 3, mspp. 403-404.

630 George introduced him to Alicia Kerwin: Thompson and Cole, The Death of Elvis, pp. 357-361.

630 the real reason for the trip was "to get more prescriptions": Ibid., p. 359; Nash, Elvis Aaron Presley, p. 703.

631 He recruited Larry to help Ginger: Interview with Larry Geller, 1989; Peter Whitmer, *The Inner Elvis*, p. 420; Geller and Spector, *"If*," p. 273.

631 redecorating the bathroom at Graceland: Jerry Hopkins interview with Ginger Alden (MVC/UMem).

631 He was worried about his health [and] his appearance: Geller and Spector, "*If*," pp. 269–270; interview with Myrna Smith, 1990.

632 He spoke more and more about the book: Geller and Spector, "If," p. 245; interviews with Larry Geller and Kathy Westmoreland.

632 A headline story in the Nashville Banner: Bill Hance, "Elvis Presley May Be Sold By Col. Parker," Nashville Banner, April 29, 1977.

632 Elvis was scheduled to open the new Hilton Pavilion: Hopkins, *Final Years*, p. 225; Jerry Hopkins interview with Henri Lewin (MVC/UMem).

632 The Banner's story was "a complete fabrication": Laura Eipper, "Manager Denies Presley for Sale," *Nashville Tennessean*, April 30, 1977.

632 Colonel was "servicing a problem of his own": Interview with Ed Hookstratten, 1995.

633 "Elvis, 42, Fears He's Losing His Sex Appeal": The Star, April 12, 1977.

633 he shot out a bedroom window: Lewis, "Hurry Home, Elvis!," vol. 3, msp. 406.

633 "We had to take care of him": Nash, Elvis Aaron Presley, pp. 618-619.

634 "He was pale, swollen": Patsy Guy Hammontree, Elvis Presley: A Bio-Bibliography, p. 114.

634 Elvis left the stage for "nature's call": Skar, Elvis: The Concert Years, pp. 230–231; Cotten, Did Elvis Sing in Your Hometown, Too?, pp. 300–301; The Star, June 21, 1977.

634 Elvis laid down an ultimatum: Geller and Spector, *"If,"* p. 276; recollection of Rose Clayton, 1998.

634 She had just gotten in from a date: Kathy Westmoreland, Elvis and Kathy, p. 291.

634-635 "How will they remember me?": Ibid., pp. 294-295.

635 He was "weak," "tired," "paunchy": Marty Bennett, "What's with Elvis: Walks Out Midway at Show in Baltimore," *Variety* review reprinted in Skar, *Elvis: The Concert Years*, pp. 230–231; interviews with Tony Brown and Kathy Westmoreland; Jerry Hopkins interviews with John Wilkinson and Tony Brown (MVC/UMem).

635 the CBS concert special . . . was announced: Larry Williams, "Elvis Signs with CBS for 'Anniversary' Show," *Memphis Commercial Appeal*, June 1, 1977. The earliest confirmation I can find of the special in the Colonel's communications with CBS is mid May (EPE), but I suspect the date of the actual agreement is somewhat earlier.

635 for the first time he stipulated: Tour statement, including full division of profits according to the "temporary settlement" previously agreed upon, with "contract rate 50–50 to be settled at end of 1977" (EPE).

635–636 Colonel simply shrugged and offered three variations: Interviews with Roger Davis, Tom Hulett, Jerry Schilling, Joe Esposito.

636 "The first two chapters are about him giving drugs": Lewis, "Hurry Home, Elvis!," vol. 3, msp. 408.

636 feelers from Frank Sinatra's camp: Joe Esposito says that there was no real substance to these rumors, despite the conviction of others (interviews with Lamar Fike and Jerry Schilling; Goldman, *Elvis*, p. 554) that they were true.

636 Larry thought it had more to do with guilt: Geller and Spector, "If," p. 255.

636 he felt like Jesus betrayed by his disciples: Lola Scobey, "Controversies About Elvis Dispelled by Producer Jarvis," *Cash Box*, September 3, 1977.

636 He was just showing them some of the features: Geller and Spector, "*If*," pp. 282–283; Nash, *Elvis Aaron Presley*, p. 671. Larry Geller does not name Charlie, but in the Nash book Billy Smith does.

637 He tried to do something for George Klein: Klein's problems were extensively covered in the *Memphis Press-Scimitar* and *Commercial Appeal*, from February 22, 1977, on; for Elvis' call to President Carter, see Douglas Brinkley, "The White House–Graceland connection that might have saved Elvis," in "The Talk of the Town," *The New Yorker*, August 18, 1977. Also, correspondence and conversation with Doug Brinkley, September 1997. 637 "In spite of what you may hear": Jay Gordon, "It Was 20 Years Ago This Month: Elvis' Last Concert Tour Revisited," *Elvis Only*, June 1997.

637 More and more the feeling grew: Interviews with Tom Hulett, Joe Guercio, Gary Smith, Myrna Smith, Joe Esposito, Tony Brown; Jerry Hopkins interview with John Wilkinson (MVC/UMem).

638 "It was like he was saying": Interview with Tom Hulett, 1990.

638 "I know I was terrible": Interview with Gary Smith, 1995.

638 "Dwight and Gary were kind to him": Interview with Joe Guercio, 1995.

638–639 a telephone conversation that took place between Myrna and Jerry Schilling: Interview with Myrna Smith, 1990.

639 Elvis was being driven from the airport: UPI dispatch, "Elvis Swings into Action — But Without His Guitar," undated clipping; Skar, *Elvis: The Concert Years*, p. 234.

639 In Cincinnati he gave everyone another surprise: This account of the last two shows, and the time in between, comes primarily from Jerry Hopkins interviews with Ginger Alden and John Wilkinson (MVC/UMem); Skar, *Elvis: The Concert Years*, p. 235; Cotten, *Did Elvis Sing in Your Hometown*, *Too*², pp. 312–313; Geller and Spector, "If," pp. 291–292.

"PRECIOUS LORD, TAKE MY HAND"

641 no July 4 fireworks this year: Donna Lewis, "Hurry Home, Elvis!": Donna Lewis' Diaries, vol. 3 (unpublished manuscript), mspp. 413ff.

641 Elvis was still frustrated and angry: Larry Geller and Joel Spector, "If I Can Dream": Elvis' Own Story, p. 299; interviews with Larry Geller, Joe Esposito, Dr. George Nichopoulos; Joe Esposito, Good Rockin' Tonight, p. 234; Rose Clayton and Dick Heard, eds., Elvis Up Close: In the Words of Those Who Knew Him Best, pp. 328–329; Charlie Hodge, Me'n Elvis, p. 189.

641 he even offered to buy her family a house: Rosemary and Ginger Alden's affidavits in Jo Alden's posthumous lawsuit against the estate.

641–642 He saw scarcely anyone: Alanna Nash, *Elvis Aaron Presley: Revelations from the Memphis Mafia*, pp. 707–709; Clayton and Heard, eds., *Elvis Up Close*, p. 327; interviews with Joe Esposito, Linda Thompson, and Kathy Westmoreland; Jerry Hopkins interview with Pat Booth (MVC/UMem); Lewis, *"Hurry Home, Elvis!*," vol. 3, mspp. 413–414.

642 "All we did": Nash, Elvis Aaron Presley, p. 709.

642 "One time I said, 'Look, they're not worth it'": Ibid., p. 708.

642 he dreamt the same dream: Ibid., p. 699; Laura Eipper, "The Legend Lives On," Nashville Tennessean, August 16, 1978; Nancy Anderson, "My Cherished Memories of Elvis," Elvis Presley: A Photoplay Tribute, 1977, p. 11.

642-643 "At first he thought": Nash, Elvis Aaron Presley, pp. 710-711.

643 he was looking forward to the tour: Interview with Dr. George Nichopoulos, 1996.

643 Ginger got her brother Mike's oldest child...to come visit: Jerry Hopkins interview with Ginger Alden (MVC/UMem); Jerry Hopkins, *Elvis: The Final Years*, p. 233; Harold Loyd, *Elvis Presley's Graceland Gates*, p. 61.

643 At Ginger's urging he arranged a special treat: Nash, *Elvis Aaron Presley*, p. 710; Albert Goldman, *Elvis*, p. 553; "The Night that Lisa Marie Will Never Forget," *The Star*, September 20, 1977; Jo Smith, "The Fairgrounds," *Elvis: The Record*, vol. 2, no. 3, p. 18.

644 He spoke to his father: "Elvis' Last Days Seemed Happy," *Memphis Press-Scimitar*, August 19, 1977.

644 he remained in good enough spirits to go for a motorcycle ride: Nash, *Elvis Aaron Presley*, p. 714; Billy Smith, "The Last Days," *Elvis: The Record*, vol. 1, no. 1, pp. 12–14. 645 Dr. Hofman cleaned Elvis' teeth: Interview with Dr. Lester Hofman, 1989; Jerry Hopkins interview with Ginger Alden (MVC/UMem); Charles C. Thompson II and James P. Cole, *The Death of Elvis: What Really Happened*, pp. 26, 224; Hopkins, *Final Years*, p. 234.

645 It was almost 12:30 A.M.: *National Enquirer,* September 20, 1977. The time is established by the time of the last fan photograph at 12:28 A.M., taken as the car drove in the gates.

645 He called down to Joe about some last-minute tour details: Interview with Joe Esposito, 1990; Esposito, *Good Rockin'*, pp. 235ff; Geller and Spector, *"If*," pp. 304–305; Thompson and Cole, *The Death of Elvis*, pp. 13–14.

645–646 Elvis and Ginger meanwhile were having much the same argument: Clayton and Heard, *Elvis Up Close*, p. 341; Lawrence Buser, "World's at a Standstill' for Elvis' Fiancée," *Memphis Commercial Appeal*, August 19, 1977; Ginger Alden, "Girl Elvis Was Going to Marry Tells Her Heartbreaking Story," *National Enquirer*, September 6, 1977.

646 "Ain't no problem," Elvis said: Nash, *Elvis Aaron Presley*, p. 715; also *Elvis: The Record*, vol 1, no. 1.

646 "Boy, that hurts": Ibid.

646 Billy left just before Ricky Stanley arrived: Thompson and Cole, *The Death of Elvis*, p. 233.

647 Tish had already gone to work: Ibid., p. 303.

647 Ginger awoke around 1:30 P.M.: The principal sources for this account are Thompson and Cole, *The Death of Elvis*, passim; Ginger Alden, "Girl Elvis Was Going to Marry Tells Her Heartbreaking Story," and "Emergency Medics Tell Inside Story of Elvis' Death," *National Enquirer*, September 6, 1977; interview with Joe Esposito, 1998; Joe Esposito, *Good Rockin*', pp. 238ff; Goldman, *Elvis*, pp. 566ff; Peter Harry Brown and Pat H. Broeske, *Down at the End of Lonely Street: The Life and Death of Elvis Presley*, pp. 412ff.

648 a team of doctors and resuscitation experts: Jerry Hopkins interview with Maurice Elliott (MVC/UMem). It should be noted that the time of death has been variously given as 3:30 (Thompson and Cole, *The Death of Elvis*, p. 7) and 3:40 (this is the time given in the postmortem report and in Jackson Baker, "Elvis: End of an Era," *City of Memphis*, September 1977).

648 "It's all over, he's gone": Interview with Joe Esposito; Jerry Hopkins interview with Maurice Elliott (MVC/UMem); Marty Lacker et al., *Elvis: Portrait of a Friend*, p. 286; Esposito, *Good Rockin'*, p. 240.

648–649 Colonel's reaction was impossible to read: Interviews with Joe Esposito, 1990 and 1997, and Lamar Fike, 1988–1989; Nash, *Elvis Aaron Presley*, p. 723.

649 Lisa was crying when Dr. Nick walked in: *Memphis Commercial Appeal*, August 19, 1977; Kate B. Dickson, "Medic Describes 'Routine' Call to Graceland," *Memphis Press-Scimitar*, August 17, 1977; *National Enquirer*, September 6, 1977; Thompson and Cole, *The Death of Elvis*, pp. 19–20.

650 there had already been a complete clean-up in the bedroom: Deposition of Daniel D. Warlick, August 30, 1979.

650 "Scattered on couches forming a complete perimeter of the room": Thompson and Cole, *The Death of Elvis*, pp. 22ff (based closely on Warlick's deposition).

 $\bf 651-652$ "Our pathologists were concerned": Jerry Hopkins interview with Maurice Elliott (MVC/UMem).

651–652 Death, he said, was "due to cardiac arrhythmia": Thompson and Cole, *The Death of Elvis*, pp. 49–50.

652 the heart found to be enlarged: Baptist Memorial Hospital, Postmortem Protocol report, with accompanying letters from two outside toxicology laboratories.

652 Codeine appeared at ten times the therapeutic level: Thompson and Cole, *The Death of Elvis*, p. 85.

653 Joe was in charge of the funeral arrangements: Interviews with Joe Esposito, 1997–1998, and Charlie Hodge, 1989; Esposito, *Good Rockin*', pp. 245ff; Pat H. Broeske, "After Death 'It Was War,'" Los Angeles Times Calendar, August 16, 1987; Brown and Broeske, Down at the End of Lonely Street, p. 420; Geller and Spector, "If," p. 310.

653–654 Vernon called the Reverend C. W. Bradley: Patsy Guy Hammontree, Elvis Presley: A Bio-Bibliography, p. 124.

654–659 the casket arrived in a single white hearse: The description of the crowd, the viewing, the funeral, and the trip to the cemtery, and much of the external detail are drawn from extensive coverage in the *Memphis Press-Scimitar* and *Commercial Appeal*, August 17–21, 1977; *Nashville Tennessean*, August 18–20, 1977; *Rolling Stone*, September 22, 1977; *New York Times*, August 18, 1977; *Boston Globe*, August 18, 1977. Also, Esposito, *Good Rockin*⁷, pp. 247–248; Geller and Spector, "*If*," p. 311

655 No one could miss the intensity of his colloquies: Interviews with Jerry Schilling and Joe Esposito; Nash, Elvis Aaron Presley, p. 730; Priscilla Presley, Elvis and Me, p. 315; Marge Crumbaker and Gabe Tucker, Up and Down with Elvis Presley, p. 233; Billy Stanley, Elvis, My Brother, p. 259.

655 "four at a time fans filed by the stone lions": UPI dispatch, Boston Globe, August 18, 1977.

656 Dedicated diarist Donna Lewis: Lewis, "Hurry Home, Elvis!," vol. 3, msp. 418.

656 Vernon returned to the living room: Interview with Lester and Sterling Hofman, 1990. 656–657 at Priscilla's request, Sam Thompson suggested that everyone go home: Interview with Sam Thompson, 1989.

657 The singers had all met in Charlie's room: Interviews with James Blackwood, Kathy Westmoreland, and Joe Guercio; Clayton and Heard, *Elvis Up Close*, p. 354; J. D. Sumner, *Elvis: His Love for Gospel Music and J. D. Sumner*, p. 99.

657 "You never wore a tie for him": Interview with Jerry Schilling, 1997.

658 a eulogy that comedian Jackie Kahane: Interview with Jackie Kahane, 1995; also, recollected text of the remarks supplied by Kahane.

658 she imagined she could hear Elvis: Kathy Westmoreland, Elvis and Kathy, p. 301.

658 The main sermon, by Reverend Bradley: Deborah White, "Sermon Sees Elvis As Life Inspiration," *Memphis Commercial Appeal*, August 17, 1977; see also Hopkins, *Final Years*, p. 245.

658 "We knew you'd be back": Nash, *Elvis Aaron Presley*, p. 731. Variations on this story appear in Alan Fortas, *Elvis: From Memphis to Hollywood*, p. 303; Westmoreland, *Elvis and Kathy*, p. 302; David Stanley, *Life with Elvis*, p. 196; and interview with Myrna Smith, 1990, with reference to Lamar's constant wisecracking.

659 a "Southern supper": Rolling Stone, September 22, 1977.

659–660 the Colonel worked out the details: Interview with Roger Davis, 1998; Report of the Guardian Ad Litem In Re the Estate of Elvis A. Presley, Deceased, No. A-655, Exhibits 10, 11, 14, 15, and 17, filed September 29, 1980, pp. 6–7; Guardian Ad Litem's Amended Report In Re the Estate of Elvis A. Presley, Deceased, No. A-655, filed July 31, 1981, pp. 6–8. There are various arguments in both reports about the percentage breakdown between the Colonel (d/b/a Boxcar Enterprises) and the Estate as well as the ownership breakdown of Boxcar, but these will not be resolved here. Suffice it to say that the Colonel's claim that the agreement was not made on August 18 but was backdated for reasons of trademark protection holds up according to Roger Davis' recollection and chronology of events, and all rumors about the Colonel negotiating the merchandising deal before Elvis was in his grave would appear to be just that.

660 Ginger Alden arranged to sell her own story: Thompson and Cole, *The Death of Elvis*, p. 258.

660 "I guess they will finally get to rest": Lewis, "Hurry Home, Elvis!," vol. 3, msp. 422.

661 "Well, I've tried to be the same all through this thing": Lloyd Shearer interview with Elvis Presley, 1962, first released by RCA as a promotional LP in 1985.

Bibliography

REFERENCE

ж.

Brown, Christopher. Elvis in Concert. Ajax, Ontario: Self-published, 1993.

. On Tour with Elvis. Ajax, Ontario: Self-published, 1991.

Corcoran, John, and Emil Farkas with Stuart Sobel. The Original Martial Arts Encyclopedia: Tradition, History, Pioneers. Los Angeles: Pro-Action Publishing, 1993.

Cotten, Lee. All Shook Up: Elvis Day-By-Day, 1954–1977, 2nd ed. Ann Arbor, Mich.: Popular Culture, Ink., 1998.

. Did Elvis Sing in Your Hometown? Sacramento, Calif.: High Sierra Books, 1995.

. Did Elvis Sing in Your Hometown, Too? Sacramento, Calif.: High Sierra Books, 1997.

Dellar, Fred, Roy Thompson, and Douglas B. Green. *The Illustrated Encyclopedia of Country Music*. New York: Harmony Books, 1977.

Elvis: Like Any Other Soldier. Reprint of the 1958 and Army Division Yearbook. Port Townsend, Wash.: Osborne Productions, 1988.

F.B.I. Files for Elvis A. Presley. Released under the Freedom of Information Act.

Federal Writers' Project of the Works Progress Administration. *Mississippi: The WPA Guide to the Magnolia State.* Golden anniversary ed. Jackson: University Press of Mississippi, 1988.

Gart, Galen, comp. and ed. First Pressings: Rock History as Chronicled in Billboard Magazine. Vol. I, 1948–1950. Milford, N.H.: Big Nickel Publications, 1986.

—. First Pressings: Rock History as Chronicled in Billboard Magazine. Vol. 2, 1951–1952. Milford, N.H.: Big Nickel Publications, 1986.

- -----. The History of Rhythm & Blues. Vols. 1–8 (1951–1958). Milford, N.H.: Big Nickel Publications, 1991–1995.
- -----. The History of Rhythm & Blues, Special 1950 Volume. Milford, N.H.: Big Nickel Publications, 1993.

Gentry, Linnell. A History and Encyclopedia of Country, Western, and Gospel Music. Nashville: Linnell Gentry, 1961.

Griggs, Bill. A "Who's Who" of West Texas Rock 'n' Roll Music. Lubbock, Tex.: Rockin' 508 Magazine, 1994.

Hardy, Phil, and Dave Laing. Encyclopedia of Rock, 1955-1975. London: Aquarius Books, 1977.

McCloud, Barry. Definitive Country. New York: Perigee, 1995.

The 1953 Senior Herald. Humes High School Yearbook. Reprint, Port Townsend, Wash.: Osborne Enterprises, 1988.

Petersen, Brian. The Atomic Powered Singer. Sweden: Self-published, 1994.

Report of Guardian Ad Litem and Amended Report of Guardian Ad Litem In Re the Estate of Elvis A. Presley, Deceased, in the Probate Court of Shelby County, Tennessee, No. A-655.

Stambler, Irwin. Encyclopedia of Pop, Rock and Soul. New York: St. Martin's Press, 1977.

Stambler, Irwin, and Grelun Landon. Encyclopedia of Folk, Country and Western Music. New York: St. Martin's Press, 1969.

Whisler, John A. Elvis Presley: Reference Guide and Discography. Metuchen, N.J.: Scarecrow Press, 1981.

Wilson, Charles Reagan, and William Ferris, eds. *Encyclopedia of Southern Culture*. Chapel Hill, N.C.: University of North Carolina Press, 1989.

Worth, Fred L., and Steve D. Tamerius. All About Elvis. New York: Bantam Books, 1981.

-------. Elvis: His Life from A to Z. Chicago: Contemporary Books, 1988.

DISCOGRAPHIES, SONG, RECORD, AND MOVIE GUIDES

Bartel, Pauline. Reel Elvis. Dallas: Taylor Publishing, 1994.

Braun, Eric. The Elvis Film Encyclopedia. Woodstock, N.Y.: Overlook Press, 1997.

Crenshaw, Marshall. Hollywood Rock. New York: HarperCollins, 1994.

The Elvis Presley Album of Juke Box Favorites, No. 1. New York: Hill and Range Songs, 1956.

Escott, Colin, and Martin Hawkins. Sun Records: The Discography. Vollersode, West Germany: Bear Family, 1987.

Hawkins, Martin, and Colin Escott. Elvis Presley: The Illustrated Discography. London: Omnibus Press, 1981.

Jancik, Wayne. Billboard Book of One-Hit Wonders. New York: Watson-Guptill, 1990.

Jenkinson, Philip, and Alan Warner. Celluloid Rock. New York: Warner Books, 1976.

Jorgensen, Ernst. Elvis Presley: A Life in Music. New York: St. Martin's Press, 1998.

Kingsbury, Paul, ed. Country on Compact Disc: The Essential Guide to the Music. New York: Grove Press, 1993.

McLafferty, Gerry. Elvis Presley in Hollywood: Celluloid Sell-Out. London: Robert Hale, 1989.

Pavlow, Big Al. The R & B Book: A Disc-History of Rhythm & Blues. Providence: Music House Publishing, 1983.

Tunzi, Joseph A. Elvis Sessions II: The Recorded Music of Elvis Aron Presley, 1953–1977. (Rev. and exp. ed.) Chicago: JAT Productions, 1996.

Weisman, Ben. Elvis Presley: "The Hollywood Years." Secaucus, N.J.: Warner Brothers Publications, 1992.

Whitburn, Joel. Pop Memories, 1890–1954: The History of American Popular Music. Menomonee Falls, Wis.: Record Research, 1986.

------. Top Country Singles, 1944–1988. Menomonee Falls, Wis.: Record Research, 1989.

------. Top Pop Records, 1955-1986. Menomonee Falls, Wis.: Record Research, 1987.

------. Top R & B Singles, 1942-1988. Menomonee Falls, Wis.: Record Research, 1988.

Zmijewsky, Steven, and Boris Zmijewsky. Elvis: The Films and Career of Elvis Presley. New York: Citadel Press, 1991.

BOOKS OF MORE GENERAL INTEREST

Alexander, A. L., ed. Poems That Touch the Heart. Garden City, N.Y.: Doubleday, 1941.

Amburn, Ellis. Dark Star: The Roy Orbison Story. New York: Lyle Stuart, 1990.

Ann-Margret with Todd Gold. Ann-Margret: My Story. New York: G. P. Putnam's Sons, 1994.

Arnold, Eddy. It's a Long Way from Chester County. Old Tappan, N.J.: Hewitt House, 1969.

Atkins, Chet, with Bill Neely. Country Gentleman. Chicago: Henry Regnery, 1974.

Atkins, John, ed. The Carter Family. London: Old Time Music, 1973.

- Bane, Michael. White Boy Singin' the Blues: The Black Roots of White Rock. New York: Penguin Books, 1982.
- Bane, Michael, and Mary Ellen Moore. *Tampa, Yesterday, Today and Tomorrow*. Tampa: Misher and King Publishing, 1981.
- Banks, Ann, ed. First-Person America. New York: Vintage Books, 1981.

Bart, Peter. Fade Out: The Calamitous Final Days of MGM. New York: William Morrow, 1990.

Barthel, Norma. Ernest Tubb Discography (1936–1969). Roland, Okla.: Ernest Tubb Fan Club Enterprises, 1969.

Bashe, Philip. Teenage Idol, Travelin' Man: The Complete Biography of Rick Nelson. New York: Hyperion, 1992.

Benson, Bernard. The Minstrel. New York: G. P. Putnam's Sons, 1977.

Berry, Chuck. Chuck Berry: The Autobiography. New York: Harmony Books, 1987.

Biles, Roger. Memphis in the Great Depression. Knoxville: University of Tennessee Press, 1986.

Black, Jim. Elvis on the Road to Stardom. London: W. H. Allen, 1988.

Blaine, Hal, with David Goggin. Hal Blaine and the Wrecking Crew. Emeryville, Calif.: Mix Books, 1990.

Blumhofer, Edith L. Restoring the Faith: The Assemblies of God, Pentecostalism, and American Culture. Urbana: University of Illinois Press, 1993.

Booth, Stanley. Rythm Oil: A Journey Through the Music of the American South. London: Jonathan Cape, 1991.

Bova, Joyce, as told to William Conrad Nowels. Don't Ask Forever: My Love Affair with Elvis. New York: Kensington Books, 1994.

Bowles, Jerry. A Thousand Sundays: The Story of the Ed Sullivan Show. New York: G. P. Putnam's Sons, 1980.

Branch, Taylor. Parting the Waters: America in the King Years. New York: Simon and Schuster, 1988.

- Braudy, Leo. The Frenzy of Renown: Fame and Its History. New York: Oxford University Press, 1986.
- Brown, Peter Harry, and Pat H. Broeske. Down at the End of Lonely Street: The Life and Death of Elvis Presley. New York: Dutton, 1997.

Buckle, Phillip. All Elvis: An Unofficial Biography of the "King of Discs." London: Daily Mirror, 1962. Burk, Bill E. Early Elvis: The Humes Years. Memphis: Red Oak Press, 1990.

- . Early Elvis: The Sun Years. Memphis: Propwash Publishing, 1997.
- -------. Early Elvis: The Tupelo Years. Memphis: Propwash Publishing, 1994.
- . Elvis: A 30-Year Chronicle. Tempe, Ariz.: Osborne Enterprises, 1985.
- ------. Elvis Memories: Press Between the Pages. Memphis: Propwash Publishing, 1993.
- -------. Elvis Through My Eyes. Memphis: Burk Enterprises, 1987.
- Cain, Robert. Whole Lotta Shakin' Goin' On: Jerry Lee Lewis. New York: Dial Press, 1981.
- Cajiao, Trevor. Talking Elvis: In-Depth Interviews with Musicians, Songwriters, and Friends. Amsterdam: Elvis: The Man and His Music/Tutti Frutti Productions, 1998.
- Cantor, Louis. Wheelin' on Beale. New York: Pharos Books, 1992.

Capers, Gerald M., Jr. The Biography of a River Town: Memphis, Its Heroic Age. 1966. Reprint, Memphis: Burke's Book Store.

Carr, Roy, and Mick Farren. Elvis Presley: The Illustrated Record. New York: Harmony Books, 1982. Cash, Johnny. The Man in Black. New York: Warner Books, 1975.

Cash, June Carter. From the Heart. New York: Prentice Hall Press, 1987.

Cash, W. J. The Mind of the South. 1941. Reprint, New York: Vintage Books.

Chapple, Steve, and Reebee Garofalo. Rock 'n' Roll Is Here to Pay. Chicago: Nelson-Hall, 1977.

Choron, Sandra, and Bob Oskam. Elvis! The Last Word. New York: Citadel Press, 1991.

Clayson, Alan, and Spencer Leigh, eds. *Aspects of Elvis: Tryin' to Get to You*. London: Sidgwick and Jackson, 1994.

Clayton, Rose, and Dick Heard, eds. Elvis Up Close: In the Words of Those Who Knew Him Best. Atlanta: Turner Publishing, 1994.

Cocke, Marian J. I Called Him Babe: Elvis Presley's Nurse Remembers. Memphis: Memphis State University Press, 1979.

Cohn, David. Where I Was Born and Raised. Notre Dame, Ind.: University of Notre Dame Press, 1967. Cohn, Nik. Rock from the Beginning. New York: Pocket Books, 1970.

Conaway, James. Memphis Afternoons. Boston: Houghton Mifflin, 1993.

Country Music Foundation. Country: The Music and the Musicians. New York: Abbeville Press, 1988.

Country Music Magazine, editors of. The Illustrated History of Country Music. Garden City, N.Y.: Doubleday, 1979.

Crumbaker, Marge, and Gabe Tucker. Up and Down with Elvis Presley. New York: G. P. Putnam's Sons, 1981.

Dalton, David. James Dean: The Mutant King. New York: Dell, 1974.

Dalton, David, and Lenny Kaye. Rock 100. New York: Grosset and Dunlap, 1977.

Daniel, Pete. Standing at the Crossroads. New York: Hill and Wang, 1986.

Davis, Jr., Sammy, Jane Boyar, and Burt Boyar. *Hollywood in a Suitcase*. New York: William Morrow, 1980.

. Why Me? The Sammy Davis, Jr., Story. New York: Farrar, Straus and Giroux, 1989.

Davis, Skeeter. Bus Fare to Kentucky: The Autobiography of Skeeter Davis. New York: Birch Lane Press, 1993.

DeCosta-Willis, Miriam, and Fannie Mitchell Delk. Homespun Images: An Anthology of Black Memphis Writers and Artists. Memphis: LeMoyne Owen College, 1989.

Delmore, Alton. Truth Is Stranger than Publicity. Edited by Charles K. Wolfe. Nashville: Country Music Foundation Press, 1977.

Dennis, Allen, ed. James Blackwood Memories. Brandon, Mo.: Quail Ridge Press, 1997.

DeWitt, Howard A. Elvis—The Sun Years: The Story of Elvis Presley in the Fifties. Ann Arbor, Mich.: Popular Culture, Ink., 1993.

Dollard, John. Caste and Class in a Southern Town. 3d ed. New York: Doubleday Anchor, 1957.

Dundy, Elaine. Elvis and Gladys. New York: Macmillan, 1985.

———. Ferriday, Louisiana. New York: Donald Fine, 1991.

Dunne, John Gregory. Vegas: A Memoir of a Dark Season. New York: Random House, 1974.

Dunne, Philip. Take Two: A Life in Music and Politics. New York: McGraw-Hill, 1980.

Early, Donna Presley, and Edie Hand with Lynn Edge. *Elvis: Precious Memories*. Birmingham, Ala.: The Best of Times, Inc., 1997.

Edwards, Michael. Priscilla, Elvis, and Me. New York: St. Martin's Press, 1988.

Elvis Presley. Prepared by the Editors of TV Radio Mirror Magazine. New York: Bartholomew House, 1956.

Elvis Presley Heights, Mississippi: Lee County, 1921–1984. Compiled by Members of the Elvis Presley Heights Garden Club. Tupelo, Miss., 1984.

Elvis Presley Speaks! Text by Robert Johnson. New York: Rave Publishing, 1956.

Escott, Colin, and Martin Hawkins. Good Rockin' Tonight: Sun Records and the Birth of Rock 'n' Roll. New York: St. Martin's Press, 1991.

Escott, Colin, Martin Hawkins, and Hank Davis. The Sun Country Years: Country Music in Memphis, 1950–1959. Vollersode, West Germany: Bear Family Records, 1987.

Escott, Colin, with George Merritt and William MacEwen. *Hank Williams: The Biography.* Boston: Little, Brown, 1994.

Esposito, Joe, with Elena Oumano. Good Rockin' Tonight. New York: Simon and Schuster, 1994.

Falkenburg, Claudia, and Andrew Solt, eds. A Really Big Show: A Visual History of the Ed Sullivan Show. Text by John Leonard. New York: Viking Studio Books, 1992.

Farren, Mick, ed. Elvis in His Own Words. London: Omnibus Press, 1977.

Finnis, Rob, and Bob Dunham. Gene Vincent and the Blue Caps. London: Rob Finnis and Bob Dunham. n.d.

Finstad, Suzanne. Child Bride: The Untold Story of Priscilla Beaulieu Presley. New York: Harmony, 1997. Fortas, Alan. Elvis: From Memphis to Hollywood. Ann Arbor, Mich.: Popular Culture, Ink., 1992.

Fowler, Gene, and Bill Crawford. Border Radio. Austin: Texas Monthly Press, 1987.

Fowles, Jib. Star Struck: Celebrity Performers and the American Public. Washington, D.C.: Smithsonian Institution Press, 1992.

Frady, Marshall. Southerners: A Journalist's Odyssey. New York: New American Library, 1980.

Gabree, John. The World of Rock. Greenwich, Conn.: Fawcett, 1968.

Gaillard, Frye. Watermelon Wine: The Spirit of Country Music. New York: St. Martin's Press, 1978.

Garbutt, Bob. Rockabilly Queens: The Careers and Recordings of Wanda Jackson, Janis Martin, Brenda Lee. Toronto: Robert Garbutt Productions, 1979.

Gart, Galen, and Roy C. Ames. Duke/Peacock Records: An Illustrated History with Discography. Milford, N.H.: Big Nickel Publications, 1990.

Gelatt, Roland. The Fabulous Phonograph, 1877–1977. New York: Collier Books, 1977.

Geller, Larry, and Joel Spector with Patricia Romanowski. "If I Can Dream": Elvis' Own Story. New York: Simon and Schuster, 1989.

Gibson, Robert, with Sid Shaw. Elvis: A King Forever. London: Elvisly Yours, 1987.

Gillett, Charlie. The Sound of the City: The Rise of Rock and Roll. Rev. ed. London: Souvenir Press, 1983.

Goldman, Albert. Elvis. New York: McGraw-Hill, 1981.

. Elvis: The Last 24 Hours. New York: St. Martin's Paperbacks, 1991.

- Goldrosen, John, and John Beecher. *Remembering Buddy: The Definitive Biography of Buddy Holly.* New York: Penguin Books, 1986.
- Goodin, Vera-Jane. Elvis & Bobbie: Memories of Linda Jackson. Branson, Mo.: Limited Star Editions, 1994.

Goodman, Fred. The Mansion on the Hill: Dylan, Young, Geffen, Springsteen, and the Head-on Collision of Rock and Commerce. New York: Times Books, 1997.

Gordon, Robert. It Came from Memphis. Boston: Faber and Faber, 1995.

. The King on the Road: Elvis Live on Tour 1954 to 1977. New York: St. Martin's Press, 1996.

Graceland: The Living Legacy of Elvis Presley. San Francisco: Collins Publishers San Francisco, 1993. Green, Douglas B. Country Roots: The Origins of Country Music. New York: Hawthorne Books, 1976.

Greenwood, Earl, and Kathleen Tracy. The Boy Who Would Be King. New York: Dutton, 1990.

Gregory, James, ed. The Elvis Presley Story. New York: Hillman Periodicals, 1960.

Gregory, Neal, and Janice Gregory. When Elvis Died. Washington, D.C.: Communications Press, 1980.

Grissim, John. Country Music: White Man's Blues. New York: Paperback Library, 1970.

Grob, Dick. The Elvis Conspiracy? Las Vegas: Fox Reflections Publishing, 1996.

Gruber, J. Richard, organizer. *Memphis: 1948–1958*. Memphis: Memphis Brooks Museum of Art, 1986.

Guterman, Jimmy. Rockin' My Life Away: Listening to Jerry Lee Lewis. Nashville: Rutledge Hill Press, 1991.

Hagarty, Britt. The Day the World Turned Blue: A Biography of Gene Vincent. Vancouver: Talonbooks, 1982. Haining, Peter, ed. Elvis in Private. New York: St. Martin's Press, 1987. Halberstam, David. The Fifties. New York: Villard Books, 1993. Haley, John W., and John von Hoelle. Sound and Glory. Wilmington, Del.: Dyne-American Publishing, 1990. Hammontree, Patsy Guy. Elvis Presley: A Bio-Bibliography. Westport, Conn.: Greenwood Press, 1985. Hand, Albert. Meet Elvis. An Elvis Monthly Special: Manchester, 1962. Harbinson, W. A. The Illustrated Elvis. New York: Grosset and Dunlap, 1976. Harbinson, W. A., and Kay Wheeler. Growing Up with the Memphis Flash. Amsterdam: Tutti Frutti Productions, 1994. Harmetz, Aljean. Round Up the Usual Suspects: The Making of Casablanca. New York: Hyperion, 1992. Hawkins, Martin, and Colin Escott, comps. The Sun Records Rocking Years. London: Charly Records, 1986. Hazen, Cindy, and Mike Freeman. The Best of Elvis. New York: Pinnacle Books, 1994. —. Memphis Elvis-Style. Winston-Salem, N.C.: John F. Blair, 1997. Hemphill, Paul. The Nashville Sound: Bright Lights and Country Music. New York: Simon and Schuster, 1970. Hess, Jake, with Richard Hyatt. Nothin' But Fine: The Music and the Gospel According to Jake Hess. Columbus, Ga.: Buckland Press, 1995. Hill, Wanda June. We Remember, Elvis. Palos Verdes, Calif.: Morgin Press, 1978. Historic Black Memphians. Memphis: Memphis Pink Palace Museum Foundation, n.d. Hodge, Charlie, with Charles Goodman. Me 'n Elvis. Memphis: Castle Books, 1988. Holmes, Richard. Footsteps: Adventures of a Romantic Biographer. New York: Viking, 1985. Hopkins, Jerry. Elvis. New York: Simon and Schuster, 1971. —. Elvis: The Final Years. New York: St. Martin's Press, 1980. —. The Rock Story. New York: Signet Books, 1970. Horstman, Dorothy. Sing Your Heart Out, Country Boy. Rev. ed. Nashville: Country Music Foundation Press, 1986. Hurst, Jack. Nashville's Grand Ole Opry. New York: Abrams, 1975. Hutchins, Chris, and Peter Thompson. Elvis Meets the Beatles. London: Smith Gryphon, 1995. The Impersonal Life. Marina del Rey, Calif.: DeVorss, 1988. Jenkins, Mary. Elvis: The Way I Knew Him. Memphis: Riverpark Publishers, 1984. Jones, Ira, as told to Bill E. Burk. Soldier Boy Elvis. Memphis: Propwash Publishing, 1992. Jorgensen, Ernst. Elvis Presley: A Life in Music. New York: St. Martin's Press, 1998. Juanico, June. Elvis: In the Twilight of Memory. New York: Arcade Books, 1997. Kienzle, Rich. Great Guitarists: The Most Influential Players in Blues, Country Music, Jazz and Rock. New York: Facts on File, 1985. Killen, Buddy, with Tom Carter. By the Seat of My Pants. New York: Simon and Schuster, 1993. Kirby, Edward "Prince Gabe." From Africa to Beale Street. Memphis: Music Management, 1983. Krogh, Egil "Bud". The Day Elvis Met Nixon. Bellevue, Wash.: Pejama Press, 1994. Lacker, Marty, Patsy Lacker, and Leslie S. Smith. Elvis: Portrait of a Friend. New York: Bantam,

1980.

Laing, Dave. Buddy Holly. London: Studio Vista, 1971.

Langbroek, Hans. The Hillbilly Cat. Self-published, 1970.

Latham, Caroline, and Jeannie Sakol. "E" Is for Elvis: An A to Z Illustrated Guide to the King of Rock and Roll. New York: New American Library, 1990.

736 👁 BIBLIOGRAPHY

Lemann, Nicholas. Out of the Forties. New York: Simon and Schuster, 1983.

. The Promised Land. New York: Alfred A. Knopf, 1991.

Levine, Lawrence W. Black Culture and Black Consciousness: Afro-American Folk Thought from Slavery to Freedom. New York: Oxford University Press, 1977.

Levy, Alan. Operation Elvis. New York: Henry Holt, 1960.

Lewis, Donna, with Craig A. Slanker. "Hurry Home, Elvis!": Donna Lewis' Diaries, Vols. 1 (1962–1966) and 2 (1967–1968). Cincinnati: Busted Burd Productions, 1996.

---. "Hurry Home, Elvis!": Donna Lewis' Diaries, Vol. 3 (1968–1977). Unpublished manuscript.

Lewis, Myra, with Murray Silver. Great Balls of Fire: The Uncensored Story of Jerry Lee Lewis. New York: Quill, 1982.

Lichter, Paul. The Boy Who Dared to Rock: The Definitive Elvis. New York: Doubleday Dolphin, 1978.

Logan, Horace, with Bill Sloan. Elvis, Hank, and Me: Making Musical History on the Louisiana Hayride. New York: St. Martin's Press, 1998.

Lornell, Kip. "Happy in the Service of the Lord": Afro-American Gospel Quartets in Memphis. Urbana: University of Illinois Press, 1988.

Loyd, Harold. Elvis Presley's Graceland Gates. Franklin, Tenn.: Jimmy Velvet Publications, 1987.

Lydon, Michael. Rock Folk: Portraits from the Rock 'n' Roll Pantheon. New York: Dial, 1971.

Lytle, Clyde Francis, ed. Leaves of Gold: An Anthology of Prayers, Memorable Phrases, Inspirational Verse and Prose. N.p., n.d.

Malone, Bill C. Country Music, U.S.A.: A Fifty-Year History. Austin: American Folklore Society, University of Texas Press, 1968.

Malone, Bill C., and Judith McCulloh. Stars of Country Music: Uncle Dave Macon to Johnny Rodriguez. Urbana: University of Illinois Press, 1975.

Mancuso, Chuck. Popular Music and the Underground: Foundations of Jazz, Blues, Country, and Rock, 1900–1950. Dubuque, Iowa: Kendall/Hunt Publishing Company, 1996.

Mann, May. Elvis and the Colonel. New York: Drake Publishers, 1975.

Mansfield, Rex, and Elisabeth Mansfield. *Elvis the Soldier.* Bamberg, West Germany: Collectors Service GmbH, 1983.

Marcus, Greil. Dead Elvis. New York: Doubleday, 1991.

------. Mystery Train. 3d rev. ed. New York: Dutton, 1990.

Marsh, Dave. Elvis. New York: Times Books, 1982.

Martin, Linda, and Kerry Segrave. Anti-Rock: The Opposition to Rock 'n' Roll. Hamden, Conn.: Shoe String Press, Archon Books, 1988.

Matthew-Walker, Robert. Elvis Presley: A Study in Music. London: Omnibus Press, 1983

McIlwaine, Shields. Memphis Down in Dixie. New York: E. P. Dutton, 1948.

McKee, Margaret, and Fred Chisenhall. Beale Black & Blue: Life and Music on Black America's Main Street. Baton Rouge: Louisiana State University Press, 1981.

McNutt, Randy. We Wanna Boogie. Hamilton, Ohio: HHP Books, 1988.

Meijers, Edwin J. Off and Back on the Mystery Track. The Netherlands: Self-published, 1992.

Michael Ochs Archives. Elvis in Hollywood. Text by Steve Pond. New York: New American Library, 1990.

Miller, Jim, ed. The Rolling Stone Illustrated History of Rock & Roll. New York: Random House, Rolling Stone Press, 1976.

Miller, William D. Memphis During the Progressive Era: 1900–1917. Memphis: Memphis State University Press, 1957.

. Mr. Crump of Memphis. Baton Rouge: Louisiana State University Press, 1964.

Milsap, Ronnie, with Tom Carter. Almost Like a Song. New York: McGraw-Hill, 1990.

BIBLIOGRAPHY 👁 737

- Moore, Scotty, as told to James Dickerson. That's Alright, Elvis: The Untold Story of Elvis's First Guitarist and Manager, Scotty Moore. New York: Schirmer, 1997.
- Morris, Willie. North Toward Home. Boston: Houghton Mifflin, 1967.
- Morrison, Craig. Go Cat Go!: Rockabilly Music and Its Makers. Urbana, Ill.: University of Illinois Press, 1996.
- Morthland, John. The Best of Country Music. Garden City, N.Y.: Doubleday Dolphin, 1984.
- Muir, Eddie, ed. 'Wild Cat': A Tribute to Gene Vincent. Brighton, U.K.: Self-published, 1977.

Murray, Albert. South to a Very Old Place. New York: McGraw-Hill, 1971.

- Nash, Alanna. Behind Closed Doors: Talking with the Legends of Country Music. New York: Alfred A. Knopf, 1988.
- Nash, Alanna, with Billy Smith, Marty Lacker, and Lamar Fike. Elvis Aaron Presley: Revelations from the Memphis Mafia. New York: HarperCollins, 1995.
- O'Grady, John, and Nolan Davis. O'Grady: The Life and Times of Hollywood's No. 1 Private Eye. Los Angeles: J. P. Tarcher, 1974.
- O'Neal, Sean. Elvis Inc.: The Fall and Rise of the Presley Empire. Rocklin, Calif.: Prima Publishing, 1996.

Palmer, Robert. Baby, That Was Rock & Roll: The Legendary Leiber & Stoller. New York: Harcourt Brace Jovanovich, 1978.

- ------. Deep Blues. New York: Viking, 1981.
- . Jerry Lee Lewis Rocks! New York: G. P. Putnam's Sons, 1981.
- . A Tale of Two Cities: Memphis Rock and New Orleans Roll. I.S.A.M. Monographs: Number 12. Brooklyn: Institute for Studies in American Music, 1979.
- Palmer, Tony. All You Need Is Love: The Story of Popular Music. New York: Viking Press, Grossman Publishers, 1976.
- Parker, Ed. Inside Elvis. Orange, Calif.: Rampart House, 1978.
- Parker, John. Five for Hollywood. New York: Lyle Stuart, 1991.
- Passman, Arnold. The Deejays. New York: Macmillan, 1971.
- Pearl, Minnie, with Joan Dew. Minnie Pearl: An Autobiography. New York: Simon and Schuster, 1980.
- Peary, Danny, ed. Close Ups: The Movie Star Book. New York: Workman, 1978.
- Percy, William Alexander. Lanterns on the Levee: Recollections of a Planter's Son. Baton Rouge: Louisiana State University Press, 1973.
- Perkins, Carl, and David McGee. Go, Cat, Gol: The Life and Times of Carl Perkins, The King of Rockabilly. New York: Hyperion, 1995.
- Perkins, Carl, with Ron Rendleman. Disciple in Blue Suede Shoes. Grand Rapids, Mich.: Zondervan Publishing House, 1978.
- Pleasants, Henry. The Great American Popular Singers. New York: Simon and Schuster, 1974.

Poe, Randy. Music Publishing: A Songwriter's Guide. Cincinnati: Writer's Digest Books, 1990.

- Porterfield, Nolan. The Life and Times of America's Blue Yodeler: Jimmie Rodgers. Urbana: University of Illinois Press, 1979.
- Presley, Dee, Billy Stanley, Rick Stanley, and David Stanley, as told to Martin Torgoff. *Elvis, We Love You Tender.* New York: Delacorte Press, 1980.

Presley, Priscilla Beaulieu, with Sandra Harmon. *Elvis and Me.* New York: G. P. Putnam's Sons, 1985. Presley, Vester. *A Presley Speaks*. Memphis: Wimmer Brothers Books, 1978.

- Presley, Vester, and Nancy Rooks. The Presley Family Cookbook. Memphis: Wimmer Brothers Books, 1980.
- Pritchett, Rev. Nash Lorene Presley. One Flower While I Live: Elvis As I Remember Him. Memphis: Shelby House, 1987.

Pugh, Ronnie. Ernest Tubb: The Texas Troubadour. Durham, N.C.: Duke University Press, 1996.

Quain, Kevin, ed. The Elvis Reader: Texts and Sources on the King of Rock 'n' Roll. New York: St. Martin's Press, 1992.

Raines, Howell. My Soul Is Rested. New York: G. P. Putnam's Sons, 1977.

Reagon, Bernice Johnson, ed. We'll Understand It Better By and By. Washington, D.C.: Smithsonian Institution Press, 1992.

Rheingold, Todd. Dispelling the Myth: An Analysis of American Attitudes and Prejudices. New York: Believe in a Dream Publications, 1993.

Rijff, Ger. Faces and Stages: An Elvis Presley Time-Frame. Amsterdam: Tutti Frutti Productions, 1986.

. Long Lonely Highway. Amsterdam: Tutti Frutti Productions, 1985.

. Memphis Lonesome. Amsterdam: Tutti Frutti Productions, 1988.

_____. The Voice of Rock 'n' Roll: Elvis in the Times of Ultimate Cool. Rotterdam: It's Elvis Time, 1993.

Rijff, Ger J., and Jan van Gestel. Elvis: The Cool King. Amsterdam: Tutti Frutti Productions, 1989.

------. Fire in the Sun. Amsterdam: Tutti Frutti Productions, 1991.

-. Florida Close-Up. Amsterdam: Tutti Frutti Productions, 1987.

Roark, Eldon. Memphis Bragabouts. New York: McGraw-Hill, Whittlesey House, 1945.

Rodriguez, Elena. Dennis Hopper: A Madness to His Method. New York: St. Martin's Press, 1988.

Rose, Frank. The Agency: William Morris and the Hidden History of Show Business. New York: HarperBusiness, 1995.

Rosenberg, Neil V. Bluegrass: A History. Urbana: University of Illinois Press, 1985.

Rovin, Jeff. The World According to Elvis: Quotes from the King. New York: HarperCollins, Harper Paperbacks, 1992.

Russell, Tony. Blacks, Whites and Blues. London: Studio Vista, 1970.

Russell, Wayne. Foot Soldiers and Kings. Brandon, Manitoba: Wayne Russell, n.d.

-------. Foot Soldiers and Kings. Vol 2. Brandon, Manitoba: Wayne Russell, n.d.

Sanjek, Russell. American Popular Music and Its Business: The First Four Hundred Years. Vol. 3, From 1900 to 1984. New York: Oxford University Press, 1988.

----. From Print to Plastic: Publishing and Promoting America's Popular Music (1900–1980). I.S.A.M.

Monographs: Number 20. Brooklyn: Institute for Studies in American Music, 1983.

Sawyer, Charles. The Arrival of B. B. King. Garden City, N.Y.: Doubleday, 1980.

Schlappi, Elizabeth. Roy Acuff: The Smoky Mountain Boy. Gretna, La.: Pelican Publishing, 1978.

Schroer, Andreas. Private Presley: The Missing Years — Elvis in Germany. New York: William Morrow, 1993.

Selvin, Joel. Ricky Nelson: Idol for a Generation. Chicago: Contemporary Books, 1990.

Shaw, Arnold. Honkers and Shouters: The Golden Years of Rhythm and Blues. New York: Macmillan, 1978.

-----. The Rockin' '50s. New York: Hawthorne Books, 1974.

Shelton, Robert, and Burt Goldblatt. The Country Music Story: A Picture History of Country and Western Music. New York: Bobbs-Merrill, 1966.

Shore, Sammy. The Warm-Up. New York: William Morrow, 1984.

Siegel, Don. A Siegel Film: An Autobiography. London: Faber and Faber, 1993.

Sigafoos, Robert A. Cotton Row to Beale Street. Memphis: Memphis State University Press, 1979.

Skar, Stein Erik. Elvis: The Concert Years, 1969–1977. Norway: Flaming Star, 1997.

Smith, Gene. Elvis's Man Friday. Nashville: Light of Day Publishing, 1994.

Smith, Wes. The Pied Pipers of Rock 'n' Roll: Radio Deejays of the 50s and 60s. Marietta, Ga.: Longstreet Press, 1989.

Snow, Hank, with Jack Ownbey and Bob Burris. *The Hank Snow Story*. Champaign: University of Illinois Press, 1994.

BIBLIOGRAPHY No 739

- Snow, Jimmy, with Jim Hefley and Marti Hefley. I Cannot Go Back. Plainfield, N.J.: Logos International, 1977.
- Sri Daya Mata. Finding the Joy Within You: Personal Counsel for God-Centered Living. Los Angeles: Self-Realization Fellowship, 1990.

—. Only Love: Living the Spiritual Life in a Changing World. Los Angeles: Self-Realization Fellowship, 1976.

Stanley, Billy, with George Erikson. Elvis, My Brother. New York: St. Martin's Press, 1989.

Stanley, David. Life with Elvis. Old Tappan, N.J.: Fleming H. Revell, 1986.

- Stanley, David E., with Frank Coffey. *The Elvis Encyclopedia*. Santa Monica, Calif.: General Publishing Group, 1994.
- Stanley, Rick, with Michael K. Haynes. *The Touch of Two Kings: Growing Up at Graceland*. N.p.: T2K Publishers, 1986.
- Staten, Vince. The Real Elvis: Good Old Boy. Dayton: Media Ventures, 1978.
- Stearn, Jess, with Larry Geller. The Truth About Elvis. New York: Jove Publications, 1980.
- Stern, Jane, and Michael Stern. Elvis World. New York: Alfred A. Knopf, 1987.
- Storm, Tempest, with Bill Boyd. The Lady Is a Vamp. Atlanta: Peachtree Publishers, 1987.

Streissguth, Michael. Eddy Arnold: Pioneer of the Nashville Sound. New York: Schirmer, 1997.

- Sumner, J. D., with Bob Terrell. Elvis: His Love for Gospel Music and J. D. Sumner. Nashville: Gospel Quartet Music Company and Bob Terrell, 1991.
- Swaggart, Jimmy. The Campmeeting Hour: The Radio Miracle of the 20th Century. Baton Rouge: Jimmy Swaggart Evangelistic Association, 1976.
- Swaggart, Jimmy, with Robert Paul Lamb. *To Cross a River*. Plainfield, N.J.: Logos International, 1977.
- Swenson, John. Bill Haley: The Daddy of Rock and Roll. New York: Stein and Day, 1982.
- Taylor, David L. Happy Rhythm: A Biography of Hovie Lister and the Statesmen Quartet. Lexington, Ind.: TaylorMade Write, 1995.
- Taylor, William J., Jr. Elvis in the Army: The King of Rock 'n Roll As Seen by an Officer Who Served With Him. Novato, Calif.: Presidio Press, 1995.
- Terrell, Bob. The Chuck Wagon Gang. Goodlettsville, Tenn.: Roy Carter, 1990.
 - ———. The Music Men: The Story of Professional Gospel Quartet Singing. Asheville, N.C.: Bob Terrell Publisher, 1990.
- Terrell, Bob, and J. D. Sumner. *The Life and Times of J. D. Sumner, the World's Lowest Bass Singer*. Nashville: J. D. Sumner, Publisher, 1994.

Tharpe, Jac L., ed. Elvis: Images and Fancies. Jackson: University Press of Mississippi, 1979.

- Thompson, Charles C. II, and James P. Cole. *The Death of Elvis: What Really Happened*. New York: Delacorte Press, 1991.
- Thompson, Sam. Elvis on Tour: The Last Year. Memphis: Still Brook Publishing, 1992.
- Tobler, John, and Stuart Grundy. The Record Producers. New York: St. Martin's Press, 1982.
- Toll, Robert. Blacking Up: The Minstrel Show in Nineteenth-Century America. New York: Oxford University Press, 1974.
- Torgerson, Dial. Kerkorian: An American Success Story. New York: The Dial Press, 1974.
- Torgoff, Martin, ed. The Complete Elvis. New York: G. P. Putnam's Sons, 1982.
- Tosches, Nick. Country: The Biggest Music in America. New York: Stein and Day, 1977.
 - ——. Dino: Living High in the Dirty Business of Dreams. New York: Doubleday, 1992.
 - ------. Hellfire: The Jerry Lee Lewis Story. New York: Dell, 1982.
 - . Unsung Heroes of Rock 'n' Roll. Rev. ed. New York: Harmony Books, 1991.
- Townsend, Charles R. San Antonio Rose: The Life and Music of Bob Wills. Urbana: University of Illinois Press, 1976.

- Tribute: The Life of Dr. William Herbert Brewster. 2d ed. Memphis: Brewster House of Sermon Songs, n.d.
- Tucker, David. Lieutenant Lee of Beale Street. Nashville: Vanderbilt University Press, 1971.
- ———. Memphis Since Crump: Bossism, Blacks, and Civic Reformers, 1948–1968. Knoxville: University of Tennessee Press, 1980.
- Turner, Steve. Hungry for Heaven: Rock and Roll and the Search for Redemption. London: W. H. Allen, 1988.
- Urquhart, Sharon Colette. Placing Elvis: A Tour Guide to the Kingdom. New Orleans: Paper Chase Press, 1994.
- Van Doren, Mamie, with Art Aveilhe. Playing the Field: My Story. New York: G. P. Putnam's Sons, 1987.
- Vellenga, Dirk, with Mick Farren. Elvis and the Colonel. New York: Delacorte Press, 1988.

Vernon, Paul. The Sun Legend. London: Paul Vernon, 1969.

Vince, Alan. I Remember Gene Vincent. Liverpool: Vintage Rock 'n' Roll Appreciation Society, 1977. Wade-Gayles, Gloria. Pushed Back to Strength. Boston: Beacon Press, 1993.

- Wallis, Hal, and Charles Higham. Starmaker: The Autobiography of Hal Wallis. New York: Macmillan, 1980.
- Ward, Ed, Geoffrey Stokes, and Ken Tucker. Rock of Ages: The Rolling Stone History of Rock & Roll. New York: Summit Books, 1986.
- Washington, Peter. Madame Blavatsky's Baboon: A History of the Mystics, Mediums, and Misfits Who Brought Spiritualism to America. New York: Schocken Books, 1995.
- Weinberg, Max, with Robert Santelli. The Big Beat: Conversations with Rock's Great Drummers. New York: Billboard Books, 1991.
- Wertheimer, Alfred, with Gregory Martinelli. Elvis '56: In the Beginning. New York: Collier Books, 1979.
- Wertheimer, Alfred, Ger Rijff, and Jan van Gestel. *Elvis Presley: Songs of Innocence*. Amsterdam: Tutti Frutti Productions, 1995.
- West, Red, Sonny West, and Dave Hebler, as told to Steve Dunleavy. *Elvis: What Happened?* New York: Ballantine Books, 1977.
- Westmoreland, Kathy, with William G. Quinn. *Elvis and Kathy*. Glendale, Calif.: Glendale House Publishing, 1987.
- White, Charles. The Life and Times of Little Richard: The Quasar of Rock. New York: Harmony Books, 1984.
- Whitmer, Peter. The Inner Elvis: A Psychological Biography of Elvis Aaron Presley. New York: Hyperion, 1996.
- Wiegert, Sue. Elvis: For the Good Times. Los Angeles: The Blue Hawaiians for Elvis, 1978.
- Wiegert, Sue, with contributions by Elvis friends and Elvis fans. "Elvis: Precious Memories." Los Angeles: Century City Printing, 1987.
 - -. "Elvis: Precious Memories." Vol. 2. Los Angeles: Century City Printing, 1989.

Williams, William Carlos. In the American Grain. New York: New Directions Press, 1956.

Winters, Shelley. Shelley II. New York: Simon and Schuster, 1989.

Wood, Lana. Natalie: A Memoir by Her Sister. New York: G. P. Putnam's Sons, 1984.

- Woodward, C. Vann. The Burden of Southern History. Rev. ed. Baton Rouge: Louisiana State University Press, 1968.
 - ——. Thinking Back: The Perils of Writing History. Baton Rouge: Louisiana State University Press, 1986.
- Wren, Christopher S. Winners Got Scars Too: The Life of Johnny Cash. New York: A Country Music/ Ballantine Book, 1971.

Wynette, Tammy, with Joan Dew. Stand By Your Man: An Autobiography. New York: Simon and Schuster, 1979.

Yancy, Becky, and Cliff Linedecker. My Life with Elvis. New York: St. Martin's Press, 1977. Yogananda, Paramahansa. Autobiography of a Yogi. Los Angeles: Self-Realization Fellowship, 1974.

CLIPPINGS, COLLECTIONS, PICTURE BOOKS, AND MEMORABILIA

Adair, Joseph. The Immortal Elvis Presley. Stamford, Conn.: Longmeadow Press, 1992.

Burk, Bill E. Elvis: Rare Images of a Legend. Memphis: Propwash Publishing, 1990.

-------. Elvis in Canada. Memphis: Propwash Publishing, 1996.

- Clark, Alan. Buddy Holly and the Crickets. West Covina, Calif.: Alan Clark Productions, 1979.
- . The Elvis Presley Photo Album. West Covina, Calif.: Alan Clark Productions, 1981.
- ------. Gene Vincent: The Screaming End. West Covina, Calif.: Alan Clark Productions, 1980.
- -------. Rock-a-billy and Country Legends. West Covina, Calif.: Alan Clark Productions.

Cortez, Diego, ed. Private Elvis. Stuttgart: FEY Verlags GmbH, 1978.

- Curtin, Jim. Unseen Elvis: Candids of the King. Boston: Little, Brown, 1992.
- DeNight, Bill, Sharon Fox, and Ger Rijff. Elvis Album. Lincolnwood, Ill.: Beekman House, 1991.

deWit, Simon. Auld Lang Syne. Rotterdam: Simon deWit Productions, 1995.

------. King of Vegas. Rotterdam: Simon deWit Productions, 1994.

Elvis in Paris 1959 (no other data).

Esposito, Joe. Elvis: A Legendary Performance. Buena Park, Calif.: West Coast Publishing, 1990.

- ———. Elvis . . . Intimate and Rare: Memories and Photos from the Personal Collection of Joe Esposito. Thousand Oaks, Calif.: Elvis International Forum Books, 1997.
- Fox, Sharon R., ed. Elvis, His Real Life in the 60s: My Personal Scrapbook. Chicago: Sharon Fox, 1989.
- Hannaford, Jim. Elvis: Golden Ride on the Mystery Train. Vols. 1 and 2. Alva, Okla.: Jim Hannaford, 1986.
- Kricun, Morrie E., and Virginia M. Kricun. *Elvis: 1956 Reflections.* Wayne, Pa.: Morgin Press, 1991 and 1992.
- Lamb, Charles. The Country Music World of Charlie Lamb. Nashville: Infac Publications, 1986.

Life: 1946–1955. New York: Little, Brown, New York Graphic Society, 1984.

Loper, Karen. The Elvis Clippings. Houston: "The Elvis Clippings," n.d.

Michael Ochs Rock Archives. Garden City, N.Y.: Doubleday, 1984.

Now Dig This. The King Forever. Wallsend, Tyne and Ware, U. K.: Now Dig This, 1992.

O'Neal, Hank (text). A Vision Shared: A Classic Portrait of America and Its People. New York: St. Martin's Press, 1976.

- Parish, James Robert. Solid Gold Memories: The Elvis Presley Scrapbook. New York: Ballantine Books, 1975.
- Rijff, Ger, and Poul Madsen. *Elvis Presley: Echoes of the Past.* Voorschoten, Holland: "Blue Suede Shoes" Productions, 1976.
- Rijff, Ger, and Gordon Minto. 60 Million TV Viewers Can't Be Wrong: Elvis' Legendary Performances on the Ed Sullivan Show. Amsterdam: Tutti Frutti Productions, 1994.

- Rijff, Ger, Trevor Cajiao, and Michael Ochs. Shock, Rattle and Roll: Elvis Photographed During the Milton Berle Show. Amsterdam: Tutti Frutti Productions, 1994.
- Rijff, Ger, Jim Hannaford, and Gordon Minto. Inside Jailhouse Rock. Amsterdam: Jim Hannaford Productions, 1996.
- Tucker, Gabe, and Elmer Williams. *Pictures of Elvis Presley*. Houston: Williams and Tucker Photographs, 1981.
- Tunzi, Joseph A. Elvis: Highway 51 South, Memphis, Tennessee. Chicago: JAT Productions, 1995.

. Elvis: Standing Room Only, 1970–1975. Chicago: JAT Productions, 1994.

- . Elvis '69: The Return. Chicago: JAT Productions, 1991.
- _____. Elvis '73: Hawaiian Spirit. Chicago: JAT Productions, 1992.
- _____. Photographs and Memories. Chicago: JAT Productions, 1998.
- . Tiger Man: Elvis '68. Chicago: JAT Productions, 1997.
- Tunzi, Joseph A., and Sean O'Neal. Elvis: The Lost Photographs, 1948–1969. Chicago: JAT Productions, 1995.

PERIODICALS

I couldn't begin to list all the periodicals, past and present, that I have consulted. Just for the briefest of references, I have found Now Dig This, Goldmine, DISCoveries, New Kommotion, Kicks, Country Music, and Picking Up the Tempo particularly useful (and frequently invaluable) over the years. In addition, I have consulted the following Elvis publications extensively: Elvis: The Man and His Music; Elvis: The Record; Elvis World; Because of Elvis; Elvis International Forum; and Graceland Express. Musician's special 1992 report, "Elvis Presley: An Oral Biography," with interviews conducted by Peter Cronin, Scott Isler, and Mark Rowland, offered an insightful portrait. Finally, Orbis' History of Rock, vols. 3 and 5, published in 1981 and 1982, has good pictures and interesting background on the early career, and life and times, of Elvis Presley.

For detailed reference to specific articles and periodical sources, however, please see the Notes (page 663).

A Brief Discographical Note

MUCH OF THE WORK THAT would once have gone into pointing people toward the best of Elvis Presley on record has finally been done (or is in the process of completion) by RCA/BMG. Thanks to the efforts of Ernst Jorgensen and Roger Semon, the vast majority of Elvis' essential performances are now available on three five-CD sets. *Elvis: The King of Rock 'N' Roll: The Complete* 50's Masters (RCA 66050), *Elvis from Nashville to Memphis: The Essential 60's Masters* (RCA 66160), and *Walk a Mile in My Shoes: The Essential 70's Masters* (RCA 66670) contain nearly everything of worth in the way of studio masters (the '60s and '70s boxes leave out all the movie soundtrack material), together with some wonderful, frequently enlightening surprises along the lines of alternate takes, rehearsal sessions, interview material, radio recordings, and live tracks.

In addition, Amazing Grace (RCA 66421) is the definitive two-CD compilation of Elvis' gospel recordings, and no respectable record collection should be without either it or Sunrise, a forthcoming two-CD set of the Sun sides (RCA 67675), which will include numerous alternate takes, Hayride performances, and the two acetates that Elvis recorded at his own expense in the Sun studio before making his professional debut with "That's All Right" in the summer of 1954. The only other truly essential purchases that I would suggest are The Million Dollar Quartet (RCA 2023), which offers a fascinating, unbuttoned view of the creative process at work, with powerfully ragged harmonies from Elvis, Jerry Lee Lewis, and Carl Perkins (the one-man-short but scarcely overvalued quartet) and the incomparable audio spectacle of Elvis imitating Jackie Wilson imitating him; Elvis/NBC-TV Special (RCA 61021) and Tiger Man (RCA 67611), which represent, respectively, the soundtrack for the '68 comeback special and the second live sit-down show complete; and Suspicious Minds (RCA 67677, forthcoming), a two-disc set which will include all the masters cut at the American studio in 1969, along with a generous assortment of outtakes from what may have been the single most productive session undertaken by Elvis after Sun. With that said, however, I should mention that Elvis' initial post-army session, whose eighteen cuts were dispersed among three singles (including "It's Now or Never" and "Are You Lonesome Tonight?") and the only album that could arguably be compared with From Elvis in Memphis (the first LP to present the American material), is scheduled to be released as a complete eighteen-track CD under the same name as the original twelve-track album, Elvis Is Back (RCA 67737). Presented in its entirety for the first time, that album, I think, will come as a revelation.

There are lots of other avenues to explore — the movie songs, live performances, alternate takes (*The Essential Elvis* series, of which volume 2, *Elvis Presley Stereo '57* [RCA 9589] is the most consistently engaging), theme- and chronology-linked compilations — but for these and numerous other permutations, I'll leave you to your own devices. The only other suggestion that I have (though this is one that could sustain almost endless exploration) is the music from which Elvis derived his inspiration: music from sources as varied as Roy Hamilton, Hank Snow, Arthur Crudup, Martha Carson, Eddy Arnold, Ray Charles, Bing Crosby, Little Junior Parker, the Ink Spots, the Statesmen, the Blackwood Brothers, and Sister Rosetta Tharpe. There are two albums out featuring original versions of some of Elvis' better-known songs (*The King's Record Collection*, volumes 1 and 2 [Hip-O 40082 and 40083]), and they are certainly a good start, but if Elvis' music moves you, it's worth more than a leisurely stroll along the frequently diverging paths of great American vernacular music. There's a wealth of inspiration to be found for music still to be made.

Acknowledgments

IN WRITING A BOOK over so long a period (and one that stretches back well beyond its formal start), one incurs debts that one can never repay. Literally hundreds of people have helped me with my research and my interviews, and I thank them all. The following are just some of the people who gave me a hand over the weeks, months, and years:

Bob Abel, Julian Aberbach, Susan Aberbach, Mrs. Lee Roy Abernathy, Curtis Lee Alderson, J. W. Alexander, Hoss Allen, Terry Allen, Patrick Anderson, Ellis Amburn, Chet Atkins, James Ausborn, Mae Axton, Buddy and Kay Bain, Eva Mills Baker and Sarah Baker Bailey, Jackson Baker, Jimmy Bank, Jonnie Barnett, George Barris, Dick Baxter, Bob Beckham, Fred and Harriette Beeson, Bill Belew, Bill Bentley, Bettye Berger, Freddy Bienstock, Steve Binder, Bar Biszick, Evelyn Black, Johnny Black, James Blackwood, George Blancet, Arthur Bloom, Arlene Piper Blum, Barbara Bobo, Barbara Boldt, Dave Booth, Stanley Booth, Joella Bostick, Ernest Bowen, Horace Boyer, Bill Bram, Will Bratton and Sharyn Felder, Doug Brinkley, Avis Brown, Estelle Brown, Jim Ed Brown, Monty and Marsha Brown, Tony Brown, James Burton, Kenny Buttrey, Sheila Caan, Trevor Cajiao, Louis Cantor, Jerry Carrigan, Martha Carson, Johnny Cash, Anne Cassidy, Margaret Chapman, Marshall Chess, Gene Chrisman, Galen Christy, Dr. Charles L. Clarke, Quinton Claunch, Rose Clayton, Jack Clement, Jackie Lee Cochran, Tommy Cogbill, Biff Collie, L. C. Cooke, Al Cooley, Daniel Cooper, X. Cosse, the Country Music Foundation, Floyd Cramer, Jack Cristil, Peter Cronin, Mike Crowley, Chick Crumpacker, Ann Curtis, T. Tommy Cutrer, Bill Dahl, Pete Daniel, Sherry Daniel, Fred Danzig, Fred Davis, Hank Davis, Richard Davis, Roger Davis, Joan Deary, Bill Denny, Jesse Lee Denson, Jimmy Denson, Howard DeWitt, Jim and Mary Lindsay Dickinson, Sander Donkers, Duff Dorrough, Carole Drexler, Elaine Dundy, Al Dvorin, Vince Edwards, Leroy Elmore, Sam Esgro, David Evans, Eddie Fadal, Charles Farrar, Charlie Feathers, Robert Ferguson, Lamar Fike, Bob Finkel, David Fleischman, D. J. Fontana, Buzzy Forbess, Trude Forsher, Alan Fortas, Lillian Fortenberry, Fred Foster, Dr. Michael J. Fox, Sharon Fox, Ted Fox, Andy Franklin, Tillman Franks, Steve Frappier, Ann Freer, Donnie Fritts, Anne Fulchino, Lowell Fulson, Ray Funk, Marty Garbus, Honeymoon Garner, Galen Gart, Gregg Geller, Larry Geller, Gary Giddins, Homer Gilliland, Cliff Gleaves, Glen Glenn, Billy Goldenberg, Stuart Goldman, John Goldrosen, Sandra Goroff-Mailly, Kay Gove, Billy Graham, Betty Grant, Sid Graves, Tom Graves, Bob Green, Alan Greenberg, Bob Groom, Joe Guercio, Jimmy Guterman, Joe Haertel, Rick Hall, Jim Hannaford, Terry Hansen, Glen D. Hardin, Gary Hardy, Buddy Harmon, Sandy Harmon, Dottie Harmony, Phyllis Harper, Homer Ray Harris, Jo Harvey, Randy Haspel, Dot Hawkins, Martin Hawkins, Rick Hawks, Cindy Hazen and Mike Freeman, Joseph Hazen, Anne Helm, Laura Helper, Skip Henderson, Curley Herndon, Lamar Herrin, Jake Hess, Leonard Hirshan, Charlie Hodge, Lester and Sterling Hofman, Big Al Holcomb, Ed Hookstratten, Gary and Michelle Hovey, Bones Howe, Eliot Hubbard, Steve Hughes, Tom Hulett, Maylon Humphries, Nick Hunter, Rick Husky, Mel Ilberman, Bill Ivey, Wayne Jackson, Mark James, Roland Janes, Jim Jaworowicz, Jimmy Johnson, June Juanico, Jackie Kahane, Sandi Kallenberg, Hal Kanter, Joan Kardashian, Marion Keisker, Captain Jerry Kennedy, Jerry Kennedy, Stan

ACKNOWLEDGMENTS 👁 745

Kesler, Rich Kienzle, Merle Kilgore, Buddy Killen, Paul Kingsbury, Millie Kirkham, Allen Klein, George Klein, Pete Kuykendall, Sleepy LaBeef, Charlie Lamb, Grelun Landon, Guy Lansky, Karen Lanza, Dickey Lee, Mike Leech, Alan Leeds, Ed Leek, Lance LeGault, Jerry Leiber, Barbara Leigh, Ed Leimbacher, David Leonard, David and Angela Less, Harry Levitch, Donna Lewis, Leonard Lewis, Stan Lewis, Dixie Locke, Horace Logan, Mary Logan, Larrie Londin, Lorene Lortie, Bert Lovitt, Bill Lowery, Archie Mackey, Poul Madsen, Kenneth Mann, Sandy Martindale, Brad McCuen, Judy McCulloh, Dick McDonough, Charlie McGovern, Gerry McLafferty, Myra McLarey, Andy McLenon, John and Pat McMurray, Scott McQuaid, Pete Mikelbank, Sandi Miller, Bill Mitchell, Chips Moman, Bill Monroe, Sputnik Monroe, Bob Moore, Bobbie Moore, Steve Morewood, Steve Morley, John Morthland, Joe Moscheo, Alanna Nash, David Naylor, Gene Nelson, Jimmy "C" Newman, Dr. George Nichopoulos, Thorne Nogar, John Novarese, Herbie O'Mell, Jim O'Neal, Sean O'Neal, Michael Ochs, Bob Oermann, Jay Orr, Terry Pace, Frank Page, Jim Page, Colonel Tom Parker, Ed Parker, Pat Parry, Marty Pasetta, Al Pavlow, Judy Peiser, Carl Perkins, Millie Perkins, Tom Perryman, Brian Petersen, Pallas Pidgeon, Ron Pietrefaso, Bob Pinson, Barbara and Willie Pittman, Randy Poe, Gail Pollock, Doc Pomus, Steve Popovich, Bill Porter, David Porter, Priscilla Presley, John Andrew Prime, Mark Pucci, Ronnie Pugh, Norbert Putnam, David Ragan, Pat Rainer, Charles Raiteri, Linda Raiteri and Beverly Love, Fred Rappaport, Erik Rasmussen, Jerry Reed, Kang Rhee, John Rich, Eleanor Richman, JillEllyn Riley, Johnny Rivers, Fran Roberts, Don Robertson, Jeffrey Rodgers, Jeff Rosen, Steve Rosen, Neil Rosenberg, John Rumble, Wayne Russell, Simon Rutberg, Ben Sandmel, Johnny Saulovich, Jerry Scheff, Tony Scherman, Billy Ray Schilling, Tom Schultheiss, Lee Secrest, Joel Selvin, Jan Shepard, Dick Shurman, Barbara Sims, John and Shelby Singleton, Louis Skorecki, Craig Slanker, the Reverend and Mrs. Frank Smith, Gary Smith, Myrna Smith, Ronald Smith, Hank Snow, the Reverend Jimmy Snow, Glen Spreen, Sri Daya Mata, Jessica St. John, Kevin Stein, Jim Stewart, Alan Stoker, Gordon Stoker, Mike Stoller, Dave Stone, Billy Strange, Peter Stromberg, Jon Strymish, Marty Stuart, J. D. Sumner, Billy Swan, Russ Tamblyn, Corinne Tate, Bob Terrell, Rufus and Carla Thomas, Linda Thompson, Sam Thompson, Roland Tindall, Dr. Daniel Tolpin, Nick Tosches, Ronny Trout, Ruth Trussell, Ernest Tubb, Justin Tubb, Gabe Tucker, Joe Tunzi, Roy Turner, Cindy Underwood, Billy Walker, Bill Wallace, Slim Wallace, Jan Walner, Harry Warner, Alton and Maggie Warwick, Dick Waterman, Monte Weiner, Jerry Weintraub, Ben Weisman, Alfred Wertheimer, Red and Pat West, Kathy Westmoreland, Jerry Wexler, Cliff White, Jonny Whiteside, Tex Whitson, Sue Wiegert, Willie Wileman, Jimmy Wiles, Don(el) Wilson, Charles Wolfe, Gloria Wolper, Terry Wood, Eve Yohalem, Chip Young, Jimmy Young, Reggie Young, David Yount, and Mrs. W. A. Zuber.

Once again Bill Millar kindly provided tapes, historical analyses, clippings, and information, as did Ger Rijff, Colin Escott, Bill Burk, Karen Loper, Andrew Simons, Dirk Vellenga, Christine Colclough, Bernard Seibel, Jay Gordon, Stephen Stathis, and Diana Magrann. Jerry Hopkins could not have been more generous in providing both insights and artifacts from his own extensive research into the life of Elvis Presley. Jim Cole tirelessly dug up all kinds of Memphis information and lore, filling in for Robert Gordon, who continued to assist in any number of ways while researching his own biography of Muddy Waters. Shelley Ritter, too, did research on deeds and trusts and allowed me to be the beneficiary of her Mississippi travels. In Nashville David Briggs remained the most gracious of hosts, while Harold Bradley went to great pains to set up a joint interview for Ernst Jorgensen and me with a number of the sixties session musicians. Mary Jarvis, too, was unfailing in her efforts to locate players and truths and is missed by all.

Jerry Schilling and Joe Esposito contributed above and beyond the call of duty, as they endured interview after interview with no agenda other than to try to clear up authorial confusion, even if it meant stirring up painful memories of their own. I can't overstate my thanks to them or to Sam Phillips, Knox Phillips, Jerry Phillips, and the entire Phillips family, for their unstinting friendship and dedication to helping this project in every way, down to the last infinitesimal detail. Scotty Moore, too, was a bulwark in providing disinterested advice and honest perspective, even as his own active role in the story diminished.

I am greatly indebted to John Bakke, chairman of the Department of Theatre and Communication Arts, for making available to me both the resources of the Mississippi Valley Collection at the University of Memphis and the tapes of the annual memorial service program, which was cosponsored by Dean Richard Ranta of the College of Communication and Fine Arts each August for ten years after Elvis' death. Andrew Solt and Malcolm Leo each helped immeasurably in opening up to me the resources, contacts, and files (not to mention knowledge, insights, and goodwill) that they developed initially in making *This Is Elvis* and in their subsequent work both together and individually over the years. And Sam Gill could not have been more helpful in guiding my wife, Alexandra, and me through the Elvis Presley General Correspondence Files in the Hal Wallis Collection at the Margaret Herrick Library, Academy of Motion Picture Arts and Sciences Library, in Beverly Hills.

Finally, Jack Soden showed both faith and friendship in opening up the archives of the Elvis Presley Estate with no aim other than to help make the story as honest and truthful as possible, while Greg Howell, the archives' curator, was indefatigable in providing on-site assistance.

Kit Rachlis once again offered the most helpful (not to mention annoyingly perceptive) editorial suggestions and advice, and Alexandra Guralnick patiently read, transcribed, challenged, and imagined the details of the story every step of the way. Ernst Jorgensen, author of the definitive book on Elvis' recordings, *Elvis Presley: A Life in Music*, read the manuscript for accuracy and more than maintained his end of the running dialogue (and endless debate) that we began more than eight years ago. My thanks to Pamela Marshall for scrupulous and empathetic copyediting (even down to the great gerund-and-gerundive controversy) and to Susan Marsh, whose passionate commitment to elegance of form and unswerving dedication to the text have guided the design of every book I have written since 1979. And thanks to my editor, Michael Pietsch, whose faith in this project from the beginning merely set the tone for his steadfast loyalty and support (and patience) in helping to shepherd it through to completion.

Thanks to all, and to all those not named, from whom I drew encouragement, sustenance, and inspiration, not to mention the courage (and enthusiasm) to go on!

Index

Page numbers in *italic* type refer to photographs.

Abel, Bob, 462–469, 708n Aberbach, Jean, 33, 96, 379-380, 448, 494-496 Aberbach, Julian, 33, 96, 99, 379-380, 383, 447, 448, 494-496 Abernathy, Lee Roy, 20 Ableser, Lee, 407 Ace, Johnny, 275 Acuff, Roy, 110 Adams, Faye, 561 Adams, Jack, 251 Adams, Nick, 68, 72, 179 Adidge, Pierre, 462-469 Adler, Buddy, 79 "After Loving You," 275, 337 Agnew, Spiro, 411-412, 416, 427, 428 Albrecq, Beverly, 504 Alden, Ginger, 613-616, 618, 619-627, 629-631, 633, 634, 637, 639, 641–643, 644–647, 649, 660 Alden, Jo, 613-614, 616, 622-623, 631, 641 Alden, Rosemary, 613, 618, 620, 626, 631 Alden, Terry, 613, 623-624, 626, 637 Alder, Vera Stanley, 175, 183 Ali, Muhammad, 432, 445, 488 Allen, Steve, 62, 294, 469 Allied Artists, 160, 187, 203, 250 "All My Trials," 455 "All Shook Up," 60, 97, 348 All Star Shows, 213, 320, 442, 493, 672n Aloha from Hawaii (1973 television special), 475, 478-480, 481-484, 488, 496-497, 501, 502, 565, 636, 709n

Also Sprach Zarathustra, 443. See also 2001: A Space Odyssey (theme from) "Always On My Mind," 461, 481, 499 "Amazing Grace," 432 American (studio), 318, 326–337, 376, 378, 502 "American Trilogy, An," 455, 483, 528, 566 "America the Beautiful," 599, 603 "And I Love You So," 561 Andress, Ursula, 142 "Angelica," 334 Anka, Paul, 347, 389 Ann-Margret, 147, 148, 149-154, 155, 159–161, 179, 184, 187, 490, 579, 657, 658 "Any Day Now," 337 "Are You Lonesome Tonight?," 64, 65-66, 82, 97, 107, 354 "Are You Sincere?," 511-512 Arnold, Eddy, 110, 202–203, 214, 334, 337, 381, 447, 507, 540 "Ask Me," 163 Atkins, Chet, 59, 65, 83, 228, 229, 230, 277, 328, 657 Aubrey, Jim, 393-394, 395, 406-407, 477 Austin, Gene, 64, 96, 110, 322, 669–670n Autobiography of a Yogi (Yogananda), 175, 177, 197-198 Aznavour, Charles, 259

"Baby, Let's Play House," 285 "Baby What You Want Me to Do?," 150, 275, 313, 323 Baer, Max, Jr., 125 Baez, Joan, 378 Bardot, Brigitte, 9, 15, 39 Bardwell, Duke, 523-524, 548, 562-563, 586 Barrasso, Tony, 266-267 Barrett, Rona, 261, 362, 444-445, 474 Barris, George, 125-127, 128, 139, 204, 221, 269, 568 Barrow, Tony, 211 Bassett, Terry, 386. See also Management III Bassey, Shirley, 347 "Battle Hymn of the Republic, The," 455 "Beach Boy Blues," 99 Bearde, Chris, 296 Beatles, 189, 207, 210-212, 230, 234, 294, 333, 357, 410, 420, 426 Beaulieu, Don, 36, 37, 289 Beaulieu, Paul, 36, 37, 40, 41, 52, 126-127, 140, 141, 247, 264 Beaulieu, Priscilla. See Presley, Priscilla Beaulieu Becket, 171, 183 Beckham, Bob, 460, 503 Belew, Bill, 296, 298-299, 304, 317, 343-344, 353, 366, 444, 478, 482, 532 Benner, Joseph, 175 Bennett, Tony, 39, 404 Benson, Bernard, 626-627 Berle, Milton, 108 Berry, Chuck, 162, 180, 286, 462, 522 Beyond the Himalayas, 175 "Beyond the Reef," 234, 235 Bienstock, Freddy, 262; and 1970 concert film, 382-383; and Hill and Range, 162, 164, 227, 269, 275, 380; and 1959 Paris trip, 33; and

Bienstock, Freddy (continued) Col. Parker, 447; and RCA recording sessions, 59. 82-83, 99, 227, 275, 278-280, 285, 433; and recording material, 45, 46, 64, 65, 122, 162, 164, 178, 224, 235, 237, 269, 276, 281, 286, 327, 330, 336, 378, 379, 381, 382, 502, 522, 560; and 1968 television special, 301, 306. 309 "Big Boss Man," 278, 279, 287, 522 Biggs, Delta (aunt), 246, 558, 586-587, 647, 656 Biggs, Pat (uncle), 246 "Big Hunk O' Love, A," 483 Billy Jack, 530 Binder, Steve, 294-302, 304, 305-313, 315, 316-317, 319, 324, 349 Bis, Olivia, 514 Bishop, Joey, 62 Bixby, Bill, 259 Black, Bill, 46, 215 Blackman, Joan, 103 Black Star. See Flaming Star Blackwell, Otis, 60, 124 Blackwood, James, 66, 405, 654, 657 Blackwood, Melissa, 575-577 Blackwood Brothers, 45, 450, 462, 657 Blanton, Gov. Ray, 657 Blavatsky, Madame, 177-178 "Blind Barnabus," 20 Blossoms, 309, 506 "Blowin' in the Wind," 223 Blue Belles, 34 "Blueberry Hill," 370 Blue Bird, The (Maeterlinck), 297 "Blue Christmas," 314, 320 "Blue Eyes Crying in the Rain," 596, 646 "Blue Hawaii," 99 Blue Hawaii, 91, 92, 99–100, 103-106, 121, 122-123, 147, 207, 351, 406 "Blue Moon of Kentucky," 380, 523, 661 "Blue Suede Shoes," 348

Blve, Allan, 296 Bodie Mountain Express, 587 Boone, Pat, 28, 74, 113, 125, 347 "Born Free," 348 "Born Ten Thousand Years Ago," 20, 275, 380 "Bossa Nova Baby," 162 Bova, Janice, 423 Bova, Joyce, 393-395, 423, 431, 432, 433-434, 438, 441, 446, 452, 453, 454, 455-456, 704n Boxcar Enterprises, 538. 539-540, 587, 659-660, 729n Box Tops, 328 Boyd, Pat. See West, Pat Boyd Boyer, Charles, 258-259, 459, 524, 525 Boyer, Dr. Sidney, 488, 548 Bradley, Rev. C. W., 653-654, 658, 659 Bradley, Harold, 279 Bradley, Gen. Omar, 411-412 Bragg, Johnny, 98 Brandin, Elisabeth, 23, 24 Brandin, Walter, 23 Brando, Marlon, 69, 78 "Bridge Over Troubled Water," 381, 383, 389, 452, 505, 533, 639 Briggs, David, 233-234, 378, 379, 381, 383, 522, 612, 615, 621, 624.658 Brinkley, Douglas, 637 Broidy, Steve, 187-188 Bronson, Charles, 116, 595 Browder, Bill, 471, 559 Brown, Earl, 298, 309-310, 322 Brown, Estelle, 368, 570, 571 Brown, James, 238-239, 294, 656 Brown, Jim Ed, 229 Brown, Gen. Richard J., 51 Brown, Tony, 547, 600, 612 Brownlee, Jo Cathy, 577-578, 579, 583-584 Buergin, Margit, 12, 13, 14-15, 18 Buffalo Springfield, 238 Bullock, Bill, 25, 59, 60, 61, 83, 92, 96, 112, 122 Bunkley, Bonnie, 66-67, 72, 117, 267 Burk, Bill, 6, 102, 617 Burnette, Johnny, 113

"Burning Love," 460, 461, 476, 481, 499, 566
Burning Love and Hits From His Movies, 482
Burton, James, 341–344, 364, 377, 378, 404, 458, 502, 511, 522, 586, 594, 596, 598
Burton, Richard, 171
Bush, George, 428
Butler, Jerry, 337
Buttrey, Kenny, 437
Bye Bye Birdie, 147, 149, 160

Caan, James, 568 Callahan, Mushy, 116 Camden (RCA budget label), 397-398, 442, 476, 481 Campbell, Glen, 223, 451 Cannon, Henry, 101 "Can't Help Falling in Love," 99, 367, 483, 533, 628 Carr, Vikki, 544 Carrigan, Jerry, 378, 379, 437, 438, 502, 503 Carson, Johnny, 443, 555 Carter, Jimmy, 637 Caruso, Enrico, 45, 224, 392 CBS concert special (1977), 635-639 Change of Habit, 338-339, 415 Chapin, Dwight, 418 Chaplin, George, 91 Charles, Ray, 69, 154, 278, 285, 348 Charro!, 319, 331 Chautauqua, 320 Cheiro's Book of Numbers, 613 Chesnut, Jerry, 561 Chow, David, 546 Chrisman, Gene, 328, 358, 502 Christmas in Berlin, 28. See also G.I. Blues Christopher, Johnny, 330, 336, 461, 522 Churchill, Winston, 168, 414 Circle G ranch, 252, 256, 265-266, 271, 274, 280, 282, 284, 340 Clair Brothers, 402, 403 Clambake, 254-256, 258-259, 275, 355 Clark, Dick, 48, 238, 347

INDEX v 749

Clark, Petula, 294, 296, 299 Clark, Sanford, 275, 380 Clarke, Cortelia, 229 Claypool, Bob, 607 "Climb. The." 154 closed-circuit television performance, plan for, 373-375, 407 Clovers, 232 Cocke, Marion, 581-582, 585, 586, 629, 630 Cogbill, Tommy, 328 Colclough, Christine, 534-535, 537 Cole, James P., 620, 650, 651 Cole, Dr. Leon, 509 Collins, Martha, 616 Collins, Ted, 249 Como, Perry, 561 Concert Associates, 373, 374 Concerts West, 386, 387, 407. See also Hulett, Tom Connolly, Ray, 356-357 Conrad, Robert, 125, 326-327 "Cool Water," 224 Cottrell, E. J., 12 "Country Bumpkin," 561 Craig, Yvonne, 159 Cramer, Floyd, 59, 100, 163, 229, 233, 234 Crawford, Christina, 87 Creedence Clearwater Revival, 365, 388, 402 Crosby, Bing, 99, 100, 108, 234, 241 Crosby, Gary, 125, 179 Crumbaker, Marge, 370 "Crying in the Chapel," 207, 223, 323, 672n Curtiz, Michael, 28

"Danny Boy," 45, 596, 658 Darin, Bobby, 72, 335 Davis, Mac, 228, 290, 315, 329, 330, 331–332, 359 Davis, Richard, 138, 185, 186, 211, 212, 238, 239, 262, 276, 378, 403, 411 Davis, Roger, 244, 283, 494, 564, 635 Davis, Sammy, Jr., 62, 72, 367–368 Day, Annette, 237-238 Deary, Joan, 482, 484, 502, 512, 521, 529 Death of Elvis, The (Thompson and Cole), 650 De Cordova, Fred, 206 del Río, Delores, 79 Denver, John, 386, 573 Derksen, Leo, 95 "Devil in Disguise," 207 Devore, Sv. 133 Diamond, Neil, 327, 329, 365, 595 Diddley, Bo, 112, 462 Dieu, Shirley, 590, 601, 653 Dill, Chief Art, 592 Diskin, Tom, 290; and Boxcar Enterprises, 539, 660; and Elvis' military service, 5, 28; and Elvis' movies, 106, 197; and Elvis' publishing rights, 496; and Las Vegas shows, 364, 489; and recording sessions, 59, 227, 275, 336, 502; and relationship with Col. Parker, 447, 448, 580; and television specials (1968): 294, 299 (1973): 485; and tours, 397, 402, 450, 527, 570, 598 "Dixie," 455 "Doin' the Best I Can," 70 "Dominick," 281 Domino, Fats, 69, 116, 167, 229, 285, 347, 353, 366, 462 Dominoes, 76, 116, 238, 285 "Don't Be Cruel," 348 "Don't Cry Daddy," 330, 331, 365, 397 "Don't Knock Elvis," 228 Doors of Perception (Huxley), 217 Dorsey brothers, 346 Double Trouble, 237-238, 240, 273 Douglas, Donna, 206 Douglas, Gordon, 114 "Down in the Alley," 232, 235, 533, 686n Drake, Pete, 277 Drifters, 65 Dr. Strangelove, 183, 185 Dunleavy, Steve, 608, 611, 633 Dunn, Gov. Winfield, 433 Dunne, Philip, 84, 85, 86, 89

Dvorin, Al, 397, 447, 452, 470 Dylan, Bob, 207, 223, 233, 235, 249, 337–338

Eagle Club (Wiesbaden), 32, 37 "Early Morning Rain," 432, 484 Easy Come, Easy Go, 240–243, 259, 273 "Ebb Tide." 333 Ed Sullivan Show, The, 210, 305, 324, 350 Elerding, Dr. George, 256 Ellington, Ann, 98 Ellington, Gov. Buford, 98, 280 Elliott, Maurice, 629, 648, 649, 651 Ellis Auditorium, 57, 58, 66, 89, 429, 432, 450 Elvis: That's the Way It Is, 405, 463, 464, 566, 570 Elvis: What Happened? (West et al.), 608, 611-612, 632, 633, 636, 642, 644, 646, 660 Elvis: Worldwide 50 Gold Award Hits, 397 Elvis — A Legendary Performer, 512, 529 Elvis As Recorded At Madison Square Garden, 476 Elvis For Everyone, 213–214 Elvis' Golden Records, 29 Elvis Is Back, 61, 83, 123, 180 Elvis On Tour, 465, 477, 481, 548, 709n Elvis Presley Boulevard, 253 Elvis Presley Music, 64, 285, 380, 495 Elvis Presley Youth Center, 89, 94, 98, 425 Emmons, Bobby, 328, 358 "End, The," 39 Epstein, Brian, 210, 211 Erickson, Leif, 169, 170 Esposito, Joan Roberts, 117-118, 127, 242, 261, 270, 272, 290, 296, 361, 443, 508, 653, 678n; and Ann-Margret, 150; Elvis' purchase of home for, 412; and Jerry Schilling, 204–205; at Las Vegas shows, 351, 390, 392; relationship with Priscilla,

750 🔊 INDEX

Esposito, Joan Roberts (continued) 145, 271, 291, 434, 445-446, 451, 456 Esposito, Joe, 50, 57, 67, 68, 72-73, 98, 116, 117-118, 127, 184, 219, 221, 226, 242, 262, 270, 272, 289, 290, 361, 371, 412, 443, 461, 508, 525, 546, 550, 601; and Ann-Margret, 150; and Christina Crawford, 87; and Circle G ranch, 253; as co-foreman with Marty Lacker, 196; and 1976 Colorado vacation, 588, 590; and 1967 crosscountry trip, 269; and Elvis' charity activities, 206: and Elvis' death, 647. 648, 649-650; and Elvis' funeral, 653, 654, 656, 658, 659; and Elvis' spiritual studies, 200; and Elvis' wedding, 260, 261, 263; and Follow That Dream, 114; and Dr. George Nichopoulos, 515, 528, 607; in Germany, 43, 48; and Hawaii vacations (1968): 296 (1969): 361 (1977): 627; and Jerry Schilling, 204, 205, 509; and John O'Grady, 412; and Larry Geller, 176, 182; and Las Vegas shows, 348, 353, 355, 368, 369, 384; and Las Vegas vacations (1960): 76 (1964): 167; as leader of group, 256, 257, 491; and 1960 Paris trip, 49; and Col. Parker, 62, 64, 254, 448, 529-530, 580, 632; and Presley Center Courts, 602, 605; and Priscilla, 127, 128, 456-457; and RCA recording sessions, 276, 341, 613, 619, 621; and Red West's wedding, 113; and Saraha Tahoe shows, 443; and Sheila Ryan, 536, 537, 568; and Tau Kappa Epsilon award, 81; and television specials (1960): 61-62

(1968): 295, 302, 312; and touring, 403, 404, 569, 603, 629, 645; and trip to Europe with Jerry Schilling, 509; and trip to Tupelo, 93; and *Viva Las Vegas*, 150 Evans, Malcolm, 212 Everett, Vince (Marvin Benefield), 228 Everly Brothers, 365 "Everybody Loves Somebody," 366

Fabares, Shelley, 220, 222 Fadal, Eddie, 94 "Faded Love," 380, 381 Fairgrounds, 77, 93, 113, 131, 143, 183, 185, 643 "Fairy Tale," 560 "Fame and Fortune," 60, 61, 63 fans: and Christmas radio special, 282-283; and Elvis' charity work, 97, 100-102; and Elvis' death, 649-650, 653, 654, 655, 656, 657, 659; and Elvis' Hollywood trip, 69; and Elvis' military service, 3, 5, 6, 7, 9, 15, 18, 19, 24, 28, 40, 52, 55, 56; and Elvis' recording decisions, 45; Elvis' respect for, 133-134, 193, 199–200, 207, 368, 389, 410, 600-601; fan clubs, 7, 95, 114, 245; and Graceland, 57, 340, 649; and Las Vegas shows, 391, 431, 475, 489, 504, 523, 537, 562, 578, 579, 616, 617; and Lisa Marie's birth, 289; and Miami train trip, 61; and Col. Parker, 25, 26-27, 28, 42, 61, 288, 311, 406; and Col. Parker's brother, 95; and Priscilla, 290-291; and 1960 television special, 63; and tours, 403, 565, 567, 569, 599, 607, 627, 629, 631 "Farther Along," 234 FBI, 392, 417, 425 Ferra, Sandy, 69, 70-72, 88-89, 106, 124, 150, 151, 177

Ferra, Tony, 69 "Fever," 19, 64-65, 97 Fields, Totie, 349 Fike, Lamar, 57, 68, 88, 117, 206, 284, 400, 424, 550, 586, 601; and Elvis' funeral, 658; and Elvis' health, 498; and Elvis' marriage, 261, 265-266; and Elvis' movies, 74, 106, 138; in Germany, 5, 10, 11, 13, 17, 18, 19, 22, 24, 31, 41, 43, 47, 48-49, 50; and 1968 Hawaii vacation, 296; and Hill and Range, 164, 236, 380; and 1960 Hollywood trip, 67; and Las Vegas shows, 353, 368, 398, 504, 562, 580; and Paris trips (1959): 32, 33, 34 (1960): 49; and RCA recording sessions, 60, 122, 164, 229, 236, 273, 276, 286, 329, 330, 337, 378, 380, 381, 382, 435, 522, 561; and television specials (1960): 61 (1968): 306, 312; and touring, 403 Fike, Nora, 296 Fink, Dr. Robert, 516 Finkel, Bob, 293–294, 296, 301, 302-305, 308, 309, 311, 316, 317, 693n Finlator, John, 417, 418, 420, 422, 423 First and Last Freedom (Krishnamurti), 177 First Artists, 564 First Assembly of God Church, 67, 185, 502 "First Time Ever I Saw Your Face, The," 432, 446, 455 Flamingos, 112 Flaming Star, 78–80, 89, 122 Flippo, Chet, 656 Flying Circle G ranch. See Circle G ranch Follow That Dream, 113-114, 116, 153-154, 281, 481 Fonda, Jane, 426 Fontana, D. J., 59, 61, 62, 64, 97, 163, 234, 305, 306, 307, 312, 317, 340, 377 "Fool, The," 275, 380 Ford, Susan, 589

Ford, Tennessee Ernie, 74 "For Lovin' Me," 432 Forrest, Steve, 79 Fortas, Alan, 57, 68, 98, 218, 226, 261; and Circle G ranch. 251, 253, 256, 266, 271, 274, 282; as Elvis' employee, 184, 201, 256, 270; and Elvis' military service, 14-15, 31; and Elvis' movies, 88, 311; and father's illness, 242, 245; and Judaism, 190; and Larry Geller, 173; and Col. Parker, 213; and Priscilla. 129; and RCA recording sessions, 206; and Scatter, 117; and 1968 television special, 312 Fortenberry, Lillian Smith Mann (aunt), 57, 78 "For the Good Times," 460, 465 "For the Heart," 595 Four Aces, 116 Four Fellows, 44 Four Lads, 285 Francisco, Dr. Jerry, 651-652 Frankie and Johnny, 205-206 Franklin, Aretha, 224, 343, 345, 108 "Frank Sinatra's Welcome Home Party for Elvis Presley," 3, 44, 54, 61-63 Frazier, Dallas, 404 Frees, Paul, 412, 417 "Froggy Went A-Courtin'," 383 "From a Jack to a King," 275, 333, 335 Frost, Richie, 341 Fugitive Kind, The, 115 Fulchino, Anne, 84, 106 Fulson, Lowell, 66, 285 Fun in Acapulco, 141, 162 "Funny How Time Slips Away," 381

Gabor, Zsa Zsa, 366, 533 Gambill, Gee Gee, 270, 290, 296, 313, 361, 371, 613 Gambill, Patsy Presley (cousin), 56, 67, 142, 270, 290, 296, 361, 613, 647 Gardner, Brother Dave, 32, 97 Garland, Hank, 59, 103

Garland, Judy, 224 Gary, John, 524 Geisler, Harry "The Bear," 659 Geller, Larry, 172, 221, 226, 265; and the Beatles, 211; and Charlie Hodge, 219; and Elvis: What Happened?, 636; and Elvis' friends, 246-247, 248, 256, 369; and Elvis' funeral, 653, 654; and Elvis' health, 616-617, 627, 628, 634; as hairdresser, 173, 176, 241, 258; and 1977 Hawaii vacation, 626, 627; at Jackie Wilson's show, 239; and Las Vegas shows, 510; and Dr. Max Shapiro's wedding, 621; and Col. Parker, 242-243, 246, 247, 606; and Red West, 222; as spiritual influence on Elvis, 173-177, 179, 180, 181-182, 187, 190, 191-196, 198, 199, 200, 203, 206, 209-210, 216-217, 218, 225, 257, 615, 631, 645, 646 Geller, Stevie, 183, 243 Gentry, Bobbie, 505 Ghanem, Dr. Elias, 488, 548, 551-552, 553, 580, 604, 605, 617, 630, 631, 657 Giancana, Sam, 167 G.I. Blues, 3, 33, 36-41, 63, 69-70, 73-75, 83, 89, 103, 104, 107, 123, 207, 351, 406 Gibran, Kahlil, 177, 625 Girl Happy, 178–179, 222 Girls! Girls! Girls!, 123-124, 138, 164, 207 Gladys Knight and the Pips, 228 Gladys Music, 123, 188, 380, 495 Glancy, Ken, 527 Gleaves, Cliff, 32, 48-49, 50, 57, 59, 61, 68, 88, 238, 239-240, 355, 371, 659 Godfrey, Arthur, 350 "Goin' Home," 286 Goldenberg, Billy, 296, 299-304, 307-308, 310, 315, 339 Golden Gate Quartet, 20, 45, 49, 65, 154, 230, 275, 380 Goldman, Albert, 367 Goldsmith, Joel S., 396

Gomez, Thomas, 281 Goodman, Diana, 568 "Good Time Charlie's Got the Blues," 522 Gordy, Emory, 460, 461, 499, 523 Gorsin, Dr. M. E., 256 Gospel music, 20, 80, 82-83, 84, 161, 224, 230, 273, 345, 461-462, 595 Graceland, iv, 19; and Anita Wood, 132; and Billy Smith, 545; and Dee Stanley Presley, 35-36, 64, 77-78, 80, 89, 93, 117; and Dewey Phillips, 321; Elvis' borrowing against, 597; and Elvis' homecoming from Germany, 7, 55; and Elvis' memories of Gladys, 222-223; Elvis' pride in, 58; and Elvis' wedding reception, 266-267; and fans at, 57, 340, 649; and Jaycee award reception, 429; Meditation Garden at, 215, 408, 660; and Priscilla, 139, 142, 280; and RCA recording sessions, 593, 594-596, 612, 621 Graham, Billy (director), 338-339 Graham, Billy (minister), 231, 418 Grant, Carol, 32 Grant, Cary, 347, 349, 385 Grant, Currie, 32, 37, 39-41, 72, 667n Grant, Earl, 39 Gratz, H. Tucker, 91 "Green, Green Grass of Home," 244, 344, 560 Grenadier, Anne, 215 Grenadier, Bernie, 215-216, 217, 244-245 Grier, Roosevelt, 332 Grob, Dick, 413, 547, 606, 628, 641, 657 Grossman, Albert, 249 Guercio, Corky, 443 Guercio, Joe, 383-385, 401, 431, 443, 484, 541, 588, 603, 638, 657

752 🔊 INDEX

"Guitar Man," 275, 276, 277, 278–279, 286, 287, 297, 298, 302, 303, 307, 308, 323 Gunter, Arthur, 285

Halberstam, David, 6 Haldeman, Bob, 418 Haley, Bill, 13-14, 462 Haley, Jack, 462 Hall, Rick, 377 Hallin, Per "Pete," 527 Hamilton, Roy, 45, 279, 318, 333-334, 364, 429, 569, 596, 624, 638 Hammer, Bob, 532, 550 Hance, Bill, 622 "Harbor Lights," 234 Hard Day's Night, A, 189 Hardin, Glen D., 341, 364-365, 369, 383, 384, 389, 524, 565, 586, 594, 596, 598, 658 Hardin, Ty, 125 Harman, Buddy, 59, 64, 163, 234 Harmonizing Four, 19, 45, 224 Harris, Emmylou, 586, 594 Harris, Richard, 298 Harrison, George, 211 Hart, Dolores, 209 Harum Scarum, 196-197, 203-204 Having Fun with Elvis On Stage, 538-539, 540, 551, 560 "Hawaiian Wedding Song," 105 Hawkins, Jim, 445 Haymes, Dick, 234 Hays, Lowell, 571-572, 573, 586, 62.2 Hazen, Joe, 27, 76, 108, 188-189, 214, 259, 477, 684n Hearn, Barbara, 69 "Heartbreak Hotel," 97, 313, 316 "Heart of Rome," 383 "Heavenly Father," 657, 658 Hebler, Dave, 544-545, 547, 550, 592, 604, 608, 609 Heider, Wally, 464 "He Knows Just What I Need," 83 "He'll Have to Go," 612 Helm, Anne, 114-115 "Help Me Make It Through the Night," 431, 437 Hemion, Dwight, 638

Hendrix, Jimi, 386, 628 Henley, Tish, 515, 559, 581, 605-606, 607, 627, 646, 647 Henley, Tommy, 511 Hess, Jake, 83, 227, 230, 231, 232, 234, 235, 279, 333, 343, 654, 657 "He's Your Uncle, Not Your Dad," 269 "Hey Jude," 333, 358 "Hi-Heel Sneakers," 279 Hilburn, Robert, 367, 371, 372, 375, 455, 475, 560 Hill and Range, 33, 44, 60, 65, 99, 113, 123, 162, 164, 227, 236, 269, 275, 380, 447, 495 Hilton, Barron, 442, 451, 488, 505 Hilton, Conrad, 505 Hilton Hotel, 442, 450-451, 475, 504, 505, 506, 523, 632 Hinton, Eddie, 404 "His Hand in Mine," 83 His Hand in Mine, 84 Ho, Don, 236 Hodge, Charlie, 51, 57, 68, 262, 270, 288, 289, 290, 371, 400, 424, 451, 458, 550, 576, 577; career of, 138, 219; and Elvis' death, 648, 649-650; as Elvis' employee, 221, 601, 608, 609, 611; and Elvis' funeral, 653, 654, 656, 657, 658; and Elvis' generosity, 413, 545, 636; and Elvis' health, 498, 552, 578: and Elvis' vocal technique, 45, 46; and Elvis' will, 625; and Ginger Alden, 623, 641, 645; and Hawaii vacations (1968): 296 (1977): 626; and 1960 Hollywood trip, 67; and informal singing, 19-20, 45, 48; and karate, 440-441; and Larry Geller, 177; and Las Vegas shows, 344, 346, 353, 354, 368, 385, 398, 490, 540, 578; and 1959 Paris trip, 32, 34; and Col. Parker, 209, 260-261; and Priscilla, 43; and RCA recording sessions, 65, 66,

83, 121, 122, 223, 224, 225, 227, 231, 232, 234, 236, 275, 369, 378, 437, 461, 511, 619; and television specials (1968): 298, 304, 305, 306, 312, 314 (1973): 480; and touring, 340, 403, 465, 624, 638; and U.S.S. Randall, 10, 13 Hoey, Michael, 290 Hofman, Lester, 266-267, 289, 644, 645, 646 Hofman, Sterling, 266-267, 289 Holly, Buddy, 364 Honey (poodle), 120, 139 Hong, Bong Soo, 546 "Hooked on a Feeling," 335 Hookstratten, Ed, 393, 412, 474, 499, 500, 501, 508, 513, 514, 600, 608, 632 Hootenanny Hoot, 155 Hoover, J. Edgar, 417, 423, 425-426 Hope, Bob, 76, 107, 108, 241, 294 Hopkins, Jerry, 663n "Hound Dog," 62, 97, 217, 285, 298, 316, 399 Houston, Cissy, 354 Houston Livestock Show and Rodeo, 347, 370-371 Howe, Bones, 70, 294-299, 302, 304, 306-309, 316-317 "How Great Thou Art," 227, 231, 334, 405, 431, 452, 506, 566, 569, 599, 657 How Great Thou Art, 273 How Green Was My Valley, 84 "How High the Moon," 348 Howlin' Wolf, 323 "How Much Is That Doggie in the Window?," 383 How to Live 365 Days a Year (Schindler), 58 Huffaker, Clair, 78 Hulett, Tom, 386, 387-388, 402-403, 407, 508, 527, 530, 556-557, 605, 628-629, 638, 657. See also Management Ш Hullabaloo, 294, 296 Humbard, Rex, 617, 654, 658, 723n Hunter, Ivory Joe, 285, 438

INDEX v 753

"Hurt," 333, 595–596, 599, 639 Husky, Rick, 81, 531–532, 549–550, 608 Hutchins, Chris, 201 Huxley, Aldous, 217

Ian and Sylvia, 223 "I Asked the Lord," 39 "I Believe," 45, 333 "I Believe in the Man in the Sky," 83 "I Can Help," 560 "I Can't Show How I Feel," 107 "If Every Day Was Like Christmas," 236 "If I Can Dream," 309, 316, 322, 331, 340 "If I Can Dream" (Geller), 265 "If I Loved You," 333 "If the Lord Wasn't Walking By My Side," 235 "If You Love Me (Let Me Know)," 534 "If You Talk in Your Sleep (Don't Mention My Name)," 522, 540 "If You Think I Don't Need You," 149 "I Got a Feeling in My Body," 522 "I Got a Woman," 348 "I Just Can't Help Believing," 385 Ilberman, Mel, 477, 491-494, 513, 527, 630 "I'll Be There," 335 "I'll Hold You in My Heart," 334 "I'll Remember You," 236, 478 "I'll Take You Home Again, Kathleen," 438 "I'll Wait Forever," 107, 132 "I'm Gonna Bid My Blues Goodbye," 285 "I'm Gonna Sit Right Down and Cry (Over You)," 45 "I'm Leavin'," 438 Imperials, 227, 232, 235, 236, 343, 345-346, 356, 392, 401, 437, 450, 506 Impersonal Life, The (Benner), 175-176, 177, 181, 222, 368, 409, 434, 583

"Impossible Dream, The," 348, 431, 443, 452, 704n "I'm Yours," 112, 203 "Indescribably Blue," 236, 273 "I Need Somebody to Lean On," 149, 154 Infinite Way, The (Goldsmith), 396 Ingersoll, John, 417, 418 Initiation of the World, The (Alder), 175, 183 Ink Spots, 46 International Hotel, 325, 339, 348, 354-355, 358, 361, 362, 366, 373, 375, 382, 392, 441-442, 510, 698n "In the Garden," 234 "In the Ghetto," 331-332, 335, 337, 338, 339-340, 365 "I Really Don't Want to Know," 381 "It Feels So Right," 60 It Happened at the World's Fair, 138, 143 "It Hurts Me," 164, 168 "It's Now or Never," 65, 82, 83, 97, 100, 167, 334, 344, 534 "I've Lost You," 380, 383, 397 "I Washed My Hands in Muddy Water," 381 "I Will Be Home Again," 20, 44, 66

Jackson, Chuck, 337 Jackson, Mahalia, 39 Jackson, Michael, 385 Jackson, Stonewall, 381 Jackson, Wayne, 329, 332 Jacobs, Ron, 101, 539 Jaeckel, Richard, 79 "Jailhouse Rock," 130, 348 Jailhouse Rock, 228, 298, 350, 468 James, Mark, 335, 461, 595 Jan and Dean, 125 Jarrett, Hugh, 401 Jarvis, Felton, 268, 290, 371; and Chips Moman, 338, 340, 376; at Elvis' funeral, 658; health problems of, 444, 455, 459; and Las Vegas shows, 345, 351, 369, 391; and Col. Parker, 512, 711n;

and RCA recording sessions, 228-237, 273, 274, 276-280, 326-329, 336, 358, 376-378, 380-381, 404, 432, 435-437, 455, 459-461, 502, 503-504, 510-511, 521, 522, 561, 593, 594-596, 612, 619, 621; and soundtrack recordings, 281, 285, 286–287; and 1973 television special, 482; and tours, 547, 570, 598, 624 Jarvis, Mary Lynch, 233, 277, 345, 377, 482, 561 Jaycee award, 427-429 Jayhew (spider monkey), 117 Jenkins, Harry, 213, 224, 237, 281, 287, 336, 387 Jennings, C. Robert, 201 Jessel, George, 96, 97 "Jingle Bells," 300, 562 Joel, Billy, 603 John, Elton, 603 John, Olivia Newton, 534 Johnson, Lynda Bird, 179 Johnson, Lyndon B., 108, 294, 427, 439 Johnson, Nunnally, 78 Johnson, Robert, 80, 96, 192 Jolson, Al, 322 Jones, George, 595 Jones, Jimmy, 45, 224, 227, 686n Jones, Quincy, 307 Jones, Tom, 212, 244, 291, 345, 348, 356, 410, 449, 451, 505-506, 509, 538, 544, 560 Jones, Ulysses S., Jr., 649 Jordanaires, 45, 59, 62, 65, 66, 83, 97, 100, 227, 230, 340 Jubilee Four, 154 Jurado, Katy, 281

Kahane, Jackie, 450, 453, 470, 588, 658 Kaiser, Robert Blair, 385, 386, 390, 401 Kanter, Hal, 105 karate: documentary on, 530–532, 546–547, 548–552; Elvis' study of, 6, 47, 49, 55, 60, 73, 79, 89, 157, 363, 372, 437, 440–441, 491, 497,

754 👁 INDEX

karate (continued) 498, 503, 530; in Las Vegas shows, 355-356, 385, 475, 489, 504, 540 Karger, Freddy, 155 Katzman, Sam, 153, 155-156, 157, 158, 159, 160, 196 Kawelo, Sandy. See Schilling, Sandy Kawelo Kaye, Danny, 290, 386 Kazan, Elia, 115 Keaton, Mike, 185 Keisker, Marion, 52, 133, 428-429, 469 Keister, Shane, 599, 600 Kelleher, Pat, 527 Kelly, Jack, 499 Kelly, Jim, 546 Kendall, Bob, 653 Kennedy, Caroline, 656 Kennedy, Det. Eugene, 593 Kennedy, Capt. Jerry, 411, 590, 592, 593-594, 597 Kennedy, Jerry (musician), 155 Kennedy, John F., 161, 651 Kennedy, Robert, 297 Kenpo Institute, 363 "Kentucky Rain," 329, 337, 365 Kerkorian, Kirk, 325, 347, 371, 373, 375, 442, 475 Kern, Buster, 372 Kersh, Kathy, 70 Kerwin, Alicia, 630-631, 646 Khrushchev, Nikita, 58 Kid Galahad, 116, 117 Killebrew, Capt. Bill, 117 King, Martin Luther, Jr., 297 King Creole, 4, 28, 29, 32, 87, 103, 207, 209, 350 Kingsley, James, 192-193, 224, 245, 289, 321, 335-336, 366, 386, 454 Kingsley, Jimmy, 138, 173, 182, 185 Kinney, Don, 590 Kirkham, Millie, 227, 391, 395, 570 "Kissin' Cousins," 180 Kissin' Cousins, 154–160, 164, 168, 178, 189, 204 "Kiss Me Quick," 112 Kiss My Firm but Pliant Lips (Greenburg), 290

Klein, George, 57, 262, 400, 422, 424, 471, 577, 613, 630, 641, 643; and American (studio) session, 326-327, 332-334; and Dewey Phillips' funeral, 321; as DJ, 31, 244, 637; at Elvis' funeral, 658; and Elvis' generosity, 245, 413; and Elvis' movies, 150. 238-239; and Elvis' wedding, 261; and Dr. George Nichopoulos, 254; and Jackie Wilson's medical fund, 584; and Judaism, 190; and karate, 440-441; and Las Vegas shows, 355; and Manhattan Club, 217; and Marty Lacker, 116; and tours, 402, 403 Knight, Gladys, 228 Knott, Dr. David, 516 "Known Only to Him," 83, 657 Koleyni, Dr. Asghan, 567 Krishnamurti, 177 Kristofferson, Kris, 431, 433, 437, 460 Krogh, Egil "Bud," 417-422, 703n Kubrick, Stanley, 443 Kui Lee Cancer Fund, 478, 484 Kung Fu, 530

Lacker, Marty, 226, 246, 262, 270, 355, 400, 424, 429, 601; and American (studio) session, 326-327; and the Beatles, 212; and Bernie and Anne Grenadier, 217, 245; and Christmas celebrations, 189-190, 586-587; and Circle G ranch, 271; and Elvis' generosity, 204, 574; and Elvis' spiritual influences/studies, 200; and Elvis' wedding, 260; and Jerry Schilling, 185; and Joe Esposito, 116, 242, 257; and Larry Geller, 190, 194; and 1964 Las Vegas vacation, 166; as leader, 182, 184, 187, 201, 219, 222; and

Col. Parker, 254, 256; and RCA recording sessions, 340, 522; and slot cars, 248; and Sonny West's wedding, 413, 414; and Stax Records, 502; and Vernon Presley, 215–216, 250 Lacker, Patsy, 184 Laginestra, Rocco, 372, 475, 478, 492-493, 512-513 Lake Tahoe shows. See Sahara Tahoe Landau, Dr. Laurenz Johannes Griessel, 46-47, 48 Landon, Grelun, 510, 511 Lange, Hope, 84, 88, 89 Lange, Johnny, 15 Lanning, Bob, 364 Lansbury, Angela, 103 Lanza, Mario, 224, 391, 461 La Rosa, Julius, 383 "Last Farewell, The," 576, 595 Lastfogel, Abe, 93, 96, 188, 241, 325 Las Vegas, Nevada: Elvis' shows in, 325-326, 339, 340-351, 352, 353-358, 364-370, 383-385, 388-393, 398-399, 431, 441-442, 455-456, 462, 467, 473-475, 487-489, 504, 523-524, 533-535, 537-538, 540-544, 553, 562, 578-580, 585-586, 615–617; Elvis' vacations to, 76–77, 78, 80, 115–116, 119, 129–130, 137–138, 166–168, 276, 281, 291, 362, 435, 604, 613-614, 630-631; Elvis' wedding in, 261; and Viva Las Vegas production, 149 "Lawdy, Miss Clawdy," 285, 314, 315, 323, 370 "Lead Me, Guide Me," 437 Leary, Timothy, 200, 217-218 Leaves of Gold, 136 Led Zeppelin, 386 Lee, Brenda, 37, 138 Lee, Bruce, 530 Lee, Dickey, 321 Lee, Peggy, 19, 64 Leech, Mike, 328, 330, 338 LeGault, Lance, 69, 159, 304, 312

Leiber, Jerry, 70, 121, 154, 313 Leigh, Barbara, 393-394, 395, 403, 409, 413, 433, 453 LeMay, Jeannie, 471-472 Lennon, John, 211, 212 Lester, Ketty, 233, 381 "Let It Be Me," 365 "Let Me Be There," 534 Let the Good Times Roll, 462, 466 Levitch, Harry, 162, 190, 197, 247, 261, 265 Lewin, Henri, 441-442, 447, 450, 488, 553, 579 Lewis, Donna, 636, 656 Lewis, Jerry Lee, 355, 404, 557 Lewis, Joe, 546 Lewis, Joseph, 282 Lewis, Smiley, 314 Liberace, 533 Lieberman, Frank, 367, 368, 488, 608 Lightfoot, Gordon, 433 "Like a Baby," 45 Lilley, Joseph, 100 Linde, Dennis, 460, 522, 595 Linkletter, Art, 418 Lister, Hovie, 405, 657, 658 Little, Barbara, 254 "Little Less Conservation, A," 331 Little Richard, 163, 462 "Little Sister." 112 Little Willie John, 64 Live a Little, Love a Little, 290, 293, 301, 306, 322, 331 Locke, Dixie, 77, 450, 502 Loeb, Mayor Henry, 96 Loesser, Frank, 300 Londin, Larrie, 599, 639 "Long Black Limousine," 329-330 "Long Tall Sally," 163 Lord, Jack, 482 Lost Country, The (Salamanca), 84 Louis, Joe Hill, 315 "Love Is My Business," 32 "Love Letters," 233-234, 235, 242, 381 "Love Me," 315 "Love Me Tender," 63, 264, 348, 370, 504

Love Me Tender, 25, 78, 103, 350

"Love's Not Worth It," 132 Loving You, 4, 104, 105, 209, 350 Lowery, Bill, 228, 229, 277 Loyd, Harold (cousin), 78, 643 Lynch, Mary. See Jarvis, Mary Lynch

MacArthur, James, 168, 644 "MacArthur Park," 298 MacInnes, Marion Keisker, See Keisker, Marion Mack, Lonnie, 163 MacLaine, Shirley, 72 Mad Dogs and Englishmen, 462, 464 "Make Me Know It," 60 "Make the World Go Away." 381 Malloy, Jim, 274, 276 "Mama Liked the Roses," 330, 336, 461 Management III, 386, 407, 449-450, 453, 459, 476, 527. See also Hulett, Tom, and Weintraub, Jerry Mann, Barry, 334 Mann, Bobbie, 530, 544 Mann, May, 36, 209, 222, 389 Man of La Mancha, 363 Mansfield, Rex, 5-6, 15, 19, 21, 30, 32, 33, 34, 37, 39, 47, 48-51, 57, 58-59 March of Dimes, 22, 24, 168 "(Marie's the Name) His Latest Flame," 112 Martin, Dean, 62, 72, 241, 325, 358, 366, 367, 368, 370 Martin, Tony, 45, 167 Mason, James, 563 Mata, Sri Daya. See Sri Daya Mata Mayfield, Percy, 337 Mayo, Virginia, 157 McBain, Diane, 222 McCachern, Lt. Sam, 650 McCarthy, Thomas, 639 McCartney, Paul, 21 McColl, Ewan, 432 McCoy, Charlie, 37, 277 McEvoy, Gene, 296 McEvoy, Kathy, 444 McGregor, Mike, 253, 280, 282

McGuire, Phyllis, 167 McIntire, John, 216 McLean, Don, 561 McMahon, Mike, 602, 633 McPhatter, Clyde, 45, 65, 334 McQueen, Steve, 453 Meditation Garden, 215-216, 408, 660, 684n Melvin, Bob, 450 "Memories," 315, 329, 354, 357 Memphian Theatre, 58, 131, 139, 161, 183, 215, 280, 320, 424, **47**I "Memphis," 162-163, 169, 179-180, 344 Memphis Mafia, 77, 116, 436 Meredith, Burgess, 281 "Mess of Blues, A," 60 Meyer, Dr. David, 433, 516 MGM: and concert films (Elvis On Tour): 459, 461-467, 477 (That's the Way It Is): 375, 385, 393; contract negotiations with, 27, 92, 137, 147, 152-153, 189, 214-215, 273, 322; and Elvis' movies, 132, 147, 149, 152, 155, 158, 165, 178-179, 189, 196, 203-204, 221, 237, 269, 280, 281, 285; and Col. Parker, 107 Milete, Shirl, 381 "Milky White Way," 83 Miller, Mindi, 565 Miller, Sandy, 532 Millionaire, The, 206 Mills, Gordon, 449 Mills Brothers, 46 Mirisch Brothers, 113, 116 Mitchell, Bill, 425 Mitchell, Willie, 217 Mitchum, Robert, 72 "Mohair Sam," 211 Moman, Chips, 326-338, 340, 341, 355, 357, 358, 376, 378, 381, 436, 696n Monroe, Jerome "Stump," 639 "Moody Blue," 595, 624 "Moonlight Sonata," 303 Moore, Bob, 59, 60, 64, 232 Moore, Mary Tyler, 338 Moore, Mickey, 207

Moore, Scotty, 340; and club dates, 245; and Memphis Charities show, 97, 98; and RCA recording sessions, 46, 59, 64, 65, 278, 285, 377; and television specials (1960): 61, 62 (1968): 305, 306, 307, 312, 313-314, 317 Morgan, Helen, 206 Morgan, Jane, 387 Morris, Ann, 184 Morris, Bill, 184, 190, 245, 400, 424, 425, 427, 428, 432 Morris, Bobby, 343, 346, 383 Moscheo, Joe, 356, 368, 393, 437, 450 Motion Picture Relief Fund, 206 Mott, Bitsy, 7, 95, 111, 607 Muhoberac, Larry, 341, 342, 364 Muirhead, Dr. Eric, 651–652 Munich, Germany, 22-25, 32 Murphy, Billy, 72 Murphy, Sen. George, 415, 416, 417, 423 Murray, Anne, 404 Muscle Shoals, 233, 377, 378, 404 "My Baby Left Me," 533 "My Blue Heaven," 96 "My Happiness," 65 "Mystery Train," 60, 349, 505, 661 "My Way," 440, 480, 600, 699n

Nadel, Arthur, 258 Nash, Dr. John, 581 Nashville Skyline, 338 Nathan, Paul, 259, 260 National General, 273, 282-283 National Quartet Convention, 405 Natividad, John, 532 NBC television specials (1968): 283, 288, 293-317, 322-325, 347 (1973): 475, 478-480, 481–484, 496–497, 693n Nelson, Gene, 155-159, 160, 196–197, 679n Nelson, Kris, 393 Nelson, Ricky, 125, 341, 393 Nelson, Vikki, 45 Nelson, Willie, 229, 381, 596, 646

Newbury, Mickey, 229, 455 Newman, Dr. Thomas "Flash," 393, 488, 490, 548 Newton, Wavne, 450 Nichopoulos, Dr. George, 400, 509; and Elvis' death, 648, 649, 651; and Elvis' diet, 583, 644; at Elvis' funeral, 658; and Elvis' generosity, 625; and Elvis' hospitalizations, 433, 515-516, 557-559, 629, 630; as Elvis' physician, 254-255, 355, 433, 439, 500, 519-520, 552, 584, 605, 624, 642, 644-645, 646; and Elvis' plastic surgery, 567; and Ginger Alden, 620, 641; and 1977 Hawaii vacation, 627; and Las Vegas shows, 579, 580–581; and Col. Parker, 607; and raquetball, 523, 574, 583, 602; and tours, 403, 424, 526-528, 569, 571, 572, 599, 634, 643 Nielsen, Sherrill, 506, 511, 522, 524, 527, 529, 542, 586, 635, 638 "Night They Drove Old Dixie Down, The," 378 Nixon, Richard, 400, 415-423, 426, 427, 432, 439, 477, 581, 637 Nixon, Sheriff Roy, 400, 405, 424 Nogar, Thorne, 256 "No More," 99 Norris, Chuck, 445 NRC (National Recording Corporation), 228

O'Brien, Jim, 397 O'Curran, Charlie, 104 Odets, Clifford, 84 *Odetta Sings Dylan*, 223, 233 O'Donnell, Red, 552 Ogdin, Bobby, 624 O'Grady, Det. John, 412, 499, 500, 542–543, 600, 608, 712n "Old Rugged Cross, The," 321 O'Melle, Herbie, 355 "One Night," 314, 315, 323 "Only the Strong Survive," 337, 338 On Stage — February 1970, 370 Orifice, Sal, 173 "O Sole Mio," 45, 65 Owens, A. L. "Doodle," 404

Pachucki, Al, 276, 327, 377, 379, 502, 503 Page, Patti, 104, 249, 383 Paget, Debra, 25 Paige, Janis, 107 "Paloma, La," 99 Pan, Hermes, 71 Paradise, Hawaiian Style, 207-208, 211, 221 Paramount Pictures, 4, 27, 36, 75, 92, 100, 104, 122, 124, 170, 171, 209, 259, 273 Paris, France, 32-35 Parker, Ed: and Elvis' funeral, 653; and Elvis' Hawaii vacations (1968): 296-297 (1977): 626; and Elvis' karate studies, 73, 316, 363, 445, 491, 497, 498, 530-532; and karate film, 546, 549, 550: and Las Vegas shows, 355-356, 393, 540, 542; and Col. Parker, 532, 540, 550; and Priscilla, 435; and tours, 547 Parker, Little Junior, 66 Parker, Marie (Mrs. Thomas), 64, 110, 210, 242, 249, 261, 272, 273, 397 Parker, Patricia Ann, 389 Parker, Colonel Thomas A., 90, 115, 172, 242, 272, 360, 556; and Aberbach brothers, 33; and Allied Artists, 187-188; and American (studio) session, 327; and Anita Wood, 132; and Ann-Margret, 151-152, 160; and the Beatles, 210–211; and Boxcar Enterprises, 538-539, 587, 659-660, 729n; and break with Elvis, 506–510; and Circle G ranch, 252; and concert films, 375, 382-383, 385,

405-407, 463, 465, 466, 469; Dutch background of, 95-96, 108-112, 657n, 712n; and Eddy Arnold, 110, 202-203, 214, 234, 337, 381, 447, 507, 540; and Elvis' charities, 89, 91-92, 93, 95, 96-97, 99, 101, 102, 108, 556-557, 566; and Elvis' death, 648, 654-655, 656, 657, 658, 659; and Elvis' film career, 4, 27-28, 73-75, 79, 104-105, 114, 122, 123, 133, 141, 147, 149, 152-153, 155-156, 160, 164-165, 171, 179, 188-189, 197, 222, 254-256, 259-260, 281-282, 322, 563-564; and Elvis' finances, 413-414; and Elvis' marriage, 260-261, 263-264; and Elvis' military service, 3, 4, 11-12, 25-27, 29, 43, 44, 48, 663n; and Elvis' spiritual studies, 180-181, 199, 201-203, 209-210; and Joe Esposito, 62, 64, 254, 448, 529-530, 580, 632; and karate film, 549, 550-551; and Larry Geller, 242-243, 246, 247, 606; and Las Vegas shows, 6, 343, 346-347, 350, 353, 354-355, 357, 358, 365, 366, 370, 382, 386, 389, 391, 399, 431, 441-442, 450-451, 474-475, 487-488, 505, 540, 553, 562, 579, 616; and Mac Davis, 331; and management partnership with Elvis, 4, 5-6, 20, 42-43, 50, 75-76, 82, 137, 165, 199, 203, 212-214, 224-225, 243-244, 248-250, 273, 287-288, 355, 361, 372-373, 397-398, 442, 447-449, 453, 459, 476, 484-485, 493-495, 506-510, 517, 529-530, 532, 533, 539-540, 556-557, 564-565, 579-580, 598-599, 632-633, 635, 659, 701–702n, 721n; and RCA recording sessions, 59, 60, 63-64, 65, 162, 227-228, 275, 287-288,

336, 338, 340, 377, 380, 432-433, 436, 502, 512, 522, 559, 584-585, 619, 622; and RCA Victor Records, 25-27, 44, 83-84, 235, 237, 476-477, 481-482, 491-494, 512-513, 630, 672n; and Sahara Tahoe show, 442, 444; and sale of Elvis' back catalogue, 491-496, 512-513; and Steve Sholes, 61, 83; and taking name of Thomas Parker, 110; and television specials (1960): 62, 63 (1968): 293, 294-295, 296, 298, 299, 301-302, 304-305, 306, 308, 309, 310-311, 314, 316, 317, 319-320, 322-323, 693n (closed-circuit): 373-375 (1973): 478-480 (1977): 635-636; and tours, 6, 136-137, 320, 325-326, 370-373, 386-388, 397, 398, 403, 404, 407, 449-450, 452, 453, 469-470, 499, 527, 529, 557, 565, 566, 587, 598, 600, 605, 606, 607, 611, 623, 629-630, 639; and Vernon Presley, 17, 35, 655 Parker, Capt. Thomas R., 110 Parkhill, George, 485, 501, 527, 539, 556, 557 Parry, Pat, 106-107, 150, 351 Parsons, Louella, 76 Pasetta, Marty, 478-479, 483, 484 Pasternak, Joe, 178 Patton, 411, 644 Peale, Norman Vincent, 58 Pearl, Minnie, 74, 101–102 Pello, Gene, 342 Pennington, Ann, 525-526 Pepper, Gary, 7 Pepper, Sterling, 245 Perkins, Carl, 348 Perkins, Millie, 84, 85-87 Person, Mennie, 573 Peter, Paul and Mary, 432 Peter, Paul & Mary in Concert, 223 Peters, Gerald, 414, 415, 509, 612, 616

Peters, Jon, 563-565 Phillips, Dewey, 45, 320-321 Phillips, Dot, 321 Phillips, Jerry, 321 Phillips, Knox, 321 Phillips, Sam, 52, 98, 321, 332, 347, 355, 357, 520 Piaf, Edith, 259 Pickett, Wilson, 328 "Pieces of My Life," 561 Pietrefaso, Ron, 411, 588, 589, 590, 594, 597 "Pledging My Love," 275 Poems That Touch the Heart, 9 Pointer Sisters, 560 "Polk Salad Annie," 365, 385, 533 Pomus, Doc, 60, 70, 82, 112, 121, 122, 149, 154, 162 Porter, Bill, 59, 60, 65, 83, 358, 366, 371, 670n Porter, Cole, 121 Power of Positive Thinking, The (Peale), 58 Prell, Milton, 116, 118, 261, 263, 325 Presley, Clettes Smith (aunt), 56, 191 Presley, Dee Stanley (stepmother), 14, 16-17, 31, 42, 46, 56-57, 58; and Graceland, 35-36, 64, 77-78, 80, 89, 93, 117; and Las Vegas shows, 351; marriage to Vernon Presley, 77-78, 80, 121, 139, 191, 533-534 Presley, Elvis Aron, 38, 148, 172, 226, 262, 268, 292, 318, 352, 360, 400, 430, 458, 486, 519, 554, 592, 618, 640, 662; acting career goals, 27, 50, 73-74, 78-80, 86-87, 115, 134, 143, 171, 183, 212, 281, 282, 311, 368, 468, 563-564; charity work of, 16, 22, 24, 89, 91-99, 101-103, 108, 161-162, 168, 206, 208, 245, 296, 429, 478, 484, 556-557, 566, 626; death of, 647-661, 728n; divorce from Priscilla, 474, 513-514, 541-542, 598, 630; and experiment with LSD, 217-218; honors received by, 81, 96, 98, 280, 427-429,

Presley, Elvis Aron (continued) 543, 689n; military service, 2, 3-7, 8, 9-13, 14-16, 19, 22-27, 32-35, 49, 50, 51, 52, 55-56, 350; recording career goals, 3, 25-27, 29, 44-46, 45-46, 50, 55, 64, 65, 80, 82-84, 122, 134, 143, 162, 207, 212-213, 223, 223-224, 227, 230, 231-232, 235, 236, 237, 273, 274-275, 277-278, 279, 285-288, 535; spiritual influences/studies, 173-183, 187, 190, 191-200, 203, 206, 209-210, 216-217, 222, 223, 225, 245, 257, 362-364, 396, 408, 409, 434, 440, 444-445, 513, 520, 524, 530, 559, 576, 583, 606, 613, 625, 627, 628, 631, 645; threats against, 392-393, 401, 431, 488-489; touring of, 317, 320, 373, 386-388, 401-403, 410-411, 452-453, 459, 464, 466, 469-471, 476, 478, 499, 526-528, 533, 547-548, 551, 557, 564, 565, 566-573, 587-588, 598-601, 603, 605-607, 611-612, 614-615, 623-624, 627-635, 637-639, 643, 644-646; use of amphetamines and other drugs, 21, 30, 50, 61, 72, 74, 76, 87, 115, 116, 118, 129, 131, 138, 139, 144, 167, 181-182, 186, 192, 200, 236, 240, 253-254, 256-257, 258, 287, 291, 362, 390, 434, 438, 439, 445, 446, 453, 456, 473, 474, 480, 487, 488, 498, 499-501, 504, 508, 509, 515-516, 519, 526-528, 529, 547, 555, 557, 572, 573, 578, 580, 584, 597, 605, 606, 607, 616, 628, 629, 630, 631, 634, 637, 642, 646-647, 648, 652-653; vocal technique of, 45, 65, 66, 83, 100, 112, 163-164, 224, 231-232, 233, 234, 278, 310, 382, 392, 467, 522, 534, 596; will of, 625-626 - films: Blue Hawaii, 91, 92, 99–100, 103–106, 121,

122-123, 147, 207, 351, 406; Change of Habit, 338-339, 415; Charro!, 319, 331; Chautauqua, 320; Clambake, 254-256, 258-259, 275, 355; Double Trouble, 237–238, 240, 273; Easy Come, Easy Go, 240-243, 259, 273; Flaming Star, 78-80, 89, 122; Follow That Dream, 113-114, 116, 153-154, 281, 481; Frankie and Johnny, 205-206; Fun in Acapulco, 141, 162; G.I. Blues, 3, 33, 36-41, 63, 69-70, 73-75, 83, 89, 103, 104, 107, 123, 207, 351, 406; Girl Happy, 178-179, 222; Girls! Girls! Girls!, 123–124, 138, 164, 207; Harum Scarum, 196–197, 203–204; It Happened at the World's Fair, 138, 143; Jailhouse Rock, 228, 298, 350, 468; Kid Galahad, 116, 117; King Creole, 4, 28, 29, 32, 87, 103, 207, 209, 350; Kissin' Cousins, 154-160, 164, 168, 178, 189, 204; Live a Little, Love a Little, 290, 293, 301, 306, 322, 331; Love Me Tender, 25, 78, 103, 350; Loving You, 4, 104, 105, 209, 350; Paradise, Hawaiian Style, 207–208, 211, 221; Roustabout, 165-166, 169-171, 189, 207, 240, 273; Speedway, 269, 272, 322; Spinout, 221, 244; Stay Away, Joe, 280-282, 285, 290, 322; Tickle Me, 187-188, 189, 203, 213; Trouble With Girls, The, 322; Viva Las Vegas, 147, 149-154, 159, 165, 168, 180; Wild in the Country, 83, 84-89, 122 songs sung/recorded by: "After Loving You," 275, 337; "All My Trials," 455; "All Shook Up," 97, 348; "Always On My Mind," 461, 481, 499; "Amazing

Grace," 432; "American Trilogy, An," 455, 483, 528, 566; "America the Beautiful," 599, 603; "And I Love You So," 561; "Any Day Now," 337; "Are You Lonesome Tonight?," 64, 65-66, 82, 97, 107, 354; "Are You Sincere?," 511-512; "Ask Me," 163; "Baby, Let's Play House," 285; "Baby What You Want Me to Do?," 275, 313, 323; "Battle Hymn of the Republic, The," 455; "Beach Boy Blues," 99; "Beyond the Reef," 234, 235; "Big Boss Man," 278, 279, 287, 533; "Big Hunk O' Love, A," 483; "Blueberry Hill," 370; "Blue Christmas," 314, 320; "Blue Eyes Crying in the Rain," 596; "Blue Hawaii," 99; "Blue Moon of Kentucky," 380, 661; "Blue Suede Shoes," 348; "Born Ten Thousand Years Ago," 275, 380; "Bossa Nova Baby," 162; "Bridge Over Troubled Water," 381, 383, 389, 452, 505, 533, 639; "Burning Love," 460, 461, 476, 481, 499, 566; "Can't Help Falling in Love," 99, 367, 483, 533, 628; "Crying in the Chapel," 207, 223, 323, 672n; "Danny Boy," 45, 596; "Devil in Disguise," 207; "Dixie," 455; "Doin' the Best I Can," 70; "Dominick," 281; "Don't Be Cruel," 348; "Don't Cry Daddy," 330, 331, 365, 397; "Down in the Alley," 232, 235, 533, 686n; "Early Morning Rain," 432, 484; "Ebb Tide," 333; "Everybody Loves Somebody," 366; "Faded Love," 380, 381; "Fairy Tale," 560; "Fame and Fortune," 60, 61, 63; "Farther Along,"

INDEX 👁 759

234; "Fever," 64-65, 97; "First Time Ever I Saw Your Face, The," 432, 446, 455; "Fool, The," 275, 380; "For Lovin' Me," 432; "For the Good Times," 460; "For the Heart," 595: "Froggy Went A-Courtin'," 383; "From a Jack to a King," 275, 333, 335; "Funny How Time Slips Away," 381; "Goin' Home," 286; "Good Time Charlie's Got the Blues," 522; "Green, Green Grass of Home." 344, 560; "Guitar Man," 275, 276, 278-279, 286, 287, 297, 298, 302, 303, 307, 308, 323; "Heartbreak Hotel," 97, 313, 316; "Heart of Rome," 383; "He Knows Just What I Need," 83: "He'll Have to Go," 612; "Help Me Make It Through the Night," 431, 437; "He's Your Uncle. Not Your Dad," 269; "Hey Jude," 333; "Hi-Heel Sneakers," 279; "His Hand in Mind," 83; "Hound Dog," 62, 97, 285, 298, 316, 399; "How Great Thou Art," 231, 334, 405, 431, 452, 506, 566, 569, 599; "Hurt," 333, 595-596, 599, 639; "I Believe," 45, 333; "I Believe in the Man in the Sky," 83: "I Can Help," 560; "If I Can Dream," 309, 316, 322, 331, 340; "If I Loved You," 333; "If the Lord Wasn't Walking By My Side," 235; "If You Love Me (Let Me Know)," 534; "If You Talk in Your Sleep (Don't Mention My Name)," 522, 540; "If You Think I Don't Need You," 149; "I Got a Feeling in My Body," 522; "I Got a Woman," 348; "I Just Can't Help Believing," 385; "I'll Be There," 335; "I'll Hold You in My

Heart," 334; "I'll Remember You," 236, 478; "I'll Take You Home Again, Kathleen," 438; "I'm Gonna Bid My Blues Goodbye," 285; "I'm Gonna Sit Right Down and Cry (Over You)," 45; "I'm Leavin'," 438; "Impossible Dream, The," 431, 443, 452, 704n; "I'm Yours," 112, 203; "Indescribably Blue," 236, 273; "I Need Somebody to Lean On," 149, 154; "In the Garden," 234; "In the Ghetto," 331-332, 335, 337, 338, 339-340, 365; "I Really Don't Want to Know," 381; "It Feels So Right," 60; "It Hurts Me," 164, 168; "It's Now or Never," 65, 82, 83, 97, 100, 167, 334, 344, 534; "I've Lost You," 380, 383, 397; "I Washed My Hands in Muddy Water," 381; "I Will Be Home Again," 66; "Jailhouse Rock," 130, 348; "Kentucky Rain," 329. 337, 365; "Kissin' Cousins," 180; "Kiss Me Quick," 112; "Known Only to Him," 83; "Last Farewell, The," 595; "Lawdy, Miss Clawdy," 285, 314, 315, 323, 370; "Lead Me, Guide Me," 437; "Let It Be Me," 365; "Let Me Be There," 534; "Little Less Conversation, A," 331; "Little Sister," 112; "Long Black Limousine," 329-330; "Long Tall Sally," 163; "Love Letters," 233-234, 235, 242, 381; "Love Me," 315; "Love Me Tender," 348, 370, 504; "Make Me Know It," 60; "Make the World Go Away," 381; "Mama Liked the Roses," 330, 336; "(Marie's the Name) His Latest Flame," 112: "Memories," 315, 329, 354, 357;

"Memphis," 162-163, 169, 344; "Mess of Blues, A," 60; "Milky White Way," 83; "Moody Blue," 595, 624; "My Baby Left Me," 533; "My Happiness," 65; "Mystery Train," 349 505, 661; "My Way," 440, 480, 600, 699n; "No More," 99; "One Night," 314, 315, 323; "Only the Strong Survive," 337, 338; "Pieces of My Life," 561; "Pledging My Love," 275; "Polk Salad Annie," 365, 385, 533; "Promised Land," 522; "Proud Mary," 365; "Rags to Riches," 404; "Reconsider Baby," 66, 285, 344; "Release Me," 370; "Return to Sender," 124, 162, 207; "Rock-a-Hula Baby," 99; "Run Along Home, Cindy," 380; "Run On," 230: "Save the Last Dance for Me," 112; "See See Rider," 370; "Separate Ways," 460, 481, 499; "Shake a Hand," 561: "She's Not You," 121; "She Thinks I Still Care," 595; "Snowbird," 404; "Softly As I Leave You," 524, 542; "So High," 234; "Soldier Boy," 60; "Solitaire," 595; "Sound of Your Cry, The," 380; "Spanish Eyes," 522, 524; "Stand By Me," 231; "Starting Today," 99; "Stay Away," 286; "Stranger in My Own Home Town," 337; "Stuck on You," 60, 61, 63, 69, 82; "Such a Night," 65, 97, 180; "Sunday Morning Coming Down," 433; "Suppose," 269; "Surrender," 82, 107; "Susan When She Tried." 561; "Suspicion," 121, 180; "Suspicious Minds," 335, 336, 337, 351, 357-358, 366-367, 461, 505, 534; "Sweet Angeline," 511;

- songs sung/recorded by (continued) "Sweet Caroline," 365; "Swing Down, Sweet Chariot," 97; "Talk About the Good Times," 522; "That's All Right," 97, 313, 661: "That's Someone You'll Never Forget," 112; "There's Always Me," 99, 100; "This Is the Story," 330; "Tiger Man," 315, 320, 349, 431, 505; "Tomorrow Is a Long Time," 233; "Tomorrow Never Comes," 381; "Tomorrow Night," 26; "Too Much Monkey Business," 286; "T-R-O-U-B-L-E," 561, 566; "Trying to Get to You," 314, 315; "Twelfth of Never, The," 480: "Unchained Melody," 45. 333, 624, 638; "Until It's Time for You to Go," 437, 460; "Up Above My Head," 323; "U.S. Male," 286-287; "Walk a Mile in My Shoes," 365; "Wearin' That Loved On Look," 330; "What'd I Say," 154, 278; "What Now My Love," 258-259, 480, 490, 504-505; "When My Blue Moon Turns to Gold Again," 314; "Where Did They Go, Lord?," 404; "Where Do I Go from Here?," 460; "Where No One Stands Alone," 213; "White Christmas," 65; "Whole Lotta Shakin'," 404: "Willow Weep for Me," 34; "Witchcraft," 63, 162; "Without Love," 334: "Wonder of You, The," 275, 369-370; "Working on the Building," 83; "Yoga Is As Yoga Does," 243; "You Don't Have to Say You Love Me," 381, 383; "You Gave Me a Mountain," 455, 480, 541; "You'll Be Gone," 121; "You'll Never Walk Alone," 279, 569, 624; "Your Cheatin' Heart," 26; "You've Lost That Loving Feeling," 366, 444

- television appearances: 1977 CBS concert special, 635–639; *The Ed Sullivan Show*, 210, 305, 324, 350; Frank Sinatra special, 3, 44, 54, 61–63; NBC television specials (1968): 283, 288, 293–317, 322–325, 347, 693n (1973): 475, 478–480, 481–484, 488, 496–497; plan for closed-circuit performance, 373–375, 407; ratings of, 63, 324, 496; *The Steve Allen Show*, 350

Presley, Gladys (mother), 17, 30, 35, 174, 289, 662; and Anita Wood, 132; as Elvis' confidante, 175; as Elvis' influence, 368; and Elvis' loneliness in Germany, 9–10, 42; Elvis' mourning of, 57, 67, 69, 77–78; and Elvis' recordings, 113; and Graceland, 222–223; grave of, 56, 77, 182, 190, 215, 222, 289, 644; in Shearer interview, 134; Sri Daya Mata's resemblance to, 199, 200, 221

- Presley, Jesse Garon (brother), 176
- Presley, Jessie (grandfather), 452
- Presley, Lisa Marie (daughter), 419, 430, 496, 514, 632, 655; birth of, 288–289; as Elvis' beneficiary, 625, 655, 660; and Elvis' death, 647, 649; and Elvis' fathering style, 271, 288–289, 574; and Elvis' privacy, 412; gift for, from Nixon, 423; at Las Vegas show, 541; and Priscilla, 395, 445–446, 453; at RCA recording sessions, 503, 560; visits with Elvis,

490, 502, 503, 576–577, 601, 623, 630, 643, 645

Presley, Minnie (grandmother), 51, 56, 162, 574; and Anita Wood, 107, 132; and Delta Biggs, 246; and Elisabeth Stefaniak, 16, 18, 22, 48, 59; and Elvis' childhood, 11, 22, 42; and Elvis' death, 654, 656; and Elvis' marriage, 247; and Elvis' will, 625; in Germany, 8, 10, 17, 19; and Jerry Schilling, 216; and Joyce Bova, 434; and Priscilla, 39, 42, 139, 142, 145, 474

Presley, Priscilla Beaulieu (wife), 38, 70, 120, 151, 262, 246, 407, 430, 486; and Anita Wood, 88, 127; and Ann-Margret, 154, 159–161; and Christmas party in Germany, 48; correspondence from Germany, 107; divorce from Elvis, 474, 513-514, 541-542, 598, 630; and Elvis' acting career, 212: and Elvis' death, 648-649, 653, 654, 656, 657; and Elvis' friends, 128, 129, 144, 146, 160, 219–220, 242, 247, 266, 271, 290; and Elvis' health, 600; as Elvis' "ideal woman," 144; and Elvis' recording career, 224; and Elvis' return to States, 43-44, 49, 51-53; and Elvis' spiritual studies, 179, 183, 191–192; first meeting with Elvis, 37, 39-40; in Germany, 36-44, 48-50, 51-53; gives Elvis slot-car track, 217; and Jerry Schilling, 205; and karate, 435, 440, 441, 445; at Las Vegas shows, 351, 353, 541–544; and Lisa Marie's birth, 288-289; living with Elvis, 141-147; and marriage to Elvis, 247, 260-261, 262, 263-265, 270-271, 280, 283-284, 287, 290-291, 320, 361-362, 369,

INDEX v 761

370, 372, 389-390, 394, 395, 396, 408, 413-415, 423-424, 427-429, 432, 433, 434-435, 441, 445-446, 451, 453-454, 456; and Meditation Garden, 215; and Mike Stone, 445-446, 456, 474, 489-490, 497, 542; and Rocca Place home, 219–221; separation from Elvis, 456-457, 459-460, 471, 474, 489-490, 497; and visits from Germany, 126–131, 138–141; and Viva Las Vegas production, 153 Presley, Vernon (father), 32, 93,

117, 121, 360, 371, 400, 424, 640, 662; and Anita Wood, 131–132; and automobile accident in Germany, 29–30; and Charlie Hodge, 13; and Christmas party in Germany, 48; and Circle G ranch, 274; death of, 660; and Dee Stanley, 14, 16-17, 31, 42, 46, 56-57, 58, 77-78, 80, 121, 139, 191, 533-534; and Elisabeth Stefaniak, 16. 18. 29-30: on Elvis' choice of career, 467-468; and Elvis' death, 647, 648, 649, 650, 653, 654, 655, 656, 658, 659, 660; and Elvis' finances, 75, 245, 250, 252-253, 343-344, 357, 386, 413-415, 454, 476, 493, 507-508, 510, 526, 532, 568, 572-573, 601, 603-605, 609, 625, 630, 685n; and Elvis' friends, 11, 17, 30, 166, 271, 411; and Elvis' health, 433, 519-520, 556, 627; and Elvis' marriage, 247, 264, 265, 267, 390; and Elvis' spiritual studies, 182–183, 190-191; and Elvis' will, 625; and Dr. George Nichopoulos, 500; in Germany, 8, 10, 11, 17, 30-31; and Ginger Alden. 623; health of, 558, 609, 616; and karate film, 549, 550; and Lamar Fike, 11, 17,

31; and Dr. Landau, 47; at Las Vegas shows, 351, 353, 431, 524: and Meditation Garden bill. 215-216; and Col. Parker's contract negotiations, 137; and Priscilla, 41, 127, 139, 140, 141, 142, 513; and Red West, 11, 17, 30-31; and song publishing, 496; and tours, 599, 639, 644; and trip to States from Germany, 35-36 Presley, Vester (uncle), 56, 78, 274, 322, 340, 656 Price, Llovd, 229, 285 Price, Ray, 370, 381 Prisonaires, 98 Pritchett, Nash (aunt), 656 "Promised Land," 522 Promised Land, 560 Prophet, The (Gibran), 625 "Proud Mary," 365 Prowse, Juliet, 71, 74 Psychedelic Experience, The, (Leary), 200 Putnam, Norbert, 378, 379, 382, 436, 437, 522, 523

Rabbitt, Eddie, 329, 337 Radio Recorders, 69-70, 99, 169, 178, 295 Rael, Jack, 249 "Rags to Riches," 39, 404 Rainbow Rollerdrome, 66, 67, 77, 139, 217 "Rainy Day Women #12 and 35," 223 Ramsay, Clark, 281 Randolph, Homer "Boots," 64, 97, 103, 155, 232 Rawlins, Judy, 74 RCA Record Tours, 459, 476, 478, 485, 494, 498, 501, 527, 630 RCA Victor Records: Camden budget label, 397-398, 442, 476, 481; contract negotiations with, 44, 64, 83-84, 112, 123, 137, 164, 203, 213-214, 224, 235, 242, 250,

442, 476-477, 491-494, 540,

672n, 676n, 679n; and

Elvis' military service, 4, 25-27, 29; and purchase of Elvis' back catalogue, 491-496, 512-513; recording sessions for, 3, 4, 44, 59-61, 63-66, 69, 82-83, 98, 99-100, 112, 116, 121-122, 146, 162-164, 223, 227-237, 274-280, 285-288, 326-337, 369-370, 376-382, 404, 432-433, 435-440, 459-461, 496, 499, 501-504, 510-511, 521-523, 528, 559, 560-561, 584-585, 593, 594-596, 612, 619, 621–622; soundtrack recording sessions, 69-70, 83, 84, 113, 121, 123, 136, 155, 162, 196, 237–238, 269, 275, 280, 285, 290, 293; and tours, 136-137, 388, 459, 476, 478, 494, 498, 501, 527, 630 "Reconsider Baby," 66, 285, 344 Red Velvet, 200 Reed, Jerry, 228, 275, 276-279, 280, 285-286, 297, 306, 313, 522 Reed, Jimmy, 69, 150, 521 Reese, Della, 76, 116, 167, 275, 337 Reeves, Jim, 59, 612 Reid, James, 57 "Release Me," 370 "Respect," 408 Return to Peyton Place, 74 "Return to Sender," 124, 162, 207 Rey, Alvino, 100 Rhee, Kang, 435, 440, 487, 491, 497, 498, 503, 509, 530, 546 Rich, Charlie, 211, 381, 557 Rich, John, 169–170, 240 Rickles, Don, 167 **Righteous Brothers**, 366 Riley, Billy Lee, 284 Rissmiller, Jim, 373-375 Rittenband, Judge Laurence J., 514 Rivers, Johnny, 173, 179-180, 344, 510 Robbins, Marty, 19, 455, 541 Robert E. Lee Raceway, 217 Roberts, Elliot, 552 Roberts, Joanie. See Esposito, Ioan Roberts

Robertson, Don, 70, 99–100, 112, 118, 121, 122, 162, 381 Robertson, Irene, 118 "Rock-a-Hula Baby," 99 *Rock Around the Clock*, 155 Roe, Tommy, 228, 232, 234, 377 Rogers, Jaime, 296 *Rolling Stone*, 347, 481, 656 Rolling Stones, 207, 224, 294, 374, 410 Roosevelt, Franklin D., 167–168,

670n, 680n Rosita, 95, 111 Roustabout, 165–166, 169–171, 189, 207, 240, 273 "Run Along Home, Cindy," 380 "Run On," 230 Russell, Nipsey, 443, 450 Ryan, Sheila, 526, 527, 535–537, 541, 544, 545, 548, 551, 560, 561, 563, 565, 568–569, 574–575

Sahara (Las Vegas casino), 115, 118, 129, 149, 262 Sahara Tahoe, 442-444, 497, 499, 504, 513, 517, 528-529, 553, 599-600 Sainte-Marie, Buffy, 437, 460 St. Jude Hospital, 168 Salamanca, J. R., 84 Sanders, Denis, 406, 407, 464 Sanders, Terry, 405 Sanford, Billy, 598 Sarnoff, Tom, 283, 296, 319, 477 "Save the Last Dance for Me," 112 Scatter (chimpanzee), 117, 124-125, 408 Scheff, Jerry, 341-343, 364, 389, 458, 460, 488, 499, 563, 565, 595, 596 Schilling, Billy Ray, 185 Schilling, Jerry, 204–205, 217, 218, 226, 246, 248, 262, 263, 371, 391, 400, 424, 431; and the Beatles, 212; and Circle G ranch, 253-254, 266; and 1976 Colorado vacation. 588-590; and Dewey Phillips' funeral, 321; and Elvis: What Happened?,

762 👁 INDEX

608: as Elvis' employee, 185-187, 258, 288, 289, 422-423, 590-591, 601; and Elvis' funeral, 653, 658; and Elvis' generosity, 413; and Elvis' health, 498; and Elvis' hospitalizations, 517, 558; and Elvis On Tour, 466-468; Elvis' purchase of home for, 412, 550; and Elvis' Washington trip, 414-415, 417-419, 421-422; and European vacation plans, 361; as film editor, 391, 466; as film extra, 270; and karate, 440; and karate film, 531, 548-552; and Kathy Westmoreland, 508-509; and Larry Geller, 265; and Las Vegas shows, 393, 488, 538; and Myrna Smith, 570, 589, 638-639; as new member of Elvis' staff, 185-187; and Col. Parker, 273, 448, 507; and RCA recording sessions, 231, 461; and Richard Nixon, 421-422; and Sandy Kawelo Schilling, 208–209, 216, 260; and 1968 television special, 319; and tours, 403, 603; and trip to Europe with Joe Esposito, 509 Schilling, Sandy Kawelo, 208-209, 216, 246, 253, 260, 361, 412 Schnapf, Larry, 521 Schwalb, Ben, 188 Schwartz, Sol, 407, 413, 417 Schwartz-Ableser Jewelers, 407, 413 Scientific Search for the Face of Jesus, A (Adams), 645 Scott, Vernon, 133 Seals, Troy, 561 Seamon, Kathy, 581 Sebring, Jay, 173, 174 "See See Rider," 370 See What Tomorrow Brings, 223 Self-Realization Fellowship, 197, 198, 206, 215, 221, 242, 444, 445

Sellers, Peter, 183, 212 "Separate Ways," 460, 481, 499 Seydel, Jergen, 47, 49 "Shake a Hand," 561 Shapiro, Dr. Max, 620-621 Sharp, Nancy, 88 Shearer, Lloyd, 133–136, 138, 663n "Sheila," 228 Shelton, Robert, 324 Shepard, Jan, 209 Shepherd, Cybill, 472, 473 Sheppard, T. G., 559, 587, 588 Sherman, Eddie, 478 Sherriff, Keith, 20 "She's Not You," 121 She's Working Her Way Through College, 157 "She Thinks I Still Care," 595 Sholes, Steve, 25-26, 29, 45, 59, 60, 61, 65, 66, 83, 96, 112, 122, 328 Shoofey, Alex, 325, 373, 431, 442, 447 Shook, Jerry, 436, 437, 438 Shore, Sammy, 348, 370, 431, 443 Shuman, Mort, 60, 70, 82, 112, 121, 149, 154, 162 Sidney, George, 149, 154, 679n Siegel, Don, 78, 79 Signoret, Simone, 84 "Silent Night," 16 Simerson, Kalani, 626 Simon and Garfunkel, 381 Sinatra, Frank, 54, 99, 108, 116, 261, 290, 341, 359, 381; and Elvis: What Happened?, 636; and Elvis' hospitalization, 581; and his 1960 television special, 3, 44, 61–63; and Juliet Prowse, 74; Las Vegas shows of, 325, 367, 368; and Motion Picture Relief Fund, 206; and Nancy Sinatra, 6; and Col. Parker, 241; and Snowmen's League, 108 Sinatra, Nancy, 6, 269, 275, 301, 358-359 Singer Presents ELVIS (1968 television special), 324. See also Presley, Elvis Aron, television appearances: NBC television specials (1968)

INDEX 763

Sitton, Ray "Chief," 114, 116, 185 Skelton, Red, 76 Skouras, Spyros, 84 Slamansky, Hank, 73 Sloan, P. F., 238 Sloane, Neil, 150 Smith, Beecher, 625 Smith, Billy (cousin), 57, 138, 280, 400, 424, 559, 574, 581, 590, 623, 628, 633, 642, 644, 646; and the Beatles, 211; and Delta Biggs, 246, 587; as Elvis' employee, 135, 258, 260, 270, 322; at Elvis' funeral, 658; and Elvis' generosity, 78; and Elvis' health, 631; and Elvis' hospitalizations, 567, 630; and Elvis' movies, 113, 117, 209; at Elvis' wedding, 263; and Ginger Alden, 620, 624, 641; and Graceland, 545; and Jerry Schilling, 186; and Junior Smith's death, 94-95; and Larry Geller, 177; and Marty Lacker, 184; and Col. Parker, 209, 258; and Priscilla, 219, 290; and RCA recording sessions, 619; and tours, 627, 628; and Vernon Presley, 166. 558 Smith, Bobby (cousin), 78, 321 Smith, Cal, 561 Smith, Charlie, 540 Smith, Gary, 638 Smith, Gene (cousin), 57, 117, 138; as Elvis' employee, 135, 162, 166; and Elvis' funeral, 658; and Elvis' generosity, 78; and Elvis' movies, 67, 68, 72, 105; and Junior Smith's death, 94: and Las Vegas vacations, 76, 129; and 1960 television special, 61; and Tupelo visit, 93 Smith, Jo (Mrs. Billy), 258, 567, 574, 620, 623, 624, 631, 633-634, 644, 646 Smith, Johnny (uncle), 78, 191,

322

Smith, Junior (cousin), 57, 67, 78,94 Smith, Kate, 249 Smith, Lester, 386 Smith, Louise (Mrs. Gene), 77 Smith, Maggie, 545, 625 Smith, Myrna, 345, 368, 549, 551, 570, 573, 589, 599, 603, 638-639 Smith, Roger, 657 Smith, Tracy (uncle), 191 Smith, Travis (uncle), 78, 94, 274, 321-322 Smothers Brothers, 426 Snow, Hank, 203, 285 "Snowbird," 404 Snowmen's League, 75, 108, 210, 354, 442 "Softly As I Leave You," 259, 524, 542 "So High," 234 "Soldier Boy," 44, 60 "Solitaire," 595 Something For Everybody, 99 Sons of the Pioneers, 224, 227 "Sound of Your Cry, The," 380 South, Joe, 228, 365 Spa Hotel (Palm Springs), 201, 210, 242, 243, 387, 493 "Spanish Eyes," 521, 522, 524 Speedway, 269, 272, 322 Spinout, 221, 244 Spreen, Glen, 328, 330, 335, 338, 346, 358, 436 Springfield, Dusty, 328, 381 Sri Daya Mata, 197, 198–200, 206, 221, 242, 243, 288, 362-363, 444, 445, 513 Stafford, Terry, 180 Stalin, Joseph, 195, 398 Stamps, 405, 450, 455, 458, 461, 522, 566, 570, 586, 593, 612, 613, 654, 657 "Stand By Me," 231 Standing Room Only (film/LP title), 455, 459 Stanley, Bill, 16, 31, 35 Stanley, Billy, 508, 623 Stanley, David, 529, 623, 628, 642 Stanley, Dee. See Presley, Dee Stanley Stanley, Rick, 517, 623, 642, 644, 646, 647

Stanwyck, Barbara, 169, 206 Star Is Born, A, 563 Starkey, Dr. Gerald, 589, 590, 597 Starks, Vaneese, 217, 284 Starr, Ben, 33 Starr, Ringo, 211 "Starting Today," 99 Statesmen, 19, 45, 223, 227, 654 Statler Brothers, 561 Stauffer, Jerry, 650 Stax: label, 328; recording sessions at, 502, 511, 521 "Stay Away," 286 Stay Away, Joe, 280-282, 285, 290, 322 Stefaniak, Elisabeth, 15-16, 18-19, 21-22, 29-30, 32, 43, 46, 48-49, 51, 56, 57, 58-59 Steve Allen Show, The, 350 Stevens, Ray, 228 Stoker, Gordon, 45, 83, 103, 122 Stoller, Mike, 70, 121, 154, 313 Stone, Mike, 297, 445-446, 456, 474, 489–490, 497, 542, 636 Strada, Al, 550, 641, 645, 647, 648 Strange, Billy, 274-276, 278, 290, 299-301, 306, 315, 329, 331 "Stranger in My Own Home Town," 337 Streisand, Barbra, 339, 345, 346, 347, 385, 451, 563-565 "Stuck on You," 60, 61, 63, 69, 82 "Such a Night," 45, 65, 97, 180, 228 Sullivan, Ed. 350 Summer label, 32 Sumner, Donnie, 506, 511, 522 Sumner, J. D., 405, 450, 453, 455, 458, 462, 488-489, 547, 566, 571, 586, 593, 605, 612, 613, 654, 657 "Sunday Morning Coming Down," 433 Sun Records, 52, 98, 107, 133, 234, 314, 332, 469, 593, 660 "Suppose," 269 Surber, Bob, 590 "Surrender," 82, 107 "Susan When She Tried," 561 "Suspicion," 121, 180

"Suspicious Minds," 335, 336, 337, 351, 357-358, 366-367, 461, 505, 534 Sutch, Screaming Lord, 353 "Suzie Q," 341 Swan, Billy, 560 "Sweet Angeline," 511 "Sweet Caroline," 365 "Sweet Inspiration," 343 Sweet Inspirations, 343, 344, 345, 347-348, 391-392, 458, 570-572, 599, 639 "Sweet Nothin's," 37 "Swing Down, Chariot," 20 "Swing Down, Sweet Chariot," 97

Take Me to the Fair, 132-133 "Talk About the Good Times," 522 T.A.M.I. Show, The, 238, 294 Tankers Fan Club, 7, 245 Tau Kappa Epsilon fraternity, 80-82 Taurog, Norman, 103, 123, 132, 169, 188, 207, 221, 222, 237, 269, 290 Taylor, Lt. William, 25 Tennessee Karate Institute, 530, 544 Tennessee State Legislature, 98 Tennessee State Prison, 98 Tewksbury, Peter, 281 "That's All Right," 97, 313, 521, 661 "That's Someone You'll Never Forget," 112 "There's Always Me," 99, 100 "There's No Tomorrow," 45, 46, 167 "This Is the Story," 330 Thomas, B. J., 335 Thomas, Danny, 168 Thompson, Charles C., II, 620, 650, 652 Thompson, Claude, 296 Thompson, Linda, 554; acting career of, 582, 613; and 1976 Colorado vacation, 588; and David Briggs, 615, 621, 624; and Elvis' funeral, 653, 657; and Elvis'

764 👁 INDEX

generosity, 545-546, 590; and Elvis' health, 551; and Elvis' hospitalizations, 515, 516-517, 558, 581; and Las Vegas shows, 473, 535, 578-579, 585; and Lisa Marie Presley, 601; and Palm Springs vacations (1973): 550 (1976): 603; and RCA recording sessions, 503, 560, 612; relationship with Elvis, 471-474, 480-481, 487, 489-490, 506, 508, 509, 520-523, 525, 537, 544, 552, 555, 559, 575, 582-583, 584, 604, 608, 619; and tours, 599, 614-615 Thompson, Sam, 545, 606, 628, 641, 645, 650, 656-657 Thornton, Big Mama, 285 Tickle Me, 187-188, 189, 203, 213 "Tiger Man," 315, 320, 349, 431, 505 "Tomorrow Is a Long Time," 233 "Tomorrow Never Comes," 381 "Tomorrow Night," 26 "Too Much Monkey Business," 286 "Torna a Surriento," 82 "T-R-O-U-B-L-E," 561, 566 Trouble With Girls, The, 322 Trumpeteers, 83 "Trying to Get to You," 314, 315 Tschechowa, Vera, 23-24 Tubb, Ernest, 381 Tucker, Gabe, 202, 203, 675n Tucker, Tommy, 279 "Tumbling Tumbleweeds," 224 Tupelo, 89, 93-94, 98, 182, 246, 425 Turner, Big Joe, 285 Tutt, Ronnie, 342-343, 364, 383, 443, 458, 502, 522, 523, 586, 598, 599, 639 "Twelfth of Never, The," 480 Twentieth Century Fox, 27, 78, 122 Twinkletown Farm, 251-252. See also Circle G ranch Twitty, Conway, 180 2001: A Space Odyssey (theme

from), 443, 444, 452, 533, 534

"Unchained Melody," 45, 333, 624, 638
United Artists, 108, 113, 116, 123, 189, 205, 211
United Recording (studio), 358
"Until It's Time for You to Go," 437, 460
"Up Above My Head," 323
Urquidez, Benny, 532
Urquidez brothers, 445
"U.S. Male," 286–287
U.S.S. Arizona Memorial, 91–92, 93, 95, 98, 99, 101–103, 108, 168, 208, 296, 478, 626
U.S.S. Potomac, 167–168

Valentino, Rudolph, 197 Van Kuijk, Ad, 95–96, 108–109, III Van Kuiik, Andreas ("Dries") Cornelis. See Parker, Colonel Thomas A., Dutch background of "Venice Blue," 259 Vesco, Robert, 557, 568 "Vie en Rose, La," 259 Viernon, Father, 559 Viva Las Vegas, 147, 149–154, 159, 165, 168, 180 Voice, 510, 511, 522, 524, 527, 529, 533-534, 547, 550, 552, 561, 585-586

Waite, George, 532, 550 Wakely, Jimmy, 138, 219 "Walk a Mile in My Shoes," 365 Walker, Deloss, 428 Walker, Ray, 59, 98, 285 Wallace, Bill, 445, 530, 544, 546 Waller, Gov. Bill, 566 Walley, Deborah, 222, 226 Wallis, Hal, 113, 241; and Aberbach brothers, 33; and Becket, 183; and Blue Hawaii, 92, 100, 103-106, 122-123; and budget, control of, 153; and concern about Elvis' appearance, 165, 242; and Easy Come, Easy Go, 240, 259, 273; and G.I. Blues, 3, 36-41,

INDEX v 765

73-74; and Girls! Girls! Girls!, 123-124; and Paradise, Hawaiian Style, 211; Col. Parker's negotiations with, 27-28, 76, 92, 137, 165, 188–189, 207–208, 214, 240-241, 243, 477; and Roustabout, 165-166, 169-171; and Snowmen's League, 108 Ward, Billy and the Dominoes, 76, 238 Warlick, Dan, 650-651 Warren, Charles Marquis, 319 "Wearin' That Loved On Look," 330 Webb, Jim (audio engineer), 462 Webb, Jimmy (songwriter), 290, 294, 298 Weill, Cynthia, 334 Weintraub, Jerry, 386, 387-388, 402, 407, 449, 453, 459, 476, 506, 527, 573. See also Management III Weisbart, David, 78-80 Weisman, Ben, 380 Weiss, Allan, 170, 207 Weiss, Steve, 387 Weld, Tuesday, 74, 80, 84, 88, 105 Weller, Freddy, 228 West, Judy (Mrs. Sonny), 451 West, Mae, 169 West, Pat Boyd (Mrs. Red), 81, 113 West, Red, 57, 68, 125, 218, 248, 251, 270, 371, 400, 424, 487, 519, 550, 592; and 1976 Colorado vacation, 589; and Elisabeth Stefaniak, 18, 22; and Elvis: What Happened?, 608, 611-612, 632, 633, 636, 642, 644, 646, 660; as Elvis' employee, 529, 538, 590, 598, 601, 603-605, 608-612; and Elvis' health, 498, 578, 597; and Elvis' movies, 69, 74, 116, 138, 290; and Elvis' wedding, 263, 264-265, 282, 290, 610; firing of, 603-604, 609; in Germany,

10, 11, 13, 15, 17, 19, 24, 25, 30-31; and karate, 157, 440, 530, 540, 544, 545; and Larry Geller, 183, 219, 222; and Las Vegas shows, 393, 394, 488, 489, 524-525, 540, 578; and Marty Lacker, 184; and Priscilla, 242, 456-457, 490; and RCA recording sessions, 121, 122, 149, 223, 224, 225, 227, 231, 234, 236-237, 241, 244, 254, 326-327, 460, 461, 481, 522, 560, 561, 595; and Sandy Ferra, 71; songwriting of, 112-113; and 1973 television special, 480; and tours, 403, 465, 571; and Vernon Presley, 11, 17, 30-31

West, Sonny, 124, 125, 218, 400, 451, 550, 592; and 1976 Colorado vacation, 589; and Elvis: What Happened?, 608, 612, 632, 633, 636, 642, 644, 646, 660; as Elvis' employee, 67-68, 98, 270, 439, 580, 598, 601, 603-605; and Elvis' health, 498, 597; and Elvis' hospitalizations, 517, 558; and Elvis' movies, 79, 105, 116, 138, 206, 282; and Elvis' Washington trip, 415, 418-419, 421-423; firing of, 603-604; and informal singing, 224; and karate, 440; and Las Vegas shows, 353, 393, 394, 395, 489, 505, 524; and 1960 Las Vegas vacation, 76; and Col. Parker, 507-508, 510; and Priscilla, 242; and RCA recording sessions, 595; and 1973 television special, 480, 481; and tours, 403, 547; and Tuesday Weld, 105; wedding of, 413, 414, 424

Westmoreland, Kathy, 458; at Elvis' funeral, 657, 658; and Elvis' generosity, 636; and Jerry Schilling, 508; and Las Vegas shows,

391-392, 562, 578; and Col. Parker, 539; and RCA recording sessions, 522; relationship with Elvis, 395-397, 401, 403, 408-410, 411, 453, 634; on tour, 410, 566-567, 569-571, 605, 623, 635 "What'd I Say," 154, 278 "What Now My Love," 258-259, 480, 490, 504-505 "What's New Pussycat?," 212 "When My Blue Moon Turns to Gold Again," 314 "When the World Was Young," 259 "Where Did They Go, Lord?," 404 Where Does Love Go?, 258-259, 459, 525 "Where Do I Go from Here?," 460 "Where No One Stands Alone," 213 Where the Boys Are, 178 White, Tony Joe, 365, 503 "White Christmas," 65 Whittaker, Roger, 576, 595 "Whole Lotta Shakin'," 404 Wiant, John, 11 Wiegert, Sue, 370, 562 Wilbanks, Janie, 13, 18, 59 Wild in the Country, 83, 84-89, 122 Wilkinson, John, 342, 343, 344, 364, 395, 396, 458, 599, 639 William Morris Agency, 93, 108, 201, 241, 304, 375, 494, 564 Williams, Andy, 511 Williams, Bill, 606 Williams, Hank, 156, 224, 495, 521, 611 Williams, Paul, 460 Williams, Tennessee, 115 Willis, Ellen, 349 "Willow Weep for Me," 34 Wills, Bob, 380 Wilson, Earl, 179 Wilson, Jackie, 19, 33, 116, 238-239, 333, 334, 584, 596, 687n "Witchcraft," 63, 162 "Without Love," 334

766 🔊 INDEX

Wolf, Steve, 373–375
Wolper, David, 462
"Wonder of You, The," 275, 369–370
Wood, Anita, 13, 31–32, 43, 51, 56, 57, 66, 67, 77, 88, 93, 106–107, 113, 131–132, 145, 672n
Wood, Bobby, 328, 502
Woodward, Fred, 7
"Working on the Building," 83
Working on the Building," 83
Worldwide 50 Gold Award Hits, 398
Wright, Faye. See Sri Daya Mata
Wruble, Larry, 516

Yancey, Becky, 142 "Yoga Is As Yoga Does," 243 Yogananda, Paramahansa, 175, 177, 197–198, 222 Yorke, Bob, 83, 96 "You Don't Have to Say You Love Me," 381, 383 "You Gave Me a Mountain," 455, 480, 541 "You'll Be Gone," 121 "You'll Be Gone," 121 "You'll Never Walk Alone," 45, 279, 333, 569, 624 Young, Chip, 232, 233, 277, 279, 377, 437, 503, 612 Young, Reggie, 328, 329, 331 "Your Cheatin' Heart," 26 Your Cheatin' Heart, 156 "You've Lost That Loving Feeling,' 366, 444

Zancan, Sandra, 471, 472, 473 Zenoff, Judge David, 261, 263–264 Ziegler, Ron, 427, 428 The author is grateful for permission to include the following previously copyrighted material:

Excerpts from Elvis Aaron Presley: Revelations from the Memphis Mafia by Alanna Nash with Billy Smith, Marty Lacker, and Lamar Fike. Copyright © 1995 by Talking Shakespeare, Inc., Billy Smith, Marty Lacker, and Lamar Fike. Reprinted by permission of HarperCollins Publishers, Inc.

Excerpts from *Elvis and Me* by Priscilla Beaulieu Presley with Sandra Harmon. Copyright © 1985 by Graceland Enterprises, Inc. Used by permission of Putnam Berkley, a division of Penguin Putnam Inc.

Excerpts from *Elvis and Kathy* by Kathy Westmoreland with William G. Quinn. Copyright © 1987 by Glendale House Publishing. Used by permission of Kathy Westmoreland.

Excerpts from Elvis Up Close: In The Words of Those Who Knew Him Best edited by Rose Clayton and Dick Heard. Copyright © 1994 by Rose M. Clayton and Richard M. Heard. Used by permission of Rose Clayton.

> Excerpts from *Elvis: What Happened?* by Steve Dunleavy. Copyright © 1977 by World News Corporation. Reprinted by permission of The Ballantine Publishing Group, a division of Random House, Inc.

Excerpts from "If I Can Dream": Elvis' Own Story by Larry Geller and Joel Spector with Patricia Romanowski. Copyright © 1989 by Larry Geller and Joel Spector. Used by permission of Larry Geller.

Lyrics from "Only the Strong Survive" by Kenny Gamble, Leon Huff, and Jerry Butler. Copyright © 1968 and 1969 by Ensign Music Corporation and Downstairs Music Company. Used by permission.

Excerpt from the Memphis Commercial Appeal.

Copyright © 1975 by the Commercial Appeal, Memphis, Tennessee. Used by permission.

Excerpt from The Honolulu Advertiser. Copyright © 1961 by The Honolulu Advertiser. Used by permission.

Excerpt from The Houston Post. Copyright © 1976 by The Houston Post. Used by permission.

Excerpt from The Nashville Banner. Copyright © 1976 by The Nashville Banner. Used by permission.